TENAFLY PUBLIC LIBRARY
TENAFLY, NJ 07670

TENAFLY PUBLIC LIBRARY, NJ

3 9119 05101096 8

THE AGE OF

Rubens

OVERSIZE
759.9493
RUB

Sutton, Peter C. c1

The age of Rubens

TENAFLY PUBLIC LIBRARY
TENAFLY, NJ 07670

DEMCO

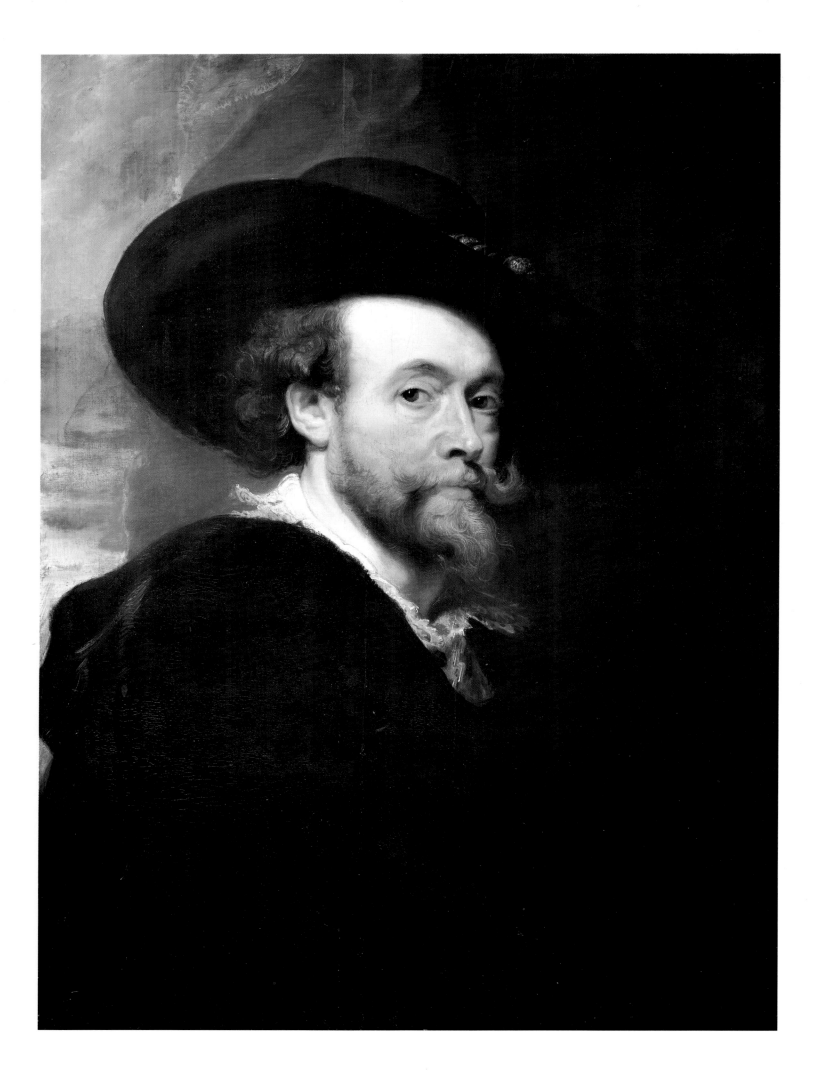

THE AGE OF

Rubens

PETER C. SUTTON

with the collaboration of MARJORIE E. WIESEMAN

and DAVID FREEDBERG, JEFFREY M. MULLER,
LAWRENCE W. NICHOLS, KONRAD RENGER, HANS VLIEGHE,
CHRISTOPHER WHITE, ANNE T. WOOLLETT

MUSEUM OF FINE ARTS, BOSTON
in association with
LUDION PRESS, GHENT

OVERSIZE
759.9493
RUB

The exhibition was organized by the Museum of Fine Arts, Boston, and was made possible by grants from the National Endowment for the Humanities and the National Endowment for the Arts, Federal agencies. Generous support was also provided by the Vira I. Heinz Endowment.

Additional support in Boston was provided by The Government of Flanders.

An indemnity has been granted by the Federal Council on the Arts and Humanities.

EXHIBITION DATES:

Museum of Fine Arts, Boston
22 September 1993 – 2 January 1994

Toledo Museum of Art
2 February – 24 April 1994

CHANGES IN EXHIBITION:

Boston only: cats. 11, 22, 28, 33, 64, 79, 95, 100, 101, 108, 109, 111, 114, 120, 125, and 129.
Toledo only: cat. 98.

COVER:

Peter Paul Rubens
Conversatie à la Mode ("The Garden of Love"),
cat. 31 (details)
Madrid, Museo del Prado, no. 1690.

FRONTISPIECE:

Peter Paul Rubens
Self-Portrait, ca. 1623-1624
Oil on panel, 86 x 62.5 cm (33 7/8 x 24 5/8 in.)
The Royal Collection © 1993 Her Majesty
Queen Elizabeth II.

Copyright 1993 by Museum of Fine Arts,
Boston, Massachusetts, U.S.A.
Library of Congress Catalogue Card No. 93-78865
ISBN 0-8109-1935-4 (cloth)
ISBN 0-87846-404-2 (paper)

Typeset in *Trinité Medium Condensed*, a type designed by Bram de Does for Enschedé en Zonen. Typesetting by Carl Zahn and Ludion Press.

Book designed by Carl Zahn

Color separations by DBL, Ghent, Belgium
Printed by Die Keure, Bruges, Belgium
Bound by Splichal, Turnhout, Belgium

Produced in cooperation with Ludion Press,
Ghent, Belgium

PRINTED IN BELGIUM

MAR 2 1 2006

Contents

Directors' Preface

ONE of the greatest achievements of Western European art, Flemish baroque painting has long been admired by the world's collectors and museum-goers. Its ravishing beauty and vitality are epitomized by the art of its greatest practitioner, Peter Paul Rubens, a man of peerless talents, versatility, and energy. Rarely has there been such a firmament of talent surrounding one central personality who so inspired his colleagues.

For the first time in the United States this exhibition gathers from the world's greatest public and private collections a representative sampling not only of the paintings of Rubens but also of his chief assistants, collaborators, and pupils, as well as examples of all of the other leading Flemish artists of the period. This exhibition offers a survey of Flemish baroque painting at the highest level of quality, while exploring the art's significance for Flemish culture and civilization. Thus it perpetuates the ongoing commitment of our two institutions to bring before the public European paintings of exceptional artistic, historical, and educational merit and significance.

As two of the leading repositories of Old Master paintings in the United States, the Museum of Fine Arts, Boston, and the Toledo Museum of Art bring rich artistic resources to this project, but it would not have been possible to mount such a comprehensive show without the extraordinary generosity of our lenders. More than seventy institutions and private collectors have temporarily foregone the pleasure of living with their paintings to have them displayed in the context of this show. For the lenders' sacrifice we are deeply grateful. The exhibition also would not have come to fruition without the largesse of our sponsors. The exhibition is supported by the United States federal funding agencies: the National Endowment for the Humanities and the National Endowment for the Arts. We also received crucial U.S. Federal Indemnification, as well as financial support from the Government of the Province of Flanders and a generous gift from the Vira J. Heinz Endowment. The Toledo showing has been generously supported by the Clement O. Miniger Foundation.

Dr. Henry L. Foster, the Chairman of the Museum of Fine Art's Board of Trustees and Mrs. Gale Guild, President, and Mr. David K. Welles, President of the Toledo Museum of Art's Board of Trustees join us in expressing our profound gratitude to the lenders and sponsors of this exhibition. We also thank Peter C. Sutton, the Mrs. Russell W. Baker Curator of European Paintings in Boston, for conceiving, selecting, and administering the exhibition and for writing substantial portions of the catalogue together with his excellent team of contributing authors. The entire staff of the Museum of Fine Arts worked especially diligently on this project during all stages of its preparation, and their counterparts in Toledo have been ideal colleagues. The installation in Toledo came under the supervision of Lawrence W. Nichols, Curator of European Paintings and Sculpture before 1900.

It is with great pleasure and pride that we welcome our visitors to this remarkable exhibition, which introduces one of the most brilliant artistic moments in Western culture and an art which speaks eloquently of the triumph of the faith, optimism, and good cheer of the Flemish peoples and culture. Though snubbed more than once in his role of diplomat for being a mere artist by training, Rubens's ardent devotion to what he called his "beloved profession" is here on display amidst all the wonderful diversity of his fellow artists' creations. They serve as a vivid reminder that most of the burning political issues, strategic alliances and obsessions with power that made the seventeenth century such a turbulent and bloody time have faded from memory or at least lost their urgency, but the passion of the art has gloriously endured.

ALAN SHESTACK
Director, Museum of Fine Arts, Boston

DAVID W. STEADMAN
Director, Toledo Museum of Art

Lenders to the Exhibition

Aachen, Städtisches Suermondt-Ludwig-Museum
Amsterdam, Kunsthandel K. & V. Waterman
Antwerp, Koninklijk Museum voor Schone Kunsten
Berlin, Staatliche Museen zu Berlin, Gemäldegalerie
Boston, Isabella Stewart Gardner Museum
Boston, Museum of Fine Arts
Bruges, Groeningemuseum
Brussels, Musées Royaux des Beaux-Arts de Belgique
Cambridge, Massachusetts, Harvard University
 Art Museums, Fogg Art Museum
Chicago, The Art Institute of Chicago
Cleveland, Cleveland Museum of Art
Greenville, South Carolina, Bob Jones University
The Hague, Rijksdienst Beeldende Kunst
The Hague, Royal Cabinet of Paintings Mauritshuis
Hanover, Niedersächsisches Landesmuseum
Hartford, Wadsworth Atheneum
Karlsruhe, Staatliche Kunsthalle
London, Thomas Agnew and Sons
London, Artemis Group
London, Richard Green Gallery
London, The Trustees of The National Gallery
London, Peter Tillou Works of Art Ltd.
Los Angeles, Collection of Daisy and Daniel Belin
Los Angeles, Los Angeles County Museum of Art
Madrid, Museo del Prado
Minneapolis, Minneapolis Institute of Arts
Munich, Bayerische Staatsgemäldesammlungen
New Haven, Connecticut, Yale University Art Gallery
New York, French & Company, Inc.
New York, Metropolitan Museum of Art
New York, Otto Naumann Ltd.
New York, collection of Saul P. Steinberg
Oberlin, Ohio, Allen Memorial Art Museum
Ottawa, National Gallery of Canada
Philadelphia, Philadelphia Museum of Art
Pittsfield, Massachusetts, The Berkshire Museum
Stiftung Schlösser und Gärten Potsdam-Sanssouci

Rotterdam, Museum Boymans-van Beuningen
St. Petersburg, The State Hermitage Museum
Sarasota, Florida, The John and Mable Ringling Museum
Seattle, Seattle Art Museum
Toledo, The Toledo Museum of Art
Vaduz, Collection of the Prince of Liechtenstein
Vicenza, Museo Civico-Palazzo Chiericati
Vienna, Gemäldegalerie der Akademie der bildenden Künste
Vienna, Kunsthistorisches Museum, Gemäldegalerie
Washington, D.C., National Gallery of Art
Würzburg, Heide Hübner GmbH

Berkeley Will Trust
The British Rail Pension Fund
Mrs. H. John Heinz III
Mr. and Mrs. George M. Kaufman
Edward Speelman Ltd.

Anonymous Private Collectors

Author's Acknowledgments

PROJECTS of this magnitude inevitably incur a multitude of debts. No single group deserves greater thanks than the lenders, and I would add my voice to the chorus of gratitude regaling sponsors. To my Directors, Jan Fontein who first approved the project, and Alan Shestack who supported it in moments of financial travail, thank you for your leap of faith.

The contributing authors to the catalogue have my abiding admiration and special thanks. None has worked more tirelessly and consistently than my co-author and good friend, Marjorie Elizabeth Wieseman. Anne Woollett not only ably assisted with the administration of the show but also contributed catalogue entries. Marci Rockoff and Regina Rudser gamefully undertook the massive chore of preparing the manuscript and attended to the exhibition's welter of correspondence. The editing of the manuscript was deftly and cheerfully undertaken by Troy Moss. Carl Zahn designed this handsome book and Peter Ruyffelaere and Paul van Calster ably looked after its production.

Many of the paintings not only in Boston's permanent collection but also being lent to the show had to be treated by the Museum of Fine Art's excellent conservation staff led by Jim Wright and assisted by Rita Albertson, Irene Konefal, Rhona MacBeth, Patricia O'Regan, Brigitte Smith, Stefanie Vietas, Jean Woodward, Kate Duffy, and Richard Newman. Andy Haines expertly framed and prepared vitrines for many of the more fragile pictures in the show. And Patricia Loiko, assisted by other members of the Registrar's office, masterfully coordinated the movement and shipment of scores of valuable works of art from more than seventy locations.

Among the official as well as informal advisers to the show, Egbert Haverkamp Begemann, David Freedberg, Christopher White, Konrad Renger, and Hans Vlieghe have been especially helpful and patient with their counsel. Otto Naumann, Simon Schama, David Freedberg, and Kristin Belkin read sections of the manuscript, caught many infelicities and improved the text. Annewies van den Hoek assisted with challenging translations from humanistic Latin and Dutch; Kristin Belkin from the German. The staffs of the Museum of Fine Arts Library and the Libraries of Harvard University, the Boston Public Library, the Frick Art Reference Library, the Rijksbureau voor Kunsthistorische Documentatie in The Hague, the Rubenianum in Antwerp, and the Witt Library at the Courtauld Institute in London were all supportive and helpful to the highest standards of their profession.

At the risk of omitting deserving people, I would also thank for their myriad contributions to the exhibition and the catalogue: George and Maida Abrams, Joost vander Auwera, Karen Baji, Arnout Balis, René Beaudette, Albert Blankert, Robert J. Boardingham, David E. Boufford, Brenda and Thomas Brod, Peter A. Brooke, Christopher Brown, Celeste Brusati, Helena Bussers, Jean Cadogan, Kim Cafasso, Alan Chong, Philip Conisbee, Charles C. Cunningham, Jr., Eva Dewes, Judy Downes, Frits Duparc, Bruce L. Edelstein, William Elfers, Adelaide Eshback, Richard Feigen, Walter Feilchenfeldt, Martin and Kate Feldstein, Jeremy Fowler, Judy Fox, Burton Fredericksen, Ivan Gaskell, Mary Gillis, Jeroen Giltay, Alain Goldrach, Steven Green, Joe Guiffre, Bob Habolt, Johnny van Haeften, Lisa Harris, Anne d'Harnoncourt, Anne Havinga, Greg Heins, John Herrmann, Roman Herzig, Richard D. Hill, Elizabeth Honig, John and Willem Hoogsteder, Bill Hutton, Chiyo Ishikawa, Katherine Johnston, Evelyn Joll, Lillian Joyce, Rachel Kaminsky, Ronda Kasl, Jan Kelch, Ian Kennedy, George Keyes, Jack Kilgore, Jennifer M. Kilian, Marijke de Kinkelder, Katy Kist, Rudiger Klessman, Wouter Kloek, David Koetser, Gerbrand Kotting, Su Ku, Darcy Kuronen, Agnes Capiau-Van Langenhove, Karin Lanzoni, Simon Levie, Walter Liedtke, Anne Marie Logan, John Loughman, Peter Manuelian, Barbara Martin, Gregory Martin, Patrick Matthiesen, Fred Meijer, Bruno Meissner, Manuela Mena, Susan Merriam, Rodney Merrington, Oliver Millar, Anne Moore, Robert Noortman, Lynn Orr, Eyk van Otterloo, George Putnam, Martha Reynolds, Joe Rishel, Franklin W. Robinson, William Robinson, Michael Armstrong Roche, Charles Roelofsz, Dr. Jose Rosado, Pierre Rosenberg, Norman Rosenthal, Pierre Rosenthal, Marjorie Saul, Erika Schneider, Ulrich Schneider, Lydia Schoonbaert, Seymour Slive, Martha Small, Janice Sorkow, Anthony and Edward Speelman, Leo Steinberg, David Steele, Jennifer Stern, Renate Trnek, Ana L. Troncoso, Evan Turner, Roman R. Vanasse, O. Praem., Eric Vandamme, Kerry Voss, Guy de Vuyst, George Wachter, John Whately, Matthew and Susan Weatherbie, James Welu, Arthur Wheelock, Sue Whithouse, Uwe Wieczorek, Gertrude Wilmers, Adam Williams, Gilian Wohlauer, Martha Wolff, Eric M. Zafran, and Martin and Henry Zimet.

In recognition of his many enduring contributions to the study of Rubens and Flemish art, we dedicate this catalogue to Julius S. Held. And for providing personal moral support in the home, where in Rubens's own words this author has been "much contented," my love to Bug, Page, and Spencer.

Curator's Preface

THE first international loan exhibition ever mounted in the United States to survey Flemish baroque painting, *The Age of Rubens* seeks above all to present the quality and diversity of this achievement. As the most creative artist of the period, Peter Paul Rubens justly occupies central stage, but the show also explores the art of his chief pupils and collaborators (notably Anthony van Dyck, Jacob Jordaens, Jan Brueghel the Elder, and Frans Snyders) and each of the painting specialties refined by Flemish artists; in addition to history painting, sections of the exhibition are devoted to portraiture, still life, animal painting, genre, and landscape.

This catalogue not only addresses the individual objects but also explores the historical context of the art. Its essays examine the role of painting in the Counter Reformation and its importance for the culture and society of the Southern or Spanish Netherlands. Among other issues addressed are the relationship of Flemish painting to the humanist and classical traditions, the forces of patronage and the marketplace, studio practices, art theory, and the physical process of picture making. A special feature of the exhibition is its examination of the collaborative and corporate nature of much Flemish art; many paintings in the show were executed by more than one artist/specialist. The willingness of Flemish painters to collaborate, working as it were in "double harness," challenges modern assumptions about artistic individuality and originality. Selected on the premise that paintings of the highest quality are the most historically representative and eloquent, the show is comprised of works of acknowledged excellence as well as paintings whose merits may have been overlooked.

The *Age of Rubens* traces the origins and development of the prevailing styles and themes of Flemish baroque painting, specifically as they relate to the religious and secular concerns of the era. The triumph of this art was to fashion a new form of painting that was neither a mere graft on the indigenous naturalistic tradition, which would flourish just to the north in Holland, nor a slavish adaptation of the international classicism exported from Italy, but an innovative amalgam of the two, with its own unique combination of vitality and grandeur. This new vision had a special relevance for all levels of society. Powerful incentives for baroque painting were provided by the official patronage of the Counter Reformation; altarpieces and other religious decorations were ordered in unprecedented numbers by the Church, foreign princes, and the Roman Catholic court. However, Flemish artists also worked for secular patrons – guilds, confraternities, magistrates, and wealthy burghers – as well as the open market. A great variety of new representational practices arose to fulfill devotional and other expressive needs no longer satisfied by older artistic conventions.

At its core, Flemish baroque painting also presents a famous art historical anomaly: whereas most great movements of art occur during periods of growth, Flemish seventeenth-century art flourished amidst war, foreign domination, social diaspora and relative economic stagnation. Paradoxically, while the art of Rubens and his contemporaries expressed optimism, health, sumptuous well being, intellectual curiosity and excitement, during his career his homeland saw diminished or contracting expectations and economic decline. For some critics Rubens has even seemed a false representative of the national patrimony – the lush hothouse product of an international array of elite patrons. However for other viewers his development has made him the standard-bearer of a spiritual renewal and dynamism that inspired his country until well into the nineteenth century. There can be no simple mechanistic explanation of cultural life, but a closer examination of the economic and social history of the period reveals a brief reprise from hardship just preceding and during the time of the Twelve Year Truce which brought a new national promise. A vital factor in this efflorescence was the surge in official patronage. The sumptuous and dignified court of the archdukes favored a few court painters, but more important was the Catholic restoration that infused all aspects of culture and daily life. The forces of the

Counter Reformation transformed the Spanish Netherlands into one of the most fervently Catholic nations on earth. Religious orders multiplied and, especially under the Jesuits, infused all levels of education. While strict orthodoxy was enforced in curricula and a censorious eye cast upon expressions of free thought, intellectual life in Flanders and Brabant nonetheless remained vital. Antwerp became a major center of religious publishing and the court in Brussels a cosmopolitan refuge for persecuted Catholics. Indeed it is a testament to the national promise that in 1609 Rubens chose to remain in the country rather than return to his beloved Italy.

The official spiritual charge to Rubens and his colleagues was to fashion a new art that would at once edify, convert, and arouse ever greater religious fervor. Paradoxically, the same Church that had tried to defeat and discredit the humanists also sought to fuse the spirit and ideals of the Renaissance with their own religious and cultural imperatives. Rubens and his fellow painters responded triumphantly not only with a new Counter Reformation iconography (particularly stressing the Passion, the Immaculate Conception, and the Assumption of the Virgin, as well as the sacrament of the eucharist and the doctrine of transubstantiation) but also a formal language that revived and vitalized classical form. The result was the most militantly religious art in Europe.

To complete his many commissions for individual works as well as vast decorative programs, Rubens employed a large group of assistants in his studio. In so doing he not only followed the practices of earlier Italian but also Flemish painters, such as Frans Floris (1519/20-1570). Many of the best Flemish artists of the day either worked for Rubens or collaborated with him. He directed and orchestrated their collective efforts with his own designs. The workings of Rubens's studio are examined in this show through the many examples of his oil sketches and modelli, which served to guide his assistants and collaborators. These practices enabled Rubens to personally direct, foster, and unashamedly profit from the skills and specialties of his assistants. However, Rubens was scarcely the only artist to collaborate with other painters; as the many paintings in this exhibition by more than one artist attest, collaboration was a conspicuous feature of virtually all branches of Flemish baroque painting. The fact that no previous exhibition has chosen to explore this fascinating phenomenon perhaps relates to the fact that a collaborative or corporate art is anathematic to modern ideals of creativity, which celebrate in painters (as opposed, for example, to cinematists) the individual genius. Indeed the critical storm that has recently arisen over the suggestion that Rembrandt also employed a large studio of assistants whose works in his manner have over the centuries accreted to and obscured the autograph œuvre tends to support these presumptions: the brooding and querulous Rembrandt of legend has better conformed to the nineteenth century's romantic notion of the artist as individualist than Rubens's public persona. That the diplomatic, impeccably social, and well-adjusted Rubens was also a brilliant manager has always been accepted more readily. Yet the vitality of many of the shared and seamless products of his studio is a testament not only to Rubens's organization skills and ability to personally educate and inspire, but also to the pervasive and peculiarly Flemish genius for specialization and collaboration. Even more than their brethren, the Dutch, the Flemish made a virtue of their readiness to specialize and cooperate in working together.

This exhibition, therefore, seeks not only to reveal Rubens's role as an artistic impresario and "prime mover" among his countrymen, but also to place him in the larger context of the extraordinary achievement of Flemish painting – an achievement still often underrated, especially in this country. While exhibitions of Flemish baroque painting appear regularly in Europe, it has been forty years since the topic has been addressed in a substantial way in an English-speaking institution (London, Royal Academy, 1953-54) and as we have noted, no major show has ever been mounted in the United States.

Another indicator of the low esteem currently accorded Flemish painting (other than works by Rubens, van Dyck, Jan Brueghel, and a few select still-life painters) is the modest prices these works receive relative to other Old Masters, not to mention impressionist or twentieth-century art. This show also seeks to redress a curious modern skepticism about Rubens and Flemish art generally. Although Rubens has always had his detractors (beginning at least with the eighteenth-century biographer Descamps, and expressed with particular malice by nineteenth-century realist painters, such as Thomas Eakins), the list of artists who paid homage to Rubens comprises an impressive role of honor – Watteau, Constable, Delacroix, Renoir, Cézanne, Picasso, and de Chirico, to name but a few. Also poets, from Baudius to Goethe, as well as scholars have

never been reticent with their praise. But in the late twentieth century Rubens and Flemish art, particularly for American audiences, is an acquired taste. Only superficially is this aversion related to modern canons of proportion - the taste for the skeletal fashions of *Vogue* or the angst and anorexia of Egon Schiele; after all, Rubens himself, in his unpublished treatise on antique sculpture, berated his contemporaries for neglecting physical fitness and falling short of the ancients' ideal of the classical human form. More fundamental is the skepticism and unease felt by viewers in our highly secularized, egalitarian age when presented with devout and hieratic art, spiritually informed and proselytizing painting, art at the service of organized religion and the state. Contemporary sensibilities treasure instead the private artistic statement, its idiosyncrasy and traces of individual emotion. In such a solipsistic climate, baroque art's celebration of the exterior aspect of gesture, of the shared ideals of authority, society, and faith can be misconstrued as mere grandiloquence or bombast. Yet this generous rhetorical language can speak again with a universal grandeur and eloquence. *The Age of Rubens* is dedicated to making this language intelligible once more, and to making Flemish baroque painting more accessible and meaningful for modern museum visitors.

In surveying the extensive artistic territory under consideration, it will be convenient to begin our reconnoitering in the field of history painting, which, as we shall see, not only was regarded by seventeenth-century art theorists as the most elevated subject matter but also the one which ideally engaged and subsumed all the other genres. This section includes introductions to the three most accomplished history and figure painters of the era, namely Rubens, Anthony van Dyck, and Jacob Jordaens, before considering the other major thematic specialties of Flemish baroque painters - scenes of everyday life, portraiture, landscape, still life, and animal painting.

Cross-references to essays in this catalogue are by the author's last name, with the exception of Sutton, "Introduction: Painting in the Age of Rubens" (Introduction); and Sutton, "The Spanish Netherlands in the Age of Rubens" (History).

PCS

Fig. 1. Marten de Vos, *Virgin and Child Welcoming the Cross*, ca. 1600, oil on panel, 112 x 88.5 cm, private collection, on loan to the Worcester Art Museum.

Introduction:
Painting in the Age of Rubens

Late Flemish Mannerism and Early Classicism: Traditions and Transitions

HISTORY PAINTING in the Spanish Netherlands during the years between the Catholic Restoration of Antwerp in 1585 and Rubens's return from Italy in 1608 largely perpetuated inherited styles and traditions, but also anticipated aspects of the pictorial triumph that followed.[1] The leading artist at the beginning of this period was Marten de Vos (1532-1603), who had trained with Frans Floris (1519/20-1570), the most influential Antwerp history painter of the mid-sixteenth century. De Vos also reaped lasting benefits from his sojourn in Italy (1552-1558), where he had worked briefly with Tintoretto in Venice.[2] A mature painting like the *Virgin and Child Welcoming the Cross* of ca. 1600 (fig. 1) well illustrates de Vos's late mannerist style.[3] The restive, decoratively animated figures, the complex architectural vistas to adjacent spaces, and the deeply saturated hues and enameled surfaces are all characteristic of his late style. Typical too is the subject matter and its treatment. While de Vos had been a Lutheran, like many of his countrymen he converted to Catholicism and answered the Counter Reformation's call for an art that could revitalize pictorial traditions according to new post-Tridentine doctrine. Themes of Christ's infancy were time-honored subjects, and the Christ Child with the Cross was a traditional allusion to the Crucifixion in the series depicting the Seven Sorrows of Mary. However in representing the infant Christ turning away from his mother's breast to welcome the cross borne overhead by angels, de Vos stresses Christ's willing acceptance of his sacrifice, a notion promoted in Catholic teachings, particularly those of the Jesuits. In devotional meditation, Ignatius of Loyola emphasized the faithful's personal identification with and joyful acceptance of Christ's Passion.

Many of the monumental and colorfully decorative features of de Vos's art were taken up by his pupil Hendrick de Clerck (ca. 1560/70-1629), who in 1594 became court painter to Archduke Ernest in Brussels and later served in the same capacity under the Archdukes Albert and Isabella.[4] Although Flemish late mannerist painters never attained the level of complexity or artifice achieved by the Rudolfine (Bartolomeus Spranger, Hans von Aachen, et al.), Haarlem (Hendrick Goltzius, Karel van Mander, and Cornelis Cornelisz.) or Utrecht (Joachim Wttewael and Abraham Bloemaert) practitioners of this style, the dense composition and the elaborate poses of a work like de Clerck's *Moses Striking the Rock at Mara* ca. 1590 (fig. 2) make a conspicuous show of formal torsions and exaggeration that are wholly in the mannerist spirit. The subject of this painting, like other Old Testament themes which gained favor at this time, typically revives the medieval tradition of Christological prefigurations recommended by the Council of Trent; the shepherd and savior of his people, Moses was an important forerunner of Christ, and the spring that he created was regarded as a prefiguration of the sacramental waters of the Christian baptism. Old Testament prefigurations remained a prominent feature of Counter Reformation iconography, figuring for example in Rubens's decorative cycle for the ceiling of the Jesuit church in Antwerp (see cat. 19).

Among the other notable late mannerist history painters are the so-called Francken Group – Hieronymus Francken the Elder (1540-1610), Frans Francken the Elder (1542-1616), and Ambrosius Francken (1544-1618)[5] – and the long underestimated but accomplished Jacob de Backer (ca. 1540-ca. 1595), who worked in an Italianate (Florentine-Roman) manner.[6] These artists perpetuated various conservative forms of late mannerism well into the early years of the seventeenth century.

More progressive and influential proved to be the contemporary efforts of Rubens's teacher, Otto van Veen (Otto Vaenius; 1556-1629), who advanced a stolid new form of classicism character-

ized by an unprecedented stillness and substance.[7] Born in Leiden, van Veen moved to Antwerp at an early age with his family, who remained loyal to the Catholic Church and their Spanish sovereign. Like his brilliant pupil, van Veen early experienced life at court as a page, and was later apprenticed to the noted humanist and artist, Domenicus Lampsonius (1532-1599), who no doubt piqued both his artistic and literary interests. Ever aspiring to be the *pictor doctus*, van Veen later was the author of several emblem books. In his art he absorbed not only the Romanist tradition of Floris, but also the more decoratively animated Italian mannerism of Federico Zuccaro, to which he was exposed during a trip to Rome in 1575. In 1587 he entered the service of Alexander Farnese at the Court in Brussels and later also received portrait commissions from Albert and Isabella. Like Rubens, he returned to Antwerp when awarded the privilege in 1589/90 of serving in absentia as "painctre de l'hostel" to the archdukes. Conceived as a processional with biblical and allegorical figures, the *Triumph of the Catholic Church* (fig. 3) shows all the power, authority, and dogmatic earnestness of van Veen's heavy art. Rubens was his pupil possibly as early as 1594/95 to 1598,[8] but no doubt recollected the *Triumph* decades later when he conceived his great tapestry cycle, the *Triumph of the Eucharist* (ca. 1625-1627; see cats. 21 and 22), portions of which employ the same processional convention.

In addition to substantial altarpieces, van Veen also painted elaborate allegories with mythological figures, like his *Allegory of the Temptations of Youth* (fig. 4) (inscribed: *typvs inconsvlte ivventvis*, "image of thoughtless youth") which depicts a young man tumbled to the ground by Cupid and Venus, who sprays a stream of milk from her breast at his mouth, while Bacchus extends a shell full of wine toward him. Their assault is countered by the god of Time, who restrains Venus, while Minerva, goddess of Wisdom, deflects the stream of milk. The painting expresses an obvious moral message. In dwelling on the struggle between sin and virtue, between human lusts and appetites, and chastity and abstemiousness, the work expresses a spirit of stoic restraint and reason that Rubens later often adopted in his own allegories.[9] The greater animation of this allegory relative to the *Triumph* (fig. 3) shows that while van Veen's personal artistic instincts favored a static ponderousness he could energize his figures when the subject called for it.

Remembered primarily for having served as the teacher of both Rubens (ca. 1593-94) and Jacob Jordaens (ca. 1607-1610), Adam van Noort (1562-1641) left very little if any detectable stylistic influence on his two august students, but presumably helped teach them and dozens of other pupils the mechanics and craft of the painter's trade.[10] A Calvinist, van Noort like so many of his fellow citizens of Antwerp found it expedient to convert to Catholicism in 1586, but, like his future son-in-law, Jordaens, probably retained strong Protestant sympathies. He became a member of the guild in 1587 and his earliest dated painting is of 1601 (*John the Baptist Preaching*, Rubenshuis, Antwerp). By this point van Noort had developed a rather flaccid and summary style in cabinet-sized history paintings. After ca. 1609-1610, no doubt in response to Rubens's art after his return to Antwerp, he began to execute more colorful, large-scale paintings with substantial figures, bland derivations of the prevailing classicism (see, as examples, the versions of *Let the Children Come unto Me*, in the museums in Brussels, inv. nos. 363, 4703; and Mainz, cat. 1962, no. 121). The influence of Jordaens also is evident in his later works.

A far more original and trenchantly plastic classicism was developed around 1605-1607 by an Antwerp painter who was nearly a generation younger than either van Veen or van Noort. Abraham Janssens's (ca. 1574-1632) importance for seventeenth-century Flemish painting has surely been underestimated. He was the most talented history painter active in Antwerp during the years immediately preceding Rubens's return from Italy. Janssens perfected his own forceful new style with large, monumentally conceived figures of an unprecedented sculptural solidity, but with a capacity for graceful movement. His earliest dated painting, the *Diana and Callisto* of 1601 (Budapest, Szépmüvészeti Múzeum, no. 51.797[11]) still is conceived in the tradition of late mannerist art, recalling more diminutive paintings by Hans Rottenhammer (1564-1625) or even Paolo Fiammingo. However the figures already display a new and vaguely pneumatic buoyancy that has more in common with the art of Jacopo Palma than that of any Northern artist. By 1605 Janssens had achieved a greater plasticity, stronger contrasts of light and shade, and a new brilliance of color (see the *Adoration of the Magi*, dated 1605, formerly C. Mostaert, Roermond[12]). With a less crowded and more subdued composition, the *Saint Luke Altarpiece* of 1606 (St. Rombouts, Mechelen[13]), and the gracefully resolved and monumental *Raising of Lazarus* dated 1607 (Munich, Bayerische Staatsgemäldesammlungen, on loan to Staatsgalerie, Schleissheim, no. 153[14]) consoli-

date the artist's progression toward a new classicism. Janssens's new style may owe something to Caravaggio in its strong contrasts of light and shade but formally is closer to the Carracci and Bolognese painting. Indeed in some of his later paintings the palette and touch can resemble Domenichino's. The *Hercules and Omphale*, also dated 1607 (fig. 5[15]) resolves its athletic composition with far greater confidence and agility than, for example, van Veen's only slightly earlier allegory (fig. 4). The subject is the playfully erotic story told by Ovid (*Fasti* II: 303-358), in which Hercules successfully seduced the Lydian queen with wine, kicking the pesky Pan out of their bed, in effect assuming the lascivious fawn's role. Hercules' blindly obsessive love for Omphale threatened to emasculate the hero; a more commonly depicted episode from their love story shows the two figures reversing the attributes of their gender roles (see also fig. 10). For the seventeenth century, the debasement and humiliation of Hercules, usually an exemplar of virtue, carried a clear moral warning against the destructive potential of lust.

Janssens's *Allegory of the Scheldt River and Antwerp* (History, fig. 7) is known to have been executed around 1609-1610, since it was described as the "schilderije genaempt Scaldis" (a painting named Scaldis) in the Antwerp magistrate's invoice dated July 1610.[16] With its reclining river god the composition anticipates aspects of the *Dead Christ with Angels* (cat. 3), the design of which in all likelihood was first conceived at this time, but this particular version was probably painted later in the 1610s. Also dating from about 1615-1617, the *Origins of the Cornucopia* (cat. 4) illustrates the master's muscular clear forms, and colorful light-toned mature style. The subject further attests to Janssens's ongoing interest in relatively rare mythological themes.

Fig. 2. Hendrick de Clerck, *Moses Striking the Rock at Mara*, ca. 1590, oil on panel (octagonal), 86.3 x 86.3 cm, Montreal, Musée des Beaux-Arts, inv. 1969.1624.

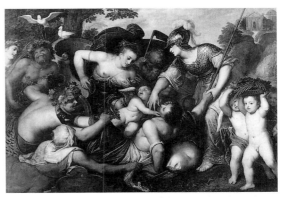

Fig 4. Otto van Veen, *Allegory of the Temptations of Youth*, oil on canvas, 146 x 212 cm, Stockholm, Nationalmuseum, inv. NM 666.

Fig. 6. Abraham Janssens, *Mary Magdalene*, oil on panel, 123 x 93.5 cm, Munich, Bayerische Staatsgemäldesammlungen (on loan to Schleissheim, Staatsgalerie), inv. no. 1762.

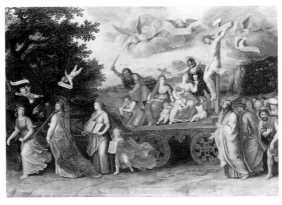

Fig. 3. Otto van Veen, *Triumph of the Catholic Church VI*, oil on panel, 76 x 106 cm, Munich, Bayerische Staatsgemäldesammlungen, inv. 812.4859.

Fig. 5. Abraham Janssens, *Hercules and Omphale*, 1607, oil on canvas, 150 x 190 cm, Copenhagen, Statens Museum for Kunst, inv. no. 347.

The artist's densely compacted, half-figure compositions constitute a separate group. They are difficult to situate chronologically, but few seem to predate ca. 1610, and again owe more to northern precedents (Jan van Hemessen, Jan Massys, Frans Floris, Abraham Bloemaert, and, of course, Rubens) than to Caravaggio. The splendor and coloristic opulence of these works is especially well appreciated in Janssens's *Mary Magdalene* in the Staatsgalerie, Schleissheim (fig. 6), which may date from the early 1620s.[17] Also from the 1620s are several handsome bucolic outdoor scenes which Janssens executed in collaboration with the landscapist Jan Wildens (1586-1653); see, for example, the *Venus and Adonis* (Kunsthistorisches Museum, Vienna, no. 728) and *Noli me Tangere* (with Galerie d'Arenberg, Brussels, 1990[18]).

Kleinmeisters: Jan Brueghel the Elder, Hendrick van Balen, and Frans Francken II

Among those painters whose artistic careers were underway before Rubens made his mark in Antwerp, there were in addition to figure painters of large-scale religious and mythological themes several very talented specialists in cabinet-sized history paintings. The most accomplished of these were Jan Brueghel the Elder, Hendrick van Balen (qq.v.), and Frans Francken II (1581-1642). Son of Pieter Bruegel the Elder, the famous "peasant painter," Jan the Elder was one of the most extraordinarily versatile and gifted Flemish painters of his day. He will figure prominently in both our discussions of landscape and still life, but must be credited here for his contributions to small-scale history subjects and allegories, which he often executed in collaboration with figure painters. By 1600, the so-called Bruegel dynasty of followers and imitators of Pieter Bruegel the Elder had become a virtual industry with relatively conventionalized products. Jan's older brother, Pieter the Younger (1564/65-1637/38), repeated his father's designs slavishly until the very end of his life, while artists like Maerten van Cleve (1527-1581), Gillis Mostaert (ca. 1534-1598), Abel Grimmer (after 1570-before 1619), and Marten Ryckaert (1587-1631) regularly tapped this same reserve for artistic inspiration.[19] To be sure, Jan the Elder also made use of designs, themes, and motifs invented by his father. His painting of the *Triumph of Death* (Graz, Alte Galerie am Landesmuseum Joanneum, no. 58, dated 1597) is exceptional however for being a virtual copy of Pieter the Elder's painting in the Prado (Madrid, no. 1393); more typical are his creative transpositions of his father's designs, for example in *The Adoration of the Magi*, which exists in versions in the National Gallery, London (no. 3547), the Kunsthistorisches Museum, Vienna (no. 617, dated 1598), the Hermitage, St. Petersburg (no. 3090), and the Koninklijk Museum, Antwerp (no. 922, dated 1600).

A highly original and independent master, Jan's detailed, almost miniaturist style and meticulous precision were much appreciated by collectors of his day. While in Italy (1590-1596) he met Cardinal Federigo Borromeo, an erudite and aesthetically refined gentleman, who remained a lifelong maecenas and friend. Borromeo wrote of Brueghel, "Even the most insignificant works of Jan Brueghel show how much grace and spirit there is in his art. One can admire at the same time its greatness and its delicacy. They have been executed with extreme strength and care, and these are the special characteristics of an artist enjoying, as he does, a European reputation. So great will be the fame of this man one day, that my panegyric will prove to be less than he deserves."[20] Returning to Antwerp, Brueghel joined the guild in 1596, and during the next decade established himself as one of the city's leading artists, soon attracting the attention of the archdukes. The latter became valuable patrons who, though they never officially appointed Brueghel to the post of court painter, extended to him important privileges, including exemptions from military service and from municipal excise and other duties.

Jan Brueghel's earliest surviving dated paintings are of 1594 and were probably painted in Rome. They depict hell scenes in the tradition of Hieronymus Bosch, Jan Mandijn, and early works by his father (see *Orpheus Singing for Pluto and Proserpina*, dated 1594, Florence, Galleria Palatina, inv. 1290[21]); or mountainous and wooded landscapes or coastal scenes, often with small biblical figures (see fig. 83). One of the latter depicts a *Rest on the Flight into Egypt* (private collection, Germany[22]), with figures attributed to Hans Rottenhammer, the German follower of Adam Elsheimer. The importance of the relationship between the two painters for Jan Brueghel's early development has recently been downplayed, and Brueghel's creative reinterpretation of his father's examples emphasized instead,[23] but these initial efforts at collaboration inaugurated a practice that Brueghel used advantageously throughout his career.

Jan worked together with several history painters, including Hendrick de Clerck (see cat. 2),[24] Frans Francken II (see fig. 58), Hendrick van Balen, and, of course, Rubens (see cat. 17). One of his many specialties was allegories, notably allegories of the Five Senses, the Four Elements, and the Seasons. These works usually depict small-scale historical figures (for example, Vulcan at his forge in an allegory of the Element of Fire, or Bacchus in an allegory of autumn) surrounded by a great variety of minutely detailed objects, animals, and plants, all symbolically reinforcing the central theme. Naturally such subjects provided Brueghel with the opportunity not merely to demonstrate his technical mastery of his craft and his powers of naturalistic observation, but also the richness of his imagination and learning, since the objects are often chosen for their subtle philosophical or spiritual meanings or associations. As we shall see, Jan Brueghel became so famous and well regarded for these allegories that when the Antwerp city fathers sought to present a suitably important gift to the archdukes upon the occasion of their official visit to the city in 1618, they asked Jan to direct the efforts of twelve painters (Rubens, Frans Snyders, Joos de Momper the Younger, Frans Francken II, Sebastian Vrancx, and others) in the creation of a pair of paintings illustrating allegories of the Five Senses (figs. 60 and 61).[25]

Brueghel may have begun painting allegories in conjunction with Hendrick van Balen by 1604 when he signed and dated the *Allegory of the Elements* (fig. 7), which shows Cybele, the earth mother, surrounded by personifications of the other Elements and an encyclopedic arsenal of symbolically charged naturalistic details.[26] Brueghel and van Balen apparently were close friends and worked together for many years. In the same year this picture was painted they both resided in the Lange Nieuwstraat in Antwerp; subsequently members of their respective families appeared as witnesses at baptisms of the others' children (in 1607 and 1613), and following Brueghel's death in 1625, van Balen served as one of the guardians of his underage children.[27] Van Balen's earliest dated painting is the celestial apparition gracing the upper registers of Abel Grimmer's *View of Antwerp* of 1600 (fig. 13, in History[28]), which shows him still a hesitant youthful worker. The Vienna *Allegory* of 1604 (fig. 7) employs a sleek figure type recalling de Clerck's art, but by 1606, when van Balen dated *The Judgment of Midas* (Staatsgalerie, Stuttgart, no. 1101[29]), his idealized little figures had become more substantial and closer to those of Rottenhammer. It has been assumed that van Balen could have met Rottenhammer, presumably in Venice, during his hypothetical trip to Italy prior to 1602; probably dating from the middle of the first decade of the century, van Balen's *Marriage of Bacchus and Ariadne* (fig. 8) even formerly carried an attribution to the German painter.[30] There are no dated works by the artist from 1608 to 1614, but the series of *Four Seasons* (Bayreuth, Neues Schloss, inv. nos. 13709-13712[31]), bearing the latter date are again

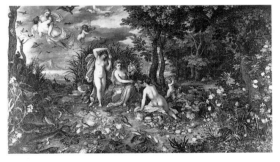

Fig. 7. Jan Brueghel the Elder and Hendrick van Balen?, *Allegory of the Elements*, 1604, oil on copper, 42 x 71 cm, Vienna, Kunsthistorisches Museum, inv. 815.

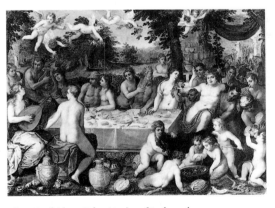

Fig. 8. Hendrick van Balen, *Marriage of Bacchus and Ariadne*, oil on copper, 33.5 x 46 cm, Leipzig, Museum der bildenden Künste, no. 1.1717.

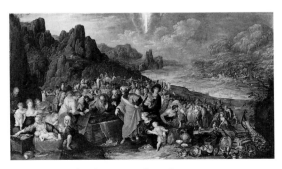

Fig. 9. Frans Francken the Younger, *The Israelites at the Red Sea*, 1621, oil on panel, 60 x 105 cm, Hamburg, Kunsthalle, inv. no. 62.

executed in collaboration with Jan Brueghel, who, as usual, provided the background settings. The figures in these works are less mannered and now fully acknowledge the impact of Rubens. In his mature career, which is initiated by works like the *Wedding Banquet of Peleus and Thetis* of 1608 (Dresden, Gemäldegalerie Alte Meister[32]), van Balen made a specialty of banquet scenes with deities or mythological figures gathered *en plein air* around a table (see cat. 1) – a theme that he continued to embellish through the second decade of the century; see, for example, the unusually densely conceived example in the Alte Pinakothek, Munich (inv. 848), which has been dated about 1620.[33]

The most productive (at least 500 paintings by his hand survive) and best remembered scion of the well-known Francken family of artists was Frans II, who, like Jan Brueghel and van Balen, painted mostly cabinet-sized history paintings (though several large-scale altarpieces also exist), often with great masses of graceful, colorful little figures.[34] Frans studied with his father and became an independent master in Antwerp in 1605. In addition to biblical and religious themes (for example *The Israelites at the Red Sea*; fig. 9[35]), he painted many mythological and allegorical subjects. An amusing little picture (fig. 10[36]) recently on the art market illustrates the artist's style of the 1620s. By this date his manner can be described as a *retarditaire* variant of late mannerism, but a tangible virtue of this conservatism was that Frans II never was wholly seduced by the formidable example of Rubens's art. Displaying all the delicacy of his touch and colors, his wit and whimsy, the *Power of Love* (fig. 10) depicts an assembly of gods and heros who variously embody love's excesses and power: Hercules and Omphale, Pandora and Epimetheus, Nessus and Deianeira, Anthony and Cleopatra, the Rape of the Sabines, Apollo and Daphne, Pyramus and Thisbe, Cupid with his chariot, Polyphemus, Acis and Galathea, and Coronis slain by Apollo's arrow. At the upper left, figures worship at the Temple of Vesta and fuel its altar fire. The grave consequences of lustful or ill-advised love carry an obvious admonition. Thus Francken makes a pictorial demonstration of his creative understanding of antique myths and humanistic knowledge. His greatest creative contribution, however, was the invention of the popular Flemish tradition of depicting collector's cabinets (or as they are often called, *cabinets d'amateurs* or *kunstkamers*), to which we will return. Frans II collaborated with at least twenty of the leading landscape, still-life, and architectural painters of his day. The popularity of his products is measured by the brisk and distinctly commercial production of his studio, manned by among others his three sons, who turned out numerous variations and repetitions of his works.

Peter Paul Rubens: The Early Years

Among the most remarkably versatile and accomplished figures in the history of art, Peter Paul Rubens was a man of seemingly universal and unlimited talents. He not only was the outstanding painter of his age but also involved in all manner of artistic endeavor, including the creation of drawings, prints, and illustrated books, as well as designs for tapestries, sculpture, and architecture. In addition to producing a vast œuvre, he was an active participant in the world of affairs, politics, and diplomacy, an intimate of kings and princes; he was fluent in five languages, traveled widely, amassed and administered a substantial personal fortune, and became a connoisseur, collector, and an expert in classical learning. Although none of his private letters have survived, his large professional correspondence offers a fascinating portrait of the public man.[37] It testifies to his renowned erudition and demonstrates that he entered into debates with many of the leading thinkers of his day. His intelligence, wit, and good judgment charmed his friends, colleagues, and patrons, while his prudent conduct, integrity, and impeccable tact secured the confidences and loyalty of the powerful and mighty. As his lifelong correspondent, Nicolas-Claude Fabri de Peiresc wrote, "Mr. Rubens evidently was born to please and delight in everything he does or says."[38] Yet, by all accounts, Rubens was a man of extraordinary spiritual and personal discipline. In the limelight throughout his career, he nonetheless was able to guard his own artistic and emotional freedoms, writing warmly of the joys of friendship, love, and family. In his lifetime, repeatedly called the Apelles of his age,[39] Rubens was eulogized probably correctly by Philippe Chifflet as "the most learned painter in the world."[40]

The son of Flemish parents, Rubens was born in Siegen, Westphalia. His father, Jan, a lawyer, had become Calvinist and had been forced to flee from Antwerp in 1568 to Cologne, where he subsequently found it expedient to convert back to Catholicism. Jan was convicted of adultery with

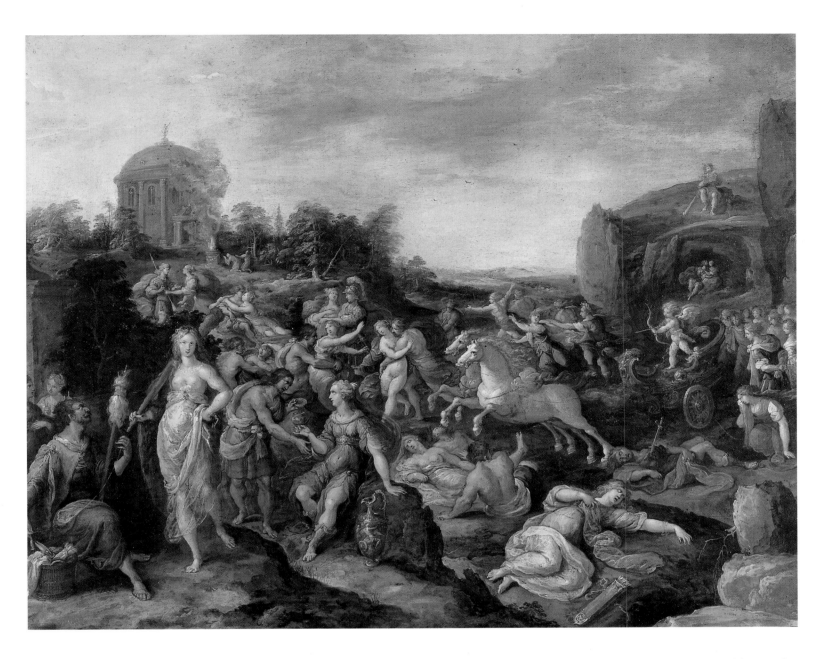

Fig. 10. Frans Francken the Younger, *The Power of Love*, oil on copper, 48.5 x 63 cm, St. Gallen, Klaus J. Lanker.

his employer, Anne of Saxony, the Princess of Orange, and thrown into the dungeon of the Castle of Dillenburg. Letters from Rubens's mother, Maria Pypelincx, written to her jailed husband and in entreaty to the House of Nassau suggest that Rubens may have inherited his strength and nobility of character from his mother. After Jan's death, Maria returned with her three sons to her native Antwerp. Peter Paul attended the Latin school run by Rombout Verdonck with his lifelong friend, Balthasar Moretus, who later became the head of the Plantin Press. The artist's formal schooling was probably concluded by about age thirteen, but Rubens remained an avid reader all his life; his letters are full of Latin quotations and allusions, and his art reveals a profound understanding of humanist learning (see White). As early as 1607, the philologist Gaspard Scioppius wrote, "I do not know what to praise most in my friend Rubens: his mastery of painting . . . or his knowledge of all aspects of *belles lettres*, or finally, that fine judgment which inevitably attends such fascinating conversation."[41]

After a brief period serving as a page at a minor noblewoman's court in Audenarde, the young Rubens returned to Antwerp where he was apprenticed to three successive artists: the landscapist Tobias Verhaecht (1561-1631), and the history painters Adam van Noort and Otto van Veen.[42] From the last he obtained more than competent instruction: he discovered a sympathetic mentor who shared and no doubt fostered his humanistic and literary interests. As Rubens's own nephew (Philip Rubens, not to be confused with the artist's brother of the same name) and many subsequent writers have observed, the paintings that he executed before his departure for Italy resemble those of van Veen. Few of these very early works have been reliably identified; the *Portrait of a Man* of 1597 (Metropolitan Museum of Art, New York, no. 1982.60.24), is probably the earliest. The

composition of the *Adam and Eve in Paradise*, ca. 1598 (fig. 11) is based on Marcantonio Raimondi's print after Raphael, although the treatment of the nudes more closely resembles van Veen's weighted classicism.[43] Another important early work is the *Battle of the Amazons* in Sanssouci, Potsdam.[44] In these early years Rubens also made copies of many prints by northern artists (Hans Holbein the Younger, Jost Amman, Tobias Stimmer, Hendrick Goltzius, and others), inaugurating a lifelong practice of studying and assimilating the art of the past and the ideas and manners of other artists by making copies. He made creative use of this extensive store of visual references and *aide-mémoires*, quoting the images in his own art but always recasting them in his own idiom.

Rubens became a master in 1598 and took his first pupil, Deodato del Monte, whose work is little known (see Vlieghe). As his nephew later wrote, however, Rubens soon "was seized with a desire to see Italy and to view at firsthand the most celebrated works of art, ancient and modern, in that country, and to form his art after these models."[45] Karel van Mander expressed the prevailing view of art theorists at this time, which posited that a visit to Italy (the "Capital of Pictura's School") was essential to the completion of an artist's training. In 1600, Rubens and his student set off for Italy, where, after visiting Venice, he quickly found employment at the court of Vincenzo Gonzaga, Duke of Mantua, possibly through an introduction from the duke's cousin, Archduke Albert.[46] The duke's handsome residences were decorated by Andrea Mantegna and Giulio Romano and naturally benefited Rubens in his artistic training. Moreover Gonzaga claimed an outstanding painting collection that boasted works by Raphael, Titian, and Correggio. Although Rubens remained in the duke's service for eight years, he spent most of his time away from Mantua, visiting, among many other places, Florence (where he witnessed the proxy marriage of Marie de' Medici and Henry IV – an experience which later proved valuable), and finally at the end of 1601, Rome.

Although by 1600 the study of antiquity and the achievements of the Italian Renaissance had become a commonplace of a northern artist's training, rarely had a painter immersed himself more fully or passionately in this study. Rubens made meticulous copies of famous antique sculpture, such as the *Belvedere Torso* and *Laocoön* (both Rome, Musei Vaticani), gems, etc. and also carefully studied the art of Mantegna, Leonardo, Raphael, Michelangelo, Titian, Tintoretto, Correggio, and many others.[47] In 1676 Hoogstraten recollected that Rubens had been criticized by his competitors for "'borrowing whole figures from the Italians,' to which the master replied that 'they were free to do the same if they thought they could benefit by it.' By this he indicated that not everyone was capable of benefiting from these copies."[48]

Although much of his time in Italy was spent absorbing the art of the past, Rubens busied himself supplying paintings for important commissions, including an altarpiece and two panels for side altars, requested by Archduke Albert and executed in 1602 for the church of Sta. Croce in Gerusalemme. The commission was probably secured through the influence of Peter Paul's older brother, Philip, who was well acquainted with the archduke's ambassador in Rome. Philip, who helped stimulate Rubens's interest in classical learning and antiquity, was then in Italy accompanying and tutoring the ambassador's brother, Guillaume Richardet, a fellow student of Justus Lipsius (see History). He appears behind Rubens in the latter's enigmatic *Self-Portrait with Friends in Italy* (fig. 12), which depicts six half-length figures standing before a darkened view of Mantua. All are in profile (recalling antique portraits) save for the artist himself, who turns to meet the viewer's gaze. To the far right is the profile of the venerable humanist, Lipsius, who could only have appeared in spirit. However just as in the later *Justus Lipsius and His Pupils* in the Pitti Palace (fig. 2, White) that Rubens painted after his brother's untimely death in 1611, Lipsius's symbolic presence serves to affirm the other sitters' shared devotion to the humanist's moral and stoical ideals. The figures on the left have not been identified with certainty but may include the artist Frans Pourbus the Younger, who was also employed at the Gonzaga court, Guillaume Richardet, and possibly Gaspar Scioppius or, more probably, another Lipsius pupil, J. B. Pérez de Baron.[49] Unlike his younger contemporary Rembrandt, who executed scores of self-portraits, Rubens painted only a few, possibly having less need of self-realization.[50] Here the image with his assembled friends serves not only to affirm the pertinence and topicality of Lipsius's moral-philosophical ideals, but also as a pictorial record of the amity of friends, whose lively intellectual discussions no doubt filled and stimulated Rubens's Italian years.

Rubens's first mission as a political ambassador was undertaken in 1603 when, as a twenty-six year old, he was sent by Vincenzo Gonzaga to Spain with gifts that the duke hoped might help

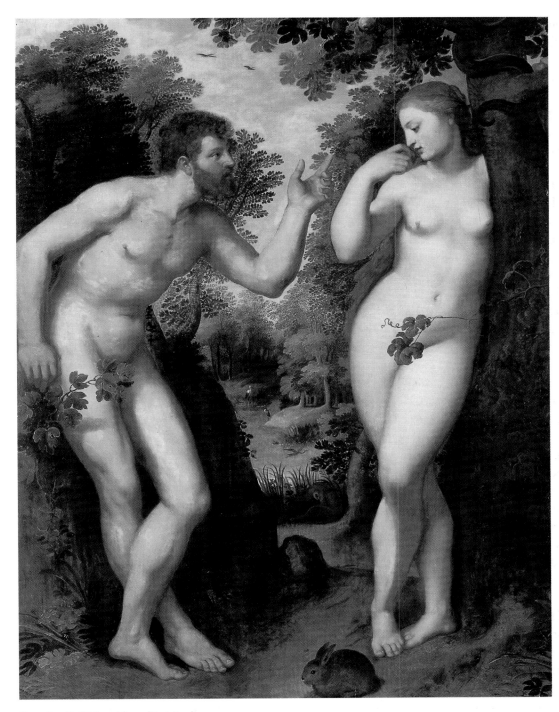

Fig. 11. Peter Paul Rubens, *Adam and Eve in Paradise*,
before 1600, oil on panel, 180 x 159 cm, Antwerp,
Rubenshuis, no. s. 164.

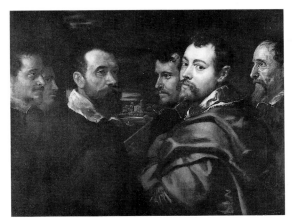

Fig. 12. Peter Paul Rubens, *Self-Portrait with Friends*,
ca. 1602 or later, oil on canvas, 77 x 101 cm, Cologne,
Wallraf-Richartz-Museum, inv. no. Dep. 248.

secure him a post as the admiral of the Spanish fleet. The intrigues and petty jealousies that Rubens witnessed at the Spanish court were scarcely the last of his long diplomatic career. He also successfully met the challenge of a request for an equestrian portrait (equitation being a traditional embodiment of controlled authority) of the Duke of Lerma (Madrid, Museo del Prado), the omnipotent favorite of the weak King Philip III. The portrait acknowledges Rubens's admiration for Titian's *Charles V on Horseback* (Madrid, Museo del Prado), which he would have known from the Spanish royal collection, while achieving a greater immediacy and vitality through more foreshortening and dazzling lighting effects. He also took the opportunity to study works by Titian, Raphael, and other Italian Renaissance masters in the king's palace, the Escorial, and elsewhere; but, a confident young man, he had little regard for contemporary Spanish painting. At sometime, probably after returning from Spain, he is reported to have visited Venice, where he not only furthered his study of Titian but also was drawn to works by Tintoretto, Bassano, and Veronese.

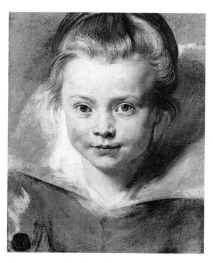

Fig. 14. Peter Paul Rubens, *Clara Serena*, oil on canvas, mounted on panel, 33 x 26.3 cm, Vaduz, Collection of the Prince of Liechtenstein, inv. 105.

When Rubens returned to Mantua in 1604 the duke finally asked him to paint something more challenging than portraits, namely a series of three large canvases depicting the *Trinity Adored by Vincenzo Gonzaga and His Family* (Mantua, Palazzo Ducale, ill. cat. 5, fig. 1), the *Baptism of Christ* (Antwerp, Koninklijk Museum voor Schone Kunsten), and the *Transfiguration* (Nancy, Musée des Beaux-Arts) for the Jesuit Church of the Holy Trinity in Mantua. Unfortunately the decorations were removed and the central canvas cut down in the early nineteenth century; however the shards of the original (see cat. 5) intimate its former glory. The three works of this ambitious project typically incorporate his Italian lessons, employing Roman and Florentine forms and quotations, but also Venetian elements – a composition recalling Veronese, iconography drawn fron Titian, and, of course, the color and atmosphere associated with Venice. By the end of 1605 he was living in Rome with Philip, who was undertaking an extensive study of Roman antiquity that would be published by the Plantin Press in Antwerp three years later under the title *Electorum libri II*, and illustrated with engravings after Peter Paul's drawings of Roman sculpture. Rubens's own ideas about the uses and abuses of classical sculpture were expressed in an unpublished treatise (probably written in the 1630s), "Concerning the Imitation of Antique Statues." Tragically this manuscript was destroyed by fire in 1720 and is now known only partially through Roger de Piles's transcription. According to Rubens, for some artists the practice of copying antique sculptures was beneficial, while for others it was "pernicious, even to the ruin of their art. I conclude that in order to attain the highest perfection in painting, it is necessary to understand the antique, nay, to be so thoroughly possessed of this knowledge, that it may diffuse itself everywhere. Yet it must be judiciously applied, and so that it may not in the least smell of the stone."[51]

Like his Dutch contemporary Frans Hals, and unlike his precocious student, Anthony van Dyck, Rubens was in some artistic respects a late bloomer, only attaining his full stride in his mid- to late twenties. However by about 1605 Rubens had fully established himself. The clearest evidence of his official recognition was his triumph over the leading local Italian artists in receiving a commission from the Order of the Oratory for the high altar of Sta. Maria in Vallicella (Chiesa Nuova) in 1606 (see cat. 7, fig. 4). In painstaking fashion, he worked out this important public commission in a series of preparatory drawings and oils, freely adapting compositional and figural elements from his studies of the Italian masters, notably Titian, Raphael, and Correggio. But before the completed altarpiece could be installed Rubens was called away by Gonzaga to accompany him to Genoa.

By shrewdly aligning itself with Spain, the city-republic of Genoa had grown prosperous. Its elegant citizens welcomed the young Rubens with portrait commissions and charmed him with their handsome architecture. Indeed he was convinced that Genoa's palazzi provided such an ideal model of domestic architecture for his own countrymen that he published a book on their elegant facades, *Palazzi di Genova un le loro piante et alzati* (Antwerp, 1622). The powerful Doria and Spinola families in particular must have been smitten with Rubens's portraits of them in all their dazzling finery. Despite the rigid cut of the sitters' "Spanish" tailoring, these images succeed in conveying a personal candor that belies the formality of their attire (see cat. 8). Although the precise dates are not known, Rubens later recalled that he visited Genoa several times during his years in Italy and he remained on good enough terms to receive later commissions, including the *Miracles of St. Ignatius* (ca. 1619-1620, S. Ambrogio, Genoa) requested for the local Jesuit Church.

Fig. 13. Peter Paul Rubens, *Self-Portrait with Isabella Brant*, ca. 1609-1610, oil on canvas, 178 x 136.5 cm, Munich, Bayerische Staatsgemäldesammlungen, no. 334.

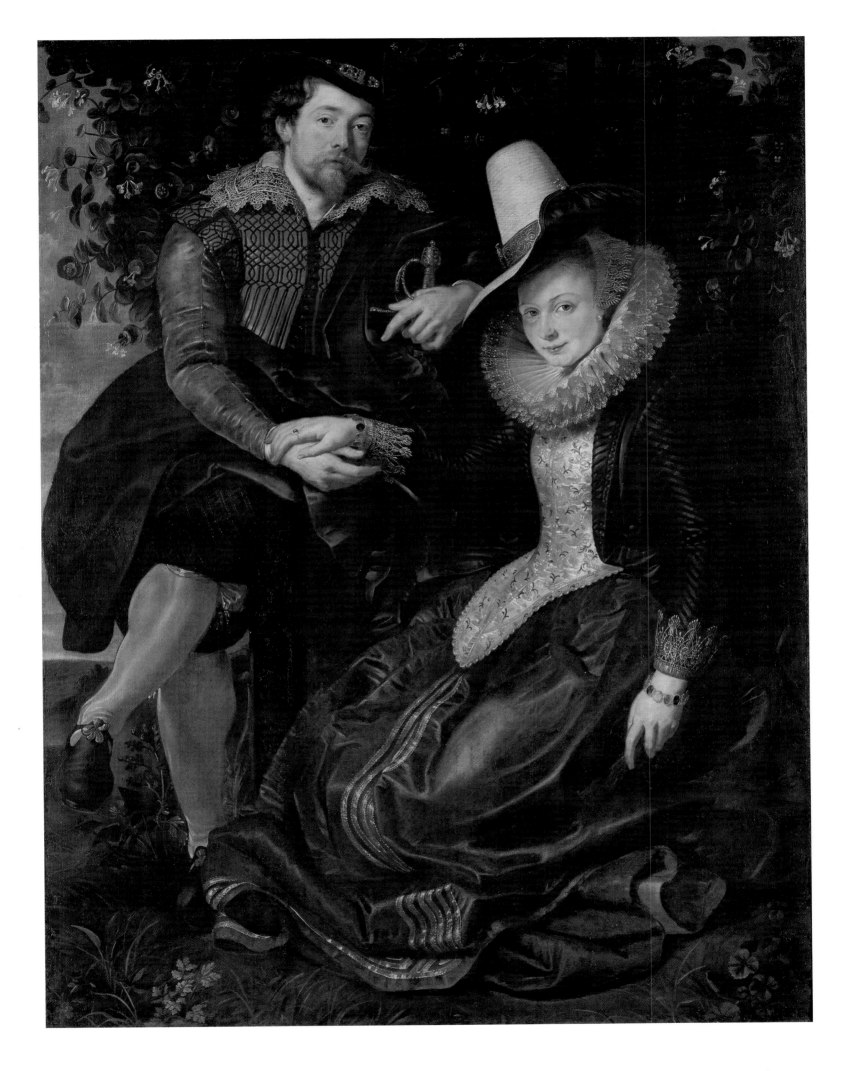

Returning to Rome he suffered a serious disappointment with the unveiling of his altarpiece for the Oratorians (see cat. 7, fig. 4); as he himself reported, the light fell so unfavorably upon it that he was requested to paint a replacement on stone. Despite this frustration, he entirely revised the composition, but never saw his final version unveiled, because he left Rome in haste for Antwerp on 28 October 1608 to be with his dying mother, unaware that she had passed away nine days before his departure. He would install the first version of the altarpiece for Chiesa Nuova in the chapel where Maria Pypelincx was buried in the Abbey Church of St. Michael. Although Rubens always loved Italy as his adopted home (as late as 1629, he wrote that the desire to return was so great that "if Fortune does not grant it, I shall neither live nor die content"[52]), and intermittently corresponded in Italian for the rest of his life, he never set foot in the country again.

Rubens in Antwerp

Soon after Rubens returned to Antwerp he wrote to a friend that he had not yet made up his mind whether to stay or return to Rome: the archdukes had encouraged him to enter their service, but having witnessed life at court in Audenarde, Mantua, and Spain, Rubens frankly stated "I have little desire to become a courtier again."[53] However with the period of the Twelve Year Truce inaugurated in 1609 and the economy and commerce of the region seemingly on the mend (see History), Rubens shared his countrymen's cautious optimism, observing "it is believed that our country will flourish again."[54] On 23 September 1609, he was appointed court painter with special permission to continue living in Antwerp rather than the court city of Brussels. The post carried an annual pension of 500 florins, full privileges and honors, as well as exemption from all the regulations and duties of the local guild. The last provision, as we shall see, was essential for the operation of the large studio that Rubens gathered around himself. Rubens painted the archdukes' portraits (see figs. 4 and 5, in History) and became a trusted friend. His nephew would later report that "Albert had a particular fondness for Rubens," adding that "Peter Paul named his first-born son Albert after the Archduke."[55] But in sum, Rubens performed more political tasks for the archdukes than artistic, and especially after Albert's death was a close confidante and agent of Isabella.

In the same year he joined the Guild of Romanists (an organization of artists who had lived in Italy) and married Isabella Brant (1591-1626) in the abbey church where his mother had been buried. His bride was the eldest daughter of Jan Brant (his portrait by Rubens is in the Bayerische Staatsgemäldesammlungen, Alte Pinakothek, Munich, no. 354), who together with Philip Rubens, the artist's brother, was one of the four secretaries of Antwerp. Despite the couple's elegant finery, the marriage portrait that Rubens painted (fig. 13) conveys an informality and mutual affection that was unprecedented in the pictorial conventions of marriage portraiture. Though buttressed by symbolism and tradition (the honeysuckle bower is the residual memory of medieval love gardens and the clasped hands are the emblem of marital fidelity[56]), and speaking clearly enough of social position, the image attests to a new middle-class concept of marital love

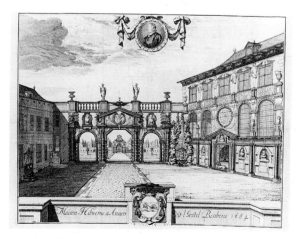

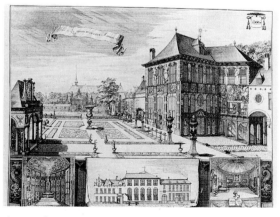

Fig. 15. Jacob Harrewyn after J. van Croes, *The Facade and Arch of Rubens's House*, dated 1684, engraving, Antwerp, Stedelijk Prentenkabinet, inv. 17.877.

Fig. 16. Jacob Harrewyn after J. van Croes, *Rubens's House*, dated 1692, engraving, Antwerp, Stedelijk Prentenkabinet, inv. 17.875.

and an unpretentious view of private life – social ideals that were just beginning to replace old aristocratic notions of marriage as primarily a pact of economic and social convenience and utility. Rubens's charmingly direct portrait of his own daughter (fig. 14) bespeaks similarly revolutionary ideas about children, who in the seventeenth century were first represented as individuals with their own childlike qualities, rather than as small adults.

At the end of 1610 Rubens bought a large house with a garden on the Wapper, which in the coming years he would extensively redecorate, according to classical and Italian Renaissance ideals, and enlarge, primarily to accommodate his studio (see figs. 15-16). The building presented to his fellow citizens of Antwerp not only a new style but also a new concept of domestic architecture. Its facade decorations conveyed his beliefs symbolically, while his humanist and stoic sympathies were expressed in two passages from Juvenal's satires inscribed on the newly constructed arches that separated the courtyard and garden: "Leave it to the gods to give what is fit and useful for us; man is dearer to them than to himself"; and "One must pray for a sane spirit in a healthy body, for a courageous soul, which is not afraid of death, which is free of wrath and desires nothing."[57] When much later, in the nineteenth century, Eugène Fromentin characterized Rubens so memorably as "un âme sans orage, sans langueurs, ni tourment, ni chimères" he expressed the conviction of many that Rubens truly lived by his principles.[58]

Rubens financed his lovely new home with an extraordinary amount of hard work and initiative. No sooner had he returned to Antwerp than he received major artistic commissions from the local municipal authorities (for example, The Adoration of the Magi [Madrid, Museo del Prado, no. 1638], originally painted for the City Council of Antwerp; ill. cat. 9, fig. 2) as well as the Catholic Church, which had embarked on an ambitious new campaign of not only converting and reeducating society (see History) but also embellishing new and restored churches with altarpieces. A new iconography as well as a new style of painting had to be devised to convey the ideals and dogma promulgated by the Council of Trent (see Freedberg). No one answered the call to promote visually the revitalized Church and to make its message accessible and understandable to the masses more successfully and passionately than Rubens.

Often Rubens secured these commissions through his well-to-do friends in Antwerp: the collector Cornelis van der Geest, for example, was instrumental in his receiving the order for the altarpiece of The Raising of the Cross for the Church of St. Walpurgis (fig. 17). Though adopting a traditional medieval triptych format that had never gone entirely out of fashion in Antwerp, the painting's central subject is rare in northern art (though treated by Hans Baldung Grien in a woodcut),[59] drawing heavily on Italian inspiration (specifically Tintoretto, Michelangelo, and Caravaggio). However Rubens has recast his sources with a bold new vitality and authority. Muscular figures strain to raise aloft the powerful and tortured body of Christ – the spiritual athlete, whose suffering is vivid but emotionally controlled as he looks heavenward toward the figure of God the Father who formerly appeared above on the (now lost) altar pediment. Originally installed at the top of a flight of sixteen steps, this vast triptych seemed the fulfillment of the ideals of Charles Borromeo (Instructiones fabricae et supellectilis ecclesiasticae [Antwerp, 1572]) and other spiritual leaders of the Counter Reformation, such as Gilio de Fabriano, Johannes van der Meulen (Molanus), Andrea Possevino, and Raffaello Borghini. It was imperative that the high altar should be monumental, prominent, and legible; it should feature the Christ figure or another New Testament subject (according to the prescription of the Third Diocese Synod of the bishopric of Antwerp in May 1610); and, perhaps most important of all, it should prompt a spiritual meditation on the life of Christ and the Passion that is so intensely felt as to appear (in Ignatius of Loyola's terms) as if it were happening before one's very eyes.[60] Rubens's painting successfully achieved the clarity, naturalism, and emotional impact necessary to stimulate the devotion and piety that were the ideals of the Counter Reformation. Moreover, its dignified and controlled Christ (so different, for example, from the Middle Ages' pathetic Man of Sorrows) seemed to embody the synthesis of stoicism and Christianity that were Lipsius's ideal.

Also a huge winged altarpiece, The Descent from the Cross painted in 1611-1614 (fig. 18) is as calm and elegiac as the Raising of the Cross (fig. 17) is passionate. That work, however, was not destined for a high altar but for the altar of a municipal shooting club in a chapel of the Cathedral (Onze-Lieve-Vrouwekerk). It too achieves a monumental clarity and naturalism, while conveying through the mourners' coordinated effort to lower the body of Christ a model of spiritual solidarity and teamwork befitting its patrons' organizational ideals. The second decade of the century

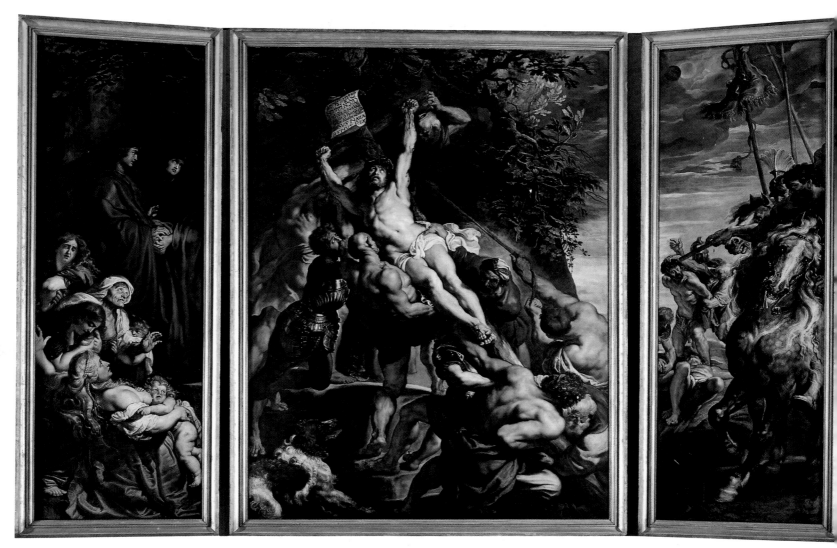

Fig. 17. Peter Paul Rubens, *Raising of the Cross*,
ca. 1610-1611, oil on panel, central panel, 462 x 341 cm,
Antwerp, Cathedral (Onze-Lieve-Vrouwekerk).

was Rubens's most classical period, when his figures were characterized by a noble simplicity, dramatic rhetorical gestures, firm modeling, clear local colors, and a pearly translucence in flesh tones. By comparison, van Veen's classicism is alternately leaden or limp, and even Janssens's seems oddly vulcanized. We appreciate this style's calmer application in paintings like the *Descent* (fig. 18), the so-called *Rockox Triptych* of 1613-1615 (cat. 16, fig. 1), and the *Tribute Money* (San Francisco, The Fine Arts Museums of San Francisco, inv. no. 44.11), while the style could also be applied more vigorously to vast images of choreographed commotion like the great *Last Judgment* (fig. 19).[61] Painted in 1615 for the Jesuit Church of Duke Wolfgang-Wilhelm at Neuburg on the Danube, this painting is now preserved in the Alte Pinakothek in Munich. What at first appears to be a Gordian knot of bodies readily untangles itself to reveal a carefully structured design that acknowledges Tintoretto and, of course, Michelangelo, but again subsumes its sources. Rubens places the emphasis not on harsh judgment and the damned, who descend to their torment relatively inconspicuously on the right, but on the saved, who appear as beautiful, sensuous nudes floating heavenward on the left. The optimistic message is one of Jesuit positivism and the promise of readily attainable salvation.[62]

During the second decade of the century, Rubens's primary artistic activity was the production of altarpieces. With the assistance of his studio, he painted more than sixty, about one third of which remained in Antwerp, the others dispersed and installed throughout Flanders and Brabant, and a few, like the Neuburg *Last Judgment* (fig. 19), sent abroad. During this same period he had also, of course, been painting independent works for private clients, such as the splendid

Samson and Delilah of ca. 1609 (fig. 20), surely one of his first efforts following his return, and the *Battle of the Amazons* of ca. 1618 (Munich, Bayerische Staatsgemäldesammlungen, Alte Pinakothek, no. 324). Both are known through collectors' cabinet paintings (by Frans Francken the Younger [ill. Muller, fig. 2], and Willem van Haecht [dated 1628, Antwerp, Rubenshuis]) to have been owned, respectively, by his friends and patrons, Nicolaes Rockox and Cornelis van der Geest. In his production for the private market, as in his public commissions, Rubens continued to make use of motifs from other artists that he found useful or simply admirable whether in treating a religious, mythological, or profane subject; for example, Raphael's tapestry cartoons and in its turn the art of antiquity provide sources for the *Battle of the Amazons*, while Michelangelesque motifs appear in the *Samson and Delilah* (fig. 20) and the *Prometheus* of ca. 1612 (cat. 10). In these same years he made "creative" copies not only of Caravaggio's famous *Deposition* (Vatican, Pinacoteca; the copy is in the National Gallery of Canada, Ottawa, no. 6431), no doubt seeking to understand better the master's naturalism, but also Parmigianino's highly mannered *Cupid Shaping His Bow* (see cat. 11). Rubens's quotations were not restricted to Italian and classical art; his *Portrait of Mūlāy Ahmad* (cat. 9), for example, is based on a lost painting (known only through a print) by Jan Vermeyen, and his *Landscape with the Flight into Egypt* of ca. 1613 (Paris, Musée du Louvre, inv. 1765; see also his variant dated 1614, Kassel, Gemäldegalerie Alte Meister, no. 87) is freely inspired by the well-known print of this subject by Hendrick Goudt after Adam Elsheimer. Rubens himself owned no fewer than eight paintings by this influential German artist, including the latter's *Judith and Holofernes* (London, Wellington Museum, Apsley House, no. WM 1604-1948). Indeed to grasp the range of Rubens's artistic interests and his concept of art it is not enough to study the master's drawings and paintings after other artists, one must also consider his activities as a collector. Although portions of his collection were sold to the Duke of Buckingham in 1627, the bulk remained intact throughout his life and attests to a voracious curiosity and acquisitiveness. Besides paintings (which were dominated by Titian and the Venetian school, but also included Early Netherlandish, German, and sixteenth-century northern art, above all that of

Fig. 18. Peter Paul Rubens, *Descent from the Cross*, 1611-1614, oil on panel, central panel, 420 x 310 cm, Antwerp, Cathedral (Onze-Lieve-Vrouwekerk).

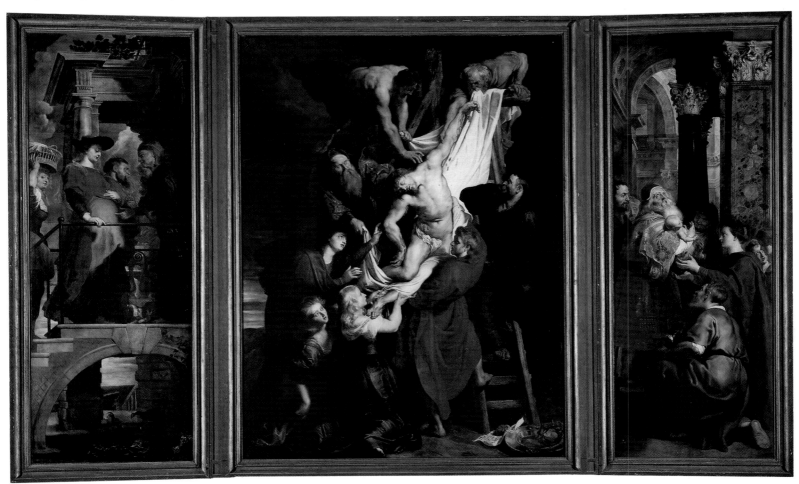

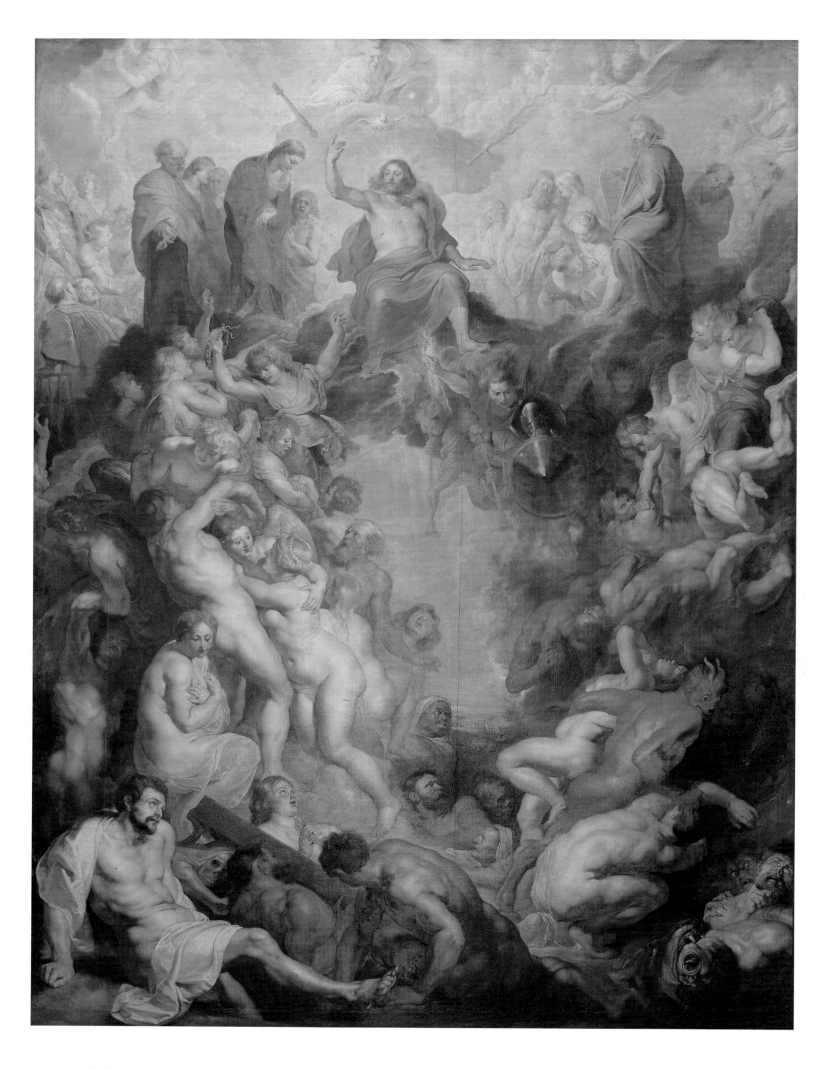

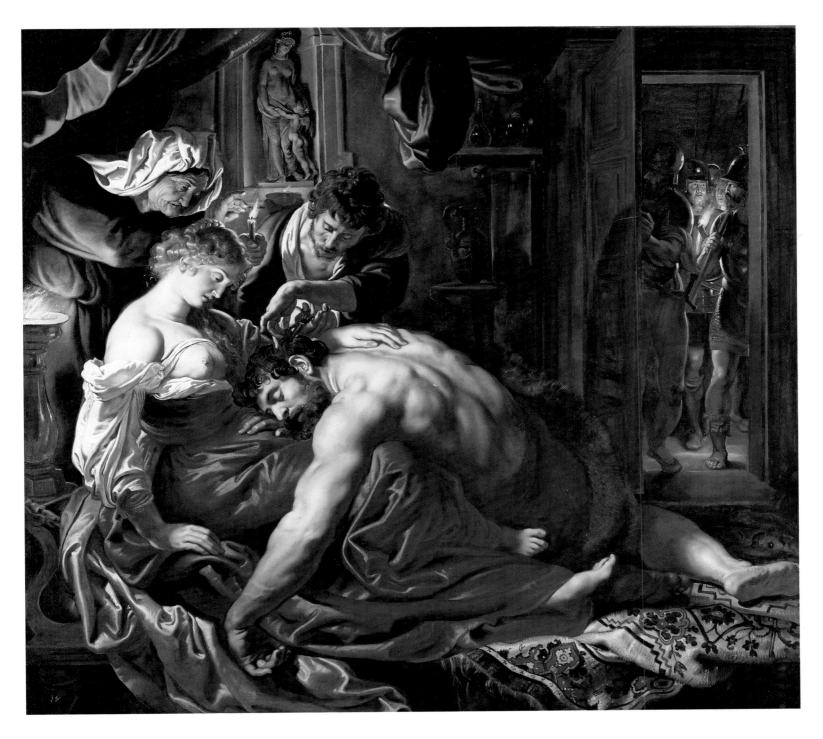

Fig. 20. Peter Paul Rubens, *Samson and Delilah*, ca. 1609, oil on panel, 185 x 205 cm, London, The National Gallery, inv. 6461.

Fig. 19. Peter Paul Rubens, *The Large Last Judgment*, 1615, oil on canvas, 606 x 460 cm, Munich, Bayerische Staatsgemäldesammlungen, no. 890.

Pieter Bruegel the Elder), there were numerous (perhaps thousands of) drawings, hundreds of pieces of classical sculpture, ancient gems, medals, ivory sculptures, and vases of crystal, agate, and jasper. For Rubens, collecting was far more than decorating, investing, or affirming social standing; it was an instructive exercise that helped put his own art and that of his students and contemporaries into better perspective.[63]

Around 1614-1615 Rubens began painting a group of large hunting scenes.[64] The earliest of these, illustrating Ovid's story of Meleager and Atalanta in *The Calydonian Boar Hunt*, is lost but is known today through copies; like *The Crowning of Diana* (see cat. 14), it depicted a mythological hunting subject. However, most of Rubens's paintings of this type represent anonymous though often noble or exotic huntsmen. Since hunting, especially of big game, was a privilege, preserve, and unadulterated passion of royalty and nobility, it is not surprising that many of Rubens's hunt scenes were owned by kings and aristocrats (the Archdukes Isabella and Albert, the Duke of Aerschot, the Marquess of Hamilton, Maximilian of Bavaria, and, of course, Philip IV of Spain all owned examples), and many found their way into hunting lodges or country homes. Isabella is reported to have been especially fond of the hunt. Two oil sketches exhibited here, the *Hunt of Meleager and Atalanta* and *Hunt of Diana* (cats. 34 and 35), were preparatory to two large canvases, now lost, that

Fig. 21. Peter Paul Rubens, *Hippopotamus and Crocodile Hunt*, oil on canvas, 248 x 321 cm, Munich, Bayerische Staatsgemäldesammlungen, inv. 4797.

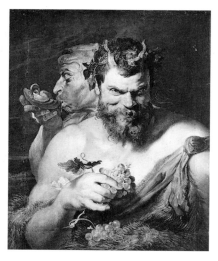

Fig. 23. Peter Paul Rubens, *Two Satyrs*, oil on panel, 67.5 x 51 cm, Munich, Bayerische Staatsgemälde-sammlungen, no. 873.

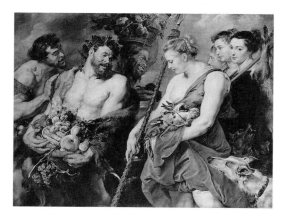

Fig. 22. Peter Paul Rubens and Frans Snyders, *Diana's Return from the Hunt*, ca. 1616, canvas, 136 x 184 cm, Dresden, Gemäldegalerie Alte Meister, no. 962 A.

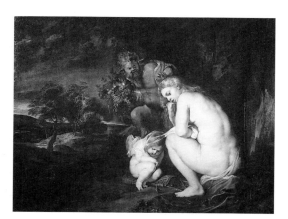

Fig. 24. Peter Paul Rubens, *Sine Cerero et Baccho Frigat Venus*, 1614, oil on panel, 142 x 184 cm, Antwerp, Koninklijk Museum voor Schone Kunsten, no. 709.

Rubens probably delivered to Philip IV in 1628 and which later hung in the Alcázar. The Spanish king subsequently asked Rubens to decorate his entire hunting lodge, the Torre de la Parada.

Particularly in peacetime, hunting was a way of testing a nobleman's mettle, courage, and dexterity with weapons; in effect, hunting became war games for the court. Depictions of the chase thus had enjoyed a long history in courtly circles, particularly in tapestries (e.g. after designs by Barent van Orley) and prints (after Stradanus). Rubens deliberately revived these traditions, but typically represented the moment of the greatest baroque drama, danger, and emotion, when the outcome of the struggle between man and beast hangs in the balance, awaiting the determined, self-possessed nobleman who rides up, parting the lowly beaters, to deliver the death blow (see *The Wolf and Fox Hunt*, New York, Metropolitan Museum of Art, no. 10.37; and *The Boar Hunt*, Marseilles, Musée des Beaux-Arts, no. 103). Surely aware of the lofty moral and ethical significance many of his patrons attached to hunting, Rubens depicted it not merely as a sport but as a societal drama.[65] Even when the hunting subjects are at their most exotic and improbable, as in the *Hippopotamus and Crocodile Hunt* (fig. 21), the cutlass-wielding gestures of the mounted horsemen, amidst the thrashing of the quarry and the desperation of the fallen trackers, express the calm resolve of the hero, a courtly ideal.

In *Diana's Return from the Hunt* of ca. 1616 (fig. 22), the goddess of the hunt is attended not only by her loyal female band but also by several surprisingly well-behaved satyrs, who carry abundant armloads of fruit, just as she carries dead game – successive courses, as it were, of life's bounty. Like his Italian Renaissance predecessors, from Piero di Cosimo to Titian, Rubens took an

obvious delight in ancient Greek tales of pagan gods of nature who assumed human form but were identified by goat-like horns, pointed ears, and other animal features. Raucous attendants of the drunken Silenus (Munich, Bayerische Staatsgemäldesammlungen, Alte Pinakothek, no. 319) or of the inebriated Hercules (Dresden, Gemäldegalerie Alte Meister, no. 987), these satyrs and their interchangeable cousin, Pan, perennially chase nymphs and buxom maenads (see cat. 17), embodying all that is drunken, lustful, and lasciviously fun (see fig. 23). However they also play a positive role in works like the illustration of the Latin expression *"Sine Cerero et Baccho frigat Venus"* (Without Food and Drink Love Would Freeze) dated 1614 (fig. 24), where a shivering Venus and Cupid are about to be figuratively warmed by a satyric Pan, who creeps merrily toward them with a cornucopia of fruit – the embodiment of abundance providing sustenance to love. Thus the satyr for Rubens is a sympathetic creature – a life-giving force, supreme representative of fertile nature, and ultimately a worthy companion and counterpart to Diana, who also was the goddess of chastity (see fig. 22 and cat. 14).[66] Though a man of high principles and stoic discipline, Rubens wrote that in matters of love, "I find by experience that such affairs should not be carried on coolly, but with great fervor."[67]

For all his fascination with pagan myths, Rubens was a devout Catholic. His nephew affirmed that he was "accustomed both in winter and summer to attend the first mass," and while he might express interest in heretical sects such as the Basilidians and Rosicrucians, Rubens's own beliefs were strictly orthodox. He was a friend and correspondant of members of Antwerp's burgeoning holy orders, and portrayed Capuchins, Franciscans, Carmelites, and Dominicans (see cat. 23). However his closest association was with the Jesuits, who were the favored order under the archdukes (see History). As we have seen, in Italy Rubens had painted an altarpiece ordered by the Gonzagas for the Jesuit Order in Mantua and also provided illustrations for a biography of Ignatius of Loyola. In Antwerp he became a member of the Jesuit Sodality and painted an *Annunciation* for their chapel (Vienna, Kunsthistorisches Museum, inv. 685). The rector of the Jesuit college in Antwerp was Father Franciscus Aguilón, whose treatise on optics, *Opticorum libri sex* (Antwerp, 1613), had been illustrated by Rubens. However Rubens's greatest contribution to the Jesuits was in the painted and sculptural decorations for their new church. These included two vast altarpieces which abandoned the old-fashioned triptych design for the portico surround and tall upright format that he now favored. They depicted *The Miracles of St. Ignatius* (fig. 25) and *The Miracle of St. Francis Xavier*, both now preserved in Vienna (Kunsthistorisches Museum, nos. 517 and 519) together with their modelli (nos. 530 and 528), and were designed to be displayed alternately. Since the two saints were not canonized until 1622, these altarpieces, completed about 1617-1618, were obviously intended to promote, in what must be an unprecedented case of pictorial special pleading, the claims on sainthood of the Society's founders.

About two years later, in March of 1620, Rubens signed a contract to provide no fewer than thirty-nine paintings to decorate the ceilings of the upper and lower aisles of the new church, which had been designed along the lines of an early Christian basilica.[68] Tragically destroyed by fire in 1718, these works are known today only through copies and Rubens's preparatory oil sketches (see cats. 18 and 19). The program was traditional, alternating Old and New Testament subjects according to medieval models of type and antitype. The 45 degree (*di sotto in sù*) perspective and foreshortening of the scenes were inspired by Renaissance Venetian models (Titian, Tintoretto, and Veronese). The fact that Rubens completed this vast commission in time for the church's consecration only eighteen months later leaves little doubt that he had help. Indeed the contract specified that Rubens was to prepare the designs with his own hands, but that the execution could be carried out by assistants (van Dyck is specifically named, but since he was in England from November 1620 to March 1621 his contribution must have been limited), provided that Rubens retouched their work where necessary.[69] Already in 1616, when he accepted his first major commission in Antwerp from Genoese patrons for a series of eight tapestry designs based on the life of the Roman Consul Decius Mus (Vaduz, Prince of Liechtenstein collection, inv. nos. 47-53, 78), he had probably been relying on van Dyck's assistance, though the evidence is contradictory: seventeenth-century sources consistently assign the execution of the Decius Mus cartoons entirely to van Dyck, but a letter written by Rubens in 1618 to the English Ambassador to The Hague, Sir Dudley Carleton, states, "I myself made [these] very handsome cartoons,"[70] and their high quality certainly argues that, at the very least, Rubens extensively reworked his assistant's paintings.

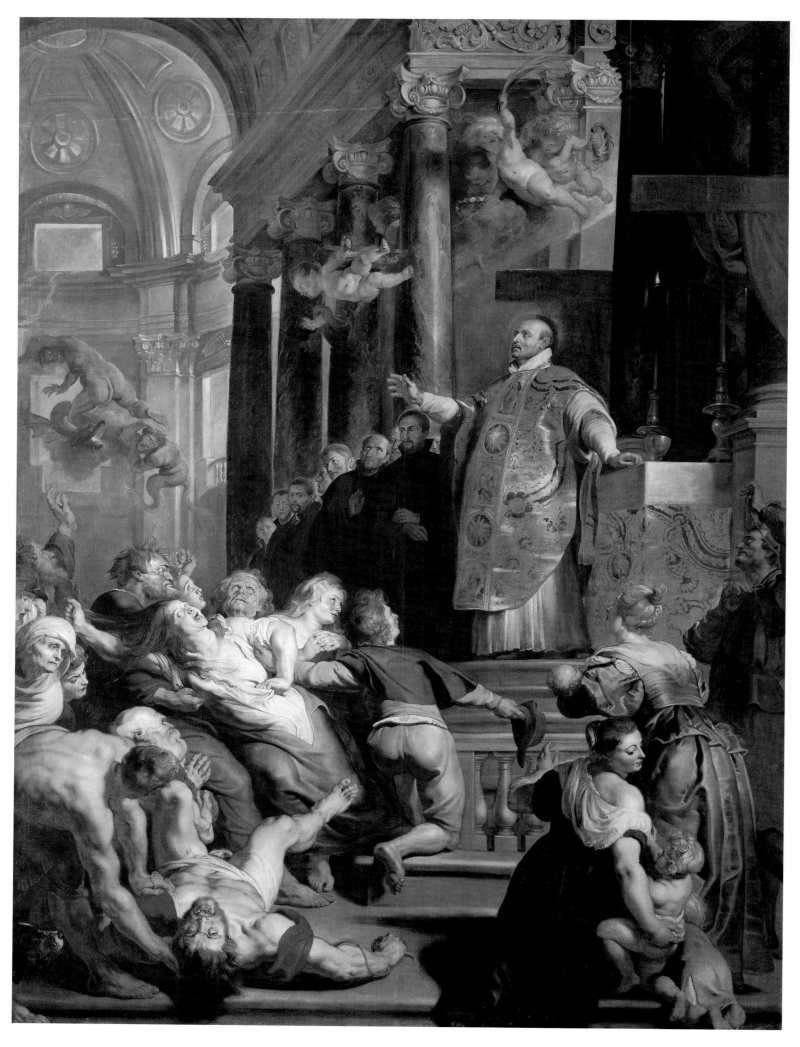

Rubens's Studio Practices

The day after the Jesuit Church was consecrated, the indefatigable Rubens was already writing to the English King James I's agent about the possibility of decorating the newly rebuilt Banqueting House in Whitehall (see cat. 29). In making his sales pitch he remarked, "regarding the hall in the New Palace, I confess that I am, by natural instinct, better fitted to execute very large works than small curiosities. Everyone according to his gifts; my talent is such that no undertaking, however vast in size or diversified in subject, has ever surpassed my courage."[71] Rubens was able to make his boast because by this point he had gathered around himself an exceptionally efficient studio. The Danish physician Otto Sperling, who visited the studio in 1621, told a story illustrating Rubens's formidable powers of concentration: Sperling found "the great artist at work. While still painting he was having Tacitus read aloud to him and at the same time was dictating a letter. When we kept silent so as not to disturb him with our talk, he himself began to talk to us while still continuing to work, to listen to the reading and to dictate his letter, answering our questions and thus displaying his astonishing power."[72] Although Sperling surely exaggerated for the sake of effect, Rubens's nephew confirmed that the artist "applied himself to his work while a reader sat near him reading from Plutarch, Seneca, or some other book, so that his attention was fixed both upon his painting and his reading."[73] However Rubens's productivity was not simply a matter of stamina and mental gymnastics. The Dane also observed "a good number of young painters each occupied on a different work, for which Mr. Rubens had provided a chalk drawing with touches of color added here and there. The young men had to work these up fully in paint, until finally Mr. Rubens would add the last touches with the brush and colors. All this is considered as Rubens's work; thus he has gained a large fortune, and kings and princes have heaped gifts and jewels upon him."[74]

As early as 1611, Rubens wrote of the many young men that he had had to turn away who wanted to join his studio: "I can tell you truly, without exaggeration, that I have had to refuse over one hundred, even some of my own relatives or my wife's, and not without causing great displeasure among many of my best friends."[75] The Antwerp guild was also annoyed because Rubens and his fellow court painter, Jan Brueghel the Elder, could engage as many artists as they chose while remaining exempt from the guild regulations that would have otherwise required them to declare and limit the number of their pupils and assistants. Moreover these unincorporated artists, not being registered with the guild, were exclusively bound to Rubens's studio since, at least officially, they were not permitted to work independently for other clients.

The practice of engaging assistants was, of course, of long standing in both the North and the South. The sixteenth-century Antwerp history painter Frans Floris, Italian Renaissance artists such as Raphael, Giulio Romano, and Titian, all had large studios, as did the seventeenth-century masters Gianlorenzo Bernini in Rome, Charles LeBrun at Versailles, and (much to many people's surprise today) Rembrandt in Amsterdam. Indeed assistants were essential for the rate of production and the execution of the large-scale decorations that distinguished the leading painters in this absolutist age. For Flemish artists, the brisk export market for their collaborative works, not only to the Iberian peninsula but to virtually all parts of Europe, placed a premium on large studios and teamwork. Some apprentices and pupils, of course, dealt with minor but essential chores in the studio – the priming of canvas or panel supports, the grinding of pigments, the preparation of palettes, or other preliminary work. However, as Sperling and other well-informed writers like Sandrart and de Piles observed, a few select assistants advanced to the actual execution of works of art based on Rubens's designs.[76] Particularly after his years in Italy, these designs often took the form of oil sketches, which Rubens and his contemporaries variously called *disegni colorito*, *schizzi*, or simply *disegni* (*desseins*, draughts or *tekeningen*), as he referred to those for the Jesuit ceiling and later for the gallery of Henry IV.[77]

An initial sketch might take the form of a bozzetto, which quickly recorded the master's first thoughts, after which the pictorial idea was elaborated in the more finished modello, a fully resolved sketch in color which his assistants could follow.[78] Modelli also were used by the master as presentation pieces for patrons, as in the cases of Rubens's *St. Ignatius* and *St. Francis* for the Jesuit Church. Rubens's contemporaries obviously recognized the value of his oil sketches as the truest records of his ideas; his contract with the Jesuits, for example, stipulated that he had to turn over his sketches to them if he failed to provide the altarpiece for the side chapel of the

Fig. 25. Peter Paul Rubens, *The Miracles of St. Ignatius*, oil on canvas, 535 x 395 cm, Vienna, Kunsthistorisches Museum, inv. 517.

church they had ordered.[79] This practice was also consistent with Renaissance art theory, which differentiated between the creative invention of a work of art and its execution. Thus Rubens and his contemporaries had theoretical justification for relying on assistants for the completion of their grand projects.

Especially after ca. 1620, however, Rubens far outdistanced his colleagues in his managerial and impressarial skills and ambitions. His studio developed to such an advanced state of organization that, even during his absences for ever-longer diplomatic sojourns, its production scarcely abated. Recognizing the enormous value of prints for the dispersion and marketing of his ideas (especially in this age before infinitely reproducible images), Rubens also extended the corporate organization of his studio to include engravers and woodcutters (notably Lucas Vorsterman, Paulus Pontius, Boetius Schelte à Bolswert, and Christoffel Jegher) who all became essential players in his industrial-scaled production process. The printmakers meticulously replicated his paintings and drawings for the far-flung public, while Rubens (ever the financially astute businessman) took constant pains to secure the copyrights for prints after his works throughout Europe, even to the point of negotiating an exclusive agreement with the States General of the United Provinces. Ironically this corporate approach to art production was only finally ideologically outmoded in the nineteenth century when advancing industrialization and manufacturing awarded new value to the "hand made" object, and the individualistic, private artistic statement or gesture.

Although we will return to the issue of collaboration in discussing Flemish artists' extraordinary penchant for specialization, it is useful here to consider Rubens's statements on the practice. The most pertinent passages appear in correspondence between Rubens and Sir Dudley Carleton concerning an exchange of the artist's work for the ambassador's collection of antiquities. In a letter of 28 April 1618 Rubens offered "the flower of my stock," in a list of twenty-four paintings, which actually specified which paintings were "original, entirely by my own hand," which were done in collaboration with assistants, and which were by assistants and only retouched by Rubens.[80] The *Prometheus* (cat. 10) was the first on the list, Rubens specifying that the "eagle [was] done by [Frans] Snyders." Several of the other works are also identifiable, including the *St. Sebastian*, described as "by my hand," now in Berlin (Gemäldegalerie, no. 798H).[81] It is significant that Carleton accepted the collaborative *Prometheus* and the other paintings which Rubens stated were "by my hand," but declined all the works by pupils (including the nineteen-year-old van Dyck's *Achilles among the Daughters of Lycomedes* [Madrid, Museo del Prado, no. 1661; ill. Vlieghe, fig. 6], which can probably be identified with the work described as "a picture of an Achilles clothed as a woman, done by the best of my pupils, and the whole retouched by my own hand"; indeed, Rubens's retouches here are so extensive as to obscure van Dyck's presence entirely) and the copies of Rubens's paintings that the master had only reworked. Writing in response the following month, Rubens disclaimed any "wish to influence your Excellency by fine words," but assured him that he "must not think that the others are mere copies, for they are so well retouched by my hand that they are hardly to be distinguished from originals."[82] Despite such assurances, Rubens's patrons repeatedly expressed their preference for works wholly by him, and he was criticized more than once for selling works executed entirely by his studio. In 1621, for example, he was obliged to replace an unidentified "Hunt" executed for Lord Danvers, who complained in a letter of 27 May that "in every paynter's opinion he hath sent hether a peece scarce touched by his own hand ... theas Lions shall be safely sent him back for tamer beastes better made."[83] Rubens apologized, saying he would "paint another Hunt less terrible than that of the lions, with a rebate on the price ... and all to be done by my own hand, without a single admixture of anyone else's work," but suggested that the misunderstanding had arisen because the go-between, Lord Carleton, had not specified whether the picture should "be a true and entire original or merely retouched by my hand."[84] Rubens was not the only Flemish artist who came under criticism for such practices; in 1648 Jacob Jordaens admitted selling paintings under his own name that were only copies by pupils that he had retouched.[85] Clearly the use of studio assistants was common enough that artists remarked on the cases of successful painters who chose not to employ them; Jan Brueghel II, for example, wrote of his collaborator, the battle painter Sebastian Vrancx (see cat. 84) "Vrancx has plenty to do but refuses to employ studio assistants, which means that the work takes a long time. He does not allow copies to be put into circulation."[86]

The fact that Rubens's system of quality control occasionally broke down is less remarkable than the fact that it ran so smoothly most of the time. Were it not for his own statement in the

letter to Carleton (and Snyders's preparatory drawing), the seamless collaboration between the two artists in the *Prometheus* (cat. 10) would probably have gone unnoticed. The copies of his own works by assistants that have only been minimally retouched by the master can often still be identified by connoisseurs, but those works (and they must have been very common indeed in such a productive studio) which were begun by assistants and then "the whole retouched by my hand" are a hybrid product that simply defies the narrow notions of originality favored in our modern era. A painting like Boston's *The Head of Cyrus Presented to Queen Tomyris* (cat. 24) is surely based on Rubens's designs but probably worked up largely by assistants and only reworked by Rubens in the more vital passages.

Collaboration

Collaborations between artists are as old as Western European panel painting, extending back at least to the joint efforts of Jan and Hubert van Eyck. In the early years of the sixteenth century, for example, Quentin Massys and the landscapist Joachim Patenir collaborated on a *Temptation of St. Anthony* (Madrid, Museo del Prado, no. 1615).[87] However the incidence of collaboration increased dramatically in the late sixteenth century and, as we have seen in the case of Jan Brueghel, Hendrick van Balen, and their contemporaries, was a common practice by the turn of the seventeenth century. This growth is directly related to the development of the discrete "genres" of painting and specialties in these years (see the "Verscheydenheden" section below). Rubens himself is reported to have collaborated, probably during his youth, on a lost painting of *Parnassus* that was executed jointly not only with his teacher, Otto van Veen, but also with Jan Brueghel the Elder.[88] During his Italian years he had agreed, in an exceptional case, to accommodate the work of another (long dead) artist, namely the venerated icon of the Virgin and Child that was incorporated into the Chiesa Nuova altarpiece in 1606-1608 (see cat. 7). However the vast majority of his collaborations were with contemporary specialists in animal painting, still-life, or landscape painting. History painting, awarded primacy by art theory, tended to dominate the subordinate genres, as Rubens himself naturally dominated the organization of his own studio. However not all of the artists with whom Rubens collaborated were assistants or students. Jan Brueghel, for example, was an independent master who, at least officially, was Rubens's supervisor in their collaborative work on the allegories of the Senses painted for the archdukes in 1618 (figs. 60 and 61).

In the case of Frans Snyders's youthful contribution of about 1612 to the *Prometheus* (cat. 10), however, we may assume that Rubens directed his efforts, probably guiding him by way of a lost oil sketch. As several authors have observed, an even earlier example of this practice is the Louvre's study for the *Recognition of Philopoemen* (fig. 26), a preliminary oil sketch for the large version of the painting in the Prado (Madrid, no. 1851) certainly by Snyders and possibly by Rubens as well.[89] In the Paris sketch, Rubens provided a summary indication of the design not only for the figures but also for the still-life elements with lightning quick strokes. However in a later sketch in the Earl of Wemyss's collection (Gosford House)[90] for the jointly executed *Cimon and Iphigenia* of ca. 1616-1618 in Vienna (fig. 27),[91] he left the right foreground empty, evidently confident that Snyders could by this point invent as well as execute the still life of fruits, birds, and a monkey that appear in the final version. (A third hand, possibly that of Jan Wildens, seems also to have been at work in the landscape.) Snyders became a valuable partner to Rubens, executing the animals, dead game, and fruit in several of his mythological paintings, including the *Crowning of Diana* (cat. 14) and *Diana's Return from the Hunt* (fig. 22), as well as the vipers in Rubens's marvelously gruesome *Head of Medusa* (cat. 12). Snyders also executed the commestibles in larder and pantry scenes painted in collaboration with the master (see, for example, *Kitchen Maid and Child with Fruit Still Life*, Bute collection, Dumfries House[92]) and the swags and garlands in outwardly decorative but no doubt allegorical paintings with statuary (see fig. 28)[93] and/or cherubs (see *Putti with a Swag of Fruit*, Munich, Bayerische Staatsgemäldesammlungen, inv. 330).[94]

Paulus Bril (see *Landscape with Psyche* dated 1610, Madrid, Museo del Prado, no. 1849) and Jan Brueghel the Elder also collaborated with Rubens, providing lush landscape settings for his history figures (see fig. 29[95]; and cat. 17). The latter also painted flower garlands with a central image of the Madonna and Child by Rubens. Brueghel was the first artist to paint the garland still lifes with a central religious image that subsequently became so popular, apparently first executing them in

Fig. 26. Peter Paul Rubens, *The Recognition of Philopoemen*, ca. 1609-1610, oil on panel, 50.5 x 66.5 cm, Paris, Musée du Louvre, no. MI 967.

Fig. 27. Peter Paul Rubens and Frans Snyders, and (possibly) Jan Wildens, *Cimon and Iphigenia*, ca. 1616-1618, oil on canvas, 208 x 282 cm, Vienna, Kunsthistorisches Museum, inv. 532.

Fig. 28. Peter Paul Rubens and Frans Snyders, *Statue of Ceres*, oil on panel, 90.3 x 65.5 cm, St. Petersburg, Hermitage, inv. no. 504.

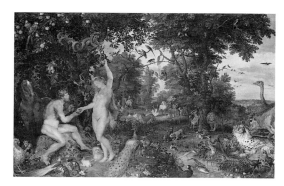

Fig. 29. Peter Paul Rubens and Jan Brueghel the Elder, *Paradise and the First Fall*, oil on panel, 74 x 114 cm, The Hague, Mauritshuis, no. 253.

Fig. 31. Peter Paul Rubens and Studio and Osias Beert the Elder, *Pausias and Glycera*, 1612-1615, oil on canvas, 203.2 x 194.3 cm, Sarasota, Florida, The John and Mable Ringling Museum of Art, acc. no. SN 219

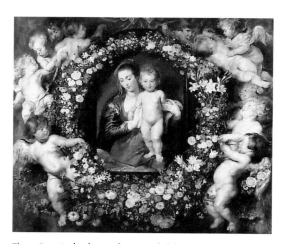

Fig. 30. Peter Paul Rubens and Jan Brueghel the Elder, *Madonna and Child Surrounded by a Flower Garland and Putti*, oil on panel, 185 x 209.8 cm, Munich, Bayerische Staatsgemäldesammlungen, no. 331.

collaboration with van Balen in 1608 and very possibly conceiving them according to instructions sent by Cardinal Borromeo.[96] The cardinal was the earliest documented owner of the garland paintings, and in a remarkable panegyric on Brueghel's talents as a still-life painter wrote, "There is no point in saying anything about the image enclosed in the garland for like a lesser light it is outshone by all the splendors surrounding it."[97] A letter that Brueghel wrote in 1621 mentions a painting with a wreath of flowers surrounding an image of the Virgin and Child painted by Rubens,[98] which Brueghel offered as a special gift to Cardinal Federigo Borromeo.[99] The period ca. 1617-1620, when Rubens and Brueghel are documented as having collaborated on this type of picture, is also a logical date stylistically for the two painters' large *Madonna and Child Surrounded by a Flower Garland and Putti* (fig. 30).[100] This work not only allowed the two artists to demonstrate their respective talents as figure and still-life painters, but also links the two zones of the painting by symbol as well as sacred allusion; the flowers in the wreath (lilies, roses, and other smaller blooms) were chosen for their Mariological symbolism, and the configuration of wreath and image, which recalls the medieval Rosary Madonna, was probably deliberately designed to resemble garlands used to honor especially miraculous images on actual altars and shrines.[101]

Following the Iconoclasm of the sixteenth century, which had so often concentrated its destructive wrath on paintings and sculptures of the Madonna, the Church sought to reaffirm the efficacy of miraculous images. Justus Lipsius, for example, devoted two treatises to the miraculous images of the Virgin at Hal (Halle) and Scherpenheuvel (Montaigu), sites that not only attracted throngs of pilgrims, but also the special veneration of the archdukes.[102] Rubens's protracted efforts to accommodate the Vallicella Madonna into his altarpiece for the Chiesa Nuova was part of a much larger programmatic effort by the Church to refute the sceptics and emphasize the special spiritual powers of certain miraculous images. Despite Cardinal Federigo Borromeo's surprisingly exclusive focus upon the beauty of the garlands themselves, their primary purpose was the adornment of the Madonna and the enhancement of her preciousness and spiritual appeal, and were thus an essential part of the image's efficacy. These associations explain the garland paintings' strong sentimental appeal for the faithful and why later artists like Daniel Seghers, Jan Philips van Thielen (qq.v.) and his other epigones could make a specialty of this art.

Another revealing case of collaboration between a Rubensian figure painter and a still-life artist, formerly believed to be Jan Brueghel the Elder but probably Osias Beert, is offered by a painting in Sarasota (fig. 31).[103] Although the design was once again conceived by Rubens, the somewhat awkward figures were probably for the most part executed by his studio. The subject of the work, long mistakenly thought to be a self-portrait of Rubens and Isabella Brant (no doubt because of the resemblance of the figures' seated poses to the famous double portrait in Munich, fig. 13), is more likely to be the theme of Pausias and Glycera. Pliny (*Naturalis Historia*, xxxv, chapter 11, 123-127) relates that Pausias, a famous Greek artist, fell in love with Glycera, the inventor of flower wreaths, and painted a highly prized painting of her plaiting her flowers, known in the ancient world as the *stephanoplocus*. Though a rare subject in art, it surely was not too obscure for Rubens, who after all had been the first artist ever to represent such subjects as the *Rape of the Daughters of Leucippus* (Munich, Bayerische Staatsgemäldesammlungen, no. 321). Moreover the subject of Pausias and Glycera was well known from the art theoretical literature of the day. Karel van Mander recounted the story in his "Den Grondt der edel vry schilder-const" (Foundations of the Noble Free Art of Painting) of 1604, in a chapter "On the Distribution and Interaction of Colors," which begins with a defense of the art of flower painting. Van Mander explains that the colors distributed by nature in fields of flowers are skillfully gathered and ordered by Glycera in her wreaths, but by painting her, Pausias attained the higher artifice of "naturalistic painting" (*naturlijk malen*; chap. 11, stanza 4, line 2).[104] The story thus not only illustrates the time-honored philosophical discussion of the competition between nature and art (and here van Mander clearly implies that the latter is the winner because art employs nature's methods as its guide and can also depict the creative process itself), but also served in the defense of the lowly genres that were the specialties of collaborators. In addressing the subject, Rubens and his followers not only emulated antiquity in executing a modern (i.e., seventeenth-century) *stephanoplocus*, but also affirmed the higher value of art's goal of naturalism. Thus Pausias and Glycera was an appropriate theme for a collaborative effort between baroque artists, who through their various specialties competed as they strove toward the shared goal of naturalistic painting.

A Wider Circle; Art for Europe

Although by 1620 Rubens had long since established himself as the leading painter in Antwerp and the Spanish Netherlands, he only consolidated his reputation throughout the courts of Europe in the 1620s. This was a decade of enormous productivity, vast commissions, and restless diplomatic activities. While the Jesuit Church's decoration and Decius Mus tapestry series had prepared him for large commissions, the cycle of paintings exalting the remarkably lackluster career of Marie de' Medici (Paris, Musée du Louvre) presented new challenges of tact and imagination.[105] Marie was the widow of Henry IV (whose proxy marriage in 1601 Rubens had witnessed as a young man in Rome) who, following her husband's assassination in 1610, reigned as Queen of France for several years before being banished (for the first time) by her son, Louis XIII. Reconciling with Louis in 1620, she returned to Paris and set about decorating her residence, the Luxembourg Palace.

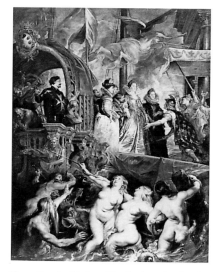

Fig. 32. Peter Paul Rubens, *The Disembarcation of Marie de' Medici at Marseilles*, oil on canvas, 394 x 295 cm, Paris, Musée du Louvre, inv. no. 1774.

Two cycles were originally envisioned, one glorifying the life of Marie de' Medici and the other devoted to her late husband.[106] The subject was a new one for Rubens and presented potential pitfalls since many aspects of the lives of the former king or queen might prove controversial, especially in the politically tendentious French court. Indeed Rubens's design for depicting Marie's flight from Paris to escape arrest by her son had in the end to be replaced by the inoffensive *Felicity of the Regency*. Rubens met the series's challenge brilliantly by swathing the skimpy accomplishments of Marie's life in the raiments of allegory, marshalling ancient gods to glorify her (see White) and Christian symbols and allusions to adorn her. In the *Disembarcation at Marseilles* (fig. 32), depicting the future queen en route to Lyon where her marriage was to be celebrated, we not only see her greeted by the deferential personification of France but also her bark safely towed to shore by Neptune and powerfully writhing naiads.

Marie's quarrels with the court ultimately lead to her flight from France in 1631. Although Rubens in characteristic fashion remained the queen's faithful defender, the intrigues at the French court protracted negotiations over the second series on the life of Henry IV. It ultimately was left abandoned after progressing as far as sketches and several large unfinished canvases. At the same time Rubens was working on the Medici cycle he also produced a series of tapestry cartoons illustrating the life of Constantine.[106bis] No commission for the series is documented but it is often assumed to have been intended for Louis XIII, who naturally would have been flattered by parallels with the life of the first Roman emperor to convert to Christianity, and who is known to have presented a set of the tapestries to Cardinal Francesco Barberini. In composing his scenes, Rubens liberally paraphrased antique sources, such as Trajan's column, and won the praise of his long-time friend and correspondent, the scholar and antiquarian Peiresc, for the historical accuracy of his figures' costumes. The two men shared the joys of collecting, especially antique gems, as well as a broad array of intellectual topics, ranging from the theory of color to perpetual motion machines. When Peiresc departed Paris in 1623, he entrusted the duty of keeping Rubens informed about topical matters in the French capital to his brother, Palamède de Fabri, Sieur de Valavez, who in turn passed the baton to the royal librarian, Pierre Dupuy. Around 1623 Rubens even briefly considered moving to France, where he then was making frequent visits and lucrative contacts. But the cunning Cardinal Richelieu soon recognized the painter as a political adversary and helped spoil the Henry IV cycle as well as any thoughts that Rubens might have entertained of relocating. With uncharacteristic pique, Rubens wrote in 1625 to Valavez, "I am tired of this court," and threatened never to return.[107]

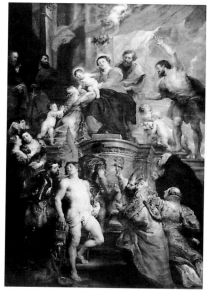

Fig. 33. Peter Paul Rubens, *Virgin and Child Enthroned with Saints*, 1628, oil on canvas, 564 x 401, Antwerp, Church of St. Augustine.

Following Archduke Albert's death in 1621, Rubens greatly increased his diplomatic activities, initially serving as a secret agent and later as a diplomatic representative of the Infanta Isabella. His artistic profession naturally provided a *passe-partout* to all the courts of Europe. However in the midst of his increasingly restless activities as a diplomat he also received his most important commission from the Infanta, namely the *Triumph of the Eucharist* tapestry series for the Convento de la Carmelitas Descalzas Reales in Madrid (see cats. 20–22).[108] Rubens prepared this series with an unprecedented thoroughness, working out the modelli with an exceptionally high degree of resolution and contriving an especially rich, symbolic program at once internally consistent and evocative of larger spiritual issues. The thought and effort expended suggest a deeply personal spiritual devotion, and indeed, few artistic projects produced during the Counter Reformation offer a more forceful illustration of the triumph of the Church and the vivid con-

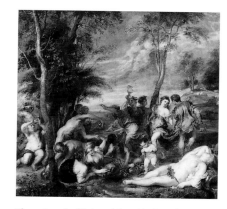

Fig. 34. Peter Paul Rubens (after Titian), *Bacchanal with the Andrians*, oil on canvas, 200 x 215 cm, Stockholm, Nationalmuseum, no. 600.

summation of its dogma. In May of 1628, Rubens wrote with the fervor of belief, "religion exerts a stronger influence upon the human mind than any other motive."[109]

When Rubens traveled to Paris in 1625 to install the Medici cycle he met George Villiers, the Duke of Buckingham, who was then serving as the escort for Marie de' Medici's daughter Henrietta Maria. The latter's proxy marriage to King Charles I of England in the newly decorated Luxembourg Palace not only had set the deadline for Rubens's work but also helped secure an alliance between Britain, France, and the United Provinces against Spain. The unprincipled Buckingham had great influence over the English king but also had a connoisseur's eye and a voracious interest in art. Rubens soon secured him as an important patron, who commissioned a ceiling for his London residence, York House, depicting the *Glorification of the Duke of Buckingham* (an oil sketch in London, The National Gallery, no. 187) as well as a large allegorical equestrian portrait of himself (an oil sketch in the Kimbell Art Museum, Fort Worth, no. AP 76.8), completed by 1627 (both destroyed by fire in 1949). About this time Rubens also sold a large portion of his collection of antiques (including the marbles acquired from Sir Dudley Carleton), paintings, and other works of art to Buckingham, for which the artist received the princely sum of fl. 84,000. With the proceeds the artist bought no fewer than seven houses in Antwerp in the Wapper and Lammenkenstraat.

Clearly by this point in Rubens's career he had attained not only international fame, but also riches, property, and rank. For his devotion to the Infanta Isabella, Philip IV had made him a peer in June of 1624. Five years later he received a Master of Arts from Cambridge University in England, and in 1630 was knighted by Charles I. Culminating his social ascendance, Rubens purchased the castle Het Steen, becoming in 1635 "Lord of Steen," the title he most favored in his later years and had placed on his tomb. It was not in fact so unusual in this period for artists, especially in Italy and Spain, to be ennobled; Rubens's earliest pupil, Deodato del Monte, won the honor, as did, for example, Justus Sustermans, Anthony van Dyck, Wenceslas Hollar, and Rubens's alter ego, Balthasar Gerbier, who served as Buckingham's agent as well as an artist-diplomat. While Rubens could still claim though somewhat disingenuously to Carleton in 1618 that he was "not a prince, and must earn my living by the labor of my hands,"[110] his bearing and accessories in his few mature self-portraits confirm his aristocratic presumptions and magnificence (see Vienna, Kunsthistoriches Museum, no. 527).

The motivations for Rubens's sale of his collection to Buckingham are not obvious. The large price surely must have been attractive, but the artist was in no special need of money. While meetings between Rubens and Gerbier held in Delft were ostensibly to negotiate the sale, they also provided a perfect pretext for secret discussions of an armistice between Britain, France, and the United Provinces; Rubens by this time was working in the interests of the Infanta with all his persuasive energy. Though always unsentimental about possessions, Rubens also may have felt at greater liberty to alter the contents of his own household because he had recently suffered the loss of his wife, probably to the plague, in June of 1626. Replying to Dupuy's condolences, the stoic Rubens briefly let down his guard, writing, "Such a loss seems to me worthy of deep feeling, and since the true remedy for all ill is Forgetfulness, daughter of Time, I must without doubt look to her for help. But I find it very hard to separate grief for this loss from the memory of a person whom I must love and cherish as long as I live."[111]

No doubt Isabella Brant's death contributed to Rubens's restlessness in the latter half of the 1620s. He continued to execute vast altarpieces and decorative projects, but during this period he devoted more of his time to the thrust and parry of politics than at any other moment in his career. From September 1628 to 1629 he was in Madrid at first working and later cooling his heels as Isabella's ambassador (as he later would in London until March 1630). At the initial news of her choice of representative, Philip IV wrote "I am displeased at your mixing up a painter in affairs of such importance."[112] However the monarch's misgivings about a man of "such a mean station," were soon dispelled; indeed so fully was he won over that he subsequently appointed Rubens to carry out the successful peace negotiations with England, remarking that "The merit of Rubens, his great devotion during his services, justify everything one can do for him."[113] Charles I allowed that he too was pleased to know a person of such merit.

Even before Rubens departed for Spain, he had shown a rekindled interest in the art of Titian. His large altarpiece of the *Virgin and Child Enthroned with Saints* (fig. 33) for the Church of the Augustinian Fathers in Antwerp not only adopts a more painterly and colorful Venetian style

than comparable subjects from the previous decade, but also paraphrases aspects of the design of Titian's *Madonna of the Pesaro Family* (1526; Sta. Maria dei Frari, Venice). Rubens found little intellectual stimulation at the Spanish court (later writing to Peiresc, he observed "there is no lack of learned men there, but mostly of a severe doctrine, and very supercilious in the manner of theologians"[114]); but clearly appreciated the attentions of the rather malleable and hedonistic Philip IV. Rubens claimed that the king visited his studio daily and in characteristically generous fashion assessed him as "a prince endowed with excellent qualities," chief among them, of course, his love of art.[115] Philip IV owned more than 1,000 paintings, including scores of works by Titian, mostly gathered by his predecessors Charles V and Philip II. These Rubens studiously copied during his protracted stay in Madrid; no fewer than thirty-two copies after Titian remained in the artist's estate at his death.[116] Some of the finest of his copies are subtly creative reinterpretations of their sources, such as *Worship of Venus* and its pendant, *Bacchanal with Andrians* (fig. 34), both now in Stockholm.[117] Formal quotes from Titian abound in his later art (see cat. 26 and cat. 28). The expressive use of saturated hues, the dissolution of contours into atmospheric veils of *sfumato*, as well as an increasingly personal, even idiosyncratic approach to drawing in his later art is unthinkable without Titian's example. Sustermans later recalled that Rubens "carried the image of Titian in his mind as a lady carries that of her beloved in her heart."[118]

Philip IV became Rubens's most important late patron, acquiring or commissioning works for the Alcázar, Buen Retiro (1632), and his hunting lodge, the Torre de la Parada (1636-1638). However Rubens also enjoyed the patronage of other high-born Spaniards including Diego Messía, the Marqués de Leganés, who owned no fewer than twenty paintings by Rubens at his death in 1655.[119] A soldier, diplomat, and connoisseur, the marqués serves to remind us how many leading political figures of the age (e.g. the Duke of Buckingham, the Earl of Arundel) were also important patrons and collectors. While serving in his diplomatic capacities in England in 1629-1630, Rubens portrayed his patron and Charles I's ambassador, the stern and austere Thomas Howard, Earl of Arundel (cat. 28), again in a Titianesque mode. A greater collector and connoisseur of classical sculpture than a statesman, Arundel undoubtedly had a significant influence on Rubens's own collecting activities and tastes.

Home and the "Dolcissima Professione"

Despite Rubens's triumph in personally negotiating an international treaty, he had paid a steep price for his patriotic public service both in lost earnings and psychic expense.[120] On his departure from England, the artist gave the painting of *War and Peace* (London, National Gallery, ill. cat. 29, fig. 4), in which Minerva restrains Mars so that Peace (Pax, though with some of the attributes of Venus) may prosper, to Charles I as a pictorial celebration of the benefits of peace.[121] These optimistic sentiments proved all too brief and precarious when new hostilities broke out. Following his return to Antwerp, he reported that he had begged the Infanta "as the sole reward for so many efforts, exemption from such assignments, and permission to serve her in my own home. Now . . . by divine grace, I have found peace of mind, having renounced every sort of employment outside my beloved profession (*dolcissima professione*). Destiny and I have become acquainted . . . and I cut through ambition's golden knots in order to reclaim my freedom."[122]

The chief interior decorative project (as opposed to the Pompa Introitus Ferdinandi, which was erected out of doors) of these later years was the ceiling decorations for the Banqueting House at Whitehall, London, which was completed by 1634 and remains the only large decorative project by the artist still in situ.[123] The chamber was used to receive foreign delegations, and for masques and other entertainments. Rubens's decorations again employed the angled views derived from Venetian prototypes that he had exploited so successfully in the Jesuit ceiling, and like the Medici cycle, glorified an individual. The overall theme was the celebration of the benevolent reign of King James I (see cat. 29), and by implication, that of his son, Charles I, then occupying the throne. Gods and allegorical figures drift and swarm in the steeply foreshortened scenes of triumph. It is a testament to Rubens's resolve in his retirement from politics that he refused to courier these works to London or even see them installed; he wrote Peiresc, "Inasmuch as I have a horror of courts, I sent my work to England in the hands of someone else." He assured his friend that "I have preserved my domestic leisure, and by the grace of God, find myself still at home, very contented."[124]

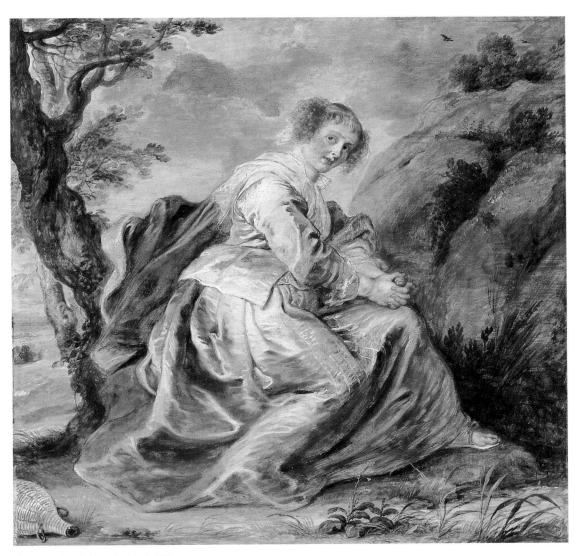

Fig. 35. Peter Paul Rubens, *Hagar in the Wilderness*,
oil on panel, 71.5 x 72.6 cm, London, Dulwich College
Picture Gallery, inv. 131.

 Part of that contentment undoubtedly had to do with the fact that Rubens had remarried on 6 December 1630. His bride was Hélène Fourment, daughter of the silk and tapestry merchant Daniël Fourment, for whom Rubens seems to have made the designs for a set of tapestries on the *Life of Achilles* at about this time.[125] Rubens wrote to Peiresc of his decision to remarry, "since I was not yet inclined to live the abstinent life of a celibate, thinking that, if we must give the first place to continence we may enjoy licit pleasures with thankfulness."[126] In choosing a very young woman from a middle-class family rather than one of the many mature women he had met at the various courts of Europe, he explained "I chose one who would not blush to see me take my brushes in hand. And to tell the truth, it would have been hard for me to exchange the priceless treasure of liberty for the embraces of an old woman"[127]; Hélène was sixteen and Peter Paul fifty-three. As Roger de Piles and others observed,[128] Rubens's pretty young wife frequently figured as a model in his paintings from this period. She played the role, for example, of the innocent *Hagar in the Wilderness* (fig. 35) as well as the worldly Aphrodite in the famous full-length image of a nude in a fur coat known as *Het Pelsken* (The Little Fur, also refered to as *Venus*; fig. 36) – the epito-me of sensual painting and the only picture that Rubens specifically left to his widow in his will.[129] Among the ladies in the *Conversatie à la Mode* (*The Garden of Love*) (cat. 31) she appears at least once; indeed all of these elegant creatures seem to bear a family resemblance to Hélène. Even Rubens's patrons recognized her; the Cardinal Infante Ferdinand wrote to his brother Philip IV, who had commissioned the *Judgment of Paris* (fig. 37), that the figure of Venus (who, of course, wins the fateful competition for the fairest) "is a very good likeness of his wife, who is certainly the handsomest woman to be seen here."[130]

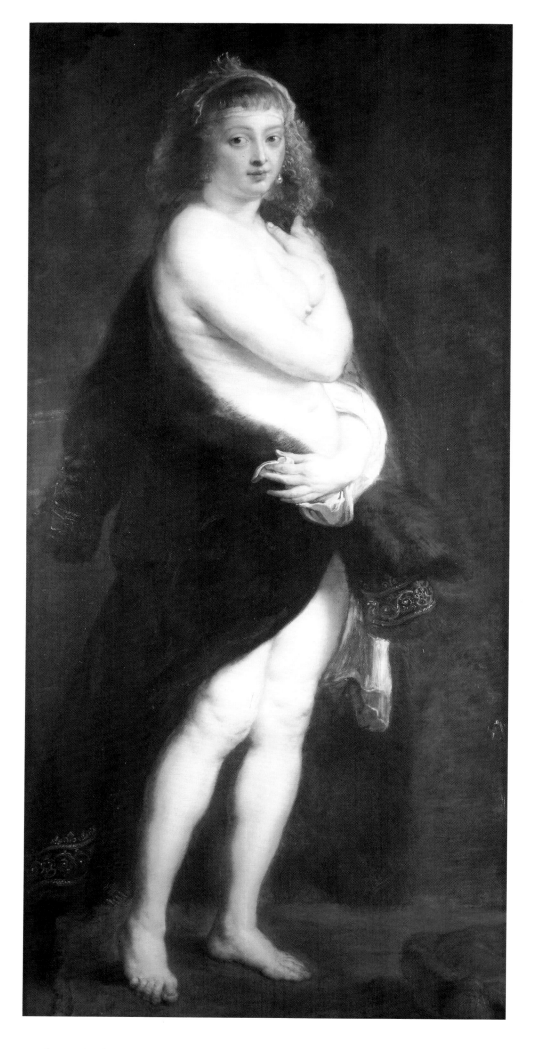

Fig. 36. Peter Paul Rubens, "Het Pelsken" (*Aphrodite*), oil on panel, 176 x 83 cm, Vienna, Kunsthistorisches Museum, inv. 688.

To celebrate the Triumphal Entry of the Cardinal Infante Ferdinand into Antwerp in April 1635, Rubens undertook the largest and most ephemeral project of his career, the decoration of the entire city with painted arches, porticos, floats, and vast and elaborate stages.[131] Nicolaes Rockox and Jan Caspar Gevaerts (Gevartius) helped devise the program and the latter wrote the explanatory texts for Theodoor van Thulden's etchings later published in the *Pompa Introitus Ferdinandi* (1642). Rubens's few surviving oil sketches, such as the image of *Neptune Calming the Seas* to facilitate Fredinand's crossing from Barcelona to Genoa (see cat. 33), show that he once again ingeniously mixed allegory and actual events in appropriately extravagant praise of his subject. Executed under difficult constraints of time and budget, the project required all of Rubens's administrative mastery to coordinate the efforts of virtually all leading artists of Antwerp, who had been conscripted en masse for the project.

During the 1620s, when Rubens undertook so many projects for foreign patrons, accepted so many great commissions for churches and palace decorations, and traveled so extensively, he all but gave up painting landscapes. Indeed scarcely three dozen painted landscapes exist from his entire career. However at the end of the decade and especially after returning to Antwerp and purchasing the castle Het Steen, Rubens renewed his interest in the art form. From about 1614 to 1620, he had painted imaginary landscapes of remarkable structural sophistication, culminating in works like the *Landscape with Cart* (cat. 89), which ultimately descends from designs used by Pieter Bruegel, Lucas van Valckenborch, and Hans Bol, but makes the scene at once more natural and universal by seeming to reconcile virtually all of the elemental oppositions of nature. When he took up landscape again in the 1630s it was with a more private, proto-romantic view of nature. Probably painted around 1635, *A Forest at Dawn with a Deer Hunt* (fig. 38) still employs compositional formulae popularized by late mannerist artists (such as Gillis van Coninxloo and Roelant Savery), but recasts these sources with an unprecedented painterly freedom. The rising sun that explodes upon the scene from behind the traditional repoussoir of a darkened tree stump not only shoots rays of shimmering light across the forest floor, but seems to drive the scampering prey as forcefully as the hunters and their dogs. The thick crepuscular atmosphere of the forest interior is shattered by this sudden burst, creating dramatic oppositions of darkness and light, day and night, but now nature's dichotomies are resolved with a more poetic, elegiac vision that again calls to mind the art of Titian.

A more cultivated and serene view of nature is offered in the parklike setting of Rubens's eminently civilized *Conversatie à la Mode* (cat. 31). With this ravishing picture the artist not only envisioned an ideal of society, discourse, fashion, and deportment, but also of love and courtship. It is an enchanted world that Rubens conceives, far from the vulgarities of daily life, where the women are forever beautiful and the men ardent but gallant. The air is filled with playfully diverting putti, while the manicured grounds are richly appointed with noble architecture and statuary that seem almost to breathe. Especially in the background this painting is executed with some of the delicacy of touch characteristic of the artist's sylvan and pastoral late mythological subjects, but the colors are deep and sure, the brushwork, especially in the figures, caressing and descriptive. Socially as well as pictorially, this ideal of arcadian high life can be regarded as the high-life counterpart of Rubens's bumptious and elemental peasant *kermesse* from the same period now in the Louvre (see Renger, fig. 5).

Five of the drawings that Rubens made for individual figures in the *Garden of Love* were reemployed in only slightly modified forms for the figures of Sts. Margaret, Apollonia, and Catherine in the splendid altarpiece of the *Crowning of St. Catherine* (cat. 32) that the artist was commissioned to paint in 1631 for the altar of St. Barbara in the church of the Augustinians in Mechelen. As the Prado's painting is properly understood as a secular *conversatie* celebrating the delights of social intercourse, so the great altarpiece now preserved in the museum in Toledo is a traditional religious *sacra conversazione* – an image of meditative conversation designed to prompt spiritual reflection, contemplation, and devotion in the faithful.[132] Like the famous *St. Ildefonso* altarpiece (Vienna, Kunsthistorisches Museum, no. 698; ill. Freedberg, fig. 5), executed at the same time following the instruction of the Infanta Isabella for the Church of Sint Jacob op den Coudenberg in Brussels, this great canvas beautifully illustrates Rubens's late style of religious painting. Both combine a sumptuousness of conception with a tenderness of expression. The shimmering highlights and glowing palette of deeply saturated hues in the *St. Catherine* are one of Rubens's greatest coloristic achievements.

Philip IV, the most impatient of patrons, ordered the more than 120 paintings for his hunting lodge, the Torre de la Parada, to be completed in little over one year's time.[133] Approximately half of these were animal paintings by Snyders and others, while the remainder were illustrations from Ovid's *Metamorphoses* and other classical texts designed by Rubens and mostly carried out by assistants (including Jacob Jordaens, Erasmus Quellinus, Cornelis de Vos, Jan Cossiers, J.-B. Borrekens, Jan van Eyck, and many others). Rubens painted more than eighty paintings for Philip during the last four years of his life; the king's brother Ferdinand provided regular accounts of the work's progress. When, for example, the gout that plagued Rubens's final years delayed the completion of the *Judgment of Paris* (fig. 37), Ferdinand assured the monarch that he would force the painter (though ill enough to have received extreme unction) to make up for lost time; when the picture was finally finished the Infante pronounced it Rubens's "best picture," adding somewhat prudishly, "The goddesses are too nude; but it was impossible to induce the painter to change, as he maintained it was indispensable in bringing out the value of the painting."[134]

It is a testament to Rubens's fame that both the kings of Spain and England requested bulletins on his health when he retired to his deathbed, finally expiring on 27 May 1640. The 314 items listed in the *Specification* advertising the sale of the best paintings in the artist's estate included ninety-three of his own paintings, ten by Titian, twenty-six by Veronese and Tintoretto, as well as numerous copies by Rubens after Titian. Also among the paintings were some that remained unfinished, and others, like the famous *Three Graces* (fig. 39), that the artist had evidently painted for his own pleasure and collection. In addition to receiving *Het Pelsken* (fig. 36) and the customary half share of the estate, Hélène Fourment purchased from the estate a version of the *Conversatie à la Mode* (see cat. 31). Among the noble buyers at the ensuing sale were Philip IV, Charles I, and Frederick Hendrick, the Prince of Orange and Stadholder of the United Provinces. At his own instruction one of Rubens's last paintings, *Madonna and Child with Saints*, was hung above the altar in his funerary chapel in the Church of St. Jacobskerk, Antwerp. The painting is still in situ beneath a marble statue of the Virgin by his favorite pupil, Lucas Fayd'herbe. The last of the five children that he had with Hélène was born eight months after his death. Rubens requested that his drawings be held intact until all of his children reached majority; when none followed him into an artistic career and none of his sons or his daughters married an artist, the drawings were dispersed in 1657.

Fig. 37. Peter Paul Rubens, *Judgment of Paris*, ca. 1639, oil on canvas, 199 x 379 cm, Madrid, Museo del Prado, no. 1669.

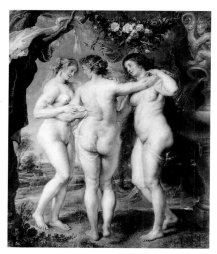

Fig. 39. Peter Paul Rubens, *The Three Graces*, oil on panel, 221 x 181 cm, Madrid, Museo del Prado, inv. no. 1670.

Fig. 38. Peter Paul Rubens, *A Forest at Dawn with a Deer Hunt*, ca. 1635, oil on panel, 62.2 x 90.2 cm, New York, Metropolitan Museum of Art, inv. no. 1990.196.

Anthony van Dyck

Rubens and Anthony van Dyck have often been characterized as possessing fundamentally opposed artistic temperaments; however, especially in modern times, these differences and the two artists' shared concerns have often been obscured by the nineteenth century's obsession with the concept of genius and the present era's cult of the psychological portrait. Whereas Rubens formed his own artistic style only gradually, van Dyck was a child prodigy who by age twenty-one was summoned to the Court of James I and soon rocketed to international acclaim. The rapidity of his ascent and the seeming ease with which this inordinately gifted artist painted has led some to conclude that he was facile, more talented than substantial. His early biographers (Bellori [1672] and Félibien [1666-1668]) characterized him as proud and ambitious, sensitive and excitable, a profligate lover of luxury but also an indefatigable worker. Others, such as Houbraken (1718-1721), fabricated romantic stories of a joint studio and of competition and jealousy between Rubens and his fast-rising assistant. Certainly the accounts of van Dyck's lavish lifestyle, servants, and magnificent wardrobe support the sobriquet he earned as a young painter in Italy, "il pittore cavalieresco." At the same time, his quarrels with other artists, his unpredictability, touchiness, and especially his restive itinerary during his last years (when even the Infante Ferdinand reported to Philip IV that he was an "archi-fou"[135]) has suggested to many a flighty or indecisive person, and, to some, an unstable personality. The ambition and social advancement that in Rubens has been portrayed as just and majesterial in van Dyck's case has more often been seen merely as a means of ingratiating himself to his patrons. However as the recent monographic exhibition of the painter's art triumphantly proved, there is nothing superficial or lightweight about van Dyck's achievement[136]; indeed he can even support comparison to the towering Rubens.

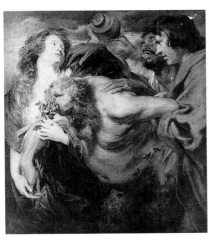

Fig. 40. Anthony van Dyck, *Drunken Silenus*, ca. 1620, oil on canvas, 107 x 91.5 cm, Dresden, Gemäldegalerie Alte Meister, no. 1017.

In point of fact the archives reveal very little about van Dyck's personality and beliefs. We know that he came from a well-to-do Antwerp merchant's family who seem to have been profoundly religious; his siblings included a nun, a priest, and three beguines. In 1628 he joined the Jesuit Confraternity of Bachelors (*Sodaliteit van de bejaerde jongmans*) in Antwerp, and he apparently was devoted to the wife that he married late in life, though he had an illegitimate daughter as well as one in wedlock. A pupil of Hendrick van Balen at the age of ten, he was probably an independent master with his own studio by 1618 when he was only 19 years old. Rubens seems to have discovered his talent about a half dozen years earlier, and painted the youth's portrait in ca. 1613-1615 (Fort Worth, Kimbell Art Museum). The period of ca. 1616-1620 probably brought the two artists into their closest contact. Bellori mentions van Dyck's collaboration on the Decius Mus cartoons in ca. 1617 (Vaduz, Prince of Liechtenstein collection), in the contract for the Jesuit ceiling decorations he was the only assistant mentioned by name, and in Rubens's well-known correspondence with Carleton in 1618 he is specified as his best pupil (*discepolo*). The question of van Dyck's status in these years has been much debated[137]; but it seems likely that he was more than Rubens's student and probably functioned as the master's premier assistant. While van Dyck surely facilitated the remarkable productivity and expansion of Rubens's studio in these years, he too profited by the experience. Van Dyck was not only able to perfect his artistic skills in the presence of Rubens's mature example, but also witness at first hand the administration of a large atelier, and benefit from the intellectual and artistic stimulus of Rubens's studio, his collection, and his circle of learned and powerful friends. Thus Rubens presented van Dyck with a social as well as an artistic ideal. Following that ideal, the younger artist also aspired to a nobleman's lifestyle; he was eventually knighted, assembled an important art collection, and even acquired a country home.

Still, for all of his emulation of Rubens, van Dyck was an independent artist from the first and expressed this individuality even at the outset of his career. Like other young artists, he experimented with several different styles and approaches to paint application before ca. 1620, and tended to use a much rougher and broader technique than Rubens. The composition of a work like the *Drunken Silenus* (fig. 40) is directly based on Rubens (compare the latter's earlier painting of the same theme, Bayerische Staatsgemäldesammlungen, Munich, no. 319) but the dry, raw, and in passages, open brushwork is a far cry from Rubens's coolly polished classicism of this period. The great *St. Jerome* here exhibited (cat. 38) again nods to Rubens but only to reveal his own independent ideas as if in creative competition with his mentor. Even when van Dyck is at

his most Rubensian, as in a work like the *Crowning with Thorns* in the Prado (fig. 41), which not only paraphrases the master's drawn copy (Antwerp, Rubenshuis) of the Belvedere Torso but also seeks to emulate his plasticity, the younger painter betrays a greater concern with pictorial, rather than structural, values. As we have seen, Rubens achieved his monumentally plastic forms through the use of individual figure drawings. Van Dyck on the other hand relied much more on compositional sketches (see the preparatory study for cat. 37, fig. 3), seeking animated but balanced designs with a greater diversity of texture, optical effects, and emotion.[138] We again find Rubens's designs paraphrased in the artist's early portraits (see cat. 36), but the humanity and psychology of the sitters are palpably enhanced.

In 1620 van Dyck was beckoned to England where he worked briefly for both the king (who awarded him an annual stipend of £100) and the Duke of Buckingham, before being granted leave by the Earl of Arundel to travel. The artist returned to Antwerp before heading to Italy, where he used Genoa as a base of operations. In Italy he did not attach himself to a court, as had Rubens, but like his predecessor found an eager market for elegantly stately, *soigné* portraits among members of wealthy Genoese families (see cat. 39). From Genoa, van Dyck traveled throughout Italy, visiting Rome, Venice, Florence, Milan, Mantua, Turin, and Palermo, where he was commissioned to paint the *Madonna of the Rosary*, a monumental effort conspicuously recalling Rubens's altarpiece for Sta. Maria in Vallicella (cat. 7, fig. 4), but animated with a febrile luxuriance that is characteristic of the younger painter's mature style. Unlike Rubens, he did not compile a large reference portfolio of drawings after the antique during his Italian sojourn (Sandrart informs us that he had little interest in "Academies of antiquity"); instead his sketchbook (London, British Museum) is filled mostly with efforts to understand the grandeur and sensitivity of Titian.[139] Sandrart affirms that van Dyck deciphered better than anyone else the secret of Titian. Although he reacted to many Italian artists (notably Raphael, Correggio, Veronese, the Carracci, and Guido Reni), Titian easily commanded the greatest influence on van Dyck, as attests a work such as the latter's *Three Ages of Man* (cat. 40), virtually his only secular history painting from the Italian period. The powerful example of the Italian master served to loosen van Dyck's brushwork and offered a model of poetic sensitivity in both composition and human expression. By the late 1620s, van Dyck had also acquired a sizable collection of paintings by the Venetian artist.[140] Indeed his immersion in Titian precedes the extensive study that Rubens undertook of the master while in Madrid in 1628-1629, and may have helped pique his mentor's interest.

Van Dyck was back in Antwerp by 1627 (when he portrayed Peter Stevens, The Hague, Mauritshuis, no. 239). Entering the Jesuit lay brotherhood the following year, he executed two altarpieces for the organization, the *Madonna and Child with Sts. Rosalie, Peter, and Paul* in 1628 and *The Mystic Vision of the Blessed Herman Joseph* in 1629 (fig. 42), both now preserved in Vienna. Expressive of surrender and devotion, the latter well illustrates the infinitely graceful style that van Dyck had developed by this point. The decade of 1620s has been regarded as the period when van Dyck consciously sought to perfect an ideal of grace (*gratia*), a delicate and effortless manner that he himself called the "airy style" (*een loechte maniere*).[141] The shift from a robust and insistently plastic style to a more painterly one, coupled with the attenuation of form and a svelte and slender figure type are certainly factors in this change, but the essence of the ideal was to avoid all affectation: to create an art whose grace conceals its own artistry.

The *Rinaldo and Armida* (fig. 43), also of 1629, is a masterpiece of van Dyck's graceful style, Venetian coloration, and approach to composition, employing an italianate *di sotto in sù* design. Ordered by Charles I, it depicts an episode from one of that king's favorite books, Torquato Tasso's *Gerusalemme liberata* (first published in 1581), which weaves a love story through a tale of the reconquest of the Holy Land by the crusaders. Performed at masques at the English court, the subject had a special appeal for the British because of its allusion to an enchanted isle ruled by enlightened leaders. However van Dyck lent the scene definitive form, showing the smitten Armida in the company of singing naiads first gazing on the slumbering Christian knight, Rinaldo.

In 1630 van Dyck was named court painter to the Infanta Isabella, but like Rubens he continued to live in Antwerp. The painter now circulated in the highest social strata and his talents as a portraitist were constantly in demand: he depicted the prince of Orange and his wife in 1628 and 1632, and Marie de' Medici when she visited Antwerp in 1631. In England the following year (1632)

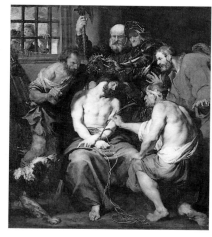

Fig. 41. Anthony van Dyck, *Crowning with Thorns*, ca. 1620, oil on canvas, 223 x 196 cm, Madrid, Museo del Prado, no. 1474.

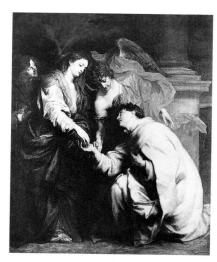

Fig. 42. Anthony van Dyck, *The Mystic Vision of the Blessed Herman Joseph*, oil on canvas, 160 x 128 cm, Vienna, Kunsthistorisches Museum, inv. 488.

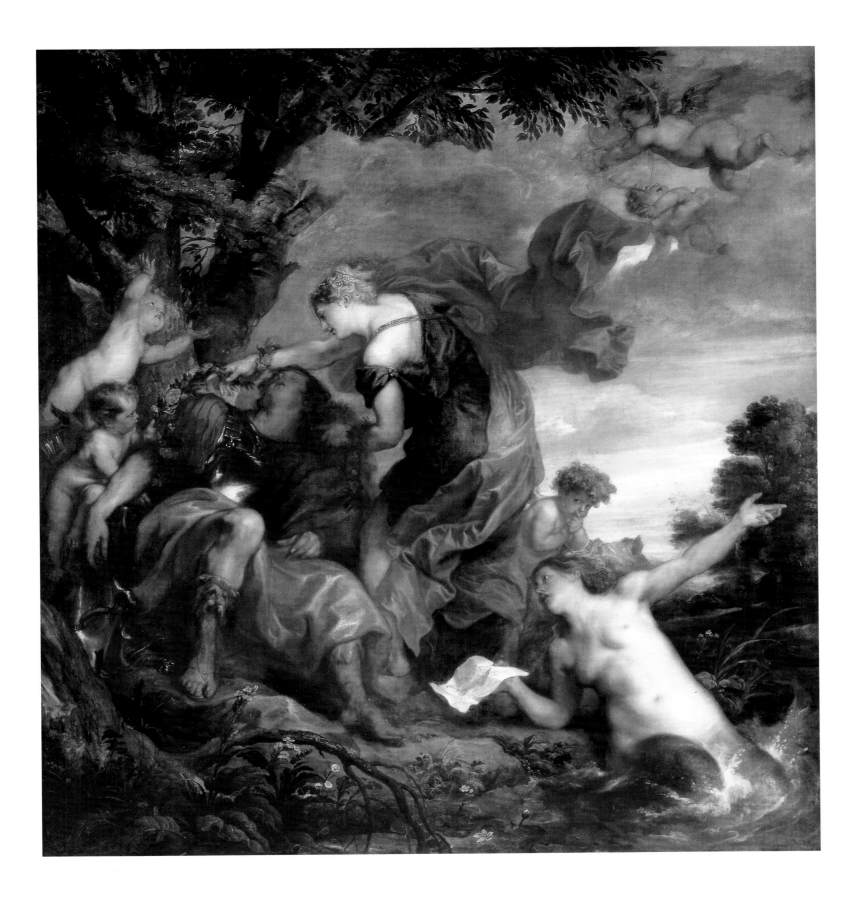

Fig. 43. Anthony van Dyck, *Rinaldo and Armida*, 1629, oil on canvas, 236 x 224 cm, Baltimore, The Baltimore Museum of Art, 1951.103.

he was appointed "Principalle Paynter ordinary to their Majesties"; he was knighted and presented with a gold chain by Charles I. It was at this time that he operated his studio at Blackfriars, where he received and portrayed England's aristocratic elite. Van Dyck had probably employed assistants even during his first Antwerp period, though only the later ones (Jean de Reyn [q.v.], Remi Leemput, Jan van Bekamp) are known by name. While in Italy he had also collaborated in traditional Flemish fashion with Jan Roos, a Genoese still-life artist (see *Vertummus and Pomona*, Galleria di Palazzo Bianco, Genoa[142]). However collaborations with independent specialists seem to have been more the exception than the rule with van Dyck.[143] More typical of his working

methods, especially after 1630, was the use of assistants to paint costumes, backgrounds, and accessories in portrait commissions. If Eberhard Jabach's description of his studio is to be believed, it was a virtual portrait industry, with a constant queue of sitters, each posing for an hour during which van Dyck painted their countenances and sketched in the salient features of the general design to be completed later by his assistants.[144] These same helpers also painted numerous copies of his portraits, thus obscuring the original œuvre, especially the later works, to this day. Like Rubens's patrons, van Dyck's noble sitters often insisted that he paint them himself with his "owne pensell."[145] Nonetheless his studio practices were emulated by later British court portraitists, such as Peter Lely, Godfrey Kneller, and Thomas Lawrence.

Clearly the same ideal of grace that harmonized van Dyck's history paintings also proved eminently suited to portraiture. The impeccably elegant *Portrait of James Stuart, Duke of Richmond and Lennox* of 1633 (cat. 41) extends to the duke all the fluid attenuation and noble poise of his faithful greyhound. Van Dyck permanently transformed portrait painting not simply by adopting a svelte new canon of proportion and an air of aristocratic insouciance but also by suggesting something of his sitters' psyches. His double portrait (fig. 44) of himself with Sir Endymion Porter, the cultivated adventurer and courtier who, as Charles I's Groom of the Bedchamber, collected art for the king (including van Dyck's *Rinaldo and Armida*, fig. 43), is a wonder of subtle psychological interplay not only between a patron and an artist but also between two friends.

Fig. 44. Anthony van Dyck, *Self-Portrait with Sir Endymion Porter*, oil on canvas, 119 x 144 cm, Madrid, Museo del Prado, no. 1489.

When van Dyck returned to the court in Brussels in 1633-1634 he painted a series of works for the gifted diplomat and churchman Abbé Scaglia (see cat. 42). He also worked during these years on his *Iconography*, a series of engraved portraits of some of the leading statesmen, collectors, and artists of the period.[146] By depicting painters in the same company as princes and scholars, van Dyck was obviously promoting the special status afforded his profession. Indeed the pride of aristocratic artists was understood even in the most rarified circles; when van Dyck returned to Antwerp shortly after Rubens's death in 1640, it was proposed that he complete the master's unfinished canvases for the Torre de la Parada, but Ferdinand in writing to Philip IV rightly anticipated that "such a great artist" as van Dyck would refuse a request to complete another man's work.[147]

In the artist's last years, he shuttled back and forth between London, where civil war threatened, and Paris, where he hoped to win the commission for the decoration of the Grand Galerie in the Louvre. There is in this peripatetic behavior the restlessness of someone seeking with increasing desperation a forum sufficient to his talents. Whether or not van Dyck's feasting and lavish lifestyle hastened his death (as Walpole surmised), the artist died at age forty-two and was buried in the choir of St. Paul's Cathedral, London.[148] Despite his short life, van Dyck's contributions have endured. The art of Rubens, Jacob Jordaens, and others all underwent a change in the 1620s to a more painterly, less plastic manner, but it was van Dyck's graceful style that proved to have the most lasting influence on successive generations of Flemish, and English, artists.

Jacob Jordaens

The third artist in the triad of the foremost Flemish baroque painters is Jacob Jordaens.[149] His was still another and very different artistic personality. Unlike Rubens and van Dyck he was not a court painter, and though in later life he received commissions from foreign nobility (chiefly from Scandinavia and the House of Orange), he was never a worldly diplomat like Rubens, nor a habitué of courts like van Dyck. Jordaens was mostly ignored by the courts in Madrid and Brussels, received no commissions from Italy or Germany, and when hired by Charles I of England in 1640 was offered employment only because Rubens had proven to be too expensive. Jordaens worked instead mostly for the local southern Netherlandish bourgeoisie and clergy. Except for brief trips in and around his own country and the United Provinces, he also never traveled abroad. Indeed he was born, married, and died in Antwerp, never living more than a block from his ancestral home. More than van Dyck or Rubens, however, Jordaens has been seen as expressing the robust, indigenous vitality and naturalism of Flemish art. Though a moralist, he expressed an optimistic view of life with images of noisy conviviality and bounty, be they secular, religious, mythological, or allegorical subjects.

Jordaens was a pupil of Adam van Noort, who subsequently became his father-in-law and who figures regularly as a model in his art together with other members of Jordaens's family.

One of eleven children, Jordaens was born into a middle-class Catholic family, who evidently were religious; one sister became a nun, two were beguines, and a brother joined the Augustinians. There is no evidence to suggest that he had an extended humanistic education like Rubens, nor was he a great letter writer. But Jordaens was fluent in French, had good knowledge of the scriptures, was acquainted with mythology, and no doubt had been exposed to Ovid's *Metamorphoses* (the "painter's bible") and its commentaries, such as Karel van Mander's *Uytleggingh* (1604). When he joined the guild in 1615 it was as a "waterscilder [sic]," a painter of cartoons or ersatz tapestries on paper. This early training was put to use, especially after ca. 1630, when he executed watercolor cartoons for tapestries.

Fig. 45. Jacob Jordaens, *Adoration of the Shepherds*, signed and dated 1616, oil on canvas, 113 x 81 cm, New York, Metropolitan Museum of Art, no. 67.187.76.

Jordaens dated only three paintings in his early career, the earliest of which is the tightly composed nocturnal scene of the *Adoration of the Shepherds*, dated 1616 (fig. 45).[150] This is already a fairly assured work suggesting that he had begun his career at least several years earlier. The dramatic lighting and half-length format are conspicuously Caravaggesque. Through Rubens's successful lobbying, Caravaggio's *Madonna of the Rosary* had come to the Dominican church in Antwerp, but probably not before 1620, so Jordaens's grasp of the Italian master's style was undoubtedly colored by the local interpretations of Rubens, Abraham Janssens and others. The robust and powerful forms and the relatively smooth execution and opalescent palette (especially the bluish-green cast of shadows and flesh) in Jordaens's early works (see, for example, *Christ Blessing the Children*, St. Louis Art Museum, no. 7:1956) are unthinkable without Rubens, who remained the single most important factor for Jordaens's art throughout his career.

In his formative years, Jordaens painted at least six other variations on the theme of the Adoration of the Shepherds, always closely grouping the half-length figures and cropping the scenes tightly, thus through the limited space focusing attention on the carefully observed rustic figures. This approach to composition served to intensify the narrative and accentuate the characters' expressions. By the time he painted the version of the theme dated 1618 in Stockholm, Jordaens had already developed the high relief, assured brushwork, and clear expanse of colors (now more golden brown in the tonalities of the flesh) that characterize the works of the next decade, generally regarded as the painter's best period. Jordaens's earliest history paintings had betrayed a certain *horror vacui*, as writhing and struggling but essentially flaccid nudes multiplied in a shallow space (see, for example, the *Battle of the Lapiths and Centaurs* of ca. 1615, formerly with Agnews, London[151]). Executed only two or three years later, a work like the very large and colorful *Allegory of Fruitfulness* (fig. 46) is far more successfully organized and reveals a surer command of composition, anatomy, and modeling, but still tends to fill up the image as in a densely conceived bas relief. Typically, several of the figures are quoted directly from Rubens. The allegorical subject of fruitfulness was one that Jordaens favored all his life, not simply because it provided an opportunity for him to demonstrate his skill at painting voluptuous female forms, but also because he seems to have instinctively loved nature in full bloom, delighting in a ripeness expressive of earthly abundance and pleasure.

Fig. 46. Jacob Jordaens, *Allegory of Fruitfulness*, signed and dated 1617, oil on canvas, 250 x 240 cm, Munich, Bayerische Staatsgemäldesammlungen, inv. no. 10411.

When Jordaens painted what is in effect the same subject in his beautifully conceived *Hommage to Pomona* (fig. 47), some of the earlier crowding has been relieved but the abundance still presses to the fore. The supple figures now are modeled more naturalistically, the heads are more individualized, and the palette less shrill. Jordaens often made use of expressive head studies (*tronies*) in this period. The model for the ruggedly creased face of the old satyr at the right, for example, is Abraham Grapheus, an officer of the St. Luke's Guild who often posed for Jordaens and other artists in these years (see fig. 56). Among Jordaens's more formal portraits, the *Young Couple* in Boston (cat. 44) conveys a refreshing directness and candor even in the absence of any information about the sitters' identities. In contrast to van Dyck, he did not probe the human soul in either his portraits or his history paintings, and would never have depicted himself holding a sunflower, or in the role of Paris, the arbiter of feminine beauty (see, respectively, van Dyck's *Self-Portraits* in the Duke of Westminster's collection and the Wallace Collection, London); indeed Jordaens's few self-portraits reveal little impulse to self-examination. He is at his best in works like the large group portrait of his family in the Prado (Madrid, no. 1549; ill. cat. 44, fig. 2), where the painter's confidence and pride perfectly complement this affable image of his loved ones.

Jordaens had contributed a *Crucifixion* (Antwerp, St. Paul's Church) to the series of fifteen paintings of the Mysteries of the Rosary that were commissioned from various Antwerp artists to decorate the former Dominican church at Antwerp about 1617.[152] During the early and mid-

1620s he also executed other important religious paintings, including the *Christ on the Cross* (Rennes, Musée des Beaux-Arts) for the Beguine church in Antwerp and the *Disciples at Christ's Tomb* (Dresden, Gemäldegalerie Alte Meister, no. 1013). The latter employs a compositional device that Jordaens had used in a somewhat earlier painting of *Moses Striking the Rock* (Karlsruhe, Staatliche Kunsthalle, no. 186), of turning all the figures in one direction and having them respond variously to an unseen source of interest, thus heightening the drama. Jordaens's very large religious painting of *St. Peter Finding the Tribute Money* (Copenhagen, Statens Museum for Kunst, no. 350) devotes most of the scene to the animated crowd of country folk and livestock who are passengers in a companionably overbooked ferryboat, while Peter appears at the far right on the quay pulling the fish with the coin in its mouth from the water. As a narrator, Jordaens's strength resided in his ability to make the great stories from the scriptures more accessible, not by marginalizing the religious element but by bringing their human dimension to the fore; both literally and figuratively he lent the subjects immediacy by avoiding depth of field, by bringing the viewer close to the quotidian reality of the narrative.

Among the mythological subjects that Jordaens painted in the late 1610s and twenties were the *Daughters of Cecrops Finding Erichthonius* (dated 1617, Antwerp, Koninklijk Museum voor Schone Kunsten, no. 842; based on Rubens's painting of this subject in the Prince of Liechtenstein collection, Vaduz), *Meleager and Atlanta* (Antwerp, Koninklijk Museum voor Schone Kunsten, no. 844; and a later treatment in the Museo del Prado, Madrid, no. 1546), *Pan and Syrinx* (Brussels, Musées Royaux des Beaux-Arts de Belgique, no. 3292), *Mercury and Argus* (Lyon, Musée des Beaux-Arts, and other versions) and *Apollo Flaying Marsyas* (Antwerp, Huis Osterrieth). As with Rubens, these pagan stories undoubtedly had a primitive visceral appeal for the artist, though they were no doubt reconciled with Christian faith as earlier incarnations of moral principles, such as one finds in van Mander's ingenious explanations of mythological subjects (see cat. 47). The same is undoubtedly true of Jordaens's memorable illustrations of Aesop's fables, notably the *Satyr and the Peasant* (versions in Munich, Bayerische Staatsgemäldesammlungen, no. 425; Brussels, Musées Royaux des Beaux-Arts de Belgique, fig. 48; and the Museum in Göteborg), which show the satyr rising in astonishment at the peasant who can blow both "hot and cold" – a classic admonition against duplicity. Jordaens brings the story vividly to life with his compelling portrayal of the peasants and the hoary rugose satyr.

During the 1630s Jordaens first addressed the themes of "The King Drinks" and "As the Old Ones Sing, So the Young Ones Pipe" (see cat. 46). In the august tradition of sixteenth-century genre painting, these two related subjects illustrate popular sayings and holiday entertainments, providing the artist with an opportunity to depict the Flemish bourgeoisie at table. While he clearly warmed to his subject, delighting in the display of high spirits and bounteous feasting, there is always a moralizing note, be it the cautionary message of proper pedagogy (children learn by example not by directive), or the more ominous and pervasive warning of the *memento mori*: the skulls, guttering candles, and short-lived flowers, which appear in the backgrounds of several of these scenes. In 1644 Jordaens returned to the subject of "As the Old Ones..." when he designed his

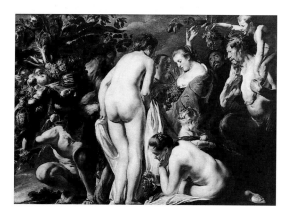

Fig. 47. Jacob Jordaens, *Hommage to Pomona*, ca. 1623, oil on canvas, 180 x 241 cm, Brussels, Musées Royaux des Beaux-Arts de Belgique, no. 119.

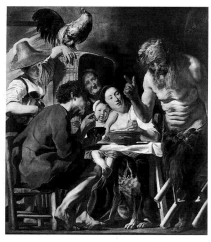

Fig. 48. Jacob Jordaens, *Satyr and Peasant*, ca. 1620-21, canvas, 188 x 168 cm, Brussels, Musées Royaux des Beaux-Arts de Belgique, no. 6179.

series of tapestries devoted to the Proverbs, a set of which were sold to Leopold Wilhelm in 1647 (another set is preserved in the Musée des Arts Décoratifs, Paris).

Jordaens dated no paintings during the decade preceding his *St. Apollonia's Martyrdom* of 1628 (Augustinian church, Antwerp; Rubens also painted an altarpiece for the same church, identified above, as did van Dyck), which marks a new direction in his art. The vertical organization and large scale of the altarpiece again acknowledge Rubens, but the touch now is more atmospheric, dissolving the contours of forms and reducing their plasticity. Shadows have become more transparent and the palette has shifted toward the reddish end of the color spectrum. After 1640 Jordaens also sought to open up his compositions, abandoning half-lengths for full-length compositions with a greater account of the figures' surroundings. At the same time the palette warmed and the brushwork loosened still further (see cat. 47). These stylistic changes follow trends set by Rubens and van Dyck, but Jordaens never achieved the former's ability to organize multiple-figure compositions in space nor the latter's linear grace.

Also like his colleagues, Jordaens built a large and comfortable home with a studio in Antwerp when he prospered, although he never attained or evidently aspired to lofty social contacts. There is no evidence, for example, that he gathered around himself a circle of humanists, philosophers, and historians akin to the learned group that gravitated to Rubens. However Jordaens's intellectual curiosity undoubtedly has been underestimated in the effort to portray him as the simple plodding burgher beside the nimble-witted *pictor doctus*. Though his version of *Prometheus* (fig. 49), painted around 1640, is virtually a caricature of the terror and agony of Rubens's majestic treatment of the subject (cat. 10), Jordaens displays his erudite knowledge of the story's classical sources not only by adding Mercury, who was the executor of Jupiter's revenge, but also a clay figure, recalling that Prometheus created mankind by instilling life into clay figures with the spark purloined from heaven. Thus Jordaens alludes to Prometheus's role as the first sculptor, and by extension the first artist. The pile of bones next to the sculpture refer to yet another episode in the story, when Prometheus tried to trick Jupiter by asking him to choose between meat and bones dressed up in meat – a ruse for which Jupiter punished him and which led to the stealing of the divine flame.[153]

Jordaens took his first pupil in 1620-1621; sixteen more students are noted in the *Liggeren* (lists) of the guild. Given his remarkable productivity and the frankly uneven quality of much of his later œuvre, especially after ca. 1640, he undoubtedly employed additional assistants. In 1635 Jordaens had assisted Rubens in the decorations for Ferdinand's Triumphal Entry, and in 1636-1638 worked on the Torre de la Parada series. Through Gerbier and Abbé Scaglia (see cat. 42), he also received a commission in 1640-1641 for twenty-two scenes of the Story of Psyche for the Queen's Closet at Greenwich, a stillborn project that mainly produced lawsuits and unfinished pictures. After Rubens's death in 1640 and van Dyck's premature demise the following year, Jordaens was anointed "premier" painter in Antwerp by Gerbier. The proud van Dyck, as we have seen, had refused to complete the unfinished works in Rubens's studio, but Jordaens readily obliged. Commissions now came fast and hard. Among the altarpieces was a large *Visitation* painted in 1642 for the church in Rupelmonde (now preserved in the Musée des Beaux-Arts, Lyon) and an *Adoration of the Magi* formerly in Dixmuiden (destroyed in World War II), both of which piled

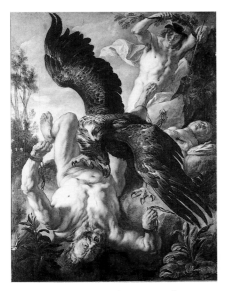

Fig. 49. Jacob Jordaens, *Prometheus*, ca. 1640, oil on canvas, 243 x 1178 cm, Cologne, Wallraf-Richartz-Museum, no. 1044.

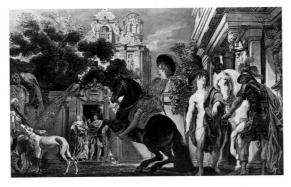

Fig. 50. Jacob Jordaens, *A Young Cavalier Executing a Levade in the Presence of Mars and Mercury*, ca. 1645, oil on canvas, 96 x 153 cm, Ottawa, National Gallery of Canada, no. 14810.

up ample bodies painted with a paler palette and ever greater painterly freedom. During this period Jordaens also was very active as a tapestry designer, illustrating, for example, a series on equitation with a group of finely executed modelli, one of which is preserved in Ottawa (fig. 50).

Jordaens's most important commission in these years, however, was for *The Triumph of Time* (1649) and *Triumph of Frederick Hendrick* (1651), commissioned in 1647 by Frederick's widow, Amalia van Solms, for the Oranjezaal in her palace Huis ten Bosch in The Hague. The agent in the negotiations was Constantijn Huygens, who was a great admirer of Rubens and other Flemish masters. The fact that Jordaens won this commission has sometimes been linked with the fact that he later joined the Reformed Church; however we must recall that Rubens and van Dyck had both earlier worked for the House of Orange and that other artists involved in the Oranjezaal project were Catholic, e.g. the Antwerp painters Theodoor van Thulden and Thomas Willeboirts-Bosschaert, as well as the Haarlem painter, Pieter de Grebber. We do not know whether Jordaens's conversion was prompted by his close ties to his father-in-law, van Noort, who was Lutheran, or encouraged by his trip north for the work at the Huis ten Bosch, but clearly it was a decision of conscience: he had been under suspicion by the Church authorities as early as 1649 and was heavily fined in 1658 for "scandalous writings." He finally joined the Reformed Congregation "the Brabant Mount of Olives" (*De Brabantse Olijfberg*) in 1671 and when he died seven years later was buried just over the border in the Northern Netherlands.[154] Some of the themes that Jordaens treated in his later drawings have been interpreted as Calvinist in content, but the evidence is debatable as to whether they reflect his new faith.[155]

In his later years Jordaens's productivity scarcely flagged as he fulfilled large commissions, especially for Scandinavian clients, including a Passion series painted in 1654-1660 for Charles X Gustavus, and thirty-nine paintings delivered to Queen Christina of Sweden for the Hall of Estates at Uppsala in 1649 (destroyed by fire in 1697). The latter agreement, negotiated by Christina's agent, Silvercroon, expressly provided for the use of assistants, stating "whatever is painted by others he should repaint in such a way that it shall pass as his, Signor Jordaens' own work, upon which he is to put his name and signature."[156] The previous year, as we have seen, Jordaens had been drawn into a dispute about the originality of three paintings executed largely by his assistants when it was reported that he had testified that these works were "repainted and altered by his hand, so that he regarded them as original and no less good than his other customary works."[157] Some of the undeniable decline in quality that one witnesses in Jordaens's late works, therefore, is surely attributable to studio assistants, but the increasingly flabby forms, muddy palette, and obscuring miasma of dull gray *sfumato* which characterize the very last works must also reflect the aged artist's failing powers; in 1671 Sandrart reported that he was still lucid and vigorous, but in 1677 Huygens found him crippled and confused. The tendency of Jordaens's modern biographers therefore to see his artistic decline as a symptom of the exhaustion of Flemish culture is unpersuasive.[158]

Rubens's Studio and Followers: History Paintings and Portraits

Rubens's studio assistants, pupils, and followers were legion. Indeed there scarcely was a history painter active in the Spanish Netherlands who went untouched by his art in some way, and many worked alongside or for him. A succinct and usefully systematic account of artists who were active in Rubens's atelier is provided by Hans Vlieghe's essay in this catalogue. In their history paintings, artists such as Jordaens, Cornelis de Vos, Gaspar de Crayer (qq.v.) (see cat. 50), Pieter Soutman (d. 1657), and Artus Wolffort (1581-1642), at least initially painted in a style related to the art of Rubens's earlier career, prior to 1620. The majority of his assistants and followers, however, such as Theodoor van Thulden (see fig. 51, painted for the Jesuit Church in Bruges), Abraham van Diepenbeeck (see cat. 51), Cornelis Schut (1597-1665), Gerard Seghers (1591-1651) (see fig. 52), Jan van den Hoecke (1611-1651), Pieter van Mol (1599-1650), Theodore Boyermans (1620-1678), Frans Wouters (1612-1659), and Jan Thomas van Yperen (1617-1651) painted in a range of styles derived loosely from Rubens's style of the 1630s.[159]

Although Jan Boeckhorst (see cat. 52) was a pupil of Jordaens, the greatest influence on his art was the elegant style of van Dyck.[160] Van Dyck also was the primary influence on Thomas Willeboirts-Bosschaert (1613-1654) and Erasmus Quellinus (fig. 53), while Diepenbeeck, Schut, and Boyermans also owed him a great debt. Indeed most of the Flemish history painters active in

the mid- to late seventeenth century (e.g. Lucas Franchoys [1616-1681], Pieter Thys [1624-1677], François Goubau [1622-1678], and Godfried Maes [1649-1700]) developed their styles from van Dyck's airy and graceful manner. Some artists, like the early seventeenth-century master Ludovicus Finsonius (Louis Finson) (ca. 1580-1618), and the later and more accomplished Theodoor van Loon (1581/82-1667) (see fig. 54), who is primarily remembered for a series of paintings on the Life of the Virgin for the pilgrimage church at Scherpenheuvel (Montaigu), are primarily followers of Caravaggio and only tangentially related to the Rubens-van Dyck tradition.[161] Still other painters like Gerard Seghers (see figs. 52 and 77) and Theodoor Rombouts (see cat. 60) began their careers as Caravaggio followers but adopted a Rubensian manner of history painting by the late 1620s. A full account of all of these history painters is beyond the scope of this survey; indeed despite the excellent efforts of Hairs, Vlieghe, and others, much work still is needed to understand these painters' accomplishments more fully.

Rubens and van Dyck, as we have seen, launched a revolution in portraiture, relaxing the strict formal conventions of sixteenth-century late mannerist portraiture and broadening its base of patronage, audience, and formal typologies.[162] However, just as Rubens's friend and colleague Frans Pourbus the Younger (1569-1622) had perpetuated these rigid conventions in his portraits painted for the courts in Italy and France, Rubens himself not surprisingly cleaved to traditional schemata when he portrayed the archdukes in 1609 (see figs. 4 and 5 in History), their columnar reserve, finery, and brilliant shot-silk backgrounds honoring his sovereigns' high station and dignity. Even when Rubens represents fellow burghers, such as the so-called *Portrait of Peter van den Hoeke* and his wife *Clara Fourment* (cats. 15a and 15b), he observed the time-honored conventions of three-quarter length pendant portraits of married couples. However Rubens clearly felt at liberty to experiment more daringly in group portraits that he conceived for his own personal use, notably his marriage portrait (fig. 13) which, as we have seen, for the first time portrayed himself and his bride – an upper middle-class couple but not nobles – lifesize, seated out of doors with studied informality. By the same token, the so-called *Four Philosophers* of ca. 1615 (fig. 2, in White) portrays Rubens and his closest circle of intellectual soul-mates seated in an interior seemingly interacting in a philosophical dialogue, a secular *conversazione* to be distinguished from the more traditional *portrait historié* – which established the basis for the conversation piece, a form of interior group portrait organized around the pretext of social discourse. The latter would become more and more popular after the middle of the century, especially in the small-scale group portraits of Gonzales Coques (see cat. 58) and his followers (see Wieseman), and was widely adopted throughout Europe in the eighteenth century. Rubens also was capable of bringing a fresh new intensity and animation to his portraits (see cat. 28) or alternatively, an immediate and moving human presence (see cat. 23, and the portrait of his daughter, fig. 14 this essay).

Van Dyck's earliest portraits, such as the *Family Portrait* in the Hermitage (cat. 36), display the painter's remarkably precocious sensitivity to personal expression, but still observe the half-length, closely cropped formal conventions of the inherited typology of family portraiture. However even before he departed for Italy, where he perfected a far more spacious and grandly baroque conception of portraiture (see cat. 39), van Dyck had experimented with enlarged settings which elaborate his upper middle-class sitters' interests and social ambitions (see, for example, *Nicolaes Rockox in His Study*, St. Petersburg, Hermitage, no. 6922; and *Isabella Brant before the Portico in Her Garden*, see cat. 59, fig. 2). Like Rubens, he initially depicted prosperous members of the bourgeoisie (rather than aristocrats) in poses, and with settings (for example, on palatial terraces or before substantial columns and views evocative of vistas at country estates) which had traditionally been reserved for noble sitters.

The lifesize group portraits which Cornelis de Vos produced for wealthy Antwerp citizens during the 1620s and 1630s follow closely in this Rubens/van Dyck tradition by employing richly furnished interiors or grandly evocative architectural backgrounds.[163] Like Jordaens, he was at his most inspired when depicting his own family in this newly informal approach to full-length portraits (see fig. 55).[164] His earliest portraits seem to date from about 1618, but de Vos only began signing his portraits in 1620. Among his best-loved paintings is the wonderfully intense and naturalistic *Portrait of Abraham Grapheus* of ca. 1619-1620 (fig. 56) which shows his colleague from the painters guild (and, as we have seen, one of Jordaens's favorite models) surrounded by trophies won by the rhetoricians chamber, the *Olijftak* (the Olive Branch),[165] with which the St. Luke's Guild was closely allied. Although the name of only three families that de Vos portrayed

Fig. 51. Theodoor van Thulden, *The Risen Christ*, oil on canvas, 573 x 360 cm, Paris, Musée du Louvre, inv. no. 1904.

Fig. 52. Gerard Seghers, *The Adoration of the Kings*, ca. 1630, oil on canvas, 405 x 320 cm, Bruges, Onze-Lieve-Vrouwekerk.

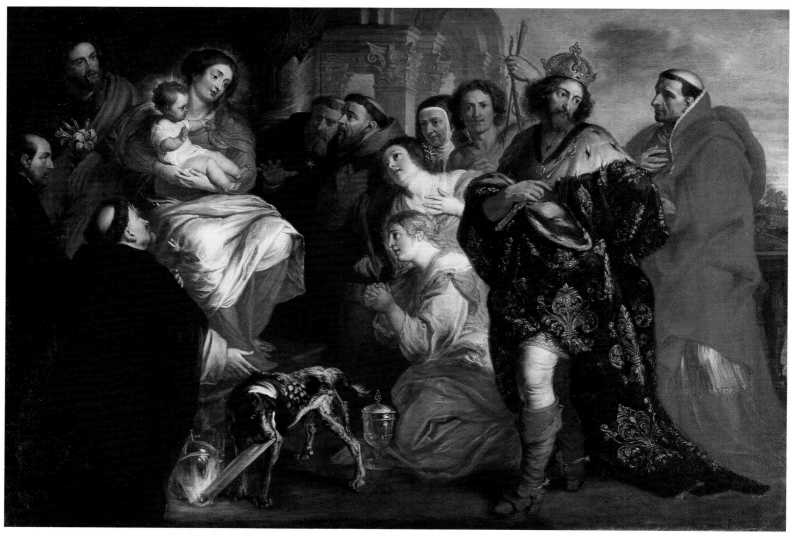

Fig. 53. Erasmus Quellinus, *Virgin and Child with Saints*, ca. 1635-1640, oil on canvas, 147.5 x 212.5 cm, Brussels, Galerie D'Arenberg.

Fig. 54. Theodoor van Loon, *Adoration of the Shepherds*, oil on canvas, 148 x 235 cm, Mechelen, Begijnhof.

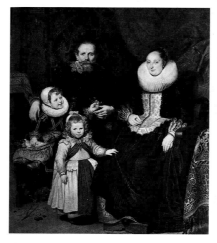

Fig. 55. Cornelis de Vos, *Portrait of the Artist and His Family*, 1621, oil on canvas, 188 x 162 cm, Brussels, Musées Royaux des Beaux-Arts de Belgique, no. 2246.

are known, he seems to have worked primarily for Antwerp merchants and followed the seventeenth century's new fashion in focusing in portraits on the nuclear family, rather than the extended kinship circle that had often been portrayed in the previous century. As Rubens offers a new image of the child, de Vos made a charming specialty of lifesize images of children (see fig. 57).[166] In the early 1630s when Rubens restricted his portrait practice to royalty and friends, and van Dyck was abroad in England, de Vos filled the vacuum by painting grandly conceived full-length family portraits for Antwerp's prosperous bourgeoisie, but he now posed his figures more formally, even somewhat rigidly, in a closed and sober but expensively decorated interior (see cat. 53). This archaizing style deliberately evokes the stiff manner of sixteenth-century aristocratic portraiture, thus offering subtle formal emphasis to the prestige seemingly conferred by rich surroundings and appointments. Research in seventeenth-century inventories has shown that these large and imposing family portraits were often hung in the front rooms on the ground floor in wealthy Antwerp homes (see Muller), thus presenting visitors, as one scholar aptly put it, with a "speculum virtutis."[167] De Vos worked on the decorations for the Triumphal Entry of Ferdinand and was also active as a history painter, painting a few religious themes as well as the *Allegory of Transitoriness* in Braunschweig (Herzog Anton Ulrich-Museum, no. 109).

Gaspar de Crayer and Erasmus Quellinus (see cat. 54) were also active as painters of life-size portraits in the tradition of Rubens, van Dyck, and de Vos. However, de Vos's own pupil, Jan Cossiers, was more attracted to genre subjects than portraits. Justus Sustermans (Suttermans) (1597-1681) was born in Antwerp, but like Pourbus, worked most of his peripatetic life for courts abroad, serving successively as court painter to Cosimo II, Ferdinand II, and Cosimo III de' Medici, and living and working throughout Italy and central Europe (Vienna, Florence, Rome, Genoa, Modena, Parma, Piacenza, Milan, and Innsbruck). Sustermans's court portraits tended to be formal and restrained, though not so static as those of his forerunner Pourbus the Younger.

The portrait painter Frans Luyckx (1604-1668), is thought to have been a pupil of Rubens but also spent most of his career abroad working as a court painter in Vienna to Ferdinand III and to his successor, Leopold I. Some foreign portraitists naturally followed the elegant clientele who gravitated to the court in Brussels. Louis Cousin was born in Grotenburg-Breivelde in 1606, and was trained in Brussels and Paris but first made his reputation in Rome (where he was known as Luigi Primo), painting portraits for the Vatican and serving as the *principe* of the Accademia di San Luca and a regent of the Congregazione dei Virtuosi. Returning to Brussels in 1657, he painted full-length portraits in the tradition of van Dyck and Sustermans but with a surprising, almost swashbuckling panache (see the so-called portraits of the Marquis de Massanova and his wife, Musées Royaux des Beaux-Arts de Belgique, Brussels, invs. 6812 and 6813). Also deserving mention are the Franchoys family of portraitists from Mechelen (Malines), Lucas I (1574-1643), Pieter (1606-1654), and Lucas II (1616-1681). Among these, Pieter, who was a student of Gerard Seghers but also worked in France, is of the most interest for his genrelike portraits (see the so-called "*Rubis sur l'ongle*," dated 1639, Brussels, Musées Royaux des Beaux-Arts de Belgique, inv. 2923).

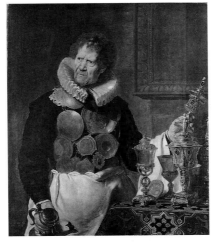

Fig. 56. Cornelis de Vos, *Portrait of Abraham Grapheus*, ca. 1619-1620, oil on panel, 120 x 102 cm, Antwerp, Koninklijk Museum voor Schone Kunsten, no. 104.

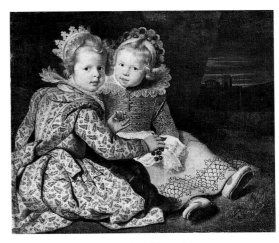

Fig. 57. Cornelis de Vos, *Portrait of Magdalena and Jan Baptist de Vos, the Children of the Artist*, oil on canvas, 78 x 92 cm, Berlin, Staatliche Museen zu Berlin, Gemäldegalerie, no. 832.

Portraits by the exceptionally gifted and original Bruges painter, Jacob van Oost, are often far more memorable than those of the lesser followers of van Dyck and de Vos. In the *Family on a Terrace* of 1645 (cat. 55), the artist adopts a three-quarter, life-size format and a more unaffected, naturalistic style than was customary for Flemish art in this period, features which seem to attest to contact with Dutch painting. Van Oost developed a a highly original, fluid but controlled, technique with a light, clear tonality and accents of local color. His paintings sometimes can be confused with those of the Haarlem classicists, Salomon and Jan de Bray, or even Jan Baptist Weenix. His haunting children's portraits (see cat. 56) are no less memorable. However the artist who had the most lasting effect on the course taken by portraiture following the death of Rubens and van Dyck, was Gonzales Coques (see cat. 58), who took the cabinet-sized format of genre painting from the Franckens and the elegant interiors, terraces, and porticos favored by the architectural painters and introduced small-scale portraits into these settings, thus creating the conversation piece. The convention was carried on by the Teniers pupil, Gillis van Tilborch (see Muller, fig. 2) in depictions of families gathered around a table in interiors decorated with gilt cordovan leather and often hung with numerous paintings. Although their command of both linear and aerial perspective is limited, Tilborch's portraits of tiny figures have a naive charm. Coques also introduced the small-scale, single-figure portrait popularized by Gerard ter Borch in Holland into the South (see cat. 59). Throughout the seventeenth century there were specialists in portraiture while many of the artists we have mentioned here (Rubens, van Dyck, de Crayer, even Tilborch) were also active as painters of other genres who might occasionally explore other areas of figure painting (usually history or genre).

"Verscheydenheden" and the Birth of the Genres

Following Italian models of art theory, Northern art theorists regarded history painting as the highest artistic aspiration. At the conclusion of his preface (*Voor-reden*) to the "Free Foundations of the Noble Art of Painting" (*Den Grondt der edel vry schilder-const*) of 1604, Karel van Mander discussed history painting as one of the various *verscheydenheden*, literally "varieties" or specialities, in which artists could perfect their innate talents. He stressed that an aspiring Netherlandish painter should perfect the subject in which he proves most adept; "If [your] perfection is not in figures and histories, so may it comprise animals, kitchens, fruit, flowers, landscape, masonry [i.e. buildings], views into rooms [i.e. perspectives], grotesques, night-scenes, fires, portraits done from life, sea-scenes, ships, or the painting of other such things."[168] He assembles two lists of specialization, the first comprised of ancient masters who perfected a specific subject (such as Protogenes' ships, Pausias's children and flowers, and Ludius's landscapes) and a second, addressed to his fellow artists, made up of subject categories justified by their correspondence to the specializations practiced by the Greeks and Romans. No less august authorities then Quintilian and Pliny are marshalled in defense of the tendency among van Mander's contemporaries to specialize. For van Mander, the section in his book devoted to ancients' "Lives" not only serves to prove that they too were striving for the naturalistic depiction of the world, but also that they discovered that subdividing nature into parts advanced their descriptive goals. "For it does not occur daily, that one can possess, learn, or apprehend everything, becoming excellent in all things. And so one finds that among those who pursued our art in old or ancient times some were better at one thing and others at another, just as you shall see in their lives."[169] Thus the antique painter Zeuxis, though remembered primarily for having formulated the most beautiful female nude from the collective parts of many women, is unexpectedly advanced by van Mander as the exemplary fruit painter, an allusion to the grapes that Zeuxis painted that fooled a flock of birds.

However history painting for van Mander is more than a mere subject category, since it comprehends and subsumes all the other *verscheydenheden*, requiring universal descriptive skill and mastery. Thus history's command of the other *verscheydenheden* also takes on the wider meaning of the variety or diversity of figures' attitudes and gestures in combination with their settings and attributes, requiring of the painter the full scope of descriptive ability.[170] In his Fifth Chapter, entitled "Van der Ordinanty ende Inventy der Historien" (On the Organization and Pictorial Formulation of Histories), van Mander explains how the successful conception and composition of history painting engages landscape and all the other *verscheydenheden*.[171]

Other seventeenth-century Northern art theorists also promoted specialization; in his *Lof der Schilder-konst* (Leiden, 1642), for example, Philips Angel wrote, "It is better to do one thing excellently than many things only passably," adding a quote from Cicero, "He who cannot become a lutenist can learn to play the pipes."[172] Samuel van Hoogstraten took up van Mander's remarks on *verscheydenheden* in the third book of his *Inleyding tot de Hooge schoole der Schilderkunst* (*Introduction to the Elevated School of Painting* [Rotterdam, 1678]), where he discusses painting's universality (*algemeenheyd*). Like van Mander he concludes that history painting is the most important art but encourages painters to learn to represent as many different aspects of the natural world as possible; truly great history painters must be proficient in the full range of pictorial skills and subjects.[173] In the second chapter of the book entitled, "Tot voor deel van die maer tot eenige byzondere verkiezingen bequaem zijn" ("On the advantage of choosing a specialty according to one's abilities") he goes on to commend specialization, and in the third chapter ("On the Three Grades of Art" [Van de dryderley graden der konst]), provides an elaborate taxonomy of painting's subject matter, based on natural history and mimetic virtuosity. Only a small fraction of Hoogstraten's own œuvre is comprised of history painting, the majority being portraits, trompe-l'œil still lifes, perspectives, cityscapes, and genre scenes.

Fig. 58. Frans Francken II, Hendrick van Balen, Sebastian Vrancx, and Jan Brueghel I, *Blazon for the Rhetorician's Guild "de Violieren"*, oil on panel, 73 x 73 cm, Antwerp, Koninklijk Museum voor Schone Kunsten, inv. no. 366.

Although the Southern Netherlands produced no indigenous art theorists who addressed this issue, Flemish painters were even more prone to specialization than their cousins to the north. Professionally independent specialists, as opposed to apprentices or studio assistants in the employ of a master, worked in double harness almost as a matter of course. We have noted Rubens's practice as a history painter of collaborating with specialists of the *verscheydenheden*, namely the landscapist and still-life painter Jan Brueghel the Elder, the animal painter Frans Snyders, and the landscapists Paulus Bril and Jan Wildens. There also were many instances when Jan Brueghel provided staffage figures for other artists' landscapes (see cats. 86 and 87). Indeed the practice of collaboration among Flemish artists was pervasive: animal painters and landscapists collaborated; genre painters worked together with still-life artists (see cat. 119); architectural painters collaborated with figure painters (see cat. 70), as did battle painters and landscapists (Jan Brueghel and Sebastian Vrancx), to name only the most common specialities. Some painters, such as the still-life specialist Daniel Seghers (q.v.), developed specific painting types which virtually necessitated collaboration, such as his niche and garland pictures (see cat. 99), while executing independent works far less frequently.

Seventeenth-century inventories list numerous paintings executed by two or more painters.[174] Paintings by three or more artists/specialists have also survived, including the *Feast of Odysseus and the Nymph Calypso* (Vienna, Akademie der bildenden Künste, inv. 583; ill. cat. 2, fig. 2), in which Joos de Momper provided the landscape, van Balen executed the figures, and Jan Brueghel the Elder painted the still-life elements and animals.[175] Given Flemish painters' propensity for teamwork, and the traditionally close social ties between poets and artists, it is fitting that when the rhetoricians chamber known as "de Violieren," which was affiliated with the guild of St. Luke, had their blazon decorated in 1618 (fig. 58), by collaborating artist/members: Hendrick van Balen and Frans Francken II, who jointly executed the figures, Jan Brueghel I, who painted the ornaments, and Sebastian Vrancx, who executed the animals.[176] The image embodies Horace's classical ideal "*ut pictura poesis*" by forming a rebus of a poem by the painter-poet, Sebastian Vrancx: "Apelles' scholieren, die Sint Lucas vieren,/ Wilt helpen versieren den Olyftak snel,/ Met ons Violieren en Apollo's laurieren,/ Vlucht droevige manieren willich, houdt Vrede wel" ("Students of Apelles who celebrate [the feast of] St. Luke/ Help us quickly! decorate the Olive Branch/ With our Violets and the laurels of Apollo,/ Melancholy ways readily flee. Keep the Peace well").[177] Collaboration was not restricted to the Brueghel circle or the early years of the century. A kitchen interior painting incorporating a still life of dead birds by Carstiaen Luyckx, a flower still life by Nicolaes van Verendael, and figures by David Teniers is signed by all three artists and cannot much predate the end of the third quarter of the century (fig. 59). Although this painting has a patchy, additive appearance, the painting here exhibited by Jan-Erasmus Quellinus, Jan Pauwel Gillemans II, and possibly Jan van Kessel or Peeter Gysels (cat. 117), is a relatively seamless case of collaborative teamwork from the latter part of the century, and the group portrait by Gonzales Coques (cat. 58) has also been assumed to have parts painted by one and possibly two other hands.

Sadly the most ambitious case of collaboration among specialists seems to be lost. When in 1618 the archdukes planned a formal visit to Antwerp, the city fathers sought to present them

with a suitably important and original gift that might reflect the artistic strengths and diversity of the municipality. The town council approached the twelve best artists in the city, but rather than ask them each to submit a painting, they commissioned them to work collectively on a single project, namely the painting of a pair of companion pieces illustrating the *Allegory of the Five Senses* (see figs. 60 and 61).[178] Clearly the city fathers felt that in such a gift the artistic sum was greater than the parts. The two large canvases preserved today in Madrid are probably only replicas (usually attributed to Jan Brueghel I, Rubens, and Snyders[179]) of the originals, which seem to have been destroyed in the fire in the Brussels palace in 1731. However they offer a clear idea of the latters' appearance, depicting rich interiors filled to bursting with still-life objects, a gallery of paintings, and a few figures, all variously alluding to the Senses. Another similarly conceived set of five smaller panels by Brueghel and Rubens, also depicting the *Five Senses* (Madrid, Museo del Prado, invs. 1394-1398[180]), bears the dates 1617 and 1618, thus supporting the dating of the other pair. The management and orchestration of the gift for the archdukes was put under Jan Brueghel I's supervision, presumably not only because of his artistic accomplishments but also because he so often successfully collaborated with the other artists. On the walls of the interiors, one sees paintings by, among others, Rubens, Snyders, Joos de Momper II, Frans Francken II, Jan Brueghel I, Sebastian Vrancx, and possibly Adam van Noort. Presumably in the lost originals these details would have been painted by their respective artists as was the case in several later gallery paintings like the one by Biset dated 1666 in Munich, Bayerische Staatsgemäldesammlungen (cat. 123, fig. 3). Thus specialization and collaboration were practices adopted not merely as expediencies of production but were regarded and commended as desirable means toward the artistic goal of the imitation of nature, and in turn became a source of official civic pride.

The artistic specialties that we now call "genres" were only theoretically and linguistically codified in the eighteenth century, but for the most part had become distinct phenomena two centuries earlier.[181] The emergence of the genres as discrete categories of painting is surely related to the expansion of the marketplace. Whereas the chief patrons of art in the Middle Ages were drawn from the relatively limited circle of the membership of the church, court, and

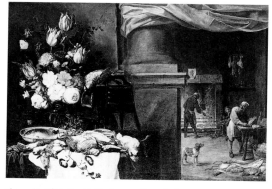

Fig. 59. David Teniers II, Nicolaes van Verendael, Carstiaen Luyckx, *Before the Kitchen*, oil on canvas, 83 x 120 cm, Dresden, Gemäldegalerie Alte Meister, no. 1091.

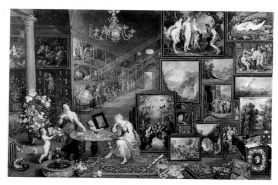

Fig. 60. Jan Brueghel I and attributed to Peter Paul Rubens, *Allegory of Sight and Smell*, ca. 1617-1618, oil on canvas, 175 x 263 cm, Madrid, Museo del Prado, inv. no. 1403.

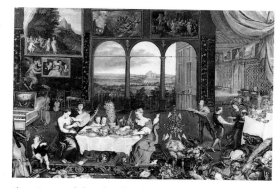

Fig. 61. Jan Brueghel I and attributed to Peter Paul Rubens, and Frans Snyders, *Allegory of Feeling, Hearing and Taste*, ca. 1617-1618, oil on canvas, 176 x 264 cm, Madrid, Museo del Prado, inv. no. 1404.

feudal nobility, the burgeoning of middle-class art consumers after 1500 brought a differentiation of product as the new buyers sought new iconographies and subjects based on their own experiences of the world. This is not to suggest that subjects were invented for the new clientele. Quite to the contrary, most of the "lesser" genres had their roots in medieval courtly or ecclesiastical art (see Renger); landscape and still life, for example, first functioned as settings and attributes in altarpieces and other religious art; scenes of everyday life (or what we call "genre" scenes) appeared as marginalia in illuminated manuscripts; and animal paintings had an ancestry in tapestries, indeed would remain an aristocratic preserve much longer than the other genres. As the upper bourgeoisie strove to emulate the tastes of the aristocracy, they appropriated their artistic subjects just as they imitated their lifestyles and appearances. Although the most important factor surely was the broadening of the marketplace, the growth of the different genres in the late sixteenth century may also have been partly stimulated by the destruction of religious paintings during the *Beeldenstorm* (Iconoclasm) of 1566, which theoretically might have favored genres other than history painting as relatively less controversial subjects.

Scenes of Everyday Life

In seventeenth-century terminology, *figuurschilders* (figure painters) denoted painters of religious and historical, as well as secular themes; there was no term to refer to painters of everyday life collectively.[182] However these "genre" painters, as they have come to be known, had established their own discrete pictorial traditions in the previous century. They were little affected by the grand achievements of Rubens and van Dyck, though the latter's grace touched some of their later practitioners. The robust good cheer of Jordaens's banquet scenes aligned itself with Flemish traditions of bourgeois genre, but Flemish genre painting would not have been greatly different for the omission of the era's three most famous painters. Its leading figures acknowledged foreign influences, both from the Northern Netherlands and Italy, but built primarily upon their own indigenous heritage. For both the high-life and low-life traditions, see the essays hereafter by Renger and Wieseman.[183]

The tradition of high-life merry company scenes had descended from medieval images of love gardens, representations of the Prodigal Son Squandering His Inheritance, and Mankind Awaiting the Last Judgment. This tradition survived into the seventeenth century in the delicately executed scenes of little figures by Frans Francken II (see, for example, his two paintings of the *Prodigal Son among Whores* in the Musée de L'Ain, Bourg-en-Bresse [no. 95259E] of ca. 1610-1615; and the Staatliche Kunsthalle, Karlsruhe [inv. 171] of ca. 1630),[184] Frans II also inherited from his uncle Hieronymus Francken I the practice of depicting balls and dances in a Venetian mode (see Hieronymus's *Venetian Carnival*, 1565, Aachen, Suermondt-Ludwig-Museum; and *Dancers with a Woman Playing the Virginal* in Stockholm University[185]). Around 1610, Frans II collaborated with the architectural painter Paul Vredeman de Vries on a *Ball at the Court of the Archdukes* (ill. Wieseman, fig. 4[186]). This image purports to be an actual ball but is probably imaginary although it gives little indication of a censorious attitude toward the pastime of dancing, Francken's more generic dance parties at times include religious details in the background of the scene, such as a painting or sculpture of *The Fall of Man*, which in traditional fashion seems to offer a moralizing counterpoint to and implicit commentary on the amusements.[187] Residual elements of genre's ancestry in religious art function moralistically in genre paintings from both the northern and southern Netherlands.[188]

The most original contribution by Frans II and his brother Hieronymus Francken II to the history of Flemish genre painting was the invention of paintings of art cabinets or galleries (*kunstkamers*).[189] These paintings depict wealthy burghers' art collections, some of which are "portraits" of actual collections (such as that of Nicolaes Rockox, see Muller, fig. 1), but most are imaginary or ideal collections of the type assembled by a new class of "*liefhebber*," or connoisseur, in Antwerp in the early decades of the seventeenth century. The allegories of the Five Senses that were executed by Jan Brueghel and his colleagues for the archdukes in ca. 1618 (see figs. 60 and 61) adopted the format and conceit of the art cabinet or gallery paintings, and later artists like Willem van Haecht painted both collection "portraits" (see the *Cabinet of Cornelis van der Geest*, Antwerp, Rubenshuis) as well as history paintings set in *kunstkamers* (see *The Studio of Apelles*, The Hague, Mauritshuis, no. 266). David Teniers II then made a specialty of these paintings when he served as the curator of Archduke Leopold Wilhelm's collections (see cats. 124 and 125).

Little is known about the life of Louis de Caullery, who is presumed to have been born in Cambrai and been active in Brussels, but he is recognized as perpetuating the high-life tradition of balls, love gardens (fig. 62) and images of the Five Senses in the guise of merry company scenes (see the painting, signed and dated 1620, on deposit in the museum in Cambrai from the Louvre[190]). His doll-like figures are scarcely individualized but claim a naive charm. De Caullery also painted carnivals and other festivities with carefully constructed architecture and street views. Sebastian Vrancx is primarily remembered as a pioneer in the painting of cavalry battles, highway bandit attacks, and soldiers plundering villages (see cat. 84), which would influence not only his pupil, Pieter Snayers, but also Esaias van de Velde (1587-1630) and later Dutch battle painters. However Vrancx also drew and painted high-life scenes in formal Italianate gardens (Naples, Museo Capodimonte, dated 1616; and Copenhagen, Statens Museum for Kunst, no. 788), which may recall his trip to Italy in ca. 1597-1600.[191] Elegantly dressed figures, musicians, maskers, and statuary populate gardens of palaces, richly appointed with porticos and other architecture enhancing the perspective. Vrancx also affirmed genre painting's origins by executing a series of four panels on the time-honored theme of the Prodigal Son (formerly Laurent Meeus collection). The artist's touch is precise and fastidious, his drawing firm, and palette of strong local colors not unrelated to Jan Brueghel I (though the mannerist landscape triad of brown, green, blue is not so pronounced). Vrancx collaborated with Jan Brueghel I and Joos de Momper, but also painted pure landscapes independently. As we have noted above, Jan Brueghel II asserted that Vrancx refused to employ assistants, which probably accounts for his relatively small œuvre. His dated paintings range from 1600 to 1633. He also was very active in the rhetoricians chamber "de Violieren," for which he not only painted part of the blazon (see fig. 58) and designed costumes, but also composed plays and verses.

Members of the same generation as the high-life genre, landscape, and battle painters who became active around the turn of the seventeenth century, the architectural painters Hendrick van Steenwijck the Younger (see cat. 76) and Peeter Neeffs the Elder (1578/90-before 1656) employed a comparably precise and colorful *kleinmeister* manner. The two perpetuated the tradition of depicting imaginary church interiors, piazzas and palace courtyards in the tradition of Hans Vredeman de Vries (1527-before 1609) who not only pioneered architectural painting but also had a pervasive influence on the many rigorously orthogonal perspective studies that dominated Netherlandish art during the first half of the seventeenth century. Widely circulated architectural recipe books were engraved after Vredeman de Vries's designs. He was the teacher of Hendrick I van Steenwijck, (ca. 1550-1603), who in turn was Hendrick the Younger's teacher and won the praise of van Mander for his "wonderfully careful and beautiful interior views of modern churches . . . with very pretty little staffage figures." Hendrick the Younger and Peeter Neeffs the Younger (see cat. 77), whose style was more fluid and lighting effects more subtle than those of his father, together represent with the Dutch architectural painters, Bartholomeus van Bassen (1590-1652) and Dirck van Delen (1606-1671), a transitional style that preserved sixteenth-century spatial conventions in paintings of church interiors, and palatial courtyards until Dutch artists working in Haarlem (Pieter Saenredam) and Delft (Gerard Houckgeest, Emmanuel de Witte and Pieter de Hooch) revolutionized architectural painting.

Later high-life painters in Flanders often reflected the influence of their Dutch counterparts. This was particularly true of Christoph van der Lamen (1606/07-1651/52) whose art resembles the small-scale merry company and guardroom scenes by the Dutch painters, Pieter Codde and especially Antonie Palamedesz. Van der Lamen's pupil Hieronymus Janssens (1624-1693) returned to the indigenous tradition of ball scenes first made fashionable by the Franckens, and continued to paint them as late as the 1680s. Indeed so devoted was he to these themes that Janssens earned the nickname, "de Danser." His conservative instincts also led him to do a series of five scenes of the *Prodigal Son* (formerly High Leigh Hall; sale London [Sotheby's], 21 May 1935).

Surely the most devotedly retarditaire Flemish artist of the early seventeenth century, however, was Pieter Brueghel the Younger (1564/65-1637/38).[192] The eldest son of the great peasant painter Pieter Bruegel the Elder, Pieter II was a pupil of Gillis van Coninxloo and the head of a large atelier that specialized in copies and imitations of his father's works; as van Mander observed as early as 1604, "hy veel zijns vaders dinghen seer aerdich copieert en nadoet" (he very artfully copied and imitated many of his father's things),[193] and continued this slavishly loyal practice for another thirty years. Although his chief importance thus is the diffusion and perpet-

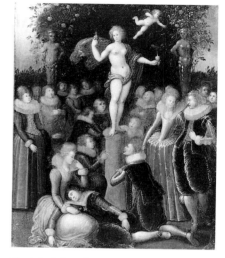

Fig. 62. Louis de Caullery, *Hommage to Venus*, oil on copper, 23 x 18.5 cm, Copenhagen, Statens Museum for Kunst, no. 1978.

Fig. 63. Adriaen Brouwer, *Tavern Scene*, ca. 1624-1625, oil on panel, 34.8 x 26 cm, Rotterdam, Museum Boymans-van Beuningen, inv. no. 1102.

Fig. 64. Adriaen Brouwer, *The Smokers*, signed, oil
on panel, 46.4 x 36.8 cm, New York, Metropolitan
Museum of Art, acc. no. 32.100.21.

uation of Bruegelian low-life genre themes and images, he also executed independent landscapes
with rustic figures in a rather halting but fastidious hand.

 The sixteenth-century tradition of peasant painting thus was not a remote memory but a living presence when the most creative low-life painter of the new age appeared on the scene in the mid-1620s. Adriaen Brouwer absorbed these earlier traditions and revolutionized the depiction of the lower classes with an unapologetic realism. With little over fifteen years of activity and only about sixty autograph works, he was not a prolific artist but had a pervasive influence. Without any dated paintings, his development is a matter of conjecture.[194] Brouwer seems to have been born in Flanders, possibly in Oudenaarde. Houbraken informs us that he studied with Frans Hals in Holland and he can be placed in Haarlem and Amsterdam in 1626-1627. The paintings that are regarded as his earliest are not life-size genre scenes painted with Hals's bravura technique but small-scale, full-length images of slightly caricatured peasants executed with a lively, stabbing and direct brushwork, crisp drawing, and a varied palette of relatively strong local hues of pale pink, yellow, red, and light blue (see fig. 63 and cat. 63). It was this style that first appealed to his Dutch colleagues, Adriaen and Isack van Ostade. By the time Brouwer returned to Antwerp in

1631-1632 he had developed a more subtly nuanced style with a masterful control of tone and hue as well as an unprecedented command of naturalism. Although his manner changed, the subjects remained more or less the same, usually peasants' taverns and other crude entertainments (see cat. 65) or low-life professions, such as barber-surgeons (cat. 64). However one new development is the landscapes that seem to originate in Brouwer's later career and are some of the freest and most poetic works by the artist.

Inscribed as a member of the rhetoricians chambers in both Haarlem and Antwerp, Brouwer, like Vrancx, Gerard Seghers, and many of his other colleagues, clearly took an interest in the world of letters, however crudely it might have been practiced by these amateur thespians and poets of Haarlem's "In Liefde Boven Al" and Antwerp's "de Violieren." His peasant themes depict all manner of uncivilized creatural behavior, appetites, and excesses, and stand in a long literary and pictorial tradition of satirizing the lower classes and rustics (de lompe boer) for the amusement and edification of an urban elite. These satires had their roots in medieval depictions of vices and sixteenth-century German and Netherlandish prints, drawings, and paintings.[195] While Brouwer's early works (fig. 63) seem to express the traditional moralizing commentaries on immoderate behavior, the later works address more specifically the variety of human emotion and the exploration of the passions, be they joking and theatrical as in *The Smokers* (which is reported to include portraits of Brouwer and his friends Craesbeeck, Cossiers, and de Heem) (fig. 64), exercises in facial contortions (fig. 65), or, in what are believed to be the latest works, true psychologically nuanced emotion (see cat. 66). The representation of different human emotions was, of course, a fascination of Rubens and his students as well as of Rembrandt at this same moment. This may in part explain why Brouwer was the artist whose works these two great artists both collected in quantity; Rubens's estate included no fewer than seventeen paintings by Brouwer, and Rembrandt in 1656 had seven paintings as well as an unspecified number of drawings.

The other truly accomplished Flemish genre painter, David Teniers, became a master in the Antwerp guild in 1632/33 just after Brouwer's return from Holland. Brouwer's peasant paintings

Fig. 65. Adriaen Brouwer, *Man Making Faces*, oil on panel, 13.6 x 10.4 cm, Maastricht and London, Rob Noortman Gallery.

were to have a lasting influence on Teniers but the latter's conception of the lower classes was always gentler, more harmonious, scarcely so raw and brutal, though at the same time less moving and insightful. Moreover the prolific Teniers, whose career lasted almost four times longer than Brouwer's, produced (again with the help of assistants, especially in the later years), a vast œuvre many times greater than his mentor's. Teniers's art also embraces a far wider range of subjects, including high-life, guardroom, religious and mythological scenes, arcadian landscapes, allegories, guild portraits (see *The Civic Guards' Procession in Antwerp*, dated 1643, St. Petersburg, Hermitage, no. 52), and even the traditional monkey satires. While Brouwer's surviving œuvre contains no certain dated work, Teniers has left us more than one hundred, thus facilitating a clear chronology.

Although reported to have studied with his father, the Elsheimerian history painter of the same name, Teniers's earliest dated paintings of 1633 take up low-life themes which clearly descend from Brouwer's examples, such as smokers in the fetid *tabagies* that served strong tobacco as well as alcohol, and card players in taverns.[196] Teniers would paint taverns and peasant scenes throughout his life; his peasant weddings first appear in 1637, and after 1640 he made a specialty of the time-honored kermesse with crowds of dancing and feasting figures. But by ca. 1640 his peasants had sworn off most of their rudest behavior (see cat. 67), becoming more domesticated as they underwent a process of social refinement different in appearance but comparable in effect to that of the ever more prosperous peasants by the Haarlemer, Adriaen van Ostade. In the 1630s and 1640s, Teniers's guardroom scenes revitalized a tradition of depicting soldiers on bivouack that also was revamped in the Northern Netherlands in these years by Willem Duyster, Simon Kick, and Jacob Duck. He brings to his soldiering subjects more exotic types, a flair for depicting armor and the accoutrements of war, as well as a more colorful palette and livelier touch (see, for example, the painting formerly at Warwick Castle[197]). His religious subjects, such as *St. Peter Freed from Prison* (Dresden, Gemäldegalerie Alte Meister, no. 1077) and the *Mocking of Christ* (Baron Willem van Dedem collection) often employ a guardroom setting. Teniers's high-life merry company subjects take up some of the theme's traditional allegorical dimensions (see *The Five Senses*, Brussels, Musées Royaux des Beaux-Arts de Belgique, no. 1257[198]) and moralizing beginnings (see *The Prodigal Son*, Paris, Musée du Louvre, inv. 1878; and Minneapolis, Minneapolis Institute of Arts, no. 458). In the early 1630s, Teniers had also painted a few barn interiors with still lifes of farm utensils (see fig. 66) that owe a debt to Rotterdam-area painters, such as Herman and Cornelis Saftleven, Pieter de Bloot, and Frans Rijkhals. These too find echoes in the painter's later stable interiors with slaughtered animals (see cat. 69) and his collaborative painting with the still-life painter Jan Davidsz. de Heem (cat. 70). Teniers also collaborated with Joos de Momper, Jan van Kessel, Carstiaen Luyckx, Lucas van Uden, Daniel Seghers, Jacques d'Arthois, and others. In 1636 Teniers married Anna Brueghel, the daughter of Jan Brueghel the Elder who had been taken into Rubens's household after her father's death; Hélène Fourment was the godmother of the couple's first child. Thus Teniers was personally associated with two of the greatest Flemish painters of the previous generation. He painted some subjects in the tradition of Brueghel, such as witches' sabbaths, and his taste for accents of bright local color may owe something to him but

Fig. 66. David Teniers the Younger, *Barn with a Couple Eating and a Still Life*, 1634, oil on panel, 46.5 x 63.5 cm, Karlsruhe, Staatliche Kunsthalle, inv. 193.

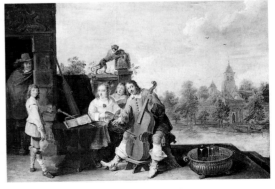

Fig. 67. David Teniers the Younger, *The Artist with His Family*, oil on panel, 38 x 58 cm, Berlin, Staatliche Museen zu Berlin, Gemäldegalerie, inv. no. 857.

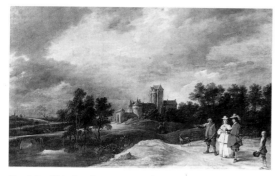

Fig. 68. David Teniers the Younger, *Landscape with Country House and Landowners Promenading*, oil on canvas, 112.2 x 169.2 cm, London, Dulwich College Picture Gallery, no. 95.

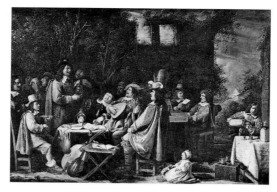

Fig. 69. Joos van Craesbeeck, *Musical Company*, oil on panel, 74 cm x 105 cm, Brussels, Musées Royaux des Beaux-Arts de Belgique, inv. 3462.

his touch was always looser, more liquid, his handling unified by tone and atmosphere in keeping with the prevailing tastes of his times. Like others before him, Teniers found in Rubens a model of the painter as nobleman. Whereas Brouwer had portrayed himself in a rustic inn on a pub crawl with his raucous colleagues (see fig. 64), Teniers's portrayed himself (fig. 67), probably around 1644, as a refined gentleman playing music with his family (an allusion to familial harmony) on the patio of an elegant structure with a country house in the parklike distance.[199]

After becoming dean of the Antwerp guild in 1645 and earning the important patronage of Antonius de Triest, bishop of Ghent, Teniers moved to Brussels, where in 1651 he became court painter to Archduke Leopold Wilhelm (and, after the latter's departure in 1656, served in the same capacity to Don Juan of Austria, the archduke's successor). Not only was Teniers the curator of Leopold Wilhelm's collection, depicting it in gallery paintings repeatedly (see cat. 124), but as his agent, also acquired works for him in important sales such as that of Charles I's paintings in London. Before 1656 Teniers worked on painted copies (see cats. 126, 127, and 128) of Leopold Wilhelm's collection of Italian masters to serve as models for the 244 engravings published in the *Theatrum Pictorium* which only appeared in 1660, four years after the archduke's departure from Brussels for Vienna, where the collection still remains, forming the core of the Kunsthistorisches Museum. From ca. 1645 on, Teniers painted more landscapes and kermesse scenes, drew inspiration more frequently from nature, and adopted a richer, more sonorous palette. He now painted rustic views with country houses and seigneurial couples walking their property interviewing the caretakers (see fig. 68). In 1662 Teniers realized that social ideal personally by purchasing a country house called "De Drie Toren" (The Three Towers) near Perck, not far from Castle Steen, formerly Rubens's estate. The castle appears in several of Teniers's later arcadian landscapes.[200] Thus in his mature later years Teniers lived the ambitious role of the aristocratic artist earlier codified by Rubens and van Dyck, and even occasionally made it the subject of his art; see, for example, the *Wedding Portrait*, dated 1651 (ill. Wieseman, fig. 6). His later paintings often repeat earlier themes, and are increasingly uneven in quality. However, as in Jordaens's case, any accusations of decadence must consider the artist's age; active until the end, Teniers was eighty at his death.

One of the most individualistic and creative followers of Brouwer in the depiction of the life of the people was Joos van Craesbeeck. Craesbeeck began his career as a baker (his father-in-law owned the bakery in the Citadel in Antwerp) and may have come in contact with Brouwer when the latter was imprisoned in the Citadel for debt in 1633. Craesbeeck painted many of the same low-life themes as Brouwer, including tavern and bordello scenes, sleeping innkeepers, luxuriously intoxicated smokers, and peasant brawls (see cat. 71). However through the use of such conspicuously moralizing features as inscriptions and a tiny skeleton in the beer mug, a work like the one in this exhibition also acknowledges the survival of earlier sixteenth-century peasant painting traditions. Although their crude features, columnar bodies and weighted, slothlike movements help convey the idle lumpen proletariat, Craesbeeck's peasants are never so nimbly depraved as Brouwer's, nor as plausibly naturalistic. His tendency, moreover, to crowd his figures into the foreground at the expense of spatial relief focuses attention on the breadth of his burlesque in the peasant's expressions. But Craesbeeck explored chiaroscuro effects that Brouwer never attempted, and cast his thematic net more broadly than Brouwer, depicting bourgeois parties, such as the so-called *Musical Company* (fig. 69), as well as artists' studios (see, for example,

Paris, Musée du Louvre, inv. 1179). Craesbeeck's *Artist's Studio* in the Lugt collection (fig. 70) depicts a painter actually painting a merry company who have posed with attributes alluding to the Five Senses. The painting is ironic on several levels; its subject pointedly reminds us of the artifice involved in painting a genre scene (though it is unlikely that an artist would pose all of his models simultaneously), which in turn is not a mere snapshot of everyday life but embodies abstract concepts and ideas.

While Craesbeeck's development is partly a matter of conjecture since he dated no paintings,[201] David Ryckaert III produced many dated works between 1637 and 1661. Born to an Antwerp family of artists, he joined the guild in 1636 and dated his *Foot Operation* two years later (Valenciennes, Musée des Beaux-Arts, inv. 46.1.392[202]), a picture which clearly is inspired by Brouwer's art (see cat. 64), but which again is gentler, less insistently coarse and brutal. His many tavern interiors and the alchemists that he painted in the late 1640s[203] owe a clear debt to David Teniers (cf. cat. 68). Although his later work can descend into conventionalized situations and types as well as sentimental anecdotes, his art is far more accomplished than that of most of Teniers's followers, including even the relatively capable ones, like Matthieu van Helmont (1623-after 1673).[204] Among Ryckaert's best pictures are several substantial canvases that he painted around the middle of the century of large gatherings of figures assembled around a table playing music (see cats. 72-73, fig. 4) or at outdoor festivities. The pair exhibited here (cats. 72 and 73) take up the theme of *"As the Old Ones Sing, So the Young Ones Pipe"* first popularized by Jacob Jordaens (see cat. 46), neatly juxtaposing high life and low life. Another pair of pendants with opposing and complementary themes from this period are the companion pieces of 1649 in Vienna, juxtaposing the joys and sorrows of the peasantry – *Boerenvreugde en Boerenverdriet* (see figs. 71 and 72) – showing, on the one hand, peasants celebrating a kermesse and on the other being abused by soldiers, a theme descended from sixteenth-century literary and pictorial traditions (see fig. 2 in History) best remembered from the works of David Vinckboons. However in the Vienna paintings not only the pain but also the frivolity seem choreographed – a morality play starring those perennial adversaries, the armed forces and disenfranchised peasantry. Like the increasing refinement in execution and gradual social elevation of peasant subjects, the nostalgic return to primal themes of genre often characterizes Flemish scenes of everyday life in the later seventeenth century.

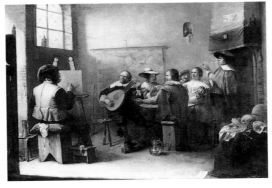

Fig. 70. Joos van Craesbeeck, *Artist's Studio*, oil on panel, 48.5 x 66 cm, Paris, Fondation Custodia, Collection F. Lugt, Institut Néerlandais, inv. 7087.

Fig. 71. David Ryckaert III, *Kermesse ("Peasants' Joy")*, 1649, oil on canvas, 120 x 175 cm, Vienna, Kunsthistorisches Museum, inv. 729.

Fig. 72. David Ryckaert III, *Soldiers Plundering ("Peasants' Sorrow")*, 1649, oil on canvas, 121 x 127 cm, Vienna, Kunsthistorisches Museum, inv. 733.

Another pleasant follower of Teniers is Gillis van Tilborch (ca. 1625-ca. 1678), who painted idealized peasant scenes as well as middle-class interiors and group portraits in the style of Gonzales Coques (q.v.).[205] His earliest works date from 1657 (see *Peasants outside an Inn*, sale London [Robinson & Fischer], 4 June 1936[206]) and attest to the initial influence of Craesbeeck, soon to be supplanted by that of Teniers. Like the latter, Tilborch painted large gatherings of peasants at village festivals (see, for example, Brussels, Musées Royaux des Beaux-Arts de Belgique, no. 6913) and open-air banquets (see fig. 73). Also by his hand are a series of small panels of half-length peasant figures personifying the Five Senses (Brussels, Musées Royaux des Beaux-Arts de Belgique, no. 3431), which again are probably inspired by Teniers's several earlier series on this theme.[207] Finally Tilborch's paintings of *kunstkamers* (see Lawrence, Spencer Museum of Art, University of Kansas, no. 54.157[208]) again are inspired by his mentor. However the artist's brushwork is dryer and softer than Teniers's and his colors more deeply saturated. It is often wrongly assumed that Tilborch's later interiors with small-scale, upper middle-class families (see fig. 2 in Muller) (some of which are portraits) are inspired by Pieter de Hooch and Delft School painting. These works, however, are much closer in conception (though not so finely executed) to similar group portraits by Gonzales Coques. Like Coques, Tilborch employs the cubic (six-plane) interior space and steeply receding perspectives favored by Vredeman de Vries (see fig. 4 in Wieseman) rather than the more intimate interior views of de Hooch, Vermeer, and their followers, which rarely show both side walls of the room, usually concentrate on a corner view, and show a much greater concern with aerial perspective. In 1670 Tilborch traveled to England, where he depicted the Tichborne family distributing alms in a painting dated 1671 (Tichborne Hall, Alresford, Hants.)

A few other Flemish painters of full-length genre compositions in small deserve note. Simon de Vos (1603-1676), who painted cabinet-sized biblical subjects in a style derived from Rubens and van Dyck (see, for example, fig. 74 the *Penitent Mary Magdalen*, recently acquired by the Herzog Anton Ulrich-Museum, Braunschweig, no. 812), also painted musical and merry company subjects that have sometimes been related to the gracefully international art of Johann Liss and also compared to the less fluid genre paintings by his Dutch contemporaries Dirck Hals and Pieter Codde.[209] De Vos's *Fortune-Teller Reading an Elegant Young Man's Palm* of 1639 (fig. 75) is a favorite in surveys of Flemish art and takes up a theme made popular in seventeenth-century painting by Caravaggio, but treats it as a full-length image on a much more intimate scale.[210] The theme conveys obvious warnings against credulity and gullibility. Like de Vos, Willem van Herp has a more graceful figure style than most Flemish genre painters. Few of his works are dated (the earliest, of 1654, is in the Duke of Sutherland's collection; see under cat. 74) but most seem to have been executed in the 1650s and 1660s; a scene of soldiers plundering a farm, dated 1664, harkens back to a theme treated in earlier works by Vinckboons and Vrancx (formerly Harrach collection, Vienna).[211] Van Herp's merry company scenes remind us of Teniers but have the carefully composed unity of Jordaens's much larger genre scenes, as well as a hint of the elegant attenuation and grace of van Dyck's figures. The latter are also recalled in the master's small-scale religious and mythological paintings, as, for example, the *St. Anthony of Padua[?] Distributing Bread* (London, The National Gallery, no. 203); van Herp is documented as having received fifty-two guilders for a picture of this subject in 1662.

Although small-scale painters like Simon de Vos occasionally painted Caravaggesque themes, the life-size, half- and three-quarter length genre scenes that artists like Gerard Seghers (1591-1651),[212] Theodoor Rombouts (see cat. 60), and Cornelis de Vos (see fig. 76) painted constitute a separate tradition within this painting type. Sometime after 1611 and before 1620, Seghers visited Italy where he became sufficiently acclimated to adopt the name "Gerardo," and obviously immersed himself in the art of Caravaggio and his Italian followers, above all Bartolomeo Manfredi, as well as that of the Utrecht follower, Gerard van Honthorst. Seghers was especially fond of chiaroscuro effects in night scenes with hidden candles or other artificial light sources (see, for example, the *Card Players*, Irkutsk, Regional Art Museum[213]). And he naturally was drawn to religious subjects which he could treat with Caravaggio's dramatic chiaroscuro and naturalism, such as *The Denial of St. Peter* (fig. 77),[214] which is obviously inspired by the great Italian master's *Calling of St. Matthew* in S. Luigi dei Francesi, Rome. Seghers later adopted a more Rubensian style (see fig. 52), became one of the leading painters of Antwerp (where he purportedly prospered to the extent of being able to build a house for the princely sum of fl. 60,000), assisted Rubens in the decorations for the Triumphal Entry of Ferdinand, and fulfilled numerous commissions in Bruges, Ghent, Louvain, and Cologne.

Fig. 73. Gillis van Tilborch, *Open Air Banquet*, oil on canvas, 114.3 x 188.0 cm, Goldendale, Washington, Maryhill Museum of Art, no. 1960.04.01.

Fig. 75. Simon de Vos, *Gypsy Fortune Teller*, 1639, signed, oil on copper, 44 x 62 cm, Antwerp, Koninklijk Museum voor Schone Kunsten, no. 899.

Fig. 74. Simon de Vos, *Penitent Mary Magdalen*, oil on copper, 38 x 31 cm, Braunschweig, Herzog Anton Ulrich-Museum, inv. 812.

Fig. 76. Cornelis de Vos, *The Card Game*, oil on canvas, 171 x 228 cm, Stockholm, Nationalmuseum, no. NM689.

Fig. 77. Gerard Seghers, *Denial of St. Peter*, 1620-1625, oil on canvas, 157.5 x 227.7 cm, Raleigh, North Carolina Museum of Art, inv. 52.9.112.

Although Cornelis de Vos was primarily a portraitist and history painter, he too painted a few half-length gaming scenes in the Caravaggesque tradition, but in the revealing light of day rather than a cloaking nocturnal shadow (see fig. 76). Theodoor Rombouts was a more devoted Caravaggio follower, who had visited Italy between 1616 and 1625, and while there seems to have worked for the Grand Duke of Tuscany, Cosimo II de' Medici. His monumentally conceived half-length genre compositions depict musicians, card and backgammon players, smokers and barber-surgeons. Unmodulated bright colors, strong value contrasts, and a thick, assured touch distinguish his style. However, Rombouts's development is difficult to plot owing to a paucity of dated works, especially from the Italian years and those immediately following his return to Antwerp, or ca. 1625-1630.[215] Works like the *Card Players* (Antwerp, Koninklijk Museum voor Schone Kunsten, no. 358) and the *Lute Player* (cat. 60) probably date from the late 1620s, or, at any rate, undoubtedly predate the master's *Five Senses* of 1632 (Ghent, Museum voor Schone Kunsten, no. s-76; ill. cat. 62, fig. 4). The date on the *Backgammon Players* (fig. 78) has sometimes been mis-read but is in fact 1634. It shows that in the early 1630s Rombouts adopted a somewhat more elegant style which boasted a greater refinement of color and surface texture, perhaps in response to Cornelis de Vos (compare fig. 76) as well as to Rubens and van Dyck. More than Seghers or the other genre painters working in this style, such as Jan Cossiers (see cat. 62) and Adam de Coster (1586-1643), Rombouts helped graft the Caravaggesque tradition to the native genre stock; his figures are imbued with an intensity of expression and vitality that distinguishes his art as the most accomplished of this group.

In addition to Flemish painters who depicted the local scene there were some who painted foreign peoples and societies. The largest group were those who traveled to Italy and joined the association of Netherlandish painters in Rome known as the Bentveughels ("Birds of a Feather"). Many of the artists depicted Roman street life – peasants, vendors, and small craftsmen – in multifigured compositions inspired by the art of the Haarlem painter Pieter van Laer (known as "Bamboccio," meaning malformed doll or puppet).[216] Jan Miel (1599-1664),[217] for example, a pupil of Gerard Seghers, is documented in Rome in 1636 and probably was there as early as 1633. He made a specialty of street scenes, carnivals with entertainers, and masked revelers (see, for

Fig. 78. Theodoor Rombouts, *Backgammon Players*, 1634, oil on canvas, 160.5 x 234.8 cm, Raleigh, North Carolina Museum of Art, no. GL 57.2.1.

Fig. 79. Jan Miel, *Tooth Puller*, oil on canvas, private collection (fomerly in the Caraceni collection).

Fig. 80. Michiel Sweerts, *Gentleman Ascending with His Luggage from a Mediterranean Port*, oil on canvas, 64 x 87 cm, Paris, Musée du Louvre, no. M.N.R.478.

Fig. 81. Michiel Sweerts, *A Young Couple and a Boy in a Garden*, oil on canvas, 37.8 x 48.6 cm, Worcester, Worcester Art Museum, no. 1961.40.

Fig. 82. Michiel Sweerts, *Procuress and Young Man*, oil on canvas, 19 x 27 cm, Paris, Musée du Louvre, no. R.F.1967-11.

example, the exceptionally large *Carnival in the Piazza Colonna, Roma*, ca. 1645, Wadsworth Atheneum, Hartford, no. 1938.603 – one of a series of five paintings commissioned for the Roman Palazzo of Marchese Tommaso Raggi under the Campadoglio), quacks and low-life professions (see fig. 79), and peasants gathered outside rural inns. Among this international assembly of painters, Miel's art is most closely related to that of the Dutch painters Johannes Lingelbach (1622-1674) and Karel du Jardin (ca. 1623-1678), the Italian Michelangelo Cerquozzi (1602-1668), and the Frenchman Sebastien Bourdon (1616-1671), and Miel's fellow Fleming Antoon Goubau (1616-1698). Although there were other genre specialists in this Roman circle, such as the minor painter Willem Reuter (ca. 1642-1681), Miel and Michiel Sweerts (q.v.) were surely the most accomplished Flemish nationals to paint the *vita populare* in the tradition of van Laer.

A remarkable and haunting artist, Sweerts and his œuvre, surprisingly, were only resurrected in this century. He too painted street scenes with beggars, soldiers gaming, travelers ascending

from harbors (see fig. 80), and images of the common folk ("fleapickers," laundresses, and women spinning or doing needlework; see cat. 75). However Sweerts also executed quietly elegiac images of male bathers, religious series in the guise of genre, such as the Seven Acts of Mercy,[218] as well as a variety of images of artist's studios, academies, and artists working from models, casts, or statuary out of doors. His Academy (Haarlem, Frans Halsmuseum, no. 270) depicts a large room with young men drawing from a live model under the supervision of a teacher, and serves to remind us that Sweerts himself was given permission in Brussels on 3 April 1656 to open an "academie van die teeckeninghen naer het leven" (academy for drawings from life). The painting in the present exhibition (cat. 75) seems to depict a school in Rome, where children are taught everything from the three "R's" to needlework and music. However the monumentality of the figures, somber yet dramatic lighting, and characteristic stillness of this image, which is such a far cry from the rowdy classrooms of Pieter Bruegel the Elder (see his engraving of The Ass at School), Jan Steen, or Adriaen van Ostade, lend the subject a ruminative, lyrical quality that belies its everyday subject. Even when the painter executes a fairly common high-life subject, such as a well-to-do couple with a child beneath an arbor in an Italian garden (see fig. 81), the crepuscular light, the spotlighting and silhouettes, and the disjunctive relation among the figures (ironically reiterated in the statuary) evokes an unresolved poetic narrative. And rarely have the dilemmas posed by the world's oldest profession been more subtly addressed than in the expressive exchange of The Procuress and Young Man (fig. 82). The painting adopts the bust-length double-figure format that had been traditional for scenes of venal love and ill-matched couples since the time of Quentin Massys but speaks afresh of temptation and restraint.

Landscapes

The Netherlandish landscape tradition traces its roots to the art of Joachim Patinir (ca. 1474-1524) and his nephew, Herri met de Bles (ca. 1480-1550), who were the first to paint the so-called "world landscape" (Weltlandschaft).[219] This convention featured a high horizon and an elevated point of view that permitted an encyclopedic account of nature. Rocky precipices, forests, and meandering rivers stretch up a panoramic vista to distant mountains and seas. Usually the biblical figures in these scenes – St. Jerome and other hermit saints, the Holy Family on the Rest on the Flight into Egypt, or St. John Preaching – are subjects that lend themselves to rural wilderness settings; by the same token, the landscapes themselves allude to, reinforce, and even embody the religious truths narrated by the figures.[220] Thus the assumption often made in the modern era that the biblical or literary staffage were a mere pretext for the painting of landscape themes is misleading. Just as with genre and still life, in the case of landscape the notion that these secular themes were "emancipated" in the interest of naturalism is an idea born of nineteenth-century concepts of realism.[221] Landscape in the early seventeenth century, like all other subjects practiced by Renaissance and baroque artists, sometimes was a carrier of metaphorical meanings, such as the Four Seasons, the Five Elements, and various religious and mythological themes; however, during the course of the century other social and aesthetic meanings and associations came increasingly to the fore.

Patinir's landscape traditions were perpetuated by sixteenth-century artists like Lucas Gassel (before 1500-after 1570) and Cornelis Massijs (ca. 1511-after 1560), but it was the great Pieter Bruegel the Elder who first extended the range of landscape's subjects and codified its early forms. His images, first captured in drawings and paintings of vast but minutely observed alpine mountain landscapes, forest interiors, and river valleys, were widely disseminated through prints after his designs. The engravings published by Hieronymus Cock had a pervasive influence on later landscapists. Bruegel's designs were also revived toward the turn of the seventeenth century by his son Jan, and artists like the highly innovative Hans Bol (1534-1593). They undoubtedly were drawn to him because Bruegel had brought a new grandeur coupled with more exacting standards of observation to the panoramic "world landscape." No longer merely backdrops for a story, his landscapes celebrated the scenery itself, recording the wonders of the natural world. This is not to suggest that Bruegel's landscapes are devoid of allegorical dimensions; one need only consider his famous series of the Months of 1565, five panels of which survive (Prague, Národní Galerie; New York, Metropolitan Museum of Art; and three in Vienna, Kunsthistorisches Museum).

Very often original themes or ideas appear in the graphic arts before they are realized in the more expensive and time-consuming media of paint. This was the case with the arrival of a simpler and more direct approach to the depiction of rural scenery, when two series of small-scale prints, also produced by Cock and designed by the eponymous Master of the Small Landscape (possibly to be identified with Joos van Liere) appeared. The two series, with the neutrally descriptive titles *Numerous and Exceedingly beautiful examples of Various Village Dwellings* (1559), and *Depictions of Estates, Country Houses, and Peasant Cottages* (1561), depict the outskirts and hamlets around Antwerp. They adopt Bruegel's practice of drawing from life but abandon the bird's-eye view for a more conventional perspective and exchange Bruegel's heroic alpine valleys for simple rural scenery. These developments had a lasting effect in both the Southern Netherlands and the North, where in Amsterdam Claes Jansz. Visscher reprinted the series in 1612. For example the conspicuous simplicity and unity of Jacob Grimmer's (ca. 1525-1590) somewhat naive depictions of the countryside and villages around Antwerp seem to respond to these developments (see his *Four Seasons* series of 1577, Budapest, Szépmüvészeti Múzeum, nos. 555-558), as do some of the works of Gillis Mostaert (ca. 1534-1598). Lucas (ca. 1540-1597) and Maerten (1535-1611) van Valckenborch, and Cornelis van Dalem (ca. 1528-ca. 1575) remain aligned with the Bruegel/Cock tradition of expansive vistas, often employing a darkened foreground which falls off to a lighted middle distance and thereafter rises steeply to a distant prospect.[222] Lucas's woodlands with pastures (see, for example, his painting of 1573, Frankfurt a.M., Städelsches Kunstinstitut, inv. no. 1221), mountain valleys, and roadside vistas (see both the *View in the Vicinity of Aix-la-Chapelle*, dated 1570, and *Landscape with Travelers by an Inn*, dated 1577; Musées Royaux des Beaux-Arts de Belgique, Brussels, invs. 3358 and 6395) are important precursors of the landscapes of Jan Brueghel the Elder and the generation of Flemish painters around the turn of the century. His later work (such as the much admired *Angler in a Woodland*, Vienna, Kunsthistorisches Museum, no. 1073; ill. cat. 78, fig. 1) is also potentially important, but may not have been available for study since after 1577 he worked for Archduke Matthias in Linz and after 1593 in Frankfurt.

The hostilities which swept the Southern Netherlands at the end of the sixteenth century, driving so many artists out of the country, were especially costly for the ranks of landscapists: Karel van Mander emigrated north; Jacob and Roelant Savery left their native Kortrijk in 1591; in the same year David Vinckboons, like Hans Bol before him, left Mechelen as the Saverys for Amsterdam; and Gillis van Coninxloo arrived in that city four years later. Coninxloo's greatest achievement was in the painting of dense, leafy forest interiors with funneling recesses and vast trees stretching to the top of the picture. These bosky works certainly begin by 1598 (see cat. 78) but it is not clear that Coninxloo could have executed this type of picture before 1587 when he first fled Antwerp for Frankenthal, Germany, another haven for Protestants. More important for the Flemish landscape painting tradition, therefore, are the forest interiors that Jan Brueghel developed from his father's designs in the last decade of the sixteenth century.

Jan Brueghel's forest hillside painted in collaboration with Hans Rottenhammer is dated 1595;[223] he probably also painted close-up views of forest interiors similar to the picture in the Ambrosiana (see cat. 78, fig. 2) about this same time.[224] The splendid painting with wood gatherers and Abraham and Isaac dated 1599 (cat. 79) proves that Jan was fully the master of the forest landscape before the turn of the century. Especially evocative here is the richness of detail in the gnarled trees, their foliage and trunks, the twisted undergrowth and lighted passages of the rushing stream and the misty prospect on the right. The leaves create a delicately lacy silhouette against the sky but are infinitely varied, never mechanical or standardized as in some later forest scenes by artists in Brueghel's circle, such as Abraham Govaerts (1589-1626) or more conspicuously Anton Mirou (1570-1653), and Alexander Keirincx (1600-1652).[225]

With dated works from 1612 to 1626, Govaerts began his career working in the style of de Momper and Coninxloo (see The Hague, Mauritshuis, no. 45, dated 1612) then in the 1620s painted woodland scenes in the manner of Jan Brueghel the Elder, but with his own more decorative variations (see *Forest with Four Elements*, dated 1624, Braunschweig, Herzog Anton Ulrich-Museum, inv. 110); he also often collaborated with figure painters (notably the Franckens and Hendrick de Clerck). Alexander Keirincx began his career in his native Antwerp painting forest views in the style of Coninxloo, Brueghel, and Govaerts (see Dresden, Gemäldegalerie Alte Meister, no. 1145, dated 1620). Despite a move by 1628 north to Utrecht, where he could have personally witnessed the rise of Dutch realist landscape painting, Keirincx became progressively more deco-

Fig. 83. Jan Brueghel the Elder, *Harbor Scene with Paul's Departure from Caesara*, 1596, oil on copper, 35.5 x 53.3 cm, Raleigh, North Carolina Museum of Art, 52.9.92.

Fig. 84. Jan Brueghel the Elder, *River Landscape*, 1603, oil on panel, 39 x 60 cm, Antwerp, Koninklijk Museum voor Schone Kunsten, no. 910.

rative and mannered in his treatment of landscape forms and foliage. His surprisingly delicate, amber-blond later works, with their exotically undulating and pendulous trees, were probably painted mostly in Amsterdam, though he also visited England in these years. They eschew Dutch naturalism for extraordinary flights of embroidered artifice (see Antwerp, Koninklijk Museum, no. 902, dated 1630; and Braunschweig, Herzog Anton Ulrich-Museum, inv. 183, dated 1640).

In addition to forest interiors, Jan Brueghel also made contributions to the history of the painting of ports, harbors, and river scenes. The *Harbor Scene with St. Paul's Departure from Caesarea* dated 1596 (fig. 83)[226] depicts a religious theme in modern, which is to say, late sixteenth-century guise, but gives over most of the scene to a fascinatingly detailed account of the local fish market and harbor. The artist's father had been a pioneer of seascape painting, but this near view of the harbor's bustling and differentiated human and marine activity, and the astonishingly complex works that shortly followed (see especially Munich's crowd scene with a profusion of detail but also a discrete religious theme in the *Harbor with Christ Reading*, dated 1598, Alte Pinakothek, no. 187)[227] were to have a lasting effect upon Netherlandish seascape painting. Despite the elevated point of view, the richness of myriad forms and color accents, and the continuing imposition of three dominant color zones (brown, green, and blue, in progressive recession), these works possess an unprecedented spatial coherence. Similarly, Brueghel's diagonally arranged river views fill the foreground with water, thus creating two interlocking triangular forms of land and water (see fig. 83).[228] Precocious though imperfectly resolved, these patterns of design still cleave to mannerist conventions of vertical space and strong local color at the expense of atmospheric unity, but make dramatic strides toward the more naturalistic river views that later Dutch artists, notably Jan van Goyen and Salomon van Ruysdael, would only fully develop almost twenty-five years later.

Several landscape subjects that subsequently became commonplaces in Netherlandish art, such as the traveling themes of the road through the wood or to market (cat. 82), the highway across the plain (cat. 83), the rest at the inn, or the entrance to the village,[229] were first popularized by Jan Brueghel the Elder.[230] Most of his landscape innovations, however, had been realized by ca. 1610, after which he contented himself by masterfully ringing the changes on tested themes and forms. An exception, however, are the "Paradise" paintings, which not only include his *Garden of Eden with Fall of Man* of ca. 1616 (fig. 29), painted in collaboration with Rubens, but also *The Entry to Noah's Ark* dated 1613 (fig. 85). These feature a wonderful menagerie of birds and animals, several of which (for example, the lions, leopards, and white horse) are derived from Rubens's drawings. Such paintings are truly tours de force in the richness of their invention, colorful motifs, and details.

As we have seen, collaboration among Flemish landscapists had long been a common working practice.[231] Brueghel collaborated with a great many artists, including Rubens, van Balen, Vrancx, Hendrick de Clerck (see cat. 2), Frans Francken II, Peter van Avont (1600-1632), Tobias Verhaecht (1561-1631), and other, lesser artists. However his most consistent partner was the man whom he called in 1622 "Mio amico Momper" (my friend [Joos de] Momper [the Younger]).[232] Four years Jan Brueghel's senior, de Momper always harbored a sentimental attachment to sixteenth-century mannerist forms but also helped to advance the baroque landscape, of which he

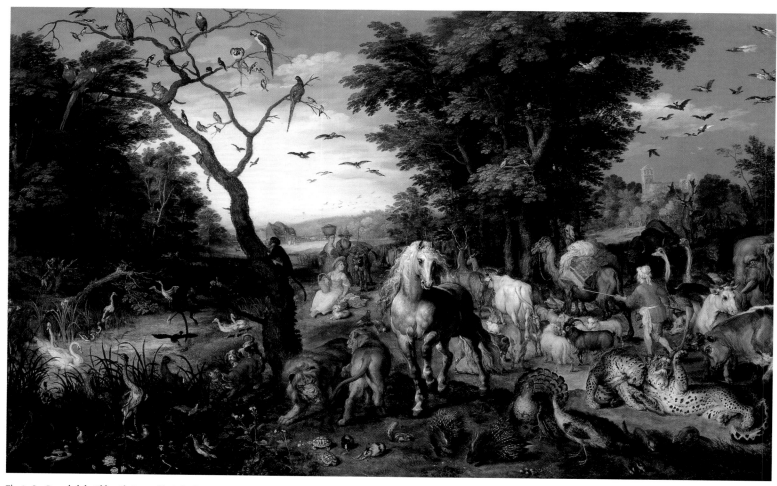

Fig. 85. Jan Brueghel the Elder, *The Entry of the Animals
into Noah's Ark*, 1613, oil on panel, 87 x 54.5 cm,
Malibu, J. Paul Getty Museum, no. 92.PB.82.

was one of the first exclusive specialists. Although his development is difficult to plot because he
only dated one painting (cat. 80) and rarely signed works, he seems to have painted world land-
scapes in the Bruegelian tradition until about 1600. A hypothetical but undocumented trip to
Italy in the 1580s would have exposed Joos to soaring mountains and enabled him to experience
the precarious highland roadways that figure so often in his art. However these works were at
least as much a product of mannerist artistic convention and fantasy as recollections of actual
alpine scenery. To judge from their frequency of appearance in *kunstkamer* paintings, these moun-
tain landscapes with travelers (see cat. 80 and fig. 86) were much admired by his patrons. Joos
also executed unpretentious scenes of villages in winter (cat. 86) and more temperate seasons,
depicting, for example, bleaching linen in spring (cat. 87), again in collaboration with Jan
Brueghel. His most productive years were the first two decades of the new century. In 1616 his
labors earned him privileges and exemptions from the archdukes. But in this same period he also
employed a sizable and productive studio that has obscured the autograph œuvre. Numerous
artists besides Jan Brueghel the Elder painted staffage in his paintings, including Jan the
Younger, Sebastian Vrancx, Hendrick van Balen, Frans II and Hieronymus II Francken, Peeter
Snyers, and David Teniers.

A contemporary of de Momper is Kerstiaen de Keuninck, who produced only a relatively
small œuvre of sixty paintings but also made a specialty in his early career, particularly before
1610, of panoramic mountain landscapes with fantastic rock formations, dramatic tonal con-
trasts, and theatrical rays of celestial light (see cat. 81). De Keuninck also painted woodland scenes
(see Cologne, Wallraf-Richartz-Museum, no. 1486, dated 1610), and landscapes with conflagra-
tions and calamities (the burning of Troy, Lot leaving Sodom, the flight of Aeneas, etc.). De Mom-
per's followers include in addition to his sons (the most talented of whom was Frans [1603-1660],
who later worked in Holland), his contemporaries, Tobias Verhaecht (1561-1631) and the more tal-
ented Ghysbrecht Lytens (1586-1643/56[?]), who painted mostly winter scenes (see, for example,
Vienna, Kunsthistorisches Museum, inv. 911).[233] We might also mention here the stylized

marine paintings of Bonaventura Peeters (see cat. 88) who as a seascape painter stands in a certain isolation save for the company of artists like Andries van Eertvelt (1590-1652), in part no doubt because Flemish maritime activity had suffered so in these years. With their fantastical rock formations and exotic shores, his shipwrecks usually conform to mannerist landscape conventions but also, especially in later years, acknowledge the tonal landscape palette made popular in the north by Dutch artists like Jan Porcellis, Jan van Goyen, and Salomon van Ruysdael.

A somewhat exceptional case in the early history of Flemish landscape is Paulus Bril (1556-1626), who like his older brother, Matthias (1551-1583), spent his mature career in Rome. Bril had inherited the northern mannerist landscape tradition and seems to have had a mutual influence on Jan Brueghel in the 1590s when they both were in Italy. His earliest dated painting *Rocky Landscape with a Bridge and Travelers* (private collection, Germany), is of 1594 (fig. 87).[234] It recalls earlier designs by Hans Bol and Lucas van Valckenborch, but employs a mannerist color scheme while simplifying the composition by lowering the viewpoint and focusing on fewer motifs. He still was painting these rocky landscapes in 1609 when he executed the *Landscape with St. Jerome* (Aix-en-Provence, Musée Granet, inv. 1112), but by then the influence of the precise little landscapes by Adam Elsheimer and possibly his Northern followers (e.g. Jacob Pynas) mix with vestiges of the more mannered Flemish tradition. Bril's views of Rome (see especially, Dresden, Gemäldegalerie Alte Meister, no. 858 [dated 1600]; Braunschweig, Herzog Anton Ulrich-Museum, nos. 60 & 61, and Museum Augsburg) inaugurated a new conception of landscape that would have important repercussions not only for Northern artists like the Flemish painter Willem van Nieulandt (1584-1635) and the Dutchmen Cornelis van Poelenburgh, Bartholomeus Breenbergh, and Herman van Swanevelt, but also Claude Lorrain and other classicist French and Italian landscapists.

With the appearance of Rubens's landscapes from the second decade of the century (see cat. 89), one group of Flemish artists broke with the earlier Bruegelian tradition of constructing landscapes from a multitude of details piled up vertically on the surface, to a more unified

Fig. 86. Joos de Momper II, *Mountain Landscape with Travelers*, oil on canvas, 192 x 294 cm, Vaduz, Prince of Liechtenstein collection, inv. 730.

Fig. 87. Paulus Bril, *Rocky Landscape with a Bridge and Travelers*, 1594, oil on copper, 18 x 23.5 cm, Germany, private collection.

Fig. 88. Jan Wildens, *Winter Landscape with Hunter and Dogs*, 1624, oil on canvas, 194 x 292 cm, Dresden, Gemäldegalerie Alte Meister, no. 1133.

Fig. 89. Jan Wildens, *Landscape with Dancing Shepherds*, 1631, oil on canvas, 135 x 201 cm, Antwerp, Koninklijk Museum voor Schone Kunsten, no. 987.

Fig. 90. Lucas van Uden and David Teniers, *Landscape with Peasants*, oil on canvas, 54.5 x 81.5 cm, New York, Gutekunst & Co.

approach to design that emphasized the overall decorative organization and beauty of the scene. Jan Wildens's art reflects the transitions of the period. Works that can be definitely assigned to his early years in Italy (1613-1616) are limited to a series of engravings of the *Months*, dated 1614, which draw inspiration from virtually all the leading landscapists of the period, including Jan Brueghel, Hans Bol, Joos de Momper, and Adriaen van Stalbemt. An undated series of paintings of the Months probably was executed about this time or shortly thereafter (Genoa, Galleria di Palazzo Bianco).[235] These develop over the course of the cycle from a stiff and halting imitation of northern sources to a much more confidently assured style (see especially the depiction of November). The precedents of Jan Brueghel and his circle are still detectable but the organizational refinement seems more indebted to Bril.

When Wildens returned to Antwerp he became a collaborator of Rubens's, painting around 1616-1617 the handsomely decorative landscape backgrounds in the master's *Piety of Rudolf I (1218-1291)*, the founder of the Hapsburg dynasty (Madrid, Museo del Prado, no. 1645), and also apparently painting the background of the *Rape of the Daughters of Leucippus* (Munich, Bayerische Staatsgemäldesammlungen, no. 321) and *Cimon and Iphigenia* (fig. 27). This period of collaboration between the two seems to have been concluded around 1620; however, Wildens also provided backgrounds for paintings by Jordaens, Snyders, Paulus de Vos, Abraham Janssens, Jan Boeckhorst, Gerard Seghers, Cornelis Schut, and Theodoor Rombouts. In 1624 he dated perhaps his best-known work, the *Winter Landscape with a Hunter and Dogs* (fig. 88), which attests to Rubens's influence in its balanced organization and broader execution but is exceptional in Wildens's œuvre because of its large-scale figures. His best works date from 1625-1635 and are usually large canvases composed horizontally, depicting rural roads, woodlands, and pastoral images (see fig. 89), often with tall trees and vistas to ponds and rolling hills. He rarely opens up the landscape or emphasizes the sky as would his Dutch counterparts. Wildens's later works alternately adopt more decorative or fastidious drawing and a muddier palette. Never an artist to aspire to the majesty and passion of Rubens's landscapes, Wildens created blamelessly pleasant, calm, and sylvan landscapes.

While Wildens certainly collaborated with Rubens, there is no evidence that the younger landscapist Lucas van Uden (1595-1672/3), who is usually mentioned together with Wildens, ever provided Rubens with backgrounds, or that Rubens ever painted staffage into his paintings.[236] There is considerable evidence, however, of Rubens's influence on van Uden, who executed numerous copies and pastiches of the master's paintings and was much taken with his broad brushwork and atmospheric palette.[237] Painted mostly between 1630 and 1650, van Uden's landscapes typically feature a hillside to one side with tall slender trees, and a lush plain opposite stretching away to a distant horizon. The plain invariably is neatly articulated and parceled out with coppices and lines of small rounded trees. A unifying light green hue pervades while yellow and light brown accents punctuate the scene. Very often David Teniers supplied van Uden's figures (see fig. 90). The landscapist's charm rests chiefly in the unpretentious delicacy and tenderness of his scenes.

There were a few minor Flemish landscapists, like Gillis Peeters (1612-1653) and Gillis Neyts (1623?-1687?), who seem to have come in contact with Dutch art and imitated its modesty of subject and unpretentious execution. Though he traveled to Italy in his youth, Jan Siberechts (q.v.) comes closest in conception to the Dutch painters in his stolid realism. His landscapes vaguely recall the color schemes and value contrasts of the Dutch Italianate landscapist Adam Pynacker, but never attain that master's atmospherics or effortless formal grace; there is instead a charming frumpiness, even naive quality to his static, enervated figures who treck silently to market or pasture, forever fording ankle-deep streams bordered by pollarded willows (cat. 93). Despite a few such acknowledgments of the north, the native landscape tradition favored a more grandly conceived and decorative naturalism. In Brussels a group of landscapists who included Lodewijk de Vadder (1605-1655), Lucas Achtschellinck (1626-1699), and Jacques d'Arthois (q.v.) emerged around mid-century and shared an interest in amply conceived woodland and village landscapes with loamy roads traveled by small staffage (often featuring hunters, drovers, and horsemen), and tall artfully distributed trees. The best-known of these painters, d'Arthois, employed a warm palette, painterly stroke, and strong value contrasts. Lodewijk de Vadder is more daring, employing a still broader and thicker touch in dramatic diagonally receding designs with emphatic contrasts of light and shade, especially when painting the texture of a sandy bank (Schleissheim, Staatsgalerie, no. 1051) or darkened silhouettes of houses against the sky (Paris, Frits Lugt collection, Institut Néerlandais, inv. no. 5972). Achtschellinck was reported to be Lodewijk de Vadder's pupil and often collaborated with Brueghelian staffage painters (Peter Bout, Theobald Michau, and Pieter van Avont).

In Antwerp, minor imitators of Jan Brueghel and Stalbemt continued to manufacture pleasant if repetitious village landscapes through the end of the century, but a later painter like Cornelis Huysmans (see cat. 91) distinguishes himself by his rich Venetian coloration and broad and spontaneous brushwork. His younger brother, Jan Baptist Huysmans (1654-1716), paints in a tighter, more controlled and restrained manner (see the two versions of *Landscape with Cattle*, Brussels, Musées Royaux des Beaux-Arts de Belgique, no. 1479 [dated 1697]; and Lyon, Musée des Beaux-Arts, inv. no. A2907) that aligns itself with the style of the Netherlandish followers of Poussin and Gaspard Dughet. The Italianate but increasingly international classicist style was practiced by artists like Johannes Glauber, Isaac de Moucheron, Albert Meyeringh, and Jacob de Heusch in the north, and, in the south, by Jan Frans van Bloemen (1662-1749), nicknamed "Orrizonte" while on his Italian sojourn, Abraham Genoels (1640-1723), and François (Francisque) Millet (1642-1679).[238] To this group we also add Gaspard de Witte (1642-1681), known in Italy as van Vittelli, whose views of Rome had a significant impact on Italian vedute painters. Although these classicist artists won the praise of contemporary writers like Arnold Houbraken and Gerard de Lairesse, they signaled the end of the indigenous Netherlandish landscape style in both Holland and the Spanish Netherlands.

Still Life and Animal Painting

As we have suggested, the elements of still life first appeared as marginalia in medieval manuscripts or as attributes in religious paintings and portraits; for example, lilies and irises in a vase were allusions to purity and forgiveness, or a still life of a meal shared by a married couple in a portrait was a symbol of their love.[239] Still life only became an independent painting type toward

the end of the sixteenth century. As with genre painting, there was no special general term to refer to the theme, rather the subjects were described individually in inventories as *een bloempot* (a vase of flowers), *ontbijtje* (breakfast piece or light meal), *fruitje* (fruit piece), *banketje* (banquet piece), *jachtje* (trophies of the hunt), and *vanitas* (*memento mori*). The works of some of the earliest sixteenth-century Netherlandish specialists in still life are unknown, such as the flower painter Lodewyck Jansz. van den Bosch, although their reputations are preserved by van Mander.[240] However the market and kitchen still lifes and genre scenes, often with subsidiary religious scenes, by Pieter Aertsen (1507/08-1575) and his nephew and follower, Joachim Beuckelaer (ca. 1533-ca. 1575), are well known and have been extensively analyzed in recent years for their "hidden" spiritual, philosophic, and moralistic meanings.[241] In their own day, Aertsen's still lifes of everyday objects were highly praised for their naturalism and received high prices; Hadrianus Junius in 1588 even likened the artist to the ancient painter Piraikos, whom Pliny mentioned as a specialist in *rhyparagraphos* (the painting of common or humble things), thus seemingly the modern painting type.[242] Samuel van Hoogstraten might call still-life painters the "common footsoldiers in the army of art," but allowed that such works appeared in even the most famous art cabinets; indeed the writer himself was a painter of illusionistic still lifes who believed that "a perfect picture is like a mirror of nature which makes things that are not appear to be and deceives in a permissibly pleasing and praiseworthy fashion."[243]

Descended from the paintings of Aertsen and Beuckelaer are a group of works executed around the turn of the century by artists from the Francken circle of still lifes of a modest meal (usually bread, beer, and herrings) set on a table and sometimes still offering a glimpse through a window of a small religious or secular scene.[244] These works are the immediate predecessors of the tabletop still lifes made popular in Antwerp by Osias Beert (see cat. 106), Clara Peeters (cats. 107, 108, 109), Jacob van Hulsdonck (q.v.), and Alexander Adriaenssen (1587-1661); and in Haarlem by their contemporaries Floris van Dyck and Floris van Schooten. All of these painters of the so-called breakfast piece, and especially its early practitioners – Beert, Peeters, and Hulsdonck – employ a steeply pitched table with plates, vessels, food, and other utensils piled up on the surface in a regular fashion which minimizes the overlapping of forms, thus providing as comprehensive an account of each object as possible. Beert favored descriptive images of desserts and dainties, sugared delicacies, nuts and plates of oysters, often set on tables with finely wrought *façon-de-Venise* glassware and wan-li porcelain. The manufacturer's dates on the back of several of his copper panels indicate that he was probably active by 1607, and he had joined the Antwerp guild as many as five years earlier. Clara Peeters's style is as precise as Beert's but more colorful and drier, with fewer glazes and an especially fastidious approach to drawing. Although little is known of her life she too seems to have begun her career in Antwerp and first dated tabletop still lifes in 1607 (see cats. 108-109, fig. 1). By 1611 (see *Still Life, Flower Vase, Covered Cup, Nuts, Confectionaries, and a Wine Decanter*, Madrid, Museo del Prado, no. 1620) she had developed a more sophisticated approach to composition than most of the early still-life painters, as well as richly varied motifs and surface detail. In addition to confectionery, including tarts (see cat. 107), large pastries, and pretzels with cheese, Peeters also was especially fond of depicting elegant metalware, which she occasionally painted with portraitlike precision in compositions of precious objects (see cats. 108-109, fig. 2); these recall Jan Brueghel's still-life interests and parallel those of the Dutchman Pieter Claesz., to whom some of her works have been attributed because the two artists shared the same initials.[245] Peeters's *Fish Still Life* dated 1611 in the Prado (Madrid, no. 1621) seems to be the earliest of its type. In addition she painted a few still lifes of flowers and shells.

Although he did not date his paintings, Jacob van Hulsdonck is properly considered to be one of the pioneers of fruit still-life painting.[246] Restricting himself far more narrowly than Peeters, most of Hulsdonck's carefully observed and colorful paintings depict grapes and peaches in a straw basket or wan-li porcelain bowl, although he also painted a few flower still lifes (see cat. 97); a painting that was recently on the market in Paris is exceptionally ambitious for the complexity of its design (fig. 91). Jacob van Es (1596-1666) also painted fruit still lifes in a bowl and *ontbijtjes*, but with greater simplicity of organization, brightly saturated hues and more convincing atmosphere. Although he became a master in 1616, his few dated works are considerably later (see Vaduz, Prince of Liechtenstein collection, no. 769, dated 1640). These large later works from the artist's mature period have more in common with the decorative designs of Snyders than the relatively static, early descriptive breakfast pieces.

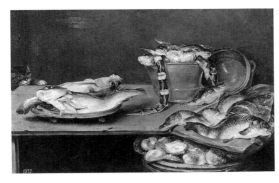

Fig. 92. Alexander Adriaenssen, *Tabletop with Fish*,
oil on panel, 60 x 91 cm, Madrid, Museo del Prado,
no. 1341.

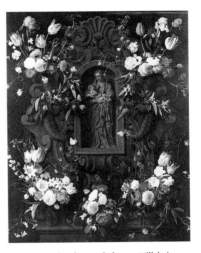

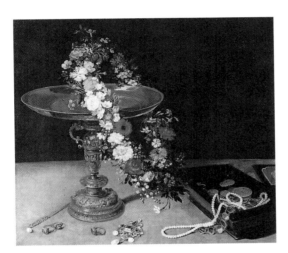

Fig. 91. Jacob van Hulsdonck, *Basket of Fruits and
Flowers on a Table*, oil on panel, 68.5 x 96.5 cm, sale
Paris (Drouot Richelieu), 4 December, 1992, no. 39.

Fig. 94. Gerard Seghers and Thomas Willeboirts-
Bosschaert, *Flower Cartouche with Statue of the Virgin
Mary*, 1645, oil on canvas, 151 x 122.7 cm,
The Hague, Mauritshuis, no. 256.

Fig. 93. Jan Brueghel the Elder, *Tabletop with Tazza,
Flower Garland, and Jewel Box*, 161(8?), oil on panel,
47.5 x 52.5 cm, Brussels, Musées Royaux des Beaux-
Arts de Belgique, no. 5013.

Among the other early painters of tabletop still lifes who deserve mention is Alexander
Adriaenssen, who painted fruit and dead game compositions but is today best remembered for
his fish still lifes (fig. 92).[247] He joined the guild in 1610 as a "waterschilder" (tempera painter)
and seems to have made a specialty of heraldic imagery (in 1635 he was engaged to paint the
coats-of-arms of the seventeen Provinces of the North and South Netherlands on an arch for the
Triumphal Entry of the Cardinal Infante), but later qualified in 1616 as a "painter on canvas."
Adriaenssen dated his first still life as early as 1623 (sale Wertheim, Berlin, 25 March 1930, no. 164),
although most of his dated works are from the 1640s (his latest bears the date 1660); his decorative
approach to design and restrained palette evidently changed relatively little. In the 1630s,
Philippe de Marlier (d. 1678) also painted a few tabletop still lifes in the early descriptive manner,
as well as flower still lifes (see cat. 97, fig. 1). Frans Ykens (1661-1693) was a very late representative
of the style. Some of the most accomplished practitioners of the tabletop tradition worked abroad.
Daniel Soreau (d. 1619), and his sons Jan (born 1591) and Isaak (see cat. 110) exported the elements
of the prototypical Flemish still life to Germany (working in Frankfurt and Hanau), where they
painted delicately delineated grapes, peaches, and raspberries in wan-li bowls and baskets, some-
times with auxiliary baskets of flowers, and often with individual blossoms, nuts, and fruit spar-
ingly distributed across the foregrounds of their light blond wood tabletops. Peter Binoit (1589-
1639) married into the Soreau family, and by the time he dated his first painting in 1615 was
executing restrained tabletop still lifes in a style reminiscent of Peeters but with more intense
colors, expressed for example, in his penchant for including bunches of red currants.

As we have suggested, the flower still life only emerged as an independent subject in oil paint-
ing around the turn of the seventeenth century. There had been isolated religious paintings of
flowers by the German sixteenth-century painter Ludiger tom Ring, as well as watercolors and
prints, by, for example, Joris Hoefnagel and Adriaen Collaert, but the earliest paintings of flower
bouquets in vases are by Roelant Savery (1576-1639), who was born in Kortrijk (Courtrai) but was

working for Rudolf II, the Holy Roman Emperor, in Prague by 1603/04.[248] As early as 1604, the Antwerp-born Jacques de Gheyn II (1565-1629) had also sold a large painting of flowers and a booklet of flower illustrations to Rudolf II.[249] Jan Brueghel the Elder apparently first turned to flower painting in 1605 (see cat. 95), after a visit to the court in Prague in the previous year, where he could have seen the earlier works by Savery and de Gheyn. Not unlike Savery's still-life designs, Brueghel's earliest dated flower still life depicts an oval-shaped bouquet in a vase organized around a central axis, but it is less crowded and more colorful. Brueghel's amazingly detailed bouquet in cat. 95 contains fifty-eight different species of flowers with a total of seventy-two varieties or color variants, thus clearly attests to the artist's botanical interests. From Jan's correspondence with Cardinal Borromeo we learn of the pains he took in seeking out rare blooms and the lengthy time it took him to complete a work like the large flower still life now in the Ambrosiana, Milan; for that picture he had to travel to Brussels to study flower specimens that were not available in Antwerp.[250] Presumably this was in the garden of the Archduke Albert, who also apparently ordered a major flower still life from Brueghel (Vienna, Kunsthistorisches Museum, no. 570).[251] The painting for Cardinal Borromeo was not finished until 25 August, though Jan had reported in June that he was working on it every morning.[252] The artist made no secret of the high value that he placed on these paintings; he wrote to the cardinal about another similar painting that it was worth as much as the jeweled diamond brooch that he had painted next to the vase in the painting.[253] Brueghel's subsequent renown for the precision of his floral "portraits" inspired his early biographers (de Bie [1661], Félibien [1666], Houbraken [1718-1721], and Weyerman [1729-1769]) to all repeat the art historical topos about his still lifes virtually exceeding the beauty of nature itself; indeed the painter later earned the sobriquet "Blumen-Brueghel" or "Brueghel des fleurs."

With his botanical interests Brueghel shared the empirical concerns of scientists like Carolus Clusius, who was prefect of the medical-botanical garden in Leiden from 1593 until his death in 1609. De Gheyn had certainly been influenced by Clusius when he was a resident of Leiden in 1596-1598, and Brueghel may have had some indirect contact, since he included lilacs in his painted bouquets only a short while after Clusius introduced them into the Netherlands.[254] Another early flower still-life painter who painted rare blooms was Ambrosius Bosschaert the Elder (1573-1621) born and trained in Antwerp but active in Middleburg. Like Jan Brueghel, he also dated his first flower still life in 1605.[255] Bosschaert's family, which included Balthasar van der Ast by marriage, founded a "dynasty" of talented still-life painters who share many features with the early generations of descriptive still-life painters in the south.[256] Indeed despite past efforts to minimize the possible contact between Jan Brueghel and Bosschaert, the very fact that their symmetrical and radially organized flower still lifes in a vase on a table or in a niche are so similar in conception and appear almost simultaneously suggests more regular communication than has been admitted. However Jan always described his blooms individually, with a technique that ranged from thin veils of paint to a subtle impasto. Invariably, his flowers are observed under an even frontal lighting and often arranged in tiers (roses toward the bottom, tulips higher up, and irises or a crown imperial at the top); in contrast, artists in the Bosschaert group were increasingly concerned with the overall pictorial effect of the bouquet with softer effects of atmosphere. Brueghel's last certain dated flower piece is of 1621, and indeed there are surprisingly few autograph flower paintings by the artist as a whole. While by the end of the 1630s Dutch flower still lifes subsumed the individual blooms to the general composition, Flemish flower pieces always retain more color and a tendency toward additive organization, largely resisting the changes that the "tonal style" wrought in the north.

As we have seen, Jan Brueghel invented the paintings of flower garlands or wreaths with central religious or mythological images, sometimes with a landscape background. He also painted a few images of baskets and bowls of flowers, and in a painting dated 161(8?) experimented with a tabletop still life, featuring a vermeil tazza surmounted by a flower wreath, a jewel box to one side, and jewelry spread out in front (fig. 93).[257] The many copies by his son Jan the Younger sometimes attain a remarkably high level of quality but rarely have the subtlety of his father's execution. The multitudes of halting and crude works by lesser Brueghel followers still blight the salesrooms today.

The one exceptionally talented Brueghel pupil was Daniel Seghers, who became the preeminent flower painter in Antwerp following Jan's death in 1625.[258] Although Seghers painted glass vases of flowers (see cat. 98), often on tables or in niches, he made a specialty of dark sculpted

cartouches or niches decorated with flowers and other foliage. These works resemble Jan's earlier wreaths but were usually composed of several individual nosegays rather than a single garland (see cat. 99) and sometimes include symbolically rich plants as well as flowers, such as thistles or holly surrounding an image from the Passion. Seghers collaborated with several figure painters, who executed the small religious scenes or portraits within his surrounds (both imitations of sculpture in shades of gray, though not properly speaking grisaille, and less frequently with small figures in color), including Erasmus Quellinus II, Gerard Seghers, Simon de Vos, Cornelis Schut, Abraham van Diepenbeeck, Thomas Willeboirts-Bosschaert, and others. Seghers became a noviciate of the Society of Jesus in 1614 and later a priest, spending two years in Rome. The painter/priest's elegantly sophisticated flower paintings attracted many patrons among the foreign nobility, including Charles I of England, Holy Roman Emperor Ferdinand III, Stanislaus IV of Poland, and even the Dutch Stadholder Frederick Hendrick and Amalia van Solms, who in 1645 rewarded Seghers (who as a Jesuit could not accept payment) with a gold palette, six gold brushes, and a gold mahlstick for a *Flower Cartouche with Statue of the Virgin Mary* painted with Willeboirts-Bosschaert (see fig. 94). Occasionally, though not necessarily more often, for Protestant clients (especially considering the subject of the stadholder's image) he would leave the central part of the flower cartouche empty to be filled in by the patron.

Segher's followers included the able Jan Philips van Thielen (see cat. 104) Frans Ykens (1601-before 1693), Jan Anton van der Baren (1616-1686, who is depicted in Teniers's Vienna Gallery painting, cat. 124, as court chaplain to Leopold Wilhelm), Hieronymus Galle (1626-after 1629), and Andries Bosman (1621-1681), who also became a Jesuit priest. Nicolaes van Verendael, Jan van Kessel, and the de Heem followers, Joris van Son (1623-1667) and Carstiaen Luyckx (qq.v.), also painted a few flower garland paintings but each had a more varied still-life œuvre that also included traditional flower bouquets in vases (see cats. 100, 101, and 105). The two large and carefully finished flower still lifes by van Kessel exhibited here were part of a series of eight that the artist is assumed to have painted while in Spain as court painter to Philip IV. In addition to flower still lifes, van Kessel's œuvre included bird concerts and fighting animals in the style of Snyders, as well as various series, including *Animals* (Madrid, Museo del Prado, no. 1554) and *The Four Parts of the World* (Munich, Bayerische Staatsgemäldesammlungen, Alte Pinakothek, invs. 1910-1913), which recall the miniature art of his father-in-law, Jan Brueghel the Elder. A significant portion of his œuvre, however, consists of isolated studies of insects and flowers painted on a cream-colored ground (see fig. 95).

Of Jan Brueghel's contemporaries only one still-life artist matched his innovative powers: Frans Snyders not only revitalized the tradition of market and kitchen still lifes with figures developed by Aertsen and Beuckelaer, but also around 1610 invented the figureless large-scale dead game still life, or "trophies of the hunt" still life. His style before his return from Italy in 1609 is a matter of conjecture,[259] however by 1610 he was executing market scenes in the tradition of Aertsen and Beuckelaer.[260] And by 1613 Snyders was painting assured if somewhat stiff table-top still lifes depicting an abundance of game, fruit, and other commestibles with a servant in a

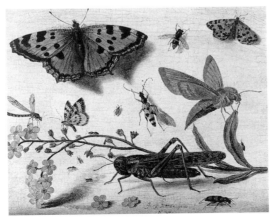

Fig. 95. Jan van Kessel, *Study of Insects and Flowers*, 1653, oil on panel, 11.4 x 14 cm, Solingen, Galerie Müllenmeister, 1980.

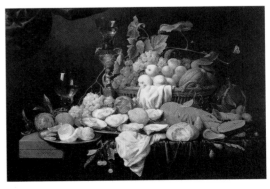

Fig. 96. Joris van Son, *Tabletop Still Life of Melon, Oysters, Lobster, and Fruit*, 1658, oil on canvas, 52 x 118 cm, private collection.

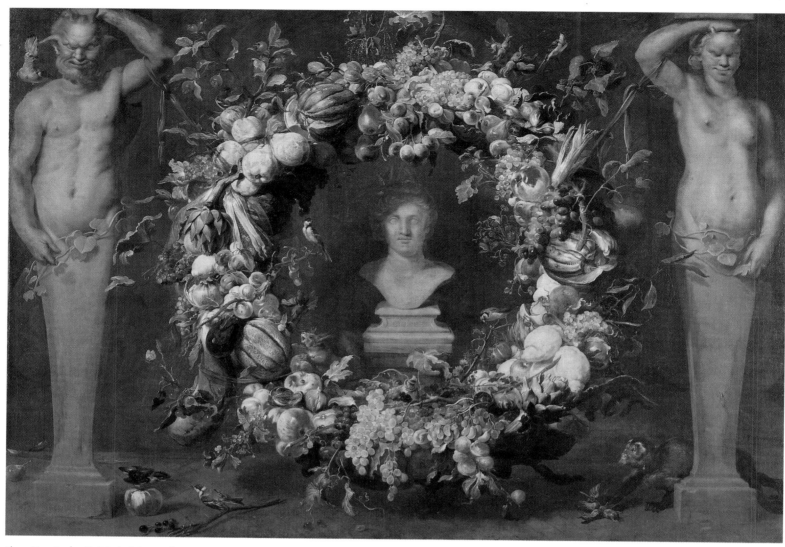

Fig. 97. Frans Snyders, *Fruit Garland, Terms, and a Bust of Ceres*, oil on canvas, 171 x 241 cm, Philadelphia, Philadelphia Museum of Art, W99-1-4.

stockroom, as well as smaller figureless still lifes of similar objects.[261] As we have seen, the eagle that he must have painted by this date for Rubens's *Prometheus* (cat. 10) reveals not a trace of youthful hestitancy. The market and pantry scenes dated 1614 and especially the tabletop still lifes with fruit baskets (reminiscent of Hulsdonck, see fig. 91) dated 1616 attest to Snyders's full artistic maturity in this period (see cat. 114).[262] Snyders's tabletop still lifes often featured a gutted roebuck surrounded by smaller game (rabbits and birds), fruit, and vegetables. Unprecedented in their monumentality and coloristic and decorative brilliance, these works established a tradition that was followed not only by Jan Fyt (see cat. 122) and Adriaen van Utrecht (1599-1652) but also continued well into the eighteenth century in the works of artists like the French painter Desportes.[263] In place of the intimacy and delicacy of tabletop still lifes by Beert and Peeters, he offers sumptuous abundance and a robust opulence. Especially beautiful is the rhythmic organization achieved in his densely composed, almost friezelike tabletop still lifes of dead game and fruit, or fruit still lifes. These feature the occasional squirrel, bird, or other small creature to enliven the design (see cat. 114). Snyders acknowledges Rubens's influence in his relatively thick paint application, bright colors, and light tonality, but his style is always more descriptive, especially in the naturalistic observation of animals, their anatomy, movements, and textures. His large hunt scenes (see cat. 121) surely owe a debt to Rubens, but employ human figures only in minor subsidiary roles, usually as tiny staffage appearing far off on the horizon. He concentrates instead on the monumental but never anthropomorphic animals and the dramatic mortal struggle of their bestial combat. Snyders's animal paintings also illustrate popular sayings, proverbs, and even Aesop's fables (known through de Dene's *De Waarachtige Fabulen der Dieren* [Bruges, 1567] and the prints of Marcus Geeraerts; see cat. 118).

In several respects, therefore, Snyders continued the moralizing tradition of sixteenth-century paintings by Aertsen and Beuckelaer, but he also was the first to establish the autonomy of animal painting and to transform this painting type into an acknowledged specialty with its own associations and values.[264] His love of monumental form and his fluid approach to design helped displace the rigidly geometric compositions that had previously prevailed. Through his partnership with Rubens, Snyders also seems to have been the first to develop fruit garlands and wreaths on a monumental format; these luscious works naturally develop out of Brueghel's earlier flower garlands (see fig. 97).[265] Surely the grandest collaborative effort ever undertaken by the firm of Rubens and Snyders was the production of mythological and hunt scenes for Philip IV's Torre de la Parada – work which continued with the aid of Snyders's atelier, including artists like Paulus de Vos, until Rubens's death in 1640 and unilaterally afterwards. Besides working with Rubens, Snyders also collaborated with van Dyck, Paulus de Vos, and Thomas Willeboirts-Bosschaert. To the increasingly atmospheric effects, more saturated and refined colors, and the suppleness of his mature style, his late works adduce sleeker, slightly attenuated forms, which seem almost the creatural counterpart to van Dyck's *grazia*. By the end of his career the childless Snyders had assembled a considerable financial legacy (fl. 8,500 bequeathed to his in-laws), and in 1659 his painting collection was valued at fl.13,645: a small fortune.

After Snyders, the most important painter of hunt scenes was his in-law, Paulus de Vos, who was probably a pupil. De Vos painted deer, boar, and fox hunts (de Vos means fox in Dutch), animal fables, and paradise scenes, as well as dramatic struggles between animals, both large (such as a bear and dogs or a horse and wolves) and small (cock and cat fights). De Vos also painted abundant stockrooms with figures, fruit, and game and a few still lifes executed with collaborators of musical instruments and scientific objects. He probably played a major role in the execution of the many animal subjects produced in Snyders's studio for the Torre de la Parada in 1637/38 (examples of which are preserved in the Prado). In their animation, his animals sometimes are more vital than Snyders's (compare, for example, his wonderful combative roosters in the painting recently offered by X. Scheidwimmer, Munich, and their source in Snyders's painting of 1615 in the Berlin Museum, no. 878[266]). But they rarely have the restrictive focus and the strong palette that confer Snyders's monumentality.

Adriaen van Utrecht (1599-1652) was also a Snyders follower and like de Vos was a member of the next generation.[267] He is not recorded as a pupil but became a master in 1625 and dated paintings from 1627 to 1652. His large kitchen, market, and storeroom paintings with serving women and dead game (see for example, Kassel, Gemäldegalerie Alte Meister, no. 156, dated 1629) clearly attest to Snyders's influence, as do his smaller tabletop still lifes of fruit and game. Yet, having traveled to Germany, France, and Italy during his *wanderjahre* (ca. 1620-1625) he gained a degree of independence. His chiaroscuro effects are often more pronounced and his touch more exacting and less fluid than Snyders's. An oddly composite painting like the *Still Life of Precious Metalware* of 1636 (fig. 98) takes up a subject favored earlier by Francken and Clara Peeters and attests to the survival of the Aertsen/Beuckelaer tradition in the inclusion of a subsidiary scene of a metalworker (his old-fashioned costume suggesting a literary subject?) busy at his forge in the background. However van Utrecht's vast and superabundant storeroom still life of 1642 in the

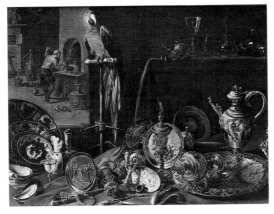

Fig. 98. Adriaen van Utrecht, *Still Life of Metalware with a Parrot*, 1636, oil on canvas, 117 x 154 cm, Brussels, Musées Royaux des Beaux-Arts de Belgique, inv. 4731.

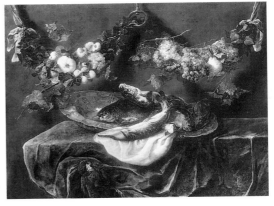

Fig. 99. Jan Fyt, *Still Life with Fish and Swags of Fruit*, oil on canvas, 119 x 154 cm, Berlin, Staatliche Museen zu Berlin, Gemäldegalerie, no. 883C.

Prado (Madrid, no. 1852[268]) signals the increasingly decorative route that still life took after about 1640. Although his naturalistic observation remains acute, the objects sacrifice some of their monumentality to the overall decorative patterning and a new spaciousness.

Jan Fyt worked for two years in Snyders's studio before traveling to Paris and Italy (1633-1641). When he returned to Antwerp he took up the traditional themes favored by local animal and game painters but made his own contributions, for example, in transferring depictions of the time-honored "trophies of the hunt" subject to the out of doors, and more effectively exploiting the traditional juxtaposition of live and dead animals (see cat. 122). Fyt's style is not as colorful as those of Snyders and van Utrecht, but freer and looser, exploring the textures of fur, down, and feathers with quick staccato brushstrokes. He painted many traditional themes, such as bird concerts in Snyders's manner (see Braunschweig, Herzog Anton Ulrich-Museum, no. 135), but also recombined inherited themes in unexpected decorative combinations, such as a tabletop still life with fish and swags of fruit (see fig. 99). The thematic analogue to his bravura brushwork was his increasingly spacious treatment of banquet pieces with dead game, fruit, and live animals on terraces or in large open rooms where a page lifts a curtain, as if to reveal the luxurious assembly.[269] Like van Utrecht's increasingly decorative still lifes, these trends seem symptomatic of the growing aristocratization of all later Flemish painting.

Fyt's pupil, Pieter Boel, also seems to acknowledge Italian precedents (such as the art of G. B. Castiglione) in some of his animal and still-life compositions depicted al fresco (see Kassel, Gemäldegalerie Alte Meister, no. GK142). Although his sumptuous subject matter is thoroughly Flemish in character, his tenebrous palette with sparkling, exceptionally painterly and slightly disembodied highlights again sometimes points to southern influences (see especially the Still Life with Animals and Fruit, Munich, Bayerische Staatsgemäldesammlungen, no. 1269). And his fish still lifes (cat. 123) have a decorative complexity and shrill, almost iridescent palette that has as much in common with the art of G. B. Ruoppolo or Giuseppe Recco as with Snyders's fish stalls or modest tabletop fish paintings of Peeters or Adriaenssen. His vanitas still lifes follow the taste for depictions of gleaming metalware that we have seen in Peeters and van Utrecht but redouble the admonition intrinsic to the subject. In his vanitas still life in Brussels (Musées Royaux des Beaux-Arts de Belgique, inv. 569), the figures of a putto blowing bubbles (homo bulla) and Father Time extinguishing a lamp bolster the message of transience embodied in the central death's head and pile of opulent still-life objects. An enormous still life dated 1663 in Lille (fig. 100) foregoes figures, employing instead an encyclopedic array of the attributes of wealth, of both secular and ecclesiastical power, and even of the arts' achievements to convey the vanity of all ambition and the inevitability of death. Boel's pupil David de Coninck (ca. 1646-after 1699) carried on the Snyders/Fyt tradition of dead game still lifes on a lifesize scale, while Adriaen de Graeff (ca. 1665-1715) and Peeter Gysels (1621-1690) (q.v.) painted these themes on a more intimate, even at times miniature, scale. The very late followers of Snyders, such as Jan Baptist Thyssens (active after 1690), only serve to illustrate the decline of this once-robust tradition.

The one painter who had the greatest influence on Flemish, indeed all Netherlandish, still life painting after ca. 1640 was Jan Davidsz. de Heem. Born in Utrecht, Jan was trained in the Dutch still-life painting tradition, probably by Balthasar van der Ast. He began his career painting fruit still lifes (until ca. 1628) and later executed "tonal" style ontbijtjes (breakfast pieces) vaguely recalling the style of Pieter Claesz., as well as flower pieces and vanitas still lifes. His family moved to Antwerp in 1635/36 and, except for extended periods spent back in Utrecht (in 1649 and 1669-1672), he remained in the Spanish Netherlands for the rest of his life, countering the general demographic trend. His most influential invention was the development of a lavish still life on a truly grand scale (see cats. 111, 112, and 113), often featuring a richly laid table in the foreground and a landscape vista beyond. This new type of sumptuous still life was imitated throughout Europe.

De Heem also experimented with more types of still life than any other painter of the period, often inventing or popularizing subjects that would later become other still-life artist's specialties, even livelihoods, such as book still lifes (often regarded as a type of vanitas), still lifes with ruins or in grottos, and still lifes of the flora and fauna of the forest floor, sometimes called kruidstuken (plant pieces) or bosstilleven (forest still lifes). The majority of his still lifes, nonetheless, were fruit and flower pieces, banketjes (meals, but more elaborate than the ontbijtje), and pronk still lifes. The Dutch word pronk, meaning ostentation or elegance, conveys the sumptuousness of

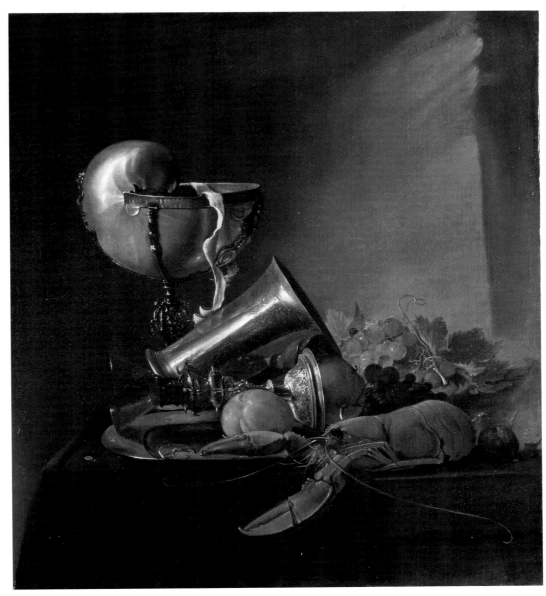

Fig. 101. Jan Davidsz. de Heem, *Still Life with Lobster and Nautilus Cup*, 1634, oil on canvas, 61.5 x 55 cm, Stuttgart, Staatsgemäldegalerie, inv. 3323.

Fig. 100. Pieter Boel, *Vanitas Still Life*, 1663, oil on canvas, 207 x 261 cm, Lille, Musée des Beaux-Arts, no. P78.

Fig. 102. Hendrik van Minderhout, *Mediterranean Harbor Scene*, 1672, oil on canvas, 160 x 238.8 cm, New York and London, Colnaghi.

de Heem's subjects, which often include rich foods such as lobsters or imported and perishable fruit, rare and expensive flowers, as well as beautifully wrought metal- and glassware (gold and silver tazzas, ewers, trays, wine coolers, and the imposing *buckelpokal* – a tall covered goblet with bulbous decorations); Chinese porcelain, rare shells, jewelry cases, watches, and silk and velvet fabrics. Often columns and other architectural elements hint at a palatial setting. De Heem developed this elegant new type of still life soon after resettling in Antwerp, where he must have been impressed by the monumental and colorfully dynamic works of Snyders and his contemporaries. A painting like the *Still life with Lobster and Nautilus Cup* dated 1634 in Stuttgart (fig. 101)[270] proves that he had explored arrangements of rich objects (the beaker, cup, and metal and glass *bekerschroef* lying on its side) and in glowing colors (the red of the lobster, the orange and deep green of the fruit, and the sheen of mother-of-pearl) before he moved south, nevertheless the Flemish environment had a liberating effect on de Heem's art. By 1640, when he dated his first large-scale *pronk* still life (see cat. 111, fig. 1), he had subsumed the vestiges of the northern "tonal" manner into more colorful atmospherics and asserted a newly brilliant palette. De Heem now multiplied the number, wealth, and opulence of his objects, while expanding his format to a truly grand and courtly scale. This exhibition includes a painting aptly described not only as the artist's largest effort but also his "magnum opus" (cat. 111).[271] Possibly painted for Charles I, it achieves an unprecedented richness, while evoking an effortless courtly ease by its seemingly casual organization; the multitude of objects are all harmoniously arranged yet individually described down to the most compellingly naturalistic specifics of shape, color, and texture – truly a tour de force of creative organization as well as of the technical mastery of the craft of painting. De Heem's luscious flower still lifes (see cat. 102) acknowledge Daniel Seghers's art (compare cat. 98) in their slick bright colors and value contrasts but are never facile in the handling of petals, leaves, or other textures. Seghers probably also inspired de Heem to use certain motifs, such as the stems and foliage that enrich the linear interest of his design. However de Heem's command of volume is more certain than Seghers's, indeed his bouquets are peerless in their ability to combine coloristic brilliance and variety while maintaining a harmonious organization of the whole in space.

Like Jan Brueghel and other flower painters who preceded him, de Heem depicts bouquets composed of flowers that bloom at different times of the year, thus proving that he followed the traditional practice of composing from a repertoire of life studies rather than an actual bouquet. The combination of short-blooming flowers from different seasons also raises the possibility of allusions to the cycle and rotation of life, to transience generally. There were, of course, biblical precedents (Job 14:1-2; Isaiah 40:6-7; Psalms 103:15-16) for this type of symbolic or associative thinking. However as Brueghel had written to Cardinal Federigo Borromeo long before, one obvious attraction of the flower still life is its permanence; he especially commended his flower still lifes for the winter months when actual gardens were withered and barren.[272] Inspired by the ancients, later poets also praised the enduring aspect of painted flowers.[273]

De Heem sometimes makes very specific symbolic allusions to temperance and vanity in his banquet and flower still lifes with the aid of legends and inscriptions, such as "Niet hoe veel [maer hoe Eel]" (Not how much but how noble: meaning it is quality not quantity that counts).[274] A sumptuous flower still life with a crucifix in the Akademie der bildenden Künste in Vienna (no. 612) includes two Dutch inscriptions. One is scarcely legible, but the decipherable words seem to refer to heaven's blessing, Hope, Fortune, Happiness, and Prosperity; the second more legible inscription reads: "The most beautiful that my eye ever met/that by the sun generates the day/and by the night closes heaven's eyes/that is the comfort of my sick heart./That sweet and pretty earthly creature,/that divine spark of fire/always gives pleasure to my mind/like the hot sun to the land."[275] While in this case it has been suggested that the painting may have had a quite personal meaning for de Heem, as a possible allusion to his second marriage in 1641, other paintings like *Fruit and Flower Garland about a Wine Glass in a Niche* of 1651 (see cat. 103) and the related *Fruit Garland with Skull, Crucifix, Snake, Glass of Wine and Bread* of 1653 (Dublin, National Gallery of Ireland, inv. 11) clearly have a more universal religious message of salvation through the sacrament of the eucharist and the institution of the Church. Like Rubens and his fellow history painters, de Heem and contemporary still-life artists were conscripted into the Counter Reformation's army of artists sent out to defeat the heretics and edify and convert by delectation. These evangelists of the brush employed a symbolic language, the basic grammar of which was readily understood (for example, the grapes and stalks of wheat as emblematic of the wine and

bread of communion), but which also probably had subtleties of vocabulary. These symbolic nuances undoubtedly would have been appreciated by spiritual devotees, just as the technical brilliance of de Heem's naturalism won the praise of connoisseurs; however their meanings now are sometimes difficult to retrieve in detail.

De Heem was exceptionally highly regarded in his day, indeed the prices of his paintings often exceeded those for works by Rubens and Rembrandt. Unlike most artists who have experienced the vicissitudes of critical fortune, de Heem has been consistantly celebrated to this day by collectors and connoisseurs. Naturally, he had many followers and imitators in both the Northern and Southern Netherlands. His influence on late seventeenth-century Netherlandish still life was pervasive, and even continued into the eighteenth and nineteenth centuries in the works of the Dutch painters, Rachel Ruysch (1664-1750), Jan van Huysum (1612-1749), and Gerard Spaendonck (1746-1822). Jan's own son, Cornelis de Heem (1631-1695), could rise to a high level in imitation of his father's *pronk* and fruit still lifes, while the works of Jan Jansz. de Heem (1650-after 1695) are less assured than those of his half-brother, Cornelis. In Antwerp the most accomplished of de Heem's many followers was Carstiaen Luyckx (see cat. 115), who had an uncanny ability to render different surfaces, substances, and textures in *banketjes*. Luyckx is purported to have become a painter to the Spanish court but his œuvre was later largely misattributed to de Heem. De Heem's other Flemish followers included Joris van Son (1623-1667), who painted splendid fruit still life compositions in his manner (see cat. 112, fig. 1), Alexander Coosemans (1627-1689), Theodoor Aenvanck (1663-after 1690), Jasper Geeraerts (1620-ca. 1654), Andrea Benedetti (born ca. 1618), Frans van Everbroeck (1638-after 1672), Andreas de Coninck (active mid seventeenth century), and Jan van den Hecke the Elder (1620-1684), all of whom painted *pronk* still lifes or fruit pieces in de Heem's manner. Jan Pauwel Gillemans the Elder (1618-1675) and Younger (1651-1721/22) painted small-scale versions of de Heem's *banketjes*, sometimes apparently in collaboration with other artists (see cat. 117). The more intimate scale that we have also observed in the works of other later painters, such as de Graeff and van Kessel, may have been designed to accommodate the dimensions of the domestically scaled architecture of a bourgeois audience increasingly attracted to upper-class subject matter. Pieter Boel occasionally painted still lifes in de Heem's manner but, as we have seen, was most influenced by the Snyders/Fyt tradition and Italian still life.

Trompe l'œil still life painting was the domain of a handful of Flemish specialists but it did not attract the following it had in Holland. More important than the rare artist Godfridt van Bouchott (active ca. 1660) and the early eighteenth-century illusionist Charles Bouillon, were Cornelis-Norbertus and Franciscus Gijsbrechts (see cat. 116). These artists had important patrons in Denmark and many of their best works are preserved in the museum in Copenhagen. A few other late seventeenth-century Flemish still-life painters deserve mention. Some of the best worked abroad: for example, the fruit, flower, and vegetable painter Abraham Brueghel (1631-ca. 1690) was mainly active in Italy, and the hauntingly beautiful flower painter, Jean-Michel Picart (d. 1682), worked mainly in Paris. The flower painter Nicolaes van Verendael (see cat. 105) maintained a high standard, and the more painterly works of Gaspar Pieter Verbrugghen I (1635-1681) and II (1664-1730) occasionally have a decorative appeal, but most local Flemish still life toward the end of the century was derivative and uninspired.

Fin de Siècle

Though scarcely the period of artistic decadence that some historians have evoked, the last quarter of the seventeenth century witnessed the emergence of relatively few significant Flemish artists. In history painting the late baroque style of painters like Pieter van Lint (d. 1690), Lucas Franchoys the Younger (d. 1681), Godfried Maas (1649-1700), and Jan-Erasmus Quellinus (1634-1715) perpetuated diluted variants of the Rubens/van Dyck legacy through the end of the century and beyond. In many regards the strongest new movement in the region was initiated by artists from outside the political boundaries of the southern Netherlands's territory, in the neighboring bishopric of Liège, where cultural ties with Paris and artistic training in Rome were traditional. The cool and restrained classicism of Bertholet Flémal (see cats. 130 and 131) attest to his many years in the French capital and admiration for Poussin's restraint and severity, and the designs of Italian Renaissance painting. Gerard de Lairesse advanced this new form of international

classicism (see cat. 132), which now betrays very few local or regional characteristics and certainly eschews the robust naturalism of the Flemish heritage. Jean-Guillaume Carlier (1638-1675) follows the example of his teacher, Flémal, fairly strictly, but the classicism of Victor Jean Honoré Janssen (1658-1736) is softened by the example of the French followers of LeBrun and, at the end, has more in common with the Coypels than Poussin. Zeger Jacob van Helmont (1687-1726) also perpetuates the classicist tradition but is essentially an eighteenth-century artist. The lifesize portraits of G. J. van Opstal (1654-1717) are fastidious and uninspired, but the small-scale portraits by François Duchatel (1625-1694) in the style of Coques (who lived until 1684) and Tilborch, can still hold one's interest.

As we have seen, many of the Flemish Italianate landscape painters (e.g. d'Arthois, Goubau, and Genoels) remained active in Antwerp and Brussels but Siberechts moved to London after 1672 and after 1695 Jan Frans van Bloemen (Orrizonte) worked exclusively in Rome. One of the most innovative and attractive artists who was active in Antwerp after 1672 was the Rotterdam-born Hendrik van Minderhout (1632-1696), who specialized in fanciful Mediterranean port scenes with wonderfully exotic figures amidst silhouetted and attenuated ships (see fig. 102). His art descends from the port scenes of Jan Baptist Weenix and Johannes Lingelbach but he animates them with slender mannered forms of great decorative appeal while lowering the tonal register and deepening the palette. Among still-life painters, Aenvaenck, Verendael, and David de Coninck (d. after 1699) respectively continued the banquet, flower, and game pieces, and Jan Baptist Boel (ca. 1650-1689), followed his father, Pieter's, interests. Among the next generation, Peeter Snyers (1681-1752) can be charming in his small-scale works, but his large figural paintings are rather fussy and frozen. The still lifes of the eighteenth-century Casteels family are decorative but blowsy.

Finally, as we have mentioned, the genre tradition of Brueghel and Teniers was perpetuated by numerous minor practitioners like Schovaerts and Gysels. Descended from the battle pieces of Vrancx and Snayers, cavalry scenes were produced by Karel Breydel and the Bredael family. And the themes of the collector's cabinet and artists' studio were developed with increasingly elegant and imaginary settings by the two late genre painters Balthasar van den Bossche (1681-1715) and Gerard Thomas (1663-1720/21). However we must wait for the eighteenth century to claim anything like a renewal of genre painting, and when it occurs with the works of Jan Jozef Horemans II (1714-after 1750) it is a staid and rather artificially theatrical affair, hardly the equal of the contributions of Brouwer and Teniers.

Epilogue: Rubens's Critical Fortune, Artistic Patrimony, and Rubenism

RUBENS, as we have seen, won the extravagant praise of his contemporaries. Although most encomia trotted out familiar literary topoi (the Flemish Apelles, the Muses' Progeny, or the reincarnation of Zeuxis), some rose above rhetoric.[276] The comments of Scioppius (1607),[277] the Leiden professors Daniël Heinsius (1609)[278] and Dominicus Baudius (1616),[279] the painter/diplomat Balthasar Gerbier (1612),[280] the poets Anna Roemer Visscher and Joost van den Vondel,[281] the Dutch Stadholder's secretary Constantijn Huygens,[282] and the eulogies of Jan Vos, Cornelis de Bie, and Alexander van Fornenbergh offer some of the earliest appreciations of the man and his art.[283] Some of these poems, like Baudius's on Rubens's *Prometheus* (cat. 10) and Giambattista Marino's (1620) on his *Hero and Leander* (cat. 6) and Vondel's translation thereof (1651) offer vivid poetic descriptions of the works of art in the classical tradition of *ekphrasis*.[284] Besides generally praising the artist's naturalism, his speed of execution and inventiveness, as well as the creative treatment of his narratives, early writers on Rubens repeatedly singled out for praise his vivid evocation of horror and terrifying realism. The immediacy of the bird's vicious attack in the *Prometheus* inspired Baudius, while for Huygens, the single most memorable painting by Rubens was the *Head of Medusa* (cat. 12, or a version thereof), which his friend, Nicolaes Sohier, hung behind a curtain to enhance its sudden effect of terrible beauty.[285] This *frisson* – a goal of much of baroque art's illusionism and special obsession with what the Italians call *terribilità* – obviously was a strong feature of Rubens's appeal for his contemporaries, notwithstanding Huygens's comment (added for dramatic emphasis) that he preferred the *Medusa* hanging in his friend's house rather than in his own.[286]

In the course of the seventeenth century, Rubens's achievement was assessed by numerous foreign critics and observers, including the Englishman Henry Peacham (in whose *The Compleate Gentlemen* [London, 1634], p. 110, Rubens is praised as "the best story teller of these times"), the Italians Baglione (1642) and Bellori (1672), the German Joachim von Sandrart (1675), and the Frenchmen Louis Moreri (1674), Roger de Piles (1635-1709), and Félibien.[287] Under Louis XIV, who hung a version of the *Queen Tomyris* (see cat. 24) behind his throne at Versailles, Paris became the cultural capital of Europe. Rubens's legacy was, of course, perpetuated in the city by the presence of his actual paintings, above all in the Medici cycle at the Palais de Luxembourg but also in, for example, the collection of the Duc de Richelieu (1629-1715), whose twenty-eight paintings by Rubens were catalogued by de Piles.[288] His art also had its advocates at the powerful French Academy, then dominated by the aesthetically autocratic Charles LeBrun (1619-1690), many of whose assistants were trained in the Rubensian tradition in Antwerp. Late seventeenth-century French painters like Charles de la Fosse (1636-1716), François Marot (1667-1719), Jean Jouvenet (1644-1717), and Antoine Coypel (1661-1722) made careful studies of Rubens's art.[289] While Félibien might characterize Rubens in the Fourth Part of his *Entrétiens* (Paris, 1685) as an "artiste détestable," the painter had his champion in the figure of de Piles, whose several publications stood to his defense.[290] A polemical debate arose which purported to oppose reason and emotion with the relative authority of line and contour versus color in art. Rubens became the ideal of the devotees of the latter (the *Rubenistes*), while Poussin was promoted by the former (the *Poussinistes*).[291] A standard criticism of Rubens, which seems to have originated in the writings of Sandrart and the judgments of C. A. du Fresnoy, was that his drawing was faulty, not "correct," in part because of his Flemish origins.[292] Without the dignity and higher values conferred by the classical models of antiquity, Flemish civilization was seen as inherently at a disadvantage to Italian culture. However in the appendix entitled "La Balance des Peintres" to his *Cours de Peinture par principes* (1708), de Piles summed up his beliefs by quantifying the achievements of great masters of the past by awarding points, schoolmaster-like, in various categories (composition, drawing, color, and expression); the two artists who tied for the highest score were Raphael and Rubens,

thus canonizing the Fleming as the equal of the most revered painter of Italian Renaissance and, by implication, vindicating the importance of "colorism" in the debate.

Rubens's art subsequently had an enormous influence on eighteenth-century French art. Antoine Watteau (1684-1721), who properly described himself as a "peintre flamand," was of Flemish origins. He made numerous copies of Rubens's paintings and drawings throughout his career, not only of the Medici cycle (see fig. 103) but also of works then in the famous collections of Pierre Crozat and the Comtesse de Verrue.[293] Often Watteau chose to copy a few figures or isolated heads rather than the entire compositions, studying their expressions and interactions. As many have observed, his conception of the *fête galant* and *fête champêtre* also owe an obvious debt to Rubens. The sensuously feminine art of François Boucher (1703-1770) also often pays clear hommage to Rubens,[294] as do the works of his gifted pupil, Jean-Honoré Fragonard (1732-1806). The Marquis de Marigny even gave Fragonard a key to the Luxembourg Gallery so that he could study the Medici cycle at his leisure. Fragonard's direct copies of Rubens's *Crowning of Saint Catherine* (fig. 104; see cat. 32). *The Education of the Virgin* (Paris, Musée du Louvre, Cabinet des Dessins), and of the *Funeral of Consul Decius Mus* (fig. 105) attest to his efforts to understand the master's animated and rhythmic approach to composition and to subtly transform these models into shimmering variants, lighter and airier designs.[295] Though considered through the example of Watteau, Fragonard's love gardens also clearly descend from Rubens's *Conversatie à la mode* (cat. 31). Even the eighteenth-century French painter of bourgeois genre scenes, Jean-Baptiste Greuze (1725-1805) found inspiration in Rubens's Medici cycle, copying the heads of the officiating bishop and his assistant in the scene of the *Proxy Marriage of Marie de' Medici* (see fig. 106).[296] Little wonder that when around 1860 Edmond and Jules de Goncourt came to write their history of French eighteenth-century painting, they observed of the painters of the previous century, "All of them descend from that founding father and that bold initiator: Watteau as much as Boucher, as much as Chardin. For a hundred years it seems that the painting of France had no other cradle, no other school, no other homeland than the galerie of the Luxembourg, the *Life of Marie de' Medici*: the God is there."[297]

Seventeenth-century artists throughout Europe were touched by Rubens's broadcast influence, notably the Spanish painters Bartolomé Esteban Murillo (1617-1682), Francisco Rizi (1614-1685), and Juan Carreño de Miranda (1614-1685),[298] Italian artists like G. C. Procaccini (1574-1625), and even South German ivory carvers.[299] During the eighteenth century, artists of many nationalities made the pilgrimage to Antwerp to study his work. Following on the heels of artists like Antonio Pellegrini (1675-1741) and Jacob de Wit (1695-1754), the great English painter Joshua Reynolds (1723-1792) finally made the trip in 1781. Like many English painters of this period, he had had relatively few opportunities to study Rubens's art; although the master was generally well regarded in England, there were still relatively few major examples of his work in the British Isles apart, of course, from the *Minerva Protecting Pax and Mars* in the Royal Collection and the Whitehall ceiling. William Hogarth, for example, commented that Rubens's "manner is

Fig. 103. Antoine Watteau, *Ariadne, Bacchus and Venus*, after Peter Paul Rubens, *Assembly of the Gods* in the Medici Cycle, red chalk with touches of black and white, London, British Museum, no. 1846-11-14-24.

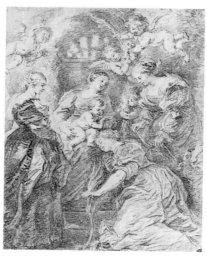

Fig. 104. Jean-Honoré Fragonard, *The Crowning of Saint Catherine*, after Peter Paul Rubens, chalk, 20.9 x 18.5 cm, Paris, Musée du Louvre, Département des Arts Graphiques, inv. 26643.

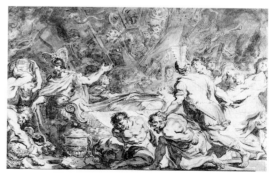

Fig. 105. Jean-Honoré Fragonard, *The Funeral of Consul Decius Mus*, after Peter Paul Rubens, ink and wash, 247 x 387 mm, sale New York (Sotheby's), 5 June 1979, no. 82.

admirably well calculated for great works, to be seen at a considerable distance, such as his cele-brated ceiling at Whitehall-chapel."[300] Jonathan Richardson's *Treatise on Painting*, published in 1715, declared Rubens the greatest painter of the seventeenth century and clearly allied the author with the *Rubenistes*.[301] But in his *Treatise on Ancient Painting* (London, 1740), George Turn-bull reiterated the qualms expressed by some members of the French Academy: Turnbull com-mended Rubens's great freedom of execution but noted that he sometimes fell into "Errors, by the Rapidity and Impetuousness of his Genius," and (echoing Dufresnoy) because of his predispo-sition to the "Flemish" canon of features and proportions.[302] Like de Piles, Reynolds was interest-ed in art theory, developing in his *Discourse IV* (1771) the concept of the Grand Style (practiced by Michelangelo, Raphael, and the Carracci) which was characterized by intellect, dignity of expres-sion, and the use of distinct local colors. According to Reynolds, this style was superior to the Ornamental Style (practiced by the Venetians and the Flemings), which only pleased the senses with bravura technique, ravishing mixed colors, and virtuosity. However in his *Discourse V* (1772) he also developed the concept of a third "Characteristical" Style, which featured the self-con-tained, unified artistic product of a vigorous imagination; both Rubens and his counterpart Poussin were representatives of this style because of their lifetime achievements in presenting a unified body of work. In codifying this third style, Reynolds also applied the concept of Genius which then had only recently been formulated by later eighteenth-century philosophers who cel-ebrated the rare capacity of some individuals to creatively break norms, conventions, and rules. According to Reynolds, "The work of men of genius alone, where great faults are united with great beauties, afford proper matter for criticism. Genius is always eccentrick, bold, and dar-ing."[303] Thus Rubens's "incorrect" drawing could be forgiven as the permissible, indeed neces-sary, faults of a genius. Though initially skeptical about Rubens, Reynolds had become a convert by the time he published his *Journey to Flanders and Holland* (1781); he wrote, Rubens's "Superiority is not in the easel pictures," but "in the general effect [of the great works], in the genius which pervades and illuminates the whole."[304] Indeed he later even declared in a letter that "those who cannot see the extraordinary merit of this great painter, either have a narrow conception of the variety of art, or are led away by the affectation of approving nothing but what comes from the Italian School."[305]

The great English landscape and portrait painter, Thomas Gainsborough (1727-1788), first responded to Rubens in the early 1760s, executing an unfinished oil sketch (now in the collection of The Honorable Michael Astor, Bruern Abbey) after a print of the master's famous *Descent from the Cross* in Antwerp Cathedral. He subsequently incorporated the design's spiral group of figures into the staffage of his own *Harvest Wagon* of 1767 (The Barber Institute, University of Birming-ham, England).[306] The following year he wrote to David Garrick commending Rubens's *The Watering Place* (London, The National Gallery, inv. no. 4815; then in the collection of the Duke and Duchess of Montagu), which in 1777 served as the general model for his own treatment of the same landscape theme (London, The National Gallery, inv. no. 109). Thus Gainsborough pro-gressed from direct copies and quotations of Rubensian figures to a general absorption of the master's landscape compositions and techniques. As with the Flemish master, landscape proved to be a highly personal feature of Gainsborough's art. Horace Walpole's opinion that "Rubens was never greater than in landscape,"[307] was emphatically supported by John Constable (1776-1837) who made a thorough study of Rubens's landscapes, including a copy of the famous *Autumn Land-scape with Castle Steen* (fig. 107), which Lady Beaumont had purchased for her husband in 1803 and brought to London. The painting was later given to the National Gallery in 1828.[308] Sir George Beaumont sent the picture to Benjamin West's (1738-1820) studio to be shown to interested artists; James Ward (1769-1859) was among those who were most deeply inspired.[309] It subse-quently became the very paradigm of the Picturesque for British artists. The dramatic landscape effects, atmosphere, and color that Constable had achieved by ca. 1812 surely owe a debt to Rubens, whose art he later singled out for praise in his "Six Lectures on Landscape Painting," in which he especially lamented the separation (sadly perpetuated to this day) of the *Castle Steen* and its companion, now in the Wallace Collection, London, no. P63.[310]

For his own part, Benjamin West was more attracted to Rubens's masterful approach to com-position in multifigure history paintings and hunting scenes, which inspired several of his large and dramatic designs in the 1780s and 1790s.[311] West even based his own *Self-Portrait* of ca. 1770 (Washington, National Gallery of Art, no. 1942.8.39) on Rubens's *Self-Portrait* in the Royal Collec-

tion, Windsor Castle (see frontispiece); this hommage proved to be precedent enough for West's young American pupil Gilbert Stuart (1755-1828) to follow suit in his own self-image of 1778 (Newport, RI, Redwood Library and Athenaeum).[312] Rubens's *Self-Portrait with Friends*, known as "The Four Philosophers," in the Uffizi (White, fig. 2) had earlier been an inspiration to eighteenth-century American portraitists who traveled to Italy, like John Smibert (1688-1757), the first painter trained in the European grand style to settle in America.[313] Indeed, Rubens's composition became the prototype for numerous English and American artists' "conversation pieces." So great was the admiration for Rubens in this era that the painter of the American Revolution, Charles Willson Peale (1741-1827), in 1784 named his fourth son in the Flemish painter's honor. The American painters John Singleton Copley (1738-1815) and John Trumbull (1756-1843) also held Rubens in high esteem.[314] However as we will see, later nineteenth-century American painters and critics were scarcely so sympathetic.

Indeed Rubens was not always universally admired either by English or continental artists. Farington's *Diary* of 24 August 1805, for example, reports that the portraitist Thomas Lawrence (1769-1830) condemned the "sensual feeling [of connoisseurs whose] pleasure was derived from the luxurious displays of Rubens"; this taste was "just that which shd. not be adopted."[315] Lawrence nonetheless personally owned superb examples of Rubens's drawing, which later much impressed Eugène Delacroix (1798-1863) when he visited England in 1825.[316] The great eighteenth-century French encyclopedist, Denis Diderot (1713-1784), was a devoted admirer of Rubens's art, and wrote with special enthusiasm of his painting *"Quos Ego"* (see cat. 33), in which he claimed the artist had actually improved on Virgil's text, thus demonstrating painting's special capacity to reveal features that poetry cannot describe.[317] In eighteenth- and nineteenth-century Germany, Rubens was exceptionally highly valued, not only because of the great holdings of his art in the Elector Palatine's collection in Düsseldorf (now Munich, Bayerische Staatsgemäldesammlungen) and the gallery in Dresden, but also because he was regarded as native son – the "German Giorgione"; until 1853, Rubens was even thought to have been born in Cologne.[318] In German literature, the classicist Winklemann, and the great poet Goethe praised the artist, the latter again hailing his special genius, and J. J. Wilhelm Heinse offered lyrical descriptions of the Düsseldorf paintings.[319] However the German romantic movement's critics, like Georg Forster, and painters, such as Philip Otto Runge (1777-1810), detested Rubens's broad and "barbaric" art, since it eschewed their exacting ideals of *"Zartheit"* – the self-consciously tender and delicate imitation of nature.[320]

Several historical events in the late eighteenth and early nineteenth century, however, helped to refocus attention on Rubens's achievement. Under Austrian Hapsburg rule since the treaty of Utrecht of 1713, Belgium had suffered especially under the rule of Joseph II of Austria, whose efforts to suppress the priests, monasteries, and religious orders had driven much art out of the country. Many of Rubens's paintings were exported or sold abroad[321]; when in 1773 Pope Clement XIV abolished the Jesuit order, for example, Marie Theresa of Austria quickly laid claim to their art, including the great altarpieces of the *Miracles of St. Ignatius Loyola* and *St. Francis Xavier* which were removed to Vienna (see fig. 25). Following the popular revolution which briefly created a United Belgium in 1789-1790, the Austrian army quickly crushed the uprising, only to be replaced in 1794 by Napoleon's troops, who before Waterloo confiscated vast quantities of Flemish art for France, much of which was never repatriated.[322] The spoils of war thus helped lay the groundwork for the strong revival of interest in Rubens and Flemish painting exhibited by French artists like Théodore Géricault (1791-1824) and Delacroix in the early decades of the nineteenth century.

The fall of Napoleon also brought a resurgence of Belgian nationalism and a rejection of French neoclassicism. The Belgian painter Matthijs van Brée (1773-1839), helped revive the Antwerp Academy, trained many of the leading Belgian painters of his day, and restored Rubens's paintings in the Antwerp Museum.[323] In an address to L'Institut Royal des Pays-Bas in Antwerp in January 1871, he evoked the "Ombre du grand Rubens! Venez éclairer nos jeunes artistes pour qu'ils soutiennent, par leurs ouvrages, l'école que vous avez rendue immortelle!"[324] Van Brée made a specialty of historical genre scenes (an especially popular nineteenth-century art form) on the life of Rubens, painting such anecdotal subjects as *Rubens Introduced to Justus Lipsius by Mevrouw Plantin-Moretus*,[325] *Van Dyck Taking Leave of Rubens* (Antwerp, Rubenshuis), and the especially sentimental *Deathbed of Rubens* with the dying artist surrounded by Gevartius, his other friends and

pupils, as well as his swooning wife (fig. 108). Though received with mixed reviews, the painting was purchased by King William I for the Museum in Antwerp. This after all was also the era which saw the creation of Luigi Rubio's romantically lacrimose *Rubens Leading Van Dyck Away from His Fiancée* (St. Petersburg, Hermitage), which shows the older mentor gently insisting that the younger artist leave for Italy to improve his art.

Just as van Brée sought to promote his countrymen's pride in their artistic heritage with paintings about the life of as well as in what was then regarded as the style of Rubens, his younger successor, the Antwerp painter, Henri de Braekeleer (1840-1888), made his fellow citizens' interest in seventeenth-century Flemish art the subject of some of his own contemporary genre scenes (see fig. 109), while also seeking to imitate aspects of the Flemish old masters' painting techniques. In his painting in the Antwerp museum he depicts a little man standing in lost profile studying a Rubens Crucifixion as well as the Teniers (cat. 69, or a version thereof) now in Boston. More systematic archival research and art historical studies of Rubens and his contemporaries were undertaken in these years by nineteenth-century authors culminating in the monumental writings of Rooses and Ruelens (for example, Rooses, Ruelens 1887-1909, and the articles published in the *Rubens-Bulletijn* 1881-1910). Much of this essential scholarship was related to the new Belgian national pride, summed up in Conrad Busken Huet's remark in the preface to his *Het Land van Rubens. Belgische reisherinneringen* (Amsterdam, 1879), "Mij is Rubens de Volmaakte Belg" (For me Rubens is the complete Belgian).

The French romantic artist Géricault executed at least five copies after Rubens, including one of the virtually obligatory copies from the Luxembourg series; tellingly the latter was an equestrian image of *Marie de' Medici at Pont-de-Cé* (Winterthur, private collection) which, like his copies of van Dyck, attest to the artist's special curiosity about baroque art's dynamic approach to horse painting.[326] Géricault also copied lions from Rubens's hunt scenes.[327] But his most creative quotations from Rubens were applied to the knot of figures in his famous *Raft of the Medusa* (Paris, Musée du Louvre) and derived from J. Suyderhoef's engraving after Rubens's *Small Last Judgment* (Munich, Alte Pinakothek), several details of which Géricault copied in pencil drawings (see

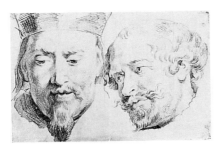

Fig. 106. Jean-Baptiste Greuze, *Two Heads from the Proxy Marriage of Marie de' Medici*, after Peter Paul Rubens, red chalk on paper, 29.2 x 43.8 mm, New York, Emile E. Wolf collection.

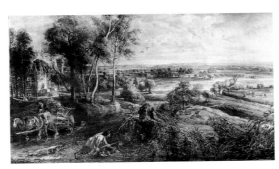

Fig. 107. Peter Paul Rubens, *Autumn Landscape with Castle Steen in Early Morning*, oil on panel, 131 x 229 cm, London, The National Gallery, no. 66.

Fig. 108. Matthijs van Brée, *Deathbed of Rubens*, 1827, oil on canvas, 290 x 363 cm, Antwerp, Koninklijk Museum voor Schone Kunsten, no. P142.

Fig. 109. Henri de Braekeleer, *Paintings in the Terninckgesticht*, oil on canvas, 64 x 80 cm, Antwerp, Koninklijk Museum voor Schone Kunsten, no. 2845.

Fig. 110. Théodore Géricault, *Fall of the Rebel Angels*, from Suyderhoef's engraving after Rubens, pencil, 20.5 x 23 cm, Stanford, Stanford University Museum of Art, no. 67.50.

fig. 110).[328] By employing this conspicuously open reference, Géricault elevated a depiction of a contemporary event – creating, as it were, a secular Last Judgment – to the lofty realm of history paintings by the great masters.

The allusions to Rubens in the *Raft of the Medusa* scarcely were lost on the young Delacroix, who had posed for figures in the *Raft*, and many years later when finally confronted with Rubens's *Raising of the Cross* in Antwerp Cathedral in August of 1850, wrote ecstatically in his journal, "I was most deeply moved!" adding immediately, "In many ways it is akin to Géricault's *Raft*."[329] Throughout his life, Delacroix made numerous copies of artists from various schools but none outweighed in numbers or attention his studies after Rubens[330]; these included general compositional studies in oils (see fig. 111[331]), head studies (fig. 112), and wonderfully free drawings of details of figures or animals in actual paintings or prints after Rubens's originals. The Fogg Art Museum's quick pencil sketch (fig. 113) after P. Soutman's etching of the mounted Arab in Munich's *Hippo and Crocodile Hunt* (see fig. 21) is a triumph of interpretive economy and vitality. Rubens occupied the supreme place among artists in Delacroix's life. As Louis Hourticq observed long ago, in final analysis the two artists painted in very different ways, with the more painterly Delacroix never attaining or truly imitating Rubens's sculptural insistence or coloristic brilliance.[332] Moreover the two artists were also very different in temperament, with Delacroix's melancholic escapism into the intellectually strange and forbidden as well as his exploration of actual remote cultures (Morocco, Greece, etc.) a far cry from the interests of Rubens, that eminently public man. But there can be no question that Delacroix personally identified with Rubens; as early as 25 January 1824, he wrote in his journal that he "cared to be Rubens," and later he seems to have secretly aspired to model himself after the master. Recalling Diderot and Copley, Delacroix repeatedly called Rubens "that Homer of painting, the father of warmth and enthusiasm in art, where he puts all others in the shade, not perhaps because of his perfection in any one direction, but because of that hidden force – that life and spirit – which he put into everything he did."[333] And again writing seven years later, toward the end of his life, "Admirable Rubens! What a magician!…his greatest quality…is the astounding relief of his figures, which is to say their astonishing vitality."[334] During his mature and later years he executed a series of lion hunts (Bordeaux, Musée des Beaux-Arts, dated 1855; Boston, Museum of Fine Arts, dated 1858; and Art Institute of Chicago, dated 1860) which not only take up a Rubensian subject but paraphrase many of the master's motifs.[335] Another important romantic painter, Sir Edwin Landseer (1802-1873) had been drawn to Rubens's hunt scenes earlier than Delacroix, painting a copy (fig. 114) of the master's *Wolf and Fox Hunt* (New York, Metropolitan Museum of Art) which subsequently became the inspiration for Landseer's *The Hunt of Chevy Chase* of 1825-1826 (Birmingham, England, Birmingham Museum and Art Gallery).[336] In the tradition of his teacher, Henri Fuseli (1741-1825), Landseer also made figure studies after Rubens, but as the "Snyders of England" his first interest was in the painting of animals.[337]

The generation of Impressionist painters who trained in Paris in the 1850s and 1860s had an unprecedentedly ambivalent attitude toward the art of the past. While Delacroix and David surely differed on aesthetic matters and the point of studying old paintings they both copied Rubens and could agree, as could even the great rebel realist, Gustave Courbet, on the value of students going to the Louvre to make copies from the old masters. While some of the budding Impressionists, especially the landscapists like Monet and Sisley, had little use for the Louvre, others, especially among the future figure painters, continued to follow the traditional course. In the register of copyists in the Louvre for the years 1850-1870, the following artists all applied for permission to make copies after various paintings by Rubens: Félix-Henri Bracquemond (1833-1914), J.-B.-A. Guillaumin (1841-1927), Edouard Manet (1832-1883), Berthe Morisot (1840-1917), Jean Auguste Renoir (1841-1919), and the sculptor Auguste Rodin (1840-1917).[338] Most of these students' paintings predictably have been lost, but both the registry and surviving copies attest to the continuing fascination with the Medici cycle. Renoir painted a copy of Rubens's *Enthronement of Marie de' Medici* (fig. 115),[339] while Paul Cézanne (1839-1906) repeatedly drew individual figures and groups from the series, finding special inspiration in the distraught figure of Bellona, the disarmed goddess of War in the *Apotheosis of Henry IV*, a motif he copied no fewer than ten times (see, for example, fig. 116). Cezanne not only drew after the *Apotheosis* early in his career, but also kept a photograph of it in his studio later in life.[340] Poussin has often been assumed to be Cézanne's chief mentor among the old masters, however, to judge from the number of surviving copies (no fewer

Fig. 111. Eugène Delacroix, *The Entombment*, 1836, after Rubens's altarpiece in Cambrai, Church of Saint-Gery, oil on canvas, 71.1 x 53.3 cm, Omaha, Joslyn Art Museum, 1958.3.

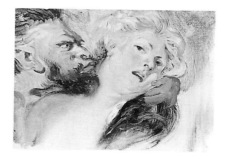

Fig. 112. Eugène Delacroix, *Satyr Embracing a Nymph*, after Rubens's *Diana and Her Nymphs* (Cleveland, Cleveland Museum of Art), oil on canvas, 161.5 x 22 cm, Germany, private collection.

Fig. 113. Eugène Delacroix, *A Mounted Arab Attacking a Panther*, from P. Soutman's etching after Rubens, pencil, 240 x 204 mm, Cambridge, MA, Fogg Art Museum, Harvard University Art Museums, inv. no. 1965.268.

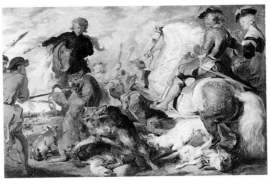

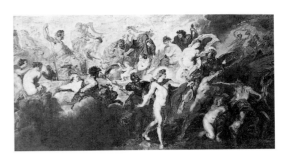

Fig. 115. Pierre Auguste Renoir, after Rubens's *Enthronement of Marie de' Medici*, ca. 1860-1862, oil on canvas, 43.2 x 81.3 cm, private collection.

Fig. 114. Edwin Landseer, *Wolf and Fox Hunt*, after Rubens (New York, Metropolitan Museum of Art), oil on panel, 40.6 x 61 cm, New York, Metropolitan Museum of Art, no. 1990.75.

Fig. 117. Paul Cézanne, *Apotheosis of Delacroix*, ca. 1894, oil on canvas, 27 x 35 cm, Aix-en-Provence, Musée Granet.

Fig. 116. Paul Cézanne after Rubens's Bellona in the *Apotheosis of Henri IV*, pencil, 20.9 x 12.2 cm, Basel, Kupferstichkabinett, inv. 1935.158.

Fig. 118. Paul Cézanne, after Rubens, *Naiads*, pencil, 31 x 45 cm, Zurich, private collection.

Fig. 119. Louis Beroud, *Les joies de l'inondation*, 1910, oil on canvas, 254 x 189 cm, New York, London, and Paris, Didier Aaron Galleries.

than twenty-nine exist after Rubens), the Flemish artist had the greater appeal.[341] Later in life, in February 1902, Cézanne advised the young painter Charles Camoin to make "studies after the great decorative masters Veronese and Rubens, as you would from nature – a thing I was only able to do incompletely myself."[342] For years Cézanne repeatedly expressed his ambition to execute a large painting honoring the memory of Delacroix; a watercolor of the subject from the mid-1870s, and a canvas of ca. 1894 (fig. 117) suggest that this unrealized painting's design – with the body of the artist borne aloft as Cezanne and his artist and collector friends (Emile Bernard, Camille Pisarro, Claude Monet, and Victor Choquet) kneel below – was based on Rubens's *Apotheosis of Henri IV*.[343] Thus in the remarkable geneology of this picture the grandfather of Modernism in painting (namely Cézanne) thoughtfully planned to honor his own mentor with a composition that conspicuously acknowledged and honored Delacroix's own role model, Peter Paul Rubens.

The single painting in the Medici cycle that consistently attracted the greatest attention was the *Disembarcation of Marie de' Medici at Marseilles* (see fig. 32), with its muscular naiads powerfully treading water at the bottom of the design. These remarkable creatures had long turned the heads of artists, and not simply those of Frenchmen; William Etty (1787-1849), for example, wrote from Paris in 1823-1824, that a "glorious water nymph of Rubens's [which he copied lifesize, working all through the winter in "excessive cold"] I had long admired would not let me leave Paris without a memorial of some of her fleshy beauties."[344] Delacroix copied the naiad on the right and Cézanne again executed one of the most interesting copies of the entire trio of lovely creatures (fig. 118); but the academic painter Louis Beroud (1852-1930) painted the most amusing hommage in his wonderfully silly *Les joies de l'inondation* of 1910 (The Joys of the Flood) (fig. 119).[345] Here the dapper copyist drops his brush in astonishment as the triumph of Rubens's illusionism is fulfilled by naiads spilling out into his space, as if released from some gigantic shattered aquarium. Ironically, the copy on the artist's easel is painted in a fauvist manner reminiscent of Cézanne's copy, thus affirming Rubens's continued relevance for the twentieth century.

Before examining these modern transpositions, however, we ought to consider the other Impressionist responses. Manet, as we have noted, registered at the Louvre in 1857 to copy Rubens's *Portrait of Hélène Fourment and Her Children*. Like many of his fellow Parisians, he enjoyed fancy dress and make believe, summoning the associations of bygone ages with costume pieces. It has been suggested that the pose of one of his costume pieces, *Mademoiselle Victorine Meurend as an Espada* (New York, Metropolitan Museum of Art, no. 29.100.53) is based on Rubens's *Venus* or *Fortune* then in the Galerie Suermondt and accessible by way of a print in the *Gazette des Beaux-Arts* in 1860.[346] However the most fascinating case of Manet's transformations of Rubens is in the landscape *Fishing in Saint-Ouen, near Paris*, known as "*La Pêche*" (fig. 120), which not only combines elements from Rubens's landscapes (the *Castle Park* in Vienna's Kunsthistorisches Museum, no. 696 [ill. Renger, fig. 6], and the *Landscape with Rainbow*, Paris, Réunion des Musées nationaux, on loan to Musée des Beaux-Arts, Valenciennes) with details from Annibale Carracci's *Landscape with Fishermen* (Paris, Musée du Louvre, no. 203), but also co-opts the figures of Rubens and Hélène Fourment (probably quoted from Schelte à Bolswert's print after the Vienna painting) for the couple in the right foreground of the scene.[347] The fact that the features of the bearded flaneur in seventeenth-century costume more closely resemble Manet's own than Rubens's implies a form of identification with the great Flemish painter not unfamiliar to us from the case of Delacroix though surely less obsessive and complete.

After living for two years in the Dutch village of Nuenen, Vincent van Gogh moved in late November 1885 to Antwerp, where he stayed for barely three months before departing for Paris. Over the years he often mentioned Rubens to his brother Theo in their famous correspondence, but it was during his stay in Antwerp that he could study the seventeenth-century master's art more closely than at any other time in his career and was most directly influenced by the artist's technique and palette. He wrote, "Rubens certainly makes a strong impression on me, I think his drawing tremendously good, I mean the drawing of heads and hands in themselves. I am fairly carried away by his way of drawing the lines in a face with dashes of pure red . . . I know he is not as intimate as Hals and Rembrandt, but they are so alive, those heads themselves."[348] In the same letter he commends Rubens's "open-hearted way of painting, his working with the simplest of means," reporting that he discussed and analyzed the master's technique with a local paint manufacturer. However when finally confronted with Rubens's altarpieces in Antwerp Cathedral he was put off by their rhetorical conventions of expression: "Nothing touches me less

than Rubens when he expresses human sorrow"; but he goes on to reiterate, "Heads and figures of women, these are his specialty. There, he is deep and intimate too."[349] A group of bust-length portraits of women that van Gogh executed while in Antwerp are among the artist's most robust and Rubensian, suggesting that the Flemish master helped initiate the loosening of van Gogh's brushwork and the brightening of his color schemes which came to fruition in his later Post-Impressionist masterpieces painted in Paris and southern France.[350]

Van Gogh's distaste for Rubens's history paintings had earlier found expression in letters written home from a trip to Paris and Madrid in 1869-1870 by a young Philadelphian, Thomas Eakins (1844-1916). Rubens's late *Birth of the Milky Way* of ca. 1636-1637 in Madrid (Museo del Prado, no. 1668), was too much for the plainspoken American realist. He wrote in unpunctuated apoplexy of his disgust for Rubens's fleshy nudes, unnatural theatrical gestures, and operatic situations: "Rubens is the nastiest most vulgar noisy painter that ever lived. His men are twisted to pieces. His modeling is always crooked and dropsical and no marking is ever in the right place or anything like what he sees in nature, his people never have bones, his color is dashing and flashy, his people must all be in the most violent action, must use the strength of Hercules if a little watch is to be wound up, the wind must be blowing great guns even in a chamber or dining room, everything must be making a noise and tumbling about, there must be monsters too for his men were not monsters enough for him. His pictures always put me in mind of chamber pots and I would not be sorry if they were all burnt."[351] Another more literary American, Henry James, harbored similar if not so dire suspicions about Rubens; reviewing Eugène Fromentin's *Les Maîtres d'Autrefois*, which contains some of the most sensitive appreciations of Rubens's art

Fig. 120. Edouard Manet, *Fishing in Saint-Ouen, near Paris (La Pèche)*, oil on canvas 76.8 x 123.2 cm, New York, Metropolitan Museum of Art, no. 57.10

Fig. 121. Pierre Auguste Renoir, after Rubens, *The Judgment of Paris*, 1908, oil on canvas, 81 x 101 cm, Japan, private collection.

Fig. 122. Giorgio de Chirico, *Judgment of Paris*, oil on canvas, 100 x 140 cm, Bologna, private collection, 1982.

Fig. 123. Giorgio de Chirico, *Self-Portrait with Helmet*, after Rubens's *Mars*, oil on canvas, private collection.

ever written, James rejects as "vanity" this "criticism in a super-subtle style . . . Mr. Fromentin, speaking roughly, takes Rubens too seriously by several shades. There are fine painters and coarse painters, and Rubens belonged to the latter category; he reigned in it with magnificent supremacy . . . His intentions had often great energy, but they had very little profundity, and his imagination, we suspect, less delicacy than Mr. Fromentin attributes to it. He belongs, certainly, to the small group of the world's greatest painters, but he is, in a certain way, the vulgarist of the group."[352] And commenting on Rubens's *The Head of Cyrus Presented to Queen Tomyris* (cat. 24) on loan to an exhibition in London the following year from Lord Darnley's collection, James wrote "like so many Rubenses [it is] extremely entertaining on first glance; but it proves on a longer inspection to be rather inexpensively 'got up.'"[353] However other American figure painters, from John Singer Sargent (1856-1925) to Jack Levine (born 1915) were not so quick to pronounce Rubens vulgar and artificial, indeed they found much to admire as well as to apply to their own art.[354]

Late in life and early in this century Renoir adopted a fuller canon of proportion in his nudes, a warmer palette which shifted to the red end of the color spectrum, and more timeless bucolic subjects. In many regards these late works attest to his reappraisal of Rubens; indeed Renoir's two versions of the *Judgment of Paris* of 1908 (fig. 121) and 1913-1914 (Japan, private collection and Hiroshima, Hiroshima Museum of Art)[355] are directly derived from the master's painting of this theme in the Prado (Madrid, no. 1669). While Renoir's last works have been scorned by critics, they also had their admirers among independent-minded artists, notably Pablo Picasso (1881-1973), whose works from the 1920s in a heavily weighted classicism, sometimes called gigantism, surely owe a debt to late Renoir and at least indirectly to Rubens. Indeed it has been persuasively argued that one of the most important modernist statements of the first half of the twentieth century, namely Picasso's *Guernica* (Madrid, Museo Nacional Reina Sofía), is based (in reverse) on Rubens's famous *Horrors of War* (Florence, Palazzo Pitti).[356] Similarly, the later works from the 1940s by the surrealist Giorgio de Chirico (1888-1978) also clearly attest to a new consideration of Rubens, when he departed from his earlier dreamlike images to return to more traditional representational painting styles and, like Renoir, depicted a variant of the Prado's *Judgment of Paris* (fig. 122),[357] as well as a *Self-Portrait in the Guise of Rubens's "Mars"* (fig. 123; compare cat. 26),[358] continuing the august tradition of identifying with the Flemish master. Like the last works of Renoir, the late paintings of de Chirico were long disdained by twentieth-century critics as the aberrations of a long-lived artist who had lost his way and fallen into decline; indeed the *Spätstil* of both painters remained out of fashion until the recent advent of a new generation of artists (one thinks of the young Italians, Sandro Chia [b. 1946] and Francisco Clemente [b. 1952] or the Colombian painter Fernando Botero [b. 1932], who often paraphrases Rubens) made painterly and colorful paintings of classical forms in arcadian and mythological settings and/or situations attractive and topical once more. Surely in such a climate one need not question Rubens's applicability to contemporary art or fear the demise of Rubenism. Indeed advances in photographic reproductive techniques have encouraged the creative appropriation of his imagery (see fig. 124).

Fig. 124. Robert Rauschenberg, *Persimmon*, 1964, oil and silkscreen ink on canvas, 66 x 55 cm, New York, Mr. and Mrs. Leo Castelli.

1. The best general history of seventeenth-century Flemish painting in English is still Gerson, ter Kuile 1960; Larsen's survey (1985) is riddled with misattributions and mistakes. Useful essays on the individual genres with up-to-date information are included in the exh. cat. *Von Bruegel bis Rubens* (Cologne/Vienna 1992-93) (the essays in the Dutch edition of the catalogue [Antwerp 1992-93] are less comprehensive and insightful); especially useful is Hans Vlieghe's historiographic review of the literature on Flemish art in Cologne/Vienna 1992-93, pp. 14ff. For the history of history painting in Antwerp, see Vlieghe's essay here translated, as well as Frans Baudouin, "1585: De Val van Antwerpen, ook een belangrijke datum voor de kunstgeschiedenis der Nederlanden," in *Willem van Oranje, 1584-1984. Herdenking door de Koninklijke Academiën van België, Brussel, 12 Oktober 1984* (Brussels, 1985), pp. 87-103; and idem, "Iconographie en stijlontwikkeling in de Godsdienstige schilderkunst te Antwerpen in de zeventiende eeuw," in *Antwerpen 1989*, pp. 329-364.

2. See Zweite 1980.

3. On the painting, see I. Gaskell, in exh. cat. London, P. & D. Colnaghi, *Gothic to Renaissance: European Painting 1300-1600* (1988), no. 31; and M. E. Wieseman, in exh. cat. Boston, Museum of Fine Arts, *Prized Possessions: European Paintings from Private Collections of Friends of the Museum of Fine Arts, Boston* (14 June-16 August 1992), no. 155, pl. 19.

4. On de Clerck see Terlinden 1952, Laureyssens 1967, and the further references cited in the Biography.

5. See J. Gabriels, *Een Kempisch Schildersgeslacht: De Francken. Bijdrage tot de Geschiedenis van het Nederlandsch Romanisme* (Hoogstraten, 1930) and Härting 1989, pp. 18-20, and further references cited there.

6. On de Backer, see J. Müller Hofstede, "Jacques de Backer. Ein Vertreter der florentinisch-römischen Maniera in Antwerpen," *Wallraf-Richartz-Jahrbuch* 35 (1973), pp. 227-260; and Cologne/Vienna 1992-93, pp. 259-260.

7. On Otto Vaenius (Otto van Veen), see Haberditzl 1908; J. Müller Hofstede, "Zum Werke des Otto van Veen, 1590-1600," *Bulletin des Musées Royaux des Beaux-Arts de Belgique* 6 (1957), pp. 127-174; J. Müller Hofstede, *Otto van Veen. Der Lehrer des P. P. Rubens*, diss. Freiburg, 1959; H. Vlieghe, "Rubens and Van Veen in Contest," in *Ars Auro Prior. Studia Ioanni Bialostocki Sexagenario Dicata* (Warsaw, 1981), pp. 477ff.

8. For discussion of the chronology of Rubens's earliest years, see Held 1983, pp. 14-35; White 1987, pp. 1-7; K. Locher, in Cologne 1977, pp. 1-11; and Belkin 1989, p. 248, note 21.

9. See G. Cavalli-Björkman, *Dutch and Flemish Paintings c.1400-c.1600*, vol. 1 (Stockholm, 1986) no. 57; and C. van de Velde, "Profane historie-schilderkunst te Antwerpen in de zeventiende eeuw," in *Antwerpen 1989*, pp. 368-396, fig. 2. Petrus Perret's engraving after the painting, or a version of it, is illustrated by Müller Hofstede 1957, p. 159. It should be noted that the painting was attributed to Rubens when exhibited in Antwerp (1977, no. 1) and the attribution was in part supported by Held (1983, pp. 14-27), who suggested that the young Rubens might have had a hand in this painting, however this seems unlikely.

10. On van Noort, see Haberditzl 1908, pp. 167ff; L. van Puyvelde, "L'Œuvre authentique d'Adam van Noort, Maître de Rubens," *Bulletin des Musées Royaux des Beaux-Arts de Belgique* 2 (1929), pp. 36ff; idem, "Nouvelles œuvres d'Adam van Noort, Maître de Rubens," *Bulletin des Musées Royaux des Beaux-Arts de Belgique* 1 (1938), pp. 143ff; Held 1953, pp. 99ff; F. van Molle, "Nota bij een onbekende kruisdraging van Adam van Noort," *Jaarboek van het Koninklijk Museum voor Schone Kunsten, Antwerpen* (1965), pp. 207ff; J. Müller Hofstede, "Zum Werk des Adam van Noort, ca. 1585-1610" (at press).

11. Budapest, cat. 1968, vol. 1, pp. 342-343, vol. 2, pl. 203; Müller Hofstede 1971, p. 219, fig. 5.

12. Müller Hofstede 1971, p. 232, fig. 10.

13. Ibid., p. 237, fig. 11. On this altarpiece see also vander Auwera 1989.

14. Müller Hofstede 1971, pp. 243-244, fig. 16.

15. Ibid., pp. 246-247, fig. 19; see also Cologne/Vienna 1992-93, cat. no. 38.1, ill.; Antwerp 1992-93, no. 26.

16. Müller Hofstede 1971, p. 247, fig. 21. See also History.

17. A similar double-figure, half-length composition is the *Atalanta and Meleager*, Le Havre, Musée des Beaux-Arts André-Malraux, inv. no. 77-4; Cologne/Vienna 1992-93, no. 38.3.

18. See exh. cat. Paris, Société Labatut, *Maîtres Anciens du XVIe au XVIIIe siecle* (J. C. Serre, J. Leegenhoek and Galerie d'Arenberg [1990]).

19. On the "Brueghel dynasty" generally, see Brussels 1980. On Pieter Brueghel the Younger, see Marlier 1969; and on Jan Brueghel the Younger, see Ertz 1984.

20. Federigo Borromeo, *Musaeum* (Milan, 1625); reprint (Milan, 1909) ed. L. Beltrami; trans. Gerson, ter Kuile 1960, p. 61.

21. Ertz 1979, cat. no. 5, fig. 126.

22. Ibid., cat. no. 10, fig. 2.

23. Ibid., pp. 499-504, for example, rightly rejects many of the cases of their supposed collaboration, and challenges the notion (begun by Peltzer 1916) that the unnamed but "young" German artist to whom Brueghel alludes so admiringly in a famous letter to Cardinal Borromeo of 10 October 1596, could be Rottenhammer, since the latter was thirty-two at the time, hence four years Jan's senior. However the subsequent collaboration between the two artists, surely at the encouragement of Borromeo, is not in doubt; see, for example, the *Musical Angels* and *Angels with a Winter Landscape*, both in the Ambrosiana, Milan (Ertz 1979, cats. 124, fig. 609, and 121, fig. 611).

24. See *The Marriage of Peleus and Thetis*, Paris, Musée du Louvre, no. R.F. 1945-17; *The Allegory of the Elements*, Madrid, Museo del Prado, no. 1409; and the *Landscape with Diana and Actaeon*, Prague, Národní Galerie, no. DO-4130; respectively, Ertz 1979, cat. no. 148, fig. 499, no. 145, fig. 438, and no. 146, fig. 626 – all of which he dates to ca. 1606-1609.

25. See Ertz 1979, pp. 356-362, cats. 332 and 333.

26. See Jost 1963, p. 92, note 50; Ertz 1979, cat. no. 110, fig. 435. However the figures in this painting have also been attributed to Hendrick de Clerck.

27. See Jost 1963, pp. 86-87, 94, note 60.

28. Ibid., p. 87, note 20, fig. 1. See also the master's signed large-scale (190 x 148 cm) *Venus and Amor*, also dated 1600 (St. Petersburg, Hermitage, no. 3256).

29. Ibid., p. 115, fig. 11; compare also van Balen's two dated paintings of 1608, *The Marriage of Peleus and Thetis* (Dresden, Gemäldegalerie Alte Meister, no. 920); and *Judgment of Paris* (Sibiu, Muzeul Brukenthal); respectively Jost 1963, figs. 17 and 18.

30. Ibid., p. 95, fig. 4.

31. See ibid., p. 122, note 114; and Ertz 1979, cats. 316-319, figs. 457-460.

32. Jost 1963, p. 109, fig. 17.

33. Ibid., p. 102, note 72, fig. 27.

34. On the artist and his work, see Härting 1989.

35. Ibid., cat. 41.

36. Ibid., cat. 378. In an unpublished letter to the dealer Lanker, Härting has elaborated her interpretation of the painting's iconography.

37. Rooses, Ruelens 1887-1909; and Magurn 1955.

38. Letter 1 August 1627, from Peiresc to Pierre Dupuy; Rooses, Ruelens 1887-1909, vol. 4 (1904), p. 290. For Peiresc on Rubens, see also Rooses, Ruelens 1887-1909, vol. 2 (1898), p. 336.

39. See Dominicus Baudius's laudatory poem of 1611, in Rooses, Ruelens 1887-1909, vol. 2 (1898), p. 44. Otto van Veen, when questioned by Sweertius for a biography published in 1628, described his former pupil as the "Apelles of the Universe" (see Haberditzl 1908, p. 191); W. Panneels's portrait engraving of Rubens of 1630 is inscribed "Petrus Paulus Rubensius, pictorum Appelle"; and Gevartius's epitaph quoted in Philip Rubens's brief biography of his famous uncle, *Vita Petri Paulus Rubenii* (first published by Baron de Reiffenberg in 1837, see *Nouveaux Mémoires de l'Académie royale des Sciences et Belles Lettres de Bruxelles* 10 [1837] pp. 1-21; for an English translation see Lind 1946, p. 41). See also, as examples of his early praise, de Bie 1661, pp. 56-59; and Roger de Piles, *Cours de Peinture par principes* (Paris, 1708), pp. 345-349.

40. Letter 6 June 1640, Rooses, Ruelens 1887-1909, vol. 4 (1904), p. 303.

41. *Hyperbolimaeus* (Mainz, 1607), p. 110; see Rooses, Ruelens 1887-1909, vol. 2 (1898), p. 4.

42. On the early years, see Glück 1933, pp. 1-45; J. Müller Hofstede, "Zur Antwerpener Frühzeit von P. P. Rubens," *Münchner Jahrbuch der bildenden Kunst* 13 (1962), pp. 79-215; I. Q. van Regteren Altena, "Het vroegste werk van Rubens," *Mededelingen van*

de Koninklijke Academie voor Wetenschappen, Letteren en Schone Kunsten van België 34 (1972), pp. 3-21; and the literature cited in note 8 above.

43. See M. Jaffé, "Rubens and Raphael," in Studies in Renaissance and Baroque Art Presented to Anthony Blunt (1967), pp. 98ff.

44. See Cologne/Vienna 1992-93, cat. no. 44.1.

45. Lind 1946, p. 38. On Rubens in Italy, see Müller Hofstede in Cologne 1977, pp. 13-354; and Jaffé 1977.

46. For Rubens in Mantua, see especially London, Victoria and Albert Museum, Splendours of the Gonzaga (cat. by E. McGrath et al., 1982).

47. It should be stressed, however, that many of the drawn copies of the Italian masters' works traditionally attributed to Rubens are now regarded as anonymous copies or copies by other artists only retouched by Rubens; see E. Haverkamp Begemann and A. M. Logan, "Dessins de Rubens," Revue de l'Art 40 (1978), pp. 89-99.

48. Hoogstraten 1676, p. 193.

49. For a discussion of the unlikely theory advanced by Frances Huemer (in "A New View of the Mantuan Friendship Portrait," The Ringling Museum of Art Journal, 1983, pp. 93-105) that the main figure on the left is Galileo Galilei, see J. Müller Hofstede, "Peter Paul Rubens 1577-1640. Selbstbildnis und Selbtverständnis," in Cologne/Vienna 1992-93, pp. 105-106, and cat. no. 65.1.

50. No doubt with some false modesty Rubens explained in a letter of 10 January 1625 (to Palamède de Fabri, Sieur de Valavez; Magurn 1955, pp. 101-102) that he had painted the self-portrait now in Windsor Castle (ill. frontispiece) for the future Charles I because he "has asked me for my portrait with such insistence that I found it impossible to refuse him. Though to me it did not seem fitting to send my portrait to a prince of such rank, he overcame my modesty." On Rubens's self-portraits generally, see Warnke 1980, pp. 5-28; and J. Müller Hofstede (see note 49 above), pp. 110-120.

51. Cours de Peinture par principes (Paris, 1708), English translation (1743), p. 89. On Rubens's theories about the uses of the antique, see Muller 1982.

52. Letter 9 August 1629, to Peiresc; Rooses, Ruelens 1887-1909, vol. 5 (1907), p. 153; Magurn 1955, p. 323.

53. Letter to Jan Faber, 10 April 1609; Rooses, Ruelens 1887-1909, vol. 6 (1909), p. 324; Magurn 1955, p. 52.

54. Ibid.

55. See Lind 1946, p. 39.

56. See H. Kauffmann, "Rubens und Isabella Brant in der Geissblattlaube," in Form und Inhalt. Kunstgeschichtliche Studien Otto Schmitt zum 60. Geburtstag (Stuttgart, 1950), pp. 257ff; and Müller Hofstede, in Cologne/Vienna, 1992-93, pp. 110-112.

57. On Rubens's house and its decorations, see F. Baudouin, Rubens' House (Antwerp, 1977); McGrath 1978; J. Muller, "Rubens's Emblem of the Art of Painting," Journal of the Warburg and Courtauld Institutes 44 (1981), pp. 221-222; idem, "The Perseus and Andromeda on Rubens's House," Simiolus 12 (1981-82), pp. 131-146; and idem 1989.

58. E. Fromentin, Les Maîtres d'Autrefois (Paris, 1876), p. 135.

59. See Warnke 1980, p. 43, fig. 27.

60. See Martin 1969; F. Baudouin, "Altars and Altarpieces," in Princeton 1972, p. 74; Glen 1977, pp. 29-30; and F. Baudouin, in Antwerpen 1989, pp. 339-340.

61. See Munich, Bayerische Staatsgemäldesammlungen, Peter Paul Rubens: Altäre für Bayern (cat. by K. Renger), 9 November 1990-13 January 1991, pp. 25-38, with earlier literature.

62. See Glen 1977, pp. 114-122; and Baudouin, in Antwerpen 1989, pp. 344-345.

63. See Muller 1989.

64. See Balis 1986.

65. See Warnke 1980, p. 120, and Balis 1986, pp. 67-69.

66. On Rubens's images of Pan and Satyrs, see especially McGrath 1983, pp. 52-65.

67. Letter to Jan Faber, 10 April 1609; Rooses, Ruelens 1887-1909, vol. 6 (1909), p. 324; Magurn 1955, p. 52.

68. On the entire series, see Martin 1968. Also Held 1980, vol. 1, pp. 31-36.

69. Martin 1968, p. 216.

70. Letter 12 May 1618; Rooses, Ruelens 1887-1909, vol. 2 (1898), p. 150; Magurn 1955, p. 63. On the tapestry cycle generally, see Baumstark 1983.

71. Letter to William Turnbull, 13 September 1621; Rooses, Ruelens 1887-1909, vol. 2 (1898), p. 286; Magurn 1955, p. 77.

72. See Rooses, Ruelens 1887-1909, vol. 2 (1898), p. 156; Goris 1940, p. 116.

73. Lind 1946, p. 41.

74. See W. von Seidlitz, Repertorium für Kunstwissenschaft 10 (1887), p. 111; Rooses, Ruelens 1887-1909, vol. 2 (1898), p. 156.

75. Letter to Jacob de Bie, 26 May 1618; Rooses, Ruelens 1887-1909, vol. 2 (1898), p. 35; Magurn 1955, p. 55.

76. Sandrart 1675, de Piles 1708, p. 349.

77. See Rooses, Ruelens 1887-1909, vol. 2 (1898), p. 69; vol. 3 (1900), p. 40; vol. 4 (1904), p. 357; and Magurn 1955, pp. 56 and 234. (See cats. 18 and 19, for Jesuit ceiling sketch.) On the words used in the seventeenth century to refer to oil sketches, see Gerson, ter Kuile 1960, pp. 86 and 186, note 177; 189, note 150; L. de Pauw de Veen, De begrippen 'schilder,' 'schilderij' en 'schilderen' in de zeventiende eeuw (Antwerp, 1969), p. 98; and J. M. Muller, "Oil Sketches in Rubens's Collection," The Burlington Magazine 117 (1975), p. 372.

78. As Gerson (Gerson, ter Kuile 1960, p. 87, note 80) observed, Roger de Piles, in praising Rubens's oil sketches in 1681, already differentiated between the two types; see Dissertation sur les ouvrages des plus fameux peintres (Paris, 1681); Œuvres diverses de M. de Piles vol. 4 (Paris, 1767), p. 386.

79. Martin 1968, p. 32-33; see also pp. 213-219. The Abbé de Mangio also apparently later tried to obtain Rubens's sketches for the Medici cycle under false pretences, see Rooses, Ruelens 1887-1909, vol. 3 (1900), p. 40.

80. Rooses, Ruelens 1887-1909, vol. 2 (1898), p. 136; Magurn 1955, p. 60.

81. Rubens, presumably caught up in his own salesmanship, does not seem to have been entirely candid; the Daniel in the Lion's Den (National Gallery of Art, Washington, D.C., no. 1965.13.1) is cited in the list as entirely by his hand but surely involved studio assistants in the background and animals, though they were working in the latter case from Rubens's drawings.

82. Letter 12 May 1618; Rooses, Ruelens 1887-1909, vol. 2 (1898), pp. 145-146; Magurn 1955, pp. 61-62.

83. Letter from Lord Danvers to Sir Dudley Carleton, 27 May 1621; Rooses, Ruelens 1887-1909, vol. 2 (1898), p. 277; Magurn 1955, p. 446, letter 46, note 1.

84. Letter to William Turnbull, 13 September 1621; Rooses, Ruelens 1887-1909, vol. 2 (1898), p. 286; Magurn 1955, p. 77.

85. Rooses 1906, p. 140. See note 157 below.

86. See Denucé 1932, p. 49.

87. See L. Silver, The Paintings of Quentin Massys (Montclair, 1989), cat. 26, fig. 114.

88. "Een stuck van Octavi ende Brugel ende van Rubens eerst geschildert met buytenlyst wesende den Berch Pernassus, geteekent Nº 362"; in the inventory of the estate of Herman de Neyt, Antwerp, 15-22 October 1642 (see Denucé 1932, p. 100; and Duverger 1984-, vol. 5, p. 18).

89. See van Puyvelde, in Brussels 1965, no. 204; Gerson, ter Kuile 1960, p. 159 (stating that the figures were by Snyders too); Jaffé 1971b, p. 187; Madrid cat. 1975, vol. 1, pp. 371-372, no. 1851; Held 1980, vol. 1, no. 278; Robels 1989, no. 260.

90. Held 1980, vol. 1, no. 233, pl. 247.

91. Robels 1989, no. 275.

92. Ibid., no. 283, ill.

93. Ibid., no. 262.

94. Ibid., no. 270. For the collaborations between Rubens and Snyders, see in addition to Jaffé 1971b, Robels 1989, pp. 353-396, cats. 260-306, and Huvenne 1985.

95. Ertz 1979, no. 308.

96. See the Madonna and Child in a Flower Garland, Milan, Pinacoteca Ambrosiana, no. 71 (Ertz 1979, no. 187, fig. 377); the painting can be dated on the basis of four letters written by Jan Brueghel the Elder to Ercole Bianchi (Cardinal Borromeo's agent) in early 1608; see Ertz 1979, p. 307. For the best general discussion of the

Madonna with flower garland paintings, see Freedberg 1981.

97. *Musaeum* (Milan, 1625) reprint (Milan, 1909) ed. L. Beltrami, p. 18.

98. Probably the version in the Museo del Prado, Madrid, no. 1418; the Louvre's version [inv. no. 1764], is regarded as an earlier version painted by the two artists around 1617, because it, or still another prototype, figures on the right in the *Allegory of Sight*, dated 1617, Museo del Prado, Madrid, no. 1394. See Ertz 1979, cat. nos. 368 and 325, figs. 391 and 383, respectively.

99. See ibid., p. 304; Freedberg 1981, p. 118.

100. Ertz 1979, p. 304, cat. 326, fig. 385.

101. See Freedberg 1981, pp. 122-126.

102. See ibid., p. 123, note 62, citing Lipsius's *Diva Virgo Hallensis. Beneficia ejus et miracula fide atque ordine descripta* (Antwerp, 1604); and *Diva Sichemiensis sive Aspricollis. Nova ejus beneficia et admiranda* (Antwerp, 1605).

103. See Sarasota, cat. 1980, cat. 40, incorrectly titled *A Scholar Inspired by Nature*. Ingvar Bergström first correctly attributed the still life; see Bergström 1957. The correct subject was first identified by Waagen (1854-57, vol. 2, p. 164), and was supported by, among others, J. G. van Gelder, "Van Blompot tot Blomglas," *Elseviers Geïllustreerd Maandschrift* 47 (1936), p. 159; Warnke 1980, p. 7; Freedberg 1981, p. 121; and J. Müller Hofstede, in Cologne/Vienna 1992-93, pp. 111-112.

104. Van Mander 1604, "Den Grondt," fol. 43v. For discussion, see W. S. Melion, *Shaping the Netherlandish Canon, Karel van Mander's Schilder-Boeck* (Chicago and London, 1991), pp. 89-91, 100-101, 104, 216-217, 260-261, 265.

105. On the Medici cycle, see J. Thuillier and J. Foucart, *Rubens' Life of Marie de' Medici* (New York, 1967); F. H. Hazelhurst, "Additional Sources for the Medici Cycle," *Bulletin des Musées Royaux des Beaux-Arts de Belgique* 16 (1967), pp. 111-135; Held 1980, vol. 1, pp. 87-136; E. McGrath, "Tact and Topical Reference in Rubens's 'Medici Cycle,'" *The Oxford Art Journal* 3 (1980), pp. 11-16; D. Marrow, *The Art Patronage of Marie de' Medici* (Ann Arbor, 1982); and R. van der Heiden, *Die Skizzen zum Medici-Zyklus von Peter Paul Rubens in der Alte Pinakothek* (Munich, 1984).

106. See I. Jost, "Bemerkungen zur Heinrichsgalerie des P. P. Rubens," *Nederlands Kunsthistorisch Jaarboek* 15 (1964), pp. 175-220.

106bis. On the Constantine series, see Du Bon 1964; Philadelphia 1964; Coolidge 1966; Held 1980, vol. 1, pp. 65-85; and P. Krüger, *Studien zu Rubens Konstantinzyklus* (Europäische Hochschulschriften series 28 [Kunstgeschichte], vol. 92; Frankfurt, 1989).

107. Letter to Palamède de Fabri Sieur de Valavez 13 May 1625; Rooses, Ruelens, 1887-1909, vol. 3 (1900), p. 110.

108. See de Poorter (1978); and Scribner (1982).

109. Letter to Pierre Dupuy, 11 May 1628; Magurn 1955, p. 261.

110. Letter to Sir Dudley Carleton, 12 May 1618; Rooses, Ruelens 1887-1909, vol. 2 (1898), p. 149; Magurn 1955, p. 62.

111. Letter of 15 July 1626; Rooses, Ruelens 1887-1909, vol. 3 (1900), p. 446; Magurn 1955, p. 136.

112. Letter of 15 June 1627, Rooses, Ruelens 1887-1909, vol. 4 (1904), pp. 82-83.

113. Letter from Philip IV to Infanta Isabella, 22 September 1630, Rooses, Ruelens 1887-1909, vol. 5 (1907), p. 260.

114. Letter of 9 August 1629; Rooses, Ruelens 1887-1909, vol. 5 (1907), p. 153; Magurn 1955, p. 322.

115. Letter to Gevaerts, 29 December 1628; Rooses, Ruelens 1887-1909, vol. 5 (1907), p. 16; Magurn 1955, p. 295.

116. See Muller 1989, pp. 94-146, passim.

117. See Stockholm, Nationalmuseum, *Bacchanals by Titian and Rubens*, 18 March-17 May 1987.

118. Quoted by J. S. Held, "Rubens and Titian," in *Titian, His World and Legacy*, ed. D. Rosand (New York, 1982), p. 286.

119. On the marqués and Rubens's other Spanish patrons, see J. Brown, "The Spanish Court and Flemish Painting," in exh. cat. Cologne/Vienna 1992-93, pp. 93-100. See also cat. 80, also owned by the collector.

120. See Rubens's complaints about his time-consuming and financially damaging service in his letter to Gevaerts, 13 January 1631; Magurn 1955, p. 370.

121. See R. Baumstark, "Ikonographische Studien zu Rubens' Krieg- und Friedensallegorien," *Aachener Kunstblätter* 45 (1974), pp. 125-234; A. Hughes, "Naming the Unnameable; An Iconographical Problem in Rubens's 'Peace and War,'" *The Burlington Magazine* 122 (1980), pp. 157-164.

122. Letter to Peiresc, 18 December 1634; Rooses, Ruelens 1887-1909, vol. 6 (1909), p. 81; Magurn 1955, p. 392.

123. On the Whitehall ceiling, see O. Millar, *Rubens: The Whitehall Ceiling* (London, 1958); Held 1980, vol. 1, pp. 185-218; R. Strong, *Brittania Triumphans* (London, 1980); J. Carlton, *The Banqueting House Whitehall* (1983).

124. See letter of 16 March 1636; Rooses, Ruelens 1887-1909, vol. 6 (1909), p. 153; Magurn 1955, pp. 402-403.

125. On the Achilles tapestry series, see Haverkamp Begemann 1975.

126. Letter of 18 December 1634; Rooses, Ruelens 1887-1909, vol. 6 (1909), p. 82; Magurn 1955, p. 393.

127. Ibid.

128. See R. de Piles, *Abrégé de la vie des peintres* (Paris, 1699), English ed. (1743), p. 252; he writes, Hélène "was indeed a Helen for beauty and helped him very much in the figures of women which he painted."

129. On *Het Pelsken*, see J. S. Held, "Rubens' 'Het Pelsken'," in *Essays in the History of Art Presented to Rudolf Wittkower* (1967), pp. 188-192; J. Bialostocki, "Reflections on Eroticism in Some Rubens Pictures: Three Paintings in the Vienna Museum," in *Rubens and His World* (Antwerp, 1985), pp. 187-192.

130. Letter to Philip IV, 27 February 1639; Rooses, Ruelens 1887-1909, vol. 6 (1909), p. 228.

131. See Martin 1972; and E. McGrath, "Rubens's 'Arch of the Mint,'" *Journal of the Warburg and Courtauld Institutes* 37 (1974), pp. 191-217.

132. See D. Freedberg, in Liedtke et al. 1992, pp. 208-210.

133. See Alpers 1971. On Rubens and Philip IV, see also M. Crawford-Volk 1981, pp. 513-529; and J. Brown, in exh. Cologne/Vienna 1992-93, pp. 99-101.

134. Letter of 27 February 1639; Rooses, Ruelens 1887-1909, vol. 6 (1909), p. 228.

135. Cust 1900, p. 143.

136. Washington 1990-91. See also Barnes 1982.

137. See most recently Barnes's discussion of the evidence pertaining to their relationship, including Guilliam Verhagen's testimony in a lawsuit in the 1660s, in Washington 1990-91, pp. 18-20.

138. On van Dyck's drawings generally, see C. Brown, exh. New York and Fort Worth 1991, with earlier literature.

139. Van Dyck's Italian sketchbook, formerly at Chatsworth and today in the British Museum, was published by G. Adriani in a fascimile edition: *Anton van Dyck: Italienisches Skizzenbuch* (Vienna, 1940; 2nd ed. 1965). Christopher Brown is preparing a new edition.

140. See J. Wood, "Van Dyck's 'Cabinet de Titian': the Contents and Dispersal of His Collection," *The Burlington Magazine* 132, no. 1051 (1990) pp. 680-695.

141. See J. M. Muller, "The Quality of Grace in the Art of Anthony van Dyck," in Washington 1990-91, pp. 27-36.

142. Washington 1990-91, cat. 39.

143. See Barnes's discussion of van Dyck's studio practices, exh. cat. Washington 1990-91, pp. 14-15.

144. Jabach quoted in Cust 1900, p. 139.

145. See Thomas Wentworth's instructions, cited by O. Millar in London 1982-83, p. 67.

146. See M. Mauquoy-Hendrickx, *L'Iconographie d'Antoine Van Dyck. Catalogue raisonné*, 2 vols. (Brussels, 1991).

147. Rooses, Ruelens 1887-1909, vol. 4 (1904), p. 310.

148. See H. Walpole, *Anecdotes of Painting in England* (London, 1876), vol. 1, pp. 334-335.

149. The best general introduction to Jordaens's art is d'Hulst 1982 and now exh. Antwerp 1993; see also Rooses 1908 and Stubbe 1948.

150. See also Jordaens's *Daughters of Cecrops Discovering Erichtonious*, dated 1617, and *Adoration of the Shepherds*, dated 1618, mentioned below.

151. See exh. cat. Cologne/Vienna 1992-93, no. 40.1

152. On the paintings executed by various artists for the Mysteries of the Rosary cycle, see A. Janssens, *Sint-Pauluskerk en haar Kunstbezit* (Antwerp, 1971), pp. 92-108; H. Vlieghe, "Rubens' beginnende invloed: Arnout Vinckenborch en het probleem van Jordaens' vroegste tekeningen," *Nederlands Kunsthistorisch Jaarboek* 38 (1987), pp. 383-384; and idem, "Rubens's Atelier," *passim*.

153. See d'Hulst 1982, p. 176; and Antwerp 1993, cat. A57; on the Prometheus myths, see cat. 10 and O. Raggio, "The Myth of Prometheus: Its Survival and Metamorphosis up to the Eighteenth Century," *Journal of the Warburg and Courtauld Institutes* 21 (1958), pp 46-62.

154. See d'Hulst 1982, p. 33.

155. See M. C. Donnelly, "Calvinism in the Works of Jacob Jordaens," *The Art Quarterly* 22 (1959), pp. 356-366; but see now C. Tümpel, "Jordaens, a Protestant Artist in a Catholic Stronghold," in Antwerp 1993, pp. 31-37, who argues, not entirely persuasively, that Jordaens's late interest in Old Testament scenes involving idolatry, the apostasy of the Israelites, or the rejection of the Gospel by the Pharisees reveals no particular religious allegiance, either Protestant or Catholic.

156. See Rooses 1908, p. 138; d'Hulst 1982, p. 30.

157. Van den Branden 1883, p. 829; Rooses 1908, pp. 137-138; d'Hulst 1982, p. 30.

158. See Stubbe 1948, p. 133; d'Hulst 1982, p. 323.

159. For most of the artists mentioned here, see Hairs 1968. On van Thulden, see also 's-Hertogenbosch/Strasbourg 1991-92; on Gerard Seghers, see Bieneck 1992.

160. See Antwerp/Münster 1990.

161. On Finsonius, see D. Bodart, *Louis Finson Bruges avant 1580-Amsterdam 1617* (Brussels, 1970). On van Loon, see T. Cornil, "Théodore van Loon et la peinture italienne," *Bulletin de l'Institut historique belge de Rome* 17 (1936), pp. 187-211; A. Boschetto, "Di Theodoor van Loon e dei suoi dipinti a Montaigu," *Paragone* 21, no. 239 (1970), pp. 42-59; and D. Coekelbergh, "Le Martyre de Saint Lambert (1617). Tableau caravagesque de Théodore van Loon," *Bulletin de l'Institut Royal du patrimoine artistique* 17 (1978-79), pp. 139-152.

162. The general history of Flemish baroque portraiture has yet to be written, but the best brief introduction appears in the latter half of K. Van der Stighelen's article "Das Porträt zwischen 1550 und 1650. Die Emanzipation eines Genre," in Cologne/Vienna 1992-93, pp. 171-182.

163. See Van der Stighelen 1990a; and Van der Stighelen 1990b.

164. Van der Stighelen 1990a, cat. no. 9, ill.

165. Ibid., cat. 7, ill.

166. Ibid., cat. 11, ill.

167. See Van der Stighelen 1990b, p. 143.

168. Van Mander, 1604, "Den Grondt", fols. 5 verso-6 recto. The passage addressed to Netherlandish artists in fol. 6 recto reads, "Ist niet de volcomenheyt in beelden en Historien, soo mach het wesen Beesten, Keuckenen, Fruyten, Bloemen, Landtschappen, Metselrijen, Prospectiven, Compartimenten, Grotissen, Nachten, branden, counterfeytselen nae t'leven, Zeen, en Schepen, oft soo yet anders te schilderen." Translated and discussed with van Mander's theory of *verscheydenheden*, by Melion 1991 (as in note 104), pp. 5-6, 25, and 29.

169. Van Mander, 1604, "Den Grondt", fol. 1 verso; trans. by Melion 1991, p. 28.

170. See Melion 1991, p. 29. Van Mander followed Alberti in his inventory of Greek and Roman specialists. In Book 3 of *De Pictura*, Alberti warns of the challenge of trying to master all aspects of *istoria* ("Since, however, the painter's surpassing work is history ... the artful painter must labor most diligently to paint beautifully not only the attitudes of the human figure, but also horses, dogs, and other animals, whatever is worthy of sight"). However van Mander promotes specializations not merely as a corollary to history painting but as legitimate alternatives.

171. See van Mander, 1604, "Den Grondt", fol. 15 recto-fol. 22 verso; Melion 1991, p. 8. In stanza 20, chapter 5, van Mander states "Door verchedenheyden is Natuere schoone" (Nature is beautiful through diversity), arguing that history painting must imitate nature, who varies all her parts to achieve beauty. Like nature, the painter must diversify his figures, varying their attitudes, expressions, characters and temperaments, just as he differentiates the other components of history, namely landscapes, buildings, attributes, and ornaments, and still life elements.

172. Philips Angel, *Lof der schilder-konst* (Leiden, 1642; reprint Utrecht, 1969), pp. 42-50.

173. Hoogstraten 1678, pp. 69-75. See, for discussion, C. Brusati, "Samuel van Hoogstratens *Hooge School of de Zichtbaere Werelt*," in exh. cat. Dordrecht, Dordrechts Museum, *De Zichtbaere Werelt: schilderkunst uit de Gouden Eeuw in Hollands oudste stad*, 29 November 1992-28 February 1993, pp. 65ff.

174. See Denucé 1932 and Duverger 1984-.

175. Ertz 1979, cat. 320, fig. 494.

176. Ibid., cat. 336, fig. 629; Härting 1989, cat. 476, ill.

177. See Speth-Holterhoff 1957, no. 64; A. Keersemaekers, "Drie rebus-blazoenen van de Antwerp Violieren," in *Verslagen en Mededelingen van den Koniglich Vlaamsch Academie voor Tael en Letterkunde* (1957), pp. 343-350; idem, "Rederijkers-Rebus-blazoenen in de zestiende-zeventiende eeuw," in *Wort und Bild* (Erfstadt, 1984), pp. 217ff; and Filipczak 1987, p. 25.

178. See de Maeyer 1955, document no. 139; Ertz 1979, pp. 356-362, cat. nos. 323 and 333, figs. 428 and 429.

179. Ibid., however Díaz Padrón (exh. cat. Madrid 1992, no. 17) has implausibly proposed an attribution to Jan Brueghel I, Frans Francken II, Hendrick van Balen, and Joos de Momper. J. Wood's review (*The Burlington Magazine*, 134 [December 1992], p. 825) also correctly rejects the attribution to Rubens.

180. Ertz 1979, pp. 328-356, cats. 327-331, figs. 399, 415, 420, 422, 425.

181. See A. Balis, "De nieuwe genres en het burgerlijk mecenaat," in Brussels/Schallaburg 1991, pp. 237-254.

182. See W. Stechow and C. Comer, "The History of the Term Genre," *Allen Memorial Art Museum Bulletin* 33, no. 2 (1975-76), pp. 89-94.

183. See also Legrand 1963.

184. See Härting 1989, cats. 160 and 161, ills. pp. 272, 273.

185. Ibid., figs. 13 and pl. 1.

186. Ibid., cat. 431, fig. 82.

187. See ibid., p. 92ff, especially cat. 434, fig. 36 (R. Begeer collection, Voorschoten); compare Joos van Winghe's *Nocturnal Party with Dancers* of 1588 (Brussels, Musées Royaux des Beaux-Arts de Belgique, inv. no. 6736) before a statue of Venus, which Renger ("Joos van Winghes 'Nachtbancket met een Mascarade' und verwandte Darstellungen," *Jahrbuch der Berliner Museen* 14 [1972], p. 190) has interpreted as a moral warning against unchaste or venal love. Härting also cites the print by Jan Saenredam after Karel van Mander of *The Dance of Salome*, which depicts the dancers in contemporary (i.e. seventeenth-century) costume in compositions that closely resemble Francken's dancing scenes.

188. See Sutton in exh. cat. Philadelphia/Berlin/London 1984, pp. xxviii-xxx; and for a discussion of Dutch genre scenes with dancers, see ibid., cat. 28 (Pieter Codde's *Dancing Party* of 163[0 or 6], private collection).

189. See Härting 1989, pp. 83-91. On the gallery painting tradition generally, see Speth-Holterhoff 1957; Filipczak 1987; Madrid 1992; K. Schütz, "Das Galeriebild als Spiegel des Antwerpener Sammlertums," in exh. cat. Cologne/Vienna 1992-93, pp. 161-169; and J. Muller's essay; and cats. 124 and 125.

190. Legrand 1963, fig. 33; note the painting of *Fortuna* (Dame Fortune) in the background. See also de Caullery's allegorical high-life scenes such as *Venus, Bacchus, and Ceres with Mortals in a Love Garden*, Amsterdam, Rijksmuseum, no. A1956.

191. See Legrand 1963, p. 190 and figs. 69 and 70; Joost vander Auwera is preparing the œuvre catalogue.

192. See Marlier 1969; and Jacqueline Folie, in Brussels 1980, pp. 137-164.

193. Van Mander 1604, fol. 234.

194. The best general introduction is Renger, in exh. cat. Munich 1986; see also Bode 1924, and Knuttel 1962.

195. See Renger 1987.

196. See, as examples, Antwerp, Koninklijk Museum voor Schone Kunsten, inv. 5043, and Kassel, Gemäldegalerie Alte Meister, no. GK139; respectively exh. Antwerp 1991, cat. nos. 1 and 3.

197. New York/Maastricht 1982, no. 18, ill., detail on cover.

198. Antwerp 1991, cat. 7.

199. Ibid., cat. 38.

200. Ibid., cats. 85, 86.

201. However, consider Legrand's (1963, pp. 129-153) hypothetical division of the œuvre into four successive periods.

202. Ibid., fig. 54.

203. See Leipzig, Museum der bildenden Künste, inv. 350; and Brussels, Musées Royaux des Beaux-Arts de Belgique, inv. 156, both dated 1648; respectively Cologne/Vienna 1992-93, cat. nos. 77.1 and 77.2.

204. See Legrand 1963, pp. 175-178. Among Teniers's lesser followers and imitators are Corneille (1613-1689) and Victor Mahu (d. 1700/01), Thomas Apshoven (1622-1654/55), Jacob Smeyers (1657-1732), F. van Houten, Jan Hulsman, Pieter Meert, and M. A. Immenraedt.

205. See Legrand 1963, pp. 160-167.

206. Ibid., fig. 58.

207. See Akademie der bildenden Künste, Vienna, nos. 821-824; and the series in the Harold Samuel collection, Mansion House, Guildhall Gallery, London, cat. (1992), nos. 67-71.

208. See Liedtke et al. 1992, cat. 95.

209. See Legrand 1963, pp. 57-62.

210. See Cologne/Vienna 1992-93, cat. 79.1; on the theme of the gypsy fortune-teller, see J.-P. Cazin, La diseuse de bonne aventure de Caravage, a dossier published by the Reunion des Musées Nationaux (Paris, 1977).

211. See Legrand 1963, p. 168.

212. See now on the artist Beineck 1992.

213. Beineck 1992, cat. A9, fig. 31.

214. Ibid., cat. A12, fig. 4.

215. Leonard Slatkes (see Liedtke et al. 1992, cat. 74), for example, disputes the traditional dating of the Two Musicians (Spencer Museum of Art, University of Kansas, Lawrence, no. 50.68) to the Italian years, suggesting instead ca. 1625-30.

216. On the Bamboccianti, see Salerno 1977-80; Briganti, Trezzani, Laureati 1983; and Cologne/Utrecht 1991-92, with earlier literature.

217. On Miel, see T. J. Kren, "Jan Miel (1599-1644): A Flemish Painter in Rome," 3 vols. in 2, diss. Yale University, 1979; Briganti et al. 1983, pp. 91-132; Philadelphia/Berlin/London 1984, pp. 254-255; and Cologne/Utrecht 1991-92.

218. See the group in the Rijksmuseum, Amsterdam, the Wadsworth Atheneum, Hartford, and in a private collection; Briganti et al. 1983, figs. 13.13-13.20.

219. The most thorough general introduction to the history of the origins of Flemish landscape is Franz 1969. See also Raczyński 1937; Thiéry 1976; Gerszi 1976; H. G. Franz, "Baumlandschaft und Waldlandschaft bei den Brüdern Valkenburch und Hans Bol. Beiträge zur niederländischen Landschaftsmalerei des 16. Jahrhunderts," Jahrbuch des Kunsthistorischen Institut der Universität Graz 15-16 (1979/80), pp. 151-174; and H. Devisscher, "Die Entstehung der Waldlandschaft in den Niederlanden," in Cologne/Vienna, 1992-93, pp. 191-202.

220. R. L. Falkenburg, Joachim Patinir: Landscape as an Image of the Pilrimage of Life (Amsterdam/Philadelphia, 1988).

221. See J. A. Emmens, "Eins aber ist nötig: Zu Inhalt und Bedeutung von Markt- und Küchenstücken des 16. Jahrhunderts," in Album Amicorum J. G. van Gelder (The Hague, 1973).

222. On the Valkenborchs, see A. Wied, Lucas und Marten van Valckenborch (1535-1597 und 1534-1612). Das Gesamtwerk mit Kritischem Œuvrekatalog (Freren, 1990).

223. See Ertz 1979, cat. 10, fig. 225, Rest on the Flight into Egypt on a Forested Hillside with a View of the Tivoli Temple.

224. See ibid., cat. 16, fig. 229 [as ca. 1595].

225. On Govaerts, see Thiéry 1986, pp. 217-223, Cologne/Vienna 1992-93, pp. 440-442; on Mirou, Thiéry 1986, p. 224, and Cologne/Vienna 1992-93, p. 446; and on Alexander Keirincx, see Amsterdam/Boston/Philadelphia 1986-87, pp. 362-364, and Cologne/Vienna 1992-93, pp. 442-443.

226. Ertz 1979, cat. 29, fig. 6.

227. Ibid., cat. 46, fig. 8.

228. Ibid., cat. 44, fig. 22. Compare the relative immediacy and naturalism of this work to river landscapes Jan painted only five years earlier, but which still are partly conceived in his father's "world landscape" tradition; e.g. the wonderfully multifarious Landscape with Young Tobias dated 1598, Vaduz, Prince of Liechtenstein Collection, inv. 477 (Ertz 1979, cat. 47, fig. 12).

229. See especially the Entrance to the Village with a Mill, dated 1603 or 1605, in a Zurich private collection; Ertz 1979, cat. 93, fig. 29.

230. Several landscapists in the Jan Brueghel circle should be mentioned, of whom Adriaen Stalbemt (1580-1662) is the most talented. Isaak van Oosten (1613-1691), Peeter Gysels (1621-1690), Matthys Schoevaerts (active ca. 1690), Frans Boudewijns (1644-1711), and Theobald Michau (1676-1765) were all followers of more or less modest aptitudes and accomplishments.

231. See also Franz 1982, pp. 165-181.

232. Ertz 1979, p. 470.

233. On Lytens, see Thiéry 1986, pp. 161-166; and Cologne/Vienna 1992-93, pp. 444-445. Later exponents of the de Momperesque mountain landscape are Hans Thielen (1586-1630) and Jacques Fouquier (1590-1659).

234. See Ertz 1979, p. 96, fig. 88; Cologne/Vienna 1992-93, cat. 23.1, ill.

235. See Adler 1980, figs. 156-167.

236. On van Uden, see Adler 1980, pp. 17ff; Thiéry 1986, pp. 167-174; Cologne/Vienna 1992-93, pp. 454-455.

237. For van Uden's copies of Rubens: Munich, Bayerische Staatsgemäldesammlungen; the Bowes Museum, Barnard Castle; Frankfurt, Städelsches Kunstinstitut; art market, Paris, after 1945; Vienna, Gemäldegalerie der Akademie der bildenden Künste; and formerly Jules Porges, Paris; see respectively Adler 1980, figs. 288-294.

238. On these artists, see A. Zwollo, Hollandse en Vlaamse Veduteschilders te Rome (1675-1725) (Assen, 1975); and Salerno 1977-80.

239. See, for example, religious flower paintings by Ludiger tom Ring the Younger of 1562 owned by the Westfälischer Kunstverein, Münster; and Hans Memling's Portrait of a Man with, on the verso, a vase of lilies and irises (Thyssen-Bornemisza collection, Lugano and Madrid), both discussed by G. Langemeyer, in "Das Stilleben als Attribut," in Münster/Baden-Baden 1979-80, pp. 22ff. See also the Master of Frankfurt's Portrait of the Artist and His Wife, dated 1496, with the still life on the table before them (Antwerp, Koninklijk Museum voor Schone Kunsten, no. 5096). On the rise of Netherlandish still life generally, see A. P. A. Vorenkamp, Bijdrage tot geschiedenis van het hollandsche stilleven in de zeventiende eeuw (Leiden, 1933); Bergström 1956; Greindl 1956 (2nd ed. 1983); Hairs, 1965; Amsterdam/'s-Hertogenbosch 1982; Amsterdam/Braunschweig 1983; Hairs 1985; Delft/Cambridge/Fort Worth 1988; H. Robels, "Entwicklungsphasen der Antwerpener Stillebenmalerei von 1550-1650," in Cologne/Vienna 1992-93, pp. 203-214; and L. Wuyts, "Enkele losse beschouwingen bij het stilleven 1550-1650," in Antwerp 1993, pp. 37-40.

240. See Bergström 1956, pp. 38-40; Hairs 1985, p. 8.

241. See J. A. Emmens, "Eins aber ist nötig: Zu Inhalt und Bedeutung von Markt-und Küchenstücken des 16. Jahrhunderts," in Album Amicorum J. G. van Gelder (The Hague, 1973), pp. 93-101; D. Kreidl, "Die religiöse Malerei Pieter Aertsens als Grundlage seiner künstlerischen Entwicklung," Jahrbuch der Kunsthistorischen Sammlungen in Wien 68 (1972), pp. 43-109; K. Moxey, Pieter Aertsen, Joachim Beuckelaer and the Rise of Secular Painting in the Context of the Reformation (New York/London, 1977); R. Genaille, "Pieter Aertsen, précurseur de l'art rubénian," Jaarboek van het Koninklijk Museum voor Schone Kunsten, Antwerpen (1977), pp. 7-96; K. M. Craig, "Pieter Aertsen and the Meat Stall," Oud Holland 96 (1982), pp. 1-15; K. M. Craig, "Pars Ergo Marthae Transit: Pieter Aertsen's 'Inverted' Paintings of Christ in the House of Martha and Mary," Oud Holland 97 (1983), pp. 25-39; K. Irmscher, "Ministrae Voluptatum: Stoicizing Ethics in the Market and Kitchen Scenes of Pieter Aertsen and Joachim Beuckelaer," Simiolus 16 (1986), pp. 219-232; Ghent, Museum voor Schone Kunsten, Joachim Beuckelaer, 12 December 1986-8 March 1987; K. Moxey, "Interpreting Pieter Aetsen: The Problem of 'Hidden Symbolism,'" Nederlands Kunsthistorisch Jaarboek 40 (1989), pp. 29-39; and E. A. Honig, "Painting and the Market: Pictures of Display and Exchange from Aertsen to Snyders" (Ph.D. diss. Yale University, 1992).

242. For a translation of Hadrianus Junius's passage on Aertsen in his *Batavia* (Antwerp, 1588, pp. 239-240), see Moxey 1977, p. 28. Karel van Mander praised the artist's efforts at naturalism, see *Het Schilderboeck* (1604), fols. 238r, 243v, 244v; for Scribanius's comments on the artist in his *Antverpia* (1610), see Jeffrey Muller in exh. Ghent 1986-87, pp. 14-17.

243. See Samuel van Hoogstraten, *Inleyding tot de Hooge Schoole der Schilderkunst* (Rotterdam, 1676), pp. 75 ("Maer deze Konstenaers moeten weten dat zy maer gemeene Soldaten in het veltleger van de konst zyn"), 76 ("in de beroemste Kunstkabinetten het meestendeel stukken vind... als hier een Wijntros, een Pekelharing, of een Haegedis, of daer een Patrijs, een Weytas, of dat noch minder is"), and 25 ("Want een volmaekte Schildery is als een spiegel van de Natur, die de dinghen, die niet en zijn, doet schijnen te zijn, en op een geoorlofde vermakelijke en prijslijcke wijze bedriegt").

244. See Hieronymus Francken II's *Tabletop Still Life*, signed and dated 1607, Antwerp, Koninklijk Museum voor Schone Kunsten, Antwerp, no. 934; and the very similarly conceived *Tabletop Still Life* with a gallows out the window, Brussels, Musées Royaux des Beaux-Arts de Belgique, inv. no. 3357, as Anonymous Southern Netherlandish. In the latter the gallows are an obvious admonition, while the print on the wall shows an owl before a mirror with the inscription *Vilen-spieghel*, an allusion to the popular satirical character in both German and Dutch literature, Till Eulenspieghel. In the Antwerp painting, the print again shows an owl but with a candle and spectacles, an allusion to a saying ("Wat baet er kaers en bril als den uyl niet sien en wil") offering a cautionary message about eating and drinking to excess (see cat. 71).

245. See Decouteau 1992. For the misattribution of works by Claesz. to Peeters, see Vroom 1980, vol. 1, pp. 88-100; and van Dedem 1981.

246. On Hulsdonck, see Griendl 1983, pp. 36-43.

247. On Adriaenssen, see Spiessens 1990.

248. See Savery's two paintings dated 1603 in the Centraal Museum, Utrecht, no. 6316, and in a private collection; K. J. Müllenmeister, *Roelant Savery. Kortrijk 1576-Utrecht 1639. Hofmaler Rudolf II in Prag. Die Gemälde mit kritischem Œuvrekatalog* (Freren, 1988), cats. 269 and 270. For discussion of the artist's still lifes, see also Sam Segal, "Roelant Savery als Blumenmaler," in Cologne/Utrecht, 1985-1986, pp. 55-64.

249. Both are mentioned by van Mander 1604, fols. 293v-294r; see F. Hopper, "Jacques de Gheyn II and Rudolf II's Collection of Nature Drawings," in *Prag um 1600* (Freren, 1988), pp. 124-131.

250. See Crivelli 1868, pp. 62-64, 74, 75; and Ertz 1979, cat. no. 143, fig. 327.

251. See Ertz 1979, p. 254, cat. 144, fig. 328.

252. Ertz 1979, p. 252.

253. See Brenninkmeyer-de Rooij 1990, esp. p. 221; see also the author's comments in The Hague 1992, pp. 11ff, where she notes that de Gheyn in the same year (1606) received no less than 600 guilders (30-40 times the price of a good painting during this period) from the Dutch States General to paint a flower piece for Marie de' Medici.

254. See Brenninkmeyer-de Rooij 1990, p. 219.

255. See Amsterdam, Galerie K. & V. Waterman, *Masters of Middelburg*, 1984, cat. no. 2, private collection.

256. See L. J. Bol, *The Bosschaert Dynasty. Painters of Flowers and Fruit* (Leigh-on-Sea, 1960).

257. Ertz 1979, cat. 337, fig. 374.

258. For Seghers and the other Flemish flower painters see Hairs 1985.

259. F. Meijer (see Rotterdam, Museum Boymans-van Beuningen, *Stillevens uit de Gouden eeuw*, 1989, cat. no. 29, note 1) has correctly questioned the attribution to Snyders of the *Dead Game and Fruit Still Life* purportedly signed and dated 1603 (formerly in Galerie Willems, Brussels, 1956; Robels 1989, p. 241, no. 89I, ill).

260. See Robels 1989, cat. 6, ill.

261. See Robels 1989, cats. 14, 110 and 113, ills.

262. See Robels 1989, cat. 16 (Cologne, Wallraf-Richartz-Museum, no. WRM.2894), cat. 17 (Art Institute of Chicago, no. 1981.182), both dated 1614, and cats. 124 (Zurich, Kunsthaus) and 125 (our fig. 96).

263. On Snyders's innovations generally, see Robels 1989; and idem, in Cologne/Vienna 1992-93, pp. 208ff.

264. It must be said however that Robels sometimes is too ready to find "hidden" emblematic meanings in Snyders's market and pantry scenes with still lifes and large figures; see, for example, her comments in Robels 1989, cats. 8, 22, 34, 36, 37, 41 and 42.

265. See P. Huvenne, "Een Vruchtenkrans van Frans Snijders herontdekt," in *Rubens and His World* (Antwerp, 1985), pp. 193-200; also Robels 1989, cats. 170-175, 270, 272-274.

266. See respectively Cologne/Vienna 1992-93, no. 102.1, and Robels 1989, no. 204, pl. VII.

267. On Adriaen van Utrecht, see Greindl 1983, pp. 90-93; and Robels in Cologne/Vienna 1992-93, pp. 204-210, 477.

268. See Díaz Padrón in Madrid, cat. 1975, vol. 1, p. 425, vol. 2, pl. 291; and Balis, in Madrid 1989, no. 81, ill.

269. See the banquet pieces with a page in Munich, Bayerische Staatsgemäldesammlungen, inv. 1805; and Vienna, Kunsthistorisches Museum, no. 389.

270. See Utrecht/Braunschweig 1991, no. 6, ill.

271. See Segal, in Delft/Cambridge/Fort Worth, 1988 p. 146.

272. See cat. 95.

273. See Joachim Oudaen's 1646 poem inspired by a flower painting (quoted by L. O. Goedde, in "A Little World Made Cunningly; Dutch Still Life and Ekphrasis," in exh. Washington/Boston 1989 p. 41), "But Alas! How short a time and the blossom must wither. Yet there is a means whereby the rose will not wither and perish. It will endure in secure colors, planted to measure by Zeuxis's hand, much better than in damp sand."

274. See the *banketje* dated 1651 in a private collection, exh. Utrecht/Braunschweig 1991, cat. 21, ill.

275. Translated by Segal in Delft/Cambridge/Fort Worth 1988, p. 147.

276. The standard work on the literary appreciation of Rubens is Arents 1940. See also Rens 1977, Freedberg 1982, and M. van der Meulen, "Rubens in Holland in de zeventiende eeuw: enige aanvullingen," in *Rubens and His World* (Antwerp, 1985), pp. 307-317.

277. *Hyperbolimaeus, hoc est Elenchus epistolae Josephi Burdonis Pseudo-Scaligeri, de Vestustate et Splendore gentis Scaligeranae* (Mainz, 1607), fol. 110v.

278. Daniël Heinsius, *Poemata* (Leiden, 1621), p. 236.

279. Dominicus Baudius, *Poematum nova editio* (Leiden, 1616), pp. 577-580.

280. See Gerbier's "Lamentation on the Death of Hendrick Goltzius" (*Eer ende Claght Dicht: Ter Eeren van den lofweerdighen constrijcken ende gheleerden Henricus Goltius* [The Hague, 1629]); for discussion see O. Hirschmann, "Balthasar Gerbiers Eer ende Claght-Dight," *Oud-Holland* 38 (1920), pp. 104-125; and Freedberg 1982, pp. 240-256.

281. For A. Roemer Visscher's poem, see Rooses, Ruelens 1887-1909, vol. 2 (1898), pp. 330-331; and see the dedication of Vondel's *Gebroeders* (Amsterdam, 1640).

282. For Huygens's comments in an unpublished autobiography of ca. 1630, see J. A. Worp, "Constantyn Huygens over de schilders van zijn tijd," *Oud Holland* 9 (1891), pp. 118-120; and van Gelder 1977, p. 182.

283. For de Vos see Rooses, Ruelens 1887-1909, vol. 2, p. 208, and for poetic references to Rubens's paintings, see *Alle de Gedichten van Jan Vos* (Amsterdam, 1726), vol. 1, pp. 326, 328, 357, and 362; de Bie 1661, p. 360; and Alexander van Fornenbergh's standardized praise appended to his Life of Quentin Massys (*Den Antwerpschen Protaeus...*) (Antwerp, 1658).

284. See G. Marino, *La Galleria del Cavalier Marino* (Milan, 1620), p. 12; and J. van den Vondel, *Poëzy of Verscheide Gedichten* (Antwerp, 1651), p. 486; see also Marino on Rubens's *Meleager and Atlanta* (1620, p. 10), and de Vos in the note above. For additional examples, see L. Ligo, "Two Seventeenth Century Poems which Link Rubens' Equestrian Portrait of Philip IV to Titian's Equestrian Portrait of Charles V," *Gazette des Beaux-Arts* 75 (1970), pp. 345-354 (citing poems by Francisco Lopez de Zarate and Lope de Vega); and van der Meulen 1985. On *ekphrasis* in Dutch literature, see K. Porteman, "Geschreven met de linkerhand? Letteren tegenover schilderkunst in de Gouden Eeuw," in *Historische letterkunde: facetten en vakbeoefening*, ed. M. Spies (Groningen, 1984),

pp. 103-108; and J. A. Emmens, "Apelles en Apollo: nederlandsche gedichten op schilderijen in de 17de eeuw," in *Kunsthistorische opstellen* (*J. A. Emmens Verzameld Werk*), part 3 (Amsterdam, 1981), pp. 5-60.

285. See Worp 1891, p. 119 ("De multis unam videor mihi perpetuo ob oculos habere, quam inter magnificam supellectilem vir amicus Nic. Sohierus Amstelodami spectandam aliquando exhibuit. Medusae abscissum caput est, anguibus, qui de capillitio nascunter, implicatum. In eo pulcherrimae mulieris gratiosum adhuc et recenti morte tum foedissimorumque reptilium involucro horridum aspectum, tam ineffabili industria miscuit, ut subito terrore perculsum spectatorem [velari n.(empe) tabella solet] ipsa tamen rei diuitate, quod vivida venustaque delectet. Sed haec domi amicorum amicorum potius quam meae laudanti...").

286. For discussion of Huygens's passage and the appreciation of Rubens's "horror," see van Gelder 1977, p. 183.

287. The best brief historiographic review of the literature and Rubens's critical fortune is van Gelder 1977. See also the catalogue of the exhibition held in Antwerp, Archief en Museum voor het Vlaamse Cultuurleven, *De Roem van Rubens*, 18 June-25 September 1977.

288. See B. Teyssèdre, "Une collection française de Rubens au XVIIe siècle: le cabinet du Duc de Richelieu, décrit par Roger de Piles (1676-1681)," *Gazette des Beaux-Arts* 62 (1963), pp. 241-300.

289. See on these and other French artists's responses to Rubens, Providence, RI, Bell Gallery, Brown University, *Rubenism*, 20 January-23 February 1975, pp. 69-107.

290. See *Dialogue sur le Coloris* (Paris, 1673); *Conversations sur la connoissance de la peinture* (Paris, 1677); and *Dissertation sur les ouvrages de plus fameux peintres* (Paris, 1681), which included "La vie de Rubens."

291. On this debate, see F. P. Chambers, *The History of Taste. An Account of the Revolutions of Art Criticism and Theory in Europe* (2nd ed. Westport, 1960), pp. 106-111; and B. Teyssèdre, *Roger de Piles et les débats sur le coloris au siècle de Louis XIV* (Paris, 1965); and J. Thuillier, "Doctrines et querelles en France au XVIIe siècle," *Archives de l'art francais* 23 (1968), pp. 125-217.

292. Although du Fresnoy's comments are generally very complementary, he wrote of Rubens, his "Design savours somewhat more of the Fleming, than the beauty of the Antique; because he stayed not long at Rome...it must be confess'd that generally speaking, he design'd not correctly"; trans. from *The Art of Painting by C. A. de Fresnoy with Remarks: Translated... by Mr. Dryden* (2nd ed. London, 1716), p. 236.

293. On Watteau's studies after Rubens, see the many drawings catalogued by K. T. Parker and J. Mathey, *Antoine Watteau: catalogue complet de son œuvre dessiné*, 2 vols. (Paris, 1957). For discussion, see Providence 1975, pp. 109-145; and O. T. Banks, *Watteau and the North* (New York and London, 1977), with earlier literature.

294. See Providence 1975, pp. 147-152.

295. See L. Réau, "Les Influences flamandes et hollandaises dans l'œuvre de Fragonard," *Revue belge d'architecture et d'histoire d'art* 2 (1932), pp. 16ff; Providence 1975, pp. 152-157; and P. Rosenberg, in Paris, Grand Palais, *Fragonard*, 24 September-4 January 1988 (also shown at New York, Metropolitan Museum of Art, 2 February-8 May 1988), cat. nos. 46, 84, 193, 217, and p. 179, fig. 5, p. 180, fig. 6; and Paris, Galerie Cailleux, *Aspects du Fragonard*, 23 September-7 November 1987, cats. 37 and 38.

296. See E. Munhall, in Hartford, Wadsworth Atheneum, *Jean-Baptiste Greuze (1725-1805)*, 1 December 1976-23 January 1977 (also shown at San Francisco, California Palace of the Legion of Honor, and Dijon, Musée des Beaux-Arts, 1977), cat. no. 25. The memoires of J. G. Wille report that he and Greuze actually climbed a ladder to examine Rubens's paintings in the Luxembourg Palace more closely; see G. Duplessis, *Mémoires et journal du J. G. Wille*, vol. 1 (Paris, 1857), p. 139.

297. E. and J. de Goncourt, *L'Art du XVIIIe siècle*, cited in Providence 1977, p. 11, note 1. For the numerous other eighteenth- and nineteenth-century French artists who made copies of the cycle, see J. Thullier and J. Foucart, *Rubens' Life of Marie de Medici* (New York, 1973), pp. 132-153; and Paris, Musée du Louvre, *Copier Créer. De Turner à Picasso: 300 œuvres inspirées par les maîtres du Louvre*, 26 April-26 July 1993, cat. nos. 38, 43, 44, 47, 50-53, 55-58, 160, 161, 165.

298. See N. A. Mallory, "Rubens y Van Dyck en el arte de Murillo," *Goya. Revista de Arte* 169 (1982), pp. 92-104; A. Pérez Sanchez, in Madrid, Palacio de Villahermosa, *Carreño, Rizi, Herrera, y la pintura Madrileña de su tiempo (1650-1700)*, January-March 1986, pp. 31-33; and J. Brown, *The Golden Age of Painting in Spain* (New Haven/London, 1991), pp. 141, 228-239, 282, 311-312.

299. See J. Hecht, "Bodies by Rubens: Reflections of Flemish Painting in the Work of South German Ivory Carvers," *Metropolitan Museum Journal* 22 (1987), pp. 179-188, with earlier literature. Ivories linked to Rubensian motifs have been attributed to François Duquesnoy (1597-1643), Artus Quellinus the Elder (1609-1688), Lucas Fayd'herbe (1617-1697), and the Augsburg sculptor, Georg Petel (1601/02-1634), and the Petel circle; see G. Glück, "Über Entwürfe von Rubens zu Elfenbeinarbeiten Lucas Faidherbes," *Jahrbuch der kunsthistorisches Sammlungen des allerhöchsten Kaiserhauses* 25, no. 2 (1905), pp. 73-79; W. Kitlitschka, *Rubens und die bildhauerei* (Ph.D. Diss. Vienna, 1963); K. Feuchtmayer and A. Schädler, *Georg Petel* (Berlin, 1973); K. Aschengreen-Piacenti, "Rubens e gli intagliatori di avorio," in M. Gregori, ed., *Rubens e Firenze* (Florence, 1983).

300. William Hogarth, *The Analysis of Beauty* (London, 1753), p. 122. For British artists' responses to Rubens, see C. White, "Rubens and British Art 1630-1790," in *"Sind Briten hier?" Relations between British and Continental Art 1680-1880* (Munich, 1981), pp. 27-43.

301. See White 1981, p. 31.

302. Cited by van Gelder 1977, p. 187.

303. Sir Joshua Reynolds, *Discourses*, ed. Robert R. Wark (San Marino, CA, 1959), p. 86. For a discussion of Reynolds's art theories and concept of Genius as they relate to Rubens, see Providence 1975, p. 184, and van Gelder 1977, p. 188.

304. Ibid.

305. White 1981, p. 42, note 29, citing E. Malone, *The Literary Works of Sir Joshua Reynolds*, vol. 2 (London, 1819), p. 427. On Reynolds's own "Rubenism" see Providence 1975, pp. 179-195.

306. On Gainsborough and Rubens, see John Hayes's article of this title in *Apollo* 78 (1963), pp. 89-97; J. Hayes, *Gainsborough Paintings and Drawings* (Oxford, 1975), pp. 35ff, cats. 51-52, 61-66, 80, 87, 105, 115, 129; and Providence 1975, pp. 197-221.

307. Cited by White 1981, p. 40; see *Anecdotes of Painting in England* (London, 1762), vol. 2, p. 81.

308. See London, The National Gallery, "Noble and Patriotic." The Beaumont Gift 1828, 3 February-3 May 1988, p. 24, plate 12.

309. See T. S. R. Boase, *English Art 1800-1870* (Oxford, 1959), p. 22.

310. Constable wrote of Rubens's landscapes, "In no other branch of the art is Rubens greater than in landscape; - the freshness and dewy light, the joyous and animated character which he has imparted to it, impressing on the level monotonous scenery of Flanders all the richness which belongs to its noblest features. Rubens delighted in phenomenae; - rainbows upon a stormy sky, - bursts of sunshine, - moonlight, - meteors, - and impetuous torrents mingling their sound with wind and wave" (C. R. Leslie, *Memoires of the Life of John Constable, R. A.* [London, 1937], p. 383; for his comments on the companion pieces which "should never be parted" since they "doubtless were painted as a pair to give more effect to it by contrast," see ibid., p. 396). On Constable and Rubens generally, see M. Cormack, *Constable* (Oxford, 1986), p. 77.

311. See H. von Erffa and A. Staley, *The Paintings of Benjamin West* (New Haven and London, 1986), cats. 54-55 and 168, also no. 519. West recommended Rubens's work to his pupils so that they might acquire "a practical knowledge of the happiest manner of distributing...colours according to nature"; see J. Galt, *The Life and Studies of Benjamin West, Esq.*, 2 vols. (London, 1817), vol. 2, p. 115.

312. See D. Evans, *Benjamin West and His American Students* (Washington, D.C. National Portrait Gallery, 1980), pp. 52-54, respec. figs. 35, 34, and 33.

313. See M. Chappel, "A Note on John Smibert's Italian Sojourn," *The Art Bulletin* 64 (1982), pp. 137-138, with additional literature.

314. Although on his visit to the Luxembourg gallery on 3 September 1774, Copley found "the Pictures very unequal in merit," he went on to compliment Rubens's drawing, likening it to "the flow of Homer's Verse," and (no doubt feeling obliged to cast his vote in the ageless debate) stated his preference for the

Fleming's distinct colors over the "one general tint" of Poussin's palette: "you cannot say [Rubens's] picture is of any one colour, so happily he has divided his colours over his picture"; see *Letters & Papers of John Singleton Copley and Henry Pelham 1739-1776* (New York, 1970), p. 250. One of the first paintings Trumbull executed at Harvard was a watercolor *Crucifixion* from a print by Rubens; see T. Sizer, *The Works of Colonel John Trumbull. Artist of the American Revolutions* (New Haven, 1950), p. 15, and for Trumbull's later appreciation of the artist, pp. 119-120; also H. Cooper et al., *John Trumbull. The Hand and Spirit of a Painter* (New Haven, Yale University Art Gallery, 1982), pp. 235-236.

315. Quoted in London 1988, p. 24 (see note 308 above).

316. See E. Delacroix, *Correspondance générale*, ed. Joubin, vol. 1 (Paris, 1935), p. 166.

317. See van Gelder 1977, p. 189, citing Diderot's letter to Falconet in J. Seznec, *Essais sur Diderot et l'antiquité* (Oxford, 1957), pp. 72-76.

318. See H. Vey, "Zeugnisse der Rubens-Verehrung in Köln während des 19. Jahrhunderts," *Wallraf-Richartz-Jahrbuch 13* (1969), pp. 93-134.

319. See O. Bock von Wülfingen, *Rubens in der deutschen Kunstbetrachtung* (Berlin, 1947), pp. 40-42, 49, 58, 65, and van Gelder 1977, pp. 190-192.

320. Ibid., p. 38; see also A. Schulz and George Forster, *Studie zur Quellen-geschichte der Romantik* (Cologne, 1930).

321. See Antwerp, *De Roem van Rubens*, 1977, pp. 23-27.

322. Ibid.; see also C. Picot, *Rapport à Mr. le Ministre de l'Intérieur sur les tableaux enlevés à la Belgique en 1794 et restitués en 1815* (Paris, 1883); and J. van den Nieuwenhuysen, "Antwerpse schiderijen te Paris (1794-1815)," *Antwerpen 8* (1962), pp. 66-77.

323. On van Brée see A. Monballieu, "M. I. van Brée en de restauratie van Rubens' schilderijen in het Museum van Antwerpen," *Jaarboek van het Koninklijk Museum voor Schone Kunsten, Antwerpen* 1977, pp. 325-359; G. Jansen, "De vergankelijke glorie van Matthijs van Brée (1773-1839)," *Oud Holland 95* (1981), pp. 228-257; and A. Repp-Eckert, "Peter Paul Rubens – Ein Vorbild für die belgischen Historienmaler?," in Cologne, Wallraf-Richartz-Museum, *Triumph und Tod des Helden. Europäische Historienmalerei von Rubens bis Manet* (30 October 1987-10 January 1988), (also shown at Zurich, Kunsthaus, and Lyon, Musée des Beaux-Arts, 1988), pp. 54-64.

324. Jansen 1981, p. 254.

325. Ibid. 1981, p. 238, fig. 9.

326. See L. E. A. Eitner, *Géricault, His Life and Work* (London, n.d. ca. 1983), p. 24, fig. 16, also p. 325, note 58. Géricault also copied van Dyck's Saventhem altarpiece of the mounted *St. Martin Dividing His Cloak* and his *Equestrian Portrait of François Moncada*.

327. See Eitner (ca. 1983), p. 232.

328. See L. Eitner, "Dessins de Géricault d'après Rubens et la génèse du *Radeau de la Méduse*," *Revue de l'Art 14* (1971), pp. 51-56; and Providence 1975, no. 55.

329. H. Wellington ed., *The Journal of Eugène Delacroix* (trans. L. Norton) (New York, 1980), p. 134; see also his entry for 20 October 1853, p. 199.

330. See B. White, "Delacroix's Painted Copies after Rubens," *Art Bulletin 49* (1967), pp. 37-48; Providence 1975, pp. 241-273; and L. Johnson, *The Paintings of Eugène Delacroix* vols. 1-6 (1981-89), vol. 2 (1981) cat. nos. 15-20, pls. 12-17, nos. D3-D5, pls. 164-165, nos. L24-L31, nos. R6-R22, pls. 166-168; vol. 4 (1986) cats. 163-166, pls. 1-3, nos. L117-119, no. D4 and no. R10.

331. See also, as an example, Delacroix's copy of Rubens's *Henry IV Conferring the Regency upon Marie de' Medici* from the Medici series, in the Los Angeles County Musuem, no. P306.58-3; see Johnson 1981-89, vol. 2, no. 20, pl. 14; and R. Brown, "A Study after Rubens by Delacroix," *Bulletin of the Los Angeles County Museum 10, no. 2* (1958), pp. 3-7.

332. See L. Hourticq, "Rubens et Delacroix," *La Revue de l'art ancien et moderne 26* (1909), pp. 222-228; see also E. Lambert, "Delacroix et Rubens: La Justice de Trajan et l'Elevation de la Croix d'Anvers," *Gazette des Beaux-Arts 74* (1932) pp. 248ff; and Providence 1975, pp. 241-253.

333. Wellington ed., *Journal* 1980, p. 199 (dated 20 October 1853).

334. Ibid., p. 406 (21 October 1860). It is noteworthy, however, that among Delacroix's numerous comments about Rubens, he also perpetuates the traditional view of the artist's infelicities in

design; writing about a photographic reproduction of the *Descent from the Cross* he noted it "interested me greatly; the inaccuracies are more apparent when they are no longer saved by execution and color" (*Journal*, p. 211, 24 November 1853).

335. See E. Twose Kliman, "Delacroix's Lions and Tigers: A Link between Man and Nature," *Art Bulletin 64* (1982), pp. 446-464, respectively figs. 34-36.

336. See R. Ormond in Philadelphia, Philadelphia Museum of Art, *Sir Edwin Landseer*, 25 October 1981-3 January 1982 (also shown at the Tate Gallery, London, 10 February-12 April 1982), pp. 26-27, figs. 27, and cat. no. 23.

337. Ibid., figs. 26 and 35. In his second lecture on the Art of the Moderns, Fuseli reiterated Reynolds's notion that Rubens and Rembrandt were exceptional geniuses, "both of whom, disdaining to acknowledge the usual laws of admission to the temple of fame, boldly forged their own keys, entered and took possession each of a most conspicuous place, by his own power"; see R. N. Wornum ed., *Lecturers on Painting by the Royal Academicians* (London, 1848), p. 401. On Henri Fuseli, see New York/Washington 1972, pp. 51, 102.

338. See T. Reff, "Copyists in the Louvre, 1850-1890," *Art Bulletin 46* (1964), pp. 552-559. F. Bazille wrote to his father in 1863 of making a *croute* (slang for poor painting) after a Rubens in the Louvre; "It is atrocious, but I am not discouraged."

339. See B. E. White, *Renoir. His Life, Art and Letters* (New York, 1984), p. 13. His copy of the central motif of Rubens's *Hélène Fourment with Her Son* of ca. 1860-1864 in the Louvre (private collection, ill. White 1984, p. 14) also survives.

340. See Philadelphia, Philadelphia Museum of Art, *Paul Cézanne. Two Sketchbooks. The Gift of Mr. and Mrs. Walter H. Annenberg* (cat. by T. Reff and I. H. Shoemaker), 1989, p. 22 and under the discussion of sketchbook no. 2, p. xxxix, verso.

341. For Cézanne's drawings after Rubens, see A. Chappuis, *The Drawings of Paul Cézanne* (Greenwich, 1973), cats. 102, 311, 369, 455-457, 489-490, 593-598, 627, 677, 721, 832, 1007, 1114, 1025, 1130, 1208-1209, 1138-1140; and Paris 1993, cats. 50-53, 55-58.

342. J. Rewald, *Paul Cézanne. A Biography* (New York, 1986) p. 201.

343. See M. Howard, *Cézanne* (London, 1990), p. 133.

344. See A. Gilchrist, *Life of William Etty, R.A.* (reprint, London, 1978), p. 210.

345. See *Didier Aaron Catalogue* (Paris/London/New York, 1992), no. 24, ill., where it is stated that the painting commemorated the flood of 1910 in Paris; and Paris 1993, no. 17.

346. See M. Fried, "Manet's Sources," *Art Forum 7* (1969), pp. 52-53; and A. C. Hanson, *Manet and the Modern Tradition* (New Haven/ London, 1977), pp. 43-44.

347. C. Sterling, in Paris, Orangerie des Tuilleries, *Retrospective Manet*, 1932, pp. 12-13; N. G. Sandblad, *Manet. Three Studies in Artistic Conception* (Lund, 1954), pp. 43-44; and Paris 1993, cat. 316.

348. See *Letters of Vincent van Gogh to His Brother 1872-1886*, 3 vols., (Boston/New York, 1928), vol. 2, letter no. 439.

349. Ibid., letter no. 444.

350. See, for example, *Young Woman with a Red Bow*, 1885, private collection; J. B. de la Faille, *Vincent van Gogh* (Paris, 1939), no. 223; and Boston, Museum of Fine Arts, *Prized Possessions: European Paintings from Private Collections of Friends of the Museum of Fine Arts*, Boston, 17 June-17 August 1992, no. 61, pl. 141.

351. See G. Hendricks, *The Life and Work of Thomas Eakins* (New York, 1974), pp. 57-58.

352. J. L. Sweeney ed., *The Painter's Eye. Notes and Essays on the Pictorial Arts by Henry James* (London, 1956), p. 119.

353. Ibid. p. 129.

354. Sargent copied Rubens and included him in his pantheon of the greatest artists; see R. Ormond, *John Singer Sargent. Paintings, Drawings, Watercolors* (New York, Evanston, 1970), p. 27. On Levine's allusions to Rubens's *Three Graces* (Madrid, Museo del Prado) in his own version of the theme (Midtown Galleries, N.Y., 1959) see S. R. Frankel ed., *Jack Levine* (with commentaries by the artist) (New York, 1989), p. 91, ill. A poem which appeared in an American periodical, *The Art Digest 11, no. 17* (1937), by George J. Cox offered a doggerel appreciation of Rubens while alluding satirically to modern viewers' biases about his nude *The Three Graces* by Rubens: "Rubens, you painted in a robust age / before pale aesthetes were emasculated / and artists reached that intro-

verted stage / that craves its nudes pneumatic or deflated. / You lived when human greatness was the theme / of poets / Yet from life not disconnected, / and even pious patrons did not dream / of loves with dietary fads connected. / And if this age of orange juice and yeast / must shun rich proteins you assimilated / its eyes at least may still contrive to feast / on the exuberance of flesh you recreated – / not all regretful fashion has decreased / the ample Grace your brushes demonstrated."

355. See respectively, London, Hayward Gallery, *Renoir* (cat. by J. House et al.), 30 January-31 April 1985 (also shown in Paris, Grand Palais, and Boston, Museum of Fine Arts, 1985-1986), cat. nos. 108 and 119, ill.

356. First proposed by J. Masheck ("Guernica as Art History," *Art News* 66 [1967], pp. 32-35, 65-68); see now A. D. Tankard, *Picasso's 'Guernica' after Rubens's 'Horrors of War'* (Philadelphia, 1984), and E. C. Oppler ed., *Picasso's Guernica* (New York/London, 1988), pp. 87, 150, 306-307.

357. See Rome, Galleria Nazionale d'Arte Moderna, *Giorgio de Chirico* (1888-1978), 1 November 1981-3 January 1982, cat. no. 123.

358. See A. Fornari, "De Chirico e Rubens," *Paragone* 1 (1950), pp. 45-47, fig. 19b.

Fig. 1. Antoon Wierix, after Maerten van Cleve,
"De Verkeerde Wereld," ca. 1579, Antwerp, Stedelijk
Prentenkabinet, inv. 17.737.

Fig. 2. Herman Muller after Guillaume Tybaut,
The Landsknecht and the Peasant, engraving, Antwerp,
Stedelijk Prentenkabinet, inv. 15.111.

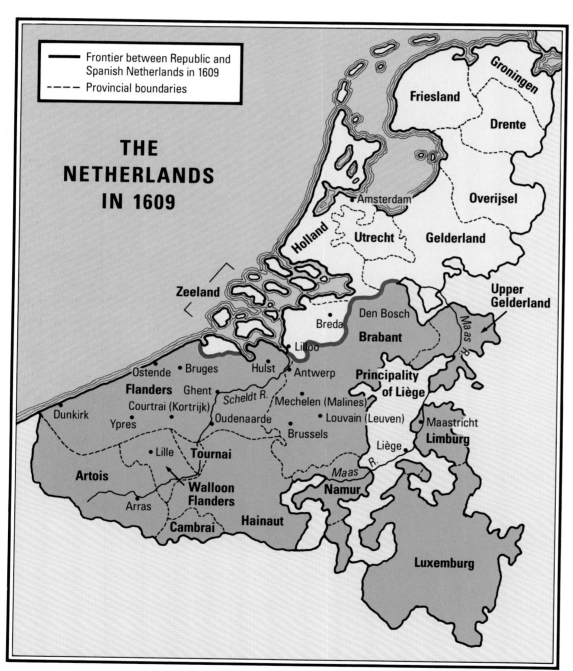

Fig. 3. Map of the Southern and Northern
Netherlands.

The Spanish Netherlands in the Age of Rubens

PETER C. SUTTON

"We are exhausted not so much by the trials of war as by the perpetual difficulty of obtaining necessary supplies from Spain, by the dire need in which we constantly find ourselves, and by the insults we must endure through the spitefulness or ignorance of these ministers, and finally by the impossibility of acting otherwise."

As RUBENS reported in exasperation in 1627, the seventeenth century was a period of humiliating foreign domination and frustration for citizens of the Southern Netherlands.[1] Throughout the artist's life, his homeland was ruled by the Spanish Hapsburgs, who were half-heartedly waging a losing war with the rebellious United Provinces to the north. During this same period the country served repeatedly as the unwilling battlefield for disputes fought among its more powerful neighbors. These bloody engagements usually involved the occupying Spanish forces, but also armies from Germany, long engulfed in the Thirty Years War, and, especially later in the century, from the ever-menacing and expansionist France. In the sixteenth century, Hapsburg Spain had been unrivaled as the most powerful state in western Europe, but by the dawn of Rubens's century its far-flung empire – spanning from Vienna and Bohemia in the east, to Milan and Savoy, Portugal and Sicily, settlements throughout the New World, and, of course, Antwerp and the Low Countries – had exceeded the limits of their vigilance and resources. During much of the seventeenth century, Spain was not so much a despotic ruler as a maladroit and distracted custodian, constantly shifting its resources and commitments as the global political landscape changed.

There was no question for Philip II (r. 1566-1598) and the Spanish court that the Protestant revolt in the Netherlands, which had produced the hysteric Iconoclasm of 1566, had to be crushed. Breaking the Protestants' will was an essential step in realizing the king's ambition of world monarchy. Thus he dispatched to the Netherlands the brutal Duke of Alba (1507-1582), who to this day is infamous for the sacking of Mechelen, the massacre of the people of Naarden, and a series of ferocious sieges in Holland. But Philip and his successors also had other anxieties: the Turks in the Mediterranean, the defense of Italy and Bohemia, the temptation to invade England, and Spain's constant and ultimately greatest fear, the containment of France, all of which usually took priority over the war in the Netherlands. Thus it was that the two ill-matched adversaries, mighty Spain and the seven small rebellious provinces of the Northern Netherlands, came to fight the longest war in modern European history (August 1566-January 1648) – a war fought to dismaying extent within the Spanish Netherlands' shifting borders, and repeatedly protracted by Spain's failure of will and purse.[2]

Just prior to Rubens's birth in 1577, the Spanish had fought the far-away insurgents in the Netherlands to a virtual standstill, but at a cost which, when added to the price of securing the eastern Mediterranean, threatened to bankrupt the treasury in Madrid. Philip recklessly repudiated his debts in 1575, thus forfeiting the machinery of credit and exchange which had enabled him to pay his troops in the field. In November 1576, mutinous Spanish soldiers unleashed the hideous "Spanish Fury." In the wake of these atrocities, Philip was forced to make concessions; the Pacification of Ghent (1576) seemed to promise the restoration of peace and unity by suspending the edict against the Protestant heresy. With its army still unpaid, Spain briefly had to admit defeat in February of 1577, but resumed its deadly assault on the Protestant "Beggars" (*Geuzen, Gueux*) scarcely six months later. The distressing situation thus created in the Netherlands was satirized in a series of prints that Antoon Wierix seems to have engraved in 1579. In one of these (fig. 1), inscribed both in Dutch "De Verkeerde Weerelt," and in French "Le Monde à rebous" (the Upside Down or Topsy-Turvy World), allegorical figures appear before a broad landscape; on the left Hypocrisy and Tyranny stand to either side of an overturned and tethered globe or monarch's

orb, while in the center the personification of Charity has fallen asleep neglecting her charges, and on the right, Time points to an open book resting on a socle with a death's head. The rebus on the book's two open pages admonishes the viewer to learn these ominous lessons well.[3]

Reconquest and Political Stabilization

To defend his claim on the Netherlands, Philip at last wisely sent Alexander Farnese (1545-1592; later Duke of Parma and Piacenza) to be Governor General (1578-1592). Farnese had been educated and trained as a soldier in Spain but had spent his youth in Brussels. Unlike the beastly Alba, he had few punitive instincts and little of the religious zealotry of his Spanish predecessors. Farnese established the Union of Arras in 1579, which formed the core of the Southern or Spanish Netherlands, and which was countered by the rebels' Union of Utrecht in the same year. The latter formally split the seventeen provinces of the original Netherlands, creating the Protestant Dutch Republic in the North, which at first still included Antwerp, Ghent, and Bruges. However, Farnese soon took the initiative. Following his important victory at Gembloux in 1578, he successively reconquered Tournai (Doornik), Maastricht, Breda, Bruges, and, after a lengthy siege, finally forced the largest and wealthiest city in the region, Antwerp, to surrender in 1585. The citizens capitulated only out of famine. Farnese pushed on into Flemish Zeeland, and further north into Brabant and Gelderland. But by this time his aging sovereign, Philip, had turned his attentions and resources to his ill-fated Armada, convinced that the English were to be blamed for the obduracy of the Dutch rebels. Philip also was increasingly distracted by events in France (the Protestant threat and the ascendancy of Henry of Navarre in 1589). Thus a crucial moment passed when Spain had the momentum to reconquer the region. Shortly thereafter the son of the murdered Dutch stadholder William the Silent, Maurits of Orange-Nassau (1567-1627), managed to reorganize resistance in the northern provinces.

The price paid by the ordinary citizenry during the ongoing hostilities was enormous. Even the battle-hardened Farnese was moved to write in 1586, "It is the saddest thing in the world to see what these people are suffering; this country is ravaged by the king's troops as well as by those of their enemies."[4] Antwerp lost more than one half of its population between 1568 (105,000) and 1589 (42,000), and the larger cities in Brabant, such as Mechelen, Leuven, Lier, and Turnhout suffered comparable loses.[5] The mortality and displacement in the countryside was no less devastating. Each spring's thaw brought marauding soldiers, who commandeered crops, livestock, and fodder, bivouacking until the first frost. Late sixteenth-century prints, like Herman Muller's image of *The Landsknecht and the Peasant* (fig. 2), juxtapose these ancient adversaries (likened in the legend to Cain and Abel) before a scene of soldiers burning and looting a farm.[6] In the face of growing pessimism from the Spanish commanders, by 1589 the Council of State regarded the hostilities with the rebels as a war without end. Farnese nonetheless had successfully brought political stabilization to the country, which would consist of ten provinces: four duchies (Brabant, Limburg, Luxemburg, and Upper Gelderland), four earldoms (Flanders, Artois, Hainaut, and Namur), and two seigniories (Mechelen and Tournai); see map (fig. 3). An essential problem from the onset for the creation of a sense of national unity in this conglomeration was the absence of any linguistic unity. In Flanders, Brabant, and Gelderland they spoke Dutch, in the Walloon provinces French, and in parts of Namur and Luxemburg, German. The political divisions had not been drawn along ethnic, cultural, or even religious lines, but arose out of a strategic stalemate created by the geography of the region; the rivers, lakes, and swamps became the boundaries simply because they offered natural defenses.

"Reconciliatie" and the Archdukes

Having tried vindictiveness without success, Philip sought a new style of governance, appointing Archduke Albert (1559-1621) to be Governor General of the Spanish Netherlands in 1598. Albert had had a varied career. A cardinal at age eighteen and later archbishop of Toledo, he received his military training under the ruthless Alba but had served with diplomatic agility as viceroy to Portugal. He was a devout man of grave demeanor (see fig. 4), who proved to be both an able administrator and general. In this latter capacity he took Calais and Hulst in 1590, and later successfully repulsed Maurits's advances into the Spanish dominions. Upon Albert's marriage in

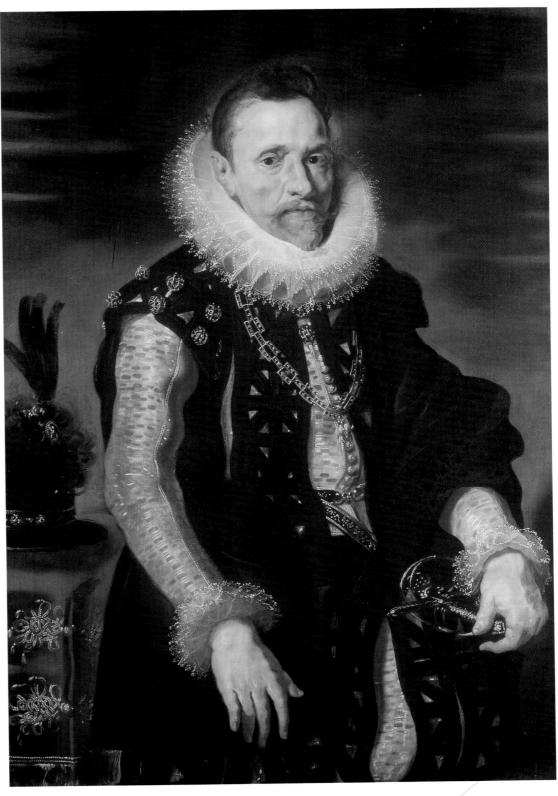

Fig. 4. Peter Paul Rubens, *Portrait of Archduke Albert*,
1609, oil on panel, 105 x 74 cm, Vienna,
Kunsthistorisches Museum, inv. 6344.

1599 to Philip's favorite daughter, Isabella Clara Eugenia (1566-1633; see fig. 5), the king ceded the appanage of the Southern Netherlands and the Franche-Comté to Isabella. Isabella shared her husband's piety as well as his sincere sense of duty. Over the next two decades this reserved but sympathetic couple managed to restore in part the regional economy as well as impart a nascent sense of nationalism, a guarded optimism and, most significantly, a sense of purpose in the otherwise discouraged populace of the region.[7] They did this not with their predecessors' techniques, by attempting to "hispanicize" Flanders, but by seeking to forge a Catholic nation – a citadel, or, as it has been called, a bulwark for the religious war. To the details of this remarkable campaign we will return shortly.

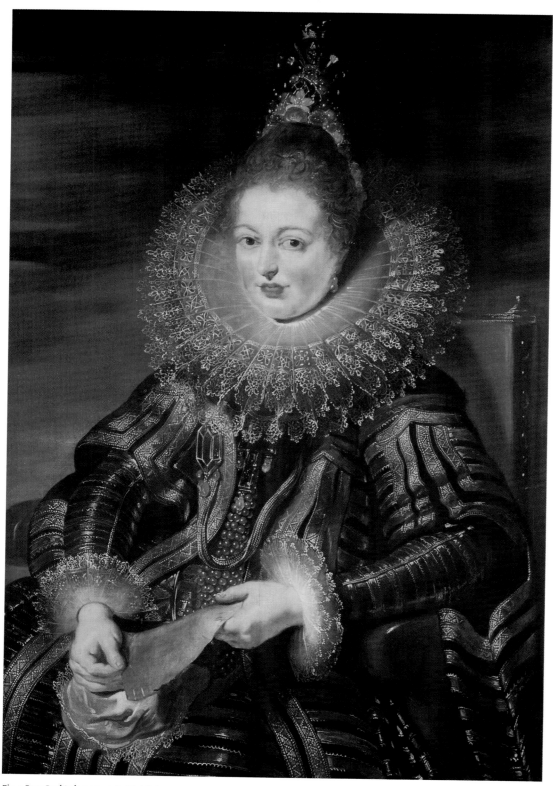

Fig. 5. Peter Paul Rubens, *Portrait of Archduchess
Isabella Clara Eugenia*, 1609, oil on panel, 105 x 74 cm,
Vienna, Kunsthistorisches Museum, inv. 6345.

It is useful here however to consider the Spanish Netherlands within the larger European context. At the moment of the triumphal entry of the newly married archdukes into Antwerp in 1599 (see fig. 6), the official religion in approximately one half of Europe was Protestantism; but by 1650 only one fifth of the continent remained so, the other regions having reconverted to Catholicism.[8] Much of the history of the first half of the seventeenth century in Europe, therefore, is a tale of resurgent Roman Catholicism. The ruthless persecution of Protestants in Hapsburg lands (the hectored Poles, for example, reverted *en masse* to the religion of their grandfathers) and in France, where Huguenots won their religious liberty with the Edict of Nantes in 1598 but were not permitted to seek new converts (especially after Henry IV found it politically expedient

to convert to Catholicism in 1593), is only part of the story. Despite the best efforts of the Synod of Dordrecht to reconcile the Calvinists and Lutherans, the increasing sectarianism of the Protestants also worked to the Catholics' advantage, as did a new political strategy borrowed from the Protestant reformers: namely to concentrate one's persuasive energies on the nobility – convert the princes first. Many powerful and unusually devout rulers emerged in this period: Sigismund III of Poland (r. 1587-1632), Louis XIII of France (r. 1610-1643), Maximilian of Bavaria (r. 1564-1576), and Ferdinand II of Styria (r. 1619-1637) all fought to restore Catholicism, using the righteous weapons of politics against the Protestants. Other regents who were more important as intellectual and cultural patrons, like Christina of Sweden (1626-1689, r. 1632-1654), also converted to Catholicism.

Fig. 8. Peter Paul Rubens, *Portrait of Ambrogio Spinola*, 1625, oil on panel, 117 x 85 cm, Braunschweig, Herzog Anton Ulrich-Museum, inv. no. 85.

The unshakable devotion of the archdukes to the Catholic faith was surely a crucial factor in their appointment as governors of the Spanish Netherlands. But in truth, secret clauses in the act of cession indentured the archdukes to Madrid. They not only had to obey the king, who retained the right to reannex the country if Isabella (aged thirty-three at marriage) died without issue, but also had to maintain Spanish garrisons in Antwerp, Ghent, Courtrai, and elsewhere. Despite these humiliations, the archdukes enjoyed a modicum of autonomy and important prerogatives: to make laws and administer justice, to print money, and to receive ambassadors. Like other successful Catholic leaders, the archdukes shrewdly appointed local nobles and members of the elite and upper bourgeoisie to important military and civil posts. Even the States General, long suspended by the Spanish, was briefly reconvened in 1600. Most importantly, they sincerely sought to convert and educate the populace.

Since the fall of Antwerp in 1584, the rebels had closed the Scheldt river, blocking the great commercial center's access to the sea and severely constricting trade. As Abraham Janssens's allegory of the city and its river convey through personification (fig. 7), Antwerp's prosperity was in no small measure dependent upon the Scheldt. Estimates suggest that shipping on the river was reduced to less than one quarter of its former volume.[9] Amsterdam's rise as a great trading center was clearly at Antwerp's expense. The siege of Ostend, undertaken in 1601 by the archdukes' resourceful new military commander, Ambrogio Spinola (see fig. 8), was designed to ensure free passage to the North Sea for a newly landlocked Antwerp. Although attempts to establish alternative trade routes through Flanders ultimately met with resistance from Ghent and Bruges, Spinola's campaign was a success. Following this victory, he led his freshly provisioned Spanish army to a series of triumphs, which, when coupled with Philip III's (r. 1598-1621) temporary peace treaties with England and France, brought the increasingly isolated and fearful Dutch rebels to the bargaining table, where in April 1609 the Twelve Year Truce was concluded.

Fig. 7. Abraham Janssens, *Scaldis en Antverpia*, ca. 1609, oil on panel, 174 x 308 cm, Antwerp, Koninklijk Museum voor Schone Kunsten, no. 212.

Fig. 6. Pieter van der Borcht, *Triumphal Entry of Albert and Isabella into Antwerp in 1599*, etching, Antwerp, Stedelijk Prentenkabinet, inv. 17.937.

Twelve Year Truce

Though it brought a welcome relief from the fighting, the terms of the treaty were scarcely favorable to the Southern Netherlands: although Philip III agreed to recognize the United Provinces as "free lands," and permitted the Dutch to pursue trade in the West Indies, the blockade of the Scheldt was to stand and the traders of the Southern Netherlands were not permitted to pursue

New World markets. The Dutch nation, however, prospered during the truce, extending their geographic and commercial reach across the globe, establishing trade routes and settlements, for example, in northeast Brazil. In the war with the Netherlands, this expansion raised the stakes for the Spanish, who feared that the successes of the Dutch would expose their weaknesses and compromise their stature as a world power. Consequently when the fighting resumed in 1621, it was not only about "religion and reputation" (the terms used to describe the dispute by the powerful Spanish minister, Olivares, as late as 1628) but also about the damage that the Dutch inflicted on Spanish trade in the West Indies and America.

Philip IV (r. 1621-1665) was intent upon crushing the United Provinces, conquering Brazil, and establishing a monopoly over New World trade. Able again to focus briefly on the Netherland-ish theater, Madrid sent substantial new support to Spinola, who had a series of new successes, highlighted by his conquest in 1625 of Breda, the seat of the House of Orange (fig. 9). In the period 1621-1627 Spain also waged successful economic warfare against the Dutch Republic, closing Iberian ports to Dutch shipping and seriously hampering Dutch trade elsewhere. Bahia in Brazil tellingly fell to the Spanish in this period. However, the reconquest of the Netherlands once again was postponed by the war of the Mantuan Succession (1627-1631), which prompted Philip IV to send an army to Lombardy. He only restored his support to the army of Flanders in 1631, at the outset of a decade when the Spanish would suffer domestically from plague and famine. The Dutch once again could recover and soon were on the assault, taking Venlo, 's-Hertogenbosch, and Maastricht. Indeed in 1632-1633 reunion with the Northern provinces again briefly seemed possible, when the Stadholder Frederick Hendrick (r. 1625-1647) was making his seasonal onslaught and both the nobility (the Duke Aerschot) and the clergy (the Archbishop of Mechelen) – two groups traditionally opposed to reunion – came out forcefully in favor of the move. Isabella, coaxing the sulking aristocrats back from their estates, even reconvened the States General in September 1632 for the first time since 1600, an act that her nephew, the king, regarded as tantamount to sedition. However Isabella died the following year and resistance to reunion grew, this time fueled most vociferously in the north by Calvinist *predikants* and other religious leaders. Again a crucial opportunity for a peaceful rapprochement had passed.

Fig. 9. Pieter Snayers?, *Landscape with Horsemen at the Siege of Breda*, oil on canvas, 140 x 226 cm, Madrid, Museo del Prado, inv. 1748.

In 1634 Philip sent his brother Cardinal Infante Ferdinand (1609-1641) (fig. 10), to the Spanish Netherlands as the new governor. In short order, the Cardinal Infante led a campaign against Swedish protestant troops in Germany's Thirty Years War, marched into France (who declared war on Spain in 1635) as far as Pontoise near Paris, and was finally called upon to attack the Dutch, then briefly allied with the French. Making his triumphal entry into Antwerp in 1635 (see cat. 33), crowned with laurels of Nordlingen, Ferdinand sparked genuine Catholic enthusiasm for the Hapsburg cause. Indeed it is a testament to the success of the archdukes' religious and educational campaigns as well as the people's love of the archduchess and her galant young successor that the popular commitment to Catholicism was never in doubt and, throughout all of the hardships, there never was a truly significant social uprising.

Spanish funding of the campaign in the Southern Netherlands peaked in 1637, by which time the financial strains of fighting on several fronts on land and sea began to threaten the very cohesion of the Hapsburg empire. Even on the Iberian peninsula, where rebellions flared in Catalonia and Portugal, it was no longer apparent that Madrid could hold the center. France's siege of Cambrai, sturdily defended by Walloon regiments, followed by their decisive defeat of the Spanish infantry at Rochroy in 1643 and the routing of the Spanish fleet off Cartegena in the same year, sent a desperate Philip IV to talk peace with the Dutch Republic. Holland too wanted peace, chiefly for economic reasons but also because they were increasingly anxious about the French themselves. The Treaty of Münster of 1648 (fig. 11) at last brought de jure peace, but conceded to the United Provinces not only their independence but also territories in northern Brabant, Flemish Zeeland, and elsewhere. It tragically left the Scheldt permanently closed, failed to regain control of trade for the Spanish Netherlands in the East Indies, and did not even secure official tolerance of Catholics in the United Provinces. Following the Treaty of Münster, the Southern Netherlands entered into a gradual decline which accelerated following the death of Philip IV in 1665.

During much of the latter half of the century the history of the Spanish Netherlands was determined by the absolutist ambitions of Louis XIV (r. 1643-1715), who scarcely gave warning before marching his troops through the country. In 1635 Holland and France mutually vowed not to make a separate peace with Spain, and later secretly negotiated an agreement to partition the Southern Netherlands. However Holland's political intrigues only served to usher in the era of French expansion which ironically forced the pragmatic Dutch to join Spain in the South's defense and ultimately brought the French invasion of the Netherlands in 1672, the famous Rampjaar (Year of Calamity). In retrospect, the Treaty of 1635 brought the Netherlands greater ruin than any other single alliance. Louis XIV annexed large portions of the Southern Netherlands before going to war in earnest with the Dutch who never again recovered central stage in Europe. Again in 1683, when Spain and France both declared war, the Southern Netherlands had to endure invasion, bombardment, and systematic terror. Concluding the War of the Spanish Succession, the Peace of Utrecht in 1713 finally assigned the region to Austria. Much of the political history of the Southern Netherlands in the seventeenth century, therefore, is one of turmoil, suffering, and foreign manipulation, but another story is told by the social and cultural history.

Fig. 10. Peter Paul Rubens, *Portrait of Archduke Ferdinand*, 1635, oil on canvas, 116.2 x 94 cm, Sarasota, Florida, The John and Mable Ringling Museum of Art, no. 626.

Fig. 11. Wenceslas Hollar, *Proclamation of the Treaty of Münster*, etching.

Exodus and Indian Summer

When Farnese occupied Antwerp in 1584 he immediately evicted all Protestants from the municipal government and local militia, but granted citizens four years to either convert or leave the country. This period of grace for Protestants to liquidate their affairs might seem humane, but it was not without official self-interest; a gradual transition ensured that the textile industry and other valuable businesses, though gravely injured, might survive. In other less strategic cities the deadline for conversion was sooner: Ghent's citizens were given two years, Nieuwpoort's six months, and Ypres's only three.[10] The result was a massive exodus. By 1589, nearly 100,000 South Netherlanders had emigrated north. Among these emigrants were not only skilled workers who helped build up Holland's textile industries but also leading entrepreneurs, industrialists, merchants, and businessmen, including, for example, Jacques and Daniel Le Maire, eventually Directors of the Dutch West India Company, and William Usselincx, founder of the Dutch East India Company. The flight of wealth was equally severe; as much as 57 percent of the capital used to establish the East India Company was Flemish in origin. Prominent humanists and intellectuals also took flight. Leiden University's faculty, for example, greatly benefited, acquiring Justus Lipsius (1547-1606), the philosophical mentor of both Rubens and his brother (see Introduction, fig. 12 and White, fig. 2), Bonaventura Vulcanius, and Jozef Justus Scaliger, while other leading South Netherlandish thinkers, such as Carolus Clusius, Caspar Barlaeus, and Daniël Heinsius, soon followed on the route north.[11] In addition, legions of craftsmen and artists emigrated – Karel van Mander, David Vinckboons, and Frans Hals, to name but three.[12] Not only the "brain drain" but also the loss of such diverse talent was debilitating. Overall, Brabantine cities that had previously claimed at least 10,000 inhabitants lost more than 40 percent of their population between 1565 and 1600.[13]

However, already by 1590 Bishop Torrentius could report to Rome that the citizens were beginning to return to Antwerp and that they had made six thousand converts in that city.[14] From a low point of 42,000 in 1589, the city's population rose to 46,000 by 1591, to 54,000 in 1612, and to a high of 67,000 in 1640.[15] While the city stagnated thereafter and did not recover the bustling 100,000 inhabitants it had enjoyed in 1565 during the closing hours of "Antwerp's Golden Age," one can legitimately speak of a partial renewal or *herleven*. With it also came a modest commercial revival.[16] With the Scheldt closed, Antwerp was no longer the *Mercatorum Emporium* of Renaissance commercial legend, but continued to function as an important disposition center for trade. Overland trade routes converged there from Germany, France, and Italy, and some waterborne shipments from Antwerp were transferred at the border marked by the States General's Fort at Lillo to larger Dutch vessels, as the political enemy became the commercial exporter. So many local merchants and firms had recently emigrated to foreign trading centers (primarily to Amsterdam, but also Cologne, Hamburg, Paris, London, Venice, and many other cities) that Antwerp's traders had an enviable network of contacts. Estimates suggest that as many as 500 Antwerp merchants were active in foreign trade in ca. 1630-1640.[17] Domestic and interregional trade also continued in manufactured goods, food stuffs, raw materials, and fuel (notably timber, charcoal, and peat); indeed some historians have argued that the Southern Netherlands's economy became increasingly autarkic.[18] Once the most important banking center north of the Alps, Antwerp's financial and brokerage businesses also rebounded to some degree, as the city's shrewd middlemen made money from commissions, bills of exchange, and brokerage fees. The fastest growing new trading networks were with Spain; indeed though it might still operate out of North Sea ports, the Southern Netherlands became in some real economic regard a Mediterranean commercial center. Philip IV even established in 1624 the *Almirantazgo*, a special arrangement designed to promote trade between Spain and the Southern Netherlands. But the benefits scarcely offset the loss of so many other trading contacts. Communications also remained difficult (it took a minimum of two and a half weeks for a letter to reach Brussels from Madrid), and convoys leaving Ostend and Dunkirk were constantly badgered by Dutch and French corsairs. (Although it should be recollected that the audacious privateers of Dunkirk, who were indulged by the Spanish, sank as many as 200 Dutch vessels in 1632 alone.)

Textiles remained the Southern Netherlands's primary industry, diversifying and even expanding in some cities over the course of the century. About 26 percent of Antwerp's popula-

tion was employed in the textile industry in 1650, a sizable increase in proportion to the (diminished) population.[19] Brussels, Leuven, and Mechelen were also major textile centers. As traditional businesses such as cloth dying and finishing became less important, Antwerp's textile industry developed new specialties, such as silk and linen weaving.[20] In this regard the city's adaptable industrialists joined the merchants and traders in shifting their products to luxury-oriented goods. The production of passementerie alone, for example, employed as many as 800 people in Antwerp at mid-century.[21] To silk weaving was added, after 1630, the production of velvet, armozeen (a heavy silk, often black in color), and taffeta. Tapestry manufacturing flourished not only in Antwerp but also Oudenaarde and Brussels.

As the capital and residential court city, Brussels was, of course, exceptional among Brabantine urban centers. It was the only major city in Brabant to enjoy substantial increases in population over its sixteenth-century totals, boasting more than 70,000 inhabitants by the late seventeenth century.[22] The city's numbers were swelled not simply by the legions of noblemen, courtiers and their entourages, the social elite, and hangers-on, but also by civil servants, professionals, and the many craftsmen, merchants, and workers needed to service a courtly society. Brussels's industries included the manufacture of tapestries, lace (an industry that eventually employed several thousand women and girls), and camlet (a fabric made from silk and wool), as well as the manufacturing of elegant horse-drawn carriages. The attraction of safe employment in the city, as well as proof of the continuing hazards of country life, is made poignantly clear by a letter written in 1655 by six linen weavers from Nivelles to the municipal authorities in Brussels requesting permission for residency: "à cause des guerres continuelles [nous desirerons] venir habiter en cette ville [Brussels] pour avec plus de repos y travailler."[23]

Further evidence of the restructuring of local manufacturing to produce luxury goods, for both domestic consumption and export, is the rise in Antwerp of the number of embroiderers and ebony workers, and the appearance of a new industry for the manufacture of expensive, carefully crafted furniture made of exotic woods and veneers.[24] Antwerp also became a leading center for manufacturing of musical instruments,[25] and for precious gold and metalwork.[26] While some traditional industries, such as glass blowing and majolica, gradually died out, the production of elegant cordovan gilt leather for wall coverings flourished under the patronage and encouragement of the court. Far larger in scale was the diamond industry, which expanded greatly in the seventeenth century; only thirty to forty masters were active in Antwerp in 1582, but 164 resided there in 1618, and no fewer than 300 workshops, often run by Portuguese Jews, flourished at mid-century.[27] Antwerp became the leading entrepot for the diamond trade; note for example, their appearance on the table in Jan Brueghel's flower still life (cat. 95). In 1629 Balthasar de Groot, who with his brother Ferdinand was one of the city's wealthiest financiers, imported from Lisbon a single lot of no fewer than 7,760 stones for splitting, cutting, and polishing.[28] The expansion of the printing and publishing industries, to be discussed further below, and the rise in the number of painters employed in Antwerp and other major cities must also be considered in the context of this general shift to an economy based on luxury goods and exports; between 1584 and 1616 the number of painters registered in the Antwerp guild almost doubled, to 216.

"Magna Civitas, Magna Solitudo"

Antwerp's prospects must have looked fairly promising when, on the eve of the Twelve Year Truce, Rubens returned to the city in late 1608. However Sir Dudley Carleton, the English ambassador to The Hague and an avid collector of Rubens's art (see cat. 10), captured the curiously vacant and artificial character of the city when he described it in 1616 as a "Great City [of] Great Solitude" (Magna Civitas, Magna Solitudo).[29] Visiting in the entourage of the German Elector in 1612, Abraham Scultetus noted, like other travelers, that the Oosterlingenhuis (by then deserted and only later restored, see fig. 12) and the handsome patrician homes in Antwerp were proof of the city's former glory, but especially to the later visitors, like Aulus Apronius (1677) and Boussingault (1673), the city seemed peculiarly empty.[30] All observers remarked on the grandeur, elegance, and cleanliness of the city, but by the third quarter of the century, according to Apronius, scarcely thirty traders entered the Bourse (stock exchange) on a given day while the institution's counterparts in Amsterdam and London received thousands daily.[31] Rubens himself best expressed the city's despondency when he wrote to Pierre Dupuy from Antwerp on 28 May 1627,

Fig. 12. Lucas van Uden, *The Oosterlingenhuis in Snow*, oil on panel, 41 x 71 cm, Antwerp, Koninklijk Museum voor Schone Kunsten, no. 769.

Fig. 13. Abel Grimmer and Hans van Balen, *View of Antwerp with God the Father, Christ, and Mary with Angels in Heaven*, 1600, oil on panel, 33 x 44 cm, Antwerp, Koninklijk Museum voor Schone Kunsten, no. 817.

"This city... languishes like a consumptive body, declining little by little. Every day sees a decrease in the number of inhabitants, for these unhappy people have no means of supporting themselves either by industrial skill or by trade. One must hope for some remedy for these ills caused by our own imprudence, provided it is not according to the tyrannical maxim, *Pereant amici dum inimici intercidant* [Let friends perish, as long as enemies are destroyed with them (Cicero)]."[32] About a year later he wrote again to Dupuy, in a similarly discouraging vein, "Here we remain inactive, in a state midway between peace and war, but feeling all the hardships and violence resulting from war, without reaping any of the benefits of peace. Our city is going step by step to ruin, and lives only upon its savings; there remains not the slightest bit of trade to support it, the Spanish imagine they are weakening the enemy by restricting commercial license, but they are wrong; for all the loss falls upon the King's own subjects. *Nec enim pereunt inimici, sed amici tantum intercidunt* [It is not the foes who perish, but the friends who fall]."[33]

There were periodic shortages of food not merely because of lean harvests but also because the peasants, understandably uncertain of the future while badgered by soldiers, often cultivated only enough for their own subsistence. However, as the century prospered, the country's agriculture flourished, especially on the gentry's large landed estates (depicted by Teniers and others), where the grain crops were the envy of foreigners.[34] Pricing and licensing systems also managed to feed Brabant's large urban populations fairly consistently. The fishing industry even rebounded during the Twelve Year Truce when Antwerp's fishermen were again allowed to cast their nets in Holland and Zeeland; during other times much of the fish was imported from the United Provinces. Although real estate values naturally fell, surprisingly the maintenance of the cities and the nation's infrastructure continued. Especially during the Twelve Year Truce there even was a brief flurry of new construction and experimentation with new baroque styles in both ecclesiastical and secular architecture.[35] This was not simply a matter of the seventy-odd wealthy families who ran Antwerp keeping up appearances; the archdukes also appointed genuinely enterprising local leaders, such as the versatile Wenceslas Coeberger (1557-1634), who during the Twelve Year Truce repaired roads, drained polders, and as an architect, engineer, and painter, even dreamt of one day joining the Scheldt and Meuse rivers by a canal, though the all too brief lulls in the hostilities never permitted the realization of his plan.[36]

Civitas Dei

Reporting to the powerful Duke of Lerma in 1611, the Portuguese soldier Marcantonio Correr explained in the simplest of terms what he saw as the spiritual corruption and demise of Antwerp: so rich had the inhabitants of this great commercial center become that they had forgotten the faith of their fathers, were beset by the devil, and created a heretic's paradise where fifty-two sects contended.[37] Catholic leaders, such as Bishops Miraeus and Malderus and the influential author and sermonizer Pater Franciscus Costerus, warned repeatedly of the lingering

presence of heretics, but the defeat and banishment of these "*ketters*" was but one goal in their ambitious program. The shared vision of the archdukes and the Church was nothing less than a creation of an absolutist Catholic state. Antwerp was to become the base of operations for a militaristic defense of the True Faith (see fig. 13), for the assault on the impious, the skeptics, and the backsliders. Here the religious ideals of the Counter Reformation were to be manifest in their purest, most rigorous form. The resolutions of the Council of Trent (1545-1563), which for all intents and purposes defined and guided the Catholic Church until the Second Vatican Council (convened in 1962), were to be followed in exemplary fashion. While Brussels might function as the official seat of power, Antwerp, with its exceptional economic, social, intellectual, and cultural resources, was the ideal spiritual capital for this new religious state. All aspects of life were to be conscripted into the cause of founding the *Civitas Dei* on earth. The scrupulous practice of Roman Catholicism became an essential condition for virtually all tolerable existence in the city.

As the former hub of Protestantism in the south, Antwerp proved the old adage that none are so righteous as the recently converted. Rome obviously recognized the strategic and symbolic value of converting the city, of transforming it into a bastion of Catholicism. In addition to its economic infrastructure, Antwerp had the advantage of a strong church organization and hierarchy with its own bishop, as well as established religious orders and lay societies. The monastic orders multiplied dramatically in the seventeenth century and greatly increased their pastoral activities. By ca. 1645 as many as 1,000 men and women, or nearly 2 percent of the city's population, resided in Antwerp's monasteries and convents, to whose numbers may be added hundreds of beguines, *geestelijke dochters,* and *kwezels* (unmarried women and widows who adhered to the spiritual conduct of a nun, but who lived in the secular community).[38] In 1645 Bishop Nemius listed thirteen monasteries and fourteen nunneries in the city.[39] All of these orders preached Catholic dogma, administered the sacraments, and fostered religious organizations, but each had its own emphasis and followers. For example, the Capuchins lived strictly abstemious lives, thus offering welcome rebuttal to the standard Protestant criticisms of materialistic papists, and earning the support of the lower classes as "street preachers." The erudite teachings of the Norbertians of St. Michael's Abbey, on the other hand, made them more influential among the well-to-do. The Augustinians stressed education, founding their college in Antwerp in 1608, while the Dominicans were known for their preaching, missionary work, and devotion to the rosary. The Franciscans converted through their powers of oratory, and the Carmelites also served the apostolates through preaching, though after 1638 increasingly emphasized meditation. The growth of the religious orders in Antwerp was so lush that it even alarmed the Catholic monarch, Philip IV, who wrote to the Cardinal Infante in 1632, "They will choke and die like too many trees in a garden."[40] The multiplication of these orders, moreover, was not restricted to Antwerp; between 1581 and 1665 the town of Mons, for example, saw the establishment of fifteen new monasteries and nunneries.[41]

The Jesuits

Of all the orders the most powerful and dynamic were the Jesuits.[42] The "Society or Company of Jesus" was a relatively late arrival among the Catholic orders, having been founded by Ignatius of Loyola (1491-1556), but their greater organization and discipline soon won wide official support; as early as 1590 Alexander Farnese granted them the generous sum of fl. 1000 per year to educate the masses and promote the Catholic faith in the north. By 1648 there were 680 Jesuit priests in Antwerp.[43] Inclined themselves to military metaphors (their leader in Rome, who acknowledged only the pope as his superior, is called the Captain General), the Jesuits were regarded by the Vatican as the light cavalry in the war against the Protestants. Dedicated and indefatigable soldiers of the Church, they moved swiftly into communities as teachers and mentors. Their professional versatility, social mobility, and cosmopolitanism could scarcely be matched by the older Catholic orders. The Jesuits reestablished their college (first founded in 1575, then closed by the Calvinists) immediately after the reconquest of Antwerp, and dedicated themselves to all aspects of education, from sophisticated instruction in the humanities, theology, and the sciences at the college level, to grade school and Sunday school instruction, and the catechizing of the poor and illiterate. Following Tridentine policy, they stressed to the masses the importance of the sacraments of the eucharist and confession; in 1640 alone the Jesuit Church dispensed 240,000 communion

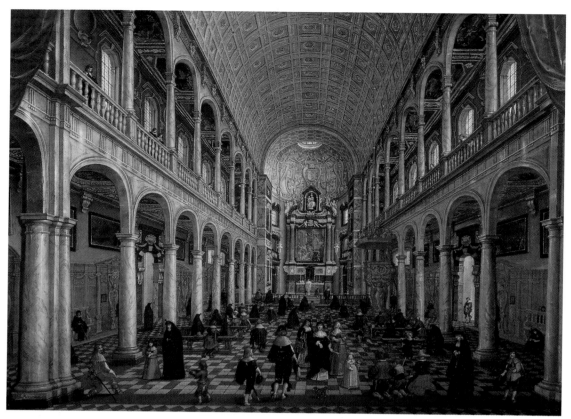

Fig. 14. Pieter Neeffs and Sebastian Vrancx, *Interior of the Jesuit Church in Antwerp*, oil on panel, 52 x 71 cm, Vienna, Kunsthistorisches Museum, inv. 1051.

wafers.[44] Through the network of the Sodalities of Mary, established by Costerus and claiming more than 2,000 members in Antwerp alone, the Jesuits had a pervasive influence on the spirituality and moral life of the people, while through the more selective Latin Sodality, where, as the name implies, the preferred tongue was Latin, they also reached the intellectual and financial elite. The Jesuits were encouraged by Costerus and others to continue to advise their charges after graduation, thus they sought to influence important social, economic, political, as well as religious decisions. The Jesuits' strategy of immersing themselves in the community and seeking to influence the upper echelons of power no doubt contributed to the suspicion in which they were held in many other European countries. They were associated, for example, in conspiracy theories surrounding the deaths of both Henry IV of France and William the Silent. However, in the Southern Netherlands the Jesuits were readily embraced by all classes.

Foreign observers commented on the accomplishments and high profile that the Jesuits maintained in Antwerp. Like other visitors, John Evelyn in 1641 wrote with admiration of the progressive educational techniques and facilities of their new College, which produced men-of-the-world trained in everything from classical literature and mathematics to drama and dancing, and did not fail to praise the beauty of their great church, St. Charles Borromeo (fig. 14), which had been dedicated in 1621.[45] Countess Arundel wrote to Inigo Jones in 1620 that she found it "a marvelous thing," while the following year Sir George Chatsworth described it at length, commending the building and its decorations to King James I.[46] Of this "Marble Temple" as it became known, Edward Brown, physician to Charles II of England, claimed in 1668 that it surpassed in grandeur all the churches in Italy[47]; while in 1657 a visiting Protestant clergyman from Bohemia, A. S. Hartmann, was predictably appalled at the structure's splendor.[48] In point of fact, at the staggering price of about 500,000 guilders, the building was too expensive, incurring huge cost overruns in spite of generous subsidies from the state, the archdukes, and Philip IV.[49] Even years

later Rubens remained unpaid for his decorations (see cats. 18 and 19). But to show the world the grandeur of the new faith, not to mention cultivating the impression that the Jesuits harbored enormous wealth, no cost was too great. Nicely capturing the order's reconciliation of worldliness with their oaths of humility and poverty is an anecdote told in an ironical tone by Apronius, who as a 24-year-old on his *Wanderjahr* in 1677 visited the Jesuits in Antwerp; they repeatedly questioned him on the costs of his travels and when told, invariably exclaimed "et aux pauvres rien!"[50]

Militant Catholicism and the Archdukes' Court

Fig. 15. Peter Paul Rubens, *Archduchess Isabella in the Habit of the Poor Clares*, oil on panel, 116 x 96.5 cm, Pasadena, Norton Simon Art Foundation.

As many foreign observers confirmed, some Protestants survived in Antwerp by going underground, and several hundred of them even commuted to Lillo on Sundays for church services. Portuguese Jews went through the motions of conversion only to practice their faith secretly at home. Simulation became a way of life, even of death; when Manuel Alvares Pinto, a member of a prominent Portuguese-Jewish family, died in 1635 he was buried in the family vault in the Church of the Descalzed Carmelites but had left secret instructions for the later procurement of a Jewish tomb.[51] The aggressiveness of Bishop Malderus and other religious authorities made many Protestants feel hunted. Hartmann in 1657 tells of darting down an alleyway in Antwerp to avoid having to kneel before a procession of the sacrament moving along the public thoroughfare,[52] and in a similar account, the epigrammatist and Catholic polemicist Richard Verstegen (1550-1640) wrote derisively of Protestants turning on their heels at the sound of the processional bell.[53] The German courtier Friedrich Lucae's personal experience of a heated religious dispute in the St. Pauluskerk with several Dominicans, who not only cross-examined him sarcastically but also virtually incarcerated him in their cloister in a effort to convert him, conveys something of the militancy of the campaign to unify the populace under one faith.[54]

This campaign had the full support of the archdukes, whose court was not only one of the most religious but also the most formal and sumptuous in the world. Their personal commitment to the faith was manifested in countless ways, from their practice of kneeling as the sacrament passed to making pilgrimages to holy sites at Scherpenheuvel (Montaigu), Laeken, and Hal (Halle). Albert himself carried the reliquary in processions and on Maundy Thursday personally washed the feet of one dozen poor people.[55] The favorite daughter of Philip II, Isabella was undoubtedly one of the most pious noblewomen in Europe.[56] After Albert's death she wore only the habit of the Poor Clares (fig. 15) and was renowned for her devotion to the eucharist (see cat. 22). She not only won the admiration of foreign statesmen (Sir William Temple, for example, wrote of her "generous and obliging disposition"[57]) but also the hearts of her own subjects. Her most devoted servant, Rubens, wrote in 1628 of Isabella, "She is a princess endowed with all the virtues of her sex; and long experience has taught her how to govern these people and remain uninfluenced by the false theories which all newcomers bring from Spain."[58]

Fig. 16. Denijs van Alsloot, *Festival on the Diesdelle with the Archdukes*, 1616, oil on canvas, 153 x 235 cm, Madrid, Museo del Prado, no. 2570.

Fig. 17. Jan Brueghel the Elder, *The Archdukes Attending a Wedding*, oil on canvas, 84 x 126 cm, Madrid, Museo del Prado, no. 1442.

The archdukes' personal involvement with and attendance at the popular fêtes and celebrations of the people are recorded in paintings by Denijs van Alsloot (fig. 16),[59] Jan Brueghel the Elder (fig. 17),[60] and others. The citizenry became particularly fond of Isabella, who despite her natural reserve entered the annual archery contest of the Grote Kruisbooggild in Brussels in 1615 and carried off the prize, for which she was named the Queen of the Guild. Even the great Dutch poet Vondel (who later converted to Catholicism in 1641) eulogized Isabella as a Netherlandish Princess.

During the archdukes' reign, the court became for many Catholic noblemen an *auberge des princes en exil*, where they might receive not only sympathetic intellectual company but also amusements, such as the hunts, carousels, and fêtes that Isabella organized. There were also outings in the country to the archducal palaces at Tervueren, Binche, and Mariemont (see Jan Brueghel's paintings in the Prado, Madrid, nos. 1429 and 1453). However, much of the Castillian community of noblemen and functionaries in Brussels remained haughty and isolated. The high standards of etiquette enforced at court by the archdukes in imitation of Spanish royalty required manners of ossifying exactitude. Predictably, the bureaucracy at court also grew increasingly rigid. Rubens, who like Jan Brueghel served as court painter in Brussels while living in Antwerp, wrote in 1626, "This Court is sterile...[unlike in France] here we go on in the ordinary way, and each minister serves as well as he can, without overstepping his rank; and in this manner each one grows old and even dies in office, without expecting any extraordinary force, or fearing disgrace. For our Princess shows neither hate nor excessive love, but is benevolent to all."[61]

Edicts, Education, and the Intellectual Life

The leaders of the Spanish Netherlands actively sought to transform society and popular culture by edict and placard. Ending centuries of popular tradition, no longer were the faithful permitted to meet in church for pleasure or business, or to bring their dogs or children to play there during services. By an edict of 20 September 1607, no one was allowed to conduct business or visit taverns during mass, and strict regulations were passed about commercial activities on Sundays and religious holidays.[62] Since 1587 primary education had been brought under closer Church supervision, and in a city like Antwerp 80-90 percent of the children attended school, though only about a quarter of these went daily.[63] The majority of students attended either the Schools for the Poor (*Armenscholen*), or Workhouses, or Sunday Schools which offered little instruction beyond heavy staples of the catechism lightly seasoned with the rudiments of reading, writing, and reckoning. Judging from the regular complaints of guild officers who lent their chapels for Sunday School instruction, there also were discipline problems.[64] The high levels of attendance only reflected the fact that Sunday School was mandatory for the poor, who could lose their charitable support (*steungeld*) and even be fined if their children were truant. The number of registered schoolmasters in Antwerp steadily declined from 75 in 1585, to 40 in 1600, to 23 in 1625.[65] While the wealthy could, of course, tutor their children at home, or send them to France or other countries to board (in 1632 the Cardinal Infante was encouraged by Madrid to establish an academy at court for the children of the wealthy, specifically to discourage the practice of foreign education), Antwerp's middle and lower classes had few options. These included one of the five *Papenscholen* (Latin Schools), the standards of which were notoriously uneven and the curriculum designed primarily for a career in the clergy (though both Rubens and the famous publisher, Balthasar Moretus, attended such schools), or one of the merchants' schools (*Walsche Scholen* or *Koopmansscholen*) where one could learn foreign languages as well as bookkeeping. Alternatively, one had the more sophisticated, humanistic, but religiously doctrinaire education of the colleges of the Jesuits, Augustinians, or Dominicans. Upon graduation, talented students might attend one of the national universities at Louvain (Leuven) or Douai, and thereafter would typically study abroad. Strict laws had been passed in the sixteenth century by Charles V and Philip II against foreign study, during which students were presumably exposed to "heretical" ideas. However, the *peregrinatio academica*, so readily facilitated by the pervasive use of Latin as a common language, continued to flourish through the first half of the seventeenth century.[66] Post-graduates typically went on to the universities of Orléans to study law, to Padua for medicine, or for higher studies generally to Bologna. Thus the history of education in the Spanish Netherlands reveals a progressive polarization between the educational opportunities of the common people and the elite.[67]

Ordinances of 1616 required all publications in the Southern Netherlands to be submitted to ecclesiastical censure, and forbade the establishment of a printing press without the approval of the bishop.[68] As a consequence, not only the number of publishing houses but also printers and bookstores dropped precipitously not only in Antwerp but also throughout the country. The archdukes reissued Madrid's Index of Forbidden Books (*Index librorum probitorum*, originally published in Antwerp in 1569), which banned such seemingly inoffensive popular folk literature as *Uilenspiegel* (Til Eulenspieghel) and *Reynaert de Vos* (Reynard the Fox), and passed strict laws about the sale of books.[69] In 1618 Antwerp Church authorities banished from schoolbooks all allusions to "amorousness and all such things that may be more attractive to youth than that which is good for them to learn."[70] Despite this conspicuous anxiety about what might be taught, read, and studied, publishing persisted in the Southern Netherlands. The operations of the Plantin Press were typical of how resourceful Flemish businessmen accommodated and even capitalized on the commercial diaspora; the mother press, run profitably by Jan Moretus (1543-1610) and his son Balthasar (1574-1641), continued to publish religious literature in Antwerp, indeed became one of the principal mouthpieces of the Counter Reformation's ideas, while the deracinated portion of Plantin took root in Leiden in 1583, profitably publishing more unorthodox, secular literature.[71] Moretus and the other leading Antwerp publisher, Jeronimus Verdussen, prospered not only from publishing humanistic works and religious handbooks, such as the perennially reissued and subtly proselytizing schooltext *Het Dubbel Cabinet der Christeljck Wysheid* (*The Double Cabinet of Christian Wisdom*) (1624), but had a virtual monopoly on the publishing of religious literature for the Iberian peninsula until 1764. They also prospered from the production of local almanacs, the commoner's second bible. Yet, while Plantin and Verdussen might carry on, there is no denying that publishing activity declined seriously when compared with the previous century, becoming an increasingly narrow and parochial affair. In Ghent, for example, during the seventeenth century, there were 14,000 editions published, of which nearly one half and one third, respectively, were religious titles and official government publications.[72] Of course, banned books circulated, but especially in the countryside, owners of "heretical" literature ran the risk of being exposed by pious informers to the bishop on his pastoral visit. Substantial libraries, occasionally with several hundred volumes, were assembled by some wealthy merchants and noblemen.[73] However it does not speak well for intellectual life at court that John Evelyn found the library shut in the Palace at Brussels, its contents neglected and of little interest.[74]

Fynes Moryson, visiting the Southern Netherlands in 1617 from his native Scotland, observed that the university in Leuven had "decayed," since its "glory was and is in the learned Professors, which of old were drawn thither from all parts, by large stipends, but now are commonly Jesuits ... for they gladly ingrosse children and young men's education and instruction, as well in Divinity as in the Liberal Arts (the Grounds of all Learning)."[75] Despite these contractions, the university boasted the repatriation of at least one renowned humanist professor, namely Justus Lipsius (Joest Lips, 1547-1606), whose works on Seneca and Tacitus were widely known. In his mature career, after developing increasingly reactionary views on religious tolerance expressed in his *Politicorum libri sex* (1589), Lipsius converted back to Catholicism, quitting Leiden University. Lipsius's conversion deeply interested the Catholic world; although invitations poured in from various courts, he settled back in his old alma mater, Louvain, where, as we have noted, he was the mentor of Rubens's brother, Philip Rubens. Philip Rubens, like many of the leading Antwerp humanists, also held an important public office, the post of city secretary; the humanists Jan Caspar Gevaerts (Gevartius, 1593-1666) and Jan Brant (1559-1639), Rubens's father-in-law, were also municipal registrars, and Nicolaes Rockox (1586-1640; see cat. 16), Rubens's friend and patron, was a burgomaster. Thus intellectual leaders exercised some real power in the magistracy.

Major publishing efforts were begun in Rubens's lifetime, including Laureis Beyerlinck's (1578-1627) Catholic encyclopedia, *Magna theatrum vitae humanae* (only published in 1671), and the vast account of the Lives of the saints in the Jesuits' great *Actae Sanctorum* (the first volume of which appeared in 1643) by Joannes Bollandus and his successors' cast of thousands.[76] While France might claim Corneille and Racine, and Holland Hooft and Vondel, literature was not a strong suit of the Southern Netherlands; the *belles lettres* prominently featured Jesuits and members of the other religious orders, such as Jacobus Wallius (1599-1690), Gulielmus Becanus (1608-1683), and Sidronius Hoschius (1596-1653). The elegant Latin of Philips van Marnix (Marnix of

Sint-Aldegonde; 1540-1598) had been the fruit of the previous century, as was (in the field of the natural sciences) the work of the great cartographer, Abraham Ortelius (d. 1598). There were a few important contributions to mathematics; Simon Stevin (1548-1620), for example, developed decimal fractions but like so many of his countrymen, emigrated North, to become a military engineer for the enemy; Michiel Coignet (1549-1623), who served as the archdukes' official mathematician, was well regarded by Kepler and made contributions to navigation[77]; the Jesuit mathematician and geometer, Gregorius de Saint-Vincent (d. 1667) produced the massive *Opus geometricum quadraturae circuli* (Antwerp, 1647) with a handsome title page by Abraham van Diepenbeeck, and taught many of the country's best scientists, including André Tacquet (1612-1660) who produced theoretical works on geometry as well as widely used schoolbooks. Another good mathematician and physicist, the Jesuit Franciscus de Aguilón (Aguilonius, 1566-1617), published a manual of optics, *Opticorum libri sex* (1613) with a title page designed by Rubens (fig. 18), and the astronomer Jan Karel della Faille (1597-1652) published on the theory of gravity, *Theoremata de centro gravitatis* (Antwerp, 1632).[78] The latter enjoyed a comfortable appointment at the Spanish court, but his letters expressed the dismay that many of his fellow thinkers must have shared at seeing the mighty uniquely obsessed with war and expressing little or no interest in science.[79] Scarcely conducive to scientific inquiry, moreover, was the repression of some controversial ideas. As late as 1691 it was forbidden in the Spanish Netherlands to teach the Copernican solar system, and then only on the condition that the earth not be mentioned. This after all was still an age that regularly mixed the spiritual and the scientific. The eccentric Brussels philosopher/doctor, J.-B. van Helmont (1579-1644), for example, purported to be able to see his soul in crystals, but his studies of fermentation and animal magnetism are still occasionally recalled, and his discovery of several gases qualified him as one of the fathers of modern chemistry.[80]

Rhetoricians, Processions, and Popular Culture

In the sixteenth century an important source of Dutch literature had been the *Rederijkerskamers* (rhetoricians chambers). These amateur local theatrical groups were decimated by the exodus of Protestant members in the 1580s, but were reconstituted during the first decades of the next century.[81] The popularity and potential political power of the theatre, especially among illiterates, was not lost on Antwerp's authorities, who in 1601 forbade in plays any profanation of religious issues and banned any words or gestures which might offend, corrupt, or despoil "good manners."[82] For the educated few, the Jesuits performed moralizing religious plays in Latin at their College; Pierre de la Serre, for example, described a particularly elaborate performance, complete with rich costumes and dancing, put on by the Jesuits on the occasion of Marie de' Medici's Triumphal Entry into Antwerp in 1631.[83] Especially early in the century, these performances could be shrilly polemical; one play about St. Ignatius put on by the Jesuits in 1610 even inspired a response of comparable volatility and malice in Holland.[84] Professional itinerant entertainers, known as *kamerspeelers*, also occasionally performed in rented spaces, but they inevitably aroused the suspicions of the Church leaders, who regarded them and their musical colleagues, the hurdy-gurdy players, as morally debasing vagabonds. Indeed toward the end of the century, actors were even accused of fomenting domestic disorder and civil unrest.[85]

Philip II had banned from all public and private places the "singing, playing or divulging... of farces, ballads, songs, comedies, refrains or other pieces... in any language, old and new... which refer to our religion, or ecclesiastic personages."[86] All songs and performances had to be submitted to the local clerics for approval. The Antwerp authorities reiterated the ban on all defamatory songs in 1605, and at least one songster was jailed for four years for singing songs critical of the archdukes.[87] As with dancing, masquerades, and other forms of ritualized flirtation, the Church also had an abiding distrust of amorous songs. While their censoring of street singers was simply another effort to control popular culture, the authorities had no inherent objection to music or singing; indeed musical groups multiplied, and song books of both religious and secular songs were published in large numbers (books of love songs remained imported contraband), and the production of beautifully crafted musical instruments such as the keyboard instruments of the Antwerp firm of Ruckers was at its peak.[88] The elegant images of balls and nocturnal fêtes often with maskers painted by Josse van Winghe, Frans Francken II, Hieronymus Francken I, Louis de Caullery, and Hieronymus Janssens (called "de Danser") are not merely a perpetuation

Fig. 18. Title page, designed by Peter Paul Rubens for Franciscus de Aguilón, *Opticorum libri sex* (Antwerp, 1613), Cambridge, MA, Houghton Library, Harvard University.

of Venetian themes but attest to local enthusiasm for such "high-life" festivities (see Wieseman, fig. 4). Sometimes the festivities might move out of doors, and in the winter the elegant maskers even took to the ice (see fig. 19).

More structured were the theatrical performances of the three official rhetoricians chambers in Antwerp, which drew their members mostly from the local middle class: *de Violieren*, allied to the St. Luke's Guild (see blazon decorations ill. Introduction, fig. 58), claimed many artists and intellectuals, including Sebastian Vrancx, Willem van Nieulandt, Jan Brueghel the Elder, and other prominent painters[89]; *de Goudbloem* was composed of self-styled literary aristocrats; while the *Olijftak* claimed a less high-brow membership. Despite their history of irreverent satire and ribald comedy, in the seventeenth century the rhetoricians chambers evolved into both tractable and seemly institutions, whose plays defended the Church, official morality, and decorum. But by mid-century their performances had become so pretentious and the language so artificial that they began to lose their audiences and fail. A late success was Willem Ogiers (1618-1689) whose plays in the vernacular on themes drawn from the Seven Deadly Sins, amusingly admonishing gluttony, greed, and overweening social ambition (*De Gulsighheydt*, 1637; *De Hooveerdigheydt*, 1644), proved to be very popular. A popular and moralizing approach was also taken by the Jesuit Father Adriaen Poirters, whose publications, such as *Het Masker van de Wereld Afgetrocken* (1646), included fables, poems, and emblems with moral messages. Poirters's works were conceived in the tradition of the Dutch poet Jacob Cats, but tailored to his Catholic audience.

The grandest and most fully orchestrated public spectacles in the Southern Netherlands were the Triumphal Entries (see fig. 6), which had celebrated visiting monarchs and nobility since Charles V's entry into Antwerp in 1520, and reached an artistic highpoint, under Rubens's supervision, with the festivities honoring the Cardinal Infante's entry into the city (*Pompa Introitus Ferdinandi*) in 1635 (see cat. 33, fig. 1).[90] These were rare and costly events with elaborate and abstruse allegorical programs expressed with substantial albeit temporary decorations, murals, floats, performances, and, above all, great pomp. If the entries were designed less for public edification than to legitimize the city's authority, the more regular religious processions were an illustration and reaffirmation of the Church's power. Processions were held about twenty times each year and about half the time out of doors, parading through the streets of the city. By their frequency and, in some cases, large scale, these rituals had a strong ideological effect on the masses, who watched as religious leaders and representatives of secular groups marched past in symbolic concord. Together the churchmen and magistrates honored God, his saints, and their reliquaries; or, in hard times such as epidemics, gathered to form the *processie van devotie* (devotional procession) which sought deliverance from suffering. The clergy, the magistracy, and the representatives of the guilds and trades all had clearly defined places in the larger of these processions, which served to consolidate socio-political relations and hierarchies (see fig. 20). From as far away as Scotland and Hamburg foreigners came to gawk at Antwerp's *processies*. The largest and most colorful of them all was the yearly *Ommegang*, held on Sinksen (Pentecost). Visitors to this popular fête filled the local hotels and taverns, and the procession itself included elaborately decorated floats with religious, allegorical, and legendary themes, masked entertainers and dancers, musicians and drummers, giants, and exotic animals.[91]

Some of the smaller cities in the Spanish Netherlands still carried on the medieval traditions of mythical, non-Christian folkloric celebrations, such as *tableaux vivants*, wildman plays, the *kalverdans*, and figures dressed as characters from the *Blauwe-Schuit* – known in part to us from the illustrations of Pieter Bruegel the Elder. As patricians throughout Europe had observed for centuries, popular festivals – the *Carnaval Carême*, the *Fêtes de Fou*, and the common *kermesse* – served to dissipate social tensions among the poor. They had a therapeutic effect by temporarily diverting the attentions of the most disenfranchised from the grim reality of their lives and material shortcomings. The excesses of the traditional *kermesse* diffused violence that might otherwise break out in social revolt and upheaval. The latter were scarcely unknown in the Southern Netherlands; Antwerp's poor rebelled in 1621 when bread prices rose drastically, and again during the economic crises of 1643-1644; they suffered stoically through the epidemics of 1649-1652, but stormed the Almoners' Hall in 1685 when charity was slashed.[92] Labor unrest broke out in Brussels in 1619, in Antwerp in 1659, and in Leuven in 1684.[93]

However in the new religious climate of the Tridentine Church, the frenzied disorder and excess of the festivals had to be controlled, their chaotic energy calmed and channeled, their

Fig. 19. Denijs van Alsloot, *Winter Recreations with Maskers before the Kipdorppoort Bastion in Antwerp*, oil on panel, 57 x 100 cm, Madrid, Museo del Prado, inv. 1346.

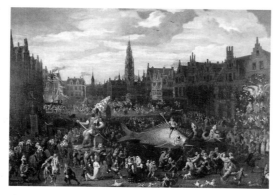

Fig. 21. Anonymous Flemish Artist, *Ommegang on the Meir in Antwerp*, late 17th century, oil on panel, 97.8 x 137.3 cm, Antwerp, Volkskundemuseum, inv. no. VM57.103.1.

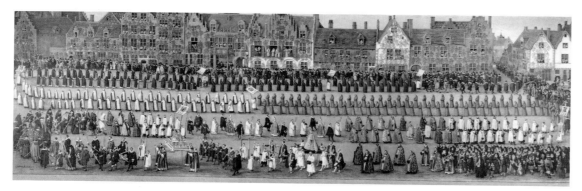

Fig. 20. Denijs van Alsloot, *The Ommegang of 1615, with the Procession of the Guilds in the Grand Place in Brussels*, 1616, oil on canvas, 130 x 380 cm, Madrid, Museo del Prado, no. 1348.

animism and magic recast in the service of Christianity. As several modern historians have observed, in the *Ommegangen* in the large cities, the authorities gradually purged or replaced these subaltern, folkloric elements with themes from classical literature or mythology, until only the giants and exotic animals remained (see fig. 21).[94] In Brussels's *Ommegang* honoring *Onze Lieve Vrouw op 't Stocksken*, for example, all the "inappropriate" secular elements (which is to say anything ludicrous, scabrous, obscene, or just playfully critical or silly) indeed even mummers, which had been indigenous to the kermesse, were replaced by allegorical figures extolling the monarchy.[95] Antwerp's *Ommegang* of 1609 celebrating the Twelve Year Truce still featured a float devoted to the Dream of *Luilekkerland* (Land of Cockaigne), but future developments in the celebration were augured by another car with allegorical figures personifying Peace, Tranquillity, and the Return of Domestic Industry.[96] In a similar fashion, traditional folkloric theatrical performances and characters (*De Vuile Bruid* [The Dirty Bride], *Kreupelenspel* [Cripples' Play], *Spel van de Wildeman* [Wildman's Play]) were co-opted and transformed by the new regime into less specifically charged players or entertainers, or into the stock characters from the courtly *commedia dell'arte*. The latter in turn cross-pollinated with the cast of Shrovetide (*vastenavond*) revelry, and gradually were removed from the canon of local myth.[97] Folk culture thus was gradually subjugated to official morality, conscripted into the army of the Church.

Witches and Whores

One of the clearest efforts to suppress folk beliefs was the Church's official campaign against superstition, and specifically sorcerers, witches, conjurers, and magicians. Signs and portents were discovered everywhere; the popular imagination, for example, spread the rumor that the stench of a great fish had spread pestilence in the environs of Grimbergen as punishment for the destruction of an abbey, and the earth tremors in Antwerp on 4 April 1640 were generally agreed

to presage grave troubles.[98] While witch hunts in the Southern Netherlands were not so rabid or bloodthirsty as in some other regions of Europe, during the high season of ca. 1560-1650, Philip II (especially in the 1590s), the archdukes, and their successors undertook a vigorous assault against superstitious beliefs.[99] Typical of the official condemnation was an edict issued by the archdukes on 10 April 1606, which reiterated the importance of persecuting sorcery in the Southern Netherlands, with reference to a directive from Philip II of 1592. Ordinances that followed condemned magicians, quacks, and fortune-tellers, naturally promoting suspicions and accusations among the general populace.

In part the Church was motivated in this campaign by a sense of competition; especially among the lower classes, the True Faith was not always distinguishable from superstition or legerdemain. Since Martin Luther had anointed every man his own priest, any form of private faith, and especially those with strong collective appeal, had a potentially threatening legitimacy for the Catholic Church. Indeed many Catholic leaders passionately believed that they were crusading against the anti-Christ. Even a sophisticated churchman like Costerus matter-of-factly stated that the "water test" was best for determining demonic possession (if the persons float, they are possessed), while a truly comprehensive survey of demonology was offered by the Antwerp father Martinus del Rio, in his handbook *Disquisitionum magicarum libri sex* (1593).[100] The Antwerp Sheriff (*Oud-Schepen*) Jan Baxius (1530-1606) pursued witches tirelessly, though the city's less paranoid Tribunal upheld only a few of his indictments. Nonetheless a Genoese citizen was banished for ten years, and in 1603 one Clara Joossen of Strasbourg was condemned to death (by both strangulation and burning!) for having made a pact with the devil, having had sex with him, and having nightly flown through the air on a stick.[101]

The devil might, of course, possess persons of either gender but women were accused more frequently, no doubt in acknowledgment of their legendary susceptibility to temptation, unsteadiness, and impulsiveness. Powerful older women, especially defiant ones living a liminal social existence, were most likely to arouse fears and suspicions, hence be victimized by the witch hunters. In both the Protestant Northern and the Catholic Southern Netherlands the middle-class ideal was the docile and affable *kinder-keuken-kerk* (children-kitchen-church) woman, celebrated alternatively in Jacob Cats's *Trouw-Ring* (1625) or in books published in Antwerp on marriage etiquette by David, Ysermans, and Hazart.[102] As learnedness and professional possibilities expanded throughout elite culture in early modern Europe, women's roles and status ironically often became more narrowly delimited. While many women, for example, had worked in obstetrics as midwives in the Middle Ages, the new "professional" male doctors in the Southern Netherlands sought to minimize the midwives' numbers by requiring them all to pass a literacy test, though many of the physicians themselves had studied medicine at Louvain, where the antique texts of Galen were still taught! The deplorable nature of seventeenth-century health care, especially for women, can scarcely be exaggerated.[103]

Visiting foreign men, on the other hand, had little but praise for the women of this country. In 1611 Moryson jotted down that he preferred the "very fayre" women of Flanders and Brabant to those of Holland, though noted that in both "the ornament of white linnen setts forth their beauty."[104] Cosimo de' Medici, though a failure at marriage himself (his wife, the niece of Louis XIV, left him), in 1668 admired the "tall and very pretty" women of Antwerp, and was so thoroughly charmed by their counterparts in Brussels that he sent them in gallant gratitude ten lap dogs as gifts.[105] Constantijn Huygens, secretary to the Dutch stadholders and a man of great and varied talents, immortalized a very different aspect of Antwerp's female society in his play *Trijntje Cornelisdr.* (The Hague, 1657), which featured the famous prostitution district in the Lepelstraat. A play performed in Amsterdam in 1629 by the *Brabantsche Camer* had the adventurous protagonist remark that there were so many *vrijsters* (sweethearts) in the Lepelstraat that he thought that he had gone to "Maiden Heaven."[106] The Catholic Church sought to crack down on prostitution, especially because the Protestants had accused the papists of laxity on the issue while simultaneously promoting the specious notion that whores were more likely to be Catholic because that faith ostensibly made it easier to receive absolution. However, Antwerp's secular authorities tended to regard prostitution as a necessary evil, even a profitable tourist attraction; thus at the beginning of the seventeenth century as many as 125 brothels operated in the district of the *lichte vrouwen*.[107] Obviously for those inclined to succumb to temptation, there were ample opportunities to compensate the flesh for the pains of the spirit. Moreover, while sexual activity

is notoriously difficult to quantify historically, there is some evidence to suggest that despite the emphatic Tridentine prohibition against premarital sex and the decline of such traditional practices as *nachtvrijen* (night cuddling) and *proefnachten* (trial nights), unmarried lovers had some access to intimacy and sexual freedom. Illegitimacy in the Southern Netherlands remained fairly constant at 2 percent of all births throughout the seventeenth century; however, especially in the first half of the century, the number of prenuptial conceptions were significantly higher and even increased (to about 15-23 percent of all first births), suggesting that the Church was far more effective at hastening the conclusion of the sacrament of marriage than at forestalling its premature consummation.[108]

Society: from the the Carriage Trade to "de Lompe Boer"

The formality and elegance of the archdukes' court influenced virtually all manifestations of social ambition among the upper classes, from dress to notions of prestige and recreation. Seigneurial types even styled their facial hair after Philip IV's. Fashions in clothing tended to be more somber and restrained than in France, but richer, and more uncomfortable than in Holland. The term *"Spaanse Brabander"* (Spanish Brabanter) became synonymous with the height of elegance and artifice or, for their detractors, the epitome of pomp and pretention. Southern Netherlandish manners and mores ideally were to be *beschaafd* (civilized) and *deftig* (elegant). Many foreign observers commented on the politeness and elevated standards of etiquette among the people, and the costliness and high quality of their clothing,[109] although the disdainful Hartmann concluded that they dressed better than the Dutch simply because they spared no expense.[110] French fashion became increasingly popular over the course of the century (indeed the so-called *Spaanse mode* was a French import) and in 1666 Lucae asserted that Antwerpers were as elegant in attire and manners as Parisians.[111] The ladies took more and more time at their toilette and expressed a special fondness for jewelry, developments verified in seventeenth-century inventories.[112] Brabantine women had long been famous for their immoderate appetite for luxurious clothing; indeed it was reported that one wealthy lady so hankered after ever greater finery that she made a pact with the devil who subsequently turned her into a black cat.[113] Priests constantly fulminated against this spreading taste for fancy dress and conspicuous consumption, lamenting the loss of what they nostalgically if selectively recalled as the local citizenry's inherent reserve and dignity.

Like other visitors, the English botanist Philip Skippon, who lived in Antwerp in 1663, described how the well-to-do rode about in coaches, and noted especially the fashion among the ladies for taking the "tour-à-la-mode" on warm evenings in their gilt carriages.[114] Virtually everyone commented on the locals' passion for promenading along the city's handsome tree-lined quai. And the French colonel Duplessis L'Escuyer estimated in 1650 that as many as 5,000 to 6,000 people might come out of the city on a holiday in summer to relax, dance, eat, and drink on the grass of the great esplanade – all, according to the colonel, in a most elegant and decorous fashion.[115] On the various *blijdeavonden* (evening celebrations), which included St. Martin's Eve, New Year's Eve, and *Driekonigenavond* (Twelfth Night or Epiphany), the well-to-do often got

Fig. 22. Erasmus de Bie, *Vastenavond in Antwerp*, ca. 1660, oil on canvas, 165 x 251 cm, Brussels, Museum van Elsene, inv. 105.

together for festivities with family and friends. *Vastenavond* (Shrovetide) was an occasion for especially lavish displays, decorations, and costumes; indeed it even attracted tourists (see fig. 22).[116] For its love of spectacle and luxury, Antwerp was even in the seventeenth century still likened to Venice. Despite this flattering parallel however, after having sat at table with the local seigneurs following an *Ommegang*, the Cardinal Infante concluded that they lived like beasts.[117]

The immoderate eating and drinking – the *gulzigheid* so shrilly censored by the priests – probably was at least as abusive among the banqueting upper-class burghers and merchants as among the aristocrats, since the former naturally liked to flaunt their means to act in as dissolute a fashion as the nobles. The clergy sought in vain to enforce laws against wedding or funerary banquets lasting longer then forty-eight hours. Richard Verstegen wrote a moralizing poem in 1617 describing twenty-five different kinds of drunks; Father Hazart (*Triomph van de Christelycke Leer* [Antwerp, 1683]) criticized excessive drinking, especially on Sunday, as contributing to idleness, unchastity, and the ruination of the family; while the common catechism left no doubt that inns were the dwelling place of the devil.[118] In 1584 there had been 370 public houses in Antwerp, or one for every thirty-two private dwellings.[119] Despite the moralists' campaign, there is no reason to suppose that drinking declined substantially in the seventeenth century, even though among the upper classes it may have become more discreet. Indeed the new taste for brandy, and later for gin, especially among the common folk, no doubt exacerbated the problem. Brouwer's fetid taverns (see cats. 63 and 66) are scarcely fiction.

Since the nobility were ultimately kept "out of the loop" of governance by the Spanish regime, they increasingly retired to the nurture and maintenance of their estates and contests of etiquette. The successful and socially aspiring businessman built his grand town house and perhaps could afford in addition to his carriage a country villa or pleasure garden outside the city. One indicator of the craving for rank was the fact that the archdukes in 1616 felt it necessary to reiterate Philip II's ban on false titles; and Ogiers's play *De Hooveerdigheyt* satirized these aspirations with a poor fellow who passes himself off as a *jonkheer* in the hope of winning the hand of a noblewoman in marriage.[120] But even as some prosperous magistrates and *rentiers* gained admission to the ranks of the nobility when social barriers became more permeable in the second half of the century, a title scarcely compensated entrepreneurs for the moribund business climate. It is difficult, of course, to take the mood of a people at the remove of three centuries, but historians have been struck by the disenchantment, pessimism, and sense of impotence among members of the merchant class, especially after the passing of the archdukes.[121] During this same period the protectionist economic policies of France under Colbert and the United Provinces were particularly damaging for the Southern Netherlandish economy and further undercut Antwerp's role as a transit center. Jules Chifflet wrote from that city in 1670, "Eight hundred shops are deserted. Sadness is to be seen on the faces of the burghers, who were once prosperous. All the scholars who formed Antwerp's pride not earlier than thirty-six years ago are dead. There only remain their beautiful epitaphs in churches and their portraits in the house of my host [Balthasar II] Moretus."[122]

Although Chifflet surely exaggerated for the sake of effect, there is no question that the middle class had grown despondent and apathetic, even torpid, while the poor remained as wretched as ever. The *Kamer van de Armen* offered charity to 4000 people in Antwerp in 1658; still ringing in the ears of the faithful was Father Costerus's admonitions that almsgiving was not merely a social obligation but a spiritual charge.[123] However the increasing numbers of beggars, and reports of skilled workers on the relief rolls, suggest that despite charity the lot of the urban poor did not improve, while the rural peasantry (*de lompe boeren*) continued to endure the depredations not only of the soldiers and brigands but also of inclemency, famines, and pestilence. With their economy in shambles, their fate in others' hands, large portions of the population in reclusive retreat in monasteries, country, or public houses, the Flemish peoples survived by evolving their famous "*braafheid*," an intranslatable word which as one particularly unsympathetic historian puts it, conveys a naive docility, at once gregarious and resigned, which has charmed or exasperated visitors and writers for three centuries.[124]

Thus there is much reason to conclude that despite the great artistic and cultural accomplishments of the Church and state in the age of Rubens, their politics led to greater social polarization and ultimately contributed to a decline from which the country would not emerge until the nineteenth century.

1. Letter to Pierre Dupuy, 6 May 1627, see Magurn 1955, p. 179. For the general history of the Spanish Netherlands in the seventeenth century, see *Algemene Geschiedenis der Nederlanden*, vols. 5-9 (Haarlem, 1979-1980); and in English, P. Geyl's two-volume study, *The Revolt of the Netherlands* and *The Netherlands Divided* (London, 1936), the latter revised (1961) and reissued as *The Netherlands in the Seventeenth Century 1609-1648* (London, 1989). On the history of Antwerp, see: F. Prims, *Geschiedenis van Antwerpen* (Antwerp, 1943); the various essays in K. van Isacker and R. van Uytven (eds.) *Antwerp, Twelve Centuries of History and Culture* (Antwerp, 1986); and in W. Couvreur (ed.), *Antwerpen in de XVIIe eeuw*, Genootschap voor Antwerpse Geschiedenis (Antwerp, 1989). For the economic history of the Spanish Netherlands, see H. van der Wee, *The Growth of the Antwerp Market and the European Economy (14th to 16th Century)*, 3 vols. (The Hague, 1963); E. Stols, *De Spaanse Brabanders of de handelsbetrekkingen der Zuidelijke Nederlanden met de Iberische Wereld 1589-1648* (Brussels, 1971); R. Baetens, *De nazomer van Antwerpens Welvaart. De diaspora en het handelshuis De Groote tijdens de eerste helft der 17de eeuw*, 2 vols. (Brussels, 1976); J. A. van Houte, *An Economic History of the Low Countries (800-1800)* (London, 1977); H. Soly, *Urbanisme en kapitalisme te Antwerpen in de 16de eeuw* (Brussels, 1977); C. Lis and H. Soly, *Armoede en kapitalisme in Pre-Industrieel Europa* (Antwerp/Weesp, 1986), and the essays in H. van der Wee (ed.), *The Rise and Decline of Urban Industries in Italy and in the Low Countries (Late Middle Ages – Early Modern Times)* (Louvain, 1988). For foreign observers' comments and spectatorial writings on Antwerp, see J. A. Goris, *Lof van Antwerpen, hoe reizigers Antwerpen zagen van de XVe tot de XXde eeuw* (Brussels, 1940).

2. On the Spanish occupation of the Southern Netherlands and its global context, see G. Parker, *The Army of Flanders and the Spanish Road (1567-1659)* (Cambridge, 1972); J. I. Israels, "A Conflict of Empires: Spain and the Netherlands 1618-1648," *Past and Present* 76 (1977), pp. 34-76; G. Parker, *Spain and the Netherlands* (Glasgow, 1979).

3. See M. Mauquoy-Hendrickx, *Les Estampes de Wierix*, part 2, (Brussels, 1979), p. 301, no. 1663, ill. p. 229. On one page of the book is the Dutch word "Ons," on the other an image of a ladder (*leer*, in Flemish) and a "T" (=Leert), meaning "Learn!"

4. Quoted in F. van Kalken, *Histoire de la Belgique* (Brussels, 1954), p. 349.

5. See Baetens, in van Isacker, van Uytven 1986, p. 164; on the population decline in other major cities in Brabant, see P. M. M. Klep, in van de Wee 1988, p. 275.

6. See Hollstein 1949-, vol. 14, p. 104, no. 123. The Dutch legend reads "In the iron age, Cain the big strong giant, and we are not rid of him yet, brought harm to the family of Abel. / The weeping, caused by war, robbery, violence and murder saddens both God and humankind. / The innocent must suffer the plague of the wicked."

7. On the government under the archdukes, see H. J. Elias, *Kerk en Staat in de Zuidelijke Nederlanden onder de regeering der aartshertogen Albrecht en Isabella* (Louvain, 1931); on their patronage, see de Maeyer 1955.

8. See G. Parker, *Europe in Crisis 1598-1648* (Glasgow, 1979), p. 50.

9. See A. K. L. Thijs, "The River Scheldt Closed for Two Centuries 1585-1790," in *Antwerp, a Port for All Seasons* (Antwerp, 1986).

10. Thijs 1990, p. 34.

11. G. Tournoy, "Het humanisme in Vlaanderen, 15de-17de eeuw," in Brussels/Schallaburg 1991, p. 206.

12. On Protestant emigration to the north, see J. Briels, *Zuid-Nederlanders in de Republiek 1572-1630, een demografische en cultuurhistorische studie* (Sint-Niklaas, 1985). On Flemish artists in the North, see idem, 1987.

13. See P. M. M. Klep, *Bevolking en arbeid in transformatie. Een onderzoek naar de onwikkelingen in Brabant 1700-1900* (Nijmegen, 1981), p. 413; and idem, "Urban Decline in Brabant," in van der Wee 1988, p. 261.

14. Thijs 1990, p. 41; and A. K. L. Thijs, "De strijd van Kerk en overheid om de controle over de cultuur produktie en beleving in Contra-Reformatisch Antwerpen (1585-ca. 1700)," in *De zeventiende eeuw* 8 (1992), p. 4.

15. See van Isacker, van Uytven 1986, p. 264; see also H. van der Wee, *The Growth of the Antwerp Market and the European Economy*, vol. 2 (The Hague, 1963), p. 261.

16. See Stols 1971; Baetens 1976; Baetens, in van Isacker,

17. See Baetens, in van Isacker, van Uytven 1986, p. 170.

18. See E. Scholliers and C. Vandenbroeke, "Structuren en conjuncturen in de Zuidelijke Nederlanden 1480-1800," *Algemene Geschiedenis der Nederlanden*, vol. 5 (Haarlem, 1979), p. 259; for an opposing view, see Baetens, vol. 1 (1976), p. 98; A. K. L. Thijs, "Nijverheid in de Zuidelijke Nederlanden 1580-1650," in *Algemene geschiedenis der Nederlanden*, vol. 7 (1980), p. 91.

19. See A. K. L. Thijs, "Structural Changes in the Antwerp Industry from the Fifteenth to Eighteenth Century," in van der Wee 1988, p. 209.

20. Ibid., p. 207.

21. Thijs 1990, p. 47.

22. See Klep 1981, pp. 354, 412.

23. (As a result of the continual wars, we would like to come to live in the city to work there in greater peace.) See R. de Peuter, "Industrial Development and De-Industrialization in Pre-Modern Times: Brussels from the Sixteenth to the Eighteenth Century," in van der Wee 1988, p. 224.

24. See R. Fabri, "Bijdrage tot de geschiedenis van het meubel te Antwerpen tijdens de zeventiende eeuw," in *Antwerpen* 1989, pp. 405-427; R. Fabri, *De 17de- eeuwse Antwerpse Kunstkast: Typologische en historische aspecten* (Verhandelingen van de Koninklijke Academie van Wetenschappen, Letteren en Schone Kunsten van België, Klasse der Schone Kunsten no. 53 [Brussels, 1991]). See also cat. 92.

25. On the manufacturing of claviers and organs, see A. M. Pols, *De Ruckers en de Klavierbouw in Vlaanderen* (Antwerp, 1942); J. Lambrechts-Douillez, "Klavecimbelbouw te Antwerpen in de zeventiende eeuw," in *Antwerpen* 1989, pp. 427-436 and G. G. O'Brien, *Ruckers: a Harpsichord- and Virginal-building Tradition* (Cambridge, 1990). On the manufacturing of violins, see G. Spiessens, "Die Antwerpse vioolbouwer Peeter Borlon (ca. 1599-1669)," in *Antwerpen* 1989, pp. 437-449.

26. See L. & F. Crooy, *L'Orfèvrerie religieuse en Belgique* (Brussels, Paris, 1911); S. Collon-Gevaert, *Histoire des arts du métal en Belgique* (Brussels, 1951); P. Baudouin, "Verkenning van de Antwerpse Edelsmeedkunst in de zeventiende eeuw," in *Antwerpen* 1989, pp. 379-410.

27. Thijs, in van der Wee 1988, p. 209. See also D. Schlugheit, *Geschiedenis van het Antwerpsche diamant slijpersambacht (1582-1797)* (Antwerp, 1935) and Antwerp, Provinciaal Diamantmuseum, *Het diamantjuweel in Rubenstijd*, 1977.

28. Van Isacker, van Uytven 1986, p. 177.

29. See Goris 1940, p. 63, citing *Letters from and to Sir Dudley Carleton Knight, during His Embassy in Holland from January 1615-1616 to December 1620* (London, 1757).

30. See Goris 1940, respectively pp. 62 (citing *Scrinium antiquarium sive miscellanea groningana nova ad historiam ecclesiasticum praecipue spectantia* [Groningen/Bremen, 1749-1765]), 87 (citing *Reise Beschreibung von Villa Franca der Chur Brandenburg durch Teutschland, Holland und Brabant, England, Frankreich . . .* [Frankfurt, 1723], pp. 145ff), and 100 (citing *Nouvelles description des Pais-Bas, et de toutes les villes des dix sept provinces* [Brussels, 1673]).

31. Goris 1940, p. 87 (see note 30 above).

32. Magurn 1955, p. 185.

33. Ibid., p. 279, letter to Pierre Dupuy, Antwerp, 10 August 1628.

34. See Geyl 1989, p. 25.

35. See J. H. Plantenga, *L'architecture religieuse dans l'ancien duché de Brabant depuis le règne des archiducs jusqu'au gouvernement autrichien (1598-1713)* (The Hague, 1926); P. Parent, *L'Architecture des Pays-Bas méridionaux. Belgique et Nord de la France aux XVIe, XVIIe et XVIIIe siècles* (Paris, Brussels, 1926); L. de Barsée, "Kort overzicht van de geschiedenis van de bouwkunst te Antwerpen," in *Bouwen door de eeuwen heen* (Ghent, 1976); and R. Tijs, "De Bouwkunst te Antwerpen in de zeventiende eeuw," in *Antwerpen* 1989, pp. 223-239.

36. On Coeberger, see de Maeyer 1955, pp. 198-206; Bernadette Huvane at Columbia University is preparing a dissertation on Coeberger.

37. Goris 1940, p. 62, citing "Verhaal der reis van Marcantonio Correr," *Relazioni Veneziane*, P. J. Blok, ed. (The Hague, 1909).

38. Thijs 1990, pp. 67-69.

39. Ibid., p. 66.

40. Van Kalken 1954, p. 400.

41. E. Stols, "Aspects de la vie culturelle aux Pays-Bas Espagnols à l'époque de Rubens," *Bulletin de l'Institut historique belge de Rome*, 48-49 (1978-79), p. 8.

42. See A. Poncelet, *Histoire de la Compagne de Jésus dans les anciens Pays-Bas* (Brussels, 1927-28); J. Andriessen, *De Jezuieten en het samenhorigheidsbesef der Nederlanden 1585-1648* (Antwerp, 1957); L. Brouwers, *Carolus Scribani S.J. 1561-1629. Een Groot man van de Contra-reformatie in de Nederlanden* (Antwerp, 1961); and R. Wittkower and I. Jaffé, eds., *Baroque Art: The Jesuit Contribution* (New York, 1972).

43. Thijs 1990, p. 69.

44. Ibid., p. 77.

45. See E. S. de Beer, ed., *The Diary of John Evelyn*, 2 vols. (Oxford, 1955), vol. 2, p. 60.

46. See Martin 1968, pp. 24 and 40.

47. Goris 1940, p. 80, citing Edward Brown, M. D., *Reisen durch Niederland, Teutschland, etc.* (Nuremburg, 1686), chapter 17.

48. Goris 1940, p. 79, citing A. S. Hartmann, "Tagebuch Adam Samuel Hartmanns über seine Kollektenreise im Jahre 1657-1659; edited by Rodgero Pruemers," in *Zeitschift historischen Gesellschaft für die Provinz Posen* 14 (1899) and 15 (1900).

49. Thijs 1990, p. 74.

50. Goris 1940, p. 86 (see note 30 above).

51. See H. P. Salomon, "The 'De Pinto' Manuscript. A 17th Century Marrano Family History," in *Studia Rosenthaliana* 9 (n.d.), pp. 2-62. On the Portuguese in Antwerp, see H. Pohl, *Die Portugiesen in Antwerpen (1567-1648)* (Wiesbaden, 1977); on anti-semitism, see idem, p. 321; Baeten 1976, vol. 1, pp. 303-304; Stols 1971 (as in note 1), vol. 1, p. 392; and Stols 1978-79, p. 217.

52. Goris 1940, p. 70 (see note 48 above).

53. Thijs 1990, p. 51.

54. Goris 1940, p. 72, citing Friedrich Lucae, *'Der Chronist'. Ein Zeit und Sittenbild aus der zweite Hälfte des siebzehnten Jahrhunderts* (Frankfurt a. M., 1854). However Lucae's story of a young servant of a visiting prince of Anholt being stabbed to death for refusing to kneel before a procession, his body lying in the street all day unclaimed by shame-faced but terrorized Protestants, may well be apocryphal since the event is purported to have occurred in 1597-99, seventy years before the telling.

55. See Elias 1931, pp. 47-48; van Kalken 1954, p. 400.

56. On Isabella, see L. Klingenstein, *The Great Infanta Isabel, Sovereign of the Netherlands* (London, 1910); M. de Villermont, *L'Infante Isabelle gouvernante des Pays-Bas*, 2 vols. (Paris, 1912); and Elias 1931, pp. 8-9.

57. Sir William Temple, *Observations upon the United Provinces of the Netherlands* (ed. Oxford, 1972), p. 47.

58. Magurn 1955, p. 176.

59. See Hans Devisscher, in Madrid cat. 1989, no. 43.

60. Ibid., no. 41, and Ertz 1979, cat. 364, fig. 291. See also Museo del Prado, no. 1439.

61. Magurn 1955, p. 142.

62. Elias 1931, p. 49. For the archdukes' many religious and social edicts, see V. Brants, *Liste chronologique des édits et ordonnances des Pays-Bas. Règne d'Albert et d'Isabelle* (Brussels, 1908), and idem, *Recueil des ordonnances des Pays-Bas. Règne d'Albert et d'Isabelle*, 2 vols. (Brussels, 1900 and 1912). See also A. Pasture, *La Restoration religieuse aux Pays Bas catholiques sous les Archiducs Albert et Isabella (1596-1633)* (Louvain, 1925).

63. On education in Antwerp, see especially, H. de Ridder-Symoens, "Het Onderwijs te Antwerpen in de zeventiende eeuw," in *Antwerpen 1989*, pp. 221-238.

64. Thijs 1990, p. 142.

65. See Stols 1978-79, p. 211, citing H. de Groote, "De zestiende-eeuwse Antwerpse Schoolmeesters," in *Bijdragen tot de Geschiedenis 50* (1967), pp. 179-318, and 51 (1968), pp. 5-52.

66. See de Ridder-Symoens 1989, pp. 234-235.

67. Ibid., p. 238.

68. Elias 1931, pp. 53-56; van Kalken 1954, p. 407; Stols 1978-79, p. 209.

69. Elias 1931, pp. 53-56; Thijs 1990, p. 178.

70. Thijs 1990, pp. 178-179.

71. On the Plantin Press, see L. Voet, *The Golden Compass. A History and Evolution of the Printing and Publishing Activities of the Officina Plantiniana at Antwerp* (Amsterdam/London/New York, 1969-1973). On the history of publishing in Antwerp, see M. Sabbe, *La Vie des Livres à Anvers au XVIe, XVIIe et XVIIIe siècle* (Brussels, 1926), and for seventeenth-century publishers and book dealers in Antwerp, see J. Lampo, "Boeken en Drukkers," in *Antwerpen 1989*, pp. 203-219.

72. Stols 1978-79, p. 209, citing J. Machiels, "De boekdrukkunst te Gent," in *Gent, Duizend jaar kunst en cultuur* (Ghent, 1975), vol. 2, pp. 1-112.

73. See Stols 1971, vol. 1, pp. 359-360; Baetens 1976, vol. 1, p. 298.

74. *The Diary of John Evelyn*, ed. E. S. de Beer (Oxford, 1955), vol. 2, pp. 70-71.

75. *Shakespeare's Europe: A Survey of the Conditions of Europe at the End of the 16th Century. Being Unpublished Chapters of Fynes Moryson's Itinerary of 1617* (New York, 1967; first ed., 1903), p. 373.

76. See I. van Eeghen, "De Acta Sanctorum en het drukken der katholieke boeken te Antwerpen en Amsterdam in de 17de eeuw," *De Gulden Passer 31* (1953), pp. 49ff.

77. See O. van der Vyver, "De Wetenschappen," in *Antwerpen 1989*, pp. 251-254.

78. On these and others' contributions, see van Isacker, van Uytven 1986, pp. 192-197; and van de Vyver, in *Antwerpen 1989*, pp. 257-259.

79. See O. van de Vyver, "Lettres de J.-Ch. della Faille S. I., cosmographe du roi à Madrid, à M.-F. van Langren, cosmographe du roi à Bruxelles, 1634-1645," *Archivum Historicum Societatis Iesu 46* (1977), p. 100.

80. Van Kalken 1954, p. 408.

81. On the history of the rhetoricians, see A. A. Keersemaekers, *Geschiedenis van de Antwerpse Rederijkerskamers in de jaren 1585-1635* (Aalst, 1952); and idem, "De Rederijkerskamers te Antwerpen: Kanttekeningen in verband met ontstaan, samenstelling en ondergang," in *Varia Historica Brabantica* (1978), pp. 173-186.

82. Thijs 1990, pp. 161-162.

83. Goris 1940, p. 88, citing Pierre de la Serre, *Histoire curieuse de tout ce qui s'est passé a l'entrée de la Reyne Mère... dans les villes des Pays-Bas* (Antwerp, 1632).

84. See A. E. C. Simioni, "The Mockers Mocked: The Brussels Play of Saint Ignatius, 1610, and Its Dutch Counter Attack," in *Archief- en Bibliotheekwezen in België 48* (1976), pp. 644-649.

85. Thijs 1990, p. 165.

86. R. Muchembled, *Culture populaire et culture des élites dans la France moderne XVe-XVIIIe siècles* (Paris, 1978), p. 199.

87. Thijs 1990, p. 156.

88. See footnote 25 above.

89. See Donnet 1907; A. A. Keersemaekers, *De dichter Guilliam van Nieuwelandt en de Senecaansclassieke tragedie in de Zuidelijke Nederlanden* (Ghent, 1957); and Keersemaekers 1982.

90. On state entries, see P. Vandenbroeck, *Rondom plechtige intredes en feestelijke stadsversieringen Antwerpen 1594-1635*, exhibition, Antwerp, 1981; H. Soly, "Plechtige intochten in de steden van de Zuidelijke Nederlanden tijdens de overgang van Middeleeuwen naar Nieuwe Tijd: communicatie, propaganda, spektakel," *Tijdschrift voor Geschiedenis 97* (1984), pp. 341-361; J. Landwehr, *Splendid Ceremonies. State Entries and Royal Funerals in the Low Countries 1515-1791. A Bibliography* (Leiden, 1971); and on the Pompa Introitus Ferdinandi, see Martin 1972.

91. On the Ommegangen, see especially Antwerp, Museum voor Folklore, *Ommegangen en Blijde Inkomsten te Antwerpen*, 1959.

92. See Baetens, in van Isacker, van Uytven 1986, p. 165.

93. Van Kalken 1954, p. 404.

94. See Muchembled 1978, pp. 188-208; H. Soly, "Openbare feesten in Brabantse en Vlaamse steden, 16de-19de eeuw," in *Het openbaar initiatief van de gemeenten in België, historische grondslagen (Ancien Regime)* (Brussels, 1984), pp. 605-636; Thijs 1990, pp. 173-179; P. Vandenbroeck, "Stadscultuur: Tussen bovengrondse eenheid en onderhuidse strijd," in *Brussels/Schallaburg 1991*, pp. 87-88.

95. Vandenbroeck, "Stadscultuur," in *Brussels/Schallaburg 1991*, p. 88.

96. Thijs 1990, p. 177.

97. See Vandenbroeck, "Stadscultuur," in *Brussels/Schallaburg 1991*, pp. 88-89.

98. See Stols 1978-79, citing E. Rodoconachi, *Aventures d'un grand seigneur italien à travers l'Europe* (Paris, 1889), p. 113; and van de Vyver 1977, p. 154. See also Th. Penneman, "Heksenprocessen in Vlaanderen inzonderheid in het Land van Waas 1538-1692," in *Annalen van de Koninklijke Oudheidkundige Kring van het Land van Waas* 79 (1976), pp. 5-136; T. Maes, "Un procès de sorcellerie en 1642, évalué à la lumière de récentes études européennes et d'après la législation et la théorie du droit du XVIIe siècle," in *Studia Mecliniensia. Bijdragen aangeboden aan Dr. Henry Joosen* (Mechelen, 1976), pp. 243-248.

99. See Elias 1931, pp. 36-46; Thijs 1990, pp. 131-134.

100. See Thijs 1990, p. 134.

101. Ibid., p. 132.

102. Cited by P. Vandenbroeck, "Vrouwenhaat, Mannenpraat," in Brussels/Schallaburg 1991, p. 110, 125, note 6: Joh. David, *Bloemhof der kerckelicker cerimonien, item den christelijcken huys-houder met eene spongie der quader sede* (Antwerp, 1607); I. Ysermans, *Triumphus Cupinis, Encomium matrimonii* (Antwerp, 1628); and C. Hazart, *Het Ghelvekigh ende deughdelyck houwelyck* (Antwerp, 1678).

103. See P. Boeynaems, "De Geneeskunde te Antwerpen in de tijd van Rubens," in exh. Antwerp, Geneesherenhuis, *Geneeskunde rond Rubens*, 1977, pp. 21-30.

104. Moryson 1617/1967, p. 371.

105. Goris 1940, p. 114, citing J. Cuvelier, "Un voyage princier en Belgique au XVIIe siècle," *Bulletin du Touring-Club de Belgique* 1923, pp. 418-434.

106. Thijs 1990, p. 136.

107. Ibid., p. 138. On prostitution, see J. Wilms, *Onder Sint-Andriestoren, de Schuif, de Boeksteeg, de beruchte Lepelstraat* (2nd ed. Antwerp, 1941), pp. 93-121; and H. W. J. Volmuller, *Het oudste beroep. Geschiedenis van de prostitutie in de Nederlanden* (Utrecht, 1966).

108. See Chr. Vandenbroeke, "Het seksueel gedrag der jongeren in Vlaanderen sinds de late 16e eeuw," *Bijdragen tot de Geschiedenis* 62 (1979), pp. 193-230. On the prohibition against premarital sex and other restrictions on courtship, see M. Cloet, *Het Kerkelijk leven in een landelijke dekenij van Vlaanderen tijdens de XVIIe eeuw* (Louvain/Ghent, 1968), pp. 323-327.

109. See for example the comments of Payen (1650) (*Les voyages de M. Payen dédiez à Monsieur de Lionne* vol. 1 [Paris, 1663]) and of Cosimo de' Medici (1668), in Goris 1940, p. 114 (see note 105 above). On fashion generally, see J. H. der Kinderen-Besier, *Spelevaart der mode. De kledij onzer voorouders in de zeventiende eeuw* (Amsterdam, 1950).

110. Goris 1940, p. 113 (see note 48 above).

111. Ibid. (see note 54 above).

112. J. Walgrave, in exh. cat. Deurne-Antwerp, Provinciaal Museum "Sterckshof," *De Mode in Rubens' tijd* 1977; and F. Sorber, "Kledij in Antwerpse Archieven uit de zeventiende eeuw," in *Antwerpen* 1989, pp. 451-485.

113. See Muchembled 1978, p. 203; and R. Muchembled, "Omgangsvormen en rituelen," in Brussels/Schallaburg, 1991, p. 98.

114. Goris 1940, p. 103, citing Philip Skippon, *An Account of a Journey made thro' part of the Low Countries, Germany, Italy and France*, vol. 4 (London, 1732); the Dutchman George Doubleth, in 1654 (see R. [Fruin], "Een Hollander op de Kermis te Antwerpen in 1654," *Bijdragen voor Vaderlandsche Geschiedenis en Oudheidkunde* 6 [1870], pp. 314ff); and the German Sigmund von Birken (*Hoch Fürstlicher Brandenburgischer Ulysses* [Bayreuth, 1668], p. 112 bis).

115. Goris 1940, p. 104, citing an unpublished ms. in the Koninklijke Bibliotheek, Brussels, no. 20996.

116. See 's-Hertogenbosch, Noordbrabants Museum, *Vastenavond-Carnaval Feesten van de omgekeerde wereld* (ed. Charles de Mooij), 20 September-29 November 1992.

117. Legrand 1963, p. 238.

118. Thijs 1990, pp. 152 and 157.

119. Ibid., p. 154.

120. Ibid., p. 193.

121. See Stols 1971, pp. 387-390; and idem, 1978-79, p. 55.

122. Van Isacker, van Uytven 1986, p. 196.

123. Thijs 1990, pp. 189 and 201.

124. Stols 1978-79, p. 221.

Painting and the Counter Reformation in the Age of Rubens

DAVID FREEDBERG

THIS ESSAY begins with an inescapable irony. To consider the problem of Flemish painting during the Counter Reformation is to deal with paintings that are almost entirely absent from the present exhibition because they are too large to transport, or because they cannot be detached from their ecclesiastical context.[1] But their background – political, religious, and theological – is of immense importance for an understanding of all picture making during the age of Rubens. Two events are crucial. Although they date from before his birth, they continued to affect the course of painting until long after his death. The first is the Council of Trent, which passed its decree on painting in 1563; the second is the great outbreak of Iconoclasm that marked the effective beginning of the Revolt of the Netherlands against Spain in August 1566. Let us begin with the latter, not only because it is more dramatic, but because its immediate effects are clearer and easier to plot.

Much attention has already been devoted to the background, motivation, organization, and consequences of Iconoclasm in the Netherlands.[2] The image breaking began in Steenvoorde in the *Westkwartier* of Flanders on 10 August 1566, ravaged Antwerp on the fearful night of 20-21 August, and then spread like wildfire all over the Netherlands, both North and South, before finally burning itself out by the middle of October that year. Thousands of works of art of every description were lost.

The destruction was terrible and almost complete. Paintings, sculptures, and glass disappeared from churches and religious houses throughout the country.[3] In Antwerp itself whole altarpieces were destroyed, or sometimes just their wings or surrounds (as occasionally happened when the central panel could be spirited away to safety). Our knowledge of Rubens's predecessors as altarpiece painters is therefore inevitably fragmentary. Thus, although the central panel of Frans Floris's famous altarpiece for the Antwerp Swordsmen (*Schermers*) – probably the most famous altarpiece of the era before Rubens – was damaged in 1566 (as recalled by an inscription of the following year), it survived (fig. 1); but its wings were lost – either then or in the course of the reframing of the altarpiece between 1640 and 1660.[4] One has only to go through the pages of van Mander's *Lives* of the Netherlandish painters to have some sense of the scale and fury of the destruction.

The chief consequence, therefore, of the Iconoclasm of 1566, was the destruction of a good many examples of religious painting of the period before 1566. What happened in the next twenty uncertain years was almost as grievous. Although the Duke of Alba, who had been sent by Philip II to restore order in the provinces, issued instructions to repair the damaged and destroyed altars, and despite the very occasional new commission,[5] the period of recovery was slow and difficult. Painters who had adopted one Reformed faith or another started to leave, in large numbers[6]; the churches that managed to continue holding services had neither the resources nor the will to commission new works; funds for commissions, both in the public ecclesiastical domain and in the private one were lacking, as the war strained the economy; and there was a general sense that it was futile to produce paintings at all. After all, why do so if they were constantly liable to destruction at the hands of Iconoclasts? Or at the hands of an uncontrollable militia, as happened in the case of the frightening events of November 1576 known as the Spanish Fury? In any event, years of Protestant polemic and Catholic doubt had raised a large question mark over the validity and status of painting itself. Could pictures (and *mutatis mutandis* sculptures) ever be adequate mediators between Man and God? Since they were nothing more than figured material objects, how could they ever be capable of circumscribing the fundamental uncircumscribability of the divine? Had not too much money been invested in them at the expense of the true images of God, the people, and above all the poor people, as Luther and many other of the major reformers claimed? Could fine paintings buy time off from purgatory? And were pictures –

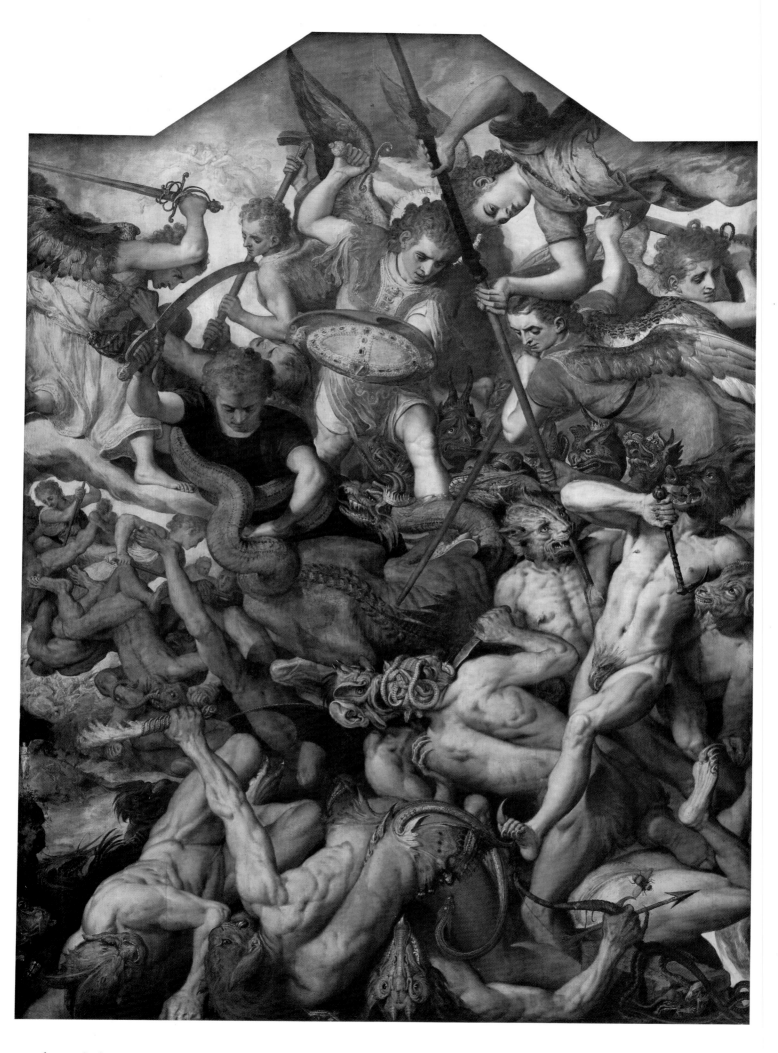

and art in general – not simply a sensual snare from the true spirit of God, best expressed in his word?

All these, it is true, were Protestant reservations of one form or another, but they continued to reverberate throughout Rubens's lifetime. Although the Council of Trent had formulated its decree on images at its very last session in December 1563,[7] the decree was disappointingly undefinitive. It failed to deal adequately with the Protestant reservations. Few were convinced by its weak responses either to the allegations against the essence and substance of the use of images in churches, or to the many criticisms of their abuse.[8] In short, there was not only a crisis of faith, but a crisis of faith in images. There were fewer artists left to produce them, and fewer people willing to commission them.

In Antwerp, the situation was intensely exacerbated by the so-called *Stille Beeldestorm,* or "quiet Iconoclasm," of 1581. At this time, the recently elected Calvinist City Council achieved the peaceful removal of images from the churches by replacing the Catholic deans and other officials of the guilds with Calvinist ones. The result was a renewed form of iconoclasm, this time carried out in an orderly fashion behind closed doors. Now the guilds themselves had the works removed from their own altars.[9] They maintained not only that the images were idolatrous, but that they needed the money that would accrue from their sale to support their poorer members – especially those impoverished by the recent troubles.[10] In many instances, therefore, the allegation of idolatry was little more than a convenient pretext for the removal of images. Many works were lost as a result, thus adding even further to the casualties of the great Iconoclasm of 1566 and the sporadic assaults against images in the intervening years.

But by 1581 the *reconquista* of The Netherlands by Alexander Farnese, Duke of Parma, was already under way. Antwerp finally capitulated in August 1584, and the Southern Provinces were effectively regained for the Spanish Crown.[11] Farnese ordered the restoration of Catholic services, and included amongst the conditions of capitulation the instruction to restore or rebuild the damaged churches. In Antwerp Cathedral alone the guilds of the Schoolmasters and Soapboilers, Smiths, Shoemakers, Barbers and Surgeons, *Oude Handboog* (Crossbowmen),[12] Cellarers and Vintners, Bakers and Millers, and *Oude Voetboog* (Longbowmen), to name only a few, all set about raising funds for new paintings.[13] The chief beneficiaries of this boom in commissions were the brothers Ambrosius, Hieronymus I, and Frans I Francken, and, above all, Marten de Vos, who replaced Frans Floris as the dominant figure in Antwerp painting.

But barely had de Vos died in 1604, when a new phase in Antwerp painting – the greatest in its history – began. It was inaugurated by two events in very different spheres: firstly, the return of Rubens from Italy at the end of 1608, and secondly, the signing of the Twelve Year Truce between Spain and the Northern Netherlands in 1609. From the point of view of the revival of painting in the South, it is hard to imagine a happier combination of circumstances. Rubens had more than proved his mettle in Italy, having made the vast paintings for the Jesuit Church in Mantua (see cat. 5) and Santa Croce in Gerusalemme in Rome, and having just completed the decoration of the high altar of the prestigious Chiesa Nuova there too (cat. 7).[14] Indeed, as a specimen of his gigantic talent, he brought back with him the first – and superior – version of the picture he painted for the high altar of the Oratorians, and installed it in the Abbey Church of St. Michael, near the tomb of his beloved mother.

Circumstances could not, in fact, have been more favorable for a promising young painter. With the political situation now stabilized, and the local economy once again on its feet (though it would never be as strong as it had been in its heyday), an immense program of ecclesiastical building and rebuilding began. This was encouraged and subsidized by the Archdukes Albert and Isabella,[15] who would soon not only become Rubens's patrons, but also take him as their confidante. Almost everywhere (or so it must have seemed) funds were made available for the restoration of the old altarpieces and the commissioning of new ones. The new churches and monasteries offered even further opportunities. It would be hard to list even a small portion of the possibilities that were opened up throughout much of Rubens's life, for even in the 1630s the program of repair, renewal, restoration, and reestablishment continued.

Take Antwerp in the decade after Rubens's return from Italy. Immediately after the signing of the truce, work began once again on the still-unfinished Churches of St. Paul and St. James; in 1611 the church of the Capuchins (still a new order in the Netherlands)[16] was begun, while in 1615 the first stone was laid of what would become the finest Jesuit church in the whole of North-

Fig. 1. Frans Floris, *Fall of the Rebel Angels,* oil on panel, 303 x 220 cm, Antwerp, Koninklijk Museum voor Schone Kunsten, inv. 112.

ern Europe. The same year saw the foundation of the church of the Augustinians; while in 1616 the church of another new order, that of the convent of the Annunciate sisters, was begun.[17] For the Dominican Church of St. Paul Rubens began painting the complex altarpiece showing the *Dispute over the Real Presence in the Holy Sacrament (The Glorification of the Holy Eucharist)*[18] and the smaller one of the *Adoration of the Shepherds*[19] almost immediately after he returned from Italy. Within a few years he produced a fine *Flagellation*[20] for a cycle of eighteen paintings devoted to the Cycle of the Rosary (appropriately, since this was a cult much encouraged by the Dominican order), to which both the very young van Dyck and Jordaens also contributed (see Vlieghe).[21] By the end of the decade he had produced the huge *St. Dominic and St. Francis of Assisi Protecting the World from the Wrath of Christ*[22] and along with Jan Brueghel and others had begun negotiations to buy Caravaggio's great *Madonna of the Rosary* to install in the church. For the Church of St. James (St. Jacobskerk) he would eventually paint the altarpiece for his own funerary chapel at the very end of his life.[23] And for the resplendent new Jesuit church he immediately started painting not only the two great works for the high altar glorifying the founding fathers of the Order, St. Ignatius Loyola (Introduction, fig. 25) and St. Francis Xavier,[24] but also the stupendous series of paintings for the ceilings of the aisles and the galleries (see cats. 18 and 19).[25] Barely had he finished these, when he started working on the *Adoration of the Magi* for the Abbey Church of St. Michael,[26] and then on the high altarpiece of the Augustinian church, which would be one of the crowning achievements of his religious painting in the 1620s.[27]

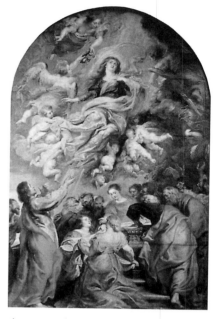

Fig. 2. Peter Paul Rubens, *The Assumption of the Virgin*, oil on panel, 487.6 x 205.2 cm, Antwerp, Cathedral (Onze-Lieve-Vrouwekerk).

As if this were not enough, one has also to reckon in those works commissioned as direct replacements for paintings that had been lost in the iconoclastic period, such as the great *Descent from the Cross* (Introduction, fig. 18) painted in 1611-14 for the altar of the *Kolveniers* (harquebusiers) in Antwerp Cathedral,[28] and, above all, the *Assumption* (fig. 2) for the high altar of the Cathedral, commissioned from Rubens in 1609-10 against the competition of his old teacher Otto van Veen (the most important painter in Antwerp and the stylistic link between de Vos and Rubens), but only completed, after many vicissitudes in 1626.[29] The prehistory of both works is significant. The *Assumption* was commissioned to replace a *Nativity* by Frans Floris, which itself had only been a stopgap measure. Originally belonging to the Gardeners' guild, Floris's work had only been moved to the high altar in 1585, to serve as a temporary replacement for the old high altarpiece of the *Assumption*, also by Floris and removed (and lost) in the "silent" iconoclasm of 1581.[30] With the *Kolveniers* the story is very different but equally telling. They seem to have had more than the usual difficulty in raising the necessary funds to comply with Farnese's 1585 order to repair and restore the damaged altars and altarpieces. Indeed, we know from a request of 1611 that the *Kolveniers* had repeatedly been urged to commission an altarpiece that would measure up to the many other new altarpieces which had recently been installed in the Cathedral.[31] And so they did, magnificently. The scale and ambition of Rubens's work appears as a direct response to the challenge of all the other new work commissioned in the wake of the disasters of 1566 and 1581.

To survey Rubens's output of religious works for public and private patrons in the decade that followed his return from Italy is to have one's breath taken away. It is testimony, of course, to the unparalleled energy and inventiveness of the artist, but it is also a direct consequence of the opportunities provided by three related factors: first by the Iconoclasm which had cleared the ground, sometimes literally, for new commissions; second by the renewed political and economic confidence afforded by the truce; and third by the religious and spiritual recovery associated with the Catholic revival not only in Antwerp but throughout Catholic Europe.[32] The altarpieces Rubens painted in Antwerp and Brussels are too numerous to list here; but the commissions flooded in from every quarter. From Ghent, for example, came the commission, discussed below, for a new high altarpiece for the church of St. Bavo,[33] from Mechelen an altarpiece for the Fishmongers in Onze-Lieve-Vrouwe over de Dijle[34] and the high altarpiece for St. John's (see cat. 9, fig. 4),[35] and then more commissions still, from Lille, Cambrai, Tournai, Valenciennes, Bergues, and so on, almost without pause.[36] Under any circumstances Rubens would have been the most sought-after of painters; but the extraordinary production of the second decade is unimaginable without the opportunities offered in the wake of the devastation of the forty-two years preceding his return to Antwerp. And the only parallel – when we think of that town alone – for such an unprecedented opportunity afforded by catastrophe for an artist of genius occurs is a later and a Protestant one: it is Christopher Wren's rebuilding of London churches after the Great Fire of September 1666. But that is another story altogether.

The effect of the great drama in the Netherlands on religious painting could hardly be better illustrated than by a comparison between the well-known Dutch church interiors of Pieter Saenredam on the one hand and those of Hendrick van Steenwijck or Pieter Neeffs on the other (cat. 77). Saenredam depicts the brilliant and whitewashed interiors of the great churches of the Northern provinces, stripped of their idolatrous imagery and almost every other kind of adornment; while Steenwijck and Neeffs show the often crepuscular and fitfully lit interiors of both real and imaginary churches, furnished as they once were with great triptychs and every other kind of visual aid to devotion. The Dutch churches, suffused though they may be with the splendor of a more than earthly illumination, testify to a new, more secular interest in the possibilities of painting. The Flemish ones evince a kind of nostalgia for the way things were – at least within churches. Though painted well into the seventeenth century, they continued to show altarpieces and other devotional pictures in now outdated formats, and decorations that had certainly been superseded. Instead of showing church interiors as they were, they betray a longing for the way they once had been. The Dutch painter generally has casual visitors within the churches, if he has them at all, but the Flemish pictures are inhabited by people intent on their devotions, celebrating Mass, or, occasionally but significantly, admiring the pictures. No contrast could be more revealing about the different states of visual culture in the North and in the South than this, nor about the different status of religious images. In the North, vigorously stimulated by an influx of painters who no longer had much interest in painting religious works, painting had become predominantly secular; in the South, the opportunities for painting altarpieces and every other kind of devotional picture were possibly even more abundant than they ever had been before.

A well-known group of paintings by David Teniers the Younger provides a further illustration of attitudes in the South. In a painting now in the Prado, a monkey paints a picture while another looks on with the aid of a magnifying glass (fig. 3). Its companion shows a similar scene, but with a monkey-sculptor instead of the simian painter.[37] Art, of course, is the ape of nature; but are not monkeys also stupid, sensual, blind to the life of the spirit? It is true that Teniers painted a large number of works showing monkeys engaged in a whole variety of activities, but it cannot be mere accident that the activity of painting is one of them. What is more, the monkey-painter works in a studio full of the kinds of non-religious paintings that were being produced in the Northern Netherlands at the time, just as the monkey-sculptor's workshop is kitted out with fragments of classical works, and he chisels away, altogether significantly, at the herm of satyr. In no case is a religious or devotional work anywhere to be seen. The message seems clear enough.

In other paintings by Teniers, however, it is the destroyers of art who are the monkeys and asses. Several compositions by him – and by Frans Francken the Younger – show typical small cabinets of the seventeenth century, where the works are broken and trampled upon by monkey- and donkey-iconoclasts, as if to remind the viewer of the stupidity of those who attack art. Teniers himself repeatedly painted the picture collection of Leopold Wilhelm, both in the shape of portrayals of Leopold's own collection, or as copies after the famous works within it, whether sacred, secular, and altogether profane (cats. 124 and 126, 127, 128). This dichotomy between love of pictures and doubts about them offers a further indication of the fundamental ambiguity of

Fig. 3. David Teniers II, *The Monkey Painter*, oil on panel, 24 x 32 cm, Madrid, Museo del Prado, inv. 1805.

Fig. 4. David Teniers II and Frans Francken II, *The Interior of a Picture Gallery*, oil on panel, 58.5 x 79 cm, London, Courtauld Institute, Princes Gate Collection, inv. 47.

attitude towards the nature and validity of visual imagery throughout the period. In the end, Teniers comes out clearly on the side of painting (the gallery-pictures such as cats. 124 and 125 leave one in no doubt of this at all); but his pictures of the ape-artists represent a full awareness of the other side of the question. However surprising it may be to find that the vestiges of anti-image sentiment lasted so long, this does indeed seem to have been the case. In fact, I would argue that *Catholic* misgivings about art – about its fundamental sensuality, for example – had as much of an influence on the art of the period as the much-vaunted ways in which it was used for spiritual and anagogical inspiration, whether on the grand, theatrical, and decorative scale, or on the small and intimately emotional one. Nothing could reveal this more clearly than the painting by Teniers and Francken (probably showing the cabinet of Pieter Steevens) in the Princes Gate collection in London (fig. 4), where the picture hanging on the wall on the left shows donkey-iconoclasts engaged in the destruction of paintings, while two connoisseurs engage in a discussion of well-known portraits by van Eyck and Rembrandt.[38] The implication, at first, may seem clear enough; but opposite the connoisseurs, as if in mute commentary on their engagement with art, sits an ape, eating a nut and chained to a ball: the very epitome of our enslavement to our material and sensual nature.[39]

It has become much harder these days to speak of the influence of the Counter Reformation on art.[40] In the first place, historians have begun to question the validity of the label itself.[41] Some prefer to speak broadly of the Catholic Reform,[42] or of the Catholic Revival; others suggest that the old notion of the Counter Reformation be divided into periods of Reaction, Reform, and Revival. But even if one retains the generic term "Counter Reformation," how exactly is one to speak of its influence on art? Can one really say that particular events (such as Iconoclasm), or certain synodal decrees (such as those of the Council of Trent and the local provincial synods), actually caused pictures to look the way they do? Or that even vaguer and more diffuse phenomena, such as the rise of new devotions, an increased emphasis on spiritual intensity, or a renewed confidence in the Church itself, had specific consequences for pictures? Many have tried; but the examples of failure, from Werner Weisbach's *Der Barock als Kunst der Gegenreformation* (1921) to the recurrent attempts to prove or disprove a specifically Jesuit influence, are legion.[43]

There is no need to end with an *aporia*, however. In fact, a number of developments in religious art during the period can be directly attributed to the effects of what used unhesitatingly to be called the Counter Reformation. First there is the reinvigoration of the old religious orders and the founding of new ones, initially under Farnese and then in the course of the great religious revival sponsored by the archdukes.[44] After 1584 the expelled clergy, monks, canons regular, and Jesuits all started returning to the South and rebuilding their houses. In that year, for example, Farnese helped found the first Capuchin convent in Antwerp; this was followed by a whole series of others in the next twenty years (Rubens painted altarpieces for the houses in Cologne and Lille),[45] so that by 1632 the Capuchins had eighteen houses. The Mendicant orders were almost all thoroughly renewed. Six of the ten monasteries belonging to the Augustinian Friars destroyed in the iconoclastic period were rapidly rebuilt, with no fewer than eleven more added between 1588 and 1622. Between 1601 and 1624 alone they founded thirteen new schools for young men. The first Netherlandish Carmel according to the Reform of St. Theresa was erected in Brussels in 1607; others swiftly followed (Rubens painted the high altarpieces for both the Brussels and the Antwerp Discalzed Carmelites).[46] And all the while the Jesuits continued to burgeon and flourish.[47] Opportunities for every kind of artist, from the painter of high altarpieces to the lowest producer of popular prints, were more abundant than ever before.

Indeed, it is in the popular domain that the religious reform and revival may be said to have had its most striking effects. The consequences for the visual arts are immense, not simply in painting, but above all in the production of popular prints. In addition to the emphasis on older devotions, such as the Rosary (the Dominican cult par excellence), many of the new orders encouraged the growth of a range of popular devotions, such as those of the Sweet Name of Jesus, the Sacred Heart of Jesus, the Holy Infant, and the Holy Family. The very names of these devotions provide some indication of the kind of sentimentality that characterizes much of the print production of the period following 1609.[48] It is not an accident that François de Sales's *Introduction à la vie dévot*, which first appeared in 1608, should have enjoyed such swift and widespread popularity in the Netherlands. And while it is true that many of the devotions, both the new and the revived ones, are represented with the kind of sweet expansiveness that is already present in

the work of the Wierix brothers, the mystical and ecstatic qualities of everyday devotional prints (one has only to think of the Theresan Carmelites), and the element of what has been generically called simple popular (*volkse*) pathos (of the kind propagated by the Capuchins),[49] seem substantially to increase as one moves towards the middle of the century.[50] While the work of the major print producer in the last three decades of the sixteenth century, Marten de Vos, already shows an increase in the range and detail of subject matter derived from scripture and from the lives of the saints, there is none of the sweetness of the later period, and nothing like the variety of cult and saints represented.

Much of this, not surprisingly, is reflected in the wide range of images associated with pilgrimage. One of the most striking features of the new forms of religiosity in the early seventeenth century is the devotion to cult images of the Virgin and saints. It was as if such images offered proof of the validity of the Catholic cult of images as a whole, and of the possibility of religious art in general.[51] It is no coincidence that in the very years that Rubens was preparing his great altarpiece in Rome intended to include within it the miraculous image of the Madonna della Vallicella,[52] Justus Lipsius was writing his comprehensive treatises on the origins and miracles of the two great Marian shrines of the Netherlands, Hal (Halle) and Scherpenheuvel (Montaigu).[53] Scherpenheuvel in particular afforded an exceptional variety of opportunities for artists who ranged from the lowliest and crudest printmakers to Wenceslas Coeberger, court painter and architect, inter alia, to the archdukes, and to a painter such as Theodoor van Loon.

No order made greater use of the possibilities of printed imagery than the Jesuits. They did so in ways that were in perfect concord with the intensely visual principles on which the *Spiritual Exercises* of St. Ignatius were based. While those exercises were largely predicated on the summoning up of the most vivid possible internal images, his successors were quick to realize the potential of real images as aids to devotion. And since the aim, amongst the Jesuits, was to reach as wide an audience as possible, and to touch the hearts of the thousands of young men entrusted to their pedagogical care, it was natural that such imagery should take the form of printed illustration. One of the first great specimens – though this was a superior and expensive production – was the *Evangelicae historiae imagines* composed by Ignatius's great friend, Jerome Nadal, and illustrated with over 150 engravings by the Wierix brothers.[54] This was followed by an extraordinary efflorescence of devotional emblem books, in which edifying, hortatory text and image are integrated with a uniformity of purpose unprecedented in the history of art. The numbers of Jesuit writers of such practical handbooks of devotion are legion, and their works ran into one edition after another. Amongst the most popular were writers such as Joannes David, Hermannus Hugo, Antonius Sucquet, Willem Hesius, Adriaen Poirters – to mention only a very few of the most successful[55]; but there were many others, including those for whom Rubens himself provided the book illustrations and title pages, such as Carolus Scribani, Baltasar Cordier, Leonardus Lessius, and Heribertus Rosweyde.[56] In the very year in which Rubens died there appeared that great culmination of all the Jesuit illustrated books, the celebration of the first hundred years of the Order, the *Imago primi saeculi*.[57]

Of course it is true that the other orders also included amongst their number many good and efficient writers of illustrated devotional handbooks, but no order had so high a proportion of such writers as the Jesuits. It may be difficult to plot the extent to which one can speak of a specifically Jesuit art in the seventeenth century, especially in Rome, and it may be even more difficult – given the elusiveness of the categories – to fix with any degree of precision the relations between Jesuit art and the baroque style (since that discussion has focused so largely on painting and architecture),[58] but the situation with printed imagery is considerably clearer. Had it not been for the Counter Reformation in general and the Jesuits in particular, devotional book illustration would never have proliferated in the way it did in the very years of Rubens's lifetime.

It hardly needs to be pointed out, however, that the consequences for paintings and prints were very different indeed. Pictures and prints have different functions and, often but not always, different audiences. Pictures, generally, are expensive, prints substantially cheaper. The function of altarpieces is tied to their ritual context in ways that prints hardly ever are. But it would be wrong, in considering the art of the period, to see them as wholly divergent. Knowledge of the great altarpieces and other religious paintings is disseminated by their transformations, both stylistic and iconographic, in reproductive form. Selective reproduction in popular prints – that is, the reproduction of *parts* of altarpieces and other devotional pictures – is just as informative.[59]

Indeed, one of the most interesting aspects of the art of the period between, roughly, 1630 and 1650 is the adaptation of a range of features from high art into its lower forms, from book illustrations and prayer cards, to pilgrimage pennants and an enormous variety of printed devotionalia. No one has yet made a careful study of the implications of the downward transformation of canonical prototypes, either in terms of the history of art or the history of art's audiences.[60] And no period would more fruitfully repay examination than this one, where prints were used on a more massive scale than ever before in the service of religious propaganda and the purposes of approved edification.

The reverse has not been attempted either. Little research has been done on the *upward* influence of popular devotional and religious prints – the influence, therefore, from low to high. In thinking about this for the period from 1609 on, certain general phenomena become very clear indeed. One, for example, is the progressive sentimentalization of altarpieces, not only after the death of Rubens, but already before.[61] Whatever the internal stylistic pressures on the development of altarpieces, there can be no doubt of the influence of popular prints and book illustrations. The public for pictures had been irrevocably conditioned by a diet of sweetly exhortative or vigorously and graphically emotional imagery, disseminated in the form of everyday engravings. It had also grown accustomed to complex iconographies, made possible by the complex and detailed captions and accompanying texts that explained them. And it had learned of a vast number of saints who had not generally entered the repertoire of the painters. Indeed – as we shall see – there was a period when the presence of saints on altarpieces, at least on their central panels, was specifically discouraged. But in time, as the iconography of pictures became more complex too, more saints than ever before began invading the altarpieces.[62]

Rubens's 1626 high altar for the Antwerp Augustinians[63] represents the first stage in the intensification of this trend. By the early 1630s the new and recently established confraternities seem to have had no difficulty in obtaining altarpieces dominated by their patron saints, as with Rubens's own *St. Ildefonso* (fig. 5)[64] and van Dyck's two exceptionally beautiful altarpieces of 1629 and 1630 for the Jesuit Sodality of the Blessed Virgin, of which he was himself a member.[65] By the middle of the century one may begin to speak of a veritable hagiographic proliferation. And the Bollandists had begun to work. They had to sort out the canonical from the non-canonical, the authorized from the popular – and the two by no means always coincided. It is no accident that the first volume of the *Acta Sanctorum* appeared just three years after the death of Rubens.

While we may remain sceptical, therefore, about attempts to define the more general influence of the Counter Reformation on art, the great iconographic treatises by Emile Mâle and J. B. Knipping, for all their diffuseness, provide an abundance of information about the way in which Catholic religious art after the Counter Reformation differed from what went before – at least from the iconographic point of view. Knipping offers many detailed explications of the intricacies of both new and old devotional subject matter, while Mâle attempts to insert such details into more general iconographic patterns. And although his concerns are with the whole of European painting, there are also, in the Netherlands specifically, some distinctive iconographic features that appear after the Council of Trent in each of the major phases of the period as a whole.

In the period between 1585 and 1609, for example, there was a predilection for large altarpieces showing the martyrdom of saints in vivid and gruesome detail.[66] There can be little question that this taste for martyrdoms – if it can be called that – is to be related not only to the great Counter Reformation martyrologia that appeared at this time, but also to the graphic accounts of contemporary Catholic martyrs, beginning with Richard Verstegen's *Theatrum crudelitatum hereticorum nostri temporis*, which appeared in Antwerp in 1587. But if there was any group that made much play of the contemporary martyrdoms – not only at the hands of the Protestants but also, of course, by more exotic persecutors, such as the Indians at Goa in 1583 and the Japanese at Nagasaki in 1597 – it was the Jesuits. The predilection for the representation of martyrdoms in Antwerp is to be paralled by the work of Jesuit painters in Rome, most notably in the extraordinary cycle in Santo Stefano Rotondo, as well as by the obsessive fetishization of the details of martyrdom and torture itself that reaches its high point in books such as Antonio Gallonio's popular *Trattato de gli instrumenti di martirio, e delle varie maniere di martoriare usate da gentili contro christiani*, first published in Rome in 1591.[67]

There can be no question that Rubens must have recalled the grim fascination of works such as these when he came to paint some of the dramatic and sometimes horrifying altarpieces of the

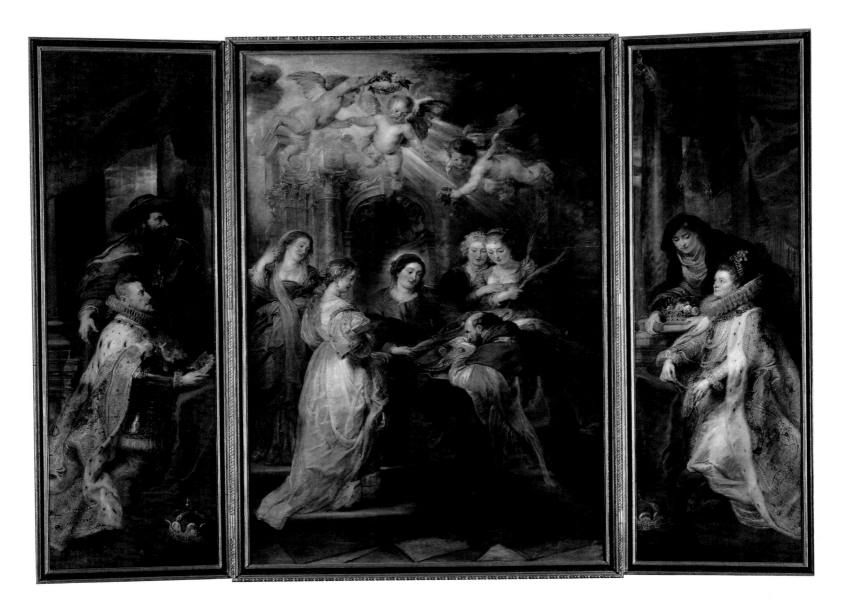

Fig. 5. Peter Paul Rubens, *The St. Ildefonso Altarpiece*, oil on panel, center 352 x 236 cm, whole 352 x 454 cm, Vienna, Kunsthistorisches Museum, invs. 678, 698.

1630s. Most striking of all, of course, is the huge altarpiece showing the *Martyrdom of St. Livinus* for the Jesuit church of St. Livinus in Ghent,[68] but its tone of fervid drama and emotion is also to be found in more conventional subjects, such as the great *Carrying of the Cross* for the newly restored Benedictine Abbey of Afflighem (both works now in Brussels).[69] It is worth recording that the Provost of Afflighem at this time – he had just instituted a wide-ranging reform of the Abbey – was Benedictus van Haeften who, paradoxically enough, was also the author of one of the sweetest devotional emblem books of all, the *Schola cordis*. This work first appeared in Antwerp in 1629,[70] but six years later van Haeften published the *Regia via crucis*, with a title page according to a design by Rubens.[71] By this time Rubens had almost certainly begun to paint the picture for the new high altar of the Abbey. Such are the poles of taste and pictorialization at the height of the Catholic Revival in the Netherlands.

In all this there lies a problem. Had not the Synod of Antwerp declared in 1610 that only scenes from the Life of Christ and the New Testament should be represented on the central panels of altarpieces?[72] Everyone has heard of how Rubens was obliged to place the patron saint of the Antwerp *Kolveniers*, St. Christopher (already then known to be an apocryphal saint), on the reverse of his great high altarpiece for them[73]; and it is clear that many of the works of the second decade concentrate on Christological, Eschatological, and Mariological subjects. In many of the smaller altarpieces, often in the by now slightly old-fashioned tripytch format, the eucharistic dimension of Christ's suffering was strongly emphasized (cat. 13).[74] Altarpieces showing scenes from the Infancy or Passion of Christ, or referring directly to the Resurrection,[75] or of the Last Judgment and the Assumption of the Virgin dominate the production of that period. But at the same time works such as the *Martyrdom of St. Stephen* for the Benedictine Abbey of St. Amand near Valenciennes,[76] the *Last Communion of St. Francis* for the Franciscan Church in Antwerp,[77] and many

others, seem to infringe this principle. Most notable in this group are the two high altars for the Jesuit church, glorifying the founder and the first great missionary of the order, painted at least four years before their canonization. It is hard to imagine a clearer indication of the self-assurance of the Jesuit order or a more striking infringement of the basic principles of iconography as enunciated by the Council of Trent and the local synods that followed in its wake – to say nothing of the many treatises that followed in the wake of the Iconoclasm of 1566, all written in an attempt to purify Catholic art of the abuses discovered in it by the Protestants.

At first sight, then, none of the official and theological recommendations seem to have had much effect. The Council of Trent and the Synod of Mechelen might insist on ecclesiastical supervision and the approval of all new altars and the avoidance of anything that could possibly be construed as licentious.[78] Yet, in practice, these principles seem to have been largely ignored. Johannes Molanus might inveigh against the representation of the naked Christ Child,[79] but to little avail. It might seem that painting continued pretty much as before; but to come to a conclusion along these lines would be too easy.

One needs, to begin with, to acknowledge the full extent of the theoretical interest in religious painting awakened by the Council of Trent and the Iconoclasm of 1566. This interest was not simply in the use and abuse of painting, but in deeper and more complex matters such as the validity, uses, effectiveness, and proper domain of religious art. The consequence was a profound reevaluation not simply of the justification and purpose of art within the church, but also of the ways in which, while avoiding the dangers of the seductiveness and lies of art, the painter might yet harness its powers – now acknowledged and discussed more fully than ever before – in the service of the faith. Having been roundly and deeply criticized for the ways in which it could mislead men and women, painting became a newly refined instrument of exhortation and edification.

It was only after the very last session of the Council of Trent, in the days before Christmas 1563 (when it finally passed its decree on images) that the great and comprehensive Counter Reformation treatises on art, from Molanus on to Paleotti and Federigo Borromeo, began to be published.[80] On the surface, it is true, their many iconographic strictures may seem to have been to no avail. But if we consider the matter a little more closely, it becomes clear that there are a number of areas in which the works of such writers – and the spirit that informed them – were of considerable consequence for painting. Thus, while Molanus disapproved of patently apocryphal subjects such as the Seven Sorrows of the Virgin, he was nevertheless prepared to tolerate them on the grounds of their popular appeal. They were everyday, traditional, and beneficial. Subjects such as these, far from being harmful, served in the edification of simple folk, and in the strengthening of their faith.[81] This, of course, was a traditional concern of all writers on images, both for and against. But subjects like the Seven Joys and Sorrows of the Virgin did, in fact, die out. It may seem that writers such as Molanus were little more than voices crying in the wilderness, and that theological strictures on painting had little effect.

Once again, however, things are not quite what they seem. Apocryphal subjects in painting indeed became much less frequent. And for all the claims of an audience largely appealed to by way of printed imagery, painting did become much more attentive to what was iconographically well founded. Molanus brought the full weight of his critical skills, honed as the editor not only of Augustine but also of Usuardus's martyrology,[82] to the old tales. He sifted the scriptural and canonical from the apocryphal, from the uncanonical popular, and from what he called the probable. At the same time, the need to establish the accuracy and well-foundedness of scriptural and hagiographic subjects is reflected not only in the early Counter Reformation writers on art (such as Molanus) and the great hagiographic archaeologists (from Baronius to the Bollandists), but also in painting.[83] There may have turned out to be more saints in pictures, and more popular saints, but there was also more security about the sources. The sources were investigated and established – and then confirmed by their appearance in art.

But the struggle to realize the needs of a broader audience for pictures had other consequences too. Following the incessant attacks on paintings and sculptures as adequate mediators between men and women on the one hand and Christ and his saints on the other, and in the wake of the relative valorization of word over image by so many of the Protestant writers, the Church revived many of the old justifications of images. Most practically of all, and with particular vigor, it took up the old notion of paintings as the books of the illiterate. Paintings became larger than ever before, and one sought, by a variety of stylistic means, to make them ever more

readable and more accessible. Although it may be difficult to define the stylistic means, it does seem possible to isolate some of the structural trends that went along with them.

For example: it is entirely in keeping with the reevaluation of the function and validity of art that already from 1570 on – as Molanus remarked – the old sculpted altarpieces, damaged or destroyed by the Iconoclasts, should have been replaced by painted altarpieces.[84] This trend continued even more strongly after the restoration of 1585, and received its greatest impetus with the advent of Rubens.[85] From 1609 on, altarpieces also became larger than ever before; and they continued to grow. Figures within them became more readable from a distance – just as befitted the new and larger churches then being built to contain the larger crowds anticipated by the promotors of the spiritual revival. Expressions, too, became more accessible (whether tenderly approachable or dolorously suffering) and gestures much clearer.

But just as proof of the causes of stylistic change is always elusive, almost everything art historians claim about the relations between stylistic change and post-Tridentine attitudes can be qualified, modified, or supplemented. In order to avoid the dangers of reductionism, explanation in the history of art must allow, firstly, for the influence of historical, economic, and other contextual factors; secondly, for the internal engine of stylistic evolution and for the fact that artists do not work in an artistic vacuum; and finally, for the possibility of great individual innovation.

All these factors come together when we consider the scale and format of altarpieces. With scale, for example, it is not only because churches were larger and altarpieces had to be accordingly more legible that paintings themselves became larger than ever before. Even before Rubens's return to Antwerp there had been a trend towards large-scale altarpieces, both in the Netherlands and in Italy itself. That return, however, meant both the appearance of an extraordinary talent on the local scene and the establishment of a workshop that from then on simply facilitated the production of large-scale altarpieces.

How is all this to be related to other economic factors? Following the signing of the Twelve Year Truce in 1609, Antwerp's economy received a sudden (though admittedly short-lived) boost. Capital shifted still further from the hands of the guilds to private individuals. Their spiritual investment in the revival of Catholicism could at last be demonstrated in the material realm without running the risk of incurring the old Protestant charges that it was better to clothe the poor – the true images of God – than to adorn the churches. Now one could even do both. Following the Twelve Year Truce, as Frans Baudouin has pointed out, the chief sponsors of new works – both large and small – were private individuals rather than the guilds themselves.[86]

While it would be hazardous to suggest any direct correlation between private wealth and scale (since such a claim would have to be balanced by the fairly constant contemporary claim to modesty), it does seem that the new group of wealthy patrons had a strong stake in ensuring the conservatism of altarpieces, at least for a while. One of the most striking aspects of Rubens's altarpieces of the second decade is the retention of the triptych format. Such patrons would have had several distinguished examples, both from the past and the present, to follow. A particularly revealing instance of the vagaries of this phenomenon is provided by the history of the commission for the high altar of St. Bavo in Ghent. The sketch of 1612, in triptych form,[87] was commissioned by Carolus Maes, Bishop of Ghent from 1610 to 1612. But such a work was never executed, since Maes's successor, Hendrick van der Burch, did not want a painting above the high altar at all. Instead, he commissioned a sculpted effigy of St. Bavo enclosed in a marble niche. When he, in turn, was succeeded by Antonius Triest in 1622, Rubens finally got his commission back again – but this time he painted the single-panel altarpiece, much more in keeping with current fashion, that still hangs in the church (albeit in a side chapel).[88] The Archduchess Isabella herself, however, retained her nostalgia for older types of devotional pictures even beyond this period. As late as the early 1630s Rubens painted the great and luminous St. Ildefonso triptych (fig. 5) which Isabella presented to the Chapel of the Brotherhood of St. Ildefonso in the Church of Sint Jacob op den Coudenberg in Brussels.[89] Both in subject and style this work is quite inconceivable outside the context of both Counter Reformation and Catholic Revival.

There are more complicated problems and paradoxes yet. At first, the Counter Reformation treatises on art, of which Molanus and Paleotti are the great Northern and Southern examples, give the impression of offering little more than an overwhelming array of cautions, restrictions, and prohibitions. They may seem – the occasional tolerance of someone like Molanus notwithstanding – to consist of little more than lists of what one could and could not paint, and of

restatements of the Tridentine insistence on the ecclesiastical control and supervision of art. But to conclude from this that the effects of such treatises were entirely negative would be superficial, not only for religious painting, but also for every other class of painting – especially that wide variety of landscape, genre, and still life that we generally associate with the Golden Age of Dutch painting, but which also flourished, as never before, in the Southern Netherlands. Paradoxically enough, the Counter Reformation treatises may even have provided a spur and a stimulus to the growth of all these genres. With landscape, genre, still-life, and painting after nature generally, one could paint more or less what one liked, free from the many inhibitions that constantly arose in the case of purely religious painting. It was as if one could now paint everything that one could see in the world of nature, as if the Calvinist recommendation to paint only those things which the eyes are capable of seeing, *quorum sunt capaces oculi*, was taken up even more seriously in the Southern Netherlands than it was in the North. Is it in this light that we are to understand the turn to vegetable and market scenes, full of the most attentive still lifes in the work of Pieter Aertsen and Joachim Beuckelaer already in the 1550s? To say nothing of the careful still lifes of Frans Snyders, Clara Peeters, Jacob van Es, Jan Davidsz. de Heem, Osias Beert, and Pieter Boel of almost one hundred years later?

It is clear that the painting of nature, of things exactly – or more or less exactly – as they are seen, becomes much more of an agenda for the Counter Reformation writers on art than is immediately apparent. After all, most of these writers express their concern about the licentiousness of the imagination, both of artist and beholder. The artist was not supposed to give himself over to free invention. He was to stay with what he could see. He had to follow approved and serious authors. There were to be no free-flowing, individualistic excesses of style. One had, in short, to cleave to things as they were (however complex such a criterion may now seem to us). No wonder that Jan Brueghel became the favorite painter of Federigo Borromeo, the writer not only of the *De pictura sacra* of 1624 but also of that great paean to the collecting of cabinet pictures, the *Musaeum* of 1625! And no wonder that one of the closest supporters and friends of that great and epistemologically omnivorous naturalist and doctor of Bologna, Ulisse Aldrovandi, was none other than Gabriele Cardinal Paleotti. Aldrovandi himself wrote a series of *Avvertimenti* about painting (as well as several pages on the painting of monstrosities) to Paleotti,[90] while Paleotti's own *Discorso intorno le immagini sacre e profane* appeared (in still unfinished form) in Bologna in 1582. It is in this work, just as in Federigo Borromeo's *De pictura sacra* and *Musaeum* of 1624-1625 that we find crystallized the same belief in verisimilitude – "il pèrno della trattatistica controriformistica" as Giuseppe Olmi has rightly called it[91] – that makes its first appearance in visual form in the work of the first great masters of Flemish still life and low life, Pieter Aertsen and Joachim Beuckelaer in Antwerp and of Bartolommeo Passerotti and Vincenzo Campi a few years later in Bologna itself (and then, of course, in that of the Carracci). It is also in this context that we must set the hard realism – to use the term broadly – of the low-life scenes of Brouwer and Teniers, as well as of extraordinary works such as Joos de Momper's and Jan Brueghel's painting of bleaching fields from the Prado (cat. 87).

If, then, the major religious paintings of the age of Rubens are necessarily absent from this exhibition, almost every other class of painting is well represented within it. It reminds us that the achievements in landscape, genre, still life (and portraiture too) are not by any means solely to be associated with Holland in its Golden Age. Each one of these classes are pursued with vigor, devotion, and success in the Southern Netherlands as well. Each grows from a realistic strain that is already present in the religious paintings of the fifteenth century as well as in the works of Pieter Bruegel the Elder. Each is fostered, paradoxically yet irrefragably, by the new attitudes toward art that arise in reaction to the Reformation and in the wake of the Tridentine recommendations, as well as in direct consequence of Iconoclasm in the Netherlands. Nowhere is the love for the new kinds of painting more fully and significantly revealed than in David Teniers's many paintings of the Gallery of the Archduke Leopold Wilhelm – those paintings that represent the culmination of the taste for cabinet pictures in the Southern Netherlands between ca. 1630 and ca. 1650 (cats. 124 and 125).[92] In works such as these, the religious functions of pictures give way to new epistemological paradigms and to a hitherto unsuspected intensity of desire to collect the objects of art. Images need no longer mediate between man and the divine. They are treasured for their objecthood, for their status as works of art and antiquity, and for their mirroring of nature.

But at the same time, as we recall from Teniers's painting of the monkey-painter from the Prado, the Ape of Nature is also the simian fool who produces the contents of the cabinets so treasured by the new bourgeois and aristocratic patrons – to say nothing of the royal ones. Yet these were the same collectors who now turned, more than ever before, to God's manifestation in the intricacies and minutiae of nature. The pictures in the cabinets became as valuable as the most precious of the other objects within them, the gems and the strange and exotic curiosa from other lands. Symbols of vanity they may sometimes have been, but their material and epistemological status had irrevocably changed. So too had that of the painters of easel pictures. The social and economic status of a painter like Joachim Beuckelaer could not have been more different than that of David Teniers the Younger.[93] A sea of change had come about. While the painting of altarpieces never really lost its prestige, the prestige of easel pictures – despite the ape – was higher than it had ever been.

It may seem easy enough to claim that this great change in the status of painting – from being valued for its essentially mediatory function to being valued for its artistic qualities alone – is to be attributed to Reformation attitudes to art.[94] But the matter, as we have seen, is considerably more complicated. Art could never entirely escape from its association with the world of the senses, however much that association might be harnessed for the purposes of edification in the course of the Catholic Revival. Nor could nature ever cease to remind one of God, however much it might be transformed in representation. The value of a picture, in short, could never lie solely in *how* it showed the world of things. This is the clear lesson to be drawn from the Catholic response to the challenge of the Reformation.

1. Some large-scale compositions, however, are represented by oil sketches such as Rubens's *The Nativity* (cat. 18) and the two sketches for the Eucharist tapestry series (cats. 21 and 22), van Dyck's *Betrayal of Christ* (cat. 37); while smaller finished paintings such as Jan Boeckhorst's *Adoration of the Magi* (cat. 52), Gaspar de Crayer's *Adolescent Virgin* (cat. 50), Abraham van Diepenbeeck's *Vision of St Ignatius Loyola* (cat. 51), Bertholet Flémal's *Mary with the Dead Christ* (cat. 131), Abraham Janssen's magnificent *Dead Christ* (cat. 3), and Rubens's *Holy Family* (cat. 27) and *Lamentation* (cat. 13) are obviously relevant to any consideration of Counter Reformation iconography. But not even the largest of these works can match the scale of the great altarpieces produced during the period.

2. For summaries of events, circumstances, and bibliography, see D. Freedberg, "De Kunst en de Beeldenstorm, 1525-1580. De Noordelijke Nederlanden"/"Art and Iconoclasm 1525-1580. The Case of the Northern Netherlands," in exh. cat. Amsterdam, Rijksmuseum, *Kunst voor de Beeldenstorm. Noordnederlandse Kunst 1525-1580* (1986), pp. 39-84; and idem, *Iconoclasm and Painting in the Revolt of the Netherlands 1566-1609* (New York/London, 1988).

3. For a survey of major works destroyed or damaged in the North Netherlands, see Freedberg 1986.

4. For the inscription, see Génard 1856, p. 177. For the history of the altarpiece see C. van de Velde, *Frans Floris (1519/20-1570) Leven en Werken* (Verhandelingen van de Koninklijke Academie voor Wetenschappen, Letteren en Schone Kunsten van België. Klasse der Schone Kunsten, 37, no. 30) (Brussels, 1975), pp. 210-213.

5. Such as Marten de Vos's St. Thomas altarpiece of 1574 for the Furriers (Bontwerkers) and Michiel Coxcie's St. Sebastian altarpiece for the Oude Handboog (i.e. the first guild of Longbowmen); see Zweite 1980, no. 56, pp. 285-286, and J. Vervaet, "Catalogus van de altaarstukken van gilden en ambachten uit de Onze-Lieve-Vrouwekerk van Antwerpen en bewaard in het Koninklijk Museum," *Jaarboek van het Koninklijk Museum voon Schone Kunsten, Antwerpen*, 1976, pp. 212-213 and 215-216.

6. J. Briels, *De Zuidnederlandse Immigratie, 1572-1630* (Bussum 1978) and Briels 1987 give the most detailed account of the immigration of painters from the Southern to the Northern Provinces and elsewhere.

7. For the text of the decree, see *Conciliorum Oecumenicorum Decreta*, ed. Centro di Documentazione, Instituto per le Scienze Religiose, Bologna (Freiburg-im-Breisgau, 1962), pp. 750-752, as well as Freedberg 1988, pp. 264-265.

8. On the Protestant criticisms and the Catholic response as formulated in the decree – as well as the problem of the extent of its effectiveness – see D. Freedberg, "Johannes Molanus on Provocative Paintings," *Journal of the Warburg and Courtauld Institutes* 34 (1971), pp. 229-245; Freedberg 1976a; idem, "The Hidden God: Image and Interdiction in the Netherlands in the Sixteenth Century," *Art History* 5 (1982), pp. 133-153; and Freedberg 1988, especially pp. 134-166.

9. F. Prims, "De Beeldstormerij van 1581," *Antwerpiensa 1939* (Antwerp, 1940), pp. 183-189; Freedberg 1976b, p. 128.

10. See F. Prims, "Altarstudiën," *Antwerpiensia 1938* (Antwerp, 1939), pp. 183-188; and idem, "Altarstudiën," *Antwerpiensia 1939* (Antwerp, 1940), pp. 357-363.

11. On the significance of 1584 for the history of Flemish art, see the excellent article by F. Baudouin ("1585: De Val van Antwerpen. Ook een Belangrijke Datum voor de Kunstgeschiedenis der Nederlanden," in *Willem van Oranje, 1584-1984* [Herdenkingen door de Koninklijke Academiën van Belgie, 12 October 1984] [Brussels, 1985], pp. 87-103) as well as the observations in Baudouin 1989, especially p. 333.

12. The case of the fate of the altarpiece of the *Oude Handboog* is an interesting and typical one for these years. Since their altar was seriously damaged in 1566, the deans commissioned a new one as early as 1575, from Michiel Coxcie. The central panel, a *Martyrdom of St. Sebastian*, survives in Antwerp, Koninklijk Museum voor Schone Kunsten, no. 371 (see Vervaet 1976, pp. 214-216); but the wings were lost during the peaceful Iconoclasm of 1581. To replace *these*, the guild commissioned Ambrosius Francken to paint new wings, at some point after the restoration of 1585, and possibly in the early years of the next century. These wings also survive in Antwerp (Koninklijk Museum voor Schone Kunsten, nos. 151-154). See Freedberg 1976b, pp. 128-131, and figs. 6 and 7.

13. Prims, "Beeldstormerij," 1940, Prims 1939, and Prims, "Altarstudiën," 1940 provide the original summaries of the archival evidence; but see also Freedberg 1976b, and Vervaet 1976 for further discussion and information.

14. Jaffé 1959, pp. 1-39; J. Müller Hofstede, "Zu Rubens's zweiten Altarwerk für Santa Maria in Vallicella," *Nederlands Kunsthistorisch Jaarboek* 17 (1966), pp. 1-78; Herzner 1979, pp. 117-132; Jaffé 1977, pp. 85-121.

15. A. Pasture, *La restauration religieuse aux Pays-Bas catholiques sous les Archiducs Albert et Isabelle (1596-1633)* (Université de Louvain, Recueil de Travaux, 2me série, 3me fascicule (Louvain, 1925) remains the basic – and excellent – source for the work of reli-

gious restoration and renewal under the archdukes.

16. See Stepanus Axters, O.P., *Geschiedenis van de Vroomheid in de Nederlanden*, vol. 4: *Na Trente* (Antwerp, 1960), pp. 44-58 on the Capuchins in the Netherlands.

17. See Baudouin 1977, p. 65 for a good outline of these new foundations, as well as a succinct sketch of the consequences of the Twelve Year Truce. On the newly introduced order of the Annunciates, see Axters 1960, pp. 59-68.

18. Vlieghe 1972, no. 56.

19. Ill. Baudouin 1977, p. 69, plate 14.

20. Oldenbourg 1921, p. 87; Rooses 1886-92, vol. 2 (1888), no. 269.

21. *Christ Bearing the Cross* (Glück 1931, p. 11) and a *Crucifixion* (d'Hulst 1982, p. 78, pl. 45) respectively.

22. Vlieghe 1972, no. 88.

23. Oldenbourg 1921, p. 426; Rooses 1886-92, vol. 1 (1886), no. 207.

24. Oldenbourg 1921, pp. 204-205; Vlieghe 1972, nos. 115 and 104 respectively.

25. Martin 1968 gives a comprehensive overview and analysis.

26. Oldenbourg 1921, p. 277; Rooses 1886-92, vol. 1 (1886), no. 174.

27. Oldenbourg 1921, p. 305; Rooses 1886-92, vol. 1 (1886), no. 214.

28. Rooses 1886-92, vol. 2 (1888), nos. 307-310, pp. 105-123; and J. van den Nieuwenhuizen, "Histoire matérielle de la Descente de Croix de Rubens," *Bulletin de l'Institut Royal du Patrimoine Artistique* 5 (1962), pp. 40-44. Martin 1969 gives a good selection of the sources and critical writing.

29. D. Freedberg, "A Source for Rubens's Modello of the *Assumption and Coronation of the Virgin* in Leningrad: A Case Study in the Response to Images," *The Burlington Magazine* 120 (1978), pp. 432-441; C. van de Velde, "Rubens's Hemelvaart van Maria in de Kathedraal te Antwerpen," *Jaarboek van het Koninklijk Museum voor Schone Kunsten, Antwerpen* 1975, pp. 245-277; and Freedberg 1984, pp. 174-175 and 191-193.

30. C. van de Velde, "De Aanbidding der Herders van Frans Floris," *Jaarboek van het Koninklijk Museum voor Schone Kunsten, Antwerpen* 1961, pp. 59-73; van de Velde, *Floris*, 1975, pp. 280-282.

31. Baudouin 1977, p. 368, note 24.

32. One of the best surveys of the relations between the Counter Reformation and Rubens's religious work of the decade after his return from Italy is provided by Glen 1977, whose pioneering work on the subject has too often remained neglected by scholars (including myself).

33. See Vlieghe 1972, nos. 71 and 72 (Oldenbourg 1921, p. 275) and pp. 105-109 for the complex history of the commission and its eventual execution.

34. Oldenbourg 1921, p. 172; Rooses 1886-92, vol. 2 (1888), nos. 245-252.

35. Oldenbourg 1921, p. 164; Rooses 1886-92, vol. 1 (1886), nos. 162-169.

36. Also to be included, for example, is the sequence of large and impressive works commissioned by the Elector Palatine Wolfgang Wilhelm for the churches of Neuburg. On these, see the excellent study (with valuable remarks on Counter Reformation elements in their iconography) by Konrad Renger, *Peter Paul Rubens. Altäre für Bayern* (Munich, Bayerische Staatsgemäldesammlungen, 1990 [Studio-Ausstellung, Alte Pinakothek, 9 November 1990-13 January 1991]).

37. Madrid, Museo del Prado, no. 1806

38. London, Courtauld Institute of Art, Princes Gate collection, no. 47; Briels 1980, pp. 164-166.

39. See the very many other paintings with this feature, such as the picture by Frans Francken the Younger in Wilton (Speth-Holterhoff 1957, pl. 20) – and this is to leave out the many cases of monkeys tied to a ball and chain, or with spectacles, or still other allegorical accoutrements in the seventeenth-century pictures of *cabinets d'amateur*; see, for example, cat. 125.

40. For the classic examples of the twenties, see W. Weisbach, *Der Barock als Kunst der Gegenreformation* (Berlin, 1921) (Counter Reformation and baroque); and N. Pevsner, "Gegenreformation und Manierismus," *Repertorium für Kunstwissenschaft* 46 (1925), pp. 243-262 (Counter Reformation and mannerism).

41. See, amongst very many, the excellent work by Hubert Jedin and Paolo Prodi, for example, H. Jedin, "Entstehung und Tragweite des Trienter Dekrets über der Bilderverehrung," *Tübinger*

Theologische Quartalschrift 116 (1935), pp. 143-188 and 404-429; H. Jedin, "Das Tridentinum und die bildenden Künste. Bemerkungen zu Paolo Prodi, Ricerche ...," *Zeitschrift für Kirchengeschichte* 74 (1963), pp. 321-339; and P. Prodi, "Ricerche sulla teoria delle arti figurative nella riforma cattolica," *Archivio italiano per la storia della pietà* (1962 [1965]), pp. 121-212.

42. The most distinguished piece on the subject is, of course, Prodi 1962; but see also, for example, T. A. Parker, "The Papacy, Catholic Reform and Christian Missions," in *The Cambridge Modern History*, vol. 3: *The Counter Reformation and Price Revolution* (Cambridge, 1968), pp. 67-90.

43. In addition to Weisbach 1921, see also F. Zeri, *Pittura e Controriforma. L'"arte senzo tempo" di Scipione de Gaeta* (Turin, 1957); and R. Wittkower and I. Jaffe, eds., *Baroque Art: The Jesuit Contribution* (New York, 1972) for a good overview.

44. Pasture 1925.

45. *St. Francis Receiving the Stigmata* (Cologne, Wallraf-Richartz-Museum; Oldenbourg 1921, p. 94; Vlieghe 1972, no. 90); *The Descent from the Cross* (Lille, Musée des Beaux-Arts; Oldenbourg 1921, p. 89; Rooses 1886-92, vol. 2, [1888], no. 311).

46. *The Assumption of the Virgin* (Brussels, Musées Royaux des Beaux-Arts de Belgique, Oldenbourg 1921, p. 120; Freedberg 1984, no. 38) and *The Transverberation of St. Theresa of Avila* (destroyed in 1940; Vlieghe 1972, vol. 2, nos. 150-152) for Brussels; and *St. Theresa of Avila Interceding for Bernardino de Mendoza* (Antwerp, Koninklijk Museum voor Schone Kunsten; Oldenbourg 1921, p. 339; Vlieghe 1972, no. 155) for Antwerp. It ought perhaps to be observed here that *The Glorification of the Eucharist* (for which the sketch survives in the Metropolitan Museum of Art in New York, Freedberg 1984, nos. 17-17a) was painted not for the Discalzed Carmelites in Antwerp, but for the Shod Carmelites there.

47. See A. Poncelet, S.J., *Histoire de la Compagnie de Jésus dans les anciens Pays-Bas*, 2 vols. (Brussels, 1927-28); Pasture 1925, pp. 308-312; and Axters 1960, pp. 22-43 for details.

48. For this and other aspects of popular print production in the age of Rubens, see D. Freedberg, "Prints and the Status of Images in Flanders," in H. Zerner, ed., *Le Stampe e la diffusione delle Immagini e degli Stili* (Atti del XXIV Congresso Internazionale di Storia dell'Arte, 1979, vol. 8) (Bologna, 1983), pp. 39-54. On the devotional uses of infant imagery, see also Freedberg 1981.

49. Axters 1960, p. 53.

50. See also Baudouin 1989, pp. 344-345 and 354-357 for further excellent comments on these trends.

51. See the comments in M. Warnke, "Italienische Bildtabernakel bis zum Frühbarock," *Münchner Jahrbuch der bildenden Kunst* (1968), pp. 77-90; and Freedberg 1981 on the relations between cult images of the Virgin and the Tridentine position on the veneration.

52. Müller Hofstede 1966, Warnke 1968, Herzner 1979, and Freedberg 1981 all discuss Rubens's task of enclosing the miraculous image of the Madonna della Vallicella in his high altarpiece for the Oratorians against the background of contemporary attitudes to Roman and other cult images of the Virgin.

53. J. Lipsius, *Diva Virgo Hallensis. Beneficia eius et miracula fide atque ordine descripta* (Antwerp, 1604); J. Lipsius, *Diva Sichemiensis sive Aspricollis. Nova eius beneficia et admiranda* (Antwerp, 1605).

54. On Nadal's work and on its relation to the Ignatian principles of visualization and imitation, see T. Buser, "Jerome Nadal and Early Jesuit Art in Rome," *Art Bulletin* 58 (1976), pp. 424-433; and Freedberg 1978b with further relevant bibliographic references in footnotes; on the illustrations in Nadal, see now also M.-B. Wadell, *Evangelicae Historiae Imagines. Entstehungsgeschichte und Vorlagen* (Acta Universitatis Gothoburgensis/Gothenburg Studies in Art and Architecture, 3) (Goteborg, 1985).

55. The basic reference work for all such writers remains M. Praz, *Studies in Seventeenth-Century Imagery* (2nd ed. Rome, 1964).

56. See Judson, van de Velde 1978 (for Rubens's work) and A. and A. de Backer, and C. Sommervogel, *Bibliothèque des écrivains de la Compagnie de Jésus*, 3 vols. (Louvain, 1869-76) for further bibliographic references.

57. *Imago Primi Saeculi Societatis Iesu a Provincia Flandro-Belgica eiusdem Societatis repraesentata* (Antwerp: Plantin-Moretus, Anno Societatis Saeculari, 1640).

58. See amongst many possible examples, J. Vanuxem, "Les

Jésuites et la peinture du XVIIe siècle," *Revue des Arts* 8 (1958), pp. 85-91, with Wittkower, Jaffé 1972 offering a good overview of the bibliography as well as a variety of possible approaches.

59. For examples, see Freedberg 1983 and the abundant illustrations in Knipping 1974.

60. Freedberg, "Source," 1978, and Freedberg 1983.

61. See Baudouin 1989, p. 354.

62. Well discussed by Baudouin 1989, pp. 350-351 and 356-357.

63. Oldenbourg 1921, p. 305; Rooses 1886-92, vol. 1 (1886), no. 214.

64. Oldenbourg 1921, p. 325; Vlieghe 1972, no. 117.

65. *Madonna and Child with Saints* and *Madonna and Child Adored by the Blessed Herman Joseph* (Vienna, Kunsthistorisches Museum, nos. 482, 388; Glück 1931, pp. 241 and 243).

66. Freedberg 1976b.

67. See Freedberg, 1976b, with full bibliographic details, as well as Buser 1976.

68. Oldenbourg 1921, p. 417; Vlieghe 1972, no. 127.

69. Oldenbourg 1921, p. 419; Rooses 1886-92, vol. 2 (1888), no. 274.

70. Praz 1964, pp. 361-362.

71. Judson, van de Velde 1978, no. 71.

72. As decreed by the Third Provincial Council of 26 June-20 July 1607 and the Antwerp Diocesan Synod of 11 May 1610; P. F. X. de Ram, ed., *Synodicon Belgicum, sive Acta omnium Ecclesiarum Belgiia celebrato concilio tridentino usque ad concordatum anno 1801* (Mechelen, 1828), pp. 142-143.

73. Rooses 1886-92, vol. 2 (1888), p. 113 gives the basic information.

74. As, for example, in the tripytch painted for the tomb of Jan Michielsen in Antwerp Cathedral (the so-called *Christ à la Paille*), and a whole series of paintings showing the *Lamentation* or the *Entombment*; see Eisler 1967.

75. On these works – often epitaph paintings – and their characteristic stylistic features, see Freedberg 1978b and Freedberg 1984.

76. Oldenbourg 1921, p. 158; Vlieghe 1972, no. 146.

77. Oldenbourg 1921, p. 190; Vlieghe 1972, no. 102.

78. For the Council of Trent's decree, see *Conciliorum Oecumenicorum Decreta* 1962, pp. 750-752; for the two important decrees of the Synod of Mechelen in 1570 and 1607, see de Ram 1828, pp. 107 and 387, as well as C. Geudens, *Het Hoofdambacht der meerseniers (Godsdienst en Kunstzin)* (Antwerp, 1891), p. 73, note 1. Freedberg 1988, p. 229, and Freedberg 1976a, give some instances of the comparatively mild restrictions and interventions that ensued.

79. Freedberg, 1971.

80. J. Molanus, *De Picturis et Imaginibus Sacris* (Louvain, 1570); *De Historia Sanctarum Imaginum et Picturarum* (Louvain, 1590, 1594, and several later editions); G. Paleotti, *Discorso intorno le immagini sacre e profane, divisi in 5 libri, dove si scuoprono varii abusi loro e si dichira il modo che cristianamente si dee osservare nelle chiese e ne' luoghi pubblici* (Bologna, 1582 [only the first two books were actually published; Latin ed., Ingolstadt, 1594]); F. Borromeo, *De Pictura Sacra libri duo, accedit eiusdem Musaeum* (Milan, 1625). For the spate of pro-image works in the Netherlands that followed in the wake of the Council of Trent and the 1566 Iconoclasm, see Freedberg, 1988, pp. 67-94.

81. J. Molanus, *De Historia Sanctarum Imaginum et Picturaram*, ed. J. N. Paquot (Louvain, 1771), pp. 89-90, 93, 319-330. For other examples of this approach – and this kind of tolerance – see Freedberg 1982, p. 136 and notes.

82. See Freedberg 1971 for the scanty biographical references – still not supplemented further – to Molanus's life and work.

83. Molanus himself, it should be remembered, published an *Indiculus Sanctorum Belgii* in Louvain, 1573 (a later edition followed in Antwerp in 1583), three years after the first publication of the first edition of the great work on painting that subsequently became known as the *De Historia Sanctarum Imaginum et Picturarum* (the 1570 edition was called the *De Picturis et Imaginibus Sacris, Liber unus, tractans de vitandis circa eas abusibus ac de earundem signficationibus*). He then went on, in 1596, to publish the larger *Natales Sanctorum Belgii* in Louvain in 1596 (reprinted at least once in Douai in 1616).

84. Molanus ed. Paquot 1771, p. 203; Baudouin 1989, p. 334.

85. See the good remarks on this subject in Baudouin 1989, pp. 339-341.

86. F. Baudouin, "Religious und Malerei nach der Teilung der Niederlände," in A. Buck, ed., *Renaissance-Reformation. Gegensätze und Gemeinsamkeiten,* (Wolfenbütteler Abhandlungen zur Renaissance Forschung, 5) (Weisbaden, 1984), pp. 15-16.

87. London, The National Gallery, no. 57; Vlieghe 1972, no. 71.

88. Vlieghe 1972, no. 72. For the long history of this commission, see G. Martin, in London, National Gallery, cat. 1970, pp. 130-133, and Vlieghe 1972, pp. 105-109.

89. Vlieghe 1972, no. 117, with earlier literature.

90. Barocchi, *Trattati d'Arte del Cinquecento* (Bari, 1960-62), vol. 2, pp. 511-517; G. Olmi, "Osservazione della natura e raffigurazione in Ulisse Aldrovandi (1552-1605)," *Annali dell'Instituto storico germanico-italiano in Trento* 3 (1977), pp. 177-180.

91. Olmi 1977, p. 168.

92. The basic reference work remains Speth-Holterhoff 1957.

93. On Teniers's social status and aspirations, see Kahr 1975 and the corrections by Davidson (Letter to the Editor, *Art Bulletin* 58 [1976], pp. 317-318) and Dreher 1977, as well as the long piece by Dreher 1978.

94. On this see the particularly suggestive pages in H. Belting, *Bild und Kult: Eine Geschichte des Bildes vor dem Zeitalter der Kunst* (Munich, 1990), pp. 1-5.

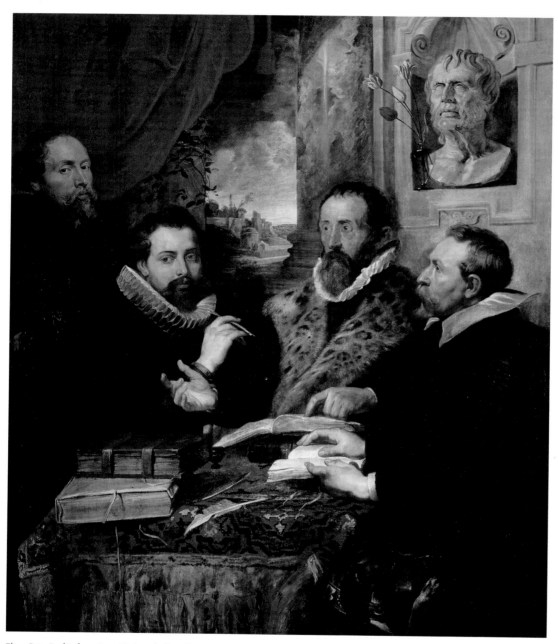

Fig. 2. Peter Paul Rubens, *Justus Lipsius and His Pupils*,
ca. 1615, oil on panel, 167 x 143 cm, Florence, Galleria
Pitti, inv. 85.

Rubens and Antiquity[1]

CHRISTOPHER WHITE

Fig. 1. Peter Paul Rubens, *The Apotheosis of Germanicus:* copy after the Gemma Tiberiana, 1626, grisaille heightened in browns on a dark brown ground on canvas, 100.7 x 78 cm, enlarged on all sides from 93 x 74.5 cm, Oxford, Ashmolean Museum.

Fig. 3. Peter Paul Rubens, *The Death of Seneca,* ca. 1608-1609, oil on panel 185 x 154.7 cm, Munich, Bayerische Staatsgemäldesammlungen, inv. 305.

SHORTLY AFTER their first meeting in Paris in 1622, the erudite antiquarian, Nicholas-Claude Fabri de Peiresc, was moved to say of Rubens that "in matters of antiquity he possesses the most universal and remarkable knowledge I have ever seen."[2] It was an opinion which Peiresc was never to revise and was one widely shared in learned circles throughout Europe. So deeply was Rubens imbued with the ideals of the classical world that to write about the artist and humanism is to attempt an assessment of virtually his entire life and art rather than treating one part of his interests. His involvement with antiquity was not limited to knowledge but he sought to emulate its virtues with Christianity.

The humanist tradition was well established in Antwerp in the sixteenth century.[3] Although without a major university, it was situated not far from Louvain, with which close intellectual ties could be maintained, and where in 1592 Justus Lipsius, the most distinguished scholar in the Netherlands after Erasmus, spent his final years. If industry and commerce were the principal motivations of the city, its inhabitants, as Guicciardini noticed, were remarkably literate and were particularly versatile in their knowledge of foreign languages. Much of humanist knowledge found expression through the extensive publishing operations run by a number of printers, of whom the most famous was Christopher Plantin, who arrived in Antwerp in 1549; indeed in the first part of the century over half the books published in the Netherlands were printed in Antwerp. Business relations led to friendship and the interchange of ideas, and Plantin was notable for his wide circle of learned correspondents throughout Europe. Already a tradition was established of merchants and city employees, well educated in the classics in their youth, becoming scholars in some part of classical literature. Their interests stimulated a lively correspondence with scholars elsewhere, thereby enriching the intellectual life of the city. One of the first and most distinguished was Pieter Gillis, or Aegidius, the Town Clerk of Antwerp, a man learned in both Latin and Greek, whose friendship with Erasmus has been immortalized by the joint commission of their portraits by Quentin Massys for their mutual friend Sir Thomas More.[4]

In Rubens's time the tradition of the amateur classical scholar continued and a number of city officials and magistrates, most of whom were friends of the artist, such as Caspar Gevartius, Jan Woverius, Nicolaes Rockox, and the artist's first father-in-law, Jan Brant, were not only widely in touch with learned men in other countries but made significant scholarly contributions of their own. Above all, the artist's brother, Philip, was the star pupil of Lipsius and, until his early death at the age of thirty-seven, the scholarly hope of the Southern Netherlands. Balthasar Moretus, a close friend from school days, as well as inheriting the management of the Plantin Press, wrote poems, panegyrics, and epitaphs in Latin. He continued his grandfather's practice of encouraging the use of the Plantin Press as a center for scholars, where they could meet regularly. (Lipsius had become such a frequent visitor that the guest room in the Plantin house was christened the Lipsius room.) And a serious interest in antiquity developed among the Catholic clergy, especially the Jesuits, in a city which became an important center of the Counter Reformation.

The humanist activities of many of Antwerp's professional citizens were matched by a growing interest in classical antiquity among its artists, many of whom made what was to become the customary journey to Italy, where they could complete their artistic education by studying the classical monuments, as well as the art of the present and more recent past.[5] Artists such as Jan Gossaert, Martin van Heemskerk, Lambert Lombard, and, most significantly as far as Rubens is concerned, Otto van Veen, brought back copies of what they saw in Rome and elsewhere in the south, which more or less influenced their subsequent work. By 1600 the journey south was an established tradition.

Rubens's own serious education began at Rombout Verdonck's school in Antwerp. The curriculum, based on the study of Latin and some Greek, followed a tradition already established in

the grammar schools set up by the Calvinist rebels during their brief spell in power between 1580 and 1585. Despite his protests to the contrary to his scholarly friend, Caspar Gevartius, in later life that "I do not deserve the honor which you confer upon me with your letters in Latin,"[6] Rubens not only acquired a fluent understanding of Latin in his early years but continued to use it throughout his life. His letters are full of quotations and allusions, which argue an extensive knowledge of the literature, for which, as it will be seen, his library provided a ready source of reference. (The school syllabus had included such books as the *Aeneid* and *Eclogues* of Virgil and works by Cicero and Terence.[7]) Greek was also part of the school curriculum, requiring the study of Plutarch's *Education of Children* in the original, and even if his knowledge of the language never became as extensive as that of Latin, Rubens made attempts to improve it so that it would seem that he attained reasonable proficiency by the 1620s.

Whatever Rubens learned from his first two masters, Tobias Verhaecht and Adam van Noort, about the practice of painting, his humanist education only seriously began with his last master, Otto van Veen, with whom he probably worked from 1594 to 1598.[8] With a cosmopolitan background, van Veen was well educated and widely traveled. He had a good knowledge of the Latin language and its literature, and his classical knowledge was reflected in his art, so that no less a figure than Abraham Ortelius could state, admittedly in the artist's autograph album, that van Veen was "the first on our globe who has reconciled painting and the liberal arts."[9] His command of allegory was reflected in his contribution to the street decorations connected with the first formal entry of Albert and Isabella into Antwerp in 1599, and his knowledge of emblems and history are recorded for posterity in several books published by him. His understanding of the classical tradition found a ready response in his apprentice, and the artist's early biographer, Roger de Piles, whose principal source was Rubens's nephew, writes of "the same penchant for literature which they [van Veen and Rubens] shared and which bound them in friendship."[10]

Following the example of earlier Northern artists, Rubens completed his formation as an artist by a visit to Italy. During his eight years there (1600-1608), Rubens built the foundations of his remarkable knowledge of classical art, literature, life, and thought. As far as his classical studies were concerned, he was fortunate in finding a place at Vincenzo Gonzaga's court, since the city of Mantua contained not only extensive Roman remains but also prime examples of Mantegna's reconstructions of the ancient world. But his profoundest encounter with the past took place in Rome, where in addition to making copies of many of the most famous pieces of ancient sculpture, which were to serve him for the remainder of his life, he was able, especially with the help of his brother, Philip, to penetrate the heart of ancient Roman life. They collaborated on a book, entitled *Electorum libri II* (Antwerp, 1608), which contained a series of essays about various aspects of ancient life, including meditations on single words or passages from ancient literature.[11] Since Philip acknowledged his brother's "keen and certain judgment" as well as his "skilled hand," it can be deduced that Peter Paul was responsible for more than making the drawings for the five illustrations in the book and presumably played the role of constructive critic if not actual contributor.

At this time Rubens's inquiry into the ancient world included theoretical speculation as well as drawings after sculpture. A notebook, unfortunately destroyed by fire in 1720, contained a combination of thoughts and illustrations about a wide variety of theoretical subjects, such as proportion, anatomy, and optics, as well as "a very unusual inquiry into the principal passions of the soul, and actions based on descriptions taken from the poets," which was clearly a study of gesture and expression.[12] What was presumably the most realized section, entitled "Concerning the Imitation of Antique Statues," was transcribed by de Piles, and includes a precept wholeheartedly put into practice in his painting by Rubens: "in order to attain the highest perfection in painting, it is necessary to understand the antique, nay, to be so thoroughly possessed of this knowledge, that it may diffuse itself everywhere."[13]

However strong his wish to return to Italy – and he was still speaking of it as a possible reality twenty years later – Rubens was overtaken by events and became quickly established at the center of artistic life in Antwerp. After his marriage he found a suitable home on the Wapper. The transformation of his property combined with the possessions he gathered around him provided him with a Mediterranean setting in a northern climate. Above all the house and its contents served to express his humanist interests.[14] A new building, Italianate in style, was added by Rubens to provide a studio and other working areas (Introduction, figs. 15-16). The facade was decorated with a combination of sculpture, busts in relief or in the round, and painting, a series

of panels painted in grisaille. The latter, simulating sculpted reliefs, illustrated subjects either of incidents from the lives of the ancient Greek artists or re-creations of works by them. In the case of the *Drunkenness of Hercules*, the representation was based on a painting by Rubens, which was derived from an ancient relief he had seen in Rome. On the reverse wall of the main house, perhaps acknowledging Zeuxis's deceptive picture of grapes described by Pliny, Rubens painted a trompe l'œil picture, based on his recently completed *Perseus and Andromeda* (St. Petersburg, Hermitage), in the center of elaborate illusionistic architecture with appropriate details of fauna and flora. The classical theme, albeit in a more rural vein, continued on the garden front, with reliefs of Bacchus and Flora, and the sculptures of Hercules and Venus and Cupid decorating the pavilion, built at the end of the garden in the form of a small rustic temple.

The triumphal archway, built in a style reminiscent of Giulio Romano and Michelangelo but ultimately classical, which separates the courtyard and garden, was crowned by statues of Mercury, the god of painters, and Minerva, the goddess of wisdom and learning, both of whom, also patrons of diplomats, were eminently suitable deities for Rubens's hearth. The quotations from Juvenal's *Satires* inscribed above the flanking arches not only reflected his humanist interests but also, as will be seen, expressed his stoic beliefs.

Rubens had already started collecting classical sculpture when he was in Italy but his holdings were immeasurably enriched in 1618 by the acquisition through exchange of the collection belonging by mischance to Sir Dudley Carleton, the English ambassador in The Hague. Although Rubens kept these sculptures for less than a decade, he could have claimed for that period to have assembled the most distinguished collection of antique sculpture in Northern Europe. To accommodate his growing collection of antiquities, Rubens added at the back of the original house overlooking the garden a semicircular room lit only by a round skylight in the ceiling, which can be immediately recognized as a derivation of the Pantheon in Rome. By taking the latter as his model, Rubens was not only choosing one of the most famous of classical buildings, but one which was specifically praised in the sixteenth century for its diffused light falling from above, a feature regarded as ideal for the display of sculpture.

Unusually for an artist, Rubens was an avid reader and an active acquirer of books. As we learn from his correspondence, Rubens shared his passion for ancient literature, as well as his interest in contemporary books and affairs, with a wide circle of learned friends. Over the course of his life he built a substantial library, which grew to such a size that the year before the artist's death it had to be moved to a separate building.[15] Unfortunately the inventory of the books drawn up at the artist's death no longer exists. Our knowledge of what he possessed has to be derived from those to which he refers in his letters, and, above all, from the series of invoices issued by his friend, Balthasar Moretus, from the Plantin Press (covering the period from 1613 up to two months before the artist's death) for extensive acquisition of books and for the binding of books already in his possession.[16]

The cost of these books was set off against what Moretus owed Rubens for the latter's numerous designs of title pages and illustrations for books published by the Plantin Press; in their breadth of subject matter they provide a further indication of the artist's range of reading, for in these instances he absorbed enough of the contents to design an appropriately allusive title page.[17] He received commissions for such antiquarian works as studies of Greek and Roman imperial coinage,[18] subjects which would have evinced an immediate response from the artist, as well as for publications by Lipsius, which will be discussed below.

As the artist's letters and the Plantin accounts make clear, classical antiquity in all its various aspects formed the predominant subject matter of the artist's library. With the advice of his scholarly friends, especially Rockox, Gevartius, and Peiresc, Rubens was assiduous in acquiring the latest studies and editions of classical texts. As well as all the famous authors, such as Cicero, Virgil, Ovid, Pliny, Herodotus, and Thucydides, and the work of all the known Roman historians, he collected books on history, geography, natural history, and hieroglyphs. Some were undoubtedly acquired to help him in his painting, whereas others, notably a large group of texts on coins and gems, were bought for his antiquarian studies. Though for the most part dependent on his learned friends for alerting him to a particular book, Rubens was able every now and then to be the one to draw their attention to the publication of a new book of mutual interest, such as happened when his visit to England in 1629 coincided with the publication of John Selden's study of ancient inscriptions in the Arundel collection, the *Marmora Arundeliana*.

It is rare, if not unique, that one can say of a great painter that if he had not been an artist he would have made an outstanding archaeologist. He himself felt the pull of the two very different activities over the years but in later life, when free time for such inquiries was in short supply, he was punctilious in insisting that he was only an amateur scholar. As he put it to Gevartius, who had asked him to look up any Marcus Aurelius manuscripts to be found in Madrid in 1628, he was not prepared to start collating texts: "For my time, my mode of life, and my studies draw me in another direction, and besides, my ruling genius keeps me away from this intimate sanctuary of the Muses."[19] Yet he retained his antiquarian interests as well as his self-confidence in his judgment on such matters. Two years later in response to the receipt of a learned disquisition on tripods from Peiresc, Rubens replied that, although he did not have time to read it, "Nevertheless, according to my accustomed temerity, I shall not fail to state my own views on the subject."[20]

Rubens's involvement in the study of the past was most fully realized in his friendship with the distinguished French antiquarian, Nicholas-Claude Fabri de Peiresc, and through him with other leading scholars of the period, such as Cassiano dal Pozzo and Guidi di Bagno in Italy and Jacques and Pierre Dupuy in France. Although previously in correspondence about the copyright of Rubens's prints through their mutual friend, Jan Woverius, Rubens and Peiresc's first meeting immediately established a lifelong friendship. They met only once again a year later, but thereafter, apart from a period when Rubens was persona non grata in France (see Introduction), they kept close touch through an erudite and wide-ranging correspondence, which covered aspects of contemporary life as well as searching into any facet of antiquity which came their way or engaged their interest. But there was to some extent, as Peiresc realized even before they met, a fundamental difference in their approach. "I am not surprised," he wrote to Rubens, "that you find more pleasure in looking at antique works of fine rather than mediocre workmanship; everyone is moved to like what is equal to his own inclinations." For his part Peiresc realized that for a complete understanding of the culture of antiquity it was essential to value works of poor quality, "which help to fill the gaps in ancient history during the most barbarous or obscure periods."[21] But this difference was perhaps more perceived than real, since Rubens was both adept and interested in discussing arcane features about antique life, such as the representation of a winged *vulva* on an intaglio,[22] which were devoid of aesthetic considerations. And it was a tribute to Rubens's knowledge that Peiresc and other scholars came to regard him as a particular authority on classical iconography.

Collecting and the study of antique cameos took pride of place in the exchange of ideas and information, supplemented by mutual gifts of casts of works in the other's collection.[23] (In view of his secrecy, it is difficult to discover exactly what cameos and gems Rubens owned.) Above all their curiosity was directed towards the two famous antique cameos, the Gemma Augustea, then in the possession of the Emperor Rudolph II in Vienna, and the Gemma Tiberiana, discovered about 1620 in the Treasury of the Ste. Chapelle, Paris, by Peiresc, who proceeded to give a fundamentally accurate classical interpretation of the subject. (In medieval times it had been identified as *Joseph at the Court of the Pharoah* and treated as a religious relic.) Their great admiration for these two works stimulated the idea of producing a book – to be written by Peiresc and illustrated with engravings after drawings by Rubens – that would be devoted to the most beautiful surviving examples of the art of intaglio and cameo. But, among other difficulties, Peiresc's irrepressible desire to include many more works than originally projected combined with Rubens's increasing disinclination, in view of his growing diplomatic activity, to undertake the laborious preparation of drawings for the engraver, and in the end the projected book never was published.

All that remains of the book today is a number of engravings after drawings by Rubens and a commentary by his eldest son, Albert, on the two great cameos, published posthumously. But the venture did lead to a very personal gift from the artist. To complement Peiresc's copy after the Gemma Augustea by Niccolò dell'Abbate, Rubens offered to paint a copy after the Gemma Tiberiana (fig. 1). The promise, which took some time to materialize owing to the artist's increasingly hectic life as well as the difficulties he faced in capturing all the variations of the sardonyx, led to irritations on both sides, but its eventual arrival at Peiresc's home in Aix-en-Provence was greeted with delight by the recipient. Now disdaining his dell'Abbate copy, Peiresc hung the Rubens in a room by itself "since it overpowers everything in its vicinity by way of painting," and concluded that "it is the depiction of the most precious gem which the world has ever seen, or at least the most beautiful monument which has survived from all antiquity up to the moment it

was realized by so excellent a hand, the one being worthy of the other."[24] (Today it hangs in the Ashmolean Museum, Oxford, where it has appropriately joined a group of Greek inscriptions, including the Parian marble, originally bought for Peiresc in Smyrna but waylaid by an unscrupulous agent working on behalf of the Earl of Arundel, and thus included in Selden's book on the collection mentioned above.)

For his introduction to the subject of Neo-Stoicism, Rubens was probably indebted to his brother, Philip. During the time that they were together in Rome, if not earlier, Peter Paul must have become fully acquainted with the tenets of a philosophy which was to play such a central part in both his art and his life.[25] Philip's master, Lipsius, who was an authority on Seneca, an edition of whose works he published in 1605, blended Stoic thought with Christian belief, thereby making his philosophy relevant to contemporary needs. The qualities of constancy and equanimity, fundamental to Stoicism, found particular response in Rubens, whose life was an example in mastering the emotions and submitting to divine fate. He publicly proclaimed the rules for the conduct of his life, when he inscribed on the triumphal arch of his house two passages from Juvenal: "Leave it to the gods to give what is fit and useful for us; man is dearer to them, than to himself" and "One must pray for a sane spirit in a healthy body, for a courageous soul, which is not afraid of death, which is free of wrath and desires nothing." And as events of his life and his consequent behavior proved, nowhere more so than in the moving letter in which he comes to terms with and acceptance of fate following the death of Isabella Brant, he splendidly lived up to his declared precepts. To Gevartius in a similar situation, he counseled: "If any consolation is to be hoped for from philosophy, then you will find an abundant source within yourself."[26]

Fig. 4. Peter Paul Rubens, *Portrait of Justus Lipsius*, ca. 1615, pen and black and brown ink over black chalk, indented for transfer, 232 x 185 mm, London, British Museum, no. H 90.

Shortly after Philip's arrival in Italy, Rubens painted the enigmatic "friendship portrait" (Cologne, Wallraf-Richartz-Museum; Introduction, fig. 12), in which among the six sitters the two brothers and Justus Lipsius are clearly identifiable. This was followed, after Rubens's return to Antwerp, around 1615 by the very much larger painting of *Justus Lipsius with Philip and Peter Paul Rubens and Jan Woverius* (Florence, Galleria Pitti; fig. 2). One of the great portraits of humanists, the imagery in which closely relates to Neo-Stoic thought, it represents two living friends, the artist and Woverius, symbolized by two tulips in bloom, with the two dead, Lipsius and Philip Rubens, symbolized by two closed tulips, seated before a bust of Seneca, a replica of that brought back from Italy by Rubens, with a view of the Palatine hill in Rome in the background.[27] (It is notable that the artist modestly stands aside from the others, drawing the curtain back on the scene.) It may have been painted to commemorate the publication of Philip Rubens's writings and the second edition of Lipsius's edition of Seneca, for both books appeared in 1615. Rubens also paid tribute to Lipsius's learning in the intricately thought out design for the title page for the 1615 *Seneca* (London, British Museum; fig. 4), in which the portrait of Lipsius is surrounded by emblematic allusions in praise of his eloquence and learning, as well as making reference to his most important publications. As Moretus in his foreword wrote, the title page should reveal "the image of the most eloquent interpreter of wisdom."[28]

Shortly after his return from Italy Rubens depicted Seneca himself in a full-scale painting representing his death (Munich, Bayerische Staatsgemäldesammlungen; fig. 3). The scene follows the account in Tacitus, in which the philosopher took his own life by cutting his veins and speeding the process by entering a bath of hot water. For this culminating moment in the life of Seneca, Rubens, as Moretus emphasized in his foreword to the Lipsius edition of Seneca's writings, based himself on what were thought to be authentic images of the Roman philosopher: the head is taken from the bust in his own collection (used in *The Four Philosophers*) and the body from the sculpture now known as the *African Fisherman* (Paris, Louvre) but in Rubens's time placed in a marble bowl or bath in the Borghese collection in Rome. Rubens's subject did more than offer a re-creation of the classical past, since it was considered at the time as a source of inspiration for those facing execution as a result of political or religious persecution.[29]

In a less specific way Stoic beliefs about the conduct of rulers underlie such works as the paintings decorating the ceiling of the Banqueting House in Whitehall, with scenes extolling the benefits of good government under the reign of James I (see cat. 29), and the decorations for the Triumphal Entry of Ferdinand into Antwerp with their numerous tributes to Hapsburg rule,[30] but the clearest expression of Stoic virtue and piety is to be found in the first of the great series, the designs for tapestries illustrating the life of the Roman Consul, Decius Mus (fig. 5); it was also the artist's first treatment of Roman history on a grand scale.[31] Decius Mus, the embodiment of

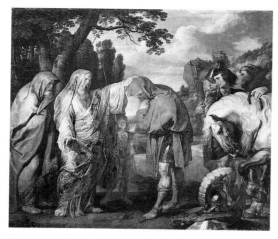

Fig. 5. Peter Paul Rubens, *The Consecration of Decius Mus*, ca. 1617, oil on canvas, 287 x 334 cm, Vaduz, Prince of Liechtenstein collection, no. G 49.

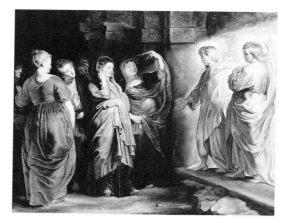

Fig. 6. Peter Paul Rubens, *The Holy Women at the Sepulchre*, ca. 1612, oil on panel, 112 x 146 cm, Pasadena, Norton Simon Museum of Art, inv. F.1972.51.P.

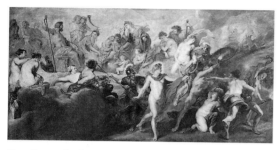

Fig. 7. Peter Paul Rubens, *Council of the Gods*, 1622, oil on canvas, 394 x 702 cm, Paris, Musée du Louvre, inv. 1780.

a stoic hero trusting unquestioningly in the wisdom of the gods, willingly sacrifices his own life in order to obtain victory for his legions.

In other ways Rubens's study of antiquity has a profound effect on his art. Other artists have been indebted to its art, thought, and life, but with Rubens the classical past informs even works, such as religious subjects and modern history, which fall within a quite different sphere of iconography.

At its most straightforward, Rubens used the antique for the study of proportion and poses, as he had recommended in his unfinished treatise referred to above. Throughout his œuvre one can observe frequent quotations of classical sculpture, in such works as different as the sober *Dying Seneca*, already mentioned, or his last and most joyous treatment of the theme of the *Three Graces* (Madrid, Museo del Prado, inv. 1670; Introduction, fig. 39), painted in response to a famous Ode by Horace but ultimately based on the classical group, the best known version of which had been discovered in Rome (Siena Cathedral). Rubens has written that the imitation of antique statues "must be judiciously applied . . . so that it may not in the least smell of the stone"[32] and nowhere are we more aware of this precept obeyed than in this inspired late painting, in which the stone is truly made flesh.

In these two examples Rubens made a straight adaptation of both subject and form. In other instances the identification may change. The figure of *Ganymede* (Vienna, collection Fürst Karl zu Schwarzenberg) is, with some variation evolved through his copies after the antique sculpture, derived from one of the sons of Laocoön. More significantly the transformation occurs in religious subjects. The *Hercules Farnese*, then in the Farnese collection in Rome (now Naples, Museo Nazionale), was, as the embodiment of the "strong hero," transposed into a figure of the Christian giant St. Christopher for the outer wings of the altarpiece of the *Descent from the Cross* (Antwerp Cathedral). The maidenly modesty expressed by the so-called statue of *Pudicity*, then in the Mattei collection, Rome (now Vatican), in which the hand is held up to the veil, was adapted for one of the holy women in the painting of the *Holy Women at the Sepulchre* (Pasadena, Norton Simon Museum of Art; fig. 6), painted in the early 1610s, and then again, among other instances, some twenty years later for one of the virgin saints in the *St. Ildefonso Altarpiece* (Vienna, Kunsthistorisches Museum; Freedberg, fig. 5).

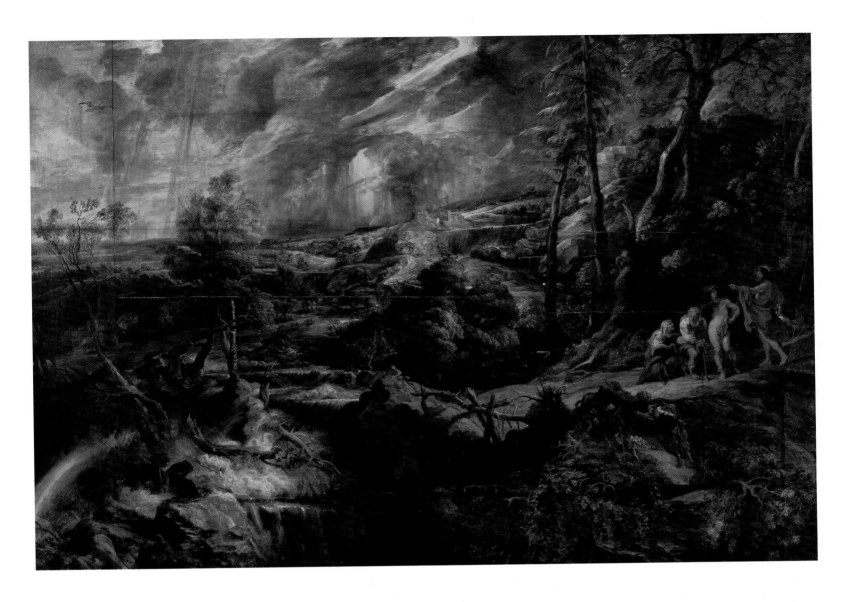

Fig. 8. Peter Paul Rubens, *Landscape with Philemon and Baucis*, late 1620s, oil on panel, 147 x 209 cm, Vienna, Kunsthistorisches Museum, inv. GG 690.

In his second set of designs for tapestry, Rubens turned once again to Roman history, this time illustrating various incidents from the life of the Emperor Constantine.[33] The cartoons, prepared *pari passu* with his work on the Medici series, may well have been a speculative venture rather than a direct commission from Louis XIII, although the subject devoted to the first Roman emperor to be converted to Christianity may have contained some implied tribute to the French king or to his father, Henri IV. As with *The Decius Mus*, the commission gave Rubens the opportunity to illustrate Roman art and life, using as visual sources such works as the reliefs on the Arch of Constantine in Rome. As in the case of *Decius Mus,* Rubens took the opportunity to include much accurate historical detail. Although some French commentators were critical about what they saw as the excessive curvature of certain men's legs in one cartoon, a charge robustly rebutted by Rubens, Peiresc, no mean critic in antiquarian matters, remarked that he "greatly admired your deep knowledge of antique costume and the precision which you have applied even to the nails of the boots."[34]

For the series devoted to the life of Marie de' Medici the use of antiquity is much more complex and is interwoven with the general allegorical.[35] It ranges from the use of classical statuary such as the *Apollo Belvedere* and the Homer for the figures of Apollo and Saturn in the *Council of the Gods* (fig. 7) to more subtle inferences likening Marie de' Medici and her husband to Jupiter and Juno or his use of descriptions of Roman marriage customs to present their relationship in an august light. In view of the richness of imagery developed in the series, perhaps no other work in Rubens's œuvre called for a greater range of literary sources and learning to dress up a none-too-heroic modern history in a guise hallowed by antiquity. A similar use of classical allegory occurs throughout the decorations for the entry of the new governor of the Spanish Netherlands, Cardinal Infante Ferdinand, into Antwerp in 1635, in which, for example, the scene, erroneously known as *Quos Ego*, from the famous description of a storm in Virgil's *Aeneid* (cat. 33), enlivens a represen-

Fig. 9. Peter Paul Rubens, *Alcibiades Interrupting the Symposium*, ca. 1601-02, pen and chalk on paper, 268 x 362 mm, New York, Metropolitan Museum of Art, inv. 40.91.12 recto.

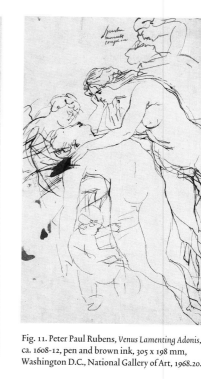

Fig. 11. Peter Paul Rubens, *Venus Lamenting Adonis*, ca. 1608-12, pen and brown ink, 305 x 198 mm, Washington D.C., National Gallery of Art, 1968.20.1.

Fig. 10. Peter Paul Rubens, *Silenus Surprised by the Water Nymph Aegle and Other Studies*, ca. 1611-13, pen and brown ink with brown wash, 280 x 507 mm, Windsor Castle, The Royal Library, H.M. Queen Elizabeth II.

tation of the new governor's safe crossing of the Mediterranean by including Neptune calming the tempest.[36] Classical allegory in a contemporary genre subject underlies another of the artist's finest performances, the *Garden of Love* (cat. 31), in which the courtly love scene, a sort of elegant fancy of life in the Netherlands, is played out in the garden of Venus with her temple and garden statuary and populated with her attendants, who actively encourage the young participants.

As we have seen, it is often impossible to separate Rubens's response to ancient art from that of literature. But in some cases one admires the power of his imagination, which enables him to re-create so vividly what he has read. This quality is found in such landscapes as *Odysseus and*

Nausicaa (Florence, Palazzo Pitti) and *Philemon and Baucis* (Vienna, Kunsthistorisches Museum; fig. 8), the former of which, his only landscape with a Homeric theme, inspired that memorable description by Jakob Burckhardt of the Greek poet and the Flemish artist meeting as "the two greatest story-tellers our earth has ever borne."[37] In the *Philemon and Baucis* the human events are tucked inconspicuously away and we are presented with a landscape totally inspired by the artist's reading of Ovid. In this instance, Rubens, no pedant, may as the source for his evocation of a thunderstorm have also recalled the story of Deucalion and Pyrrh, where Ovid describes how "across the wide plains the rivers raced, overflowing their banks, sweeping away in one torrential flood crops and orchards, cattle and men, houses and temples, sacred images and all."[38] And in one of the last major commissions, the decorations for the Torre de la Parada, a hunting lodge outside Madrid, Rubens turned once again to the *Metamorphoses* as his principal source. Although not unmindful of what other artists had made of such stories, Rubens's inspired series of some sixty scenes, carried out at great speed to satisfy an impatient patron, re-create mythology, at least in his preparatory sketches, with tingling realism.[39] Probably done about the same time, possibly also for Philip IV, the *Hunt of Diana* (cat. 35) and the *Hunt of Meleager and Atalanta* (cat. 34), although more finished than the Torre de la Parada oil sketches, brilliantly re-create the spirit of Ovid.

But in addition to these illustrations of classical subjects, which partly reflect the existing visual tradition, one discovers previously unrepresented subjects in his œuvre which exhibit Rubens's unusual knowledge and understanding of classical writers. Probably shortly after he arrived in Italy, Rubens summarily drew a scene from Plato's *Symposium*, showing the drunken Alcibiades interrupting the philosophical party (New York, The Metropolitan Museum of Art; fig. 9). Connecting with no known larger work, it has been suggested that it "was created for an unusual and private occasion...perhaps even a memorable dinner party when the conversation turned to philosophy and love,"[40] conceivably to amuse his brother, Philip.[41] Executed about a decade later, also without precedent or ulterior purpose, a drawing of *Silenus Surprised by the Water Nymph Aegle* (Windsor Castle; fig. 10) beautifully catches the spirit of Virgil's bucolics, read by the artist at Verdonck's school, by showing the nymph rubbing mulberries on the brow of the god, bound hand and foot, in order to persuade him to redeem his promise to sing a song.[42] Three drawings of *Venus Lamenting Adonis*, done at much the same time, combine, if not in fact for the first time, an adaptation of a classical group of *Menelaus and Patroclus* (Florence, Palazzo Pitti, now restored) with an illustration of a subject taken from the best-known poem of the late Greek pastoral poet Bion; in the version (Washington D.C., National Gallery of Art; fig. 11) in which the fluidity and freedom of the penwork conveys the greatest emotional intensity, the artist has underlined the psychological relationship between Venus and Adonis by inscribing (in Latin) the words: "She draws out the soul of the dying man with her mouth."[43]

Rubens's re-creation of works by Greek artists, painted as simulated sculpted reliefs on the facade of his studio, has already been mentioned. It has been suggested that the large *Prometheus Bound* (cat. 10), painted in conjunction with Snyders, may partly re-create a work by Euanthes, the Alexandrian painter, which once apparently hung in the Temple of Zeus at Pelusium.[44] Other lost works of antiquity, known only from descriptions by classical writers, may have been the inspiration for representations of his family. The portrait of *Albert and Nicolaes Rubens* (Vaduz, collection of the Prince of Liechtenstein) may be a recollection of the picture by Parrhasius, described by Pliny, of two boys "whose features express the confidence and simplicity of their age," while *Hélène Fourment as Aphrodite* ("Het Pelsken") (Vienna, Kunsthistorisches Museum; Introduction, fig. 36) may have been done, with help of existing classical representations of the goddess as well as of Titian, in emulation of the Cnidian Aphrodite of Praxiteles, which according to Pliny "excelled all works of art in the world," an assessment which to the artist combining art and life might have seemed appropriate.[45]

In another painting done with Snyders, which was still in the artist's possession at his death (British Royal Collection), Rubens selected an unusual vegetarian subject from the rarely illustrated fifteenth book of the *Metamorphoses* of *Pythagoras Forbidding the Eating of Animals and Beans* (fig. 12).[46] But one of Rubens's most inspired re-creations of classical stories occurs in the late picture of the *Feast of Venus Verticordia* or *Changer of Hearts* (Vienna, Kunsthistorisches Museum; fig. 13),[47] which is pictorially redolent of all that he had worshiped in Titian, an admiration even more overtly expressed in his "re-interpretations" of the Venetian master's pictorial reconstruc-

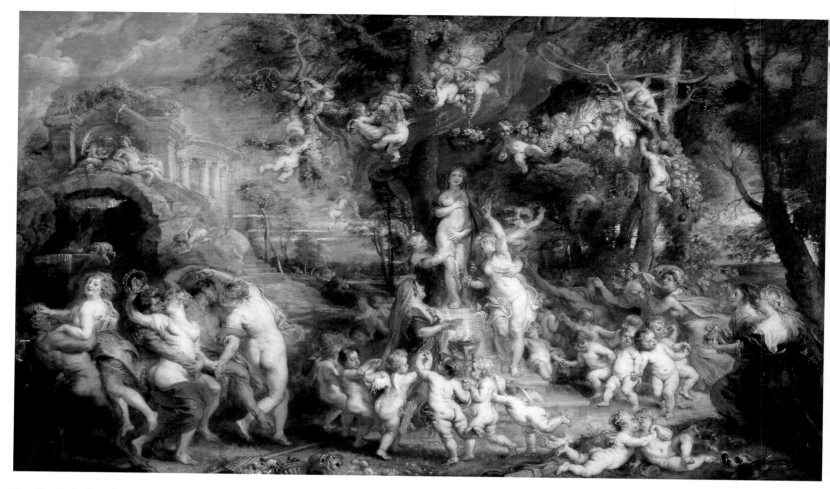

Fig. 13. Peter Paul Rubens, *The Feast of Venus Verticordia*, mid-1630s, oil on canvas, 217 x 350 cm, Vienna, Kunsthistorisches Museum, inv. GG 684.

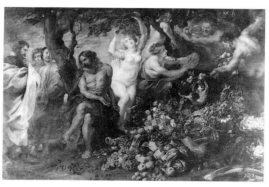

Fig. 12. Peter Paul Rubens, *Pythagoras Forbidding the Eating of Animals and Beans*, ca. 1618-20, oil on canvas, 262 x 378 cm, Windsor Castle, H.M. Queen Elizabeth II.

tions from Philostratus's *Imagines*, the *Worship of Venus* and the *Bacchanal of the Andrians* (both Stockholm, Nationalmuseum). It combines archaeological inquiry with a perfect re-creation of the classical spirit. The tripod in the center, which holds the fire for the incense, recalls the illustrated correspondence between Rubens and Peiresc on the subject, referred to above, while the grotto, only added in the course of painting, may well derive from an engraving of an ancient nymphaeum sent by the Frenchman. It realizes pictorially Ovid's description in the *Fasti* of the feast inaugurating Venus's month of April, when matrons, girls, and courtesans, all in their different ways, worship the goddess. To these are added Ceres and Bacchus from the mythological world as well as a host of nymphs, fauns, satyrs, and putti, all of whom are caught up in the frenzied dance presenting Venus with their customary gifts. Mortals and imaginary spirits intermingle in an enchanted atmosphere in a universal paean to love. If the artist has perfectly caught the essence of his subject, one senses that his magical evocation reflects something of the man himself as well as his art.

1. The subject of this essay was treated in a series of erudite and elegant lectures by W. Stechow, subsequently published as *Rubens and the Classical Tradition* (Cambridge, MA, 1968). The theme, touching as it does on most aspects of Rubens's life and art, has in its various details been extensively discussed by a very large number of scholars, who in the course of this summary essay cannot be properly acknowledged. But I must pay general tribute to one scholar, Julius Held, much of whose research into this subject as part of his overall understanding of the artist is contained within his *Rubens Selected Drawings* (Held 1959), and, even more so, in his *The Oil Sketches of Peter Paul Rubens. A Critical Catalogue* (Held 1980). Elizabeth McGrath has, in her customary way, been both helpful and generous, and has kindly cast a critical eye over this essay.

2. Rooses, Ruelens 1887-1909, vol. 2 (1898), p. 336; Peiresc to Guidi di Bagno, 26 February 1622.

3. A discussion of the subject occurs in L. Voet, *The Golden Compasses*, 2 vols. (Amsterdam, 1969); see also J. J. Murray, *Antwerp in the Age of Plantin and Brueghel* (Norman, OK, 1970).

4. See L. Campbell et al., "Quentin Matsys, Desiderius Erasmus, Pieter Gillis and Thomas More," *The Burlington Magazine* 120 (1978), pp. 716ff.

5. See J. Müller Hofstede, "Rubens und die niederländische Italienfahrt: Die humanistische Tradition," in exh. cat. Cologne 1977, pp. 21-37. For a recent survey, see Carl van de Velde, "Aspekte der Historienmalerei in Antwerpen in der zweiten Hälfte des 16. Jahrhunderts," in exh. cat. Cologne/Vienna 1992-93, pp. 71-78.

6. Magurn 1955, p. 293.

7. The school curriculum can be deduced from the Latin classics purchased from the Plantin Press (see M. Rooses, "Petrus-Paulus Rubens en Balthasar Moretus. I," *Rubens-Bulletijn* 1 [1882], p. 212).

8. See Müller Hofstede 1977, pp. 25-30.

9. J. van den Gheyn, *Album Amicorum de Otto Vaenius* (Brussels, 1911), p. 47.

10. *Conversations sur la connaissance de la peinture* (Paris, 1677), p. 185.

11. See A. S. Hoch, in J. S. Held, *Rubens and the Book* (Williamstown, 1977), pp. 173-174; and Judson, van de Velde, 1978, vol. 1, pp. 77-85.

12. The manuscript was seen by Roger de Piles (*Dissertation sur les ouvrages des plus fameux peintres* [Paris, 1681], p. 36). It had earlier been referred to by Bellori, *Le vite de' pittori, scultori et architetti moderni*, vol. 1 (Rome, 1672), p. 247. See Jaffé 1966, vol. 1, pp. 16-47, and Müller Hofstede 1977, pp. 50-67.

13. *Cours de peinture par principes* (Paris, 1708); English trans. (1743), pp. 86-87.

14. See inter alia, for the decoration of his house and studio, McGrath 1978, pp. 245-277, and J. Muller, "The Perseus and Andromeda on Rubens's House," *Simiolus* 12 (1981-82), pp. 131-146; for his collection of painting and sculpture, see Muller 1989.

15. I am indebted to Elizabeth McGrath for showing me a copy of her chapter on Rubens's library, which will be published as part of her forthcoming volume on history in the *Corpus Rubenianum Ludwig Burchard*.

16. See M. Rooses, "Petrus-Paulus Rubens en Balthasar Moretus. IV," *Rubens-Bulletijn* 2 (1883), pp. 176-207.

17. See Held, *Rubens and the Book* (as in note 11), and Judson, van de Velde, 1978.

18. H. Goltzius, *Graeciae Universae Asiaeque Minoris et Insularum Nomismata Veterum* (Antwerp, 1618) (Judson, van de Velde 1978, no. 43), and J. de Bie, *Nomismata Imperatorum Romanorum* (Antwerp, 1617) (Judson, van de Velde 1978, no. 39).

19. Magurn 1955, pp. 293-294.

20. Ibid., p. 365.

21. Rooses, Ruelens 1887-1909, vol. 2 (1898), pp. 316-319.

22. See A. A. Barb, "Diva Matrix, A Faked Gnostic Intaglio in the Possession of P. P. Rubens and the Iconology of a Symbol," *Journal of the Warburg and Courtauld Institutes* 26 (1953), pp. 193-238.

23. See M. van der Meulen, *Petrvs Pavlvs Rvbens Antiqvarivs: Collector and Copyist of Antique Gems* (Alphen aan den Rijn, 1975).

24. R. Ruelens, "Notices et documents: le peintre Andrien de Vries," *Rubens-Bulletijn* 1 (1882), pp. 192-193; cited by D. Jaffé, "The First Owner of the Canberra Rubens, Nicholas-Claude Fabri de Peiresc (1580-1637) and His Picture Collection," *Australian Journal of Art* 5 (1986), p. 33, who has discovered further fascinating information about the commission. (See also D. Jaffé, *Rubens' Self-portrait in Focus* [Canberra, Australian National Gallery, 1988], pp. 16-19.) The painting was published by its then owner, C. Norris ("Rubens and the Great Cameo," *Phoenix* 8 [1948], pp. 178-188), who had discovered it in a sale in North Wales and subsequently bequeathed it to the Ashmolean Museum.

25. For the most recent discussion, see M. Morford, *Stoics and Neostoics: Rubens and the Circle of Lipsius* (Princeton, 1991); see also under note 26 and F. Huemer, "Philip Rubens and His Brother the Painter," in *Rubens and His World. Bijdragen opgedragen aan Prof. R.-A. d'Hulst* (Antwerp, 1985), pp. 123-128.

26. Magurn 1955, p. 337.

27. See Prinz 1973, pp. 410-423.

28. I. Lipsius, L. *Annaei Senecae...Opera...Omnia* (Antwerp, 1615) (Judson, van de Velde 1978, no. 30). The volume also included illustrations of the *Death of Seneca* and the *Bust of Seneca* (idem, nos. 31-32) based on the antique sculptures mentioned below in connection with the painting of the *Death of Seneca*. Some twenty years later Rubens designed a titlepage for an edition of Lipsius's own works: *Opera Omnia*, vol. 1 (Antwerp, 1637) (idem, no. 73).

29. See Morford, *Stoics*, pp. 184-185.

30. Ibid., pp. 204-210.

31. See Held 1980, vol. 1, pp. 19-30, R. Baumstark, *Peter Paul Rubens: Tod und Sieg des römischen Konsuls, Decius Mus* (Vaduz, 1988) and Morford, *Stoics*, pp. 195-203.

32. See note 12.

33. See, for example, Du Bon 1964, and Held 1980, vol. 1, pp. 63-86.

34. Rooses, Ruelens, 1887-1909, vol. 3 (1900), p. 85.

35. See, notably, J. Thuillier and J. Foucart, *Rubens' Life of Marie de' Medici* (New York, 1967); Held 1980, vol. 1, pp. 87-136, and R. Millen and R. Wolf, *Heroic Deeds and Mystic Figures* (Princeton, 1989).

36. See Martin 1972.

37. Burckhardt 1898, p. 157; quoted by Stechow 1968, p. 2.

38. See Adler 1982, no. 29.

39. See Alpers 1971; and Held 1980, vol. 1, pp. 249-302.

40. E. McGrath, "'The Drunken Alcibiades': Rubens's Picture of Plato's *Symposium*," *Journal of the Warburg and Courtauld Institutes* 46 (1983), pp. 228-235.

41. Held 1959 (2nd rev. ed., 1986), p. 72.

42. See Burchard, d'Hulst 1963, vol. 1, no. 51.

43. See E. Mandowsky, "Two *Menelaus and Patroclus* Replicas in Florence and Sir Joshua Reynolds' Contribution," *Art Bulletin* 28 (1946), p. 117, and Held 1959 (2nd. rev. ed., 1986), no. 58.

44. C. Dempsey, "Euanthes Redivivus: Rubens's *Prometheus Bound*," *Journal of the Warburg and Courtauld Institutes* 30 (1967), p. 421.

45. J. S. Held, "Rubens' *Het Pelsken*," reprinted in Held 1982a, p. 110, who discussed other subjects by Rubens that can be linked to descriptions by Pliny of works by ancient artists.

46. See McGrath 1983, p. 231, and Muller 1989, p. 124.

47. See P. Fehl, "Rubens's 'Feast of Venus Verticordia,'" *The Burlington Magazine* 114 (1972), pp. 159-162.

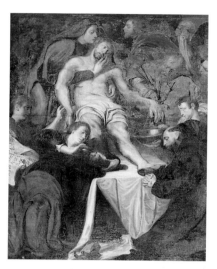

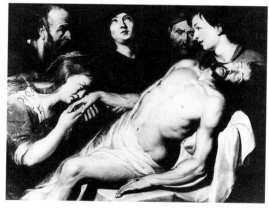

Fig. 1. Deodato del Monte, *Lamentation of Christ*, signed and dated 1623, oil on canvas, ca. 300 x 250 cm, Munsterbilzen, Church.

Fig. 2. Arnout Vinckenborch, *Bathsheba Bathing*, oil on canvas, 117.5 x 157.5 cm, Kassel, Staatliche Kunstsammlungen, Gemäldegalerie Alte Meister, inv. 163.

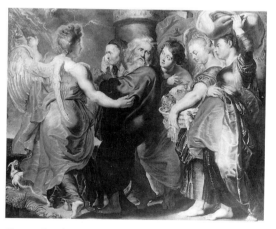

Fig. 3. Artus de Bruyn, *Lamentation of Christ*, oil on panel, 92 x 120 cm, Maastricht, private collection.

Fig. 4. Jacob Jordaens after Peter Paul Rubens, *Flight of Lot and Family*, oil on canvas, 170 x 199 cm, Tokyo, Museum of Western Art.

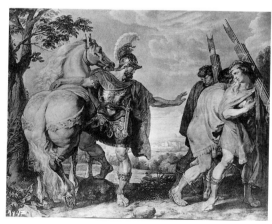

Fig. 5. Peter Paul Rubens and Anthony van Dyck, *Decius Mus Dismissing the Lictors*, oil on canvas, 284 x 342 cm, Vaduz, Prince of Liechtenstein collection, inv. 50.

Rubens's Atelier and History Painting in Flanders: a Review of the Evidence[*]

HANS VLIEGHE

THE DELEGATION of artistic work in seventeenth-century Antwerp was far from unusual. It had long been customary, after all, for painters to have specific parts of their work executed by specialized colleagues.[1] Thus it is not exceptional to see Rubens turning to established specialists like Jan Wildens or Jan Breughel for the landscape and still-life parts of his compositions. In another sense, however, the activity in Rubens's atelier was exceptional in character. His methods were based on a twofold tradition stemming from the Italian Renaissance of a separation between invention and execution; in this tradition, a staff of well-trained, permanent assistants made varying contributions to the completion of his paintings under the authoritative eye of the master.[2] Rubens himself informs us extensively about the various degrees of his personal intervention in his paintings in his famous correspondance of 1618 with the English diplomat and collector Sir Dudley Carleton. In these letters the artist makes a clear distinction between work that he explicitly cites as from his own hand, and other paintings that were executed by students but that were afterwards retouched by him. However, as he goes on to say, the latter were also to be considered as originals because of that final inspection.[3]

It is hardly possible to calculate, even approximately, how many students and assistants Rubens employed. The registers of the guild of St. Luke do not help, since Rubens, thanks to his privileged status as a court artist, was exempt from the normal obligation of registering his students with the Antwerp painters' guild[4]; but even if he had not been exempt, the listings of students in the *Liggeren* (public register) could only have provided partial information. A considerable discrepancy seems to have existed between the rules and their practical application in the sixteenth and seventeenth centuries.[5] On one matter there can be agreement: the number of Rubens's assistants has to have been substantial. This can be deduced not only from his enormous and often rapidly executed production and from the large number of surviving atelier replicas and copies, but also from written testimonies that can hardly be misunderstood. There is the well-known letter of 1611, in which Rubens wrote that he had to refuse over a hundred would-be students because he could not find a place for them any longer, and that many apprentice painters were serving under other masters in the city until he could take them on.[6] It was evidently a great honor to be allowed to work for Rubens since some aspiring artists were willing to endure a waiting period with less renowned painters.

Other documents inform us about a number of specific artists who worked in Rubens's atelier. Unquestionably, one of the main sources is a short biography, written in 1676 for Roger de Piles by Philip Rubens, the painter's nephew, in which he explicitly mentions six students.[7] The significance of other names that turn up, however, should be interpreted very cautiously. By no means all the painters who contributed to the execution of the large series that Rubens undertook for the Pompa Introitus Ferdinandi (1635) and the Torre de la Parada[8] can be considered artists trained by him. Each of these commissions had to be finished with great speed and for that reason work was contracted out to some of the most prominent history painters of Antwerp. Not all these painters had a special relationship with Rubens's atelier on the Wapper.[9] But then again, from certain stylistic hallmarks it has been possible to trace formative impulses that some painters received from Rubens. This article assembles the various kinds of data into a coherent ensemble, in chronological order.

Deodato del Monte (1582-1644) is Rubens's first known pupil and collaborator.[10] This is proven by the fact that Rubens made a deposition on his behalf in 1628, from which it is known that del Monte traveled with him to Italy.[11] The fact is confirmed by other documents as well. It appears that del Monte witnessed the stipulation of a contract between Rubens and the Oratorians in Rome for the execution of a *Nativity* intended for the high altar of the church of San Filippo Neri in Fermo.[12] In October 1608 del Monte returned with Rubens to Antwerp, where he imme-

diately became a member of the St. Luke's Guild. Not much is known about his artistic activities. The impression that remains is that he was rather sporadically active as a painter. As an "ingenieur" he was hired for unspecified work by Catholic sovereigns such as the Duke of Neuburg, the Spanish King Philip IV, and the Archdukes Albert and Isabella. There are indications that he was active as an art dealer as well.

Two paintings can be attributed to del Monte with certainty, a *Transfiguration*, painted in 1614 for the cathedral in Antwerp (now Antwerp, Koninklijk Museum voor Schone Kunsten)[13] and a *Lamentation of Christ* signed and dated 1623 in the church of Munsterbilzen (fig. 1).[14] Both paintings show that del Monte attempted to link himself with the classicizing plasticity of Rubens's work of the period from 1612 to 1620. In fact, del Monte's *Lamentation of Christ* is identifiably inspired by the *Holy Trinity*, a painting that Rubens executed around 1613-1615 for the order of the Shod Carmelites in Antwerp (now Antwerp, Koninklijk Museum voor Schone Kunsten).[15]

The work of two other painters is related to the classicistic and strongly sculptural style that characterizes Rubens's work in the period between 1612 and 1620: Arnout Vinckenborch and Artus de Bruyn. For the decoration of the Dominican church in Antwerp (now St. Pauluskerk) they cooperated with Rubens on the execution of fifteen paintings depicting the Mysteries of the Rosary.[16] There are reasons to believe that these artists were involved in Rubens's atelier.

The œuvre of Vinckenborch (ca. 1590-1620) has recently been reconstructed.[17] It consists primarily of biblical subjects, composed in a horizontal format. It is remarkable that his style as a whole not only leans towards the classicizing monumentality, the cool local colors, and the smooth painting of Rubens's work of 1612-1620, but that it also incorporates numerous motifs borrowed quite literally from compositions by Rubens from the same period. It is significant that the works of Rubens in question were not visible in public buildings, but were apparently destined for a private clientele. This indicates that Vinckenborch could only have seen them in Rubens's own atelier. A typical example is his *Adoration of the Magi* in Skalbmierz (Poland), which recalls in detail Rubens's own version of the theme from about 1615-1620 (Lyon, Musée des Beaux-Arts).[18] A recently discovered work by Vinckenborch is the *Bathsheba Bathing* at Kassel (fig. 2),[19] in which the main figure was modeled exactly on the nude nymph Callisto in Rubens's *Jupiter and Callisto*, dated 1613 (Kassel, Gemäldegalerie Alte Meister). Other facets of Vinckenborch's artistic practice also indicate a clear familiarity with the customs of Rubens's atelier. A large number of anatomical studies of nude men can be attributed to him; in format they recall similar studies made by Rubens around the same time. One wonders if Vinckenborch could even have drawn from models that were posing in Rubens's atelier.[20] As noted above, the "horizontal" cooperation with skilled specialists in landscape and still life figured in the workshop habits of Rubens; especially towards the end of the first decade of the seventeenth century, for example, Rubens called on Frans Snyders for still lives. Exactly at that time, Vinckenborch executed two figures for a *Kitchen Scene* that was otherwise painted by Snyders; the old man with his characteristic curly hair and beard and the young maid he approaches reveal Vinckenborch's hand unmistakably, and are types which occur in his other works.[21] The figures are nonetheless so Rubensian that the question legitimately arises whether they could not have been executed in Rubens's own atelier.[22]

Artus de Bruyn (ca. 1590/95-1632) was also among the group of younger painters who cooperated in the Cycle of the Rosary; he executed the *Mocking of Christ* for the cycle.[23] The work, painted around 1617, was also strongly dependent on the distinctive style of Rubens during the period from 1612 to 1620, both in formal conception and in motifs. This dependence appears in another work by de Bruyn, his fully signed *Lamentation* in a private collection (fig. 3).[24] This painting was presumably made for the private market. From the inventory of de Bruyn's estate in 1632, it appears that he had relationships with art dealers in France and Spain. From the same inventory it can be deduced that de Bruyn must have had connections with Rubens's atelier. First, we know from this document that he owned two oil sketches by Rubens – a *Saint Catherine* and a *Venus*. Such sketches could only have had two destinations during Rubens's lifetime: either as the jealously preserved property of the atelier, or as the property of the customer, who might sometimes ask Rubens in a special agreement to receive both the sketch and the finished painting. It thus seems probable that these paintings were modelli that de Bruyn had borrowed from Rubens in order to execute large-scale paintings in his own atelier, paintings which then could have been retouched by Rubens.[25] Second, the inventory lists two paintings, presumably done by de Bruyn himself, from the cycle of Decius Mus for which Rubens had made the designs in the years 1617-

1618.[26] The fact that de Bruyn was involved in the complex process of producing this series – whatever the actual function of the compositions mentioned in his estate may have been – is another argument in favor of the idea that he played a role in Rubens's atelier during the late 1610s.

Like de Bruyn, Jacob Jordaens (1593-1678) was trained by Adam van Noort. He became an independent master in 1615. Even before this period, he presumably had had considerable artistic experience.[27] The *Flight of Lot and His Family* of around 1613-1615 (Tokyo, Museum of Western Art; fig. 4) can be attributed to him on solid stylistic grounds. This work is an exact replica of an original by Rubens, but in the undulating contours of the somewhat stocky figures and in the cool but shrill colors, it shows a close relationship with other early works by Jordaens.[28] Jordaens did not draw exclusively on Rubens in these works. In addition to unmistakably Rubensian characteristics, his work also shows a remarkable affinity with the style of artists of an older generation. Both the mannerist torsions of van Balen and the heavy classicism of Janssens seem to have influenced the young Jordaens. This somewhat retrospective attitude is also notable in relation to Rubens; it is striking that the compositional structure of many of Jordaens's earliest works seems to be closer to the work of Rubens done just after his return from Italy (between 1609 and 1612) than to the classicistic monumentality of the following years which was so stimulating for painters like Vinckenborch and de Bruyn.[29] Like Rubens's earliest work in Antwerp, Jordaens's œuvre is characterized by a preference for half figures; they seem to crowd together in the foreground and are viewed obliquely. From 1616 on, a strongly Caravaggesque streak emerges that can only be explained via the influence of Rubens. Moreover, Rubens himself, who in his Italian years before 1608 had already been in contact with the style of Caravaggio, revives this stylistic approach in the late 1610s; it is during this period that his *Old Woman and the Coal Fire* and *Judith with the Head of Holophernes* are executed. About the same time Rubens painted his somewhat altered copy of Caravaggio's *Deposition* (Ottawa, National Gallery of Canada). Towards the end of the 1610s and the beginning of the 1620s, Jordaens's figures tend to relate formally to Rubens's classicizing monumentality of the period 1612-1620, and this relationship is also affirmed in the rich and saturated palette. From the beginning, however, Jordaens characterizes his figures as more common.

Jordaens's active cooperation in the projects of Rubens's atelier are documented with certainty only from the 1630s on. By that time he was a well established painter himself with a good reputation and an active atelier, working in his own distinctive style. Their later collaboration therefore should be considered occasional; Rubens contracted out work for the Pompa Introitus of 1635 and the Torre de la Parada of 1636-1638. Furthermore, it is known that Jordaens completed some of Rubens's unfinished paintings after the latter's death.[30] In the same way, Jordaens's contemporary Gerard Seghers (1591-1651) carried out work for which Rubens had formulated only the concept at his death. Seghers was also involved in the decorations of the Pompa Introitus.[31] However, there is no further evidence that Seghers, who came back from Italy to Antwerp in 1620 as a fully qualified painter, worked under the direction of Rubens.[32]

The case of the early work of Jordaens is different. The replica of the *Flight of Lot and His Family* could only have originated under the authoritative eyes of Rubens himself. Jordaens seems to have been so immersed in the style of Rubens that it must be assumed that in the earlier years of his career he worked for a time in Rubens's service. The fact that he was one of the painters involved in the Cycle of the Rosary for the St. Paul's church in Antwerp tends to confirm this.

Another painter who participated in this group was the young Anthony van Dyck (1599-1641), who painted a *Christ Bearing the Cross* for the above-mentioned cycle, about 1617. He became a master in 1618, and until his departure from Antwerp in 1621 he was to play a leading role in Rubens's workshop.[33] One can form a clearer picture of van Dyck's significance there than of any other painter. In his famous correspondence with Sir Dudley Carleton, Rubens calls van Dyck in 1618 "il meglior mio discepolo."[34] In 1620 he entrusted him with the execution of the now-lost ceiling paintings for the former Jesuit church in Antwerp, depicting themes from the Bible and the lives of the saints.[35] In other respects as well, Rubens made good use of van Dyck's services. As is known from Gianpietro Bellori's well documented biography of van Dyck written in 1672, Rubens commissioned the younger artist to make drawings after his compositions for prints engraved by Lucas Vorsterman around 1620.[36] Finally, from the inventory of Rubens's estate of 1640, it appears that a significant number of the many studies of heads kept in the atelier had

been executed by van Dyck; these studies of character and expression were referred to in formulating larger compositions.[37]

Rubens's influence is easy to identify in the early work of the young but precocious van Dyck, work that he had produced in his independent atelier around 1615 prior to becoming a master. Paintings of this time, such as the *St. Jerome* (Vaduz, Prince of Liechtenstein collection; cat. 38, fig. 1), are unmistakably variants of more or less contemporary compositions by Rubens. The young painter, however, already displays his own characteristic style, not so much adapting Rubens's polished and classicistic modeling as painting with a free and personal touch.[38] His style is also much more expressive than that of Rubens in the late teens. Striking is his preference for figures that press to the foreground and are rendered with foreshortening. Like Jordaens, he is more connected in spirit with the work that Rubens painted just after his return from Italy.[39] Nevertheless, van Dyck knew how to adapt himself perfectly to the wishes of Rubens when he was active in his atelier from 1618 on. The only work conceived by Rubens himself in which the hand of van Dyck is clearly recognizable is the series of cartoons made for the tapestry cycle of the *History of Decius Mus* (Vaduz, Prince of Liechtenstein collection). In some of the pictures from this cycle, van Dyck's expressive touch emerges in the faces of some background figures (fig. 5). The freely painted and expressively distorted faces are easy to identify in the light of the rest of his early work. The monumental figures in the foreground, on the other hand, reveal Rubens's own hand in their sculptural smoothness.[40] The division of tasks can possibly be reconstructed as follows: first, Rubens would have had van Dyck paint the pictures or a part thereof, after which he retouched certain, more conspicuous areas. According to his own description, the work done in this way could, in any case, pass as "de mia mano."[41] Another work of which Rubens wrote in 1618 that it was executed by van Dyck after his (Rubens's) design is *Achilles among the Daughters of Lycomedes* (Madrid, Museo del Prado; fig. 6).[42] Yet it is impossible to recognize van Dyck's hand in this painting. The only explanation seems to be that Rubens himself retouched this painting so thoroughly that the first work of his collaborator has been totally submerged in his own touch.

In addition to working for Rubens, van Dyck painted a large number of paintings on his own, mainly for the private market. Those pictures are notable for both his personal stylistic idiom and a remarkable interest in Rubens's post-Italian style. He also made a few variants on Rubens's themes from the years between 1609 and 1612, such as his *Samson and Delilah* (London, Dulwich College) and his *Brazen Serpent* (Madrid, Museo del Prado). Curiously enough, however, he also painted work on his own, the smooth finish of which clearly reflects the contemporary style of Rubens, as in the *St. Martin* executed for the Parish Church at Zaventem. The wishes of the patron may have played a role in this respect.[43]

Cornelis de Vos (1584/5-1651) was already among the more established painters in Antwerp when he was approached to execute two paintings for the Cycle of the Rosary. Just these pictures, the *Nativity* and the *Presentation in the Temple*, reveal an intimate relationship with Rubens's workshop. From the 1610s on, Rubens's work became increasingly influential for de Vos's compo-

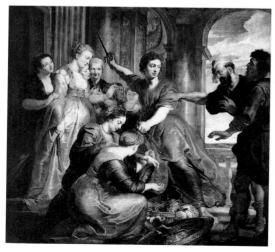

Fig. 6. Peter Paul Rubens and Anthony van Dyck, *Achilles among the Daughters of Lycomedes*, oil on canvas, 246 x 267 cm, Madrid, Museo del Prado, cat. 1661.

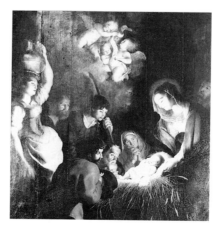

Fig. 7. Cornelis de Vos, *The Nativity*, oil on panel, 216 x 160 cm, Antwerp, Church of St. Paul.

sitional schemes and motifs.[44] Close contacts between de Vos and Rubens's workshop were established in the later 1630s especially, when in two brief successive periods he assisted in the execution of paintings after Rubens's design for the Pompa Introitus Ferdinandi and the Torre de la Parada. Furthermore, he had previously made copies after Rubens's work at the latter's request. In 1626 he was paid for two unspecified copies that were part of the large lot of paintings sold by Rubens to the Duke of Buckingham. The fact that since the 1620s landscape backgrounds and still-life details in de Vos's paintings were executed by his relatives, Frans Snyders, Jan Wildens and Paulus de Vos, who were the same specialists Rubens turned to for this kind of work, implies that a special relationship existed. Conversely, in the same years and thereafter de Vos provided staffage for paintings mainly done by those specialists. A particularly close contact with Rubens's studio must have existed shortly before and around 1620; in some paintings, such as the two for the cycle of the Rosary and the *Holy Family* formerly in Potsdam, he followed Rubens so literally in certain motifs that one has to assume a close personal connection with the atelier.

The composition of the *Nativity* (fig. 7) derives in reverse from Rubens's picture of the same name as engraved in 1614 by Theodoor Galle for the *Missale Romanum*. But it is also clear that de Vos was acquainted with Rubens's pictorial style of the period. The striking local color gives the figures a quiet grandeur, but most noticeable of all is the treatment of light. The divine light shed by the Christ Child on the bystanders is a well-known theme in the iconology of the Nativity, and it is obvious that this aspect of Galle's print after Rubens has been strongly accentuated. In de Vos's interpretation, nevertheless, a certain acquaintance with Caravaggesque light effects can be detected, similar to that seen in Rubens's works from the first decade after his return from Italy. It is in this context that we should consider the head of the old woman that looms up so realistically from the darkness – an effect reinforced by the strongly modulated light. One recognizes in her the face of the *Old Woman and the Coal Fire* that Rubens must have painted at almost the same time (Dresden, Gemäldegalerie Alte Meister). It should be noted that independent of Rubens's example, de Vos was attracted to the style of Caravaggio at the same time as his younger colleague Jordaens. The same old woman reappears in a different pose in the *Presentation in the Temple*, the second picture that de Vos made for the Cycle of the Rosary, which is as strongly influenced by Rubens as his *Nativity* was. The strongly modeled figures are illuminated in the same way against the dark background.

De Vos's explicitly Rubensian approach in the Cycle of the Rosary may have to do with Rubens's direction of the cycle as a whole. The way in which he handles the motif of the old woman, however, shows that he was already acquainted with the workshop of Rubens in this period. This conclusion can also be drawn from the *Holy Family*, formerly in the Bildergalerie of Sanssouci in Potsdam, a work that can be dated around or shortly after 1620 at the latest. The lively interaction of the figures, their monumental and sculptural appearance with strong contours accentuated by a well considered distribution of light in the interior of the room, the local colors, and the effective suggestion of fabrics, all these features are found in similar devotional pictures painted by Rubens shortly before 1620. Rubens's example is particularly recognizable in the Madonna. Her features can be traced to specific representations of the Madonna created by Rubens in the late teens. The same face occurs in Rubens's *Madonna of the Rosary* of about the same time; the pose of Mary's upper body and her protecting right arm also seem to be derived from this painting. The other figures recall actual examples of Rubens's work less literally, but the heroic and Raphaelesque pose of Joseph and the lush corporality of the two children attest to strong ties with the style of Rubens. It is as if shortly before and around 1620 Cornelis de Vos observed Rubens very attentively and consciously tried to assimilate his style. The same instinct emerges in some of his portraits painted around the same time.

Gaspar de Crayer (1584-1669) was a contemporary of de Vos.[45] Although born in Antwerp, he spent his career in Brussels, where he became a master in the painters guild in 1607 after an apprenticeship with Raphaël Coxcie. Especially in the later teens, however, he was much influenced by the work of Rubens's most "classicistic" years from around 1612/13 to 1620. Not only was he able to assimilate and adapt Rubens's motifs and compositional schemes, but he also managed to imitate the plasticity and monumentality typical of Rubens's work. This has to do with the ready visibility of Rubens's works of the 1610s in the churches and public buildings of Brussels; it is striking that de Crayer borrows motifs from works that he was able to see in his own town. Presumably de Crayer adopted his conspicuous Rubensianism to cater to contemporary taste in

Brussels, a taste that was surely stimulated by the presence of the court. De Crayer's later work displays a significant tenderness of expression which can be partly, but not fully, explained by a reorientation toward the work of van Dyck, which was to become very influential from the 1640s on and certainly after the middle of the century.

The question arises to what degree this extensive familiarity with the formal language of Rubens was the result of a personal contact between the two painters; unfortunately, hardly any historical evidence exists to clarify this relationship. Yet the contact ought to have been there, since de Crayer uses motifs derived from Rubens that could only have been visible in paintings stored in his workshop. The most significant example is his sketch for the *Triumph of Scipio Africanus* (fig. 8), a preliminary sketch for one of the festive decorations installed on the triumphal arches that were set up in Ghent on the occasion of the triumphal entry of the Cardinal Infante Ferdinand in that city.[46] That sketch visibly derives from Rubens's oil sketch, presently in the Wallace Collection in London, for the *Triumph of Henry IV*, a work that de Crayer only could have seen in Rubens's atelier. Based on the smaller number of figures, de Crayer's sketch appears to be a somewhat reduced version converted to a vertical format. Furthermore, in a letter of 10 June 1640 sent to his brother, the Spanish King Philip IV, Ferdinand makes a cryptic remark, saying that de Crayer was "pogo amigo" of Rubens, which means either that he was a little bit of a friend, or more pejoratively, that he was not a friend of Rubens at all.[47] This notwithstanding, the relationship does not appear to have been so bad since de Crayer played the role of mediator at the sale of Rubens's paintings after his death in 1640. He may have acted on behalf of the Spanish king who, as is known, acquired a great number of works from Rubens's estate. De Crayer even received a painting from Rubens's widow, Hélène Fourment in thanks for his services – the unfinished *Miracles of St. Benedict*, now in the Museum in Brussels.[48]

The activities of Pieter Soutman (ca. 1580-1657) in Rubens's workshop are to some extent comparable to those of van Dyck. Like his fellow colleague Vinckenborch and the engravers Vorsterman and Schelte à Bolswert, he came to Antwerp during the Twelve Year Truce, drawn by the magnetic attraction of Rubens's workshop, which surpassed any artistic enterprise in Holland at that time. He played a role in the years between 1615/16 and 1624, making preliminary sketches for graphic work after Rubens's paintings. He also made engravings himself after Rubens's work, but this dates from his later years after his return to Holland.[49] Very little is known about his work as a painter. There is good reason to believe that he took part in the execution of hunting scenes that Rubens conceived shortly before and around 1620. Soutman's *Four Evangelists* (Stockholm, Nationalmuseum; fig. 9) presumably dates from Soutman's time in Antwerp; not only in composition and figural types but also in sculptural monumentality, this painting corresponds to the works of Rubens in the later teens, particularly to his interpretation of the same theme around that time (Potsdam, Stiftung Schlösser und Gärten, Potsdam-Sanssouci).[50]

Abraham van Diepenbeeck (1596-1675) came from 's-Hertogenbosch to Antwerp, where he was registered as a glass painter in the St. Luke's Guild. At first his artistic activity seems to have consisted mostly of designing and painting glass windows for the various churches and monasteries of Antwerp. From the surviving drawn and painted preparatory studies for this work, it can be seen that his œuvre corresponds stylistically with the more dynamic designs that are so characteristic for Rubens's work from 1620 on. Drawings for prints and book illustrations assumed a very important role in Diepenbeeck's later activity. These drawings clearly show how masterfully the painter succeeded in eclectically adapting quite a number of Rubensian motifs for his own compositions.[51] Therefore, it is not surprising to learn that in the later twenties Diepenbeeck worked as a draftsman in the service of Rubens. On several occasions he drew designs for prints under the master's direction, for example the design for the title page of the *Vitae patrum* by Heribertus Rosweyde, published by Moretus in 1628.[52] Similarly, in 1636 he carried out Rubens's ideas in his preparatory drawing for a print representing *Neptune and Minerva*.[53] Shortly after Rubens's death, in 1642, Diepenbeeck had the printmaker Hendrick Snijers, who worked for him, engrave a number of Rubens's compositions that Diepenbeeck had copied earlier.[54] Rubens knew how to exploit the drawing talents of the young Diepenbeeck for other purposes as well. Recently it has been shown that, probably in 1632, Diepenbeeck made drawings after famous mannerist paintings of Primaticcio and Niccolò dell'Abbate in Paris and Fontainebleau on behalf of Rubens.[55]

The number of paintings that can be attributed to Diepenbeeck with certainty is not large, and most date from his later period, from around 1650 on. Nevertheless, it seems probable that he

Fig. 8. Gaspar de Crayer, *Triumph of Scipio Africanus*, oil on panel, 35.5 x 26.9 cm, London, Courtauld Institute of Art, Princes Gate Collection, inv. 34.

Fig. 9. Pieter Claesz. Soutman, *The Four Evangelists*, oil on canvas, 130 x 187 cm, Stockholm, National-museum, inv. NM 343.

Fig. 10. Peter Paul Rubens and Abraham van Diepenbeeck (?), *Triumph of Divine Love*, oil on canvas, 389 x 482 cm (detail), Sarasota, The John and Mable Ringling Museum of Art.

was involved in the realization of some of Rubens's paintings. The *Saint Cecilia* (New York, Metropolitan Museum of Art) is one such painting; long attributed to Rubens, only recently could it be related to Diepenbeeck with certainty.[56] The facial expression of the saint, who is shown in a typical foreshortening, corresponds perfectly with the physiognomy of some of Rubens's figures painted in the twenties. The close familiarity with Rubens's style seems to indicate that the young Diepenbeeck played some sort of role in the execution of Rubens's paintings. More specifically he seems to be involved in the genesis of the cartoons on canvas for the series of tapestries, dedicated to the *Triumph of the Eucharist* (see cats. 20, 21, 22). It is generally accepted that these cartoons painted in 1627-1628, should be considered largely atelier work.[57] In my opinion, the facial expressions of the angels in the cartoon of the *Triumph of Divine Love* (fig. 10) are closely related to the nude putti in Diepenbeeck's *Portrait of St. Norbert* of 1634 (Antwerp, Onze-Lieve-Vrouwekerk).[58]

The mysterious Willem Panneels (ca. 1600-after 1632) was presumably in contact with Rubens not long after Diepenbeeck had been. In 1627-1628 Panneels became a master of the guild of St. Luke, after working in the workshop of Rubens for several years. Important in this connection is Rubens's statement of 1 June 1630 that Panneels had been a good caretaker of his house and atelier from 1628 to 1630 when he was abroad on a diplomatic mission.[59] From this time dates a large number of drawings firmly attributed to Panneels that copy paintings, oil sketches, and drawings by Rubens.[60] In addition, he made a number of etchings after Rubens's compositions as well as his own. In the captions of these etchings he states with no little pride: *Excelentissimi Pictoris P. P. Rubens olim Discipulus*.[61] The engravings after his own designs illustrate his style well; his heroic-looking figures have unmistakably Rubensian origins, but their anatomy seems both inflated and slack. Recently, painted work has also been attributed to him on the basis of these characteristics, of which the *St. Sebastian* (Brussels, Musées Royaux des Beaux-Arts de Belgique) is an especially good example.[62] Shortly after 1630 Panneels left for the Rhineland, and after 1632 no further information is known about him.

Together with Panneels, Justus van Egmont (1601-1674) of Leiden, who is mentioned by Philip Rubens as a student of his uncle, acted as a witness in arranging a certificate for Deodato del Monte.[63] He is generally identified with the painter Justo, who was in Paris in 1625 in connection with the delivery of paintings from the Marie de' Medici cycle.[64] It is tempting to conclude that he himself was involved in the execution of this project. Before his contacts with Rubens, van Egmont had gained substantial experience. Around 1616 he seems to have cooperated somehow with the young van Dyck when the latter had his own workshop in his house "Den Dom van Keulen" (the Cathedral of Cologne). Sometime in 1618 van Egmont left for Italy. After becoming a master in 1628, he established himself in Paris, where he stayed until 1649. From that time dates a number of aristocratic portraits which have little to do with Rubens's work. In his later years back in the Netherlands, he made a great number of designs for several series of tapestries that show a strong affinity with the formal language of Rubens's monumental cycles of the twenties – with the difference that van Egmont was able to translate these designs into the more highly charged baroque style of the later seventeenth century.[65]

Possibly somewhat later Jan Cossiers (1600-1671) appeared in the atelier of Rubens. Before he became a master in Antwerp in 1628-1629, he spent an extended period in Rome and Aix-en-

Provence.[66] In that last city Nicolas Peiresc gave him a letter, dated 26 October 1626, for his friend Rubens, in which he recommended Cossiers warmly to the older artist.[67] Presumably, this intercession had a favorable effect. From the later correspondence of Rubens with Peiresc, it appears that Cossiers's parents did not approve of their son accompanying Rubens on his visit to Madrid in 1628.[68] In the 1630s, Cossiers took part in the execution of paintings after Rubens's designs for the series of the Pompa Introitus Ferdinandi and the Torre de la Parada.[69] From Cossiers's earlier years a number of large-scale genre paintings survive which are not unrelated to the nearly contemporary Caravaggesque compositions by Theodoor Rombouts and others. Cossiers may have sought a niche in the Antwerp art market with his scenes of fortune-tellers, gypsies, and smokers. Only in the later phase of his career do his religious paintings seem to have played a more substantial role. These early genre scenes were populated with fleshy figures that reveal a familiarity with Rubens's paintings in the 1630s. The rather free technique, which differs from the smooth manner of painting of Rombouts and the other followers of Caravaggio, might also have been borrowed from Rubens.[70]

Like Diepenbeeck, Theodoor van Thulden (1606-1669) came from 's-Hertogenbosch. He is recorded in Antwerp as early as 1621, and he became a master in that town in 1626. His earliest known work dates from 1630 and reveals a certain affinity with the work of his father-in-law, Hendrick van Balen, in its mannered style and taste for decorative embellishment. After his stay in Paris (1632-1633), where he was active as a painter and etcher, he returned to Antwerp, where in 1635 Rubens recruited him for the project of the Pompa Introitus Ferdinandi. Between 1636 and 1638 he also participated in the execution of paintings for the Torre de la Parada.[71] Although nothing is known about other contacts with the atelier of Rubens, it is likely that van Thulden was much more important to Rubens than merely as an occasional collaborator. This becomes apparent from the many political and allegorical compositions van Thulden made from the late thirties until his death. The fleshy, sensuous physical types and the soft palette show a great familiarity with the most salient features of Rubens's late style.[72]

Around 1626 Jan Boeckhorst (ca. 1604-1668) came from Münster in Westphalia to Antwerp. The reports of Cornelis de Bie and Philip Rubens, stating that "Long John," as he was called by his contemporaries, was a member of Rubens's workshop, can be confirmed by other information. Seventeenth-century estate inventories show that after Rubens's death Boeckhorst completed a number of paintings that had been left unfinished; the purpose of this work was undoubtedly to make the paintings more saleable. Some of these paintings survive, like the Resurrection of the Blessed (Munich, Alte Pinakothek), the David (Frankfurt a.M., Städelisches Kunstinstitut) and the Vanitas (Kassel, Gemäldesammlungen Alte Meister). The mere fact that Boeckhorst was asked to intervene in such a way to perform such surgery seems to indicate that he was intimate with the workshop of Rubens. That he was actually employed by Rubens is proved by the fact that in 1655 a painting in a collection in Antwerp is described as "being the Silenus by 'Long John,' retouched by my lord Rubens."[73] This reflects a typical practice of Rubens's workshop, and recalls the way that Rubens had previously had Anthony van Dyck paint paintings on his own which, after retouching, could be sold under Rubens's name.[74]

One example of a painting conceived by Rubens but painted by Boeckhorst is the Storeroom with Maid and Child (collection Lady Bute, Dumfries House, Cumnock; fig. 11). It was painted by Boeckhorst in cooperation with Snyders in accordance with Rubens's design with some final retouching in important areas by the master. The very Rubensian Farmers on the Way to Market (Antwerp, Rubenshuis) may also have originated in a design of the great artist.[75] Both works date from the thirties and reveal the closest connection with Rubens's style of the same years – particularly in the physiognomy of the monumental and well-upholstered figures. Rubens also got Boeckhorst involved in his commissions for the great series of that time: the decorations for the Triumphal Entry of the Cardinal Infante (1635) and the mythological compositions for the Torre de la Parada (1636-1638). From the late forties onwards a change occurs in Boeckhorst's style; he reoriented his manner to the softer and emotionally more attractive style of van Dyck, thus joining a fashion that was spreading among other painters in Antwerp as well.

The role played by Erasmus Quellinus II (1607-1671) in the atelier of Rubens is especially well documented by his working drawings for prints made after the master's designs. Worthy of particular mention are the modelli that he made from 1637 on for book illustrations designed by Rubens for the Officina Plantiniana. Just as with similar work done by van Diepenbeeck in the

Fig. 11. Jan Boeckhorst and Frans Snyders (after a design by Peter Paul Rubens), *Storeroom with Maid and Child*, oil on canvas, 168 x 168 cm, Dumfries House, Cumnock, collection Lady Bute.

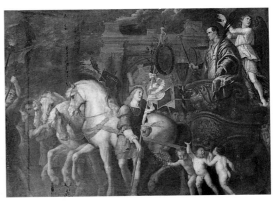

Fig. 12. Erasmus Quellinus, *Triumph of Julius Cesear* (after Mantegna), oil on canvas mounted on panel, 97 x 117 cm, Prague, Národní Galerie, no. 0-10011.

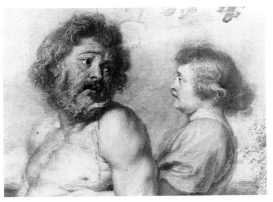

Fig. 13. Peter Paul Rubens and Erasmus Quellinus, *Achilles and Chiron* (detail), oil on panel, 110 x 88 cm, Madrid, Museo del Prado, inv. 2454.

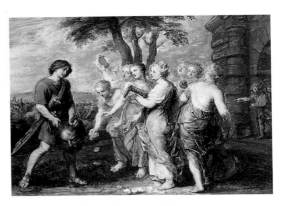

Fig. 14. Jan van den Hoecke, *The Triumph of David*, oil on panel, 58.4 x 80 cm, Fort Worth, Kimbell Art Museum, inv. AP 1966.03.

same context, Rubens's designs must have left great freedom for his collaborator: he restricted himself to general instructions and compositional schemes which were then worked out by Quellinus in a detailed preparatory drawing. Quellinus also seems to have done this kind of work for clients other than the printing house of Balthasar Moretus. The fact that Rubens left him considerable freedom indicates that he fully trusted the ability of his young collaborator to create compositions.[76]

His participation in painted compositions by Rubens – i.e., his work for the Pompa Introitus Ferdinandi of 1635 and the Torre de la Parada of 1636-1638 – also deserves mention. In a letter to his brother the Spanish King Philip IV dated 10 June 1640, the Cardinal Infante Ferdinand discussed four paintings ordered by Philip from Rubens. At the death of the painter they remained unfinished in his workshop, and the Cardinal Infante therefore proposed to have them completed by the "primer official" of Rubens. Rooses has already suggested that this top-rated assistant had to be Quellinus.[77] The suggestion seems to be reinforced by three other recently discovered paintings that were likewise mentioned in Rubens's estate. The three are copies after Mantegna's *Triumph of Julius Caesar* (Prague, Národní Galerie), which were also described as unfinished in the inventory of 1640; one of them reveals the hand of Erasmus Quellinus throughout (fig. 12) and another does in some details.[78] Much earlier, even in the early thirties before he became a master (in 1633-1634), Quellinus seems to have participated as a colleague in the execution of Rubens's work. It has already been suggested that he cooperated in the execution of the "petit patrons" for tapestries from the Achilles series.[79] On close consideration, Quellinus's hand, indeed, appears to be recognizable in a number of these tapestry designs. A striking example is the head of the young Achilles in *Achilles and Chiron* (Madrid, Museo del Prado; fig. 13), whose execution is closely

related to that of the head of Europa in the *Rape of Europa* signed by Quellinus from the cycle of the Torre de la Parada (Madrid, Museo del Prado).

The style of Quellinus is distinctive. From the beginning he displays a somewhat classicistic preference for a more linear and sculptural design than Rubens's freer pictorial expressiveness. He therefore does not seem to have received his real training from Rubens. His own father, Erasmus Quellinus I, who was a sculptor, is a possible candidate. A kind of sculptural classicism, moreover, was to characterize Quellinus's style after Rubens's death, when he shows the closest affinity with the style of his brother, the sculptor Artus Quellinus, who returned to Antwerp in 1640 after many years in Rome. There he had developed a style that was closely linked to the idealized classicism of François Duquesnoy and the Bolognese painters.[80]

Until recently Jan van den Hoecke (1611-1650) was also known only as a painter of strongly classicizing works that bespeak a great familiarity both with antiquity and with the style of the Bolognese school. In this connection, there is a strong affinity with the works of Guido Reni which had actually been copied by van den Hoecke. Until recently, his known œuvre was restricted to the important ensemble of mainly allegorical compositions in the Kunsthistorisches Museum in Vienna, all of which date from his Italian years (from at least 1638 on) and the time thereafter when he worked in the service of the Habsburgs, first in Vienna and then in Brussels at the court of the Archduke Leopold Wilhelm until his early death.[81]

Little exact historical information is available about van den Hoecke's years in Antwerp. Curiously enough, the registers of the St. Luke's Guild in Antwerp not only do not record the workshop in which he had his training but are even silent about his attaining the rank of master. He may have worked as an assistant in the workshop of his father, but he also could have been apprenticed to Rubens. Together with his father, Gaspar, he was involved in the decorations for the Pompa Introitus Ferdinandi.[82] Curiously enough, in his well-known biography of Rubens, Philip Rubens lists van den Hoecke among the master's "plurimos discipulos".[83] Recently it has become possible to reconstruct the activity of van den Hoecke in Antwerp before his departure for Italy.[84] Works from the period include a number of oil sketches, such as the *Triumph of David* in Fort Worth (fig. 14) that both in characterization of the figures and in the smooth painting technique are related to Rubens's work of the thirties. Furthermore, it is known that – presumably in the same early years of his career – van den Hoecke made copies after Rubens, and that via one of his drawings he may have taken over a motif from a painting by Orazio Gentileschi. Before van den Hoecke arrived at the striking classicism of his later years, Rubens's œuvre appears to have been an important point of reference for him.

I am aware that the survey offered here consists purely of a compilation of facts.[85] It goes without saying that Rubens's significance was not limited to what has been documented here. Yet, merely through the diverse geographic origins of the painters discussed above, one gains an impression of what power of attraction the atelier on the Wapper must have had. There is no doubt that Rubens provided two major innovations: one organizational, the large-scale, hierarchic workshop; the other stylistic, the introduction of baroque monumentality. These innovations set a lasting example for virtually the whole of the seventeenth century, even for artists who had no direct contact with Rubens's activities. It had to be this way for a painter who – very early in his career and as few before him – had been recognized as an incomparably superior artist.

Translated by Annewies van den Hoek and John Herrmann

* The evidence concerning the Antwerp painters who collaborated with Rubens has already been presented in my article "Historienmaler und Rubens' Atelier: Eine Quellenstudie," in Cologne/Vienna 1992-93, pp. 133-142.

1. For a recent discussion of this practice, see Van der Stighelen 1990.

2. A summary of this appears in H. Vlieghe, *De schilder Rubens* (Utrecht and Antwerp, 1977), pp. 34-46.

3. Magurn 1955, pp. 59-67.

4. De Maeyer 1955, pp. 293-294 (doc. 62).

5. Not all the students or collaborators of painters turn up in the registers of the St. Luke's Guild, as appears from studies on Frans Floris (C. van de Velde, *Frans Floris, Leven en Werken* [Brussels, 1975], vol. 1, pp. 99ff) and Cornelis de Vos (Van der Stighelen 1991a). Some painters were already active before officially becoming masters in the guild; the best-known example of this is Anthony van Dyck's activities in the years before he became a master in 1618 (in this connection, see S. J. Barnes, "The Young van Dyck and Rubens," in exh. cat. Washington 1990-91, pp. 17-25; and, above all, the recent findings on van Dyck's earliest workshop before he became a master, in Van der Stighelen 1991b).

6. Magurn 1955, p. 55.

7. Baron de Reiffenberg, ed., "Vita Petri Pauli Rubenii (1676)," *Nouveaux Mémoires de l'Académie Royale des Sciences et Belles-Lettres de Bruxelles* 10 (1837), p. 11.

8. On these projects for the triumphal entry of Cardinal Infante Ferdinand into Antwerp, and the decorations for Philip IV's hunting lodge, see Introduction.

9. On these commissions, see Martin 1972 and Alpers 1971. Judging from the style of their work, the painters mentioned in connection with these commissions, like de Reyn, Schut, Wolffort, and others, do not seem to have received any formative impulses from Rubens; they must rather have acted as occasional collaborators.

10. N. Scheuer-Raps's monograph on the artist (*Deodat del Monte* [Aalter, 1956]) is not very thorough; see also Hairs 1977, pp. 46-48.

11. This unique document was published in de Bie 1661, pp. 135-136.

12. Published in M. Jaffé, *Peter Paul Rubens and the Oratorian Fathers* (Florence, 1959), p. 20.

13. Scheuer-Raps 1956, pp. 49-50.

14. Scheuer-Raps 1956, pp. 54-63, repr.

15. Oldenbourg 1921, p. 91.

16. For the state of research on this important series, see H. Vlieghe, "Rubens' beginnende invloed: Arnout Vinckenborch en het probleem van Jordaens' vroegste tekeningen," *Nederlands Kunsthistorisch Jaarboek* 38 (1987), p. 394, note 1.

17. Vlieghe 1987.

18. Vlieghe 1987, pp. 388-390, fig. 7.

19. Inv. no. 1134; canvas, 117.5 x 157.5 cm; previously unpublished.

20. Vlieghe 1987, pp. 393-394, figs. 11-13.

21. Robels 1989, p. 177, no. 10, ill.; the older man with curly hair closely resembles a similar type to the left in the *Adoration of the Magi* in Skalbmierz (see, above, note 18).

22. Robels 1989, p. 177.

23. H. Vlieghe, "Artus of Antoni de Bruyn?," *Jaarboek van het Koninklijk Museum voor Schone Kunsten, Antwerpen* 1969, pp. 170-172, fig. 1.

24. Vlieghe 1969, pp. 172-173, fig. 2.

25. H. Vlieghe, "De boedelinventaris van Artus de Bruyn," *Jaarboek van het Koninklijk Museum voor Schone Kunsten, Antwerpen* 1973, pp. 225-226, 230.

26. Vlieghe 1973, pp. 226, 230.

27. According to d'Hulst 1982, pp. 44ff.

28. d'Hulst 1982, pp. 38, 48.

29. H. Vlieghe, "Evolutie van de Antwerpse monumentale historie- en portretschilderkunst ten tijde van Jan Boeckhorst," in Antwerp/Münster 1990, p. 54.

30. Alpers 1971, nos. 9, 25, 41, 59; Martin 1972, nos. 6, 14; and J. R. Martin, "Rubens's Last Mythological Paintings for Philip IV," *Gentse Bijdragen tot de Kunstgeschiedenis* 24 (1976-78), pp. 113-118.

31. Working from Rubens's sketch presently in the Metropolitan Museum of Art, New York, Seghers made the now-lost *Glorification of the Eucharist* for the high altar of the Carmelite church in Antwerp before 1642 (Freedberg 1984, pp. 72-75, no. 17, fig. 40). For his contribution to the Pompa Introitus, see Martin 1972, pp. 138-139, no. 35, fig. 65.

32. A problematic painting is the *Salome with the Head of John the Baptist* (Madrid, Palacio Real), a work bearing the signature *Gdo. Segers ft.* (see exh. cat. Madrid 1977-78, no. 131, ill.) The style of this composition is so closely related to Rubens's works of shortly before 1615 that it could be a copy of a lost painting by Rubens, for which drawings exist and which is also known in other copies (Burchard, d'Hulst 1963, no. 42, 112, ill.). The abbreviated Italian version of the artist's first name could indicate that the painting was made during his Italian period between 1611 and 1620. In that case the piece should not, of course, be considered a product of Rubens's workshop.

33. See the excellent summary in Barnes 1990-91.

34. Rooses, Ruelens 1887-1909, vol. 2 (1898), p. 137; Magurn 1955, pp. 61, 441. Van Dyck is one of six painters specifically mentioned as students of Rubens in the biography of 1676 by Philip Rubens (see above, note 7).

35. Martin 1968, pp. 39-40.

36. Bellori 1672, p. 254; see also Vey 1962, p. 32.

37. Denucé 1932, p. 70; Muller 1989, p. 145.

38. Washington 1990-91, no. 2, ill.; for the very early artistic activities of van Dyck, see especially the new findings of Van der Stighelen 1991b, p. 54.

39. See for this Vlieghe, "Evolutie," in Antwerp/Münster 1990, p. 54.

40. For the history of this series and the fact that it was already connected with van Dyck in the seventeenth-century sources see Held 1980, pp. 19-24 and Baumstark 1988. Van Dyck's hand seems particularly recognizable in the following paintings of the cycle: *Decius Mus Relating His Dream; The Consecration of Decius Mus; The Dismissal of the Lictors*. Baumstark (1988, p. 18) doubts that the contribution of van Dyck can be recognized in the cartoons in Vaduz.

41. Rooses, Ruelens 1887-1909, vol. 2 (1898), p. 137; Magurn 1955, p. 61.

42. Madrid, cat. 1989, no. 49; Magurn 1955, pp. 61, 442.

43. See among others, Brown 1982, pp. 27-52.

44. This discussion of Cornelis de Vos's history paintings and their relationship to Rubens follows the main lines of the extensive study of the subject in K. van der Stighelen and H. Vlieghe, "Cornelis de Vos (1584/5-1651) als historie- en genreschilder," *Academiae Analecta* 1993 (in press).

45. See particularly Vlieghe 1972.

46. See H. Vlieghe, "Two 'poeteryen' by Gaspar de Crayer," *The Burlington Magazine* 108 (1966), pp. 67-72.

47. See Rooses, Ruelens 1887-1909, vol. 6 (1909), p. 304; Vlieghe 1972, p. 310.

48. See Vlieghe 1972-73, vol. 1, p. 115.

49. De Bie (1661, p. 154) reports that Soutman was a student of Rubens; this information may also be found in Rubens's biography of 1676 by his nephew Philip (see above, note 7); Soutman's etchings after Rubens, especially his famous hunting scenes, were not executed in Antwerp but in Holland, as is shown by Balis 1986, pp. 47-48.

50. On Soutman's contribution to Rubens's hunting scenes, see Balis 1986, p. 40; for his *Four Evangelists*, see Vlieghe 1972-73, vol. 1, no. 55.

51. See the brief monograph by Steadman (1982, passim).

52. Judson, van de Velde 1978, no. 57, fig. 193.

53. Judson, van de Velde 1978, no. 86, fig. 290.

54. Van den Branden 1883, p. 784.

55. J. Wood, "Padre Resta's Flemish Drawings. Van Diepenbeeck, Van Thulden, Rubens, and the School of Fontainebleau," *Master Drawings* 18 (1990), p. 3-53.

56. H. Vlieghe, Review of New York, Metropolitan, cat. 1984, *Oud Holland* 100 (1986), pp. 200-221, ill.

57. De Poorter 1978, pp. 133-136.

58. Steadman 1982, fig. 6.

59. P. Génard, "Petrus-Paulus Rubens en Willem Panneels," *Rubens-Bulletijn* 1 (1882), pp. 220-223; for a summary of the scanty biographical information on Panneels, see M. Rooses, "Panneels (Guillaume)," in *Biographie Nationale de Belgique*, vol. 16 (Brussels, 1901), cols. 550-553.

60. J. Garff and E. de la Fuente Pedersen, *Rubens Cantoor. The Drawings of Willem Panneels*, 2 vols. (Copenhagen, 1988).

61. "Previously student of the most excellent painter P. P. Rubens." See Hollstein 1949-, 15, pp. 109-127.

62. A. Balis, "Van Dyck: Some Problems in Attribution," *Studies in the History of Art* 47, 1991 (in press); many thanks to Arnout Balis for making his manuscript available to me for use in this article.

63. See above, notes 7 and 12.

64. In this connection and for other biographical information on van Egmont, see Hairs 1977, pp. 44-45.

65. A good example is the tapestry of the Zenobia series (see in this context among others, G. Delmarcel, exh. cat. Brussels, Koninklijk Museum voor Kunst en Geschiedenis, *Brusselse wandtapijten in Rubens' eeuw*, 1977, nos. 38-41, ill.)

66. For a good summary of the biographical information, see Hairs 1977, pp. 31-32.

67. Rooses, Ruelens 1887-1909, vol. 3 (1900), pp. 477-479.

68. Rooses, Ruelens 1887-1909, vol. 5 (1907), pp. 26-27.

69. Martin 1972, pp. 166-167; Alpers 1971, nos. 17, 32, 51, 52.

70. See, for example, L. H[ardy]-M[arais], in Lille/Calais/Arras 1977, no. 9, ill.

71. Martin 1972, passim; Alpers 1971, no. 31.

72. Vlieghe 1990a, p. 58; for a recent study of van Thulden, see especially Roy 1991-92.

73. "Wesende Silenus, van Lange Jan, by myn Heer Rubbens geretocceert".

74. The information gathered here concerning Boeckhorst's relationship with Rubens's workshop is more extensively discussed in Vlieghe 1990b, where the paintings discussed are illustrated (figs. 49-51).

75. See the illustration in Antwerp/Münster 1990, no. 34.

76. For Quellinus in general, see de Bruyn 1988. Quellinus's work in Rubens's service has been discussed in detail in Vlieghe 1977a; he, too, is one of the students mentioned by Philip Rubens (see above, note 7).

77. For his participation in the serial commissions, see Martin 1972, pp. 187-189 and Alpers 1971, nos. 1, 12, 13, 16, 27, 47, 51; for the Cardinal Infante's correspondence concerning the completion of Rubens's unfinished compositions by Quellinus, see Rooses, Ruelens 1887-1909, vol. 6 (1909), pp. 304-305.

78. L. Slavivcek, in exh. cat. Retretti, Retretti Art Center, *Rubens*, 1991, pp. 114-119, ill.

79. Haverkamp Begemann 1975, p. 60.

80. In this context, see also Vlieghe, "Evolutie," in Antwerp/Münster 1990, p. 58.

81. G. Heinz, "Studien über Jan van den Hoecke und die Malerei der Niederländer in Wien," *Jahrbuch der kunsthistorischen Sammlungen in Wien* 63 (1967), pp. 109-164.

82. Martin 1972, p. 142.

83. "His multitude of students"; see above, note 7.

84. H. Vlieghe, "Nicht Jan Boeckhorst, sondern Jan van den Hoecke," *Westfalen* 68 (1990), pp. 166-183.

85. The other artists who are mentioned in contemporary documents in connection with the activities in Rubens's workshop are not discussed here. Jacob Moermans is, however, the only painter mentioned as Rubens's student in the records of the St. Luke's Guild in Antwerp (1621-22) (Rombouts, van Lerius 1872, vol. 1, p. 574); he appears to have primarily been active in the production of series for the open market (Hairs 1977, pp. 43-44). A document of 1634 indicates that Frans Wouters (1612-1659) left the atelier of the landscape painter van Avont for that of Rubens (van den Branden 1883, p. 1634). Wouters remained faithful to his training, and from his work it can be concluded that he was a painter of small history pictures and landscapes (see among others Hairs 1977, pp. 48-52). The relatively well-documented activities of Lucas Fayd'herbe (1617-1697), for whom Rubens wrote a certificate of recommendation in 1640, are obviously connected with sculpture after his master's designs (see, for example, exh. cat. Brussels) 1977, p. 96.

Flemish Genre Painting: Low Life - High Life - Daily Life

Konrad Renger

Genre painting, i.e. the representation of scenes from everyday life, is generally thought to be a feature of Dutch painting of the so-called Golden Age.[1] Its origins are commonly ascribed to Holland's deliverance from Spanish domination: "The setting for its inception and flowering could only have been provided by a liberated people; in its existence lies the proof of the spirit of independence, which is reflected in it," wrote Wilhelm von Bode in 1906.[2] Dutch genre painters, such as Jan Vermeer of Delft, Pieter de Hooch, Jan Steen, or Gerard ter Borch, are among the most popular painters of early modern art, of any country. Their pictures illustrate the domestic everyday life of the new republic's new bourgeoisie. By contrast, the Flemish counterpart in the Southern Netherlands (mainly in the provinces of Flanders and Brabant) remained under Spanish rule, without establishing its own government.

In the seventeenth century there was little genre painting in the south, despite the fact that its origins can be found there and not in the north. Genre painting in the south, when practiced at all, favored elegant musical and dancing parties, battles, beggars and, above all, peasants: i.e., themes which reflect the old social hierarchies. These subjects developed from French and Burgundian courtly art of the fourteenth and fifteenth centuries, from representations of dance and musical parties, tournaments and battle scenes, rural life, pastorals, and peasants at work.[3] The media used were costly and restricted to the courtly sphere: ivories, illuminated manuscripts, tapestries, frescoes. In the course of the fifteenth century, with the rise of the cities, the new bourgeoisie adopted traditionally aristocratic themes, endowing them with a new iconography.[4] Panel paintings, previously restricted to religious themes, increasingly depicted secular subjects; new, cheaper media also came into use, especially woodcuts and engravings. The new subjects, however, could develop only within the prosperous bourgeoisie of court cities such as Mechelen (Malines) and Brussels, and the merchant towns of Ghent and Bruges. This was the milieu of Jan van Eyck (ca. 1390-1441), painter for the Dutch and Burgundian courts, and a pioneer in the depiction of secular subjects. Scenes of courtly parties fishing or hunting may well have originated with him.[5] Among his patrons, however, also numbered the new urban upper class of Ghent and Bruges, mainly bankers and merchants. His painting, *Woman at Her Toilet*, which survives in copies only, is of special significance in this context. Seemingly a genre scene, the picture is an allegory of pride (superbia) and lust (luxuria); it was to influence many similar scenes.[6]

In the sixteenth century the economic center of the Southern Netherlands shifted from Bruges to Antwerp, followed by the artistic center. The connection between economic prosperity and artistic creativity was already recognized by the Dutch artist and theorist Karel van Mander, who wrote in 1604: "The famous and magnificent city of Antwerp, which owes its flourishing to its trade, has attracted the most important artists from everywhere who have congregated there in large numbers because art is drawn to wealth."[7]

Genre painting in Antwerp dates back as early as Quentin Massys (1465/66-1530), founder of the Antwerp school of painting. Massys created strongly moralizing and didactic genre pictures which are characterized by markedly ugly men and women and an exaggerated, almost caricatured manner.[8] Christian morality is no longer expressed in terms of religious allegory but in terms of scenes from everyday life, a trend which was to increase in the next generation. The tavern scenes by the Braunschweig Monogrammist (active in the second quarter of the sixteenth century) and the kitchen pictures by Pieter Aertsen (1509-1575) and Joachim Beuckelaer (ca. 1535-1574) contain warnings of the dangers of gluttony (gula), sloth (desidia), and lust (luxuria), vices which are part of the medieval seven deadly sins.

The most commonly depicted protagonists in Aertsen's kitchen and market pieces are peasants, i.e. representatives of the lowest social class.

Peasants and country life generally constitute the most important subjects of fifteenth- and

sixteenth-century secular art. The topos goes back to the pastoral literature of antiquity. Virgil's bucolic poetry lived on in the medieval pastourelle; that of his Greek predecessor Theocritus was rediscovered at the end of the fifteenth century. Peasant subjects eventually also appear in the visual arts, at first at the courts, the only milieu for secular art. Especially popular were planting and harvesting scenes and depictions of other peasant activities connected with the labors of the months cycles with their illustrations of seasonal tasks. These include scenes of hard labor, especially the cutting and chopping of wood, frequently observed by elegantly dressed ladies and gentlemen of the court. The subject of upper-class spectators at country events remained popular in panel paintings of the sixteenth and seventeenth centuries.

Besides depictions of seasonal labors, we also find the more idyllic pastoral, especially in fifteenth-century tapestries, sometimes explicitly based on the *bucoliques de Virgille*, as we learn from contemporary accounting books.[9] Leading in the genre was the Burgundian court whose inventories frequently list tapestries depicting shepherds.[10] These seem not to have been regarded simply as wall decorations by the Burgundian dukes, who identified with these subjects. From the inventory of Philip the Bold (1404), for example, we learn that the shepherds on a specific tapestry represent the Duchess of Artois and the Duke of Flanders.[11] Courtly interests extended to the more indecorous aspects of rural life as well. In the inventory of King Charles VI of France of 1422 is listed a tapestry with two persons "dont l'un pisse en une orine."[12]

Alongside depictions of the idyllic, the occupational, and the earthy aspects of rural life, there existed also a purely negative image of the peasant which exposed him to ridicule and derision. This image arose in German literature of the thirteenth century, particularly in the writings of Neidhart von Reuenthal. Its origin can be found in the social tensions caused by the rising peasant class and the impoverished nobility.[13]

A similar development took place in the Netherlands. Here, too, the peasant war was the result of social tensions between knights and peasants. This is demonstrated in the so-called *Kerelslied* of 1320-1330, a song which ridicules the peasant. "Kerel" is a middle-Netherlandish word for a free man, but not a knight, in short, a farmer or villager (*dorpaere*). Only later is the term used to describe an unrefined (*onbeschaafd*), rough (*ruw*), and clumsy (*ongelikt*) peasant. The word "dorpaere" (*dorper, doerper*) was introduced into chivalric vocabulary around 1170; it designates a rough man, lacking in courtly refinement.[14] The song's description of the "kerels" dressed in rags, trousers torn and caps askew, is reminiscent of sixteenth- and seventeenth-century peasant imagery. Furthermore, the "kerel" is said to frequent kermesses, get drunk, and start brawling.

The foolish peasant becomes a topos in subsequent literature where, however, he no longer is the object of knightly ridicule, but an example of moral degradation for the urban bourgeoisie. He appears in sixteenth-century German literature, above all in the poems of Hans Sachs, published in Nuremburg with woodcuts by Erhard Schön and the brothers Beham.[15] Thus the literary topos becomes part of the visual tradition. It is this tradition of satirical representations of

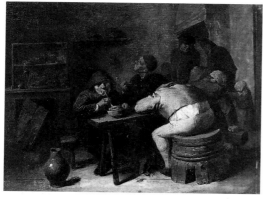

Fig. 1. Adriaen Brouwer, *The Smokers*, oil on panel, 20 x 28 cm, Paris, Musée du Louvre, inv. 1070.

Fig. 2. Adriaen Brouwer, *Taste*, oil on panel, 23.7 x 20.5 cm, monogrammed upper left: B., Munich, Bayerische Staatsgemäldesammlungen, inv. 626.

peasants that underlies the work of Pieter Bruegel the Elder (ca. 1525-1569) and even Adriaen Brouwer.

In his depictions of village kermesses, weddings, and dances, Bruegel created his own peasant imagery which, in the eighteenth century, gave him the nickname "Peasant Bruegel." Only since the relatively recent discovery of his humanistic interests and his close contacts to Antwerp scholars do we recognize in Bruegel the *pictor doctus*. His deceptively realistic prints and paintings are, in fact, witty satires on the social and human condition.[16] The seemingly harmless activities in *Children's Games*, or the merry cavortings in *Carnival and Lent*, should be seen as manifestations of human folly. The excessive behavior of Bruegel's festive peasants is meant as moral warning to the city dweller. For the bourgeois patron Bruegel transposed the courtly themes previously depicted on tapestries into the bourgeois medium of panel painting. His works were much appreciated during his lifetime, his prints widely dispersed, his paintings copied well into the seventeenth century. Rubens owned twelve paintings by Bruegel; his interest in the art of his illustrious predecessor was manifested in numerous copies and adaptations.[17] At first Bruegel's influence in the Southern Netherlands was only indirect, since the followers who were closest to him iconographically and stylistically – for example, Hans Bol (1534-1593), Roelant Savery (1576-1639),[18] and David Vinckboons (1576-1632) – emigrated to Amsterdam after the Spanish occupation of Antwerp in 1584. There they were instrumental in the development of genre painting in the Northern Netherlands.[19]

In Antwerp peasant pictures initially appeared less frequently. Towards the end of the sixteenth century another type of genre painting took their place, mainly through the works by members of the Francken family. In small-figured cabinet pictures, the Franckens depicted elegant banquets, dancing, or music-making parties of aristocratic ladies and gentlemen or Antwerp patricians.[20] The most productive member of the family was Frans Francken the Younger (1581-1642) who, furthermore, together with Jan Brueghel the Elder (1568-1625) established the new genre of gallery painting.[21] These representations – whether of real Antwerp collections or allegories on the art of painting – became a speciality of Antwerp artists.[22] By proudly presenting their collections, Antwerp burghers yet again followed courtly traditions, i.e. the representation of the princely cabinet of man-made and natural curiosities, known in Germany as the "Kunst-und Wunderkammer."[23] In the course of the sixteenth and seventeenth centuries, these developed into pure art collections and painting galleries.

Courtly traditions also influenced Sebastian Vrancx (1573-1647), who depicted elegant social gatherings set indoors or in open spaces. However, beyond their genre character these pictures are meant to convey a moral message to the wealthy burghers. His distinctive, well-rounded figures with strong local colors are reminiscent of Bruegel.[24] A different aspect of Vrancx's œuvre is displayed in his scenes of warfare and looting, partly based on contemporary events, partly invented. With their references to the war between Spain and the Netherlands, they are of topical significance (see cat. 84). Vrancx's pupil and successor Pieter Snayers (1592-1667) specialized exclusively in painting battle scenes, for which Rubens employed his services.[25]

Representations of military life, mainly guardroom scenes, were also popular in the Northern Netherlands.[26] Without denying their topical relevance, it should be noted that the bourgeois owners of these paintings still were conscious of the courtly tradition of battle scenes and tournaments that lay at their root.

As mentioned above, the Southern Netherlands remained under Spanish rule, without independent government and without establishing new pictorial themes. Iconographically Flemish art remained traditional. This may explain why scenes of peasant life, with their long tradition in literature and art, continued to be the most significant branch of genre painting in the seventeenth century.

The main practitioner of the peasant genre in the seventeenth century is Adriaen Brouwer (1605/06-1638). His œuvre of only about sixty paintings is exclusively devoted to scenes of peasant life, sometimes placed outdoors, but mostly in taverns, or lowly hovels.[27] Although Flemish, Brouwer spent several years as a young man in Holland (ca. 1626-1632) where he was influenced by local styles of genre painting which, in turn, were dependent on Pieter Bruegel. At first he continued in the tradition of the sixteenth century, following not only Bruegel but also his German predecessors. He was familiar with German moralizing woodcuts which he adapted in his early pictures, retaining their moralizing content. In representations of drinking, fighting, and sleep-

ing peasants, he denounces the vices of gluttony and intemperance (gula), wrath (ira), and sloth (desidia) (see fig. 1). Thus Brouwer represents the culmination of a tradition dating back to the Middle Ages.[28]

Although Brouwer retains the tavern brawl as one of his favorite subjects, at the beginning of the 1630s we observe a change of intent, from representation of the vices, to the expression of human senses and emotions, such as anger, joy, pain, and pleasure. At the same time he invents new subjects: primitive medical procedures (cat. 64), for example, and the new fashion of smoking (fig. 1). In focusing on human conditions Brouwer transcends the narrow limits of moralizing didacticism which define previous efforts in the genre. He raises human conditions to a universal level and makes them worthy of pictorial representation. In doing so he not only adds an entirely new dimension to the peasant genre, but to genre painting in general. In his lively representations of expressions and gestures Brouwer's mastery is comparable to that of Rubens and Rembrandt. His accomplished painterly technique, expressed in the translucency of his paint layers, the rich nuances of his palette, and the confident handling of light and shade, is equal to that of his younger Dutch contemporaries Pieter de Hooch or Jan Vermeer.

Brouwer's closest follower was David Teniers the Younger (1610-1690) whose early work is deceptively similar to that of the older master in technique, color, and composition.[29] However, in the course of his long life Teniers's catalogue of subjects was much expanded to include elegant social gatherings or their satirical counterparts, enacted by monkeys, as well as eerie scenes of alchemy and witchcraft (see cat. 68). Teniers's renderings of his favorite theme, peasants smoking or drinking in interiors, are closely modeled on those by Brouwer without, however, conveying the latter's broader meaning.

From 1651 Teniers was court painter in Brussels and keeper of the collection of Archduke Leopold Wilhelm, governor of the Southern Netherlands. He made copies of the archduke's paintings in individual panels as well as in gallery pictures of the entire collection (see cats. 124, 126, 127, and 128). He remained in court service under Don Juan of Austria, Leopold Wilhelm's successor, and was on favorable terms with King Philip IV of Spain.[30] It surely is significant that Teniers the peasant painter becomes Teniers the court painter in Brussels. Peasant life is yet again a subject of courtly art, even the models are socially acceptable: one of Teniers's peasants poses as a model in the gallery of the archduke (fig. 3). It is no coincidence that Teniers's pleasant village festivities were reproduced in tapestries of Brussels manufacture.[31] Thus the peasant genre returns to the courtly milieu from which it developed in the course of the fifteenth century.

Like Teniers, the Brouwer followers Joos van Craesbeeck (1605 or 1608-ca. 1661) and, to some extent, David Ryckaert III (1612-1661)[32] imitated, in their early works, their model's technique and palette (see cats. 71, 72, and 73). Ryckaert also used Brouwer's peasant types who, for example, inhabit his *Studio* of 1638 (fig. 4): one of them poses for the elegantly attired painter who is working on a genre scene in a landscape; another, seated at an easel, is himself occupied with painting. A painting of a shepherd with his flock in the foreground of the scene demonstrates that, in this artist's studio, both types of genre painting are practiced, the low-life peasant scene and the bucolic pastoral.

Another painter of Flemish peasant scenes is Gillis van Tilborch, of Brussels (ca. 1625-1678), whose early works closely follow Brouwer's in technique and content,[33] but who later came under the influence of Craesbeeck. In their later work, these painters and their contemporary Gonzales Coques (1614 or 1618-1684; see cats. 58 and 59), also turned to the representation of bourgeois life.

The strongly individualistic painter Jan Siberechts (1627-ca. 1703) introduced his own style into the popular genre. His peasants and country maids at work are shown in curiously frozen poses (cat. 93).

Brouwer remains the decisive force throughout the development of the peasant genre in the seventeenth century. His early work was influenced by Dutch low-life genre as practiced around 1630 in Rotterdam and Middelburg; later he, in turn, became important for individual Dutch painters, such as Cornelis Saftleven, of Rotterdam,[34] and Adriaen van Ostade, of Haarlem.[35] Furthermore, his influence was not restricted to practioners of peasant genre, but also included more versatile painters such as Jan Steen. Many of the latter's figures, in their theatrical mimicry, their expressions of pain or anger, are unthinkable without the example of Brouwer.[36]

Rubens too was one of Brouwer's admirers: he owned seventeen of his paintings[37] and gener-

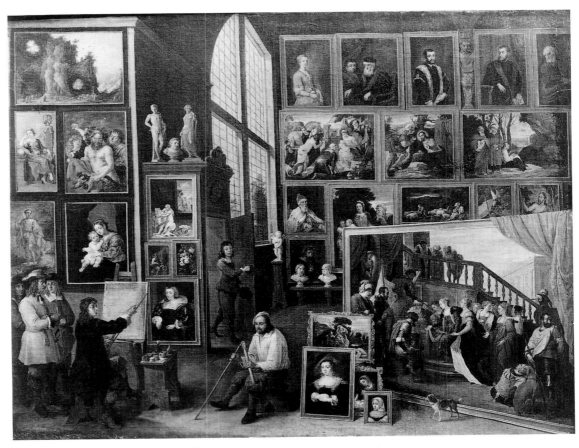

Fig. 3. David Teniers II, *Gallery of the Archduke Leopold Wilhelm*, oil on canvas, 96 x 125 cm, Munich, Bayerische Staatsgemäldesammlungen, inv. 1819.

Fig. 4. David Ryckaert, *Painter in his Studio*, 1638, oil on panel, 59 x 95 cm, Paris, Musée du Louvre, inv. MI 146.

ally was not above taking inspiration from the younger artist. His most intensive exercise in the peasant genre, the *Kermesse Flamande* (Paris, Musée du Louvre, fig. 5), shows Brouwer's influence even in individual figures. Among the enthusiastic crowd of drinkers around a table in front of the inn is one who greedily pours the contents of a huge pitcher into his wide-open mouth, a motif repeatedly encountered in Brouwer's paintings.[38] Across from him another peasant, worn out from too much drink, has fallen asleep on the table. This figure closely resembles one of Brouwer's protagonists in *The Smokers* (see fig. 1),[39] down to such details as the shirt untidily protruding between jerkin and trousers. Overall the subject of the scene in front of Rubens's inn is intemperance and its harmful consequences for old and young (a huge tankard is given to a child). One is reminded of the ironic inscription underneath Bruegel's *Fair at Hoboken*: "The peasants rejoice at such festivals/ To dance, jump, and drink themselves drunk as beasts/ They must observe these festivals even if they fast and die of cold."[40] It remains an open question whether Rubens, whose painting is imbued with the spirit of Bruegel, likewise intended to convey a moral message.

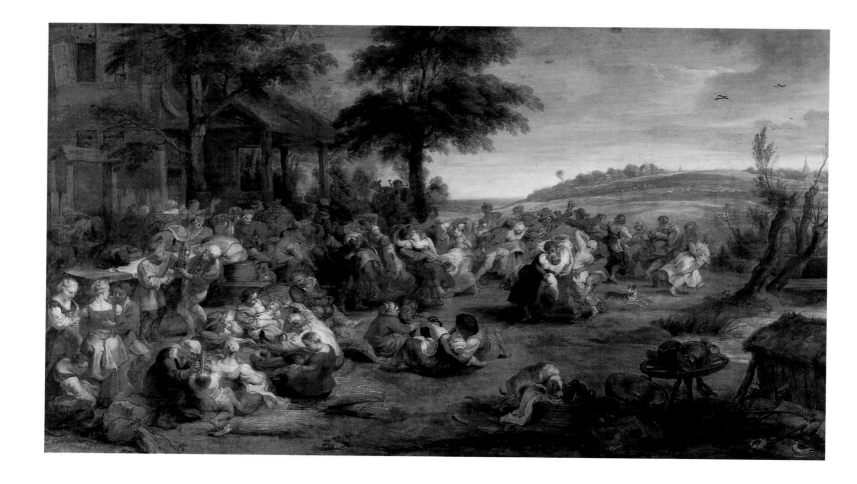

Fig. 5. Peter Paul Rubens, *Kermesse*, oil on panel, 149 x 261 cm, Paris, Musée du Louvre, inv. 1797.

Rubens repeatedly concerned himself with the subject of drunken and fighting peasants in the manner of Bruegel. He drew drunken peasants being conducted home, and collected and reworked drawings of a similar kind.[41]

From the *Specification* which advertised the sale of works of art from Rubens's estate (1640), we know that he made a copy after a Bruegel painting, now lost, of drunken peasants fighting over a game of cards.[42] This is not the place to discuss which, if any, of the three existing versions associated with Rubens in the literature can be identified with the work mentioned in the inventory. Suffice it to say that Bruegel's composition was well known, as witnessed by the many surviving copies, among which an engraving by Lucas Vorsterman deserves special mention (fig. 6).[43] The print is accompanied by Latin verses which feature Tityrus and Melibaeus, characters from Virgilian pastoral poetry. By introducing such characters, the vulgar peasant brawl has been elevated into the classically inspired literary sphere.

Fig. 6. Lucas Vorsterman after Peter Paul Rubens's copy after Pieter Bruegel the Elder, *Peasants Fighting over a Game of Cards*, engraving, Braunschweig, Herzog Anton Ulrich-Museum.

Fig. 7. Frans van den Wijngaerde after Peter Paul Rubens, *Lansquenets Carousing*, etching, Munich, Staatliche Graphische Sammlung.

The idea for this transformation may well have come from Rubens himself who, in his pictures of rural life, frequently stressed its idyllic aspects. In his *Peasant Dance* (Madrid, Museo del Prado) and *Pastoral Landscape with a Rainbow* (St. Petersburg, Hermitage), shepherds in antique dress have joined the Flemish peasants.[44] By combining contemporary and antique elements, Rubens continued the tradition of fifteenth-century tapestries, the *bucoliques de Virgille*.[45]

In the *Shepherd and Shepherdess* in Munich, from Rubens's last years, the artist concentrated the action in two figures.[46] A shepherd dressed *al antica*, with fur draped around his waist, crowned with ivy, and carrying a bagpipe on his back, embraces a young woman in contemporary clothes who half-reluctantly and half-eagerly accepts his passionate approach. In the sale record of Rubens's goods, drawn up in 1645, the picture appears under the title "Silvia."[47] A certain Silvia is the mistress of the shepherd Coridon in the Dutch print series of 1630, "Les plus belles courtisanes de ce temps."[48] Rubens's shepherdess, with her jaunty pose and provocative glance, would perfectly suit this description. Shepherds and their loves thus descend from the idyllic sphere of the pastoral to the realities of life.

Love in its more drastic form likewise is the subject of two pictures with lansquenets (mercenaries) which, significantly, also remained in Rubens's possession: "A Switzer with his sweethart, with a bottle, with a satyre" and "A Switzer where the Boores bring him money and Cover a table."[49] In *A Switzer, His Mistress, and a Satyr* (Genoa, Palazzo Bianco), a soldier in breastplate, fur cap, and the slashed breeches of the German "Landsknecht," grabs the bare breast of his mistress. Cupid pulls the sword from its scabbard: where love rules, arms are at rest. The wine pitcher in the arms of the girl and the satyr raising his glass leave us in no doubt as to the power of wine in the pursuit of love.

The other picture with lansquenets which remained in Rubens's possession is the so-called *Lansquenets Carousing*, known in copies (fig. 7) and in a fragment of Rubens's preparatory design (Paris, Fondation Custodia, Collection F. Lugt).[50] The scene depicts soldiers in "Landsknecht" uniform looting peasants, while others enjoy their wine in the company of camp followers. One of the man puts his hand up the skirt of his girl who does not seem to protest too much. The whole picture, with its exaggerated gestures and mimicry bordering on caricature, elicits amusement rather than compassion. Rubens created this image of plundering and carousing mercenaries at the same time as he was exploring the idyllic pastoral, as witnessed by the sketch on the verso of his preparatory drawing in the Lugt Collection.[51] Here we find preliminary studies for the figures in his *Pastoral Landscape with a Rainbow* in St. Petersburg, discussed earlier.

Rubens's two pictures of lansquenets have little in common with the "Boerenverdriet," the compassionate description of the sufferings of peasants in times of war.[52] They are depictions of the pleasures of army life on the periphery of war. By dressing his soldiers in old-fashioned "Landsknecht" uniforms, Rubens transformed contemporary events into ageless genre scenes inspired by sixteenth-century German and Swiss prints, such as those by Albrecht Altdorfer and Urs Graf.[53] In his early years Rubens had copied sixteenth-century German dress, including the fanciful uniforms and extravagantly plumed hats of the "Landsknechten," but his aim had been quite a different one.[54] These drawings make up part of his costume studies, collected for documentary purpose, without any iconographic reference, topical or otherwise.

The paintings by Rubens discussed so far do not strictly come under the category "genre" or "peasant genre," as traditionally defined. With the exception of a *Shepherdess* and the two pictures with landsquenets, they are, above all, landscapes with staffage of varying degrees of significance in which rural life takes its course, frequently transformed into pastoral idylls. In this respect they are related to Rubens's great harvest pictures[55] in which we recognize – via Bruegel – the allegorical representations of summer in the labors of the months cycles of Franco-Flemish courtly art.

The continuation of courtly traditions, however, is not restricted to Rubens's pictures of rural life, but can be found in some of his other so-called genre pictures. An interesting example is the *Tournament before a Castle* in Paris (fig. 8),[56] where knights on horseback are engaged in combat in front of a medieval tower and a castle which combines medieval and Renaissance forms. Two boys in historical dress pick up lances, while a third, wearing a doublet and slashed breeches, runs alongside the rider in the center. The painting is a conscious evocation of the medieval past whose courtly, chivalrous world is here represented in the context of a landscape.

Other courtly traditions enter into the iconography of the *Garden of Love* (see cat. 31): alle-

gories of love as found on French ivory bridal caskets of the early fourteenth century, or early fif-teenth-century representations of gardens of love from Burgundy and Flanders.[57] Courtly iconographic traditions play an even greater part in the *Park of a Castle* in Vienna (fig. 9),[58] in which elegant couples play amorous games in front of a castle. Couples similarly engaged can be found in medieval illuminated manuscripts, on tapestries and frescos; one only needs to mention the so-called "Spieleteppich" (Games Tapestry) woven in Alsace ca. 1385-1400 (fig. 10).[59]

Rubens's numerous hunting pictures, his first works in the category loosely defined as genre, should also be seen in the tradition of courtly art.[60] Traditionally an exclusively courtly sport, as represented in frescos, tapestries, and illuminated manuscripts, Rubens's hunting pictures were created for princely patrons. Thus they differ from his other genre scenes discussed so far which are of a more private nature, as witnessed by the fact that many remained in the artist's possession.[61] It is significant for Rubens's thinking that his genre pictures comply with courtly iconography, a feature they share with contemporary Antwerp genre painting.

A painter whose work includes genre pictures of a distinct nature is Jacob Jordaens (1593-1678). During the 1620s he worked with Rubens, whose figure types and compositional format he adopted. By the time he painted his first genre scene, a decade later, he had developed his own unique style. His genre subjects fall outside the category of themes discussed so far. In such works as *The King Drinks*, or "*As the Old Ones Sing, so the Young Ones Pipe*" (cat. 46), Jordaens castigates Flemish culinary excesses; works such as *Satyr and Peasant*, based on Aesop's fable, condemn dishonesty and fickleness.

Jordaens the Protestant was particularly attracted by the proverbs of the Dutch poet Jacob Cats, whose moralizing interpretations he took as seriously as did his Dutch contemporaries. Jordaens, however, did not portray them in small cabinet pictures but on large canvases and even in life-size tapestries. A series of tapestries depicting Proverbs was bought by Archduke Leopold Wilhelm in 1647 and taken to Vienna.[62] Thus tapestries, long the medium of courtly art per se, become the vehicle of bourgeois moralizing genre.

Jordaens's preference for large formats was not only influenced by his designs for tapestries, but also by his origins as a history painter, particularly of large altarpieces. Furthermore, to some extent it was determined by the taste of his generation. The more or less contemporary Utrecht Caravaggisti Hendrick ter Brugghen, Gerard van Honthorst, and Dirck van Baburen also painted large-scale genre scenes, as had Caravaggio himself. Knowledge of the latter's art had reached Antwerp in various ways, not only via Utrecht, and it left its mark on the style and iconography of several Antwerp artists. Of particular significance were Caravaggio's images of gypsies, fortune-tellers, and cardsharps.[63] Jan Cossiers (1600-1671), who repeatedly treated these subjects in large-figured paintings, familiarized himself with Caravaggio's art during his stay in Rome in 1624. In Antwerp he occasionally worked with Rubens whose style, however, he did not adopt until later in his career.[64]

Closely related in his use of large-scale figures is Theodoor Rombouts (1597-1637) who initially also came under the influence of Caravaggio. He is recorded in Rome in 1620.[65] The *Cardsharps*

Fig. 8. Peter Paul Rubens, *Tournament before a Castle*, oil on panel, 72 x 106 cm, Paris, Musée du Louvre inv. 1798.

Fig. 9. Peter Paul Rubens, *Park of a Castle*, oil on panel,
52.5 x 97 cm, Vienna, Kunsthistorisches Museum,
inv. 696.

Fig. 10. Tapestry, *Social Games*, 1400, Nuremburg,
Germanisches Nationalmsueum, inv. GEW 668.

(Antwerp, Koninklijk Museum voor Schone Kunsten) and *The Dentist* (Madrid, Museo del Prado)
are dependent on Caravaggio not only compositionally but also in individual figures. Simon
de Vos (1603-1676) transposed these subjects from the large-scale format to small cabinet picture;
a typical example is the *Gypsy Fortune-Teller*, dated 1639 (Antwerp, Koninklijk Museum voor
Schone Kunsten; ill. Introduction, fig. 75). At the same time de Vos adopted the figure styles of
Frans Francken the Younger, Rubens, or van Dyck for his charming history and genre pictures.

We have seen that Caravaggio's influence not only produced a new style but also new sub-
jects. These subjects stood outside those determined by the courtly tradition which runs like a
thread through genre painting in the Southern Netherlands.

Translated by Kristin Belkin

1. For the history of the term, see W. Stechow and C. Comer, "The History of the Term *Genre*," *Allen Memorial Art Museum Bulletin* 33 no. 2 (1975-76), pp. 89-94. In the first half of the twentieth century the term "genre" carried various definitions, all of which, however, regard "genre" as the depiction of daily life without recognizing a meaning beyond the purely visible. The term has been retained despite the fact that over the last fifty years or so more and more hidden meanings have been discovered in these so-called scenes of everyday life, i.e., they are no longer considered "purpose free" [objective]. For a history of the iconography of genre painting, see exh. cat. *Die Sprache der Bilder. Realität und Bedeutung in der niederländischen Malerei des 17. Jahrhunderts* (Braunschweig, 1978), pp. 34-38. Legrand 1963 does not present a clear idea of genre painting in the Southern Netherlands since she discusses history paintings together with scenes of everyday life.

2. W. von Bode, *Rembrandt und seine Zeitgenossen* (Leipzig, 1906), p. 37. The development of Dutch genre painting was always seen in connection with the foundation of the Dutch Republic. Taking this as a starting point, Brieger saw genre painting as bourgeois art per se: L. Brieger, *Das Genrebild. Die Entwicklung der bürgerlichen Malerei* (Munich, 1922).

3. R. van Marle, *Iconographie de l'Art Profane au Moyen Age et à la Renaissance*, vol. 1: *La Vie Quotidienne* (The Hague, 1931), pp. 48-126.

4. Brussels/Schallaburg 1991; see especially the contributions by Arnout Balis, Jan Muyle, and Paul Vandenbroeck.

5. O. Pächt, *Van Eyck. Die Begründer der altniederländischen Malerei*, ed. M. Schmidt-Dengler (Munich, 1989), pp. 115-118.

6. L. Baldass, *Jan van Eyck* (Cologne, 1952), pp. 71f; M. J. Friedländer, *Early Netherlandish Painting*, vol. 1 (Leiden/Brussels, 1967), pl. 62. Memling's *Bathsheba* (Stuttgart, Staatsgalerie; ill. Friedländer, *Early Netherlandish Painting*, vol. 6a, pl. 78) and the so-called "Liebeszauber" (Magic of Love) (Leipzig, Museum der bildenden Künste; exh. Cologne, *Herbst des Mittelalters. Spätgotik in Köln und am Niederrhein*, 1970, no. 17) ultimately go back to van Eyck's model. Later successors to van Eyck's scene are Paulus Moreelse's *Young Woman before a Mirror* (Cambridge, Fitzwilliam Museum; exh. Amsterdam 1976, no. 47), and Gerard ter Borch's *Girl before a Mirror* (Amsterdam, Rijksmuseum; see E. de Jongh, *Zinne- en minnebeelden in de schilderkunst van de zeventiende eeuw* [n.p., 1967], pp. 77ff).

7. Van Mander 1604, fol. 219 (in the life of Joachim Patinir): "De vermaerde heerlijcke stadt Antwerpen, door de Coopmanschap in voorspoet wesende, heeft over al tot haer ghewenckt nde uytnemenste onser Consten, die veel hun tot haer oock begheven hebben, om dat de Const gheern is by den rijckdom."

8. L. Silver, *The Paintings of Quentin Massys, with Catalogue Raisonné* (Montclair, 1984), pp. 134-160.

9. H. Göbel, *Wandteppiche*, part 1: *Die Niederlande* (Leipzig, 1923), p. 134.

10. Göbel 1923, vol. 1, pp. 80f; J. von Schlosser, "Ein veronesisches Bilderbuch und die höfische Kunst des XIV. Jahrhunderts," *Jahrbuch der kunsthistorischen Sammlungen des allerhöchsten Kaiserhauses* 16 (1895), p. 216: "Tapisserien der Herzöge von Burgund," no. 15 "… un tapis… a l'istoire de Bergiers et Bergières…"; p. 217, no. 18 "… et ung aultre de Bergeres…", no. 28 "… grans tapiz… a devise de Bergiers et de Bergières…"; p. 219, fol. 27, No. 30 "ung tappis de la Dance de bergiers."

11. "Ung grant tappis de haultelice a moutons, ou soint pointraiz ma dame d'Artois et mon seigneur de Flandres"; Schlosser 1895, p. 219, fol. 27, No. 28.

12. Schlossen 1895, p. 221, no. 223.

13. Renger 1986, p. 118, notes 12 and 13.

14. Grimm, *Deutsches Wörterbuch*, vol. XI, I, 1, col. 353, s. v. "dorpere."

15. K. Moxey, *Peasants, Warriors, and Wives, Popular Imagery in the Reformation* (Chicago/London, 1989), pp. 35-53.

16. K. Renger, "Bettler und Bauern bei Pieter Bruegel d. Ä.," *Sitzungsberichte der kunstgeschichtlichen Gesellschaft zu Berlin* n. f. 20 (1971/72), pp. 9-16; S. Alpers, "Bruegel's Festive Peasants," *Simiolus* 6 (1972/73), pp. 163-176; idem, "Realism as a Comic Mode: Low-Life Painting Seen through Bredero's Eyes," *Simiolus* 8 (1975/76), pp. 115-144; H. Miedema, "Realism as a Comic Mode: the Peasants," *Simiolus* 9 (1977), pp. 205-219; idem, "Feestende boeren – lachende dorpers. Bij twee aanwinsten van het Rijksprenten-

kabinet," *Bulletin van het Rijksmuseum* 29 (1981), pp. 191-213; H. J. Raupp, *Bauernsatiren. Entstehung und Entwicklung des bäuerlichen Genres in der deutschen und niederländischen Kunst ca. 1470-1570* (Niederzier, 1986), pp. 271-281; P. Vandenbroeck, *Over wilden en narren, boeren en bedelaars. Beeld van de andere, vertoog over het zelf* (exh. cat. Antwerp, 1987) pp. 63-116.

17. Muller 1989, pp. 128-132; M. Jaffé, "Rubens and Bruegel," in: *Pieter Bruegel und seine Welt. Colloquium veranstaltet vom Kunsthistorischen Institut der Freien Universität Berlin und dem Kupferstichkabinett der staatlichen Museen Stiftung preussischer Kulturbesitz* (Berlin, 1975), pp. 37-42.

18. H. J. Raupp, "Bemerkungen zu den Genrebildern Roelant Saverys," in Cologne/Utrecht 1985-86, pp. 39-45; Müllenmeister 1988.

19. On the influence of painters from the Southern Netherlands on the art of the northern provinces, see Briels 1987. See also the review by Bob Haak, in *Simiolus* 18 (1988), pp. 262-264.

20. Härting 1989, passim.

21. Ibid., pp. 83-91.

22. M. Winner, *Die Quellen der Pictura-Allegorien in gemalten Bildergalerien des 17. Jahrhunderts zu Antwerpen* (diss. Cologne, 1956); idem, "Gemalte Kunsttheorie: Zu Gustave Courbets 'Allegorie réelle' und der Tradition," *Jahrbuch der Berliner Museen* n. f. 4 (1962), pp. 151-185; and Filipczak 1987. Also useful, especially for its illustrations, is Speth-Holterhoff 1957.

23. J. von Schlosser, *Die Kunst- und Wunderkammern der Spätrenaissance. Ein Beitrag zur Geschichte des Sammelwesens* (Leipzig, 1908), pp. 92, 120-137. Collections of Roman antiquities already were being painted in the sixteenth century, including some by Netherlandish artists: see C. Hülsen, *Römische Antikengärten des 16. Jahrhunderts* (Abhandlungen der Heidelberger Akademie der Wissenschaften, phil. hist. Klasse) (Heidelberg, 1917).

24. On Vrancx, see Winkler 1964, pp. 322-334; vander Auwera 1981 and Keersemaekers 1982, pp. 165-186.

25. I. Jost, "Bemerkungen zur Heinrichsgalerie des P. P. Rubens," *Nederlands Kunsthistorisch Jaarboek* 15 (1964), p. 188, note 40. On the collaboration between Rubens and Snayers see also Alpers 1971, pp. 117-119.

26. P. Sutton, in Philadelphia/Berlin/London 1984, pp. XXXVI-XXXVIII; J. S. Fishman, *Boerenverdriet. Violence between Peasants and Soldiers in Early Modern Netherlandish Art* (Ann Arbor, 1982).

27. See most recently Renger 1986, passim.

28. Renger 1987.

29. W. von Bode, *Die Meister der holländischen und flämischen Malerschulen*, revised by E. Plietzsch (Leipzig, 1958), pp. 537f; Klinge-Gross 1969; and most recently, Antwerp 1990, passim.

30. Antwerp 1990, p. 13ff.

31. Göbel 1923, p. 434.

32. Renger 1986, pp. 52-53, 59-62.

33. E.g. *The Drinker* (Rotterdam, Museum Boymans-van Beuningen): exh. cat. *Rubens en zijn tijd / Rubens and His Age* (Rotterdam, 1990), no. 46.

34. E.g. Saftleven's *Interior with Card Players* (Berlin, Gemäldegalerie) is influenced by Brouwer's *Tavern Scene*: Renger 1986, no. 16, pl. 12. For Saftleven's painting, see W. Schulz, *Cornelis Saftleven, 1607-1681. Leben und Werk* (Berlin, 1978), no. 662.

35. B. Schnackenburg, *Adriaen van Ostade, Isack van Ostade. Zeichnungen und Aquarelle* (Hamburg, 1981), pp. 28-29; Renger 1986, pp. 65-66.

36. K. Braun, *Alle tot nu toe bekende schilderijen van Jan Steen* (Rotterdam, 1980), nos. 32, 86, 88, 89, 140, 145, 205, 344, 346, 353, B 225, B 228.

37. Muller 1989, pp. 139-142.

38. Rotterdam, Museum Boymans-van Beuningen, (ill. Knuttel 1962, fig. 44; exh. cat. *Rubens en zijn tijd / Rubens and His Age* [Rotterdam, 1990], no. 1); Philadelphia, Philadelphia Museum of Art (ill. Knuttel 1962, fig. 39; Philadelphia/Berlin/London 1984, no. 20).

39. Paris, Musée du Louvre; ill. Knuttel 1962, pl. XI.

40. "Die boeren verblijen hun in sulken feesten / Te dansen springhen en dronckendrincken als beesten / Sij moeten die kermissen onderhouwen / Al souwen sij vasten en steruen van kauwen"; see Miedema, "Feestende boeren" (see note 16), pp. 201-

202; see also R. van Bastelaer, *Les estampes de Pieter Brueghel l'ancien* (Brussels, 1908), no. 208.

41. See, for example, the drawing in Braunschweig, Herzog Anton Ulrich-Museum (Burchard, d'Hulst 1963, no. 151); or the drawing at Chatsworth, sometimes attributed to van Dyck, but recently given to Rubens by Julius Held (Held 1986, no. 4). The sheet formerly in Berlin, Kaiser Friedrich-Museum, and recently on the New York art market, is by a different artist, extensively reworked by Rubens (Burchard, d'Hulst 1963, no. 155 [as entirely by Rubens]). On Rubens's interest in these sixteenth-century themes, see K. Renger, in exh. cat. *Rubens in der Grafik*, Göttingen/Hanover/Nuremburg 1977, pp. 8-11.

42. Muller 1989, p. 120, no. 143. Pieter Bruegel's original probably was in the possession of Jan Brueghel the Elder. Burchard and d'Hulst (1963, no. 156) identified various existing works with Rubens's copy, none of which is entirely convincing. On the question of Bruegel's original and Rubens's copy, see also K. Belkin, in Antwerp 1992-93, pp. 170-171.

43. Van den Wijngaert 1940, no. 730. The inscription underneath the print reads as follows: "Tityrus et Sterili quondam Meliboeus in agro / Incaluére Scyphis, et rixâ forte coortà / Caprinam ob lanam, Stiuâ rastroque rigentes / Conseruére manus, e duro robore Scamnum / Cum cyathis volitat, cereuisia tela ministrat. / Hos inter potà plorans cum Baucide Daphne / Et Corydon caecos cupiunt sedare furores. / Vidit Bruegelius, Martem admiratus agrestem / Horridaque exiguà descripsit bella tabellâ. / Cede merum Coum, Cous concedat Apelles: / Nescio quid maius Brabantica rura tulére." The engraving is dedicated to Jan Brueghel, "son of Pieter Bruegel, Apelles of his time."

44. On the Prado painting, see Oldenbourg 1921, p. 407; and M. Díaz Padrón, in Madrid cat. 1975, vol. 1, no. 1691; vol. 2, fig. 1691; on the Hermitage picture, see Adler 1982, no. 39; Cologne/Vienna 1992-93, pp. 452-453, no. 89.3. On the pastoral in Rubens, see J. Müller Hofstede, "Zwei Hirtenidyllen des späten Rubens," *Pantheon* 24 (1966), pp. 31-42. On the *Peasant Dance*, especially its use of antique and contemporary dress, see K. Belkin, in Madrid cat. 1989, pp. 170-171.

45. See notes 9-11.

46. Oldenberg 1921, p. 415.

47. Génard 1865, p. 81, no. XXI: "Van Balthasar van Engelen, acht hondert guldenen eens, voor een stuck schilderye van Silvia voor den prince van Orangien vercocht" (A painting of Silvia, bought by Balthasar of England [Balthasar Gerbier] for 800 guilders for the Prince of Orange [Frederick Hendrick]); see also van Gelder 1950-51, p. 143. For the listing of the painting in the *Specification* of 1640, where it is identified as "Vn berger caressant sa bergère," see Muller 1989, p. 114, no. 94.

48. A. M. Kettering, *The Dutch Arcadia. Pastoral Art and Its Audience in the Golden Age* (Montclair, 1983), pp. 51-53.

49. Muller 1989, p. 112, no. 89, pl. 38, p. 113, no. 90.

50. The best of the copies is in Munich, Bayerische Staatsgemäldesammlungen, inv. no. 309 (oil on panel, 59.4 x 90.2 cm); see J. S. Fishman, *Boerenverdriet: Violence between Peasants and Soldiers in Early Modern Netherlandish Art* (Ann Arbor, 1982), pp. 45-61. For Rubens's drawing, see exh. cat. *Flemish Drawings of the Seventeenth Century from the Collection of Frits Lugt, Institut Néerlandais Paris*, London/Paris/Bern/Brussels, 1972, no. 85, fig. 44; and Held 1986, no. 232, fig. 208.

51. Exh. cat. London/Paris/Bern/Brussels 1972, no. 85, fig. 45.

52. One of the earliest representations of peasants being plundered and tormented by soldiers is a drawing by Albrecht Altdorfer of 1506/08 in Berlin: see H. Mielke, *Albrecht Altdorfer. Zeichnungen, Deckfarbenmalerei, Druckgraphik*, exh. cat., Berlin/Regensburg 1988, no. 17. The best-known image of the subject was produced by Pieter Bruegel the Elder, the original is lost and the composition known only through copies; see G. Marlier, *Pierre Brueghel le Jeune* (Brussels, 1969), pp. 274-278. The subject was also treated by Bruegel's follower Marten van Cleve: see *Flämische Malerei von Jan van Eyck bis Pieter Bruegel d. Ä.* (Vienna, 1981), pp. 156f.

53. F. Winzinger, *Albrecht Altdorfer Zeichnungen* (Munich, 1952), nos. 7, 11, 12; see also C. Anderson, *Dirnen, Krieger, Narren: Ausgewählte Zeichnungen von Urs Graf* (Basel, 1978). On the sexuality of mercenaries, see Moxey (note 15), pp. 81-93; see also van Marle 1931, pp. 289-300.

54. K. L. Belkin, *The Costume Book* (Corpus Rubenianum Ludwig Burchard, XXIV), London, 1981, no. 25, figs. 119, 128.

55. Florence, Palazzo Pitti: Adler 1982, no. 48, fig. 127; London, Wallace Collection: Adler 1982, no. 55, fig. 138; London, National Gallery: Adler 1982, no. 53, fig. 136.

56. Adler 1982, no. 65, fig. 148. For earlier courtly representations of tournaments, see e.g. *February*, Trent, Torre Aquila: E. Castelnuovo, *Il ciclo dei Mesi di Torre Aquila a Trento* (Trent, 1987), pp. 48f.; see also van Marle 1931, pp. 143-156. For Rubens's interest in medieval tournament books, see H. Mielke, in Berlin, cat. 1977, pp. 94-96.

57. Glück 1933, pp. 82-153. On Rubens's *Garden of Love*, see most recently Goodman 1992. As to the influence of courtly love iconography on bourgeois representations of love, see T. Vignau Wilberg-Schuurman, *Hoofse minne en burgerlijke liefde in de prentkunst rond 1500* (Leiden, 1983).

58. Adler 1982, no. 42, fig. 118; Hans Devisscher, in Vienna, Kunsthistorisches, cat. 1989, p. 170 (repr.).

59. H. Göbel, *Wandteppiche*, part III: *Die germanischen und slawischen Länder*, vol. 1: *Deutschland* (Leipzig, 1933), pp. 84-86, fig. 57; van Marle 1931, pp. 73f, fig. 63. See also the tapestry known as *La main chaude* (London, Victoria and Albert Museum), Tournai, first third of the sixteenth century (Göbel 1923, no. 235); the *Fishing Party*, Paris, Louvre, Cabinet des Dessins, Netherlandish, first half of the fifteenth century (Pächt 1989 [as in note 5], fig. 69); the scenes with snowballing (January) and lovers in front of a castle (May), in the Torre Aquila, Trent (Castelnuovo 1987, as in note 56, pp. 56f).

60. M. Warnke, *Peter Paul Rubens* (Cologne, 1977), pp. 109-114; and Balis 1986.

61. Muller 1989, nos. 89, 90, 94, 103, 104, 135, 136, 143.

62. D'Hulst 1982, pp. 301f.

63. Nicolson 1979, p. 219.

64. Ibid., p. 43; and de Mirimonde 1965.

65. Roggen 1935; Roggen 1949-50; Roggen 1951; and Nicolson 1979, pp. 83f.

Fig. 1. Gonzales Coques, *A Family Group out of Doors*,
ca. 1660-1665, oil on canvas, 64.2 x 85.5 cm, London,
The National Gallery, inv. 821.

The Art of "Conversatie": Genre Portraiture in the Southern Netherlands in the Seventeenth Century

Marjorie E. Wieseman

ALONGSIDE the magnificent life-sized portraits produced by Rubens and van Dyck, Cornelis de Vos, Jacob Jordaens, and Jacob van Oost, are portraits conceived on an intimate, even diminutive scale, that comprise a distinct tradition within seventeenth-century Flemish portraiture. With roots in the sixteenth century, this portrait type flourished particularly after about 1640, in works by Gonzales Coques, David Teniers the Younger, Gillis van Tilborch, and others. These paintings are perhaps most accurately described as genre portraits, though the term is at best ambiguous and unhistorical. A "genre portrait" can be loosely defined as an informal and spontaneous small-scale portrait generally representing a couple, family, or other group, with at least equal attention given to the representation of the sitter's environment. The attributes and activities which draw the figures together are selected from everyday experience, so that they reflect the sitter's aspirations, social status, aesthetic refinement, or other abstract qualities.[1]

Gonzales Coques's *Family Group out of Doors*, in the National Gallery, London (fig. 1), is a typical example of the genre portrait. It depicts an elegantly dressed family enjoying the pleasant diversions of a promenade through a garden replete with a splashing fountain at the right and a portico or gatehouse flanked by two herms as caryatids at the left. One child pushes an infant in a *loopstoel* (walker); another plays with a bird on a stick; others gather flowers while a young girl softly strums a guitar. The peaceful setting and lively interaction of gestures and glances suggest that this family is privileged to inhabit a world undisturbed by quotidian realities. The contemporary appeal of the genre portrait is not difficult to comprehend.

As defined, the seventeenth-century genre portrait is similar to (and in many respects was the prototype for) the eighteenth-century "conversation piece,"[2] with some significant differences. This study is not restricted to private conversations, and considers also some informal depictions of archducal or princely visits as crucial to the development of the seventeenth-century genre portrait in the Southern Netherlands. As a key component of the genre portrait is the plausibility of its representation of everyday life (or rather, the perception of such a likeness), those paintings more properly described as *portraits historiés*, with figures in pastoral or historicizing costume cast in allegorical, literary, or historical roles are excluded.[3]

Earlier writers have emphasized the studied informality and "naturalness" of the conversation piece as a reflection of the sitters' intimate private life.[4] There is, however, more than a little calculated artifice at play in the construction of these images and in the message they convey about the sitters' place in society. Although this is a trait common to a great many portraits of both individuals and groups, the works under consideration encode the message in distinctly narrative ways, blurring or purposely obscuring the boundary between genre painting and portraiture. The genre portrait is not unique to the Southern Netherlands, but its development there overshadowed and to some extent displaced the development of the kind of small-scale bourgeois genre painting that flourished so vigorously during the same period in the United Provinces. In fact, most critical discussions of the Southern Netherlandish small-scale group portrait are to be found under the rubric of genre painting, a rather awkward taxonomic gerrymandering.[5] Comparatively few of the sitters in these works can be identified with any certainty, and indeed it can be difficult to discern the individual character of figures rivaled (and at times eclipsed) by the lavishness of their surroundings. The ability to detect "portraitlike" qualities is notoriously subjective, but can be guided by the degree of communication between the figures within the composition and the viewer: genre scenes tend to be hermetic and self-contained, whereas portraits more often consciously engage the viewer to complete the presentation of a well-fashioned self-image.[6]

It is however the very closeness of the two painting types, rather than the ability to distinguish clearly between them, that is at the core of the genre portrait.

Seventeenth-century genre portraits were surely meant to be considered simultaneously as both portraits and anonymous genre paintings. The contemporary viewer readily understood that there was a pleasant fiction involved in the construction of these images, yet at the same time was asked to believe that the real-life persons represented – very likely known to the viewer – comfortably inhabited this artificial world. The image plays upon the superficial resemblances between genre painting (art) and portraiture (life) to produce a portrait redolent with associations that benefit the persons represented. David Smith has noted in reference to Dutch genre portraits that the "proximity of life and art" in these paintings reflects the degree to which life itself was becoming more of an art among the upper classes, increasingly proscribed by the artifice of fashion and etiquette.[7]

The distinction between portraiture and genre painting was apparently no less fluid in the seventeenth century. Estate inventories of the period mention works by Coques and his colleagues both as *contrefeytsels* (portraits) and as *conversaties*. *Conversatie* was a generic and appropriately ambiguous term used in the Southern Netherlands primarily, although not exclusively, to describe bourgeois or high-life genre scenes.[8] Although it is almost always impossible to determine from these inventories whether the *conversatie* also involves portrait likenesses, in *Het Gulden Cabinet* (1661), Cornelis de Bie repeatedly uses this term to describe group portraits by Coques:

> ... in an exceptionally beautiful Conversatie which he painted on copper for the pious and art-loving *Sr. Jacob le Merchier*, Merchant of the prosperous city of *Antwerp*, representing him with his wife and all their children / *Gonsael* [Gonzales Coques] has depicted himself from the side, in profile, seated at a table conversing with the aforementioned *Sr. Le Merchier*; they are both in an attitude of discussion [and] each is represented perfectly true-to-life. ...[9]

De Bie goes on to praise the abundance of detail found in other *conversaties* by Coques, François Duchatel, Tilborch, Joos van Craesbeeck, and Adriaen Brouwer.

Appearing rather abruptly as a distinct portrait type about 1640, the genre portrait synthesizes the formal traditions of bourgeois and aristocratic group portraiture with the compositional schemae, narrative informality, and popular connotations of genre painting. As Konrad Renger notes elsewhere in this catalogue, fifteenth-century illuminations of courtly pastimes are often the ultimate source for many of the themes of seventeenth-century genre painting: battles and tournaments, balls, masques, banquets, and promenades.[10] The cultivated and peaceful garden locale which was the preferred setting for many of these activites had, and continued to have, a long iconographic history as a secular and religious love garden. In the sixteenth century these archetypal images of a courtly idyll – lords and ladies promenading before dreamlike castles, for example – were also occasionally conscripted as the setting for portraits of noble families. The anonymous *Portrait of the Thiennes Family* (ca. 1535-1540; Brussels, private collection; fig. 2) depicts an extended family group gathered in a parklike landscape before the family castle of Rumbeke, in south West Flanders.[11] Like earlier miniatures and tapestries, this painting creates an idealized world, yet in this case one populated and possessed by real people. Unfortunately, there are only a few portraits from the period with a similarly expansive garden setting, or which adduce a comparable degree of informality and narrative detail into the rigid conventions of the group portrait. Not until the 1630s is the garden format revived as a setting for small-scale group portraits; possibly the first of these is Rubens's *Self Portrait-with Hélène Fourment in the Garden* (Munich, Bayerische Staatsgemäldesammlungen, Alte Pinakothek, inv. 313; fig. 3).

For a more sustained expression of the medieval courtly idyll in group portraiture, one need only turn to the court itself, and some relatively informal compositions that also incorporate portraits of the archdukes. In the first decades of the seventeenth century, the court of Albert and Isabella at Brussels was (despite the governors' personal sobriety) a vibrant international center for diplomacy, politics, and society. The papal nuncio Guido Bentivoglio (1579-1621), in residence at the Brussels court from 1607 to 1615, noted that the court was "plus gaye et plus agréable" than the court at Madrid, "à cause de la liberté du pays et du meslange de tous de nations."[12] Visits of foreign princes, ambassadors, and other dignitaries were pleasantly marked by processions, theatrical performances, balls and masques; in the summer the favored pastimes included hunts and promenades.[13] Depictions of these courtly festivities by Frans Francken the Younger (1581-1642),

Fig. 2. Anonymous, *Portrait of the Thiennes Family before the Castle at Rumbeke*, ca. 1535-1540, Brussels, private collection.

Fig. 3. Peter Paul Rubens, *Self-Portrait with Hélène Fourment in the Garden*, ca. 1630-1631, oil on panel, 97.5 x 130.8 cm, Munich, Bayerische Staatsgemäldesammlungen, Alte Pinakothek, inv. 313.

Louis de Caullery (before 1582-1621/22), Sebastian Vrancx (q.v.) and others frequently included diminutive likenesses of the rulers and their honored guests amidst a grander spectacle, casting these charming hybrids into a taxonomic limbo somewhere between history painting and genre, portraiture, and (occasionally) political allegory.[14] The emphasis in many of these paintings on specific battles or other historical occurrances removes them somewhat from the mainstream of genre portraiture, which is by definition non-specific, but they nonetheless touch on issues relevant to genre portraits of the latter part of the century.

Frans Francken the Younger's *Ball at the Court of Albert and Isabella* (ca. 1610; The Hague, Mauritshuis, inv. 244; fig. 4), for example, is a thorough blend of realism and fiction. Although probably meant to recall festivities held during the visit of Charlotte de Montmorency (seated to the right of the archdukes) to the court at Brussels in 1609-10, the scene depicts no single documented event. Similarly, the identifiable figures of the archdukes and their peers are mixed indiscriminately with anonymous staffage; the palatial architecture (by Paul Vredeman de Vries) is minutely detailed but entirely imaginary. Free of allegory and unencumbered by the negative moralizing overtones encoded in the artist's pure genre versions of similar dances,[15] the painting introduces recognizable portraits in a fictitious but completely plausible context to create a scene that embodies the elegance and politesse that characterized courtly society.

Although it is not known for certain who commissioned the *Ball at the Court of Albert and Isabella*,[16] comparable works by Jan Brueghel the Elder and Denijs van Alsloot were done under the auspices of archducal patronage, and record a more intimate side of the rulers than was projected by official state portraits. Jan Brueghel's expansive view of the archdukes at a peasant wedding feast (ca. 1621-23; Madrid, Museo del Prado, inv. 1442; ill. History, fig. 17), though again depicting no actual historical event, was painted in response to the rulers' noted love for mingling with their subjects on festive occasions.[17] Portraits of the archdukes before their several residences frequently assumed the same anecdotal format, in which diminutive – but nonetheless recognizable – likenesses of the governors and their entourages are posed before distant, topographically accurate palace views (such as Jan Brueghel the Elder's *Albert and Isabella before the Castle at Mariemont*, dated 1611; Munich, Bayerische Staatsgemäldesammlungen, Alte Pinakothek, inv. 1893).[18] At least equal weight is given to the surroundings as a means of identifying the sitters and situating them in an appropriately regal and seigneurial context, with concrete indications of their status. Despite the apparent informality of the composition, the archdukes are nonetheless the proprietors of all they survey. Denijs van Alsloot and Pieter Snayers also produced works in this vein[19]; towards the end of the century, Adam Frans van der Meulen painted similar compositions for Louis XIV in France, although with a decidedly political bent (see also cat. 94). The synthesis of court and countryside in these portraits of the archdukes by Brueghel and others shaped the visual expression of signeurial ideals in later genre portraits.[20]

The majority of portraits produced during the first half of the seventeenth century are, however, quite different from these informal courtly images. Favored by a bourgeois clientele were large-scale likenesses, generally three-quarter length, which focused closely about the figures and

Fig. 4. Frans Francken the Younger and Paul Vredeman de Vries, *Ball at the Court of Albert and Isabella*, ca. 1610, oil on panel, 68 x 113.5 cm, The Hague, Mauritshuis, inv. 244.

admitted few background details (see cats. 15a and 15b). There are of course exceptions, notably in more lavishly appointed portraits of artists and their families.[21] Portraits of aristocratic sitters, on the other hand, were frequently at full length, and graced by bits of classical architecture and swags of drapery. The demarcation between aristocratic and bourgeois portrait conventions began to dissolve after about 1620, and full-length poses and lavish settings begin to appear in portraits of upper middle-class sitters as well.[22]

The most direct precursor of the diminutive genre portrait was the large-scale family portrait, which enjoyed a particular vogue among the bourgeoisie about 1620-1650 in Antwerp (Cornelis de Vos, see cat. 53), Bruges (Jacob van Oost, see cat. 55) and other cities.[23] These compositions were often filled with lavish decorative elements verifying, as it were, the sitter's wealth and social standing but, as in van Oost's *Portrait of a Bruges Family* of 1645 (cat. 55), the figures still clearly dominate the composition. Rubens's *Self-Portrait with Hélène Fourment in the Garden* (fig. 3) is a conspicuous departure from this tradition in the scale of both the figures and the work itself.[24] The figures are subordinate to their surroundings, here recognizable as an enlarged and somewhat romanticized view of the garden of Rubens's own house in Antwerp. The setting is accorded a dominant role in the composition, invoking associations with the medieval love garden; the peacocks in the foreground, the statue of Venus in the pavilion, and the dolphin fountain beyond are familiar elements in this iconography. The small-scale portrait is, moreover, an intimate format that invites closer inspection, and carries with it as well the connotation of a precious object fit for a collector's cabinet.[25] In Rubens's portrait, the small scale, coupled with the greater emphasis on the setting in the iconography of the portrait, creates a private glimpse of sitters in a domestic context with conspicuously idyllic and aristocratic overtones, and sets the stage for the subsequent development of the small-scale genre portrait.

The popularity of the genre portrait in the Southern Netherlands has much to do with the aristocratization of the middle class during the course of the seventeenth century. Although this kind of social aspiration was common throughout Northern Europe, it was especially felt

in the Southern Netherlands, where it brought about distinct changes in the social structure.[26]

Over the course of the seventeenth and eighteenth centuries, and particularly after 1650, there was an unprecedented increase in the number of families elevated to the nobility in the Southern Netherlands, a circumstance that irrevocably altered the character of the aristocracy.[27] The old feudal nobility, its power and numbers diminished by the Eighty Years War, was additionally compromised by the so-called "Noble's Conspiracy" of 1631-1632, an ill-fated attempt to overthrow Spanish rule and establish an independent Catholic state. Newcomers to the nobility were drawn largely from the ranks of wealthy merchant families, civil servants, and military officers. In general the Spanish crown tended to support the new aristocracy, often at the expense of established nobility, and to grant them further titles as they rose through the ranks.

Aside from wealth and a successful petition to the king of Spain, there were few requirements for those aspiring to the aristocracy: the ownership of at least one fief, and complete disinvolvement from commerce or trade.[28] The Spanish government, alarmed that so many merchants were closing their businesses in order to join the aristocracy, eased the restrictions against mercantile activities towards the end of the century; in fact, however, most were voluntarily setting aside businesses that were no longer profitable.[29] Members of the new nobility were part of a widespread inclination to retire from speculative trade and assume the more gentlemanly vocation of *rentier*, living off the income accruing from investments and rents.

In addition to the growing numbers of citizens with legitimate titles, there were also a good number of aspirants who merely assumed noble titles and a flamboyant lifestyle without troubling to obtain royal consent. These *"sinjoors,"* or self-styled gentlemen, soon became a standard figure of ridicule in contemporary satire; G. A. Bredero's popular farce *De Spaanse Brabander* (1617) mocks just such a poseur.

Perhaps even more eagerly than they sought the official patents of nobility, the upper bourgeoisie aspired to the luxurious lifestyle enjoyed by the aristocracy. In the face of economic and political instability, wealthy citizens managed to fabricate a sophisticated lifestyle much remarked upon by visitors to the Southern Netherlands. The sumptuous homes of Antwerp merchants were repeatedly likened to those of princes: in 1641 John Evelyn described his visit to the merchant and art dealer Diego Duarte, "an exceedingly rich Merchant, whose Palace I found to be furnish'd like a Princes."[30] Twenty years later, Michel de Saint Martin had much the same reaction: "La ville d'Anvers est l'une des plus considerables ... pour sa grandeur, la beauté et la magnificence de ses bâtiments publics et particuliers ... et les richesses des Marchands, dont l'un qui est Portugais, possede une belle maison superbement meublée, et capable de loger un Prince."[31] In actuality, however, comparatively few new civil structures were constructed during the century. Most homeowners opted for the more expedient and cost-effective solution of embellishing and updating older houses with grand new portals or Italian-style galleries, and some lavish new interior furnishings.[32] In addition to their city dwellings, the most ambitious and successful citizens aspired to country estates. Although land tenure was inseparably linked to nobility, the widespread enthusiasm for life on rural estates exercised a powerful appeal independent of any noble title.[33] Other conspicuous "status symbols" became *de rigeur* as well, such as hunting and the possession of a fine carriage. Knowledge of music and the fine arts were the mark of a well-rounded gentleman, as haute bourgeois and noble alike aspired to become dilettantes in the finest sense of the word.

During the course of the century France gradually superseded Spain as the preferred model in matters of language, dress, and etiquette.[34] French was traditionally the language of the Netherlandish nobility – despite years of Spanish domination – and the international language of culture and refinement.[35] Visitors to the Southern Netherlands were struck by the extravagant dress of the local citizens, especially the women, the most fashionable of whom affected the French style. Manners were also gallicized among the aristocracy and upper bourgeoisie, a direct result of the wide circulation of French courtesy literature.[36] The French poet Jean François Renard's favorable opinion of the city of Antwerp was undoubtedly colored by his appreciation of "les manières de ses habitants dont les plus polis tâchent à se conformer à nos manieres Françaises, et par les habits et par la langue qu'ils font gloire de posseder en perfection."[37]

The proliferation of titles and the conspicuous social transformation of the new aristocracy not only swelled the ranks of the true nobility but also produced an upper middle class fully conversant in the outward manifestations of nobility. Thus it was not the greater number of nobles

Fig. 5. Gonzales Coques, *Portrait of a Young Scholar and His Sister*, signed and dated 1640, oil on panel, 41 x 59.5 cm, Kassel, Gemäldegalerie Alte Meister, inv. GK 151.

per se that created the eager market for the genre portrait – with its origins in aristocratic imagery and emphasis on the material manifestations of status and privilege – in the Southern Netherlands after about 1640. Rather, it was the acute sense that with sufficient money and ambition it was possible to transcend the traditional class boundaries between the bourgeoisie and the nobility, leaving little to stand in the way of assuming the visual imagery as well.[38]

Gonzales Coques was the first Flemish artist to fully realize the potential of the small-scale group portrait; other artists quickly followed his lead. Coques's earliest genre portraits are dated 1640, just about the time he became a master in the guild of St. Luke. The *Portrait of a Young Scholar and His Sister* (dated 1640; Kassel, Gemäldegalerie Alte Meister, inv. GK 151; fig. 5) details the pleasant diversions of a learned dilettante in a richly decorated chamber. The walls are hung with gilt leather, paintings line the upper walls, and the fashionable young woman at right plays a harpsichord decorated with a painting of the Judgment of Midas. On the table at the left are several books, a statuette, a globe, and an hourglass; the latter may have been included as a *vanitas* reminder of the transience of earthly pleasures.[39]

The densely enclosed setting and the prominent role given to the art within the chamber in many respects recalls contemporary *kunstkamer* paintings, which, however, had developed from quite different antecedents. The formal and thematic evolution of collectors' cabinet paintings from allegorical scenes to a superficially more realistic blend of fact and fiction was succeeded by paintings in which the artworks were no longer the primary focus of the composition, but rather a decorative accessory.[40] The genre portrait interior, on the other hand, evolved from the detailed perspective studies of architecture first popularized by Hans and Paul Vredeman de Vries (see cat. 76). The inclusion of fewer and less specific paintings in genre portraits (as opposed to the

kunstkamer paintings) was not only probably a more accurate reflection of actual domestic interiors, but also served to shift the emphasis of the composition to the portrait figures. Although there continued to be portraits of collectors in which the artworks assumed the dominant role, for example David Teniers's depictions of the Archduke Leopold Wilhelm in his paintings gallery (see cat. 124), and numerous *kunstkamer* paintings by Coques, Tilborch, Biset, and others,[41] the majority of genre portraits incorporate paintings and other works of art as generic indicators of cultural refinement.

Musical concerts were also a recurring theme in genre portraits, reflecting the contemporary practice among the nobility and upper bourgeoisie of holding informal domestic performances with family and friends.[42] Musical instruments became ubiquitous props denoting social refinement. A harpsichord, for example, such as that depicted in Coques's *Portrait of a Young Scholar and His Sister* (fig. 5) was popular only among the upper classes since it was costly to buy and maintain, and thus came to be viewed as a status symbol.[43] The concerts themselves were a handy vehicle for representing casual interaction among the figures; among many examples, see Gillis van Tilborch's *Family Concert* (Glasgow, Hunterian Art Gallery), Coques's *Portrait of the van Eyck Family* (Budapest, Szépmüvészeti Múzeum, inv. 573) and Teniers's *The Artist with His Family* (Berlin, Staatliche Museen zu Berlin, Gemäldegalerie; ill. Introduction, fig. 67). And finally, from the mid-sixteenth century, musical concerts in family portraits were emblematic of familial harmony.[44]

Outdoor gardens and terraces are the most typical settings for the genre portrait, and have the most direct connection with the aristocratic traditions in portraiture – presented most notably by Anthony van Dyck – that spawned the genre. Gonzales Coques's *Family Group* (cat. 58), for example, is posed on a terrace framed by columns, swags of drapery, fountains, and formal plantings; the family depicted in the National Gallery portrait (fig. 1) is surrounded by a verdant parklike landscape. Genre portraits with outdoor settings seem to have developed slightly later than interior views, although such conjectures are hindered by the lack of dated paintings. In addition to the diverse indigenous traditions outlined above, Coques may have been inspired in his use of outdoor settings by the works of the Hague portraitist Jan Mijtens (1614-1670), who painted pastoral family groups on a reduced scale as early as 1638 (Paris, Musée du Louvre, inv. 1590). Coques would have known of Mijtens's works from his numerous visits to The Hague through the mid-1640s, made in connection with his work for the Dutch stadholders.[45] Strengthening a possible connection between the two artists, Coques's early *Portrait of a Family in a Landscape* of 1647, in the Wallace Collection, London (inv. P 92), depicts figures in pastoral dress – virtually all his other portraits in outdoor settings show sitters in contemporary dress – and is in the somewhat larger scale favored by Mijtens.

Geared to a clientele drawn largely from the same socio-cultural milieu with much the same aspirations and expectations regarding their self-image, it is hardly surprising to find a high degree of similarity among genre portrait compositions – as well, sometimes, as outright repetition. The paintings draw upon a standard vocabulary of decorative elements with obvious aristocratic associations, either repeated verbatim from one painting to the next, or lightly rearranged into different combinations. In Coques's *Family Group out of Doors* (fig. 1), for example, the gateway

Fig. 6. David Teniers the Younger, *Wedding Portrait*, signed and dated 1651, oil on copper, 68.5 x 86.5 cm, London, collection Edgar Evens.

Fig. 7. Gillis van Tilborch, *Portrait of a Merchant Family*, ca. 1665-1670, oil on canvas, 107 x 145 cm, sale London [Sotheby's], 7 April 1982, no. 85, as by Gonzales Coques.

at the left, the base of the fountain at the right, the trees in the background, and the figure of the young girl playing the guitar each appear in at least one other work by the artist.[46] On occasion, specifically identifiable elements are used to evoke the same associations, as in David Teniers's so-called *Wedding Portrait* (1651; London, collection Edgar Evens; fig. 6), set in a fanciful re-creation of the garden behind Rubens's house in Antwerp, with the distinctive garden pavilion as the center-piece of the composition.[47] The inclusion of a château in the landscape setting, either specifically rendered and potentially identifiable, as in Tilborch's *Family Portrait* (Rajec, Castle), or the more anonymous abstractions which figure in works by David Teniers and others (see Introduction, fig. 68), remained a popular allusion to wealth and seigneurial status.[48] Not only background elements, but figural poses – and less frequently, entire groupings – were quoted from portraits of regal and aristocratic sitters by artists such as Anthony van Dyck. The latter's magnificent *Portrait of the Fourth Earl of Pembroke and His Family* (ca. 1633-34; Wiltshire, Wilton House, collection Earls of Pembroke) was the model for at least two group portraits by Coques,[49] who also made use of individual poses from van Dyck's compositions. It was not without reason that Coques became known as "the little van Dyck"!

Just as there was a somewhat standardized vocabulary of poses and decorative elements, there were also a selective range of activities deemed appropriate for the genre portrait: musical interludes and open-air repasts, sedate promenades, and recollections of the hunt are among the most prevalent. Hunting had by law long been the privilege of the nobility, and although by the latter part of the century restrictions had eased to admit the upper bourgeoisie, it continued to be an indicator of elevated social status.[50]

A few genre portraits integrate specific references to a sitter's profession into otherwise standard "aristocratic" settings of columns and swaths of drapery. In Gillis van Tilborch's *Portrait of a Merchant Family*, ca. 1665-1670 (fig. 7), for example, the cargo crane in the right background was a distinctive feature of the Antwerp wharf; together with the docked ships it proclaims the sitter's profession in shipping or trade.[51] Such a forthright expression of commercial activity within the exclusive context of the genre portrait indicates how far the boundaries between the nobility and the upper bourgeoisie had been breached in both art and life by the late seventeenth century.

Although the goal of most genre portraits was to envelop the sitter in an ambiance of prosperity and high social standing, there are a handful of works representing interests and priorities that go beyond material success. Most express religious concerns; rather than depicting portrait figures in prayer, or experiencing a miraculous apparition, however, they highlight religion as a routine part of active life. Some allude subtly to the sitter's faith, as in Hieronymus Janssens's *Family Portrait* (ca. 1670; Vienna, Liechtenstein'sche Fürstliche Sammlungen), where the sitters are gathered in a chamber decorated with religious paintings and a prominently placed crucifix.[52] A number of works adopt the Works of Mercy as the vehicle for a religious genre portrait, a theme popular in large-scale portraits as well. The subject is drawn from Matthew's account of Christ's Sermon on the Mount, where he speaks of returning at the Last Judgment to weigh men's souls by their performance of good works. In the Counter Reformatory Southern Netherlands, chari-

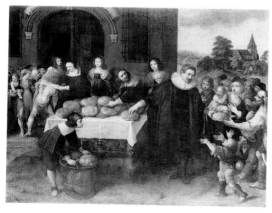

Fig. 8. Gonzales Coques and Frans Francken the Younger, *A Flemish Family Performing Acts of Charity*, 1639, oil on canvas, 108 x 140 cm, sale London [Sotheby's], 11 December 1985, no. 55.

table relief of the poor was mostly left to lay organizations and private citizens, with the understanding that performing these essential deeds would secure the donor's salvation.[53] A *Flemish Family Performing Acts of Charity* (1639; fig. 8) shows the distribution of bread and clothes to the poor. The well-dressed family (the man possibly an administrator of a charitible institution) was depicted by Coques; the humble, faceless supplicants by Frans Francken the Younger. Over the arched doorway to the right is the inscription "NAER.DET.EEN.EEWIGH.WOONSEL" (after this an eternal dwelling), leaving no doubt as to the motivation for this charity.[54] Another portrait of a *Family Distributing Bread and Clothes to the Poor*, possibly by Gillis van Tilborch, features the prominent bulk of Antwerp's Onze-Lieve-Vrouwekerk in the background.[55]

The genre portrait appealed to the new aristocracy (and the aristocratized bourgeoisie) of the Southern Netherlands as a visual document of having mastered the niceties of refined social intercourse and acquired the material accoutrements of wealth and status. The aggrandizement and confirmation of the sitters' place in society was accomplished in these delightful portraits not only via the representation of a wealth of material goods, but also more subtly in the resemblance of these portraits to precious cabinet pictures. The elaborate settings establish the sitters in a world of refinement comparable to or surpassing that of idealized genre and history paintings; the animated interaction of the figures supports the illusion that this is life as usual. The genre portrait can thus be compared to the more formal *portrait historié*, although the sitters do not assume specific historical or mythological roles; on the contrary, their own lives have been idealized and elevated to the stuff of legend.[56] Indeed, the swiftness of the social transformation from merchant to titled nobility and landed gentry – often realized within a single generation – must have had for many the chimerical character of a fairy tale. Paradoxically, this realization of temporal fragility found reassurance and refuge in a form of portraiture connected – however distantly – to the romanticized courtly idyll of the middle ages. As Oliver Banks once suggested, "The tradition of representing the elegant diversions of a *beau monde* amid a setting of glittering palaces was perhaps intentionally archaic, the nostalgic evocation of a world shattered by the political [and social] upheavals of the seventeenth century."[57]

1. Cf. L. de Vries, "Jan Steen zwischen Genre- und Historien-maler," *Niederdeutsche Beiträge zur Kunstgeschichte* 22 (1983), p. 122. See also the definitions proposed by D. Smith, in "Irony and Civility: Notes on the Convergence of Genre and Portraiture in Seventeenth-Century Dutch Painting," *Art Bulletin* 69 (1987), pp. 407-430; and idem, "Rhetoric and Prose in Dutch Portraiture," *Dutch Crossing* 41 (summer 1990), pp. 72-109. I am indebted to David Freedberg, Otto Naumann, and Peter Sutton for their helpful comments and suggestions during the preparation of this essay.

2. See S. Sitwell, *Conversation Pieces: A Survey of English Domestic Portraits and Their Painters* (New York and London, 1937); R. Edwards, *Early Conversation Pictures from the Middle Ages to about 1730: A Study in Origins* (London, 1954), pp. 9, 33-35; A. Staring, *De Hollanders Thuis: Gezelschappen uit drie eeuwen* (The Hague, 1956), pp. 57-59; and M. Praz, *Conversation Pieces: A Survey of Informal Group Portraits in Europe and America* (University Park and London, 1971), especially pp. 34, 56.

3. There are comparatively few *portraits historiés* in the Southern Netherlands in the seventeenth century outside court circles; see N. de Poorter, "Von Olympischen Göttern, Homerischen Helden und einem Antwerpen Apelles," in Cologne/Vienna 1992-93, p. 123.

4. See, for example, Praz 1971, pp. 33-37.

5. For example, Legrand 1963. In an analysis of the furnishings depicted in paintings of seventeenth-century Flemish interiors, Paul Vandenbroeck ("De 'salette' of pronkkamer in het 17de-eeuwse Brabantse burgerhuis. Familie en groepsportretten als iconografische bron, omstreeks 1640-1680," *Monumenten en Landschappen* 9, no. 6 [November-December 1990], p. 42) comments that interiors with a "portraitlike" character are nonetheless more reliable documents than genre paintings, which include allegorical or emblematic meanings.

6. Smith 1987, p. 408; see also Smith 1990, passim. The author, however, overemphasizes the differences between genre paint-ing and portraiture, rather than examining the similarities.

7. Smith 1987, p. 423.

8. L. de Pauw de Veen, *De Begrippen 'Schilder', 'Schilderij' en 'Schilderen' in de Zeventiende Eeuw* (Verhandelingen van de Koninklijke Vlaamse Academie voor Wetenschappen, Letteren, en Schone Kunsten van België. Klasse der Schone Kunsten, vol. 31 [Brussels, 1969]), pp. 172-173, 199; and the various paintings mentioned in estate inventories in Denucé 1932, passim.

9. "Ghelijck onder ander van sijn [Coques's] wercken ghesien can worden in een uytnemende fraey Conversatie die hy gheschildert heeft op copere plaet voor den Vromen en seer Const-lievenden Sr. *Jacob le Merchier* Coopman binnen de Rijcke-stadt van *Antwerpen*, afbeeldende sijn eyghen Figuer met sijn Huysvrouwe ende alle de kinderen / waer hij *Gonsael* sijn selven aen een tafel sittende heeft gheconterfeyt van ter zijden oft in porphiel als koutende met den voorsz. Sr. *Le Merchier*, sijnde van ghelijcken in een discourerende actie / alles soo uytghebeldt elck verthonende sijn werckelijck leven van volmaecktheyt" (De Bie 1661, p. 398). The painting has not been identified with certainty, although K. Van der Stighelen has suggested that de Bie's description refers to our cat. 58.

10. See Renger's essay in this catalogue.

11. Van der Stighelen, in Cologne/Vienna 1992-93, p. 172.

12. Guido Bentivoglio, *Les relations* (trans. by F. P. Gaffardy; Paris 1642), pp. 189-190.

13. See K. Proesmans, "Feest en vermaak aan het hof van Albrecht en Isabella," *Musica Antiqua* 6 (August 1989), pp. 123-127.

14. These artists were probably familiar with similar paintings of balls at the Valois court in France, executed ca. 1576-1584 (see L. Colliard, "Tableaux représentant des bals à la cour des Valois," *Gazette des Beaux-Arts*, ser. 6, vol. 61 [1963], pp. 147-156). The genre was probably transmitted to the Netherlands by Hieronymus Francken the Elder (ca. 1540-1610), who spent much of his career at the court of Henry IV in France, and painted several such balls and fêtes; see Härting 1989, pp. 18-19.

15. Härting 1989, pp. 91-96.

16. Based on certain changes in the figures and architecture, it has been proposed that the painting was commissioned by Philips Willem, Prince of Orange, shown dancing with his wife, Eleonora (The Hague, Mauritshuis, *Solving the Mystery of a Ballroom Scene: A Technical and Art-Historical Investigation of a Flemish Painting* [exh. 1992]).

17. De Maeyer 1955, p. 155, citing the following passage from *Le soleil éclipsé ou discours sur la vie et la mort du sérénissime archduc Albert* (Brussels, 1622): "... ceste familiarité qu'il monstrait au peuple se trouvait à leurs festes. Ainsi l'avés-vous veu tirer au papegay, s'en aller à la foire des verres, assister aux danses villageoises et aux aultres exercises du peuple guayement. Et bien qu'en toutes ses rencontres ce grand prince fust toujours sérieux, si ravailloit-il ceste gravité et radoucissait ceste fermeté parce qu'il voyait servir à la récreation de sa cour et du peuple.... Tout cela le faisait aimer grandement de son peuple." Similar paintings were also produced at this time in the Northern Netherlands by Adriaen van de Venne: *The Princes Maurits and Frederick Hendrick at the Horse Market in Valckenburg* (1618; Amsterdam, Rijksmuseum) and *The Harbor at Middelburg* (1625; Amsterdam, Rijksmuseum); the latter commemorates the departure of Elizabeth Queen of Bohemia from Middelburg on 12 May 1613.

18. For a discussion of these works, see Ertz 1979, pp. 157-163, and cat. nos. 177, 238, 245, 246, and 321.

19. See de Maeyer 1955, pp. 162-168, 171-174.

20. As, for example, in works such as Gonzales Coques and Gaspar de Witte, *The van Parijs-Rubens Family before the Castle at Merksem*, ca. 1674 (Kraainem, collection Baron and Mrs. X. de Donnea de Hamoir).

21. For example, Rubens's *Self-Portrait with Isabella Brant* (1609; Munich, Bayerische Staatsgemäldesammlungen, Alte Pinakothek, inv. 334; [ill. Introduction, fig. 13]) and *The Four Philosophers* (ca. 1611-12; Florence, Palazzo Pitti, inv. 85; [ill. White, fig. 2]); and Jacob Jordaens's *Self-Portrait with Wife and Daughter Elizabeth* (ca. 1621-22; Madrid, Museo del Prado, inv. 1549 [ill. cat. 44, fig. 2]).

22. Van der Stighelen, in Cologne/Vienna 1992-93, p. 179.

23. For the connotations of the large-scale family portrait, see cat. 53 and the additional literature cited there.

24. Van der Stighelen, in Cologne/Vienna 1992-92, p. 181, note 45. Although the figures and most of the background were painted by Rubens, the panel was considerably enlarged at the top, right, and bottom by another hand at a later date. For technical details of the painting, see Munich, cat. 1983, p. 435; and R. an der Heiden, *Peter Paul Rubens und die Bildnisse seiner Familie in der Alten Pinakothek* (Munich, 1982), pp. 28-30; on the iconography of the work see Vlieghe 1987, pp. 165-167 (with summary of the earlier literature) and most recently, J. Müller Hofstede, "Peter Paul Rubens 1577-1640: Selbstbildnis und Selbstverständnis," in Cologne/Vienna 1992-93, pp. 112-113.

25. On the connotations of the small-scale portrait, with particular relevance to the work of Thomas de Keyser, see A. J. Adams, "The Paintings of Thomas de Keyser (1596/7-1667): A Study of Portraiture in Seventeenth-Century Amsterdam" (Ph.D. diss., Harvard University, 1985), vol. 1, pp. 206-209. Cardinal Federigo Borromeo, the great Milanese patron of Jan Brueghel the Elder, assembled a collection of particular elegance and refinement and particularly prized works of meticulous craftsmanship and diminutive scale; see his *Musaeum* (Milan, 1625), passim; and A. Quint, *Cardinal Federigo Borromeo as a Patron and a Critic of the Arts and His MVSAEVM of 1625* (New York and London, 1986), p. 95.

26. E. Stols, "Aspects de la vie culturelle aux Pays-Bas Espagnols à l'époque de Rubens," *Bulletin de l'Institut historique belge de Rome* 48-49 (1978-79), pp. 221-222.

27. K. Degryse ("De Antwerpse adel in de 18de eeuw," in *De adel in het hertogdom Brabant* [Brussels, 1985], pp. 133-134) has noted that in 1794, less than a quarter of noble families in Antwerp had patents of nobility dating from before 1650. More generally on the history of the nobility in the Southern Netherlands, see J. Lefevre, "De adel: De 16de, 17de en 18de eeuw," in *Flandria Nostra*, vol. 4 (Antwerp, 1959), pp. 345-393.

28. Dreher 1978b, p. 690.

29. Degryse 1985, p. 134.

30. E. S. de Beer, ed., *The Diary of John Evelyn* (Oxford, 1955), vol. 2, p. 67 (5 October 1641).

31. Michel de Saint Martin, *Relation d'vn voyage fait en Flamande, Brabant, Hainavt, Artois, Cambreses &c. en l'an 1661* (Caen, 1667), p. 445; see A. de Behault de Dornon, "Relation d'un séjour de Michel de Saint Martin à Anvers en 1661," *Annales de l'Académie royale d'Archéologie de Belgique*, ser. 5, vol. 4 (1902), p. 193.

32. Stols 1978-79, p. 214. Vandenbroeck (1991, p. 46) has observed that paintings of interiors from this period generally show a melange of older architectural forms and furnishings with a few fashionable new pieces, which would reflect this practice. See also Michel de Saint Martin (as in note 31, pp. 406f; de Behault de Dornon 1902, p. 189) who comments on the architecture and sculptural ornamentation – both interior and exterior – of private homes in Antwerp.

33. On the appeal of *buitenleven* in the Southern Netherlands, see Vergara 1982, pp. 10-14 and 160-170; and Dreher 1978, especially pp. 689-695.

34. See Goodman 1992, pp. 23-25, with further literature.

35. The household diary (*huishoudboek*) of the well-to-do Bruges *schepen* Pieter C. van Nieumunster (died 1652) is written mostly in Flemish, but breaks into Spanish when the author wishes to appear particularly rich or fashionable; see Jos. de Smet, "Het dagelijks leven van een rijke familie in de 17de eeuw, Naar het handboek van Jonker van Nieumunster van Brugge 1638-1668," *Biekorf* 58 (1957), p. 277.

36. Goodman 1992, pp. 31-37.

37. *Voyage de Regnard en Flandre, en Hollande, en Danemark et en Suède* (1681), introduction and notes by A. de Marsy (Paris, 1874), pp. 25-26.

38. Van der Stighelen (in Cologne/Vienna 1992-93, p. 180) notes that the process of the social emancipation of the more elevated strata of the middle class cleared the way for the establishment of a new genre – the genre portrait – which had the potential for new formulae of form and content.

39. De Mirimonde 1967, p. 188.

40. On the development of the *kunstkamer* in Flemish painting, see cat. 125, and the additional literature cited there. See also Jeffrey Muller's essay in this catalogue, which also touches on the differences between the two types of painting.

41. *Kunstkamer* paintings by Coques, Tilborch, Charles Emanuel Biset, and others are discussed in Speth-Holterhoff 1957, pp. 165-190.

42. On musical practices among the upper classes in the seventeenth century and their representation in paintings, see Leppert 1977, vol. 1, pp. 116-157; and K. Moens, "De Vrouw in de huismuziek, een iconografische studie naar 16de- en 17de-eeuwse schilderijen en prenten uit de Nederlanden," *Jaarboek van het Vlaams centrum voor oude muziek* 2 (1986), pp. 43-63.

43. De Mirimonde 1967, p. 193; Leppert 1977, vol. 1, p. 131.

44. E. de Jongh, in Haarlem 1986, pp. 40-45.

45. As noted above, the genre portrait seems to have developed roughly simultaneously in the Northern Netherlands but with slightly different results. The exchange of influence between the two countries during this period and its effect on the development of the genre portrait is difficult to evaluate. In addition to Coques's occasional presence in The Hague from as early as 1643, the Dutch portraitist and genre painter Gerard ter Borch was in Antwerp about 1640 and again briefly in 1648. Gudlaugsson (*Geraert ter Borch* [The Hague, 1959-60], vol. 1, p. 44) rightly suggests that ter Borch's small full-length portraits influenced Antwerp artists like Coques, Joos van Craesbeeck, and David Teniers, as this format was more developed in the Northern Netherlands than in the South. See also Walter A. Liedtke, "Towards a History of Dutch Genre Painting II: The South Holland Tradition," in *The Age of Rembrandt, Studies in Seventeenth-Century Dutch Painting* (Papers in Art History from The Pennsylvania State University, vol. 3 [eds. R. E. Fleischer and S. Scott Munschower], 1988), pp. 102-103.

46. See K. Van der Stighelen, in Liedtke et al. 1992, p. 286, noting the similarities with works in Kansas City, Nelson-Atkins Museum of Art (inv. 32-18); London, The Wallace Collection (inv. P 223); and The Queen's Gallery, Buckingham Palace.

47. Oil on copper, 68.5 x 86.5 cm. Vlieghe (1987, p. 167) cites Teniers's painting in connection with Rubens's *Self-Portrait with Hélène Fourment in the Garden* (fig. 3). For examples of the garden screen and garden facade of Rubens's house in paintings by other artists, see cat. 59.

48. See Dreher 1978b, esp. p. 701. Gillis van Tilborch, *Family Portrait*, oil on canvas, 117 x 120 cm; Rajec, Castle, as by Barent Graat. Compare also the anonymous *Musical Company* in a private collection illustrated in de Mirimonde 1967, fig. 32.

49. Dresden, Gemäldegalerie Alte Meister, inv. 1097; and sale de Ridder, Paris (Georges Petit), 2 June 1924, no. 13.

50. E. de Jongh, in Haarlem 1986, pp. 261-264; see also Sullivan 1984.

51. Compare Nicolaes Maes's portrait of the Dordrecht merchant and sea-captain Job Jansz. Cuyter and his family (1659; Raleigh, North Carolina Museum of Art), posed on the quay before the Groothoofdspoort in Dordrecht, with a view of merchant ships in the background.

52. Joos van Craesbeeck's *Family Portrait* (oil on canvas, 61 x 48.2 cm; sale London [Christie's], 21 November 1952, no. 158 [as by Tilborch]), shows a couple seated at a table with a large crucifix; the man looks at a book with images of saints as the woman reads from a small missal. The two children standing behind the couple are rather less devout.

53. See S. D. Muller, *Charity in the Dutch Republic: Pictures of Rich and Poor for Charitable Institutions* (Ann Arbor, 1985), pp. 57, 103 and 270, note 24; the author notes that Flemish *Works of Mercy* are more openly expressive of religious faith in good works than Dutch examples. On Antwerp organizations devoted to the relief of the poor, see R. Baetens, "Between Hope and Fear," in van Isacker, van Uytven 1986, pp. 180-181; and Thijs 1990, pp. 201-206. The theme was also popular for group portraits of administrators of charitable organizations, although these paintings are generally larger in scale, with a less narrative, more symbolic and administrative focus.

54. The painting was considerably cut down in about 1895. The original composition, measuring 167.5 x 258 cm, placed a greater emphasis on the religious context of the portrait, and included the representation of additional acts of charity to the right (this portion of the painting, measuring 100 x 81 cm, is now in the Musées Royaux des Beaux-Arts de Belgique, Brussels, inv. 6242, as by Frans Francken the Younger) and, in a swirl of clouds directly over the man distributing bread, a vision of Christ at the Last Judgment, with saints. See J. P. Ballegeer, "Bij het 17de-eeuwse Vlaamse schilderijenfragment 'De Werken van Barmhartigheid' in de Koninklijke Musea voor Schone Kunsten van België te Brussel," *Bulletin des Musées Royaux des Beaux-Arts de Belgique* 18 (1969), pp. 141-147.

55. Oil on canvas, 110 x 106 cm; sale Brussels (Fievez), 22-28 June 1922, no. 37 (as by Coques). Abraham van Diepenbeeck also painted a *Portrait of a Man Distributing Bread to the Poor* (1629; Munich, Bayerische Staatsgemäldesammlungen, Alte Pinakothek, inv. 817). Tilborch's *Distribution of the Tichborne Dole on Lady Day* (1670; oil on canvas, 46 x 81 in.; Tichborne Park, near Alresford, Hants.) represents the Tichborne family in a charitable act of secular origin.

56. Thus the genre portrait in the Southern Netherlands can be said to fulfill much the same function as the pastoral portrait and *portrait historié* in the Northern Netherlands; Wishnevsky (1967, pp. 135-136) similarly correlates the pastoral portrait and *portrait historié* with the aristocratization of the regent class in the Northern Netherlands.

57. O. T. Banks, *Watteau and the North: Studies in the Dutch and Flemish Baroque Influence on French Rococo Painting* (New York and London, 1977), p. 206.

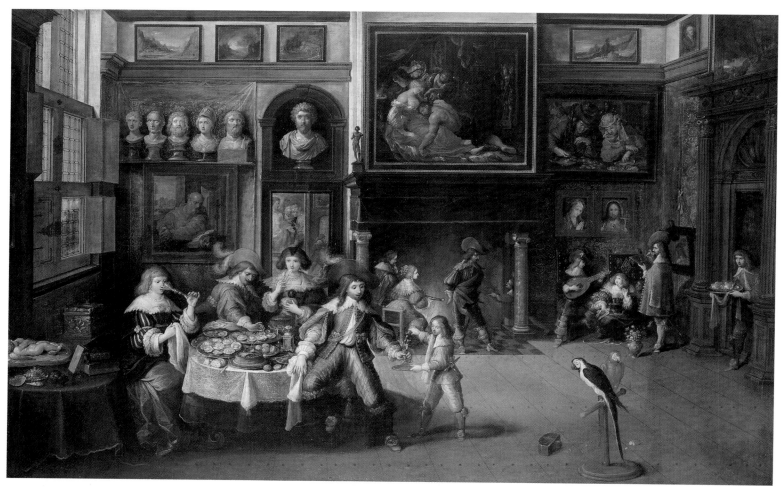

Fig. 1. Frans Francken the Younger, *Interior of Burgomaster Nicolaes Rockox's House*, oil on panel, 62.3 x 96.5 cm, Munich, Bayerische Staatsgemälde-sammlungen, inv. 858.

Fig. 2. Gillis van Tilborch, *Family in an Interior*, ca. 1670, oil on canvas, 80 x 104 cm, The Hague, Mauritshuis, inv. 262.

Private Collections in the Spanish Netherlands: Ownership and Display of Paintings in Domestic Interiors[*]

Jeffrey M. Muller

The size and subjects of most paintings in this exhibition suggest that they were meant to hang in private homes. Even religious pictures such van Dyck's *St. Jerome* (cat. 38) would have fitted just as well in the best room of a prosperous burgher's house as in the chapel of church. The great altarpieces painted by seventeenth-century Antwerp artists are too large to travel.[1] In any case, a history of the Catholic Church as patron of the arts in the Spanish (i.e., Southern) Netherlands has yet to be written.[2] The same is true for other institutional sources of patronage. In her pioneering article on the relationships between painters and the civic militia companies of Antwerp, Nora de Poorter has given a glimpse of the active role played by guilds as patrons of art.[3] Lavishly decorated guildhouses contained a wealth of art that commemorated or played a part in the histories of the guilds. It is obvious, for example, that the development of the group portrait in the Spanish Netherlands was fueled by commissions from the guilds. There is, however, no full-scale documentation or study of the use of art by these organizations in Antwerp or in any other city of the Spanish Netherlands.[4] Knowledge is just as sketchy regarding the patronage of art by different levels of government.[5] The notable exception is Marcel de Maeyer's book on the patronage of painting dispensed by the Archdukes Albert and Isabella.[6] There is likewise, to date, no comprehensive view of art as integral to the culture of the court nobility or of the unpropertied working class: the highest and lowest levels of society.[7] By contrast, the place of art in the private lives of the prosperous and substantial middle classes – from wealthy merchants and magistrates to humbler professionals, artisans, and lay-members of religious orders – recently has been the focus of considerable attention. A great deal of documentation and a variety of case studies have made it possible to enter the houses of citizens living in different cities of the South Netherlands during the seventeenth and eighteenth centuries and see what kinds of paintings they owned, how the pictures fitted with other possessions, and understand art as a potential sign of social, religious, and political values. At the same time, new perspectives and frameworks for interpretation have been developed by other recent work on the social, economic, and cultural history of the Spanish Netherlands in particular, and of early modern Europe (1400-1800) in general. It is possible, therefore, to give an overview of painting as an element in the material and ideological culture of domestic life among the middle class in the Spanish Netherlands. This is especially appropriate, given that most pictures in this exhibition were made for such a setting. The present state of research, however, allows only a fragmented account, inevitably clearer and more detailed in some parts than in others.

The pictures themselves are the most immediate and persuasive evidence of the important role played by art in the lives of seventeenth-century citizens. But only a tiny fraction remains of what once existed.[8] What does survive has gained new meanings and lost old ones. No domestic interior of the seventeenth-century Spanish Netherlands remains intact to show the ensemble of which paintings formed an integral part.[9] Two major sources make possible a reconstruction of what was lost. First, legal documents recording possession of valuable goods, including art, contain an enormous amount of varied information about private homes of earlier times.[10] Second, it is especially in the case of the seventeenth-century Spanish Netherlands that certain kinds of pictures, representing art galleries and domestic group portraits, can be used as visual evidence to complement and render vivid what the pages from the archives tell us.[11]

Historians have made greater use than art historians of abundant archival material such as probate inventories to gather quantitative evidence regarding the history of private collections in seventeenth-century Delft, Amsterdam, Metz, and Douai, and in eighteenth-century Ghent.[12] These studies have charted long-term trends in the average numbers, relative value, and subject

matter of pictures owned by collectors in different income brackets, belonging to different religious denominations, and according to each city. As Philip Benedict has pointed out in his analysis of picture collections in the provincial French city of Metz, one cumulative effect of such archival research has been to demonstrate that a large and varied segment of the urban population in Western Europe owned paintings. If there were, on the average, twice as many pictures in Delft households as in Metz, this was a matter of degree within a common trend.[13] No similar quantitative study of collecting in a city of the Spanish Netherlands during the seventeenth century has yet been published. Inez Bourgeois has accomplished this, however, for eighteenth-century Ghent, with striking results.[14] During the first half of the eighteenth century possession of paintings was widespread, with one or more paintings recorded in 86.6 percent of all inventoried households and, on the average 12.1 pictures per household. This is even higher than John Michael Montias's figure of eleven pictures per household in Delft during the 1640s.[15] If Ghent is representative of the other cities in the South Netherlands, then one can argue that there was no long-term decline in private collecting of pictures until the late eighteenth century when Bourgeois demonstrates a significant decrease in numbers of pictures owned per household. Bourgeois's data do not include any indication of attributions or points of origin of pictures, so it is impossible to use her figures to draw conclusions regarding continued local production at a high level. But these figures do challenge the habit of perceiving decline at some point during the seventeenth century in the production and consumption of art in the Spanish Netherlands. In any case, more studies like that of Bourgeois, setting out the quantity, subject matter, value, points of origin, and attributions of pictures in seventeenth-century Spanish Netherlands cities (Ghent, Bruges, Mechelen, Lille, Brussels, and smaller towns such as Dendermonde, as well as Antwerp), probably would demonstrate an extraordinary wealth of art owned by a wide segment of the population over the whole century, and probably continuing into the first half of the eighteenth century.

During the seventeenth century Antwerp regained and even expanded its position as one of the major centers for the production, collecting, and dealing of art. Although no quantitative studies of Antwerp collections have been published to date, Erik Duverger's ongoing transcription and publication of all seventeenth-century documents in the Antwerp City Archive and in the Archive of the Public Center for Social Welfare relating to art collections – primarily probate inventories and testaments – is making available to historians a unique resource for the study of patronage.[16] It is already possible to draw quantitative conclusions from this data. Katlijne Van der Stighelen, for example, has combed the inventories published by Duverger to break down the ownership of portraits by different professions in Antwerp between 1600 and 1642. She is able to demonstrate increasingly widespread ownership among a great variety of professions during this time.[17]

In a similar way, I have recorded the numbers of pictures of different kinds of subject matter listed in the testaments and probate inventories published by Duverger for two decades: 1600 to 1609 and 1643 to 1652.[18] These figures establish a large scale on which to measure the contents of Antwerp painting collections in the given decades and on which to observe any significant changes that might have occurred from the beginning to the middle of the seventeenth century. The statistics also provide a standard for comparison with the contents of private collections in other cities. The table (Table 1) makes this comparison with Delft for which Montias has compiled similar statistics.[19] In this table I have grouped pictures under the broadest headings in order to simplify comparison with the figures given by Montias.

The differences and similarities between Antwerp and Delft collections are straightforward and consistent through the first half of the century. Paintings of mythology and secular history, portraits, and genre scenes were equally popular in both cities. The percentage of religious pictures declined significantly in both cities while the share of landscapes and still lifes increased respectively in Antwerp and Delft from early to mid-century. Landscape and still life were more favored in Delft collections from the start. Although the proportion of religious pictures declined in Antwerp, this does not necessarily indicate a significant trend towards secularization of art collections, especially in comparison with Delft where the percentage of religious pictures was noticeably lower from the beginning to the mid-point of the century. Religious pictures were still the best-represented category at mid-century in Antwerp collections, and their sheer number increased more than five-fold from the first decade. The presence of religious art in Antwerp

Subject Category	Antwerp 1600-1609		Delft 1610-1619		Antwerp 1643-1652		Delft 1640-1649	
	No.	%	No.	%	No.	%	No.	%
Mythology, secular allegory, and historical scenes	155	10.1	43	9.1	863	8.8	171	8.3
Religious paintings	763	49.9	175	37.0	3978	40.2	583	26.5
Portraits and Heads, called "Tronien"	359	23.4	80	16.9	2103	21.2	479	21.8
Landscape, including seascapes, city views, perspectives, and scenes of conflagration, but excluding landscapes with explicit narrative content	98	6.9	121	25.6	1643	16.7	573	26.1
Still-life, including "kitchens" which may contain figures and animals	36	2.3	20	4.2	571	5.8	256	11.7
Other genres including merry companies, scenes of peasant life, animals and hunts, battles	114	7.4	34	7.2	723	7.3	131	5.9
Totals	1525		473		9881		2193	

Table 1.

households was significantly strengthened by an abundance of sculptures in wood, plaster, ivory, and silver, of Virgins, crucifixes, saints, and angels. It is remarkable, nevertheless, that the percentage of religious pictures in Catholic Ghent had plummeted to 14.4 percent by 1720-1722, while landscapes increased to 40.7 percent of the total.[20] When Duverger has published enough data to allow conclusions regarding the second half of the seventeenth century, it may very well turn out that a long-term trend towards secularization also changed the character of Antwerp collections. At this point it does not seem too daring to assume that the dominance of Catholicism in the Spanish Netherlands and of Protestantism in the United Provinces of the Netherlands was the most important cause of the fundamental difference between middle-class collections in Antwerp and Delft during the first half of the seventeenth century. Benedict has documented an even sharper divergence along denominational lines in seventeenth-century Metz, where 61 percent of the pictures in Catholic households were religious in content, while only 27 percent of the pictures owned by Protestants were religious.[21] The Catholic Church encouraged the use of images in public and private devotion. Protestant denominations strictly limited or prohibited the use of images in worship and prayer. I will return below to the issue of religious art in private homes.

Viewed closer up, the inventories published by Duverger can help in determining the place and meanings of different kinds of pictures in seventeenth-century households. The documents were written by notaries, members of the professional middle-class.[22] The inventories usually were taken room by room. Frequently, they give an exact record of the quantity and subjects of pictures hanging in separate parts of a house, along with the other furnishings of each room. Inventories also contain a great deal of information about individual works: particular subjects, identities of portraits, types of frames, relative size, the material of the support (panel, canvas, copper, or marble), attributions to artists, distinctions between originals and copies, broad judgments of quality. Details like these are reported with considerable regularity. Robert Muchembled has also drawn attention to the character of the inventories as social documents recording the hierarchical values of the notaries themselves.[23] An inventory might be written with detailed enthusiasm indicative of respect for the wealth and luxury of a member of the same upper middle-class to which the notary belonged. In other cases, curt and dismissive notations suggest a lack of interest or even contempt. Montias has observed a variety of expertise in connoisseurship among Delft notaries.[24] It is significant for Antwerp's position as a major center of artistic production and collecting that the city's notaries seem to have possessed a uniformly high level of skill at connoisseurship; all of them were knowledgeable about issues of attribution, authenticity, quality, and subject matter.

Even though most Antwerp inventories do not include an estimated or realized value of property, they describe different degrees of luxury which can be correlated with the wealth, social position, personal interests, and tastes of the owners. Many inventories of only one or two rooms, containing a handful of pictures and other works of art, record what was left behind by humble artisans, tradesmen, and widows.[25] Paintings in their homes usually are identified by subject matter and medium, without any attributions to a particular artist. An example is the inventory of Joris Mochaerts, a mason who took sick while serving in the army at Breda and died at Lier on 31 August 1624.[26] He was a widower who had married again and left behind an eleven-month-old daughter from his second marriage. Only seven works of art (five paintings and two sculptures) are listed, identified by subject and medium with no attributions, and found all together in one room: the kitchen. Both sculptures were sacred images; one was a gilded wood carving of St. Christopher and the other a silver Lamb of God (Agnus Dei). Two of the pictures also depicted Christian subjects; both of the Virgin Mary painted on panel in oil. The other paintings varied in subject: the story taken from Roman history of Cimon and Pero, in which the daughter suckles her father in prison; an oil on canvas of a peasant; and a water-color on canvas depicting a "kitchen," which could have been either a still life or a scene with abundant food and figures as well. All the pictures were framed. Probably they were purchased on the open market at a low price.[27] Portraits, which had to be commissioned and would have cost more, are noticeably lacking. Otherwise, these few pictures conform to the general profile of Antwerp collections given in the table above.

As an example at the upper end of the scale of Antwerp middle-class collections, one can cite the inventory of the goods left behind by Johanna Greyns, who died 10 June 1626.[28] She had been the widow of Cornelis I Janssens van Biesthoven and the mother-in-law of the secretary of the city Alexander della Faille. By birth and marriage, therefore, she belonged to a group of families prominent in Antwerp's government and commerce.[29] The plan and decoration of her house conformed to a pattern which Ria Fabri sets out as typical for the prosperous burgher class in Antwerp.[30] One can imagine from the inventory a two-story house, deeper than it was wide. The rooms on the ground floor opened from front to back on either side of a corridor. A front room ("Voercamer"), a large downstairs room ("grootte Neercamer"), and a dining room ("Eetcamer") were located closest to the street, with a back room ("Achtercamer") and the kitchen further to the rear, and Alexander della Faille's office ("contoir") somewhere between. The ground floor clearly served as the more public and ceremonial space in which the family gathered, guests were entertained, and clients were received. Upstairs were the bedrooms: one for the children, a second occupied by della Faille's wife, and the third belonging to Johanna Greyns herself. Works of art decorated all these rooms, a total of forty-one paintings, six sculptures, one print, a map, and several embroidered or painted cloths. Twenty paintings and two sculptures depicted religious subjects. Five portraits, all oil on panel, recorded the likenesses of family members. The one print was a portrait of the Archduchess Isabella. Otherwise there were four landscapes, four scenes of peas-

ant life, three still lives, two seascapes, two panoramas of conflagration, and one view of a country villa. One painting, exceptionally, was identified by the name of the artist alone, "Floris," demonstrating the high value still attached to the works of the great sixteenth-century Antwerp painter Frans Floris. Three other paintings were attributed: a *Seascape* to Hendrik Vroom of Haarlem, the acknowledged master in that subject; a *Peasant Celebration* to Pieter Aertsen, one of the sixteenth-century inventors of the Netherlandish tradition of peasant genre scenes; and a *Landscape* to Tobias Verhaecht, a leading Antwerp painter in this specialty and Rubens's first teacher. Johanna Greyns owned forty-one pictures, four attributed to important artists, in comparison with the five paintings found in the kitchen of the mason Joris Mochaerts. Whereas Mochaerts probably could not afford portraits of his family, Greyns owned five. The order and surroundings in which her pictures were hung must have enhanced the impression of comfortable prosperity.

The most luxurious displays were reserved for the "back room" and the dining room on the ground floor. These contained the greatest variety and quantity of objects and must have been the centers of social life. The walls in both rooms were covered by fashionable and expensive gold leather hangings. A harpsichord in each room added to the air of cultivation and conviviality. Keyboard instruments were played mostly by women.[31] One sees this in many paintings and it is confirmed by written sources. So the presence of women was implied by these instruments. Other conventional items of luxury included, in the "back room," a wood cabinet with closing doors, probably placed along a central line of sight, a Turkish carpet, and a painted cloth over the mantelpiece. In the dining room there were two small heads carved out of stone and an "Indian" cloth covering the mantelpiece.

The pictures in each room were limited in number and probably arranged in a symmetrical pattern over the gold leather wall hangings. Six pictures decorated the "back room": two seascapes, two small landscapes, a Crucifixion, and the head of an apostle. Nine pictures hung in the dining room, a large landscape, a Last Judgment, a peasant market scene, a Deposition from the Cross, two small panels of the Supper at Emmaus, a male and female peasant, each painted on a separate panel, and a small still life of shells. The engraved portrait of the Archduchess Isabella was also framed and hung with the paintings.

Bedrooms, kitchen, and office were more simply furnished. Only two paintings hung in the kitchen, a Virgin Mary and a "kitchen." Alexander della Faille's office contained an Old Testament scene from the life of Jacob and a small panel of a death's head. The bedroom of his wife, Maria Janssens van Biesthoven, was decorated with a wood crucifix and four pictures: a portrait of her father, a small Temptation of St. Anthony, a Deposition from the Cross, and the panel attributed to Frans Floris.

At first sight the pictures appear scattered randomly throughout the house. A closer look, however, suggests that the arrangement followed a generally accepted convention of decorum for the display of art in private homes. The English diplomat Sir Henry Wotton, in his *Elements of Architecture* published in 1624, articulated a rule of number which seems to have been observed tacitly by prosperous Antwerp collectors. Wotton advised, regarding "the disposing of *Pictures* within" a house: "First, that no *Roome* bee furnished with too many, which were a *Surfet of Ornament*, vnlesse they bee *Galleries*, or some peculiar *Repository* for *Rarities of Art*."[32] Sir William Sanderson, in his *Graphice* of 1658, warned the reader: "spare your purse and pains, not to Clutter the Room with too many Pieces, unless in *Galleries* and *Repositories*, as rarityes of severall Artizans intermingled; otherwise it becomes only *Painters-Shop*, for choyce of sale."[33] Indeed, in Antwerp only painters and dealers crammed large numbers of pictures into the various rooms of their houses. For example, it took from 15 to 22 October 1642 to inventory all the works of art in the house of Herman I de Neyt, "dealer in paintings."[34] Seventy-three pictures and all kinds of other art objects were recorded in his "downstairs room" ("Neercamer"), whereas the "large downstairs room" in Johanna Greyns's house contained only two choice paintings: Pieter Aertsen's *Peasant Celebration* and the *Landscape* by Tobias Verhaecht.

There also was a decorum of subject that called for agreement between the function of a particular room and the kinds of pictures hung in it. Sir Henry Wotton recommended that pictures "bee as *properly* bestowed for their quality, as fitly for their *grace*: that is, *chearefull* Paintings in *Feasting* and *Banquetting* Roomes; *Grauer Stories* in *Galleries*, *Land-schips* and *Boscage*, and such *Wilde* workes in open *Tarraces*, or in *Summer houses* (as we call them) and the like."[35] Sixteenth- and seventeenth-century Italian writers gave similar advice. The more accessible rooms of a gentle-

man's house were to be decorated with scenes of magnificence and virtue.[36] Portraits of illustrious and historical figures were viewed as expressions of political and personal allegiance and were to be displayed in the most public rooms, according to a strict hierarchy that mirrored the status of the individuals portrayed.[37] Sanderson gave particular instructions to hang portraits of the king and queen in the dining room, set apart from any others "in reverence to their Persons." However "Your own and your wives or Children, best become your discretion, and her modesty, (if she be faire) to furnish the most private, or Bed-Chamber; lest, (being too publique) an Italian-minded Guest, gaze too long on them, and commend the worke for your wive's sake."[38]

The arrangement of pictures in Johanna Greyns's house shows some agreement with this decorum of subject. A place of honor was reserved in the dining room for the engraved portrait of the Archduchess Isabella. Two paintings of a sacred meal (the Supper at Emmaus) and the display of food in a peasant market were obviously appropriate, as were the "chearfull" pictures of a peasant and his wife, along with a large landscape. In the kitchen a painting of a kitchen must have expressed the desire for abundance and for a cornucopia of good things. Upstairs, the children's room was decorated with the light-hearted view of a country villa, literally called a "play house" ("Speelhuys").[39] Johanna Greyns's bedroom was filled with sacred images of devotion (four pictures of the Virgin), penitence (St. Jerome), fervent prayer (the Agony in the Garden), and promise (a Resurrection), which made this place almost like a private chapel for the contemplative soul. One family portrait was kept in a bedroom upstairs, while the four others hung downstairs in the front room. Two of them portrayed Johanna Greyns herself, but the sober dress of the 1620s clearly repressed the kind of sexual response which fashion and portraits evoked later in the century and to which Sanderson pandered (see for example, the *Portrait of a Woman* by Gonzales Coques, cat. 59).

Although some paintings may have been chosen to mirror or define the function of a particular room, in Johanna Greyns's house nothing like consistency or strict order was observed. The only room without a religious image was the children's room. Landscapes and seascapes hung alongside Crucifixions. An image of the Virgin watched over the kitchen along with the painting of a kitchen. This loose observance of decorum was typical of Antwerp collections.[40]

By now it is evident that Johanna Greyns's collection, in the setting of her house, was a form of self-representation that conveyed strong signals. Claim to a certain social status was inherent in the display of luxury.[41] Roland Baetens has suggested that this kind of display also advertised the prosperity and creditworthiness crucial for merchant families such as the Greyns, della Failles, and Janssens van Biesthovens.[42] Family portraits reinforced these messages by setting out pedigree and connections. The religious images placed everywhere in the house declared adherence to the Catholic faith. The portrait of the Archduchess Isabella expressed loyalty to the Hapsburg government. Religious images and portraits hung in the bedrooms reflected personal devotion and loyalty.

By describing what was average and conventional it may be that one loses those strange moments which make history unpredictable and interesting, like life itself. Several documents published by Duverger record these kinds of surprising events in which art is the object of some vital passion. On 20 September 1631, Augustijn Tyssens, old clothes dealer, sealed a bet with the art dealer Hans Sieberecht. If, before two years to the day, the king of Spain and the States of Holland declared a truce in their war, then Tyssens would pay Sieberecht 200 guilders for a painting of *The Adoration of the Magi* by the Antwerp artist Hans Jordaens. If no truce was signed by 20 September 1633, then Tyssens got to keep the painting without having to pay for it. This was no small bet, since the average annual wages of an uneducated worker was 180 guilders, 20 guilders less than the value set on the painting.[43] In this agreement there is a palpable sense of anxiety about war and peace, speculative risk in a capitalist society facing uncertain times, and desire for luxury all invested in one painting of the birth of Christ.[44]

An even more remarkable outburst of bravado over a painting took place on 24 August 1646. According to her sworn testimony, Jacomyne Strypens, wife of Franchoys de Boot and a resident of Dendermonde, was in Antwerp for several days and, on the afternoon of 24 August, between four and five, paid a visit to the house of Guilliam van Kessel. She was in the "back room" ("achtercamer") with van Kessel's daughters when he came in with another person whom she identified as Jan Mastelyn. The two men had some business to attend to and withdrew from the "small room" – by which she must have meant the "back room" – to the large one. Jacomyne

Strypens followed the men "out of curiosity" and also to see this other room. The first thing her eyes fell on was a painting standing on the "half buffet," which she said that she liked. Mastelyn also stared fixedly at the painting, then turned to his host, van Kessel and said: "If you sell me that piece I will give you 300 guilders for it. What do you say?" Van Kessel demurred, saying that he could get more for it from people outside the city and pointing to Jacomyne Strypens. She turned to Mastelyn in reply, telling him: "Well Sir, you must be rich if you want to pay 300 guilders for such a piece, and you must understand these things very well." Mastelyn persisted; yes, he did understand these things, and what about it Mr. van Kessel. Van Kessel agreed, reluctantly of course, and they shook hands to seal the bargain. It was after Mastelyn reneged that van Kessel requested a deposition from Jacomyne Strypens.

This sequence of events reveals several ways in which art provided a fulcrum for social interaction among burghers in seventeenth-century Antwerp. First, there was the interaction of gender. Jacomyne Strypens was visiting with van Kessel's daughters in the small "back room," which along with the kitchen may have been the usual domain of women.[45] It was her curiosity which led her to follow the two men into the more splendid and bigger room decorated with a cabinet and the painting. This more luxurious room apparently was the privileged domain of the man of the house. Here, one can also perceive a ritual between owner and visitor, by which the visitor of high status is invited into the best room. In this case the painting was immediately the center of a variety of responses. It captured attention and impressed people. Jacomyne Strypens reacted with pleasure and judgment showing that she must have been accustomed to looking at paintings and that it was a normal part of conversation to compliment the owner on his possession. Mastelyn reacted with an aggressive macho impulsiveness that crystallized another social relationship; competitive posturing between two men over money and knowledge about art. Van Kessel kept cool and used the painting as a means to outsmart his acquaintance. When the woman sarcastically challenged both Mastelyn's expertise and his financial competence, he was compelled to follow through. In this exchange, the handshake carried legal weight. The picture was an object of privilege, pleasure, desire, competition, value, and knowledge put to the test.

A very different attachment to works of art was expressed by the priest Bartholomeus Bosco, who dictated his testament on 2 September 1627 as he lay sick in bed in his dwelling close by the cloister of the Minderbroeders. All the art he owned was of a sacred character.[46] He chose to be buried in the church of the Augustinian Fathers, in front of the altar of St. Appollonia which was decorated one year later by Jordaens's painting of the Martyrdom of that saint, now in the Koninklijk Museum at Antwerp.[47] First, Bosco requested that the Augustinians hang over his grave as an epitaph a painting of the Nativity of Christ which stood at the moment in his bedroom. All the other paintings in his bedroom were bequeathed to the English Theresians in 't Hoplant, along with two gold rings. A fine silver crucifix standing near his altar went to the Latin Sodality of the Jesuits. To the wife and to Maria the daughter of Augustino Bosco, presumably his sister-in-law and niece, he left respectively, a small wood altarpiece with the Blessed Virgin inside and a "tree curiously made with the Blessed Virgin of Scherpenheuvel." Finally, he gave to a certain (spiritual?) "daughter" named Elizabeth Loopman, who once lived with him, his gold medal with the Sweet Name of Jesus which he had worn around his neck.

Works of art spoke here no less of wealth and privilege. These worldly values were translated into spiritual terms. Father Bosco's burial place inside the church in front of the altar was privileged and paid for by an additional bequest of books, priestly ornaments, and 1,000 guilders. This world and the next were bridged by the painting of the Nativity which hung over his bed and would hang above his grave; a constant reminder of death and the promise of resurrection. His special love for his niece Maria was expressed through the gift of a replica of the miraculous Virgin of Scherpenheuvel which after its endorsement by the Archdukes Albert and Isabella quickly became an important symbol of Catholic devotion in the Spanish Netherlands. The gold medal with Christ's name which hung around his neck would be worn by Elizabeth Loopman for whom he felt some strong attachment. The silver cross commemorated his association with the Latin Sodality. In all these bequests art assured a kind of immortality; bringing the priest close to heaven in the church where mass was said, keeping his name alive in the epitaph, and perpetuating memory of him in the thoughts of his grateful heirs.

Written documents may tell us a great deal about private collections in the Spanish Netherlands, but they do not by themselves make it possible to visualize the actual appearance of a

collection displayed in one of the main rooms of a burgher's house. This kind of knowledge is very important, because the meanings and functions of works of art are strongly affected by the way they are presented. Two distinct but closely related genres of painting, both native to seventeenth-century Antwerp, provide evidence of this kind. The first is the *kunstkamer* or gallery painting in which many works of art are crammed into one space where these miniaturized reproductions dominate the viewer's attention. Recent interpretations have argued that these paintings often contain allegories of religion and art theory.[48] The second type of painting is the family group portrait set within the best room of the house – a *pronkkamer,* or "showroom" – in which there are fewer works of art and the family portrait is the center of attention.[49] It must be recognized in each case that this visual evidence is embedded within artistic traditions that adhere to their own ground rules of genre, iconography, and style, and carry their own social and ideological messages; not the least of which is the extraordinary importance of pictures and collections for the Antwerp middle-class. These pictures are not straightforward documents of any interior that actually existed. Part of their iconography, however, involves the repetition of certain conventions for the decoration of rooms and the display of art. There is enough agreement with information contained in various inventories to allow the conclusion that these iconographic conventions represent schematized and generalized versions of actual conventions for decoration and display.

The repetition of these conventions is so consistent that two pictures – one from each genre – will suffice to illustrate the kinds of visual evidence available. The first is a *kunstkamer,* painted in Antwerp around 1635 by Frans Francken the Younger, which depicts an ideal view of *The Large Salon in the House of Nicolaes Rockox* (Munich, Alte Pinakothek; fig. 1).[50] Francken's painting is of unique interest, because what it shows can be compared with the room-by-room inventory of Rockox's possessions made after his death in December 1640.[51] Rockox (1560-1640) was one of the wealthiest and most powerful citizens of Antwerp. He had been burgomaster several times and also had served as alderman (*schepen*) in the municipal government.[52] His patrician house in the fashionable Keizerstraat – now reconstructed as a museum – was decorated in a manner representative of his exalted status. In comparison with Johanna Greyns, for example, he owned seventy-five to her forty-one paintings, attributed to a wide range of artists, including pictures by his friend Rubens. These were supplemented by bound volumes of prints. His active pursuit of humanist and antiquarian studies also led Rockox to form a significant collection of ancient sculptures and coins.[53] Many of the paintings and sculptures listed in the inventory of Rockox's house are included in Francken's *Kunstkamer,* only not at all in their original order. Probably this is the "groote Saleth," the large salon, hung with golden leather, in which Rubens's *Samson and Delilah,* placed above the mantelpiece, did actually hang (the picture is now in the National Gallery, London; ill. Introduction, fig. 20).[54] Otherwise, Francken painted an assemblage of paintings and sculptures taken from other parts of the house.[55] The fashionable couples gathered in the room are generic types of high society engaged in activities which might make them personifications of the five senses as part of a larger allegory completed by the works of art Francken chose to include. Obviously this *Kunstkamer* does not document any real place or event. It is, however, a plausible fiction scrupulously based on fact, and as such, it shows what the best room in Rockox's house could have looked like. A bare wood-planked floor, a ceiling of exposed beams, a bank of windows with lead-mullion panes, wood shutters opening inwards, the marble fireplace, a cornice applied below the ceiling, and the golden leather hangings suspended from below the cornice; all were characteristic for this kind of room and established a conventional frame that set sharp limits and expectations for the display of art. The fireplace was the monumental center and demanded special treatment. In Francken's *Kunstkamer* one sees a cloth running below the mantelpiece which must be similar to one of the painted and printed mantelpiece cloths recorded in the house of Johanna Greyns. Rubens's *Samson and Delilah* is the largest painting in the room. Its dimensions agree exactly with the chimney wall behind, and its importance is stressed by the double gold bordered frame. Fireplace pictures were given a separate name in the inventories (*schouwstuk,* chimney piece), a sign of the conventional and major role they played in the visual order of a room.[56] No inventory confirms that other paintings were hung in loose symmetry on either side of the fireplace as they appear in Francken's *Kunstkamer.* Inventories do provide examples of rooms where only the chimney piece was framed in gold, while all the other paintings were in simple black or brown wood frames, although this was by no means a hard and fast

rule.[57] Dimensions and, to a large extent, subject matter also were prescribed for the pictures that hung along the narrow strip of wall between cornice molding and ceiling. As in Francken's *Kunstkamer*, many of these pictures were landscapes of an equal height. An entry in the inventory of the Antwerp painter Jeremias Wildens, made in 1653, records "seven paintings, being landscapes, standing above the golden leather, by Momper."[58] These pictures served an important decorative function by covering the bare gray walls, almost like wallpaper. Landscapes were relatively cheap, could be purchased in series, and were neutral in both subject matter and color.

In Gillis van Tilborch's *Portrait of a Family in an Interior*, painted around 1670 (The Hague, Mauritshuis; fig. 2), it seems as if paintings have been reduced to an almost purely decorative function and restricted to the most conventional spaces.[59] A seascape "chimney piece" covers the wall above the fireplace while three landscapes and a peasant interior, all of the same height, fill the empty surface above the golden leather. As in Francken's *Kunstkamer of Nicolaes Rockox*, the "chimney piece" is accentuated by a gilded frame, the most lustrous surface in the room, especially in contrast to the matte black strips of wood around the other pictures. It would have been easy to avoid looking closely at any of these paintings. They all hang above eye level and no obtrusive or loaded subjects, such as the dramatic *Samson and Delilah* or the *St. Jerome* in Francken's *Kunstkamer*, demand attention. Everything in this room is color-coordinated. Paul Vandenbroeck has observed in this and other paintings like it a subdued palette of brown, black, and burnished gold with a few accents of red and traces of blue.[60] A visit to the Meeting Room of the Brouwershuis in Antwerp, a nearly intact mid-seventeenth-century interior replete with golden leather, wood-beam ceilings, a gray marble fireplace, a gold-framed "chimney piece," and a bank of mullioned windows, should warn historians not to confuse a subdued palette with simplicity or spareness.[61] The effect produced, exaggerated in the setting of a corporate board room, is of understated luxury and also of a darkly luminous interior with sunlight alternately absorbed into deep hues of black, brown, and cool gray, and reflected by burnished surfaces of leather, gilded corbels, mirrors, and picture frame, to fill the space with a warm golden radiance. Van Tilborch's painting is similar and may display a fashion for decoration around 1670, as Francken's *Kunstkamer* does for 1635. There is, however, not enough corroborative evidence from inventories to justify taking van Tilborch's painting, or paintings like it, at face value as literal documents of middle-class interiors. It is not yet known whether the conventions of these paintings repeat schemata of genre and individual style, as do the kunstkamer paintings, or whether they reproduce the actual appearance of real rooms. At the very least, the repetition of constant elements such as the "chimney piece," colors of frames, and rows of landscapes above golden leather indicates the survival of customs from the early to the late seventeenth century.

In this essay I have given an overview of the contents, function, and appearance of middle-class collections in the Spanish Netherlands. Most of the evidence is concentrated on Antwerp because this city was the great center of production and therefore has attracted the lion's share of attention from art historians. It is not at all certain, however, that Antwerp's leading position as a center of production caused a real distinction in quantity and quality between private collections there and in other cities of the Spanish Netherlands and, on a larger scale, throughout Western Europe.

The 1,900-odd Antwerp inventories published thus far by Duverger do, nevertheless, give the impression of a cornucopia of art filled mostly with the city's own production. Muchembled's descriptions of luxury in Douai and Bourgeois's account of the decoration of homes in eighteenth-century Ghent suggest that this wealth spread throughout the Spanish Netherlands and lasted well into the eighteenth century. Pictures were collected avidly and used in many different ways; from wall decoration, to gambling chip, to devotional object. If Antwerp was typical, then there were more religious pictures in collections of the Catholic Spanish Netherlands than in collections of the Protestant North during the first half of the seventeenth century. It appears that collections North and South followed a major trend throughout the century towards secularization.

In recent years different writers have identified one or another "first cause" in social history as the fundamental explanation for the brilliant flowering of art and collecting in the Spanish Netherlands, above all in Antwerp. It could be that burghers collected art for the sake of investment and social prestige in a time of modest recovery below the level attained during Antwerp's rule as the great commercial power of the sixteenth century.[62] Or perhaps, in the face of lost

control over finance and commerce, which passed from the hands of Mediterranean Europe first to Antwerp, then to Amsterdam in the seventeenth century, and later to London, cultural activity provided a cheap form of compensation.[63] More simply, a system of production made more efficient by organized workshops and guilds and an export trade controlled by merchants with a wide network for distribution could have given Antwerp the edge in the market for luxury goods, including diamonds and harpsichords as well as painting, sculpture, books, and other kinds of art.[64] Producers and dealers consumed each other's goods in an environment of sophisticated taste, while merchants put on lavish displays of wealth. Maybe, on the other hand, explanations dependent on economic cause and effect – positive or negative – assume a relationship between art and money which never had the force of necessity or consequence. Might it not be political power which had the sole means to impose its will through innovation in art? If Antwerp's feeble political strength in the seventeenth century seemed to contradict this sweeping hypothesis, then it was easy to argue that the city's cultural efflorescence was forced from outside by the real powers of the Spanish government and the Catholic Church.[65] This hypothesis, however, perpetuates a view of the Spanish Netherlands that robs the middle-class of any initiative and turns every achievement into co-optation. Because they concentrate on production and collecting in Antwerp, all these explanations fail to explain the extraordinary popularity of painting in middle-class private collections throughout the South and North Netherlands. They are simplistic because they assume that culture is always dependent on some other more fundamental level of society: politics or economy. One should keep in mind Fernand Braudel's observation that culture has a slower and longer kind of existence in history than political or economic phenomena, and that culture is composed of spiritual as well as material elements.[66] Two developments are necessary to get the discussion beyond the stage of guessing at answers. First, more statistical studies along the lines of those accomplished by Montias for Delft and Amsterdam are needed to document collections in the Spanish Netherlands. Art historians need to integrate this kind of information with other innovative approaches to social history and with their own traditional methods such as iconography and the contextual criticism of works of art. Second, the relationship between art and society in the Spanish Netherlands has to be examined afresh, without the heavy burden of preconceptions built up over the last century.

* Grateful acknowledgement is due to Arnout Balis, Troy Moss, and Peter Sutton, who all gave me help in writing this essay. Research was conducted as part of a larger project on the history of Counter-Reformation art in Antwerp, supported by a National Endowment for the Humanities Fellowship for University Teachers.

1. As observed by David Freedberg in this catalogue.

2. An impressive model for this kind of study is A. Lottin, *Lille citadelle de la Contre-Réforme? (1598-1668)* (Dunkirk, 1984). Lottin uses a wide range of archival and printed sources to demonstrate how the Counter Reformation worked within the complex structure of urban life at all levels of society. A. K. L. Thijs, *Van Geuzenstad tot katholiek bolwerk: Maatschappelijke betekenis van de Kerk in contrareformatorisch Antwerpen* (Turnhout, 1990), has applied this kind of broad social approach to the history of Counter Reformation Antwerp in which he charts the crucial role played by visual images. Especially valuable is his discussion of popular devotional prints and of prayer sheets – *suffragia* – used by Marian sodalities. A searching overview of iconography and style in the paintings of Counter Reformation Antwerp is given by Frans Baudouin, 1989, pp. 329-365.

3. De Poorter 1988, pp. 202-252. Also see J. Vervaet, "Catalogus van de altaarstukken van gilden en ambachten uit de Onze-Lieve-Vrouwekerk van Antwerpen en bewaard in het Koninklijk Museum," *Jaarboek van het Koninklijk Museum voor Schone Kunsten, Antwerpen* (1976), pp. 197-244.

4. An important change in this regard is gradually taking place through the publication of some inventories and other documents of property belonging to Antwerp guilds in Duverger 1984-; 6 vols. to date.

5. See the recent survey of the functions of history painting in seventeenth-century Flemish cities by Hans Vlieghe, "Maatwerk en confectie," in Brussels/Schallaburg 1991, pp. 255-268.

6. De Maeyer 1955.

7. Recently, however, G. Rooijakkers, "Opereren op het snijpunt van culturen: Middelars en media in Zuid-Nederland," in *Cultuur en maatschappij in Nederland 1500-1850*, eds. P. te Boekhorst, P. Burke, and W. Frijhoff (Boom, 1992), p. 272, has discussed the use of religious prints as talismans among country folk during the eighteenth century. Also see J. Weyns, *Volkshuisraad in Vlaanderen: naam, vorm, geschiedenis, gebruik en volkskundig belang der huiselijke voorwerpen in het Vlaamse land van de middeleeuwen tot de eerste wereldoorlog*, 4 vols. (Beerzel, 1974), vol. 2, pp. 781-822.

8. See A. van der Woude, "The Volume and Value of Paintings in Holland at the Time of the Dutch Republic," in *Art in History: History in Art: Studies in Seventeenth-Century Dutch Culture*, eds. D. Freedberg and J. de Vries (Santa Monica, 1991), p. 294, who concludes that 90 percent of the pictures extant in Holland around 1700 were lost by 1800. W. Brulez, *Cultuur en getal: aspecten van de relatie economie-maatschappij-cultuur in Europa tussen 1400 en 1800* (Amsterdam, 1986), p. 55, gives no statistical evidence for his assumption that 1 percent survives of all paintings produced between 1400-1800.

9. The closest is the Meeting Room (Vergaderzaal) of the Brewers' House (Brouwershuis) in Antwerp. This room has much in common with what is known to have existed in the best rooms of the wealthiest Antwerp citizens. The public and corporate function of the Brouwershuis required greater luxury (marble tiled floor) than was normal in private homes: see F. Smekens, *Het Brouwershuis*, Stad Antwerpen Oudheidkundige Musea (Antwerp, 1982).

10. See A. van der Woude and A. Schuurman, eds. *Probate Inventories: A New Source for the Historical Study of Wealth, Material Culture and Agricultural Development* (Utrecht, 1980).

11. For a well-balanced assessment of the value of group portraits as visual evidence for the reconstruction of seventeenth-

century middle-class domestic interiors, see P. Vandenbroeck, "De 'salette' of pronkkamer in het 17de-eeuwse Brabantse burgerhuis. Familie- en groepsportretten als iconografische bron, omstreeks 1640-1680," *Monumenten en Landschappen* 9, no. 6 (1990), pp. 41-62. Paintings of kunstkamers or art galleries will be discussed below.

12. See J. M. Montias, *Artists and Artisans in Delft: A Socio-Ecomonic Study of the Seventeenth Century* (Princeton, 1982), pp. 220-271; idem, "Works of Art in Seventeenth-Century Amsterdam. An Analysis of Subjects and Attributions," in *Art in History: History in Art: Studies in Seventeenth-Century Dutch Culture*, eds. D. Freedberg and J. de Vries (Santa Monica, 1991), pp. 331-372; P. Benedict, "Towards the Comparative Study of the Popular Market for Art: The Ownership of Paintings in Seventeenth-Century Metz," *Past and Present* 109 (1985), pp. 100-117; I. Bourgeois, "Dekoratieve voorwerpen en binnenhuisversiering te Gent in de 18de eeuw: vloer- en wandbekleding, gordijnen, schilderijen, spiegels," *Oostvlaamse Zanten* 63 (1988), pp. 81-97.

13. Benedict 1985, pp. 105-106.

14. Bourgeois 1988, pp. 89-93.

15. Montias 1982, p. 200, notes b and c.

16. Duverger 1984-, 6 vols. to date.

17. K. Van der Stighelen, "Burgers en hun portretten," in Brussels/Schallaburg 1991, pp. 141-156.

18. Duverger 1984-, vol. 1 (1984), pp. 3-212; vol. 5 (1991), pp. 57-489; vol. 6 (1992), pp. 3-393.

19. Montias 1982, pp. 238-246, table 8.3 on p. 242.

20. Bourgeois 1988, p. 93.

21. Benedict 1985, p. 109.

22. See Baetens 1976, vol. 1, p. 280, for an introduction to the socio-economic position of this group.

23. R. Muchembled, "Luxe et dynamisme social à Douai au 17e siècle," in *Nouvelles approches concernant la culture de l'habitat/New Approaches to Living Patterns*, colloque International/International Colloquium, Université d'Anvers/24-25. 10. 1989/University of Antwerp, eds. R. Baetens and B. Blondé (Turnhout, 1991), p. 199.

24. Montias 1982, pp. 230-238.

25. Muchembled 1991, p. 200, notes that in 95 out of the 216 probate inventories that form the basis of his study of luxury in Douai from 1613 to 1668 only one room is mentioned.

26. Duverger 1984-, vol. 2 (1985), pp. 333-334, no. 483.

27. Brulez 1986, p. 68, gives a breakdown of prices for pictures in the Antwerp art trade, basing his figures on a random selection of one out of every three pictures listed in J. Denucé's publications of the records of two major Antwerp art dealers, Musson and Forchoudt (Denucé 1931; idem, 1949). In the sample of 1,947 pictures, 39 percent cost less than five guilders; 37.8 percent between five and twenty guilders; 18.2 percent between twenty and one-hundred guilders; 5 percent one-hundred or more guilders. Prices varied according to attribution and subject matter.

28. Duverger 1984-, vol. 2 (1985), pp. 475-477, no. 578.

29. Baetens 1976, vol. 1, pp. 122-123, for references to members of all these families active in the Antwerp silver and tapestry trades.

30. See R. Fabri, "De 'inwendighe wooningh' of de binnenhuisinrichting," in Brussels/Schallaburg 1991, pp. 128-131.

31. See E. Schreurs, "Klanken in de stad," in Brussels/Schallaburg 1991, p. 164; also Karel Moens in same, p. 464, cat. no. 227.

32. Sir Henry Wotton, *The Elements of Architecture*, ed. Frederick Hart (London, 1624); reprint ed. Charlottesville, 1968, p. 98.

33. Sir William Sanderson, *Graphice. The Use of the Pen and Pensil* (London, 1658), p. 26.

34. Duverger 1984-, vol. 5 (1991), pp. 10-39, no. 1212.

35. Wotton 1624, pp. 99-100.

36. As in Gio. Battista Armenini, *De' veri precetti della pittura* (1587); reprint ed. Hildesheim and New York, 1971, p. 175; Gian Paolo Lomazzo, *Trattato*, in *Scritti sulle arti*, ed. R. P. Ciardi, 2 vols. (Florence, 1973-1974), vol. 2, p. 299; G. Mancini, *Considerazioni sulla pittura*, introd. L. Venturi, eds. A. Marucchi and L. Salerno, 2 vols. (Rome, 1956-57), vol. 1, p. 143. See Muller 1989, pp. 40-43, for a more extended discussion of these sources.

37. Mancini 1956-57, vol. 1, p. 143; Lomazzo 1973-74, vol. 2, p. 299.

38. Sanderson 1658, pp. 26-27.

39. Different Antwerp words for country house are listed by R. Baetens, "La 'Belezza' et la 'magnificenza': Symboles du pouvoir de la villa rustica dans la région Anversoise aux temps modernes," in *Nouvelles approches concernant la culture de l'habitat/New Approaches to Living Patterns*, Colloque International/International Colloquium, Université d'Anvers/24-25. 10. 1989/University of Antwerp, ed. R. Baetens and B. Blondé (Turnhout, 1991), p. 164.

40. For other Antwerp kitchens with kitchen paintings, see Duverger 1984-, vol. 1 (1984), p. 17, no. 7; p. 127, no. 67; p. 162, no. 77; p. 167, no. 82; p. 187, no. 100; p. 239, no. 145; p. 296, no. 178; p. 315, no. 185; p. 328, no. 195; p. 364, no. 225; p. 390, no. 247; p. 395, no. 249; p. 465, no. 254; p. 477, no. 259; p. 484, no. 266; vol. 2 (1985), p. 30, no. 297; p. 34, no. 300; p. 49, no. 315; p. 54, no. 317; p. 63, no. 324, and many more examples. For downstairs rooms with portraits of kings, see Duverger 1984-, vol. 1 (1984), p. 142, no. 69; p. 159, no. 74; p. 187, no. 100; p. 346, no. 209; p. 462, no. 254; p. 476, no. 258; p. 478, no. 259; vol. 2 (1985) p. 215, no. 400; p. 294, no. 453; p. 302, no. 456; p. 435, no. 546; p. 440, no. 548 and other examples. Van der Stighelen 1991, p. 146, notes that portraits were hung in the most important ground floor rooms of Antwerp middle-class households.

41. See Muchembled 1991, p. 198, who interprets possessions of luxury as a "silent discourse" of self-representation addressed to others.

42. Baetens 1976, vol. 1, p. 281.

43. Brulez 1986, p. 68.

44. Baetens 1976, vol. 1, p. 298, perceives frequent wagering as one of the most characteristic expressions of the speculative instinct of the Antwerp merchant class.

45. Fabri 1991, p. 138, makes this argument, but does not provide enough evidence to clinch it.

46. Duverger 1984-, vol. 3 (1987), p. 69, no. 619.

47. See F. Peeters, *Sint-Augustinus kerk te Antwerpen* (Antwerp, n.d.), pp. 170-176.

48. See Speth-Holterhoff 1957; M. Winner, "Die Quellen der Pictura-Allegorien in gemalten Bildergalerien des 17. Jahrhunderts zu Antwerp," diss. Cologne, 1957; Müller Hofstede 1984, pp. 243-289; Filipczak 1987; E. Mai, "Pictura in der 'constkamer' – Antwerpens Malerei im Spiegel von Bild und Theorie," in Cologne/Vienna 1992-93, pp. 171-182.

49. See Vandenbroeck 1990.

50. See Ursula Alice Härting, *Studien zur Kabinettbildmalerei des Frans Francken II. 1581-1642: Ein repräsentativer Werkkatalog* (Hildesheim, Zurich, and New York, 1983), pp. 162-164 and cat. no. A 381; R. W. Scheller, *Nicolaas Rockox als oudheidkundige* (Antwerp, 1978); Filipczak 1987, pp. 58-59; Muller 1989, p. 41, note 89.

51. Duverger 1984-, vol. 4 (1989), pp. 382-387, no. 1130, 19-20 December 1640.

52. See Baetens 1976, vol. 1, p. 289, for an estimate of Rockox's wealth; p. 280, on Rockox's street, the Keizerstraat; pp. 308-309, on Rockox's position in the city government.

53. Scheller 1978. Also see Baetens 1976, vol. 1, p. 298, who argues that Rockox's considerable library was another sign of his elite position.

54. See C. Brown, *Rubens "Samson and Delilah,"* Acquisition in Focus, The National Gallery, London, 1983.

55. Francken included a *Penitent St. Jerome* by Jan Sanders van Hemessen, pendant *Heads of Christ and the Virgin*, and a number of sculptures which actually were displayed in an adjacent room, "de Camer achter 't groot Salet," and in Rockox's office ('t comptoir). On the other hand, most of the paintings recorded as hanging in the "groote Saleth" are missing.

56. Duverger 1984-, vol. 5 (1991), p. 140, no. 1282, inventory of Sibylla van Uffels, 28 January 1644: "Een schilderye schouwstuck van Joos de Momper van Emaüs," one of many examples.

57. In the "Saele" of the house of Gabriël van Mechelen there hung "Een schilderije voor de schouwe wesende Poëterije op panneel geschildert met dobbel vergulde lijst." The four other pictures in the room were displayed in simpler frames: see Duverger 1984-, vol. 5 (1991), p. 151, no. 1292, 31 March 1644.

58. Duverger 1984-, vol. 6 (1992), p. 476, no. 1902: "In de groote

Neercamer: Seven schilderijen wesende Lantschappen staende boven de goude leiren van Momper;" also see Duverger 1984-, vol. 5 (1991), p. 125, no. 1268, inventory of Hendrik Sinteleer, 30 September 1643; in the "Salette voor aen Straete: Thien Lantschapkens staende boven de goude leiren."

59. For a detailed description of this picture see Vandenbroeck 1900, p. 46; also his catalogue entry in Brussels/Schallaburg 1991, p. 460, no. 223.

60. Vandenbroeck 1990, p. 59.

61. For the Brouwershuis, see above, note 9.

62. My explanation (Muller 1989, pp. 56-57), based on analogy with Robert S. Lopez's analysis of culture in Quattrocento Florence: "Hard Times and Investment in Culture," in *The Renaissance: Six Essays* (New York, 1962), pp. 29ff.

63. This is the cause of cultural efflorescence proposed by F. Braudel, *Civilisation matérielle, économie et capitalisme, XVe-XVIIe siècle*, 3 vols. (Paris, 1979), vol. 3, pp. 52-53. He notes that while Amsterdam triumphed in the seventeenth century, Rome was the center of baroque style which pervaded Europe. This strangely ignores the brilliant and original painting produced in Holland.

64. This is my extrapolation from Baetens 1976, vol. 1, pp. 111-134, who stresses the importance of export industries, including luxury goods such as painting, for Antwerp's revived prosperity. J. de Vries, "Art History," in *Art in History: History in Art: Studies in Seventeenth-Century Dutch Culture*, ed. D. Freedberg and J. de Vries (Santa Monica, 1991), pp. 265-266, cites the economic organization of some Dutch cities as the reason for their dominance in production of painting.

65. Brulez 1986, pp. 13-20, effectively challenges explanations of cultural innovation based on economic conjuncture, proposes the alternative theory of political power, and offers the rationalization for Antwerp.

66. Braudel 1979, vol. 3, p. 52.

The Age of Rubens

Catalogue of the exhibition

Authors of Catalogue Entries

PETER C. SUTTON	PCS
MARJORIE E. WIESEMAN	MEW
ANNE T. WOOLLETT	ATW
LAWRENCE W. NICHOLS	LWN

Hendrick van Balen

(1575-Antwerp-1632)

Hendrick van Balen was born in Antwerp in 1575. According to van Mander, he was a pupil of Adam van Noort (1562-1641), although this cannot be confirmed in guild records. Van Balen joined the Antwerp guild of St. Luke in 1592-1593. He apparently made a trip to Italy sometime prior to 1604; he is assumed to have come in contact with the German painter Hans Rottenhammer (1564-1625) in Venice, because of the similarity in their works. Van Balen was back in Antwerp by 1602. On 11 September 1605 he married Margareta Briers (d. 1638), by whom he had eleven children: three sons (Jan [1611-1654], Gaspar, and Hendrick II [1620-before 1638]) became painters, and their daughter Maria married the painter Theodoor van Thulden (q.v.) in 1635.

Van Balen owned a large house on the Lange Nieuwestraat in Antwerp. He served as dean (*deken*) of the guild of St. Luke in 1609-1610, and as Dean of the Society of Romanists in 1613; membership in the latter was restricted to persons who had traveled to Rome. Also in about 1613 he traveled on a diplomatic mission to the Northern Netherlands in the company of Rubens and Jan Brueghel the Elder (qq.v.), where he made the acquaintance of Hendrick Goltzius and other Haarlem artists. Van Balen died in Antwerp on 17 July 1632 and was buried in the St. Jacobskerk. His elaborate marble tomb was designed by the sculptor Andries Colijns de Nole (1598-1638), and is surmounted by a *Resurrection* painted by van Balen himself.

Primarily known as a painter of intimate cabinet pictures illustrating histories, allegories, and mythological scenes, van Balen also painted some large-scale works and in 1620-1621 designed a window (now destroyed) for the south transept of the Onze-Lieve-Vrouwekerk in Antwerp. His early works are sinuous and highly colored mannerist compositions; after about 1610, however, his work was influenced by Rubens's more robust style, which he interpreted in a lighter, more decorative mode. He frequently collaborated with other Antwerp painters, supplying figural accents for landscapes and floral garlands by Jan Brueghel the Elder and the Younger (1601-1678), Joos de Momper (q.v.), and Gaspar de Witte (1624-1681). His studio was one of the largest and most active in Antwerp. The registers of the St. Luke's Guild record twenty-six pupils from 1604, among them Anthony van Dyck, Frans Snyders (qq.v.), Andries Snellinck (1587-1653), and Justus Sustermans (1597-1681).

Van Mander 1604, fol. 208a; de Bie 1661, p. 100; Houbraken 1718-21, vol. 1 (1718), p. 81; Weyerman 1729-69, vol. 1 (1729), p. 349; Descamps 1753-64, vol. 1 (1753), p. 237-239; Immerzeel 1842-43, vol. 1 (1842), pp. 26-27; Kramm 1857-64, vol. 1 (1857), p. 49; Michiels 1865-76, vol. 7 (1869), pp. 253-268; Rombouts, van Lerius 1872, passim; van Lerius 1880-81, vol. 2, pp. 235-337; van den Branden 1883, pp. 463-467; Wurzbach 1906-11, vol. 1 (1906), pp. 48-49; Donnet 1907, pp. 20-21, 96-98, 101-102, 138-139, 162, 176, 203, 337, 357, 379-380, 418, 428; Thieme, Becker 1907-50, vol. 2 (1908), pp. 406-407; Pelzer 1916, passim; Dilis 1922, p. 456; Vaes 1926-27, pp. 209-211, 213-216; Gerson, ter Kuile 1960, pp. 60, 62, 63, 67, 112, 143; Jost 1963; Legrand 1963, pp. 49-57; Brussels 1965, p. 10; de Mirimonde 1966a; Bodart 1970, vol. 1, p. 66, vol. 2, p. 9; Ertz 1979, passim; Freedberg 1981; Díaz Padrón 1983; Müllenmeister 1983; Díaz Padrón 1984; Ertz 1984, passim; Härting, Müllenmeister 1988; Cologne/Vienna 1992-93, pp. 305-307.

Paulus Pontius after Anthony van Dyck, *Hendrick van Balen*, engraving, from the *Iconography*.

Jan Brueghel the Elder

(Brussels 1568-Antwerp 1625)

Anthony van Dyck, *Jan Brueghel the Elder*, etching.

The second son of the famous peasant painter, Pieter Bruegel the Elder (before 1525-1569), Jan Brueghel was born in Brussels in 1568. According to van Mander he was a pupil of Pieter Goetkindt (d. 1583) in Antwerp, although this claim is not confirmed by documents. At about the age of twenty-one he made the traditional voyage to Italy, stopping along the way in Cologne where his sister lived. He arrived in Italy around 1589 and is documented as decorating a clock in Naples in 1590. His earliest works known to us were executed in 1592-1594 in Rome, where he was patronized by Cardinal Ascanio Colonna, who also employed Rubens's brother Philip. In Rome he undoubtedly met the landscapist Paulus Bril (q.v.) and the two had an important reciprocal influence on one another.

In 1595-1596 he was in Milan where he won the favor of the great collector Cardinal Federigo Borromeo, for whom he executed paintings throughout his career. The correspondence between the two (first published by Crivelli, 1868) offers important insights into Brueghel's art. By October of 1596 he had settled back in Antwerp. The following year he became a master. In 1601 he became a citizen and the following year was named dean of the guild. On 23 January 1599 he married Elisabeth de Jode, who on 13 September 1601 bore his first son, Jan the Younger, who also became an artist. Elisabeth died in 1603, perhaps while giving birth to their daughter, Paschasia, who subsequently married the painter Jan van Kessel (q.v.). Jan remarried in 1605 to Catherine de Marienbourg, who bore him eight additional children.

The artist traveled to Prague in 1604 and to Nuremburg in 1606. The remainder of his career was determined by his appointment in 1606, like Rubens, as a (non-resident) painter to the court of Archdukes Albert and Isabella Clara Eugenia in Brussels. Residing in Antwerp during these years, Jan became close friends and collaborated with not only Rubens (who served as his amanuensis in his letters to Cardinal Borromeo), but also Joos de Momper the Younger, Hendrick de Clerck, Hendrick van Balen, and Sebastian Vrancx (qq. v.).

Around 1613 he was sent with Rubens and van Balen on an official mission to the United Provinces of the Northern Netherlands, a trip which resulted in fruitful artistic cross-fertilization but most benefited the Northern artists who were strongly influenced by Brueghel's landscapes. Attesting to Brueghel's fame, Johann Wilhelm Neumyr's description of Ernest of Saxony's visit to Antwerp in February of 1614 notes the nobleman's eager pursuit of the works by the city's two "eminent" painters, Rubens

and Jan Brueghel. In 1615, the Antwerp authorities further honored the painter by presenting four of his works to the regents of Brussels who were making an official visit to the city. Although Jan's only documented student was Daniel Seghers (q.v.), he had many imitators including Jan Brughel the Younger who can come very close to his style. The artist died in Antwerp on 25 January 1625, the victim of an outbreak of cholera that also killed three of his children.

One of the most successful and celebrated Flemish artists of his day, Jan Brueghel was a specialist in landscape and still life, earning the sobriquet "Velvet [de Velours] Brueghel" for his subtly detailed and delicate record of surfaces. Often he filled his compositions with a wealth of incident and decorative minutiae, however, he also was strongly committed to naturalistic observation and made a lasting contribution to the rise of realistic landscape and still-life painting. In addition to the latter subjects, Brueghel executed, often in his miniaturist style, history subjects, including mythological and religious scenes, and allegories (the Five Senses, Four Elements, etc.) as well as fanciful hell scenes.

Van Mander 1604, fol. 234; de Bie 1661, p. 89; Duvivier 1860; Crivelli 1868; van den Branden 1883, pp. 312-313, 374, 444-445, 648, 651-652; H. Hymans in Thieme, Becker 1907-50, vol. 5 (1911), pp. 98-99; Vaes 1926-27, passim; Glück 1933, pp. 256, 354-356, 403, 417; van Puyvelde 1934; Denucé 1934; Combe 1942; Puyvelde 1950, pp. 76, 180-183, 210; Sterling 1952, pp. 43, 51-52, 55, 61, 104; Thiéry 1953; de Maeyer 1955, pp. 144-159; Bergström 1956, pp. 50, 65-66, 109, 196, 206, 208, 274; Hairs 1957; Speth-Holterhoff 1957, pp. 51-60; Gerson, ter Kuile 1960, pp. 56-61; Winner 1961; Nemitz 1963; Hairs 1964; Brussels 1965, pp. 21-26; Franz 1969; Winner 1972; Schreiner 1975; Gerszi 1976; Paris 1977-78, pp. 49-55; London 1979; Ertz 1979; Brussels 1980, pp. 165-225; Ertz 1984, passim; Müller Hofstede 1984; Ertz 1986, p. 392; Härting 1989, p. 158 and passim; Brenninkmeyer-de Rooij 1990; Cologne/Vienna 1992-93, pp. 283-285, 310-313, 438-439.

Hendrick van Balen and Jan Brueghel the Elder
1. The Banquet of the Gods

Oil on copper, 29.5 x 41.3 cm (11 ⅝ x 16 ¼ in.)
Signed lower left: V BAL..
Private collection, Switzerland

PROVENANCE: Galerie Edel, Cologne.

IN A SMALL forest clearing, gods and goddesses cluster about a table laid with food and sumptuous tableware. At the head of the table is Jupiter, wearing a small crown; behind and to the right stands Mercury, identifiable by his winged cap. At the right, and in the shadowy foreground area extending from the left edge of the composition, serving women and putti ferry jugs of wine, and baskets and bowls of fruit to the table. At the left, the dense foliage parts to admit a ghostly glimpse of figures bringing additional contributions to the banquet. Chubby putti circle overhead, scattering flowers over the assembled company.

The Banquet of the Gods – as well as more narrowly defined pretexts for divine gatherings, such as the Marriage of Peleus and Thetis, the Marriage of Bacchus and Ariadne, the Feast of Acheloüs, and the Feast of Odysseus and Calypso – was an especially popular theme for cabinet-sized mythological paintings in the late sixteenth and early seventeenth centuries.[1] Van Balen was particularly drawn to the subject in all its permutations during the 1600s and 1610s, and the many dated examples permit an accurate reconstruction of the development of the theme in the early years of the artist's career.

The slim, gracefully proportioned figures in van Balen's work of the first decade of the 1600s are clearly indebted to works by Hendrick de Clerck and Hans Rottenhammer, although his palette is subtler and more luminous than the bold primary colors affected by the latter. In the present painting, the blossom-wielding putti hovering overhead and the contre-jour figure of the woman seen from the rear carrying a jug are the most conspicuous remnants of Rottenhammer's legacy.[2] The Banquet of the Gods can be dated to about 1608 or slightly later.[3] In his earliest interpretations of the theme, van Balen placed the banqueting table in the immediate foreground and parallel to the picture plane; in later works, the table is shifted further back in the compositional space, and viewed from behind a darkened repoussoir of figures silhouetted against a brightly lit mid-

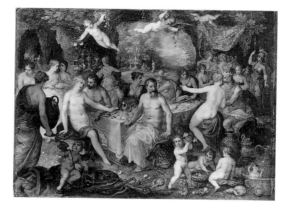

Fig. 1. Hendrick van Balen and Jan Brueghel the Elder, Banquet of the Gods with the Marriage of Peleus and Thetis, ca. 1606-1607, oil on copper, 34.5 x 46.5 cm, Copenhagen, Statens Museum for Kunst, inv. Sp. 225.

dleground. The foreground space is increasingly devoted to lavish still-life displays, often painted by Jan Brueghel the Elder; compare the artist's more elaborate Marriage of Peleus and Thetis in Copenhagen (fig. 1). A number of figural motifs recur with minor variations throughout van Balen's mythological œuvre; the woman carrying a jug and the parenthetically posed nude women seated at the table find corollaries in many of his compositions.

Van Balen collaborated frequently with Jan Brueghel from at least 1604 (Ceres with the Four Elements, dated 1604, Vienna, Kunsthistorisches Museum, inv. 815) until the latter's death in 1625. In fact, the two artists were neighbors in the Lange Nieuwstraat in Antwerp and Brueghel and his wife were godparents to two of van Balen's children.[4] In paintings executed jointly by the two artists, van Balen painted the figures and Brueghel contributed the landscape background and still-life elements. In the present painting, Brueghel's hand can be recognized in the coloristic harmony of the landscape, and the delicate brushwork that amply describes forms without becoming fussy or pedantic.

MEW

1. On the Banquet of the Gods generally, see: H. Bardon, Le festin des dieux. Essai sur l'humanisme dans les arts plastiques (Paris, 1960); more specifically on the theme in works by van Balen and his circle, see Jost 1963, pp. 95-101ff; Ertz 1979, pp. 407-415; and A. de Bosque, Mythologie et maniérisme aux Pays-Bas 1570-1630, peinture – dessins (Antwerp, 1985), pp. 209-220.

2. The relationship between Rottenhammer and van Balen is discussed in Jost 1963, pp. 102-115; see also Pelzer 1916, passim.

3. The lack of dated paintings by the artist between 1608 and 1616 makes a precise chronology difficult; see Jost 1963, p. 120.

4. Jost 1963, p. 94, note 60.

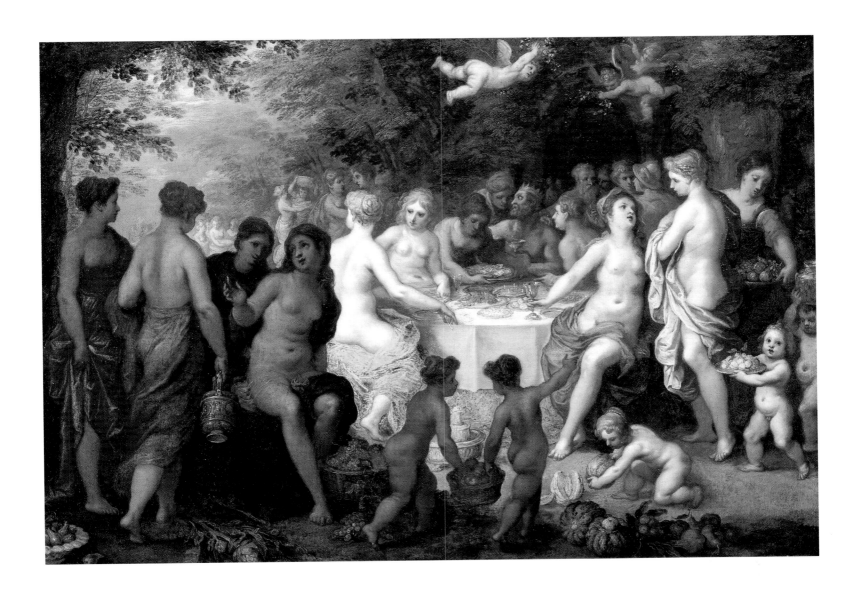

Hendrick de Clerck

(ca. 1570-Brussels-1630)

Hendrick de Clerck was born in Brussels about 1570. He was a pupil of the prolific late-mannerist painter Marten de Vos (1532-1603) in Antwerp, and possibly also of Joos van Winghe (1544-1603) in Brussels. Terlinden suggested that de Clerck may have traveled to Italy in his youth, although there is no documentation for such a trip. From as early as 1590 de Clerck painted altarpieces and other works for churches in Brussels (most notably Notre Dame de la Chapelle) and environs; his compositions and figural types are clearly influenced by de Vos and Frans Floris (1519/20-1570). His work was much in demand, and he seems to have been financially successful as well. De Clerck was active as court painter to Archduke Ernest, governor of the Netherlands, from 1594 until 1595. On 4 June 1596, Ernest's brother, Emperor Rudolph II of Prague, wrote a letter to the newly appointed Archduke Albert (no doubt at de Clerck's request) recommending the artist's services. De Clerck is first documented in the archdukes' employ in 1606. De Clerck was buried in the Church of Saint-Géry in Brussels on 27 August 1630; his widow survived him by more than a decade, dying on 14 October 1641. De Clerck's son Jacob was also a painter, and became a master in the Brussels guild of St. Luke on 10 January 1634.

In addition to large-figured religious works, de Clerck also executed cabinet pictures with mythological and historical themes. Many were done in collaboration with other artists, such as Denijs van Alsloot (ca. 1580-1628) or Jan Brueghel the Elder (q.v.), who contributed the landscape and still-life elements. In contrast to the powerfully muscled figures which characterize his large religious works, the figures in de Clerck's mythological paintings are graceful, elegant, and decorative, reminiscent of similar late-mannerist compositions by Hendrick van Balen (q.v.) or Hans Rottenhammer. These compositions generally date from the period after his appointment as court painter to the archdukes.

De Bie 1661, p. 163; Houbraken 1718-21, vol. 1, p. 221; Weyerman 1729-69, vol. 2 (1729), p. 12; Descamps 1769, passim; Kramm 1857-64, vol. 3 (1859), pp. 876-877; Michiels 1865-76, vol. 5 (1868), pp. 433ff; Neefs 1876, vol. 2, p. 453; Pinchart 1878, pp. 293, 303; de Bruyn 1879; von Frimmel 1891, pp. 125ff, 215-216, 319, 322; von Frimmel 1904a; Wurzbach 1906-11, vol. 1 (1906), p. 287; E. Plietzsch, in Thieme, Becker 1907-50, vol. 7 (1912), pp. 85-86; van Tichelen 1932; Terlinden 1952; de Maeyer 1955, pp. 84-89 and passim; Laureyssens 1966; Laureyssens 1967; Madrid, Prado, cat. 1975, pp. 77-81; Madrid 1977-78, pp. 35-36; Ertz 1979, pp. 513-514; Laureyssens 1985-88.

Hendrick de Clerck and Jan Brueghel the Elder
2. *A Fantastic Cave Landscape with Odysseus and Calypso*

Oil on copper, 34.6 x 49.5 cm (13 ½ x 19 ½ in.)
Mrs. H. John Heinz III

PROVENANCE: collection Adolphe Schloss, Paris, by 1926 [as by Jan Brueghel the Younger, "L'île enchantée"][1]; sale A. Schloss, Paris (Charpentier), 5 December 1951, no. 10 [as Hendrick de Clerck and Cornelis van Dalem; frs. 1,100,000]; private collection, France.

IN THE SHELTER of a grotto bridging land and sea, the nymph Calypso enlists the myriad treasures of both worlds, as well as her own considerable charms, to ensnare and captivate the stalwart Greek hero Odysseus.[2] The lovers embrace in the foreground of the scene; at their feet, by steps leading to a shallow pool, is an oriental carpet heaped with discarded finery, a jewel casket, mirror, and other toilet articles. To the left of the couple is an abundant selection of the earth's bounty. A beribboned lapdog and a mischievous monkey face off over a pile of fruits; a guinea pig and a tortoise explore the terrain in a more leisurely fashion. A variety of flowering and fruit-bearing plants grow in pots and on the ground; above, an apple tree and grapevine flourish amicably entwined, home to a parrot, a peacock, and several smaller birds. In the distance is a formal garden. Treasures of the aquatic world dominate the right half of the composition. Mollusks and crustaceans seem to swim out of the water and onto a plate. The arching grotto walls are thickly encrusted with shells, branches of coral, and bits of seaweed; trees and vines take root in the rocks above. Thin ribbons of water cascade from crevices; further back in the cave a woman collects water in a basin. In the distance is a view of a rocky coastline.

Behind the figures of Odysseus and Calypso, preparations are being made for a feast: on the right, a lavish display of metalware (including a salver depicting Perseus and Andromeda), a wine cooler and wine glasses; a table being laid with delicacies on the left. In the distance, two women cook over an open fire. Up a few steps to the left is a smaller chamber with improbably angular walls housing a loom, a table with books, and a small chest; on the walls are a lute, a mirror, and a clock.

This minutely detailed copper is the joint product of Hendrick de Clerck, who painted the figures, and Jan Brueghel the Elder, who executed the grotto and the encyclopedic array of still-life elements. The two artists collaborated occasionally between ca. 1606 and 1609, when both were employed at the court of the archdukes in Brussels.[3] As in works painted by de Clerck and his more frequent collaborator Denijs van Alsloot,[4] the balance of figures to landscape (and the relative contribution of each artist) is different in each of these works. In the *Allegory of Abundance, with the Four Elements* by Brueghel and de Clerck in the Prado (Madrid, inv. 1401), for example, the voluptuous nude figures take prece-

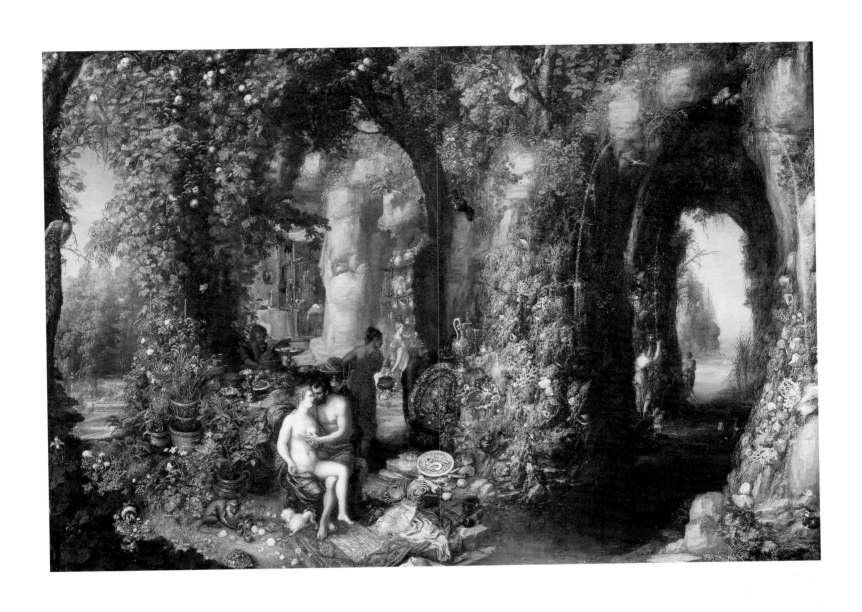

dence, whereas in the *Diana and Actaeon* (Prague, Národní Galerie), the staffage is dwarfed by the extensive landscape.

The literary subject, sensuous nudes, and exotic setting of the tale of Odysseus and Calypso was ideally suited to the meticulously crafted format of the small cabinet painting, prized by sophisticated collectors for its refined execution and endless variety of detail. Other subjects popular in the first decades of the seventeenth century, and also offering ample opportunity for encyclopedic display, included the Banquet of the Gods (see cat. 1) and the related theme of the Feast of Acheloüs (see fig. 1), and allegories of the Four Elements[5] or Five Senses. A significant number of these paintings were the work of two or more artists, showing each specialized talent to its best advantage and creating a "kunstkamer" in microcosm. In a *Feast of Odysseus and Calypso* in the Akademie der bildende Künste, Vienna, for example (fig. 2), Joos II de Momper painted the craggy forms of the landscape and grotto, Jan Brueghel the animals and still-life elements, and Hendrick van Balen the figures.[6]

Formally and thematically the Vienna painting has much in common with the present work. In both paintings, the immediate foreground is reserved for a wealth of still-life elements, with the figures pushed more to the middle- and background. In contrast to Gerard de Lairesse's later interpretation of the theme of Odysseus and Calypso (cat. 132), both de Clerck and van Balen focused on preparations for an elaborate banquet, an aspect of the narrative stressing a concentration of minute detail, rather than the dramatic action of Hermes' arrival to interrupt the lovers' idyll. Although de Clerck's early figure types are more closely allied to the works of Marten de Vos and Frans Floris, his later mythological paintings (after about 1600), like those of van Balen, were influenced by the elegant mannerist figure types of Hans Rottenhammer (1564-1625). De Clerck's figures tend to be slimmer and less anatomically defined than those by van Balen, however.

The attribution of the landscape in *Fantastic Cave Landscape with Odysseus and Calypso* in the 1951 catalogue of the Schloss sale to Cornelis van Dalem (ca. 1528-ca. 1575) is untenable both stylistically and chronologically. Although van Dalem also painted grotto scenes, his are highly artificial creations, populated with insignificant, wraithlike figures.

MEW

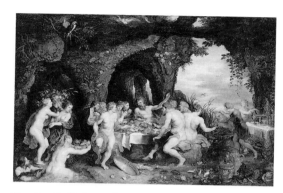

Fig. 1. Peter Paul Rubens and Jan Brueghel the Elder, *The Feast of Acheloüs*, oil on panel, 107.9 x 163.8 cm, New York, The Metropolitan Museum of Art, inv. 45.141.

Fig. 2. Joos de Momper, Hendrick van Balen, and Jan Brueghel the Elder, *Feast of Odysseus and Calypso*, oil on panel, 80 x 115 cm, Vienna, Akademie der bildende Künste, inv. 583.

1. C. Brière-Misme, ms. catalogue of the Schloss collection (1926), in the Frick Art Reference Library, New York.

2. See cat. 132 for the story of Odysseus's seven-year visit with Calypso on the island of Ogygia.

3. Ertz 1979, pp. 513-514; see also de Maeyer 1955, p. 89; and Terlinden 1952, pp. 105-106. A painting by de Clerck and Brueghel of the Feast of Acheloüs was listed in the 1682 inventory of the estate of Diego Duarte in Antwerp: "Een raer stuck vol figuren daer Theseus van Achilous getracteert wort in een spelonke. De figuren van de Clerck, heel curieuse ende den gront, verschiet en alle het bijwerck van den fluweelen Bruegel. gld. 240."

4. On the collaboration of de Clerck and Alsloot, see Laureyssens 1967.

5. In addition to the *Allegory of Abundance with the Four Elements* in the Prado (inv. 1401), de Clerck executed a related painting of *Paradise* (*Allegory of the Four Elements with the Creation of Man*) in collaboration with Denijs van Alsloot, ca. 1607 (Munich, Alte Pinakothek, inv. 2890).

6. Ertz 1979, pp. 410, 610, cat. 320; Jost 1963, p. 124 (as by van Balen).

Abraham Janssens

(ca. 1575-Antwerp-1632)

Probably born in 1575 (but possibly baptized on 15 January 1576; in August 1618, he was described as "about 43 years old"), Abraham Janssens was a pupil of Jan I Snellinck (1549-1638) in 1584/85. He became a master in the Antwerp Guild in 1601, was named a dean in the guild on 23 September 1606, and head dean (*opper deken*) in 1607. He married Sara Goetkind (d. 17 April 1644) on 1 May 1602; she bore eight children, including Abraham II (born February 1616), who later became a painter and art dealer. Janssens probably made at least one trip to Italy. An Abraham Janssens is mentioned in Rome in August 1598, thus well before Rubens, who arrived in Italy only in 1600. Later, in the spring of 1601, "Abram Jansegna fiamengo," aged 27, was listed as a pupil living in the house of Willem van Nieulandt (1584-1635/36) in Rome. Some historians have also speculated on a second trip to Rome, since his earliest dated works of 1601 (see Introduction) show little Italian influence, but acknowledge the late mannerist style of Flemish Romanism favored by Ambrosius Francken I, and Otto van Veen. The influence of Caravaggio is detectable in the tonal contrasts of some of his earliest works but the Italian master's importance on his first independent classicizing style (ca. 1605-1607) has surely been overestimated. This art, in fact, has more in common with the Carracci and Bolognese painters. In 1605/06 he received an important commission from the artist's guild in Mechelen to paint the altarpiece for their new chapel in the St. Rombouts Church. In 1609, Janssens was commissioned for fl. 750 to paint the *Union of the Scheldt River and the City of Antwerp* (*Scaldis en Antverpia*) for the Antwerp Town Hall (now in the Koninklijk Museum voor Schone Kunsten, Antwerp; ill. History, fig. 7); Rubens executed an *Adoration of the Magi* for the same chamber (now Madrid, Museo del Prado; ill. cat. 9, fig. 2). The following year he became a member of the local confraternity of Romanists. In 1614 the Antwerp guild known as "Oude Voetboug" commissioned him to paint an *Allegory of Concord* (now Municipal Art Gallery and Museum, Wolverhampton) for their meeting hall in the Huis van Spanien. After 1615 the influence of Rubens became more pronounced in his art. Janssens remained active in Antwerp throughout his career, exporting many paintings to Spain before dying in the city on 25 January 1632. On 22 December 1643, he was described by two deans of the Antwerp guild as "a very famous master and painter" ("een seer fameus meester ende schilder").

A painter of religious, mythological, and allegorical figures, Janssens was an important immediate predecessor and contemporary of Rubens. The large sculptural forms of his compositions and a striking blend of realism and classicism exerted a powerful influence on Rubens's art in the second decade of the century. His pupils include Steven Wils (d. 1628), Gerard Seghers (1591-1651), and Theodoor Rombouts (q.v.).

De Bie 1661, pp. 65-67; Sandrart 1675, vol. 2, p. 300; Le Comte 1699, vol. 2, p. 301; Houbraken 1718-21, vol. 1 (1718), pp. 65, 79; Weyerman 1729-69, vol. 1, pp. 322 ff; Descamps 1753-64, vol. 1, pp. 261-263; Mensaert 1763; Immerzeel 1842-43, vol. 2 (1843), p. 80; Kervyn de Volkaersbeke 1857-58, vol. 1, pp. 20-21; vol. 2, pp. 14, 51, 156, 233; Kramm 1857-64, vol. 3 (1858), pp. 196-197; Michiels 1865-76, vol. 8 (1869), pp. 306-325; van den Branden 1883, pp. 478-482; Rombouts, van Lerius 1872, vol. 2, p. 79; Rooses 1879, pp. 241-243; Wurzbach 1906-11, vol. 1 (1906), p. 748; Donnet 1907, passim; Oldenbourg 1923; K. Zoege von Manteuffel, in Thieme, Becker 1907-50, vol. 18 (1925), pp. 411-413; Roggen 1932; von Schneider 1933, p. 89; Hoogewerff 1936, p. 98; Pevsner 1936; Hoogewerff 1942-43, vol. 2, p. 10; Held 1952; Held 1953; Brussels 1965, pp. 105-106; Longhi 1965; d'Hulst 1969; Bodart 1970, vol. 1, pp. 53-55; Müller Hofstede 1971; Bodart 1976; Paris 1977-78, pp. 98-100; Chomer 1979; vander Auwera 1985, pp. 148-154; vander Auwera 1989; Cologne/Vienna 1992-93, pp. 328-331.

Abraham Janssens
3. *The Dead Christ in the Tomb, with Two Angels*

Oil on canvas, 117.5 x 147.3 cm (45 ⅛ x 58 in.)
[painted surface]
New York, Metropolitan Museum of Art, Gift of
James Belden in memory of Evelyn Berry Belden,
inv. 1971.101

PROVENANCE: collection Robert Goulborne Parker, Browsholme Hall, near Clitheroe, Yorkshire; sale R. G. Parker, London (Christie's), 9 May 1958, no. 21 [as by G. B. Caracciolo; bought in]; collection James Belden, Paris and Washington, D.C., 1958-1971.

EXHIBITIONS: New York, The Metropolitan Museum of Art, *The Painter's Light* (1971), no. 4 [dated ca. 1610].

LITERATURE: Müller Hofstede 1971, p. 250, note 135; R. Spear, *Caravaggio and His Followers* (Cleveland, 1971), pp. 114-115; Nicholson 1979, p. 62; New york, Metropolitan, cat. 1984, pp. 109-111; H. Vlieghe, Review of Liedtke 1984, in *Oud Holland* 100 (1986), p. 202; Nicholson 1990, vol. 1, p. 129, vol. 3, ill. 1393; Liedtke et al. 1992, p. 341.

DISPOSED in the cramped confines of a cavelike space, the lifeless body of Christ extends across the width of the painting. His head and torso, encircled by the shroud and slumped against a rough stone sarcophagus, are angled to face the viewer. At the right, the kneeling figures of two mourning angels attend his recumbent body. The brilliant light emanating from the right creates a stark contrast of light and shadow, emphasizing the firmly modeled contours of forms. In the background, the entrance to the cave affords a view of a rocky landscape with three tiny crosses atop a craggy promontory. The instruments of Christ's passion are heaped in the immediate foreground. There is a second, probably workshop, version of the composition in the Church of St. John the Baptist, Lage Zwaluwe (Noord Brabant, The Netherlands). Published by Müller Hofstede as the original, it is certainly a copy of the present work.[1]

Liedtke dates the *Dead Christ in the Tomb* to about 1609-1610, citing in comparison the similarly emphatic sculptural modeling and tight spatial organization of Janssens's *Scaldis en Antverpia* (completed 1609; Antwerp, Koninklijk Museum voor Schone Kunsten, inv. 212; ill. History, fig. 7), one of the few securely dated works of the artist's mature œuvre.[2] Müller Hofstede dated the Lage Zwaluwe version of the composition to about 1609-1610 as well, but described the New York painting as a "repetition with workshop participation of about 1615."[3] Joost vander Auwera dates the present painting about 1619, suggesting that it may be an autograph replica of a lost original of ca. 1609.[4] Vlieghe also supports a later date for the *Dead Christ*, dating it "not before 1620," based on the lighter palette and less emphatic chiaroscuro.[5] Liedtke has proposed that considerable changes in pigment color may have occurred, creating a greater contrast between light and dark areas.[6]

The composition of Janssens's *Dead Christ* is probably based on the print by Jacob Matham after Hendrick Goltzius's *Savior in the Tomb, with Two Angels* (fig. 1).[7] Christ's wounds and the marks of his suffering are minimized in Janssens's painting, how-ever, in keeping with a more heroic conception of Christ's body.[8]

Probably commissioned as an altarpiece or epitaph, Janssens's powerful image demonstrates the effectiveness of the close-up view for devotional purposes. The inherent drama and immediacy urged empathy with the Passion, and aroused the individual devotion of the viewer. While personal identification with Christ's suffering was an important factor in Counter-Reformatory doctrine, this type of image had sources in indigenous Northern artistic traditions as well. Vander Auwera has related the compositional and psychological concentration of such scenes to so-called *Andachtsbilder*, traditional devotional images popular from the fifteenth century.[9] The iconic impact of the New York painting is enhanced by Janssens's spare, sculptural style. David Freedberg has discussed Rubens's adoption of an analogous style in the mid-1610s in the context of his commissions for painted epitaphs; his reasoning suggests that Janssens's *Dead Christ* may have been intended to hang over a tomb as well.[10] The funerary imagery would have been deemed appropriate, as well as Janssens's stark, haunting style, "stripped of all incidentals, iconographic and stylistic."[11] Appropriately for an image erected to perpetuate the memory of the deceased unto eternity, the *Dead Christ* presents a timeless moment rather than a specific narrative event. The sculptural qualities of the painting are not only inherently allied with the idea of permanence and a rejection of the transitory and ephemeral, but also approximate the three-dimensional sculptures which frequently decorated tombs and often enframed the paintings themselves.

MEW

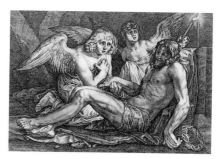

Fig. 1. Jacob Matham after Hendrick Goltzius, *The Savior in the Tomb, with Two Angels*, engraving.

1. Müller Hofstede 1971, pp. 250-251, ill. Müller Hofstede later stated that the New York painting was an autograph work of high quality; see New York, Metropolitan, cat. 1984, pp. 109-110.

2. New York, Metropolitan, cat. 1984, p. 110.

3. Müller Hofstede 1971, p. 250, note 135.

4. In correspondence with the Metropolitan Museum of Art, dated 7 August 1981; see New York, Metropolitan, cat. 1984, p. 111, note 1.

5. Vlieghe 1986, p. 202.

6. New York, Metropolitan, cat. 1984, p. 109.

7. As noted by ibid., p. 110; see Müller Hofstede 1971, pp. 230, 255-256 and 263-264 for other examples of Janssens's interest in engravings of the Goltzius school.

8. On this see J. Shearman, "The 'Dead Christ' by Rosso Fiorentino," *Bulletin of the Museum of Fine Arts* 64 (1966), esp. p. 151. On the presence of the mourning angels, see the entry on Bertholet Flémal's *Mary with the Dead Christ and Mourning Angels*, cat. 131.

9. Vander Auwera 1989, p. 37; see also Eisler 1967; and, on the development of earlier imagery, S. Ringbom, *From Icon to Narrative. The Rise of Dramatic Closeup on Fifteenth-Century Devotional Painting* (Abo, 1965).

10. This suggestion was made by Vlieghe (1986, p. 202); see Freedberg 1978b, pp. 70-71; and Eisler 1967, p. 48.

11. Freedberg 1978a, p. 70.

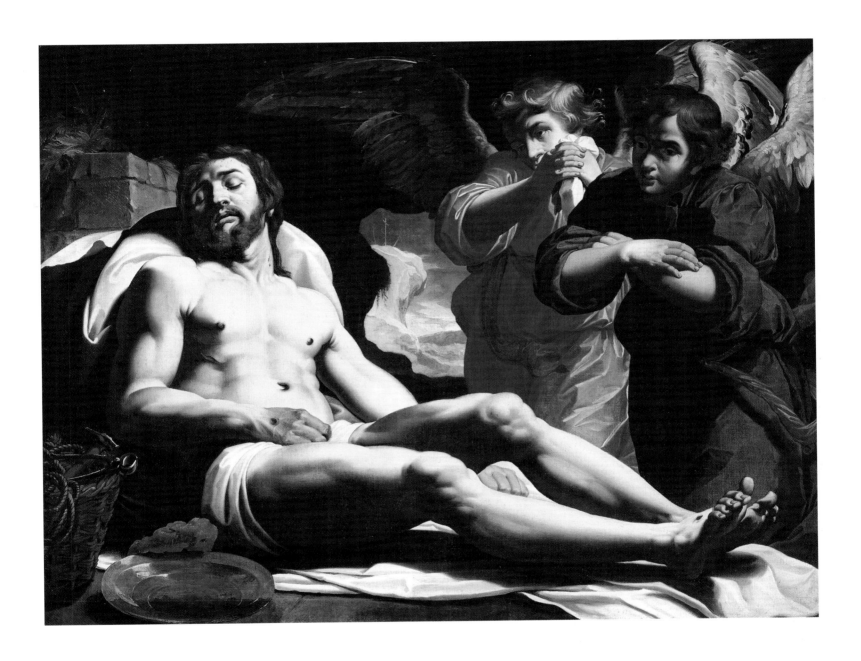

Abraham Janssens
4. The Origin of the Cornucopia, ca. 1615-1620

Oil on canvas, 108.6 x 172.7 cm (42 ¾ x 68 in.)
[painted surface]
Seattle, Seattle Art Museum, inv. 72.32, purchased
with funds from PONCHO in Honor of Dr. Richard
E. Fuller's 75th Birthday, 1972

PROVENANCE: French provincial castle; Galerie Heim, Paris.
EXHIBITIONS: Bellevue Art Museum, Bellevue, WA, *European and American Paintings from the Seattle Art Museum Collection*, November 1975.
LITERATURE: *Gazette des Beaux-Arts*, ser. 6, vol. 79 (1973), suppl. p. 122; *Selected Works: Seattle Art Museum* (Seattle, 1991), p. 92.

THREE muscular women are seated before a landscape, their loins swathed in draperies of red, yellow, and blue respectively. The garlands of reeds entwined in their hair, as well as the two vessels spilling water to either side of the composition, designate the woman as naiads, or river nymphs. The woman in the center fills the mouth of a large cornucopia with grapes; the woman at the left bends to pick up a melon or gourd. Spread across the foreground are various other fruits and vegetables, including artichokes, figs, grapes, apples, and a head of cauliflower. Further back, two other nymphs gather grapes. To the left of the scene is a distant view of a circular temple atop a hill.

The subject of Janssens's painting is taken from Ovid's *Metamorphoses* (IX: 82-93). Hercules challenged the river god Acheloüs to a contest for the hand of Deianeira, daughter of King Oeneus of Calydon. The two rivals fought, with Acheloüs assuming first the form of a snake, then that of a bull. In overcoming Acheloüs, Hercules wrenched off one of the bull's horns, which was later retrieved by a group of river nymphs; as Acheloüs relates the story, "My Naiads filled it full of fragrant flowers / And fruits, and hallowed it. From my horn now / Good Plenty finds her wealth and riches flow."[1]

The Origin of the Cornucopia is not a theme encountered frequently in Netherlandish art; in fact, Janssens's painting seems to be among the earliest representations of the subject. It was treated also by Hendrick van Balen and Jan Brueghel the Elder (The Hague, Mauritshuis, inv. 234), and by both Rubens and Jordaens later in the century. Janssens's painting seems to be unique, however, in specifically identifying the nymphs as naiads through the inclusion of their customary attributes of overturned water vessels. Rubens depicted the three nymphs filling a cornucopia in a painting now in Madrid (Prado, inv. 1664).[2] Jacob Jordaens's exuberantly fecund *The Shaping of the Horn of Plenty* (Copenhagen, Statens Museum for Kunst, inv. 351; fig. 1) represents the nymphs accompanied by satyrs, together with Hercules and Acheloüs in the guise of a bull with a single horn. In contrast to the more light-hearted mood which pervades these compositions, Janssens's cool palette and sharply contoured Michelangelesque figures impart a sober monumentality to the scene.

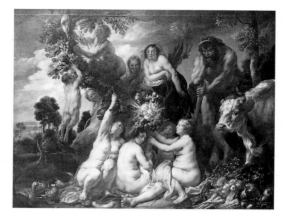

Fig. 1. Jacob Jordaens, *The Shaping of the Horn of Plenty*, signed and dated 1649, oil on canvas, 240 x 311 cm, Copenhagen, Statens Museum for Kunst, inv. 351.

Fig. 2. Abraham Janssens, *Abundantia (Allegory of the Summer Months)*, ca. 1610, oil on canvas, 118 x 97 cm, Brussels, private collection, 1965.

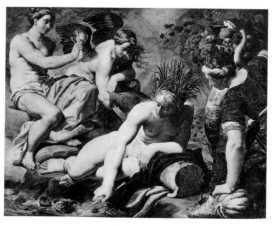

Fig. 3. Abraham Janssens, *Four Elements*, ca. 1612-1613, oil on canvas, 165 x 198 cm, Houston, Sarah Campbell Blaffer Foundation, inv. 77.3.

The Origin of the Cornucopia bears a close formal relationship to more generally conceived seasonal allegories, particularly those of autumn and summer, which emphasize the abundant fruits of the earth. Held suggested that the present painting may represent autumn in a series of four allegories of the seasons, although there are no additional works by Janssens known that would complete the cycle.[3] In fact, Janssens's so-called *Abundantia (Allegory of the Summer Months)* (ca. 1612-1613; fig. 2) may instead be a representation of the Origin of the Cornucopia.[4] The three half-length figures filling a horn of plenty are similarly crowned with circlets of reeds; at the lower left is an overturned urn from which a stream of water flows.

Although Janssens's stylistic development is notoriously difficult to reconstruct, *The Origin of the Cornucopia* probably dates to the middle of the artist's career, about 1616-1617.[5] The painting does

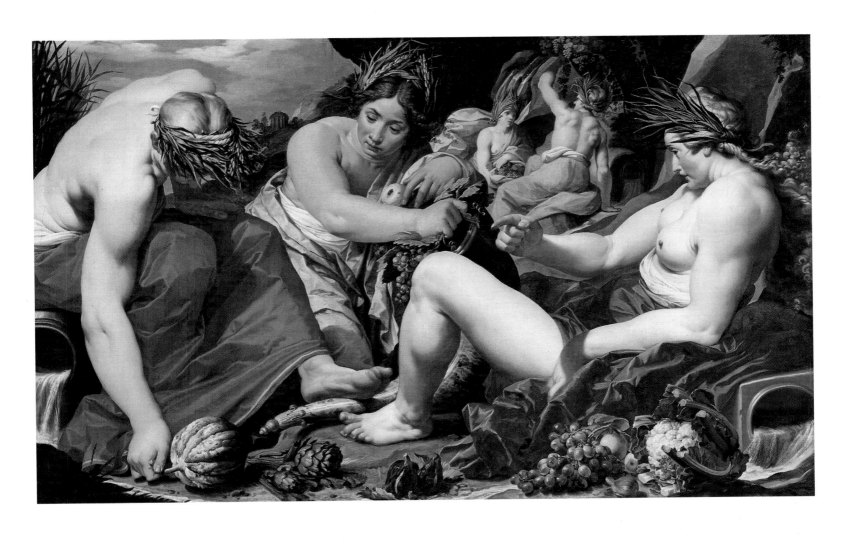

Peter Paul Rubens

(Siegen 1577-Antwerp 1640)

not exhibit the heightened chiaroscuro characteristic of the artist's more Caravaggesque phase of about 1609 (compare the *Scaldis en Antverpia*, completed 1609; Antwerp, Koninklijk Museum voor Schone Kunsten, inv. 212; ill. History, fig. 7). The cool palette accentuated by strong primary colors, as well as the rather hard Michelangelesque figures, are typical of Janssens's compositions of the later 1610s. Among the paintings most closely related to the present work are *Peace and Abundance Binding the Arrows of War*, signed and dated 1614 (Wolverhampton, Municipal Museum and Art Gallery); *Gathering of the Olympian Gods* (ca. 1614-1615; Munich, Alte Pinakothek, inv. 4884), and *Four Elements* (ca. 1612-1613; Houston, Sarah Campbell Blaffer Foundation, inv. 77.3; fig. 3). The latter painting has been dated ca. 1610, but probably dates somewhat later because of the more open composition, with figures distanced from the picture plane.

The head and torso of the naiad at the far right of the *Origin of the Cornucopia* also appears in a half-length composition of *Meleager and Atalanta* in the Musée des Beaux-Arts, Besançon.[6]

MEW

1. Ovid, *Metamorphoses* (translated by A. D. Melville; Oxford and New York, 1986), p. 201 (IX: 91-93). An alternative explanation for the invention of the cornucopia is given in Ovid's *Fausti* (V: 121-24), where it had its origin in the horn of the goat Amalthea that suckled the infant Jupiter.

2. As *Ceres with Two Nymphs*, ca. 1625-1627; oil on canvas, 223 x 162 cm. There is a related sketch (oil on panel, 31.6 x 24.1 cm) in London, Dulwich College Picture Gallery, inv. 171. On the latter painting see Held 1980, vol. 1, pp. 344-345.

3. In correspondence with the Seattle Art Museum, dated 15 August 1972.

4. On the *Abundantia*, see Brussels 1965, no. 112; and Müller Hofstede 1971, pp. 257-258.

5. Suggested by Joost vander Auwera, in correspondence dated 28 October 1992. A later date of about 1619 was suggested by both Julius Held and Justus Müller Hofstede, in correspondence with the Seattle Art Museum dated 15 August 1972 and 10 January 1973, respectively; see also Seattle 1991, p. 92.

6. Possibly a copy, according to Joost vander Auwera (letter dated 17 November 1992).

Peter Paul Rubens was born at Siegen in Germany on 28 June 1577. His father, Jan Rubens, was a lawyer and magistrate originally from Antwerp, who in 1568 had fled that city together with his wife, Maria Pypelinckx, because of his Calvinist faith. The Rubens family moved from Siegen to Cologne in 1578, where they remained until Jan's death in 1587. Maria Pypelinckx (d. 1608) returned to Antwerp with Rubens and his older brother, Philip (1573-1611). The young Rubens received an excellent education, and was particularly well versed in the classics. He had a facility for languages and as an adult could converse and correspond in Italian, French, German, Spanish, and Latin, in addition to his native Flemish. Although Rubens is not listed as a pupil in the records of the Antwerp St. Luke's Guild, he probably studied with Tobias Verhaecht (1561-1631) in 1591, with Adam van Noort (1562-1641) in 1592, and with Otto van Veen (1556-1629) in 1596. Rubens became a master in the guild of St. Luke in 1598.

On 9 May 1600, Rubens set out for an extended Italian sojourn to further his artistic education. Shortly after his arrival he was engaged as court painter to Vincenzo Gonzaga, Duke of Mantua. Rubens held this post until 1608, although he spent by far the majority of his time working for other patrons in other cities. Rubens was in Rome in 1601-1602, where he painted three altarpieces for the church of Sta. Croce in Gerusalemme. In 1603-1604 Rubens was sent by Gonzaga as his envoy to the court of Spain in Valladolid. Rubens spent several months in Genoa in 1606 (see cat. 8), and at the end of this year was awarded the commission for the high altarpiece at Sta. Maria in Vallicella in Rome (see cat. 7).

Notified of his mother's serious illness, Rubens left Italy on 28 October 1608, arriving in Antwerp on 11 December. Less than a year after his return, Rubens was named court painter to the Archdukes Albert and Isabella. In part through the agency of powerful friends such as Nicolaes Rockox, Rubens was immediately the recipient of prestigious commissions, such as an *Adoration* for the Town Hall in Antwerp in 1609 (now Madrid, Museo del Prado; ill. cat. 9, fig. 2), and altarpieces for the Cathedral and the Church of St. Walpurgis in 1610 and 1611, respectively (Introduction, figs. 17 and 18).

Rubens married Isabella Brant (1591-1626) on 3 October 1609 in the Abbey Church of St. Michael in Antwerp. The couple had three children, Clara Serena (1611-1623), Albert (1614-1657), and Nicolaes (1618-1655). In January 1611 Rubens purchased a house on the Wapper in Antwerp; renovations to the house were completed in 1615 and an extension

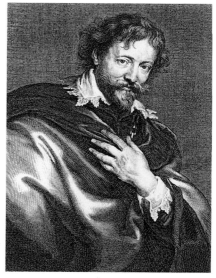

Paulus Pontius after Anthony van Dyck, *Peter Paul Rubens*, engraving, from the *Iconography*.

housing Rubens's studio was completed in 1618. From the outset of his career in Antwerp Rubens worked in collaboration with other artists (notably Jan Brueghel [see cat. 17] and Frans Snyders [see cats. 10, 12, 14]), and oversaw a stable of assistants, including his most skilled apprentice, Anthony van Dyck, who was active in his atelier from the mid-1610s. With the aid of these numerous assistants, Rubens embarked on a series of large decorative cycles during the late 1610s and 1620s, including the history of the Roman consul Decius Mus; tapestry designs illustrating the history of Constantine (ca. 1621-22) and the triumph of the eucharist (ca. 1627-28; see cats. 20, 21, 22); the life of Marie de' Medici (1622-25); and ceiling paintings and altarpieces for the Jesuit Church in Antwerp (1618-1621; see cats. 18, 19).

In addition to his artistic enterprises, Rubens was active as a diplomat from 1622, and continued as political agent for the Infanta Isabella until 1633. Rubens's diplomatic missions occasioned visits to Spain (1628-29), France, England (1629-30), and the Northern Netherlands (1627); in each instance he also secured foreign commissions for easel paintings, altarpieces, portraits, and decorative works.

Wearying of the demands of his political career, during the last decade of his life Rubens devoted more time to his family and his art. He married Hélène Fourment (1614-1673), the 16-year-old daughter of a wealthy tapestry dealer, on 6 December 1630; five children resulted from this union, the last born after Rubens's death. In 1635 Rubens purchased the Castle of Steen at Elewijt, outside Antwerp. At the end of his life, Rubens was again involved in orchestrating the activities of his colleagues and studio assistants for decorations for the triumphal entry of Archduke Ferdinand into Antwerp (1635), and decorations for the Torre de la Parada for Philip IV of Spain (1636 and after).

In early 1640 Rubens became seriously ill, suffering acute attacks of gout which had plagued him for nearly fifteen years. He drew up a new will on 27 May, and died on 30 May 1640. Rubens's funeral took place in the St. Jacobskerk in Antwerp on 2 June 1640. The artist's own painting of the *Madonna and Child Adored by Saints* was installed above the altar in his memorial chapel there. On a stone tablet in the floor, an epitaph composed by Rubens's friend Jan Caspar Gevaerts is dedicated to "Peter Paul Rubens . . . who, among the other gifts by which he marvellously excelled in the knowledge of ancient history and all other useful and elegant arts, deserved also to be called the Apelles, not only of his own age but of all time. . . . "

Baglione 1642, pp. 362ff; de Bie 1661, pp. 56-59; Bellori 1672, pp. 217-248; de Piles 1677; de Piles 1681; Hecquet 1751; Michel 1771; Smith 1829-42, vol. 2 (1830); Sainsbury 1859; Génard 1877; Michiels 1865-76, vol. 6, pp. 374-444, and vol. 7, pp. 5-252, 472-479; Voorhelm Schneevoogt 1873; Rooses 1879, pp. 247-394 and passim; van den Branden 1883, pp. 358-383, 409-430, 482-590 and passim; Rooses 1886-92; Rooses, Ruelens 1887-1909; Burckhardt 1898; A. Rosenberg 1905; Oldenbourg 1918a; Oldenbourg 1921; Glück, Haberditzl 1928; Burchard 1929; Arents 1940; Norris 1940; van den Wijngaert 1940; Bouchery, van den Wijngaert 1941; Evers 1942; Keiser 1942; Arents 1943; Evers 1943; Glück 1943; Goris, Held 1947; van Puyvelde 1947; Rotterdam 1953; de Maeyer 1955, pp. 92-129; Magurn 1955; Cambridge/New York 1956; Held 1959; Gerson, ter Kuile 1960, pp. 70-105; Müller Hofstede 1962; Incisa della Rocchetta 1962-63; Burchard, d'Hulst 1963; Jaffé 1963; Brussels 1965, pp. 165-230; Warnke 1965; Eisler 1967; Thuillier 1967; Martin 1968; Stechow 1968; Martin 1969; London, National Gallery, cat. 1970, pp. 105-233; Alpers 1971; Martin 1972; van Regteren Altena 1972; Vlieghe 1972-73; Prinz 1973; Renger 1974; Haverkamp Begemann 1975; Madrid, cat. 1975, pp. 223-342; Renger 1975; Antwerp 1977; Baudouin 1977; Cologne 1977; Glen 1977; Huemer 1977; Jaffé 1977; Genoa 1977-78; Paris 1977, pp. 148-204; Berlin 1978; Freedberg 1978a; Freedberg 1978b; McGrath 1978; de Poorter 1978; Judson, van de Velde 1978; Held 1980; Adler 1982; Held 1982a; Vergara 1982; Freedberg 1984; Balis 1986; Vlieghe 1987a; White 1987; d'Hulst, Vandenven 1989; Muller 1989; Pilo 1990; Cologne/Vienna 1992-93.

Peter Paul Rubens
5. *Portrait of Francesco IV Gonzaga*, ca. 1605

Oil on canvas, 52.8 x 39.5 cm (20 ¾ x 15 ½ in.)
New York, Otto Naumann Ltd.

PROVENANCE: Church of Santissima Trinità, Mantua, until July 1801; Etienne-Marie Siauve (divisional commander of French military police at Mantua) until September 1801; private collection, Bucharest; private collection, Zurich; private collection, London (1985).

LITERATURE: M. Jaffé, "Rubens's Gonzaga Altarpiece: Another Portrait Rediscovered," *Apollo* 121 (1985), pp. 379-382; Held 1986a, pp. 68-69 (as "Portrait of Vincenzo Gonzaga"); U. Bazzotti, "Precisiazione sulla Pala della Trinità di Mantova," in C. Limentani Virdis and F. Bottacin, eds., *Rubens dall'Italia all'Europa* (Atti del convegno internazionale di studi, Padova, 24-27 maggio 1990) (Vicenza, 1992), pp. 40, 42-43, 45.

A RUDDY-CHEEKED teenage boy clad in a brocade doublet with a white lace collar is seen at bust length and turned to the right, his gaze directed upwards. Rubens's lively brushwork heightens the spontaneity of the sitter's features and crisply curling forelock. The background elements – at the left, a hand leafing through a small book; at the rear, the skirted armor, pike shaft, and red garment of another figure; and at the right, details of a sculpted column – suggest a much larger composition.

Rubens's vibrant portrait is a fragment of an immense canvas representing the Gonzaga family in adoration of the Trinity (figs. 1, 2). Together with two other canvases depicting the *Baptism of Christ* (now Antwerp, Koninklijk Museum voor Schone Kunsten, inv. 707) and the *Transfiguration* (now Nancy, Musée des Beaux-Arts), the *Adoration of the Trinity* was commissioned by Vincenzo Gonzaga, Duke of Mantua, to decorate the *capella maggiore* of the Jesuit Church of Santissima Trinità in Mantua.[1] All three paintings were completed by Rubens between August 1604 and May 1605, although he had probably begun planning the compositions at least two years prior to that time.[2] The original design of the *Adoration of the Trinity* (Mantua, Museo del Palazzo Ducale, invs. 6846, 6847; figs. 1, 2) showed Vincenzo Gonzaga and his wife, Eleonora de' Medici, kneeling together with the duke's deceased parents, Guglielmo Gonzaga and Eleonora of Austria, and flanked by their five children and several halberdiers. In the upper register, filling the sky between the majestic Solomonic columns of the portico, several angels unfurl a fictive tapestry displaying an image of the Trinity, the object of the Gonzagas' worshipful gaze.

The unusually secular emphasis on family likenesses in the *Adoration* was inspired by Venetian prototypes, specifically portraits of doges accompanied by their patron saints with the Virgin and Child. Rubens would have seen such works during his recent visits to Venice in 1600 and 1604. His representation of the Trinity as an image on a tapestry – rather than an actual vision – neatly sidestepped a theological dilemma: technically, only saints and the blessed dead were afforded heavenly visions. That the Gonzagas are shown worshiping an *image* rather

Fig. 1. Peter Paul Rubens, *The Gonzaga Family Adoring the Trinity*, 1604-1605, oil on canvas, 185 x 462 cm (upper portion) and 185 x 462 cm (with additions) (lower portion), Mantua, Museo del Palazzo Ducale, invs. 6846, 6847.

Fig. 2. Proposed reconstruction of Rubens's *Adoration of the Trinity* (from Bazzotti 1992, p. 46, fig. 31).

Fig. 3. Proposed reconstruction of left side of Rubens's *Adoration of the Trinity* (from Bazzotti 1992, p. 45, fig. 30).

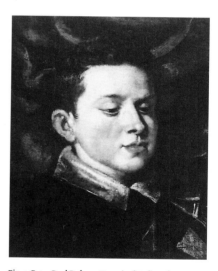

Fig. 4. Peter Paul Rubens, *Portrait of Ferdinando Gonzaga*, 1604-1605, oil on canvas, 48 x 38.2 cm, Mamiano, Fondazione Magnani-Rocca.

than the beatific vision also reinforces the sort of devotion to surrogate images particularly advocated by the Jesuits.[3] The *Baptism* and the *Transfiguration* which flanked the *Adoration of the Trinity* in the *capella maggiore* represented New Testament manifestations of the Trinity; the choice of subjects was inspired by the recent decorations of the Gesù in Rome.[4]

The decorations of the *capella maggiore* are long since dispersed, and the present fragmented state of the *Adoration* gives only a partial idea of its original appearance. The central portion of the composition (fig. 1) is now actually composed of two large sections; several smaller fragments – including the present painting – are scattered in other collections.[5] The present state of the painting is evidence of its tumultuous history.[6] In 1776 the Jesuit Church of the Santissima Trinità was turned over to the Augustinians, with the provision that Rubens's paintings be kept safe in the chapel. Following the French occupation of Mantua in early 1797 the paintings remained in the church, which had now become a

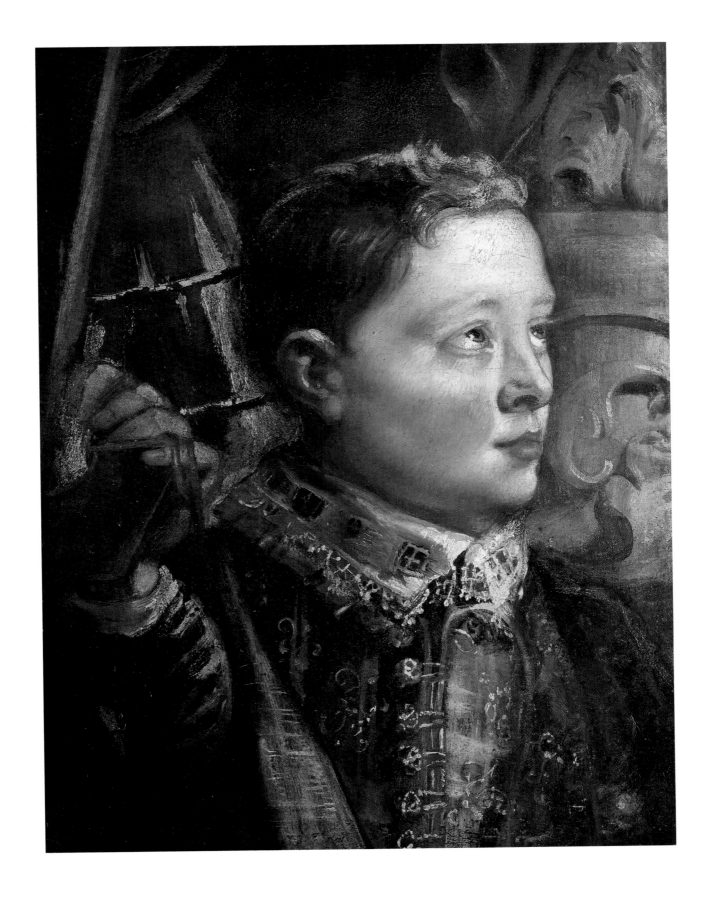

warehouse for salt and fodder. The *Transfiguration* was removed and sent to France in late 1797; the *Baptism* seems to have been sold in 1799. The *Adoration* remained in the church/storage depot until July 1801, when Felice Campi, an administrator and vice director of the Accademia Virgiliana, petitioned the French Administration to remove the painting, which was by then in a precarious state of preservation. In consultation with the French administrator Etienne-Marie Siauve, and the painter and engraver Luigi Rados, it was decided to cut the individual portrait heads from the canvas, which was reportedly flaking and rotted in many places.[7] The large central sections and some of the fragments were ultimately put on deposit in the museum in Mantua. On 30 December 1806, the painter Giuseppe Pellizza stated that he had received 1390 lire mantovane, in addition to 105 lire for materials, "for having converted the large Painting by Rubens, depicting the most Holy Trinity, from the church of the same name (which had been cut and ruined during the time it was in the Warehouse of the Seige), into two canvases, restored it and brought it to its first reintegration."[8] The present state of the *Adoration*, with discontiguous fragments patched to either side of the kneeling Gonzagas, reflects Pellizza's "reintegration."

Oddly, no visual record of Rubens's original composition survives, and attempts at reconstruction are guided only by a few brief written descriptions; the most detailed of these was published more than twenty years after the dismembering of the original painting (see note 13). The most thorough and plausible reconstructions of the *Adoration* have been those proposed by Ugo Bazzotti (fig. 2).[9] Much of the discussion surrounding modern attempts at reconstruction concerns the placement and proper identification of the three Gonzaga sons – Francesco IV (1586-1613), Ferdinando (1587-1625), and Vincenzo II (1594-1627) – at the left side of the painting (fig. 3). The identification of the portrait of Ferdinando (fig. 4) is relatively straightforward: as the middle son, he is positioned in the center of the group, and as the only son to become a Knight of Malta, he wears the Maltese Cross emblazoned on his chest. With downcast eyes, the pious Ferdinando (who was named a cardinal in 1607) reads from a small prayer-book; a portion of the book and his left hand appear at the lower left of the present painting. The identification is confirmed by a preliminary drawing by Rubens in Stockholm (ca. 1601-1602), inscribed with the name of the sitter.[10]

The curly haired princeling posed in front and to the [viewer's] left of Ferdinando (fig. 5) is most con-

vincingly identified as Vincenzo, the youngest son, although some scholars have suggested that he – rather than the young man depicted in the present painting – should be identified as Francesco IV Gonzaga.[11] Their argument centers on the fact that this is the largest and most prominent of the three likenesses (thus appropriate to the eldest son, first in the order of succession). X-rays reveal another, rather different head beneath the painted surface, which corresponds closely to a second drawing by Rubens in Stockholm, there identified as Francesco Gonzaga (fig. 6).[12] Of the several possible alternatives, the most plausible solution is that Rubens first planned to have Francesco Gonzaga at the outside (far left) of the group (as revealed by the x-ray of the Vienna fragment), but later situated the eldest son and heir closest to his father and grandfather, thus physically next in line of succession.[13] In doing so, he modified the heavy jowl and lolling head depicted *ad vivum* in the Stockholm drawing, resulting in the more flattering painted likeness.[14] Appropriately, Francesco emulates his father and grandfather in directing his attention to the vision of the Trinity, while his younger brothers read, or glance engagingly at the viewer.

MEW

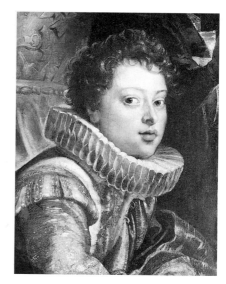

Fig. 5. Peter Paul Rubens, *Portrait of Vincenzo II Gonzaga,* 1604-1605, oil on canvas, 67 x 51.5 cm, Vienna, Kunsthistorisches Museum, inv. 6048.

Fig. 6. Peter Paul Rubens, *Portrait of Francesco IV Gonzaga,* black and red chalk, 226 x 161 mm, Stockholm, Nationalmuseum, inv. 1918/1863.

1. On the history of the commission, the subsequent history of the paintings, proposed reconstructions of the central canvas, and the iconography of the program, see most recently: C. Norris, "The Tempio della Santissima Trinità at Mantua," *The Burlington Magazine* 117 (1975), pp. 73-79; Huemer 1977, pp. 26-31; J. Müller Hofstede, in Cologne 1977, pp. 100-105 and 318-323; U. Bazzotti, "La pala della Trinità," in Mantua 1977, pp. 28-53; R. Navarrini, "I documenti rubensiani conservati nell'Archivo di Stato di Mantova," in Mantua 1977, pp. 54-67; G. Schizzerotto, *Rubens a Mantova fra Gesuiti, principi e pittori con spigolature sul suo soggiorno italiano (1600-1608)* (Mantua, 1979), pp. 99-109; E. McGrath, in London, Victoria and Albert Museum, *Splendours of the Gonzaga* (4 November 1981-31 January 1982), pp. 214-221; and Bazzotti 1992, pp. 39-48.

2. On the dating of the commission, see Bazzotti, in Mantua 1977, p. 34. Rubens received 1300 lire mantovane for the three paintings.

3. Müller Hofstede, in Cologne 1977, pp. 101-102; and McGrath, in London 1981-82, pp. 216-217.

4. McGrath, in London 1981-82, p. 215.

5. Other loose fragments include portraits of the two other sons of Vincenzo Gonzaga and Eleonora de' Medici: *Portrait of Ferdinando Gonzaga* (oil on canvas, 48 x 38.2 cm, Mamiano, Fondazione Magnani-Rocca); *Portrait of Vincenzo II Gonzaga* (oil on canvas, 67 x 51.5 cm, Vienna, Kunsthistorisches Museum, inv. 6048); *Portrait of Margherita Gonzaga* (oil on canvas, 64.8 x 51.5 cm, London, formerly collection W. Burchard); *Halberdier* (oil on canvas, 128 x 77.5 cm, Mantua, Museo del Palazzo Ducale, inv. 695); and *Lapdog with Eleonora Gonzaga* (oil on canvas, 67 x 34 cm, Mantua, Museo del Palazzo Ducale, inv. 697).

6. Recounted most succinctly by Norris 1975, pp. 74-79.

7. It is unclear whether Campi and Siauve were doing their best to rescue portions of a severely damaged painting, or had mercenary motivations for removing the more saleable portrait heads. See Norris 1975, pp. 78-79; and Navarrini, in Mantua 1977, pp. 56-57.

8. ". . . per aver ridotto il gran Quadro di Rubens, titolare della chiesa della SS.ma Trinità, stato tagliato e rovinato in tempo che il locale era

Peter Paul Rubens
6. Hero and Leander, ca. 1604-1605

Oil on canvas, 96 x 128 cm (37 ¾ x 50 ⅜ in.)
New Haven, Connecticut, Yale University
Art Gallery, Gift of Susan Morse Hilles,
inv. 1962.25

Magazzino d'Assedio, in due quadri, ristaurati, e ridotti alla sua prima reintegrazione." Bazzotti 1992, p. 48, note 2.

9. Bazzotti, in Mantua 1977, pp. 39-50; with further refinements, based on the discovery of the present painting, published in Bazzotti 1992.

10. Black and red chalk, 224 x 160 mm, Stockholm, Nationalmuseum, inv. 1917/1863. See Held 1986a, pp. 68-69. The inscription dates from the eighteenth century.

11. Held (1986a, p. 69) concisely summarizes the various opinions concerning the identification of the sitters in the two Stockholm drawings, the Vienna fragment, and the *Portrait of Francesco Gonzaga* exhibited here.

12. X-ray illustrated by (among others) Norris 1975, p. 75, fig. 4.

13. As suggested by Jaffé (1985) and Bazzotti (1992). McGrath (in London 1981-82, pp. 215, 221) notes Rubens's emphasis on traditional dynastic precedence in his design for the *Adoration*. The description of the original composition of the *Adoration of the Trinity* given by Giuseppe di Opprandino Arrivabene (in his manuscript continuation [ca. 1823] of L. C. Volta's *Compendio cronologica critica della Storia di Mantova* [Mantua, 1806-23], and probably based on Volta's recollections of the painting) supports this arrangement, clearly listing the sitters from the center out: "The Holy Trinity with a homage of angels above; and beneath, in life-size kneeling figures, on the right [sic] the Duke Guglielmo Gonzaga and his son the prince Vincenzo; behind these the latter's little sons, Francesco, Ferdinando, and Vincenzo, with two Swiss guards. On the left [sic] the wives of the first two mentioned, the Archduchess Eleonora of Austria and the Princess Eleonora de' Medici, and, behind these, the latter's daughters Eleonora and Margherita with another Swiss guard, and a small, curly haired white dog." See Norris 1975, pp. 76-77.

14. Compare also the portrait of Francesco attributed to Frans Pourbus the Younger, in a private collection (ill. Bazzotti 1992, p. 47, fig. 32).

PROVENANCE[1]: seen in Italy (probably Mantua) by Giambattisto Marino, before 1615; (possibly) the heirs of the Duke of Buckingham, York House, London, 1635; (possibly) sold by Troyanus de Magistris, Amsterdam, 8 October 1637 ["een schildery van Leander by Ribbens gedaen"; fl. 424, to Rembrandt]; (possibly) sold by Rembrandt to Lodewijk van Ludick, 1644 (fl. 530); (possibly) collection Jan Six [1618-1700], Amsterdam; sale Sir Peter Lely, London, 18-21 April 1682, no. 53 [3 pieds 2 pouces by 4 pieds 2 ¼ pouces (ca. 102.6 x 135.7 cm); £85, to Creed]; in Venice by 1684-1685, where it was acquired by Johann Georg III, Elector of Saxony; mentioned in the 1687 inventory of the Dresden Gallery; exhibited in the Dresdener Schloss, 1707; subsequently left the collection (probably mid-eighteenth century); collection Counts Slinski, Poland, before 1890; collection Eugen Sokolowski, Uman; collection Mrs. Dagmar Carlsson, Hova (Sweden); art market, London, 1958.

EXHIBITIONS: Antwerp 1977, no. 4; Cologne 1977, no. 8.

LITERATURE: Giambattista Marino, "Leandro morto tra le braccia delle Nereidi di Pietro Paolo Rubens," in *La Galeria* (Milan, 1620), p. 12; Joost van den Vondel, "Op den dode Leander, in d'armen der zeegodinnen, door Rubens geschildert," in *Poëzy of Verscheide Gedichten* (Amsterdam, 1651), p. 486; Jan Vos, "Op het lijk van Leander in d'armen der zeegodinnen, door Rubens geschildert," in *Alle de Gedichten* (Amsterdam, 1662), vol. 1, pp. 533-534; M. Jaffé, "Rubens in Italy: Rediscovered Works," *The Burlington Magazine* 100 (1958), pp. 415, 419-421 [ca. 1606; painted in Genoa or Rome]; J. Müller Hofstede, "Some Early Drawings by Rubens," *Master Drawings* 2 (1964), p. 9 [ca. 1604-1605]; M. Jaffé, "A Sheet of Drawings from Rubens's Italian Period," *Master Drawings* 7 (1970), pp. 48, 50 note 2; H. Mielke, in Berlin, cat. 1977, p. 43; J. Müller Hofstede, in Cologne 1977, pp. 147-149, 216; Jaffé 1977, pp. 69-72; A.-M. Logan and E. Haverkamp Begemann, "Dessins de Rubens," *Revue des Arts* 42 (1978), pp. 90-92; F. Huemer, "A New View of the Mantuan Friendship Portrait," *The Ringling Museum of Art Journal* 1983, pp. 97-99; A. Golahny, "Rubens' *Hero and Leander* and Its Poetic Progeny," *Yale University Art Gallery Bulletin* 1990, pp. 21-38; K. Lohse Belkin, in Liedtke et al. 1992, pp. 172-174.

LEANDER, a young man of Abydos, was separated from his beloved Hero, a virgin priestess of Aphrodite, by the swift waters of the Hellespont. Each night he swam the narrow strait of the Dardanelles to be with her, guided by the lamp burning in her tower. One night the lamp went out, and the devoted Leander drowned in the storm-tossed waters. Stricken with grief, Hero committed suicide by leaping from her tower into the sea.[2]

A school of fourteen sea nymphs propel the hapless Leander's corpse to shore through surging, stormy waves; the monstrously gaping mouth of a whale at the lower left suggests even greater dangers lurking beneath the surface of the water. Two weeping genii, carrying extinguished torches, whirl in the sky above. At the far right Hero, clad in brilliant rose, plunges precipitously into the sea. Jagged shards of lightning split the sky, casting an eerie phosphorescence over the roiling sea. Rubens's painting is constructed around a highly stylized rhythm uniting the figures with the liquid sea: the pliant bodies of the nereids merge sensuously with the swelling waves, in marked contrast to the rigidity of Leander's lifeless body and the bright flurry surrounding Hero's headlong plunge.

In interpreting the tale of the ill-fated lovers, Rubens was inspired by the texts of Ovid (*Heroides,*

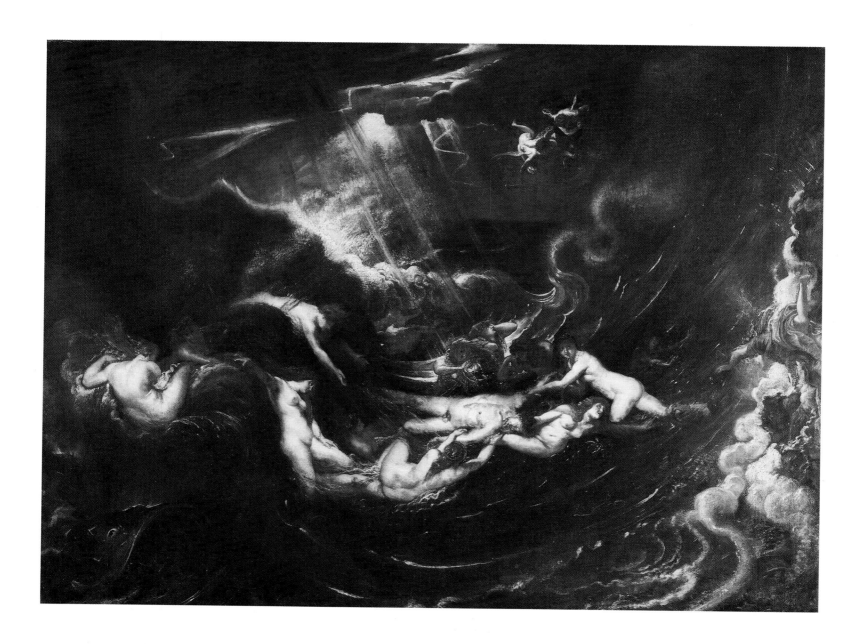

first century B.C.), Virgil (*Georgics*, first century B.C.) and the Greek poet Musaeus (*Hero and Leander*, fifth century A.D.), as well as by visual sources drawn from Tuscan and Venetian art. He characteristically enhanced the drama of his pictorial and literary sources by juxtaposing the deaths of Hero and Leander, and by giving prominence to the grieving nereids, which do not occur in any ancient or Renaissance accounts of the tale. Golahny has suggested that Rubens may have been inspired in the latter by the Greek poet Bion's *Lament for Adonis* (second century B.C.), in which Venus and the nymphs mourned Adonis's violent and untimely death with a fervor that animated all nature.[3]

Rubens's *Hero and Leander* displays his equally facile and eclectic command of visual sources. The pose of the nereid seen from the rear at the far left, for example, is based on Michelangelo's *Leda and the Swan* (then at Fontainebleau), which Rubens probably knew from the engraving by Cornelis Bos.[4] Jaffé has similarly described Leander's pose as Michelangelesque, and noted that the steeply foreshortened figure of Hero is reminiscent of the careening saint in Jacopo Tintoretto's *St. Mark Rescuing a Christian Slave* (1548; Venice, Accademia).[5] The fitful highlights that fleck the stormy atmosphere of Rubens's painting are also indebted to the Venetian master's charged palette and theatrical manipulation of light and dark.

Fig. 1. Peter Paul Rubens, *Two Nereids*, black chalk with white chalk highlights, 222 x 306 mm, Berlin, Staatliche Museen Preussischer Kulturbesitz, Kupferstichkabinett, inv. 13773.

Several drawings can be related to the present painting. Two sheets of sketches in Rotterdam and Edinburgh are early experiments with compositional forms and figural groupings[6]; a third sketch in Berlin is a more detailed study of the two sea nymphs at the left of the composition (fig. 1).[7]

A slightly larger copy of the New Haven painting (probably a work by Rubens's studio) is in Dresden, where it has been since at least 1659; Rubens's original entered the same collection ca. 1685.[8] Although Jacob Burckhardt[9] and subsequent writers (prior to the rediscovery of the present painting) deemed the Dresden version the original, the 1687 inventory of the Dresden collection clearly described the New Haven painting as "rechtes Original, von Peter Paul Rubenssen, Antwerpener gemahlt," and the version which remained in Dresden as "only a copy, whereas this one [the original in New Haven] is much older in colors and more delicately painted, the other [the Dresden copy] not as good, with newer and brighter colors."[10] A pen and wash copy after Rubens's *Hero and Leander* in Paris was probably made about 1619 by Lucas Vorsterman, in preparation for an (unexecuted) engraving after the composition.[11]

In addition to these visual records of the *Hero and Leander*, the dramatic pathos of Rubens's composition inspired poetic tributes as well. Giambattista Marino included a verse devoted to the painting in his *Galeria*, a collection of 600 poems about works of art; the Dutch poets Joost van den Vondel and Jan Vos published verses honoring Rubens's painting in 1650 and 1662, respectively.[12] The poems also emphasize the role of the sorrowing nereids (Vos refers to Leander as "twice drowned; / first in the salt sea, now in a flood of tears"[13]), and intimate the relentless rhythmic power of the sea. Unlike Rubens's painting, however, the poems make no

mention of Hero's suicide and follow more closely the written tradition of Ovid and Musaeus. The detail constitutes a small episode in the ongoing contest between the arts of painting and poetry. Whereas poetic descriptions of Hero's anguish over Leander's demise create the most affective written account, Rubens's inspired compression of the narrative to include both Leander's death and his lover's suicide in a single composition results in the more powerful visual image.

MEW

1. The distinguished provenance of the painting is discussed in Jaffé 1958, pp. 420-421. It is not certain that the same painting figured in all of the early collections listed here (between 1613 and 1682), although the measurements given in the Lely sale catalogue clearly refer to the New Haven painting and not the copy in Dresden (see below).

2. Ovid, *Heroides*, 18-19; Virgil, *Georgics*, 3:258ff; and Musaeus, *Hero and Leander* (trans. C. Whitman; London and Cambridge, MA, 1975), pp. 291-389. See also the entry on David Teniers's copy after Domenico Feti's version of the subject (cat. 126); Feti's composition was inspired by Rubens's painting.

3. Golahny 1990, p. 22.

4. Noted by Müller Hofstede 1964, p. 10, and others.

5. Jaffé 1977, p. 70.

6. Respectively: pen and ink, 175 x 290 mm, Rotterdam, Museum Boymans-van Beuningen; and pen and ink, 204 x 306 mm, Edinburgh, National Gallery of Scotland. Both drawings have been dated to about 1602, although the attribution of the Edinburgh sketch is disputed. See J. Müller Hofstede, in Cologne 1977, p. 149; and Golahny 1990, pp. 24-26.

7. J. Müller Hofstede, in Cologne 1977, pp. 216-217, no. 37; and H. Mielke, in Berlin, cat. 1977, pp. 43-45, no. 9. Golahny (1990, p. 35, note 14) suggests that the Berlin drawing is a copy after the New Haven painting, lacking the "rigorous observation of form and surface" that mark Rubens's other life studies.

8. Oil on canvas, 128 x 217 cm; Dresden, Gemäldegalerie Alte Meister, inv. 1002. On the Dresden painting, see Hans Posse, "Hero und Leander von Peter Paul Rubens," in *Karl Koetschau: von seinen Freunden und Verehrern zum 60. Geburtstag* (Dusseldorf, 1928), pp. 109-117; and J. Müller Hofstede, in Cologne 1977, p. 147.

9. Burckhardt 1898 (ed. 1950), p. 103.

10. ". . . nur ein Copey, sintemahlen das mitgebrachte viel älter an Farben und zierlicher gemahlt, das andere hingegen nicht so gut und von neueren und frischeren Farben ist." See Jaffé 1958, pp. 420-421; and Golahny 1990, p. 36, note 28.

11. Chalk, pen and ink, with wash, 600 x 912 mm; Paris, Musée du Louvre, Cabinet des Dessins. A letter by Rubens to Pieter van Veen, dated 23 January 1619, announces the artist's intention of having Vorsterman engrave the "favola di Leandro." See Rooses, Ruelens 1887-1909, vol. 2 (1898), pp. 199-200; and Magurn 1955, pp. 36-37.

12. The three poems and their relationship to Rubens's painting are discussed extensively by Golahny 1990, esp. pp. 27-33.

13. "Tot tweemaal toe verdronken; / Eerst in de zoute zee, nu in een tranenvloedt." See Golahny 1990, p. 31.

Peter Paul Rubens

7. Saints Gregory, Domitilla, Maurus, and Papianus, 1606

Oil on canvas, 146.5 x 120 cm (57 ⅝ x 47 ¼ in.)
Berlin, Staatliche Museen zu Berlin, Gemäldegalerie
(on loan from the Bundesrepublik Deutschland),
inv. 6

PROVENANCE: possibly identical with a painting described as "Sinte Gregorius met dry figures, van Rubens," in the inventory of Jan-Baptista Borrekens, Antwerp, 1668; King Frederick II of Prussia, Schloss Charlottenburg, Berlin (mentioned in 1769); Neues Palais, Potsdam, cat. no. 3327; Emperor Wilhelm II, who took the painting with him into exile in Doorn, Holland; acquired during World War II for Adolf Hitler's projected museum in Linz, Austria; Central Collecting Point, Munich; since 1966 in the Museum at Berlin-Dahlem.

EXHIBITIONS: Rotterdam 1953, no. 3; Rechlinghausen, Ausstellung zu den 10. Ruhrfestspielen, 1956, no. 211; Antwerp 1977, no. 15, ill.; Cologne 1977, no. 16, ill. p. 343; Naples, Galleria di Capodimonte, and New York, The Metropolitan Museum of Art, Caravaggio e il suo tempo (The Age of Caravaggio), 1985, no. 55, ill. p. 185.

LITERATURE: C. F. Förster, Das Neue Palais bei Potsdam (Berlin, 1923), p. 57; L. Burchard, "Skizzen des jungen Rubens," Sitzungsberichte der Berliner kunstgeschichtlichen Gesellschaft, Berlin, 8 October 1926, p. 2, no. 3; (possibly) Denucé 1932, p. 225; Evers 1943, pp. 111-116, 119, 327; van Puyvelde 1950a, p. 150; M. Jaffé, "Rubens at Rotterdam," The Burlington Magazine 96 (1954), p. 54; A. Seilern, Flemish Paintings and Drawings at 56 Princes Gate, London SW7 (London, 1955), pp. 25-26; K. Arndt, in Kunstchronik 9 (1958), p. 355; M. Jaffé, " Peter Paul Rubens and the Oratorian Fathers," Proporzioni (Estratto anticipato) 1959, pp. 23-25; Proporzioni 4 (1963), pp. 209-214; Held 1959, p. 128, under no. 74; Gio. Incisa della Rochetta, "Documenti editi e inediti sui quadri del Rubens nella Chiesa Nuova," Atti della Pontificia Accademia Romana di Archeologia, 3rd series, Rendiconti 35 (1962-63), p. 165; Burchard, d'Hulst 1963, pp. 47, 52-53; J. Müller Hofstede, "Rubens's First Bozzetto for Sta. Maria in Vallicella," The Burlington Magazine 104 (1964), p. 445, fig. 4; J. Müller Hofstede, (review of Burchard/d'Hulst 1963), Master Drawings 4 (1966), p. 440; M. Warnke, "Italiänische Bildtabernakel bis zum Frühbarok," in Münchner Jahrbuch der bildenden Kunst 19 (1968), p. 80, fig. 15; Vlieghe 1972-73, vol. 2, pp. 52-55, cat. no. 109b, fig. 25; Jaffé 1977, p. 95, fig. 323, note 62; Berlin-Dahlem, Gemäldegalerie, Staatliche Museen, Catalogue of Paintings (Berlin-Dahlem 1978), pp. 376-377, ill.; J. Kelch, Peter Paul Rubens. Kritischer Katalog der Gemälde im Besitz der Gemäldegalerie Berlin (Berlin-Dahlem, 1978), pp. 7-13, fig. 3; Herzner 1979, pp. 129-131, fig. 4; Held 1980, vol. 1, pp. 540-542, cat. no. 396, vol. 2, pl. 386; M. Jaffé, "A Sketch for a Rubens Altarpiece Partially Recovered," The Burlington Magazine 127 (1985), p. 453; Padua/Rome/Milan 1990, p. 70, under cat. no. 70.

FOUR SAINTS stand on steps before an arch framing a landscape view with classical ruins in the distance. In the center on the uppermost step is St. Gregory the Great dressed in a gold and white papal cope, pluvial, and skullcap, holding a book in his left hand, and extending his right in an attitude of rapture and reverence. He looks aloft at a ray of heavenly light. To his right, standing in profile, the female St. Domitilla is also sumptuously attired in gray-violet drapery over a white gown with a yellow ochre shawl. She holds a palm branch. To the left is St. Maurus, mounting the stair with his back to the viewer, and St. Papianus, both dressed in Roman military attire. In the distance are classical ruins with a hillside sometimes identified as the Palatine Hill in Rome.

In 1606 the twenty-nine-year-old Rubens received the commission for the high altar of the Chiesa Nuova of the Roman Oratory recently constructed on the site of the Church of Sta. Maria in Vallicella. This prestigious award, the most important undertaking of his Italian career, consolidated the fame he had won over many of the leading Italian painters of his

day. While Annibale Carracci was by then enfeebled, and Federico Zuccaro and Caravaggio had left town, Cavalieri d'Arpino, the fashionable Christofasso Roncalli, and the youthful Guido Reni were all available to execute the commission. But as worthy as the ambitious young painter's proposal may have been, his chances were surely enhanced by having been promoted by the wealthy Genoese Monsignor Giacomo Serra (1570-1623), an influential prelate of the court of Rome and Commissary-General of the Papacy, who offered 300 scudi toward the project on condition that his Netherlandish protégé receive the commission. Its completion, however, proved to be difficult; Rubens's first completed version of the altarpiece had to be replaced by a second.

The documents pertaining to the commission for the Oratorians were first published by Jaffé in 1959 and 1963, and clarified by their discoverer, Incisa della Rocchetta, in 1962-63.[1] The whole project has been discussed in detail relatively recently not only by Jaffé but also by Justus Müller Hofstede, Martin Warnke, Volker Herzner, and Julius Held.[2] The commission was complicated by the fact that some of the Oratorian fathers wanted to move to the high altar at the Chiesa Nuova an old damaged fresco image of the Virgin, known as the Madonna della Vallicella, which was purported to have miraculous powers. How this Gnadenbild was to be combined with the new altarpiece was not specified however. The contract of 25 September 1606 includes the Oratorians' request not only to see some work by the artist but also a "disegno" made by him for the project. Further, they reserved the right to reject the finished work until it had been installed above the altar, after which time they must accept it. In the second and binding section of the contract, Rubens was charged with the execution of the painting in accordance with the "disegno o sbozzo" (drawing or rough sketch) that he had submitted, and which evidently was approved by the congregation. The subject is also described as depicting on one side, the holy martyrs Papianus and Maurus; and on the other Sts. Nereus, Achilles, and Flavia Domitilla; St. Gregory the Great was in the center; and finally, the Holy Virgin above, "con molti altri ornamenti."[3] St. Gregory had recently become a co-patron with the Madonna of Sta. Maria in Vallicella. St. Domitilla, who had been martyred with her eunuchs, Sts. Nereus and Achilles, was venerated by the leading Oratorian, Cardinal Baronio, who in 1597 had the eunuchs' relics transferred to his titular church, SS. Nereo ad Accilleo. Silver reliquary heads of the Roman martyrs, Sts. Papianus and Maurus, were already placed on the altar of the Chiesa Nuovo in 1605.

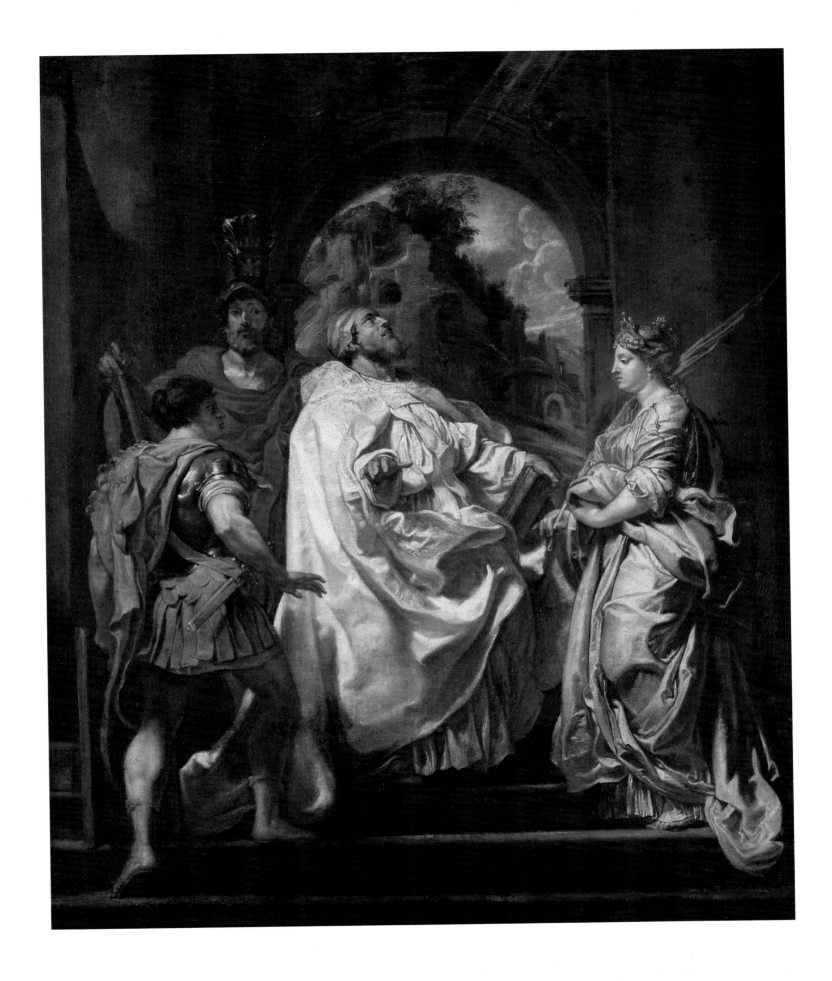

First calling attention to the present work, then in the Neues Palais in Potsdam, Burchard (1926) placed it at the beginning of the project.[4] Evers tried to connect the picture with a later stage in the development of the subject (discussed below), but his opinion has not found support.[5] A more persuasive theory, and one accepted by most authors, is Jaffé's proposal that Rubens painted the Berlin canvas as the illustration of his skill and prowess ("qualche opera fatta dal pittore nominado").[6] As Held observed, this theory is in perfect accord with Rubens's ambition and pride, that he would not rely on a work already finished but instead would welcome an opportunity to demonstrate to the fathers his ability and the speed at which he could work. Held goes on to observe that it was "equally characteristic that instead of a conventional subject, [Rubens] chose to submit . . . a preliminary, if only approximate, formulation of the very subject that he probably knew would have to be dealt with on the altar."[7] As Jaffé surmised, Rubens probably had foreknowledge of the likely program for the altar conveyed by Serra, whose interests as a potential patron were represented within the Oratorian congregation by P. Artemio Vannini.[8] The Berlin painting therefore can be seen as an aggressive bid to secure what Rubens himself described in a letter to Annibale Chieppio of 2 December 1606 as one of the most coveted commissions in all of Rome ("la più bella e superba occasione di tutta Roma").[9]

A very cursory compositional sketch of Sts. Gregory and Domitilla surrounded by saints is an early preparatory drawing for the composition (fig. 1).[10] The Berlin painting then is presumed to be a large modello in oils that preceded the artist's acceptance by the congregation on 2 August 1606.[11] Between that date and 25 September, Rubens submitted his "disegno o sbozzo," which Jaffé first recognized as the large drawing in Montpellier (fig. 2), thus fulfilling his legal prerequisites for the commission.[12] As Egbert Haverkamp Begemann observed in 1953, the fact that the Berlin design is simpler than subsequent versions of the composition (for example, there are only four saints rather than six, and no putti) argues in favor of its position early in the genesis of the composition.[13] Clearly he conceived the design as a sort of "Sacra Conversazione" with the image of the Madonna and Child at the upper center. Still another compositional sketch by Rubens is only known through an etching by J. de Wit[14]; and a drawing for St. Domitilla is in The Metropolitan Museum of Art (fig. 3).[15]

The final altarpiece, now in Grenoble (fig. 4), was completed by early June 1607 and was to incorporate

Fig. 1. Peter Paul Rubens, *Sts. Gregory and Domitilla Surrounded by Other Saints*, pen and brown ink, 210 x 370 mm, Farnham, Wolfgang Burchard collection.

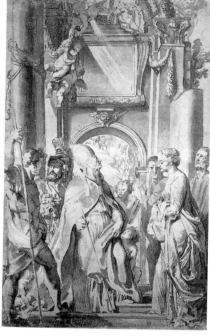

Fig. 2. Peter Paul Rubens, *Sts. Gregory and Domitilla Surrounded by Sts. Maurus and Papianus, Nereus and Achilles*, pen and ink with wash, 735 x 435 mm, Montpellier, Musée Fabre, inv. 864.2.706.

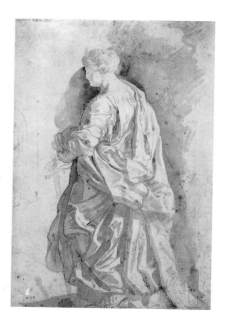

Fig. 3. Peter Paul Rubens, *St. Domitilla*, pen and ink over chalk with wash, 470 x 315 mm, New York, The Metropolitan Museum of Art, no. 65.175.

the miraculous picture of the Madonna di Vallicella while omitting the Roman landscape in the distance.[16] A small oil sketch in the Seilern collection at the Courtauld galleries closely corresponds to the Grenoble painting and was probably the final modello.[17] Unfortunately the altarpiece proved to be unacceptable to the Oratorians. From a long letter that Rubens wrote to Chieppio on 2 February 1608, he suggested that they seemed to be pleased with the picture, but that the lighting was so bad that the figures in their different shades of color could scarcely be distinguished from one another.[18] Rubens wanted to move the painting from the high altar to a more suitable place, but the fathers insisted that in that case he should make a copy on schist, slate, or some other non-reflecting surface. Not wanting to have two versions of the same painting in Rome, Rubens suggested that his old patron, Duke Vincenzo Gonzaga, buy the original, but the latter claimed he could not afford it.[19] Rubens was left with no other option but to keep it for himself. He took it with him when he returned to Antwerp shortly thereafter and in September 1610 installed it in the Church of St. Michael's Abbey near the grave of his mother, Maria Pypelincx. It remained there until it was removed to Paris by Napoleon's troops in 1794 from whence it was sent to Grenoble in 1811.

During his last month in Rome, Rubens painted yet another version of the painting on schist for the high altar of Chiesa Nuova. That work is still in situ and is comprised of three large separate paintings of equal size.[20] The central image is the *Madonna della Vallicella Adored by Angels*, while the paintings of the saints were hung on the side walls of the choir. As several authors have observed, the final conception of the image stresses more emphatically the miraculous nature of the image of the Madonna. These changes undoubtedly were to accommodate reservations that some of the church authorities had not only about the lighting but also the iconography of

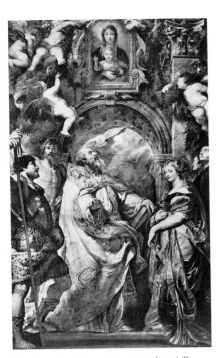

Fig. 4. Peter Paul Rubens, *Sts. Gregory and Domitilla Surrounded by Sts. Maurus and Papianus, Nereus and Achilles*, oil on canvas, 477 x 288 cm, Grenoble, Musée des Beaux-Arts, inv. no. 97.

Rubens's first version.[21] The problems were specifically in the "invenzione dal mezzo insopra," suggesting that it was the relationship between the new canvas and the old enshrined fresco, specifically the emphasis awarded the Madonna della Vallicella. As Freedberg has noted, the final image of the Madonna surrounded only by the "serried ranks of the celestial hierarchy" is wholly removed from the earthly sphere; the changes emphasize the supernatural apartness and miraculous or acheiropoitic nature of the image.[22] The actual fresco was installed directly behind Rubens's panel of the Madonna. As Warnke showed, it is the culmination of a whole line of Italian *Einsatzbilder* – miraculous or especially venerated images set into larger and usually later paintings.[23]

Among the formal sources that have been cited for the Berlin painting, Warnke suggested that Raphael's Homer from his *Parnassus* fresco might be the source for the figure of St. Gregory holding his book.[24] However Held, following an earlier suggestion of Evers, correctly suggested that Raphael's Aristotle from the *School of Athens* made more sense both formally and iconographically.[25] Held also noted that Domitilla's form in the Berlin painting already anticipates her elegant appearance in the Grenoble altarpiece, "though her head, seen in classically inspired profile, gave way in the later work to a three-quarter view, permitting her to establish a sympathetic contact with the faithful approaching the altar."[26] Oldenbourg, following Haberditzl, noted that elements of the figure grouping are derived from Correggio's *Madonna di San Giorgio* (Dresden, Gemäldegalerie), which Rubens copied in a drawing now in the Albertina, Vienna.[27] Kelch also noted the resemblance to the lower zone of Titian's *Sei Santi* (from the Church of San Niccolo dei Frari, in Venice [now in the Vatican Museum]), which Rubens would have known at first hand and could have refreshed his memory of through the Boldrini woodcut.[28]

Another version of the Berlin painting, now in the Museum der Siegerlandes, Siegen (inv. no. R-207), was accepted by Burchard, Bauch, and Benesch and published elaborately by Müller Hofstede in 1964,[29] but was correctly rejected by Arndt,[30] Vlieghe,[31] and Held.[32]

P C S

1. See M. Jaffé, *Proporzioni* (1959), pp. 5-37; *Proporzioni* 4 (1963), pp. 209-251; and Gio. Incisa della Rocchetta, *Rendiconti* 35 (1962-63), pp. 161-183.

2. Jaffé 1977, pp. 85-99 (a revision of his earlier publication). See J. Müller Hofstede, *The Burlington Magazine* 106 (October 1964) pp. 442-450; idem, "Zu Rubens zweitem Altarwerk für Sta. Maria in Vallicella," *Nederlands Kunsthistorisch Jaarboek* 17 (1966), pp. 1-78; M. Warnke, *Münchner Jahrbuch der bildenden Kunst*, 3rd series, 19 (1968), pp. 70-90; Herzner 1979, pp. 117-133; and Held 1980, vol. 1, pp. 357-540.

3. Incisa della Rocchetta 1962-63, pp. 163-167.

4. Burchard 1926, p. 2 no. 3.

5. Evers 1943, pp. 111-116. See especially the analysis by Egbert Haverkamp Begemann, in Rotterdam 1953, pp. 33-35, cat. no. 3.

6. Jaffé 1963, pp. 209-214.

7. Held 1980, vol. 1, p. 541.

8. Jaffé 1977, p. 86, note 16.

9. Letter of 2 December 1606. Rooses, Ruelens 1887-1909, vol. 1 (1887), p. 354.

10. See Vlieghe 1973, vol. 2, pp. 50-51, cat. 109a, fig. 24.

11. Ibid., no. 109d, fig. 25; Held 1980, no. 396, pl. 386.

12. See Jaffé 1959, pp. 25-26, figs. 13-16; idem, 1963, p. 229. Vlieghe's objection (1972-73, p. 57) that the drawing is not by Rubens and is a somewhat free adaptation of the [final] Roman altarpiece was correctly rejected by Müller Hofstede (1977, p. 204), Warnke (1968, p. 81-82), Herzner (1979, p. 129) and Held (1980, p. 541). On the drawing, see also Padua/Rome/Milan 1990, no. 64, ill.

13. Rotterdam 1953, pp. 33-34, no. 3.

14. Vlieghe 1972-73, no. 109f; reproduced in Müller Hofstede 1964, fig. 9.

15. Vlieghe 1972-73, no. 109b. A study in oils of Domitilla is in the Accademia Carrara, Bergamo, no. 430; see Padua/Rome/Milan 1990, no. 17.

16. Vlieghe 1972-73, no. 109, fig. 23.

17. Ibid., no. 109g, fig. 30. Evers (1943, pp. 108-112, fig. 15). A. Seilern, *Catalogue of Paintings and Drawings at 56 Princes Gate London SW7* (London, 1972, pp. 22-23), and Warnke (1968, p. 85, note 135) regard the painting as following the Grenoble painting, however Müller Hofstede (1964, p. 450) and Vlieghe feel it immediately preceded it.

18. Rooses, Ruelens 1887-1909, vol. 1 (1887), pp. 403-405.

19. Ibid., p. 410.

20. Rooses 1886-92, vol. 1 (1886), pp. 270-275, no. 205; vol. 2 (1888), pp. 276-278, nos. 442 and 443.

21. See Warnke 1968, pp. 84ff.

22. Freedberg 1981, p. 125.

23. Warnke 1968, pp. 61-70.

24. Ibid., p. 81.

25. Held 1980, vol. 1, p. 541; Evers 1943, p. 108.

26. Ibid.

27. Oldenbourg 1921, p. XX; F. M. Haberditzl, "Über einige Handzeichnungen von Rubens in der Albertina," *Die graphischen Kunste* 35 (1912), pp. 2ff. For the Albertina drawing, see Vienna, Albertina, *Die Rubenszeichnungen der Albertina*, exh. 1977, no. 58. Jaffé (1963, p. 227) noted that the figure of Maurus seen from behind closely resembles Correggio's St. George.

28. Kelch 1978, p. 10; for Boldrini's print, see his fig. 4. Müller Hofstede (1964, pp. 446ff) already connected the Titian with Rubens's drawing in the Burchard collection (fig. 1).

29. Müller Hofstede 1964, pp. 442-450, fig. 1.

30. K. Arndt "Meisterwerke aus Badem-Württembergischen Privatbesitz," *Kunstchronik* 9 (1958), pp. 355-356.

31. Vlieghe 1972-73, no. 109e, fig. 26.

32. Held 1980, vol. 1, p. 542.

Peter Paul Rubens
8. Portrait of Marchesa Brigida Spinola Doria, 1606

Oil on canvas, 152.2 x 98.7 cm (60 x 38⅞ in.)
Washington, D.C., National Gallery of Art, inv. 1612

PROVENANCE: collection Marchese Giacomo Massimiliano Doria (first husband of the sitter), Genoa, 1606; (possibly) collection Gian Vincenzo Imperiale (second husband of the sitter), Genoa, 1661[1]; (probably) collection Francesco Maria Imperiale (stepson and son-in-law of the sitter); (probably) collection Rati Opizzone, Turin; collection General Sir John Murray (ca. 1768-1827), Clermont, Fifeshire, Scotland[2]; sold by T. Murray to Sir Thomas Lawrence, London, 1830 [for £304.10] collection Simon Horsin-Déon, Paris, 1848; collection J. Pariss; sale E. MacLean and others, London (Christie's), 4 February 1854, no. 76 [property of J. Pariss; bt. in at 70 gns.][3]; dealer C. J. Nieuwenhuys, London; sale Nieuwenhuys, London (Christie's), 17 July 1886, no. 92 [£304.10, to Charles Wertheimer]; collection Bertram W. Currie, Minley Manor, Hampshire; sale London (Christie's), 16 April 1937, no. 116 [£2835, to Goldschmidt]; Duveen Brothers, Inc., New York, by 1946; Samuel H. Kress collection, 1961.

EXHIBITIONS: London, Wildenstein, *A Loan Exhibition of Works by Peter Paul Rubens, Kt.*, cat. by Ludwig Burchard (1950), no. 55; London 1953-54, no. 180; Washington, National Gallery of Art, *Exhibition of Art Treasures for America* (10 December 1961-4 February 1962), no. 81; Antwerp 1977, no. 7; Cologne 1977, no. 91; Sarasota, The John and Mable Ringling Museum of Art, and Hartford, Wadsworth Atheneaum, *Baroque Portraiture in Italy. Works from North American Collections*, cat. by John T. Spike (1984-85), no. 60; Padua/Rome/Milan 1990, no. 23.

LITERATURE: S. Horsin-Déon, *De la conservation et de la restauration des tableaux* (Paris, 1851), pp. 34, 35; Rooses 1886-92, vol. 4 (1890), p. 273, no. 1064, and vol. 5 (1892), p. 350; K. Bauch, "Beiträge zur Rubensforschung," *Jahrbuch der preussischer Kunstsammlungen* 45 (1924), p. 190; Burchard 1929, pp. 321-324; Valentiner 1946, p. 155, no. 5; Goris, Held 1947, p. 26, no. 2; C. Seymour, Jr., *Art Treasures for America, Kress Anthology* (London, 1961), pp. 144, 215; Müller Hofstede 1965, pp. 94-96, 110-111, 138-139, 141 and 142; M. Jaffé, "Some Recent Acquisitions of Seventeenth-Century Flemish Painting," *National Gallery of Art, Reports and Studies in the History of Art* 1969, p. 26; C. Eisler, *Paintings from the Samuel H. Kress Collection, European Schools Excluding Italian* (Oxford, 1977), pp. 101-103; Huemer 1977, pp. 35-39 passim, and 169-172; Jaffé 1977, p. 76; G. Biavati, "Il recupero conoscitivo dei Rubens ‹·'genovesi,'» in *Rubens e Genova* (exh. cat. Genoa, Palazzo Ducale, 18 December 1977-12 February 1978), pp. 150-153; Washington, cat. 1985, p. 361; M. Jaffé, in *The Treasure Houses of Britain* (exh. cat. Washington, National Gallery of Art, 3 November 1985-16 March 1986), p. 559.

ONE OF THE most commanding portraits of Rubens's Italian period, the *Portrait of Marchesa Brigida Spinola Doria* combines the stylized formality of traditional court portraiture with a sympathetic insight into the sitter's personality. The stately figure of the Marchesa is posed before an impressive architectural backdrop which, in lustrous burnished bronze, complements the metallic sheen of her white satin gown. The wind-tossed splash of red drapery makes a dramatic foil for the porcelain delicacy of her face, which is further isolated by her stiffly wired lace-edged ruff and crowned with crisp coppery curls and an elaborate pearl hair ornament. The Marchesa's regal bearing is enhanced by the opulence of her costume: the shimmering white and gold satin and heavy jewel-encrusted ornaments are dazzling manifestations of Rubens's bravura brushwork. Lightninglike highlights flash against the deeper undertones of the painting, a conscious echo of the jagged bursts of light that dramatize the late works of Jacopo Tintoretto.[4]

The painting was substantially cut down on all four sides during the mid-nineteenth century.[5] The original full-length composition is preserved in Rubens's preparatory drawing, now in the Pierpont Morgan Library, New York (fig. 1),[6] and in a lithograph published in 1848 (fig. 2).[7] The Marchesa was originally depicted on the terrace of a villa, before a grand loggia of Ionic columns supporting a massive cornice. At the left, the architecture gives way to a low balustrade with an urn, and beyond, a view of foliage and a distant sky. An inscription on the reverse of the present canvas – BRIGIDA. SPINVLA. DORIA / ANN: SAL: 1606. / AET: SVAE. 22. / P. P. RVBENS ft – duplicates (with the addition of the artist's name) an inscription originally on the lower right corner of the painting and visible in the print.

Marchesa Brigida Spinola Doria (d. 1648), daughter of Gasparo Spinola and Maria Doria, was baptized in Genoa on 9 May 1583.[8] She married her cousin Giacomo Massimiliano Doria, son of the Doge Agostino Doria, on 9 July 1605. Following the early death of her first husband, in 1621 she married Gianvincenzo Imperiale, an important early patron of Rubens.[9] The present portrait was probably commissioned to commemorate the marriage of Brigida Spinola and Giacomo Doria, and executed during Rubens's visits to Genoa in the spring of 1606.

Rubens visited Genoa on numerous occasions during his Italian sojourn, and maintained ties with the republic for two decades after his return to Flanders: in a letter dated 19 May 1628, he stated, "I have been several times in Genoa, and remain on very intimate terms with several eminent personages in that republic."[10] He first visited the city briefly in early 1604, en route from Spain to Mantua, and returned several times during 1606 and 1607.[11] Although Rubens was primarily occupied with portrait commissions in Genoa, he also executed an altarpiece for the church of the Gesù, and made a detailed study of Genoese architecture. His drawings of the plans and elevations of various palazzi were engraved and published in *Palazzi di Genova* (Antwerp, 1622), with a dedication to Carlo Grimaldi.

Rubens's illustrious Genoese patronage was centered in the tightly-knit oligarchy of the republic's banking patriciate, among them the Pallavicini, Durazzo, Grimaldi, Doria, Imperiale, and Spinola families.[12] The *Portrait of Marchesa Brigida Spinola Doria* and the *Portrait of Caterina Grimaldi*, also dated 1606 (Kingston Lacy, The National Trust [Bankes collection]; fig. 3), are the only dated portraits from the artist's Genoese period and provide a reference for the dating of other works. Rubens's Genoese portraits are for the most part monumental full-length likenesses, majestically composed but incorporating

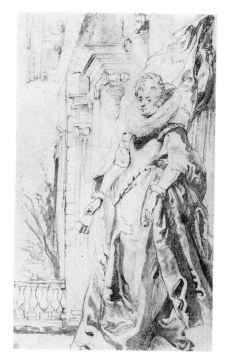

Fig. 1. Peter Paul Rubens, *Study for the Portrait of Marchesa Brigida Spinola Doria*, pen and brown ink with wash over black chalk, 315 x 178 mm, New York, Pierpont Morgan Library, acc. no. 1975.28.

Fig. 2. Lithograph by F. Lehnert after Peter Paul Rubens, *Portrait of Marchesa Brigida Spinola Doria*, published in *L'Artiste, Revue de Paris*, ser. 7, vol. 10 (1848).

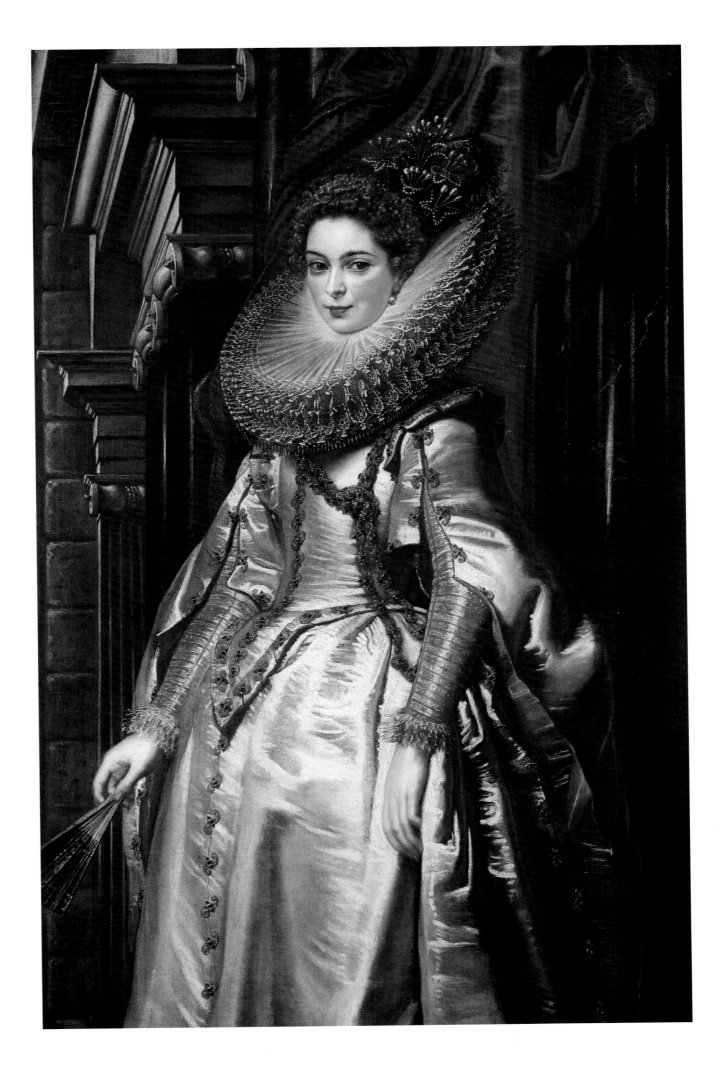

a keenly observed humanity. Although there are no exact one-to-one correspondences, the architectural settings are comparable to and undoubtedly inspired by the grand terraces which were a dominant feature of Genoese palazzi. With the activation of the background and the emphatically sculptural presence of the figure, Rubens's portraits are vibrant successors to the indigenous Italian and Hispano-Flemish traditions of court portraiture,[13] and were a significant influence on later portrait painting. Rubens's most important disciple in this regard was Anthony van Dyck (see cat. 39) who portrayed several members of the Genoese patriciate during the 1620s.

The precise ownership of the *Portrait of Marchesa Brigida Spinola Doria* between 1606 and the early nineteenth century is not entirely clear. The painting may be identical to a work mentioned in a 1661 inventory of paintings in the collection of the late Giovanni Vincenzo Imperiali, Brigida Spinola Doria's second husband: "Un Ritratto di donna in piedi del Rubens, alt palmi 9 x largh. p. 7."[14] The measurements approximate the dimensions of the Washington painting in its original state. Although the majority of paintings listed in this inventory entered the collection of Christina of Sweden and subsequently the Orléans collection, this portrait apparently remained in the family's possession. Among the papers of William John Bankes (who acquired Rubens's portraits of Caterina and Maria Grimaldi at Genoa before 1841) is a note which seems to refer to the Washington portrait: "TORINO / Chevr Rati Opizzone / Conseiller d'Etat à Turin. Rue de la Providence No: 22: has the companion picture by Rubens of the pair which I purchased; portrait of a Lady full length (standing) (with a fan) the same date upon it 1606, & the age, & name of the Lady (Spinola Doria, I think) – is desirous of selling it; it was a present from the head of the Family Imperiali to his (the Chevr's) father-in-law when the Imperiali was quitting the palace in Campetto."[15]

<div align="right">MEW</div>

1. The painting is not mentioned in the inventory made at the death of Gian Vincenzo Imperiale, Genoa, in 1648; the inventory is published in R. Martinoni, *Gian Vincenzo Imperiale politico, letterato e collezionista genovese del seicento* (Padua, 1983), pp. 231-242.

2. According to the 1886 sale catalogue. See note 15 below.

3. "Portrait of Brigida Spinola Doria . . . whole length, in a white dress, richly ornamented, standing on the terrace of a palace"; as pendant to lot 75, A. van Dyck, *Portrait of the Doge of Genoa [Giovanni Vincenzo Imperiale]* (now Brussels, Musées Royaux des Beaux-Arts de Belgique, inv. 3463).

4. Tintoretto's work was a potent influence on the young Rubens; compare also the dramatic lighting effects in such paintings as the *Portrait of the Duke of Lerma* (1603; Madrid, Museo del Prado) or *The Baptism of Christ* (1604-1605; Antwerp, Koninklijk Museum voor Schone Kunsten, inv. 707). See Jaffé 1977, pp. 36-37; C. Janson, "L'Influence de Tintoret sur Rubens,"

Gazette des Beaux-Arts 19 (1938), pp. 77ff; and G. M. Pilo, "Rubens e l'eridità veneta," in Pilo 1990, esp. pp. 89-110.

5. The painting is described as "whole length" in the sale catalogue of 1854.

6. Pen and brown ink with wash over black chalk, 315 x 178 mm, acc. no. 1975.28; see F. Stampfle, *Netherlandish Drawings of the Fifteenth and Sixteenth Centuries and Flemish Drawings of the Seventeenth and Eighteenth Centuries in the Pierpont Morgan Library* (New York and Princeton, 1991), pp. 139-140. The drawing is annotated by Rubens with color notes corresponding to the finished portrait. A second drawing of the composition (probably a copy) is in the Ecole Nationale Supérieure des Beaux-Arts, Paris, inv. 682 (as by Cornelis de Vos).

7. Lithograph by F. Lehnert, in *L'Artiste, Revue de Paris*, ser. 7, vol. 10 (1848).

8. Biographical information taken from Müller Hofstede 1965, p. 96, and Eisler 1977, p. 101; for further details see the references cited there.

9. On Imperiale's patronage of Rubens, see C. Sterling and L. Burchard, "La découverte et l'histoire d'une œuvre inconnue de Rubens," *L'Amour de l'art* 9 (1937), pp. 295ff.

10. Letter from Rubens to Pierre Dupuy, dated Antwerp, 19 May 1628; Magurn 1955, p. 265.

11. On the proposed dates of Rubens's visits to Genoa – which are not well documented – see L. Tagliaferro, "Di Rubens e di alcuni genovesi," in *Rubens e Genova* (exh. cat. Genoa, Palazzo Ducale, 18 December 1977-12 February 1978), especially pp. 36-42.

12. On Rubens's Genoese portraits, see Burchard 1929, Longhi 1939, Müller Hofstede 1965, and (less reliably) Huemer 1977, pp. 33-43.

13. Compare, for example, Frans Pourbus the Younger's static and conventional portrait of the Infanta Margherita Gonzaga (dated 1605; Florence, Palazzo Pitti). See Müller Hofstede 1965, p. 122, and passim.

14. *Il Grechetto a Mantova: Lettere e altri documenti, intorno alla storia della pittura* (Fonti di Storia della Pittura, I) (Genoa, 1971), p. 60. Müller Hofstede (1965, pp. 96, 101, 102), however, suggested that this entry may also refer to a portrait of Gianvincenzo's first wife, Caterina Grimaldi, which was also commissioned from Rubens in 1606.

15. From the Bankes papers, Dorset County Record Offices; cited by Jaffé, in exh. cat. Washington 1985-86, p. 559. Bankes's note is unfortunately undated; as noted in the Provenance above, a *Portrait of Brigida Spinola Doria* was in the Murray collection prior to 1827 (which would indicate that Bankes saw the painting in Genoa before that date), but a separate annotation by Bankes states that he purchased his two Rubens portraits in Genoa in 1840 (which would indicate that he saw the present portrait sometime thereafter). The only reference to the presence of the *Brigida Spinola Doria* in the Murray collection is in the 1886 sale catalogue. An alternative provenance was proposed by Seymour (1961, p. 215), who suggested that the *Brigida Spinola Doria* was probably brought from Genoa to London ca. 1802-1806 by Mr. Irvine, an agent of the art dealer William Buchanan. Buchanan (1824, pp. 106ff) publishes a letter from Irvine (in Genoa, dated 1 October 1802) that describes the purchase of paintings by Rubens from the collection of Giorgio Doria, although none of these works are described. Seymour was not aware of the Bankes note quoted above. Müller Hofstede 1965, pp. 141-142, note 15, also discusses the provenance of the Washington portrait.

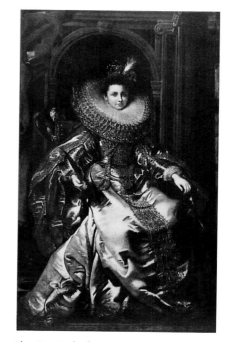

Fig. 3. Peter Paul Rubens, *Portrait of Caterina Grimaldi*, signed and dated 1606, oil on canvas, 241.3 x 139.7 cm, Kingston Lacy, The National Trust (Bankes collection).

Peter Paul Rubens
9. Portrait of Mūlāy Ahmad

Oil on panel, 99.7 x 71.5 cm (39 ¼ x 28 ⅛ in.)
Boston, Museum of Fine Arts, M. Theresa B. Hopkins
Fund, inv. 40.2

Fig. 1. Anonymous after Jan Vermeyen, *Portrait of Mūlāy Ahmad*, etching, inscribed MVLEI AHMET PRINCEPS AFRICANVS FILIVS REGIS TVNISI, Rotterdam, Museum Boymans-van Beuningen.

PROVENANCE: (possibly) mentioned in the *Specification* of Rubens's estate, 1640, no. 148 or 149 ["Deux pourtraits d'vn Roy de Thunis, apres Anthoine More"]; Jacques Jean de Raedt (1757-1838), Mechelen[1]; William Waldegrave, Baron Radstock of Castletown, Longhill Castle, Wiltshire and Coleshill, Berkshire; his sale, London (Christie's), 12-13 May 1826, no. 23 [as "Portrait of Tamerlane"; £136.10, to Nieuwenhuys]; Duke of Wellington (Wellesley collection); Marquis du Blaisel; sale Marquis du Blaisel, Paris, 16-17 March 1870, no. 110 [as after Antonio Moro; bought in at frs. 6000]; sale Marquis du Blaisel, London (Christie's), 17-18 May 1872, no. 147 [bought in at £150]; E. Secrétan, Paris; sale Secrétan, Paris (Chevallier), 1 July 1889, no. 159 [frs. 2600, to Sedelmeyer]; John Wanamaker, Lindenhurst; acquired from Wanamaker 1940 [via Paul Drey, New York].

EXHIBITIONS: Baltimore, The Baltimore Museum of Art, *From El Greco to Pollock: Early and Late Works by European and American Artists* (1968), no. 13.

LITERATURE: Smith 1829-42, vol. 2 (1830), p. 33; Rooses 1886-92, vol. 4 (1890), nos. 1067-1068; Denucé 1932, p. 63, nos. 148-149; J. S. Held, "Rubens' 'King of Tunis' and Vermeyen's Portrait of Mūlāy Ahmad," *Art Quarterly* 3 (1940), pp. 173-181 (reprinted in Held 1982, pp. 3-8); Goris, Held 1947, p. 28, no. 11; Constable 1949, pp. 129-131; Held 1980, vol. 1, p. 600; Boston, cat. 1985, p. 252; Balis 1986, p. 142; Stebbins, Sutton 1986, p. 40; H. J. Horn, *Jan Cornelisz Vermeyen: Painter of Charles V and His Conquest of Tunis* (Doornspijk, 1989), vol. 1, pp. 15, 19, 73-74 notes 145-148, 78 note 185, 291, vol. 2, pl. A47; Muller 1989, p. 121, pl. 68; K. Belkin, in Liedtke et al. 1992, pp. 186-189.

RUBENS'S bold portrayal of Mūlāy Ahmad, posed before an extensive landscape, conveys with powerful immediacy the decisive temperament and regal bearing of the sitter. With watchful gaze fixed to the left, his left hand clutching a sheathed sword and right hand hovering at his hip, the young Moor seems poised for instantaneous movement. He is clad in a loose dark olive tunic offset by a gold embroidered rose sash with a tassel, and a similar band slung over his right arm. His rich coppery skin is contrasted against the gleaming white of his turban and scarf and the full sleeves which cascade over his wrists. In the distance, three turbaned horsemen gallop over a gently rolling landscape dotted with low bushes and palm trees. The massive ruins in the distance were identified by Held as the ancient aqueduct near the river Medjerda, connecting Zaghwan and Carthage,[2] and (more convincingly) by Constable as the ruins of the arena El Djem in Tunis.[3]

Mūlāy Ahmad was the son of Mūlāy Hasan, Berber King of Tunis, who had been driven from power in 1534 by the famous corsair Khair al-Din (better known as Barbarossa), at the command of the Sultan of Turkey. Responding to the pleas of the deposed monarch who had taken refuge in Spain, in 1535 Charles V launched a "crusade" to defeat Khair al-Din, capture Tunis, and reinstate Mūlāy Hasan as ruler. Mūlāy Ahmad seized the throne in 1542, when his father returned to Europe to seek further assistance from Charles V. When Hasan rushed home, he was given a choice between life in prison and blinding; he chose the latter. Ahmad remained in control of Tunis until 1569, when he too fled to Spain.[4]

Rubens's portrait of Mūlāy Ahmad is a copy after a lost painting by the Dutch artist Jan Cornelisz. Vermeyen (1500-1559). Vermeyen accompanied Charles V on his Tunisian campaign in 1535 and made drawings of battle scenes in situ, which were later incorporated in a series of twelve tapestries commemorating the expedition and glorifying Charles as the defender of Christianity.[5] In addition to these ambitious works chronicling Charles's victory, Vermeyen painted portraits of both Mūlāy Hasan and Mūlāy Ahmad. Although the latter paintings no longer exist, the compositions survive in a woodcut portrait of Mūlāy Hasan and an etched portrait of Mūlāy Ahmad (fig. 1). The latter bears the inscription MVLEI AHMET PRINCEPS AFRICANVS FILIVS REGIS TVNISI (Mulei Ahmet Prince of Africa, Son of the King of Tunis), indicating that it was made prior to Ahmad's usurping the throne in 1542.[6]

Rubens's painting reverses the etched composition which, as Held pointed out, probably indicates that he knew Vermeyen's original painting since he would have had no obvious reason to reverse an image he knew only from the print.[7] Vermeyen's original may be recorded in several seventeenth-century Antwerp inventories, for example, that of the Antwerp painter and dealer Herman de Neyt in 1642: "Den Moor van Meester van Aelst, met Tunis achter. Den vader vanden voors[chreven] Moor die Keyser Carel te voet valt".[8] Rubens introduced several minor changes in his copy after Vermeyen. He reduced the full-scale battle in the background of the etching to the three ghostly horsemen at the left, thus focusing greater attention on the imposing likeness in the foreground. He also elongated the figure of Mūlāy Ahmad to more idealized proportions, and extended Vermeyen's rather cramped composition from half- to three-quarter length.

The *Portrait of Mūlāy Ahmad* is presumably one of the "Two portraits of a King of Tunis, after Anthoine Mor" mentioned in the 1640 inventory of Rubens's estate; works by Vermeyen were almost invariably attributed to either Pieter Coecke van Aelst or Antonis Mor in seventeenth-century inventories.[9] Although Rubens drew and painted copies and adaptations of works by earlier artists for a variety of reasons,[10] the fact that the *Mūlāy Ahmad* remained in his own collection suggests that his interest in Mūlāy Ahmad as a historical figure was at least matched by his fascination with the Moorish prince's features as a character study, or *tronie*. Frans Floris was probably the first to develop the *tronie* (a head- or bust-length study of facial expression, lighting effects, or some other specific artistic prob-

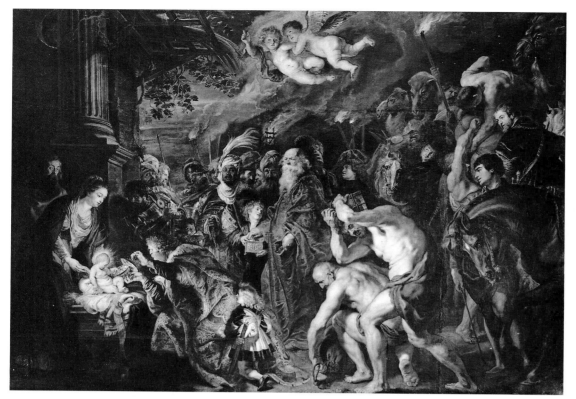

Fig. 2. Peter Paul Rubens, *Adoration of the Magi*,
ca. 1610, oil on canvas, 346 x 488 cm, Madrid, Museo
del Prado, inv. 1638.

Fig. 3. Peter Paul Rubens (?), *Head of a Turbaned
African*, oil on paper laid down on panel, 54 x
ca. 39.3 cm, sale London (Christie's), 11 December
1987, no. 19.

Fig. 4. Peter Paul Rubens, *Adoration of the Magi*,
ca. 1617-19, oil on panel, 318 x 276 cm, Mechelen
(Malines), St. Janskerk.

lem) as an independent art form; in Floris's atelier
(as in Rubens's) these finished studies were often
worked into larger compositions designed by the
master and executed with studio assistance.[11]
Rubens's portrait of Mūlāy Ahmad is traditionally
thought to have served as the source for the African
magus Balthasar in several of his representations of
the *Adoration of the Magi*, including that executed for
the Antwerp Town Hall in ca. 1610 (now Madrid,
Museo del Prado, inv. 1638; fig. 2).[12] The relationship
between the Boston painting and this larger work
has thus led scholars to suggest a date of ca. 1609-
1610 for the former.[13] More recently, however, it has
been proposed that Balthasar's features in the Prado
Adoration and his intricately folded turban may have
been derived not from the *Mūlāy Ahmad*, but possi-
bly from an earlier oil sketch for a *Head of a Turbaned
African* (fig. 3).[14] Consequently, as Held has suggest-
ed, there is no reason to assume that the Boston *Por-
trait of Mūlāy Ahmad* predates the Prado *Adoration*,
and on stylistic grounds a date of ca. 1613-1614 seems
more plausible. Rubens did reuse the features of the
Tunisian prince for the figure of Balthasar in his
Adoration of the Magi painted for the St. Janskerk
(Cathedral) in Mechelen, ca. 1617-1619 (fig. 4),[15] and
as one of the huntsmen in the *Tiger, Lion and Leopard
Hunt* of ca. 1616-1617 (Rennes, Musée des Beaux-Arts,
inv. 811.1.10).[16]

MEW

1. C. J. Nieuwenhuys; *A Review of the Lifes and Works of Some of the Most
Eminent Painters, etc.* (London, 1834), p. 198, no. 47.

2. Held 1940, p. 178.

3. Constable 1949, p. 129.

4. Held 1940, p. 174.

5. The cartoons for the tapestries are in the Kunsthistorisches Museum,
Vienna; the tapestries are in the collection of the Patrimonio Nacional,
Madrid.

6. Constable 1949, p. 129.

7. Held 1940, p. 177.

8. "The Moor by Master [Pieter Coecke] van Aelst, with Tunis in the back-
ground. The father of the aforementioned Moor, who prostrates himself
before Emperor Charles." Denucé 1932, p. 63; also cited in Held 1940,
p. 174. For paintings in other inventories that might be identified with
Vermeyen's originals, see Muller 1989, p. 121.

9. Held 1940, p. 177; see also Horn 1989.

10. For a discussion of Rubens's theory and practice of copying works of
art, see Muller 1989, pp. 59-61; and the entry on *Cupid Sharpening His Bow*
(after Parmagianino, cat. 11), with further references.

11. C. van de Velde, *Frans Floris (1519-1570) Leven en Werken* (Brussels, 1975),
pp. 65-74, 104-106; and L. de Vries, "Tronies and Other Single Figured
Netherlandish Paintings," in H. Blasse-Hegeman et al., eds., *Nederlandse
Portretten* (*Leids Kunsthistorisch Jaarboek* 8 [1989], The Hague, 1990), p. 191.

12. On this painting and a related sketch in the Groninger Museum in
Groningen, see C. Norris, "Rubens' Adoration of the Kings of 1609," *Neder-
lands Kunsthistorisch Jaarboek* 14 (1963), pp. 129-136; and Held 1980, vol. 1,
no. 325, pp. 450-453.

13. Held 1940, p. 179.

14. Held 1980, vol. 1, p. 600; see also Held 1982a, p. 8. The execution of this
painting is rather weak, however, and the attribution to Rubens has
been doubted.

15. A bust-length copy after this figure, holding a gold casket, is in a
private collection on loan to the Rubenshuis, Antwerp (oil on panel,
65 x 50 cm); see exh. cat. Padua/Rome/Milan 1990, no. 39.

16. D. Rosand, "Rubens's Munich *Lion Hunt*: Its Sources and Significance,"
Art Bulletin 51 (1969), p. 30, note 9.

Peter Paul Rubens and Frans Snyders
10. *Prometheus Bound*, ca. 1611-1612, completed by 1618

Oil on canvas, 243 x 210 cm (95 ½ x 82 ½ in.)
Philadelphia Museum of Art, Purchased for the
W. P. Wilstach collection, inv. W'50-3-1

PROVENANCE: traded by the artist to Sir Dudley Carleton, 1 June 1618; offered unsuccessfully by Carleton to the king of Denmark, September 1618; possibly passed from Carleton to King Charles I; possibly with dealer Matthijs Musson, Antwerp, 1658; Charles, fourth Earl of Manchester, Kimbolton Castle, Huntingdonshire, in inventory of 28 September 1687; in the collection of the earls and dukes of Manchester until sold at auction (Knight, Frank & Rutley) at Kimbolton Castle, 18 July 1949, no. 8; acquired by dealer Martin B. Asscher, London, who sold it to the Philadelphia Museum of Art.

EXHIBITIONS: London, British Institution, 1850, no. 142; Manchester, City of Manchester Art Gallery, *Art Treasures of the United Kingdom*, 1857, no. 534; London, British Institution, 1867, no. 126; Cleveland, Cleveland Museum of Art, *The Venetian Tradition*, 1956, no. 41, pl. XLIV; Philadelphia, Philadelphia Museum of Art, "Philadelphia: 100 Years of Acquisitions," 3 May-3 July 1983 (no catalogue).

LITERATURE: Dominic Baudius, *Poematum nova editio* (1616), p. 578; W. S. Lewis and R. S. Brown eds., *Horace Walpole's Correspondence with George Montague*, vol. 2 (New Haven, 1941), pp. 76, 78 [letters of 25 and 30 May 1765]; A. Young, *A Six-Month Tour through the North of England*, vol. 1 (London, 1770), p. 56; R. Cumberland, *An Account and Descriptive Catalogue of the Several Paintings in the King of Spain's Palace in Madrid* (London, 1787), pp. 16-17; W. H. Carpenter, *Pictorial Notices* (London, 1844), p. 142; C. B., *Les Trésors de l'art à Manchester* (Paris, 1857), p. 156; Thoré-Bürger 1857, p. 188; A. A. Lavice, *Revue des Musées d'Angleterre* (Paris, 1867), p. 241; Rooses 1886-92, vol. 3 (1890), pp. 152-153, no. 671, vol. 5 (1892), pp. 340-341; Rooses, Ruelens 1887-1909, vol. 2 (1898), pp. 136, 187; Oldenbourg 1921, p. 79; Lugt 1949, p. 18; van Gelder 1950-51, p. 127, no. 18; H. Comstock, "The Connoisseur in America," *The Connoisseur* 127 (1951) pp. 116-117, ill. p. 117; "Diamond Jubilee Accessions," *The Philadelphia Museum Bulletin* 46, no. 229 (1951), p. 43, ill. p. 94; F. Kimball, "Rubens' *Prometheus*," *The Burlington Magazine* 94 (1952), pp. 67-68, ill., p. 66; Larsen 1952, pp. 68, 217, no. 53; A. E. Popham, "A Drawing of Frans Snyders," *The Burlington Magazine* 94 (1952), p. 237; van Puyvelde 1952, pp. 58, 116, 204, no. 67; Held 1954, p. 7, pl. 5; Magurn 1955, p. 60, letter no. 28, p. 441, ill. opp. p. 144; Greindl 1956, p. 74; O. Raggio, "The Myth of Prometheus: Its Survival and Metamorphoses up to the Eighteenth Century," *Journal of the Warburg and Courtauld Institutes* 21 (1958), pp. 58, 61-62, pl. 9d; J. S. Held, "Prometheus Bound," *Philadelphia Museum of Art Bulletin* 59 (1963), pp. 17-32, fig. 1; A. Kesting, "Zweimal der gefesselte Prometheus," *Museen in Köln Bulletin* 5 (1966), p. 446-448, ill.; C. Dempsey, "Euanthes Redivivus: Rubens's *Prometheus Bound*," *Journal of the Warburg and Courtauld Institutes* 30 (1967), pp. 420-425, pl. 55a; Cologne, Wallraf-Richartz-Museum, cat. 1967, p. 60; Stechow 1968, pp. 40-41, fig. 26; Robels 1969, p. 54; Jaffé 1971b, pp. 185, 195, no. 13; J. R. Martin and C. L. Bruno, "Rubens's Cupid Supplicating Jupiter," in Martin 1972, pp. 17, 19, fig. 11; E. H. Turner, "Collectors and Acquisitions," *Apollo*, n.s. 100 (1974), p. 40, fig. 1; Baudouin 1977, p. 74, fig. 38; Jaffé 1977, p. 21; E. K. J. Reznicek, "Opmerking bij Rembrandt," *Oud Holland* 91 (1977), pp. 90-91, 105, fig. 11; John Rowlands, in London, British Museum, *Rubens Drawings and Sketches* (exh. 1977), pp. 13, 76, under cat. no. 80; Paris 1977-78, p. 28, under cat. no. 11, ill.; Braun 1979, vol. 1, p. 39. ill., p. 104, no. 112; Held 1980, vol. 1, p. 334, under cat. no. 245; Blankert in Washington/Detroit/Amsterdam 1980-81, under cat. no. 14; P. C. Sutton, "'Tutti finiti con amore': Rubens' *Prometheus Bound*," in *Essays in Northern European Art Presented to Egbert Haverkamp Begemann* (Doornspijk, 1983), pp. 270-275, fig. 1; White 1987, p. 134, fig. 5; Robels 1989, pp. 35, 119, 354-356, cat. no. 261; Sutton 1990, pp. 251-261, cat. no. 91, ill.; C. van de Velde, in Liedtke et al. 1992, pp. 184-185, ill.

PROMETHEUS writhes in agony as a huge eagle, talons gripping his head and groin, devours his liver. The hero's nude body, powerfully muscled and steeply foreshortened, is chained at the wrist to the rock. Prometheus lies on blue and white drapery, his leg drawn up in pain. At the lower left blazes his fallen torch. Above the eagle's outstretched wings spread the limbs of a tree. Beyond the silhouette of the boulders on the left is a glimpse of an open landscape.

The earliest mention of this painting is in a laudatory poem composed by the Leiden University professor and acquaintance of Rubens's brother Philip, Dominicus Baudius, who sought to evoke the horrible immediacy of the work, describing the scene as if the bird were alive, and imagining flames jetting from its eyes.[1] Baudius's poem is dated 7 April 1612, thus providing an *terminus ante quem* for the commencement of Rubens's work on the painting. As Julius Held observed, a date of 1611-1612 for the painting is also supported by its stylistic resemblance to the *Juno and Argus* (Cologne, Wallraf-Richartz-Museum, no. 1040), which not only employs comparable paint handling but also includes a similarly contorted nude and is documented as having been completed by 11 May 1611.[2] The *Prometheus* evidently remained for as long as six years in Rubens's studio (or conceivably was purchased back from its owner by the artist from an intermediary owner), because it is mentioned by Rubens in a letter of 28 April 1618 to Sir Dudley Carleton, the British ambassador to The Hague.[3] This was part of a correspondence begun the previous year in which Rubens sought to exchange several of his own paintings for a collection of ancient marbles owned by Carleton. Promoting the paintings as "the flower of my stock," Rubens listed the present painting first, describing it as "A Prometheus bound on Mount Caucasus with an eagle which pecks his liver. Original by my hand the eagle done by Snyders." Although this probably was not the first instance of the long and fruitful collaboration between Rubens and Snyders, it was an early example and the only case certified by Rubens himself. Snyders's preparatory drawing for the eagle is preserved in the British Museum (fig. 1).[4] The success of this collaboration and the vitality of the eagle that so impressed Baudius would seem, as Robels noted, to give the lie to the oft-quoted letter of Tobey Matthew to Carleton purporting that it was Rubens's opinion that Snyders was not as accomplished at painting live animals as dead ones.[5] Held reasonably surmised that Rubens probably conceived the composition's overall design in a lost sketch.[6] This may have resembled Rubens's oil sketch of the *Recognition of Philopoemen* (see fig. 26 in Introduction[7]) of ca. 1609, which served as the initial conception for a large version of the composition by Rubens and Snyders in the Prado (no. 1851).[8]

The myth of Prometheus inspired a great variety of moral, religious, and philosophical interpretations.[9] Hesiod informs us that Prometheus, a Titan,

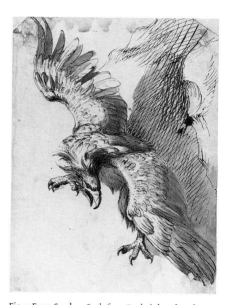

Fig. 1. Frans Snyders, *Study for an Eagle*, ink and wash, 280 x 200 mm, London, British Museum, inv. no. 1946-7-13-176.

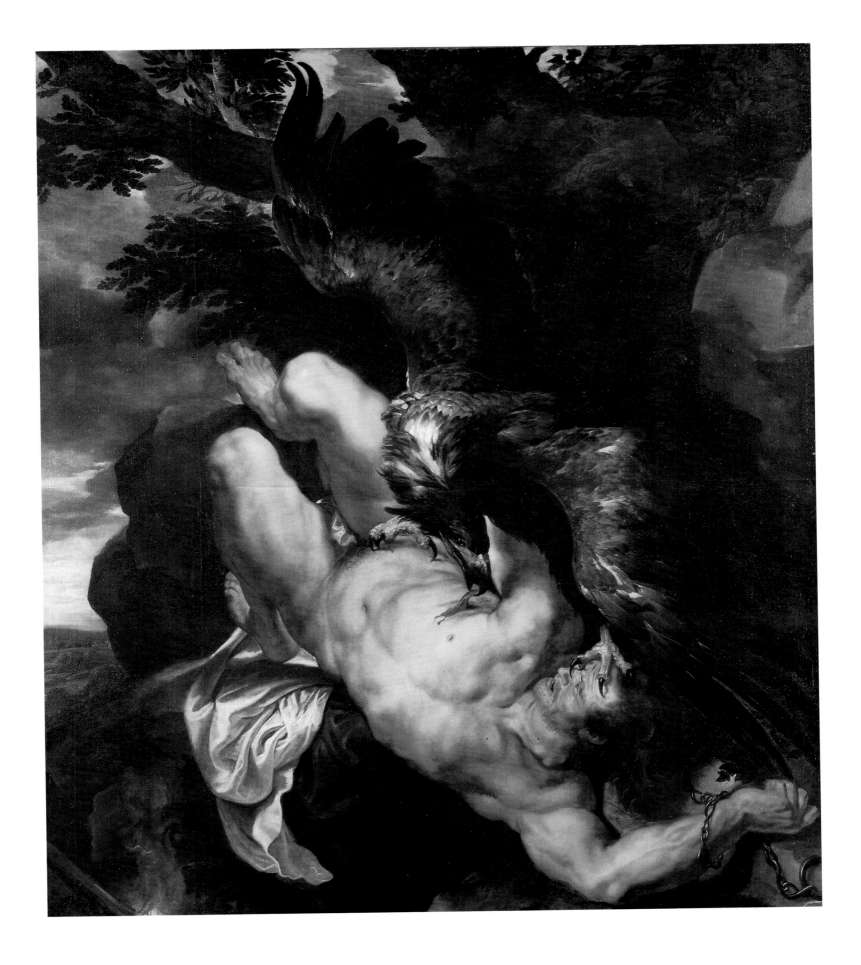

was punished for stealing fire from heaven by Zeus, who fastened him to Mount Caucasus where an eagle daily devoured his ever-regenerating liver until Hercules set him free. Zeus took fire away from man because Prometheus had tricked him. However in Aeschylus's account, Prometheus was not a trickster but a tragic hero who benefited man not only with fire but also reason and wisdom. Plato interpreted the story morally, seeing the fire as creative power. In later classical literature Prometheus is a master craftsman making men from clay; the church fathers subsequently drew parallels with God the creator. As the hero of endurance, Prometheus was also the ideal spiritual sufferer, while still others saw his torment as a matter of reason and intellect. In the Renaissance, Prometheus thus became the model of the true philosopher.

It was at this time that the story became confused with the myth of Tityus. Tityus was the son of Earth who assaulted Leto (Latona), the mother of Apollo and Artemis, and was punished in the underworld by having his immortal liver pecked at by vultures. (Baudius, typically reflecting the confusion between the two myths, mistook Prometheus's attacker in the Rubens for a vulture.) Often interpreted as an allegory of the tortures of immoderate love, the Tityus subject was treated by Michelangelo in his famous drawing of 1532, now in Windsor Castle (fig. 2).[10] As Oldenbourg first observed, Rubens seems to have derived features of his Prometheus from this important prototype of a figure lying in agony.[11] Another important potential source, which also probably acknowledges the Michelangelo, was Titian's *Tityus*, which Rubens could have known from his trip to Spain in 1603 (the original or a faithful copy is in the Museo del Prado, Madrid, no. 427) or through Cornelis Cort's engraving of 1566 after the original. The latter turns the image in the same direction as in the Rubens and adds a torch, thus effectively transforming Tityus into Prometheus.[12] Held also suggested that the formal history of Prometheus's pose could be traced to the figure of Heliodorus in Raphael's *Expulsion of Heliodorus* fresco in the Vatican, or the nude in the *Rich Man in Hell* by Barent van Orley in Brussels (Musées Royaux des Beaux-Arts, no. 1822), but allowed that a reclining figure with one leg bent and the other outstretched had become virtually a formula for figures undergoing a painful ordeal.[13] The famous Laocoön sculpture group from antiquity, which Rubens sketched on several occasions during his time in Rome, could also be recalled in Prometheus's tormented pose.[14] If, as Dempsey has theorized, the *Prometheus* was an attempt to reconstruct the Alexandrian painter

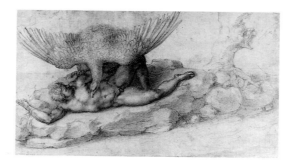

Fig. 2. Michelangelo, *Tityus*, chalk with stumping, 190 x 329 mm, Royal Library, Windsor Castle, no. RL 12771 (recto).

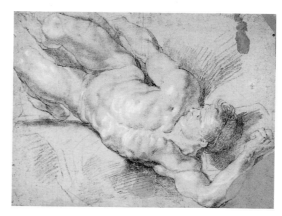

Fig. 3. Peter Paul Rubens, *Reclining Male*, chalk and heightening, 420 x 548 mm, Paris, Musée du Louvre, inv. 20207.

Euanthes' famous work in the Temple of Zeus at Pelusium (as described by Achilles Tatius), then Rubens's effort was an homage to the art of antiquity.[15]

The *Prometheus* is related to other dramatic and often violent works from the master's years immediately following his return from Italy, including the *Juno and Argus* mentioned above, *Judith Killing Holofernes* (Frankfurt, Städelsches Kunstinstitut, no. 15690), *Samson and Delilah* (London, The National Gallery, no. 6461) and *The Death of Hippolytus*, of which there are two painted versions (Cambridge, Fitzwilliam Museum, no. PD 8-1979; and London, Courtauld Institute, no. 19). A black chalk drawing in the Louvre (fig. 3) is a study for the beleagured Hippolytus but, as Frits Lugt observed, also served for Prometheus in the Philadelphia painting.[16]

Rubens's painting made an enormous impact on his contemporaries, followers, and later artists. In addition to numerous outright copies,[17] the painting inspired related treatments of the theme by Jacob Jordaens (Cologne, Wallraf-Richartz-Museum, no. 1044; ill. Introduction, fig. 49), Theodoor Rom-

bouts (Brussels, Musées Royaux des Beaux-Arts, no. 6084), and several other Rubens followers.[18] Among Dutch artists who responded to the picture were Dirck van Baburen (see *Prometheus Chained by Vulcan*, Amsterdam, Rijksmuseum, no. A1606) and Rembrandt. The latter conspicuously adopted Prometheus's pose for the figure of Samson in his great *Blinding of Samson* of 1636 (Frankfurt, Städelsches Kunstinstitut, no. 1383), which was painted as a gift for his patron, Constantijn Huygens, who was an acquaintance of Dudley Carleton and a great admirer of Rubens's art.[19]

A curious technical feature of Rubens's canvas is a 17 ¼ inch (44 cm) addition by the artist running the full height of the left side of the composition. This addition was appended by the artist to the composition only after the original paint film had dried, and possibly as long as six years after the painting was executed – the period between when Baudius saw the picture and when Rubens reports to be putting the finishing touches on it for Carleton.[20] This substantial addition serves to convert a tightly composed composition to a more open, expansive design of the type Rubens favored around 1620. This addition also includes Prometheus's torch (nowhere to be found in x-rays of the original section of canvas), which, as we have seen, is essential to clarify the subject's identity.

<div align="center">PCS</div>

1. Dominicus Baudius, *Poematum nova editio* (1616), p. 578. For the Latin text, see Sutton 1990, p. 259, note 1; trans. by C. Dempsey 1967, p. 421.

2. See Cologne cat. 1967, p. 95-98; Held 1963, pp. 29-30. For the letter to Jacob de Bie of 11 May 1611, mentioning the Cologne painting, see Magurn 1955, p. 55, letter no. 22.

3. Rooses, Ruelens 1887-1909, vol. 2 (1898), p. 136; Magurn 1955, p. 60, letter no. 28.

4. See A. E. Popham 1952, p. 237; Robels 1989, cat. no. Z89.

5. See Robels 1989, p. 35; Rooses, Ruelens 1887-1909, vol. 2 (1898), pp. 99-101, letter no. 148.

6. Held 1963, p. 21.

7. See Held 1980, vol. 1, no. 278, vol. 2, pl. 277.

8. See Robels 1989, p. 35; and C. van de Velde, in Liedtke et al. 1992, p. 184.

9. See O. Raggio 1958, pp. 44-62; and Held 1963, pp. 25-27.

10. A. E. Popham and J. Wilde, *The Italian Drawings of the XV and XVI Centuries in the Collection of His Majesty the King at Windsor Castle* (London, 1949), p. 429, pl. 21.

11. Oldenbourg 1918b, p. 180; however, the author was only familiar with a copy or version of Rubens's original, then in the Museum in Oldenbourg, Germany (Sutton 1990, p. 256, note 16, fig. 91-4).

12. Sutton 1990, fig. 91-6.

13. Held 1963, p. 28.

14. Noted by Held (ibid.) and several other authors, e.g. van de Velde, in Liedtke et al. 1992. Among other works of art that Rubens copied that featured a violent, upside down pose, and may thus have been recollected in his conception, are the nude figure of Abel (Cambridge, Fitzwilliam Museum; Burchard, d'Hulst 1963, no. 33) copied from M. Coxie's *Cain and Abel* (Toledo, Hospedale de Santa Cruz) and the figures in *Enchained*

Prisoners after a fresco in the Palazzo Farnese by Salviati, which Rubens copied in a drawing now in Antwerp (Burchard, d'Hulst 1963, no. 93).

15. See Dempsey 1967, pp. 420-425.

16. Lugt 1949, vol. 2, no. 1029.

17. See Sutton 1990, note 35. See also the painting that was with Pietro Scarpa, Venice, as "J. Jordaens," panel 105 x 71 cm (adv. in *The Burlington Magazine*, April 1970).

18. See Sutton 1990, p. 258, notes 37, 40-41.

19. See E. K. J. Reznicek, "Opmerkingen bij Rembrandt," *Oud Holland* 91 (1977), pp. 88-91; and van Gelder 1950-51, pp. 137-138.

20. Sutton 1983, pp. 270-275.

Peter Paul Rubens
11. *Cupid Shaping His Bow*, 1614

Oil on canvas, 142 x 108 cm (55 ⅞ x 42 ½ in.)
Signed and dated at bottom: P·P·RVBENS·F· / 1·6·1·4·
Munich, Bayerische Staatsgemäldesammlungen,
inv. 1304

PROVENANCE: first recorded in the inventory of the Residenz at
Munich, 1748, no. 75 ("Cupido avec Deux Enfants"), Munich, Hofgarten-
galerie, no. 679.

EXHIBITIONS: Antwerp 1977, no. 30; Moscow, Pushkin Museum, and
St. Petersburg, Hermitage, no. 32.

LITERATURE: Smith 1829-42, vol. 2 (1830), p. 77, no. 237 (as after Correg-
gio); Rooses 1886-92, vol. 3 (1890), p. 69; Oldenbourg 1918b, p. 196; Olden-
bourg 1921, p. 72; S. J. Freedberg, *Parmagianino: His Works in Painting*
(Westport [CT], 1950), p. 186; L. van Puyvelde, "Les sources du style de
Rubens," *Revue belge d'archéologie et d'histoire de l'art 21* (1952), p. 31;
Munich, cat. 1973, pp. 57 ff; F.-A. Dreier, "Anmerkungen zur 'Frierenden
Venus' von Peter Paul Rubens," *Niederdeutsche Beiträge zur Kunstgeschichte*
16 (1977), pp. 49, 51; Jaffé 1977, p. 32; H. von Sonnenburg, "Rubens' Bild-
aufbau und Technik, II: Farbe und Auftragstechnik," *Maltechnik/Restauro*
2 (1979), pp. 36-39, 45; Munich, cat. 1983, p. 452; C. Limentani Virdis,
"*Italiam versus negociorum suorum causa.* Osservazioni su Rubens e i suoi
modelli in Italia," *Artibus et historiae 13* (1986), p. 86.

Cupid Shaping His Bow is a free copy after a painting
by Francesco Mazzola, called Parmagianino (1503-
1540), executed for the Cavaliere Baiardo of Bologna
in about 1531-1534 (fig. 1). Confiscated by the Span-
ish crown in 1585, Parmagianino's painting was sub-
sequently sold by King Philip III to Rudolph II in
1603, and sent to Prague.[1] It is very likely that
Rubens would have seen the picture during his visit
to Spain in 1603.

Rubens made liberal use of earlier sources in his
compositions, from the sculpture of antiquity to
motifs gleaned from paintings by his close contem-
poraries. Far from slavish copies, Rubens's creative
adaptations were informed by a well-defined theory
of artistic imitation, as outlined in his brief essay on
the imitation of ancient sculpture, *De Imitatione Sta-
tuarum*.[2] Rubens maintained that thorough knowl-
edge of classical sculpture was essential for an artist
to achieve perfection. The painter must take pains,
however, to avoid giving a stonelike appearance to
his works, and should impart a sense of life to his
figures through a study of real flesh and its charac-
teristics in light and shadow. Jeffrey Muller has not-
ed that Rubens's theory of artistic imitation, as out-
lined in *De Imitatione Statuarum*, corresponds to that
formulated in antiquity by Quintillian and revived
by Renaissance theorists.[3] These treatises establish
three levels of artistic influence. The first, *translatio*,
involved the meticulous copying of a model in order
to master its form, which the artist could then imi-
tate, at the second level of *imitatio*. On the third and
highest level of *aemulatio*, the artist sought to sur-
pass his model through his own imagination.[4]

Rubens practiced all three levels of artistic imita-
tion in his work.[5] Rubens's use of classical sources,
as well as formal and stylistic quotations from more
recent Northern and Italian art, was particularly fer-
tile and inventive during the first half of the 1610s.
In paintings such as the *Venus, Bacchus and Ceres*

(ca. 1613-1614; Kassel, Gemäldegalerie Alte Meister,
inv. GK 85; fig. 3), for example, he based Venus's pose
on that of the Crouching Aphrodite of Doidalsos
(fig. 2); the figures are arranged across the fore-
ground of the composition in the manner of a sculp-
tural relief; and the painting itself is stylistically
indebted to late mannerist works by Abraham
Janssens (q.v.) and Hendrick Goltzius.[6] Rubens's
Flight into Egypt of 1614 (Kassel, Gemäldegalerie
Alte Meister, inv. GK 87) closely emulates Adam
Elsheimer's evocative rendering of the subject (1609;
Munich, Alte Pinakothek, inv. 216).[7]

Although Rubens's interpretation of Parmagia-
nino's *Cupid Shaping His Bow* retains the major com-
positional forms of the original and employs a simi-
larly polished technique, characteristically his copy
has been altered to express a more personal vision.
Rubens's Cupid is more naturalistic in proportion
and pose; his wings have been enlarged to appear
more plausible, and his rippling musculature is
quite different from the sinuous contours of the
original. Rubens substitutes a grassy hillock for the
books beneath Cupid's foot in the original (there
symbolizing Love's victory over science and knowl-
edge), and replaces the artificially compressed space
of the original with a more spacious wooded land-
scape. The two putti in the background – now seen
at full length – are petulant and fussy, robust, and
typically Rubensian. The presence of the putti is
explained in Vasari's description of Parmagianino's
original: ". . . one takes the other by an arm, and
laughing wishes that he touch Cupid with a finger;
and that one who does not wish to touch him cries,
showing that he is afraid lest he burn himself in the
fire of love."[8]

Cupid Shaping His Bow is one of only a handful of
dated paintings by Rubens. The majority of dated
works were executed in the years 1613-1614,[9]
although a few others are scattered throughout his
career. There is no concrete explanation for Rubens's
choosing to sign and date these particular pieces, for
they are not grand altarpieces or commissions of sur-
passing importance. Suggestions regarding these
dated works have attempted to relate them to
Rubens's adoption of an academic classical style dur-
ing this period.[10] The two events are seen as related,
and closely connected with Rubens's desire to supply
models for his expanding studio during the 1610s.[11]
Perhaps more plausibly, however, Franz-Adrian
Dreier has suggested that Rubens signed and dated
those works in which he felt that he had significant-
ly improved on his models, in which he had succes-
fully achieved the classical requisite of *aemulatio*.[12]
In *Cupid Shaping His Bow* Rubens deftly transformed

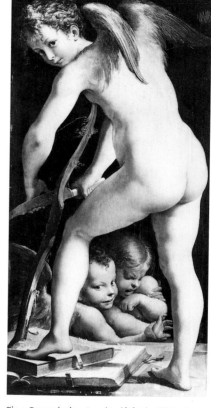

Fig. 1. Parmagianino, *Amor (Cupid Shaping His Bow)*;
oil on panel, 135 x 65 cm, Vienna, Kunsthistorisches
Museum, inv. 62.

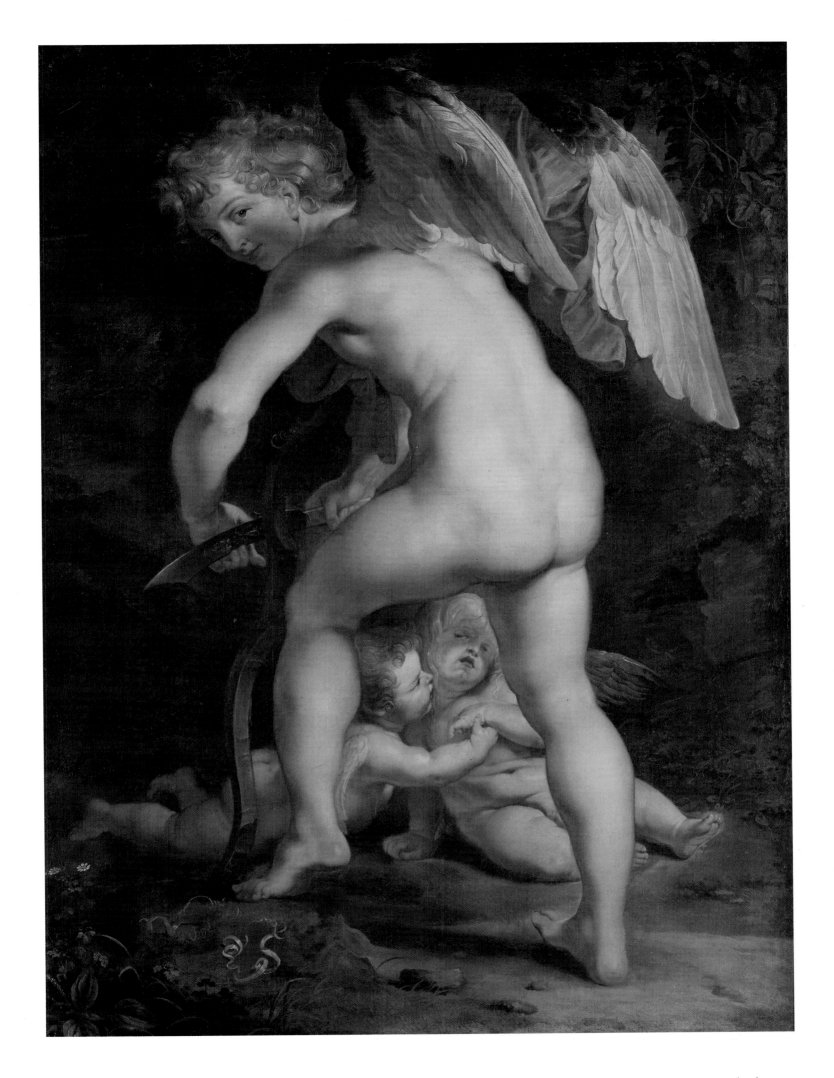

Fig. 2. Hellenistic, 3rd century B.C., *Crouching Aphrodite of Doidalsos*, marble, h. 81.9 cm, Vatican City, Musei Vaticani (Pio-Clementino Museum), no. XXXIV.35.80.

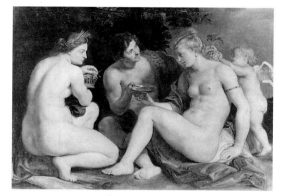

Fig. 3. Peter Paul Rubens, *Venus, Bacchus and Ceres*, ca. 1613-1614, oil on canvas, 140.5 x 198.8 cm, Kassel, Gemäldegalerie Alte Meister, inv. 85.

the glassy artificiality of his model into a spirited and brilliantly colored expression of his own artistic personality.

MEW

1. Freedberg 1950, pp. 184-185. It is not known exactly when the painting was sent to Prague, although as Freedberg notes (p. 185): "In substantiation of the departure of the original from Spain before the end of the first decade of the seventeenth century, the Spanish royal inventory of 1611 makes no mention of the 'Amor.'" See also Limentani Virdis 1986, p. 86, note 23. In 1631 the picture was transferred from Prague to the Schatzkammer in Vienna.

2. Muller 1982 presents a detailed analysis of the essay. The precise date of Rubens's essay is not known. Muller (1982, p. 229) cites Justus Müller Hofstede ("Rubens und die Kunstlehre des Cinquecento. Zur Deutung eines theoretischen Skizzenblattes im Berliner Kabinett," in Cologne 1977, p. 53) in dating the essay soon after Rubens's return to Antwerp in 1608. Warnke (1980, p. 177) dates the essay to the last decade of Rubens's life.

3. Müller 1982, pp. 230-231.

4. Ibid.; also A. W. Lowenthal, *Joachim Wtewael and Dutch Mannerism* (Doornspijk, 1986), p. 40.

5. The basic literature on Rubens's varied use of classical and Italian borrowings includes Oldenbourg 1918b; Haberditzl 1908; E. Kieser, "Antikes im Werke des Rubens," *Münchner Jahrbuch der bildenden Kunst* 10 (1933), pp. 110ff; Meisel 1959 (see note 11 below); Stechow 1968; Jaffé 1977; and Limentani Virdis 1986.

6. Rubens's relationship with Janssens is discussed in Pevsner 1936, p. 124 and passim. Rubens's relationship with Goltzius is less well studied. Rubens met the older artist on his visit to Haarlem in 1612 (see van Gelder 1950-51; and more recently R. de Smet, "Een nauwkeurige datering van Rubens' eerste reis naar Holland in 1612," *Jaarboek van het Koninklijk Museum voor Schone Kunsten, Antwerpen* [1977], pp. 199-220). Goltzius's paintings of this period, for example the *Vertumnus and Pomona* of 1613 (Amsterdam, Rijksmuseum, inv. A2217), are strikingly similar to

Rubens's compositions in their focus on a few large-scale muscular figures arranged in a shallow space before a landscape background.

7. K. Andrews, *Adam Elsheimer: Paintings – Drawings – Prints* (Oxford, 1977), pp. 154-155. Elsheimer's painting was reproduced in a print by Hendrick Goudt in 1613.

8. Cited in Freedberg 1950, p. 89.

9. In addition to the *Cupid*, other dated paintings from this period are: *Jupiter and Callisto*, 1613 (Kassel, Gemäldegalerie Alte Meister, inv. GK 86); *Venus Frigida*, 1614 (Antwerp, Koninklijk Museum voor Schone Kunsten, inv. 709); *Flight into Egypt*, 1614 (Kassel, Gemäldegalerie Alte Meister, inv. GK 87); *Susannah and the Elders*, 1614 (Stockholm, Nationalmuseum, inv. 603); and *Lamentation*, 1614 (Vienna, Kunsthistorisches Museum, inv. 515; our cat. 13).

10. Oldenbourg 1918b, pp. 163-165.

11. For example, V. H. Meisel, "Rubens and Antique Art," Ph.D. diss., University of Michigan, 1959, p. 90, note 164 and p. 290. This reasoning does not, however, explain why Rubens suddenly decided to supply signed and dated examples of his art to a studio that had already been operating successfully for five years.

12. Dreier 1977, p. 49. Dreier cites Julius Held (Held 1959, p. 58ff) in noting Rubens's reworking of drawings by earlier masters as a method of "improving" upon them.

Peter Paul Rubens and Frans Snyders
12. The Head of Medusa

Oil on canvas, 68.5 x 118 cm (27 x 46 ½ in.)
Vienna, Kunsthistorisches Museum, inv. no. 3834

PROVENANCE: (probably) identical with the "Medusa's head with snakes [by] Rubens and Subter [sic]" in the 1635 inventory of the Duke of Buckingham's painting collection (see below, Davies 1906/07, p. 379); (probably) sale Buckingham, Antwerp, 1648 [as by Rubens] (see Fairfax 1758, p. 15, no. 8); sold on 14 May 1649 by William Aylesbury to Salomon Cock, together with other paintings from the Buckingham sale (see Duverger 1984-, vol. 5 (1991), p. 482, doc. 1559); not in the collection of Archduke Leopold Wilhelm, probably brought instead by Ferdinand III to Prague, inv. (1718), no. 38 [as by Rubens]; Prague, inv. (1739), no. 29 [as by Rubens with the measurements: "1 Elle 4 Zoll zu 2 Ellen"]; Prague, inv. (1763), no. 106; in 1876 brought from Prague to Vienna; Allerhöchsten Kaiserhaus, cat. (1884) no. 1193.

EXHIBITIONS: Antwerp 1977, p. 77, no. 27, ill.; Vienna 1977, no. 23, pl. 78 [as ca. 1617-1618, by Rubens and a collaborator].

LITERATURE: B. Fairfax, Catalogue of the Curious Collection of George Villiers, Duke of Buckingham (London, 1758), p. 15, no. 8 [as by Rubens]; Eduard Ritter von Engerth, "Kunsthistorische Sammlungen des allerhöchsten Kaiserhauses, Gemälde," Jahrbuch der Kunsthistorischen Sammlungen des ah. Kaiserhauses, Wien 2 (1884), no. 1193; Rooses 1886-92, vol. 3 (1890), no. 636 [before 1625]; vol. 5 (1892), p. 338 [as by Rubens and Jan Brueghel I, about 1620]; A. Rosenberg 1905, p. 223, ill. [as by Rubens and Jan Brueghel I, ca. 1614]; R. Davies, "An Inventory of the Duke of Buckingham's Pictures at York House in 1635," The Burlington Magazine 10 (1906-1907), p. 379; A. Rosenberg, 1905, 3rd ed. 1911, p. 232, ill. [ca. 1620]; Oldenbourg 1921, p. 80, ill. [as by Rubens and Brueghel, ca. 1614]; Glück 1933, p. 162 [ca. 1612]; G. Glück, in Kunsthistorisches Museum, Katalog der Gemäldegalerie (Vienna, 1928) no. 846 [as by Rubens ca. 1610]; van Gelder 1950-51, p. 137; Brussels 1965, p. 289; Müller Hofstede 1971, p. 271; Kunsthistorisches Museum, Vienna, Verzeichnis der Gemälde (Vienna, 1973), p. 147 [as ca. 1617-1618]; Hairs 1977, p. 16, note 31; Dony 1979-80, vol. 1, no. 296, pl. 62; J. M. Muller, "The Perseus and Andromeda on Rubens's House," Simiolus 12 no. 2/3 (1981-82), pp. 143; A. Balis, "Facetten van de Vlaamse dierenschilderkunst van de 15de tot de 17de eeuw," exh. cat. Antwerp 1982, pp. 44-45, fig. 28; C. Lawrence, "'Worthy of Milord's House'? Rembrandt, Huygens and Dutch Classicism," Konsthistorisk tidskrift 54 (1985), pp. 17-18; Robels 1989, pp. 370-371, cat. no. 276; Duverger 1984-, vol. 5 (1991), p. 482, doc. 1559 ["no. 70. Item un peinture de la Teite de Méduza de Rubens."].

THE DECAPITATED HEAD of Medusa (see Ovid Metamorphoses, IV: 617-803), her serpentine locks writhing hideously, lies on a stony ledge in a landscape. Some of the intertwined snakes bite one another and others give birth, while drops of Medusa's blood are transformed into still other tiny vipers. Medusa's horrible face is wide-eyed and of a deathly pallor. A scorpion, two spiders, and a brightly spotted lizard appear in the foreground. The ground rises steeply at the back right and in the left distance is a landscape prospect.

According to Ovid, Medusa was the loveliest of Phorcys's daughters, particularly admired for her beautiful hair. However after being violated by Neptune in the Temple of Minerva, the goddess turned her hair into a knot of hideous snakes. Gazing upon the face of Medusa would turn one to stone. However the brave and resourceful Perseus snuck up on Medusa while she slept, being careful only to look at her reflection in his shield, and decapitated her with his sword. The head proved essential to Perseus in several later adventures, including the freeing of Andromeda. He eventually gave the head to Minerva

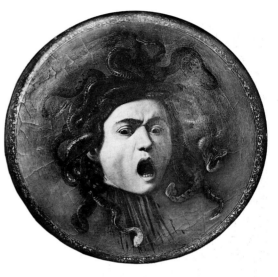

Fig. 1. Caravaggio, The Medusa Head on Minerva's Shield ca. 1597, oil on canvas on wood, diam. 55 cm, Florence, Uffizi, no. 135.

who decorated her breastplate (Aegis) with the deadly image.

Wolfgang Prohaska discussed in detail the tradition of representing Medusa and her iconography in his entry for the painting in the catalogue of the exhibition held in Vienna in 1977.[1] The head of Medusa was most commonly represented in narrative isolation on the shield of Minerva, either in actual sixteenth-century metalwork or in decorative shields painted on wood. The latter tradition probably originated with a lost early work by Leonardo da Vinci which was mentioned in the inventory of the Medici and vividly described by Vasari in 1568.[2] Perhaps inspired by the Leonardo, Caravaggio also produced a head of Medusa on Minerva's shield, which is now in the Uffizi (fig. 1), and which according to Baglione, was sent by Cardinal del Monte to Grand Duke Ferdinand I de' Medici of Tuscany, probably about 1600.[3] In all likelihood Rubens knew the painting by Caravaggio, which he could have seen on his trip to Florence in 1600 or later. As Prohaska observed, Caravaggio's painting was already celebrated in a madrigal of 1602 by Gaspare Murtolas, which drew attention to its apotropaic political aspects.[4] Giambattista Marino's Galleria (Venice, 1620, p. 28) also emphasized the Grand Duke's association with Medusa, "Ché las versa Medusa è il valor vostro."[5] Prohaska further speculated that an iconographic aspect, which though not the original reason for Rubens's conception might have appealed to its later owner, the Duke of Buckingham, was the notion expressed by Ludovico Dolce and by Cesare Ripa which associated the head with the intellect

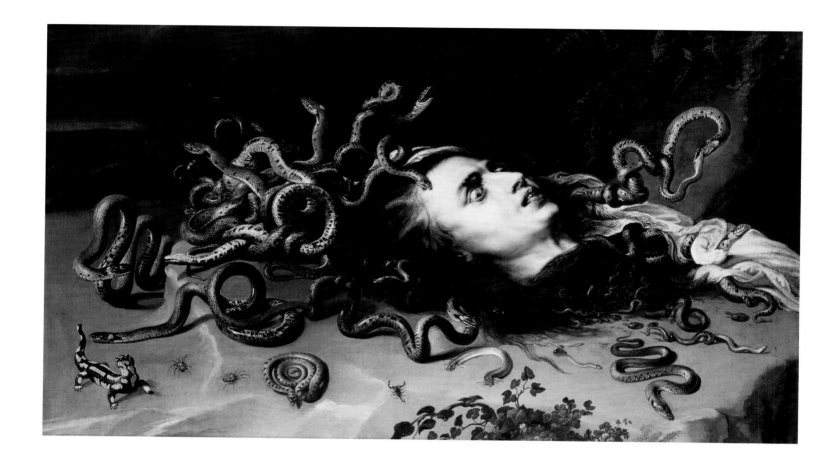

or reason that combats the enemies of virtue.[6] Sixteenth-century emblems also suggest that Perseus with the head of Medusa could embody the idea that acts of glory (and, implicitly, works of art), when achieved through the efforts of wisdom and eloquence, could render humankind rigid with amazement.[7]

Not all interpretations of Medusa were so positive. Karel van Mander, for example, claimed that Perseus was the "reason or the intellect of our souls while Medusa was the wicked carnal desires or natural lusts which transform in mankind all reason, prudence and wisdom into unfeeling stones."[8] Van Mander went on to note Medusa's "ungodly denial of any spiritual covenant" and "unchastity" (an allusion, no doubt, to Neptune's rape in the temple); thus she offers warnings against "misusing God's gifts or dishonoring God or his commandments through pride."[9] Since Medusa was proud of her beauty and especially her hair, Minerva turned the latter into snakes. Given such a wide range of associations and interpretations (*in malo* and *in bono*) it is unclear whether Rubens regarded the image as a

positive or negative one. However in light of the breadth of his own readings in the classics as well as in their exegeses, the appeal of the image's complexity surely was a strong one.

The fact that the image is not mounted on Minerva's shield, as customarily depicted, but lying apparently cast down in a landscape probably also has a bearing on its meaning. The snakes that miraculously metamorphose from Medusa's blood illustrate Ovid's reference to the drops of blood that rained down as Perseus soared with the gorgon's head over Libya, "the spattered desert gave them life as snakes, smooth snakes of many kinds, and so that land / still swarms with deadly serpents to this day" (*Metamorphoses*, IV: 622-624). It is equally unclear whether the landscape and the hill or mountain adumbrated above the stony ledge on which the head lies allude to a larger narrative context, such as Perseus's encounter with Atlas "so huge," who upon seeing the head of Medusa "became/ A mountain; beard and hair were changed to forests,/ Shoulders to cliffs, hands ridges; where his head/ Had lately been, the soaring summit rose;/ His bones were turned to

stone" (*Metamorphoses*, IV: 662-666). What is certain is that the rhetorical gore and horror of the decapitated head appealed to Rubens's high baroque conception of drama just as strongly as it had to Caravaggio.

The reptiles, insects, and landscape in this scene have long been thought to be by another hand. Already in the 1635 inventory of George Villiers, the Duke of Buckingham, they were attributed to "Subter" (no doubt, Snyders). However these elements have most consistently been attributed to Jan Brueghel the Elder, beginning with Rooses in 1890.[10] Rooses did, however, mention that Snyders had been suggested, an attribution revived by G. Heinz, who also suggested the possibility of Paulus de Vos.[11] Hella Robels dismissed an attribution to Paulus de Vos on chronological grounds but supported the attribution to Snyders, which indeed seems to be the most plausible.[12] The dating of the painting has ranged from 1610 to 1625; Glück suggested ca. 1610 or 1612, Müller Hofstede, around 1612, on the basis of the possible relationship to Caravaggio, and Prohaska suggested around 1617-1618 because of the resemblance of the gorgon's head to the possessed people in Rubens's *Miracle of St. Ignatius Loyola* also in the Kunsthistorisches Museum, Vienna (inv. no. 517; ill. Introduction, fig. 25).

The snakes of Medusa's hair have been identified by Dr. José Rosado of the Museum of Comparative Zoology at Harvard University as *Natrix natrix*, the European grass snake (or water snake), which are still quite common today. The smaller snakes near the severed neck seem to be fictionalized, smaller variations of the *Natrix*, and the coiled snake to the right of the salamander does not exist. However the lizard in the lower left is an accurate rendition of the European fire salamander, *Salamandra salamandra ssp.*[13] Arnout Balis has observed that one odd little worm in the lower center with a head on each end conforms to the fanciful description offered by the Roman author Pliny of an *amphisbaena*.[14] Thus hand in glove with the rigorous empirical observation that imbued naturalistic animal painting with its outward realism was a continuing recognition of the uncritical scientific theories of classical antiquity.

There is a copy of the painting in the Mahrisches Landesmuseum, Brünn,[15] which van Gelder thought might be the famous painting that was in the early seventeenth-century collection of Nicolaes Sohier in Amsterdam. The latter was called a work of "Rubbens ende Snijders" when described between 1629 and 1631 by Constantijn Huygens in his memoirs, where it was vividly characterized as being so horrible as to require a curtain to cover it.[16]

A Caravaggesque painting in the Uffizi, Florence (no. P1472, "Unknown Flemish School, 17th Century") that may have been inspired by Rubens's *Medusa*, also depicts the severed head lying on the ground.[17]

PCS

1. Vienna 1977, pp. 82-83, cat. 23. Apparently the subject caught on among Flemish animal painters: Erasmus Quellinus's estate of 1678 includes "'t Hooft van Medusa, van Feyt" [Jan Fyt]; see de Bruyn 1988, pp. 315.

2. Quoted by Prohaska in Vienna 1977. Vasari described the snakes "animalaccio molto orribile e spaventoso, rapprestando lo effetto stesso che la testa già di Medusa"; G. Vasari, *Le Vite de' più eccellenti pittori*, vol. 4 (Florence, 1879), p. 23; see also the edition by R. Bettarini with commentaries by P. Barrochi (Florence, 1966) vol. 4, pp. 21-22. Vasari claims that Leonardo never finished his Medusa.

3. See D. Heilkamp, "La Medusa del Caravaggio e l'armatura della scia Abbas di Persia," *Paragone* 199 (1966), pp. 62-76; W. Friedlander, *Caravaggio studies* (Princeton, 1955), cat. 13, pl. 14, p. 82; M. Kitson, *The Complete Paintings of Caravaggio* (New York, 1967), no. 28, ill.; H. Hibbard, *Caravaggio* (New York, 1983), no. 37, ill. p. 68.

4. See Heilkamp and Prohaska in Vienna 1977, p. 82: "E questa di Medusa / La chioma auvelenata, / Di mille serpi armata? / Si, si: non vedi come / Gli occhi ritorce e gira? / Fuggi lo sdegno, e l'ira / Fuggi, ché se stupore agli occhi impetra, / ti cangerá anco in pietra," *Rime* (Venice, 1603), madrigal no. 473 (reprinted by M. Cinotti, *Immagine del Caravaggio* [Milan, 1973], pp. 51-55).

5. Vienna 1977, pp. 82-83. Evers (1943, pp. 203-204) discussed the Perseus story in relation to allegories of state in triumphal arches of the sixteenth and seventeenth centuries.

6. Vienna 1977, pp. 82-83. See Ludovico Dolce, *Dialogo dei colori* (ed. 1913) p. 140; Ripa (ed. Rome, 1603), p. 426. The notion of Minerva's triumph through victory of rationality over sensuality inspired Mantegna to paint *Philosophia* with a Medusa shield, and the English poet Milton to observe that Minerva, "the unconquer'd Virgin," wore the gorgon on her shield as a symbol of her "chaste austerity and noble grace" (*Comus*, lines 446-450).

7. See B. Anulus, *Picta / Poesis / ut Pictura Poesis erit* (Göttingen, 1552) p. 10; Henkel, Schöne 1967, cols. 1665-1666.

8. K. van Mander, *Uytlegginghe* (van Mander 1604) book 4, fol. 39b.

9. Ibid.

10. Rooses 1886-92, vol. 3 (1890), p. 636; see also A. Rosenberg 1905, no. 223; Oldenbourg 1921, no. 80; and Vienna cats. 1938, no. 846, and 1966, no. 11. In the 1928 Vienna catalogue the snakes were attributed to Rubens himself.

11. Heinz's verbal attribution was reported by Prohaska in Vienna 1977, p. 83. Prohaska himself left the attribution open.

12. See Robels 1989, pp. 370-371, no. 276.

13. Letter of 29 April 1992 in MFA files.

14. See A. Balis, "Facetten van de Vlaamse dierenschilderkunst van de 15de tot de 17de eeuw," in *Het Aards Paradijs*, exh. cat. Antwerp 1982, p. 45, note 40, citing C. Plinius Secundus, in *Naturalis historiae libri*, XXXVIII, VIII, 85.

15. Inv. no. A2, panel, 60.8 x 112.2 cm. See Rooses 1886-92, vol. 3 (1890), under no. 636; exh. Brussels 1965, p. 289; J. G. van Gelder, "Das Rubens-Bild. Ein Rückblick," in *Peter Paul Rubens Werk und Nachruhm* (Augsburg, 1981) p. 14, fig. 4, p. 38, note 12; and Robels 1989, p. 370, no. 276a.

16. On Huygens's comments, see S. A. Worp, "Constantijn Huygens over de schilders van zijn tijd," in *Oud Holland* 9 (1891), p. 119. Robels (1989, p. 371, nos. 276b & c) also mentions two other copies: with dealer Christopher Gibbs, London 1977 (canvas, 85 x 111 cm); and in the Staatliche Kunstsammlungen, Dresden, inv. no. 1050, by Victor Wolfvoet the Younger (1612-1652), probably made at the auction of the collection of the Duke of Buckingham in Antwerp in 1648 (canvas, 44.5 x 59 cm).

17. See *Gli Uffizi, Catalogo Generale* (Florence, 1979), p. 485, ill.; canvas, 49 x 74 cm, as ca. 1620-1630.

Peter Paul Rubens
13. Lamentation, 1614

Oil on panel, 40.5 x 52.5 cm (16 x 20⅝ in.)
Signed and dated on the left: P·P·RVBENS·F·1·6·1·4
Vienna, Kunsthistorisches Museum, Gemäldegalerie,
inv. no. 515

PROVENANCE: Marquess of Hamilton, inventory of 1638 (in the Hamilton archives, Lennoxlore), no. 210 [as "Ruvens"]; the Gallery of Archduke Leopold Wilhelm; inv. of 1659, no. 235 [as "Von Peter Paul Rubbens Original"]; Vienna cat. 1884, no. 1158; cats. 1906, 1928, 1938, no.839; cat. 1963, no. 305.

EXHIBITIONS: Vienna 1977, no. 11, pls. 19, 22.

LITERATURE: Storffer, Gemaltes Inventarium der Aufstellung der Gemälde-galerie in der Stallburgischen Gemäldegalerie des Kunsthistorischen Museums (Vienna, 1720-33), vol. 3 (1733), no. 18 [as "Justus Eyckmann"]; Christian von Mechel, Verzeichnis der Gemälde der kaiserlich königlichen Bilder Gallerie in Wien (Vienna, 1781-83), p. 122, no. 21 [as Rubens]; Joseph Rosa, Gemälde der K. K. Gallerie, Part 2, Niederländische Schulen (Vienna, 1796), p. 92, no. 19 [as "Eyckens"]; Smith 1829-42, vol. 2 (1830), p. 97, no. 315; E. R. von Engerth, in Kunsthistorische Sammlungen des allerhöchsten Kaiserhauses 2 (1888), no. 325; Rooses 1886-92, vol. 2 (1888), no. 325; A. Rosenberg 1905, no. 80, ill.; Oldenbourg 1921, p. 107; Held 1959, p. 112; H. Kauffmann, Albrecht Dürer in der Kunst und im Kunsturteil um 1600. Anzeiger des Germanischen Nationalmuseums Nürnberg 1940-1953 (Nuremburg, 1954), p. 52, note 98; Wilenski 1960, vol. 1, p. 637, vol. 2, pl. 530; Garas 1967, p. 62, fig. 55; Glen 1977, p. 93, fig. 34; R. Leiss, Die Kunst des Rubens (Braunschweig, 1977) pp. 333, 342, 344; Dony 1979-80, vol. 1 (1979), p. 117, no. 197, pl. 54; R. Baumstark, in exh. cat. New York 1985, p. 318; Balis 1986, p. 105; Wolfgang Prohaska, in Vienna, Kunsthistorisches, cat. 1989, no. 58, ill.

THE BODY of Christ lies steeply foreshortened on a white winding cloth spread over a sheaf of wheat. He is supported by his mother, the Virgin Mary, who gently closes his dead eyes. On the left kneels Mary Magdalen, who weeps as she wrings her blond hair. Standing at the Virgin's right, St. John consoles her. To the right of John are the three additional grieving Marys: Mary Cleophas, Mary Joses, and Mary Salome. In the background is the rocky mouth of the tomb. In the lower left is a brass basin with the sponge that was used to assuage the crucified Christ's thirst, the crown of thorns, and the three bloody nails of the crucifixion.

The painting was assigned unconditionally to Rubens when in the Marquess of Hamilton's collection during the artist's lifetime. It was also inventoried as his original work when in Leopold Wilhelm's collection in 1659 (see Provenance). The inexplicable attribution to "Eyckmann" by Storffer and "Eyckens" by Rosa must be discounted. Nonetheless the picture's relatively small scale and high degree of finish are not wholly characteristic of Rubens. The painting is much more fully resolved and polished than Rubens's oil sketches (modelli) on this scale, though its *soigné* control differs also from the labored or congealed appearance of a copy. The image has a monumentality that belies its size. Its intimate dimensions are exceptional among his other completed multifigure religious paintings. Also unusual, though undoubtedly autograph, are the full signature and date; Rubens would never sign an oil sketch in such a manner, so he clearly regarded the present painting as a complete and independent work of art. Wolfgang Prohaska has discussed these features of the painting and thoughtfully proposed that it may

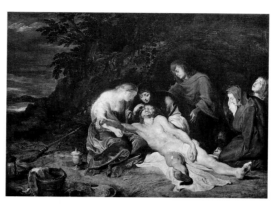

Fig. 1. Peter Paul Rubens, *Lamentation*, oil on panel, 55 x 73 cm, Antwerp, Koninklijk Museum voor Schone Kunsten, no. 319.

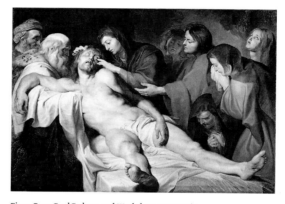

Fig. 2. Peter Paul Rubens and Workshop, *Lamentation*, oil on canvas, 150 x 205 cm, Vaduz, collection of the Prince of Liechtenstein, inv. no. 62.

have been conceived as a devotional picture (*Andachtsbild*) for private use, or functioned as a precious portable altar (*Reisealtärchen*).[1]

Closely related in design to the painting is the unsigned *Lamentation* in the museum at Antwerp (fig. 1) with an expanded landscape by Jan Wildens, Lucas van Uden, or another Rubens collaborator, but probably not Jan Brueghel the Elder as has sometimes been suggested.[2] The figure group is repeated verbatim, while in addition to the landscape, several more still-life elements (a lantern, hammer, wash bucket, broom, and the Magdalen's ointment jar) have been added to expand the allusions to Christ's Passion. In a larger three-quarter length version on canvas in Vaduz (fig. 2) the design is varied by Rubens who undoubtedly was working with assistants.[3] Christ's body now is supported by Joseph of Arimathea; Nicodemus stands behind him and the weeping Magdalen has been moved to the far right. Christ's dramatically foreshortened body no longer

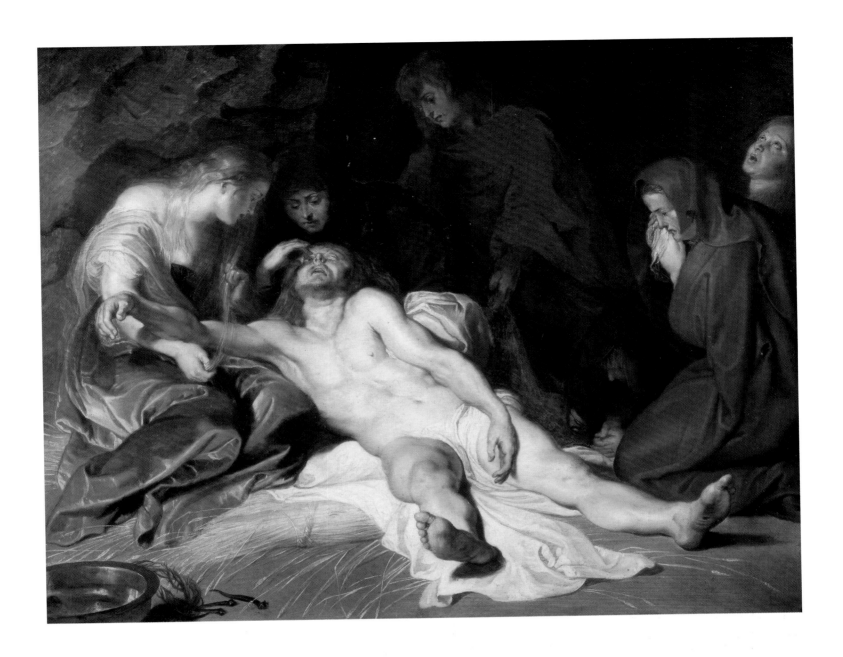

lies on the ground but is elevated on the Stone of Unction, as in Rubens's well-known version of the subject known as *Christ à la Paille* (Antwerp, Koninklijk Museum voor Schone Kunsten, nos. 300-304), painted as a burial monument for Jan Michielsen, who died in 1617.[4]

The subject of the Lamentation or Pietà was one that Rubens addressed very early in his career in a painting probably executed in Italy, possibly commissioned by Cardinal Scipio Borghese and now preserved in the Borghese Gallery, Rome (inv. no. 411).[5] As Balis observed, among a series of figure studies in pen, ink, and wash on the verso of Rubens's well-known drawing *Silenus and Aegle* of ca. 1611-1612 at

Windsor Castle, there are several tiny figures of a reclining male nude with strongly foreshortened right leg, which may document an early conception of Christ's pose in the Vienna painting.[6] Rubens used the same pose for a recumbent invalid in the right foreground of his *Miracle of St. Francis of Paola* (Munich, Alte Pinakothek, no. 74),[7] and in reverse for the figure of Lazarus in a drawing in Berlin of ca. 1616-1618 (Kupferstichkabinett, no. 5684),[8] and for the figure of Christ in *The Holy Trinity* of ca. 1620 (Antwerp, Koninklijk Museum voor Schone Kunsten, nos. 314).[9] Although the pose was altered, the strong foreshortening of this figure was also maintained in the altarpiece of the *Entombment* of 1616 in the

church of St. Géry in Cambrai,[10] and its preparatory oil sketch in Munich (Alte Pinakothek, no. 59).[11] This foreshortened pose for the dead Christ has, of course, a remote ancestry in Mantegna's famous painting in the Brera in Milan.[12] However this source and those that various authors purport to see in Albrecht Dürer's drawings of the Lamentation (Bremen, Kunsthalle, and the Fogg Art Museum, Harvard University, Cambridge, MA) have been so fully assimilated as to be undetectable within the larger general pictorial tradition of representing the theme with Mary and other mourners clustered about the body on the ground.[13] On the other hand, Prohaska's observed that a lost design by Raphael, known through a print by Enea Vico of 1548, might have influenced Rubens's conception (notably in the grouping of the three Marys on the right) and may be a more direct source, especially since Raphael's design clearly inspired the design of the *Lamentation* (Paris, Louvre, inv. 1997 bis) by Rubens's teacher, Otto van Veen.[14]

As Panofsky and Eisler have shown, this type of devotional painting or *Andachtsbilder* was designed to elicit strong emotions from the faithful by alluding to Christ's "last farewell" and transubstantiation through the Eucharist.[15] The Madonna closes her dead son's eyes in a gesture that Emile Mâle traced to the medieval *Revelations of St. Brigit*.[16] She plays the role of coredeemer or priest, the *Virgo Sacerdos*, who, as Eisler notes, could be imagined leading the mass in the sacrament of communion with the chant "*Ave, Verum Corpus, natum de Maria Vergine.*" Christ's blood mixes with the wheat on which he lies. The symbolic wheat under Christ's body is not only repeated in the other versions of this composition in Antwerp and Vaduz, but also in the *Christ à la Paille* (from whence, of course, the name) and the *Resurrected Christ Triumphant* (Florence, Palazzo Pitti, inv. 479). As Eisler noted in discussing Rubens's Northern sources for this theme (especially a large lost *Lamentation* by Hugo van der Goes), the motif of the wheat already appears in Hugo's *Portinari Altarpiece* (Florence, Uffizi, invs. 3191-3193).[17] In Rubens's painting in Antwerp (fig. 1), the eucharistic imagery is further strengthened by the inclusion in the landscape of grape and ivy vines, symbols of the eternal life ensured through the sacrament of the eucharist.[18] And in the Liechtenstein painting and the *Christ à la Paille* the presence of the Stone of Unction, where Christ was prepared for burial, underscores both the finality of the "last farewell" and its eucharistic import.[19] Thus the painting is a true *Imago Pietatis* designed to elicit the highest and most spiritual emotion from the viewer.

PCS

1. Prohaska, in Vienna, Kunsthistorisches, cat. 1989, p. 138. The signature and date adopt the same form as other works by Rubens from this period; see for example, *Venus Frigida*, Antwerp, Koninklijk Museum voor Schone Kunsten, no. 709, signed and dated: P.P. RVBENS F.1.6.1.4. and the *Cupid Shaping His Bow*, cat. 11).

2. See Rooses 1886-92, vol. 2 (1888), p. 137, no. 324; A. Rosenberg 1905, no. 77; Antwerp, cat. 1988, p. 326, no. 319. See also E. Duverger, "Het legaat van Barones van den Hecke-Baut de Rasmon aan het Museum van Antwerpen," *Jaarboek van het Koninklijk Museum voor Schone Kunsten, Antwerpen* (1974), pp. 248-250. Like others before him, Prohaska (Vienna 1977, p. 62) wrongly assigned the landscape in the present work to Jan Brueghel.

3. Rooses 1886-92, vol. 2 (1888), no. 326, pl. 113; see R. Baumstark in New York 1985, pp. 318-321, no. 202. The painting was acquired by Prince Johan Adam in 1710 from the Antwerp dealers Jacob van Bedt and Justus Forchoudt as a work by Rubens, but was catalogued in the Liechtenstein Gallery as by van Dyck from 1767 until 1931. Wilhelm von Bode ("Peter Paul Rubens," *Die graphische Künste* 11 [1888], pp. 22-23) alone argued in favor of Rubens's authorship. Baumstark emphatically supported this attribution in 1985 (see above), unconvincingly rejecting both the Vienna and Antwerp paintings in favor of the Vaduz picture. However, the labored quality of the latter's subsidiary figures surely attests to workshop involvement.

4. See Rooses 1886-92, vol. 2 (1888), no. 327; M. Jaffé, "Rubens's *Le Christ à la Paille* Reconsidered," *Apollo* 95 (1972), pp. 107-114; Antwerp, cat. 1988, p. 320, nos. 300-304.

5. See Oldenbourg 1921, p. 35; P. della Pergola, *Galleria Borghese*, vol. 1, *Dipinti* (Rome, 1959), pp. 182-183, no. 272, ill.; and Brussels 1965, no. 192, ill.

6. Balis 1986, p. 105, under cat. no. 2a. See also Held 1959, no. 29, pl. 30 for the verso.

7. Vlieghe 1972-73, no. 103b; Held 1980, vol. 1, no. 406.

8. Held 1959, cat. no. 43, pl. 43.

9. Oldenbourg 1921, no. 91; Antwerp, cat. 1988, p. 323, no. 314, ill.

10. See J. Foucart, in Paris 1977-78, cat. 118.

11. Held 1980, vol. 1, p. 501, cat. 366, color pl. 6.

12. Eisler 1967, p. 68, refers to "Rubens's Mantegnesque *Lamentation* in the Liechtenstein collection." The phrase is repeated by Glen 1977, p. 93.

13. See Kauffmann, *Albrecht Dürer in der Kunst und im Kunsturteil* (1954), p. 52; see also Prohaska in Vienna 1977, p. 62. For the Dürer drawings, see F. Winkler, *Die Zeichnungen Albrecht Dürers* (Berlin, 1939), vol. 4, no. 883, ill. and no. 881, ill.

14. Prohaska in Vienna 1977, p. 62; see for the Vico and van Veen, J. Müller Hofstede, "Ein Frühwerk Jacopo Bassanos und eine Komposition Raffaels," *Münchner Jahrbuch der bildenden Kunst* 15 (1964), pp. 131-144, figs. 9 and 18.

15. See E. Panofsky, *Early Netherlandish Painting* (Cambridge, MA, 1953), pp. 333ff; and Eisler 1967, pp. 67-70.

16. Mâle 1932, pp. 282-283.

17. Eisler 1967, pp. 69-70.

18. Glen 1977, p. 93.

19. Eisler 1967 (p. 68) likens the iconography of these pictures to Caravaggio's so-called *Entombment* in the Chiesa Nuova, which Rubens knew well and even copied (Ottawa, National Gallery of Canada, inv. 6431). In that work the figures stand on the Stone of Unction; see further for its iconography, M. A. Graeve, "The Stone of Unction in Caravaggio's Painting for the Chiesa Nuova," *Art Bulletin* 40 (1958), pp. 223-238.

Peter Paul Rubens and Frans Synders
14. The Crowning of Diana

Oil on canvas, 165.5 x 187 cm (65 ⅛ x 73 ⅝ in.)
Stiftung Schlösser und Gärten Potsdam-Sanssouci,
inv. GK I 6293

PROVENANCE: Honselaersdijk Castle, the Netherlands, probably by
1637-1638; inv. 1707, no. 65 [as by Rubens and Snyders]; bequeathed by
the House of Orange to the Prussian branch of the family in about 1742;
Berliner Schloss; Leineschloss, Hanover.

LITERATURE: Friedrich Nicolai, Beschreibung der königlichen Residenz-
städte Berlin und Potsdam (2nd ed., Berlin, 1779), p. 658, no. 21; Johan Gott-
lieb Puhlmann, Beschreibung der Gemälde, welche sich in der Bildergalerie der
daranstossenden Zimmern und in dem weissen Saale im königlichen Schlosse zu
Berlin befinden (Berlin, 1790), no. 53; Johann Friedrich Daniel Rumpf,
Beschreibung der äusseren und inneren Merkwürdigkeiten der königlichen
Schlösser in Berlin, Charlottenburg, Schönhausen, in und bey Potsdam (Berlin,
1794), no. 53; idem, Berlin und Potsdam. Eine Beschreibung aller Merk-
würdigkeiten in dieser Städte und ihre Umgebungen, vol. 1 (Berlin, 1823),
p. 319; Parthey 1863-64, vol. 2 (1864), p. 447, no. 36; E. Henschel-Simon, ed.,
Die Gemälde und Skulpturen in der Bildergalerie von Sanssouci (Berlin, 1930),
no. 117; D. F. Slothouwer, De Paleizen van Frederik Hendrik (Leiden, 1945),
p. 484; H. Börsch-Supan, "Die Gemälde aus dem Vermächtnis der Amalie
von Solms und aus der orangischen Erbschaft in den brandenburgisch-
preussischer Schlössern," in Zeitschrift für Kunstgeschichte 30 (1967),
pp. 160-161, cat. 97, fig. 15; D. P. Snoep, "Honselaersdijk: restauraties op
papier," in Oud Holland 84 (1969), p. 288, fig. 8; G. Eckhardt, Die Gemälde in
der Bildergalerie von Sanssouci (1st ed. 1975; 4th ed. Potsdam, 1990), pp. 65-
66; G. Bartoschek, Flämische Barockmalerei in der Bildergalerie von Sanssouci
(Potsdam, 1985), n. p., ill. on cover; Balis 1986, p. 31, note 47, p. 58, note 42,
p. 182, note 27, fig. 3; Robels 1989, pp. 372-374, no. 279, ill.

DIANA, goddess of the hunt, sits in a landscape sur-
rounded by dead game, wild animals, and members
of her entourage. She rests her right foot on a dead
stag which lies beside other prey – a wild boar, hares,
and small birds. One of three hunting hounds rests
its paws on her right leg. In her left hand she holds
the leashes of a leopard and a lion, while in her right
hand she cradles her spear. She is given a crown of
myrtle by a winged female genius. On the right two
of her followers are presented with fruit by two
satyrs who have climbed a tree. One of Diana's assis-
tants collects the fruit in her drapery. At the back
left another attendant blows a hunting horn to
announce the conclusion of the hunt. Diana wears a
red gown and open-toed buskins decorated with
lion's heads and red ribbons. At her waist and
strapped to her shoulder is her hunting horn. To
accommodate her myrtle wreath her hair is drawn
up in a topknot held by a barrette in the shape of the
crescent moon that is her symbol.

As Börsch-Supan first observed, this painting was
recorded in 1707 as a chimney piece in the "groote
zael" of the castle at Honselaersdijk, one of the coun-
try villas of Amalia van Solms, wife of the Dutch
Stadtholder Frederick Hendrick.[1] In all likelihood
the painting was already there in 1637-1638, when
the decorations for the large banquet hall were com-
pleted with canvases devoted exclusively to the
theme of Diana and her hunts, including other
works by the Dutch painters Christiaen van Couwen-
bergh, Pieter de Grebber, and Jacob van Campen.[2]
In discussing the program, Börsch-Supan cited the
precedents of the Diana gallery at Fontainebleau.[3]

Fig. 1. Copy after Peter Paul Rubens, Calydonian Boar
Hunt, oil on canvas, 162.5 x 348 cm, Towcester,
Northamptonshire, collection of Lord Hesketh,
Easton Neston.

Fig. 2. Copy after Peter Paul Rubens, Diana and Her
Nymphs Hunting Deer, oil on canvas, 162 x 352 cm,
Bürgenstock, Switzerland, collection of Fritz Frey.

The attribution to Rubens and Snyders recorded
in the Honselaersdijk inventory of 1707 was support-
ed by Nicolai in his description of the royal residence
in Berlin and Potsdam in 1779, but questioned by
the later cataloguers, Puhlmann (1790) and Rumpf
(1794), who assigned the painting instead to "[Abra-
ham] Diepenbeck and Snyders." Parthey (1864) men-
tioned it only as "Rubens-Schule." And as late as
1930, when E. Henschel-Simon in Sanssouci's cata-
logue first noted that it had descended from the
inheritance of the House of Orange, it was cata-
logued as the work of an "unknown pupil of Rubens
[from] around 1620." Börsch-Supan (1967) uncondi-
tionally reasserted Rubens's authorship, while Eck-
hardt (1975) admitted that it was the master's con-
ception but regarded it as largely executed by the
workshop with the animals by Paulus de Vos. The
resemblance to Suzanna Fourment of the nymph
biting into the fruit suggested to Eckhardt a date
of 1625, even though Rubens's original conception
could date earlier.

Balis (1986), on the other hand, defended
Rubens's authorship and directly related the paint-
ing to the two pendant scenes of mythological deer
and boar hunts by Rubens which he took to Madrid
in 1628.[4] While the originals in the Alcázar have
been lost, faithful replicas in Bürgenstock and
Easton Neston are known (figs. 1 & 2) and the two
preparatory oil sketches by Rubens are preserved (see

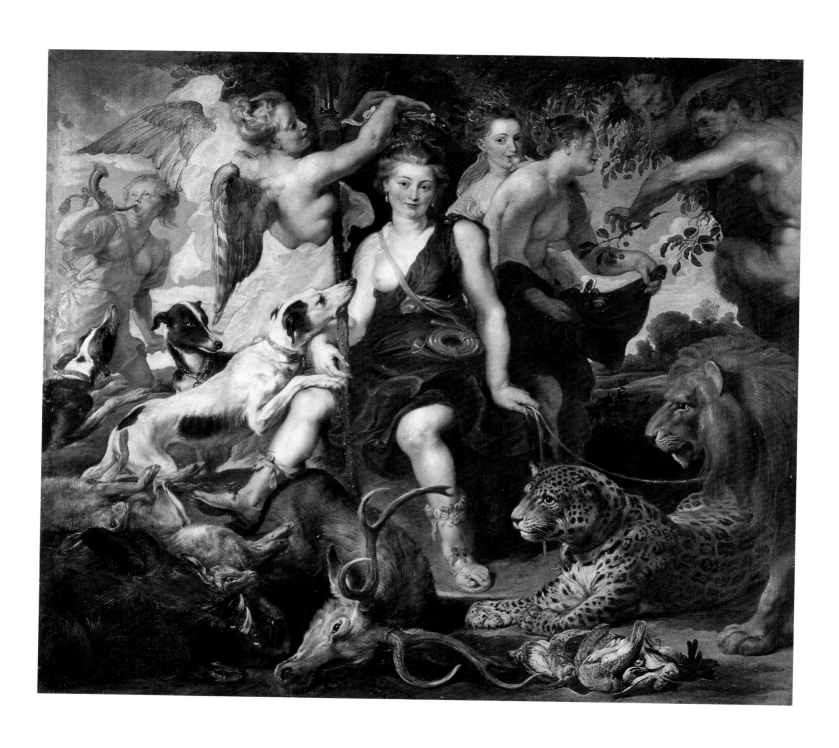

Fig. 4. Frans Snyders, *Hound*, black chalk with white heightening on gray paper, 227 x 299 mm, Ghent, Museum voor Schone Kunsten, inv. no. 1910-AD.

Fig. 3. Peter Paul Rubens and Jan Brueghel the Elder, *Diana and Her Nymphs Setting out for the Hunt*, signed falsely "P.P.R.," oil on panel, 62 x 98.7 cm, Paris, Musée de la Chasse et de la Nature, inv. no. 68-3-1.

cats. 34 and 35).[5] Balis likened the figure types of Diana, the genius crowning her, and the nymphs to the Atalanta in the one painting and the Diana and her companions in the other. The dead stag in the Sanssouci painting repeats in reverse the pose of the wounded animal in *Diana and Her Nymphs Hunting Deer* (fig. 2). Since the Potsdam canvas is also the same height as the two lost originals from the Alcázar (as well as the copies at Bürgenstock and Easton Neston and its possible replica in Mexico City), Balis thoughtfully speculated that it might have formed part of Philip IV's original commission for the *Salón nuevo*, "perhaps as a central piece illustrating the outcome of the deer and boar hunt ... The iconographic and stylistic affinity to the two mythological *Hunts* can ... perhaps be used to round out our picture of the latter [the *Crowning*]."[6] Balis and Robels also upheld the attribution of the animals and game in the Potsdam picture to Snyders.[7] The central figure in the *Crowning of Diana* is closely related to her counterpart in the *Diana and Her Nymphs Setting out for the Hunt* (fig. 3) which Rubens painted as part of a series in collaboration with Jan Brueghel the Elder. The latter work, perhaps executed around 1624, probably predates the Alcázar and Sanssouci paintings, and thus represents a somewhat earlier stage in Rubens's thinking about the Diana themes. Ertz reasonably argued that these paintings done in collaboration with Brueghel were commissioned by the Infanta Isabella, who later served, probably not accidentally, as the intermediary between Rubens and Philip IV in the commission for the Alcázar.[8]

Robels speculated that an oil sketch by Rubens might have once recorded the lion and leopard in the Potsdam painting.[9] The fact that Paulus de Vos paraphrased these creatures in the *Orpheus* (Madrid, Prado, no. 1844) which he painted in collaboration with Theodoor van Thulden, might seem to support an attribution to de Vos for the Sanssouci animals. Robels cautioned that de Vos often repeated Snyder's motives, but also allowed the possibility of his participation in the present work; a drawing by Snyders for the retrieving hound which Robels believes to be preparatory is in the museum in Ghent (fig. 4).[10]

Diana (Artemis) was the virginal defender of chastity who was later identified with the moon goddess (Luna). Since at least the fourth century B.C. she has been depicted as a tall athletic woman in a short tunic and sandals, often carrying a bow and arrow or spear. Her depiction here, with one breast exposed, may also recall Diana's frequent descriptions. Rubens would not only have known classical literary accounts of Diana's exploits but also descriptions of the existence of ancient pictures of the hunt in the *Eikones* of the elder and younger Philostratus, as well as actual Roman sarcophagus reliefs. Although her iconographic role as the virgin athlete and champion of chastity – associations which no doubt would have appealed to the Infanta and Amalia van Solms – Rubens probably was initially attracted to the Diana theme for its opportunity to depict a beautiful female nude; he first painted her with sleeping nymphs, spied upon by lascivious satyrs.[11] Later, in his series of collaborative paintings with Jan Brueghel the Elder from the early 1620s, he concentrated on the goddess's role as huntress by surrounding her with the pack of hounds and booty as allusions to the chase (see fig. 3). However, as Balis observed, it was only later in his career, toward 1628, that Rubens depicted Diana as an active huntress (see fig. 2) even though he had been painting hunting scenes for more than a decade. In his efforts to revive the ancient genre of hunting scenes (medieval and Renaissance artists treated mythological hunts only incidentally), Rubens also may have considered Diana's classical guise as Mistress of Beasts[12]; Balis was the first to suggest that the *Crowning of Diana* casts her in this role.[13]

Several later works by Dutch artists seem to recall the present painting, acknowledging its presence in Honselaersdijk; see, for example, the Dianas by Gerard van Honthorst (dated 1650, Copenhagen, Statens Museum for Kunst, no. 322) and Pieter de Grebber (Leipzig, Museum der bildenden Künste, no. 1166).

P C S

1. See Börsch-Supan 1967, pp. 160-161, 195, no. 97. In the 1707 inventory it was described as "voor de schoorsteen een Diana met veel wilde dieren soo levende als doode en Nymfen door Rubbens en Snijers." S. W. A. Drossaers and Th. H. Lunsingh Scheurleer, *Inventarissen van de Inboedels in de Verblijven van de Oranjes*, vol. 1 (The Hague, 1974), p. 525, no. 82.

Peter Paul Rubens
15a. *Portrait of a Man, Called Peter van Hecke*

Oil on panel, 114.5 x 90.5 cm (45 x 35 ⅝ in.)
Edward Speelman, Ltd.

2. See also D. P. Snoep 1969, pp. 288-89, note 38, fig. 8; Eckhardt 1975, pp. 62-66, no. 42; Balis 1986, p. 184, note 28; Robels 1989, pp. 372-373.

3. Börsch-Supan 1967, p. 160.

4. Balis 1986, p. 182.

5. See Balis 1986, cat. nos. 12 (copy no. 1) and 13 (copy no. 2), respectively figs. 81 and 86. A large canvas of the *Deer Hunt* in the Piedecases collection, Mexico City, may be the lost original from the Alcázar or only a replica or copy; see Balis no. 13 (copy no. 1), fig. 83.

6. Balis 1986, p. 182.

7. Robels 1989, pp. 372-373, cat. no. 279.

8. As noted by Balis 1986, p. 57. See J. Müller Hofstede, "Rubens und Jan Brueghel: Diana und ihre Nymphen," *Jahrbuch der Berliner Museen* 10 (1968), pp. 200-222.

9. Robels 1989, p. 374.

10. Robels 1989, no. Z53. She also mentions a drawn copy of the entire composition (her cat. AZ 126) in the Museum Boymans-van Beuningen, Rotterdam.

11. See Rooses 1886-92, vol. 3 (1890), nos. 599-600; K. E. Simon, "Rubens Satyren und die ruhende Diana," *Jahrbuch der preussischen Kunstsammlungen* 63 (1942), pp. 110-113.

12. See Ch. A. Christou, *Potnia theron. Eine Untersuchung über Ursprung, Erscheinungsform und Wandlungen der Gestalt einer Gottheit* (Thessaloniki, 1968).

13. Balis 1986, p. 58, note 42.

PROVENANCE: Vicomtesse de Spoelberch, Belgium; Léon Gauchez, Paris; Baron Edmond de Rothschild, Paris (before 1890); by descent to Baron Edmond de Rothschild, Château de Pregny, Geneva; Colnaghi's, New York.

LITERATURE: Rooses 1886-1892, vol. 4 (1890), pp. 192-193, no. 966 [ca. 1618]; A. Rosenberg 1905, p. 172; G. Glück, review of Rosenberg 1905, in *Kunstgeschichtliche Anzeigen* 1905, p. 58 [as by van Dyck] (reprinted in Glück 1933, p. 161); W. von Bode, "Kritik und Chronologie der Gemälde von Peter Paul Rubens," *Zeitschrift für bildende Kunst* n.f. 16 (1905), pp. 200-201 [as by van Dyck]; Schaeffer 1909, p. 149 [as by van Dyck]; Glück 1931, p. 106 [as by van Dyck]; E. Duverger, "De verzameling schilderijen van de Antwerpse zijde- en tapijthandelaar Peter van Hecke de Jonge, schoonbroer van P. P. Rubens, naar een inventaris van 1646," *Jaarboek van het Koninklijk Museum voor Schone Kunsten, Antwerpen* 1971, p. 163 [as by Rubens]; John Rowlands, in London, British Museum, *Rubens Drawings and Sketches* (exh. 1977), p. 77; M. Jaffé, "Rubens's Portraits of Nicolaes Rockox and Others," *Apollo* 119 (1984), pp. 275-281, ill.; Held 1986a, p. 125; Vlieghe 1987a, pp. 116-118; Larsen 1988, vol. 2, p. 31, no. 48 [as by van Dyck, ca. 1618].

Fig. 1. Peter Paul Rubens, *Portrait of a Man (Peter van Hecke?)*, black chalk, 413 x 345 mm, London, British Museum, inv. 1885-5-5-9-48.

Peter Paul Rubens
15b. *Portrait of a Woman, Called Clara Fourment*

Oil on panel, 114.5 x 90.5 cm (45 x 35 ⅝ in.)
Edward Speelman, Ltd.

PROVENANCE: Vicomtesse de Spoelberch, Belgium; Léon Gauchez, Paris; Baron Edmond de Rothschild, Paris (before 1890); by descent to Baron Edmond de Rothschild, Château de Pregny, Geneva; Colnaghi's, New York.

LITERATURE: Rooses 1886-1892, vol. 4 (1890), p. 160, no. 934 [ca. 1618]; A. Rosenberg 1905, p. 173; G. Glück, review of Rosenberg 1905, in *Kunstgeschichtliche Anzeigen* 1905, p. 58 [as by van Dyck] (reprinted in Glück 1933, p. 161); W. von Bode, "Kritik und Chronologie der Gemälde von Peter Paul Rubens," *Zeitschrift für bildende Kunst* n.f. 16 (1905), pp. 200-201 [as by van Dyck]; Schaeffer 1909, p. 150 [as by van Dyck]; Glück 1931, p. 107 [as by van Dyck]; E. Duverger, "De verzameling schilderijen van de Antwerpse zijde- en tapijthandelaar Peter van Hecke de Jonge, schoonbroer van P. P. Rubens, naar een inventaris van 1646," *Jaarboek van het Koninklijk Museum voor Schone Kunsten, Antwerpen* 1971, p. 163 [as by Rubens]; M. Jaffé, "Rubens's Portraits of Nicolaes Rockox and Others," *Apollo* 119 (1984), pp. 275-281, ill; Vlieghe 1987a, pp. 118-119; Larsen 1988, vol. 2, p. 31, no. 48 [as by van Dyck, ca. 1618].

STANDING before a wall with a column nearly masked by a heavy fall of red drapery, a man of young middle age is depicted at knee-length, turned to the right. He is clad in a black doublet and breeches, plain white cuffs and a soft lace-trimmed ruff, with a black cloak slung over his left shoulder. He holds his hat in his left hand, which rests on the base of the column at the right. The woman is also depicted at three-quarter length, seated in an armchair covered in red velvet. Her black costume is relieved by a frothy white millstone ruff, lace-trimmed sleeve cuffs, and a parade of gold buttons. She wears a pearl necklace and earrings; her chignon is bound by a

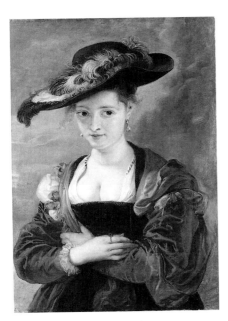

Fig. 2. Peter Paul Rubens, *Portrait of Suzanna Fourment* ("*Le Chapeau de Paille*"), ca. 1620-1625; oil on panel, 79 x 54.5 cm, London, The National Gallery, inv. 852.

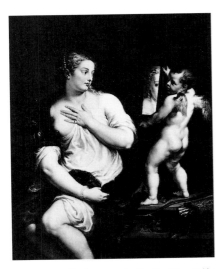

Fig. 3. Peter Paul Rubens, *Venus Looking in a Mirror Held by Cupid*, ca. 1628-1629; oil on canvas, 137 x 111 cm, Madrid, Thyssen-Bornemisza collection, inv. 266.

jeweled circlet. In her right hand she holds an ostrich-feather fan. At the left, the red drapery is hoisted to admit a view of a coastal landscape with a two-masted merchant ship. Similar vignettes appear in other Netherlandish portraits of married women, and have been interpreted as metaphors for the virtuous housewife.[1]

The portraits were first published by Rooses as by Rubens, and dated ca. 1618; the attribution and dating were reiterated by Rosenberg in 1905. However, both Bode and Glück, in their reviews of Rosenberg, reattributed the portraits to Anthony van Dyck during his first Antwerp period (ca. 1618-1620), when the latter's portrait style was particularly close to that of his mentor. However, even at this early stage of his career, van Dyck's impulsive, restless brushwork is quite different from Rubens's bold, sure touch. The attribution of the portraits to Rubens is now generally accepted, and is strengthened by a drawing for the man's portrait in the British Museum (fig. 1), which is by Rubens's hand.[2] The dating of the paintings, however, is still subject to some debate.

Held and Haverkamp Begemann have dated the portraits to ca. 1620[3]; Jaffé, "not earlier than 1627-28, and possibly about 1630-31."[4] Vlieghe (working from photographs) has suggested a date of after 1630, based on comparison with other portraits by Rubens of the period, such as the Vienna *Self-Portrait* of ca. 1638-1640 and the *Portrait of Jan Brant* (dated 1635; Munich, Alte Pinakothek, inv. 354).[5] Vlieghe contends that the London sketch for the man's portrait (fig. 1) is consistent with Rubens's drawing style of the 1630s. His argument for a late dating is supported by the sketch on the verso of this sheet, which is related to Rubens's late *St. Cecilia* in Berlin (ca. 1635-1640; Berlin, Gemäldegalerie, inv. 781). Held, on the other hand, dates the drawing ca. 1620-1622, and suggests that the sketches for the St. Cecilia on the verso may well be connected to an earlier conception of the project, noting that the pose of the hands and the fabric of the sleeves is only generically related to the finished painting.[6] The execution of the portraits, as well as the evidence of the related drawing (*pace* Vlieghe) argue most convincingly for a date of about 1620-1622, a date not inconsistent with the ages of the proposed subjects of the portraits, Peter van Hecke and Clara Fourment.

Since Rooses, the sitters have traditionally been identified as Peter van Hecke the Younger (1591-1645) and Clara Fourment (1593-1643), the older sister of Rubens's second wife, Hélène.[7] This identification is based largely on the woman's strong familial resemblance to accepted portraits of Hélène and Suzanna Fourment; there are no other likenesses of either van

Hecke or Clara Fourment known to confirm the identification. Rubens portrayed other members of the Fourment family, by whom he was befriended well before his marriage to Hélène in 1630 (see, for example, his portrait of Suzanna Fourment in the National Gallery, London, inv. 852; fig. 2); it is entirely conceivable that he painted portraits of Clara and her husband as well.

The van Heckes and Fourments were among the richest and most powerful merchant families in Antwerp during the first half of the seventeenth century.[8] Peter van Hecke the Elder (1543-1620) and Daniël Fourment (d. 1643) were partners in a profitable silk and tapestry trade. Peter van Hecke the Younger and Clara Fourment were married in Antwerp on 26 February 1612. The two families were further allied through the marriage of Peter's sister Antoinette van Hecke to Peter Fourment; Daniël Fourment the Younger, Clara's brother, was married to Clara Brant, sister of Rubens's first wife, Isabella. Peter van Hecke and Clara Fourment had seven children; Rubens was godfather to the youngest, Ferdinandus, who was baptized on 15 October 1635. The younger van Hecke continued in the family silk, tapestry, and diamond trade. In addition, Clara Fourment was active as an independent lace merchant from 1622; the business was taken over by her daughter Johanna (b. 1614) after her death.[9]

An inventory made on 23-25 October 1646 of van Hecke's estate lists seventy-three paintings but curiously, in light of the deceased's profession, no tapestries.[10] Of the paintings, only eight mention the name of the artist: "Een schoustuck wesende Lantschap geschildert van Momper" ("A chimney piece, showing a Landscape painted by Momper"), and seven paintings by Rubens, including "Een Contrefijtsel van Rubbens wesende Venus en Cupido" ("A figure piece by Rubens, showing a Venus and Cupid"). The latter painting has convincingly been identified as Rubens's version of the subject now in the Thyssen-Bornemisza collection, painted about 1628-1629 (fig. 3).[11] Although no family portraits are specifically mentioned among the artworks in van Hecke's estate, this does not exclude the possibility that the present works were in van Hecke's collection; in the seventeenth century family portraits were frequently not considered part of the art collection *per se*.[12] Copies of both portraits were sold at Brussels in 1950.[13]

MEW

cat. 15a

cat. 15b

Peter Paul Rubens
16. Portrait of Burgomaster Nicolaes Rockox

Oil on panel, 39.1 x 31.1 cm (15 ⅛ x 12 ¼ in., octagonal)
Philadelphia, Philadelphia Museum of Art, inv. 44-9-9,
Gift of Mrs. Gordon A. Hardwick and Mrs. W. Newbold
Ely in memory of Mr. and Mrs. Roland L. Taylor

1. Vlieghe 1987a, p. 119, citing E. de Jongh, in Haarlem 1986, p. 209. De Jongh traces the metaphor to Proverbs 31:10-14 ("Who can find a virtuous woman? for her price is far above rubies. . . . She is like the merchants' ships; she bringeth her food from afar"), and notes that the text was paraphrased throughout the sixteenth and seventeenth centuries in moralizing texts which describe the virtuous wife, for example Jacob Cats's *Houwelick* (1625): "Sy is gelijck een schip, dat over zee gevaren / Vervult het gantsche landt met alle nutte waren" ("She is like a ship that sails over the seas, supplying the whole land with all necessary things").

2. A. M. Hind, *Catalogue of Drawings by Dutch and Flemish Artists . . . in the British Museum*, vol. 2 (London, 1923), no. 91; see also Held 1986a, p. 125, with a discussion of the attribution of the drawing to Rubens.

3. Held 1986a, p. 125; E. Haverkamp Begemann, verbal opinion to the owner.

4. Jaffé 1984, p. 276.

5. Vlieghe 1987a, p. 117.

6. Held 1986a, p. 125, no. 143 ("the recto of the drawing, as well as the painted portrait, can hardly be dated other than to the years around 1620").

7. Rooses 1886-92, vol. 4 (1890), pp. 160, no. 934 (Fourment) and 192-193, no. 966 (van Hecke).

8. For biographical details of the two families, see Duverger 1971; and, on the Fourments, P. Génard, *P. P. Rubens, Aanteekeningen over den grooten meester en zijne bloedverwanten* (Antwerp, 1877), pp. 408-411.

9. Duverger 1971, p. 147.

10. Stadsarchief Antwerpen, Notaris D. Guyot 1871 (1646), fol. 254; excerpts published in Duverger 1984-, vol. 5 (1991), pp. 360-363; and Duverger 1971, pp. 168-171.

11. See Muller 1989, pp. 104-105, with further references. The painting was purchased by Peter van Hecke from Rubens's estate on 1 March 1641 for fl. 300. As Muller points out, because the entire amount was credited to the artist's estate and not shared with Rubens's sons by his first wife, the painting must have been painted after the death of Isabella Brant in June 1626 (for the terms of Isabella Brant's last testament, see Muller 1989, p. 78, and M. Rooses, "Staet van den sterffhuyse van joffrouwe Isabella Brant," *Rubens-Bulletijn* 4 [1896], pp. 156-157). The painting in van Hecke's collection cannot, therefore, be identified with the version of the subject now in Liechtenstein (as suggested by Rooses 1886-92, vol. 3 [1890], p. 174; and Duverger 1971, pp. 156-158), which dates to the 1610s.

12. C. W. Fock and R. E. O. Ekkart, as cited in B. Brenninkmeyer-de Rooij and E. de Heer, "William III and the Royal Collections," in exh. cat. The Hague, Mauritshuis, *Paintings from England: William III and the Royal Collections* (1988-89), p. 15, note 22. See also Van der Stighelen 1991a on the role of portraits in Antwerp collections 1600-1642. Several likenesses of prominent persons (such as Ambrogio Spinola and the Earl and Countess of Arundel) and portraits of the twelve Roman emperors are mentioned in the van Hecke inventory (Duverger 1971, pp. 150-153).

13. *Portrait of Peter van Hecke*, oil on panel, 113 x 90 cm; and *Portrait of Clara Fourment*, oil on panel, 113 x 87 cm; sale Baron Albert von Goldschmidt-Rothschild, Brussels, 1950; ill. Vlieghe 1987a, figs. 125, 126. Both paintings formerly in the collection of Baron Max von Goldschmidt-Rothschild (1926), as by van Dyck.

PROVENANCE: Collection Ludwig Knaus, Berlin, 1883; sale Knaus, Berlin (Lepke), 30 October 1917, no. 8 [M. 83,000; to Böhler, Munich]; sale Camillo Castiglione, Amsterdam (F. Muller), 17-20 November 1925, no. 72 [fl. 33,000, to Drey]; dealer A. S. Drey, Munich; Roland L. Taylor, Philadelphia, by 1927.

EXHIBITIONS: Berlin, Königliche Akademie der Künste, *Die Ausstellung von Gemälden älterer Meister im Berliner Privatbesitz*, 1883, p. 53; on loan to the Pennsylvania Museum (Philadelphia Museum of Art), 1927-28.

LITERATURE: *Zeitschrift für bildende Kunst*, 1883, p. 321; Rooses 1886-92, vol. 4 (1890), p. 242, under no. 1035; A. Rosenberg 1905, p. 126, ill. [as "Portrait of a Man," ca. 1615-18]; Wurzbach 1906-11, vol. 2, p. 492; J. O. Kronig, in Herbert Cook, ed., *A Catalogue of the Paintings at Doughty House, Richmond*, vol. 2: *Dutch and Flemish Schools* (London, 1914), under no. 329; Oldenbourg 1921, p. 81, ill. [as 1614-15]; Arthur Edwin Bye, "Loan Collection of Paintings from Flemish and Dutch Schools," *The Pennsylvania Museum Bulletin* (Philadelphia Museum of Art) vol. 23, no. 117 (December 1927-January 1928), p. 11 [as "Portrait of Nicolaes Rockox," 1615]; R. A. M. Stevenson, *Rubens: Paintings and Drawings* (Oxford and New York, 1939) no. 26 [as 1614-15]; Goris, Held 1947, p. 48, no. A31: Larsen 1952, p. 216, no. 28 [as ca. 1614]; Philadelphia, cat. 1964, p. 60; Sutton 1990, pp. 262-265.

IN 1927 Arthur Edwin Bye suggested that this freely executed sketch, previously catalogued as "Portrait of a Man," was a portrait of Nicolaes Rockox (1560-1640); this identification was upheld by Sutton in 1990 as a "plausible hypothesis."[1] Rockox, a numismatist, antiquarian, connoisseur, and nine-time burgomaster of Antwerp, was a friend and patron of Rubens from the latter's return from Italy in 1608 until his death in 1640. In a letter dated 3 July 1625, Rubens describes his friend as "an honest man and a connoisseur of antiquities . . . a good administrator, and all in all a gentleman of the most blameless reputation."[2] Rockox was instrumental in securing for Rubens the commission to paint an *Adoration of the Magi* for the Antwerp Town Hall in 1609 (now Madrid, Museo del Prado, inv. 1638), as well as the *Descent from the Cross* altarpiece for the Antwerp Cathedral in 1611 (painted 1612-14).[3]

In addition to these public projects, Rockox also commissioned works from Rubens for his personal collection, including a *Samson and Delilah*, dated 1609,[4] and in 1613-15, a triptych of the *Doubting Thomas* with flanking portraits of Rockox and his wife Adriana Perez (d. 1619).[5] The triptych served as an epitaph over the tomb of Rockox and his wife in the Church of the Recollects in Antwerp. The portrait of Rockox on the left wing of the altarpiece shows a man youthful for his mid-forties, with close-cropped hair thinning at the temples and a short beard. Rockox's features are slightly less idealized in an informal oil sketch by Rubens, possibly executed ca. 1612-13 in preparation for the Antwerp portrait. Despite the disparity in age and the inherent subjectivity of such comparisons, there are many points of similarity between the sitter represented in these two likenesses and the subject in the Philadelphia painting. Although the latter work has

Peter Paul Rubens
and Jan Brueghel the Elder
17. Landscape with Pan and Syrinx

Oil on panel, 58 x 94 cm (22⅞ x 37 in.)
England, property of the British Rail Pension Fund,
ref. 7214

been variously dated between 1614 and 1618,[6] the
sitter here is visibly older, suggesting a later date for
the work. Among the other portraits of Rockox,
Anthony van Dyck's drawn likeness, datable to the
artist's second Antwerp period (ca. 1627-32), records
a heavier visage and somewhat receded hairline.[7]
Based on the relative ages of the sitters in these
examples, Rubens's study in Philadelphia (if it
depicts Rockox, which seems likely) was probably
executed about 1625 or slightly later. The sketchy
execution of the work makes it difficult to date pre-
cisely on stylistic grounds.

The octagonal central portion of the portrait was
enlarged to a rectangular format at some later date.
The irregularity of the octagon and the angle of the
grain of the wood panel (about 25 degrees off the
vertical) suggest that the central section was also
reshaped at this time, and that the angle of the sit-
ter's head was originally canted further to the view-
er's right.[8] Comparable portraits of men in ruffs by
Rubens include the *Portrait of an Old Man (Jan van
Ghindertalen?)* (ca. 1622-25; Berlin, Staatliche Museen
zu Berlin, inv. 776F), and *Portrait of Henri de Vicq* (1625;
Paris, Musée du Louvre, inv. 458).

<div align="center">MEW</div>

1. Arthur Edwin Bye, "Loan Collection of Paintings from Flemish and
Dutch Schools," *The Pennsylvania Museum Bulletin* (Philadelphia Museum
of Art) vol. 23, no. 117 (December 1927-January 1928), p. 11; Sutton 1990,
p. 262.

2. Magurn 1955, pp. 112-113, no. 64; and Rooses, Ruelens 1887-1909, vol. 3
(1900), pp. 372-376; from Rubens to Palamède de Fabri, Sieur de Valavez.

3. The altarpiece was commissioned by the Guild of Arquebusiers, of
which Rockox was the head; his likeness is included in the *Presentation in
the Temple*, the right wing of the altarpiece.

4. London, The National Gallery, inv. 6461. The painting is featured
prominently in Frans Francken the Younger's *Interior of Nicolaes Rockox's
'Kunstkamer'* (Munich, Bayerische Staatsgemäldesammlungen, Alte
Pinakothek, inv. 858), ill. Muller, fig. 2.

5. On the iconography of the triptych, see A. Monballieu, "Bij de icono-
grafie van Rubens' Rockox-epitaphium," *Jaarboek van het Koninklijk Muse-
um voor Schone Kunsten, Antwerpen* (1970), pp. 133-155.

6. See Literature, above, and the discussion in Sutton 1990, p. 262. Held (in
a letter dated 8 March 1981, Philadelphia Museum of Art files) wondered
whether the portrait could have been done immediately after Rubens's
return to Antwerp in 1608.

7. Vey 1962, pp. 263-264, no. 193. Several other portraits of Rockox are
known, and listed in Sutton 1990, p. 262. In addition to those cited above,
there is a portrait by Otto van Veen dated 1600 (Antwerp, Rubenshuis);
a formal portrait by van Dyck dated 1621 (St. Petersburg, Hermitage,
inv. 6922); and an oil sketch by van Dyck dated 1636 (private collection).
The last-mentioned painting, probably based on the Windsor Castle
drawing of ca. 1627-32, in turn served as the model for Paulus Pontius's
1639 engraved bust portrait of Rockox. On van Dyck's oil sketch see
Julius S. Held, in Washington 1990-91, p. 360.

8. See the detailed condition notes on the painting in Sutton 1990, p. 265.

PROVENANCE: (possibly) the painting described as "Den Pan en
Siringa van Sig. Rubens, den gront vader Saliger" (without dimensions)
in the estate of Jan Brueghel the Elder (from the diary of Jan Brueghel
the Younger; see Vaes 1926-27, p. 209); (possibly) in the 1627 inventory of
Jan Brueghel the Younger, described as "een Pan et Siringa, met twee
copyen," sold with two other paintings to M. Gault of Paris for fl. 300 (see
Vaes 1926-27, pp. 212-213); Counts Schönborn, Schloss Pommersfelden;
Sale A. M. Le Comte de Schönborn (Château de Pommersfelden), Paris
(Hôtel Drouot), 17-18 May 1867, no. 210 (frs. 7000); Salomon Goldschmidt;
Sale "M.G . . . ," Paris (Georges Petit), 14-17 March 1898, no. 95, ill. (to Max,
for frs. 9200); Baron Rothschild, Vienna; Kunstsalon Franke, Leipzig, 1933;
with Rosenberg & Stiebel, New York, ca. 1960; with Edward Speelman,
London 1979-80.

EXHIBITIONS: London, Thomas Agnew & Sons Ltd., *Thirty Five Paint-
ings from the Collection of the British Rail Pension Fund*, 8 November-
14 December 1984, no. 3, ill.

LITERATURE: T. Thoré-Bürger in the Pommersfelden sale catalogue,
Paris (Hôtel Drouot), 17-18 May 1867, p. 84, under no. 210; G. Campori,
Riccolta di catal. ed. invent. ined. (1870), p. 191; (possibly) Denucé 1934,
p. 142; Pigler 1956, p. 191; M. Jaffé, "Rubens and Raphael," in *Studies in
Renaissance and Baroque Art Presented to Anthony Blunt* (London/New York,
1967), p. 100, fig. 3; Jaffé 1977, p. 23, note 50; Ertz 1979, pp. 417, 420, 622,
cat. no. 384a, fig. 504; M. Kitson, in *The Burlington Magazine* 122 (Septem-
ber 1980), pp. 646, 664, fig. 63.

THE NYMPH, Syrinx, nude to the waist wearing
loose-fitting rose and white drapery flees from the
lunging satyr, Pan, along the banks of the river
Ladon. The landscape background recedes from right
to left in a wedge shape to a distant horizon. The riv-
er is lined with tall reeds and filled with waterplants,
flowers, ducks, herons, snipes, kingfishers, and other
waterfowl.

The subject is drawn from Ovid's *Metamorphoses*
(1: 686-715) which recounts the tale told by Mercury
of a chaste naiad who revered and even dressed like
the virgin goddess, Diana, and who "Many a time / . . .
foiled the chasing satyrs and those gods / Who haunt
the shady copses and coverts / Of the lush country-
side." Pan mistook her for Diana and chased her "To
Ladon's peaceful, sandy stream and there / Her flight
barred by the river, [she] begged her sisters, / The
water nymphs, to change her; and when Pan /
Thought he had captured her, he held instead / Only
the tall marsh reeds, and while he sighed, / The soft
wind stirring in the reeds sent forth / A thin and
plaintive sound; and he, entranced / By this new
music and its witching tones, / Cried 'You and I shall
stay in unison!' / And waxed together reeds of differ-
ent lengths / And made the pipes that keep his dar-
ling's name."[1]

The subject enjoyed popularity with baroque
painters in both northern and southern Europe,[2]
and it was probably treated collaboratively by Jan
Brueghel the Elder and Peter Paul Rubens more than
once.[3] As Ertz observed, in the estate of Jan Brueghel
there is a "Pan and Syrinx by "Sig[no] Rubens, the
background by 'Saliger'['the deceased']" (see Prove-
nance) and the same painting was probably the pic-

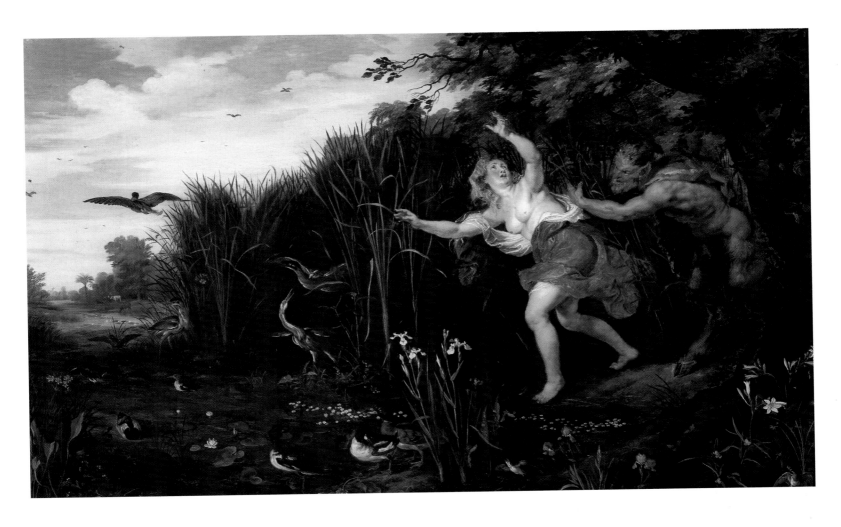

ture listed in Jan Brueghel the Younger's inventory of 1627 as being sold to a Paris collector together with two copies.[4] The present painting was dated approximately by Thoré-Bürger, "1615, or perhaps before" in the catalogue of the Pommersfelden sale in 1867. He praised the work, observing "Cette figure de femme est d'un élan, d'une finesse, d'une qualité extraodinaire. . . . Le paysage et les accessoires, par Brueghel de Velours, ont plus d'ampleur et de solidité que dans les tableaux où Brueghel a travaillé tout seul." Ertz only knew the painting from a photograph sent to him as his book went to press, but regarded it as a work of superior quality and suggested a date shortly before Jan's death, around 1623, while noting the possible relationship to the citation in the inventory of the artist's estate (see Provenance). A painting of the same subject but with larger figures set against a screen of reeds may be compared; it sold in London at Christie's in 1973 as a collaboration between Jan I and Rubens; however the certainty of the attribution of that picture was correctly ques-

tioned by Ertz.[5] In the museum in Schwerin is a very close variant of the present composition with the figures in the same positions but with the landscape reversed (it recedes from left to right), and other smaller changes in the details of the setting (see fig. 1)[6]; once again Ertz correctly doubted the attribution of this work.[7] Paintings in the Pinacoteca di Brera, Milan (inv. 623) and a sale in New York in 1986 are merely truncated copies of the present painting.[8] The popularity of Jan's paintings of this subject is reflected in the fact that no fewer than sixteen copies by his sons are mentioned in documents.[9]

The theme of Pan and Syrinx in a landscape naturally lent itself to Flemish painters' penchant for collaboration. Rubens returned to the subject presumably in the 1630s, in a canvas now in Buckingham Palace which Ertz thought had been painted with the landscapist Jan Wildens (fig. 2).[10] A copy in the Louvre of an original painting of this subject by Rubens and Wildens was also identified by Adler.[11] And, among others, Hans van Balen and Jan

Fig. 1. Attributed to Jan Brueghel the Elder and Peter Paul Rubens Workshop, *Pan and Syrinx*, panel, 51.5 x 85.6 cm, Schwerin, Staatliche Museum, inv. no. G 163.

Fig. 2. Peter Paul Rubens and Jan Wildens, *Pan and Syrinx*, oil on canvas, 61 x 88 cm, Buckingham Palace, H. M. the Queen.

Brueghel the Younger also collaborated on the subject (London, The National Gallery, no. 659).[12]

The subject had been treated individually and earlier by, among others, Hendrick Goltzius and Karel van Mander. The latter's drawing of this subject in the Uffizi (Florence, no. 8602) follows the narrative practice of having Syrinx metamorphose into reeds, her hands sprouting vegetation, as commonly appeared in depictions of the story of Apollo and Daphne. Rubens followed this tradition when he took up the theme (again alone) in his oil sketch (Bayonne, Musée Bonnat, no. 955) for the Torre de la Parada decorations.[13] At least as common, however, was the tradition of having Pan merely embrace the bulrushes that would become his beloved pipes, which, as Ovid noted, are also referred to as the syrinx. The Greeks regarded music as a potent force in arousing emotions, indeed charged with a moral force capable of inducing love and sexual submission. The "reeds of unequal length," called the pan-pipes in honor of their creator (and corresponding to the satyrs' discovery of the *tibia*), became through its association with the story of Pan's musical challenge

to Apollo the attribute of Dionysiac passion and impetuosity as opposed to Apolline rationality.[14] Thus Pan's flute came to be regarded as an instrument of notorious power.[15]

In Rubens's paintings, Pan and his virtually interchangeable bacchic colleagues, the satyrs, almost always appear as the representatives of abundance and natural fertility.[16] Although frequently drunk and invariably lascivious, they have Rubens's obvious sympathy. The god's lustful if usually unsuccessful amorous pursuits recall familiar episodes from classical poetry and personify Horace's passage, *nympharum fugientum amator* (lover of the nymphs who flee from him).[17] Rubens's contemporary Karel van Mander also stressed Pan's role as the passionate force of nature which complemented Syrinx's celestial aspect, while appending a musical moral to his exegesis: "In the beginning Pan was understood to be Nature, which is to say everything; in Greek as well, Pan means [that which is] all encompassing. This 'everything' is overcome by love. . . . Syrinx, who was loved by Pan, represents the gracefully complementary sweet stirring of the heavenly spheres, which lends order and restraint to [Pan's] masterful art, which [in its final form] is represented by the swift river Ladon. However since Syrinx defeated the love of the gods of the fields or the Satyrs, it may be understood that the best music scarcely is esteemed or cherished by ignorant people."[18]

PCS

1. Ovid, *Metamorphoses*, trans. by A. D. Melville (Oxford, New York, 1986), pp. 21-22.

2. See Pigler 1956, vol. 2, pp. 190-193; DIAL 97B5.

3. See Denucé 1934, p. 142 (valued at fl. 142); and Ertz 1979, pp. 417, 542, document no. 7.

4. Ertz 1979, p. 542, document no. 16. Jan Brueghel the Younger also is recorded as having painted a collaborative work of this subject with Rubens in 1626 (see Ertz 1979, p. 544, documents 158a [Vaes 1926-27, p. 210]), while still other examples of this subject are mentioned later in Jan II's account books of 1628 (Ertz 1979, p. 543, doc. no. 88) and 1646 (doc. nos. 117, 124; see also Denucé 1934, pp. 156-157). In the account books of the Antwerp dealer Forchoudt of 1698, there appears (no. 26) "Een dobbel doeck Pan en Seringo" by Jan Brueghel (Denucé 1930, p. 240; Ertz 1979, p. 551, cat. no. 556).

5. Sale London (Christie's), 23 March 1973, no. 27, ill.; see Rooses 1886-92, vol. 3 (1890), no. 660; A. C. Mayer, "Shorter Notices," *The Burlington Magazine* 65 (1934), p. 236, ill.; M. Jaffé, "Rubens & Raphael," in *Studies in Renaissance and Baroque Art Presented to Anthony Blunt* (London/New York, 1967), p. 100, note 15; Ertz 1979, p. 417, fig. 501 [as Rubens(?)-Jan Brueghel the Elder (?)], cat. no. 384.

6. See Sogo Museum, Japan, *Niederländische Malerei und Grafik des 17. Jahrhunderts aus dem Staatlichen Museum Schwerin*, 9 June-24 July 1988, no. 12, ill.

7. Ertz 1979, p. 419, fig. 502.

8. Respectively Ertz 1979, fig. 503, and sale New York (Sotheby's), 5 November 1986, no. 13, ill. (60.5 x 71 cm).

9. Ertz 1979, p. 420.

Peter Paul Rubens
18. The Nativity, 1620

Oil on panel, 32 x 47.5 cm (12 ⅝ x 18 ¾ in.)
Vienna, Gemäldegalerie der Akademie der
bildenden Künste, inv. no. 638

10. See Rooses 1886-92, vol. 3 (1890), no. 659; Oldenbourg 1921, no. 217; Ertz 1979, pp. 416-418, fig. 500.

11. Adler 1980, no. G120, p. 221, fig. 155 (Paris, Musée du Louvre, no. M.N.R. 404).

12. See London, National Gallery, cat. 1970, pp. 9-10.

13. Alpers 1971, cat. 47a, fig. 160, panel, 27.8 x 27.8 cm.

14. See for example Jordaens's painting in the Musées Royaux des Beaux-Arts de Belgique, Brussels, no. 3292, as well as the many examples from this period by Dutch artists such as Cornelis Poelenburgh and his followers, and Salomon de Bray. Moses van Uyttenbroeck made a specialty of landscapes with Syrinx being actively transformed; see E. J. Sluijter, De "Heydensche Fabulen" in de Noordnederlandse schilderkunst, circa 1590-1670 (Ph. D. diss. Leiden, Rijksuniversiteit, 1986), p. 68, note 2.

15. See L. F. Kaufmann, The Noble Savage. Satyrs and Satyr Families in Renaissance Art (Ann Arbor, 1979), pp. 20-21.

16. On satyrs and pans in Rubens's art, see Held 1980, vol. 1, pp. 353-355; E. McGrath, "The Painted Decorations of Rubens' House," Journal of the Warburg and Courtauld Institutes 41 (1978), pp. 264-273; and idem, "Pan and the Wool," The Ringling Museum of Art Journal (1983), pp. 52-58.

17. Horace, Odes, Book III.18, 1. For additional classical references to Pan's identity, see McGrath 1982, note 9.

18. K. van Mander, Wttleginghe op den Metamorphosis (Haarlem, 1603), book 1, fol. 10.

PROVENANCE: (Possibly) Victor Wolfvoet estate, 1652 (see Denucé 1932): "een Kersnachten wesende een schetsken van Rubens, op paneel..."; sale Jacques de Roore, The Hague, 4 September 1747, no. 44 (to de Groot); sale Anthoni und Stephanus de Groot, The Hague, 20 March 1771, no. 7; Count Anton Lamberg-Sprinzenstein (1740-1822), Vienna, who bequeathed it to the Akademie in 1821.

EXHIBITIONS: Zurich, Kunsthaus, Kunstschätze aus Wien (and sixteen other venues internationally) 1946-1953; Antwerp, De Madonna in de Kunst, 1954, no. 91; Vienna 1977, p. 101, no. 36; Antwerp 1977, no. 50.

LITERATURE: Rooses 1886-92, vol. 1 (1886), p. 21, no. 2 bis; Th. von Frimmel, Geschichte der Wiener Gemäldesammlungen Viertes Capitel: Die Galerie in der Akademie der bildenden Künste (Leipzig, Berlin, 1901), p. 121; Oldenbourg 1921, p. 212, ill.; R. Eigenberger, in Vienna, Akademie der bildenden Künste, Die Gemäldegalerie (Vienna, Leipzig, 1927), p. 339, no. 639; van Puyvelde 1947, p. 17, no. 39; Vienna, Akademie der bildenden Künste, Sammlungkatalog (Vienna, 1961), pp. 36-37. no. 34; Martin 1968, pp. 60-62, no. 2a, fig. 17; Baudouin 1972, p. 88, fig. 58; H. Hutter, Peter Paul Rubens in der Gemäldegalerie der Akademie der bildenden Künste in Wien (Vienna, 1977), p. 19, ill. pl. 9; Held 1980, vol. 1, pp. 35-37, 48-49, no. 18, vol. 2, pl. 20.

A FORESHORTENED scene of the Nativity, or, more properly speaking, the Adoration of the Shepherds, appears as if viewed from below through a gray oval painted frame. Wearing blue and red, the Virgin is seated on the right beside the manger. Her face and those of all the other figures are illuminated by the miraculous glow of the sleeping Christ Child. Behind her stands Joseph, dressed in a brownish-yellow cloak, who gestures toward the child. At the left are the press of adoring shepherds. The foremost has bare legs and feet, wears a green tunic, and raises his hat as he approaches, holding a staff to steady himself as he descends several low steps. Behind him a smiling old woman kneels in prayer on the ground beside the manger, while another woman with a marketing basket on her hip stands to the left. The bearded head of a fourth shepherd carrying a lamb is at the back center. In the foreground is a still life of stable implements (a basket and pitchfork) and a brass milk can, while at the back right the ox stands in his stall.

This is the modello for the central plafond of the north gallery of the Jesuit Church (St. Charles Borromeo) in Antwerp which burned in 1718. In the contract of 29 March 1620 for the decorations, signed by Jacobus Tirinus, Superior of the Professed House of the Society of Jesus, the present subject was listed as "no. 11 Nativitas Christi."[1] Although the final ceiling was destroyed, the appearance of Rubens's original painting was recorded in copies drawn by the Dutch artist Jacob de Wit (three sheets: in the British Museum, London; Stedelijk Prentenkabinet, Antwerp; and the Courtauld Institute, London [ex-Count Seilern][2]) and by Christian Benjamin Müller (Stedelijk Prentenkabinet, Antwerp).[3] These several copies all confirm that in the final painted version the oval format was converted to an octagonal one, and that the

figures were reduced in scale relative to the architecture. Some minor changes were also introduced: the basket and pitchfork were omitted; the position of the legs of the foremost shepherd were reversed and the suggestion of steps eliminated; the Virgin's slightly awkward right hand was hidden; the lamb omitted; and a doorway added at the back left. The last detail was probably difficult to see in the original since the surviving copies do not agree on whether it was an archway or whether it was supported by a column or a square pier. As Martin observantly noted, Rubens also revised at the modello stage the old woman at the center; *pentimenti* in the present work show that she first held her hands out in surprise but then was altered to clasp them in prayer.[4]

Her original gesture of amazement was closer to that of her counterpart in Rubens's early altarpiece of the same subject (fig. 1), painted in 1608 for San Filippo Neri, the church of the Oratorian Fathers in Fermo.[5] The Fermo *Adoration* anticipates several aspects of the present design, including the nocturnal lighting and the general placement of the figures, but accommodated angels hovering overhead within an upright design. The barelegged shepherd has been traced by Martin, Burchard, and d'Hulst to Titian, who included a similar figure raising his hat in his *Adoration of the Shepherds* painted in 1532-1533 for the Duke of Urbino in Pesaro (Florence, Pitti Gallery). Although that painting is now only a ruin, its design is preserved in painted copies and woodcuts.[6]

As Knipping observed and Martin discussed in detail, the iconographic program of the Jesuit Church ceiling continues the medieval tradition of

Peter Paul Rubens

19. *Elijah's Ascension to Heaven in the Fiery Chariot*, ca. 1620

Oil on panel, 32.5 x 44.2 cm (12 x 17 3/8 in.)
Private collection

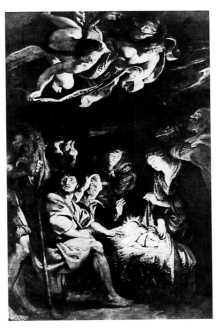

Fig. 1. Peter Paul Rubens, *Adoration of the Shepherds*, 1608, oil on canvas, 299.8 x 193 cm, Fermo, Museo Civico.

drawing typological correspondences between Old and New Testament subjects.[7] Type and antitype were alternated throughout the program; thus the series begins in the eastern-most bay of the north gallery with the *Fall of the Rebel Angels*, which was followed by the present work. Old and New Testament scenes occupied, respectively, odd and even numbered bays. Precedents for Rubens's decorations can be traced to Venetian painting, above all to Titian's illusionistic murals in the wood-framed ceiling compartments of Sto. Spirito in Isola (today called Sta. Maria della Salute), but also to decorations by Tintoretto (Scuola di San Rocco), and to Veronese's soffits for the Doge's Palace. Martin correctly observed that the system of foreshortening, with the scene canted at a 45 degree angle from the viewer's line of sight (assumed to be perpendicular to the ceiling), is most indebted to Veronese's ceiling for San Sebastiano.[8]

PCS

1. See Martin 1968, pp. 216 and 219.
2. See respectively ibid., figs. 19-21.
3. Ibid., fig. 18.
4. Ibid., p. 61.
5. See Jaffé 1977, pp. 93-94, pl. 340; Padua/Rome/Milan 1990, cat. 22, ill.
6. Burchard, d'Hulst 1963, p. 150; Martin 1968, p. 60; for the Titian and the woodcut by Master IB, see H. E. Wethey, *The Paintings of Titian*, vol. 1 (London, 1969) pp. 117-118, cat. no. 79 and pl. 85. Since the shepherd in Titian's original was oriented in the same direction as in the Rubens, it seems more likely that Rubens had seen the painting rather than the print after it. Wethey and Martin both noted that the motif of the shepherd doffing his hat later appears in Jacopo Bassano's *Adoration of the Shepherds* of ca. 1550 at Hampton Court. Hans Tietze (*Tizian* [Vienna, 1936], vol. 1, pp. 155-156) observed that it may originate in an even earlier composition by Titian or some other Venetian painter, since it already figures in a mural of 1528 by Giovanni da Asolo in the Scuola del Santo, Padua.
7. See Knipping 1974 (first published in 1939), vol. 1, p. 180ff; Martin 1968, p. 31ff; Held 1980, vol. 1, p. 36.
8. Martin 1968, p. 42; for the respective ceilings by Titian, Tintoretto, and Veronese, see J. Schultz, *Venetian Painted Ceilings of the Renaissance* (Berkeley/Los Angeles, 1968), plates 11, 92, and 42.

PROVENANCE: Herman de Neyt, Antwerp, inventory 15-21 October 1642 ("Een schets van den propheet Elias opgevoert, van Rubbens" no. 747); purchased in 1801 from François-Xavier de Burtin, Brussels (with four other sketches for the Jesuit ceiling) by Duke Ernst II of Gotha-Altenburg; Herzogliches Museum, Gotha (until 1951); E. & A. Silberman Galleries, New York; Curtis O. Baer, New Rochelle, New York.

EXHIBITIONS: Brussels, Musée du Cinquantenaire, *Exposition d'art ancien, L'Art belge au XVIIᵉ siècle*, 1910, no. 365; Brussels, Musées Royaux des Beaux-Arts de Belgique, *Schetsen van Rubens*, August-September 1937, no. 66; Rotterdam 1953, p. 57, no. 30, ill. 30; Cambridge/New York 1956, no. 30, ill.; New York, E. & A. Silberman Galleries, 1957, no. 11, ill.; Brussels 1965, p. 211, ill.; New York, Knoedler & Co., 1967, no. 48, ill.

LITERATURE: Rooses 1886-92, vol. 1 (1886), no. 15 bis; C. Aldenhoven, *Katalog des herzoglichen Museums, Gotha* (Gotha, 1910), no. 38; A. Rosenberg 1905, p. 197, ill.; Oldenbourg 1921, p. 210, ill.; Denucé 1932, p. 99; van Puyvelde 1947, pp. 28, 77, fig. 35; Jaffé 1953, pp. 34, 64, ill.; Held 1954, p. 35; J. Rosenberg, in *The Art Quarterly* 19 (1956), pp. 139-142; M. Bernhard, *Verlorene Werke der Malerei in Deutschland in der Zeit von 1939 bis 1945; zerstörte und verschollene Gemälde aus Museen und Galerien* (Munich, 1965), p. 128, pl. 135 [incorrectly as "lost," despite the several post-war exhibitions in which it figured]; L. Steinberg, "Deliberate Speed," *Art News* 66 (1967), p. 45; Martin 1968, no. 15a, pp. 104-105, 200, fig. 81; Held 1980, vol. 1, p. 46, no. 15, vol. 2, pl. 16.

ELIJAH soars aloft in the golden chariot of fire but looks back down at the viewer and, by implication, to Elisha, as Elijah prepares to drop his cloak. The prophet wears a rose tunic and holds out his light gray mantle. The chariot is red and gold and the horses white. The subject is drawn from the Old Testament, 2 Kings 2:11: "And it came to pass, as they still went on, and talked, that, behold, there appeared a chariot of fire, and horses of fire, and parted them both asunder; and Elijah went up by a whirlwind into heaven."

This painting is one of the oil sketches for the ceiling of the Church of St. Charles Borromeo, the new Jesuit church dedicated to Ignatius Loyola in Antwerp.[1] Rubens signed a contract on 29 March 1620 with Jacobus Tirinus, the Superior of the Jesuits, to deliver thirty-nine ceiling paintings for the side aisles and galleries of the new church. The agreement required that Rubens make small sketches (called in the contract, *teekeninge*, or "drawings") from which the large paintings could be executed by van Dyck and the master's other pupils, but stipulated that Rubens himself must touch up the final works.[2] Thirty-three oil sketches survive, of which seven are smaller sketches in grisaille; only twenty-nine (five grisailles and twenty-four oil sketches) were finally executed on a larger scale, since the iconographic program of the decoration evidently was still being developed as Rubens worked (a partial list of subjects to be treated was appended to the contract).[3] The program celebrates the typological correspondence between Old and New Testament subjects, a concept supported by biblical texts (see Matthew 12:40; John 3:14) and promoted by the *Speculum humanae salvationis* and the *Biblia pauperum* (see cat. 22).[4]

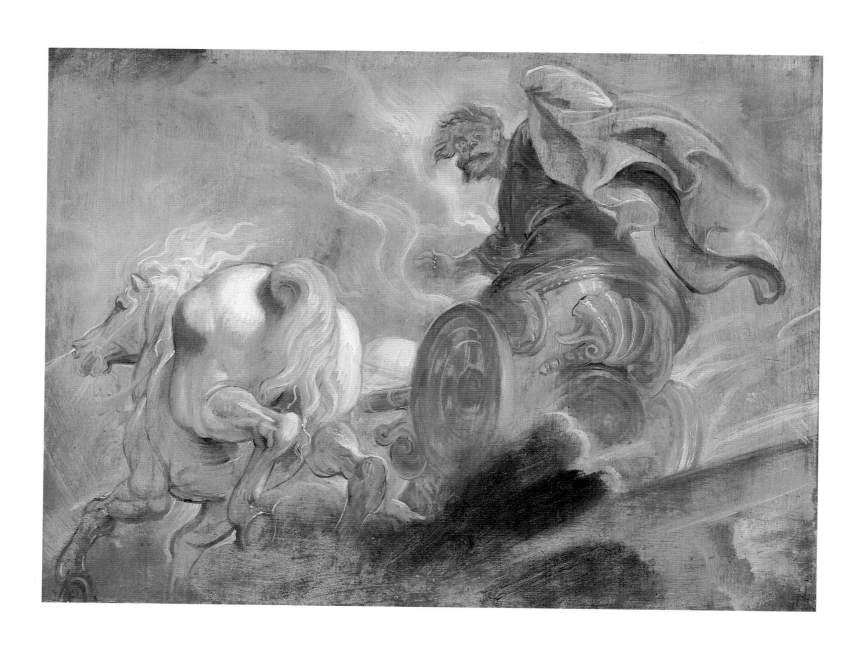

Fig. 1. Peter Paul Rubens, *The Ascension of Christ*, oil on panel, 33 x 32 cm, Vienna, Gemäldegalerie der Akademie der bildenden Künste, inv. no. 634.

With some variation, the system essentially alternated Old and New Testament subjects in the ceilings of the gallery's bays. Unfortunately these ceiling decorations were destroyed by fire on 18 July 1718. However, in addition to a careful description written soon after the fire by P. Jan Baptist van Caukercken,[4] drawings were made after most of the paintings by Jacob de Wit in 1711 and 1712 (now lost, but known through engravings by Jan Pont of 1751) and by Christian Benjamin Müller of Dresden (nineteen of which were engraved by Johann Justin Preissler and published in 1735).

The subject of the present painting was described in the contract of 1620 as "25° Elias curru igneo in coelum [raptus]." As van Puyvelde observed in the Brussels 1965 exhibition catalogue, Rubens paradoxically achieves the effort of the Prophet's ascension into the limitless heavens by the use of a descending diagonal.[5] Leo Steinberg, noting the time-honored convention of depicting a galloping horse descending in a three-quarter back view, cited a sixteenth-century woodcut by Guiseppe Scolari of *The Rape of Proserpine* as a possible source for Rubens, but acknowledged the latter's invention in converting the horse's plunge into an ascent.[6] Although the copies by de Wit and Müller indicate that Rubens made minor changes to the final octagonal-shaped ceiling canvas (the space between the horse and chariot was reduced, a decoration on the front of the vehicle obscured, and an acanthus-shaped ornament on the back added[7]), no doubt the master encouraged his pupils and collaborators to replicate his dramatic effects both in the figures and sky. Van Puyvelde, Steinberg, Martin, and Held were all rightly appreciative of the spontaneity and energy of Rubens's swift touch in this sketch.[8] Held concluded it was foolhardy to try to establish an exact sequence or chronology of all the Jesuit ceiling sketches since they were executed in such a brief period of time, but allowed that the execution became thinner and the tonality lighter in the later works of the series. Thus the present sketch, though not among the very earliest, like the other narrative scenes probably preceded the rendering of the single figures for the aisles.

Rubens's cycle of ceiling decorations, according to the Jesuit father Michael Grisius in 1622, was to adorn the church with "noble pictures which either represent the mysteries of our salvation in parallel fashion from the Old and New Testament [the decorations on the upper level], or show various personages, both male and female, who are distinguished for their sanctity [the saints depicted closer to the faithful on the lower level]."[9] The program therefore is traditional, even medieval, in its pairing of type and antitype in nine scenes of the life of Christ and the Virgin, together with nine subjects from the Old Testament. This type of symbolic method had already been popularized in the fourteenth and fifteenth centuries through the widely circulated illustrated books, *Biblia pauperum* and *Speculum humanae salvationis*.[10] Elijah's disappearance in a fiery chariot had been cited as a prefiguration of Christ's Ascension in both books.[11] Thus *Elijah's Ascension* appeared on the south gallery beside *The Ascension of Christ*, the modello for which is preserved in the Vienna Akademie (fig. 1).[12] Elijah's act of dropping his mantle to Elisha (who subsequently used it, just as his forbearer had, to part the waters of the Jordan; see 2 Kings 2:8 and 14) was also interpreted metaphorically as a symbol of the transferal of leadership, as literally the passing on of the mantle. As early as 1640 Elijah's gesture was interpreted as an allusion to the Jesuits' enjoined poverty and renunciation of worldly goods.[13] While Held regarded as unlikely the notion that such an association could have been a factor in Rubens's use of the subject twenty years earlier, he would entertain the possibility that the theme was connected with the Antwerp Jesuits' efforts to challenge the Carmelites' special claim to being the true inheritors of the "mantle" of Elijah.[14] That controversy only fully emerged in 1675 with the publication of the saints of April in the *Acta sanctorum*.

PCS

1. See, above all, Martin 1968; and Held 1980, vol. 1, pp. 33-38.

2. The contract was published by Baron de Reiffenberg, "Nouvelles Recherches sur Pierre-Paul Rubens," in *Nouveaux Mémoires de l'Académie Royale de Belgique* 10 (1937), pp. 17-19; for the text in English, see Martin 1968, pp. 213-219.

3. For discussion of all the existing sketches see Held 1980, vol. 1, pp. 38-62.

4. See M. Rooses, "Beschryvinge van de schilderyen door P. P. Rubens eertyts voor onse Marbere Kercke geschildert tot Plafons . . . ," in *Rubens-Bulletijn* 3 (1888), pp. 272ff; and E. Duverger, "J. B. van Caukercken (1675-1755), auteur van de Beschrijving van de Zolderstukken van Rubens in de Jesuïetenkerk te Antwerpen," *Jaarboek van het Koninklijk Museum voor Schone Kunsten, Antwerpen* 1977, pp. 281-290.

5. Brussels 1965, p. 211.

6. Steinberg 1967, p. 45, with an ill. of Scolari's print. Prof. Steinberg kindly informs this author (private communication 19 October 1992) that he would now trace the source to a motif found in Giulio Romano's *Battle of the Greeks and Trojans* in the Ducal Palace at Mantua (ceiling fresco, Sala di Troia).

7. See Martin 1968, pp. 104-105, figs. 82-85.

8. Van Puyvelde (in Brussels 1965, p. 211) characterized the little sketch as a "summit" in the Flemish baroque, Steinberg (1967, p. 45) claimed "no painting is more sudden and fiery," Martin (1968, p. 105) called it one of the "most vivid of Rubens's oil sketches," and Held (1980, vol. 1, p. 46) especially commended its "great brio."

9. See Martin 1968, p. 195, citing Michael Grisius, *Honor S. Ignatio de Loiola Societatis IESV fundatori et S. Francisco Xaverio . . . habitus à patribus domus*

Peter Paul Rubens
20. *The Adoration of the Eucharist*

Oil on panel, 31.8 x 31.8 cm (12 ½ x 12 ½ in.)
Chicago, The Art Institute of Chicago, Mr. and
Mrs. Martin A. Ryerson collection, no. 37.1012

professae & collegij Soc. Iesu Antverpiae 24 Julij 1622 (Antwerp, 1622), pp. 13-14.

10. See H. Cornell, *Biblia pauperum* (Stockholm, 1925); and J. Lutz & P. Per-drizet, *Speculum humanae salvationis* (Mulhouse, 1907), Martin 1968, p. 200, note 77, cites the interpretation of Rabanus Maurus (*De universo* III, ii) "Elijah represents Christ, for as he was carried aloft in a fiery chariot, even so did Christ take up to heaven the flesh in which he was born, suffered and rose again."

11. See Martin 1968, p. 200, citing Cornell 1925, p. 291, pls. 12, 18, 43; *Speculum* cap. xxiii (Lutz-Perdrizet 1907, p. 69).

12. See Martin 1968, no. 14b, fig. 80.

13. See Martin 1968, p. 200, note 77, citing the *Imago Primi Saeculi Societatis Iesu* (1640), p. 176, which included an engraving of Elijah in his fiery car casting off his mantle as an emblem of "unencumbered poverty."

14. Held 1980, vol. 1, p. 46, citing Mâle 1932, pp. 443ff. On the Carmelites' claim on Elijah as their founder, see Knipping 1974, vol. 1, p. 154.

PROVENANCE: with Dowdeswell, Paris, 1914; Mr. and Mrs. Martin A. Ryerson, Chicago.

EXHIBITIONS: Antwerp 1977, no. 70, ill.

LITERATURE: Rooses 1886-92, vol. 1 (1886), nos. 53-55; Valentiner 1946, p. 167, no. 126 [as about 1634-1635]; Goris, Held 1947, pp. 34-35, no. 57; *Paintings in the Art Institute of Chicago* (Chicago, 1961), pp. 407-408 [about 1626-1627]; Julius S. Held, "Rubens' Triumph of the Eucharist and the Modello in Louisville," *Bulletin of the J. B. Speed Art Museum* 26, no. 3 (1968), pp. 12-17, fig. 10; J. Maxon, *The Art Institute of Chicago* (London, 1970), pp. 45-46, ill. [1626-1627]; Scribner 1975, p. 319, fig. 4, note 8; Cologne 1977, pp. 364-365, ill.; de Poorter 1978, pp. 84-87, 101-105, 176, 258-262, nos. 1-5a, fig. 95; Held 1980, vol. 1, cat. no. 111, pl. 114, color pl. 12 [ca. 1626]; Scribner 1982, p. 22, note 39, pp. 96-98, note 9, fig. 31; White 1987, p. 183, ill.; W. Brassat, "Für die Einheit der katholischen Liga. Zum politischen Gehalt des Eucharistie-Zyklus von Peter Paul Rubens," *Idea: Jahrbuch der Hamburger Kunsthalle* 7 (1988), pp. 45-46, 57-59, fig. 7; Liedtke et al. 1992, p. 359, ill.

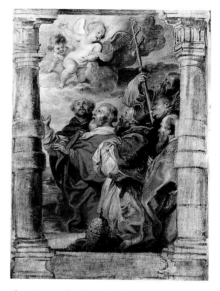

Fig. 1. Peter Paul Rubens, *The Adoration of the Blessed Sacrament by the Ecclesiastical Hierarchy*, oil on panel, 66.7 x 46.7 cm, Louisville, J. B. Speed Art Museum, acc. no. 66.16.

RUBENS was commissioned by Infanta Isabella Clara Eugenia (1566-1633), daughter of Philip II of Spain and widow of Archduke Albert, to design a series of tapestries known today as the Triumph or Apotheosis of the Eucharist for the church of her beloved convent of the Discalzed (barefoot) Carmelite Nuns (Covento de las Señoras Religiosas Descalzas Reales) in Madrid.[1] The Infanta had been educated in the convent and, following her husband's death in 1621, wore exclusively the black habit of the tertiary of the order (History, fig. 15). The convent was renowned for its veneration of the eucharist; processions were held in honor of the sacrament on Good Friday and on the Feast of Corpus Christi. The final tapestries (woven in Brussels by Jacob Geubels, Jacob Fobert, Jan Raes, and Hans Vervoert) are still preserved in the convent but Rubens's original designs have been dispersed.

Comprised of six individual scenes and framing architecture, the sketch from Chicago is a bozzetto depicting the Adoration of the Eucharist. Unlike the other modelli and bozzetti from this series, which record the designs of individual tapestries, this sketch shows how the wall of the church would appear when covered with the tapestries. At the upper center, above the low balustrade and beneath a semicircular arch topped with a seraph, two cherubs hold up the monstrance, which radiates a brilliant light. Flanked by Solomonic columns, the two cloud-filled scenes in the upper register show angels worshiping the eucharist with music and prayers; on the left angels play a viola de gamba and a lute, on the right a long horn and a lute, while smaller angels sing from hymnals. In the lower story, terrestial worshipers kneel in adoration between Doric columns: on the left are secular leaders, including the Holy Roman Emperor and the king and queen of Spain; and on the right, ecclesiastics, including the pope, a cardinal, and a Dominican. Angels gesture

heavenward, linking these lower scenes with the celestial realms of the upper tier. Two standing standard bearers bracket the scenes, completing the symmetry. Since the scenes would be reversed in the final tapestries, the angels play their instruments with the "wrong" hands, the men holding the standard and pontifical cross use their left hands, and the secular and ecclesiastical leaders are shown in the wrong heirarchical orientation: the pope and the other spiritual leaders should properly appear on the viewer's left, or to the right of the altar. Between the two lower scenes is a decorative panel framed by an egg-and-dart molding and depicting a large swag, probably composed of grapes and sheaves of wheat, symbolically alluding to the chalice and loaves in the scene's corners and to the eucharist itself.

The darkened rectangular central field is screened with a grille consisting of eight horizontal and seven vertical bars. The meaning of this detail has been debated but most authors agree that it is not part of the fictive architectural realm of the tapestries, but of the church's actual architecture. While de Poorter refused to speculate on this "unidentifiable shape,"[2] Held maintained that it was the screen of the "actual tabernacle" on the altar,[3] but Scribner observed that the dimensions of the screen (roughly 3 x 3.5 meters, when calculated according to the size of the completed tapestries) precluded Held's theory, and argued more persuasively that it represented the screen that separated the nuns in clausura from the rest of the congregation.[4] The Church of the Descalzas Reales was extensively renovated in the eighteenth century, but reconstructions of its appearance in 1569 based on the description of López de Hayos,[5] also led Wolfgang Brassat to conclude that the screen was that of the nun's choir.[6]

Rubens's altar tapestries combine two hierarchies, the natural and supernatural, with representatives of church and state below and a heavenly chorus above, all worshiping the sacrament. Rooses first realized that the altar tapestries were meant to hang as a single composition, basing his reconstruction on a small painting on copper (then owned by the Abbé Le Monnier in Paris), which combined the five altar tapestries but omitted the architectural setting.[7] Elias Tormo in 1942 attempted to reconstruct the tapestries of the altar in three tiers and additions,[8] but Held was the first to recognize that the Chicago sketch, previously catalogued only as Rubens School, is the master's depiction of the entire tapestry group in situ and en suite.[9]

Modelli for several individual scenes in the altar group have also been preserved. Although the modello of its pendant depicting the temporal leaders is

Fig. 2. Peter Paul Rubens, *Angels Playing Musical Instruments*, oil on panel, 64.5 x 82.4 cm, Potsdam, Sanssouci, Bildergalerie, inv. no. G-K 1.17745.

lost, the modello for the *Ecclesiastical Hierarchy* has survived in Louisville (fig. 1).[10] The latter sketch alters the composition with fewer larger figures, relieving the sense of crowdedness. An acolyte kneeling between the cardinal and the pope has been eliminated entirely, and the pose and costume of the pope have been changed; instead of swinging a censer he now crosses his hands across his chest in prayer. He also now wears a cope, the papal camauro, and mozetta. The space between the columns has shrunk and the single large angel has now been replaced by two playful putti. The overall effect is of an image at once more compact, orderly, and monumental. Held first noted that the composite sketch preserved in Sanssouci (fig. 2) is the modello for the scenes of musician angels in the upper tier, two panels having been joined into one and the framing architecture obscured by overpaint.[11]

As noted, the modello for the secular leaders has been lost, but like the Louisville sketch, it probably closely resembled the completed tapestry in the Descalzas Reales. The Potsdam painting also shows considerable changes from the Chicago bozzetto, while its greater resolution of details permits a clearer identification of the people depicted. Much more prominent now is the Emperor Ferdinand II, while the three royals who now kneel behind him in a more orderly fashion are Philip IV of Spain, his wife, Queen Isabella of Bourbon, and Sor Margarita de la Cruz (not Infanta Isabella Clara Eugenia, as Held suggested), sister of the late Archduke Albert and representative of the convent. Tormo postulated that the military figures behind were Sts. Leopold and Rudolf, who would be logical protectors for the house of Austria, and function more generally as "milites christiani."[12]

Peter Paul Rubens
21. The Meeting of Abraham and Melchizedek

Oil on panel, 66 x 82.5 cm (26 x 32 ½ in.)
Washington, D.C., National Gallery of Art,
Gift of Syma Busiel, 1958, no. 1506

Brassat suggested that the changes in composi-
tions of the temporal and ecclesiastical leaders
reflected political concerns.[13] He maintained that
the prominence of Ferdinand II over Philip IV and
his company and the absence of any especially dis-
tinguishing characterization of the pope were not
aesthetically determined but reflected a veiled politi-
cal commentary. While Held maintained that "The
vigorous pope can probably be identified as the still
youthful Urban VIII (Maffeo Barberini),"[14] Brassat
emphatically maintained that the latter was not rep-
resented in the cycle.[15] Relations between Madrid
and the Vatican had been strained for some time.
Urban VIII, who became pope in 1623, was regarded
by many as having made too many political conces-
sions among the community of European powers,
especially toward France. He seemed to some Haps-
burg leaders in Madrid and Brussels to be more con-
cerned with his own independence and power as the
temporal leader in Italy than as the spiritual pilot of
the Catholic restoration. Ferdinand II, on the other
hand, had been trained by Jesuits and remained a
militant opponent of Protestantism, and thus might
more logically be brought to the fore of the composi-
tion as a model of exemplary conduct in a secular
leader.

PCS

1. The standard books on the eucharist series are de Poorter 1978, and
Scribner 1982.

2. De Poorter 1978, p. 259.

3. Held 1968, p. 12; Held 1980, vol. 1, p. 159.

4. Scribner 1975, p. 519, note 8, p. 96; Scribner 1982, pp. 96.

5. See de Poorter 1978, p. 55.

6. Brassat 1988, pp. 58-59.

7. Rooses 1886-92, vol. 1 (1886), nos. 53-55.

8. See E. Tormo, En las Descalzas Reales: Estudios históricos, iconográficos y
artísticos, vol. 3: Los Tapices: La Apoteosis eucarística de Rubens (Madrid, 1945).

9. Goris, Held 1947, pp. 34-35, no. 57; see also Held 1968, pp. 12-15.

10. See Held 1968, pp. 2-22; Held 1980, vol. 1, p. 161, no. 113.

11. Held 1968, p. 16; Held 1980, vol. 1, pp. 159-160, no. 112, pl. 166.

12. Tormo 1945, p. 14.

13. Brassat 1988, pp. 48-50.

14. Held 1968, p. 18; Held 1980, vol. 1, p. 161, under no. 113.

15. Brassat 1988, p. 49.

PROVENANCE: Sale Jean de Julienne, Paris, 30 March 1767, no. 98 (to
Horion?) [incorrectly as on canvas]; sale J. B. Horion, Brussels, 1 Septem-
ber 1788, no. 20; (possibly) sale Simon McGillivray, London (Christie's),
6-7 May 1825, no. 25 (to G. Dyson); sale J. G. Dyson, London, 18 June 1825,
no. 14 (to Crawford); sale Lady Stepney, London (Christie's), 1 May 1830,
no. 93 (bought in); sale Lady Stuart, London (Christie's), 15 May 1841,
no. 73 (to Nieuwenhuys); sold by Nieuwenhuys to Sir Thomas Baring
(1772-1848); sale Baring, London (Christie's), 3 June 1848, no. 121; bought
by Nieuwenhuys for Mr. Thomas Baring II (1800-1873); bequeathed by
him to his nephew, Thomas George Baring, first Lord Northbrook;
second Lord Northbrook, Bramdean, Alresford (1925); P. & D. Colnaghi,
London 1930; sale Walter Stoye, London (Sotheby's), 2 July 1958, no. 44, ill.
(purchased by Carstairs Gallery, New York); Syma Busiel.

EXHIBITIONS: London, British Institution, 1841, no. 69; London, New
Gallery, 1898, no. 123; London, New Gallery, Exhibition of Pictures by Mas-
ters of the Flemish and British Schools, Including a Selection from the Works of
P. P. Rubens, 1899-1900, no. 141; London, Guildhall Gallery, 1906, no. 116;
London, Colnaghi's, Paintings by Old Masters, 1934, no. 12, ill.; London,
Royal Academy, 1938, no. 106; London, Royal Academy, 1953-1954, no. 205;
London, Colnaghi's, 1954, no. 12.

LITERATURE: Smith 1829-42, vol. 2 (1830), under nos. 504 and 641; vol. 9
(1842), no. 288; Waagen 1854-57, vol. 2 (1854), p. 182; Rooses 1886-92, vol. 1
(1886), p. 63, no. 46bis, p. 149, under no. 120; J. Weale and J. P. Richter, A
Descriptive Catalogue of the Collection of Pictures Belonging to the Earl of North-
brook (London, 1889), no. 87; A. Blunt (review of Royal Academy exhibi-
tion), Apollo 27 (1938), pp. 6, 8, ill.; van Puyvelde 1940a, p. 33, under no. 8
[as a replica of Prado sketch]; G. Gepts, "Tafereelmaker Michiel Vriendt,
Leverancier van Rubens," Jaarboek van het Koninklijk Museum voor Schone
Kunsten, Antwerpen (1954-1960), pp. 85, 86; V. H. Elbern, in exh. cat. Essen,
Villa Hügel, Peter Paul Rubens, Triumph der Eucharistie, Wandteppiche aus
dem Kölner Dom (1954-55), p. 28 [as a replica of Prado sketch]; V. H. Elbern,
"Die Rubensteppiche des Kölner Domes, ihre Geschichte und ihre Stel-
lung im Zyclus 'Triumph der Eucharistie,'" Kölner Domblatt 10 (1955),
p. 72 [as "variant" of Prado sketch]; V. H. Elbern, "Der Eucharistische
Triumph, ergänzende Studien zum Zyclus des P. P. Rubens," Kölner
Domblatt 14/15 (1958), pp. 134-136, fig. 54; L. van Puyvelde, "Projets de
Rubens et de Van Dyck pour les tapissiers," Gazette des Beaux-Arts, ser. 6,
57 (1961), pp. 146-147, 149, fig. 3 [wrongly as in the John G. Johnson Col-
lection, Philadelphia, which is a copy, cat. 1941, no. 661]; E. Haverkamp
Begemann, "Purpose and Style: Oil Sketches of Rubens, Jan Brueghel,
Rembrandt," in Stil und Überlieferung in der Kunst des Abendlandes 3 (Berlin,
1967), pp. 106-107; Scribner 1975, pp. 524-525, figs. 11 and 15; de Poorter
1978, pp. 110, ill. 288-292, no. 7c figs. 122, 124, 127; Held 1980, vol. 1,
pp. 144-146, no. 92, vol. 2, pl. 94; Scribner 1982, pp. 39-40, fig. 5; White 1987,
p. 184, pl. 207; Sutton 1989, p. 21, note 33; Liedtke et al. 1992, pp. 197-199, ill.

THE PATRIARCH Abraham, fresh from victory
in battle, is met by the priest-king of Salem or
Jerusalem, Melchizedek, who greets him with bread,
wine, and blessings. The Bible (Genesis 14:17-20)
describes the scene as follows: "And the king of
Sodom went out to meet him, after his return from
the slaughter of Chedorlaomer and of the kings that
were with him, at the Valley of Shaveh, which is the
king's dale. And Melchizedek King of Salem brought
forth bread and wine: and he was the priest of the
most high God. And he blessed him, and said Blessed
be Abram of the most high God, possessor of heaven
and earth: And blessed be the most high God, which
hath delivered thine enemies into thy hand. And he
gave him tithes of all." The two protagonists, each
attended by his entourage, meet at the gates of a city
or the steps of a palace. Wearing ermine-lined robes
and a papal camauro as well as a laurel wreath,

Fig. 1. Peter Paul Rubens, *The Meeting of Abraham and Melchizedek*, oil on panel, 15.6 x 15.6 cm, Cambridge, Fitzwilliam Museum, Cambridge University, inv. no. 231.

Fig. 2. Peter Paul Rubens, *The Meeting of Abraham and Melchizedek*, oil on panel, 86 x 91 cm (originally 65 x 68.5 cm), Madrid, Museo del Prado, no. 1696.

Melchizedek leans toward Abraham who mounts the stair. Holding the two loaves presented to him, Abraham is dressed in soldier's armor and wears the short cloak of a general. Two priests stand behind Melchizedek and a small boy holds his train. Muscular attendants carry in baskets of bread to be distributed by the priests and two young pages, as well as huge gilded urns of wine that they set on the steps. At the left stand six of Abraham's soldiers wearing helmets and armor, and carrying spears. A boy attends the general's charger. Like many of the larger images in this tapestry series the entire scene is depicted as a tapestry within a tapestry, held up by putti and attached by festoons of fruit and vegetables to the entablature of the Doric architecture. On the low proscenium-like space in the bottom foreground rests a sculpted base decorated with cherub heads and gilded festoons.

With only minor changes (chiefly in the width of the design) this modello served as the model for one of the final tapestries for Rubens's Triumph of the eucharist series for the Convent of the Descalzas Reales in Madrid (see also cats. 20 and 22); a full-scale cartoon, largely executed by assistants and now preserved in the John and Mabel Ringling Museum of Art in Sarasota, Florida (inv. 212), preceded the final weaving.[1] The program is comprised of four Old Testament subjects which prefigured the eucharist: in addition to Abraham and Melchizedek, the Gathering of Manna (the modello for which is in the Los Angeles County Museum of Art, no. 69.20[2]), Elijah and the Angel (the bozzetto and modello are both in the Musée Bonnat, Bayonne[3]), and the Sacrifice of

the Old Covenant (see cat. 22). Only the last mentioned is an exceptional thematic choice, the other three being standard prefigurations for the eucharist in Netherlandish painting. Dirck Bouts's altarpiece of *The Last Supper* (1464-1467) in St. Peter's Church in Louvain, for example, includes all three of these subjects on its wings.[4]

Melchizedek, whose name means "King of Justice," was generally regarded as a precursor of Christ, and his offering of bread and wine an obvious metaphor of holy communion. During the Counter Reformation, Old Testament prefigurations, familiar from medieval traditions, were marshalled as venerated prototypes by those who would defend Catholic doctrine against Protestant attacks, especially the Jesuits.[5] In his earlier work on the decorations for the Jesuit ceiling, Rubens created anagogic parallels specifically linking Old Testament subjects with New Testament themes. However, as Scribner has pointed out, in the Descalzas Reales series, there are no New Testament subjects, only allegorical subjects which represent the fulfillment of the Old Testament prefigurations.[6] Indeed Christ himself never appears in the series, since the dogma of the Counter Reformation made his physical presence not only unnecessary but redundant. Christ's real presence was exalted in his sacramental form in each of the scenes symbolically alluding to the eucharist.

Although no preparatory drawings are known for the eucharist series, there are a group of bozzetti, including a small sketch in Cambridge that is probably Rubens's first conception for the Meeting of Abraham and Melchizedek (fig. 1).[7] This work differs considerably from the Washington modello, employing a more or less square format, flanked by Solomonic columns, posing Abraham more frontally, and orienting the scene (as with the other bozzetti) in the same direction as the final tapestry, which is to say, the reverse of the modello and cartoon. Why Rubens oriented his bozzetti in this direction is unknown but they may have been "corrected" for the benefit of the patrons when the program was presented for approval.

A unique feature of the Abraham and Melchizedek image in the series is the existence of a second modello, now preserved in the Prado (fig. 2).[8] This work represents an intermediary stage between the Cambridge bozzetto and the Washington modello, still employing a narrow, nearly square format and Solomonic columns like the former, but anticipating the arrangement of figures perfected in the latter. The meeting is here set upon the steps of the temple, the figures depicted in profile and viewed distinctly from below. These features recall Rubens's earlier

Fig. 3. Peter Paul Rubens, *The Meeting of Abraham and Melchizedek*, canvas transferred from panel, 204 x 250 cm, Caen, Musée des Beaux-Arts, inv. no. 172.

Fig. 4. Peter Paul Rubens, *The Meeting of Abraham and Melchizedek*, oil on panel, 49 x 65 cm, Paris, Musée du Louvre, Département des Arts Graphiques, no. M.I.963.

large-scale and independent treatment of the Abraham and Melchizedek subject in the museum in Caen (fig. 3),[9] especially in the low point of view. The final version of this scene, executed in 1620-1622 for the Jesuit ceiling, was destroyed by fire in 1718 but its appearance is preserved in the modello now in the Louvre (fig. 4).[10] (The Prado's modello was unfortunately expanded on all four sides at an early date, apparently in an effort to elaborate the architecture surrounding the image.)

As both de Poorter and Scribner concluded independently in their extensive studies of the eucharist series, the organization of the fictive architectural framework for the tapestries involved Solomonic columns on the second tier or story and Tuscan on the first. Thus when Rubens decided to replace *The Triumph of Hope* (for which there is a bozzetto in the collection of Richard Feigen, New York[11]) on the first tier with the Abraham and Melchizedek, he convert-

ed the columns in the second version now in Washington to the Tuscan order, raised the point of view to compensate for the lower hanging, and widened the overall design. However he retained the asymmetrical architectural design first worked out in the rejected *Triumph of Hope*, with one column on the right and two on the left covered by a fictive tapestry. Rubens also added more figures to the design, notably among Abraham's military entourage and the burly servants bringing wine at the lower right. The large wine jug at the center of the Prado modello was also eliminated. Among the six modelli showing the Tuscan order, only the Washington modello is completely finished in all details of the architecture – the gilded wreaths below, the fluting of the lower half of the shaft of the column, the pittings of the rustication, the capital and its bands and rosettes, the egg-and-dart molding, and the beading of the cornice.

Initials carved into the back of the wood panel record that it was manufactured by Rubens's favorite panel maker, Michiel Vriendt.[12] De Poorter lists no fewer than seven copies and engravings after the painting, which attest to the popularity of the composition.[13]

PCS

1. See de Poorter 1978, no. 7d, figs. 128-129.

2. De Poorter 1978, no. 8b, fig. 134. The bozzetto is in the Musée Bonnat, Bayonne, inv. no. 456(P) (de Poorter 1978, no. 8a); the cartoon is in the Ringling Museum, no. 211 (de Poorter 1978, no. 8c).

3. De Poorter 1978, respectively nos. 9a and 9b, figs. 138 and 139. The cartoon is in the Musée des Beaux-Arts, Valenciennes (de Poorter 1978, no. 9c, fig. 141).

4. De Poorter 1978, p. 192, and Scribner 1982, p. 33, have both stressed the importance of Bouts's painting as a ready source for Rubens. See also de Poorter's discussion (pp. 191-192, figs. 57-60) of influential tracts, such as *Speculum humanae salvationis*, and prints promoting the standard prefigurations of the eucharist and typological thinking generally.

5. See Mâle 1932, pp. 337-339; Knipping 1974, vol. 2, pp. 300-302.

6. See C. Scribner (review of de Poorter), *The Burlington Magazine* 122 (1980), p. 772.

7. See de Poorter 1978, no. 7a, fig. 120; Held 1980, vol. 1, p. 143, cat. no. 90, vol. 2, pl. 92.

8. De Poorter 1978, no. 7b, figs. 121 and 126; Held 1980, vol. 1, p. 144, cat. no. 91, vol. 2, pl. 93.

9. See Oldenbourg 1921, no. 110, ill.; Paris 1977-78, no. 120, ill. (where earlier treatments of the theme by Jan van Scorel, B. van Orley, P. Pourbus, and Marten de Vos are mentioned); and Cologne/Vienna 1992-93, no. 44.9, ill. Rubens treated the theme of Abraham and Melchizedek even earlier in his design for the *Missale Romanum* (1613-1616) engraved by Th. Gallé.

10. Oldenbourg 1921, no. 211, ill.; Martin 1968, p. 76, no. 7b.

11. De Poorter 1978, no. 21, fig. 220.

12. See Gepts 1954-60, pp. 85-86.

13. De Poorter 1978, p. 289.

Peter Paul Rubens

22. *Sacrifice of the Old Covenant*

Oil on panel, 70.8 x 87.6 cm (27 ¾ x 34 ½ in.)
Boston, Museum of Fine Arts, Gift of William
A. Coolidge, 1985.839

PROVENANCE: in the Netherlands as late as 1637, when the artist
Matthijs van den Bergh (active at Antwerp and Alkmaar) copied the
painting; the Electors Palatine; Robert Spencer (1611-1702), second Earl of
Sunderland; by descent to the Earl of Spencer, Althorp House (mentioned
in Althorp inventories of 1746, 1750, and 1802); by descent to the seventh
Earl of Spencer (1892-1975), who sold it in 1962; with Thomas Agnew and
Sons, Ltd., London; William A. Coolidge, Topsfield, MA.

EXHIBITIONS: Manchester, City of Manchester Art Gallery, *Art Trea-
sures of The United Kingdom* (cat. by G. Scharf), 1857, no. 575; London,
Dowdeswell Gallery, *A Loan Exhibition of Sketches and Studies by Peter Paul
Rubens*, 1912, no. 4; London, Thomas Agnew and Sons, Ltd., *Loan Exhibi-
tion of Pictures by Old Masters on Behalf of Lord Haig's Appeal for Ex-Service
Men*, 1924, no. 13; London, Thomas Agnew and Sons, Ltd., *Exhibition of
Pictures from the Althorp Collection, in Aid of the Friends of the Fitzwilliam
Museum*, Cambridge, February-March 1947, no. 15; Manchester, City of
Manchester Art Gallery, *Art Treasures Centenary, European Old Masters*,
1957, no. 89, ill.; Boston, Museum of Fine Arts, December 1962 (no cat.);
Cambridge, MA, Fogg Art Museum, *Rubens: A Variety of Interests, In Honor
of Ruth S. Magurn*, 20 May-30 June 1974, no. 25.

LITERATURE: T. F. Dibdin, *Aedes Althorpianne, or an Account of the Man-
sion Books and Pictures at Althorp, the Residence of George John, Earl of Spencer,
K.G.* (London, 1822), vol. 1, p. 15; Smith 1829-42, vol. 2 (1830), no. 937;
A. van Hasselt, *Histoire de Peter Paul Rubens* (Brussels, 1840), no. 21; Waagen
1854-57, vol. 3 (1857), p. 458; W. Bürger, *Trésors d'Art en Angleterre* (Paris,
1865), p. 197; A. Lavice, *Revue des Musées d'Angleterre* (Paris, 1867), p. 268;
Rooses 1886-92, vol. 1 (1886), p. 65, no. 46bis; Oldenbourg 1921, no. 294, ill.;
P. Toynbee, "Horace Walpole's Journals of Visits to Country Seats, etc.,"
The Walpole Society 16 (1927-28), p. 31; E. Tormo, *En las Descalzas Reales:
Estudios históricos, iconográficos y artísticos*, vol. 3: *Los Tapices: La Apoteosis
eucarística de Rubens* (Madrid, 1945), p. 42, no. E-5; van Puyvelde 1948,
no. 61; N. Beets, "Het Offer van het Oude Verbond door Rubens. Een
gewassen pentekening van de Meester," *Oud Holland* 69 (1954), pp. 34, 42;
V. H. Elbern, *Peter Paul Rubens: Triumph der Eucharistie, Wandteppiche aus
dem Kölner Dom*, exh. cat. Villa Hugel, Essen, 1954, p. 30; idem, "Die
Rubensteppiche des Kölner Domes, ihre Geschichte und ihre Stellung
im Zyklus 'Triumph der Eucharistie von P. P. Rubens,'" *Kölner Domblatt*
10 (1955), p. 73, fig. 26; K. J. Garlick, "A Catalogue of Pictures at Althorp,"
The Walpole Society 45 (1974-76), pp. xiii, 100, 107, 117; J. Held, "Rubens's
'Triumph of the Eucharist' and the Modello in Louisville," *J. B. Speed Art
Museum Bulletin* 26 (1968), p. 6; Scribner 1975, p. 524, ill.; de Poorter 1978,
vol. 1, pp. 111, 114, 118, 316-319, no. 106, vol. 2, fig. 146; Held 1980, vol. 1,
pp. 140-141, 146-147, no. 93, vol. 2, pl. 95; Scribner 1982, pp. 47-53, 200-201,
fig. 41; *The Museum Year: 1985-86*, Museum of Fine Arts (Boston, 1987),
p. 38, ill.; Sutton 1989, pp. 5-21, fig. 1 (and detail in color on cover); Liedtke
et al. 1992, p. 358, ill.

THE PAINTING depicts a scene of an Old Testa-
ment sacrifice as if represented on a tapestry sus-
pended from architecture. On the left, standing
beside an altar on which are a fire and the sacrificial
lamb, is the high priest wearing a red ephod and
breastplate with twelve precious stones alluding to
the Twelve Tribes of Israel. With his right hand he
gestures heavenward while holding in his left the
knife of the sacrifice. A young assistant at his side
holds a basin in which to catch the blood. Various
figures led by elegantly dressed youths holding
tapers climb the steps carrying animals for the sacri-
fice. A hooded figure with a dark beard wearing
voluminous yellow drapery carries a lamb under his
arm; beyond him is a white-bearded man wearing a
red papal camauro. At the lower right a half-naked
man partly obscured by the lower edge of the archi-
tecture carries a lamb over his shoulder. Behind
him are a woman and child. At the back right four

hooded men carry the golden ark of the Covenant on
staves resting on their shoulders.

The ark was a chest kept in the holy of holies and,
as the central object of Jewish worship, was regarded
as the Throne of God. The ark is identified by the
decoration on the lid, consisting of two crouching
cherubim who extend their wings over a basket of
manna. All about the ark worshipers rejoice and
musicians blow horns and trumpets (1 Chron. 15:28).
In the left foreground is a table supported by a gold-
en griffin and equipped with stavelike handles so
that it can be carried. On it rest the twelve loaves of
shewbread (the "loaves of proposition" that antici-
pate the bread of the Last Supper; Lev. 24:1-10).
Behind is another bearded figure with a lamb. In the
lower center two naked children bring a pair of
white doves (possibly an allusion to Lev. 14:22 or
Lev. 1:14). Stretched between two Doric columns the
illusionistic tapestry is suspended at the upper cen-
ter from the architrave by a cartouche decorated
with the tetragram, Yahweh (God, literally "I am
who I am") in Hebrew letters. To either side, winged
putti hold up the fictive tapestry and a festoon of
fruit and vegetables. In the center of the lower edge
of the architecture is a low pedestal with claw feet
supporting a lamp, decorated on either side with
horns of plenty containing grapes and wheat as allu-
sions to the eucharist.

Like *Abraham and Melchizedek* (cat. 21), this model-
lo for the Triumph of the Eucharist series was un-
doubtedly conceived as one of the four Old Testa-
ment prefigurations; however unlike the other
scenes it is not a standard typology or even, it seems,
an identifiable biblical event. There has been consid-
erable debate about the subject. The modello was
engraved in the seventeenth century by Adriaen
Lommelin (active ca. 1636 and later), and this print
was identified in 1767 as the "Sacrifice de Samuel à
l'occasion du recouvrement de l'Arche, qui avoit été
enlevée par les Philistins" (Sacrifice of Samuel upon
the recovery of the ark from the Philistines).[1]
Although Samuel did burn an offering of a suckling
lamb, as Scribner observed, he was not a high priest,
as the figure's dress here suggests, nor can the
impressive architecture in the background be identi-
fied as the house of Abinadab.[2] When the painting
was at Althorp in about 1830, John Smith identified
it as the processional transfer of the ark from the
house of Obed-edam to Jerusalem, which King David
celebrated with sacrifices to God, and blessings and
food for his people (2 Sam. 6:12-19; 1 Chron. 15:25-
16:3).[3] However, as several authors have observed, no
figure in the Boston modello can be identified as the
then youthful King David who, moreover, was usu-

ally depicted as "dancing and playing" before the ark as it is carried through the gates of the city (1 Chron. 15:29).[4] Nora de Poorter argued that the scene depicts the consecration of Solomon's temple and the installation there of the ark.[5] After King David's death, his son Solomon built the temple that succeeded the tabernacle decreed by Moses as the abode of the ark; its consecration and the attendant sacrifices are extensively described in the Bible (2 Chron. 5:1-7:10; 1 Kings 7:1-51). In support of her argument, de Poorter pointed to the resemblance of the structure in the background to the reconstruction of

Solomon's temple in the commentary on Ezekiel's vision by Jeronimo del Prado and the Spanish Jesuit architect Juan Bautista Villalpando, *In Ezeckielem explanationes et Apparatus Urbis ac Templi Hiersolymitani* (Rome, 1596-1604), a book that Rubens himself is known to have owned.[6] Elbern had earlier speculated that Rubens based the design of the ark on a description in the book[7]; and de Poorter persuasively suggested that Villalpando's illustration of the *Altar of Incense in the Temple of Jerusalem* inspired details like the winged sejant lions and cherubs' heads in a garland of fruit on the sacrificial altar in the Rubens.[8]

However, once again, none of the celebrants in the modello bears the attributes of a king and, as Scribner observed, the putative temple of Solomon lacks its chief identifying feature, namely Solomonic columns.[9]

Early recognizing the problems presented by the modello's identification, Rooses used the more generalized title, *The Sacrifice of the Old Covenant*.[10] Knipping also thought that, rather than depicting a specific biblical episode, it represented the Paschal lamb and "all which in the Jewish temple-rite could prefigure the New Sacrifice"[11]; in a typological series including representations of Abraham and Melchizedik, the Gathering of Manna, and Elijah and the Angel, one would traditionally expect the fourth prefiguration to be the Paschal feast, as in Dirck Bouts's polyptych in Louvain. Tormo and Elbern concluded that the image depicted two separate Old Testament episodes, the sacrifice and the procession of the ark.[12] The ark was transported several times: first by David, who fetched it to Jerusalem in two stages, and later by Solomon who installed it in the holy of holies. The latter scene accords better with Rubens's image but still presents inconsistencies with details of the sacrifice in the foreground. Held and Scribner also at last came to the conclusion that Rubens conflated several Old Testament references into a single scene, rather than illustrated a specific passage.[13]

Details such as the shewbreads and other implements integral to the sacrifice of the Old Law were cited in seventeenth-century literature as prefiguring the eucharist.[14] In the ark, theologians found analogies with the monstrance containing the consecrated host that is supremely honored in the Church. De Poorter further observed that Rubens emphasized the typological function of the ark by situating between the cherubim a basket of manna, the heavenly bread of the Old Testament.[15] As noted, the grapes and wheat on the pedestal are an obvious symbol of the eucharist, while the small burning lamp probably alludes to the lamp outside "the veil of the testimony, in the tabernacle of the congregation" (Lev. 24:2-3), that Aaron was commanded to keep continually lit and which corresponds to the lamp kept burning beside every Christian tabernacle. In all its details, the Boston sketch of the ark carried in triumphal procession to the temple amid sacrifices that prefigure the mass implies a correlation between the temple and its successor, the Church.

Rubens deliberately introduced spatial ambiguities into his designs, playing on various levels of pictorial reality. While he recanted his first thought of extending the arm of the woman in the lower right

Fig. 1. Peter Paul Rubens, *The Victory of the Sacrament over Pagan Sacrifices*, panel, 86 x 106 cm (with later additions), Madrid, Museo del Prado, no. 1699.

of the tapestry illogically over the framing column (note the pentimento), elsewhere (for example, in the *Victory of the Sacrament over Pagan Sacrifices*, fig. 1) he deliberately projected the fictive figures of the tapestry into the "real" space of the architecture. As all authors have agreed, this type of illusionistic tapestry, complete with spatial ambiguities, was probably inspired by the works of Raphael (e.g. the fresco decorations for the Sala di Constantino in the Vatican, and the Farnesina frescoes) and his school, especially Giulio Romano. These traditions revealed to Rubens the advantages of organizing his program within an architectural framework that not only helped articulate the space but enriched the symbolic program by introducing different levels of reality.

The exact arrangement of all of Rubens's eucharist tapestries for the church of the Descalzas Reales in Madrid has not been deduced, but Scribner and de Poorter are probably correct in assuming that the *Pagan Sacrifices* (fig. 1) hung directly above the *Sacrifice of the Old Covenant*.[16] The two share a consistent perspective and lighting system and correspond in design and symbolism, both including altars and temple porticos and depicting sacrifices (one pagan, the other Jewish). On the upper tier the sacrifice is overthrown by the angelic herald of the eucharist, while on the lower it prefigures the fulfillment of the eucharist, thus Scribner regarded the two works as a pair "presenting contrasting views of the Pre-Christian sacrifice."[17] Some of Rubens's pairs also symbolically complement others; for example, just as on the upper level *Pagan Sacrifices* (fig. 1) anticipates the *Victory of the Eucharistic Truth over Heresy*, so its counterpart below, the *Sacrifice of the Old Covenant* anticipates *The Triumph of Faith*. The ark prefigures the chalice and the host held by Faith, and the sacri-

fices of the former are complemented by the references to Christ's Passion in the latter.[18]

Elbern first proposed that Rubens chose to design eleven large tapestries in his series as a reference to the eleven curtains of the Jewish tabernacle, the curtains which surround the holy of holies (see Exodus 26:7).[19] Müller Hofstede developed this idea,[20] but it was Scribner who realized that the number and the allusion, in conjunction with the architecture, explain the entire rationale of the series. While the hangings allude to God's dwelling place in the Temple, the Solomonic columns which frame the individual scenes recall the columns that were brought from the Temple of Solomon in Jerusalem to St. Peter's in Rome, thus symbolically transforming the temple into the new Christian Church. Thus Rubens "conceptually and illusionistically recovered the ancient, long since destroyed Holy of Holies, but transformed [it] into its new Christian identity, wherein the Ark is replaced by God's Eucharistic Presence."[21]

Formerly in the Brussels Palace, the canvas cartoon based on the Boston modello was destroyed by fire in 1731.[22] The final tapestry was woven by Jan Raes, Jacob Fobert, and Hans Vervoert, and like the others, is preserved in the Descalzas Reales.[23] A bozzetto for the present scene, mentioned in the Wolfvoet estate inventory of 1652, is now lost, but de Poorter was probably correct in identifying its design in a drawing after Rubens formerly in a private collection in Paris (fig. 2).[24] Like the other bozzetti from the series, it is oriented in the opposite direction of the modelli, but already depicts the architectural frame, the sacrifice, and the procession with the ark, while omitting several subsidiary figures, especially in the corners.

Surviving with the paint surface in excellent condition, the Boston painting was sought out by several discriminating collectors during its history, including the Electors Palatine, and Robert Spencer (1611-1702), second Earl of Sunderland, from whom it descended to the Earls of Spencer and hung in Althorp House for more than two and a half centuries (see Provenance).

PCS

Fig. 2. After a bozzetto by P. P. Rubens, *Sacrifice of the Old Covenant*, chalk, 150 x 187 mm, formerly (ca. 1930) in the collection of André de Hevesy, Paris.

6. Rubens purchased the book from Balthasar Moretus in 1615; see M. Rooses, "Petrus Paulus Rubens en Balthasar Moretus IV," *Rubens-Bulletijn* 2 (1883), p. 190.

7. Elbern 1955, p. 73.

8. De Poorter 1978, vol. 1, p. 312, vol. 2, fig. 62.

9. Scribner 1982, p. 48. De Poorter (1978, vol. 1, p. 312) sought to identify the old man in the camauro as Solomon but allowed that there was no reason for Rubens to depict him in papal attire.

10. Rooses 1886-92, vol. 1 (1888), pp. 64-65, no. 48; he adds, however, "ce groupe rappelle probablement le transport de l'Arche sainte de la maison d'Obed-Edom au temple."

11. Knipping 1974, vol. 1, p. 188; see also original Dutch ed. of 1939-40, vol. 1, p. 247.

12. Tormo 1945, vol. 1, p. 121-122; vol. 3, pp. 41-42; Elbern 1955, p. 73.

13. Held 1980, vol. 1, p. 146; Scribner 1982, p. 48.

14. De Poorter 1978, vol. 1, p. 310, cites examples from R. Bellarminus's *De Controversiis christianae fidei. Adversus huius temporis Haereticos*, vol. 3 (Venice, 1603) and L. Richéome's *Tableaux Sacrez des figures mystiques du très-auguste sacrifie et sacrement de l'Eucharistie* (Paris, 1609).

15. De Poorter 1978, vol. 1, p. 309.

16. Scribner 1982, p. 118; de Poorter 1978, vol. 1, p. 97.

17. Scribner 1982, p. 118.

18. Ibid.

19. Elbern 1955, p. 58.

20. J. Müller-Hofstede, "Neue Ölskizzen von Rubens," *Städel Jahrbuch* 2 (1969), pp. 204-205. De Poorter 1978, pp. 185-187, rejects the idea, but see Scribner's review in *The Burlington Magazine* 122 (November 1980), p. 772.

21. Scribner 1975, p. 524.

22. De Poorter 1978, vol. 1, p. 319, no. 10c.

23. Ibid., pp. 307-315, no. 10.

24. See Denucé 1932, p. 150, and de Poorter 1978, vol. 1, p. 315, no. 102.

1. See de Poorter 1978, vol. 1, p. 317, copy no. 11, vol. 2, fig. 147; F. Basan, *Catalogue des estampes gravées d'après P. P. Rubens* (Paris, 1767), p. 6, cat. no. 20.

2. Scribner 1982, p. 47.

3. Smith 1829-42, vol. 2 (1830), no. 937.

4. De Poorter 1978, vol. 1, pp. 310-311; Held 1980, vol. 1, p. 149; Scribner 1982, p. 47.

5. De Poorter 1978, vol. 1, p. 312.

Peter Paul Rubens

23. Portrait of Michiel Ophovius, ca. 1615-1618

Oil on canvas, 111.5 x 82.5 cm (43 ⅞ x 32 ½ in.)
The Hague, Royal Cabinet of Paintings Mauritshuis,
inv. 252

Fig. 1. Peter Paul Rubens, *Saint Dominic and Saint Francis of Assisi Protecting the World from the Wrath of Christ*, ca. 1618-1620, oil on canvas, 555 x 361 cm, Lyon, Musée des Beaux-Arts, inv. 166.

Fig. 2. Peter Paul Rubens, *Portrait of Michiel Ophovius*, ca. 1630-1635, brown wash with white highlights and traces of red chalk, 23.3 x 19 cm, Paris, Cabinet des Dessins du Musée du Louvre, inv. RF 2383.

PROVENANCE: (probably) Dominican monastery of St. Paul, Antwerp[1]; sale J. F. de Vinck de Wesel, Antwerp, 27 April 1813 (sale postponed to 16 August 1814), lot 1 (fl. 3800, to Stier); sale H. J. Stier d'Aertselaer, Antwerp, 29 July 1822, lot 6 (to de Vries for King Willem I, fl. 460); collection Willem I, King of the Netherlands.

EXHIBITIONS: Antwerp 1977, no. 45; 's-Hertogenbosch, Noordbrabants Museum, *Het Beleg van 's-Hertogenbosch in 1629* (1979), no. 14; Hartford, Wadsworth Atheneum, 24 September 1990-2 May 1991.

LITERATURE: Smith 1829-42, vol. 2 (1830), p. 13, no. 26 and pp. 113-114, no. 383; Rooses 1886-92, vol. 4 (1890), pp. 226-227, no. 1013; The Hague, Mauritshuis, cat. 1895, pp. 346-347; A. Rosenberg 1905, p. 316; (possibly) de Wit 1910, p. 59; Oldenbourg 1921, p. 167; The Hague, Mauritshuis, cat. 1977, pl. 206; J. Müller Hofstede, "'O felix Poenitentia.' Die Büsserin Maria Magdalena als Motiv der Gegenreformation bei Peter Paul Rubens," in *Imagination und Imago. Festschrift Kurt Rossacher* (Salzburg, 1983), p. 225, note 74 [as not by Rubens]; The Hague, Mauritshuis, cat. 1985, pp. 274-275, 433; C. Lawrence, "Rubens's Portrait of Ophovius: A New Source for Van Mildert's Effigy," *Source: Notes in the History of Art* 5 (1986), p. 30; idem, "Rubens and the Ophovius Monument: a New Sculpture by Hans van Mildert," *The Burlington Magazine* 129 (1987), pp. 587-588; Vlieghe 1987a, pp. 139-143, no. 126; B. Broos, "Een schilderij nader bekeken: Peter Paul Rubens *Portret van Michiel Ophovius*," *Mauritshuis Nieuwsbrief* 4 (April 1991), pp. 13-16.

RUBENS'S *Portrait of Michiel Ophovius* depicts an active man of early middle age, his tousled hair lightly touched with silver. The stark black and white of the sitter's Dominican habit is an effective foil for his dynamic personality; the red lining of the hood complements his ruddy complexion. His foreshortened right hand is extended in a rhetorical gesture as if he were addressing the viewer; his lips are slightly parted as if speaking: appropriate gestures for this fiery spokesman of the *Ordo Praedicatorum*. The light coming from the left throws the planes of Ophovius's face into high relief and emphasizes the translucent glitter of his forceful gaze.

Michiel Ophovius was born in 's-Hertogenbosch in 1571 and entered the Dominican monastery of St. Paul in Antwerp at the age of fourteen. After studies in Leuven (Louvain) and Bologna, he returned to Antwerp and devoted himself to the order's primary vocation of preaching. He became one of the most outspoken proponents of the Counter Reformation in the Northern Netherlands. In 1623, while on one of his visits north exercising his militant zeal in his capacity as Prefect of Dominican missions in the United Provinces, he was arrested and imprisoned in The Hague for eighteen months. In 1626 Ophovius was appointed Bishop of 's-Hertogenbosch, the furthest outpost of the Catholic Southern Netherlands, but returned to Antwerp after the city fell to Frederick Hendrick of Orange in 1629. Ophovius died in Lier on 4 November 1637. His body was brought to St. Paul's in Antwerp for burial on 5 January 1638.[2]

Rubens and Ophovius may have known each other as early as 1608, when the artist returned from Italy. The two were certainly friends, although there is no evidence that Ophovius was Rubens's confessor, as has frequently been suggested.[3] Both were engaged in diplomatic activities for Isabella, but more importantly, both Rubens and Ophovius were involved in the campaign to rebuild and redecorate the Dominican Church of St. Paul in Antwerp. Among the works commissioned from Rubens by the church was a painting of *Saint Dominic and Saint Francis of Assisi Protecting the World from the Wrath of Christ* for the main altar (fig. 1; ca. 1618-1620, now Lyon, Musée des Beaux-Arts); the features of St. Dominic are based on those of Michiel Ophovius.[4]

The Mauritshuis *Portrait of Michiel Ophovius* may be identical to the work first mentioned by Jacob de Wit as hanging in a room in the Dominican monastery (ca. 1748): "In One of the Chambers in the Convent one sees the portrait of Ophovius, the last Bishop of 's Hertogenbosch, painted by Rubens. This [portrait] has been circulated in a print by van den Bergh."[5] Although van den Bergh's print reproduces the composition of the Hague picture, the gap in the painting's early history prevents positive identification of the present painting with that described by de Wit. Moreover some doubt has been expressed as to whether the Mauritshuis *Portrait of Michiel Ophovius*, the best of all the known versions of the composition, is entirely original. As Vlieghe has noted, weak passages in the folds of the garments may suggest studio assistance, although the strongly modeled and very expressive head is unmistakably by Rubens's hand. Of the several other known versions of this portrait,[6] an example presently on loan to the Rubenshuis (Antwerp) from a private collection is of the highest quality. Müller Hofstede[7] suggested that the latter painting was the original, and d'Hulst termed it "of no less quality" than the Mauritshuis version.[8] As Vlieghe emphasizes, however, the slightly parted lips of the sitter in the Mauritshuis portrait (a feature not retained in the replica) is an integral part of the "speaking" likeness created by Ophovius's direct gaze and rhetorical gesture, traditional elements in portraits of preachers and orators.

In addition to the present painting and its variants, Rubens portrayed his friend on several other

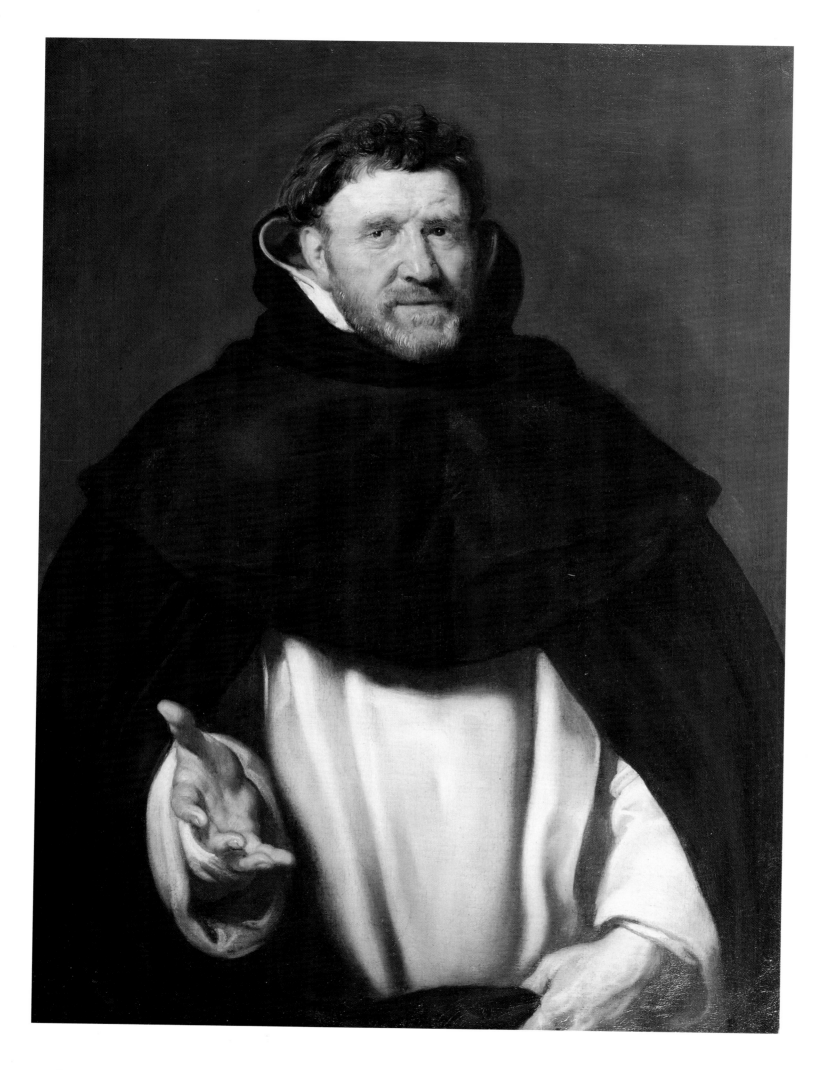

Peter Paul Rubens and Studio
24. The Head of Cyrus Brought to Queen Tomyris, ca. 1622-1623

Oil on canvas, 205 x 361 cm (80 ¾ x 142 ⅛ in.)
Boston, Museum of Fine Arts, Juliana Cheney
Edwards Collection, inv. 41.40

occasions as well.[9] Among these likenesses, a drawing in the Louvre (fig. 2) depicts the sitter at a more advanced age, hunched in his chair, with a furrowed brow. The drawing dates to about 1630-1635, and is very likely contemporaneous with the tomb effigy of Ophovius in the Church of St. Paul, Antwerp, executed by Hans van Mildert from Rubens's design.[10]

Both Rooses and Burchard dated the Mauritshuis portrait to about 1630, in part because of the correspondence between Rubens and Ophovius concerning the latter's grave monument in 1631. An earlier date of ca. 1615-1618 is more likely, however; the sculptural rendering of the figure and the strong local coloring are typical of Rubens's work of this period.[11] The age of the sitter is moreover closer to that of the St. Dominic featured in the altarpieces at Lyon and Kassel, which have also been dated to the late 1610s.

<div style="text-align:center">MEW</div>

1. As noted in Broos 1991 (p. 13), the portrait was probably removed from the Dominican Cloister in Antwerp during the French Revolution.

2. On Ophovius, see P. J. A. Nuyens, in National Biografisch Woordenboek, vol. 5 (Brussels, 1972), cols. 659-661; as well as Lawrence 1987, pp. 584-585, with further references.

3. This tradition apparently originated with the inscription on an eighteenth-century etching after the portrait by N. van den Brande; see Voorhelm Schneevoogt 1873, p. 185, no. 266.

4. As first noted in Rooses 1886-92, vol. 1 (1886), p. 282, no. 209, with reference to the very similar figure of St. Dominic in Rubens's The Virgin Receiving Homage from Four Penitents and Other Saints (Kassel, Staatliche Gemäldegalerie Alte Meister, inv. GK 119). On Rubens's other paintings for the Church of St. Paul see L. van Puyvelde, "Drie Vroege Werken van Rubens in de Sint-Pauluskerk," Jaarboek van de Oudheidkundige en Geschiedkundige Kringen van België 24/25 (1951), pp. 65-68; and Lawrence 1987, p. 585, with further references.

5. De Wit 1910, p. 59: "In Eene van de Kamers van het Convent siet men het portret van Ophovius, Laesten Bischop van S'Hertoghen bosch, door Rubens geschildert. Het selve gaet in print uyt door van den Bergh gesneden."

6. Vlieghe 1987a, p. 140, lists several copies.

7. Müller Hofstede 1983, p. 225, note 74.

8. In Antwerp 1977, p. 113.

9. Vlieghe 1987a, pp. 139 and 142-144, cats. 125, 127, and 127a; see also the likenesses of Ophovius as St. Dominic noted above.

10. From a diary kept by Ophovius between August 1629 and January 1632, we know that Ophovius went to Rubens's home on 4 February 1631 to discuss plans for the monument. The Louvre drawing may date from this period. Excerpts from the diary are published in M. Rooses, "Rubens en Ophovius," Rubens-Bulletijn 5, no. 3 (1900), pp. 161-163. On the monument itself see Lawrence 1987.

11. Oldenbourg 1921 also dated the portrait to ca. 1618, as did Vlieghe (1987a, p. 141). Müller Hofstede (1983, p. 212) suggested a date of about 1625 for the version of the portrait on loan to the Rubenshuis.

PROVENANCE: (probably) collection Infanta Isabella Clara Eugenia, Brussels; (probably) collection Cardinal Infante Ferdinand (d. 1641), Brussels; (probably) sold in December 1643 to an anonymous buyer [letter from P. Christyn to M. Musson, Brussels, 16 December 1643]; (probably) in the possession of the art dealer Matthijs Musson, Antwerp, by 26 October 1645, when offered for sale to Amalia van Solms, wife of the Dutch Stadholder Frederick Hendrick; collection of Queen Christina of Sweden (d. 1689), Palazzo Riario, Rome, by 1662; Cardinal Deccio Azzolino, Duke of Bracciano, Rome, 1689; Marchese Pompeo Azzolino, 1689-1696; Prince Don Livio Odescalchi; Marchese Baldassare Odeschalchi; collection sold en bloc to Philippe, Duc d'Orléans, 1721; by descent to Louis-Philippe (Egalité), Duc d'Orléans, Palais Royale, Paris; sold in 1792 to Thomas Moore Slade and imported into England; Earl of Darnley, Cobham Hall, Kent, from 1793; purchased by the sixth Earl of Harewood, Harewood House, Yorkshire, in 1924; acquired by the Museum in 1941.

EXHIBITIONS: London, The Orleans Gallery, 1793, no. 142; London, British Institution, 1821, no. 50; London, British Gallery, 1822; London, British Institution, 1853, no. 1; Manchester, City of Manchester Art Gallery, Art Treasures of the United Kingdom, 1857, no. 579; London, Royal Academy, 1877, no. 99; London, Guildhall, Flemish and Modern Belgian Painters, 1906, no. 89; London, Grafton Galleries, National Loan Exhibition, 1909-10, no. 30; Brussels 1910, no. 25; on loan to the City of Leeds Public Art Gallery, ca. 1936 (see Borenius 1936); Boston, Museum of Fine Arts, A Tribute to Rubens, 6 December 1977-26 February 1978 (no cat.).

LITERATURE: I. M. Silos, Pinacotheca sive romana pictura et sculptura, libri duo ... (Rome, 1673), p. 63, no. CXII; Dubois du Saint-Gelais 1727, p. 410; Galerie du Palais Royale ... (Paris, 1786-1808), vol. 3 (1808), fol. 3 (engraved by R. Delaunay); Buchanan 1824, vol. 1, p. 159ff; Smith 1829-42, vol. 2 (1830), pp. 206-207, no. 745, and vol. 4 (1842), p. 315; Waagen 1854-57, vol. 3 (1857), p. 23; W. Bürger [T. Thoré], Trésors d'art en Angleterre (Paris, 1860), p. 183; Voorhelm Schneevoogt 1873, pp. 137-138, under nos. 14-20; Rooses 1886-92, vol. 4 (1890), pp. 3-5, no. 791 [studio work, retouched by Rubens]; Rooses 1904, vol. 2, pp. 385-386; A. Rosenberg 1905, no. 174a; C. Stryenski, La Galerie du Régent Philippe, Duc d'Orléans (Paris, 1913), p. 188, no. 468; Oldenbourg 1921, p. 175 [ca. 1616-1618]; M. Dobroklonsky, "Einige Rubenszeichnungen in der Eremitage," Zeitschrift für bildende Kunst 64 (1930-31), p. 34; T. Borenius, Catalogue of the Collection of the Sixth Earl of Harewood, Harewood House, Yorks. (London, 1936), pp. 63-64, no. 117; C. C. Cunningham, "A Great Rubens Comes to the Museum," Bulletin of the Museum of Fine Arts 39 (1941), pp. 35-40; B. K. McLanathan, Queen Tomyris and the Head of Cyrus: A Museum of Fine Arts Picture Book (Boston, 1945); Goris, Held 1947, p. 39, no. 83 [ca. 1620]; Constable 1949, pp. 131-132; Denucé 1949, pp. 13-14, 41-42; Burckhardt 1898 (ed. 1950), p. 74; de Maeyer 1955, pp. 412-414; Ottawa 1969, pp. 41, 217-218, under no. 252; R. A. Ingrams, "Rubens and Persia," The Burlington Magazine 116 (1974), fig. 35; Pigler 1974, vol. 2, p. 344; d'Hulst 1974, vol. 2, pp. 492-493, under no. B19; M. Jaffé, "Exhibitions for the Rubens Year-1," The Burlington Magazine 119 (1977), p. 628; G. R. Kruissink, "Tomyris en het hoofd van Cyrus van Rubens via Pontius tot volkskunst," Antiek 12, no. 3 (1977), pp. 165-172; R. W. Burger, "Rubens's 'Queen Tomyris with the Head of Cyrus,'" Bulletin of the Museum of Fine Arts 77 (1979), pp. 4-35; Boston, cat. 1985, p. 252; Held 1986a, p. 108; M. Facos, "Rubens's The Head of Cyrus Brought to Queen Tomyris: an Alternative Interpretation," Rutgers Art Review 8 (1987), pp. 39-53; Vlieghe 1987a, p. 147; Liedtke et al. 1992, p. 366.

THE OLDEST and most detailed account of the story of Queen Tomyris is in Herodotus (1.204-215). Cyrus, King of Persia (ruled 559-529 B.C.), sought to conquer the Massagetae, the Central Asian tribe ruled by Tomyris. When his efforts to seduce the queen came to naught, he resorted to warfare. After suffering a deceptively crushing defeat, the Persians set a trap for the Massagetan army, which was under the command of Tomyris's son Sargapises. They left a banquet of food and wine for their unsuspecting foes, who consumed the drugged victuals and fell asleep. The Persians returned, slaughtered the Mas-

sagetae and took Sargapises captive. According to Herodotus's account, Tomyris threatened Cyrus: "Bloodthirsty Cyrus, be not uplifted by this that you have done; it is no matter for pride if the fruit of the vine . . . has served you as a drug to master my son withal, by guile and not in fair fight. Now therefore take this word of good counsel from me: give me back my son and depart unpunished from this country; . . . But if you will not do this, then I swear by the sun, the lord of the Massagetae, that for all you are so insatiate of blood, I will give you your fill thereof."[1]

Sargapises committed suicide while in captivity (or, according to some later accounts, was murdered by Cyrus). In a subsequent battle the Persians were soundly defeated by the Massagetae; Tomyris scoured the battlefield for Cyrus's corpse, and deposited his severed head in a skin filled with human blood, thereby fulfilling her pledge of revenge.

The first illustrations of the story of Queen Tomyris appear in mid-fourteenth century manuscripts in a Christian context, as a prefiguration of the Virgin Mary's victory over Satan.[2] A now-lost painting by the Master of Flémalle (known through several fifteenth- and sixteenth-century copies and variants) is probably the earliest easel painting of the subject,[3] and may well have influenced Rubens. Flémalle's painting hung in the Episcopal Palace in Ghent from 1587 until at least 1662; it is conceivable that Rubens saw the painting there, or he may have known of it through a copy.[4] Not only was the subject itself rare in Northern art, but several specific details are common to both paintings, such as the female attendant holding a lapdog, the magnificent architectural setting, and the prominent inclusion of a sword as a reference to the decapitation of the Persian king.[5] Another version of the theme by Rubens (Paris, Musée du Louvre, inv. 1768; fig. 1), which probably postdates the present painting, is more compactly composed, with the few figures seen from a dramatic *di sotto in sù* perspective.

The Boston *Head of Cyrus Brought to Queen Tomyris* was probably painted about 1622-1623. The theatrical conception relates closely to scenes from the Marie de' Medici series, which was executed between 1622 and 1625. It has long been recognized that Rubens's sons Albert (b. 1614) and Nicolaes (b. 1618) served as the models for the two young pages at the left; the boys' apparent ages – about 8 or 9 and 4 or 5 – confirms a date of ca. 1622-1623 for the painting.[6]

Rubens's earliest conception of the design, a sketch in bistre and oil color on paper now in the Hermitage,[7] shows the scene in reverse, and significantly reduced on either side. The servant lowering Cyrus's head into the basin of blood is depicted frontally, rather than in profile. No later drawing or oil sketch survives that records Rubens's progress towards the final composition; there is, however, a charming detailed study of the heads of the two serving women at the left (Vienna, Graphische Sammlung Albertina, inv. 402; fig. 2). Many of the individual figures also appear in other works by the master from the late 1610s and early 1620s, which suggests that they may have been worked up from sketches and *tronies* kept in the atelier. The portly figure in oriental dress behind the kneeling servant is clearly modeled on Rubens's *Portrait of Nicolaas de Respaigne* (Kassel, Gemäldegalerie Alte Meister, inv. 92), which has been dated by Vlieghe to ca. 1616-1618.[8]

Although the design of the *Queen Tomyris* is certainly by Rubens, the final execution was largely – if not wholly – the work of studio assistants. The uneven facture and some particularly awkward, poorly formed passages (notably the legs and feet of the kneeling servant and the hands of the women) reveal nothing of Rubens's brush. It is nonetheless a vain exercise to attempt to ascribe portions of the painting to any of the individual artists active in Rubens's studio during the period, as the objective of this smoothly run enterprise was to eradicate individual contributions in the interest of a seamless whole.[9]

The provenance of the Boston painting is securely documented from about 1662 (when it was first recorded in the Roman collection of Queen Christina of Sweden) until the present. However, the first decades of the painting's history are not entirely clear. Berger[10] has proposed that the painting was commissioned by the Infanta Isabella, and inherited by her successor, Cardinal Infante Ferdinand (d. 1641). The painting was apparently sold from the governors' palace in Brussels along with several other works in December 1643, during a period of political turmoil. A letter of 16 December 1643 from P. Christyn, an art dealer in Brussels, to his Antwerp colleague Matthijs Musson, mentions a large painting by Rubens of "the head of Cyrus which is being presented to a Queen, with many accompanying figures therein, that is very well painted."[11] The painting of Queen Tomyris – together with five other Rubenses from the Infante's collection – is mentioned in a memorandum from Musson to Amalia van Solms, dated 26 October 1645: "A picture of King Cyrus whose head is being placed in his blood, with different figures, quite pleasant, by Rubens, life sized."[12] Neither of these brief descriptions conclusively suggests the Boston and not the Louvre painting, although the references to "many" and "differ-

Fig. 1. Peter Paul Rubens, *The Head of Cyrus Brought to Queen Tomyris*, oil on canvas, 263 x 199 cm (original painted surface 200 x 179 cm), Paris, Musée du Louvre, inv. 1768.

Fig. 2. Peter Paul Rubens, *Heads of Two Women*, black chalk with white highlights in pen, 290 x 236 mm, Vienna, Graphische Sammlung Albertina, no. 402.

ent" figures would tend to indicate the more expansive of the two compositions. It is also unclear if the painting was acquired by Amalia van Solms,[13] or when it entered the collection of Queen Christina. Granberg has noted that the existence of a seventeenth-century copy of *The Head of Cyrus Brought to Queen Tomyris* at Skokloster Castle in Sweden argues for the presence of the original in that country prior to the queen's abdication and move to Rome in 1654,[14] although the painting is not mentioned in any of the inventories of her collection prior to 1662.[15]

Whatever the early history of the *Queen Tomyris*, this massive canvas was surely painted in response to a specific commission, and expressed a specific iconographic program. Berger has noted that the Infanta Isabella was repeatedly likened to powerful warrior queens of antiquity – including Tomyris – in public imagery, particularly in the wake of her

demonstrated prowess with the crossbow in 1615.[16] Unlike Rubens's contemporary allegories from the Marie de' Medici series, however, there is nothing in the present painting to suggest such personal ties with the Infanta. A more convincing iconography is indicated by the scenes of Queen Tomyris that decorated the royal reception room at the Alcázar palace in Madrid, and Rubens's version of the subject now in the Louvre (fig. 1), which hung to the left of Louis XIV's throne in the Salon d'Apollon at Versailles from at least 1682. In both instances the image was a reminder of the power and virtue of the reigning monarch, a symbol of heroic strength and just retribution.[17] Furthermore, as noted earlier, the *Queen Tomyris* by the Master of Flémalle hung in the Episcopal Palace in Ghent, where it would have been an equally appropriate image for the bishop as dispenser of ecclesiastical justice.[18]

Fig. 3. Paulus Pontius after Peter Paul Rubens, *The Head of Cyrus Brought to Queen Tomyris*, 1630, engraving, 407 x 591 mm.

In the ca. 1662 and 1689 inventories of the collection of Queen Christina of Sweden, the present painting was paired with a painting by Rubens of *The Continence of Scipio*.[19] The two paintings were apparently kept together through the eighteenth century. Although comparable in size and composition, the two works entered Christina's collection from different sources and thus were probably not conceived as pendants by the artist; as Berger notes, moreover, there is no iconographic tradition to support the pairing of these two subjects.

The Head of Cyrus Brought to Queen Tomyris was reproduced in an engraving by Paulus Pontius, dated 1630 (fig. 3). The print differs most conspicuously from the painting in placing Tomyris and her attendants upon a dais, and introducing a small dog who laps at the basin of blood in the foreground. Numerous copies of the *Queen Tomyris* are known in a variety of media, the majority of which were clearly done from Pontius's engraving rather than the original painting.[20] Rubens's composition also had an impact on his more creative colleagues; works such as Frans Francken the Younger's roughly contemporary *Queen Tomyris with the Head of Cyrus* (Dijon, Musée des Beaux-Arts, inv. 120) and Erasmus Quellinus's *Salome Being Handed the Head of St. John the Baptist* (ca. 1645; sale London [Phillips], 20 April 1993, no. 82) are indebted to Rubens's dramatic interpretation of Queen Tomyris's revenge.[21]

MEW

1. Herodotus, *Histories*, 1.212.

2. See Berger 1979, p. 7, and the further references cited there.

3. G. Hulin de Loo, "Le tableau de 'Tomyris et Cyrus' dans l'ancien palais épiscopal de Gand," *Bulletin de la Société d'histoire et d'archéologie de Gand* 9 (1901), pp. 222-233; see also Berger 1979, pp. 8-9.

4. Hulin de Loo 1901, pp. 229ff; and C. van de Velde, "Enkele gegevens over Gentse schilderijen," *Gentse bijdragen tot de kunstgeschiedenis en de oudheidkunde* 20 (1967), pp. 198ff.

5. Berger 1979, p. 9.

6. Rooses 1886-92, vol. 4 (1890), p. 4, and others; see also Rubens's double portrait of Albert and Nicolaes in the collection of the Prince of Liechtenstein, Vaduz, of ca. 1627-1628. Facos (1987, pp. 43-44) prefers a later date for the *Queen Tomyris*, ca. 1624-1625.

7. On this drawing, see Dobroklonsky 1930-31; and Held 1986, no. 100, pp. 108-109.

8. Vlieghe 1987a, p. 147.

9. See Facos's discussion of various informal opinions (1987, p. 48); also Berger 1979, p. 35.

10. Berger 1979, pp. 10-15, 26-29.

11. "... het hooft van Cirus dat aen een Coninghinne gepresenteert wordt met vele figueren die daer inne mekuamen, dat seer treffelyck geschildert is." Denucé 1949, pp. 13-14, doc. 21; de Maeyer 1955, p. 412, doc. 259.

12. "Een stuck van den koninck Sieres daer het hooft in syn bloet woort ghesteeken, met diefernte fuegueren, heel plaesant, van Ruebens, het leven groet." Denucé 1949, p. 42; and de Maeyer 1955, p. 414, doc. 260, both with the mistaken transcription of "vieffernte" for "diefernte"; Berger (1979, pp. 12, 27) followed by Facos (1987, pp. 50, 52) translated this as "fifteen," rather than "different"; Berger noted the correct transcription in 1982 (ms. in Museum files).

13. The painting is not mentioned in the Oranje-Nassau inventory of 1654 or any subsequent inventory; see Berger 1979, pp. 12-13.

14. O. Granberg, *Drottning Kristinas Tafvelgallerei på Stockholms Slott v Rom* (Stockholm, 1896), pp. 4-6, 23. An alternative and largely unsubstantiated history has been proposed by Facos (1987, pp. 50-52), who would have the painting commissioned by the Brussels Town Hall in ca. 1624-1625, and presented to the Swedish queen during her visit to the city in 1654-1655.

15. Berger 1979, pp. 14, 27-28.

16. Ibid., pp. 15-20.

17. Ibid., pp. 20-21.

18. See Facos 1987, p. 42.

19. Berger 1979, pp. 30, 32; on the *Scipio*, see Rooses 1886-92, vol. 4 (1890), p. 25 no. 809. Berger (ibid., fig. 14) illustrates a copy of the work, which was destoyed in 1836.

20. See for example, the several copies listed by Berger 1979, p. 32; and Kruissink 1977.

21. On the former, see Härting 1989, p. 340, no. 351; on the latter, see de Bruyn 1988, pp. 56-57, 152, no. 79.

Peter Paul Rubens

25. *St. Norbert Overcoming Tanchelm,* ca. 1622-1623

Oil on panel, 66.5 x 46 cm (26 ¼ x 18 ⅛ in.)
Private collection

Fig. 1. Anonymous Antwerp artist, late 16th century, *St. Norbert,* engraving, 104 x 71 mm.

Fig. 2. Peter Paul Rubens, *Adoration of the Magi,* 1624, oil on panel, 447 x 336 cm, Antwerp, Koninklijk Museum voor Schone Kunsten, inv. 298.

PROVENANCE: dealer Van Diemen, Berlin and New York, 1930; dealer Colnaghi, London; dealer P. de Boer, Amsterdam; collection Dr. O. Hirschmann, Amsterdam; collection Curtis O. Baer, New Rochelle, New York; by descent to the present owner.

EXHIBITIONS: Amsterdam, J. Goudstikker, *Rubens-Tentoonstelling* (cat. by L. Burchard; August-September 1933), no. 17; Brussels, Musées Royaux des Beaux-Arts de Belgique, *Schetsen van Rubens* (August-September 1937), no. 27; New York 1942, no. 17; Rotterdam 1953, no. 36; Cambridge/New York 1956, no. 35.

LITERATURE: Smith 1829-42, vol. 2 (1830), no. 384; Rooses 1886-92, vol. 2 (1888), p. 329, no. 476 (described from print); van Puyvelde 1940a, no. 50; Is. Leyssens, "Hans van Mildert 158?-1638," *Gentsche Bijdragen tot de Kunstgeschiedenis* 7 (1941), pp. 122-123; Goris, Held 1947, no. 63; Jaffé 1953, p. 35; Haverkamp Begemann 1954, p. 16; W. L. Kitlischka, *Rubens und die Bildhauerei; die Einwirkung der Plastik auf sein Werk und Rubens' Auswirkung auf die Bildhauer des 17. Jahrhunderts* (Ph. D. diss., Vienna, 1963), pp. 112-115, 157-159; Burchard, d'Hulst 1963, vol. 1, p. 117 (under no. 70); M. Jaffé, "Rediscovered Oil Sketches by Rubens, II," *The Burlington Magazine* 111 (1969), p. 529; Held 1980, vol. 1, pp. 577-578, no. 420.

TANCHELM was an early twelfth-century critic of Catholic doctrines and practices. Specifically, he denied the religious authority of bishops and clergy, opposed tithing, and argued that the sacrament of the eucharist was ineffectual for the salvation of the participants. His heresy was particularly successful in Antwerp; to combat it, St. Norbert (ca. 1080-1134), founder of the Premonstratensian (or Norbertine) Order, went to that city accompanied by twelve members of his Order. He took over the old Church of St. Michael and reestablished the orthodox celebration of the eucharist. The Tanchelmian heresy was eventually suppressed, and the Abbey of St. Michael became one of the most powerful religious institutions in Antwerp.[1] Canonized in 1582, St. Norbert was zealously venerated in Counter-Reformatory Antwerp, in celebration of his fervent defense of the sacrament of the eucharist, as well as of the authority of the clergy and ecclesiastical hierarchy.[2]

In accordance with the established iconography of the saint (compare fig. 1), Rubens's sketch depicts St. Norbert clad in the white habit of the Premonstratensians, wearing an abbot's miter, holding a crozier in his left hand, and a monstrance containing the eucharist in the other. He stands victorious atop the fallen figure of the arch heretic Tanchelm. The sketch is executed largely in *brunaille,* with discrete touches of color: the green of Tanchelm's stockings, the greenish-blue to lavender and pink hues of the sky. Some underdrawing is visible in the sweeping lines of St. Norbert's drapery; the faces of the figures are more thickly painted.

Rubens was intimately involved with the Premonstratensian Abbey of St. Michael over the course of two decades. His mother and brother Philip were buried in the church (in 1608 and 1611, respectively); he donated an altarpiece of the *Madonna and Child*

with Saints in 1610 following his return to Antwerp[3]; and in the early 1620s he was commissioned by the Abbot Mattheus Yrsselius to execute an altarpiece for the high altar. Yrsselius (Mattheus Gorissen van Eersel, 1541-1629) was abbot of St. Michael's from 1614 until his death. He was devoted to restoring the splendor of the beleaguered Abbey, which had suffered from religious disturbances and a major fire in 1620.[4] Rubens's portrait of Yrsselius (ca. 1622; Copenhagen, Statens Museum for Kunst, inv. 613) hung to one side of the high altar in the Church of St. Michael.

The altarpiece itself, an *Adoration of the Magi* (1624; now Antwerp, Koninklijk Museum voor Schone Kunsten, inv. 298; fig. 2), was surrounded by a tabernacle crowned by statues of the Virgin and Child flanked by St. Norbert and St. Michael, patron saint of the Abbey. The exhibited sketch is Rubens's design for one of these figures, which were translated into sculpture by Hans van Mildert.[5] Infra-red examination of the sketch reveals the outline of a rectangular pedestal supporting the figural group beneath the grassy hillock which now covers the lower portion of the panel.[6]

Friend and artistic partner of Rubens, Hans van Mildert (1588-1638) became a member of the Antwerp guild of St. Luke in 1610, but only in 1628 was he made a citizen (*poorter*) of the city. Among his more notable commissions was an altar for the church of St. Gommarus, Lier (1626), and the execution of the high altar in the Cathedral of St. Jan in 's-Hertogenbosch. In addition to his collaboration with Rubens on the sculptural decorations for St. Michael's, van Mildert also translated into stone Rubens's designs for the tomb of Michiel Ophovius (see cat. 23), and for the sculpture on the façade and high altar of the Jesuit church in Antwerp (ca. 1619-1622).[7]

Van Mildert made several adjustments in translating Rubens's sketch for the figure of St. Norbert into three dimensions (fig. 3). Tanchelm's costume and hair are completely reworked, and the saint now wears the pallium of an archbishop about his shoulders and a more elaborate miter. As a whole, van Mildert's group is more static and conventional than Rubens's lively sketch: the expressions of the figures are less intense, their drapery less agitated. In its present state, the statue shows St. Norbert holding a chalice in his right hand (also a symbol of the eucharist), rather than the monstrance depicted in the sketch; from early descriptions of the altar, however, it appears that this may be a later replacement.[8]

In designing the high altar for the Church of St. Michael, Rubens carefully orchestrated the

Peter Paul Rubens
26. Portrait of a Man as the God Mars

Oil on panel, 82.6 x 66.1 cm (32 ½ x 26 in.)
Private Collection

iconography of the ensemble to accord with the Roman Catholic faith of the Premonstratensian Order. In keeping with the importance the Order placed on the celebration of the eucharist, Rubens's *Adoration of the Magi* stresses the sacramental character of the event, incorporating references to the liturgy in such objects as censers, candelabras, and the quasi-ecclesiastical garments of the Magi.⁹ The statues atop the altar surround – St. Michael vanquishing Lucifer, St. Norbert defending the sacraments and offices of the Church, and the Virgin and Child triumphant over sin and temptation – were designed by Rubens as an extension of the iconography expressed in the painting itself. Rubens's portrait of Yrsselius, placed to the side of the altar, was also a part of the ensemble: depicted in the traditional attitude of a donor (as in the side panels of earlier altarpieces), the abbot's prayer is directed towards the Christ Child depicted in Rubens's painting.¹⁰

MEW

Fig. 3. Hans van Mildert, *St. Norbert*, alabaster, ca. 250 cm high, Zundert, Noord Brabant (The Netherlands), Church of St. Trudo.

1. St. Norbert's fight against Tanchelmian heresy and the history of the Abbey Church of St. Michael is summarized in Held 1980, vol. 1, p. 577. See also *Sint Norbertus in de Brabantse Kunst* (exh. cat. Averbode, Abdij der Norbertijnen, 1971), pp. 11-13; Knipping 1974, vol. 1, p. 170; Thijs 1983, p. 575ff; and M. Konrad, "Antwerpener Binnenraüme im Zeitalter des Rubens," in P. Clemin, ed., *Belgische Kunstdenkmäler* (Munich, 1923), pp. 192-197. I am grateful to Roman R. Vanasse, O. Praem., for his thoughtful comments on this entry.

2. Averbode 1971, lists numerous representations of the saint in all media, including works by Cornelis de Vos and Abraham van Diepenbeeck. See also Knipping 1974, vol. 2, p. 303.

3. The painting was the first version of the altarpiece Rubens had painted for the Chiesa Nuova in Rome. On this project see further under cat. 7.

4. Biographical information on Yrsselius and a more detailed discussion of Rubens's portrait of him are to be found in Vlieghe 1987a, pp. 204-206.

5. The sculptures and the tabernacle are now in the Church of St. Trudo, in Zundert, Noord Brabant (The Netherlands). They were removed from the Church of St. Michael following the secularization of the abbey during the French occupation of 1796-1797, and were purchased by the Church of St. Trudo in 1803. See Leyssens 1941, p. 119.

6. Infra-red examination by Rhona MacBeth, Department of Paintings Conservation, Museum of Fine Arts, Boston.

7. Baudouin 1977, pp. 154-155 and 168-171. More general information on van Mildert may be found in Leyssens 1941; and M. Casteels, in Brussels 1977, pp. 247-250 (with further literature).

8. Held 1980, p. 578 cites a 1629 description of the altar which describes the figure of St. Norbert, "... who holds in his right [hand], extended in triumph, the receptacle of the Holy Sacrament, and in his left hand the cross of the abbot" (translation Held; from J. Ch. vander Sterre, *Echo S. Norberti Triumphantis* [Antwerp, 1629], p. 59).

9. Held 1980 vol. 1a, p. 456.

10. Vlieghe 1987a, p. 206.

PROVENANCE: sale Gerrit Muller, Amsterdam, 2 April 1827, no. 58 (fl. 1550, to C. J. Nieuwenhuys); Edward Gray, London, by 1830 (see Smith); Sir Anthony de Rothschild, 1st Bt., London, by 1854 (see Waagen); by descent to Sir Anthony's daughter Annie, who in 1873 married the Honorable Eliot Constantine Yorke; sale the Honorable Mrs. Yorke, London (Christie's), 6 May 1927, no. 37; purchased by A. Contini Bonacossi, Rome; Samuel H. Kress, New York, 1929, thence by descent; David Paul, Florida.

EXHIBITIONS: San Francisco, Golden Gate International Exposition, *Masterworks of Five Centuries*, 1939, no. 96, ill; San Francisco, Palace of the Legion of Honor, *Seven Centuries of Painting: A Loan Exhibition of Old and Modern Masters*, 29 December 1939-28 January 1940, no. L-46, ill.; New York, World's Fair, *European and American Paintings 1500-1900: Masterpieces of Art*, May-October 1940, cat. 67, fig. 67; Toronto, Art Gallery, *An Exhibition of Great Paintings in Aid of the Canadian Red Cross*, 15 November-15 December 1940, no. 24 [ca. 1620-25]; New York 1942, cat. no. 8, ill. [ca. 1620]; New York, Wildenstein & Co., *A Loan Exhibition of Rubens* (cat. by Ludwig Burchard), 20 February-31 March 1951, cat. no. 11, ill.

LITERATURE: Smith 1829-42, vol. 2 (1830), no. 899; Waagen 1854-57, vol. 2 (1854), p. 281; Rooses 1886-92, vol. 4 (1890), p. 297, no. 1100; A. Burroughs, *Art Criticism from a Laboratory* (Boston, 1938), p. 137; A. Frankfurter, "Revising Rubens," *Art News* 41 (1942) pp. 16-19, 33; Goris, Held 1947, pp. 29-30, cat. no. 21, pl. 3; A. Fornari, "De Chirico e Rubens," *Paragone* 1 (1950), pp. 45-47, fig. 19b; C. Eisler, *Paintings from the Samuel H. Kress Collection, Excluding the Italian School* (Oxford, 1977), pp. 109-110, cat. no. KX-5, fig. 97.

WEARING parade dress inspired by classical images of Roman legionnaires – cuirasse, chain mail, a lion's pelt, and a helmet with a white plume – a man in armor holding a lance in his left hand is viewed half-length. With his back partially turned, he looks over his left shoulder at the viewer. With his steady gaze, prominently bridged nose, light brown mustache and goatee, the subject is highly individualized and has often been assumed to be a portrait, although the sitter has not been identified.

Although sold in 1827 as "A Roman Soldier," and listed by Waagen (1854) and Rooses (1890) respectively as a "warrior" or "un guerrier" while in the Rothschild collection, the painting was sold in 1927 as a depiction of Mars, the Roman god of war, an identification that has won general acceptance and is probably correct.¹ Whether the painting is also a portrait has been debated but most writers seem to tacitly assume that the figure portrays an actual person.² Although *portraits historiés* of this sort were much more common in the Northern provinces than in the Spanish Netherlands,³ Rubens on rare occasions painted imaginary portraits of real people in the guise of literary figures, specifically the gods of mythology. In the famous series of paintings glorifying the life of Marie de' Medici from the Palais de Luxembourg (now in the Louvre), for example, the Queen Mother appears as Mars's sister, the Roman goddess Bellona (inv. 1781), and together with her husband as Juno and Jupiter (inv. 1775).

Usually the aggressive and wrathful Mars was a wicked and disruptive figure in the art of Rubens

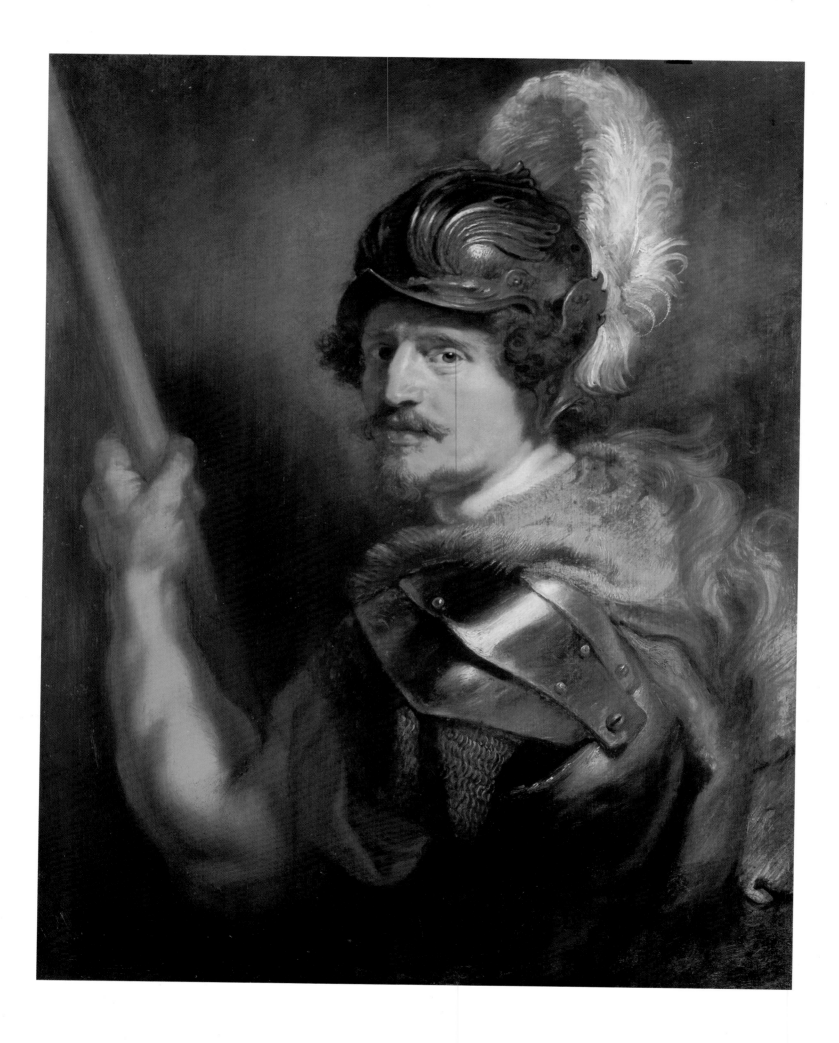

Fig. 1. Aegidius Sadeler, after Titian, *Titus*, from the series of engravings of Roman Emperors, ca. 1593.

and his contemporaries; for example, in the master's *Minerva Protects Pax from Mars* (cat. 29, fig. 4), which served as a present to the English King Charles I when Rubens acted as emissary of peace, shows Mars driven off by Minerva (goddess of Wisdom), an encounter recalling their famous conflict in the Trojan War (*Iliad* 5:825ff) and an outcome obviously benefiting peace.[4] Mars also plays a menacing role in the *Horrors of War* (Florence, Pitti Palace) and in a lost painting that Rubens himself described in a letter before it was sent to an unknown patron in Florence in 1638 as depicting Venus caught between desperate Europe and savage Mars.[5] Mars, of course, is a more inviting figure when disarmed and placated, as depicted in the story of Mars and Venus, which Rubens treated in a painting of ca. 1615-1617 (formerly in Schloss Konigsberg, now lost[6]), the *Venus, Mars and Cupid* of ca. 1630-1635 in the Dulwich Picture Gallery (no. 285)[7] and (possibly) in an oil sketch now in the Gemäldegalerie, Berlin, no. 533.[8] The pacifist message (not unlike the rallying call of the 1960s, "Make Love Not War") of this great mythological theme was certainly not lost upon either Dutch or Flemish painters during this war-racked century.[9]

On the other hand, if the present painting is a portrait, it must be interpreted *in bono* as celebrating the sitter's martial virtues; thus it may be compared in spirit to Rubens's *Crowning of the Hero* (Munich, Alte Pinakothek, no. 997) which shows an armored warrior crowned by winged victory, standing over a fallen satyr, Venus and Cupid, with Envy in the background; its pendant depicts *Drunken Hercules* (Dresden, Gemäldegalerie, no. 957), thus juxtaposing one of antiquity's great heros but disgraced by temptation. In addition to Mars's bellicose associations with strength and courage, the attribute of the lion's pelt in the present painting also alludes implicitly to the heroic virtues of Hercules and Samson, who wore a similar trophy of valor. However none of the ready candidates for the role of Catholic general or warlord offer a convincing resemblance to the present sitter; Ambrogio Spinola, who was not only a successful general but also, after 1621, an advisor to Isabella and a champion of Rubens (compare, however, his portrait by Rubens, in the Herzog Anton Ulrich-Museum, Braunschweig, no. 85; ill. History, fig. 8) or the Hapsburg Prince Ferdinand of Austria, who had recently routed the Protestants, bear little resemblance.

As Held first observed, the heroic pose and conception of the figure seem to recall Venetian prototypes.[10] Eisler correctly stresses the work's resemblance to idealized portraits by Titian, which may well have been copied by Rubens and were certainly known to him at first hand from the twelve Caesars in the Gabinetto dei Cesari at the Palazzo del Tè owned by Rubens's Italian patron and benefactor, the Duke of Mantua.[11] Titian's paintings, executed ca. 1537-1539, were destroyed by the fire at the Alcázar in 1734 but can be imperfectly judged from copies and engravings.[12] Among these, the figure of *Titus* (fig. 1) seems to have been closest in pose and conception to Rubens's *Mars*; however, the latter's pose (turning away from the viewer, holding a weapon powerfully in his left hand, and looking over his shoulder) had earlier appeared in the full-length depiction of the god of war in Lucas van Leyden's print of *Mars and Venus*, also undoubtedly known to Rubens.[13] Rubens had long been personally fascinated with imaginary portraits of classical deities and rulers. As Eisler noted, he painted a *Head of Hercules* (formerly in the collection of Ludwig Burchard[14]) early in his career. Rubens also seems to have begun a series of bust-length Roman emperors,[15] and in 1619 contributed his half-length *Julius Caesar* (Berlin, Jagdschloss Grunewald) to the famous series of Twelve Emperors done by different artists for Frederick Hendrick, stadholder of the United Provinces.[16]

While Ludwig Burchard in 1929 dated the present painting "between 1620-1626," in 1951 he suggested an earlier date of "between 1615 [and] 1618," which won general approval.[17] Lili Nash, in her catalogue of the Rubens exhibition held at Schaeffer and Brandt Inc. in 1942, inferred a date before ca. 1620,[18] and Larsen proposed 1617/18.[19] However Eisler was probably correct in again placing the date in the first half of the 1620s, when Rubens's portrait style became somewhat broader and his interest in Venetian art began to increase.[20] There is no reason, however, to accept Eisler's view, first promoted by Burroughs (who claimed, improbably, to see Gaspar de Crayer's style in features of the painting[21]), that the picture was completed by an assistant.[22] The view, shared by Smith, Rooses, and Burchard (see Literature above), that the picture is entirely autograph, is also correctly accepted by Held and Haverkamp Begemann.[23]

According to Michael Jaffé, the helmet worn by *Mars* actually belonged to Rubens; it appears again worn by a soldier in the *Raising of the Cross* (Brussels, Musées Royaux des Beaux-Arts de Belgique, inv. 163). Jaffé argued that Rubens believed it to be antique, although it seems to be a burgonet of the sixteenth century; he has not found the original helmet, but it was illustrated in Jacob Spon's *Miscellanea eruditae antiquitatis* (Lyon, 1685).[24]

PCS

1. Waagen 1854-57, vol. 2 (1854), p. 281; Rooses 1886-92, vol. 4 (1890), p. 297, no. 1100; Goris, Held 1947, cat. 21, entitled it the "so-called 'Mars'"; Burchard (1951) accepted it as a portrayal of Mars.

2. Goris and Held (1947), p. 29, suggested it "might be [a] disguised portrait"; Burchard (in New York, Wildenstein, 1951, p. 16) suggested that the sitter might be a fellow artist of Rubens painted with the attributes of Mars; Eisler 1977, p. 109, did not dispute the idea that the painting bears portraitlike features.

3. Wishnevsky 1967 (see also the comments by N. de Poorter in her essay in Cologne/Vienna 1992-93).

4. Rooses no. 825.

5. See Rooses no. 827 and oil sketch for the painting, London, The National Gallery, no. 279. For the letter, see Magurn 1955, p. 408.

6. See Evers 1943, fig. 292. See also the anonymous prints after Rubens's Mars and Venus in Voorhelm Schneevoogt 1873, p. 121, no. 15 and p. 125, no. 52. A painting by Rubens sometimes assumed to represent Venus and Mars with Cupid, Bacchus, and a Fury in the Palazzo Bianco, Genoa; inv. P.B. 160 (cat. 1950, p. 12; see also Rooses 1886-92, vol. 4 [1890], no. 833; and Oldenbourg 1921, no. 359) may be an allegorical portrait; but as Rooses and Muller (1989, no. 90, pl. 38) have noted, this painting is probably identical with the work described in the "Specifications" of Rubens's estate as "A switzer with his sweethart, with a bottle, with a satyr not fullmade vppon Cloth (sic)." E. Papone, Il Passato Presento. I Musei del Commune de Genova (Genoa, 1991), no. 9, ill.

7. See Peter Murray, Dulwich Picture Gallery: A Catalogue (London, 1980), p. 114, no. 285, ill.

8. See Berlin, cat. 1986, p. 243, ill. as "P. P. Rubens?"

9. On the theme of Mars and Venus in Dutch and Flemish seventeenth-century art, see E. de Jong, Een schilderij centraal. De Slapende Mars van Hendrick ter Brugghen, Centraal Museum, Utrecht (1981), pp. 14-18; and P. C. Sutton, "A Pair by Van Bijlert," Mercury 8 (1989) pp. 4-16. A rare case of another Flemish portrait historié is T. Willeboirt Bosschaert's Mars and Venus (Friedrich Wilhelm, elector of Brandenburg, and Louisa Henrietta, Countess of Nassau?), signed, oil on canvas, 215 x 255 cm, Amsterdam, Rijksmuseum, no. C400.

10. Goris, Held, 1947, p. 30.

11. See Eisler 1977, pp. 109-110. Of the thirty-three copies after Titian in Rubens's inventory of June 1640, twenty-six were portraits (see Denucé 1932, pp. 58-59, nos. 38-41, nos. 49-69, no. 74, and no. 79).

12. See H. E. Wethey, The Paintings of Titian, vol. 3 (London, 1975), pp. 43-47, figs. 32-47.

13. See Hollstein 1949-, vol. 10, p. 137, no. 1. Rubens copied Lucas's prints on several occasions. An armored figure powerfully holding a lance was a standard pose for heroes and militant saints; see, for example, Rubens's Hero Crowned by Victory (Dresden, Gemäldegalerie Alte Meister, no. 956), and the figure of St. George in his altarpiece Madonna with Saints for his own burial chapel in the St. Jacobskerk, Antwerp.

14. Eisler 1977, p. 109; see M. Jaffé, "Rubens at Rotterdam," The Burlington Magazine 96 (1954), p. 55, fig. 25. In the Latour sale, London, 19-20 March 1768, no. 22, there was "A Head of Mars" by Rubens; see also sale William Dodd, London (Richard's), 16-17 February 1798, no. 55, "A Head of a Warrior" by Rubens; the same description (again without dimensions) in sale Thomas Martin, London (Phillips), 6 May 1830, no. 93. See also sale Paris (Paillet), 17 May 1774, no. 106, "La Tête d'un Empereur" by Rubens (canvas, 24 x 19 pouces); sale Paris, 5 February 1776, no. 29, "Le buste d'un Guerrier, vu de trois quarts et de proportions naturelle" by Rubens (panel, 28 x 24 pouces); sale Coclers, Paris (Lebrun), 9 February 1789, no. 50, "Un Soldat vu en buste, la tête penchée sur la poitrine; il a l'epaule couverte d'une cuirasse" by Rubens (panel, 21 x 17 in.).

15. See M. Jaffé, "Rubens's 'Roman Emperors,'" The Burlington Magazine 113 (1971), pp. 300-303; idem, 1977, pp. 17-18, pl. 1; and E. McGrath, "'Not Even a Fly': Rubens and the Mad Emperors," The Burlington Magazine 133 (1991), pp. 699-703.

16. See R. Oldenbourg, "Die niederländischen Imperatorenbilder im königlichen Schlosse zu Berlin" [publ. first in Jahrbuch der preussischen Kunstsammlungen 38 (1917), pp. 203ff], in Peter Paul Rubens, ed. W. Bode (Munich & Berlin, 1922), pp. 182-191; and see also H. Börsch-Supan, in Jagdschloss Grünewald (Berlin, 1981), pp. 48-52; and P. van Duinen, "Keizers in de Republiek; een serie Romeinse keizersportretten door twaalf Nederlandse schilders (ca. 1615-ca. 1625)," Ph.D. diss., Amsterdam, Vrije Universiteit, 1989.

17. Letter of 29 January 1929 to Samuel Kress (cited by Eisler 1977, p. 110, note 7) and New York, Wildenstein 1951, no. 11.

18. New York 1942, no. 8.

19. Larsen 1952, p. 216, cat. 47.

20. Eisler 1977, p. 109.

21. A. Burroughs, Art Criticism from a Laboratory (Boston, 1938), p. 137.

22. Eisler 1977, p. 109.

23. Respectively letter 23 May 1988, and private communication December 1992.

24. Letter (18 April 1972) quoted by Eisler 1977, p. 110, note 15.

Peter Paul Rubens

27. The Holy Family with Saint Anne

Oil on canvas, 115 x 90 cm (45 ¼ x 35 ⅜ in.)
Madrid, Museo del Prado, no. 1639

Fig. 2. Peter Paul Rubens, *Holy Family with Infant St. John the Baptist*, oil on canvas, 144.7 x 116.9 cm, London, Thos. Agnew and Sons.

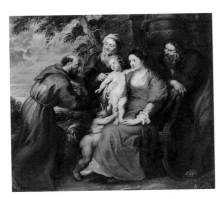

Fig. 1. Peter Paul Rubens, *Holy Family with the Infant St. John*, oil on panel, 26 x 22.6 cm, Ilchester, Viscountess Galway.

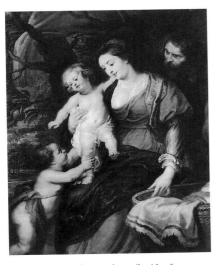

Fig. 3. Peter Paul Rubens, *The Holy Family with St. Francis*, oil on canvas, 189 x 214.5 cm, Windsor Castle, Royal Collection, H. M. the Queen.

PROVENANCE: Royal Monastery of San Lorenzo at El Escorial (mentioned there in 1667 and 1698) where it was selected by Diego Velázquez to adorn the Salas de los Capítulos; deposited in the Prado in 1839; Prado inv. of 1849, no. 451; catalogues of 1854-1858, no. 451; 1872-1907, no. 1560; 1910-1975, no. 1639.

LITERATURE: P. de los Santos, *Descripción del Real Monasterio de San Lorenzo de El Escorial* (1698), fol. 75; Caimo, *Voyage d'Espagne* (1773), pp. 22, 176; A. Ponz, *Viaje de España* (1776), vol. 2, p. 138; V. Poleró, *Catálogo de los cuadros del Real Monasterio de San Lorenzo de El Escorial* (1857), no. 451; Louis Viardot, *Les Musées d'Espagne, d'Angleterre et de Belgique, Guide et Mémento de l'artiste et du voyageur faisant suite aux Musées d'Italie* (Paris, 1843), p. 92; Cruzada Villaamil 1874, p. 346; P. de Madrazo, *Joyas del Arte en España* (Madrid, 1878), p. 33 with lithograph by B. Blanco; Rooses 1886-92, vol. 1 (1886), pp. 296-297, no. 222; A. Rosenberg 1905, p. 296 [ca. 1626-1630]; Pedro Beroqui, "Adiciones y correcciones al catálogo del Museo del Prado," *Boletín de la Sociedad Castellana de Excursiones* (1917-18), p. 359; Oldenbourg 1918b, p. 204; A. P. Mitchel, "Two French Enamelled Watches," *The Burlington Magazine* 35 (1919), p. 246; Oldenbourg 1921, p. 110; Glück 1933, p. 161 [ca. 1628]; F. J. Sánchez Cantón, *Fuentes Literarias para la Historia de Arte Español*, vol. 2 (Madrid, 1933), p. 295; Madrid, cat. 1975, vol. 1, pp. 229-231, no. 1639, vol. 2, p. 163, ill.; A. E. Perez Sanchez, "Rubens y la Pintura Barroca Española," *Goya Revista de Arte* 140-141 (1977), pp. 93-94; New York, Metropolitan, cat. 1984, p. 141, notes 9 and 13; Madrid, cat. 1989, p. 293, no. 243, ill.; M. Jaffé, *Rubens Catalogo Completo* (Milan, 1989), no. 989; exh. London, National Gallery, *The Queen's Pictures*, 1991, p. 126, under cat. no. 39 [around 1630].

THE THREE-QUARTER length Madonna holds the standing Christ Child in her lap, supporting his left foot with her left hand and embracing him with her right hand. The infant is nude and the Virgin's breast exposed. Behind and embracing the pair is the smiling figure of St. Anne, wearing a white headdress. In the right background, St. Joseph cups his bearded chin in his hand and stares intently at the child.

This painting was mentioned and described by P. de los Santos, in his *Descripción del Real Monasterio de San Lorenzo de El Escorial* in the editions of 1667 and 1698. The text reads: "another painting of the same dimensions, an original by Rubens's hand. The subject is also Our Lady with the Christ Child, Saint Joseph, and Saint Anne, the whole executed with such joy that it never fails to warm the hearts of those who contemplate it. Our Lady is seated; the Christ Child is nude and standing on her knees, so appealing, so cheerful, and with such tenderness it stirs the soul."[1] This painting is one of a series of images of the Holy Family, with and without other saints, that Rubens developed in the late 1620s and early 1630s. Some of these works were conceived on a three-quarter format, while others were full length. As Viardot first observed in 1843, the Prado's painting is clearly "Raphaelesque," recalling studies that Rubens had made of Raphael's Madonnas decades earlier when in Rome.[2] The warm coloration, on the other hand, seems to attest to Rubens's intense study of Titian's art on his visit to Spain in 1628-1629.

A print after this composition by Paulus Pontius records the painting's design exactly as it appears,

upright in format and with the figures viewed to the knees, while prints by Schelte à Bolswert (who did not work for Rubens until about 1633) and others enlarge the design to full length, adding a landscape, pilaster balustrade, brickwork, and a cradle at the family's feet.[3] Since no such full-length painted or drawn variant of the present design is known by Rubens, these additions may only be the elaboration of the printmaker or another designer from Rubens's studio. However a fragmentary oil sketch in the collection of Viscountess Galway, Ilchester (fig. 1), shows that Rubens conceived a variation of this design which introduced a more animated pose for the Christ Child, omitted St. Anne, and added the young St. John the Baptist reaching up toward the infant from the lower left.[4] This sketch seems to have been the basis for a painting (fig. 2) now with Agnew's in London; indeed x-rays of that picture show that it originally corresponded more closely to the Galway sketch.[5] With small variations, the poses of the Madonna, Child, and Sts. Anne and Joseph are also reiterated in the larger, and probably later, horizontally disposed canvas in the Queen's collection at Windsor Castle of the *Holy Family with St. Francis* (fig. 3).[6] A still later variant of this design (probably executed by Rubens with some workshop assistance) in The Metropolitan Museum of Art, New York (inv. no. 02.24) adopts the playful pose for the Christ Child that first appeared in the oil sketch (fig. 1).[7] As Jaffé noted, further development of this idea may be detected in the animated poses of the Madonna and Child in the *Meeting of the Holy Families under the Apple Tree*, which Rubens painted for the exterior wings of the St. Ildefonso triptych (Vienna, Kunsthistorisches Museum, no. 321).[8] The latter adds the family of St. John and returns to an upright design while further developing the landscape. Many paintings by Rubens from the 1630s revise earlier compositions, and in the case of such subjects as the Holy Family, the formal development is virtually continuous. The precise sequence and relationship of all of these paintings, however, is open to discussion.

In the few recorded attempts to date the present work, Rosenberg suggested a date of ca. 1626-1630, and Glück of 1628, while the authors of the catalogue of the exhibition of the Queen's paintings in London in 1991 proposed a date of around 1630, implying that the Prado picture followed the related *Holy Family with St. Francis* in the Royal Collection (fig. 3). However it is not clear that the Windsor Castle painting was executed first. That work was originally conceived as a three-quarter length composition, probably without the Baptist and the lamb (a copy of the work in this state was in the collection of R. de

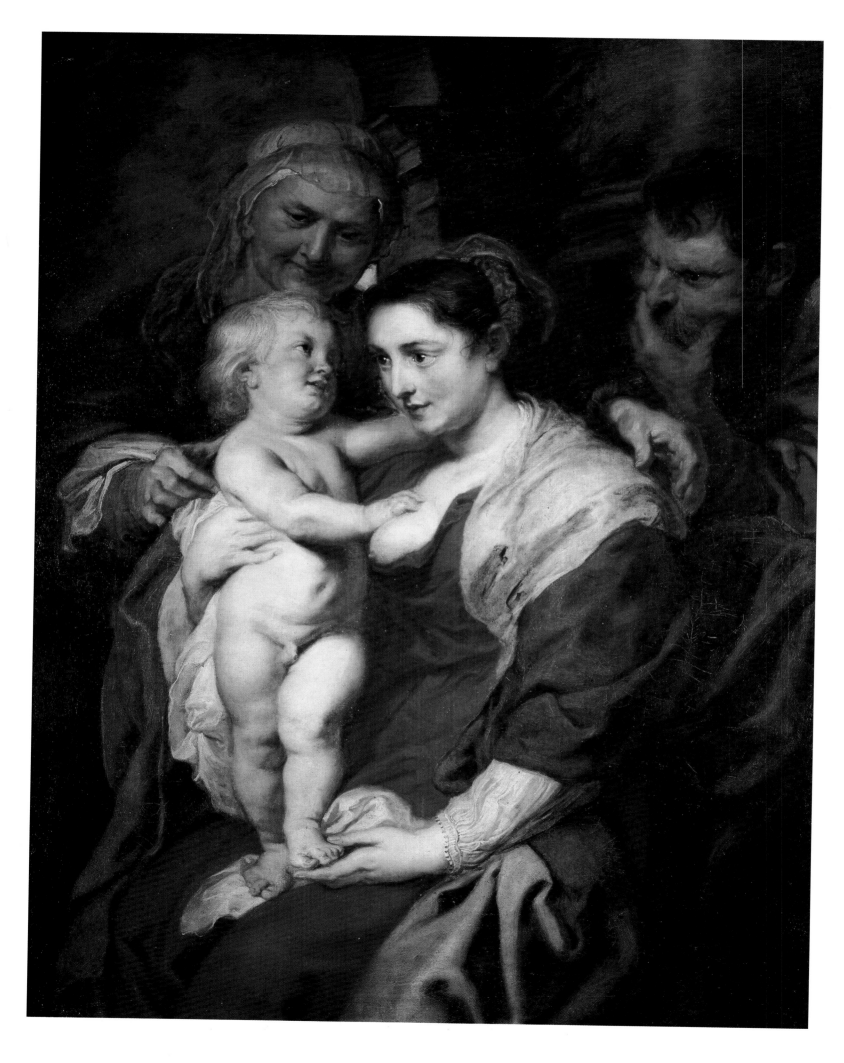

Lammine, Sint-Genesius-Rode, Belgium, 1974), to which Rubens or members of his studio later added a strip at the bottom of the canvas to convert it to full-length design. Spruyt's etching of 1788 seems to record the initial state of the Windsor composition.[9] Nothing intrinsic to the Windsor painting, even in its original state, argues for its primacy; indeed the figure and facial type of the Virgin in the Prado picture have more in common with Rubens's Madonnas from earlier in the 1620s. On the other hand, the Madonna's oblique gaze in the Prado painting is not focused on the Christ Child but directed out of the picture, which could imply the original presence of the missing St. Francis, and thus support the assumption that the Windsor picture was first.

Antwerp was famous for its Cult of Mary, and Rubens himself renowned for his fervent personal worship of the Madonna. While some theologians criticized the worship of the Virgin as a form of idolatry, for many of the faithful her intercession and mediatorship were more effective and universal than that of all the other saints combined. Rubens's devotion to the Cult of Mary is reflected in his rebuttal to criticism for having designed an engraved illustration showing Mary on Christ's right by referring to Psalm 45:9: "At your right hand stands the Queen, [so I] thought it only reasonable to award this place of honor to the First Lady of Heaven."[10] And we may recall his painting of 1638 for his own burial chapel was a depiction of the Madonna and Child with Saints. Like other Flemish painters, Rubens's teacher, Otto van Veen, had painted a series of fifteen panels illustrating the Life of the Virgin (Bayerische Staatsgemäldesammlungen[11]) and Rubens himself painted among other scenes The Education of the Virgin by Her Parents (see the oil sketch in the collection of the Prince of Liechtenstein, Vaduz, inv. no. 116; and the large finished painting from the Carmelite Church now in the Museum in Antwerp, no. 306).

The Counter Reformation brought a strong new pictorial and literary interest in the Immaculate Virgin, which Rubens expressed in works like the altarpiece of the Apocalyptic Woman (traditional symbol of the Virgin Mary as the enemy of heresy) painted for the Church of Freising in Bavaria.[12] Since the Middle Ages, interest in the Immaculate Conception had stimulated curiosity about the Virgin's youth and her mother, St. Anne. This exceptional devotion reached a peak toward the turn of the fifteenth century, and was expressed in the many late medieval images of Sint Anna-te Drieën (St. Anne in Three), which often took the form of St. Anne and the Virgin and Child in the hortus conclusus – the enclosed garden of the Song of Songs, which was the symbol of

their purity.[13] In its extreme forms this interest in exactly when Mary was exempted from Original Sin and hence, in the extended "immaculate" family, resulted in images of the Holy Kinship which were so crowded as to resemble modern photographic portraits of sports teams or class reunions. However, even after the theological backlash which prompted Jacob Lydias among others to mock the devotion to St. Anne in his Uylen-spiegel, St. Anne's apocryphal life was still venerated in depictions by Otto van Veen (Antwerp, Museum of the Commission of Public Assistance). And while St. Anne was increasingly replaced in baroque images of the Holy Family by St. Elizabeth and the infant St. John (see, for example, Rubens's Holy Family with Infant St. John, Cologne, Wallraf-Richartz-Museum, no. 1038), Rubens and his circle continued to depict her regularly (see, for example, cat. 50; and Rubens workshop, Holy Family with St. Anne, Raleigh, North Carolina Museum of Arts, no. 52.9.107). In Jacob Jordaens's early Holy Family in The Metropolitan Museum of Art, New York (acc. no. 71.11), St. Anne is joined by Sts. John and Elizabeth.[14]

The many extant copies and workshop variants of the Prado painting testify to its popularity.[15] Perez Sanchez has also shown that the composition was taken up by the artists in the circle of Alonso Cano and other anonymous Spanish baroque artists.[16]

PCS

1. See Madrid, cat. 1975, vol. 1, p. 230; translated by Michael Armstrong Roche.

2. L. Viardot, Les Musées d'Espagne (1843), p. 92.

3. See Didier Bodart, in exh. cat. Rome, Gabinetto Nazionale delle Stampe, Rubens e l'Incisione, 1977, p. 45, no. 63; Vorhelm Schneevoogt 1873, nos. 136-139.

4. See Jaffé 1966, p. 533, fig. 6; and Held 1980, vol. 1, p. 506, no. 370, vol. 2, pl. 362.

5. Oil on canvas, 144.7 x 116.9 cm, with Agnew's, London. Provenance: General Wade; Charles Ingram, Temple Newsam (1765); the Viscounts Halifax; sale London (Christie's), 12 December 1947, no. 117, to Agnew's; Count Matarazzo, São Paulo, Brazil, thence by descent until 1989. Literature: Waagen 1854-57, vol. 3 (1857), p. 332; Rooses 1886-92, vol. 1 (1886), p. 300, no. 226; [M. Jaffé], "Announcements," The Burlington Magazine 111 (1969), p. 642; Vlieghe, 1972-73, vol. 2, p. 93; Held 1980, vol. 1, p. 506; Jaffé 1989, p. 317, no. 988. Held (1980) initially regarded the painting as a school piece, like the painting also derived from the Ilchester sketch owned by Lord Scarlesdale at Kedleston (canvas, 135 x 150 cm), but according to Agnew's, subsequently gave a favorable opinion in 1990.

6. Rooses 1886-92, vol. 1 (1886), no. 234; Oldenbourg 1921, pp. 285, 466 ill.; Jaffé 1989, no. 881; exh. London 1991-92, no. 39.

7. New York, Metropolitan, cat. 1984, pp. 140-46, pl. 58, 59. A version of the composition in the Fine Arts Gallery of San Diego (cat. 1947, pp. 112-113; New York, Metropolitan, cat. 1984, fig. 26) was correctly regarded by Held (Goris, Held 1947, p. 50, under no. A48) as a studio variant from the 1630s which combines features of both the New York and Windsor paintings.

8. Jaffé 1966, p. 533, fig. 7. See also Rooses 1886-92, vol. 1 (1886), p. 310.

Peter Paul Rubens
28. Portrait of Thomas Howard, Earl of Arundel, 1629-1630

Oil on canvas, 122.2 x 102 cm (48 ⅛ x 40 ⅛ in.)
Boston, Isabella Stewart Gardner Museum,
inv. P21S15

9. See Voorhelm Schneevoogt 1873, p. 191, no. 148.

10. See Rooses 1886-92, vol. 5 (1892) p. 53, note 1.

11. Bayerische Staatsgemäldesammlungen, inv. nos. 1861-1875.

12. See K. Renger, *Peter Paul Rubens Altäre für Bayern*, exh. Munich, Bayerische Staatsgemäldesammlungen, Alte Pinakothek, 9 November 1990-13 January 1991, pp. 85-86, fig. 36.

13. See M. Levi d'Ancona, *The Iconography of the Immaculate Conception in the Middle Ages and Early Renaissance* (New York, 1957), pp. 5ff; Knipping 1974, pp. 281-282.

14. See New York, Metropolitan, cat. 1984, pp. 144-118, pl. 50. A second version formerly in Schleissheim, no. 1027 is now in Munich (see New York, Metropolitan, cat. 1984, fig. 21). It is interesting that the figure of St. Anne in the Metropolitan's painting probably was originally conceived as St. Elizabeth but was changed when the picture was expanded and a new figure of St. Elizabeth was added.

15. See Galeria Sabauda, Turin, no. 393; sale London (Christie's) 13 July 1962, no. 30; sale Vienna, 4 April 1935, no. 37; Earl of Spencer, Althorp House (see Smith 1829-42, vol. 9 [1842], p. 313); Freiherr von Heyl zu Herrnsheim, Worms (see Glück 1933, p. 161, note 167); Statens Museum for Kunst, Copenhagen, cat. 1946, no. 617 (27 x 20 cm); sale Emile-Moritz Oppenheim Paris, 14 October 1878, no. 57; Lynch collection (M. Milkovich, *The Lynch Collection* [Binghampton, 1967], no. 45 [without Sts. Anne and Joseph]); collection of Count Constantin de Bousies; and in a garland attributed to Jan Brueghel (*Trésors de l'art Belge*, 1912, p. cxxxix).

16. Perez Sanchez, "Rubens y la Pintura Barroca Española," pp. 93-94, ills.

PROVENANCE: collection Greville, first Earl of Warwick, Castle Howard, by 1763[1]; by descent to the fifth Earl of Warwick; London, Colnaghi's, 1898; purchased by Mrs. Gardner through Bernard Berenson, March 1898; shipped on the *Saxonia* from Liverpool, 15 October 1901.

EXHIBITIONS: London, British Institution, 1818, no. 47; London, British Institution, 1852, no. 22; Manchester, City of Manchester Art Gallery, *Art Treasures of the United Kingdom* (cat. by G. Scharf), 1857, no. 107; London, South Kensington Museum, *First Special Exhibition of National Portraits*, 1866, no. 723; London, Royal Academy, *Winter Exhibition*, 1871, no. 158; London, Royal Academy, *Winter Exhibition*, 1889, no. 169.

LITERATURE: Smith 1829-42, vol. 2 (1830), pp. 307-308, no. 1128; Waagen 1854-57, vol. 3 (1857), p. 213; T. E. J. Thoré [W. Bürger], *Trésors d'art exposés à Manchester en 1857* (Paris, 1857), p. 353; Rooses 1886-92, vol. 4 (1890), p. 128, no. 890; A. Rosenberg 1905, p. 307; H. Hymans and M. Rooses, in *Noteworthy Paintings in American Private Collections* (New York, 1907), pp. 130, 219-223 [Rooses as ca. 1629; Hymans as painted ca. 1638 from a sketch made in 1629]; M. F. S. Hervey, *The Life, Correspondence and Collections of Thomas Howard, Earl of Arundel* (Cambridge, 1921), pp. 281, 283; Oldenbourg 1921, pp. 288, 466-467 [as Portrait of Count Hendrick van den Bergh]; P. Hendy, *Catalogue of the Exhibited Paintings and Drawings in the Isabella Stewart Gardner Museum* (Boston, 1931), pp. 307-311; Goris, Held 1947, p. 27, no. 6, pls. 16, 18, 20; Magurn 1955, pp. 320-321; Burchard, d'Hulst 1963, pp. 263-264; D. Piper, *Catalogue of Seventeenth-Century Portraits in the National Portrait Gallery, 1625-1714* (Cambridge, 1963), p. 15; E. Haverkamp Begemann, S. Lawder, and C. Talbot, *Drawings from the Clark Art Institute* (New Haven and London, 1964), pp. 28-29 (under no. 22); London, The National Gallery, cat. 1970, pp. 203-205, passim; P. Hendy, *European and American Paintings in the Isabella Stewart Gardner Museum* (Boston, 1974), pp. 213-215 [possibly as late as 1638]; Huemer 1977, pp. 89-90, 94, 107-109, 110; J. Walsh, Jr., "Paintings in the Dutch Room," *Connoisseur* 198 (1978), pp. 53, 56-57; D. Howarth, *Lord Arundel and His Circle* (New Haven and London, 1985), pp. 152-153; D. Howarth, N. Penny, et al., *Patronage and Collecting in the Seventeenth Century: Thomas Howard Earl of Arundel* (exh. cat. Oxford, The Ashmolean Museum, November 1985-January 1986), p. 9, ill. cat. 1, fig. 1; White 1987, pp. 224-226; P. P. Fehl, "The Ghost of Homer: Observations on Rubens's Portrait of the Earl of Arundel," *Fenway Court* 1987, pp. 7-23; L. Stainton and C. White, *Drawing in England from Hilliard to Hogarth* (exh. cat. London, British Museum, 1987), pp. 67, 70; Liedtke et al. 1992, pp. 202-204.

DESCRIBED by Rubens as "one of the four evangelists and the supporter of our art,"[2] Thomas Howard, second Earl of Arundel and Surrey (1585-1646) was a preeminent connoisseur, arbiter of taste, patron, and collector in England during the first decades of the seventeenth century.[3] In 1606 Arundel married Alathea Talbot (d. 1654), daughter of the Earl of Shrewsbury; it was Shrewsbury who encouraged Arundel's nascent interests in classics and the arts. On his first trip to the continent in 1612, Arundel spent a month in the Southern Netherlands (where he was introduced to Rubens and other local artists) before continuing on to Italy.[4] Arundel again visited Italy in 1613-1614 in the company of the architect Inigo Jones; it was particularly during this trip that he began to acquire works for his renowned collection of drawings, paintings, antique sculpture, and inscriptions.[5]

Arundel's career as a statesman was rather less spectacular than his artistic avocations. He was made a Knight of the Garter in 1611, and in addition held the hereditary titles of Premier Earl and Earl Marshal of England (the latter title was restored to

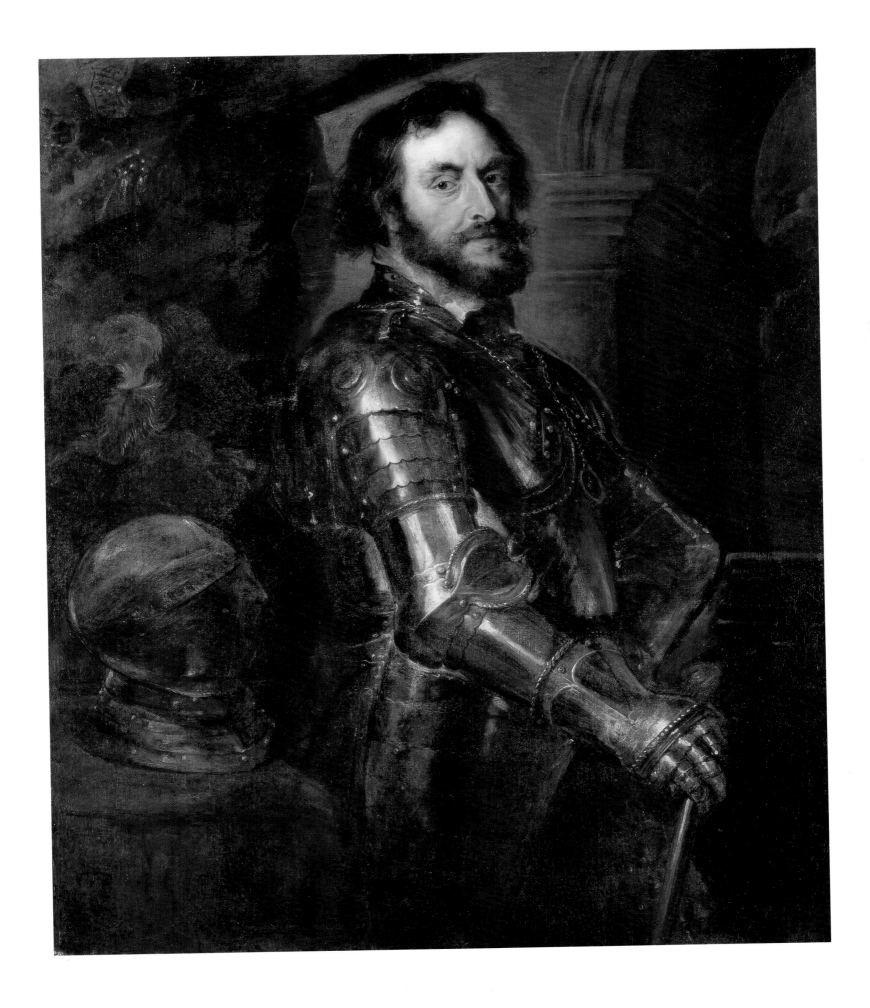

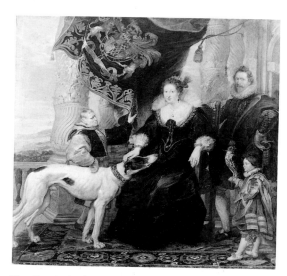

Fig. 1. Peter Paul Rubens, *Portrait of Alathea, Lady Arundel, with Her Dwarf Robin and Sir Dudley Carleton*, 1620, oil on canvas, 261 x 265 cm, Munich, Alte Pinakothek, inv. 352.

the Howard family by James I in 1621). He was ostracized from court in 1625 at the instigation of his rival George Villiers, Duke of Buckingham, but was restored to favor shortly before the latter's assassination in 1628. For the next decade Arundel served Charles I as ambassador; in 1638 he was made Captain-General of the English army against the Scots, an ill-advised appointment which resulted in humiliating failure. Arundel retired to the Netherlands in 1642, and died at Padua in 1646.

In 1620 Rubens executed a magnificent large-scale portrait of the Earl's wife, Alathea Talbot, with her dwarf Robin and Sir Dudley Carleton, a mutual friend of Rubens and the Arundels (Munich, Alte Pinakothek, inv. 352; fig. 1). From early June 1629 through March 1630 Rubens was in England to facilitate a truce between England and Spain; Arundel was also present at the negotiations, and their friendship was renewed. The two men shared a passionate interest in classical sculpture: in August 1629 Rubens wrote to Nicholas-Claude Fabri de Peiresc of seeing "at the house of the earl of Arundel an infinity of antique statues and Greek and Latin inscriptions,"[6] and Arundel's collection was certainly a model for the formation of Rubens's own collection.

In contrast to other portraits of Arundel, which emphasize his activities as a collector or various other interests,[7] the Gardner portrait depicts the sitter in his role as Earl Marshal of England. As Earl Marshal Arundel wielded enviable power; he was in effect the head of the nobility, custodian of chivalric honor and, through the Marshal's Court, had juris-

diction over rights of title. As symbol of his office Arundel holds a gold baton, and wears the "Lesser George" of the Order of the Garter suspended from a gold chain. Rubens's magnificent likeness conveys not only the cermonial pomp associated with the office of Earl Marshal, but also Arundel's innate reserve and haughty demeanor; the influence of Titian's commanding portraits of men in armor has rightly been stressed.[8] Although Rubens idealized his sitter somewhat, the accuracy of his likeness is borne out by a contemporary description of Arundel: "He was tall of Stature, and of Shape and proportion rather goodly than neat; his Countenance was Majestical and grave, his Visage long, his Eyes larges, black and piercing; he had a hooked Nose, and some Warts or Moles on his Cheeks: his Countenance was brown, his Hair thin both on his Head and Beard; he was of stately Presence and Gate, so that any Man that saw him, though in ever so ordinary habit, could not but conclude him to be a great Person...."[9]

Fehl's suggestion[10] that Rubens originally included Arundel's famed bronze head of "Homer" (now London, British Museum) behind or instead of the helmet on the table at the left of the composition is, as Liedtke points out,[11] contradicted by both iconographic and technical evidence. Such an allusion to Arundel's avocation as collector and scholar would be misplaced in a portrait that so obviously emphasizes the sitter's role as a statesman. The visual evidence for this hypothesis is far from compelling as well, and Rubens's drawing for the composition (see below, and fig. 4) clearly shows a helmet at the lower left.

The Gardner portrait of the Earl of Arundel was probably left unfinished by Rubens when he returned to Antwerp in late March 1630. The most recent cleaning of the painting (1975) has made more visible the extent of Rubens's contribution.[12] Although the head and upper body are brilliantly and fluidly executed in a manner consistent with Rubens's finest portraits of about 1630, much of the background, of the figure below the waist, and the area to the left of the figure (including the curtain and the helmet resting on the table) were only summarily sketched in by the master and subsequently completed by another hand. Highlights on the right gauntlet, the helmet, and on the armor below the waist (removed or toned down in 1975) were also added later, possibly as late as the late nineteenth century. At the same time, Rubens's original highlights on the figure's armored chest and upper arm were made more pronounced. At some point strips of canvas from another painting were added to all four sides of the original canvas, enlarging the measure-

Fig. 2. Peter Paul Rubens, *Portrait of Thomas Howard, Earl of Arundel*, 1629, oil on canvas, 68.5 x 53.3 cm, London, National Portrait Gallery, inv. 2391.

Fig. 3. Peter Paul Rubens, *Portrait of Thomas Howard, Earl of Arundel*, 1629-1630, oil on canvas, 67 x 54 cm, London, The National Gallery, inv. 2968.

Peter Paul Rubens

29. *The Peaceful Reign of King James I,* ca. 1632-1633

Oil on panel, 64.2 x 47.3 cm (25 ¼ x 18 ⅝ in.)
Vienna, Gemäldegalerie der Akademie der Bildenden Künste, inv. 628

Fig. 4. Peter Paul Rubens, *Portrait of Thomas Howard, Earl of Arundel,* brown and black ink with brown and gray wash, heightened with white and touches of red, 460 x 355 mm, Williamstown, Sterling and Francine Clark Art Institute, inv. 991.

ments to 138.3 x 116.4 cm; these strips were removed in the restoration of 1947. The area of the plumed helmet to the left of the figure has been extensively reworked; the original paint surface is abraded and little remains of Rubens's original brushstrokes.

In addition to the present painting, three other portraits of Arundel by Rubens have been ascribed to the period 1629-1630: two bust-length likenesses, one in armor (London, National Portrait Gallery, inv. 2391; fig. 2) and another in a fur-trimmed robe (London, The National Gallery, inv. 2968; fig. 3); and a vibrant ink and wash sketch in the Clark Art Institute, Williamstown (fig. 4).[13] The drawing was probably executed first, as a compositional study, followed by the more detailed studies of the sitter's physiognomy.

<div align="right">MEW</div>

1. Information recorded in an inscription on an engraving after the portrait by James Basire, included as the frontispiece to *Mamora Oxoniensia* (1763).

2. Rubens's comment was relayed to the Earl in a letter dated 17 July 1620, from Francesco Vercellini, a member of Lady Arundel's retinue. See Hervey 1921, p. 175; and Fehl 1987, p. 7, note 2.

3. On Arundel's life see Hervey 1921, and Howarth 1986.

4. On Arundel's visit to Antwerp, see Howarth 1986, pp. 33-34.

5. Arundel's activities as a collector are discussed extensively in Howarth 1985 (with further literature); see also exh. cat. Oxford 1985-86.

6. Rooses, Ruelens 1887-1909, vol. 5 (1907), p. 152; this translation from Muller 1989, p. 25.

7. Daniel Mijtens's portrait of Arundel (1618; Arundel Castle, collection of the Duke of Norfolk) shows the Earl before his sculpture gallery lined with the "Arundel Marbles"; the pendant depicts Lady Arundel before a similar corridor hung with paintings. Anthony van Dyck's double portrait of the Earl and Countess of Arundel (the so-called "Madagascar Portrait" of 1639; Arundel Castle, collection of the Duke of Norfolk) commemorates the Earl's ambitious scheme for colonizing Madagascar.

8. Compare for example Titian's *Portrait of Francesco Maria I della Rovere, Duke of Urbino,* ca. 1536-1538 (Florence, Galleria degli Uffizi, inv. 926).

9. Sir Edward Walker, "A Short View of the Life of the Most Noble and Excellent Thomas Howard Earl of Arundel and Surrey," in *Historical Discourses upon Several Occasions* (London, 1705); reprinted in Howarth 1986, p. 221. Walker was secretary to Arundel towards the end of his life.

10. Fehl 1987.

11. Liedtke et al. 1992, p. 204.

12. Notes on the conservation treatments of 1975 and 1947 are contained in the files on the painting at the Isabella Stewart Gardner Museum.

13. On Rubens's other portraits of Arundel, see Huemer 1977, pp. 83-95, 105-110; London, The National Gallery, cat. 1970, pp. 203-205; and Piper 1963, pp. 13-16. The "picture of the Earle of Arundell upon Cloth," mentioned as no. 97 in the 1640 inventory of Rubens's estate (see Muller 1989, p. 114), should probably be identified with one of the two London sketches rather than the Gardner portrait.

PROVENANCE: collection Count Anton Lamberg-Sprinzenstein, Vienna; bequeathed by him to the Akademie in 1821.

EXHIBITIONS: Paris, Stockholm, Copenhagen, London, *Kunstschätze aus Wien* (1947-49); Rotterdam 1953, no. 88; Vienna 1977, no. 48; Minneapolis/Houston/San Diego 1985, no. 29.

LITERATURE: Rooses 1886-92, vol. 3 (1890), p. 284, no. 766; Th. von Frimmel, *Geschichte der wiener Gemäldesammlungen* 4 (1901), p. 159; Oldenbourg 1921, p. 335; Eigenberger 1927, pp. 333-334; C. Janson, "L'influence de Veronèse sur Rubens," *Gazette des Beaux-Arts,* ser. 6, vol. 37 (1937), p. 27; van Puyvelde 1947, p. 39, no 6; O. Millar, "The Whitehall Ceiling," *The Burlington Magazine* 98 (1956), pp. 258ff; P. Palme, *Triumph of Peace, A Study of the Whitehall Banqueting House* (Stockholm, 1956), p. 241, pl. VI; O. Millar, *Rubens: The Whitehall Ceiling* (London, 1958), p. 17; E. Croft-Murray, *Decorative Painting in England, 1537-1837,* vol. 1 (London, 1962), p. 208; Baumstark 1974, p. 146; Björn Fredlund, *Arkitektur i Rubens Maleri* (Göteborg, 1974), p. 104; Hutter 1977, pp. 13, 20; Held 1980, vol. 1, pp. 188-189, 194-195, cat. 130, and vol. 2, pl. 134; G. S. Keyes, in Minneapolis/Houston/San Diego 1985, pp. 76, 102.

The Peaceful Reign of James I is one of fifteen sketches related to Rubens's paintings for the ceiling of the Banqueting House at Whitehall Palace in London, the only one of the artist's decorative projects to remain *in situ.* The Banqueting House was designed by Inigo Jones (1573-1652), and constructed in 1619-1622. Appended to a rambling palace extending from Whitehall to the Thames River, the Banqueting House was intended to provide a setting "for processional activities, for triumphs, masques and barriers, for public audiences, the ritual of healing, and other solemn ceremonies of state," and to function "as a stage for the display of royal might and glory."[1] Rubens's involvement with the project dates as early as 1621; in a letter to William Trumbull, English ambassador in Brussels, he states: "As for his Majesty and His Royal Highness the Prince of Wales, I shall always be very much pleased to receive the honor of their commands; and regarding the hall in the New Palace, I confess that I am, by natural instinct, better fitted to execute very large works than small curiosities. . . . My talent is such that no undertaking, however vast in size or diversified in subject, has ever surpassed my courage."[2] Rubens's confidence did not go unrewarded, and plans for the project were refined during his trip to England in 1629-1630 as special envoy to the court of Charles I. Apparently only one sketch, a preliminary design for the ceiling as a whole (fig. 1), was done in England; the remainder of the sketches and the finished canvases were done in Antwerp. Taking into account the other projects issuing from Rubens's studio during the period, Held has dated the sketches for the Whitehall ceiling to ca. 1632-1633.[3] The paintings themselves were completed by August 1634, but remained in Rubens's studio for over a year until they were sent to London in October 1635.[4] In a letter of 16 March 1636, Rubens wrote, "Inasmuch as I have a horror of courts, I sent my work to England in

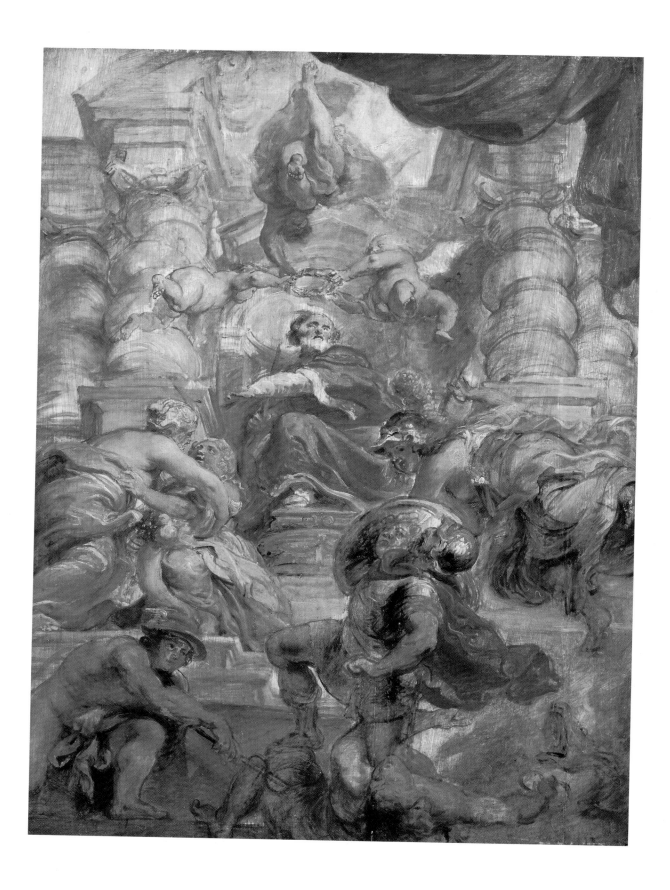

Fig. 1. Peter Paul Rubens, *The Apotheosis of James I and Other Studies*, oil on panel, 95 x 63.1 cm, Glynde Place (Sussex), collection of Mrs. Humphrey Brandt.

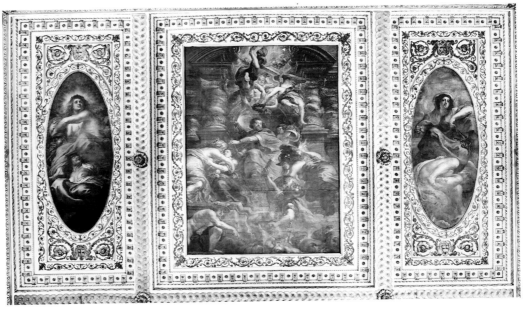

Fig. 3. Peter Paul Rubens, *The Peaceful Reign of James I*, oil on canvas, London, Whitehall, Banqueting House, south end.

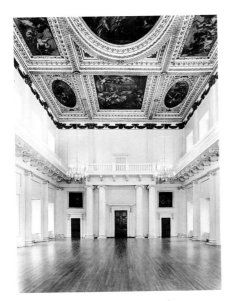

Fig. 2. Banqueting House, Whitehall, London: interior view.

the hands of someone else. It has now been put into place, and my friends write me that His Majesty is completely satisfied with it."[5]

The ceiling of the Banqueting House is divided into nine sections; the three major canvases in the center depict subjects allegorically glorifying the reign of James I and implying the exaltation of James's son Charles I, the reigning monarch (fig. 2). *The Peaceful Reign of James I* specifically champions James I as a ruler devoted to the cause of peace. Installed directly over the chair of state at the south end of the hall (directly opposite the entrance), it was meant to be the first painting seen by the visitor as he entered the hall.[6]

James I is seated on a throne in the center of the composition, flanked by twisted Solomonic columns supporting a massive entablature, which creates the illusion of a second story rising above the hall itself. Two airborne putti and a larger genius hold a wreath over the king's head. The two embracing figures to the left of the king represent Peace and Plenty; the figure just below is Mercury, brandishing his caduceus, a traditional symbol of peace. The identification of the figures to the right of the throne is somewhat more problematic, however. The two main figures are identified as Mars, the god of war, and Minerva, goddess of wisdom. Mars is victorious over the writhing figure of Discord, who has snakes in her hair and in her hand. Stepping over the

recumbent figure, Mars seeks to ascend to the king's throne, but is pushed away by the ever-vigilant Minerva. The intentions of the figures are made clearer and more forceful in the finished version of the painting (fig. 3). In the Vienna sketch, Minerva holds a lance, which is replaced in the final version by the infinitely more effective thunderbolt. The firebrand in Mars's right hand is moved directly before the king in the finished painting, and the fierce dragon at his side is increased in prominence.

The most plausible interpretation of the figures' actions is that given by Held,[7] based in part on a description of the Whitehall painting published in an eighteenth-century broadsheet: "KING JAMES the FIRST / on the THRONE Pointing to PEACE / and PLENTY Embracing MINERVA / and WISDOM Driving with a / Thunderbolt REBELLION and ENVY / into HELL and MERCURY laying them / to SLEEP with his CADUCEUS."[8] Minerva (wisdom) repulses Mars's rebellious and warlike actions, which threaten the king; the king turns sharply from the conflict on the right to welcome Peace and Plenty with open arms. Held's interpretation differs from those of Millar, d'Hulst, and Gordon in his more menacing interpretation of the figure of Mars as representing armed rebellion, and in his contention that the king's attitude should be read more as an acceptance of peace and plenty, rather than solely as expressing his disdain for war.[9] Held also

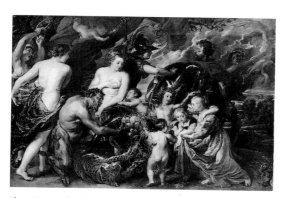

Fig. 4. Peter Paul Rubens, *Minerva Protects Pax from Mars (Peace and War)*, oil on canvas, 203.5 x 298 cm, London, The National Gallery, inv. 46.

7. Held 1980, vol. 1, pp. 193-194.

8. The broadsheet is preserved in a single copy in the Victoria and Albert Museum, London (V. & A. photo 107-1908). L. van Puyvelde ("Rubens' Glorification of James I at Whitehall," *Message* 12 [1942], pp. 38-41) was the first to recognize the importance of the sheet, which probably served as a guide for visitors to the hall in the Banqueting House.

9. For the alternative interpretations of the figures, see Millar 1958, p. 16; d'Hulst 1968, p. 105; and D. J. Gordon, "Rubens and the Whitehall Ceiling," in *The Renaissance Imagination* (Berkeley, Los Angeles, and London, 1977), pp. 41-42.

10. On the iconography of the London *Peace and War*, and Rubens's other treatments of this theme, see Baumstark 1974, especially pp. 152-162; and more recently, A. Hughes, "Naming the Unnamable: An Iconographical Problem in Rubens's 'Peace and War,'" *The Burlington Magazine* 122 (1980), pp. 157-165.

11. *Peace Embracing Plenty* (oil on panel, 62.9 x 47 cm, New Haven, Yale Center for British Art); and *Wisdom Keeping Armed Rebellion from the Throne of King James* (oil on panel, 70.5 x 85.3 cm, Brussels, Musées Royaux des Beaux-Arts de Belgique, inv. 3283).

12. Held 1980, vol. 1, p. 195.

raised the possibility that the allegorical grouping refers to a specific historical event, namely the Gunpowder Plot of 1605, which posed a serious threat to the king at the outset of his reign.

The benefits of peace and prosperity was a recurring and heartfelt preoccupation in both the artistic and diplomatic spheres of Rubens's activity. As noted earlier, Rubens had been dispatched to London in 1629 by Philip IV of Spain as a special envoy empowered to negotiate a truce that would lead ultimately to the conclusion of a treaty between England and Spain. The consequences of peace also inspired Rubens's contemporaneous *Peace and War* of 1629 (fig. 4; London, The National Gallery), painted during the artist's English visit as a gift for Charles I. The trio of Minerva, Mars, and Discord seen in *The Peaceful Reign of James I* figures also in the National Gallery painting, as Minerva drives the god of war and the furies away from Venus, goddess of peace, and her attendants.[10]

Details of the Vienna sketch are more fully worked out in two sketches in New Haven and Brussels.[11] In addition, two copies of the Vienna sketch are known: one formerly in the Gatschina Palace, Russia; and one in a private collection in the United States.[12]

MEW

1. Palme 1956, pp. 191, 120.

2. Letter of 13 September 1621. Rooses, Ruelens 1887-1909, vol. 2 (1898), p. 286; and Magurn 1955, p. 77.

3. Held 1980, vol. 1, p. 187.

4. Evers 1943, p. 83.

5. Letter of 16 March 1636, to Peiresc. Rooses, Ruelens 1887-1909, vol. 6 (1909), p. 153; Magurn 1955, p. 402.

6. On the correct placement and viewing angles of the paintings in the Whitehall ceiling, see J. S. Held, "Rubens's Glynde Sketch and the Installation of the Whitehall Ceiling," *The Burlington Magazine* 112 (1970), pp. 274-281. For a summary discussion of the Venetian sources for the Whitehall ceiling, see Held 1980, vol. 1, p. 188.

Peter Paul Rubens

30. Hercules as Heroic Virtue Overcoming Discord, ca. 1632-1633

Oil on panel, 63.7 x 48.6 cm (25 ⅛ x 19 ⅛ in.)
Boston, Museum of Fine Arts, Ernest Wadsworth
Longfellow Fund, inv. 47.1543

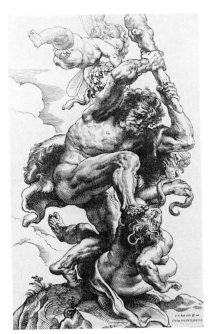

Fig. 1. Christoffel Jegher, *Hercules Slaying Discord*, woodcut, inscribed: *Christoffel Jegher sc. / C. I.* [and] *P. P. Rub. delin. et exc. / CVM PRIVILEGIIS*; Antwerp, Stedelijk Prentenkabinet, no. 19.895.

PROVENANCE: sale Fontaine-Flament (Lille), Paris, 10 June 1904, no. 67 [as attributed to Rubens; frs. 1000, to Sedelmeyer]; sale Paris (Sedelmeyer), 3-5 June 1907, no. 42, ill. [frs. 2000]; sale Marczell von Nemes, Paris (Drouot), 19 March 1919, no. 19 [as studio of Rubens; frs. 1500]; London, Thos. Agnew and Sons.

EXHIBITIONS: London, Agnew's, June 1946, no. 18; Cambridge/New York 1956, no. 42; Cambridge, MA, Fogg Art Museum, *Rubens: A Variety of Interests, In Honor of Ruth S. Magurn*, 20 May-30 June 1974; Boston, Museum of Fine Arts, *Tribute to Rubens*, 6 December 1977-26 February 1978 (no cat.).

LITERATURE: O. Millar, "The Whitehall Ceiling," *The Burlington Magazine* 98 (1956), pp. 263-264; idem, *Rubens: The Whitehall Ceiling* (London, 1958), pp. 18-19; M. L. Myers, "Rubens and the Woodcuts of Christoffel Jegher," *The Metropolitan Museum of Art Bulletin* 25 (1966), pp. 22-23; Baudouin 1977, pp. 258-259, ill.; D. J. Gordon, "Rubens and the Whitehall Ceiling," in *The Renaissance Imagination* (Berkeley, Los Angeles, and London, 1977), pp. 42-44; Held 1980, vol. 1, pp. 211-213; Boston, cat. 1985, p. 253; Liedtke et al. 1992, p. 358.

MUSCLES bulging with explosive power, the nude Hercules forces the furiously writhing body of his adversary (Discord) to the ground with a foot placed upon her head. His lion skin cape billows behind him as he prepares to deliver the decisive blow with his upraised club. Above the hero's head, a chubby putto descends to award him a leafy crown. At some time prior to the Sedelmeyer sale in 1907, the panel was much overpainted (particularly in Hercules' hair and beard) to present a more finished appearance; these alterations were removed during restoration in ca. 1946. The panel was cleaned and restored again in 1987.

Hercules as Heroic Virtue Overcoming Discord, like *The Peaceful Reign of James I* (cat. 29), is Rubens's modello for one of the nine panels that comprise the ceiling decoration of the Banqueting House at Whitehall Palace in London (see cat. 29, fig. 2).[1] Flanking the three central canvases are six ancillary scenes: four elongated ovals in the corners, depicting allegorical triumphs of virtues over vices; and in the center, processional friezes of putti. All four allegorical triumphs, as well as the putto friezes, were roughly sketched out in Rubens's original conception of the Whitehall ceiling, the bozzetto now at Glynde Place (cat. 29, fig. 1).[2] The figures developed in the Boston sketch appear within a lightly drawn oval at the lower right of the bozzetto; the group is inverted in relation to the central image, which reflects the actual orientation of the *Hercules* canvas on the ceiling itself.[3] Apart from minor shifts in the poses of the two figures, which are more steeply foreshortened in the spontaneous Glynde sketch, the only change is the addition of the hovering putto in the Boston modello. The putto was eliminated in Rubens's final version for the ceiling, but was retained in Christoffel Jegher's masterful woodcut after Rubens's design (fig. 1).[4] The slight changes between the Boston modello and Jegher's woodcut (the more vertical axis given the figures of Hercules and Discord, and the contrasting horizontal flight of

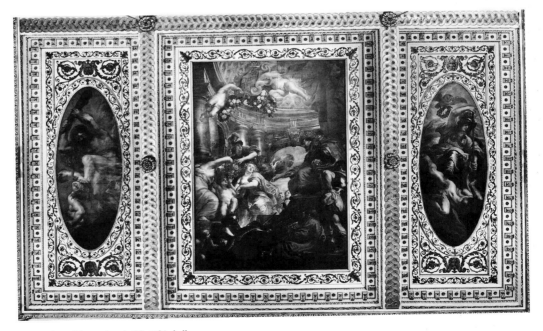

Fig. 2. A view of the south end of the Whitehall ceiling, showing *The Union of the Crowns* flanked by *Hercules as Heroic Virtue Overcoming Discord* and *Minerva (Prudence) Conquering Sedition*, London, Whitehall, Banqueting House.

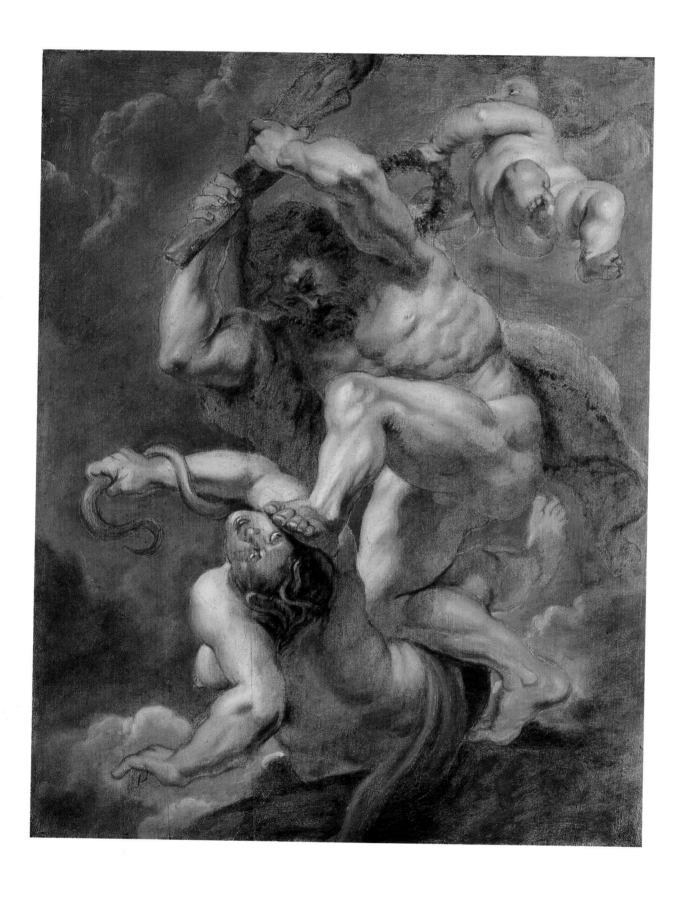

Peter Paul Rubens
31. Conversatie à la Mode ("The Garden of Love")

Oil on canvas, 198 x 283 cm (78 x 111 ½ in.)
Madrid, Museo del Prado, no. 1690

the putto, for example) reinforce the conception of the figures as an independent sculptural group.

The six subsidiary compositions in the side bays of the Whitehall ceiling complement the themes depicted in the central sections. Located to either side of *The Union of the Crowns* at the north end of the hall, *Hercules as Heroic Virtue Overcoming Discord and Minerva (Prudence) Conquering Sedition* (fig. 2) depict Hercules and Minerva as guardians warding off the evils which might threaten the reign of the young Charles I, virtues triumphant over forces detrimental to the peaceful political unity expressed in the central scene.[5] The eighteenth-century broadsheet describing the Whitehall ceiling identifies the subject of the Boston sketch as "HERCULES / Representing / Heroic Virtues / Demolishing / ENVY." The majority of scholars have indeed identified the recumbent foe as Envy,[6] although Evers and Palme identified her as Discord,[7] and Oliver Millar opted for "Envy (or Rebellion)."[8] The snakes in the crone's hair and the coiled serpent clutched in her hand are the attributes of Discord; compare Rubens's design for the *Opening of the Doors of the Temple of Janus*, one of the stages of welcome in the Pompa Introitus Ferdinandi, in which the door is dragged open by the serpent-bedecked hag Discord and Tisiphone, one of the Furies.[9] Held's identification of the figure in the sketch – and in the final painting – as Discord is convincing and appropriate in light of the thematic relationship of the scene to the central canvas.

<div align="right">MEW</div>

1. For the history of the project for the Whitehall ceiling, see cat. 29 and the further literature cited there.

2. See Millar 1956, pp. 263-264.

3. See ibid., p. 263; and J. S. Held, "Rubens's Glynde Sketch and the Installation of the Whitehall Ceiling," *The Burlington Magazine* 112 (1970), pp. 274-281.

4. On Jegher's woodcuts after Rubens, see Meyers 1966, pp. 7-23; and Renger 1975, pp. 172ff, esp. p. 180. Renger identifies the subject of Jegher's woodcut as *Hercules in Combat with Hydra*. A trial proof with corrections by Rubens is in the Bibliothèque Nationale, Paris.

5. The identification and interpretation of the four Allegorical Triumphs given by Held (1980, vol. 1, pp. 211-216) are the most reasoned in forging iconographic connections between the central and subsidiary images of the Whitehall project.

6. See the references cited in Held 1980, vol. 1, p. 212.

7. Evers 1943, p. 262; and P. Palme, *Triumph of Peace, A Study of the Whitehall Banqueting House* (Stockholm, 1956), p. 240.

8. Millar 1956, p. 263; and idem, 1958, p. 18.

9. See Held 1980, vol. 1, p. 212, and pp. 238-240, no. 161.

PROVENANCE: in the Spanish royal collection by 1666.

EXHIBITIONS: Brussels 1965, no. 217, ill.; Antwerp 1977, no. 91, ill.

LITERATURE: Rooses 1886-92, vol. 4 (1890), pp. 63-67, no. 835; A. Rosenberg 1905, no. 388; Oldenbourg 1921, no. 348; G. Glück, "Rubens Liebesgarten," *Jahrbuch der kunsthistorischen Sammlungen* 35 (1920-21), pp. 49-98; M. Eisenstadt, *Watteaus Fêtes Galantes und ihre Ursprünge* (Berlin, 1930), p. 142; Evers 1942, pp. 339-348; Burchard and d'Hulst, in exh. cat. Antwerp, *Tekeningen van P. P. Rubens*, 1956, pp. 104-105, under no. 128; Held 1959, vol. 1, pp. 153-154, under no. 152; W. Burchard, "The 'Garden of Love' by Rubens," *The Burlington Magazine* 105 (1963), pp. 428-432; Burchard, d'Hulst 1963, vol. 1, pp. 278-281, under no. 180; A. Glang-Süberkrüb, *Der Liebesgarten: eine Untersuchung über die Bedeutung der Konfiguration für das Bildthema im Spätwerk des Peter Paul Rubens* (Bern/Frankfurt, 1975); Díaz Padrón, in Madrid cat. 1975, vol. 1, pp. 280-282, no. 1690, vol. 2, pl. 184; R. Liess, *Die Kunst des Rubens* (Braunschweig/Berlin, 1977), pp. 396-409; Held 1980, vol. 1, pp. 412-413; E. Goodman, "Rubens's Conversatie à la Mode: Garden of Leisure, Fashion and Gallantry," *Art Bulletin* 64 (1982), pp. 247-259; White 1987, pp. 268-271; C. van de Velde, in Madrid, cat. 1989, pp. 168-167, cat. 54, ill.; E. Goodman, *Rubens The Garden of Love as Conversatie à la Mode* (Amsterdam/Philadelphia, 1992); M. Vidal, *Watteau's Painted Conversations: Art, Literature and Talk in Seventeenth- and Eighteenth-Century France* (New Haven and London, 1992), pp. 68-70.

SUMPTUOUSLY dressed men and women gather in a formal garden with statuary and a fountain at the side of a fairytale palace with massive portico. Two standing couples bracket the scene, converging on a group seated on the ground in the center. In the middle of this group are three women and a lutenist. At the upper right is a disarmingly anthropomorphic statue of *Venus lactans* (or *Venus alma*), seated on a dolphin (symbol of the speed and impatience of love) and spouting water from her breasts. A peacock perches on the rim of the fountain's basin, and on the steps below, a lap dog appears between the gentleman's legs. At the back is a rusticated stone garden pavilion supported by atlantids and sheltering a statue of the Three Graces. Other couples embrace beneath its arches. In the sky *amoretti* gambol with a pair of doves, a torch, a chaplet of roses, and other symbols of love, while some fire their love darts. At the lower left one of the putti playfully pushes the couple at left toward the group. Beyond a balustrade to the left the parklike landscape stretches to a distant vista.

Although the sequence of their execution is debatable, Rubens painted three versions of this composition, of which the Prado's painting is justifiably the most famous. A painting on panel at Waddesdon Manor (fig. 1) extends and elaborates the present composition with additional figures and a standing female statue (based on a bronze by Francesco di Sant'Agata) in the fountain; Wolfgang Burchard argued that this was the first version and later repainted by Rubens.[1] A larger two-part drawing in the Metropolitan Museum of Art (figs. 2 and 3) follows the Waddesdon composition more closely than the Prado design and undoubtedly served as a model for Christoffel Jegher's (two-block) woodcut after

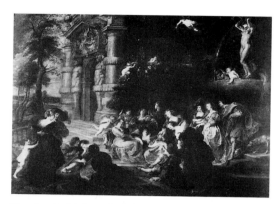

Fig. 1. Peter Paul Rubens, *The Garden of Love*, 198 x 283 cm, Buckinghamshire, Waddesdon Manor.

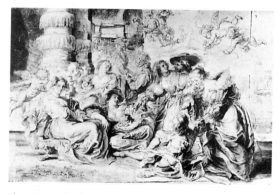

Fig. 2. Peter Paul Rubens, *The Garden of Love* (left portion), pen, brown ink, and gray-green wash over black chalk, touched with indigo, green, yellow and white paint on paper, 463 x 705 mm, New York, Metropolitan Museum of Art, inv. 58.96.1.

Fig. 3. Peter Paul Rubens, *The Garden of Love* (right portion), pen and ink over traces of black chalk, touched with white, blue, gray and green paint on paper, 463 x 705 mm, New York, Metropolitan Museum of Art, inv. 58.96.2.

Rubens of the subject.[2] In the study published in 1963 on Rubens's drawings, Burchard and d'Hulst specified the Waddesdon version as the earliest (ca. 1630-1632), the double drawing second (1632-1633), and the Prado painting later.[3] However, Glang-Süberkrüb, who offers the fullest account of the various versions, their histories, and critical assessments, rejected the Waddesdon painting as a later product of the atelier, and suggested it was perhaps by Theodoor van Thulden (q.v.).[4] Goodman did not speculate on the sequence of the two painted versions but suggested that on the basis of style the Prado picture could date as late as ca. 1634-1635.[5] Considering the Waddesdon painting's support, it may be the picture described in 1645 in Rubens's estate as "Een conversatie à la mode op paneel."[6] The greater concentration and focus of the Prado's design certainly results in the more successful painting, but not necessarily the later version.

To judge from the many preparatory drawings (all executed in a large format in black, red, and white chalk) for the individual figures in the Prado picture, Rubens took special care with the elaboration of its design. In addition to the two drawings of the entire group in New York, there exist nine elaborate studies for virtually all of the principal figures. The Louvre, for example, owns studies for the woman standing in profile on the right holding an ostrich-feather fan as well as a drapery study of the girl kneeling with her arms in the man's lap at the left.[7] The Fodor Museum (Gemeentemuseum) in Amsterdam owns four studies, including sheets for the standing woman and her solicitous partner at the left, and for the man descending the stairs on the right.[8] Since no oil sketch is known for the overall composition, Rubens seems to have relied exclusively on these unusually elaborate chalk studies to resolve the enchantingly harmonious relationships between the couples and other figures and their gloriously rich setting.

The theme of the love garden can be traced to medieval manuscript illuminations and traditional representations of the *hortus conclusus* (the enclosed garden, symbol of chastity). In the late sixteenth and early seventeenth century artists like Hans Bol and Louis de Caullery (see Introduction, fig. 62) depicted elegant figures in love gardens or anonymous park-like landscapes,[9] subjects which were also taken up by the first generation of Dutch high-life genre painters, David Vinckboons, Willem Buytewech, Esaias van de Velde, and others, who made a specialty of such *buitenpartijen*.[10] Rubens inherited these pictorial traditions as well as the perpetuation of the love garden tradition in print series such as Crispijn de

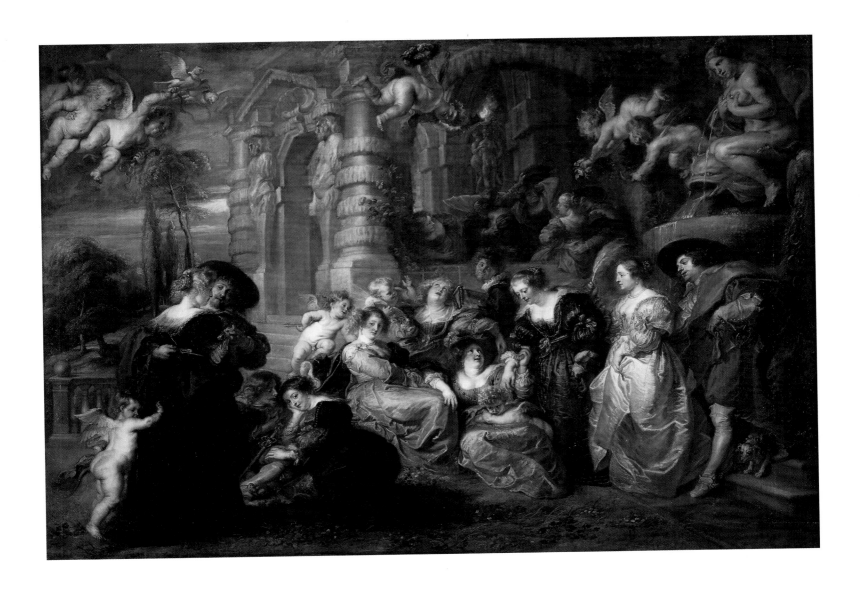

Passe's *Hortus Voluptatum* (1959).[11] His *Garden of Love* stands in this tradition just as clearly as his later *Castle in a Park* (Kunsthistorisches Museum, Vienna, no. 696, ill. Renger, fig. 8), points the way to Watteau and the rococo's *fête champêtre* and *fête galante*.[12]

Many interpretations of the painting's subject have been offered, some autobiographical. Glück assumed without foundation, for example, that the couples on the left were Rubens and his bride, and that the other figures were members of her family.[13] In truth most of the women in the painting bear a superficial generic resemblance to Hélène Fourment, though only the woman seated at the left of the central trio of women seems certain to be modeled on

her. By all accounts, Rubens had reason to rejoice in the pleasures of renewed marital love and the domestic peace that he could begin to enjoy again in the early 1630s when he wrote of being at last "at home, very contented." The present work may be compared, as Glück observed, with the *Self-Portrait with Hélène and Nicolaes in the Garden* of this period (ill. Wieseman, fig. 3). However Held and others have surely been correct in warning against a narrowly autobiographical reading of the picture.[14] More central to the painting's meaning are its allegorical dimensions and important links between the medieval love garden and anticipation of the eighteenth-century's *fête champêtre*. Noting the promi-

nence of the Venus statue on the right, Evers in 1942 stressed that the picture should be interpreted as a "Garden of Love," applying the title first given the subject in the eighteenth century, and identifying the three women in the center of the composition as the Three Graces as well as (less plausibly) claiming that they personified the senses of Hearing, Sight, and Touch.[15] The idea that the trio in the foreground are the Graces "who bestow on mankind the blessing of festive meetings,"[16] or at very least are incarnations of the mythological companions of Venus embodied in the statue beneath the portico at the back, has gained wide acceptance.[17] Details like Juno's peacock and the small yoke held by one of the putti can allude, of course, to love's bondage, marriage, and wedlock – all concepts naturally suited to love gardens. In her monographic study of the painting, Glang-Süberkrüb has proposed an elaborate interpretation of the subject as a neoplatonic allegory of love with the central women embodying the different types (sensual, earthly or human, and celestial love) as well as the progressive stages of love.[18]

Goodman has also studied the iconology of this work in depth, profitably exploring the seventeenth-century association of the titles "Conversatie à la Mode" (which in 1645 was applied to two copies of the paintings in Rubens's estate), and "Conversatie van Joffrs" ("Conversatie of Young Women"), the title given a version of the theme (probably the Waddesdon Manor painting) when it appeared in the collection of Rubens's son Albert.[19] In 1654 the Antwerp art dealer Matthijs Musson received a painting from a "Heer van Barchon" on consignment to be sold for the substantial sum of 1800 guilders and described as "een Conversasi alamode van Rubens geschildert."[20] The Dutch term "conversatie" was often used in seventeenth-century inventories to describe what we now call genre scenes, but had broader connotations than a mere conversation, being associated with social intercourse, a circle of acquaintance, and a society of friends (see Wieseman). Rubens himself used the phrases "conversatie van de jouffrouwen" in a well-known letter of 1629 to denote the society of young Antwerp ladies that his brother-in-law fancied.[21] By reviewing contemporary literature on etiquette, fashion and deportment, courtesy books, and love poetry, Goodman demonstrates that for Rubens and his contemporaries "conversatie à la mode" was an ideal of modern, which is to say fashionable seventeenth-century, social refinement, recreation, civility, and, of course, amorous daliance. Three prints after the paintings executed by Peter Clouwet in 1665 bore the titles "Venus Lusthoff," "Le Iardin de Venus," "Le Iardin des Meuses" (Muses), thus antici-

pating the eighteenth-century title "Garden of Love." The painting as a whole is interpreted in the motto of the print as symbolizing good fortune and love ("bene volentiae et auroris symbolum"). Not insignificantly, the Dutch verses on these prints seem to have been penned by the painter and amateur poet Jan Davidsz. de Heem (q.v.), who gave the figures in the scene time-honored names from love poetry (Cloris and Amant, Philis and Damon, Tirce and Florisel, and Roosemont and Clooris) and whose lyrics celebrate the eminently social ladies' amusements and the games that they play with their suitors.[22] A garden of love thus was an ideal locale for a "conversatie van joffrs." While inscriptions and prints, especially those created twenty years after an artist's death, need not document the painter's original intent, these verses express, albeit far less compellingly, ideals of coyness, coquetry, and courtship befitting the gallant gestures, flirtatious side-long glances, and tender regards shared by the couples in Rubens's masterpiece. Though arriving at different explanations than Glang-Süberkrüb, Goodman also reads the gestures and psychology of Rubens's figures as a progressive account of "love's nascence, love's declaration and acceptance, and love's fulfillment."[23]

The many copies and repetitions of Rubens's painting are listed by W. Burchard and Glang-Süberkrüb.[24]

PCS

1. Burchard, d'Hulst 1963, vol. 1, pp. 428-432. The Waddesdon painting adds another couple in the right foreground as well as a standing lady wearing a hat (based on the portrait of Hélène Fourment in the Gulbenkian collection, Lisbon).

2. For the drawings, see Held 1959, no. 152; for the prints after, see Goodman 1992, figs. 3 and 4.

3. Burchard, d'Hulst 1963, vol. 1, pp. 280-281.

4. Glang-Süberkrüb 1975, pp. 66, 93-94.

5. Goodman 1992, p. 3.

6. Antwerpsch Archievenblad 2 (1865), p. 87.

7. See Sérullez, in Paris, Musée du Louvre, Rubens, ses maîtres, ses élèves (1978), cat. nos. 25 and 26.

8. See Burchard, d'Hulst 1963, nos. 181, 184, 185. See also the studies in the museums in Berlin (Burchard, d'Hulst 1963, no. 183) and Frankfurt, and in a Dutch private collection (Glück, Haberditzl 1928, nos. 197 and 203 respectively).

9. See Legrand 1963, pp. 76-84.

10. See Philadelphia/Berlin/London 1984, pp. xxiv-xxx.

11. Daniel Franken, L'œuvre gravé des van de Passe (Amsterdam/Paris, 1981), no. 1337.

12. See especially O. T. Banks, Watteau and the North: Studies in the Dutch and Flemish Baroque Influences on French Rococo Paintings (New York/London, 1977), esp. pp. 218-227. On the conversatie and fête champêtre in Watteau's art, see now M. Vidal, Watteau's Painted Conversations: Art, Literature, and Talk in Seventeenth- and Eighteenth-Century France (New Haven and London, 1992).

13. Glück 1920-21, pp. 96-98. See also Eisenstadt 1930, p. 142.

14. Held 1980, vol. 1, p. 400; Goodman 1992, p. 3.

15. Evers 1942, pp. 339-348.

16. Antwerp 1977, p. 91.

17. Held 1980, vol. 1, p. 412.

18. Glang-Süberkrüb 1975, pp. 15ff; for critical appraisals, see R. Liess, *Die Kunst des Rubens* (Braunschweig) Berlin 1977, pp. 396ff, and Goodman 1992, pp. 4-5.

19. See Goodman 1992, pp. 6ff, note 17. On the estate references see Denucé 1932, pp. 77, 78; Glang-Süberkrüb 1975, pp. 82-83.

20. Denucé 1949.

21. Letter of 23 November 1629 to Jan Caspar Gevaerts (Gevartius); Rooses, Ruelens 1887-1909, vol. 5 (1907), p. 239; Magurn 1955, p. 350.

22. For the prints, see Voorhelm Schneevoogt 1873, p. 149, no. 110; Hollstein 1949-, vol. 4, p. 173, no. 2; for the full inscriptions and translations, see Goodman 1992, pp. 78-81, notes 290 and 293.

23. Goodman 1992, p. 83.

24. Burchard, d'Hulst 1963, p. 432; Glang-Süberkrüb 1975.

Peter Paul Rubens
32. *The Crowning of Saint Catherine*, 1631 (1633?)

Oil on canvas, 265.8 x 214.3 cm (104 ⅝ x 84 ⅛ in.)
Toledo, The Toledo Museum of Art, 50.272

PROVENANCE: Church of the Augustinians, Mechelen, 1631 (1633?)-1765; collection Gabriel-François-Joseph de Verhulst, Brussels, 1765; his sale, Brussels (de Neck), 16 August 1779, no. 43; collection Dukes of Rutland, Belvoir Castle, Leicestershire, 1779-1911; dealer Francis Kleinberger, Paris, 1911-1912; collection Leopold Koppel, Berlin, 1912-1933; collection Albert Koppel, Berlin, 1933-1950.

EXHIBITIONS: Berlin, Königlichen Akademie der Kunst, *Austellung von Werken alter Kunst*, 1914, no. 139.

LITERATURE: Nicolas de Tombeur, *Provincia Belgica ordinis F. F. Eeremitarum, S. P. N. Augustini* (Louvain, n. d. [ca. 1723-27]), p. 118 (Stadsarchief Mechelen, MS. 5); Mensaert 1763, p. 175; Descamps 1769, p. 122; Michel 1771, pp. 152ff; J. F. Mols, *Pièces justicatives pour l'état des tableaux de Pierre Paul Rubens existant en Europe–1776 Tomus tertius*, fols. 56-57 (Bibliothèque Royal de Belgique, MS 5736); *Catalogue de Tableaux, Vendus à Bruxelles, depuis l'année 1773* (Brussels, [1803]), pp. 233ff; Sir Joshua Reynolds, "A Journey to Flanders and Holland in the Year 1781," *The Works of Sir Joshua Reynolds, Knight* (ed. E. Malone) (Edinburgh, 1867), pp. 177-178; Smith 1829-42, vol. 2 (1830), p. 47, no. 134, vol. 9 (1842), p. 245, no. 57; A. van Hasselt, *Histoire de P.-P. Rubens* (Brussels, 1840), p. 112; Waagen 1854-57 vol. 3 (1854), p. 399; Canon J. Schoeffer, *Historische Aanteekeningen Mechelen* (Mechelen, 1858), vol. 2, p. 509 (Stadsarchief Mechelen, MS. M 3014/vol. 2 [a]); T. Lejeune, *Guide de L'Amateur de Tableaux* (1864), vol. 2, p. 334; Rooses 1886-92, vol. 2 (1888), pp. 236-238, no. 400, pl. 139 (engraving by Pieter de Jode the Elder), vol. 5 (1892), p. 432; L. Gauchez, "Rubens en Angleterre," in *P. P. Rubens, sa Vie et ses Œuvres* (Paris, n.d. [ca. 1900]), p. 176; Lady V. Manners, "Notes on Pictures at Belvoir Castle," *Connoisseur* 6 (1903), p. 71; Rooses 1904, vol. 2, p. 541; E. Plietzsch, "Die Ausstellung von Werken alter Kunst in der Berliner Kgl. Academie der Künste," *Zeitschrift für bildende Kunst* 25 (1914), p. 229, ill.; Oldenbourg 1921, p. 343; Glück, Haberditzl 1928, p. 58; Ministry of the Interior, *Verzeichnis der National wertvollen Kunstwerke* (Berlin, 1927), no. 159, p. 9; G. Glück, in Thieme, Becker 1907-50, vol. 29 (1935), p. 143; Evers 1942, p. 501 note 354; idem, 1944, p. 79; *Toledo Museum News* 130 (1951), ill.; *Art Quarterly* 15, no. 3 (1952), pp. 262-263, ill.; van Puyvelde 1952, pp. 155, 214 notes 184-185, detail ill. opp. p. 146; J. Held, "Rubens in America," *Art Digest* 28 (1954), p. 13, 34-35, ill. p. 12; J. Jacob, "'A Holy Family' and Other Related Pictures by P. P. Rubens," *Jaarboek van het Koninklijk Museum voor Schone Kunsten, Antwerpen* (1954-60), p. 15, fig. 7; Gerson, ter Kuile 1960, pp. 104-105; J. Jacob, "The Liverpool Rubens and Other Related Pictures," *Liverpool Bulletin* 9, no. 3 (1960-61), pp. 20-21, fig. 10; Burchard, d'Hulst 1963, pp. 267-269, 288-291, 307-309; M. Jaffé, "Rubens," in *Encyclopedia of World Art* (New York, 1966), vol. 12, p. 595; O. Wittmann, "The Golden Age in the Netherlands," *Apollo* 86 (1967), p. 467, color pl. 14, p. 471; Vlieghe 1972-73, vol. 2 (1973), p. 88; A. Glang-Süberkrüb, *Der Liebesgarten. Eine Untersuchung über die Bedeutung der Konfiguration für das Bildthema im Spätwerk des P. P. Rubens* (Kieler Kunsthistorische Studien, vol. 6) (Bern/Frankfurt a. M., 1975), p. 116 note 23; Toledo, cat. 1976, pp. 146-147, color pl. 6; Jaffé 1977, pp. 42, 110; Baudouin 1977, p. 333, color pl. 84; O. von Simson, "Das letzte Altarbild von Peter Paul Rubens," *Zeitschrift des deutschen Vereins für Kunstwissenschaft* 37 (1983), p. 66, fig. 3; New York, Metropolitan, cat. 1984, vol. 1, p. 183 note 11; U. Söding, *Das Grabbild des Peter Paul Rubens in der Jakobs-Kirche zu Antwerpen* (Hildesheim, 1986), pp. 99-100, 106-107, 115-116, 118, 129, 135-136, 153, 243 notes 266 and 269, p. 247 note 290, pl. 41; White 1987, p. 242; C. Scribner III, *Peter Paul Rubens* (New York, 1989), p. 126; D. Freedberg, in Liedtke et al. 1992, pp. 208-210, ill.

THOUGH critical opinion of the Toledo Rubens has been essentially unanimous in deeming it a superior example of the artist's late style, "entirely by Rubens himself," as Burchard and others have noted,[1] justifiable uncertainty remains concerning its exact dating, and the very identification of its subject has been debated – unnecessarily – in the recent literature. Multiple documents attest to Rubens's having painted an altarpiece for the church of the Augustinians in Mechelen (Malines), which, due to its subsequent uninterrupted provenance, can be demon-

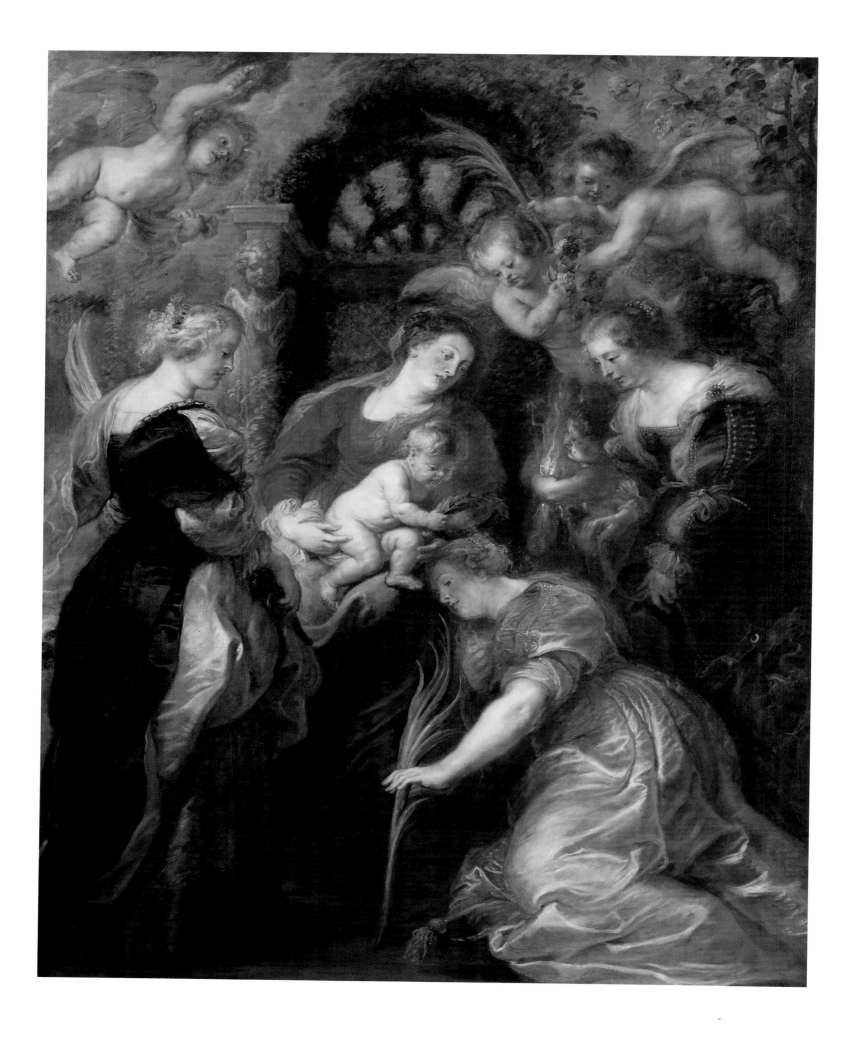

strated to be the present work. In 1952 van Puyvelde called attention to the late eighteenth-century writings of J. F. Mols, who recorded locating a document in the registers of the Augustinians in Mechelen, asserting that Rubens received 620 florins for the work delivered to their church in 1631, paid in part from alms raised for this purpose, and in part by donation of 100 florins from the Corporation of Tanners.[2] Seemingly unaware of Mols's discovery, Rooses in 1886-92 had published Nicolas de Tombeur's early eighteenth-century claim that it was in 1633 that Rubens painted a picture for the altar of St. Barbara in the Augustinian church in Mechelen for a fee of 620 florins; de Tombeur also observed that the Tanners contributed 100 florins towards the cost.[3] Whereas the de Tombeur/Rooses date of 1633 has been generally adopted for the Toledo canvas, thus apparently postdating the *St. Ildefonso Triptych* (see Freedberg, fig. 5), which was installed in Brussels in February 1632, the existing documentary evidence would seem to support a date of 1631.

The circumstances and context in which the Toledo Rubens was displayed in Mechelen may be pieced together from a number of sources.[4] The Church of the Augustinians, erected in 1609 on the location of an earlier church torn down in 1580, was Tuscan in style, having a side aisle on the north and a cloister abutting it on the south. On the main altar stood a triptych depicting the Crucifixion, painted in 1607 by Ambrosius Francken.[5] The church had three other altars, one at the front of the side aisle, dedicated to Nicolas of Tolentino, and two others to the left and right of the rood screen before the choir. That at the left was dedicated to the Virgin and displayed a *Purification of the Virgin* by Cornelis Schut, now in Antwerp, the dimensions of which are almost identical to those of the Toledo canvas.[6] Rubens's *Crowning of St. Catherine* was installed above the altar to the right. As noted above, the records of the Tanners guild and de Tombeur refer to the Rubens as displayed over the altar dedicated to St. Barbara. Schoeffer in 1858 describes it as the altar of St. Apollonia.[7]

In 1765 the Augustinian fathers sold the painting to the Chevalier de Verhulst, a collector in Brussels, for 9,500 florins and wine valued at 120 florins. At the sale of Verhulst's famous collection in 1779 the picture was acquired for the fourth Duke of Rutland, whose agent informed the new owner only days after the purchase, "I have the greatest satisfaction, my dear Lord, in being able to acquaint you that at Verhulst's sale on Wednesday last, his celebrated Rubens was knocked down to you for 12,000 florins."[8] Sir Joshua Reynolds, who played a significant role in forming the duke's collection, would write of it two

years later as, "the famous picture by Rubens."[9] The painting remained at Belvoir Castle until 1911, at which time it passed through Kleinberger in Paris and was sold on the advice of Wilhelm Bode to the Berlin collector Leopold Koppel, at whose death in 1933 it was inherited by his son. Hermann Göring subsequently appropriated the work, which was discovered after the Second World War in a salt mine near Salzburg. Restored to its proper owner, the painting then entered Toledo's collection in 1950.

As noted by Mensaert, who in 1763 was writing while Rubens's painting was still in Mechelen, the dramatis personae of the altarpiece are the Virgin Mary seated on a foliated throne, and on her lap the infant Christ, who is shown in the act of placing a laurel crown on the head of the kneeling St. Catherine (fig. 1), with St. Apollonia at the left, and St. Margaret at the right.[10] The author of the 1779 Verhulst sale catalogue was the first to correctly identify the subject as *The Crowning of Saint Catherine*, a specific designation maintained by Waagen, Schoeffer, Rooses, Burchard, Jacob, Wittmann, Baudouin, White, Scribner, and Freedberg.[11] Since Smith's interpretation of the picture in 1830 as "The Marriage of St. Catherine," many writers have persisted in calling it by this title or its variant, "The Mystic Marriage of St. Catherine."[12] The confusion in part can be accounted for by the fact that the visionary scene Rubens portrays here has no exact literary foundation. Rather, it is an instance of creative genius taking liberty with a text to create a new iconographic program.

The canonical image of The Mystic Marriage of St. Catherine derives from Jacobus de Voragine's *Golden Legend* (ca. 1275), with which Rubens was certainly familiar. There one reads that in Alexandria in ca. A.D. 300 the erudite young Egyptian queen converted to Christianity, was baptized, and thereafter experienced a mystical vision in which the Christ Child married her: "in token of this [he] set a ring on her finger."[13] Because Catherine then refused the advances of the emperor Maxentius, she was tortured on a set of four spiked wheels that were miraculously destroyed by a thunderbolt. Ultimately, she was martyred by decapitation. In the painting, the radiating spokes of the trellis above the Virgin doubtless allude to Catherine's usual attribute, the wheel.[14] Rubens's crowning of the saint conveys the same metaphor of divine matrimony to God that the more often depicted bestowal of the ring does, and thus evokes the theological concepts inherent in the more traditional iconography of the Mystic Marriage. His deviation from that iconography, however, would seem to place greater significance on Cather-

ine's martyrdom, indeed martyrdom in general, a not uncommon concept within Rubens's œuvre and Counter Reformation imagery as a whole.[15] Rubens would have known the two passages in de Voragine's story of Catherine which mention a crown: the first when Catherine defiantly tells the emperor that Christ alone "shall be my reward, for he is the hope and crown of them that fight for him"; and the second when she converted Maxentius's wife by promising that "the crown of martyrdom" would be hers.[16] It is enticing to speculate that a later passage provided inspiration to Rubens: "Christ appeared to her with a great multitude of angels and virgins, and said to her: Daughter, know thy maker, for whom thou hast emprised this travallous battle; be thou constant, for I am with thee.[17]

Rubens frequently painted St. Catherine, either alone, or paired – significantly for our purposes – with St. Barbara. He also represented various scenes from her life, such as the Mystic Marriage, her martyrdom, angels transporting her body, and her entombment.[18] On one previous occasion Rubens depicted St. Catherine being crowned, albeit by an angel, on the exterior of the right wing of his *Raising of the Cross* of 1610-1611, executed for the Church of St. Walpurgis in Antwerp.[19] Rubens's most famous depiction of her remains his monumental work of 1628 painted for the high altar of the Augustinian Church in Antwerp. There the kneeling saint kisses the outstretched hand of the infant Christ standing on the lap of the Virgin, a subject no less novel than that encountered in the canvas executed for the Augustinian Church in Mechelen.[20]

At the left in the work now in Toledo stands St. Apollonia, a third-century virgin martyr also of Alexandria. She bears a palm branch in her left hand and clutches pincers in her right, a symbol of the torture she endured by having her teeth extracted. Her end came when she leapt into a fire.[21] St. Margaret, holding a demonic dragon on a leash, looks on at right (fig. 2). For not acquiescing to a marriage proposal from Olybrius, governor of Antioch, she was imprisoned and devoured by Satan in the form of a dragon. Her cross induced the beast to burst, releasing her unscathed. Like St. Catherine, with whom she is often depicted, she was eventually beheaded.[22] Three putti flutter above strewing flowers, offering a floral crown, and holding aloft a palm branch. A fourth appears between Sts. Catherine and Margaret clutching lightning bolts and flames, an allusion certainly to the destruction of Catherine's wheel of torture, but possibly also to Apollonia's death, as well as to an episode in the life of a fourth saint associated with Rubens's painting – St. Barbara.[23]

As discussed above, the Toledo Rubens was originally installed as part of an altarpiece dedicated to St. Barbara. Her omission from Rubens's work is therefore initially surprising and has even induced some to consider the figure kneeling before the Christ Child as St. Barbara.[24] An unpublished explanation put forth by Burchard might well hold the key to this seeming anomaly. Noting that St. Barbara, a third-century virgin martyr from Asia Minor, is seldom represented without St. Catherine, and, moreover, is often also paired with St. Margaret, Burchard hypothesized that *The Crowning of St. Catherine* by Rubens must have fit into the structure of the entire altarpiece in such a way that it was surmounted by a sculptural representation of St. Barbara. "On this assumption," Burchard wrote, "the altar, which was dedicated to St. Barbara, had for its subject the so-called 'Virgo inter Virgines,' the Holy Virgin surrounded by the maiden-saints and martyrs Barbara, Catherine, Apollonia, and Margaret."[25] Parallels for such multimedia iconographic ensembles are readily found within Rubens's œuvre and often involve his own designs for sculpture.[26] In addition, we have Rubens's own words on the subject, including his desire for his own burial chapel: [Rubens's] "painting of the Holy Virgin and child surrounded by saints, accompanied by an image of the Holy Virgin in marble."[27]

One further dimension merits consideration in a discussion of the iconography of Rubens's *Crowning of Saint Catherine* – the degree to which aspects of Rubens's life may have influenced the representation. To begin with, the setting, symbolic of the celestial paradise,[28] could have been inspired by Rubens's own garden architecture (see Introduction, figs. 15 and 16). A comparable background, including a balustrade vaguely reminiscent of the radiating trellis found in the Toledo canvas, is encountered in his *Self-Portrait with His Wife Hélène Fourment and Their Son Peter Paul* of ca. 1639.[29] Secondly, Hélène, age sixteen at their marriage in December 1630, was probably the model for both Catherine (fig. 1) and Margaret (fig. 2), her features easily recognizable from Rubens's numerous portraits of her. It may even not be too far-fetched to find a further reference to his wife. While Rubens was engaged with this canvas, Hélène was approximately the same age as St. Catherine, the patron saint of young girls, at the time of her martyrdom. So too, St. Margaret might have had personal relevance to the couple: she was the patron saint of women in childbirth, and in January 1632 Hélène gave birth to a daughter, Clara Joanna, followed in July 1633 by the birth of a son, Frans.[30]

Fig. 1 Peter Paul Rubens, *The Crowning of St. Catherine*, detail of St. Catherine.

Fig. 2 Peter Paul Rubens, *The Crowning of St. Catherine*, detail of St. Margaret.

Fig. 3 Peter Paul Rubens, *Studies for a 'Coronation of St. Catherine'*, pen and ink on paper, 258 x 418 mm, Rotterdam, Museum Boymans-van Beuningen.

Fig. 4 Peter Paul Rubens, *Head, Left Arm, and Right Hand of a Woman*, black, red, and white chalk on paper, 244 x 393 mm, Stockholm, Nationalmuseum.

Though no modello for the painting is known, a number of drawings have been preserved that relate to the Toledo painting. A rapidly executed series of pen sketches on a single sheet may record Rubens's first thoughts about the composition (fig. 3).[31] A chalk study for St. Catherine's head, left arm, and right hand exists (fig. 4), and her pose is adapted from two drawings that also relate to Rubens's *Garden of Love* (see cat. 31).[32] For the figures of the Virgin, St. Apollonia, and St. Margaret studies have been identified which also are related to both the *St. Ildefonso Triptych* (ill. Freedberg, fig. 5) and *Garden of Love*, contemporaneous undertakings whose compositions, particularly that of the former, are inextricably linked to *The Crowning of St. Catherine*.[33] The Toledo picture exhibits numerous pentimenti, the most noticeable of which are the raising of St. Catherine's left hand, and the repositioning of drapery folds on both the Virgin's and St. Apollonia's garments.

LWN

1. Letter of 13 March 1950 preserved in the Toledo Museum's files. Prior to its initial public exhibition in Berlin in 1914 when the painting became more widely known, only a solitary voice of condemnation is to be heard, that of Gauchez (ca. 1900). Recently Glang-Süberkrüb (1975) has incomprehensibly rejected the work as autograph, and Söding (1986, p. 136), while begrudgingly accepting it, unaccountably labels it "ein Pasticcio aus Rubens-Figuren."

2. Van Puyvelde 1952, p. 155, and p. 214, note 185. Mols 1776, MS 5736, fols. 56-57; "1631 Suivant les registres des R. R. P. P. Augustins de Malines le *Couronnement de Ste Catherine*, autrefois, dans leur Eglise a été achevé et placé en 1631 pour lequel Rubens reçu six cent vint florins, qu'ils payèrent en partie des aumones qu'ils recueillerent à cet effet et pour lequel le corps de Métiers des *Tanneurs* donna £100." The document(s) to which Mols refers have to date not been located.

3. For de Tombeur (ca. 1723-27), see Rooses 1886-92, vol. 2 (1888), p. 237 note 1. Records of the Tanners Guild list the payment as having been made in two installments of fifty florins each in the years 1633 and 1635. For a transcription of the payments, the first of which makes reference to the St. Barbara altar, see ibid., p. 237 note 2.

4. See de Tombeur (ca. 1723-27), Mensaert 1763, Descamps 1769, Michel 1771, and Schoeffer 1858.

5. Schoeffer (1858, p. 508) states that he was unable to ascertain if *The Crucifixion* was by Francken or Coxcie. It was replaced in 1693 by a *Magdalene Washing the Feet of Christ* by Erasmus Quellinus the Younger. The Quellinus would seem to be lost; it is not cited in de Bruyn 1988. Descamps (1769, p. 122) also mentions a *St. Augustine Washing the Feet of Our Lord* by Rombouts as displayed on the right of the main altar in some manner.

6. Oil on canvas, 257 x 200 cm, Antwerp Koninklijk Museum voor Schone Kunsten, inv. no. 328, see G. Wilmers, "The Paintings of Cornelis Schut (1579-1655)" (Ph.D. diss., Columbia University, 1991), pp. 190-193, no. A14, pl. A14. Wilmers dates the Schut in the early 1630s, and it is therefore not unlikely that it and the Rubens were commissioned simultaneously.

7. This apparent change in dedication presumably accounts for Rooses's unfounded statement (1886-92, vol. 2 [1888], p. 237) that the Rubens was transferred to the altar of St. Apollonia. While still in Mechelen, the picture was copied by Fragonard in a drawing still today in the Louvre (inv. RFF. 3726663; ill. Introduction, fig. 104); see J. Guiffrey and P. Marcel, *Inventaire général des Dessins du Musée du Louvre et du Musée de Versailles: Ecole française* (Paris, 1910), vol. 6, p. 103, ill.; and P. Cabanne, *Fragonard* (Paris, 1987), p. 36, ill. (in both erroneously as *Le Couronnement de Sainte Marguerite*).

8. Alleyne Fitzherbert to the Duke of Rutland, 20 August 1779; see *Historical Manuscripts Commission, 14th Report, Appendix Part I: The Manuscripts of the Duke of Rutland, Preserved at Belvoir Castle*, vol. 3 (London, 1897), p. 20.

9. Reynolds 1867, pp. 177-178. He nonetheless added a saint and confused the name of another: "St. Catherine, St. Agnes, Christine, Marguerite, and other female Saints."

10. Mensaert 1763, p. 175. Descamps (1769, p. 122), who remembered that he had seen Rubens's picture when it was in Mechelen, identifies the figures as the Virgin, the Christ Child, St. Catherine, "et d'autres Saints," which Michel (1771) maintained.

11. See Literature; for Burchard, see discussion below. The inscription on Pieter de Jode the Elder's engraved copy of ca. 1640 (Voorhelm Schneevoogt 1873, no. 36 [other copies nos. 37-39]), had also appropriately recorded the subject (in translation): "Christ solemnly places a crown on the head of the virgin Catherine, a friend of His mother's."

12. Smith's (1830, p. 47) description reads: "The Marriage of St. Catherine. The Virgin is represented placing a ring on the finger of St. Catherine, who is prostrate at her feet; St. Agnes, St. Christina, St. Margaret, and other female saints, are in the composition . . ." Smith (1842, p. 245), while correcting himself by noting Christ crowns St. Catherine, still mistakenly records the other saints.

13. Jacobus de Voragine, *Legenda Aurea*, transcribed from *The Golden Legend or Lives of the Saints as Englished by William Caxton* (London, 1900), vol. 7, pp. 14-15. For St. Catherine, see D. H. Farmer, *The Oxford Dictionary of Saints* (Oxford, 1978), pp. 69-70; and J. Hall, *Dictionary of Subjects and Symbols in Art* (London, 1975), pp. 58-59.

14. See Jaffé 1977, p. 42, who suggests the pergola setting may have been a tribute to Mantegna's *Madonna della Vittoria*, today in the Louvre, but known to Rubens from his stay in Mantua. A painted copy of *The Crowning of St. Catherine*, oil on copper, 53 x 40 cm, formerly in Dresden (Gemäldegalerie Alte Meister, no. 998B) clearly deriving from de Jode's engraving (see note 11) but rendered in the original direction, curiously includes a broken wheel in the foreground. Another copy, by J. A. Beschey, panel, 13 ½ x 7 ¾ in., is in a private collection.

15. In this regard, it is highly plausible that the prominent position of St. Catherine's palm in the picture's lower center had the dual function of suggesting the saint's martyrdom *and* that possibly called for by the onlooker gazing up at the canvas elevated above the altar.

16. De Voragine/Caxton 1900, vol. 7, pp. 20 and 22.

17. Ibid., vol. 7, p. 22.

18. Vlieghe 1972-73, nos. 74, 75, 68, 69, 76, 77, 78, and 79, respectively. Gerson and ter Kuile (1960, p. 104) state that within the *St. Ildefonso Triptych* the saints to the left of the Virgin can be identified as Barbara and Catherine, but Vlieghe (1972-73, vol. 2, p. 83) remarks that the pair, as well as the pair to the right of the Virgin, are unidentifiable.

19. Oldenbourg 1921, p. 36. In Rubens's preparatory oil sketch in the Dulwich College Picture Gallery, London (Held, 1980, no. 350B), the single putto's crowning of St. Catherine renders the activity more pronounced than in the final composition.

20. Oldenbourg 1921, p. 305. Vlieghe (1972-73, vol. 2, pp. 25 and 88) refers to the Antwerp painting as *The Madonna Adored by the Saints* and that in Toledo as *The Holy Virgin and Child Adored by Saints*; see also Baudouin 1977, p. 201.

21. For St. Apollonia, see Farmer 1978, pp. 20-21; and Hall 1975, p. 29. The patron saint of dentists, her story is not found in de Voragine's *Golden Legend*. She appears near St. Catherine in Rubens's 1628 altarpiece for the Antwerp Augustinian Church (see note 20).

22. De Voraigne/Caxton 1900, vol. 4, pp. 66-72. For St. Margaret, see Farmer 1978, pp. 260-261; and Hall 1975, p. 194.

23. The story of St. Barbara is found in de Voraigne/Caxton 1900, vol. 6, pp. 198-205. The daughter of a nobleman named Dioscurus, she was first sequestered in a tower by her father to remove her from her suitors. Subsequently when attempting to behead her, he was struck by lightning. For St. Barbara, see Farmer 1978, p. 28; and Hall 1975, pp. 40-41.

24. Van Puyvelde 1952; von Simson 1983; and Söding 1986.

25. See note 1.

26. See, for example, his program, in collaboration with the architect Brother Peter Huyssens, for the high altar of the Antwerp Jesuit Church (now St. Charles Borromeo). There displayed alternately was originally Rubens's *Miracles of St. Ignatius Loyola* or *Miracles of St. Francis Xavier*, above which was Hans van Mildert's *Enthroned Madonna and Child*, a sculpture designed by Rubens; see F. Baudouin, "Altars and Altarpieces before 1620," in Princeton, 1972, pp. 85-91. For a differing interpretation of the relevant sketch, see Held 1980, no. 395, pp. 532-533.

27. "Eene schilderye van onse Lieve Vrouwe met het Kindeken Jhesu op haren arm, vergeselschapt met verscheyden Heyligen etc, ende noch een beldt von O. L. V. van marmeren steen" (transcribed from von Simson 1983, p. 61 note 2); the picture described is Rubens's *Virgin and Child with Saints*, St. Jacobskerk, Antwerp. In a letter of 19 March 1614, Rubens writes concerning another project that it was necessary for him to put "considerable effort into drawing up the plan for the entire work, as much for the marble ornamentation as for the picture" (transcribed from Baudouin 1972, p. 73). For a discussion of the problem, see ibid., pp. 45-92.

28. Scribner 1989, p. 126.

29. New York, The Metropolitan Museum of Art, no. 1981.238; New York, Metropolitan, cat. 1984, vol. 1, pp. 176-187.

30. Rubens and Hélène had three more children: Isabella Helena in May 1635, Peter Paul in March 1637, and Constantina Albertina in February

1641. That St. Apollonia's countenance appears to derive from a different model may have its explanation in the fact that, though regularly depicted by artists as a beautiful maiden, her story describes her as an aged deaconess at the time of her martyrdom (Farmer, 1978, pp. 20-21), an unflattering circumstance that would not have been missed by Rubens.

31. Burchard, d'Hulst 1963, no. 194 verso.

32. Ibid., nos. 186, 180, and 184 respectively.

33. Ibid., nos. 174 and 187; and Glück, Haberditzl 1928, nos. 197 and 203, respectively. Yet another instance of the interrelation between the Toledo and Madrid pictures is the heretofore seemingly unnoticed replication of a putto in the upper left corners of both works.

Peter Paul Rubens

33. *Neptune Calming the Tempest (The Cardinal Infante Ferdinand Voyaging from Barcelona to Genoa)*, 1635

(before 9 February)

Oil on panel, 49 x 64 cm (19¼ x 25¼ in.)
Cambridge, Massachusetts, Harvard University Art
Museums, Fogg Art Museum, 1942.174

PROVENANCE: sale London (Prestage and Hobbs), 20 February 1761, no. 73 [£25]; sale Duke of Grafton, London (Christie's), 13 July 1923, no. 141; sale Martin Steinberg, Amsterdam (F. Muller), 25 October 1932, no. 512; Siegfried Kramarsky, Amsterdam and New York; acquired by the Museum in 1942, purchased from Alpheus Hyatt Fund.

EXHIBITIONS: London, Royal Academy, 1882, no. 217; Amsterdam, Galerie Goudstikker, *Rubens-Tentoonstelling*, 1933, no. 39, ill.; Brussels, *Equisses de Rubens*, 1937, no. 91, ill.; Rotterdam, Museum Boymans, *Meesterwerken uit vier eeuwen, 1400-1800*, 25 June-15 October 1938, no. 178, ill.; New York, Wildenstein Gallery, *A Loan Exhibition of Rubens*, 20 February-31 March 1951, no. 28; Cambridge/New York 1956, no. 43, ill.; New York, Wildenstein Gallery, *Gods and Heroes. Baroque Images of Antiquity*, 30 October 1968-4 January 1969, no. 46, ill.

LITERATURE: Smith 1829-42, vol. 2 (1830), p. 85, no. 91; Rooses 1886-92, vol. 3 (1890), p. 297, under no. 774; van Puyvelde 1940a, pp. 90-91, no. 90; J. Rosenberg, "Rubens' Sketch for *The Wrath of Neptune*," *The Bulletin of the Fogg Museum of Art* 10, no. 1 (1942), pp. 5-14, ill.; Goris, Held 1947, p. 40, no. 87; Martin 1972, pp. 53, 55-56, no. 3a, figs. 8 and 9; M. Meiss, "Raphael's Mechanized Seashell. Notes on a Myth, Technology and Iconographic Tradition," *Gatherings in Honor of Dorothy E. Miner* (Baltimore, 1974), p. 330, fig. 22; Held 1980, vol. 1, pp. 227-228, color pl. 20, vol. 2, pl. 156; Dresden, Gemäldegalerie Alte Meister, *Katalog der ausgestellten Werke* (1985), p. 287; K. A. Mortimer, *Harvard University Art Museums. A Guide to the Collections* (New York, 1986), p. 164, no. 187, ill.; C. van de Velde, in Liedtke et al. 1992, pp. 206-207, ill.

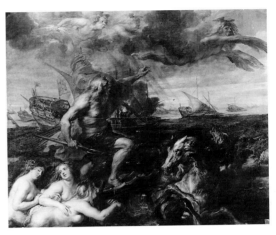

Fig. 1. Peter Paul Rubens, *Neptune (The Journey of the Cardinal Infante Ferdinand)*, canvas, 32.6 x 38.4 cm, Dresden, Staatliche Kunstsammlungen, no. 964B.

NEPTUNE, the god of the sea, rides over a stormy sea in a shell drawn by sea horses (*hippocampi*). His progress is announced by a triton blowing a large conch shell. Attending the god's car are three swimming nereids. His long white hair and beard flowing, Neptune half stands on the shell and gestures broadly at three personifications of the wind above him. Beyond the sea god are several sailing vessels and triremes representing the fleet that the Cardinal Infante Ferdinand took from Barcelona to Genoa in April 1633. During his crossing, Ferdinand encountered a storm which forced him to seek refuge in the tiny harbor of Codaques for thirteen days. The prince's odyssey was recorded, complete with the obligatory literary flourishes and exaggeration, by Don Diego de Aedo y Gallert in a book published in Antwerp in 1635 (complete with a title page designed by Rubens) which probably inspired Rubens's conception of the theme.[1]

This painting is an oil sketch for one of the scenes that appeared on the "Stage of Welcome," the first construction the prince would see in the Mechelse Plein, behind Antwerp's St. Joriskerk, when he made his Triumphal Entry into Antwerp. Originally the stage was conceived as a smaller construction with a single scene depicting the *Arrival of the Prince* (see the oil sketch in the Hermitage, St. Petersburg, no. 48).[2] However, when the prince's arrival was delayed, Rubens expanded the program (receiving official approval to proceed on 9 February 1635, but probably anticipating and beginning the work in advance) to include three scenes, featuring not only the *Journey* and the *Arrival* but also the *Meeting of the Two Ferdi-*

nands (see the oil sketch in a private collection).[3] One can gain some idea of the extraordinary richness and elaboration of the temporary structure from Theodoor van Thulden's etching for the famous *Pompa Introitus Ferdinandi* (Antwerp, 1641), a volume commissioned by the city of Antwerp to commemorate the event (see fig. 2). Rooses was the first to observe that the larger finished version of the Fogg's sketch is in Dresden (fig. 1).[4] The mythological allusion in the composition's foreground is to a passage from Virgil's *Aeneid* (1:135) which recounts how Aeneas's ships were scattered in a storm until an angry Neptune commanded the winds, saying, with dramatic pause for effect, *Quos ego – sed motos praestat componere fluctus* (Whom I [will punish] but first I must set the waves at rest). Thus in characteristically erudite fashion, Rubens has drawn a parallel between contemporary events, namely the progress of the Spanish fleet, and episodes taken from a great Latin epic, implicitly conferring heroic virtues upon the incoming governor. The first to recognize the Virgilian allusions in this work was Roger de Piles.[5] However, as Martin has pointed out, the title *Quos ego* which the Dresden painting acquired as early as the eighteenth century and which the Fogg picture has carried repeatedly, is erroneous or at least incomplete, since it overlooks the central role of Ferdinand in the painting.[6] It should be noted that Rubens's friend, the humanist Gevartius (Jan Casper Gevaerts [1593-1666]), who composed the Latin inscriptions on the construction as well as the text for the *Pompa Introitus Ferdinandi*, neither makes reference to Virgil's words nor to the fleet of Aeneas.

In the Dresden painting, which was possibly begun by Rubens but undoubtedly completed by

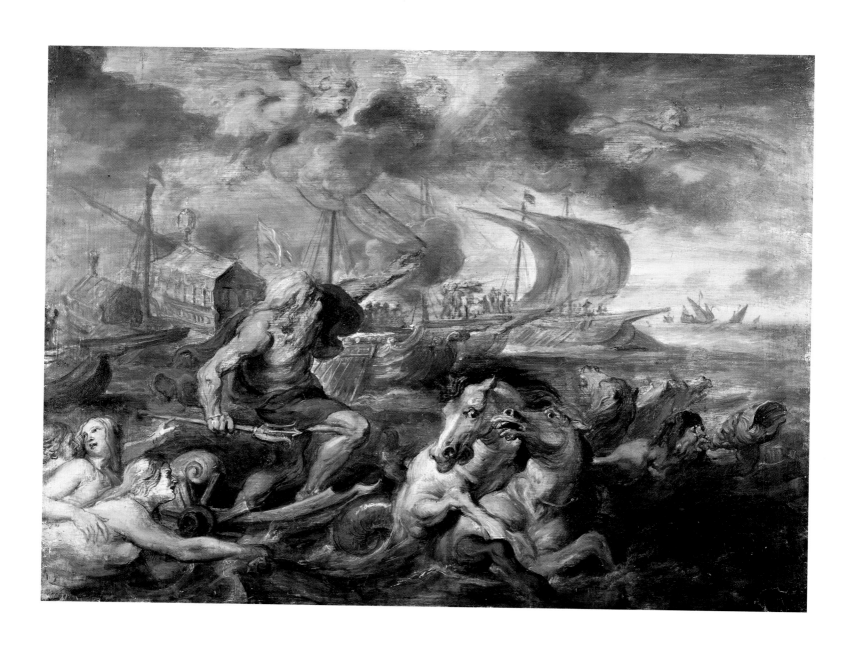

Fig. 2. Theodoor van Thulden, *The Stage of Welcome*, etched illustration from *Pompa Introitus Ferdinandi* (Antwerp, 1641).

1. See Martin 1972, pp. 22, 41; *Viaje del Infante Cardenal Don Fernando de Austria, desde 12. de Abril 1632. que salio de Madrid con su Magestad D. Felipe IV. su hermano para la ciudad de Barçelona, haste 4. de Novembre de 1634. que entro en la de Bruselas* (Antwerp, 1635).

2. Martin 1972, no. 1a, pl. 3; Held 1980, vol. 1, no. 154, vol. 2, pl. 154.

3. Martin 1972, no. 4, fig. 13; Held 1980, vol. 1, no. 147, no. 157.

4. Rooses 1886-92, vol. 3 (1890), p. 297, under no. 774, when the painting was still in the Duke of Grafton's collection. See Martin 1972, no. 3, fig. 7.

5. See Martin 1972, p. 54, note 5: R. de Piles, *Dissertation sur les Œuvres des plus fameux peintres, dédiée à Monseigneur le duc de Richelieu* (Paris, 1681).

6. Martin 1972, vol. 1, p. 52.

7. See Held 1980, vol. 1, p. 228.

8. Meiss 1974, p. 330.

9. *Aeneid*, I:146-147; Meiss 1974, p. 321, note 6, acknowledging Held.

10. See Martin 1972, vol. 1, p. 52, respectively figs. 10 and 12.

assistants, Neptune is a larger and more commanding presence, all the figures are grouped more tightly, and the personifications of the winds are given more form and detail. Now clearly identifiable, they are: Auster, the south wind (who – on the authority of Lucretius and Virgil – holds a thunderbolt), and Zephyr, the west wind, who together gustily expel the northwind, Boreas, now rendered (following Pausanias) with serpentine legs.[7] The south and west winds naturally were favorable to Ferdinand's journey from Barcelona to Genoa. Millard Meiss discussed a curious technological detail that appears in both the finished painting in Dresden and the Fogg sketch, namely the tiny paddle on the side of Neptune's shell. This seems to descend from Raphael's famous *Galatea* in the Villa Farnesina, which Rubens had undoubtedly seen in Rome and could recall through Marcantonio Raimondi's engraving.[8] Held first pointed out that Virgil's text describes how Neptune "allays the Flood, and on light wheels (*rotis levibus*) glides over the uppermost waters."[9] Martin also correctly observed that Rubens's "agitated sea horses" are probably inspired by Raphael's composition and may also acknowledge a print by Bonasone after Perino del Vaga.[10]

PCS

Peter Paul Rubens

34. Hunt of Meleager and Atalanta, ca. 1627-1628

Oil on panel, 24.2 x 61.9 cm (9 ½ x 24 ⅜ in.)
Switzerland, private collection

PROVENANCE: with the Duke of Saxe-Coburg-Gotha, Vienna, who sold it to the Galerie Sanct Lucas, Vienna in 1939.[1]

LITERATURE: Held 1980, vol. 1, pp. 340-341, no. 251, vol. 2, pl. 273; Balis 1986, no. 12a, p. 187, fig. 82; A. Balis, "Rubens' Jachttaferelen: Bedenkingen bij een onderzoek," *Academiae Analecta; Mededelingen van de Koninklijke Academie voor Wetenschappen, Letteren en Schone Kunsten van België, Klasse der Schone Kunsten 47,* no. 1 (1986), p. 127; S. Orso, *Philip IV and the Decoration of the Alcázar of Madrid* (Princeton, 1986), pp. 56-57, 157, fig. 32; Robels 1989, p. 376.

IN DIRECT accordance with Ovid's account of the hunt of the monstrous boar sent by the maligned virgin goddess Diana to wreak havoc in the lands of King Oeneus (*Metamorphoses*, VIII: 270-419), Atalanta has lodged her arrow behind the ear of the Calydonian boar from mid-stride. At the right Meleager, barefoot and clad in a red chlamys, prepares to plunge his spear into the shoulder of the beast, which surges and thrashes amidst the pack of both attacking and wounded hounds. Beneath their feet lies the nude corpse of Ancaeus, who has been disembowled in the course of his brash assault on the giant boar. Two huntsmen carrying spears keep pace with the hunt in the background, and to the left of Atalanta another man sounds the call on his horn. The surrounding landscape consists of an open plain bordered by woods.

Like its companion (cat. 35), the *Hunt of Meleager and Atalanta* was the preliminary work for one of the eight canvases which arrived in Madrid with Rubens in 1628. Held was the first to distinguish this composition from other versions of the subject by Rubens as the counterpart to the *Hunt of Diana*, with which it shares the friezelike distribution of figures and highly "finished" character.[2] A studio copy after the lost original, now at Easton Neston (see cat. 14, fig. 1), best conveys what must have been the final form of the canvas. The sketch differs from this version in only a few minor respects: for example, the right arm of the hunter wearing a hat at the rear appears behind him, whereas in the painting it extends forward so that the hand is visible in front of his companion's chin. Atalanta's right arm in the sketch is somewhat more curled, and Meleager grasps his spear further up the shaft, away from the tip. The diagonal axis of the large tree base was not incorporated into the final painting.

The hunt of Meleager and Atalanta had a firmly established pictorial tradition as one of the most familiar Ovidian episodes. Rubens treated the subject of the mythological hunt of the Calydonian boar in a number of compositions predating the present sketch. The reliefs of a third-century Roman sarcophagus (now at Woburn Abbey),[3] as well as Giulio Romano's drawing, *The Calydonian Boar Hunt* (London, British Museum),[4] contributed to Rubens's construction of these early works, in which Meleager and Atalanta typically face the cornered boar together from one side. What may be Rubens's earliest hunt scene, *The Calydonian Boar Hunt* of ca. 1614-1615 (known only through a copy),[5] and subsequent canvases (*The Boar Hunt*, Marseilles, Musée des Beaux-Arts, inv. 104; and *Calydonian Boar Hunt*, Vienna, Kunsthistorisches Museum, inv. 523; fig. 1) focus on the final climactic stage of the chase with concentric, multifigured compositions. In the oil sketch, however, Rubens retained the classically derived figural motifs of the hound biting the ear of the boar and Meleager's stance, but departed from precedent with both an elongated rectangular format and isonomic portrayal of man and beast. Most of the participants included in Ovid's account have been eliminated, including the Dioscuri, Castor and Pollux (*Metamorphoses*, VIII: 372-275), who appeared as dynamic figures on horseback in the earlier hunts. The boar, seen in three-quarter view rather than in profile, assumes a more interactive and central role as he twists and faces the viewer. With the assault on their quarry suspended between the two hunters, three phases of the Calydonian hunt are presented simultaneously: Atalanta wounding the boar with an arrow, the boar's furious strikes at the onrushing hounds, and Meleager's bringing the animal to bay.

Balis has suggested that Rubens borrowed the figure of the hunter with a spear running behind the boar from an early *Boar Hunt* of ca. 1617-1618 by Frans Snyders and Anthony van Dyck (Dresden, Gemäldegalerie Alte Meister, no. 1196; fig. 2).[6] The motif of the hound on its back that appears in the center foreground of the Snyders/van Dyck composition recurs a decade later in this oil sketch for Philip IV. The hound lying directly in front of Meleager is derived from Giulio Romano's *Death of Procris*, and appeared first in *The Judgment of Paris* (Madrid, Museo del Prado, inv. 1662). Rubens used the figure of the boar viewed from the front again as the central figure in a sketch dating from the early 1630s whose composition must have originated with our modello (*The Calydonian Boar Hunt*, Jersey, collection of Sir Francis Cook), and finally again in the very large canvas, *Landscape with the Calydonian Boar Hunt* (Madrid, Museo del Prado, inv. 1662; fig. 3) which assimilates the figures into a majestic landscape.[7]

Rooses asserted that Rubens "treated his hunting-pieces in a lighter and more superficial manner than his other creations . . . to him they were decorative paintings."[8] However, the inclusion of two mythological hunting scenes among eight paintings for the 1628 commission not only served to cultivate Philip IV's passion for the chase, but also under-

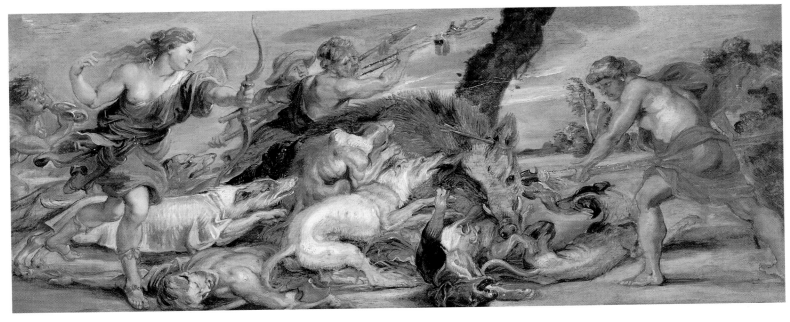

cat. 34

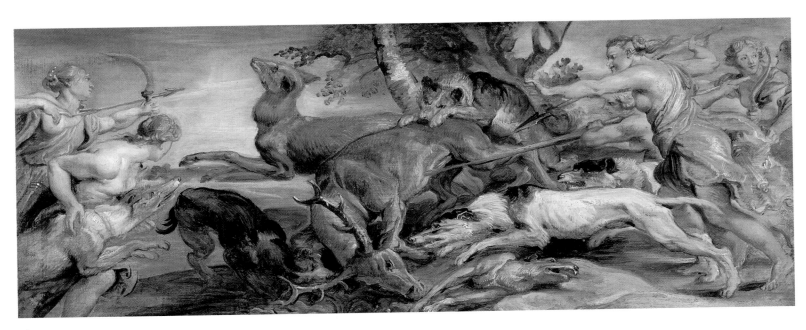

cat. 35

Fig. 1. Peter Paul Rubens, *Calydonian Boar Hunt*, oil on canvas, 257 x 416 cm, Vienna, Kunsthistorisches Museum, inv. 523.

Fig. 2. Anthony van Dyck and Frans Snyders, *Boar Hunt*, ca. 1616-1617, oil on canvas, 191 x 301 cm, Dresden, Gemäldegalerie Alte Meister, inv. 1196.

Fig. 3. Peter Paul Rubens, *Landscape with the Calydonian Boar Hunt*, oil on canvas, 160 x 260 cm, Madrid, Museo del Prado, inv. 1662.

scored the parallel to be drawn by important visitors and officials to the Alcázar between the Spanish monarch's personal virtues and the paintings' heroic subjects. Juan Mateo's treatise *Origen y dignidad de la caça* (1634) records that Philip IV himself couragously faced and slew a cornered boar.[9] As the exclusive privilege of the aristocracy, the chase served as the recommended noble exercise for military action, and by extension an image such as the *Hunt of Meleager and Atalanta* provided visual parallels with militaristic engagements of the first half of the seventeenth century.

The final canvases are similar in style and size to *The Crowning of Diana* (cat. 14), which Rubens probably executed with the assistance of Frans Snyders, and thus are assumed to have originally formed a series. No copies after the oil sketch are known; all copies after the lost original listed by Balis follow the canvas at Easton Neston in every respect.[10]

ATW

1. See Balis 1986, p. 184, note 23.

2. Although he rightly observes that the composition represented here best corresponds to the description given in the 1636 Alcázar inventory ("dos lienzos de mano de Rubens ... que el uno es una montería de jabalíes, con una ninfa, con un arco en la mano, con el que ha clavado una flecha al jabalí, y hay perros muertos y otros vivos y unos cazadores con venablos en las manos"), Held (1980, pp. 340-341) dates the sketch to ca. 1635-1638.

3. The sarcophagus was in Rome during the sixteenth and seventeenth centuries, where Rubens could have seen it. For an illustration and lengthy discussion, see C. Robert, *Die antiken Sarcophag-Reliefs* 3, no. 2 (Berlin, 1904), no. 224, pl. LXXVII.

4. P. Pouncey and J. A. Gere, *Italian Drawings in the Department of Prints and Drawings in the British Museum. Raphael and His Circle* (London, 1962), vol. 1, no. 85, pp. 64-65; vol. 2, pl. 78. Rubens would have known the image, as it was one of four which hung in Marmirolo, the Gonzaga hunting lodge. Alpers 1971, no. 237, p. iii.

5. See Balis 1986, no. 1, pp. 91-95.

6. Ibid., pp. 32-34; no. 12, p. 186.

7. See cat. 35, note 15.

8. Rooses 1904, vol. 1, p. 263.

9. Alpers 1971, p. 103.

10. Balis 1986, no. 12, p. 185.

Peter Paul Rubens
35. Hunt of Diana, ca. 1627-1628

Oil on panel, 24.4 x 61.5 cm (9 ⅝ x 24 ¼ in.)
Switzerland, private collection

PROVENANCE: with the Duke of Saxe-Coburg-Gotha, Vienna who sold it to the Galerie Sanct Lucas, Vienna in 1939.[1]

LITERATURE: Held 1980, vol. 1, pp. 324-325, no. 237, vol. 2, pl. 274; Balis 1986, pp. 181, 184 note 23, 187, 189, 191 note 15, 192, no. 13a, fig. 87; A. Balis, "Rubens' Jachttaferelen: Bedenkingen bij een onderzoek," *Academiae Analecta; Mededelingen van de Koninklijke Academie voor Wetenschappen, Letteren en Schone Kunsten van België, Klasse der Schone Kunsten 47*, no. 1 (1986), p. 127; S. Orso, *Philip IV and the Decoration of the Alcázar of Madrid* (Princeton, 1986), pp. 56-57, fig. 33; Robels 1989, p. 376.

IN FRONT of a small stand of trees, the virgin goddess of the hunt and her band of chaste nymphs and dryads converge on their prey. Diana, her left arm outstretched, takes aim at the stag which has succumbed to the spear wielded by the nymph beside her. Two more of the goddess's companions bring up the rear. As a white hound lunges over the body of a wounded companion toward the flagging quarry, another member of the pack clamps its jaws into the hindquarters of the stag. A nymph clad in gray at the far left prepares to release an arrow at the fleeing hind, while another releases a hound. In keeping with the technique advocated by antique and Renaissance treatises on the training of hounds, a fifth dog attacks the stag from the left by gripping its ear.

This colorful oil sketch and its pendant, *The Hunt of Meleager and Atalanta* (cat. 34), are Rubens's preliminary studies for two canvases, a "Boar Hunt" and a "Deer Hunt" (now destroyed), which hung in the *salón nuevo* of the Alcázar in Madrid.[2] The final versions of the two compositions were among eight paintings Rubens presented to Philip IV during his diplomatic visit to Spain in 1628. Comprised of various subjects, the group may have been commissioned by the king through the intercession of Infanta Isabella for the newly renovated rooms in the royal palace in Madrid.[3] The pair of large mythological hunts joined an already substantial collection of nearly thirty paintings by Rubens and his Antwerp associates acquired by the Spanish queen by 1623.[4] Following their transfer to the *pieza ochevada* in the late 1640s, they continued to constitute an influential portion of the decoration in the ceremonial rooms of the palace until they were lost in a fire which consumed much of the Alcázar itself in 1734.

Assigning citations in Spanish inventories to known hunt scenes of this subject has proved problematic.[5] While the extremely damaged canvas of *The Hunt of Diana* (coll. J. Serrano Piedecasas, Mexico City, 1970) may, as Díaz Padrón believed,[6] be the original painting taken to Spain in 1628, our clearest record of the final form of the composition conceived in the oil sketch is a competent studio copy at Bürgenstock (cat. 14, fig. 2).[7] The sketch differs from this version in the following minor respects: the nymph at the far left has not yet released her arrow, while in the Bürgenstock canvas the shaft is lodged in the tree; among the changes in attire, the customary quiver which identifies Diana is more clearly visible in the sketch, and she is barefoot. The sketch may also have been larger at one time. Held relates that two strips were removed from the top and bottom of the panel.[8]

Despite its relatively late date, this modello is Rubens's first treatment of Diana actively engaged in the vigorous business of the chase, thus representing a decisive alteration in the artist's iconography of the goddess. Her role as huntress appeared not long after Rubens's collaboration with Jan Brueghel the Elder between 1620 and 1625 on four "après-chasse" scenes for the Infanta Isabella, in which the abundant display of booty only indirectly alludes to the tumultuous pursuit of game (see cat. 14, fig. 3).[9] Both Isabella and Philip IV were avid proponents of and participants in the elite sport of hunting, an affiliation which could provide a potentially personal resonance for the theme of the mythological hunt in this sketch and its pendant. However, it is not clear that the subject in this case has any deeper import beyond its literary associations. The *Hunt of Diana* recalls the description of the goddess in classical texts as the *Elaphebolos* or deer hunter, an association underscored by the friezelike composition, which itself recalled the decoration on antique sarcophagi.[10]

The entire composition, including the animal elements, is Rubens's invention, as the authorship of this sketch verifies. Rubens probably collaborated in the execution of the final painting, however, with a specialist in animal figures, most likely Frans Snyders whose hand is evident in *The Crowning of Diana* from the same period (see cat. 14).[11] As both Held and Balis have noted, the *Hunt of Diana* was undoubtably a "famous" composition.[12] The animal motifs devised by Rubens proved singularly influential and were frequently utilized by other Antwerp artists, including Frans Snyders and Paulus de Vos. The particularly emotive central figures of a stag and hind fleeing in tandem superbly demonstrate what Balis described as Rubens's efforts "to achieve a pregnant formulation of each animal motif, so that the beast was not merely described but pictured as an individual capable of willing and feeling."[13] Rubens's anthropomorphic treatment of animals infused the pursuit of game with a dramatic power which ultimately engendered a new category of hunt: the dramatic animal hunts without human figures produced by Frans Snyders, Jan Fyt, and

Fig. 1. Peter Paul Rubens, *Deer Hunt*, oil on panel,
41 x 63 cm, Antwerp, Koninklijk Museum voor
Schone Kunsten, inv. 766.

Pieter Boel (see cat. 121). Snyders's familiarity with
The Hunt of Diana is indicated by his adoption of the
falling stag with the hound biting its ear as the cen-
tral figure in the *Deer Hunt* (Brussels, Musées Royaux
des Beaux-Arts, inv. 3229).[14] The figure of the
wounded hound on its back is an adaptation of a
similar figure which appeared first in Rubens's *Boar
Hunt* (Marseilles, Musée des Beaux-Arts, inv. 103),
and subsequently in the *Boar Hunt* by Anthony van
Dyck and Frans Snyders (Dresden, Gemäldegalerie
Alte Meister, inv. 1196; see cat. 121, fig. 2).[15]

For Rubens the *Hunt of Diana* was a point of
departure for two works executed in the 1630s: an oil
sketch for the Torre de la Parada of *Diana Hunting
Deer* (ca. 1636-1637, Bedfordshire, Luton Hoo,
Wernher collection) a decade later, and a sketch of
approximately the same date, *Deer Hunt* (ca. 1636-
1637, Antwerp, Koninklijk Museum for Schone Kun-
sten, inv. 766; fig. 1), in which the affecting flight of
the two deer has been heightened by the addition of
a fawn poised at the edge of a cliff.[16] For the figures
of the goddess and her companions in the *Hunt of
Diana*, Rubens has referred to his early *Calydonian
Boar Hunt* (Vienna, Kunsthistorisches Museum, inv.
523; see cat. 34, fig. 1). Diana bears some resemblance
in physique to the early Atalanta, and the nymph
with the hound seen from the rear in the sketch has
been transposed from the figure of the huntsman in
the center foreground of the Vienna hunt.

The copies after preparatory drawings and the
original paintings are discussed by Balis.[17] None of
them differs substantially from the oil sketch dis-
cussed here, although at least two incorporate the
action into an expanded landscape. A copy after a
preparatory drawing for the *Hunt of Diana* inscribed
"Sniders" is in the collection of the Rugby School,
Warwickshire.[18]

ATW

1. See Balis 1986, p. 184, note. 23.

2. The first description of the paintings occurs in the 1636 Alcázar inven-
tory: "Otros dos liencos de mano de Rubenes largos y angostos con
molduras doradas y negras de figuras al natural que el uno es vna mon-
teria de jabalies con una ninfa con vn arco en la mano con el que a claua-
do una flecha a jabali y ay unos perros muertos y otros vivos y vnos
caçadores con benablos en las manos = y el otro es de una caça en que
estan matando un benado muchos Perros y ninfas que estan en auito de
caçadoras que le ban siguiendo con lancas y otra ninfa que despidio vna
flecha que la clauo en vn arbol y otra que tiene un perro." Compiled in
Balis 1986, pp. 182-183, note 1. See also Cruzada Villaamil 1872, p. 325, and
M. Crawford Volk 1980, p. 180. For the list of works believed to be taken
to Spain in 1628, see E. Harris, "Cassiano dal Pozzo on Diego Velázquez,"
The Burlington Magazine 112 (1970), p. 372, note 37.

3. According to the Florentine envoy, the paintings were "ordinatili par
servᵒ. di S. Mᵗᵃ., da porsi in questo Palazzo." C. Justi, *Diego Velasquez und
sein Jahrhundert*, 1, 1888, p. 240, note 1. Correspondence between Isabella
and Philip IV testify to her involvement, and in particular to settling
Rubens's compensation of £ 7,500. Balis 1986, p. 183, notes 7 and 8;
Rooses-Ruelens 1887-1909, vol. 1 (1887), pp. 129-130, no. 108. It has been
suggested that the eight paintings may have been selected from a stock
of pictures in Rubens's studio. See Balis 1986, pp. 180, 183 note 9.

4. As related in the 1636 inventory; see note 2 above for sources. Among
them was Rubens's *Diana as Huntress* (Madrid, Museo del Prado,
inv. 1727).

5. Balis 1986, pp. 180-181.

6. M. Díaz Padrón, "La cacería de venados de Rubens para el ochavo del
Alcázar en Méjico," *Archivo español de arte* 43 (1970), pp. 131-150, fig. 1. Balis
1986, pp. 181, 189, fig. 83 (during treatment), and fig. 85 (detail).

7. Balis 1986, no. 13, copy 2, p. 188.

8. Held 1980, vol. 1, p. 324, no. 237.

9. For the developement of Rubens's iconography of Diana, see cat. 14.
The four works are discussed in Ertz 1979: *Departure for the Hunt*, no. 354,
fig. 464; *Return from the Hunt*, no. 356, fig. 472; *Satyrs Spying on Sleeping
Nymphs*, no. 355, fig. 471; *Unloading Booty* (lost), fig. 476.

10. Sarcophagi were an important source of inspiration for Rubens's
hunt scenes in general. See cat. 34.

11. See cat. 14.

12. Held 1980, vol. 1, p. 325; Balis 1986, p. 190.

13. Balis 1986, p. 76.

14. See Robels 1989, no. 237, p. 335, ill.

15. The complex evolution of this motif is discussed at length by Balis
1986, p. 79, note 58.

16. While Held (1980, vol. 1, pp. 633-634, vol. 2, pl. 484) and Adler (1982,
no. 56, pp. 149-150, fig. 56) disputed the authorship of the Antwerp
sketch, Balis argued that, among other things, the similarities in the
form of the fleeing hind with the sketch discussed here indicated
Rubens's hand. Balis 1986, p. 34, note 55.

17. Balis 1986, no. 13, pp. 187-189.

18. M. Díaz Padrón, "La cacería de venados de Rubens para el ochavo del
Alcázar en Méjico," *Archivo español de arte* 43 (1970), pp. 131-150, fig. 2; Balis
1986, no. 13a, p. 192.

Anthony van Dyck

(Antwerp 1599-Blackfriars, London 1641)

Anthony van Dyck, *Self-Portrait*, etching.

Born in Antwerp on 22 March 1599, Anthony (Antonio, Anthonio, Antoon) van Dyck (Dijck) was the seventh child of Frans van Dyck, a merchant of silk, linen, and other textiles, and Maria Cuperis (Cuyperis), a skilled embroiderer. His father was the head of the Confraternity of the Holy Sacrament in Antwerp Cathedral and several of his sisters had religious callings: Susanna Cornelia and Isabella became Beguines, and Anna an Augustinian nun. His brother Theodoor, called Waltman, became a Norbertine canon at St. Michael's Abbey and later a priest at Minderhout; Anthony himself joined the Jesuit Confraternity of Bachelors (*Sodaliteit van de bejaerde Jongmans*) in Antwerp in 1628. When only ten years old, in 1609, Anthony was recorded as a pupil of Hendrick van Balen (q.v.) in the register of the guild of St. Luke in Antwerp. Although still a minor, on 3 December 1616 and 13 September 1617 van Dyck and his siblings sought to receive partial payment of the estate left by his grandmother. He was registered as a master in the guild on 11 February 1618; his father granted him his majority four days later.

Van Dyck was a remarkably precocious talent. Notwithstanding guild regulations and doubts about the reliability of an old man's memory, in 1660 the seventy-year-old Guilliam Verhagen claimed that van Dyck had been working independently as early as ca. 1615-1616. In a letter to Sir Dudley Carleton of April 1618, Rubens described the young painter as "the best of my pupils," and in the contract dated 29 March 1620 for paintings commissioned for the ceiling of St. Charles Borromeo, the Jesuit church in Antwerp, he was specified as one of Rubens's *dicipelen* and probably played a major role in the execution of Rubens's designs. A document of 1661 states that van Dyck executed the painted models for Rubens's cartoons for the Decius Mus tapestry series, which was woven in 1618. Van Dyck was living in a house called the "Dom van Keulen" on the Lange Minderbroederstraat when in 1620 or 1621 he engaged Herman Servaes and Justus van Egmont as assistants to make copies of his *Apostles*. The young painter's fame and clientele, grew swiftly. On 17 July 1620, Francesco Vercellini, traveling with the Countess of Arundel, reported to the Earl of Arundel that van Dyck was still working with Rubens ("sta tutavia [*sic*] con il sr Ribins"), that his work was as highly appreciated as Rubens's, and that he probably would not want to leave Antwerp. However, according to Thomas Locke, by 20 October 1620 van Dyck was in England, and by 25 November of that year he was in the service of James I, earning an annual stipend of £100. On 26 February 1621 van Dyck received payment in that amount for "speciall ser-

vice . . . pformed [*sic*] for his Ma[jes]tie." Two days later he was granted leave by the Earl of Arundel to travel for eight months.

Van Dyck probably stopped in Antwerp before departing for Italy in October of 1621. He arrived in Genoa probably by late November. In Italy, he traveled extensively to northern and central Italian cities (Rome, Venice, Mantua, Milan, Florence, and Bologna) and also visited Palermo from the spring to September of 1624. However, the greater part of his work was executed in Genoa, where he lived in the house of the painter Cornelis de Wael and distinguished himself as a portraitist. On his visit to Rome in 1622 he filled his sketchbook with drawings from life and copies of various artworks. In 1625 he made a short trip to the south of France (Marseille and Aix-en-Provence). In the autumn of 1627 van Dyck returned to the Spanish Netherlands and established a studio in Antwerp, the start of his so-called "Second Antwerp Period." In December of 1628 he was awarded a gold chain valued at fl. 750 for his portrait of the Infanta Isabella, and in a document of 27 May 1630 described himself as her court painter ("schilder van Heure Hoocheyd"). On 27 May 1628, the Earl of Carlisle wrote to the Duke of Buckingham from Brussels that he had met Rubens at the home of "Mnsr Van-digs." On 6 March 1628, now a man of property, he made a will in Brussels. Evidence of his prosperity at this time is his subscription in the amount of fl. 4,800 for a loan issued by the city of Antwerp on 20 March 1630. Van Dyck had also amassed a considerable art collection. In December of 1630 the Antwerp restorer J.-B. Bruno mentioned van Dyck's exquisite personal collection, and J. Puget de la Serre, in his account of his travels with the Queen Mother, Marie de' Medici, to Antwerp (4 September-16 October 1631), noted his admiration for van Dyck's "Cabinet de Titien."

Van Dyck may have visited The Hague in the winter of 1628-1629, where he painted the portrait of the Stadholder Frederick Hendrick and his wife and son; he was certainly in the northern capital during the winter of 1631-32. By April 1632 van Dyck had moved to London, where on 5 July 1632 he was knighted by Charles I and described as "principalle paynter [*sic*] in Ordinary to their majesties at St. James." He lodged briefly with Edward Norgate, author of a treatise on miniature painting, and later established his studio at Blackfriars on the outskirts of London. On 20 April 1633 he received from the king a gold chain and medal worth £110, and on 17 October was promised an annual salary of £200. From early in 1634 to sometime before June 1635 van Dyck was again active in the Southern Netherlands, working mainly in Brus-

Anthony van Dyck
36. Family Portrait

Oil on canvas, 113.5 x 93.5 cm (44¾ x 36⅞ in.)
St. Petersburg, The State Hermitage Museum,
inv. no. 534

sels where he depicted the new governor general, the
Cardinal Infante Ferdinand. On 18 October 1634 he
received the highest honor that could be bestowed by
the St. Luke's Guild in Antwerp: Dean of the Guild
honoris causa, and his name was inscribed in capital
letters in the list of members. Only Rubens had pre-
viously received this honor. In the spring of 1635 van
Dyck returned to England, and during the following
months a road and dock were constructed at Blackfri-
ars to facilitate the personal visits of King Charles I to
van Dyck's studio. In 1639 van Dyck married Maria
Ruthven, lady-in-waiting to the queen; the couple
had one daughter.

In the autumn of 1640 van Dyck was once again
in Antwerp. Rubens had died in May of that year.
The Cardinal Infante Ferdinand wrote Philip IV on
23 September 1640 stating that van Dyck did not
wish to finish Rubens's paintings for the Torre de la
Parada, but would accept a new commission from
the king. By 10 November (again according to the
Cardinal Infante) van Dyck had already left for Eng-
land, but may have gone first to Paris, where he was
recorded in January 1641; he was back in England by
May 1641. Ill much of the summer, he nonetheless
traveled after 13 August 1641 to the Northern Neth-
erlands and subsequently to Paris. On 16 November
he stated in a request for a passport to travel from
Paris to England that his illness was worsening. On
1 December 1641 his daughter Justiniana was born,
and three days later he made a will in London. Van
Dyck died at Blackfriars on 9 December and was
buried in the choir of St. Paul's Cathedral two days
later. His tomb and remains were both destroyed in
the Great Fire of 1666.

De Bie 1661, pp. 74-78; Bellori 1672, pp. 253-264; Sopriani 1674, passim;
Sandrart, Peltzer 1925, p. 174 and passim; Houbraken 1718-21, vol. 1,
pp. 179-188; Weyerman 1729-69, vol. 1, pp. 309-310; Descamps 1753-64,
vol. 2, pp. 8-28; Descamps 1769, passim; Smith 1829-44, vol. 3 (1831),
pp. xvii-xxxiv, 1-246, vol. 9 (1842), pp. 368-404; Nagler 1835-52, vol. 4 (1837),
pp. 41 ff; Immerzeel 1842-43, vol. 1 (1842), p. 210 ff; Carpenter 1844;
Kramm 1857-64, vol. 2 (1858), pp. 389 ff; Galesloot 1868; Michiels 1865-76,
vol. 7 (1869), pp. 289-359; Rombouts, van Lerius 1872, vol. 1, pp. 457-459,
545, 547; vol. 2, pp. 21, 98, 175, 214; Walpole 1876, passim; Guiffrey 1882;
Michiels 1882; van den Branden 1883, pp. 521, 692-746, 929; Bertolotti
1887; London 1887; Antwerp 1899; Cust 1900; London 1900; Wurzbach
1906-11, vol. 1 (1906), pp. 448-475; vol. 3, pp. 79-80; New York 1909; Schaef-
fer 1909; F. M. Haberditzl, in Thieme, Becker 1907-50, vol. 10 (1914),
pp. 263-270; Vaes 1924; Vaes 1927; Glück 1931; Glück 1933; van Puyvelde
1933; van Puyvelde 1941; van den Wijngaert 1943; Antwerp 1949;
van Puyvelde 1950b; Genoa 1955; de Maeyer 1955, pp. 193-197; Mauquoy-
Hendrickx 1956; Vey 1956; Held 1958; Vey 1958; van Gelder 1959;
Antwerp/Rotterdam 1960; Gerson, ter Kuile 1960, pp. 109-126; Vey 1962;
Millar, 1963 passim; Adriani 1965; Brussels 1965, pp. 52-76; Jaffé 1966; Lon-
don 1968; London, National Gallery, cat. 1970, pp. 26-67; Strong 1972; Lon-
don 1972-73; Larsen 1975; Paris 1977-78, pp. 69-85; Princeton 1979; Larsen
1980; Ottawa 1980a; Ottawa 1980b; Paris 1981; Brown 1982; London 1982-
83; Brown 1984; Liedtke 1984-85; Barnes 1986; Larsen 1988; Washington
1990-91; New York 1991.

PROVENANCE: acquired (according to sale cat. 1770) in Antwerp in
1762 by M. de la Live de Jully; sale Live de Jully, Paris, 2-14 March 1770,
no. 7 ["Le portrait de Snyders... aussi celui de sa femme et de son fils,"
3 pieds 7 pouces x 2 pieds 11 pouces; to Mrs. Groenbloedt, Brussels, for
12,000 livres, or, according to annotation in Rijksbureau voor Kunsthis-
torische Documentatie exemplar, to Mr. Metrat for 12,020 livres];
acquired for Catherine the Great of Russia in 1774 (for 9,000 livres).

EXHIBITIONS: Brussels 1910, p. 148, no. 117, ill. 57; Leningrad, The
State Hermitage Museum, 1938, no. 33; Montreal, International Fine Arts
Exhibition, Expo, *Terre des Hommes, Exposition Internationale des Beaux-
Arts/Man and His World*, 1967, no. 65, ill. p. 137; Washington, D.C., Nation-
al Gallery of Art, *Master Paintings from the Hermitage and State Russia Mu-
seum, Leningrad*, 1975-76, no. 17, ill.; Leningrad, The State Museum of the
Hermitage Museum, *Rubens i flammandskoe barakko: Vystavka k 400-letiiu
50 dnia rozhdeniia Pitera Paulia Rubensa, 1577-1640*, 1978, no. 9; Vienna,
Kunsthistorisches Museum, *Gemälde aus der Eremitage und den Puschkin-
Museum*, 1981, pp. 34-37; Rotterdam, Museum Boymans-van Beuningen,
*Meesterwerken uit de Hermitage. Hollandse en Vlaamse schilderkunst van de
17e eeuw*, 19 May-14 July 1985, no. 32, ill.; New York, Metropolitan Mu-
seum of Art, *Dutch and Flemish Paintings from the Hermitage*, 26 March-
5 June 1988 (also shown at the Art Institute of Chicago, 9 July-18 Sep-
tember 1988), no. 37, ill. p. 81; Washington 1990-91, cat. no. 9, ill.

LITERATURE: *Catalogue historique du cabinet de peinture et sculpture
française de M. de Lalive* (Paris, 1764), pp. 114-115 [identified as "[Frans]
Sneyders" and his family]; J. H. Schnitzler, *Notice sur les principaux tableaux
du Musée impérial de l'Ermitage à St. Petersbourg* (St. Petersburg, 1828), p. 103;
Smith 1829-42, vol. 3 (1831), p. 88, no. 300, vol. 9 (1842), p. 382, no. 51;
J. Guiffrey, *Sir Anthony van Dyck. His Life and Work* (1846), p. 278, no. 847;
C. Blanc, *Trésors de la Curiosité*, vol. 1 (Paris, 1857), p. 165; G. F. Waagen, *Die
Gemäldesammlungen in der kaiserlichen Ermitage zu St. Petersburg* (Munich,
1864), p. 149, no. 627; Hermitage cat. 1870, pp. 76-77, no. 627; W. Bode,
"Anton van Dyck in der Liechtensteingalerie," *Die graphischen Künste*
(1899), p. 46; Cust 1900, pp. 18, 236, no. 56 [as possibly Jan Wildens and his
family]; St. Petersburg, Hermitage, cat. 1901, pp. 81-82, no. 627; M. Rooses,
"Die Vlämischen Meister in der Ermitage, Anton van Dyck," *Zeitschrift für
bildende Kunst* 15 (1904), p. 1616; Schaeffer 1909, p. 160, ill.; F. de Wyzena,
"L'exposition de l'art flamand du XVIIe siècle au Palais du Cinquante-
naire de Bruxelles," *La Revue de l'art ancien et moderne* 28 (1910), p. 193, ill.
opp. p. 188; L. Dumont-Wilden, "Exposition de l'art belge au XVIIe siècle
à Bruxelles," *Les Arts* (1910), p. 25, ill.; M. Rooses, "De Vlaamsche Kunst in
de XVIIe eeuw tentoongesteld in het jubelpaleis te Brussel in 1910," *Onze
Kunst* 19 (1911), pp. 45-46; L. Réau, "La Galerie de Tableaux de l'Ermitage
et la collection Semenov," *Gazette des Beaux-Arts* 8 (1912), p. 474; E. Hei-
drich, *Vlämische Kunst* (Jena, 1913), p. 34; Mayer 1923, pl. xv; H. Rosen-
baum, "Der junge Van Dyck (1615-21)" (Ph.D. diss. Munich, 1928), p. 34;
Glück 1931, p. 108, ill.; Leningrad, Hermitage, cat. 1958, p. 152, 241,
no. 218; Leningrad, Hermitage, cat. 1963, pp. 100-101, no. 5, ills. 10-15B;
Leningrad, Hermitage, cat. 1964, no. 15, pl.; Larsen 1980, vol. 1, no. 128, ill.;
Alle tot nu toe bekende schilderijen van Van Dyck (Rotterdam, 1979), no. 49,
ill.; Ottawa 1980a, no. 72, ill. (not exhibited); Brown 1982, pp. 50-51, ill.
p. 41; London 1982-83, p. 12, ill.; Barnes 1986, vol. 1, p. 122, ill., vol. 2, ill.

A YOUNG husband and wife are viewed three-quar-
ter length with a child seated on the mother's lap.
The infant is perhaps one year old and looks up at its
father, who leans forward resting his right hand on a
leather chairback. He is dressed entirely in black
with a short white collar fringed with lace. The
mother wears a tall millstone ruff, gold embroidered
stomacher, and black jacket with lace cuffs over a
gray-green dress. Her elegant attire is completed by a
gold cap with pearls and a gold bracelet. The child is
richly dressed in gold jacket, lace cap and collar,
white apron, green dress, and it wears a string of red
coral beads and holds a doll. In the closely cropped
design a red curtain hangs at the back right and the

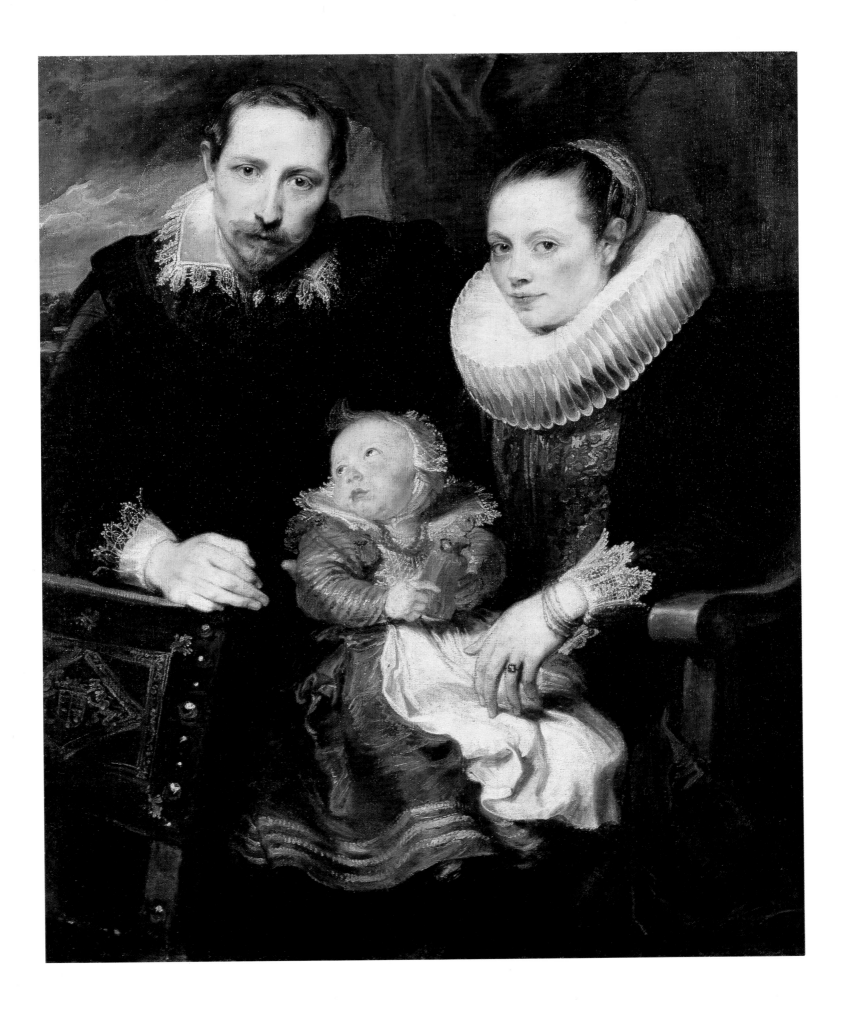

suggestion of a landscape is just visible behind the man on the left. Especially effective for the intimacy of the group is the father's sensitive, even solicitous expression as he leans protectively over his family and meets the viewer's gaze.

Several writers observed the strong influence of Rubens's portraits on the picture. Barnes persuasively cited the master's *Portrait of Jan Brueghel the Elder and His Family* in the Princes Gate collection, Courtauld Institute, London (inv. no. 18) as the painting's source.[1] Rubens's portrait is usually dated about 1612-1613, while van Dyck's is thought to have originated in the last years before his departure from Antwerp, or ca. 1620-1621. Barnes dates the latter as early as "around 1619," finding its design somewhat "awkward" in the resolution of its complex setting but noting that the execution is broader and more painterly than in the earliest works which had yet to respond fully to Venetian painting. Larsen also dated the work earlier, but surely prematurely, as "ca. 1617-1618." Although it has often been compared with the composition of the St. Petersburg picture, the *Family Portrait* formerly in the Cook collection, and later with Somerville and Simpson Ltd., London, has correctly been rejected by Barnes as the work of a van Dyck follower.[2] The assumption that van Dyck's work is a further development of Cornelis de Vos's family portraits probably reverses the direction of influence, since Katlijne Van der Stighelen has persuasively demonstrated that the latter's family portraits seem to follow examples, above all by Rubens but also by van Dyck, whose style established a new candor of expression, intimacy, and informality.[3]

When the painting was in the La Live de Jully collection in the late eighteenth century it was rightly characterized as one of the artist's masterpieces but the sitters were incorrectly identified as the "célèbre peintre Sneyders (sic), . . . [et] sa femme et son fils." The identification was supported by Smith, Guiffrey, Blanc, Waagen, and the subsequent nineteenth-century cataloguers of the Hermitage's collection, until Somof questioned it in the 1901 catalogue, noting that Frans Snyders (who was born in 1579) and his wife Margaretha de Vos would have been older than the parents appear here.[4] The fact that Snyders had no children further supports Somof's doubts, and comparisons not only with Snyders's portrait in the *Icongraphie* (engraved by Paulus Pontius, van Dyck's drawing for which is in the British Museum), but also with van Dyck's painted portraits of Snyders and his wife in the museum in Kassel (inv. no. GK125) and in the Frick Collection in New York (nos. 09.1.39 and 09.1.40), reveal no more than a superficial resemblance – the men's shared adoption of the popular fashion for a goatee and mustache.[5] Also acknowledged and rejected without comment by Somof was Lionel Cust's tentative theory that the sitters could be the painter Jan Wildens and his wife[6]; the assumption was still entertained as a possibility by McNairn in 1980 and Brown in 1982.[7] Although Wildens's first child was born in 1620, comparisons once again with van Dyck's portrait of Wildens (formerly in the Kunsthistoriches Museum, Vienna)[8] are not coercive.

Pentimenti and x-rays show that van Dyck changed the man's collar from a tall millstone ruff to the broader lace collar now visible.[9] The Hermitage's curators assumed that these changes had possibly been made by van Dyck himself as late as 1630 in order to update the sitter's attire to a more fashionable cut[10]; however it has also been argued that these changes were taken to rectify an "overloaded" composition.[11] Copies of the painting are in the Staatsgalerie, Stuttgart, and in the collection of Mrs. Culling Hanburg, Bedwell, Hertfordshire.[12]

PCS

1. Barnes in Washington 1990-91, p. 97. For the Rubens, see Vlieghe 1987a, vol. 2, pp. 60-62, cat. no. 79, fig. 46-50. and Courtauld Institute Galleries, *The Princes Gate Collection* (London, 1981) cat. 66, pl. XI.

2. Barnes, in Washington 1990-91, p. 97. See Glück 1931, no. 112.

3. See for example Vienna 1981, p. 34; Rotterdam 1985, p. 102.

4. St. Petersburg, Hermitage, cat. 1901, pp. 82-83.

5. Respectively Glück 1931, nos. 97, and 98 and 99. On the Frick's pendants, see especially Katlijne Van der Stighelen, "The Provenance and Impact of Anthony van Dyck's Portraits of Frans Snyders and Margaretha de Vos in the Frick Collection," *Hoogsteder-Naumann Mercury* 5 (1987), pp. 37-48.

6. Cust 1900, pp. 18, 236, no. 56.

7. Ottawa 1980a, pp. 156-157; Brown 1982, pp. 50-51.

8. Glück 1931, no. 120. A double portrait formerly in the Detroit Institute of Arts (no. 1889.66) attributed to van Dyck and once thought to depict Wildens does not portray the artist; see J. S. Held, *The Collections of the Detroit Institute of Arts, Flemish and German Paintings of the 17th Century* (Detroit, 1982), pp. 27-29, ill. Compare also Rubens's portrait of Wildens (whereabouts unknown); Vlieghe 1987a, no. 157, fig. 234 and fig. 236 (P. Pontius's engraved portrait).

9. See Van der Stighelen 1990b, pp. 121-144; and idem, 1990a. See also Barnes's remarks in Washington 1990-91, p. 97.

10. Hermitage cat. 1963, p. 100, ill.

11. New York 1988, p. 82.

12. See Cust 1900 and Washington 1990-91, p. 98.

Anthony van Dyck
37. The Betrayal of Christ

Oil on canvas, 141.9 x 113 cm (55⅞ x 44½ in.)
Minneapolis, Minneapolis Institute of Arts,
The William Hood Dunwoody, Ethel Morrison
Van Derlip, and John R. Van Derlip Funds,
inv. no. 57.45

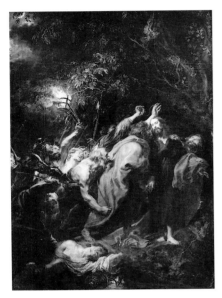

Fig. 1. Anthony van Dyck, *The Betrayal of Christ*, oil on canvas, 344 x 249 cm, Madrid, Museo del Prado, no. 1477.

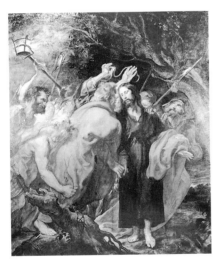

Fig. 2. Anthony van Dyck, *The Betrayal of Christ*, oil on canvas, 274 x 222 cm, Bristol, England, City of Bristol Museum and Art Gallery.

PROVENANCE: collection Lord Egremont, by 1896; sold in that year to Sir Francis Cook, Bart., Doughty House, Richmond, Surrey; purchased through Rosenberg and Stiebel, New York, 1957.

EXHIBITIONS: Antwerp 1899, no. 10; London 1900, no. 85; The Toledo Museum of Art, *Masterpieces from the Cook Collection*, 1944-45, no. 250, ill.; London 1953-54, no. 218; New York, Knoedler & Co., *Masters of the Loaded Brush, Oil Sketches from Rubens to Tiepolo*, 1967, pp. 73-75, no. 53, ill.; Princeton 1979, no. 24, ill.; Ottawa 1980, p. 20, no. 45, ill.; Washington 1990-91, pp. 110-113, no. 13, ill.

LITERATURE: Henri Hymans, "Antoine van Dyck et l'exposition de ses œuvres à Anvers à l'occasion du troisième centenaire de sa naissance," *Gazette des Beaux-Arts*, ser. 3, vol. 22 (1899), p. 230; Henri Hymans, "Ausstellungen und Versteigerungen: Anvers Exposition Van Dyck," *Repertorium für Kunstwissenschaft* 22 (1899), pp. 418-419; Cust 1900, pp. 31, 208, no. 10, p. 321, no. 85, p. 237, no. 4; M. Friedländer, "Die v. Dyck-Ausstellung in London, 31. Winter-Exhibition der Academy," *Repertorium für Kunstwissenschaft* 23 (1900), p. 169; Bode 1906, p. 261; Schaeffer 1909, p. 39, ill.; H. Rosenbaum, "Der junge Van Dyck (1615-1621)," diss., Munich, 1928, pp. 65-66; Glück 1931, pp. xxxii, 71, 527, ill.; *Abridged Catalogue of the Pictures at Doughty House, Richmond, Surrey, in the Collection of Sir Herbert Cook, Bart.* (London, 1932), p. 35, no. 250; M. Delâcre, "Le Dessin dans l'œuvre de Van Dyck," *Académie Royale de Belgique, Classe des Beaux-Arts, Mémoires*, ser. 2, vol. 3 (1934), pp. 63, 70, 83-85, ill.; P. Bautier, "Tableaux de l'école flamande en Roumanie," *Revue belge d'archéologie et d'histoire de l'art* 10 (1940), p. 45; Vey 1956, p. 168; Vey 1958, pp. 180, 196-197, 202, 5; W. Stechow, "Anthony van Dyck's 'Betrayal of Christ,'" *Minneapolis Institute of Fine Arts Bulletin* 49 (1960), pp. 4-17, fig. 1; *Catalogue of European Paintings in the Minneapolis Institute of Arts* (Minneapolis, 1970), no. 75, ill.; Vey 1962-67, vol. 1, pp. 150, 155-156; Madrid cat. 1975, p. 101; C. Brown, "Van Dyck at Princeton," *Apollo* 110 (1979), p. 145, ill.; Larsen 1980, p. 294, cat. no. 299, pl. XIX; Brown 1982, p. 39; G. S. Keyes, "Paintings of the Northern School," *Apollo* 117 (1983), pp. 196-197, ill.; J. R. Martin, "The Young van Dyck and Rubens," *Revue d'Art Canadienne / Canadian Art Review* 10 (1983), p. 41, fig. 9; Barnes 1986, vol. 1, p. 27, note 9, p. 29, note 14, p. 33, note 30; Larsen 1988, vol. 1, p. 464, fig. 482, vol. 2, pp. 109-110, no. 259; N. de Poorter, in Madrid, cat. 1989, p. 196; New York 1991, p. 128, fig. 3; Liedtke et al. 1992, p. 330, ill.

CHRIST is depicted at the climactic moment of his betrayal in the Garden of Gethsemene. A wave of soldiers and citizens rushes in from the left, wielding bristling swords and spears and flooding the night scene with the glare of torches. Enveloped in voluminous yellow-tan drapery, Judas leads the crowd, pressing close to Christ to expose him. Surrounded, the tall dignified figure of Christ stands silently, resigned to the fulfillment of the Old Testament prophecies. All about him the throng swarms – a leering helmeted soldier menaces him with an ax while one of the pharisees raises the rope over his head to capture him. At the lower left, the apostle Peter (dressed, like Christ, in blue) assaults Malchus, the servant of the high priest, preparing to cut off the ear of his prone and struggling victim. The torchlight flickers luridly in the leaves of the tree overhead, overwhelming the pale light of the crescent moon. Like a theatrical footlight, an overturned lantern at the lower center enhances the tumult and drama.

As Wolfgang Stechow observed in his seminal article on this picture, the scene is based on the Gospel of St. John (18:1-12): while all four gospels mention the event, St. John alone speaks of the priests and pharisees coming with torches and weapons to capture Christ, and he alone identifies Peter and Malchus as the protagonists in the secondary drama.[1] Stechow also summarized the problems in identifying the function of this picture, which is too broadly executed and sketchy to be a traditional presentation modello, but also too large and complete to be a working sketch.[2] As Barnes reiterated, the technique is too loose and the effects too daring to imagine the work as having been acceptable as a finished, independent commission in Antwerp in ca. 1620.[3] Closely related to the painting in design and conception is the version in the Prado (fig. 1), which is more than twice its size and more finished in execution.[4] The Prado's painting was in Rubens's collection at the painter's death (together with van Dyck's *St. Jerome*, cat. 38), Rotterdam, and was bought in 1641 by Philip IV of Spain. The two compositions accord in most details, although the figures of Peter and Malchus have been changed; the assaulted servant is no longer upside down and tumbling terrible-eyed into the viewer's space, but spread out horizontally across the bottom of the composition as Peter wields his sword.

Still a third large version, formerly in Lord Methuen's collection in Corsham Court and now belonging to the Bristol Museum (fig. 2), eliminates the Peter and Malchus group entirely and replaces them with a darkened tree stump, and moves the figures of Christ and Judas closer to the center of the design.[5] Delâcre regarded the Prado version as first,[6] Vey considered the Corsham picture primary,[7] and, after initially regarding the Minneapolis painting as a sketch for the Prado painting, Larsen raised the possibility that it could instead be a later reduction.[8] Glück admitted that the sequence of the three versions was difficult to ascertain,[9] and Barnes rightly cautioned that we know very little about van Dyck's practice (concentrated especially in the period of ca. 1619-1621) of making multiple large-scale versions. However she held out the possibility that the Bristol painting might have been executed between the Minneapolis and Madrid versions.[10] This writer finds it unlikely that van Dyck, having worked out the Peter/Malchus group, would have eliminated it at an intermediary stage and then reintroduced the figures in the final version. Most logical is Stechow's reasoning that the Minneapolis painting was first, the larger, more resolved Prado painting with the reconfigured Peter/Malchus group was second, and the ex-Corsham picture, which simplifies and consolidates the scene, was the final version.[11] Stechow's theory was also supported by Martin and Feigen-

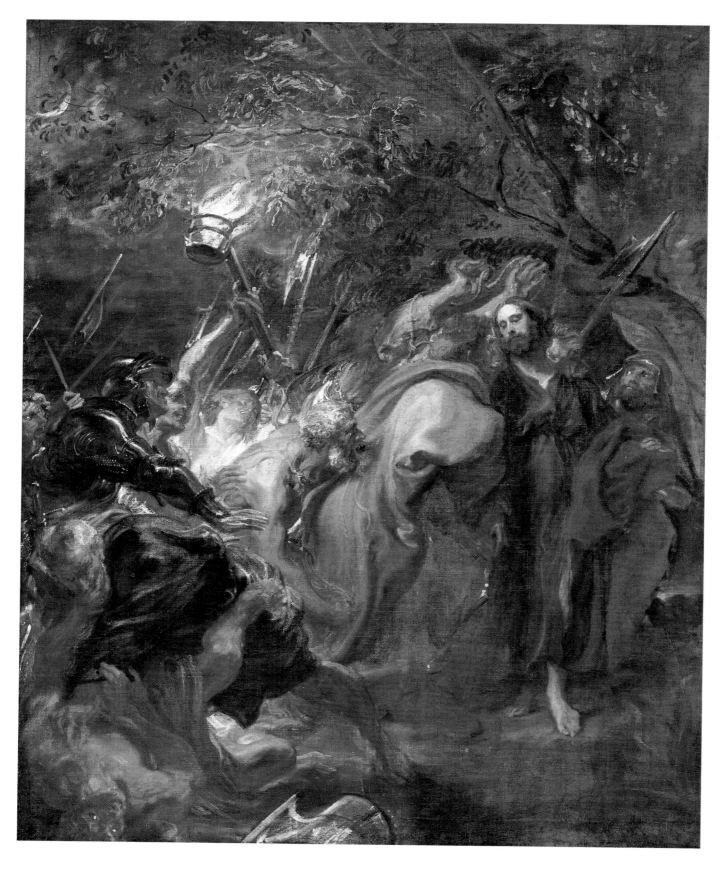

Fig. 3. Anthony van Dyck, *The Betrayal of Christ*, pen and ink and black and red chalk on paper, 553 x 403 mm, Hamburg, Kunsthalle, inv. no. 21882.

baum[12] and Shapiro.[13] Cust's original contention, that the painting then at Corsham Court could have been painted as many as ten years later, namely upon van Dyck's return to Antwerp, seems unlikely, however.[14] Most authors agree that the paintings were probably painted within a relatively limited time period, perhaps a year or two, and were undoubtedly painted before van Dyck's departure for Italy in 1621.[15]

Like Cust, Bode, and many authors, Keyes rightly stressed the importance of Titian's late style and Venetian art generally for van Dyck's unprecedentedly sketchy execution, even suggesting that the Minneapolis picture could have been painted in Italy.[16] However, van Dyck had begun developing his "furia del pennello" even earlier. One hardly need accept the anecdotes confected by van Dyck's earliest biographers (which state that out of gratitude for the master's instruction he gave Rubens gifts of paintings before departing on his journey, and in turn was given Rubens's best horse for the ride); nonetheless it is likely that van Dyck left the Prado painting with Rubens before he left, thus implying a date before October 1621 for the present work as well. Martin and Feigenbaum,[17] as well as Barnes,[18] have reminded us that van Dyck in his youth made a practice of executing two versions of a given subject, one sketchy and the other highly finished. The purpose of this practice is difficult to ascertain. No doubt van Dyck admired Rubens's confidently broad brushwork but the Minneapolis painting exceeds in freedom anything that that master ever attempted.

What Stechow and other authors have found so remarkable is the thought and deliberation that van Dyck expended on this exceptionally spontaneous-looking picture. An extraordinarily large group of preparatory and related drawings have been identified and discussed by Delâcre, Vey, and Stechow.[19] Most are rapid sketches, but they include no fewer than six drawings in both horizontal and vertical formats for the final composition. A drawing in the Albertina in Vienna (inv. 17537) anticipates the upright design of the Minneapolis painting and the tumultuous nocturnal throng coming to capture Christ but omits the Peter/Malchus group.[20] A drawing in the Louvre (inv. 19909) also employs the upright design but depicts the apostles still sleeping in the lower left,[21] a subject partly anticipated by a sheet in Berlin (inv. 5683).[22] A more finely executed and quite large drawing in Hamburg (fig. 3) that has been squared for transfer adds the Peter and Malchus episode and most closely anticipates the Minneapolis painting.[23] Yet another drawing in the Museum Boymans-van Beuningen, Rotterdam

(inv. v.95), depicts the same armored soldier in profile who appears at the left but depicts the Peter and Malchus group differently, and thus may be an intermediate idea executed between the Minneapolis and Prado versions.[24]

The subject of the Betrayal or Taking of Christ was popular in fifteenth- and sixteenth-century Flemish painting.[25] Night scenes had also been painted for more than a century (notable early examples are by Hugo van der Goes and Geertgen tot Sint Jans) and, of course, had more recently been a specialty of Adam Elsheimer and his admirer Rubens; however van Dyck's painterly treatment of the night again reminds us more of North Italian painting and artists like Tintoretto. For the general ancestry of van Dyck's design, Stechow pointed to the importance of the Betrayal scenes in Dürer's "small" woodcut Passion (ca. 1510) and "Engraved Passion," and more specifically cited the importance of three drawings by Marten de Vos of the Betrayal, the closest of which is a nocturnal image in the museum in Brussels.[26] As Barnes noted, the latter drawing not only augurs Judas's gesture and the Rubenesque man in armor, but probably was consulted again by van Dyck when he altered the Peter/Malchus group for the Prado version.[27] However, Stechow's confidence in the belief that these changes in the design must have been recommended by Rubens is harder to share.[28] The figure of Malchus in the lower left of the Minneapolis picture closely resembles the corresponding figure in Rubens's *Miracles of Ignatius Loyola* in Vienna (ill. Introduction, fig. 25).[29] It has also often been observed that van Dyck quoted his own figures in this scene; his St. Jerome in the Gemäldegalerie, Dresden,[30] appears in the partially nude and bearded figure just behind Judas, and the head of his Apostle Judas Thaddeus[31] is reiterated in the figure flanking Christ.

A copy of the present painting was recently on the art market in New York and exhibited *hors de catalogue* at Princeton in 1979; still another is in the Museum of Cluij, Romania.[32] Anne Lurie demonstrated that Jordaens's drawn copy (collection of Michael Jaffé, London) was the source for his own later painting of this subject.[33]

P C S

1. Stechow 1960, pp. 4-17.

2. Ibid., p. 6.

3. Washington 1990-91, p. 113.

4. Glück 1931, no. 69, ill.; Madrid cat. 1975, vol. 1, pp. 100-102, no. 1477, pl. 71; Larsen 1988, vol. 2, no. 260, ill.

5. Glück 1931, no. 70; Lord Methuen, *An Historical Account of Corsham Court, The Methuen Collection of Pictures* (1958), p. 6; Larsen 1988, vol. 2, no. 258, ill.; Washington 1990-91, no. 14, ill. As Vey (1958, p. 201, note 4) and Stechow

Anthony van Dyck
38. St. Jerome

Oil on canvas, 165 x 130 cm (65 x 51 ⅛ in.)
Rotterdam, Museum Boymans-van Beuningen,
Stichting Willem van der Vorm, inv. VdV no. 22.

(1960, p. 17, note 27) noted, this version is probably the "autaerstuk" of *Ons Heer in 't Hoffken* which was characterized as being of altarpiece scale when Nicodemus Tessin saw it in the collection of Alexander Voet in Antwerp in 1687 (see *Antwerpsch Archievenblad* 22 [1908], pp. 39 and 72; *Oud Holland* 18 [1900], p. 203). Glück (1931, p. 527) wrongly suggested that this reference was to the Minneapolis painting.

6. Delâcre 1934, p. 84.

7. Vey 1958, p. 180; 1972, vol. 1, p. 155.

8. Larsen 1988, vol. 2, p. 109.

9. Glück 1931, p. 527.

10. Washington 1990-91, pp. 114-116.

11. Stechow 1960, pp. 6ff.

12. Princeton 1979, pp. 101-102.

13. Knoedler, *Masters of the Loaded Brush*, 1967, p. 74.

14. Cust 1900, p. 31.

15. See as examples Stechow 1960, p. 7 (as painted just prior to his trip); Martin and Feigenbaum, in Princeton 1979, no. 24 (as executed between March and October 1621); N. de Poorter, in Madrid, cat. 1989, p. 196 [1620/21]; Barnes, in Washington 1990-91, cat. nos. 13-14 [ca. 1620].

16. Keyes, "Paintings of the Northern School," (1983), p. 45, with references to A. McNairn's research in the exh. cat. of Ottawa 1980, cat. 45, in which he maintained that it was the "modello" for the Prado painting and that at least one drawing by van Dyck of *Peter and Malchus* seems to acknowledge Titian's altarpiece of the *Death of St. Peter Martyr* in the Church of SS. Giovanni e Paolo; however, see Stechow 1960, note 4. On the Venetian influences on the Minneapolis painting, see Cust 1900, pp. 30-31; Bode 1906, p. 261; Vey 1958, pp. 180, 196-197; Stechow 1960, p. 6; and Barnes, in Washington 1990-91, pp. 110-112.

17. Princeton 1979, p. 101, citing the example of the two versions of the *Martyrdom of St. Sebastian* (Norfolk, Chrysler Museum; and Munich, Alte Pinakothek).

18. Barnes, in Washington 1990-91, pp. 113-114, citing also the two versions of *St. Martin and the Beggar* (in Saventhem; and Windsor Castle) and *Christ Crowned with Thorns* (formerly Berlin [destroyed]; and the Prado, Madrid).

19. See Delâcre 1934, pp. 67ff; Vey 1958 and 1972, pp. 147-158, cats. 79-86; and Stechow 1960.

20. Vey 1972, cat. 83, fig. 113; Stechow 1960, p. 8, fig. 5.

21. Vey 1972, cat. 84, fig. 114; Stechow 1960, p. 8, fig. 8.

22. Vey 1972, cat. 81, fig. 108; Stechow 1960, p. 8, fig. 7.

23. Vey 1972, cat. 86, fig. 115; Stechow 1960, p. 13, fig. 10.

24. Vey 1972, cat. 85, fig. 116.

25. See DIAL 73 D31.31.

26. Brussels, Musées Royaux des Beaux-Arts de Belgique, De Grez collection, no. 3934; Stechow 1960, p. 7, note 8.

27. Washington 1990-91, p. 112, fig. 3.

28. Stechow 1960, p. 14.

29. See Martin 1983, p. 41.

30. See Glück 1931, p. 524, and his no. 68.

31. Glück 1931, p. 524 and his no. 44; also Martin and Feigenbaum 1979, p. 101.

32. Canvas, 130 x 83 cm. See Bautier 1940; Washington 1990-91, p. 113.

33. A. T. Lurie, "Jacob Jordaens's *The Betrayal of Christ*," *Bulletin of the Cleveland Museum of Art* (March 1972), p. 71.

PROVENANCE: collection of Peter Paul Rubens; purchased from Rubens's estate by King Philip IV of Spain, 1641; until 1656 in the Royal Palace, Madrid; El Escorial, 1656-1800; King Joseph Bonaparte of Spain, who gave it to Maréchal Soult (Nicolas-Jean de Dieu, Duke of Dalmatia), who took it to Paris; dealer William Buchanan, who brought it to England shortly before 1840; Matthew Anderson, Jesmond Cottage, near New Castle, 1857; Henry Spencer Lucy, Charlecote Park, Warwick, 1857-1865; Fairfax Lucy, Charlecote Park, Warwick, 1900; sale Lucy, London (Christie's), 1 June 1945, no. 40, to dealer S. & R. Rosenberg; David Bingham, New York, 1946-1955, whose widow in 1956 sold it to Willem van der Vorm, Rotterdam; Stichting Willem van der Vorm.

EXHIBITIONS: London, The Gallery, *Paintings from the Collection of the Maréchal Soult, Duc de Dalmatie, and Other Celebrated Galleries*, 1840, no. 2; Manchester, City of Manchester Art Gallery, *Art Treasures of the United Kingdom*, 1857, no. 594; Rotterdam, Boymans-Museum, *Antoon van Dyck, Tekeningen en Olieverfschetsen*, 1960 (not in catalogue); Ottawa 1980a, no. 74, ill.

LITERATURE: Francisco de los Santos, *Descripcion breve del Monasterio de San Lorenzo el Real* (Madrid, 1657), fols. 47r-47v; Francisco de los Santos, *Descripcion breve del Monasterio de San Lorenzo el Real* (Madrid, 1667), fol. 50r; Padre Norberto Caimo, *Lettere d'un vago Italiano ad un suo Amico* (Pittburgo, 1761), p. 95; A. Ponz, *Viage de España*, 18 vols. (Madrid, 1772-1794), vol. 2, p. 87; A. Ponz, *Viage de España*, 3rd ed. 18 vols. (Madrid, 1787-1794), vol. 2, p. 83; Waagen 1854-1857, vol. 4 (1857), p. 480; W. Bürger [T. Thoré], *Trésors d'Art en Angleterre*, 3rd ed. (Paris, 1865), pp. 223-224; *Antwerpsch Archievenblad* 2 (1865), pp. 85, 126, 136; A. Lavice, *Revue des Musées d'Angleterre* (Paris, 1867), pp. 268-269; Guiffrey 1882, p. 251, no. 195b; Cust 1900, p. 68, 250, no. 66; Glück 1931, p. 525, no. s. 57; W. R. Valentiner, "Van Dyck's Character," *Art Quarterly* 13 (1950), pp. 102, 104-105, fig. 10; G. Marlier, "Een onbekend schilderij van Antoon van Dyck," *West-Vlaanderen* 4 (1955), p. 299; D. Hannema, *Beschrijvende catalogus van de schilderijen uit de kunstverzameling Stichting Willem van der Vorm* (Rotterdam, 1958), no. 20, figs. 30-32 (2nd ed. 1962) pp. 25-26, no. 22, figs. 42-44; d'Hulst & Vey, in Antwerp/Rotterdam 1960, p. 97; H. Gerson, "Antoine van Dyck. 'De Heilige Hieronymus,'" *Openbaar Kunstbezit in Nederland* 6 (1962), no. 25; H. van de Waal, "Rembrandt's Faust Etching, a Socinian Document, and the Iconography of the Inspired Scholar," *Oud Holland* 79 (1964), p. 40, note 85, fig. 28; Rotterdam, Museum Boymans-van Beuningen, *Old Paintings 1400-1900* (Rotterdam cat. 1972) p. 209, ill. p. 111; D. Hannema, *Flitsen uit mijn leven als verzamelaar en museum directeur* (Rotterdam, 1973), p. 137, ill. 19; *Bulletin Museum Boymans* 1973, p. 44; F. Haskell, *Rediscoveries in Art: Some Aspects of Taste, Fashion and Collecting in England and France* (London, 1976), p. 36, fig. 89; J. Walsh, "Stomer's Evangelists," *The Burlington Magazine* 118 (1976), p. 508, fig. 89; Princeton 1979, p. 83; J. C. Ebbinge Wubben, "Van Museum Boymans tot Museum Boymans-van Beuningen; herinneringen aan enkele verzamelaars," in *Essays in Northern European Art Presented to Egbert Haverkamp Begemann* (Doornspijk, 1983), p. 81, fig. 5; R. Baumstark, in New York 1985, p. 306; Larsen 1988, vol. 1, p. 145, fig. 58; vol. 2, p. 97, no. 225; Muller 1989, p. 134, no. 229, pl. 94; N. de Poorter, *Rubens and His Age*, Museum Boymans-van Beuningen (Rotterdam, 1990), pp. 45-47, cat. no. 6, ill.; Barnes, in Washington 1991, pp. 82, 84, 95.

THE WHITE bearded St. Jerome is seated and viewed full length facing the observer. Nude to the waist, he wears a voluminous red drapery about his loins. In his hands he holds a long scroll, an allusion, like the pile of books at the lower right, to Jerome's scholarly work as one of the Four Fathers of the Church and translator of the Bible into Latin. Above and to the left a young angel places its left hand lightly on Jerome's shoulder while holding a quill pen in the other hand as a symbol of divine inspiration. The lion that (according to popular legend) became Jerome's loyal companion after the saint (Androcles-like) removed a thorn from his paw lies sleeping at the lower left. The leafy bower with

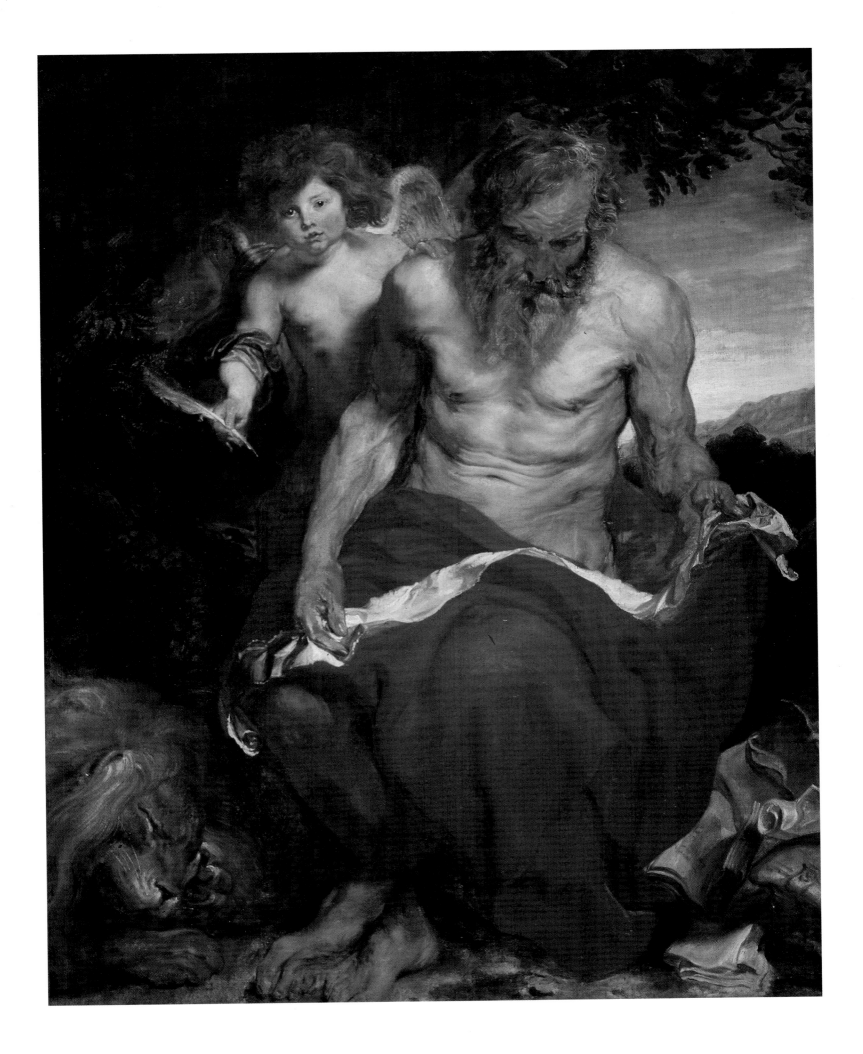

glimpse of rushing stream on the left and a blue mountain valley in the prospect on the right is scarcely the desert of Syria to which the saint retreated as a penitent, but it accords with the traditional pictorial conception of the wilderness.

Van Dyck painted at least four different versions of St. Jerome (excluding replicas, derivations, and copies), all of which seem to date from his early career, ca. 1620 or before. Although he had shown an interest in expressive images of the physical types and the psychology of the saints in his earliest works, such as the well-known series of Apostles, Jerome evidently held a special fascination for the artist. It is difficult to establish the exact chronology or sequence of his various treatments of the theme, but with its very broad and coarse manner and minor spatial and formal infelicities, the version in Vaduz (Prince of Liechtenstein collection, inv. no. 56) is probably the earliest (fig. 1). It follows its source in Rubens's *St. Jerome* of ca. 1615 (Dresden, Gemäldegalerie Alte Meister, no. 955) closely, showing Jerome full length and bent over in profile. In this very early work, van Dyck already depicts the saint working on the Vulgate not in his study in the monastery in Bethlehem, where it was actually written (as had earlier Flemish artists like Joos van Cleve, Marinus van Roemerswael, and Rubens [see Potsdam, Sanssouci, no. 58]), but rather out of doors. The tradition of conflating Jerome's two roles of scholar and penitent can be traced in Northern painting back to at least the art of Jan Sanders van Hemessen (see St. Petersburg, Hermitage, no. 451 [dated 1543], and London, Buckingham Palace, no. 579 [dated 1545]) and was treated more recently by Marten de Vos (Antwerp, Hospital van Stuivenberg Church).[1] Tradition thus had tended to mix the attributes of Jerome the man of learning with those of Jerome the hermit and severe ascetic. The vivid red of his drapery is probably an allusion to the apochryphal legend that Jerome was made a cardinal; although he held a papal appointment, the office of cardinal did not yet exist during his lifetime (342-420).

A half-length version of St. Jerome by van Dyck in the Prado (Madrid, no. 1473) returns to the theme of Jerome venerating the cross, as does a full-length version in a horizontal format with an elaborate landscape with gnarled trees and a swag of drapery (Dresden, Gemäldegalerie Alte Meister, no. 1024[2]; fig. 2). The latter shows Jerome with the rock in his hand that he used to mortify the flesh that so loved Cicero and classical literature. In all of these other versions the saint is viewed in profile, seated or kneeling. Evidently van Dyck was inspired to explore the saint's life not simply because it offered an opportunity to paint a wizened though still powerful older man's body, but also because Jerome was a spiritual patriarch whose intellectual accomplishments informed all of Christianity. The challenge to convey the aged saint's spirituality and intellectual stamina obviously appealed to the young artist, then still a teenager. The ambitious young van Dyck may also have regarded this exercise as a challenge of *aemulatio* – a competitive theory of art first formulated by literary theorists but paraphrased by seventeenth-century theories of art. *Aemulatio* involved a deliberate allusion to an esteemed prototype by a borrower who sought to overcome mere *imitatio* by attempting to surpass his model. Not only is Vaduz's painting based on Rubens's painting in Dresden but the latter in turn has a source in Titian's painting from Santa Maria Nuova (now in the Brera, Milan[3]), which van Dyck also could have known through Rubens's copies.[4] Thus van Dyck could measure his own conceptual aptitude in history painting against the two artists whose work he held in the highest esteem.

By turning Jerome to face the viewer frontally in the present work, van Dyck may also have recollected Rubens's still earlier *St. Jerome in His Study* of ca. 1609-1610.[5] As in the Vaduz painting, however, the saint is again depicted working out of doors. In his frontal pose we can better appreciate the saint's concentration, his desiccated leathery trunk, and powerful shoulders and arms. Despite its appearance of having been painted from life, the torso of van Dyck's nude Jerome may also recall Rubens's drawing (Antwerp, Rubenshuis) after the famous antique sculpture known as the *Belvedere Torso* (Vatican Museum), or his drawing (St. Petersburg, Hermitage) after the antique *African Fisherman* (formerly known as "Dying Seneca"; Paris, Musée du Louvre). Considering van Dyck's possible classical sources for Jerome's exceptionally finely observed realism, the unusual detail of the childlike angel resting its hand on the saint's shoulder and holding a quill may also call to mind an unexpected pictorial source, namely Caravaggio's first version of the *St. Matthew and the Angel* for San Luigi dei Francesi (formerly Berlin, Kaiser Friedrich Museum, destroyed World War II), though we hasten to add that van Dyck could only have known this controversial image indirectly. De Poorter observed that the same model for Jerome seems to appear in two other drawings by van Dyck.[6] She also correctly observed that St. Jerome's reccurrence in van Dyck's early œuvre is paralleled by that of another famous penitent, Mary Magdalen. The latter was sometimes paired with Jerome in Counter Reformation images of Christ among the sinners.[7]

Fig. 1. Anthony van Dyck, *St. Jerome*, ca. 1615, oil on canvas, 157.5 x 131 cm, Vaduz, collection of the Prince of Liechtenstein, inv. no. 56.

Fig. 2. Anthony van Dyck, *St. Jerome*, 1618, oil on canvas, 192 x 215 cm, Dresden, Gemäldegalerie Alte Meister, inv. 1024.

6. De Poorter 1990, p. 47; for the drawings, see Vey 1962, no. 110, and a head study (Louvre, Paris), ill. by Glück 1931, p. 28 left.

7. See, for example, Hieronymus Wierix's print of 1581 (Louis Alvin, *Catalogue raisonné* [Brussels, 1866], no. 122); for discussion, Knipping 1974, vol. 2, p. 316.

8. De Poorter 1990, p. 47. She also lists several inferior versions of the design which she rightly concludes cannot be regarded as genuine (her note 7).

The provenance of the painting attests to its high regard even in van Dyck's lifetime. It was one of three paintings of the subject by van Dyck that were in Rubens's private collection (the Dresden version also seems to have been owned by van Dyck's teacher). Rubens had presumably acquired it in 1620/21, shortly before van Dyck's departure for Italy. It was sold from Rubens's estate to King Philip IV of Spain. In the Palace in Madrid until 1656, it was given by Philip IV to the monastery at Escorial together with forty-one other religious paintings selected and installed by the great Spanish painter, Velázquez. *St. Jerome* adorned the sacristy of El Escorial until 1800 when Joseph Bonaparte gave it away.

De Poorter noted several large pentimenti which prove that the present work is the primary version and that the other version of this composition in the Nationalmuseum, Stockholm (no. 404), is an autograph replica produced some time later.[8]

PCS

1. For all the above images, see DIAL 11 H (HIERONYMUS IX 30). Baumstark (in New York 1985, p. 306, under no. 195) and Barnes (in Washington 1990-91, under cat. 2) mistakenly suggested that van Dyck invented this iconography. On the traditions of representing St. Jerome, see R. Jungblut, *Hieronymus. Darstellung und Verehrung eines Kirchenvaters* (Tübingen, 1966).

2. Washington 1990-91, cat. 8.

3. H. E. Wethey, *The Paintings of Titian*, vol. 1: *The Religious Paintings* (London, 1969), no. 105. Among the other earlier Northern artists who seem to have responded to the Titian is Michiel Coxcie (see *Penitent St. Jerome*, Clara Aschmann, Maroggia, Switzerland, 1965)

4. See the copy of Rubens's lost drawing after the picture, Haarlem, Teylers Museum; ill. Washington 1990-91, p. 95, fig. 1.

5. See the various versions listed by Vlieghe 1972-73, vol. 2, nos. 120-121.

Anthony van Dyck
39. *Portrait of the Marchesa Elena Grimaldi, 1623*

Oil on canvas, 246 x 173 cm (97 x 68 in.)
Washington, D.C., National Gallery of Art,
Widener collection, inv. 1942.9.92

PROVENANCE: collection of Giambattista Cattaneo, Genoa (by 1780); collection Nicola Cattaneo, Genoa (by 1828); collection Cattaneo della Volta (until 1906); P. & D. Colnaghi & Co., London; sold by M. Knoedler & Co. to P. A. B. Widener, 1908; by descent to Joseph Widener.

EXHIBITIONS: New York 1909, no. 4; Washington 1990-91, pp. 174-176, no. 36.

LITERATURE: Carlo Giuseppe Ratti, *Instruzione di Quanto puo' Vedersi di Più Bello in Genova in Pittura, Scultura ed Architettura ecc.* (Genoa, 1780), p. 106; Allan Cunningham, *The Life of Sir David Wilkie . . .*, 3 vols. (London, 1843), vol. 2, pp. 494-495, vol. 3, pp. 38-39; Federigo Alizieri, *Guida Artistica per la Città di Genova*, 2 vols. (Genoa, 1846-47), vol. 1, pp. 422-423; Cust 1900, p. 242; W. Suida, *Genua* (Leipzig, 1906), p. 166; W. Roberts, "The Cattaneo Van Dycks," *The Connoisseur* 18 (1907), pp. 44, 47; C. J. Holmes, "Rembrandt and Van Dyck in the Widener and Frick Collections," *The Burlington Magazine* 13 (1908), p. 316; W. Walton and L. Cust, "Exhibition in New York of Portraits by Van Dyck," *The Burlington Magazine* 16 (1909-10), pp. 296, 301-302; C. J. Holmes, *Notes on the Art of Rembrandt* (London, 1911), p. 180, note 1; W. R. Valentiner and C. Hofstede de Groot, *Pictures in the Collection of P. A. B. Widener at Lynnewood Hall, Elkins Park, Pennsylvania* (Philadelphia, 1913), no. 50; W. R. Valentiner, "Rubens and Van Dyck in Mr. P. A. B. Widener's Collection," *Art in America* 1 (July 1913), pp. 166, 170; Valentiner 1914, pp. 208-210; L. Wittler, "The Cattaneo-Lomellini Van Dycks," *International Studio* 90 (1928), pp. 37-38; Burchard 1929, pp. 321, 323-324 and 344; Glück 1931, p. 187, ill.; B. Berenson, C. Hofstede de Groot, W. R. Valentiner, and W. Roberts, *Pictures in the Collection of Joseph Widener at Lynnewood Hall, Philadelphia* (Philadelphia, 1931), n.p.; H. G. Fell, "Van Dyck for the National Gallery: The Abbé Scaglia Adoring the Virgin and Child," *Connoisseur* 101 (February 1938), p. 99; E. Waldmann, "Die Sammlung Widener," *Pantheon* 22 (1938), p. 342; van Puyvelde 1950b, pp. 139, 144; Vey 1962, vol. 1, p. 62 (1625); L. Ragghianti Collobi, *Disegni della Fondazione Horne in Firenze* (exh. cat. Florence, 1963), p. 61, no. 249; M. Jaffé, "Van Dyck Portraits in the De Young Museum and Elsewhere," *Art Quarterly* 28 (1965), p. 43; J. Müller Hofstede, "New Drawings by Van Dyck," *Master Drawings* 11 (1973), pp. 156-157; Huemer 1977, p. 37; Larsen 1980, vol. 1, no. 411; Brown 1982, p. 93; P. Kaplan, "Titian's 'Laura Dianti' and the Origins of the Motif of the Black Page in Portraiture (2)," *Antichità Viva* 21, no. 4 (1982), p. 14; Washington, cat. 1985, p. 146; Barnes 1986, pp. 112-115, 122, 124, 222-226, no. 30; Larsen 1988, vol. 1, pp. 220-221, vol. 2, pp. 137-38; C. Christiansen, M. Palmer, and M. Swicklik, "Van Dyck's Painting Technique, His Writings, and Three Paintings in the National Gallery of Art," in Washington 1990-91, pp. 46-48; M. Jaffé, "Van Dyck at the National Gallery of Art," *The Burlington Magazine* 133 (1991), pp. 142-143; New York 1991, p. 172, fig. 1; Liedtke et al. 1992, p. 334.

CAPTURED in her stately progress across an overgrown terrace, the young woman is clothed in a deep green dress with gold braid trim, accented by a lace ruff and striking red sleeve cuffs. She holds a sprig of orange blossoms in her right hand,[1] from antiquity a symbol of chastity and therefore a suitable attribute for brides.[2] On the ground beneath her feet are various plants, including clover, ivy, sage, red calendula, and, at the right, a spiky thistlelike plant.[3] The remarkably attenuated proportions of the young woman's figure are reiterated in the graceful lines of the Corinthian columns behind her; the lush capitals paraphrase her extravagant ruff. Delicate tendrils of hair have escaped the pearl headdress to curl softly about her face. The brilliant red parasol solicitously wielded by a young black page acts as a foil for the sitter's delicate features and porcelain complexion, a modish update on the swath of drapery in Rubens's *Portrait of Marchesa Brigida Spinola Doria.*[4]

The strong parallel between van Dyck's Genoese portraits and those by Rubens, and specifically the correlation between the *Marchesa Elena Grimaldi* and Rubens's *Marchesa Brigida Spinola Doria* (cat. 8), was first noted by Burchard, and more recently detailed by Barnes.[5] It is clear that van Dyck was consciously working from the example set almost two decades earlier by his illustrious predecessor in painting his own likenesses of the Genoese patriciate. In the case of the *Elena Grimaldi* and *Brigida Spinola Doria*, both portraits (in their original formats, see cat. 8) situate the figure at full length before a majestic architectural mise-en-scène, heightening the inherent grandeur with a slightly lowered viewpoint. For both painters, Titian's *Lavinia as Bride* (fig. 1) was an important precedent for the pose of the figure.[6] Despite compositional similarities, however, there are major differences between these works by Rubens and van Dyck, for example in their depiction of movement. The *Brigida Spinola Doria* is static, iconic; *Elena Grimaldi* undulates in a subtle processional motion, enhanced by the forward sweeping diagonals of the page lofting the parasol above her head. Like Titian's *Lavinia* (and unlike the *Brigida Spinola Doria*), van Dyck's *Elena Grimaldi* gathers the folds of her voluminous skirt with her left hand so that she does not trip as she glides ineluctably forward.

The rich palette and diffused, atmospheric quality of van Dyck's portrait is particularly Venetian in character, evoking not only Titian but also works by Veronese.[7] The painting is infused with a soft ambient light, in contrast to the artificial, almost mannerist illumination that sharply defines the forms of Rubens's portrait. Similarly, the architecture in van Dyck's portrait is more graceful, with a fluid, vertical emphasis; the forms themselves are softened atmospherically and punctuated by slivers of the sky, while in Rubens's portrait the massive, densely sculptural forms of the portico are strengthened by the crisp illumination (an effect heightened by the painting's cropped state).

The most obvious difference between the two works, however, is the addition of the black page in van Dyck's portrait, a secondary figure that paradoxically serves to focus attention on the Marchesa. This motif also had its source in Titian, in the latter's *Portrait of Laura Dianti* (ca. 1523; Madrid, collection Thyssen Bornemisza). Genoa was a key port in the slave trade in the sixteenth and seventeenth centuries, and black house servants were highly valued among the local nobility.

During the recent cleaning of the picture, strips of more coarsely woven canvas were removed which

Fig. 1. Titian, *Lavinia as Bride*, ca. 1555, oil on canvas, 102 x 86 cm, Dresden, Gemäldegalerie Alte Meister, inv. 170.

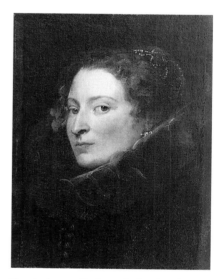

Fig. 2. Anthony van Dyck, *Portrait of Marchesa Elena Grimaldi*, oil on canvas, 42.5 x 31.25 cm, Washington, D.C., National Museum of American Art, Smithsonian Institution, inv. 1929.6.155.

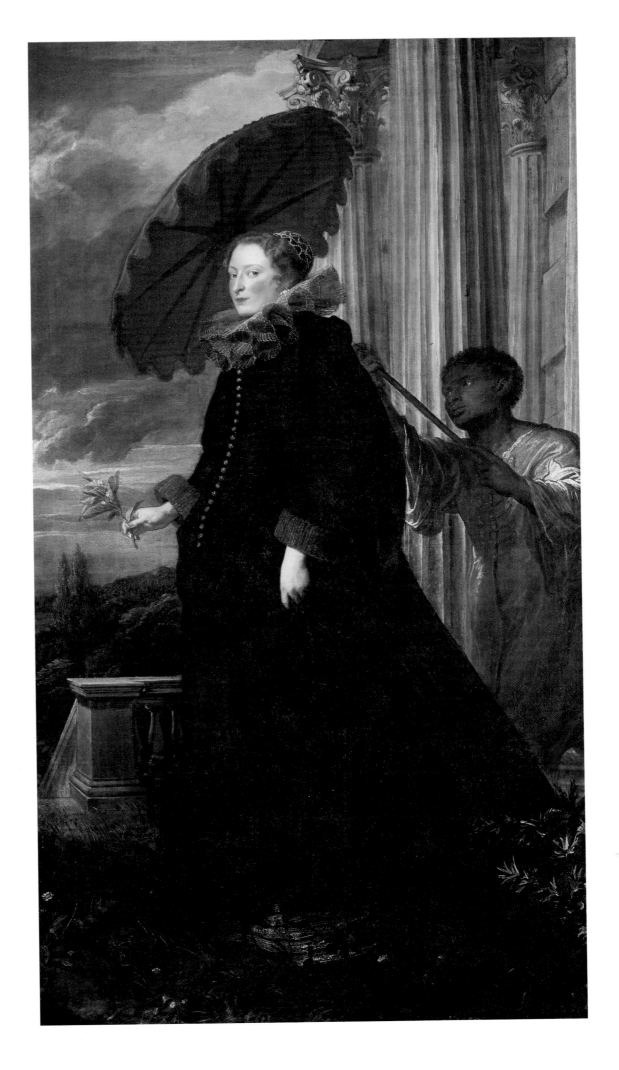

Anthony van Dyck
40. The Ages of Man

Oil on canvas, 120 x 165 cm (46 ¼ x 64 ½ in.)
Vicenza, Museo Civico-Palazzo Chiericati,
Restored for Mr. Giuseppe Roi's will, in memory
of Gino Barioli, 1986, inv. no. A228

had been added to the bottom (6 cm [2 ⅜ in.]) and the right (24.5 cm [9 ½ in.]) and left (16 cm [6 ¼ in.]) sides of the original canvas sometime after the mid-seventeenth century.[8] The absence of underdrawing in infrared examination of the painting suggests that van Dyck made the preparatory sketch in brushed umber pigment (rather than a dry medium such as charcoal), which is not revealed in infrared examination; this sort of underpainting would also accord with contemporary accounts of van Dyck's swift painting technique.[9] Another stage in the construction of the portrait is suggested by an oil sketch of the head (fig. 2), which was probably done from life to secure the sitter's features for the completion of the portrait in the studio. The sketch shows van Dyck's early idea of tucking a flower behind the sitter's right ear, a detail which was painted out in the final version of the portrait.

Although the sitter has traditionally been called Elena Grimaldi, Marchesa Cattaneo (wife of Giacomo Cattaneo), there is only strong circumstantial evidence for this identification.[10] Van Dyck also painted portraits of the Cattaneo children, Filippo and Clelia (Washington, D.C., National Gallery of Art, invs. 1942.9.93 and 1942.9.94).

MEW

1. Not an olive branch, as stated by Jaffé 1991, p. 143.

2. On the symbolism of the orange blossom, see M. Levy d'Ancona, *The Garden of the Renaissance. Botanical Symbolism in Italian Painting* (Florence, 1977), pp. 272-275; and E. de Jongh, in Haarlem 1986, p. 189.

3. Identified by Jaffé 1991, p. 143.

4. On the parasol, see Barnes 1986, pp. 225-226.

5. Burchard 1929, p. 323; Barnes 1986, pp. 109-116, esp. pp. 114-115; and idem, in Washington 1990-91, pp. 174, 176.

6. See Barnes 1986, p. 112, and idem, in Washington 1990-91, esp. p. 176. Rubens knew the portrait from the d'Este collection in Modena; his copy of it is in the Kunsthistorisches Museum, Vienna (inv. 531). Van Dyck made a sketch after the Titian portrait at about this time (1623) in his Italian sketchbook (London, British Museum, fol. 104v); see Adriani 1965.

7. On the inclusion of black pages in (primarily) sixteenth-century portraits see P. Kaplan, "Titian's 'Laura Dianti,'" 1982, no. 1, pp. 11-18 and no. 4, pp. 10-18; on later seventeenth-century Netherlandish examples, see M. Otte, "'Somtijds een moor': De neger als bijfiguur op Nederlandse portretten in de zeventiende en achttiende eeuw," *Kunstlicht* 8 (fall 1987), pp. 6-10.

8. Copies from before this date show the composition in its original state. For a more complete technical analysis of the painting, see C. Christensen, M. Palmer, and M. Swicklik in Washington 1990-91, pp. 46-48.

9. For example, Everard Jabach's description of van Dyck's technique, quoted in de Piles 1699-1700; cited also in Cust 1900, pp. 138-139; and Washington 1990-91, p. 47. Van Dyck's portrait of Jabach is in the Hermitage, St. Petersburg.

10. See Barnes 1986, pp. 224-225; and idem, in Washington 1990-91, p. 176.

PROVENANCE: Carlo II, Duke of Mantua, inventory dated 10 November 1665: "le quattro età" in the "altro camerino" (see d'Arco 1857, p. 189 and Virdis 1986, pp. 172-173); inv. 1700 ["Van Dic . . . le Quatro età dell'uomo"]; inv. 1709 ["tre figure con putin che dorme di van Dic"]; inv. 1711 ["another picture of Van Dyck representing an armed man, a sleeping child and a young girl holding some roses and an old man"]; bequest of Paolina Porto-Godi, 1826.

EXHIBITIONS: Venice, *I Capolavori dei Musei veneti* (cat. by Rodolfo Palucchini) 1946, no. 277, ill.; Genoa 1955, no. 49, ill.; Milan, *Museo Ritrovato-Restauri, Acquisizioni, Donazioni 1984/1986*, 1986, pp. 137-138, ref. no. B.33; Padua, Palazzo della Ragione, *Fiamminghi: Arte fiamminga del seicento nella Reppublica Veneta* (cat. by C. Limentani Virdis), 5 June-1 October 1990, p. 186, no. 78; Washington 1990-91, no. 41, ill.

LITERATURE: Antonio Magrini, *Il Museo Civico di Vicenza solennemente inaugurato il 18 agosto 1855* (Vicenza, 1855), p. 54 [as by Rubens]; Carlo d'Arco, *Delle Arti e degli artifici di Mantova* (Mantua, 1857), vol. 2, pp. 184-186; Ludwig Justi, *Giorgione* (Berlin, 1908), vol. 1, p. 358; Schaeffer 1909, p. 58, ill.; C. Frizzoni, "Die Städtische Gemäldegalerie zu Vicenza," *Zeitschrift für bildende Kunst* 24 (1913), p. 193, ill.; K. Woermann, *Geschichte der Kunst aller Zeiten und Völker*, 6 vols. (Leipzig & Vienna, ca. 1915-22), vol. 5 (1920), p. 261; L. Justi, *Giorgione* (Berlin, 1924), p. 282; Glück 1931, pp. xxxvi, 146, ill. 535; Glück 1933, p. 286; T. Hetzer, *Tizian: Geschichte seiner Farbe* (Frankfurt a. M., 1935), p. 229; L. Justi, *Giorgione* (Berlin, 1936) vol. 2, pp. 282-285, pl. 5; C. Sterling, "Van Dyck's Paintings of S. Rosalie," *The Burlington Magazine* 74 (1939), p. 62; G. Fasolo, *Guida del Museo Civico di Vicenza* (Vicenza, 1940) pp. 168, 169, ill.; W. Arlsan, *La Pinacoteca Civica di Vicenza* (Rome, 1946), pp. 13, 25, no. 285, fig. 39; R. Pallucchini, *I Capolavori dei Musei veneti* (Venice, 1946), p. 172, no. 277, ill.; A. Podestà, "La Mostra dei Capolavori dei Musei veneti," *Emporium* 12 (1946), p. 165, ill. p. 162; Millar 1955, p. 314; F. Barbieri, *Le Museo Civico di Vicenza; Dipinti e Sculture dal XVI al XVIII Secolo* (Venice, 1962), vol. 2, pp. 246-248; *Racolte di quadri a Mantova dei sei-settecento; Fonti per la storia della pittura* (Munzambano, 1976), vol. 4, pp. 47, 59, 71, 72; Larsen 1980, vol. 1, no. 434, ill.; Brown 1982, p. 97, ill. p. 87; J. D. Stewart, "'Hidden Persuaders': Religious Symbolism in Van Dyck's Portraiture; With a Note on Dürer's 'Knight, Death and the Devil,'" *Revue d'Art Canadienne/Canadian Art Review (RACAR)* 10 (1983), pp. 60-61, ill. p. 5; Barnes 1986, vol. 1, pp. 184-185, no. 18, vol. 2, fig. 83; C. Limentani Virdis, "'Le Quattro età dell'uomo' di Van Dyck: Qualche Precisiazione," *Arte veneta* 40 (1986), pp. 172-174, fig. 1; Larsen 1988, vol. 1, p. 230, no. 475 [ca. 1623-25], fig. 187; P. Joannides, "Titian's *Daphnis and Chloe*. A Search for the Subject of a Familiar Masterpiece," *Apollo* 133 (June 1991), p. 377, note 13, fig. 3.

IN THIS HALF-LENGTH composition of four figures, an infant sleeps on a pillow on the left, a young man at the center dressed in armor receives roses from a young blond woman in sleeveless drapery, and an old bearded man appears in profile at the back left. The warrior wears a red cape and holds a field commander's baton; the pearly skinned young woman wears a dark green tunic clasped at the shoulder and dark purple and blue drapery; the old man is enveloped in tan.

Although sometimes titled the "Four Ages of Man" in early inventories (see Provenance), the scene actually depicts Three Ages, with the couple on the right personifying adulthood, the sleeping infant youth, and the old man who is exiting the scene old age. The only surviving allegory from van Dyck's years in Italy, the deep saturated palette of this quiet and brooding work clearly attests to the artist's admiration for sixteenth-century painting. With the sole exception of Rubens, no other artist had a more

Fig. 1. Titian, "*The Ages of Man*" (*Daphnis and Chloe?*), oil on canvas, 90 x 151 cm, Edinburgh, collection of the Duke of Sutherland, on loan to The National Gallery of Scotland.

profound and lasting effect on van Dyck's art than Titian. All writers who have discussed this work have stressed its debt to Titian and Giorgione; indeed, Justi (1908), Glück (1931), Sterling (1939), and Larsen (1988) posited a lost composition by one of these masters, but Barnes has rightly objected that this theory underestimates van Dyck's creative powers.[1] Giorgione had explored the themes of the periodization or successive ages of mankind and their respective interests and activities in works like his *Three Philosophers* (Vienna, Kunsthistorisches Museum, no. 551), while Titian actually addressed the theme of the Three Ages in both his early very Giorgionesque pastoral scene of ca. 1512/15 in the Duke of Sutherland's collection (fig. 1),[2] and his late study of three bust-length heads (known as "An Allegory of Prudence") in The National Gallery, London

(no. 6376).[3] The latter depicts a youth, a middle-aged man, and an old man. The painting in Edinburgh (fig. 1), on the other hand, depicts two infants asleep in one another's arms while a putto climbs over them, a young shepherd and shepherdess in musical and no doubt amorous dalliance on the left, and, in the distant landscape, meditating on two skulls and no doubt on his own death, is an old man.[4] The painting's subject has recently been identified as Daphnis and Chloe,[5] but at least as early as Sandrart's account of the picture in 1689 and shortly thereafter in the Odescalchi collection it was known as the Ages of Man, or La Vita Umana.[6] This interpretation probably was already current when van Dyck considered the painting in the 1620s. That Titian chose to depict the second and perfect stage of life, namely adulthood, as a loving couple has underscored for many authors that painting's importance as van Dyck's source. However, the fact that van Dyck's couple are dressed not as bucolic figures but as a soldier and his gentle lover, suggested to Stewart that they alluded to the mythological lovers, Mars and Venus.[7] The latters' mutual attraction had, since antiquity, been regarded as evidence of gentle love's power over bellicose rage and force – the discordia concors which creates peace and harmony.[8] Frizzoni reported that Gronau had suggested that van Dyck's warrior might recall one of Titian's series of eleven Roman emperors, which were part of the ducal collection in Mantua that van Dyck would have seen on his visit in ca. 1623.[9] Justi theorized that van Dyck's decision to depict maturity as a figure in armor was inspired by Giorgione's lost painting of the Vita Umana, which was recorded by Ridolfi in the Cassinelli collection, Genoa.[10] However Barnes pointed out that both Justi and Glück overestimated van Dyck's reliance on this picture, since Ridolfi's description also mentions, in addition to a powerful man in armor, an infant at a nurse's breast, a young man conversing with scholars, and an old stooped man contemplating a skull.[11] However there can be little question that the charming interchange between the man and the woman in van Dyck's painting reiterates the richly layered associations conveyed by the mythological tale of Venus and Mars. Their pagan love had been accommodated by Renaissance philosophers with the Christian virtues of carita and fortezza, the complementary qualities which embody a resolution of opposites and a balanced and symmetrical existence. The infant sleeping on the left, whose pose is recalled in that of the Christ Child in van Dyck's Holy Family in the Alte Pinakothek, Munich (no. 553),[12] also recalls the attitude of sleeping Cupid, whose slumber since

antiquity ensured a higher, purer form of love. Thus the motif may be seen as complementing and ennobling the traditional theme of the Ages of Man.

P C S

1. Justi 1908, p. 358; Glück 1931, p. xxxvi; Sterling 1939, p. 62; Larsen 1988, vol. 2, p. 191, cat. 475; refuted in Barnes 1986, p. 185, no. 18; and idem, in Washington 1990-91, p. 188.

2. H. E. Wethey, The Paintings of Titian, 3 vols. (London, 1969-75), vol. 2, pp. 182-184, no. 36, pls. 13-16.

3. Wethey, vol. 2 (1975), pp. 145-146, no. 107, and E. Panofsky, "Titian's Allegory of Prudence," in Meaning and the Visual Arts (New York, 1955), pp. 146-168.

4. On the iconography of the Titian, see E. Panofsky, Problems in Titian. Mostly Iconographic (New York, 1969), pp. 94-96. On the theme of the ages of man, see F. Boll, "Die Lebensalter," Neue Jahrbücher für das klassische Altertum 16 (1913), pp. 89ff; A. Englert, "Die menschlichen Altersstufen in Wort und Bild," Zeitschrift für Volkskunde 15 (1905), p. 399; and 17 (1907), p. 16; Knipping 1974, vol. 1, p. 91; Budapest, cat. 1968, vol. 2, p. 475.

5. See Joannides 1991, pp. 374-382.

6. Sandrart, Peltzer 1925, pp. 272, 414.

7. Stewart 1983, pp. 60-61, ill. 5.

8. On the Venus and Mars theme, see E. Wind, Pagan Mysteries in the Renaissance (London, 1958), pp. 84-88; E. H. Gombrich, "Botticelli's Mythologies," Symbolic Images. Studies in the Art of the Renaissance (London, 1985), pp. 66-69; Panofsky 1969, pp. 126ff; and for Northern art, see E. de Jong, Een Schilderij centraal. De slapende Mars van Hendrick ter Brugghen Centraal Museum (Utrecht, Centraal Museum, 1980), pp. 14-18; P. C. Sutton, "A Pair by Van Bijlert," Mercury 8 (1989), pp. 8-13; C. Dempsey, "Mavors armipotens: The Poetics of Self-Representation in Poussin's Mars and Venus," Der Kunstler über sich in seinem Werk (Weinheim, 1992), pp. 435ff; and cat. 26.

9. Frizzoni 1913, p. 193.

10. Justi 1936, pp. 282-285; see C. Ridolfi, Le maraviglie dell'arte (Venice, 1648), pp. 81-83.

11. Barnes in Washington 1990-91, p. 188, cat. 41.

12. Glück 1931, no. 228, ill.; Munich, cat. 1983, p. 185, no. 555; see also the sleeping soldier in van Dyck's The Risen Christ, Glück 1931, no. 251, ill.

Anthony van Dyck
41. Portrait of James Stuart, Duke of Richmond and Lennox, 1633

Oil on canvas, 215.9 x 127.6 cm (85 x 50 ¼ in.)
New York, The Metropolitan Museum of Art,
inv. 89.15.16

PROVENANCE: collection of Sir Paul Methuen (1672-1757), Grosvenor Street, London; by descent to his cousin and godson, Paul Methuen (1723-1795), Corsham Court, Wiltshire; Paul Cobb Methuen (1752-1816); Paul Methuen, first Baron Methuen of Corsham (d. 1849); Frederick Henry Paul Methuen, second Baron Methuen, until 1886; collection Henry G. Marquand, New York, 1886-1889; given by Marquand to the museum in 1889.

EXHIBITIONS: London, British Institution, 1835, no. 15; London, British Institution, 1857, no. 1; London, Royal Academy, 1877, no. 138[1]; New York, The Metropolitan Museum of Art, Loan Collection of Old Masters and Pictures of the English School (1888), no. 18; Paris 1936, no. 21; New York, The Metropolitan Museum of Art, Art Treasures of the Metropolitan (1952-53), no. 112; Boston, Museum of Fine Arts, Masterpieces of Painting in the Metropolitan Museum (1970), no. 40; Washington 1990-91, no. 66.

LITERATURE: Horace Walpole, Catalogue of the Collection of Pictures of the Duke of Devonshire, General Guise, and the late Sir Paul Methuen (Strawberry Hill, 1760), p. 30; J. Britton, The Beauties of Wiltshire . . . (London, 1801), vol. 2, p. 291; J. Britton, An Historical Account of Corsham House in Wiltshire (London, 1806), p. 55, no. 174; Smith 1824-42, vol. 3 (1831), p. 172, no. 594; Waagen 1838, vol. 3, p. 107; Waagen 1857-58, vol. 1 (1857), p. 396; Giuffrey 1882, p. 275, no. 788; W. von Bode, "Alte Kunstwerke in den Sammlungen der Vereinigten Staaten," Zeitschrift für bildende Kunst n.f. 6 (1895), p. 17; Cust 1900, pp. 117-118, 173, 278; Schaeffer 1909, pp. 371, 514; W R. Valentiner, "Frühwerk des Anton van Dyck in Amerika," Zeitschrift für bildende Kunst n.f. 21 (1910), p. 230; idem, Aus der niederländischen Kunst (Berlin, 1914), p. 112; Bode 1919, p. 363; Oldenbourg 1922, p. 75; A. M. Hind, Catalogue of Drawings by Dutch and Flemish Artists . . . in the British Museum (London, 1923), vol. 2, p. 67 (under no. 54); Glück 1931, pp. XLIV, 411, 564-565; van Puyvelde 1950, pp. 69, 88, 185; T. Rousseau, Jr., "A Guide to the Picture Galleries," The Metropolitan Museum of Art Bulletin 12 (1954), pp. 4, 31; Antwerp/Rotterdam 1960, pp. 133-134 (under no. 96); Vey 1962, p. 288 (under nos. 214 and 215); Brussels 1965, pp. 67 (under no. 67) and 303-304 (under no. 326); Larsen 1980, p. 115, no. 832; Brown 1982, pp. 191-192; Held 1982, pp. 334, 337, ill.; London 1982-83, p. 91; New York, Metropolitan, cat. 1984, vol. 1, pp. 50-54 (with extensive earlier literature); W. Liedtke, "Flemish Paintings in the Metropolitan Museum-II: Van Dyck, Jordaens, Brouwer, and Others," Tableau 6 no. 4 (1984), p. 29; Liedtke 1984-85, pp. 41-42, 44-45; Müller Hofstede 1987-88, p. 178; Larsen 1988, vol. 2, p. 380, no. 968, and pp. 503-504, nos. A273/1-6; Washington 1990-91, pp. 259-261; New York 1991, p. 228, fig. 1.

VAN DYCK's Portrait of James Stuart, Duke of Richmond and Lennox exemplifies the qualities that inspired a seemingly insatiable demand for the artist's portraits, not only in the Southern Netherlands, but in England and throughout Europe. Here, the aristocratic figure strikes a jaunty, self-assured pose, with one hand at his hip, the other resting on the head of his faithful greyhound. Stuart's blond hair is worn long, with a fashionable lovelock cascading over his left shoulder. He sports a black doublet and breeches, the doublet slashed to reveal a white chemise, topped by a broad flat lace collar. Around his neck he wears a gold medallion of St. George slaying the Dragon, the so-called Lesser George, suspended from a green ribbon. The Order of the Garter is emblazoned upon the left shoulder of his casually draped cloak, and the Garter itself can be glimpsed beneath the bow at his left knee. This dashing figure is set against a neutral backdrop composed of the vertical angle of a wall at the right, and a swath of muted green drapery at the left. The drapery, together with Stuart's ribbon and pale green

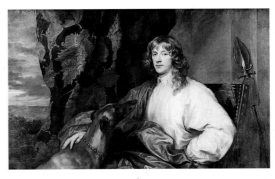

Fig. 1. Anthony van Dyck, Portrait of James Stuart,
ca. 1636, oil on canvas, 99.5 x 160 cm, London,
Kenwood House (Iveagh Bequest).

stockings, is virtually the only note of color in an otherwise muted palette of black, white, and golden tan.

Cousin to Charles I of England, James Stuart (1612-1655) succeeded his father, Esmé, as Duke of Lennox in 1624.[2] In accordance with Scottish custom, Stuart's closest male relative, his uncle King James I, became his guardian and tutor at his father's death. Stuart was named gentleman of the bedchamber upon Charles I's accession to the throne in 1625, and was knighted in 1630. Following his studies at Cambridge and travels abroad to France, Italy, and Spain, Stuart was named privy councillor, and was elected to the Order of the Garter on 18 April 1633. In 1637 he married Mary Villiers, daughter of George Villiers, Duke of Buckingham (1592-1628), the favorite of Charles I. Stuart was created first Duke of Richmond in 1641. He held several important offices during the reign of Charles I and remained loyal to the king throughout the Civil War, until the latter's execution in 1649. Stuart was buried in Westminster Abbey in London after his death in 1655.

The exhibited portrait was probably commissioned to commemorate Stuart's reception into the Order of the Garter in 1633, either upon his election to the Order in April of that year or following his official installation on 6 November. In any event, it was certainly painted before van Dyck's return to Flanders in the winter or early spring of 1634. Although the Order of the Garter was founded in the mid-fourteenth century, it gained in prominence during the reign of Charles I. The king instituted changes which not only enchanced the prestige of the Order and its knights, who were recognized as "persons of the highest honour and greatest worth,"[3] but which also focused increasingly on the religious aspect of the Order. In 1629, Charles I added the silver radiance encircling the badge of the Cross of St. George, which increased its visual prominence

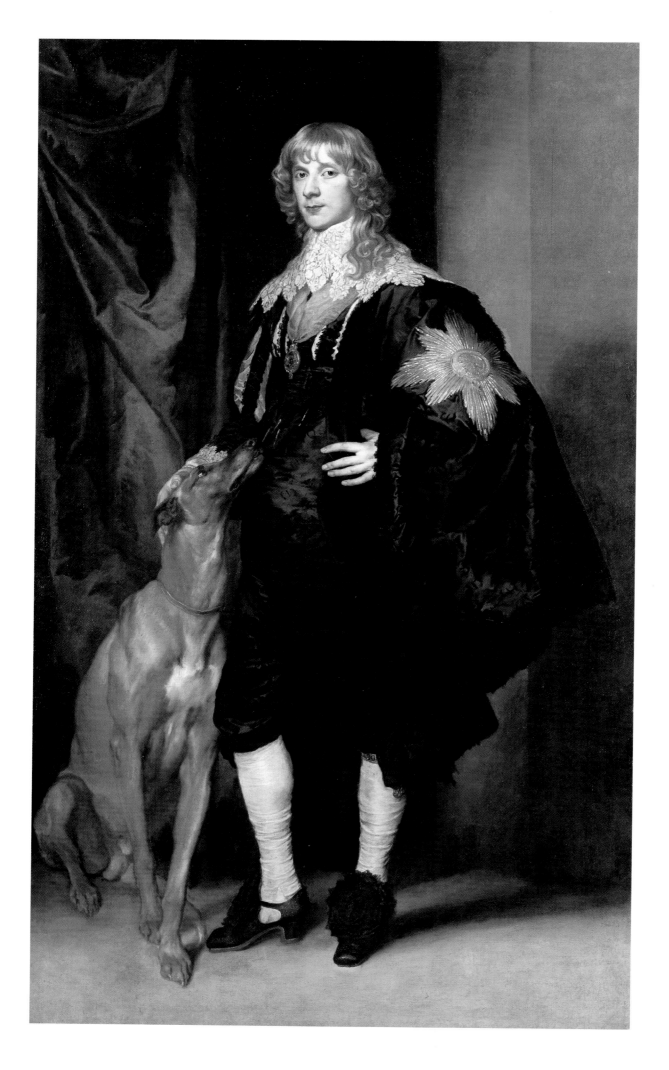

Fig. 2. Anthony van Dyck, *Sketch for the Figure of James Stuart*, black chalk with white heightening, 477 x 280 mm, London, British Museum, inv. 1874.8.8.142.

Fig. 3. Anthony van Dyck, *Studies of a Dog*, black chalk with white heightening, 470 x 328 mm, London, British Museum, inv. 1874.8.8.141.

and, by virtue of its conscious association with the insignia of the French Order of Saint-Esprit, carried religious connotations as well.[4] In addition to the badge, knights of the Order of the Garter wore the medallion of the Lesser George suspended from a ribbon or chain about the neck.

The aristocratic poise and nonchalant dignity that characterize van Dyck's portrait of James Stuart are not accomplished solely through the use of elegant dress or the trappings of prestigious office. The artist's use of a slightly lowered viewpoint subtly emphasizes the attenuated grace and hauteur of his subject. Stuart's assertive stance, with one hand on hip, is a gesture traditionally associated with military power or social position.[5] Most importantly, however, it is the expression of calm internal strength which gives such power to van Dyck's likeness of the courtier Stuart. Manuals of gentlemanly conduct which enjoyed wide currency at the court of Charles I, such as Baldassare Castiglione's *The Book of the Courtier* or Henry Peacham's *The Compleat Gentleman* (1622), describe the qualities that characterized the ideal gentleman. Such persons cultivated *virtù*, a combination of accomplishment and natural ability; Peacham posited that a person of *virtù* "was innately superior, a feature characterized visually by an elegant *savoir-faire* and by an exclusiveness of society, limited to one's set of equals who also possessed *virtù* and who elevated living to a fine art."[6] Van Dyck's portrait of James Stuart, the archetypal gentleman courtier, sublimely conveys the understated elegance and self-possession to which lesser men aspired.

The composition of van Dyck's *Portrait of James Stuart* is based on Titian's commanding *Portrait of Charles V with Hound* (1533; Madrid, Museo del Prado, inv. 409), which was then in the collection of Charles I. Van Dyck transformed the palpable machismo of his Venetian model into a more sinuous tensile elegance, in keeping with the character and social position of his subject.[7] In each portrait, the attentive dogs echo the demeanor of their masters. With sleek limbs and listing posture, Stuart's dog gazes yearningly up at his master. The greyhound was an ubiquitous attribute of nobility, as it alluded to hunting, traditionally the prerogative of the aristocracy.[8] More specific to Stuart personally, the inclusion of the dog in this portrait, as well as in the later Kenwood likeness (see below), may give credence to the (apocryphal?) tale of Stuart's hound having saved his life during his travels on the continent.[9]

Several copies and versions of the Metropolitan's *Portrait of James Stuart* are known.[10] Van Dyck executed at least one other portrait of Stuart, a more informal likeness which postdates the present work

(ca. 1636; London, Kenwood House [Iveagh Bequest], fig. 1).[11] Van Dyck's preliminary sketch for the figure, as well as more detailed studies for the dog, are in the British Museum (figs. 2, 3).[12]

MEW

1. Henry James commented on the painting at the Royal Academy exhibition in 1877: "Then there is one of the fine Van Dycks I spoke of – a certain Duke of Richmond of Charles I's time. He is dressed in black satin, with wrinkled stockings of a pale faded blue, and he rests his right hand upon the head of a great deerhound which is seated on his haunches beside him, and which leans his long nose against his thigh and looks up with a canine softness that is admirably indicated. The gentleman's yellow hair falls upon his satin mantle, and his face, which is not handsome, is touchingly grave. Such a give-and-take of gentlemanliness between painter and model is surely nowhere else to be seen." Henry James, "The Old Masters at Burlington House, 1877," in *The Painter's Eye* (J. L. Sweeney, ed.) (Cambridge, 1956), p. 128.

2. This biography of Stuart is derived from that contained in Walter Liedtke's entry on the painting in New York, Metropolitan, cat. 1984, p. 50.

3. G. F. Beltz, K. H., *Memorials of the Noble Order of the Garter, from Its Foundation to the Present Time* (London, 1841), p. xciii.

4. Washington 1990-91, p. 259. On Charles I's interest in reforming the Order of the Garter, see Strong 1972, pp. 59-63.

5. On the interpretation of this gesture, see J. Spicer, "The Renaissance Elbow," in *A Cultural History of Gesture from Antiquity to the Present Day*, J. Bremmer and H. Roodenburg eds. (Oxford, 1991), pp. 84-128.

6. C. M. S. Johns, "Politics, Nationalism and Friendship in Van Dyck's 'Le Roi à la Ciasse,'" *Zeitschrift für Kunstgeschichte* 51 (1988), pp. 250-251. On the cult of the courtier at the court of Charles I, see also W. L. Ustick, "Changing Ideals of Aristocratic Character and Conduct in Seventeenth-Century England," *Modern Philology* 30 (1932), pp. 147-166, esp. pp. 153-155; and A. Bryson, "The Rhetoric of Status: Gesture, Demeanour and the Image of the Gentleman in Sixteenth- and Seventeenth-Century England," in L. Gent and N. Llewellyn, eds., *Renaissance Bodies* (London, 1990), pp. 136-153.

7. Washington 1990-91, p. 260; and Held 1982, p. 334, the latter with pejorative connotations.

8. New York, Metropolitan; cat. 1984, p. 51; see also Johns (note 6), p. 250. Traditionally, the dog also connotes fidelity, and its presence in Stuart's portrait has also been interpreted as an expression of his devotion and fealty to Charles I, appropriate in his role as courtier (Liedtke, in New York, Metropolitan, cat. 1984, p. 50, note 2).

9. Cust 1900, p. 117.

10. Larsen 1988, vol. 2., pp. 503-504 (no. A 273/1-6) notes several copies or studio replicas of the painting; see also New York, Metropolitan, cat. 1984, p. 51.

11. On the Kenwood painting, see London 1982-83, p. 91, cat. 48. Other portraits of James Stuart by or attributed to van Dyck include: *Portrait of James Stuart as Paris* (Paris, Musée du Louvre, inv. 1246); *Portrait of James Stuart*, probably a studio work (Wilton House, collection Lord Pembroke); *Portrait of James Stuart*, ca. 1637 (known in several versions: Lucern, coll. Alice Bucher; and London, coll. Duke of Buccleuch, in addition to the several replicas/copies listed in Larsen 1988, cat. A 276/1-4). On the latter painting, see Müller Hofstede 1987-88, pp. 177-178; and Larsen 1988, cat. 971. Van Dyck also depicted other members of Stuart's family, including a double portrait of his younger brothers, *Lord John Stuart with His Brother, Lord Bernard Stuart, Later Earl of Litchfield* (ca. 1638-1639; Broadlands, Romsey).

12. Respectively: black chalk with white heightening, 477 x 280 mm, inv. 1874.8.8.142 (Vey 1962, pp. 287-288, no. 214); and black chalk with white heightening, 470 x 328 mm, inv. 1874.8.8.141 (Vey 1962, p. 288, no. 215).

Anthony van Dyck
42. *The Abbé Scaglia Adoring the Virgin and Child*, ca. 1634

Oil on canvas, 106.7 x 120 cm (42 x 47 ¼ in.) oval
London, The National Gallery, inv. 4889

PROVENANCE: collection of Abbé Cesare Alessandro Scaglia; bequeathed to Princess Henrietta of Lorraine Phalzburg, 1641; collection of Madame la Douairière Peytier de Merchden; sale Antwerp, 3 August 1791, lot 2 (fl. 3000); sale, John Knight of Portland Place, London (Phillips), 24 March 1819, lot 80 (bought in); John Knight, second sale, London (Phillips), 17 March 1821, no. 35 (bought in); sale John Knight, London, 24 May 1839, no. 16; with Edmond Higgonson, Saltmarsh Castle, Hertfordshire, by 1841; sale Edmond Higgonson, London (Christie's), 6 June 1846, lot 215 [to Anthony de Rothschild, Bt., 410 gns.]; with his widow, Lady de Rothschild until 1910; by descent to her daughter Constance, Lady Battersea; sale, London (Thomas Agnew and Son Ltd.), after 1931; purchased by Anthony de Rothschild and presented to The National Gallery, London, in memory of Louisa, Lady de Rothschild and her daughter, Lady Battersea, 1937.

EXHIBITIONS: London, Royal Academy, *Exhibition of the Works by the Old Masters, and by Deceased Masters of the British School*, 1870, no. 30; London, Royal Academy, *Exhibition of Works by Van Dyck 1599-1641*, 1900, no. 24; C. Brown, "The Abbé Scaglia Adoring the Virgin and Child," *Painting in Focus Number 2-Anthony van Dyck*, London, National Gallery, 1974.

LITERATURE: Smith (1829-42), vol. 3 (1831), pp. 102, no. 362; Cust 1900, p. 249, no. 46; Glück 1931, pp. 366; Schlugleit 1937; H. Granville Fell, "Some Topics of the Moment," *The Connoisseur* 101 (1938), p. 99; van Puyvelde 1950b, pp. 148; exh. cat. Elewijt 1962, p. 123; Vey 1962, no. 201; London, National Gallery, cat. 1970, pp. 48-52, no. 4889; Knipping 1974, vol. 2, p. 258, 260; Brown 1982, pp. 157-159; London 1982-83, p. 58; C. Brown, "Van Dyck and Titian," in *Bacchanals by Titian and Rubens*, ed. Görel Cavalli-Björkman, 1987, p. 159; Larsen 1988, vol. 1, p. 379, vol. 2, p. 406, no. 1035; Washington 1990-91, pp. 40, 274; New York 1991, pp. 32, fig. 22, 252; A. Cifani and F. Monetti, "New Light on the Abbé Scaglia and Van Dyck," *The Burlington Magazine* 134 (1992), pp. 510-514.

WITHIN an oval format the seated Virgin, splendidly arrayed in shimmering robes of rose and blue, gazes down regally at the beholder. She raises one end of the cloth swathed across her lap with her right hand, while the enveloped Christ Child blesses the reverent figure kneeling to the left. From his lower vantage, the abbé fixes his gaze upon the Virgin with outstretched and folded hands. Viewed in three-quarter profile, Scaglia wears a black soutane and broad white collar. The rich green curtain behind the Virgin and Child emphasizes their monumentality and proximity to the front plane of the image. Behind the abbé rugged peaks loom beneath a bank of radiant clouds and a brilliant vaulted sky.

By incorporating his refined portrait style with the tradition of donor portraiture, van Dyck has produced a votive picture in the spirit of the Counter Reformation which evokes personal and political as well as sacred associations. The time-honored subject belies what is in fact a devotional double portrait of two influential political figures. The supplicant has been identified as Cesare Alessandro Scaglia di Verrua (1592-1641), Abbot of Stafforda and Mandanici. Two other portraits by van Dyck confirm the likeness: the standing portrait of the abbé by van Dyck (1634, collection of Viscount Camrose; fig. 1) and the image engraved by Paulus Pontius after van Dyck for the *Iconography*. As a member of an eminent Piedmontese family and second son of Count Filiberto Gherardo Scaglia, he continued the diplomatic work of his father for the House of Savoy under Duke Carlo Emanuele I and Duke Vittorio Amadeo after enjoying early success in ecclesiastical spheres. Following a period as ambassador in Rome (1614-1623) and Paris (1625-1627), he served as the duke's agent in the delicate negotiations for peace between England and Spain in 1629. Peter Paul Rubens first became acquainted with the abbé in Antwerp while representing the interests of the Infanta Isabella. Although contemporary references to the abbé's character are varied and conflicting, Rubens appreciated Scaglia's skill as a diplomat and his extensive experience in the courts of Europe. Rubens wrote to Gerbier that "we find Scaglia extraordinarily capable in affairs of such importance. . . ."[1] While described as "amantissimo delle belle arti," the diplomatic association of the two men apparently never resulted in a commission for the artist.[2] Like Rubens, Scaglia too was devotedly pro-Spanish, but his vehemently anti-French position (stemming in part from Cardinal Richelieu's refusal to elevate him to abbot) ultimately isolated him from Vittorio Amadeo of Savoy with the signing of the Treaty of Cherasco in 1631.[3] He retired to Brussels in 1632 on the considerable revenues from several benefices, where he enjoyed a luxurious lifestyle and played a minor role in diplomatic affairs as advisor to the duke of Savoy's brother, Prince Thomas, Captain General of Spanish troops in the Southern Netherlands. After refusing a missive from Philip IV to move to Spain, Scaglia took up residence in Antwerp in 1639, and continued to maintain his connections with several Antwerp artists, including Frans Snyders, Jacob Jordaens, and Daniel Seghers. From 1639 until his death, Scaglia was engaged in the negotiations between Rubens, Jordaens, and Balthasar Gerbier for the decorations (never executed) depicting the History of Psyche for the Queen's House in Greenwich.[4] Abbé Scaglia died 21 May 1641 and was buried in the Franciscan Church of Recollects.

The Queen of Heaven in this painting is also undoubtably a portrait, however her identity has not been certified. Martin and Brown have proposed the French-born Duchess Christina of Savoy (1606-1663), sister of Louis XIII and Queen Henrietta Maria of England, and her son Francis Hyacinth (b. 1632) as models.[5] Despite some physical resemblance and the possibility that the abbé wanted to promote better relations with the duke of Savoy, the duchess's designs to bring the Duchy into closer French orbit makes it less likely that the abbé would have wished to flatter her. However, recent archival research suggests that Henrietta of Lorrain, Princess of Phalzburg (1611-1660) may be a more likely model. Her portrait

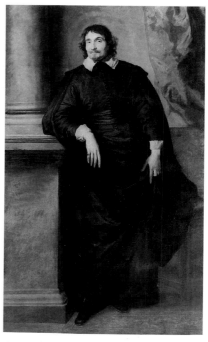

Fig. 1. Anthony van Dyck, *Cesare Alessandro Scaglia, Abbé of Stafforda and Mandanici*, oil on canvas, 200.6 x 123.2 cm, England, Viscount Camrose.

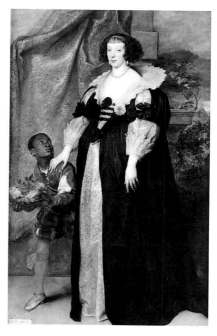

Fig. 2. Anthony van Dyck, *Henrietta of Lorraine*, 1634, oil on canvas, 213.4 x 127 cm, Hampstead, Kenwood House, Iveagh Bequest.

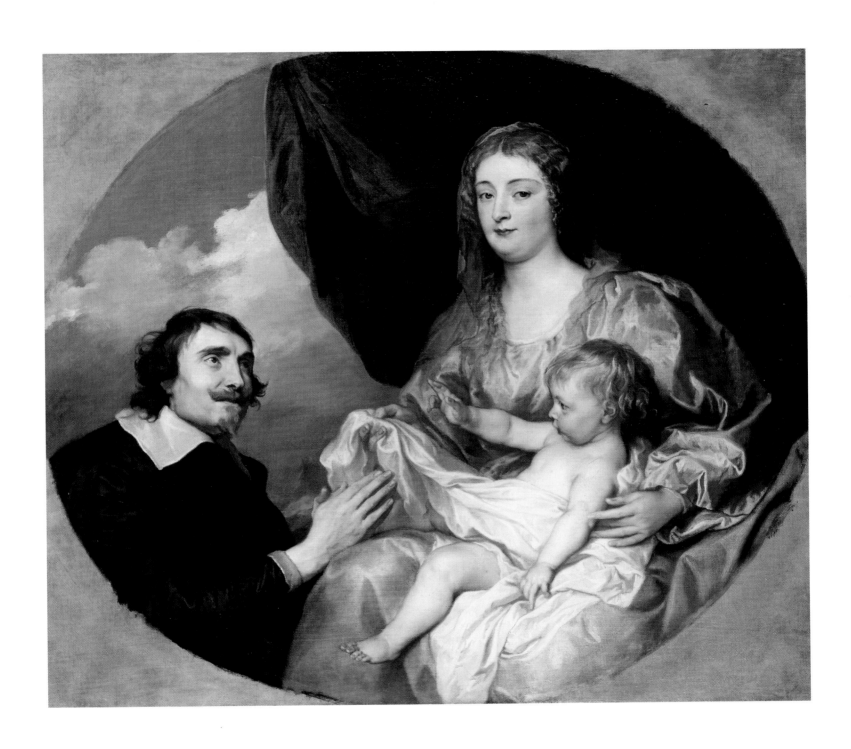

by van Dyck (Iveagh Bequest, Kenwood House; fig. 2) was also painted in 1634, and the work considered here ranks as the first listed in the "Gratificationes" of the Abbé Scaglia's last testament, bequeathed to her: "Pro Principissa de Falchenburch Imago Beatae Mariae rotunda cum puero Jesulo et figura Illustrissimi Domini."[6] Although the extent of the connections between Scaglia and Henrietta are not yet fully known, it may be that this idealized Virgin was intended as an allusion to the princess of Phalzburg whose anti-French political orientation was shared by the abbé.

Van Dyck executed a substantial number of commissions, particularly portraits, for members of the Brussels court during his return to the southern Netherlands 1634-1635. Among them was the equestrian portrait of Scaglia's patron, Prince Thomas of Savoy (now in Turin). Scaglia himself commissioned two other pictures in addition to the *Adoration*: the magnificent full-length portrait mentioned above (fig. 1), and a *Lamentation* (Antwerp, Koninklijk Museum voor Schone Kunsten) intended for the Chapel of Seven Sorrows in the church of the Monastery of Recollects in Antwerp.[7] The unusual oval format of the *Adoration* and its dual function as a devotional double portrait may suggest that it was intended to adorn Scaglia's private chapel.[8]

For the format of the composition, van Dyck consulted his *Italian Sketchbook*, compiled during his tenure in Italy 1622-1624. He borrowed the image of a male saint adoring the Virgin and Child after a lost work by Titian (fig. 3).[9] This is one of the most direct examples of the Italian master's influence upon van Dyck. By employing an oval rather than a rectangular format and reworking the figural arrangement, van Dyck increases the proximity and intimacy of the supplicant and the adored and complements the eloquent convergence of gestures at the center. The role of the Virgin Mary as intercessor received renewed emphasis in Counter Reformation doctrine, and the placement of the Virgin's hands between the abbé and Christ underscores the primacy of her position between mankind and the Savior.

Various studies and pentimenti attest to the artist's evolving preparation of the composition. Two sketches in the British Museum document the care taken to achieve both a likeness and a reverent attitude of absorption with special attention paid to the direction of his gaze and the positioning of his folded hands (fig. 4).[10] Among the pentimenti are alterations to the position of Christ's left foot, indicating that it initially occupied a lower position. His right foot may also have been lower and placed in front of the abbé's wrist at first, as it appears in the

sketch after Titian.[11] This "stradling" posture of the Christ Child is echoed in the figure of the sleeping child in van Dyck's *Ages of Man* (cat. 40) among others.

Three direct copies after this work exist, and Martin (1970) and Larsen (1988) also list a number of variants, some of which replace the abbé with a female figure.[12]

ATW

1. Antwerp, 19 May 1627. Magurn 1955, p. 181. C. Brown, "The Abbé Scaglia."

2. G. de Gregory quoted in A. Cifani and F. Monetti, "New Light on the Abbé Scaglia and Van Dyck," pp. 509. Scaglia's associations with eminent artists included a sojourn from Spain to Genoa with Velázquez in 1629.

3. His subsequent tenure as ambassador in London on behalf of Philip IV in 1631 found him "suffering from bodily indisposition in addition to his mental troubles, and is very little seen. The talk about his departure is uncertain, but the soundest conjecture is that he himself does not know whither to turn, as he is on bad terms with France and his master . . . ," according to the Venetian ambassador at the English court, Giovanni Soranzo. 31 October 1631. *Calendar of State Papers Venetian . . . ,* A. B. Hinds, ed. vol. 22, 1919, p. 558.

4. For a detailed account of this project, see D. Schlugleit, "L'Abbé Scaglia, Jordaens et 'l'histoire de Psyche' de Greenwich House (1639-1642)," *Revue Belge d'archéologie et d'histoire de l'Art 7,* 2 (1937), pp. 153ff.

5. While clearly unrelated to any studio "type" utilized by van Dyck in other religious works (*The Virgin and Child with St. Catherine,* ca. 1630, New York, The Metropolitan Museum of Art, no. 60.71.5), the assertion in the 1819 Phillips catalogue that the Duchess of Arenburg and her son were the models is highly implausible. This identification is repeated in Smith (1831) p. 102, no. 362, as "portraits of the Duchess of Aremburg (sic) and her infant Son, in the characters of the Virgin and Child"; Cust 1900, p. 249. London, National Gallery, cat. 1970, pp. 48-52, no. 4889; C. Brown, 1974; Cifani and Monetti, 1992, p. 512.

6. Cifani and Monetti, 1992, pp. 511, 514. The bequest to the princess included a flower painting on panel by a Jesuit - probably Daniel Seghers.

7. Scaglia paid for the erection of an altar in the chapel of Our Lady of the Seven Sorrows which was consecrated in 1637. The standing portrait of the abbé was ultimately sold by the Franciscans and replaced with a second version of the composition bearing a lengthy inscription. Washington 1990-91, no. 70, pp. 272-274; Elewijt 1962, pp. 123. The establishment of the branch of Recollects within the Franciscan order is discussed in E. de Moreau, *Histoire de l'Eglise en Belgique,* vol. 5, 1952, pp. 414-415.

8. H. Granville Fell, "A Van Dyck for the National Gallery," *The Connoisseur 101* (1938), p. 99. Van Dyck utilizes a horizontal format for the treatment of a similar subject in the *Virgin and Child with Two Donors* (1630-1632), Paris, Musée du Louvre, no. 1962.

9. Anthony van Dyck, *Virgin and Child after Titian,* fol. 46. See Adriani 1965.

10. British Museum, inv. 1845.12.8.3. The preparatory drawing for the Count of Nassau-Seigen in armor (Vaduz, collection of the Prince of Liechtenstein) appears on the reverse. Vey 1962, vol. 1, pp. 272-273.

11. Martin 1970, p. 50.

12. Martin 1970, p. 50; Larsen 1988, pp. 512, no. A307/1-10. Among these is an engraving by Coenrad Waumans.

Fig. 3. Anthony van Dyck, *Virgin and Child,* after Titian (*Italian Sketchbook,* fol. 46), London, Trustees of the British Museum, 1957-1214-14207.

Fig. 4. Anthony van Dyck, *Two Studies of the Head of the Abbé Scaglia,* black chalk on greenish gray paper, London, The Trustees of the British Museum, inv. 1845.12.8.3 (verso).

Anthony van Dyck

43. *Princess Elizabeth and Princess Anne,* ca. 1637

Oil on canvas, 30 x 42 cm (11 ¾ x 16 ½ in.)
Inscribed by a later hand: *The Princess/Elizabeth*
(lower left); *Henry Duke/of Glocester* [sic] (lower right)
England, property of the British Rail Pension Fund,
ref. 3538

PROVENANCE: possibly acquired in the eighteenth century by an ancestor, and thence by descent to Lord Chesham.

EXHIBITIONS: London, Royal Academy, winter 1879, no. 131; London, Thos. Agnew and Sons, *Haig Fund Appeal,* 1922, no. 2; London 1953-54, pp. 95-96, no. 317; London, Thos. Agnew and Sons, *European Pictures from an English County* (Hampshire), 1957, p. 17, no. 13, ill; London 1968, no. 49; London 1972-73, p. 76, no. 106, ill; London 1982-83, p. 72, no. 27; London, Thos. Agnew and Sons, *Thirty Five Paintings from the Collection of the British Rail Pension Fund,* 8 November-14 December 1984; Washington 1990-91, no. 101, ill.

LITERATURE: Glück 1931, p. 384; Millar 1963, vol. 1, p. 99; Vey 1967, p. 307; Larsen 1988, vol. 1, p. 308, ill., vol. 2, no. 810, p. 320; New York 1991, p. 264, fig. 3.

IN ONE of the few oil sketches to date from the period of the artist's tenure at the Stuart court, the young Princess Elizabeth (1635-1650) (left) wears a simple white cap, a set of pearls strung on a brown ribbon around her neck, and a white shift. Her head is set against a darker ground, and beneath her lowered gaze lies the upturned rosy countenance of her infant sister, Princess Anne (1637-1640), who also wears a smooth white skull cap. The veracity and sensitivity which characterizes the heads of the two youngest children of Charles I and Henrietta Maria may well derive from life studies made by the artist in preparation for the large group portrait in which they appear with their elder siblings: "The Picture of the Kings five Children in one piece with a great dogg . . . in a blue and carved guilded frame," which hung above the table in the king's breakfast chamber at Whitehall (fig. 1).[1] The assured touch (note the firm, sinuous outline of Princess Elizabeth's left cheek) and confident modeling of the heads in gray and pink suggests that the study was executed in the final stages of the painting's organization. However, while the tender interaction of the princesses captured in the swift sketch recurs in the painting, the figures have been shifted slightly to enable Princess Elizabeth to support the upright Princess Anne. In addition, some of Princess Elizabeth's golden hair has been allowed to escape onto her brow from beneath a more elaborate cap. She also now wears a pearl earring.

The inscription added later in the seventeenth century mistakenly identifies Princess Anne as Henry, later Duke of Gloucester (1640-1660). While the brevity of her life may have led a subsequent chronicler astray, she is correctly identified on the Windsor painting and by van Dyck himself in his *Mémoires.*[2] Julius Held estimates that van Dyck commenced work on the study of the princesses in May or June of 1637, thus approximately two to three months after Princess Anne was born on 17 March of that year.[3] It is a measure of van Dyck's skill that they appear almost twice their age in the final composition.

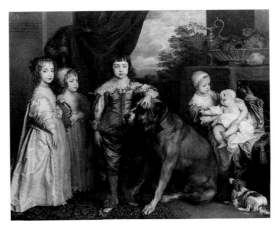

Fig. 1. Anthony van Dyck, *The Five Eldest Children of Charles I,* oil on canvas, 133.4 x 151.8 cm, Windsor Castle, collection of H. M. Queen Elizabeth II.

By the late 1630s, he had already completed two paintings of the three eldest royal children (Prince Charles, Princess Mary, and Prince James) in his capacity as court painter to Charles I: *The Three Eldest Children of Charles I,* 1635 (Turin, Galleria Sabauda, no. 264); and *The Three Eldest Children of Charles I,* 1636 (Windsor Castle, H. M. the Queen).[4] This study of the newest members of the royal family adds an engagingly intimate note to this series of formal group portraits.

Van Dyck preferred the more expedient medium of chalk to oil when making preparatory sketches, particularly for portrait studies.[5] Two such chalk drawings are associated with the Windsor picture: *Prince Charles* (Windsor Castle, Royal Library, inv. 13018), and *Prince James* (Oxford, Christ Church Library, inv. G.G. 15).[6] The surety of execution distinguishes this sketch from earlier portrait studies in oil, such as the *Portrait of a Bearded Man Wearing a Wheel Ruff,* and *Man Wearing a Falling Ruff,* ca. 1634 (Oxford, Ashmolean Museum, inv. A175 and A176).[7] The smooth finality of *Princess Elizabeth and Princess Anne* suggests that it may have been executed in the studio following the artist's usual practice of recording his first ideas in chalk – an easier technique for *ad vivum* studies than oil.[8] The sketch may then have had a dual function, as both a preparatory study and, as Held has suggested, possibly as a gift to Queen Henrietta Maria.[9]

The final composition at Windsor Castle spawned numerous subsequent versions; a copy of the figures of Princess Elizabeth and Princess Anne is located at Highclere Castle.[10]

ATW

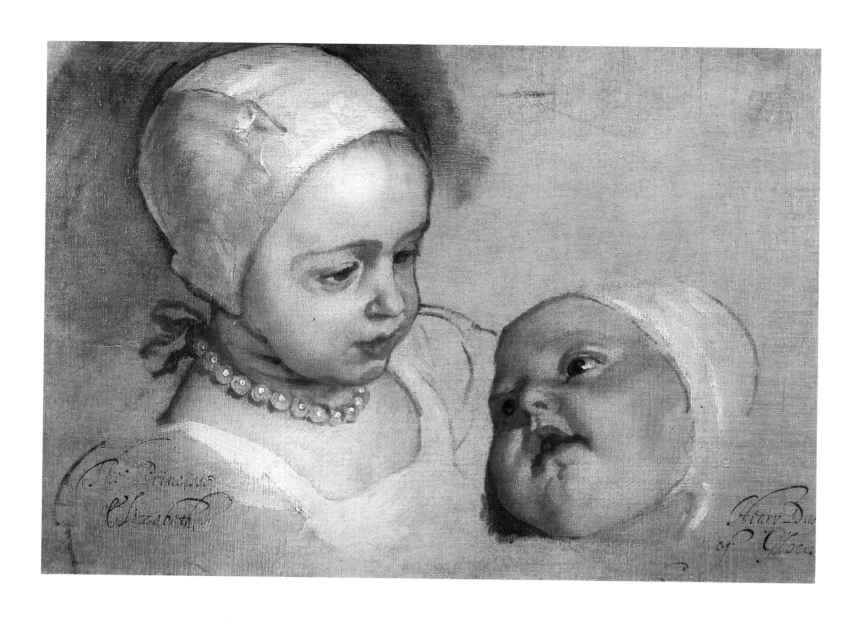

1. O. Millar, ed., "Abraham van der Doort's Catalogue of the Collections of Charles I," *The Walpole Society* 37 (1960), pp. 34-35. The picture was painted for the king, and van Dyck recorded it in his *Mémoires* of 1638 as "Le Prince Carles avecq le ducq de Jarc Princesse Maria, P^sc Elisabet P^r Anna," for which he asked £200 and Charles I paid £100. Millar 1963, vol. 1, p. 99.

2. London 1982-83, p. 72; W. Hookham-Carpenter, *Mémoires et documents inédits sur Antoine van Dyck, P. P. Rubens, et autres artistes contemporains* (1845), pp. 66-67.

3. Washington, 1990-91, p. 362. Her sister Elizabeth (born 28 December 1635) was then probably a year and a half old.

4. Turin cat. no. 264; Millar 1963, vol. 1, p. 98, no. 151.

5. According to one of van Dyck's sitters, Richard Gibson, he "woud take a little piece of blue paper upon a board before him, and look upon the life & draw his figures & postures all in Suden lines, as angles with black Chalk & heighten with white chalk." Quoted in M. K. Talley, *Portrait Painting in England: Studies in the Technical Literature before 1700* (London 1981), p. 320.

6. See Vey 1967, vol. 1, nos. 238 and 239.

7. Both were preparatory studies for the *Magistrates of Brussels* (1634), which was destroyed in 1695. *Catalogue of Paintings in the Ashmolean Museum* (Oxford, 1962), pp. 50-51, nos. 137 and 138.

8. The design of the painting would have been set before the sketch was made. From the angle of Princess Anne's head, the artist may even have sketched her as she lay in her crib. The sketch has frequently been identified as a preliminary study from life. See Thos. Agnew and Sons (London, 1957), under no. 13; London 1972-73, p. 320; London 1953-54, p. 96.

9. Washington 1990-91, p. 362

10. See Larsen 1988, vol. 2, pp. 479-480. Millar 1963, vol. 1, p. 99.

Jacob Jordaens

(1593-Antwerp-1678)

Pieter de Jode after Jacob Jordaens, *Jacob Jordaens*, engraving, from Cornelis de Bie, *Het gulden cabinet . . .*, 1661, fol. 239.

Jordaens was born in Antwerp in May of 1593. The precise date is unknown since the portrait of the artist engraved by P. de Jode gives 19 May, while the baptismal registry at the Onze-Lieve-Vrouwe-Kerk records 20 May. Jacob was the eldest son of eleven children born to a well-to-do canvas merchant (*sargieverkooper*) of the same name, and Barbara van Wolschaten. Jacob's father sold painted wall coverings of a type then manufactured in Mechelen which substituted for tapestries or cordovan leather. In 1607 at the age of fourteen Jordaens was apprenticed to Adam van Noort (1562-1641), who also was a teacher of Rubens. He was admitted as a master "waterschilder" (tempera painter) to the guild in 1615/16, which qualified him to paint cartoons for tapestries and wall coverings of the type sold by his father. On 15 May 1616 he married his teacher's daughter, Katharina van Noort (1589-1659). The couple acquired a house on the Hoogstraat in 1618 and had three children, Elisabeth (born 26 June 1617), Jakob (2 July 1623), who also became a painter and died in Denmark, and Anna Catherina (23 October 1629). His earliest dated paintings are of 1616. In 1620/21 the first of his many students (Charles du Val) is mentioned, and in 1621, after initially declining the honor, Jordaens became a dean of the Antwerp guild.

Jordaens had numerous students but none between 1623 and 1633, by which time he was surely active in Rubens's atelier, not as a pupil but as an independent master who collaborated with him. In 1628 he was commissioned to paint an altarpiece for the Augustinian Church in Antwerp. Together with Rubens and Cornelis de Vos (q.v.), he worked in 1634-1635 on the Triumphal Arch of Philip (*Philipusbogen*) and Temple of Janus for the entry of the Cardinal Infante Ferdinand into Antwerp. Jordaens executed decorative paintings for the project after Rubens's designs. In 1637-1638 he again collaborated with Rubens, working once more from the latter's designs, on the cycle of decorations for the Torre de la Parada in Madrid.

Having received an inheritance from his parents in 1633, Jordaens was wealthy enough to acquire on 11 October 1639 a house called "de Halle van Lier" or "de Turnhoutse halle" in the Hoogstraat in Antwerp, have it demolished and construct a grand house, of which the rear facade and part of the adjoining studio still stand. He decorated the walls with a series of twelve apostles and a *Susanna and the Elders*, and the ceilings with signs of the zodiac and various mythological subjects. In 1639 Charles I commissioned him via Balthasar Gerbier to decorate the queen's chambers at Greenwich. Jordaens also executed an ensemble of thirty-five paintings for Queen Christina of Sweden in 1648. The following year, through the influence of Constantijn Huygens, Jordaens received the commission to decorate the main wall of the Huis ten Bosch in The Hague with an immense painting of the *Triumph of Frederick Hendrick*. And in 1661 he was asked to paint three large lunettes for the Amsterdam Town Hall.

Despite the facts that he was born Catholic, had two sisters (Magdalena and Elisabeth) who were beguines, one (Catharina) who was a nun, and a brother (Abraham) who was an ordained priest, and notwithstanding the fact that Jordaens painted altarpieces for Catholic churches repeatedly between 1617 and 1663, he became a fervant Protestant convert at the end of his life. Jordaens continued to work until the end of his life but the quality of these late works is often uneven and at times feeble. On 5 June 1677, Constantijn Huygens visited the artist and reported that he was confined to a chair and not entirely clear in his mind. Jordaens and his daughter Elisabeth both died on 18 October 1678, and both were buried in the Dutch community church of Geuze-Put. Jordaens's nephew sold the artist's house on 7 July 1708, and on 22 March 1734 a sale was held in The Hague of his collection of 111 paintings, including forty-four works by the master.

A portraitist, history and genre painter, as well as a draughtsman and printmaker, Jacob Jordaens, together with van Dyck and Rubens, was one of the greatest Flemish painters of the seventeenth century. His robust naturalism soon absorbed the mannerisms he had inherited from earlier Flemish artists, such as Abraham Janssens, and he developed his own vigorous, colorful, and plastic style while working with Rubens and van Dyck in the late 1620s. Though he never shared Rubens's fascination with the classical tradition and the antique, he expressed the dynamism and vitality of the baroque more consistently. An indefatigable worker, he helped complete the vast decorative projects that foreign nobility and monarchs commissioned during this era and earned a place of honor among his Antwerp colleagues. After Rubens's death in 1640, he was regarded as the premier painter in Antwerp, and developed a looser, more febrile and movemented style while shifting to a deeper, more sonorous palette. Despite some decline in his powers at the close of his career, many of the later works are expressive and accomplished.

Jacob Jordaens
44. Portrait of a Young Married Couple, ca. 1621-1622

Oil on panel, 124.5 x 92.4 cm (49 x 36 ⅜ in.)
Boston, Museum of Fine Arts, Robert Dawson Evans
Collection, 17.3232

De Bie 1661, pp. 238-239; Sandrart 1675, vol. 2, pp. 336 ff; Le Comte 1699, vol. 2, p. 303; Houbraken 1718-21, vol. 1 (1718), pp. 154-158, vol. 2, pp. 275 ff; Weyerman 1729-69, vol. 1 (1729), pp. 382 ff; Descamps 1769, passim; Nagler 1835-52, vol. 6 (1838), pp. 479 ff; Génard 1852, pp. 203-244; Kramm 1857-64, vol. 3 (1858), pp. 821 ff; Génard 1869-72, vol. 6 (1869), pp. 405-472, passim ; Michiels 1865-76, vol. 7 (1869), pp. 360-407, vol. 8 (1869), p. 34; Rombouts, van Lerius 1872, vol. 1, pp. 443-444, 514, 521-523, 566, 572, 598, vol. 2, pp. 53, 86, 123, 164, 181, 240, 299, 373, 418, 466; Rooses 1879, pp. 539-569; van den Branden 1883, pp. 814-842; Unger 1891, p. 195; Antwerp 1905; Buschmann 1905; Rooses 1906; Wurzbach 1906-11, vol. 1 (1906), pp. 765-772; Rooses 1914, pp. 262-269; Oldenbourg 1918a, pp. 106-121; K. Zoege von Manteuffel, in Thieme-Becker 1907-50, vol. 19 (1926), pp. 151-155; Kauffmann 1927; Burchard 1928; Held 1933; Schlugleit 1937; Crick-Kuntziger 1938; Held 1939; Held 1940a; Held 1940b; Stubbe 1948; Held 1949; d'Hulst 1952; d'Hulst 1953a; d'Hulst 1953b; van Puyvelde 1953; d'Hulst 1956a; d'Hulst 1956b; d'Hulst 1961; Brussels 1965, pp. 107-124; Held 1965; d'Hulst 1966a; Antwerp/Rotterdam 1966-67; d'Hulst 1967a; d'Hulst 1967b; Ottawa 1968-69; Held 1969; d'Hulst 1969b; Jaffé 1969; d'Hulst 1974; Paris 1977-78, pp. 102-119; Antwerp 1978a; Antwerp 1978b; d'Hulst 1980; d'Hulst 1982; Tijs 1983; Jaffé 1984; Nelson 1986; Wyss 1987; Nelson 1990; Antwerp 1993.

PROVENANCE: (probably) collection Earl Sydney (died 1890); Blakeslee Galleries, New York (1907); collection Robert Dawson Evans, from 1907; Misses Abby and Belle Hunt; bequeathed to the Museum by Mrs. Robert Dawson Evans (née Hunt), 1917.

EXHIBITIONS: London, Royal Academy, 1880, no. 54 [as Rubens; coll. Earl Sydney]; Boston, Doll and Richards (October-November 1927); New York 1942, no. 4 [as Rubens]; Los Angeles 1946-47, no. 16 [as Rubens]; Ottawa 1968-69, no. 35 [as Jordaens]; Boston, Museum of Fine Arts, *The Great Boston Collectors: Paintings from the Museum of Fine Arts* (13 February – 2 June 1985), no. 8 [as Jordaens].

LITERATURE: *Bulletin of the Museum of Fine Arts* (February 1910), p. 5; W. R. Valentiner, in *Zeitschrift für bildende Kunst* n.f. 23 (1912), pp. 183-184 (as by Rubens; notes also attributions to Jordaens and proposes as a portrait of Jordaens by Rubens); Valentiner 1914, p. 179; A. Ames, "Depth in Pictorial Art," *Art Bulletin* 8 (1925), p. 22; A. Burroughs, *Art Criticism from a Laboratory* (Boston, 1938), pp. 149-151; E. Keiser, in *Münchner Jahrbuch der bildenden Künste* n.f. 13 (1938-39), p. 186; Goris, Held 1947, p. 47 (no. A23; "characteristic early work of Jacob Jordaens"); Constable 1949, p. 127 (as Rubens); d'Hulst 1956, p. 82; Gerson, ter Kuile 1960, p. 127; M. Jaffé, "Van Dyck Portraits in the De Young Museum and Elsewhere," *Art Quarterly* 28 (1965), p. 53; d'Hulst 1982, p. 270; M. Jaffé, in *The Burlington Magazine* 126 (1984), p. 784 (review of d'Hulst 1982); Stebbins, Sutton 1986, p. 42 (datable to 1615-1620); E. de Jongh, in Haarlem 1986, pp. 126-127; M. Vandenven, in Liedtke et al. 1992, pp. 220-221.

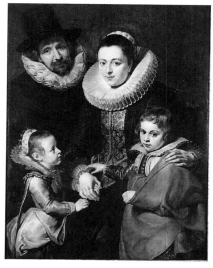

Fig. 1. Peter Paul Rubens, *Portrait of Jan Brueghel and His Family*, ca. 1612-1613, oil on panel, 125.1 x 95.2 cm, London, Courtauld Institute Galleries, Seilern Bequest, inv. 18.

POSED BEFORE a stone portico, a young married couple turns engagingly towards the viewer. The woman is modishly dressed in a black bodice and brocade stomacher over a reddish-mauve skirt; a large ruff frames her demurely downcast head. She holds a pair of gloves in her left hand; on the forefinger of her right hand she wears a wedding ring.[1] Her partner stands beside her to the left, his hand propped jauntily on his hip. A lace-trimmed white collar provides the only bright note to the otherwise unrelieved black of his costume. Just beyond the portico to the right lies the tumbled fragment of a Corinthian capital, and in the distance, a hilly evening landscape.

Portrait of a Young Married Couple was acquired by the Museum as a work by Rubens, although Jordaens had tentatively been proposed as the author of the work as early as 1910.[2] In defending the traditional attribution to Rubens, critics cited the high quality of the work, as well as the strong local colors, hard illumination, and well-defined contours which are typical of Rubens's works from the early 1610s (compare, for example, Rubens's *Portrait of Jan Brueghel and His Family*, ca. 1612-1613 [London, Courtauld Institute Galleries, inv. 18], fig. 1). However, these same characteristics also marked Jordaens's works of the late 1610s and early 1620s. In addition, the rougher, more vigorous brushwork, florid flesh tones, and distinctive execution of certain passages such as the hands are unmistakable evidence of Jordaens's authorship. X-rays reveal that the man's head was originally turned in profile to the right; alterations were also made in the position of his right hand and arm, in the downward tilt of the young woman's head, and the shape of her ruff.[3]

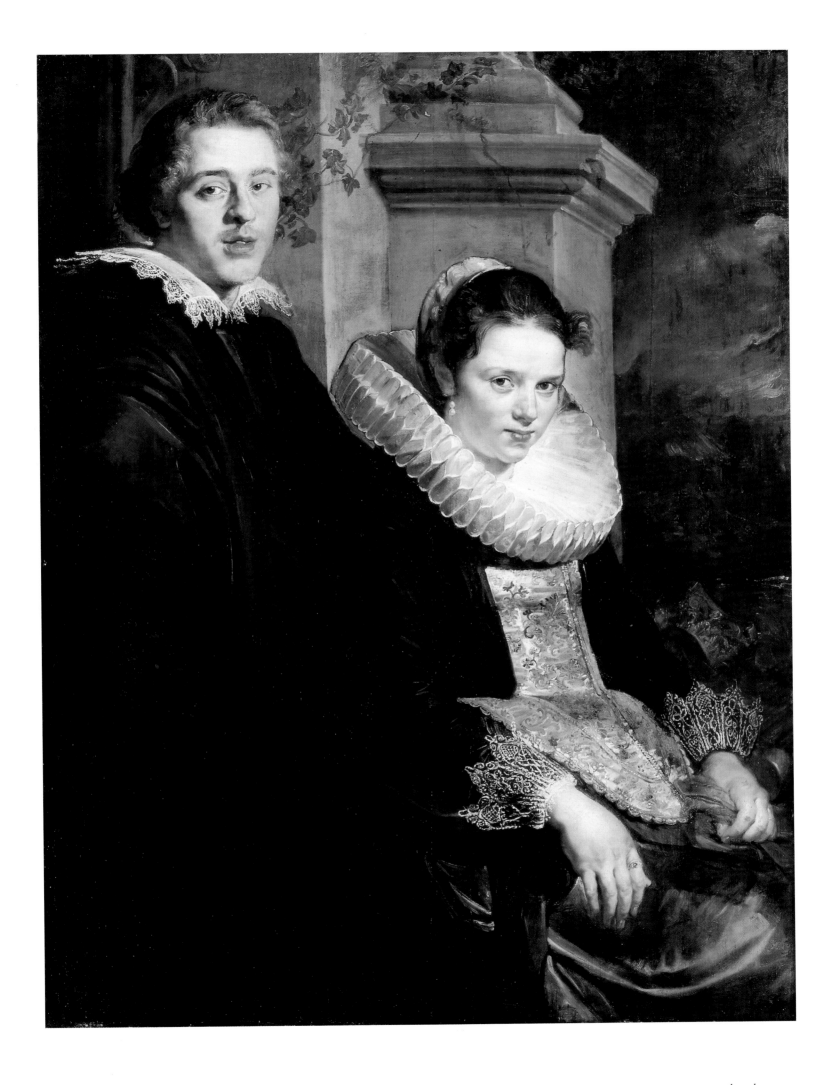

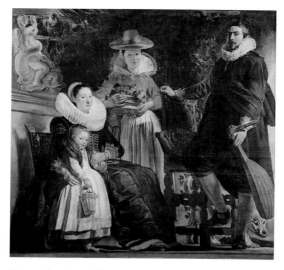

Fig. 2. Jacob Jordaens, *Self-Portrait with Family*, ca. 1621-1622, oil on canvas, 181 x 187 cm, Madrid, Museo del Prado, inv. 1549.

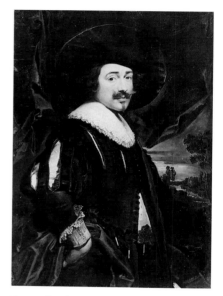

Fig. 3. Jacob Jordaens, *Portrait of a Man*, ca. 1624, oil on panel, 105.5 x 73.5 cm, Washington, D.C., National Gallery of Art, inv. 1969.2.1.

D'Hulst dates the *Portrait of a Young Married Couple* to ca. 1621-1622, citing Jordaens's *Portrait of a Man* in the Uffizi (inv. 1652, possibly a self-portrait) as more or less contemporary.[4] Other comparable works by Jordaens include the compositionally more complex *Self-Portrait with Family* in the Museo del Prado, Madrid, of ca. 1621-1622 (fig. 2), as well as the slightly later *Portrait of a Man*, ca. 1624 (Washington, D.C., National Gallery of Art, inv. 1969.2.1; fig. 3). Although an earlier date of ca. 1615-1620 has been proposed for the Boston painting on the basis of the sitters' costume, and the thick creamy application of paint is characteristic of the artist's early works,[5] a slightly later date seems to fit more comfortably within Jordaens's stylistic development. The spatial organization of Jordaens's portraits of about 1620-1622, though still somewhat compressed, is more plausible than that of his rather additive and claustrophobic earlier portraits, such as the *Portrait of the Jordaens Family* in St. Petersburg (Hermitage, inv. 484; ca. 1615-1616) and *Jordaens with the Van Noort Family* in Kassel (Gemäldegalerie Alte Meister, inv. 107; ca. 1615-1616).

The identity of the young couple represented in this portrait is not known. In general, Jordaens's clientele (like that of his contemporary Cornelis de Vos, q.v.) was drawn from a quite different segment of society than the sitters in portraits by Rubens and van Dyck. Those of his sitters who have been identified are affluent middle-class merchants and burghers[6] and members of Jordaens's own family, in contrast to the impressive roster of powerful clergymen, princes, and heads of state portrayed by Rubens and van Dyck. The suggestion of grand classical architecture that forms the backdrop to the *Portrait of a Young Married Couple* (and that is common to many portraits of the period) hints at the social aspirations of the sitters.

Although married couples were conventionally depicted in separate pendant portraits, Jordaens's use of the double portrait format was certainly not unique. Rubens's *Self-Portrait with Isabella Brant* of ca. 1609 ("The Honeysuckle Bower Portrait," ill. Introduction, fig. 13) may have been the most immediate inspiration for Jordaens's portrait; Frans Hals's roughly contemporary *Portrait of Isaac Massa and Beatrice van der Laan* (ca. 1622, Amsterdam, Rijksmuseum, inv. A133) may also be cited in this context. All three portraits incorporate similar symbolic elements alluding to love and marriage. Ivy, for example, whether clinging to a wall or twined about a tree, was from antiquity a symbol of love, marriage, mutual trust, affection, and friendship; the interdependency of vine and support was a particularly

appropriate image for a double marriage portrait.[7] Although gloves and their etiquette were invested with a myriad of meanings in the seventeenth century, the gloves held by the young woman in Jordaens's portrait probably functioned as a symbol of conjugal trust: to take off one's gloves was a sign of friendship, and was also symbolic of openness and the underlying promise of fidelity.[8] Even the ruined capital lying in the shadows at the right of the portrait can be claimed as part of the symbolic language of this portrait. In seventeenth-century literature ruins were paradoxically a symbol not only of transience and vanity but also of permanence, and thus the fragment may have been included here as an allusion to the enduring love of the young couple.[9]

MEW

1. Customs regarding the wearing of wedding rings were not yet standardized in the seventeenth century, although it was apparently fashionable among urban dwellers to wear wedding rings on the forefinger, usually of the right hand. See E. de Jongh, in Haarlem 1986, pp. 138-140; and J. J. Voskuil, "Van onderpand tot teken. De geschiedenis van de trouwring als beeld van functieverschuiving," *Volkskundig Bulletin* 1 (1975), pp. 47-79.

2. Claude Phillips (Wallace Collection, London), in correspondence, dated March, 1910; the attribution to Jordaens was echoed in correspondence from (among others) Julius S. Held (1935), Adolf Goldschmidt (1936), I. Q. van Regteren Altena (1937), Ludwig Burchard (1937), Jakob Rosenberg (1938), and Charles Sterling (1939), and was changed by the Museum in 1951.

3. Burroughs 1938, ill. frontispiece and fig. 58.

4. D'Hulst 1982, pp. 265-266.

5. Sutton, in Stebbins, Sutton 1986, p. 42. Edith Greindl (in correspondence, dated 31 December 1937), dates the portrait to 1615 or slightly earlier on the basis of the costume.

6. Among the named sitters depicted in Jordaens's portraits are the merchant Rogier le Witier, his wife, Catharina Behagel and mother, Madeleine de Cuyper (1635; Vorselaar, collection Baron R. de Borrekens); the wine merchant Johan Wierts and his wife (ca. 1635; Cologne, Wallraf-Richartz-Museum) and Govaert van Surpele, burgomaster of Diest, with his wife (London, National Gallery). See d'Hulst 1982, pp. 264-293; and Antwerp 1993, cat. nos. A46-A48, and A50-A52.

7. E. de Jongh, in Haarlem 1986, pp. 126-127; see also E. de Jongh and P. J. Vincken, "Frans Hals als voortzetter van een emblematisch traditie. Bij het huwelijksportret van Isaac Massa en Beatrix van der Laen," *Oud Holland* 76 (1961), pp. 127-129.

8. D. R. Smith, *Masks of Wedlock: Seventeenth-Century Dutch Marriage Portraiture* (Ann Arbor, 1982), pp. 78-79, 81.

9. As noted by Sutton, in Stebbins, Sutton 1986, p. 42. On the column (broken or entire) as a metaphor for chaste fidelity in marriage portraits, see E. de Jongh, "Bol vincit amorem," *Simiolus* 12 (1981-82), pp. 157-158.

Jacob Jordaens

45. *Adam and Eve (The Fall)*

Oil on canvas, 203 x 183 cm (80 x 72 in.)
Toledo, The Toledo Museum of Art, 87.201

PROVENANCE: presented by the Earl of Kintore to the Town Council of Inverurie; hung in the local town hall and subsequently lent to the Corporation of the City of Aberdeen, where it was stored in the Art Gallery in 1966; sale "The Property of the Gordon District Council," London (Christie's), 11 April 1986, no. 12, ill. [as "The Temptation"]; acquired by the Toledo Museum of Art from Alex Wengraf, London.

LITERATURE: Toledo Museum of Art, *Annual Report* (Toledo, 1988), ill. on cover; K. Belkin, in Liedtke et al. 1992, pp. 229-231, ill. [ca. 1645-50].

IN AN OPEN LANDSCAPE Adam and Eve sit beneath the Tree of Knowledge. On the left Eve reaches up to pull down a bough and eat the fruit proffered by the serpent. To the right Adam is seated on the ground and extends his right hand beseechingly toward Eve. At the upper left is a large parrot and to the right, a second parrot. Between the couple rest a fox and a dog.

This little-known painting surfaced in London in a sale in 1986. It is probably the original of the composition which is known also through an expanded and elaborated version (fig. 1)[1] which d'Hulst had correctly characterized as only a product of Jordaens's studio.[2] That work depicts the two figures in the same position but extends the composition laterally to include a goat and a horse on the left and a cow on the right. Pentimenti in the present work attest to its primacy. The contours of both figures have been adjusted and Eve's head was originally lower and cocked back, looking up at the serpent.[3] Another version of the subject which reverses the present design and adds a goat and sheep in the middle and a cow on the right is in the museum in Budapest (fig. 2).[4] A preparatory drawing for the latter design is in the Hessisches Landesmuseum, Darmstadt (inv. no. AE921),[5] and at least one copy is known.[6]

Although Jordaens drew quite a number of Old Testament subjects he painted relatively few of them (for example, Susanna and the Elders, the Finding of Moses, Isaac Blessing Joseph, and Moses Striking the Rock). In this instance, the subject was one that many Northern artists had treated earlier, including Jan Gossaert, Jan van Scorel, Michiel Coxcie, Frans Floris, as well as the Dutch mannerist artists Hendrick Goltzius, Joachim Wttewael, and Cornelis Cornelisz. van Haarlem.[7] Presumably its appeal was not only iconographic – mankind's first fall or original sin – but also aesthetic, since it provided the opportunity to depict monumentally conceived nudes and animals out of doors.

The immediate inspiration for Jordaens's composition is Peter Paul Rubens's copy (fig. 3) of ca. 1628-1629 of Titian's great *Adam and Eve* of ca. 1560-1570 that hung in the Alcázar, now also preserved in the Prado, Madrid (no. 429).[8] As Panofsky showed, Ti-

Fig. 1. Studio of Jacob Jordaens, *Adam and Eve*, oil on canvas, 112.5 x 154 cm, Warsaw, Narodowe Muzeum, inv. M.Ob.1328.

Fig. 2. Jacob Jordaens, *Adam and Eve*, oil on canvas, 184.5 x 221 cm, Budapest, Szépmüvészeti Múzeum, no. 5551.

tian's sources in turn were Giulio Romano's *Fall of Man* in the Camera della Segnatura in the Loggia of the Vatican, and Dürer's famous engraving of the subject of 1504, which partly inspired the posture of his figure of Eve and the emphasis on the symbolic animals.[9] While the creatures in Dürer's image alluded to the four human Temperaments (sanguine, phlegmatic, choleric, and melancholic),[10] Titian introduced a new animal as Eve's companion, the fox, who reappears in both Rubens's copy and Jordaens's Toledo painting. The fox is a symbol of luxury and, more frequently in bestiaries, of the devil himself.[11] Opposing the fox is the dog, which since the time of Pliny has been a symbol of fidelity.[12]

The fact that in all four of the works by Giulio Romano, Titian, Rubens, and Jordaens, Adam remains in a seated position (while Eve strains up to

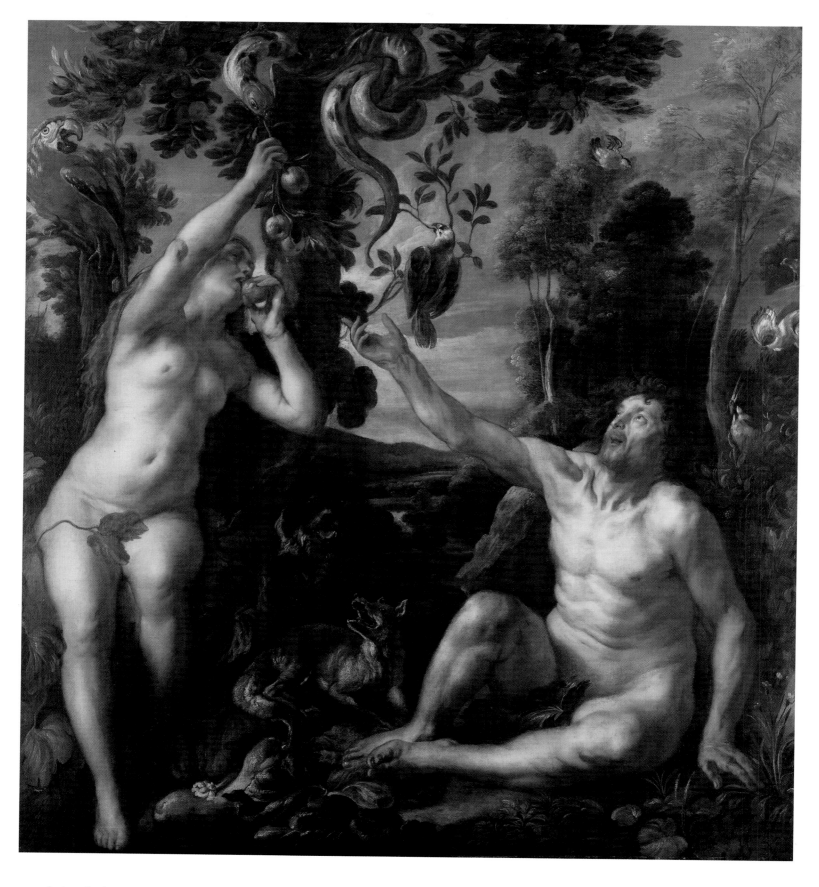

Fig. 3. Peter Paul Rubens after Titian, *Adam and Eve*, oil on canvas, 184 x 237 cm, Madrid, Museo del Prado, no. 1692.

pluck the apple) follows the biblical text and expresses the essence of Christian anti-feminist dogma, since the pose implies Adam's passive role at the moment of the first transgression, an act which forfeited all innocence and immortality: "She took of the fruit thereof and did eat, and gave also unto her husband with her, and he did eat" (Genesis 3:6). Never reticent in depicting human appetite, Jordaens represents Eve gobbling one apple as she reaches for a second. The expression of his wide-eyed and simian Adam squatting on the ground rather than on a convenient stump as in his models, is ambiguous: he appears not only to yearn upward towards the fruit but also to stare in gawking craven amazement at Eve's transgression. The artist breaks with pictorial tradition in placing Eve on Adam's left or less important side, a rare but not unprecedented arrangement (see the prints of Lucas van Leyden).[13] Finally, unlike Titian and Rubens, Jordaens has given the serpent a reptile's head rather than human form, thus returning to a conception closer to that of Dürer's print. A fascinating departure from its prototype in Rubens's copy is the inclusion of the parrot that Titian had omitted but which appeared originally in Dürer's print. Jordaens did Rubens one better by adding a second parrot. As Panofsky again explained, the parrot in the Middle Ages came to be regarded through a confusing series of non sequiturs as a symbol of the virgin birth of Christ; according to Franciscus de Retza's *Defensorium inviolatae virginitatis Mariae*, the young Julius Caesar encountered a parrot in a forest which addressed him with the words "Ave Caesar," which was taken not only as proof of miracles but also as an allusion to the angelic salutation "Ave Maria," which proclaimed the Virgin as the "New Eve" – a notion supported for the faithful by the fact that EVA (Eve) spelled backwards is AVE.[14] However the multiplication of parrots and other colorful birds into a veritable aviary suggests that their exotic appeal was at least as interesting to Jordaens as their symbolism. The palette and broad atmospheric techniques of this painting suggest a date from the artist's mature career, about 1640-1645.

P C S

1. See van Puyvelde 1953, p. 125 [ca. 1628-1630]; and Narodowe Muzeum Warsaw, *Catalogue of Paintings. Foreign Schools* (Warsaw, 1969), vol. 1, p. 185, no. 536.

2. D'Hulst 1974, vol. 3, p. 318, under no. A241. See also d'Hulst 1982, p. 208, note 17.

3. I am grateful to William Hutton for sharing with me photographs of the painting when it was in a stripped state during the treatment by Gabrielle Kopelman.

4. See van Puyvelde 1953, p. 124 (as formerly overpainted and datable ca. 1628-1630), and A. Pigler, *Katalog der Galerie Alter Meister, Szépmüvészeti Múzeum* (Budapest, 1968), vol. 1 pp. 345-346, no. 5551, vol. 2, pl. 218.

5. D'Hulst 1974, vol. 3, no. A242, fig. 257.

6. Sale Amsterdam (F. Muller & Co.), 9 December 1902, no. 31, ill. (155 x 183 cm; see Rooses 1908, p. 251); presumably identical with the painting later with L. Traugott, Stockholm, from sale Wilhelm Trübner, Berlin (Lepke), 5 June 1918, no. 286, ill.; and last seen in sale New York (Parke Bernet), 18 June 1974, no. 155. Another version seems to have been in the Bezine sale, Brussels (Fievez), 14-15 June 1927, no. 145, ill.

7. See DIAL 71A42.

8. See Madrid, cat. 1975, vol. 1, pp. 284-285, vol. 2, p. 186, ill. Rubens also painted an *Adam and Eve* very early in his career (ca. 1600; Rubenshuis, Antwerp, ill. Introduction, fig. 11), which is based on Marcantonio Raimondi's engraving after Raphael, as well as the later collaborative painting of the same subject in the Mauritshuis, The Hague, painted with Jan Brueghel the Elder (ill. Introduction, fig. 29).

9. E. Panofsky, *Problems in Titian, Mostly Iconographic* (New York, 1969), pp. 27-29.

10. On the Dürer, see Erwin Panofsky, *Albrecht Dürer* (Princeton, 1943), vol. 1, pp. 84-85, vol. 2, cat. no. 108.

11. Panofsky 1969, p. 28, note 3, cites the *Physiologus latinus*, ed. F. J. Carmody (Paris, 1939), pp. 29ff, xv; and T. H. White, *The Book of Beasts* (New York, 1954), pp. 53ff. On the fox, see also L. Réau, *Iconographie de l'art chrétien* (Paris, 1955), vol. 1, part I, pp. 111-131. At least one other Northern painter explored this symbolism; J. Saenredam's print after Cornelis Cornelisz. van Haarlem (*The Illustrated Bartsch*, vol. 3, part 2 [1980] p. 351, ill.) includes a fox among the animals.

12. See Réau 1955, vol. 1, part 1, p. 109.

13. See Belkin (in Liedtke et al. 1992, p. 231) who, acknowledging Zirka Filipczak, notes that Jordaens also reversed the customary dexter and sinister positions of spouses in his portraits; she also raises the very interesting question of whether Jordaens had personal reasons for extending this practice to the first human couple.

14. Panofsky 1969, p. 29; and J. J. M. Timmers, *Symboliek en Iconographie der christelijke Kunst* (Roermond, 1947), p. 570, no. 1138. On the parrot's symbolism, see also E. K. J. Reznicek, "De reconstructie van 't Altaer van S. Lucas van Marten van Heemskerk," *Oud Holland* 70 (1955), pp. 233ff. On the parrot's other non-Christian associations, see cat. 46.

Jacob Jordaens
46. As the Old Ones Sing, So the Young Ones Pipe

Oil on canvas, 145.5 x 218 cm (58 ⅝ x 85 ⅞ in.)
Inscribed on the sheet held by the old woman: *Een Nieu Liedeken / van Calloo / Die Geusen* (A New Song of Calloo, The Beggars)
Ottawa, National Gallery of Canada, no. NGC 15790

PROVENANCE: Hon. Francis Charteris, later seventh Earl of Wemyss at Amisfeld, East Lothian, Scotland (ms. inv. of 1771, no. 137); by descent to the Earl of Wemyss and March, Gosford House, East Lothian, Scotland, inv. 1948, no. 275; sale London (Sotheby's), 26 March 1969, no. 89; purchased through Agnew's, London, 1969.

EXHIBITIONS: London, Royal Academy, 1889, no. 78; Edinburgh, National Gallery of Scotland, *Pictures from Gosford House*, August-September 1957, no. 30; Ottawa 1968-69, pp. 100, 196, 197, no. 67, ill. p. 286; 1969 Canadian Tour (Edmonton/Victoria/Vancouver/Calgary/Saskatoon/Regina/Winnipeg/Stratford/Hamilton/St. John's/Charlottetown/Halifax/Quebec City); London, Ontario Regional Art Gallery, *Seven Ages of Man*, 1980, pp. 102-103; Vancouver Art Gallery, *Masterworks from the Collection of the National Gallery of Canada*, 1983, p. 28, ill.

LITERATURE: Waagen 1854-57, vol. 3 (1857), p. 441; C. Hofstede de Groot, "Hollandsche Kunst in Schotland, part II," *Oud-Holland* 11 (1893), p. 221; Rooses 1908, pp. 78, 263; van Puyvelde 1953, p. 205; D. Carritt, "Pictures from Gosford House," *The Burlington Magazine* 99 (1957), p. 343; J. S. Boggs, "Jordaens and Canada," *Connoisseur* 169 (1968), p. 256; H. Gerson, "Jordaens and Canada," *Art News* 67 (December 1968), pp. 37-39; M. Jaffé, "The Robust Virtuosity of Jordaens," *Apollo* 88 (1968), p. 364; Jaffé 1969, p. 13, ill. cover; de Mirimonde 1969, pp. 230-231, fig. 28; J. Michalkowa, "Jordaens in Ottawa," *Biuletyn Historii Sztuki* 31 (1969), pp. 313, 315-316; *Art at Auction: The Year at Sotheby's and Parke Bernet 1968-69* (New York, 1970), p. 75, ill. p. 101; J. S. Boggs, *The National Gallery of Canada* (Toronto/Oxford, 1971) pp. 65, 94, pl. xiii; d'Hulst 1974, vol. 2, no. A249, fig. 264; Paris 1977-78, pp. 111-112, no. 72; d'Hulst 1982, pp. 176, 179, p. 335, note 65, ill. p. 184; M. Laskin, Jr., and M. Pantazzi, *European and American Painting, Sculpture and Decorative Arts*, National Gallery of Canada, Ottawa (1987), vol. 1, pp. 150-152, vol. 2, p. 130, fig. 127; K. Renger, "Wie die Alten sungen . . . Kompositionsänderungen im Werk von Jacob Jordaens," *Kunst und Antiquitäten* 4 (1989), p. 52; Nelson 1990, pp. 113, 119, note 45, fig. 6; I. Németh, "Het spreekwoord, 'Zo d'ouden zongen, zo pijpen de jongen,' in schilderijen van Jacob Jordaens en Jan Steen: motieven en associaties," *Jaarboek van het Koninklijk Museum voor Schone Kunsten, Antwerpen* (1990), pp. 276-277, fig. 4; Liedtke et al. 1992, pp. 222-225, ill; Cologne/Vienna 1992-93, p. 426; Antwerp 1993, pp. 178, 182, under cat. no. A55, fig. A55a.

SEVEN FIGURES representing three generations have gathered around a heavily laden table to feast, play music, and sing. On the left a mother holds a baby with a *rinkelbel* (whistle-rattle) with her right arm, and raises a glass with her left hand. Beside her to the right an old woman seated in a tall wicker chair sings from a paper. To her right is a standing man and boy both playing flutes, and a laughing jester holding up a wicker birdcage containing a bird and its peeping brood. On the far right a very stout man holding a covered ceramic wine pitcher appears to sing. In the foreground is a chair laden with a basket of fruit, with a parrot perched on the back. A dog emerges from beneath the heavily laden table at the bottom right and sniffs the basket of fruit. At the upper left is a niche with flowers in a glass vase, a snuffed candle, a book, and some documents. Perched on the high-backed wicker chair beside the niche is an owl. A curtain hangs from a rod on the back wall.

Jordaens repeatedly painted, drew, and designed at least one tapestry illustrating the popular saying "As the old ones sing, so peep (pipe) the young ones," an expression that implicitly admonishes parents and elders to set a good example for children. As

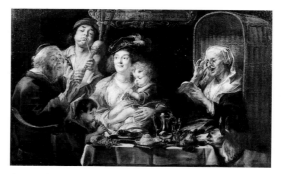

Fig. 1. Jacob Jordaens, "*As the Old Ones Sing, So the Young Ones Pipe*," signed and dated 1638, oil on canvas, 128 x 192 cm, Antwerp, Koninklijk Museum voor Schone Kunsten, no. 677.

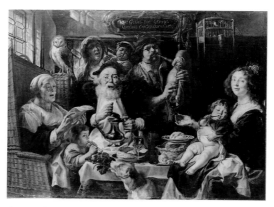

Fig. 2. Jacob Jordaens, "*As the Old Ones Sing . . . ,*" oil on canvas, 154 x 208 cm, Valenciennes, Musée des Beaux-Arts (on loan from the Louvre, Paris, inv. 2407-MR 794).

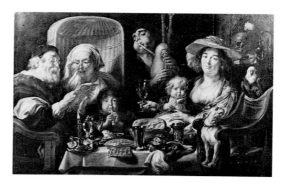

Fig. 3. Jacob Jordaens and Studio?, "*As the Old Ones Sing*", oil on canvas, 120.8 x 186.5 cm, Berlin, Verwaltung der Staatlichen Schlösser und Gärten, Schloss Charlottenburg, no. G.K. 1.3842.

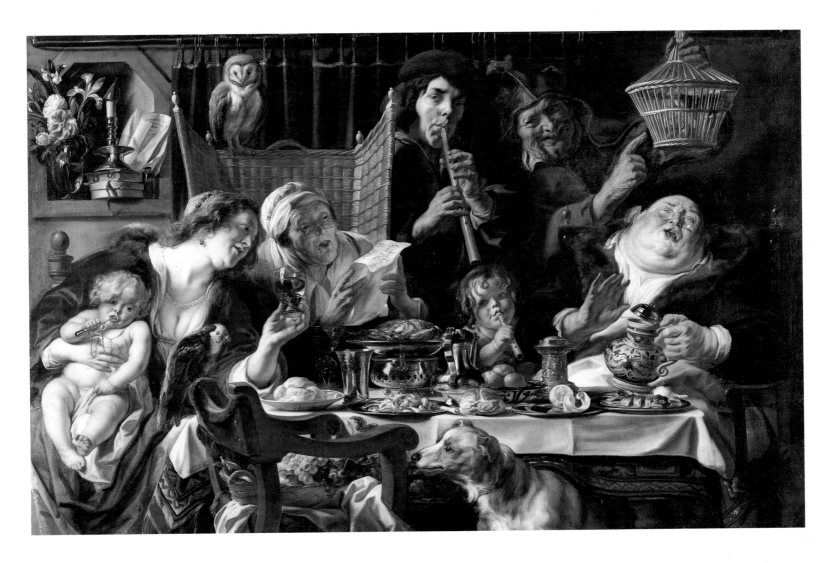

Fig. 4. After Jacob Jordaens, *A Pair of Fools with an Owl*, engraving.

Rooses already observed early in this century, the earliest dated example of these paintings and drawings is the version of 1638 in Antwerp (fig. 1), which is literally inscribed "SOO D'OVDE. SONGEN. SOO PEPEN DE JONGE."[1] The pedagogic notion embodied in the expression can be traced to biblical passages (Ezekiel 16:44: "Behold, everyone who uses proverbs will use this proverb about you, 'Like mother like daughter'"). The saying's message was not only conveyed by Erasmus but also and probably most importantly for Jordaens (as d'Hulst and others have observed) by the Calvinist poet Jacob Cats, in his emblem book *Spiegel van den Ouden ende Nieuwen Tijdt* (The Hague, 1632), part 2, no. 13.[2] When in 1644 Jordaens undertook a commission to produce a series of eight tapestries illustrating *Spreekwoorden* (Proverbs), he chose his subjects from Cats's *Spiegel*.[3]

Rooses observed that the painting of the reputable and rather well-to-do family making music

in the painting in Antwerp (fig. 1) seems to be a straightforward illustration of the proverb, but in other later examples the scenes "become noisier and the children are set an example by their parents in other things besides singing and piping."[4] De Mirimonde and Nelson both discussed Jordaens's paintings of this theme in relationship to his early family portraits with figures making music.[5] Nelson further observed that the familial harmony (*concordia*) implicit in the theme of a family playing music could be related to changing social ideals and the increasing celebration of the conjugal family as the primary forum for moral instruction in Netherlandish culture. Dirck Volckertsz. Coornhert quoted the expression employing it *in bono* in the sense of the elder's exemplary wisdom providing positive models of conduct.[6]

A painting of the same subject in Valenciennes (fig. 2) employs many of the same figures (for exam-

ple, the bagpipe and flute players, whose activities play on the word "pijpen") as well as compositional elements that appear in the Antwerp picture (fig. 1); it is inscribed in Latin: *Ut Genus est genius concors consentus ab ortu* (The mind of the child conforms from birth to that of the people).[7] However we now notice that the merriment has become giddier and the imbibing of wine more conspicuous. There are also two new details in the Valenciennes painting that recur in the Ottawa painting, namely the owl perched on the chair at the left and a bird in a birdcage at the upper right. These elements undoubtedly play on the original form of the saying, which was expressed in the imagery of birds implicit in the verb "pepen" (to peep). The bird in the cage might also symbolize youth and its promise yearning to be free, while the owl also had other associations. Since antiquity, when it was the attribute of Athena (Minerva), the owl had been a symbol of wisdom and learning.[8] It even was still cited by Alciati in the sixteenth century as a symbol of wise and laconic counsel.[9] However because the bird was a nocturnal creature who avoided the light and staggered about when caught in the day, it had increasingly negative associations with spiritual darkness, ignorance, drunkeness, and debauchery.[10]

Closely related to the "Zo de Ouden zongen . . ." theme in Jordaens's art was the banqueting subject of Twelfth Night, also known as the "Bean King" or "The King Drinks," examples of which are found in the museums in Brussels (no. 3545), Vienna (inv. 786), Kassel (no. 108), and in the Louvre (inv. 1406), the last forming the pendant to the Valenciennes painting (fig. 2). At celebrations of the Epiphany, banqueters assumed various different roles; the King was selected by receiving a bean baked in a cake and was attended by a Steward, Doctor, Butcher, Cook, Herald, Singer, and the Court Fool. The Fool's traditional literary and theatrical role was exposing human foibles; in the large *King Drinks* by Jordaens in the Kunsthistorisches Museum, Vienna, the Fool's moralizing role is made explicit by the Latin inscription: *Nil similius insano quam ebrius* (No one is more like a fool than a drunk). Fools were often depicted in sixteenth- and seventeenth-century art with owls as the symbol of their stupidity. Jordaens himself depicted a couple of laughing Fools holding an owl in a niche (fig. 4).[11] The sightlessness of the owl in daylight became a symbol of mankind turning a blind eye to good, as captured in the popular Dutch saying *Wat baet er kaers en bril, als den uyl niet zien en wil* (What need does the owl have for a candle or spectacles if he cannot and will not see).[12] The owl's association with Gula, the sin of gluttony and drunkeness,

was conveyed in the saying *Hij is zoo beschonken als een uil* or its variant *Zo zot als een uil* (As drunk as an owl).[13] A birdcage appears in the Valenciennes painting (fig. 2) and a more rustic version is held up by the laughing Fool in the present picture. The birds peeping inside obviously underscore the central theme by offering an analogy (again in the tradition of Cats) to the natural world. However birdcages also often appear in Netherlandish art as symbols of love and eroticism.[14] So the inclusion of the Fool would be designed not only to underscore the stupidity of the merry company in the Ottawa painting but also warn of the possibility of sexual debauchery resulting from the drinking.

Still another composition by Jordaens of the theme "As the Old Ones Sing . . ." exists in three versions: in a private collection in Belgium[15]; in Schloss Charlottenburg, Berlin (fig. 3)[16]; and with an enlarged format in the museum in Dresden.[17] As d'Hulst and others have emphasized,[18] that design includes a niche in the background which may be compared to the one in the Ottawa painting. The objects in it likewise seem to emphasize a warning of human transience and mortality. In the Berlin painting the message of *memento mori* or *vanitas* is conveyed by a skull, a tulip blossom that will soon fade, books and documents that yellow with time, and, on the table, a guttering candle. The inscription on a piece of paper in the niche even reads "Cogita Mori" (think on death).[19] While the Ottawa painting omits the inscription and the most conspicuous symbol of death, namely the skull, it too undoubtedly issues a moralizing warning. Finally, the parrot that appears in both the Berlin and Ottawa paintings was naturally renowned for its ability to uncritically imitate speech, so since the time of Pliny had been a symbol of the student who learns everything – the good as well as bad, the coarse and crude as well as the proper and polite. Thus again a pedagogical note is sounded.

The degree to which Jordaens was truly censorious in delivering his moral message, however, is unclear; like other great moralists before and after him, such as Jan Steen, he comically conscripted vice in defense of virtue. But Nelson is right to remind us that Jordaens was surely as concerned with depicting the good-hearted merriment of family festivities as with sermonizing.[20] In several of Jordaens's paintings of "As the Old Ones Sing . . ." and the related subject of "The King Drinks," he used his own family as models; the very stout fellow on the right in the Ottawa painting, for example, has been assumed to be the elderly (and uncharacteristically beardless) Adam van Noort, the artist's father-in-law who lived

Fig. 5. Jacob Jordaens, *"As the Old Ones Sing"*, chalk on paper, 160 x 200 mm, St. Petersburg, Hermitage, no. 4213.

with him from 1634 until his death at age eighty-four in 1641.[21] However one must beware the temptations of the biographical fallacy; there is, of course, no reason to assume that Jordaens was here or elsewhere offering an autobiographical account of his own life or family.

The inscription on the sheet of paper held by the old woman was first deciphered in the catalogue of the Gosford House exhibition in 1957, no. 30. Rooses had earlier noted that variants of the "As the Old Ones Sing . . ." in the museum in Würzburg and owned by the Duc d'Arenberg also made reference to this song.[22] "Een nieu liedeken van Calloo. Die Geusen" (A New Song of Calloo. The Beggars) refers to the victory of the Cardinal Infante Ferdinand of Spain over the forces of Frederick Hendrick of Orange at Calloo, near Antwerp, in June 1638 (see History). The rebels who rose up against Spanish rule were nicknamed the beggars (*geuzen*); the reference is to the first two words of the song. R.-A. d'Hulst noted that the entire song has been published.[23] The reference to the defeat and discrediting of the Stadholder could complement the painting's *vanitas* associations, since it recalls how the mighty may fall and temporal power pass.

As Michael Jaffé observed in the Ottawa exhibition catalogue of 1968, a drawing in the Hermitage, St. Petersburg, of "As the Old Ones Sing . . ." (fig. 5) anticipates many aspects of the Ottawa painting's design and presumably was preparatory to it.[24] Although there is no physical or stylistic reason to assume that the present work is a copy or the product of the artist's workshop, we know from a document of 25 August 1648 (Prot. Not. H. van Cantelbeck, Antwerp) that about two years prior to that date Jordaens had painted several versions of some subjects including "Zo de Ouden zongen" for Sr. Martinus van Langenhoven, and that some of these paintings were only partly by his hand, some being only copies retouched by the master.[25]

PCS

1. Rooses 1908, p. 74, and for further literature, see exh. cat. Antwerp 1993, cat. A55, ill. Schelte à Bolswert's print after this painting is inscribed in Latin: "Quod cantant patulo tubis maiores ore frequenter/Hoc resonare tubis canta juventa studet" (what the elders customarily sing with full voice, the cautious youth is eager to echo on the pipes). The verses go on to flatter the painter, likening him to the fifth-century B.C. Greek painter Zeuxis, who was renowned for his naturalistic illusions: "A very Zeuxis, the painter shows this well, surpassing art itself, as if there were life in the old people and sound in the pipes." Although the Antwerp painting is the earliest dated example, Konrad Renger ("Wie die Alten sungen . . . Kompositionsänderungen im Werk von Jacob Jordaens," *Kunst und Antiquitäten* 4 [1989], pp. 52-59) has shown that the large version of this theme dated 1646 in the Alte Pinakothek, Munich (no. 806) has been enlarged on all sides, and has concluded that its original central portion could have been executed as early as the 1630s.

2. On Erasmus, see F. A. Stoett, *Nederlandsche spreekwoorden, spreekwijzen, uitdrukingen en gezegden*, 4th ed. (Zutphen, 1925), vol. 2, p. 123, no. 1736. On the expressions see P. J. Harrebommée, *Spreekwoordenboek der Nederlansche Taal* (The Hague/Leiden, 1931), pp. 1541, 1744. Cats in his *Spiegel van den Ouden ende Nieuwen Tijdt* (The Hague, 1632), p. 65, cited the German phrase "Was die Alten sungen, so pfeifen die Jungen." The emblematicist Johan de Brune (*Nieuwe wijn in oude le'er zacken* [Middelburg, 1636], pp. 180, 239) also used the expression. For general discussion of the theme, see Rooses 1908, pp. 74-81; d'Hulst 1982, pp. 176-181; Nelson 1990, pp. 112-113; and István Németh, "Het spreekwoord 'Zo d'ouden zongen, zo pijpen de jongen' in schilderijen van Jacob Jordaens en Jan Steen: motieven en associaties," in *Jaarboek van het Koninklijk Museum voor Schone Kunsten, Antwerpen* (1990), pp. 271-286.

3. For the tapestry design see Kristi Nelson, "Jordaens as a Designer of Tapestries," diss. Univ. of North Carolina, 1979, cat. no. 26; and Antwerp 1993, under A69.

4. Rooses 1908, p. 74.

5. De Mirimonde 1969, esp. pp. 222-225; Nelson 1990, esp. pp. 109-110.

6. Cited by Németh 1990, p. 273: Dirck Volckertsz. Coornhert, *Zedekunst dat is Wellevenkunste* (Utrecht, 1586), p. 191.

7. For discussion, see Cologne/Vienna 1992-93, no. 75.1. When the Antwerp painting (fig. 1) was engraved by Schelte à Bolswert, it too was appended with a Latin text: "Quod cantant patulo maiores ore frequenter / Hoc resonare tubis canta juventa studet" (What the parents sing with full throat / the children resonate with wind instruments).

8. See P. P. Paszkiewicz, "Nocturnal Bird of Wisdom: Symbolic Functions of the Owl in Emblems," *Bulletin du Musée National de Varsovie* 23, nos. 1-4, (1982), pp. 56-83.

9. A. Alciati, *Emblemata liber* (1550), no. 19, inscribed "Prudens magis quam luquax" (Prudent rather than loquacious).

10. See Paszkiewicz 1982, pp. 61ff; and P. Vandenbroeck, "Bubo Significans. Die Eule als Sinnbild der Schlechtigkeit und Torheit, vor allem in der niederländischen und deutschen Bilddarstellung und bei Jheronimus Bosch," in *Jaarboek van het Koninklijk Museum voor Schone Kunsten, Antwerpen* (1985), pp. 19-136.

11. The Dutch inscription on the print reads: "Al syn maer met ons twee, / Doch ons geslacht is sterck. / Sy draeghen niet ons Kleedt, / Maer sy doen oock het selve werck" (Although there are just the two of us, our ancestry is strong. They may not dress like us, but they do the same work). The French inscription repeats the same saying: "Encore que nous sommes qu'a deux. / Nouse sommes beacoup d'une lignage: / Nous ne sommes pas vestuz comme eux;/ Mais ils faisant le mesme ouvrage." See also J. van Sande's print after this design in Vandenbroeck 1985, p. 81, fig. 2.

12. See Jan Steen's well-known painting of a ruinously inebriated couple in *After the Drinking Bout* (Amsterdam, Rijksmuseum, no. C232) which includes a print on the back wall of an owl with spectacles and candle; see also cat. 71.

13. See S. Slive, "On the Meaning of Frans Hals' 'Malle Babbe,'" *The Burlington Magazine* 105 (1963), p. 435; and Paszkiewicz 1982, pp. 66, 69-72. On still another association of the owl as the most hated or despised of all birds, see cat. 119.

14. See E. de Jongh, *Zinne- en minnebeelden in de Schilderkunst van de zeventiende eeuw* (Amsterdam, 1967), p. 41; idem, "Erotica in vogelperspectief. De dubbelzinnigheid van een reeks 17de-eeuwse genre-voorstellingen," *Simiolus* 3 (1968-69), p. 48; Amsterdam, 1976, p. 252; and Németh 1990, p. 284.

15. See Antwerp 1976, no. 21, ill. (canvas, 125 x 189 cm).

16. See Ottawa 1968-69, no. 66, fig. 66.

17. Reproduced Rooses 1908, p. 253.

18. D'Hulst 1982, p. 179; Ottawa 1968-69, no. 67; Larkin and Pantazzi in *Catalogue*, National Gallery of Canada, 1987, p. 151; Renger 1989, p. 52; Nelson 1990, p. 113.

19. The painting in a Belgian private collection (see note 15) is inscribed "Coga Mori."

20. Nelson 1990, p. 113.

21. Larkin and Pantazzi, 1987, p. 151. Compare Jordaens's *Portrait of Adam*

Jacob Jordaens
47. Bacchus Discovering Ariadne

Oil on canvas, 121 x 127 cm (47 ⅝ x 50 ⅛ in.)
Boston, Museum of Fine Arts, M. Theresa B. Hopkins
Fund, acc. no. 54.134

van Noort in the Fitzwilliam Museum, Cambridge, no. 2083; the sitter's identity is confirmed by Hen. Snyer's engraving after a destroyed painting by Jordaens (see M. Bernhard and K. Martin, *Verlorene Werks der Malerei in Deutschland in der Zeit von 1939 bis 1945: zerstörte und verschollene Gemälde aus Museen und Galerien* [Munich, 1965], pl. 123). Németh (1990, p. 276) also likened this figure generally to the characters in the "Vette Keuken" (Fat Kitchen) pictorial tradition.

22. Rooses 1908, p. 79.

23. D'Hulst 1982, p. 335, note 66. See *Annalen van den Oudheidkundigen kring van het land van Waas* (St. Niklaas, 1938), vol. 50, pp. 55, 58-59, 64.

24. Ottawa 1968-69, no. 214, ill. There is also a drawing of this subject in the Museum Boymans-van Beuningen, Rotterdam (d'Hulst 1974, cat. no. A189; see Ottawa 1968-69, no. 215, ill).

25. See Rooses 1908, p. 81, and Introduction.

PROVENANCE: sale The Hague, 18 July 1753, no. 18 [fl. 28] (see Terwesten 1770); sale Johan van Nispen, The Hague, 12 September 1768, no. 611 ["De Histoire van Bacchus en Ariadne," canvas, 48 x 51 duim; fl. 80, to Terwesten]; sale Panné, London (Christie's), 26-29 March 1819, no. 69 ["Bacchus presenting the Crown to Ariadne, and Satyrs looking down on her from a woody Bank," canvas, 47 ½ x 49 in.; £3.13.6]; Mrs. M. Whitehead; Dr. Alfred Scharf, London; sale London (Sotheby's), 28 January 1953, no. 69; acquired for the Museum in 1953.

EXHIBITIONS: London 1953-54, no. 296; Ottawa 1968-69, no. 97, ill.; Antwerp 1993, no. A75, ill.

LITERATURE: Terwesten 1770, p. 80; Rooses 1908, pp. 92-93; van Puyvelde 1953, p. 196; *Bulletin of the Museum of Fine Arts* 52 (1954), p. 91, ill.; d'Hulst 1956a, p. 219; M. Jaffé, in Ottawa 1968-69, p. 129, no. 97, ill.; d'Hulst 1982, p. 216, fig. 193, note 35; Boston, cat. 1985, p. 154, ill.; M. Vandenven, in Liedtke et al. 1992, pp. 232-233, ill.

ATTENDED by his entourage of satyrs, Bacchus discovers Ariadne sleeping on the island of Naxos. Standing on the left, he is nude save for his chaplet of grape leaves and holds aloft the crown that he will toss into the heavens to create a constellation in Ariadne's honor. Behind him stands winged Cupid with a quiver of arrows and a thyrsus. Atop the wooded bluff on the right, three hoary satyrs peer down lasciviously at the recumbent Ariadne.

This late work by Jordaens employs the soft, languorous figures and the warm sensuous palette and atmospheric technique that he developed in the 1640s. During this period, Jordaens's forms became more corpulent, less resilient, even flacid, and as d'Hulst observed, "muscle increasingly gives way to fat.... Sleep, which often fixes the female forms in artificial poses, symbolises the victory of what is dull and corporeal over will, energy and motion."[1] Female nudes had always played an important role in the artist's mythological scenes and frequently are

Fig. 2. Jacob Jordaens, *Antiope Asleep*, 1650, oil on canvas, 130 x 93 cm, Grenoble, Musée des Beaux-Arts, inv. 85.

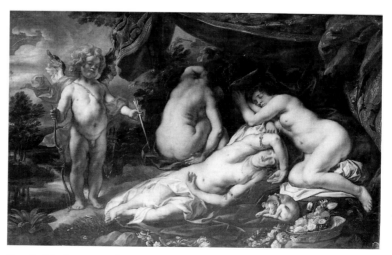

Fig. 1. Jacob Jordaens, *Venus Asleep*, oil on canvas, 160 x 260 cm, Antwerp, Koninklijk Museum voor Schone Kunsten, no. 5023.

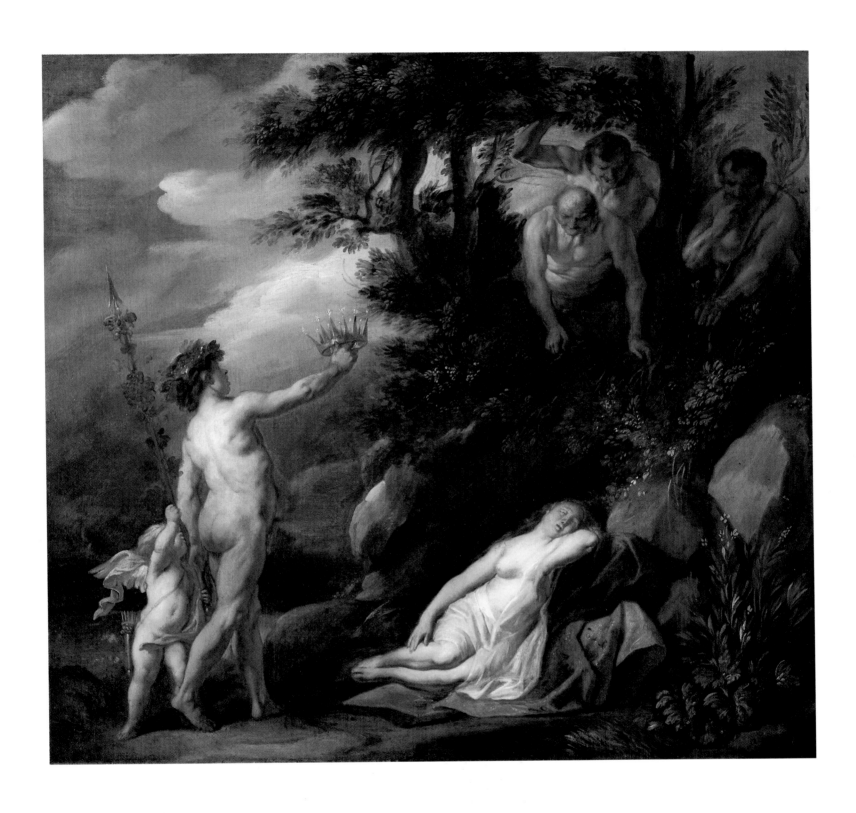

depicted sitting, crouching, or recumbent. Typical of Jordaens's later treatment of the nude is the *Venus Asleep* in Antwerp (fig. 1). D'Hulst cites the precedents of Rubens's art, such as his *Cimon and Iphigenia* in the Kunsthistorisches Museum (see Introduction, fig. 27) for this work, not only for the *Bacchus and Ariadne* in Boston, but also the *Venus Asleep* in the museum in Kiev (no. 204), and *Antiope Asleep* dated 1650 in the museum in Grenoble (fig. 2).[2] Support for the dating of the present painting in the late 1640s is also provided by stylistic resemblances to the *Shaping of the Horn of Plenty* dated 1649 in the Statens Museum for Kunst in Copenhagen (no. 351; ill. cat. 4, fig. 1).[3] A similar wooded setting with a hillock also appears in Jordaens's *Apollo and Marsyas*, sale London (Sotheby's), 24 March 1965, no. 122.[4]

Jordaens painted Bacchus in his role as the drunken god of wine in the *Triumph of Bacchus* (Brussels, Musées Royaux des Beaux-Arts de Belgique, inv. no. 3693; and Kassel, Gemäldegalerie Alte Meister, no. 109)[5] and also depicted the bibulous *Youth of Bacchus* (Warsaw, Narodowe Muzeum).[6] Here, however, he depicts the relatively svelte and well-behaved young Bacchus as the smitten suitor of Ariadne. In another painting from the late 1640s, he also depicted *Ariadne in Bacchus's Entourage* (Dresden, Gemäldegalerie Alte Meister, no. 1009). The story of Bacchus and Ariadne was recounted by Ovid in his *Metamorphoses* (VIII: 176-182), *Ars Amatoria* (I: 529-562) and *Fasti* (III: 507-526).[7] Bacchus discovered Ariadne after she was deserted by Theseus on Naxos and immediately fell in love with her, but soon abandoned her to conquer India. Returning in triumph, he found Ariadne declaiming against the faithlessness of both her loves and wishing for death. He comforted her and "took her crown / And set it in the heavens to win her there / A star's eternal glory; and the crown / Flew through the soft light air and, as it flew, / Its gems were turned to gleaming fires, and still / Shaped as a crown their place in heaven they take" (*Metamorphoses*, VIII: 177-181).[8] The jewels of Ariadne's diadem were transformed into the constellation known as Corona Borealis.

Earlier Italian artists, like Titian (see London, The National Gallery, no. 35) and the Carraccis, had treated the theme,[9] but it was not a common subject among Northern painters.[10] Moses van Uyttenbroeck and Cornelis van Poelenburgh painted the meeting of Bacchus and Ariadne on the seacoast, but Jordaens seems to have been the first Northern painter to depict Bacchus tossing the crown aloft.[11] Karel van Mander had recounted and interpreted the theme in 1603 morally, as an admonition against excessive drinking and temptation; the transforma-

tion into heavenly stars of the crown "of the dishonorable life" (which he noted had been made by Vulcan for his unfaithful wife, Venus) was for van Mander a symbol of redemption.[12] Given Jordaens's penchant for moralizing themes (see cats. 45 and 46) and specific tendency to criticize the weakness of the flesh, a similar meaning may be here intended.

D'Hulst mentions a smaller version (canvas, 69 x 48 cm) of this picture as appearing in the Gustave Couteaux sale, Brussels, 1874; and a drawing of the same subject by the master in red chalk, pen and brown ink, in the Vonklinkosch sale, Vienna, 1889.[13]

PCS

1. D'Hulst 1982, p. 216.

2. Ottawa 1968-69, no. 99, fig. 99; d'Hulst 1982, note 36, fig. 194; Antwerp 1993, cat. A81.

3. Rooses 1908, p. 145, ill. p. 147; see also K. Erasmus, "Eine Studie zum Gemälde 'Der Ueberfluss' von Jacob Jordaens in Klg. Museum in Kopenhagen," *Monatsheft für Kunstwissenschaft* (1908), pp. 708-709; d'Hulst 1982, note 37.

4. See Stuttgart, Staatsgalerie, *Masterpieces from Baden and Wurtemberg Private Collections*, 1958-59, no. 97, pl. 50.

5. Rooses 1908, pp. 88, ill. p. 90; d'Hulst 1982, p. 216, fig. 181.

6. Rooses 1908, p. 257; Ottawa 1968-69, no. 95, fig. 95; d'Hulst 1982, p. 220.

7. For discussions of Ovid's texts, see G. H. Thompson, "The Literary Sources of Titian's Bacchus and Ariadne," in *The Classical Journal* 51 (1956), pp. 259ff. And on the theme, see also F. W. Hamsdorf, *Dionysos/Bacchus, Kult und Wandelungen des Weingottes* (Munich, 1986), pp. 21-22, 110-129.

8. Ovid, *Metamorphoses* (trans. by A. D. Melville) (Oxford, 1986), p. 176.

9. For discussion of Titian's influential work, see E. Panofsky, *Problems in Titian: Mostly Iconographic* (New York, 1969), pp. 139-144.

10. See Pigler 1974, vol. 2, pp. 46-51; and DIAL no. 92.D1 (+13); E. J. Sluijter, *De "heydensche fabulen" in de Noordnederlandse schelderkunst circa 1590-1670* (diss. Leiden, 1986), pp. 80, 144, 420-421.

11. Sluijter (ibid.). Gerard de Lairesse (see especially The Hague, Mauritshuis, no. 83), Gerard Hoet, Pieter van der Werff, and others were to follow.

12. K. van Mander, *Wtlegghingh op den Metamorphosis* (Haarlem, 1603-04), part 2, fols. 71-72.

13. See Antwerp 1993, p. 234, under no. A75.

Unknown Flemish Caravaggist
48. The Taking of Christ

Oil on canvas, 147 x 194 cm (58 x 76 ½ in.)
Boston, Museum of Fine Arts, Juliana Cheney
Edwards Collection, no. 1979.154

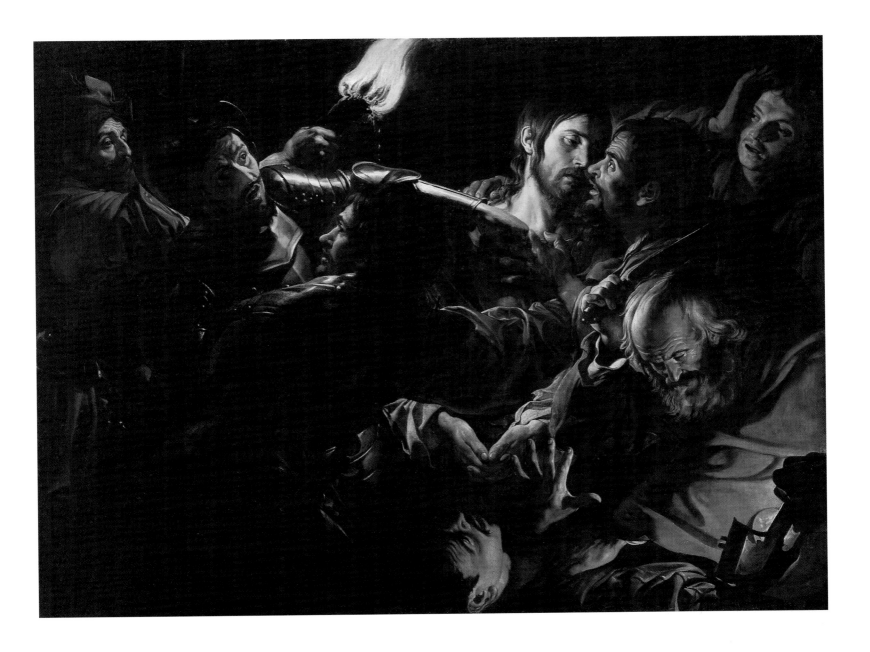

PROVENANCE: private collection, Switzerland; P. & D. Colnaghi, London, until 1978.

EXHIBITIONS: London, P. & D. Colnaghi, *Paintings by Old Masters*, 1978, no. 21 [as Dirck van Baburen]; Tokyo, Isetan Museum of Art, *Masterpieces of European Painting from the Museum of Fine Arts, Boston*, 21 October-4 December 1983 (also shown at Fukuoka, Fukuoka Art Museum, 6-29 January-29 1984; and Kyoto, Kyoto Municipal Museum of Art, 25 February-8 April 1984), no. 5, ill. [as Valentin de Boulogne].

LITERATURE: K. Roberts, "Current and Forthcoming Exhibitions," *Burlington Magazine* 120 (July 1978), p. 475, ill. [as Dirck van Baburen]; B. Nicholson, *The International Caravaggesque Movement* (Oxford, 1979), p. 18, pl. 121 [as Baburen]; "La Chronique des arts," *Gazette des Beaux-Arts* 95 (1980), (supplement) p. 32, no. 168 [as Valentin de Boulogne]; L. J. Slatkes, "Review of Nicholson's *International Caravaggesque Movement*," *Simiolus* 12, nos. 2/3 (1981-82), p. 180 [as "a joint venture of Valentin and Douffet"]; Boston, cat. 1985, p. 288, ill. [as by Valentin de Boulogne]; G. Grasso, *La continuità di una scelta culturale. Cesare Viazzi studioso antiquario* (Genoa, 1988), p. 25 [as by Bartolomeo Manfredi]; M. Mojana, *Valentin de Boulogne* (Milan, 1989), p. 249, no. 166 [as not by Valentin]; N. H. J. Hall, *Colnaghi in America*.

IN A CROWDED and shallow composition illuminated by torchlight, Judas has just kissed Christ, revealing him to the soldiers in the Garden of Gethsemane (Matthew 26:47-52). Christ stands quitely at the right center, his hand clasped at his waist and turning in silent acceptance towards Judas, who embraces him in profile. At the left, two armor clad

soldiers reach for Jesus beneath the torch held by a bearded figure on the far left. In the right foreground, lit by an open lantern, the balding St. Peter raises his sword to cut off the ear of the fallen Malchus, servant of the high priest. At the far right another man, possibly St. John, raises his hand to his head and seems about to flee. The commotion of the scene is enhanced not only by the dramatic lighting but also by the opposing gestures and expressive entanglement of outstretched hands.

This painting has carried a wide variety of attributions to various followers of Caravaggio, and seems to be based on the recently rediscovered original of the same subject by the influential Italian master.[1] The life-size, half-length format, the densely conceived design, the theatrical lighting, as well as individual gestures all seem indebted to Caravaggio's design. When exhibited by the dealer Colnaghi, the painting was attributed to the Utrecht caravaggist, Dirck van Baburen (ca. 1595-1624), an assignment supported by Benedict Nicholson in his study of the international Caravaggesque movement.[2] Baburen's own style can be appreciated in his version of the *Taking of Christ* (Rome, Galleria Borghese, no. 28) which displays a very different manner even in the very early years. Baburen's modeling is much slicker, given to larger areas of unmodulated tone and cooler, less saturated colors. Soon after entering Boston's permanent collection in 1979, the painting was assigned to the French Caravaggist, Valentin de Boulogne (1591-1632), under whose name it was exhibited in Japan in 1983-84 and published in the summary catalogue of 1985. Slatkes tacitly accepted the attribution to Valentin, speculating however that it could be a "joint venture" with Gérard Douffet.[3] However, once again, even in his early works, Valentin had a finer, dryer touch and rarely ventured such a warm color scheme. Marina Mojana correctly rejected the attribution to Valentin in her recent monograph on the artist; implicitly rejecting Giovanni Grasso's alternative attribution to the Italian master Bartolomeo Manfredi, she correctly suggests that it is most likely by a northern Caravaggist who might have been active in Rome in the second decade of the seventeenth century, adding that the name of Hendrik van Somer had been suggested privately.[4] The proposal to return the search for the painting's author to the North is a useful one and supported by the work's broad and colorful naturalism, although the painting – notwithstanding anatomic infelicities in some of the figures (note the painfully torqued neck of the soldier in the left foreground) – is simply too bold in both design and facture for the rather wan van Somer.

The painting is closer in style to the Flemish Caravaggists than to their Utrecht counterparts. For example, it has points of comparison in the gestures and figure types with Gerard Seghers's *The Denial of St. Peter* (Raleigh, North Carolina Museum of Art, no. 52.9.112; see Introduction, fig. 77), and Seghers's *St. Peter in Prayer* (St. Petersburg, Hermitage, no. 5129) is close in type and conception to his more violent counterpart in the Boston picture.[5] While the comparisons are not so compelling as to warrant an unqualified reassignment of the Boston painting to that artist, the present state of research suggests that the Southern Netherlands was the most likely place of origin of a painter given to such a strong and spirited technique.

PCS

1. Caravaggio's 1602 original was recently discovered in an Irish religious college; see *The Art Newspaper* 4, no. 28 (May 1993) pp. 1, 3; and W. Friedländer, *Caravaggio Studies* (Princeton, 1955), cat. 21; one of several copies was in the Sannini Collection, Florence (Friendländer 1955, pl. 27). See also Agnes Czobar, "L'Arrestation de Christ, du Caravage," *Bulletin du Musée Hongrois des Beaux-Arts* 10 (1957), p. 30ff; and the copy in sale New York (Sotheby Parke Bernet), 9 January 1980, no. 180.

2. Nicholson 1979, p. 18.

3. Slatkes (review of Nicolson 1979) in *Simiolus* 12, no. 2/3 (1981-82), p. 180.

4. M. Mojana, *Valentin de Boulogne* (Milan, 1989), p. 249, no. 166; Grasso 1988, p. 25. On van Somer, see R. Kultzen, "Eine Anmerkung zum Werk von Hendrik van Somer," *Weltkunst* 48, no. 19 (1978), p. 2069.

5. See, respectively, Bieneck 1992, cat. nos. A12 and A62.

Theodoor van Thulden

(1606-'s-Hertogenbosch-1669)

Theodoor van Thulden lived and worked in an area spanning the Northern and Southern Netherlands at a time when these national borders were not strictly defined. When the artist was baptized in the Sint-Janskerk in 's-Hertogenbosch on 9 August 1606 the church was Catholic, in a Catholic city firmly allied with the South; when he was buried in the same church in 1669, both the church and the city were Protestant, and well within the borders of the Northern Netherlands. Van Thulden was the eldest of at least ten children born to Jacobus Gerardsz. van Thulden, a cloth merchant, and Heyltje Dirckxdr. van Meurs. The family moved to the town of Oirschot sometime between 1621 and 1625, but Theodoor apparently continued on to Antwerp, where in 1621/22 he was a pupil of the portrait painter Abraham van Blyenberch (d. after 1623). He became a master in the guild of St. Luke in 1626/27.

Van Thulden went to Paris in ca. 1631. He painted a series of works for the church of the Trinitarians, which he later engraved. He also made a great number of drawings after works by artists of the School of Fontainebleau, including a series of both drawings and prints after decorations by Primaticcio and Niccolò dell'Abbate for the Galerie d'Ulysse at Fontainebleau.

The artist returned to Antwerp by 1634. In 1635, together with Erasmus Quellinus (q.v.) and others, he assisted with the execution of Rubens's designs for the Pompa Introitus Ferdinandi. He was subsequently commissioned by the city of Antwerp to produce a book of prints commemorating the event, a project which was delayed for several years because a commentary, written by Jan Caspar Gevaerts, was not finally published until 1643.

On 24 July 1635, van Thulden married Maria van Balen, daughter of Hendrick van Balen (q.v.) and godchild of Rubens; the couple's first child was born the following year. Also in 1635 van Thulden became a citizen of Antwerp and joined the Kolveniers guild. In 1636/37 he took on a pupil, Caspaer van Cantelbeek; it was also in these years that he worked with Rubens on the decorations for the Torre de la Parada.

Van Thulden was elected *deken* (dean) of the Antwerp St. Luke's Guild in 1638/39, and *hoofddeken* (head dean) in 1639/40. The position brought him more grief than prestige, however, as in 1641 he was found personally accountable for the debts which had accumulated during his tenure as head of the guild. These difficulties, coming close on the heels of the debacle surrounding the publication of the *Pompa Introitus*, may have persuaded van Thulden to leave Antwerp with his family and resettle in Oirschot.

Van Thulden relocated to 's-Hertogenbosch in ca. 1646/47 but maintained close contacts with Antwerp and, thanks to the 1648 Treaty of Münster, which greatly facilitated relations between the Northern and Southern Netherlands, continued to execute commissions for patrons both North and South. In 1648-1651 he executed six large decorative paintings for the Huis ten Bosch in The Hague, and at least ten works (now lost) for the Noordeinde and Honselaersdijk palaces. He designed three windows for the Chapel of the Holy Sacrament in the Cathedral of Saint-Michel in Brussels, and in 1647 painted three altarpieces for the Trinitarian church in Paris. Van Thulden's last works are dated 1666. He was buried in the Sint-Janskerk in 's-Hertogenbosch on 12 July 1669.

Van Thulden's early works retain a trace of mannerism in their decorativeness and attention to detail, and a certain lyricism that is more closely allied to works by van Dyck than by Rubens. Not until after his return from Paris in the mid-1630s do his works begin to display Rubensian color contrasts, dynamic forms, and tactile rendering of stuffs. Van Thulden's paintings never attain the robust vitality of Rubens's works, however, but translate it into a more accessible elegance, delicate and sentimental. His late works of the 1660s are more classicizing, reflecting widespread trends after mid-century. Primarily a history painter, van Thulden had a predilection for moralizing allegories; he also executed portraits from the early 1640s, after his move to the Northern Netherlands. His most productive period was ca. 1648-1660. No pupils are mentioned in the guild records of 's-Hertogenbosch (he may have been exempt from registration requirements), although he worked closely with his brother-in-law and assistant, Hendrick van Balen the Younger.

De Bie 1661, p. 241; Dezalliers d'Argenville 1727, passim; Descamps 1753-64, vol. 2, pp. 112-113; Mariette 1853, vol. 6, p. 12ff; Michiels 1865-76, vol. 8 (1869), pp. 116-137; Rombouts, van Lerius 1872, vol. 1, pp. 574, 609, 637, vol. 2, pp. 86, 109, 113, 320; Rooses 1879, pp. 422-425 and passim; van Lerius 1880-81, vol. 2, pp. 244, 329-331, 339-344, 348, 350, 352 and 356-357; van den Branden 1883, pp. 566, 569, 771-777, 1278, 1371; Rubens-Bulletijn 3 (1888), pp. 136ff, 144; Donnet 1896, pp. 355-402, passim; van Sasse van Ysselt 1900; Rooses 1903, p. 442; Donnet 1907, pp. 216, 233-235; Wurzbach 1906-11, vol. 2 (1910), pp. 710-711; van Sasse van Ysselt, Juten 1911; Oldenbourg 1918a; Schneider 1928; H. Schneider, in Thieme, Becker 1907-50, vol. 33 (1939), pp. 110-111; Lefévre 1945; van Gelder 1948-49; Gerson, ter Kuile 1960, pp. 102, 136, 141; Laureyssens 1960; Legrand 1963, pp. 101, 234 and 257-258; Gerlach 1964; Brussels 1965, p. 264; Hairs 1965b; 's-Hertogenbosch 1970; Martin 1972, passim; d'Hulst 1973; Roy 1974; Hairs 1977, pp. 125-148; Paris 1977-78, pp. 233-238; Roy 1979; d'Hulst 1981; de Mirimonde 1981; Logan 1985; Roy 1985; Haarlem 1986, pp. 285-288; 's-Hertogenbosch/Strasbourg 1991-92; Cologne/Antwerp 1992-93, pp. 363-367.

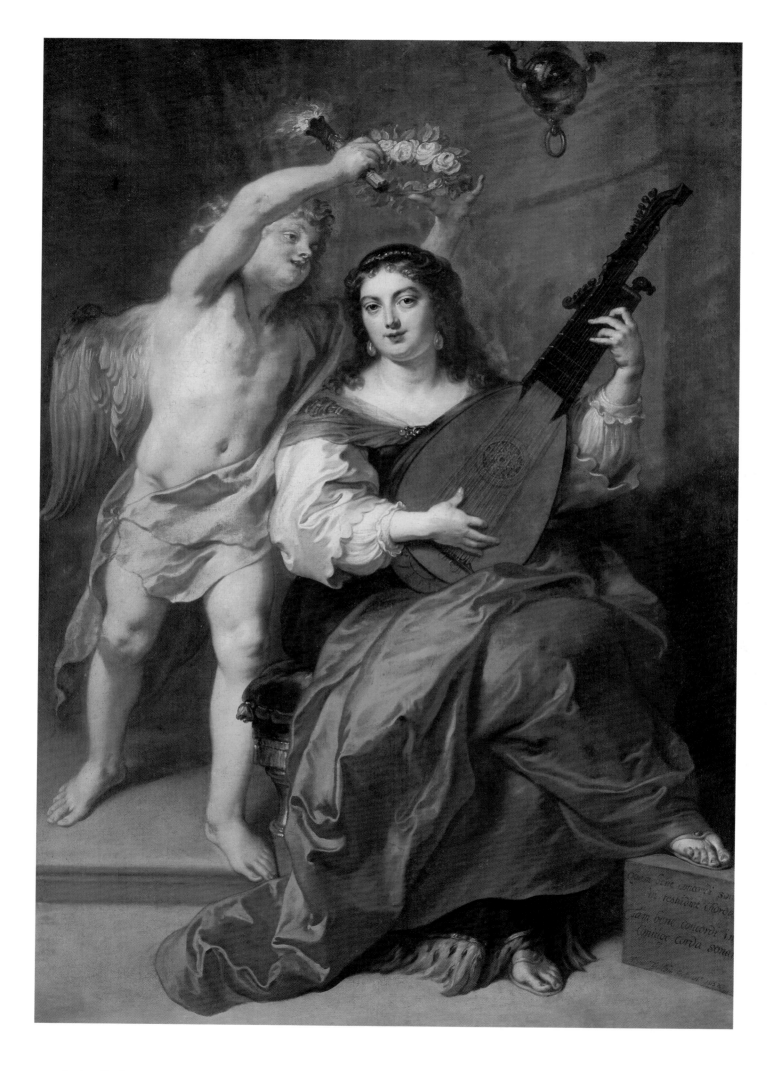

Theodoor van Thulden
49. *Music: Allegory of Conjugal Harmony,* 1652

Oil on canvas, 194 x 135 cm (76 ⅛ x 53 ⅛ in.)
Inscribed, signed and dated on block at lower right:
*Quam bene concordi sona[nt]/ in testudine chorda[e] / Tam
bene concordi in / Coniuge corda sonant / T. van Thulden
fec.ᵗ. Aº. 1652*
Brussels, Musées Royaux des Beaux-Arts de Belgique,
inv. 3430

PROVENANCE: purchased from Mr. B.-Colt. de Wolf, Brussels, 1898.[1]
EXHIBITIONS: Tokyo, Fuji Art Museum, *The 17th Century-The Golden
Age of Flemish Painting,* 1988, no. 76.
LITERATURE: Schneider 1928, p. 205; Hairs 1965b, pp. 37-38, 67-73;
H. Vlieghe, "Nieuwe toeschrijvingen aan Antwerpse schilders uit de
zeventiende eeuw," *Gentse Bijdragen* 20 (1967), p. 176; A. P. de Mirimonde,
"Les Allégories de la Musique II: Le retour de Mercure et les allégories de
beaux-arts," *Gazette des Beaux-Arts* 73 (1969), p. 355; Amsterdam 1976,
pp. 105-106; Hairs 1977, pp. 131, 139; Leppert 1977, vol. 1, p. 99, vol. 2,
p. 152; de Mirimonde 1981, pp. 209-212; Haarlem 1986, p. 286; N. Schnei-
der, *Les natures mortes. Réalité et symbolique des choses. La peinture des natures
mortes à la naissance des temps modernes* (Cologne, 1990), p. 176; 's-Hertogen-
bosch/Strasbourg 1991-92, pp. 74, 205-208, and p. 265, no. 101.

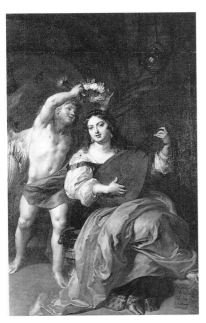

Fig. 1. Theodoor van Thulden, *Music: Allegory of Conjugal
Harmony,* signed and dated 1646, oil on canvas, 165 x
150 cm, Château d'Aulteribe (Puy-de-Dôme).

Fig. 2. Theodoor van Thulden, *Music: Allegory of Conjugal
Harmony,* oil on canvas, 203 x 132 cm, 's-Hertogenbosch,
Noordbrabants Museum, inv. 7.773.

Fig. 3. Jacob Cats, Emblem from *Silenus Alcibiadus, sive
Proteus . . . Sinne- en minnebeelden* (ed. Rotterdam, 1627),
p. 254, engraving, Amsterdam, Rijksprentenkabinet,
no. 327-J-14.

SWATHED in voluminous draperies, her unbound
hair crowned by a circlet of pearls, the seated woman
depicted here is at once a personification of music and
an allegorical figure representing marital harmony.
She plays the theorbo, a bass variant of the lute with
two sets of strings secured to separate pegboards; this
particular example is of a type popular in the North
and South Netherlands.[2] The detailed rendering of
the theorbo, as well as the placement of the woman's
hands on the strings, suggests that the artist was
knowledgeable in the musical arts. Behind the seated
figure of music, Hymen, the winged god of marriage,
brandishes the flaming torch of love and steps for-
ward to crown her with a wreath of roses, the symbol
of love triumphant and traditional attribute of
Venus. A hanging lamp is visible at the upper right.

Music: Allegory of Conjugal Harmony is a superb
example of van Thulden's mature style, which com-
bines robust baroque figures in a restrained, almost
classicizing arrangement. The neutral architectural
background and generally subdued palette enhance
the serenity and grace of the composition. The figure
types and the softened contours of the forms are
comparable with those in other works of the period,
for example *The Provinces of Flanders, Brabant, and
Henegouw (Hainaut) Paying Homage to the Virgin,* dated
1654 (Vienna, Kunsthistorisches Museum, inv. 760).
Two other versions of the present painting are
known: the first, signed and dated 1646, is more
frontally arranged (fig. 1; Château d'Aulteribe [Puy-
de-Dôme]); a second unsigned version of the Brussels
painting is a replica generally considered to be by
van Thulden himself (fig. 2; 's-Hertogenbosch,
Noordbrabants Museum, inv. 7.773).[3] Although sev-
eral oil sketches or studies for larger paintings by the
artist have been preserved, the existence of multiple
versions of a composition on the same scale appears
to be unique in his œuvre and suggests that this
must have been regarded as one of his most success-
ful designs.

The woman representing music in the present
painting has been identified as an allegorical por-
trait of Maria van Balen, the wife of the artist.[4]
Although there are no documented portraits of
Maria van Balen known with which to confirm this
identification, the iconography of the painting and
specifically the inscription at lower right make this a
viable assumption.

There is a long tradition in literature and in the
visual arts of using musical analogies to express the
concept of concord and harmony in marriage.[5]
Although van Thulden's painting presents this idea
in allegorical terms, in countless Dutch and Flemish
marriage portraits of the sixteenth and seventeenth
centuries the same concept is expressed in a more
realistic fashion, simply and most often via the inclu-
sion of a lute or other stringed instrument in the
composition. Lutes in particular were associated with
conjugal and familial harmony; the measured ratios
of the strings, and the tuning of the strings to one
another, represented the ideal love between a man
and a woman, as well as unanimity amongst family
members.[6] Among the many contemporary exam-
ples which could be cited in this context is Jacob Jor-
daens's *Self-Portrait with Family* of ca. 1621-1622, in
which the artist conspicuously carries a lute at his
side (Madrid, Museo del Prado; see cat. 44, fig. 2).[7]

The lute also carried more specifically romantic
connotations. In an emblem from Jacob Cats's *Sinne-
en minnebeelden* (1618), the concept of harmony is rep-
resented by a man with two lutes (fig. 3): in tuning

Gaspar de Crayer

(Antwerp 1584-Ghent 1669)

one lute, the strings of the other begin to resonate to the same pitch, thus symbolizing two hearts attuned to each other. Cats's analogy is particularly appropriate to van Thulden's painting. The Latin distich inscribed on the stone block at the lower right in the Brussels painting can be translated as: "Like the strings of a well-tuned lute, so beat the hearts in a harmonious marriage," a sentiment remarkably similar to that expressed in Cats's emblem. The inscription appears in a slightly different form on the 's-Hertogenbosch version of the composition: "Like the harmonious sounds of a lute, so is the marriage partner crowned by harmony" ("Quam bene concordia in testudine sonat, tam bene concordia coniuge[m] coronat").

MEW

1. Schneider's suggestion (Schneider 1928, p. 205 note 3) that the Brussels painting may have come from the collection of J. P. Weber in Cologne (sale Cologne, 25 August 1862, no. 382) is not tenable; the Weber painting, signed and dated 1646, is the version now in the Château d'Aulteribe (Puy-de-Dôme).

2. De Mirimonde 1981, p. 209.

3. Alain Roy, in 's-Hertogenbosch/Strasbourg 1991-92, p. 74, discusses the popularity of van Thulden's composition.

4. Schneider 1928, p. 205, was the first to propose this identification. Hairs (1977, p. 131) rejected the identification of the sitter as Maria van Balen, and proposed that the portrait may have been a marriage gift done either on commission or for a friend.

5. The tradition is discussed briefly by E. de Jongh, in Haarlem 1986, pp. 40-45.

6. See E. de Jongh, in Haarlem 1986, p. 44; and idem, in Amsterdam 1976, pp. 104-107.

7. Jordaens also represented himself as a lutenist in two other family portraits of ca. 1615-1616: Portrait of the Jordaens Family (St. Petersburg, Hermitage, inv. 484) and Jordaens with the van Noort Family (Kassel, Gemäldegalerie Alte Meister, inv. GK 107).

Born in Antwerp on 18 November 1584, de Crayer may have been a pupil of Raphaël Coxcie (ca. 1540-1616) in Brussels, where he became a member of the guild on 3 November 1607. Beginning in 1610, he had several students, and in 1614-1616 was named dean of the guild. He married Catharina Janssen van Daveland from Brussels in 1613. De Crayer not only played a role in the municipal government of Brussels, serving as an alderman in 1626, but also had connections with the archducal court. As early as 1612 he was a buyer of art for Archduke Albert and after the latter's death became an "archer noble" in the court of the Archduchess Isabella. In 1635 de Crayer was named court painter to the Cardinal Infante Ferdinand, and upon the latter's death became "painter to the king" (Philip IV of Spain). During these years he also enjoyed the patronage of the Spanish aristocrat Diego Messía de Guzmán, Marqués de Leganés, who lived in the Low Countries from 1627/28 and who was an eminent diplomat and connoisseur. Also important for his career was his close relation to the Archbishop of Mechelen, Jacob Boonen, who commissioned many works in the 1620s and 1630s, including numerous paintings for the abbey of Afflighem. In 1635 he painted a series of pictures for the entry of the Cardinal Infante into Ghent. He moved to that city in 1664 and became a member of the guild there in the same year. De Crayer died in Ghent on 27 January 1669.

De Crayer's large œuvre is almost exclusively devoted to religious paintings for churches; there are few profane subjects or portraits. Although Rubens was a crucial influence, de Crayer's œuvre reveals several distinctive stylistic periods. Especially in his large commissions, de Crayer employed many collaborators.

De Bie 1661, pp. 244-245; Houbraken 1718-21, vol. 1 (1718), p. 123; Weyerman 1729-69 vol. 1 (1729), p. 327; Descamps 1753-64, vol. 1 (1753), pp. 350-356; Michiels 1865-76, vol. 8 (1869), pp. 390-410; Rombouts, Lerius 1872, vol. 1, pp. 320, 339; Rooses 1879, pp. 522ff, 544ff; Maeterlinck 1900; Wurzbach 1906-11, vol. 1 (1906), pp. 357-358; Lindemans 1912-13; K. Zoege von Manteuffel, in Thieme, Becker 1907-50, vol. 8 (1913), pp. 70-72; Velge 1913; Oldenbourg 1918, pp. 128-130; Sacré 1924-25; Sandrat, Peltzer 1925, p. 188; Bautier 1926; van Terlaan 1926; Denucé 1932, pp. 76, 102, 111; Carton de Wiart 1941; Lindemans 1949; Kraus 1952; Díaz Padrón 1963-67; Vey 1963; Brussels 1965, pp. 48-49; Speth-Holterhoff 1966; Vlieghe 1966a; Vlieghe 1966b; Vlieghe 1967; Vlieghe 1967-68; Díaz Padrón 1968; Vlieghe 1972; Held 1974; Paris 1977-78, pp. 64-68; Vlieghe 1979-80; de Man 1980; Mai 1991.

Jacob Neefs after Anthony van Dyck, *Gaspar de Crayer*, engraving, from Cornelis de Bie, *Het gulden cabinet . . .*, 1661, fol. 245.

Gaspar de Crayer
50. *The Young Virgin Mary with Saints Anne and Joachim*

Oil on canvas, 155 x 111 cm (61 x 43 ¾ in.)
Brussels, Musées Royaux des Beaux-Arts de Belgique, inv. no. 66

Fig. 1. Gaspar de Crayer, *The Martyrdom of Saint Catherine*, oil on canvas, 242 x 188 cm, Grenoble, Musée des Beaux-Arts, inv. no. 67.

Fig. 2. Gaspar de Crayer, *Joachim and Anne with the Adolescent Virgin and Other Saints*, oil on canvas, 350 x 245 cm, Ghent, Church of St. Stephen.

PROVENANCE: the Church of the Convent of Augustine Sisters, called "Sion," in Brussels; transferred to the museum after the suppression of the convent under the French occupation in 1792.

LITERATURE: *Description de la ville de Bruxelles* (Brussels, 1743), p. 175; Mensaert 1763, vol. 1, p. 120; Descamps 1769, p. 81; Derival de Gomicourt 1782-83, vol. 2, p. 128; E. Fétis, *Catalogue descriptif et historique du Musée royal de Belgique* (Brussels, 1864), no. 173; Musées Royaux des Beaux-Arts de Belgique, Brussels, *Catalogue de la Peinture Ancienne*, Brussels, 1927 and 1959, no. 131; Vlieghe 1972, pp. 233-234, cat. no. A214, vol. 2, fig. 204; Knipping 1974, vol. 2, p. 251.

THE ADOLESCENT VIRGIN stands before her mother, St. Anne, who embraces her. At the right stands her father, Joachim, with arms outstretched, eyes lifted heavenward. On the left are two angels, one of whom adorns the Virgin's pearl headdress with a rose selected from the straw basket held by the second angel. Three cherubim hover in the clouds overhead. Between the two angels on the left the landscape opens across a broad plain; at the right rises a brick wall with molding.

Hans Vlieghe has carefully plotted Gaspar de Crayer's stylistic development.[1] Prior to 1618, he seems to have worked primarily in the tradition of sixteenth-century Flemish history painters like Frans Floris and Otto van Veen, but from 1619 (the date of de Crayer's *Job in Derision*, Toulouse, Musée des Beaux-Arts[2]) to about 1630 the subjects and compositions of his history paintings were influenced by Rubens, while his portraits owed more to van Dyck. The latter's influence became still stronger in both the handling and sentiment of de Crayer's works from the 1630s and 1640s, while late works (after 1649) reveal a more classicist strain. Like many of his best paintings, such as *The Martyrdom of St. Catherine* (fig. 1), the present painting probably dates from the early 1620s, when de Crayer employed large clear forms and bright saturated colors in the style of Rubens's first mature Antwerp period. De Crayer's own artistic personality however is evident in the delicacy of the figures' gestures and features. They are not so monumental or dynamic as the works of the master. The drapery is painted with an opaque touch that renders it volumetric by the strong contrasts of the tone; in other areas of the composition the pigment is relatively thinly applied.

De Crayer later varied and expanded the present composition for a larger altarpiece of *Joachim and Anne with the Adolescent Virgin in the Presence of Other Saints* [Stephen, Dorothy, Barbara, and Clare de Montefalco] (fig. 2), which is the pendant to *St. Nicholas of Tolentino Celebrating Mass for the Souls in Purgatory* in the Augustinian Church of St. Stephen in Ghent.[3] The figures of Anne and the young Virgin were reversed and slightly altered in still another later treatment of the theme by de Crayer which exists in two versions, both dated 1644, in the Vestisches Museum, Recklinghausen, and in an unknown collection.[4] Willem van Herp also copied the figures in de Crayer's Brussels painting in a horizontal format in his depiction of *The Veneration of the Virgin*.[5]

As we have seen repeatedly (see cat. 27, and Freedberg), the defense of the Virgin Mary against the Reformation's profanation of her was one of the highest priorities for the Church and the archdukes.[6] The Virgin and her veneration were regarded as the most potent weapons against heresy. In celebrating the ideas of the immaculate conception, naturally there arose interest in the Virgin's youth and parents, particularly St. Anne, and the family was often depicted in casually intimate, even bourgeois, contexts. Rubens, for example, painted the youthful Virgin having her hair cleaned by St. Anne with a gesture that became traditional for Netherlandish genre painting as the "moederzorg" (maternal care) theme (ca. 1616, Vaduz, collection of the Prince of Liechtenstein, no. 116); Rubens also painted a charming *Education of the Virgin with Saints Anne and Joachim* (Antwerp, Koninklijk Museum voor Schone Kunsten, no. 306). De Crayer's own œuvre is devoted to a great extent to various depictions of the Virgin's life and veneration: he not only depicted the Education of the Virgin (e.g. Nantes, Musée des Beaux-Arts),[7] but also the Annunciation,[8] Visitation,[9] and quite frequently the Assumption,[10] as well as numerous images of the Crowning of the Virgin,[11] and Glorification,[12] and her efficacy as a savior, intercessor, and Queen of Heaven.[13]

PCS

1. See Vlieghe 1972, and the addenda and corrigenda in Vlieghe 1979-80.

2. Vlieghe 1972, cat. A11, fig. 13; see also Paris 1977, cat. 27, ill.

3. Respectively, Vlieghe 1972, cats. A142 and A141, figs 135 and 136.

4. Respectively, Vlieghe 1972, cat. nos A91 (210 x 151 cm) and A90 (205 x 163 cm), figs. 91 and 90.

5. Oil on copper, 67 x 85 cm; sale New York (Sotheby's), 7 April 1988, no. 51, ill.

6. See Knipping 1974, vol. 2, p. 245ff.

7. Vlieghe 1972, cat. A92, fig. 92.

8. Ibid., cat. A4, fig. 7, and cat. A 93, fig. 94.

9. Ibid., cat. A5, fig. 8.

10. Ibid., cats. A62, A63, A98, A135, A136, A158, A159, A199 and A219.

11. Ibid., cats. A200 and A201.

12. Ibid., cats. A72, A80, A81, A99, A104, A138 and A210.

13. Ibid., cats. A84, A126, A139, A140 and A211.

Abraham van Diepenbeeck

('s-Hertogenbosch 1596-Antwerp 1675)

Paulus Pontius after Abraham van Diepenbeeck,
Abraham van Diepenbeeck, engraving, from Cornelis
de Bie, *Het gulden cabinet . . .* , 1661, fol. 285.

Abraham van Diepenbeeck was born in 's-Hertogen-bosch (then part of the Southern Netherlands), and baptized on 9 May 1596. His father and teacher, Jan Roelofszn. van Diepenbeeck (d. 1620), was a glass painter. The young artist emigrated to Antwerp in 1621, and after joining the guild in 1622/23, began working on a series of twelve windows for the Carmelite cloister in Antwerp. A string of commissions followed, and in 1624, citing his own excellence as a glass painter, van Diepenbeeck petitioned the city fathers for permission to stay in Antwerp. His request was granted, and he was at the same time exempted from military service. In a document dated 2 December 1643, van Diepenbeeck stated that he had been in France sometime before 1629, and after 1629 resided in 's-Hertogenbosch and Eind-hoven. He became a citizen of the city of Antwerp in 1636. Van Diepenbeeck married Catherine Heuvick in June 1637; the couple had eight children before Catherine's death in 1648.

Elected an officer of the glass painters' guild in October 1637, van Diepenbeeck declined the honor – contending that he was a painter and not a glass painter – and resorted to legal action when the guild insisted he serve. He joined the painters' guild of St. Luke in 1638, and was elected dean (*deken*) in 1641. Upon his reelection the following year, van Diepen-beeck attempted single-handedly to change the rules of the guild, and when the other members objected, removed the guild archives and treasury to his own home. Not unexpectedly, the artist was subsequent-ly impeached from his position as dean of the guild. In 1664 he began proceedings to be reinstated into the guild, which he finally achieved in 1672. This was not van Diepenbeeck's only legal tussle: in 1648 he instigated a suit against Gonzales Coques (q.v.), demanding full payment for a series of designs he had supplied Coques illustrating the story of Psyche – designs which, it was found, had been copied from prints after Raphael. The matter was decided in 1654 by the deans of the guild of St. Luke, who deemed that van Diepenbeeck had already received sufficient payment for his work.

Van Diepenbeeck probably made a second trip to France: a visit to Paris is documented by a drawing signed and dated 1650. The artist married Anna van der Dorn in May 1652, and four children were born of this second marriage. By 1665 the artist had pur-chased an imposing house on the Lange Nieuwe-straat, certainly an indication of his financial suc-cess. He died in Antwerp and was buried in the St. Jacobskerk on 31 December 1675.

Until 1638 van Diepenbeeck was active mostly as a glass painter, although he also, from 1627, worked for the Plantin Press making preparatory drawings for engravings after Rubens's paintings. The major-ity of van Diepenbeeck's own paintings – altarpieces, histories, and portraits – were executed in the 1640s and early 1650s. He continued to produce drawings and oil sketches (the latter from ca. 1640-1655) for engravings, and after Rubens's death was particu-larly sought after as a designer of title pages. During the latter part of his career, from the mid-1650s until his death in 1675, the artist was almost exclusively active as a draughtsman. His vigorous compositions reflect the influence of Rubens and Anthony van Dyck (q.v.).

Meyssens 1649, p. 48; de Bie 1661, pp. 284-286; Sandrart 1675, vol. 2, p. 319; Houbraken 1718-21, vol. 1 (1718), pp. 289-290; Weyerman 1729-69, vol. 1 (1729), pp. 320 ff; Dezallier d'Argenville 1745-52, vol. 2, p. 199; Descamps 1753-64, vol. 2, pp. 110-113; Descamps 1769, passim; Immerzeel 1842-43, vol. 1 (1842), p. 182; Mariette 1853, vol. 2, p. 107; Michiels 1854, pp. 387-390; Kramm 1857-64, vol. 2 (1858), pp. 339-340; Michiels 1865-76, vol. 8 (1869), pp. 138-150; Galesloot 1868; Rombouts, van Lerius 1872, vol. 1, p. 587, vol. 2, pp. 98, 99, 106, 124, 138-139, 169, 195, 311, 423, 444; Rooses 1879, pp. 324-325; van den Branden 1883, pp. 777-786, 968-970; Cauwenberghs 1891, pp. 60, 90; Hezenmans 1894; Schouten 1894, pp. 245-250; Verreyt 1900; Spilbeeck 1901; Verreyt 1901; Wurzbach 1906-11, vol. 1 (1906), pp. 403-405; Juten 1911; Zoege von Manteuffel, in Thieme, Becker 1907-50, vol. 9 (1913), pp. 243-245; de Mendoça 1940-41, pp. 57-67; Hollstein 1949-, vol. 5, pp. 241-243; Brussels 1965, p. 49; Duverger 1972a; Duverger 1972b; van Dyck 1974; Hairs 1977, pp. 151-182; Paris 1977-78, pp. 68-69; Steadman 1982; Hensbroek-van der Poel 1986; Cologne/Vienna 1992-93, pp. 315-317.

Abraham van Diepenbeeck
51. The Vision of Saint Ignatius, ca. 1645-1650

Oil on canvas, 127 x 91.4 cm (50 x 36 in.)
Pittsfield, Massachusetts, The Berkshire Museum,
inv. 1915.36

PROVENANCE: Schloss Schönborn, Pommersfelden, by 1719 (ref. sale 1867); sale A. M. le Comte de Schönborn (Château de Pommersfelden), Paris (Hôtel Drouot), 17-18 May 1867, no. 205 [as by Rubens; frs. 11,500 to Mason, "amateur américain"][1]; Ehrlich Galleries, New York, by 1914; gift of Zenas Crane, 1915.

EXHIBITIONS: Hanover/Raleigh/Houston/Atlanta 1991-93, no. 219.

LITERATURE: Rooses 1886-92, vol. 2 (1888), pp. 287-288, no. 452 [as by Rubens; formerly in Schönborn collection]; Goris, Held 1947, p. 52, no. A 66 [possibly by Theodoor van Thulden]; Steadman 1982, pp. 21, 92 no. 21; Z. Z. Filipczak, "'A Time Fertile in Miracles': Miraculous Events in and through Art," in exh. cat. Hanover/Raleigh/Houston/Atlanta 1991-93, pp. 197-198, and p. 452.

IGNATIUS OF LOYOLA, clad in the somber black robes of the Jesuit order, kneels praying with folded arms before a cluster of vine-wrapped columns; on the ground nearby are a hat, stick, and water bottle, all attributes of the pilgrim. In the air just before him, Christ and God the Father appear in a drift of clouds. Swathed in red drapery, Christ embraces the cross with one arm as he looks down at Ignatius; God the Father seems to act as intercessor between the two. In the distance at the lower right is a view of Rome.

St. Ignatius, founder of the Jesuit order, was born at Loyola in northern Spain in 1491. As a young man, he took part in several military campaigns and was seriously wounded during the siege of Pamplona in 1521. During his protracted convalescence, he was inspired by reading the lives of the saints and vowed to devote his life to the service of God. He retreated to Manresa in Catalonia, where he began writing the *Spiritual Exercises* (first publ. 1548), a set of brief instructions for the cultivation of a disciplined spiritual and sensual imagining and reliving of Christ's life, death, and resurrection. Ignatius subsequently embarked on a study of grammar, humanities, philosophy, and theology which led him from Barcelona to Paris (where he met Francis Xavier in 1529), Antwerp, London, and Venice. In Paris in 1534, Ignatius, together with Francis Xavier and five others, took vows of poverty and chastity and made a pledge to serve as missionaries in Jerusalem. When their planned mission was thwarted by war, the group offered their services to Pope Paul III. In 1539 they organized into a religious order, and in the following year the Society of Jesus was officially approved by papal bull. Ignatius served as General of the Society, and energetically directed its far-flung missionary and educative activities from Rome until his death in 1556. After a vigorous campaign of propaganda, Ignatius was canonized in 1622, together with Francis Xavier, the other leading member of the Jesuit order.[2]

The vision depicted in Diepenbeeck's painting was one of several experienced by the saint and described in his *Autobiography* (written 1553-1555).[3] In 1537, en route from Vicenza to Rome to dedicate himself to the service of the pope, Ignatius stopped at the wayside chapel of La Storta on the outskirts of Rome: "One day, a few miles from reaching Rome, while in a church praying, he felt such mutation in his soul and saw so clearly that God the Father placed him with His Son, Christ, that he could never have the nerve to doubt that God the Father placed him with His Son."[4] Although the exact nature of the vision is not described in the *Autobiography*, one of Ignatius's closest associates, Diego Laínez, wrote in 1559 that Ignatius "told me that it seemed to him that God the Father had impressed upon his heart the following words: 'I shall be propitious to you in Rome' [Ego vobis Romae propitius ero]. . . . Then another time he said that it seemed to him that he saw Christ carrying a cross on his shoulder and the Eternal Father nearby who said to Christ: 'I want you to take this man for your servant.' And because of this, conceiving great devotion to the holy name, he wished to name the congregation the 'Company of Jesus.'"[5]

Ignatius's reported vision of Christ with the Cross and God the Father was similar to one experienced by St. Peter, the first pope, also on the outskirts of Rome, which prompted Peter to return to the city to face his own martyrdom. It is not surprising that representations of the vision at La Storta were included in nearly every illustrated Life of Ignatius published in the late sixteenth and early seventeenth centuries, for this strong connection with the establishment of the papacy was an important factor in enhancing the legitimacy of the Jesuit order.[6]

Although the earliest painted images of Ignatius (such as Rubens's altarpiece for the Jesuit Church in Antwerp, ca. 1617; see Introduction, fig. 25) concentrated on his preaching (the fundamental mission of the Jesuits) and the miracles attributed to him in defense of his eligibility for canonization, the vision at La Storta became increasingly popular as a theme for Jesuit altarpieces during the course of the century. Abraham Bloemaert's painting of the subject for the Jesuit Church in 's-Hertogenbosch (before 1630) is similar in conception to the present work (fig. 1)[7]; both artists were probably inspired by a print in one of the many illustrated biographies of the saint. A version of the theme attributed to Jan Cossiers is in the St. Walpurgis Church, Bruges.

The Pittsfield *Vision of St. Ignatius* was attributed to Rubens from the eighteenth century; Goris and Held questioned this attribution, and suggested that it was the work of a pupil influenced by Rubens's

Fig. 1. Cornelis Bloemaert after Abraham Bloemaert, *The Vision of St. Ignatius at La Storta*, engraving, Cambridge, MA, Harvard University Art Museums, Fogg Art Museum, no. G 384.

Jan Boeckhorst

(Münster ca. 1604-Antwerp 1668)

style of the 1630s, possibly Theodoor van Thulden. Steadman rightly ascribed the work to Diepenbeeck in 1982, noting that the figure types, handling of the drapery, and overall silvery tonality are comparable to works by the artist from the late 1640s, such as the *Annunciation* in Deurne (ca. 1646-1649, Church of St. Fredegund). Rooses notes a copy after the *Vision of St. Ignatius* in the Church of the Assumption, Cologne.[8] In addition, a painting of "St Ignatius in an attitude of prayer" (oil on canvas, 48 x 38 duim [ca. 122 x 96.5 cm]) by Diepenbeeck was in the sale Amsterdam, 6 August 1810, no. 24.

MEW

1. Possibly John H. Mason, Providence, R.I., although not in the sale of his collection (Boston [Leonard], 3-14 February 1910).

2. On the Jesuits in the Southern Netherlands, see the essays by Sutton (History) and Freedberg, and the further references cited there.

3. The *Autobiography*, dictated by Ignatius to Luis Goncalves da Cámara, was first published in Latin only in 1731 (in *Acta sanctorum*), and in the original Spanish and Italian only in 1904 (*Monumenta Historica Societatis Iesu*).

4. Translation from Antonio T. de Nicolas, *Powers of Imagining: Ignatius de Loyola* (Albany, 1986), p. 294.

5. *Fontes narraviti de S. Ignatio de Loyola* (*Monumenta historica Societatis Iesu*) (Rome, 1943-60), vol. 2, p. 133; quoted in G. E. Ganss, S.J., ed., *Ignatius of Loyola: The "Spiritual Exercises" and Selected Works* (Mahwah, 1991), p. 42. The cross is also mentioned in the Order's official biography of Ignatius, written by Pedro de Ribadeneira (first pub. Naples, 1572; pub. Antwerp, 1587).

6. See U. König-Nordhoff, *Ignatius von Loyola. Studien zur Entwicklung einer neuen Heiligen-Ikonographie im Rahmen einer Kanonisationskampagne um 1600* (Berlin, 1982), esp. pp. 131-133; and exh. cat. Hanover/Raleigh/Houston/Atlanta 1991-93, pp. 197-198, 542.

7. Reproduced in a print by Cornelis Bloemaert (Hollstein 1949-, vol. 2, nos. 18, 46).

8. Rooses 1886-92, vol. 2 (1888), p. 288. See also the painting in the sale Joseph Lemmer, London (Coxe), 16 March 1803, no. 41 ("P. P. Rubens. A Cabinet Piece, representing God the Father and Christ, who embraces a cross, and is attended by an Angel in the clouds, appearing to a priest, who is in the habit of a Jesuit," 3 x 2 ½ [feet]; £10.10).

In a testament written in Antwerp on 10 September 1639, Jan Boeckhorst gave his age as thirty-five, thus placing his date of birth sometime in 1604 or late 1603. He was born and raised in Münster, where his parents, Heinrich Boeckhorst and Catherina Helskamp, were quite well to do. Jan-Erasmus Quellinus, son of Erasmus Quellinus II (q.v.), a friend of the artist, stated that Boeckhorst was a student of philosophy and did not begin painting until age twenty-two. In ca. 1626 the artist (nicknamed "Lange Jan," Tall John) established himself at Antwerp, where he became a student of Jacob Jordaens (q.v.). Boeckhorst may have subsequently worked with Anthony van Dyck (q.v.) during the latter's second Antwerp period, ca. 1627-32. He became a member of the guild of St. Luke in 1633/34, and in 1635 worked with Rubens on the decorations for the Pompa Introitus Ferdinandi. His first recorded independent commissions date from the same year.

In 1637 Boeckhorst made a brief trip to Genoa and Venice, where he became strongly influenced by the works of Titian, Tintoretto, and Veronese. Following his return to Antwerp, the artist again worked with Rubens, contributing a History of Hercules to the decorations for the Torre de la Parada, which Philip IV had commissioned from Rubens in autumn 1636. Boeckhorst was documented in Rome at the end of 1639 and probably did not return to the Netherlands until ten years later. From 1651 to 1665 he designed illustrations for several books, including a Roman Missal and a Breviary, for the Plantin Press in Antwerp. Boeckhorst died in Antwerp on 21 April 1668 and was buried in the collegiate St. Jacobskerk on 24 April.

There are few extant documents relating to the work of Boeckhorst. This combined with the artist's practice of rarely signing or dating his works (many have been attributed to other painters) makes the study of his œuvre difficult. Boeckhorst painted primarily large history paintings with mythological and biblical subject matter, and particularly after about 1650 received many prestigious commissions for altarpieces in Antwerp and throughout Flanders. He also painted some portraits. Although Rubens's example can be detected in Boeckhorst's working process and in his penchant for baroque movement in his compositions, the best of his paintings evoke a lyricism and graceful theatricality clearly indebted to van Dyck, Titian, and Veronese.

Jan Boeckhorst
52. The Adoration of the Magi

Oil on canvas, 182 x 251 cm (71 ½ x 98 ⅛ in.)
Initialed and dated lower right: J B 1652
Greenville, South Carolina, Bob Jones University,
no. P.68.433

De Bie 1661, p. 254; Descamps 1753-64, vol. 2, pp. 170-172; Kervyn de Volkaersbeke 1857-58, pp. 20-21, 66, 71, 76-77, 81-82; Kramm 1857-64, vol. 1 (1857), p. 137; Michiels 1865-76, vol. 9 (1874), pp. 67-71, 255-261; Rombouts, van Lerius 1872, vol. 2, pp. 48, 56, 382; van Lerius 1880-81, vol. 1, pp. 51-71; van den Branden 1883, pp. 560, 563, 902-906; Oldenbourg 1915, pp. 162-165; Oldenbourg 1922, pp. 96, 133-135, 189; Oldenbourg, Bode 1922, pp. 169-181; Delen 1927, pp. 148-150; Denucé 1931, pp. 304, 308; Glück 1933, passim; Bouchery, van den Wijngaert 1941, pp. 65-67; van Puyvelde 1942, p. 32, nos. 201-202; Denucé 1949, pp. 79, 81-82; Lugt 1949, vol. 2, p. 76; van Puyvelde 1953; Griendl 1956, p. 57; Hairs 1964, pp. 135, 264, 420; Brussels 1965, pp. 13-15; Hairs 1966; Held 1967; Biographie Nationale 1866-1964, vol. 37 (1971), cols. 60-75; Ostrand 1975; Hairs 1977, pp. 63-98; Logan 1977; Lahrkamp 1982; Díaz Padrón 1983; Held 1983; Jaffé 1983a; Vlieghe 1983; Jaffé 1983b; Held 1985; Held 1986; Jaffé, Cannon-Brookes 1986; Vlieghe 1987; Antwerp/Münster 1990; Cologne/Vienna 1992-93, pp. 139-140, 307-309.

PROVENANCE: Prince Murat, Château de Chamblay, Oise, France; sale Murat, Paris (Hôtel Drouot), 5 May 1961, no. 116; with David Koetser, Zurich, from whom it was acquired in 1967.

EXHIBITIONS: Raleigh, North Carolina Museum of Art, Baroque Paintings from the Bob Jones University Collection, 7 July-2 September 1984 (also shown at Colnaghi Gallery, New York), pp. 30-32, no. 5, ill.

LITERATURE: Held 1967, pp. 146-148, fig. 10; The Bob Jones University Collection of Religious Paintings, vol. 3 Supplement (Greenville, 1968), p. 54, no. 326, pl. 1; P. Elsen, ed. "College Museum Notes," The Art Journal, 27, no. 4 (1968), p. 406; M. L. Hairs, "Boeckhorst (Jan, Jean ou Johannes)," in Biographie nationale, vol. 37 (Brussels, 1971), p. 65; N. Foulon, Johan Boeckhorst 1605-1668, zijn leven en zijn werk (Ph.D. diss. Rijksuniversiteit, Ghent, 1971-72), pp. 37-40, no. s.3; J. E. Ostrand, "Johan Boeckhorst, His Life and Work" (Ph.D. diss. University of Missouri, Columbia, MO, 1975), pp. 119-120, no. A8; Hairs 1977, pl. IV; Held 1980, vol. 1, p. 620, under no. A12; Lahrkamp 1982, p. 35, no. 9; Jaffé 1983b, p. 483, fig. 24; Hans Vlieghe, "De Ontwikkeling van Boekhorst's werk," in exh. cat. Antwerp/Münster 1990, p. 70, note 44; Liedtke et al. 1992, p. 268, no. 85, ill.

PROFFERING their gifts, the magi and their entourage approach the holy family sheltered in a thatched stable beneath a sky filled with tumbling cherubs and rent by the divine light of the heavenly star. His elaborate gold train held by a page, the eldest king, Caspar, swings the censer of incense, while Balthasar, dressed in green and lavender, holds a precious metalware box of myrrh, and Melchior, the young black magus in the white robe, kneels holding a platter of gold. Dressed in blue and crimson, the Virgin Mary supports the delightfully animated Christ Child as he stands on her lap, while Joseph leans on his staff behind. At the left are soldiers in armor bearing red and purple standards, a page in red leading a dappled gray horse, and a dog. A large cow appears at the far right. The subject is described in Matthew 2:1-2: "When they had heard the king, they went their way; and lo, the star which they had seen in the East went before them, till it came to rest over the place where the child was. When they saw the star, they rejoiced exceedingly with great joy; and going into the house they saw the child with Mary his mother, and they fell down and worshipped him. Then, opening their treasures, they offered him gifts, gold and frankincense and myrrh."

This painting is one of Jan Boeckhorst's largest and finest efforts and has been characterized by Vlieghe as the earliest dated example of the high baroque style that the artist developed after mid-century.[1] Earlier in his career, Boeckhorst had executed, besides family portraits in the tradition of Cornelis de Vos, figure paintings in a style derived from Rubens's paintings of the 1610s and 1620s, and from the early works of Jordaens, whom de Bie claims was Boeckhorst's teacher. These works feature large, firmly modeled figures in clearly organized, monumental compositions (see for example the Farmers on a Road, Antwerp, Rubenshuis; and the

Virgin and Child, Hamm, Städtisches Gustav-Lübcke-Museum²). But following van Dyck's second stay in Antwerp (ca. 1627-1632) and especially after Rubens's death in 1640, Boeckhorst adopted a more atmospheric technique and a richer, more deeply saturated palette, as well as a more angular, slightly attenuated figure type. Many of these changes, as Vlieghe and others have observed, attest to the powerful influence of van Dyck, whose works Boeckhorst is documented as having copied.³ Van Dyck's precedents may also have brought forth Boeckhorst's natural inclinations to a brooding emotionalism and a restive, slightly mannered elegance. His "Venetian" color scheme of dark rich hues and veils of tone also undoubtedly owes much to van Dyck, who was his conduit to the richly conceived religious art of Veronese.

The Greenville painting well illustrates Boeckhorst's mature style and attests to his success in clear and dramatic staging. Although the painting distantly recalls works by Rubens and Veronese (compare especially these precedessors' treatments of the theme, in the museum in Lyon, no. 167, and The National Gallery, London, no. 268, respectively), and more directly by Jordaens (Cherbourg, Musée Thomas Henry), Boeckhorst diffuses the densely urgent compression of the Flemish compositions and simplifies the richness of Veronese's conception. Distancing the protagonists from each other, he accentuates the length and studied languor of their gestures. Despite these conspicuously theatrical effects, the spiritual emotion of the work is intensely poignant.

This painting is one of several large narrative depictions of biblical and mythological themes treated on a broad horizontal format that Boeckhorst executed in the 1650s (see fig. 1).⁴ Vlieghe likened the relatively open composition and the softer tonality and sentiment to those of Boeckhorst's *Adoration of the Shepherds* (fig. 2), which he would also date in the early 1650s⁵; even the cow (probably inspired by Rubens's *Adoration* in the museum in Antwerp) is paraphrased. Boeckhorst also seems to have represented the theme of the Adoration of the Magi in another very large painting from the 1650s.⁶

The theme of the Adoration of the Magi had great popular appeal, not merely because of the subject's inherent pictorial richness, but also because it fulfilled the Counter Reformation's goals of manifesting a mystical and divine presence on earth. Like other traditionally popular scenes from the life of the Christ Child, namely the Annunciation and the Adoration of the Shepherds, through legions of angels, a blaze of heavenly light, and the figures'

Fig. 1. Jan Boeckhorst, *Achilles among the Daughters of Lycomedes*, oil on canvas, 124 x 188 cm, Munich, Bayerische Staatsgemäldesammlungen, Alte Pinakothek, no. 136.

Fig. 2. Jan Boeckhorst, *Adoration of the Shepherds*, oil on canvas, 120 x 150 cm, Copenhagen, Statens Museum for Kunst, no. Sp. 239.

Cornelis de Vos

(Hulst ca. 1584/5-Antwerp 1651)

exultant and overawed gestures, the subject of the Magi offered the opportunity to convey the immediacy of God. The Church commemorated the adoration of the Magi as part of the feast of the Epiphany (6 January), which celebrated the first manifestation of Christ to mankind. David Steel noted that Boeckhorst departed from the traditional iconography in having Balthasar, the youngest king, offer the gold, rather than Caspar, the eldest.[7] He also suggested that the Christ Child's pose may have been derived from the description of the adoration recorded by St. Bridget of Sweden, who wrote of the child "skipping with joy," at the Magi's arrival[8]; however, it must be said that both Rubens and van Dyck had earlier depicted the Christ Child as an animated figure standing on his mother's lap.[9]

<div align="center">P C S</div>

1. Vlieghe in Antwerp/Münster 1990, p. 20; and Liedtke et al. 1992, p. 268.

2. See Antwerp/Münster 1990, cats. 34 and 3, respectively, ills.

3. See Denucé 1932, p. 169. In the inventory of Jeremias Wildens of 1653: "Een contrefeytsel int harnas van Joannes Bronckhorst naer Van Dyck;" and "Een Christus tronie van Bronckhorst naer Van Dijck."

4. See also *Solomon and the Queen of Sheba* (private collection, Antwerp) and *Esther before Ahasuerus* (formerly art market, London), respectively Antwerp/Münster 1990, cat. no. 2 and fig. 39, and Lahrkamp 1982, nos. 58, 5, and 3a and b.

5. Antwerp/Münster 1990, p. 70, cat. no. 8. Lahrkamp (1982, cat. 8) had dated it to the artist's early period.

6. Bruges, St. Jacobskerk, 440 x 275 cm, Lahrkamp 1982, p. 37, no. 10, ill.

7. Exh. Raleigh/New York 1984, p. 30.

8. Ibid.

9. See, for example, Rubens's *Adoration of the Magi* in Lyon mentioned above; and van Dyck's so-called *Madonna of the Partridges*, St. Petersburg, Hermitage, no. 603.

Cornelis de Vos was born in Hulst in Zeeland in ca. 1584/5 (a document dated 29 April 1604 gives his age as "about 20 years old"; in a document of 3 August 1635 the artist gave his age as fifty). De Vos's brother Paulus (1595-1678) was also a painter; his sister Margaretha married Frans Snyders (q.v.) in 1611. The de Vos family moved from Hulst to Antwerp in about 1596, and in 1599 Cornelis became a pupil of David Remeers. Upon completing his apprenticeship in 1604, de Vos applied for a passport to travel and "learn his profession" ("alleenelyck omme de landen to besiene, ende zyn ambacht te leerene"), but there is no evidence of his actually having embarked on this journey. He became a master in the guild of St. Luke in 1608, was elected dean in 1619 and high dean (*opperdeken*) in 1620. He became a citizen of the city of Antwerp in 1616. At this time his profession was recorded as "merchant" (*koopman*), indicating that he was an art dealer as well as a painter. In this capacity, he visited the fair at Saint-Germain in Paris in 1619 and in subsequent years. De Vos married Suzanne Cock (d. 1668), half-sister of Jan Wildens (q.v.), on 27 May 1617. They had six children between 1618 and 1632. Along with artists such as Jacob Jordaens (q.v.), de Vos worked with Rubens on the decorations for the Pompa Introitus Ferdinandi in 1635, and for the Torre de la Parada from 1637. De Vos was quite well off financially; on 18 July 1648 he drew up a testament leaving the sizeable sum of fl. 3000 to each of his six children. He died in Antwerp on 9 May 1651.

Although much of de Vos's œuvre is devoted to portraiture, he also painted Caravaggesque genre scenes, and history paintings strongly influenced by Rubens in their composition and execution. De Vos was the premier portraitist of haute-bourgeois and patrician society in Antwerp. His carefully observed and honest likenesses are intimate and probing, yet are presented in formal settings that reflect in detail the wealth and social standing of the sitter. While de Vos was influenced by van Dyck's work from the mid-1620s, his portraits emphasize more the bourgeois qualities of solid prosperity than the courtly grace and refinement expressed by van Dyck. De Vos had seven recorded pupils between 1615 and 1642, among them the genre and history painter Simon de Vos (1603-1676) in 1615, and Willem Eversdyck in 1633.

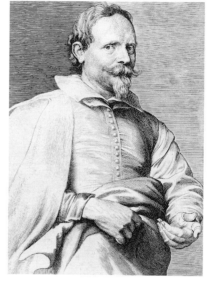

Lucas Vorsterman after Anthony van Dyck, *Cornelis de Vos*, engraving, from the *Iconography*.

Cornelis de Vos
53. Portrait of Anthony Reyniers and His Family, 1631

Oil on canvas, 170.1 x 245 cm (67 x 96 ½ in.)
Signed and dated on chair rung, lower left: C. DE VOS. F. A° 1631; on the table is a letter inscribed: *A S^nr Anthony / Reiniersen Coopman / tot Antwerpen*
Philadelphia, Philadelphia Museum of Art (purchased for the W. P. Wilstach collection, inv. W02-1-22)

PROVENANCE: purchased for the W. P. Wilstach collection, Philadelphia, 6 November 1902; as part of the Museum of Art since 2 January 1922.

LITERATURE: *Catalogue of the W. P. Wilstach Collection, Memorial Hall, Fairmount Park, Philadelphia*, edited by C. H. Beck (Philadelphia, 1903), no. 201 (and subsequent catalogues of the collection); Oldenbourg 1918a, p. 79 (as datable to about 1625); *Catalogue of the W. P. Wilstach Collection, Memorial Hall*, edited by M. Brockwell, with notes by A. E. Bye (Philadelphia, 1922), pp. 134-135, no. 340; Muls 1933, pp. 31, 79; Greindl 1939a, pp. 142-143, 145, 166, fig. 8; Greindl 1939b, p. 114; Greindl, in Thieme, Becker 1907-50, vol. 34 (1940), p. 552; Greindl 1944, pp. 120-121, pl. 76; Wilenski 1960, vol. 1, pp. 233, 247-248, 251, 274-275, 282, 295, 297, 303, and 331, vol. 2, pl. 600; Philadelphia, cat. 1965, p. 69; Larsen 1967, pp. 6-7; Larsen 1985, p. 244; Haarlem 1986, p. 208, fig. 44b; Sutton 1990, pp. 337-340; Van der Stighelen 1990a, pp. 9, 153-158; Van der Stighelen 1990b, pp. 130-131, 137; Van der Stighelen, in Brussels/Schallaburg 1991, p. 146; Van der Stighelen, in Liedtke et al. 1992, pp. 265-267.

IN A ROOM magnificently hung with green-ground gilt leather, a family has gathered around a carpet-covered table. At the left, a swag of red drapery forms a backdrop for the father, flanked by his two young sons. On the right, two daughters edge close to their mother, who holds the youngest child on her lap. The faces of the individual sitters are sharply personalized (note, for example the unstintingly recorded cross-eyed gaze of the mother). Their clothing is elegant but sober, with the exception of the girl on the right, whose salmon and olive-green silks add a vibrant splash of color to the composition.

Aside from two self-portraits of the artist with his family (fig. 1),[1] the Philadelphia painting is Cornelis de Vos's only family portrait in which the sitters have been identified, thanks to an inscription on the letter lying on the table: "A S^nr Anthony / Reiniersen Coopman / tot Antwerpen." The Antwerp merchant Anthony Reyniers (d. 1649) was at least forty-nine years old when this portrait was painted in 1631.[2] He married Maria Le Witer (d. 1669) in the Onze-Lieve-Vrouwekerk (South) in Antwerp on 12 November 1617. The couple is portrayed with their children (from left to right): Adam, aged about ten (baptized 28 October 1621 in the St. Walpurgis Kerk, Antwerp); Anthonius, age 4 (baptized 18 April 1627 in the Onze-Lieve-Vrouwekerk [North], Antwerp); Clara, age 2 (baptized 27 January 1629 in the Onze-Lieve-Vrouwekerk [North], Antwerp); and Catharina, age 1 (baptized 31 April 1630). The eldest girl is probably Magdalena Reyniers, for whom no baptismal record survives.[3] The double portrait of an older couple hanging on the rear wall probably represents the deceased parents of Anthony Reyniers, Adam Reyniers (d. 1586) and Magdalena del Becq (d. 1585).[4] The inclusion of portraits of deceased family members was a device already used in sixteenth-century portraiture to visually document family genealogy.[5]

De Bie 1661, p. 104; Houbraken 1718-21, vol. 1, pp. 188 ff; Descamps 1769, pp. 171, 206; Nagler 1835-52, vol. 20 (1850), p. 552; Nagler 1858-79, vol. 1 (1858), p. 1018; Goethals 1862, vol. 2, p. 744; Michiels 1865-76, vol. 8 (1869), pp. 293-301; Rombouts, van Lerius 1872, vol. 1, pp. 286, 409, 447, 517, 520, 543, 555, 562, 564, 581, 657, 680; and vol. 2, pp. 20, 54, 141, 145, 220, 382; Rooses 1879, pp. 531-539 and passim; Geudens 1904, pp. 19, 24, 28; Wurzbach 1906-11, vol. 2 (1910), pp. 818-819; Heins 1914; Rooses 1914; Oldenbourg 1918a; Delen 1927, pp. 223, 434; Prims 1927, pp. 393-395; Adriaanse 1930, p. 104; Denucé 1931, pp. 121, 161, 166; Denucé 1932, pp. 163, 166, 195, 204, 255, 266, 370; Glück 1933, pp. 337-341; Muls 1933; Greindl 1939a; Greindl 1939b; E. Greindl, in Thieme, Becker 1907-50, vol. 34 (1940), pp. 550-552; Greindl 1944; van Puyvelde 1950; Speth-Holterhoff 1957, pp. 45, 88-90; Plietzsch 1960, pp. 136-137; Brussels 1965, pp. 277-282; Alpers 1971, passim; Martin 1972, passim; Müller Hofstede 1972; Paris 1977-78, pp. 249-253; Vlieghe 1984; Díaz Padrón 1986; Van der Stighelen 1987; Van der Stighelen 1988; Van der Stighelen 1989b; Sutton 1990, p. 337; Van der Stighelen 1990a; Van der Stighelen 1990b; Van der Stighelen 1991a; Cologne/Vienna 1992-93, pp. 367-369, 411-412.

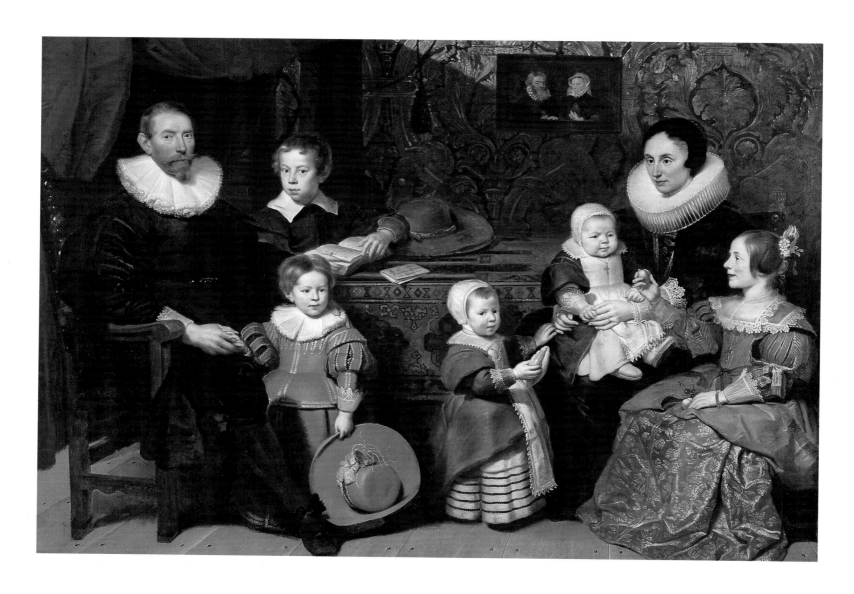

Family portraits by Cornelis de Vos date from about 1618 (Braunschweig, Herzog Anton Ulrich-Museum, inv. 206) to about 1640 (fig. 2). The majority depict richly clad sitters within an elegant domestic setting, or on a garden terrace. Husband and sons are customarily positioned on the heraldic right (dexter) side of the composition, and wife and daughters on the heraldic left (sinister) side. In general, individual figures are rather isolated, and expressions of familial affection are restricted to a subtle play of hand gestures (as in the conjunction of hands of Maria Le Witer and her daughters), or alluded to indirectly through the use of symbols. In the *Portrait of the Reyniers Family*, for example, the eldest daughter (Magdalena) offers a peach to Catharina, seated on her mother's knee; another peach and some cherries lie in Magdalena's lap. By virtue of its shape, the

peach was a traditional symbol of the heart, and also indicated sincerity; the cherries refer to spring, youth, paradise, and eternal life. The same combination of fruits also appears in de Vos's portrait of his own children Magdalena and Jan Baptist de Vos (Berlin, Gemäldegalerie, inv. 832) and has been interpreted as a reference to the loving bond between siblings.[6]

This type of monumental family portrait was fashionable in Antwerp from about 1620; its popularity waned about mid-century and was replaced by smaller "conversation pieces," diminutive genre likenesses such as those produced by Gonzales Coques (see cat. 58). The large-scale format was particularly popular among the bourgeoisie, and markedly less so among the aristocracy.[7] Although the majority of de Vos's family portraits remain

Fig. 1. Cornelis de Vos, *Self-Portrait with Wife and Two Oldest Children*, dated 1621, oil on canvas, 188 x 162 cm, Brussels, Musées Royaux des Beaux-Arts de Belgique, inv. 2246.

unidentified, the absence of heraldic or armorial devices from the paintings indicates that the sitters were not from the nobility. These monumental family portraits were usually hung in the *voorkamer* or *salet*, the large well-furnished public rooms of the home.[8] Such a prominent location not only made these portraits an obvious showcase for the pride and material ambitions of a well-to-do-family, but also demanded a carefully crafted image of familial harmony and moral standards.

Van der Stighelen has perceptively noted that de Vos's family portraits document the seventeenth century's changed attitudes towards the family. In contrast to the extended family commonly portrayed in paintings of the late sixteenth century (such as Frans Pourbus's *Portrait of the Hoefnagel Family*, 1571 [Brussels, Musées Royaux des Beaux-Arts de Belgique, inv. 4435], or Otto van Veen's *Portrait of Cornelis van Veen with His Family*, 1584 [Paris, Musée du Louvre, inv. 1911]), by the first half of the seventeenth century the nuclear family was considered a valid independent unit in society.[9] Concurrent with this was a growing emphasis on "orthodoxy" in family life: in the sixteenth century, for example, it was not uncommon for illegitimate children to be raised in the same home as their legitimate siblings and to be given the same legal rights. More restrictive attitudes prevailed in the seventeenth century, however, and are reflected in contemporary portraiture. In the exhibited painting, for example, Antonetta, Anthony Reyniers's illegitimate daughter, is excluded from the family portrait,[10] and we are presented with a tidy and rather conservative image of a prosperous and self-contained family unit.

MEW

1. *Self-Portrait with Wife and Two Oldest Children*, 1621 (Brussels, Musées Royaux des Beaux-Arts de Belgique, inv. 2246); and *Self-Portrait with Wife and Children*, ca. 1634 (St. Petersburg, Hermitage, inv. 632).

2. In his father's will, dated 1582, Anthony was referred to as a minor and thus could have been any age under twenty-five. Biographical information on the Reyniers family is published in Sutton 1990, p. 338; and Van der Stighelen 1990a, pp. 155-156.

3. Magdalena married Paulus Kersavont on 27 December 1639. In a testament made by Anthony Reyniers's illegitimate daughter, Antonetta, dated 11 January 1668, Magdalena is referred to as the elder sister of Clara and Catharina (Stadsarchief Antwerpen, N.3527, "Die XI January A° 1668"). See Van der Stighelen 1990a, p. 156.
The other children of Anthony Reyniers and Maria Le Witer were: Antonio (baptized 16 January 1623 at St. Walpurgis, Antwerp); Johannes Baptista (baptized 23 July 1631 at Onze-Lieve-Vrouwekerk [North], Antwerp); Dominicus (baptized 28 December 1632 at Onze-Lieve-Vrouwekerk [North], Antwerp); Marie Isabelle (baptized 9 April 1634 at Onze-Lieve-Vrouwekerk [North], Antwerp); Bartolomeus (baptized 17 August 1635 at Onze-Lieve-Vrouwekerk [North], Antwerp); and Sara (baptized 3 January 1637 at Onze-Lieve-Vrouwekerk [North], Antwerp). See Sutton 1990, p. 338.

4. As Van der Stighelen (1990a, p. 155) notes, the likeness of the woman does not resemble Jacob Jordaens's portrait of Madeleine de Cuyper, the

Fig. 2. Cornelis de Vos, *Portrait of a Family with Three Sons and a Daughter*, signed and dated 1631, oil on canvas, 165 x 235 cm, Antwerp, Koninklijk Museum voor Schone Kunsten, inv. 841.

mother of Maria Le Witer (ca. 1635; Vorselaar, collection of Baron R. de Borrekens); reproduced in d'Hulst 1982, p. 274. Jordaens also painted portraits of Maria's brother Rogier Le Witer, "Groot Aalmonoezier te Antwerpen," and his wife Catharina Behagel (dated 1635; Vorselaar, collection of Baron R. de Borrekens).

5. On the use of this motif, see B. Hinz, "Das Familienbildnis des J. M. Molenaer in Haarlem. Aspekte zur Ambivalenz der Porträtfunktion," *Städel Jahrbuch* 4 (1973), pp. 207-216; and Van der Stighelen 1990a, p. 155, note 384.

6. Van der Stighelen 1990b, p. 40.

7. Van der Stighelen 1990b, p. 136, citing the study of M. van Huffel, *Het monumentale familieportret in de Zuid-nederlandse schilderkunst van de zeventiende eeuw. Een iconografische en typologische studie* (unpublished thesis, Leuven, 1985).

8. Van der Stighelen 1990b, p. 138, from a study of Antwerp inventories from the period 1600-1650, published in Duverger 1984-.

9. That this was a conscious choice may be inferred from the fact that in 1621, the date of his first *Self-Portrait with Family*, de Vos resided in the home of his parents together with his two unmarried brothers, yet none of these other family members are included in the portrait. See Van der Stighelen 1990b, p. 136.

10. For the documents concerning Antonetta (who used her father's surname), see Van der Stighelen 1990a, p. 156.

Erasmus Quellinus the Younger

(1607-Antwerp-1678)

Erasmus II Quellinus was born in Antwerp on 19 November 1607. The eldest of eleven children, he was the son of Erasmus I (ca. 1584-1642), a sculptor originally from Liège, and Elisabeth van Uden. His younger brother Artus I Quellinus (1609-1668) was among the most accomplished Flemish sculptors of the seventeenth century. Erasmus II was probably a pupil of Rubens (q.v.) from about 1629, and joined the guild of St. Luke in 1633/34. He married Catherina de Hemelaer in ca. 1634; their son Jan-Erasmus, baptized on 1 December 1634, also became a painter.

Much of Quellinus's work through the 1630s and 1640s was done in collaboration with or under the direction of Rubens. He assisted his mentor in the decorations for the Pompa Introitus Ferdinandi in 1635 and the Torre de la Parada in 1637, and collaborated with him on a number of individual paintings as well. The majority of his career prior to 1642, however, was devoted to the graphic arts: he was active as a designer of book illustrations and title pages for the Plantin Press in Antwerp, and also worked with the printmaker Christoffel Jegher. Upon Rubens's death in 1640 Quellinus became the chief designer for the Plantin Press. In 1643 Quellinus joined the rhetoricians chamber "de Violieren"; at about the same time he began to direct more of his energies to painting. The artist was in Liège for several months in 1646-1647, where he painted three altarpieces. More important, however, was his contact with Liégeois painters such as Gérard Douffet (1594-1661/65) and Bertholet Flémal (q.v.), and their influence can be felt in Quellinus's works of the late 1640s and 1650s.

Upon his return to Antwerp in 1647 Quellinus was named the official painter of the city, and in this capacity he designed decorations for public events and spectacles through the 1660s. In Amsterdam in 1656, the artist executed two ceiling paintings for the new Amsterdam Town Hall; his brother Artus had designed the sculptural program for the building.

Following the death of his first wife, Quellinus was married in 1663 to Françoise de Fren, sister-in-law of David II Teniers (q.v.). He purchased two adjoining houses on the Happaertstraat in 1671, and constructed a gallery there to house his vast art collection. Quellinus died – probably of the plague – on 7 November 1678. In the ensuing years, disputes arose between his widow and his son Jan-Erasmus over the division of his estate.

A versatile and prolific artist, Quellinus's painted œuvre is composed primarily of altarpieces and history paintings, although he was also a skilled portraitist. His earliest works are heavily influenced by Rubens, but by the early 1640s he had developed an elegant, decorative, and rather eclectic style of his own. Towards the end of his career, Quellinus returned to a more robust Rubensian style. He collaborated with a number of artists, painting figural scenes and trompe l'œil sculptural images within flower garlands by Daniel Seghers, Jan Philips van Thielen, Jan van Kessel the Elder (qq.v.), and Joris van Son; he also collaborated with Jan Fyt (q.v.; see cat. 54), Pieter Boel, Joos de Momper (qq.v.), Abraham Genoels, and others. Quellinus had several pupils, the most famous of whom was the genre painter, engraver, and mezzotint artist Wallerant Vaillant (ca. 1622-1677).

Erasmus II Quellinus, *Self-Portrait*, engraving.

Meyssens 1649; de Bie 1661, pp. 260-265; Houbraken 1718-21, vol. 1 (1718), pp. 291ff, vol. 2 (1719), p. 102, and vol. 3 (1721), p. 229; Descamps 1769, passim; Immerzeel 1842-43, vol. 2 (1843), pp. 332-333; Génard 1854, passim; Kramm 1857-64, vol. 5 (1864), pp. 1330-1331; Génard 1860; Abry 1867, pp. 195-196; Michiels 1865-76, vol. 8 (1869), pp. 52-92; Rombouts, van Lerius 1872, vol. 1, pp. 435-436, 445, 457, 486, 490, 506-508, 517, 520, 534, vol. 2, pp. 47, 114, 123-124, 137, 139, 150, 153, 161, 170, 194, 203, 280, 312, 330-331, 389, 423-424, 465; Rooses 1879, pp. 493-498 and passim; van den Branden 1883, pp. 786-793; Levin 1888, pp. 136-137; van Even 1890; Wurzbach 1906-11, vol. 2 (1910), pp. 370-372; Donnet 1907, pp. 294, 314-315; Schneider 1925; Gabriëls 1930, passim; Denucé 1931, pp. 116ff; Denucé 1932, pp. 272-296; Thieme, Becker 1907-50, vol. 27 (1933), pp. 508-509; Legrand 1956; Legrand 1963, pp. 215-216; Brussels 1965, pp. 16off; Vlieghe 1967a; Hairs 1968; Alpers 1972, passim; Hairs 1973; Hendrick 1973; de Bruyn 1974-80; Hollstein 1949-, vol. 17 (1976), pp. 280-283; de Bruyn 1977; Hairs 1977, pp. 99-124; Vlieghe 1977a; Paris 1977-78, pp. 140-142, 263-264; de Bruyn 1979; de Bruyn 1980; de Bruyn 1981; de Bruyn 1983; de Bruyn 1984; de Bruyn 1985; de Bruyn 1986; de Bruyn 1988; de Bruyn 1990; Cologne/Vienna 1992-93, pp. 340-342.

Jan Fyt

(1611-Antwerp-1661)

Jan Fyt was baptized on 15 March 1611 in the Onze-Lieve-Vrouwekerk in Antwerp, the son of a well-to-do merchant, Peter Fyt, and Esther de Meere. He began his apprenticeship with the obscure painter Hans van den Berch (dates unkown) in 1620/21, then entered the atelier of Frans Snyders (q.v.), where he remained until about 1631. In 1629 he became a member of the painters' guild, but left on travels two years later. He was living in Paris in 1633-1634. In June of 1635 he sent fl. 150 to his sister Anne who was a Beguine in Antwerp. At an unknown date he traveled to Italy where he worked in Venice, receiving commissions for the Palazzi Sagredo and Contarini. Fyt apparently joined the *Schildersbent* in Rome and was given the nicknames "Glaucus," "Goedhart," and "Goudvink." According to Jan-Erasmus Quellinus's marginal annotations to his personal copy of de Bie, Fyt also visited Naples and Florence. He returned to Flanders by 5 September 1641 when he stood as guarantor for his brother Peter, a tapestry merchant, whose goods had been confiscated. In April 1642 Fyt requested a passport to visit Holland but was back later the same year when he initiated legal proceedings against Erasmus Quellinus. In 1643, Jeroom Pickaert (ca. 1628-after 1674) had been working for five years in Fyt's workshop. Other pupils and assistants include the little-known Jacob van de Kerckhove, listed as Fyt's apprentice in 1649, and Balthasar Treouts (dates unknown) in 1659. Pieter Boel (q.v.) was Fyt's best known pupil. Joining the Confraternity of Romanists in 1652, Fyt was generous in its support. In 1654 he married the well-to-do Johanna Francisca van den Zande, but was forced to sue his father-in-law for the promised dowry. Fyt initiated several lawsuits in his life, and in 1656 sued the art dealer Frans Diericx for wrongly selling a painting under his name. In 1660 Jan Brueghel the Younger (1601-1678), Erasmus Quellinus (who owned many works by Fyt), and Jan Peters (1624-1677) appraised the artist's daily wage at eighteen guilders. However, even in Fyt's own lifetime his paintings sold for as much as 370 guilders – a very considerable sum. Fyt made a will on 14 July 1661 and died on 11 September of that year. He was buried in the Church of the Abbey of St. Michael in Antwerp.

A prolific painter chiefly of dead game still lifes and hunting pieces, often with live animals (dogs, cats, eagles, parrots, and other birds), Fyt also painted a few flower and fruit still lifes. Strongly influenced by his teacher, Frans Snyders, he also seems to have been impressed by Italian animaliers and still-life painters. He often collaborated with other painters, above all Erasmus Quellinus but also Jacob Jordaens (q.v.), Thomas Willeboirts Bosschaert (1614-54), Theodoor van Thulden (q.v.), and Cornelis Schut (1597-1655).

De Bie 1661, pp. 339, 566; van Rijssen 1704, pp. 349, 357; Houbraken 1718-21, vol. 2 (1719), p. 142; Weyerman 1729-69, vol. 2 (1729), p. 215; Immerzeel 1842-43, vol. 1, p. 257; Kramm 1857-64, vol. 2 (1858), pp. 519-520; Michiels 1865-76, vol. 9 (1874), pp. 191-194; Rombouts, van Lerius 1872, vol. 1, p. 573, vol. 2, pp. 2, 209, 306; Lanzi 1882, vol. 3, p. 212; van den Branden 1883, pp. 796, 1085-1092; Levin 1888, p. 133; Wurzbach 1906-11, vol. 1 (1906), pp. 560-562; Thieme, Becker 1907-50, vol. 12 (1916), pp. 612-614; Glück 1933, pp. 343-348, 353, 362-364, 417-418; Griendl 1949; Sterling 1952, pp. 12, 51, 58-59, 74-75, 90; Hairs 1955, pp. 133-135, 212-213; Greindl 1956, pp. 75-84, 158-167; Speth-Holterhoff 1957, pp. 22, 24, 167, 179, 183; Brussels 1965, pp. 90-95; London, National Gallery, cat. 1970, pp. 80-81; Mecklenburg 1970, pp. 22-27; Paris 1977, pp. 94-95; Hairs 1983, pp. 95-107, 218-233; Sullivan 1984, pp. 19-22 et passim.

Erasmus Quellinus and Jan Fyt
54. Portrait of a Boy with Two Dogs

Oil on canvas, 136 x 103 cm (53 ½ x 40 ½ in.)
Antwerp, Koninklijk Museum voor Schone Kunsten,
no. 407

PROVENANCE: Baut de Rasmon family, van Wannegem-Lede Castle, when engraved by Filip Spruyt in the eighteenth century; bequest of Baroness van den Hecke-Baut de Rasmon, 1859.

EXHIBITIONS: Antwerp 1899, no. 100, ill. [as A. van Dyck]; London 1927, no. 323 [as Quellinus and Fyt]; Antwerp, Stedelijk Feestzaal, *Scaldis: Tentoonstelling Oude Kunst en Cultuur*, 20 July-9 September 1956, no. 569; Liège, Salle de l'Emulation, *Visages d'enfants*, 1956; Antwerp 1993, no. 61.

LITERATURE: van den Branden 1883, p. 1019 [as by van Dyck and Fyt]; Schaeffer 1909, p. 300, ill.; R. Oldenbourg, *Die flämische Malerei des XVII. Jahrundert* (Berlin, 1910), p. 63, [as follower of van Dyck]; Glück 1919, pp. 185-186, fig. 4; A. J. J. Delen, *Iconographie van Antwerpen* (Brussels, 1930), p. 134, no. 246; Glück 1933, pp. 344-345; Antwerp, cat. 1958, p. 186, no. 407; R. van Luttervelt, "Het kinderportret van Erasmus Quellin en Jan Fyt in het Museum te Antwerpen," *Jaarboek van het Koninklijk Museum voor Schone Kunsten, Antwerpen* (1954-60), pp. 17-20, ill. p. 18; G. Gepts, "Erasmus Quellien en Jan Fyt, Kinderportret," *Openbaar Kunstbezit in Vlaanderen* (1965), pp. 20a-20b, ill.; E. Duverger, "Het legaat van Barones van den Hecke-Baut de Rasmon aan het Museum van Antwerpen," *Jaarboek van het Koninklijk Museum voor Schone Kunsten, Antwerpen* (1974), pp. 246-247, no. 21; de Bruyn 1984, p. 311; de Bruyn 1988, pp. 62, 226-227, cat. 176, ill.; Antwerp, cat. 1988, p. 299, no. 407, ill.

AN ELEGANTLY DRESSED chubby young boy of about six stands in a landscape holding a falcon and the leashes of two dogs. He is dressed in an ankle-length light blue robe decorated with ribbons, and wears a short brimmed hat sporting plumes. On his left hand is a falconer's glove while a game bag hangs from his right hip. At his side are a greyhound and a small brown and white spaniel. On the horizon at the left of the open landscape is a glimpse of the city of Antwerp; in its profile one can make out the blunt St. Jacobstoren, the sharp spire of the Cathedral (Onze-Lieve-Vrouwekerk), and the tower of the Abbey Church of St. Michael.

Before Glück assigned this painting to Quellinus and Fyt it had been attributed to van Dyck or a follower.[1] As late as in the 1958 catalogue of the Antwerp Museum, the child was assumed to be a little girl; however, Luttervelt noted that despite the long dress, other details of the costume (notably the flat collar with tassels and the feathered beret) indicate that the child is a little boy.[2] While Schaeffer had dated the painting as early as ca. 1627-1632 when it was wrongly assigned to van Dyck,[3] Luttervelt observed that the costume points to a date of around 1655.[4] The activity of hunting with dogs and a bird of prey further supports the identification of the "sitter" as a boy, since hunting, especially on foot, was almost exclusively a male pursuit.[5] The fact that the plump little fellow staring off into the distance not only assumes a manly role as a hunter but also adopts a slightly incongruous air of masculine insouciance and authority (clearly acknowledged by the deferential hounds), serves to reminds us that the modern notion of children as something other than small adults is a pedagogic concept that had only just begun to develop in the seventeenth centu-

Fig. 1. Erasmus Quellinus and Jan Fyt, *Diana with Hunting Dogs and Dead Game*, oil on canvas, 79 x 119 cm, Berlin, Staatliche Museen zu Berlin, Gemäldegalerie, no. 967.

ry. Luttervelt observed that falconry had long been the prerogative of the nobility in the Netherlands[6]; we recall that St. Bavo's medieval attribute was a falcon to underscore his noble birth, and Holbein's portrait of 1542 of an unknown man in the Mauritshuis, The Hague (no. 277), is assumed to be a portrait of an aristocrat merely because he holds a falcon. Especially in peacetime, hunting was one of the few activities that tested the martial skills of the male aristocracy. By the mid-seventeenth century, however, the wealthier ranks of the merchants and professional classes had begun to imitate not only the dress and manners but also the pastimes of the nobility. Thus, as Luttervelt observed, it is not clear whether this anonymous young boy is an aristocrat or just a little "bourgeois gentleman."[7] The fact that the town of Antwerp appears on the horizon instead of a country house might seem to argue for the latter.

De Bruyn supported the attribution to Quellinus in his monograph on the painter, comparing the little boy's facial type to that of the infant Jesus in Quellinus's *Holy Family* in Dunkirk.[8] Quellinus painted at least two other paintings of hunters with dogs by Jan Fyt, but in those works the subjects are grown men: the painting wrongly attributed to Jordaens and Fyt in the sale Brussels (Fiévez), 16 December 1929, no. 48[9]; and the *Hunter with Dogs and Game* in the Cummer Gallery of Art, Jacksonville (A.G. 61.9).[10] Two small boys with a large hound also figure in a painting of 1652 signed only by Jan Fyt (but probably also a case of collaboration between the two painters) in the Gemäldegalerie Alte Meister, Dresden, no. 1211.[11] Still another instance of collaboration between Fyt and Quellinus at about the same time is the mythological hunting scene of *Diana with Dogs and Dead Game* preserved in Berlin (fig. 1).[12] In his collaborations with other artists,

Jacob van Oost the Elder

(1603-Bruges-1671)

Quellinus worked most consistently with the still-life painters Daniel Seghers and Jan Philips van Thielen, but he also worked with Joris van Son, Jan van Kessel, and Gaspar de Witte. His collaboration with Fyt is supported by seventeenth-century documents and seems to have peaked in frequency in the decade of the fifties. Filip Spruyt, who engraved the painting in the eighteenth century, made an inventory of public and private collections in Ghent in ca. 1789-1791.[13]

PCS

1. Glück 1919, pp. 185-186, fig. 4.

2. Luttervelt (1954-1960, pp. 17-18) compared the costume to that of the three-year-old Willem III of Orange in A. Hanneman's portrait of 1654 in the Rijksmuseum, Amsterdam, no. A 3889.

3. Schaeffer 1909, p. 300.

4. Luttervelt 1954-60, p. 17.

5. An apparent exception, *The Portrait of a Young Girl as a Hunter with a Dog*, probably by the Haarlem classicist Caesar van Everdingen, and also from the van den Hecke-Baut de Rasmon bequest to the Museum in Antwerp (inv. 382, as "Northern Netherlandish"), is explained by the fact that the picture is a *portrait historié*. The young girl is dressed not in seventeenth-century costume but in the antique toga and sandals of the devotees of the goddess of the hunt and chastity, Diana.

6. Luttervelt 1954-60, p. 20.

7. Ibid. Delen (1930, p. 246) suggested, without any foundation, that the sitter could be a member of the della Faille family, while Gepts (1965) speculated that he could be an ancestor of the Baut de Rasmon family who left the picture to the museum.

8. De Bruyn 1988, p. 227, see cat. 195.

9. Ibid., p. 227, no. 177, ill.

10. Ibid., p. 241, cat. no. 202, ill; see also Liedtke et al. 1992, p. 357, cat. no. 379, ill.

11. De Bruyn 1988, pp. 31, 62, cat. 153, ill.

12. Ibid., p. 60, cat. 142, ill.

13. See Filip Spruyt, *Description de tous les Tableaux que renfrent les Eglises, Couvents, Communautés de la Ville de Gand . . .* (1759-91); and E. Duverger, "Filip Spruyt en zijn inventaris van Kunstwerken in openbaar bezit te Gent (ca. 1789-1791)," *Gentse Bijdragen* 19 (1961-66).

Jacob van Oost was baptized in the Sint-Walburga-kerk in Bruges on 1 July 1603, the son of Jan van Oost and Gheraertdyne Weyts. He became a master in the Bruges guild of St. Luke on 18 October 1621. On the basis of stylistic evidence, and the fact that there is no mention of the artist in city records for the period, it is presumed that van Oost was in Italy ca. 1622-1627. He returned to Bruges by 1628, when he was appointed a "vinder" of the painters guild. He became vice-dean ("onderdeken") in 1629, dean in 1633, and continued to hold various posts in the guild through the 1640s. Van Oost married Jacquemyne van Overdille in 1630, but Jacquemyne died only a few months after the birth of their son, Martinus, in May 1631. The artist was married for the second time to Maria Tallenaere on 12 January 1633; six children were born of this union. Van Oost's first important commission was the restoration in 1636 of Jan van Eyck's *Madonna with Canon van der Paele*, then in the Church of Sint Donaas in Bruges. He executed commissions for various religious and civic institutions in Bruges, and was named official painter of the city in 1651. Van Oost held this position until his death in 1671.

Van Oost's works may be divided into portraits and subject paintings, the latter predominantly religious pieces, but also including a few genre scenes. His portrait style developed in a linear, chronological manner, from simple monochromatic compositions towards more volumetric figures, looser brushwork, and tactile rendering of stuffs. The evolution of his subject paintings is not so straightforward, however. The artist painted alternately in a tenebrous Caravaggesque manner and in a style more influenced by the art of Rubens and van Dyck. Though the former is most evident before 1650, it never entirely disappears from his œuvre.

Descamps 1753-64, vol. 2, pp. 51-58; Descamps 1769, passim; Immerzeel 1842-43, vol. 2, p. 279; Michiels 1865-76, vol. 8 (1869), pp. 421-434; van de Poele 1899; de Schrevel 1899; H. Hymans, in *Biographie Nationale* 1866-1964, vol. 6 (1901), cols. 215-218; de Meyer 1903; Verkest 1903; Wurzbach 1906-11, vol. 2 (1910), pp. 254-255; van den Haute 1913, pp. 102, 106-108, 110-111, 113, 115-117, 120-122, 124, 126-127, 135, 169, 205; Thieme, Becker 1907-50, vol. 26 (1932), p. 24; Bautier 1946; d'Hulst 1946; d'Hulst 1951; Held 1955; Vermeersch 1966; Bodart 1970, vol. 1, pp. 76-77; Fuchs 1975; Bruges 1981, pp. 371-375; Meulemeester 1984; Papi 1990.

Jacob van Oost the Elder
55. *Portrait of a Bruges Family*, 1645

Oil on canvas, 150.5 x 255.5 cm (59 ¼ x 100 ½ in.)
Signed and dated on the balustrade at right:
I. V. OOST. F 1645
Bruges, Groeningemuseum, inv. o.181.1

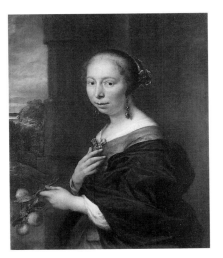

Fig. 1. Govaert Flinck, *Portrait of a Woman*, signed and dated 1648, oil on canvas, 76.5 x 62.5 cm, Stuttgart, Staatsgalerie, inv. 2290.

PROVENANCE: given (?) to the Museum by Jonkvrouw Rapaert de Grass before 1910, through the agency of the Vrienden van de Musea.

EXHIBITIONS: Bruges, *Tableaux de l'ancienne Ecole néerlandaise exposés à Bruges dans la grande salle des halles*, 1867 (catalogue by W. H. J. Weale), pp. 169-170; Brussels 1910, p. 270, no. 628; London 1927, no. 649; 's-Hertogenbosch, *Belgische Kant van de 16de eeuw tot heden*, 1948, p. 51, no. 360; Bruges, Groeningemuseum, *Schilderijen geschonken door de "Vrienden van de Musea"* (1903-1914), 1959, no. 14; Brussels 1965, no. 162.

LITERATURE: *Bulletin Communal de la ville de Bruges* 54 (1911), pp. 183-184; H. Fierens-Gevaert, *La peinture à Bruges, Guide historique et critique* (Brussels and Paris, 1922), p. 62; P. Bautier, "Le peintre Jacques van Oost le Vieux," *Bulletin Officiel du Touring-Club de Belgique* 34 (15 Oct. 1928), p. 465; Bruges, *Stedelijk Museum van Schone Kunsten, Geïllustreerde Catalogus* (catalogue by E. Hosten and E. I. Stubbe), 1931, p. 167, no. 181; Bautier 1946, p. 7; d'Hulst 1946, p. 91; J. Dochy, *De Schilderkunst te Brugge, Geïllustreerde Gids* (Bruges, 1947), p. 83; E. Michel, *Les grands maîtres flamands au seizième et au dix-septième siècle* (n. p., 1951), p. 17; Held 1955, p. 148; Gerson, ter Kuile 1960, p. 140; Vermeersch 1966, pp. 25a-b; V. Vermeersch, *Brugges Kunstbezit* (Bruges and Utrecht, 1969), vol. 1, pp. 204-207; Fuchs 1975; A. Vandewalle and W. Le Loup, "Ongekend werk van Jan Garemijn in het confrerieboek van de H. Dorothea," *Handelingen van het genootschap voor geschiedenis te Brugge* (1980), p. 187; V. Vermeersch, *Brugge. Duizend jaar kunst, van Karolingisch tot Neogotisch 875-1875* (Antwerp, 1981), pp. 374-375; Meulemeester 1984, pp. 110, 176, 180-181, 184-185 and 267-270, cat. A23; D. de Vos, *Groeningemuseum Bruges (Musea Nostra, I)* (Brussels, 1987), pp. 62-63, 65; Greindl et al. 1990, p. 302, ill.

VAN OOST'S charmingly provincial portrait of a well-to-do family on an outdoor terrace is dominated by the rather stiff commanding figure of a middle-aged man dressed in black. With magisterially outstretched arm, he indicates a prospect of formal gardens and the distant profile of the city of Bruges. At his left, his young wife is richly garbed in a blue skirt trimmed with rows of silver braid; her stomacher is adorned with bows and a miniature portrait of a woman suspended from a red ribbon.[1] A knot of embroidered ribbon is pinned to her left sleeve cuff, and she holds a fan also decorated with ribbons. Hanging from her waist are a silver and tortoiseshell knife case and (probably) a small purse. At her side, a young boy in a buff-colored suit smiles engagingly at the viewer. Seated on the steps at the center of the composition, a young woman has set aside her sewing basket to converse with the youth standing on the steps below her. Placing his left hand over his heart, he offers her a branch of peaches. Peaches traditionally signified the heart[2]; the gesture of pointing to the heart or placing the hand upon the breast was included in the personifications of sincerity and friendship in Cesare Ripa's *Iconologia*. Gesture and attribute were frequently united in portraiture, as for example in Govaert Flinck's *Portrait of a Woman* (1648; Stuttgart, Staatsgalerie, inv. 2290; fig. 1).[3] Further to the left in van Oost's composition, a more plainly clad nurse descends the steps holding a chubby infant in her arms. The child wears a cap with red and white feathers, and a padded bumper bonnet. At the far left of the scene, a gardener with a spade over his shoulder steps down to the elaborate formal garden, which is busily tended by several other laborers.

Minute inscriptions recording the ages of six of the eight persons depicted in the painting have been cleverly incorporated into the composition. On the heel of the man's shoe is written AETA. SUAE 46; on the fan held by the woman at the right, AETAT. SUAE 26; on the hat carried by the young boy, AETAT. SUAE 3; on the cushion in the basket next to the seated girl, AETAT. SUAE 15; on the boot of the standing youth, AETAT. SUAE 17; and on the biscuit grasped by the infant carried in the nurse's arms, AETAT. SUAE 1 1645.[4] The ages of the nurse and of the gardener are not given. From the respective ages of the four offspring, it may be surmised that the woman depicted at the right is the man's second wife, and that the two older children are products of the first marriage.[5]

Despite this detailed information, and despite the fact that the portrait undoubtedly represents a well-to-do family with a country estate in the vicinity of Bruges, it has thus far not been possible to identify the sitters. Weale suggested that the portrait depicted members of the Keignart or van Doorn family[6]; Fierens Gevaert wrongly identified the older man as Leonardus van Kerckhove, who was portrayed at age forty-eight by Jacob van Oost the Younger in 1665 and thus would have been only twenty-eight at the time the present picture was painted.[7] Vandewalle and Le Loup suggested that the man may have been a member of the brotherhood of St. Dorothy in Bruges, probably because of the horticultural emphasis of van Oost's composition.[8] Meulemeester also investigated the possibility that the sitters in van Oost's portrait were members of the family of the former owner of the picture, Rapaert, but was unable to discover any concrete evidence for this.[9]

The expansive ambiance evoked by the terrace and formal garden of a country estate was a popular convention in seventeenth-century portraiture for conveying wealth and status; it appears also in works by Anthony van Dyck, Gonzales Coques (cf. cat. 58), Cornelis de Vos, Jacob Jordaens, and others.[10] Rarely, however, does the landscape vista include an identifiable city profile, as in the *Portrait of a Bruges Family*.[11] The juxtaposition of city and country estate reflects a theme recurrent in contemporary *hofdichten* (country house poems), of the bucolic country retreat as a well-deserved reward for diligent labor in the bustling confines of the city.[12] This is echoed in van Oost's painting by the background vignette of the formal garden, in which beauty and order result

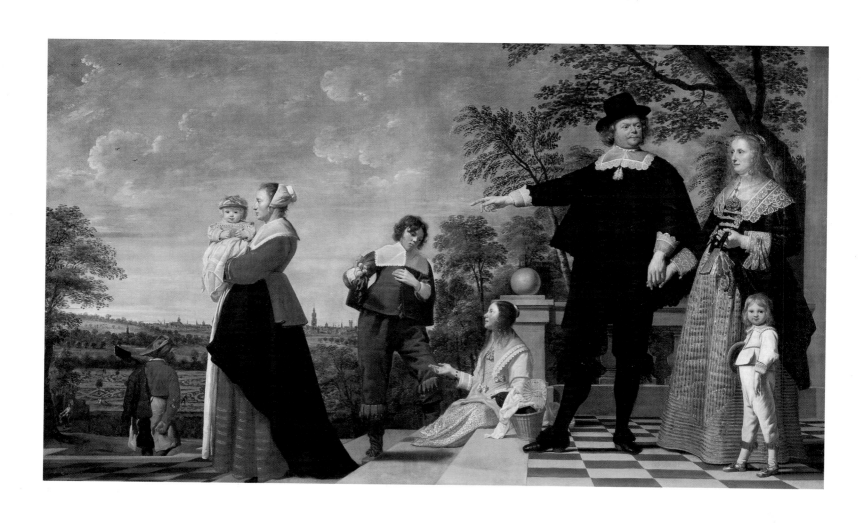

from the attentive care and industry of the garden-ers.[13] In fact gardens and horticultural matters were a major attraction of the rural retreat, and descrip-tions of carefully pruned and cultivated nature were at the core of every seventeenth-century *hofdicht*.

MEW

1. Meulemeester (1984, p. 268) suggests that this may be an image of the woman's patron saint.

2. On the iconography of peaches see also cat. 53, Cornelis de Vos, *Portrait of Anthony Reniers and His Family*.

3. See E. de Jongh, in Haarlem 1986, pp. 54-55.

4. Vermeersch 1966, p. 25a notes five inscriptions; all six are given in Meulemeester 1984, p. 268.

5. Meulemeester 1984, p. 268.

6. In exh. cat. Bruges 1867, p. 170.

7. Fierens Gevaert 1922, p. 62; followed by Bautier 1928, p. 7.

8. Vandewalle and Le Loup 1980, p. 187.

9. Philippe Rapaert was born in 1599, so would have been forty-six at the time van Oost painted the portrait; Cornelis Rapaert was baptized in the St. Walpurgis church on 3 September 1628 and would have been seven-teen in 1645. No other documentary information pertaining to the fam-ily agrees with the facts provided by van Oost's painting. See Meule-meester 1984, p. 268.

10. Cornelis de Vos, *Portrait of the Artist and His Family* (ca. 1634; St. Peters-burg, Hermitage, inv. 623); Jacob Jordaens, *Portrait of the Jordaens Family* (Madrid, Museo del Prado, inv. 1549).

11. Other examples include: Erasmus Quellinus and Jan Fyt, *Portrait of a Boy with Two Dogs* (cat. 54); Jacob Grimmer, *View of "Het Kiel" near Antwerp* (1579; Antwerp, Koninklijk Museum voor Schone Kunsten, inv. 674); and Gonzales Coques and Gaspar de Witte, *Portrait of the van Parijs-Rubens Family by Merksem Castle, with Antwerp in the Distance* (ca. 1674; Kraainem, collection X. de Donnea de Hamoir [1963]). See also Jacob Matham's painting of the brewery and country house of Jan Claesz. van Loo in Haarlem, which juxtaposes the two monuments for the sake of the attached poem upholding the country retreat as the pleasureable reward for diligent work in the city (1627; Haarlem, Frans Halsmuseum, inv. 206).

12. See K. Schmidt, "Hollands buitenleven in de zeventiende eeuw, I," *Amsterdams Sociologisch Tijdschrift* 4 (1977), pp. 438-441; and Vergara 1978, pp. 158-170. On the *hofdicht* in the Netherlands, see P. A. F. van Veen, *De soeticheydt des buyten-levens, verghelschapt met de boucken* (Utrecht, 1960). In Dutch art, Seymour Slive has related a portrait of Amsterdam burgomas-ter Andries de Graeff before his country estate at Soestdijk (by Jacob van Ruisdael and Thomas de Keyser; Dublin, National Gallery of Ireland, inv. 287) to a poem by Joost van den Vondel which specifically describes Soestdijk as de Graeff's bucolic retreat from his urban cares and responsi-bilities. See exh. cat. The Hague, Mauritshuis, and Cambridge, Fogg Art Museum, *Jacob van Ruisdael* (1981-82), p. 23.

13. Sixteenth-century allegories of spring, for example, by Pieter Bruegel the Elder (pen and bistre drawing, 221 x 289 mm, dated 1565, Vienna, Albertina, inv. 23.750; print after by Pieter van der Heyden, dated 1570) frequently interject upper-class observers into scenes of planting and gardening.

Jacob van Oost the Elder
56. Portrait of a Boy Aged Eleven, Possibly Jacob van Oost the Younger, 1650

Oil on canvas, 80.5 x 63 cm (31 11/16 x 24 13/16 in.)
Signed, inscribed and dated: ÆTAT: SVÆ ii 1650.IVO. (VO in monogram)
London, The Trustees of The National Gallery, inv. 1137

PROVENANCE: purchased from Miss M. A. Thomas, London (with the aid of the Clarke Fund), 1883; lent, through the Arts Council of Great Britain, to the Graves Art Gallery, Sheffield, 1958-63.

LITERATURE: de Meyer 1903, p. 37; Wurzbach 1906-1911, vol. 2 (1910), p. 254; P. Bautier, "Le peintre Jacques van Oost le Vieux," *Bulletin Officiel du Touring-Club de Belgique* 34 (15 October 1928), p. 465; von Schneider 1933, p. 112; Bautier 1946, p. 8; d'Hulst 1946, pp. 96-97; d'Hulst 1951, pp. 182, 186; Held 1955, p. 149; London, National Gallery, cat. 1970, p. 103; Meulemeester 1984, pp. 158, 181-182 and p. 278, cat. A29; H. Buijs and M. van Berge-Gerbaud, *Tableaux flamands et hollandais du Musée des Beaux-Arts de Lyon* (Paris and Lyon, 1991), p. 112.

LOST IN DREAMY CONTEMPLATION, the young boy stands silhouetted against a gold brown backdrop. He wears a brown velvet jacket, partially unbuttoned at neck and waist to reveal a white chemise. His wispy curls are crowned by a beret sporting a bushy squirrel's tail, and his hands are tucked into a soft fur muff. Van Oost's composition derives its charm and expressive power from the combination of the simple silhouette of the figure, a limited palette of warm neutral tones, and a delicate technique which softens outlines and imparts a tac-tile sensuality to the soft velvet and fur.

As the leading painter in Bruges during the mid-seventeenth century, van Oost was of necessity a pro-lific portraitist (see also cat. 55, *Portrait of a Bruges Family*, dated 1645).[1] The present painting is perhaps the artist's most sensitive portrayal, gently evoking a young boy's introspective mood. It can be grouped stylistically with several other paintings by the artist from about 1650 or slightly before, among them the *Old Woman Giving a Letter to a Young Man* (ca. 1645-1650; Lyon, Musée des Beaux-Arts, inv. A121; fig. 1), *Portrait of a Boy* (ca. 1645-1650; Bruges, private collec-tion), and the somewhat earlier *David with the Head of Goliath* (ca. 1645; St. Petersburg, Hermitage) and *Two Boys before an Easel* (ca. 1645; London, The National Gallery, inv. 3649).[2] Each of these paintings is marked by traces of the Caravaggesque style which dominated van Oost's art of the 1630s and earlier 1640s, although it has been tempered by a certain softness which may be attributed to a more Flemish influence on his art. Unlike the majority of the artist's compositions (including his portraits), which can be detached and impersonal, this handful of paintings displays a lyrical, almost melancholy sen-sibility, and an insight into the psychology of the person represented. The Lyon painting in particular shares with the *Portrait of a Boy Aged Eleven* an inter-est in the detailed re-creation of the tactile qualities of fur and velvet.

In simplicity and directness of presentation, van Oost's *Portrait of a Boy Aged Eleven* may also be com-pared with three bust-length portraits by the artist, which are dated or datable to about 1665: *Portrait of*

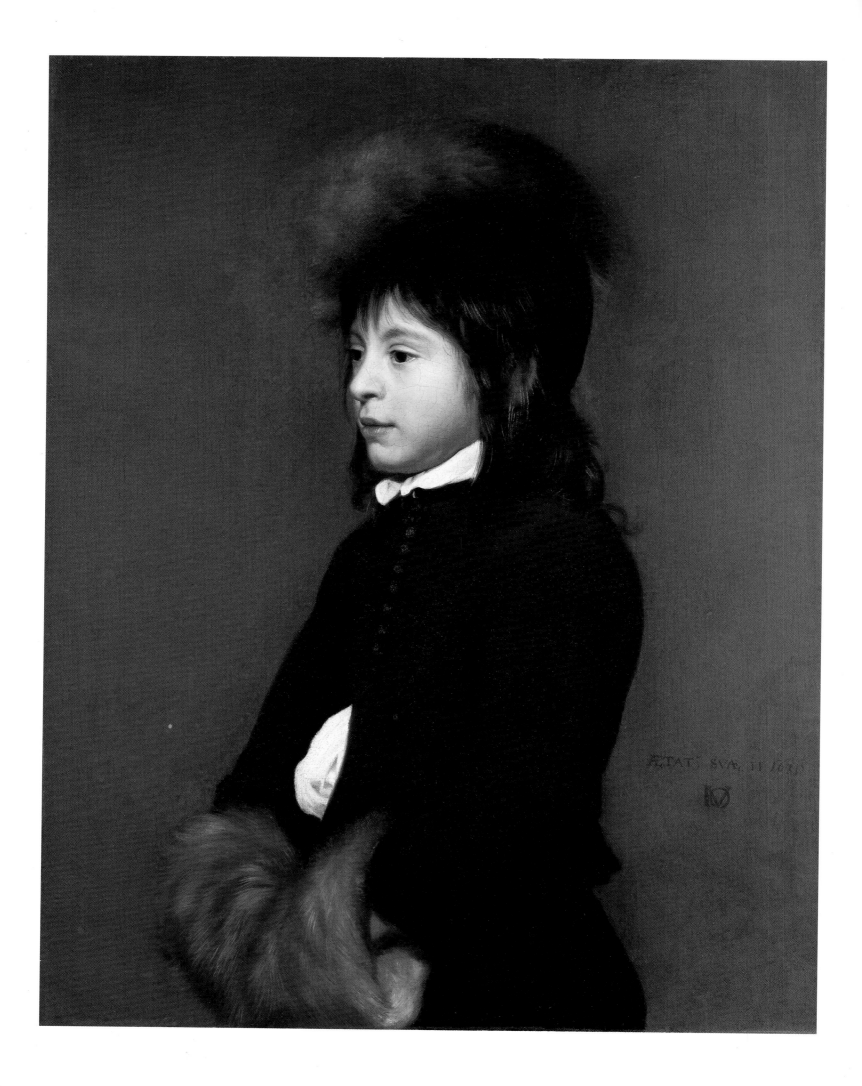

Michiel Sweerts
(Brussels 1618-Goa, India 1664)

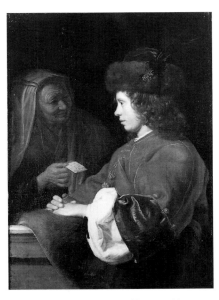

Fig. 1. Jacob van Oost the Elder, *Old Woman Giving a Letter to a Young Man*, signed, ca. 1645-1650, oil on canvas, 110 x 78.5 cm, Lyon, Musée des Beaux-Arts, inv. A121.

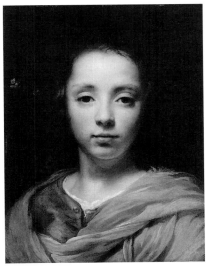

Fig. 2. Jacob van Oost the Elder, *Portrait of a Young Woman*, ca. 1665, oil on canvas mounted on panel, 41.3 x 31.7 cm, private collection.

Ellen Kirstine Ulfeldt and *Portrait of Lenora Sophie Ulfeldt* (both Hillerød, National Historisk Museum [Frederiksborg]), and *Portrait of a Young Woman* (private collection; fig. 2).[3]

Meulemeester has proposed, quite convincingly, that the London portrait depicts the artist's son, Jacob van Oost the Younger.[4] Baptized in Bruges on 11 February 1639, he would have been eleven years old in 1650, the age and date recorded on the portrait. This personal connection between the artist and his sitter would also account for the rare sensitivity and tenderness that imbue the portrait.

When acquired by The National Gallery in 1883, the painting bore an improbable attribution to the Dutch painter Isack van Ostade (1621-1649) because of the monogram "IVO." Catalogued for several years as "Dutch School," the painting was correctly attributed to van Oost in 1898.[5]

MEW

1. On the artist's career as a portraitist, see Meulemeester 1984, pp. 175-185.

2. D'Hulst 1951, pp. 182-186; and Meulemeester 1984, pp. 156-158, 181.

3. Meulemeester 1984, cats. A42 and A43; on the *Portrait of a Young Woman*, see P. C. Sutton, in *Prized Possessions: European Paintings from Private Collections of Friends of the Museum of Fine Arts, Boston* (exh. cat. Boston, Museum of Fine Arts, 1992), p. 190.

4. Meulemeester 1984, pp. 181, 278. On the younger van Oost, who was also a talented painter, see ibid., pp. 199-205; and M. van Dalle, "Jacques van Oost, dit le jeune, peintre et bourgeois de Lille," *Revue belge d'archéologie et d'histoire de l'art* 8 (1938), pp. 139-171.

5. London, National Gallery, cat. 1970, p. 103. London, The National Gallery, *Descriptive and Historical Catalogue of the Pictures in the National Gallery* (74th ed., 1889), pp. 130-131 [as Dutch School]; and London, The National Gallery, *Descriptive and Historical Catalogue of the Pictures in the National Gallery* (78th ed., 1898), pp. 384-385 [as van Oost].

Michiel Sweerts (see cat. 57) was baptized in the Church of St. Nicolaes in Brussels on 29 September 1618, son of the linen merchant David Sweerts. Nothing is known of Sweerts's early life or artistic training. By the mid-1640s he was in Rome, and during 1646-1651 is recorded as living on the Via Margutta, in an area of the city densely populated by Northern painters. He is mentioned as an "aggregato" (unofficial assistant) in the minutes of the Academia di San Luca. A document of 1651 refers to the painter as "Cavaliere," but it is not known when or why he received the title. He remained in Rome at least until 1652, and probably later, then returned to his native city. On 3 April 1656 Sweerts received permission from the magistrates of the city of Brussels to open an academy for life drawing, which was specifically dedicated to developing proper drawing technique in painters of tapestry cartoons. In the same year Sweerts published a series of engravings – mostly portrait heads – which were used as examples for the instruction of these pupils. Sweerts became a member of the Brussels guild of St. Luke only in 1659.

Sweerts was probably in Amsterdam from ca. 1659-1660, possibly active as a portraitist. The Lazarist lay priest De Chameson, who met Sweerts in Amsterdam in the summer of 1661, stated that the artist was quite well paid for his likenesses. While in Amsterdam, probably in late 1660, the artist joined the Société des Missions Etrangères as a lay brother, under the direction of Monseigneur François Pallu. From the start, Sweerts was fervently, almost fanatically devoted to the cause: De Chameson's diary notes that he "eats no meat, fasts almost every day, sleeps on a hard floor and gives his possessions to the poor; each week he takes communion three or four times." In November 1661 Sweerts was part of a mission that departed from Paris for the Orient, stopping in Marseilles in the last days of 1661 and subsequently in Aleppo, where the artist painted a few paintings. By July of 1662, however, Sweerts was, in Pallu's words, "not the master of his own mind"; another member of the mission wrote of Sweerts's overweening zeal: "he lectures everyone, concerns himself with priestly affairs and in the end with everything. In company, he contradicts everyone, particularly the Bishop himself." Sweerts was subsequently dismissed from the mission as a result of his instability and intractability. He made his way from Esfahan (Iran) to the Portuguese Jesuit center at Goa, on the west coast of India. According to a note in the archives of the Missions Etrangères, Sweerts died at Goa in 1664.

Michiel Sweerts is one of the most enigmatic Flemish painters of the seventeenth century. In

Michiel Sweerts

57. *Self-Portrait as a Painter*

Oil on canvas, 94.5 x 73.4 cm (37 ¼ x 28 ⅞ in.)
Oberlin, Ohio, Allen Memorial Art Museum, Oberlin
College, R. T. Miller Jr. Fund, inv. 41.77

Rome, Sweerts painted Bamboccianti genre scenes and history paintings combining a stark Caravaggesque chiaroscuro and blunt realism with a noble, almost classical simplicity and serenity more closely related to works by Nicolas Poussin or the Le Nains. Reflecting his own interests in artistic education, he painted several scenes of artist's studios and drawing academies. About 100 paintings by the artist are known; only three are dated.

Bartsch 1803-21, vol. 4 (1805), pp. 413ff; Nagler 1835-52, vol. 18 (1848), p. 57; Immerzeel 1842-43, vol. 3 (1843), p. 125; Kramm 1858-64, vol. 5, pp. 1594ff; Wauters 1877; Bertolotti 1880, pp. 184ff; Launey 1894; Launey 1905; Martin 1907; Brom 1910, p. 34; Kronig 1910; Wurzbach 1906-11, vol. 2 (1910), pp. 684-685; Hoogewerff 1911; Hoogewerff 1913, passim; Hoogewerff 1916; Martin 1916; Valentiner 1930; Baudiment 1934, passim; Longhi 1934; Verwoerd 1937; E. Trautscholdt, in Thieme, Becker 1907-50, vol. 32 (1938), pp. 348-350; Longhi 1950; Rome 1950; Stechow 1951; Hoogewerff 1952, pp. 85-86; Kultzen 1954; Bloch 1958; Longhi 1958; Nicholson 1958; Rotterdam/Rome 1958; Waddingham 1958; Incisa della Rocchetta 1959; van Regteren Altena 1959; Schaar 1959; Plietzsch 1960, pp. 199-205; Waddingham 1961; Bedo 1962; Bloch 1965; Brussels 1965, pp. 256-257; Bloch 1968; Castelfranci Vegas 1969; Bodart 1970, vol. 1, pp. 419-431; Waddingham 1972; Bloch 1973; Horster 1974; Kultzen 1980; Waddingham 1980; Kultzen 1982; Briganti, Trezzani, Laureati 1983, pp. 301-325; Kultzen 1983; Liedtke 1983; Waddingham 1983; Hollstein 1949-, vol. 29 (1984), pp. 127-136; Waddingham 1986; Kultzen 1987; Montreal 1990, pp. 185-187; Cologne/Utrecht 1991-92, pp. 270-283.

PROVENANCE: collection William Twopenny, London; collection Edward Twopenny, Woodstock Castle, Sittingbourne, Kent; sale E. Twopenny, London (Foster), 5 March 1902, no. 57 (as "Portrait of Gerard Torburg" (sic); £189, to Buttery); (possibly) dealer Thomas Agnew & Sons, London; collection Washington B. Thomas (1857-1929), Boston, 1902/3-1929; collection Mr. and Mrs. William Tudor Gardiner, Gardiner, Maine, 1929-ca. 1941; dealer M. Knoedler & Co., New York, 1941; acquired by the museum in 1941.

EXHIBITIONS: Boston, Copley Society, *Old Masters*, 1903, no. 86; Boston, Museum of Fine Arts, *Art in New England. Paintings, Drawings, Prints from Private Collections in New England*, 1939, no. 129; Rotterdam 1958, no. 43; Rome 1958-59, no. 44; London, Kenwood (London County Council), *An American University Collection*, 1962, no. 32; The Hague, Mauritshuis, and The Fine Arts Museums of San Francisco, *Great Dutch Paintings from America*, 1990-91 (catalogue by Ben Broos et al.), no. 64.

LITERATURE: E. W. Moes, *Iconographia Batavia* (The Hague, 1897-1905), vol. 2 (1905), no. 7756; W. Martin 1907, pp. 136, 138-140, p. 145, no. 1; Wurzbach 1906-11, vol. 2 (1910), p. 684; E. Trautscholdt, in Thieme, Becker 1907-50, vol. 32 (1938), p. 348; W. Stechow, "Die Sammlung des Oberlin College in Oberlin, Ohio," *Phoebus* 2, no. 3 (1949), p. 121; V. Bloch, "Nederland en Italië," *Maandblad voor Beeldende Kunst* 26 (1950), p. 218; Stechow 1951, pp. 211-214, and note 18; W. Stechow, "A Self-Portrait by Michael Sweerts," *Allen Memorial Art Museum Bulletin* 9, no. 2 (1952), pp. 64-65; J. C. Ebbinge Wubben, "Een Romeins straattafereel door Michael Sweerts," *Bulletin Museum Boymans Rotterdam* 4 (1953), p. 4 note 3; Kultzen 1954, vol. 1, pp. 139-141, 143, vol. 2, p. 300, no. 69; H. Gerson, "Michael Sweerts en tijdgenoten. Tentoonstelling in het Museum Boymans," *Het Vaderland* (15 November 1958), p. 14; Rotterdam 1958, pp. 25, 54, no. 43; Waddingham 1958, p. 71; Rome 1958-59, pp. 50-51, no. 44; "Catalogue: Painting," *Allen Memorial Art Museum Bulletin* 16, no. 2 (1959), p. 78; "Foreword," *Allen Memorial Art Museum Bulletin* 16, no. 3 (1959), p. 137, ill.; Incisa della Rocchetta 1959, p. 117; E. Schaar, "Michael Sweerts e i bamboccianti. Ausstellung im Palazzo Venezia in Rom," *Kunstchronik* 12 (1959), p. 44; Bedo 1962, p. 107; B. N[icholson], "Current and Forthcoming Exhibitions," *The Burlington Magazine* 104 (1962), p. 310; H. van Hall, *Portretten van Nederlandse beeldende kunstenaars* (Amsterdam, 1963), p. 323; Rosenberg, Slive, ter Kuile 1966, p. 173; Oberlin, cat. 1967, pp. 145-146; Bloch 1968, pp. 24-25 and fig. 25; Rotterdam, Museum Boymans-van Beuningen, *Portretten van Kunstenaars 1400-1800* (1969), p. 50; Bodart 1970, vol. 1, p. 424 note 2; A. Bader, "An Unknown Portrait of Michael Sweerts," *The Burlington Magazine* 114 (1972), p. 475, ill. fig. 46; A. Bader and W. Stechow, *Selections from the Bader Collection* (Milwaukee, 1974), under no. 24; "Allen Memorial Art Museum, Oberlin College, Oberlin, Ohio," *Apollo* 103 (1976), p. 85; M. R. Waddingham, "Michael Sweerts, *Boy Copying the Head of a Roman Emperor*," *The Minneapolis Institute of Arts Bulletin* 63 (1976-77), pp. 59, 64 note 14; M. Chiarini, "L'Autoritratto di Michael Sweerts già nella collezione del cardinale Leopoldo di Medici," *Paragone* 30, no. 355 (1979), pp. 63-64; *Gli Uffizi. Catalogo Generale* (Florence, 1980), p. 1014, under no. A920; Liedtke 1983, p. 21; New York, Metropolitan, cat. 1984, p. 294; P. C. Sutton, *A Guide to Dutch Art in America* (Grand Rapids and Kampen, 1986), pp. 210-213, ill. fig. 305; Kultzen 1987, p. 217; B. Broos and J. Roeding, in exh. cat. The Hague/San Francisco 1990-91, pp. 442-447.

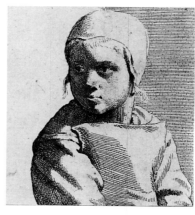

Fig. 1. Michiel Sweerts, *Head of a Boy*, 1656, etching, 90 x 81 mm, from *Diversae facies...* (Brussels, 1656).

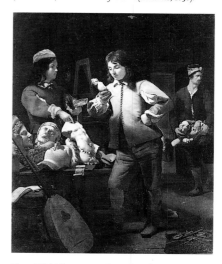

Fig. 2. Michiel Sweerts, *In the Studio*, oil on canvas, 74.3 x 60 cm, Detroit, The Detroit Institute of Arts, no. 30.297.

THE ARTIST stands before a mountainous Italianate landscape, beneath a luminous cloud-filled sky. The dramatic backlighting casts the left side of his face and much of his body into shadow, and is characteristic of the varied and unusual effects Sweerts explored in his compositions. The undulating waves of his dark hair, silhouetted against the sky, are reiterated by the folds of his billowing white sleeves. With his right hand he delicately grasps a paintbrush tipped with paint; with his left he holds additional paintbrushes, a palette, and mahlstick. The slight downward angle of the artist's gaze underscores an impression of gentlemanly poise and self-confidence.

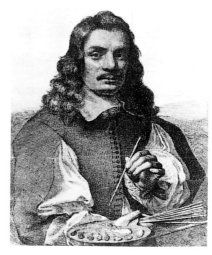

Fig. 3. Michiel Sweerts, *Self-Portrait as a Painter*, ca. 1656, etching.

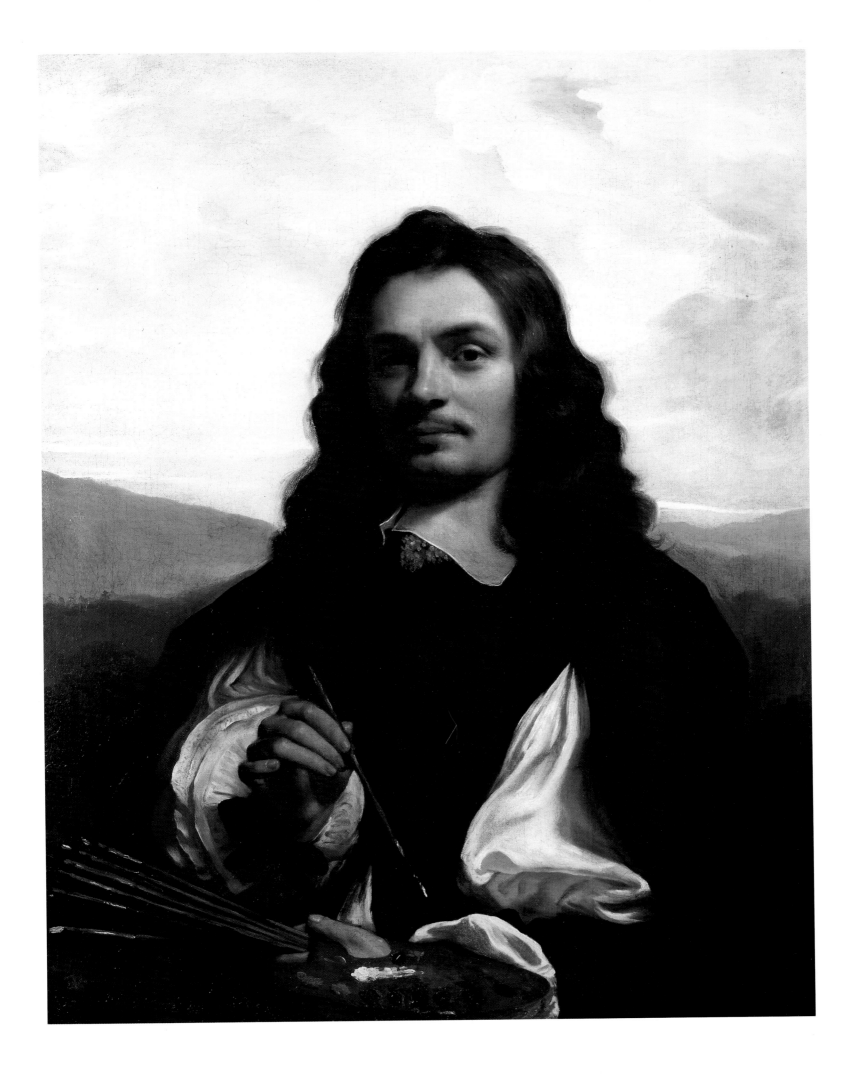

In addition to the present work two other self-portraits have been given to Sweerts, each presenting the artist in a different context, with different attributes. An early likeness, probably painted about 1648-1650, shows the artist as "bohemian," wearing a velvet beret with a swooping feather (Florence, Galleria degli Uffizi, inv. 1633).[1] In a self-portrait now in the Bader collection, probably painted about 1655, the artist points to a skull as a vanitas reminder.[2]

The Oberlin *Self-Portrait* belongs to a long tradition in Netherlandish art of painters depicting themselves with the implements of their craft; compare, for example, Antonis Mor's masterful *Self-Portrait* of 1558 (oil on canvas, 113 x 87 cm; Florence, Galleria degli Uffizi, inv. 1637). Sweerts was probably aware of the series of artists' portraits compiled by Domenicus Lampsonius and published in Antwerp in 1572[3]; his pose and bearing in the present *Self-Portrait* are analogous to the likeness of the painter Pieter Coecke van Aelst, engraved by Hieronymus Wierix for Lampsonius's volume.[4] Sweerts's elegant garb, and particularly the emphasis on the aristocratic, tapering hand holding the paintbrush, also recall the portraits of artists in Anthony van Dyck's *Iconography*. Raupp has noted that such elegantly formed hands command respect and indicate inner nobility; the overall message of the artists' likenesses in the *Iconography* – and the same might be said of Sweerts's *Self-Portrait* – is one of self-control and inner order and harmony, a virtuoso ideal combining aristocratic bearing, intellect, and prestige.[5]

Martin[6] dated the Oberlin *Self-Portrait* to about 1656, based on a comparison to the only dated portrait by the artist, the *Portrait of a Young Man* of 1656 in the Hermitage (inv. 3654). Stechow[7] dated the painting somewhat later, ca. 1658-1660, based on the erroneous assumption that the artist was born in 1624. The Oberlin painting appears to depict a man in his mid- to late thirties, so a date of about 1656 is convincing; moreover, a date during the early years of Sweerts's Brussels period (prior to his move to Amsterdam in about 1661) is strongly supported by what is known of the artist's professional activities at that time.

On 3 April 1656, Sweerts received permission to open an academy for life drawing in Brussels, which he intended for the instruction of painters of tapestry cartoons.[8] Probably in conjunction with founding the academy, Sweerts published a series of twelve etchings of *tronies*, bust-length images of men and women, both young and old, in exotic costume and everyday dress, displaying a variety of facial expressions and lighting effects (fig. 1).[9] These drawings were intended as models for the representation of genre "types"; several of the heads recur in Sweerts's own paintings.[10] Sweerts's numerous scenes of artists drawing from nude models or plaster casts in the studio, or from people and monuments *en plein air*, explicitly attest to his ongoing didactic commitment to drawing from the model (fig. 2).[11] Electing to portray himself as a painter during this time, therefore, is consistent with his multivalent interest in the training and status of artists. The image surely involved a degree of self-promotion as well, although it must be said that his academy was not a success. In the Oberlin *Self-Portrait as a Painter*, Sweerts has depicted himself as the gentleman-painter, honoring and ennobling his profession as he sought to impart his knowledge and experience to young artists.

Sweerts reproduced the painting (in mirror image) in an etching inscribed "Michael Sweerts Eq. Pi. et fe." (fig. 3). The artist claimed the title "Eques" (knight) or Cavaliere from as early as 1651, although it is not clear how he might have acquired the title. Sweerts apparently presented the Brussels St. Luke's Guild with a self-portrait in 1660, the year after he joined the Guild.[12] Schaar[13] and others have tentatively identified this work with the Oberlin painting, as an appropriate monument to Sweerts's conception of himself and his profession.

MEW

1. On this painting, see Chiarini 1979.

2. Oil on canvas, 78.7 x 60.3 cm, Milwaukee, collection Dr. and Mrs. Alfred Bader; see Bader 1972; and Bader, Stechow 1974, no. 24. A third "self-portrait" in the Fogg Art Museum (oil on canvas, 66 x 48.3 cm, Cambridge, Fogg Art Museum, The Harvard University Art Museums, inv. 1941.110) was given to Sweerts by Ben Broos (The Hague/San Francisco 1990-91, pp. 444-445) but is probably not by him. The painting is attributed to Jan van Dalem in E. P. Bowron, *European Paintings before 1900 in the Fogg Art Museum* (Cambridge, 1991), pp. 104, 176 ill.

3. Facsimile ed., J. Puraye, *Dominique Lampson. Les effigies des peintres célèbres des Pays-Bas* (n.p., 1956); for an analysis of the text, see J. Becker, "Zur niederländischen Kunstliteratur des 16. Jahrhunderts: Domenicus Lampsonius," *Nederlands Kunsthistorisch Jaarboek* 24 (1973), pp. 45-61.

4. Noted by Broos and Roeding, in The Hague/San Francisco 1990-91, p. 445.

5. Raupp 1984, pp. 96-126, passim; see also Broos and Roeding, in The Hague/San Francisco 1991, pp. 445-446.

6. W. Martin 1907, p. 136.

7. Stechow 1951, p. 211.

8. Wauters 1877, pp. 305-306.

9. *Diversae facies in vsvm iuvenvm et alorvm delineatae per Michael^lem: Sweerts Equit. Pict. etc.* (Brussels, 1656); see J. Bolten, *Method and Practice: Dutch and Flemish Drawing Books 1600-1750* (Landau, Pfalz, 1985), pp. 96-99, 254-255; and Hollstein 1949-, vol. 29 (1984), pp. 128-131, nos. 2-14.

10. Kultzen 1954, vol. 1, pp. 133-135.

11. Bolten 1985, p. 295; see also Waddingham 1976-77 and Kultzen 1982, on Sweerts's atelier paintings.

12. Wauters 1877, p. 306.

13. Schaar 1959, p. 44.

Gonzales Coques

(1614 or 1618-Antwerp-1684)

Paulus Pontius after Gonzales Coques, *Gonzales Coques*, engraving, from Cornelis de Bie, *Het gulden cabinet...*, 1661, fol. 313.

The exact date of Gonzales Coques's birth is not known. De Bie stated that the artist was born in 1618. Van Lerius (1872) claimed to have found record of his baptism in Antwerp Cathedral on 8 December 1614, but Wurzbach suggested that this document referred instead to the artist's sister, Gonzala, and that he was born sometime before 1618. A self-portrait inscribed "Aet.29.1646" was sold in Amsterdam (Mensing), 15 November 1938. Son of Pieter Willemssen Cocx and Anna Beys, Coques altered his given name from Gonsalo to Gonzales after 1643, and his family name from Cocks or Cocx to Coques after 1667. The artist was a pupil of Pieter Brueghel II (1564-1638) in 1626/27, and later, of David Ryckaert II (1586-1642). It has been suggested that Coques visited England before joining the Antwerp guild of St. Luke in 1641. He married Catharina Ryckaert (1610-1674), daughter of his former teacher, in August 1643, two months after the birth of their child, Catharina Gonzalina (d. 1667) – a situation which caused considerable enmity between Coques and his wife's brother, David Ryckaert III (q.v.). The couple's second child, Jacqueline, was born in 1649.

Through the mid- to late 1640s, Coques traveled frequently to the Northern Netherlands, where he worked for the Dutch Stadholder Frederick Hendrick and his wife, Amalia van Solms. He painted portraits and other paintings, acted as agent for the Antwerp art dealer Matthijs Musson, and in 1647 was awarded a gold chain by the stadholder. In the same year he was asked to design ten paintings illustrating the story of Psyche for the stadholder's palace at Honselaersdijk. The prestigious commission turned sour, however, when the sketches (which Coques had subcontracted to Abraham van Diepenbeeck [q.v.]) were found to be copied from Raphael's frescoes for the Palazzo Farnesina. Coques abruptly fled to Antwerp, and for the next several years was involved in a suit brought against him by van Diepenbeeck concerning the payment for these designs.

This scandal notwithstanding, Coques served as dean of the painters' guild in Antwerp in 1665/66 and again in 1680/81, when he was instrumental in defending members' rights to exemption from civic guard duties. He was a member of the rhetoricians chamber "de Violieren" from 1643/44, and from 1661 a member of "de Olijftak." He was court painter to the Count of Monterey, governor of the southern Netherlands, from 1671. Following the death of his first wife in 1674, Coques married Catharina Rijsheuvels in 1675. He died in Antwerp, and was buried in the St. Joriskerk on 18 April 1684.

Nicknamed the "petit Van Dyck" because of his elegant small-scale compositions, Coques was a favored portraitist among patricians and aristocrats in the southern Netherlands, as well as in England, Holland, and Germany. His portraits of individuals show the influence not only of Anthony van Dyck, but also of Dutch masters of the small-scale portrait such as Thomas de Keyser and Gerard ter Borch. His group portraits are delightful fusions of portrait and genre, with figures ranged across a garden terrace or in a richly appointed interior. Coques's touch is lively and richly textured, his palette warm and glowing. In addition to his Flemish followers, among whom were Charles-Emmanuel Biset (1633-1691), François Duchatel (1616-1694), and Gillis van Tilborch (ca. 1625-ca. 1678), Coques's portraits of family groups are closely allied with those by his Dutch contemporary Jan Mijtens (ca. 1614-1670).

Meyssens 1649; de Bie 1661, pp. 316-319, 397-398; Houbraken 1718-21, vol. 2 (1719), p. 40; Weyerman 1729-69, vol. 2 (1729), p. 141; Descamps 1753-64, vol. 2, pp. 262-266; Smith 1829-42, vol. 4 (1833), pp. 251-264, vol. 9 (1842), pp. 582-587; Immerzeel 1842-43, vol. 1 (1842), p. 146; Kramm 1857-64, vol. 1 (1857), pp. 263-264; Michiels 1865-76, vol. 9 (1874), pp. 30-60, 246-255; Rombouts, van Lerius 1872, vol. 1, pp. 635-636, vol. 2, pp. 115, 121, 150, 154, 161, 361, 364-365, 436, 479, 481, 501, 507; Rooses 1879, pp. 581-584; van Lerius 1880, vol. 1, pp. 132-158; van den Branden 1883, pp. 965-973; Unger 1891, pp. 189-190, 206; Bredius 1901, p. 10; Wurzbach 1906-11, vol. 1 (1906), pp. 333-336, vol. 3 (1911), p. 67; Donnet 1907, pp. 290, 324, 415, 428, 446ff; K. Zoege von Manteuffel in Thieme, Becker 1907-50, vol. 7 (1912), pp. 383-386; Cust, van den Branden 1915; Denucé 1932, passim; Slothouwer 1945, pp. 317-318; Denucé 1949, pp. 25, 27, 31; van Gelder 1948-49; van Gelder 1949; Reznicek 1954; Speth-Holterhoff 1957, pp. 165-183; Gerson, ter Kuile 1960, pp. 149, 156; Plietzsch 1960, pp. 199-205; Legrand 1963, pp. 95-101; Brussels 1965, p. 43; de Mirimonde 1967; Duverger 1972a; Drossaers, Lunsingh Scheurleer 1974-76, passim; Paris 1977-78, pp. 58-59; Raupp 1978, pp. 121-128; Peter-Raupp 1980, pp. 84-90, 205-211; de Vuyst 1981; Steadman 1982, p. 3; Filipczak 1987, pp. 126-127, 142-143, 156, 230; Duverger 1984-, vol. 5 (1991), pp. 233-234; Cologne/Vienna 1992-93, p. 393.

Gonzales Coques
58. Portrait of a Family on a Terrace

Oil on copper, 56 x 77 cm (22 x 30 5/16 in.)
Würzburg, Heide Hübner GmbH, inv. 19033

PROVENANCE: collection M. Steinkruys, Antwerp; purchased from this collection by John Smith, ca. 1828; sale John Smith, London (Stanley), 2-3 May 1828, no. 63; collection George Granville Levenson-Gower, second Marquess of Stafford (later Duke of Sutherland); sold by George Granville, second Duke of Sutherland, to W. Morant, 1846; collection J. M. Oppenheim, London; sale Oppenheim, London (Christie's), 4 June 1864, no. 33 [as "The anatomy lesson of Dr. Ruyter"; 115 gns., to Rutley]; collection J. L. Mieville; sale Mieville, London (Christie's), 29 April 1899, no. 59 [as representing "Dr. Ruyter," landscape and animals painted by P. Gysels, architecture by A. Ghering; 300 gns.,˙to Buttery]; collection Sir Joseph B. Robinson, Bt.; sale Robinson, London (Christie's), 6 July 1923, no. 52 [bought in]; by descent to Ida Princess Labia, Capetown; The National Gallery of South Africa, Capetown, on loan (1962-1977); sale London (Sotheby's), 27 November 1963, no. 20 [bought in]; sale London (Sotheby's), 6 July 1966, no. 79 [bought in]; City Museum and Art Gallery, Birmingham, on loan (1977-1981); The National Museum of Wales, Cardiff, on loan (1981-1988); Museum of Fine Arts, Boston, on loan (1988-1989); sale London (Sotheby's), 6 December 1989, no. 104, ill.; P & D. Colnaghi, London; Heide Hübner GmbH, Würzburg.

EXHIBITIONS: London, Royal Academy, The Robinson Collection, 1958, no. 14; Capetown, The National Gallery of South Africa, The Joseph Robinson Collection, 1959, no. 16; Zurich, Kunsthaus, Sammlung Sir Joseph Robinson 1840-1929, 1962, no. 12; London, Wildenstein, Twenty Masterpieces from the Natale Labia Collection (26 April-26 May 1978), no. 9; Brussels/Schallaburg 1991, no. 225; Cologne/Vienna 1992-93, no. 60.1; Antwerp 1992-93, no. 51.

LITERATURE: Smith 1829-42, vol. 4 (1833), p. 257, no. 15; A. Jameson, A Companion to the Most Celebrated Private Galleries of Art in London (London, 1844), p. 204, no. 121; Waagen 1854-57, vol. 2 (1854), p. 71; van den Branden 1883, p. 485; Wurzbach 1906-11, vol. 1 (1906), p. 335; Thieme, Becker 1907-50, vol. 7 (1912), p. 385; Plietzsch 1960, p. 205, note 1; de Vuyst 1981, pp. 253-254; P. Vandenbroeck, in exh. cat. Brussels/Schallaburg 1991, pp. 148 ill., 462; O. Ydema, Carpets and Their Datings in Netherlandish Paintings 1540-1700 (Zutphen, 1991), p. 156; K. Van der Stighelen, in exh. cat. Cologne/Vienna 1992-93, pp. 393-394.

A WELL-DRESSED COMPANY of five people is amicably gathered around a table on the terrace of a sumptuous palace. At the left is a formal garden bordered by trees crowned with wispy foliage; the greenery is carried into the foreground space with large pots of thistles and other leafy plants. Based on details of the women's costume and coiffures, the painting can be dated to about 1670 or slightly later.

Although the identity of the sitters in Coques's portrait is unknown, we can infer much about their status and interrelationships by examining symbolic attributes within the painting.[1] The palatial architecture carries connotations of wealth and position, while the garden at the left probably refers to the popular allegorical tradition of the love garden. Situated before the garden, the couple at the left are either lovers or a married couple, united by their entwined poses and the various symbols surrounding them. The thistles in the pot at the left, for example, are a traditional symbol of fidelity; the ivy-twined tree trunk, a recurring image in marriage portraits, referred to mutual trust and interdependency in a relationship.[2] The pheasants foraging about the pots are also appropriate in this context as a token of sensual love.[3] The seated woman offers a

morsel of food to the parrot perched atop its brass cage. Originally a Mariological symbol, the caged parrot was frequently included in marriage portraits as an attribute of chastity.[4] The significance of the parrot as chastity in the present painting is affirmed by the encircling pose and direct gesture of the man. Finally, the wide-eyed lapdog clasped in the woman's arms – as well as the two other dogs in the composition – is a well known symbol of fidelity.

The relationship between the three people at the right of Coques's portrait, however, is not so clearly defined. The older man seated behind the table is speaking with the man to his left – possibly a visitor, to judge from the cloak draped over his shoulder. Standing between the two men is a woman who holds in her left hand an orange (?) and rests her right hand behind the back of the older man, casually expressing the bond between them. With a slim metal-tipped instrument, the older man points to the roughly spherical object held in his left hand, and seems to be explaining something about it. Unfortunately it is impossible to determine exactly what this object is. An earlier identification of the item as a monkey's skull led to the sitters in the painting being identified as "Dr. Ruyter" and his family.[5] More recently it has been suggested that the object is a piece of pottery[6] or perhaps a chamois-covered pillow used in metalworking and other fine crafts.[7] While the eventual identification of the sitters in Coques's gemlike portrait may indeed revolve around this one puzzling detail, the lack of specificity with which it is painted makes it unlikely that the riddle will be solved.[8] Nonetheless, Coques's Portrait of a Family on a Terrace exquisitely captures the rarefied and idealized ambiance assiduously courted by the elite of the Southern Netherlands during the second half of the century.

In the Portrait of a Family Coques collaborated with at least one other artist, who contributed the architecture in the right half of the composition; the landscape background and the still-life elements at lower left may have been executed by yet a third artist. Earlier authors have suggested Antoon Ghering (d. 1668) as the author of the unusually sumptuous and detailed architectural backdrop,[9] but chronologically and stylistically more convincing is an attribution to Wilhelm Schubert von Ehrenberg (1630-1675), with whom Coques collaborated on other occasions.[10] The present painting shares the precise incised lines and contours characteristic of Ehrenberg's work; compare also the Painting Gallery done in collaboration with Charles Emmanuel Biset and other artists (Munich, Bayerische Staatsgemäldesammlungen, inv. 896; ill. cat. 123, fig. 3).

Gonzales Coques
59. Portrait of a Woman as Saint Agnes

Oil on silver, 18.3 x 14.4 cm (7 3/16 x 5 11/16 in.)
London, The Trustees of The National Gallery,
inv. 1011

Smith and others[11] have convincingly attributed the landscape and animals in the present painting to Peeter Gysels (1621-1690) (q.v.), an artist known for his finely painted small-scale still lifes situated on terraces before parklike landscapes.

MEW

1. The most thorough discussion of the painting is by K. Van der Stighelen, in Cologne/Vienna 1992-93, p. 393, upon which much of the following is based.

2. Similar imagery is included in Rubens's *Self-Portrait with Isabella Brant* of ca. 1609 ("The Honeysuckle Bower Portrait," Munich, Alte Pinakothek, inv. 334; ill. Introduction, fig. 13); see further cat. 44, and the additional paintings and references cited there.

3. The erotic connotations of pheasants, and other game birds are discussed by E. de Jongh in "Erotica in Vogelperspectief: De dubbelzinnigheid van een reeks 17de eeuwse genrevoorstellingen," *Simiolus* 1 (1968-69), passim.

4. On the symbolism of the parrot in seventeenth-century portraits, see E. de Jongh, in Haarlem 1986, p. 145.

5. In sale Oppenheim, London (Christie's), 4 June 1864, no. 33 (see Provenance). Smith (1829-42, vol. 4 [1833], p. 257) was the first to refer to the object as a skull.

6. Paul Vandenbroeck, in exh. cat. Brussels/Schallaburg 1991, p. 462; the author mistakenly sees a paintbrush in the man's other hand.

7. K. Van der Stighelen, in exh. cat. Cologne/Vienna 1992-93, p. 393.

8. K. Van der Stighelen has recently suggested that this painting is the one described by de Bie in *Het Gulden Cabinet* (1662, p. 398) as depicting the family of the Antwerp jeweler and goldsmith Jacques le Merchier with the artist himself seated at the far right. For de Bie's description, see Wieseman.

9. Smith (1829-42, vol. 4 [1833], p. 257) was the first to suggest that Ghering was responsible for the architecture in the present painting.

10. For example, *Picture Gallery in the Former Palais de Granville*, oil on canvas, 116 x 189 cm (Leeuwergem, coll. Baroness Idès della Faille [1957]); Speth-Holterhoff 1957, ill. fig. 66.

11. Smith 1829-42, vol. 4 (1833), p. 257; Plietzsch 1960, p. 205, note 1.

PROVENANCE: sale Comte Charles de Proli, Antwerp (Grange), 23 July 1785, no. 59 [fl. 49; 6 3/4 x 5 pouces]; sale Dr. Thomas Newton and others, London (by private contract), 8 April 1788 and ensuing days, no. 446 [as "Agnes Rubens"]; (possibly) sale Dr. Newton, London, 21-22 March 1794, no. 19 ["A lady's portrait, fine, a miniature, in oil"; not sold]; collection Lord Northwick (1770-1859) by 1858; sale Lord Northwick, Thirlestane House, Cheltenham (Phillips), 23 August 1859, no. 1676 [to Agnew for James Fallows, 84 gns.]; sale James Fallows, London (Christie's), 23 May 1868, no. 162 [to Pearce, 51 gns.]; given to The National Gallery as part of the Wynn Ellis Bequest, 1876.

LITERATURE: Wurzbach 1906-11, vol. 1 (1906), p. 334; Thieme, Becker 1907-50, vol. 7 (1912), p. 385; Plietzsch 1960, p. 203; Wishnevsky 1967, pp. 68-69, 170; London, National Gallery, cat. 1970, pp. 19-21; de Vuyst 1981, pp. 291-293, cat. S86.

Fig. 1. Anthony van Dyck, *Portrait of Mary Villiers as St. Agnes*, 1637, oil on canvas, 186.7 x 137.2 cm, collection of Her Majesty Queen Elisabeth II.

A DELICATE silvery tonality pervades this diminutive likeness of a young woman posed before a classicizing portico. A red brocade underskirt peeps from beneath her white satin gown, which is accented with jeweled clasps and a gauze scarf; she holds a blue shawl wound loosely about her body. The costume and "à la hurluberlu" hairstyle can be dated to about 1680.

The young woman is represented as St. Agnes, with the saint's customary attributes of a lamb and a sword, references to her martyrdom. While this imagery may have been chosen to reflect the sitter's given name (Agnes), it is perhaps more likely that it indicates her marital status, as St. Agnes was the patroness of young women about to be married.[1] Anthony van Dyck's *Portrait of Mary Villiers as St. Agnes* (fig. 1), for example, was painted on the eve of her marriage to James Stuart, Duke of Richmond and Lennox in August 1637 (see cat. 41); in this instance the sitter holds a palm of martyrdom instead of a sword.[2] The miniature scale and costly silver support of the present portrait suggests that it may have been painted as a betrothal gift.

The majestic architectural backdrop of Coques's portrait is based on the garden screen which was designed by Rubens to connect the two wings of his house on the Wapper in Antwerp (see Introduction, figs. 15 and 16).[3] The same setting (with minor alterations) was used by van Dyck in his *Portrait of Isabella Brant* (fig. 2).[4] Coques has inserted a bust of a bearded man (possibly Hercules) in the niche above the central portal, which in van Dyck's portrait is occupied by an oversized scroll.

It has been suggested that Coques incorporated the garden screen from the Rubenshuis in his portrait as an allusion to the sitter's surname – either Rubens, or one of the subsequent owners of the property.[5] Rubens's house was purchased in 1660 by Jacob van Eycke (d. 1670), and in 1680 his widow sold the property to her brother, Canon Hendrick Hillewerve.[6] Hillewerve made some improvements to the house and garden, and in 1684 and 1692 commis-

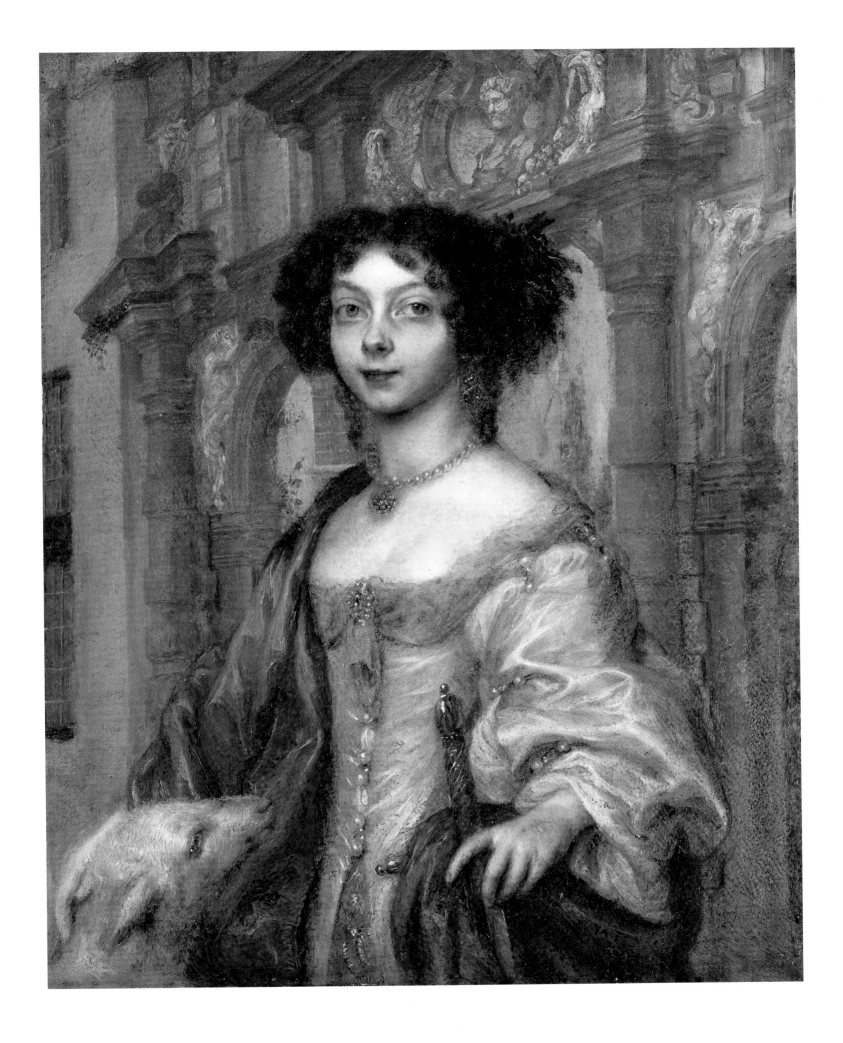

Theodoor Rombouts

(1567-Antwerp-1637)

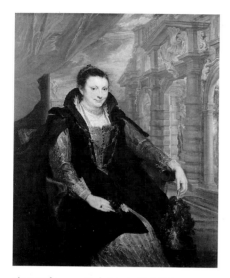

Fig. 2. Anthony van Dyck, *Portrait of Isabella Brant*,
ca. 1621, oil on canvas, 153 x 120 cm, Washington, D.C.,
National Gallery of Art, inv. 1937.1.47.

sioned prints illustrating several views of the property. The young woman depicted in Coques's portrait may have come from the Hillewerve family, although there is no record of a family member named Agnes, and marriage records do not list any family marriages during this period.⁷ Coques may simply have considered the palatial structure an appropriate setting for his elegant likeness.

<div align="right">MEW</div>

1. London, National Gallery, cat. 1970, p. 20.

2. On the van Dyck portrait, see O. Millar, *The Tudor, Stuart and Early Georgian Pictures in the Collection of Her Majesty the Queen* (London, 1963), p. 102, cat. 159.

3. First noted in London, National Gallery, cat. 1970, p. 19.

4. The screen appears also in Jacob Jordaens's *Gods and Nymphs before a Bath*, ca. 1643-1645 (Madrid, Museo del Prado, inv. 1548).

5. In the 1788 sale of the painting, for example, the work was catalogued as a portrait of Agnes Rubens, a fictitious identity concocted from the sitter's attributes and the architectural setting.

6. On the history of the Rubenshuis and its owners, see most recently P. Huvenne, "Het Rubenshuis," *Openbaar Kunstbezit van Vlaanderen* 26, no. 4 (1988).

7. London, National Gallery, cat. 1970, p. 21.

Baptized in Antwerp on 2 July 1567, Theodoor (Theodor) Rombouts was the son of Bartholomeus Rombouts and Barbara de Greve. He was mentioned as an apprentice to Frans Lanckvelt (active 1597-1638/9) in 1608 and later was a student of Abraham Janssens (q.v.). He left for Rome on 7 September 1616, and also visited Florence and in 1622, Pisa. Rombouts was back in Antwerp by 23 February 1625, and became a master in Antwerp. On 20 September 1627 he married Anna van Thielen, sister of the flower painter Jan Philips van Thielen (q.v.); the couple had a daughter, Anna Maria, on 7 August 1628. Together with Gaspar de Crayer (q.v.), Nicolaes Roose, and Joseph Stadius he was commissioned to decorate the triumphal arches for the entry of Cardinal Infante Ferdinand into Ghent. Rombouts had several students including his brother-in-law, Jan Philips van Thielen, and Nicolaes van Eyck. He built his own house and atelier in imitation of Rubens but fell as a result into debt and died soon thereafter at age seventy on 14 September 1637. One month later his wife married the painter Gerard Wery and died in 1639.

A painter of religious as well as allegorical and genre scenes, Rombouts was a Caravaggist in his treatment of the last mentioned. After his return from Italy in 1625 he gradually absorbed the influence of Rubens's softer and more atmospheric later manner as well as that of van Dyck's second Antwerp period. Van Dyck painted a portrait of Rombouts that was engraved by Paulus Pontius for the *Iconography*.

De Bie 1662, p. 163; Houbraken 1718-21, vol. 1, p. 174; Descamps 1753-63, vol. 1, pp. 425-427; Papebrochius ed. 1848, vol. 4, p. 364; Michiels 1865-76, vol. 8 (1869), pp. 351-361; Rombouts, van Lerius 1872, passim; Rooses 1879, pp. 364, 527-531 and passim; van den Branden 1883, pp. 564, 885-890; Caullet 1906-1907; Wurzbach 1906-11, vol. 2 (1910), p. 467; Donnet 1907; von Schneider 1933, pp. 105-109; K. Zoege van Manteuffel, in Thieme, Becker 1907-50, vol. 28 (1934), p. 560; Roggen 1935; Roggen 1949-50; Roggen 1951; Brussels 1965, pp. 163-164; de Mirimonde 1965; Nicolson 1990, vol. 1, pp. 164-167 and vol. 3, ills. 1008-1028; Vlieghe 1990b.

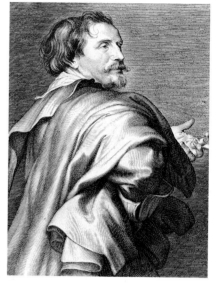

Paulus Pontius after Anthony van Dyck, *Theodoor Rombouts*, engraving, from the *Iconography*.

Theodoor Rombouts
60. Lute Player, ca. 1625-1630

Oil on canvas, 111.3 x 99.7 cm (43 ¾ x 39 ¼ in.)
Signed on tankard at right: TR
Philadelphia, Philadelphia Museum of Art,
John G. Johnson Collection, cat. no. 679

Fig. 1. Theodoor Rombouts, *The Musicians*, ca. 1616-1625, oil on canvas, 200 x 121.3 cm, Lawrence, KS, Spencer Museum of Art, University of Kansas, inv. 50.68.

PROVENANCE: (probably) sale Jean Adriaen Snyers, Antwerp, 4 May 1818, no. 8 ("Théod. Rombouts. Un Joueur de Guitare, il est placé derièrre un table, sur laquelle sont deux recueils de musique, une pinte et un pipe . . . sur toile, 3 pieds 9 pouces, large 3 pieds 3 pouces" [ca. 121 x 105.6 cm]); John G. Johnson collection, Philadelphia (acquired between 1892 and 1913).

EXHIBITIONS: New York, Metropolitan Museum of Art, *A Caravaggio Rediscovered, "The Lute Player,"* 1990, no. 16 (entry by Andrea Bayer), ill.

LITERATURE: Philadelphia, Johnson, cat. 1913, p. 169, Philadelphia, Johnson, cat. 1941, p. 36; M. Hoog, "Attributions anciennes à Valentin," *La Revue des arts: Musées de France* 6 (1960), p. 274; de Mirimonde 1963, pp. 167-168; Philadelphia, Johnson, cat. 1972, p. 732, ill. p. 206; Nicolson 1979, p. 84, pl. 90; Liedtke et al. 1992, p. 358.

SEEN HALF-LENGTH behind a table covered with a bright carpet probably of Turkish origin[1] stands a man who gazes out at the viewer while occupied with the tuning of his lute, an eight-course instrument having a single geometric rosette. He wears a dark violet doublet over white cuffs and a collar. A pleated beret with colorful ostrich plumes rests on his head, enlivening the upper portion of the composition. Before him are two books of music, one opened and resting upon a second closed one, smoking paraphernalia (including a clay pipe), a knife, and an earthenware tankard.

As Bayer has observed, the general design of the composition derives ultimately from Caravaggio's *Lute Player*, known in two versions,[2] with which Rombouts could have become acquainted during his stay in Rome. However, similarities in costume and the overall tenor of the figure's demeanor suggest that representations of single, male lute players by the Utrecht Caravaggisti Dirck van Baburen and Hendrick ter Brugghen are more likely sources for the type.[3] A date in the mid-1620s to about 1630 is likely for the Rombouts.

Rather than being a portrait of a professional lute player, the painting is related to a genre painting tradition that existed in both Italy[4] and the north (cat. 61), which represented figures in theatrical garb with accompanying accessories. Rombouts's œuvre is replete with multifigured "concerts" in which a lutist appears or a lute is included as a supporting motif, as in his life-size *Musicians* (Lawrence, Kansas, Spencer Museum of Art, inv. 50.68; fig. 1) in which the similarities with the Johnson picture of facial type and outlandish dress betray the depiction of a stock character.[5]

The allegorical associations of music with love in its many aspects is a long one in Renaissance and baroque art,[6] and lute players, depending on the context, have been interpreted in both a positive and negative sense.[7] Representations of single female figures tuning a lute, as the man does in the present case, are often found in seventeenth-century Dutch painting, with examples by ter Brugghen, Gerard

van Honthorst, Jan van Bijlert, and Jan Vermeer being well known metaphors for the invitation of love. Emphasizing the importance of Rombouts's figure rendered in the act of tuning his lute, Bayer has recently stressed the likelihood of the present work alluding to the attainment of harmony.[8] Liedtke is credited with suggesting that the canvas may be an admonition to practice temperance because of "the conspicuous alignment of the tuning pegs, tankard, and pipe, along with the stern glance of the musician."[9] It is possible that Rombouts's inclusion of the foreground motifs allows for yet an additional reading. Whereas music books and tankards are not infrequently included by painters in such scenes, the presence of smoking supplies and the knife are rare if not unique in this context. One wonders, therefore, if Rombouts did not intend his composition, at least on some secondary level, as an allusion to the Five Senses: Hearing – the strumming of the lute, Sight – the music books, Smell – the pipe, Taste – the beer, and Touch – the knife, as well as, perhaps, the hand adjusting the tuning pegs.

Copies after Rombouts's *Lute Player* are to be found in Paris,[10] Antwerp,[11] and Dunkerque.[12]

LWN

1. Opinion of John Mills, noted in Museum files, 21 October 1980.

2. St. Petersburg, Hermitage, inv. 217, ca. 1595-96; and in a private collection, ca. 1596-97; see New York 1990, nos. 4 and 5.

3. See Baburen's *Lute Player*, 1622, in Utrecht, and ter Brugghen's *Lute Player*, 162[6 or 8], in Stuttgart; Albert Blankert et. al., *Nieuw Licht op de Gouden Eeuw, Hendrick ter Brugghen en tijdgenoten* (exh. cat. Utrecht and Braunschweig, 1986-87), nos. 36 and 24. Louis Finson's (before 1580-1617) *Lute Player* in Dresden also has much in common with the painting by Rombouts and not inconceivably was known to the younger fellow Fleming; see S. Slive, *Frans Hals*, (exh. cat. Washington, London, Haarlem, 1989-90), p. 168, fig. 14b. For Finson, see the biography by M. J. Bok in exh. cat. Utrecht/Braunschweig 1986-87, p. 257.

4. Among Italian examples are Bartolomeo Passerotti's *Portrait of a Lute Player* of 1576 in Boston, see New York 1990, no. 11; and Annibale Carracci's *The Lute Player Mascheroni* in Dresden (ibid.), fig. 30.

5. For a list of such compositions, see Nicolson 1979, pp. 83-84; for Rombouts's *Musicians* in Lawrence, Kansas, consult A. P. de Mirimonde, "The Musicians by Theodor Rombouts," *Register of the Museum of Art, the University of Kansas* 3 (1965), pp. 2-9; and K. Christiansen, in New York 1990, pp. 47-48.

6. See A. P. de Mirimonde, "La Musique dans les allégories de l'amour," *Gazette des Beaux-Arts* 68 (1966), pp. 265-290, and 69 (1967), pp. 319-346.

7. Compare the overt bawdiness of Honthorst's *Procuress* of 1625 in Utrecht with Molenaer's *The Duet* of ca. 1629-1631 in Seattle (the instrument here more accurately identified as a theorbo) in which the music-making couple may serve as a metaphor for harmony; exh. cat. Utrecht/Braunschweig 1986-87, no. 66, and Philadelphia/Berlin/London 1984, no. 77, respectively.

8. Bayer, in New York 1990, p. 76.

9. As noted by Bayer, in New York 1990, p. 76.

10. Oil on canvas, 70 x 79 cm, Paris, Musée du Louvre, inv. M.I.933; cat. 1979, p. 114, ill.

11. Oil on canvas, 114 x 99 cm, Antwerp, Koninklijk Museum voor Schone Kunsten, inv. 984; de Mirimonde 1965, fig. 13.

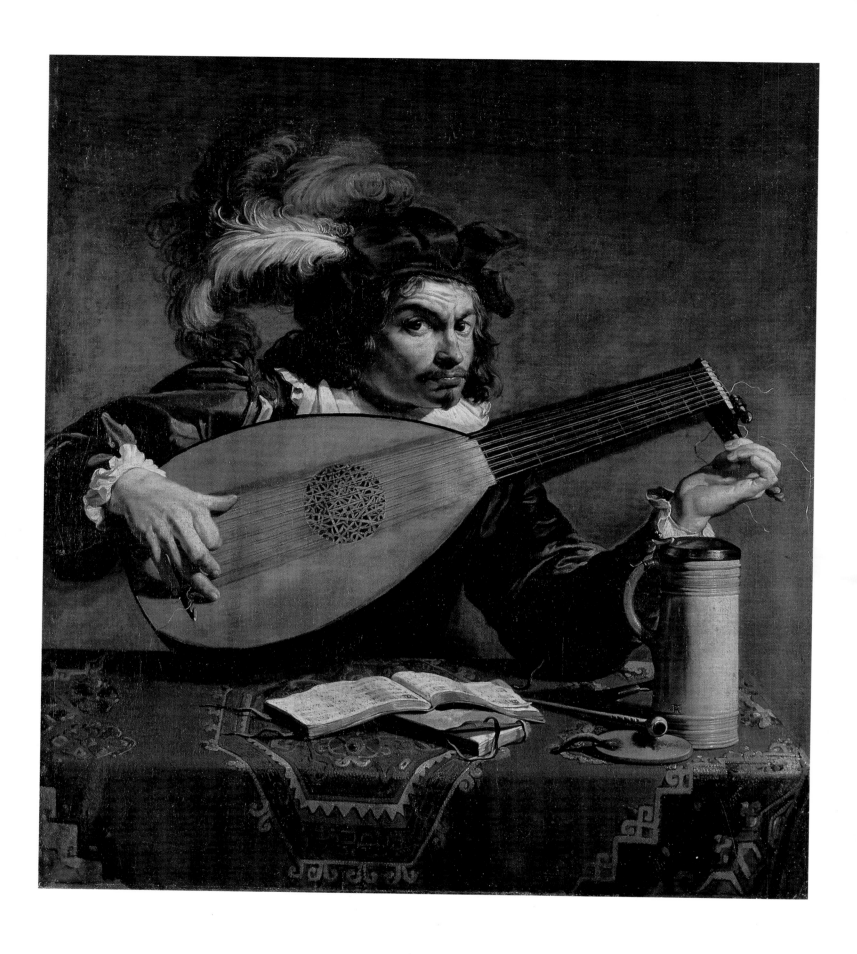

Jean de Reyn

(Bailleul ca. 1610-Dunkerque 1678)

12. Michel Hoog, "Attributions anciennes à Valentin," *La Revue des Arts 6* (1960), fig. 8. Nicolson 1979, p. 84, lists a fourth, presumably also a copy, as being in the collection of Sir William Dugdale, Merevale Hall, Atherstone.

Born in the town of Bailleul near Lille around 1610, by mid-century Jean de Reyn was the leading painter in Dunkerque, which at that time formed part of the Spanish Netherlands. Little is known of de Reyn's training and early career. Descamps states that he was a pupil and assistant of Anthony van Dyck (q.v.) and accompanied him to England in the 1630s, where he remained perhaps until 1640-1641. De Reyn made a brief trip to Paris under the patronage of the Maréchal de Grammont, but had settled in Dunkerque by 1641, when he executed an altarpiece for the Church of St. Pierre in nearby Bergues. De Reyn was twice married: to a widow Willaert in Dunkerque on 24 June 1643; and to Françoise Huys (died 1686) on 17 October 1666. Four children were born of this second marriage. De Reyn resided in Dunkerque for the remainder of his life, and died there on 20 May 1678.

De Reyn painted history paintings – primarily religious scenes – and fashionable portraits of the well-to-do. He executed numerous commissions for churches and religious institutions in Dunkerque and its environs. Many of his compositions were inspired by those of Rubens and van Dyck; he is also reputed to have painted copies of these masters' works. While van Dyck's soft and painterly manner is the dominant stylistic factor in de Reyn's work, the Dunkerque painter also executed paintings with more solid, tactile forms and more sculptural contours, which may be compared to works by Pieter van Mol (1599-1650; in Paris from 1631) and Pieter Franchoys (1606-1654). De Reyn's only recorded pupil was Philippe de Corbehem (1630-1696).

Descamps 1753-64, vol. 2, pp. 189-191; Descamps 1769, pp. 35, 312-314, 316, 318-319, 321-322; Nagler 1835-52, vol. 13 (1843), p. 71; Couvez 1852, passim; Kramm 1857-64, vol. 5 (1861), pp. 1362-1363; Valabrègue 1885; Valabrègue 1887; Wurzbach 1906-11, vol. 2 (1910), p. 531; Lesmarie 1930; Thieme, Becker 1907-50, vol. 27 (1935), p. 259; Baron 1948; Alpers 1977, pp. 248-249; Hairs 1977, p. 33; Lille/Calais/Arras 1977, pp. 103-106; Paris 1977-78, pp. 45-48; Larsen 1985, p. 248; Larsen 1988, vol. 1, p. 492.

Jean de Reyn (attributed to)
61. The Lute Player

Oil on canvas, 157 x 114 cm (62 x 45 in.)
Boston, Museum of Fine Arts, Maria Antoinette
Evans Fund, inv. nr. 34.541

Fig. 1. Jean de Reyn, *Death of the Four Crowned Martyrs*, signed and dated 1640, oil on canvas, 280 x 220 cm, Dunkerque, Church of St.-Eloi.

PROVENANCE[1]: sale [Marquis de Brunoy], Paris, 2 December 1776, no. 23 [as by van Dyck; frs. 6000, to LeBrun]; sale Poullain, Paris, 15 March 1780, no. 34 [as by van Dyck, formerly in the collection of M. de Montmartel; frs. 2406., to M. Le Bas de Courmont]; collection M. de Courmont; sale Lambert and du Porail, Paris, 27 March 1787, no. 62 [as by van Dyck; frs. 1800, to LeBrun]; collection Prince Lucien Bonaparte [as by van Dyck]; (possibly) his sale, London (Stanley), 14/16 May 1816, no. 102 [as by van Dyck, "*A Gentleman playing the Guitar*. To the curious in ancient Costume this Portrait will be very interesting. The Carnations are fine, and the whole in good preservation"; £80]; Marlborough collection; Smith collection (to 1853); Thomas Baring (Earl of Northbrook) collection, from 1853; P. & D. Colnaghi & Co., London, by 1930; purchased by the Museum, 1934.

EXHIBITIONS: London, Royal Academy, 1870, no. 38 (Baring collection); London, Grosvenor Gallery, *Exhibition of the Works of Van Dyck* (1887), no. 5 (Northbrook collection); London, Royal Academy, *Exhibition of Works by van Dyck* (1900), no. 86 (Northbrook collection).

LITERATURE: Smith 1829-42, vol. 3 (1831), p. 84, no. 281 [as by van Dyck]; Waagen 1854-57, vol. 4 (1857), p. 98 [as by van Dyck]; *A Descriptive Catalogue of the Collection of Pictures belonging to the Earl of Northbrook* (catalogue by W. H. James Weale and J. P. Richter, London, 1889), p. 89, no. 128 [as by van Dyck]; Hanfstaengl, *The Masterpieces of van Dyck* (New York, n.d.), p. 46; *Pantheon* 15 (1935), p. 80; "A Recently Acquired Painting of the Seventeenth Century," *Bulletin of the Museum of Fine Arts* 33 (1935), p. 2; de Mirimonde 1967, p. 182.

TWISTED CASUALLY in his chair, an elegant young man peers intently in the viewer's direction as he fingers his lute. He wears a patterned black doublet with slashed sleeves over a white chemise with flat collar and cuffs. His breeches are trimmed with aiguillettes and a band of lace, which fall into his soft boot tops. A black cloak is draped across his left hip. On the basis of the costume, the painting can be dated to the late 1630s or early 1640s. Situated close to the picture plane, the life-size figure dominates the composition; only the suggestion of a doorway at the left further defines the space. The palette, based on shades of brown and gray, is enlivened with the accents of his rosy flesh, white chemise, and brick-red boot tops.

The *Lute Player* was attributed to Anthony van Dyck from its earliest appearance at the Marquis de Brunoy sale in 1776 until the early part of this century, although the solidity of the figure and concise delineation of forms evince little of van Dyck's airy grace.[2] Since then, various artists have been proposed as the author of this work, including the Maître de Ribaucourt,[3] Pieter Franchoys,[4] or an anonymous French artist.[5] The present (and most convincing) attribution to Jean de Reyn was first proposed in 1939 by Charles Sterling[6] and reiterated more strongly in 1983 by Eunice Williams. The crisp execution and sculptural modeling of forms in the Boston painting compare favorably with documented works by the artist, such as his 1640 *Death of the Four Crowned Martyrs* (Dunkerque, Church of Saint-Eloi; fig. 1). Similar portrait compositions in de Reyn's œuvre, focusing on a dynamic, plastic figure against a neutral backdrop include his portrait of

Pierre II Corneille (ca. 1667; Versailles, Musée Lambinet; fig. 2). The proposed dating of the work to the early 1640s is consistent with de Reyn's stylistic development, and thus it may have been painted about the time of his move from England to Dunkerque.

The format of a full-length, life-size figure playing a musical instrument is unusual. Among de Reyn's contemporaries, Theodoor Rombouts also painted life-size figures of musicians, but their exaggerated movements and outlandish dress clearly proclaim them to be theatrical genre figures (see cat. 60). The majority of contemporary portraits of musicians, or figures posed with musical instruments, are three-quarter rather than full-length likenesses, and the sitters hold their instruments rather than actively play them. Compare, for example, Anthony van Dyck's *Portrait of François Langlois* (ca. 1625-1626; London, Viscount Cowdray collection), or his *Portrait of a Young Man with a Chittarone* (ca. 1625-1630; Madrid, Museo del Prado).

It has been suggested that de Reyn's *Lute Player* is a likeness of Jacques Gaultier, a Frenchman who was lutenist at the court of Charles I in England from 1617 to 1647.[7] Despite superficial likenesses, however, an etching of Gaultier by Jan Lievens (ca. 1632-1634) shows an older and rather heavier man, with tousled wiry hair and a double chin (fig. 3). A plausible alternative identification for the sitter has not yet been found.

MEW

Fig. 2. Jean de Reyn, *Portrait of Pierre II Corneille*, ca. 1667, oil on canvas, 127 x 94 cm, Versailles, Musée Lambinet, inv. 41.

1. The accepted provenance of this picture places it in the sales [Mme de Montmartel], Paris, 11 August 1772, and [Lebrun] Paris, 19 January 1778 (both as by van Dyck), although there is no lot of this description in either of these sales.

2. The 1889 Northbrook collection catalogue, though attributing the *Lute Player* to van Dyck, notes: "The figure has more natural, and less artificial, refinement than usual in Van Dyck. The treatment is very masterly, the colours very harmonious, but unusually broken for Van Dyck" (p. 89).

3. This attribution was given to the painting prior to its acquisition in 1934, on the basis of comparison with the *Portrait of a Family* now in Brussels, Musées Royaux des Beaux-Arts de Belgique (formerly in the Ribaucourt collection; inv. 3267). The latter painting is of lesser quality and by a different hand than the Boston picture.

4. Proposed by Jacob Rosenberg (verbally, 1937), and corroborated by Leo van Puyvelde (verbally, 1939) and L. Jacobs van der Merlen (letter dated 16 June 1949). Compare such works as Franchoys's *Drinker* (1639; Brussels, Musées Royaux des Beaux-Arts de Belgique), or *Portrait of a Man in Armor* (Dresden, Gemäldegalerie Alte Meister).

5. J. Byam Shaw (letter dated 7 October 1934, in the Museum files).

6. Note in Museum files. This opinion was also voiced by Ludwig Burchard in ca. 1941 (note on the back of a photo in the Rubenianum, Antwerp).

7. The identification was proposed by Otto Benesch in an [undated] note in the Museum files. A brief biography of Gaultier is found in *Groves Dictionary of Music and Musicians*, vol. 3 (5th ed., 1954), p. 578.

Fig. 3. Jan Lievens, *Portrait of Jacques Gaultier*, ca. 1632-1634, etching, 265 x 212 mm, Amsterdam, Rijksmuseum-Stichting, inv. D 58 III.

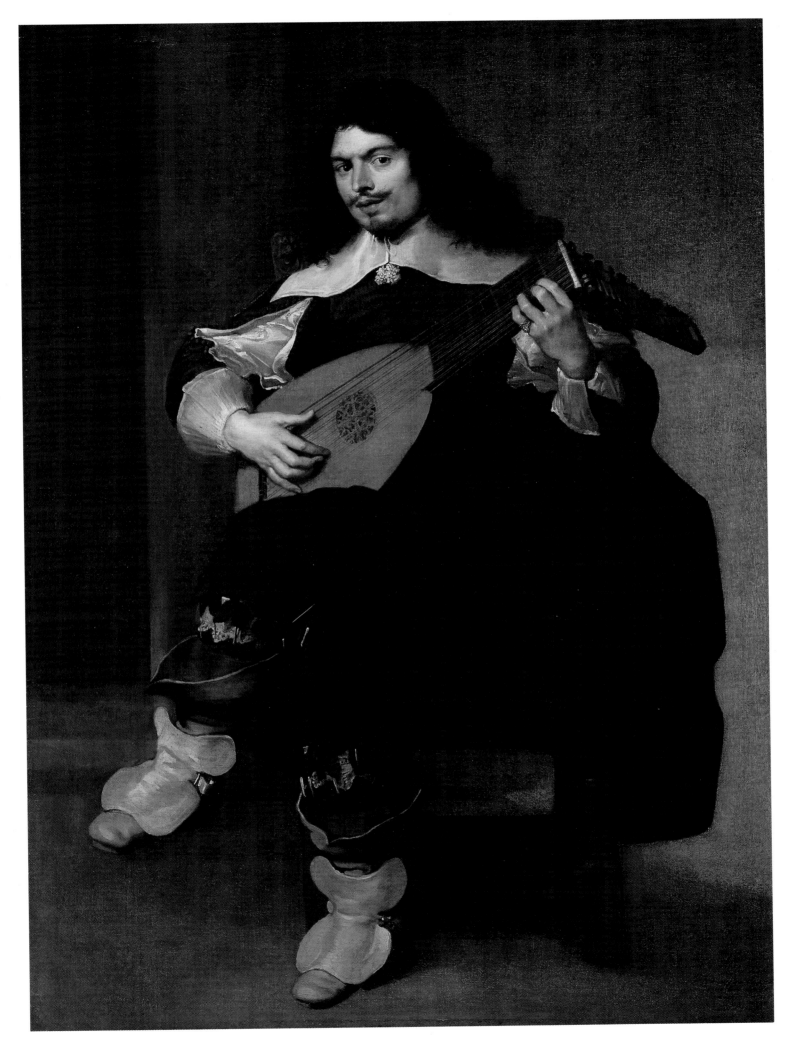

Jan Cossiers

(1600-Antwerp-1671)

Son of the painter Anthoni Cossiers (d. 1646/7) and
Maria van Cleef, Jan Cossiers was baptized in
Antwerp on 15 July 1600. He was a pupil of his father,
and possibly of Cornelis de Vos (q.v.). En route to
Italy in 1623, Cossiers stopped in Aix-en-Provence,
where he collaborated on several paintings for the
Confraternity of Penitents. He is documented in
Rome in October 1624, but little else is known of his
activities there. Cossiers returned to Aix on his way
back to Antwerp in 1626, probably to visit with the
celebrated humanist Nicolas-Claude Fabri de
Peiresc, who recommended the young painter to
Rubens. Cossiers joined the Antwerp guild of
St. Luke in 1628/29, and the rhetoricians chamber
"de Violieren" in 1632/3. He married Jeanne Darra-
gon (d. 1639) on 20 May 1630, and shortly after her
death married Maria van der Willigen on 26 July
1640. Five children were born of the first marriage (of
whom two were alive in 1639), and eleven of the sec-
ond. Both wives also enriched his life with material
goods: through his marriages Cossiers became the
owner of several houses and rental properties in
Antwerp.

Cossiers was elected dean (deken) of the guild of
St. Luke in 1640. Guild records also mention a num-
ber of pupils active in his studio between 1632/33
and 1666/67. Along with several of his colleagues,
Cossiers worked with Rubens on projects for the Tri-
umphal Entry of the Cardinal Infante Ferdinand
into Antwerp in 1635, and on decorations for the
Torre de la Parada in 1637-38. He counted the king of
Spain and the Archdukes Ferdinand and Leopold
Wilhelm among his patrons, and received numerous
commissions from secular and religious institutions
as well, most notably the Church of the Beguinage in
Mechelen. Cossiers died in Antwerp on 4 July 1671.

Cossiers was an eclectic and independent painter,
skilled in a variety of genres and stylistic modes. The
half-length format and deep chiaroscuro of his genre
scenes are clearly indebted to Caravaggio, but this
influence is expressed in a very personal way. His
history paintings are more difficult to categorize,
and reflect a range of stylistic influences through
the course of his career. The Flemish Caravaggesque
manner of Theodoor Rombouts (q.v.) and Gerard
Seghers predominates, but there are traces also of
the more painterly style of Rubens and Jacob
Jordaens (qq.v.).

De Bie 1661, pp. 266-267; Houbraken 1718-21, vol. 1 (1718), p. 235;
Descamps 1769, pp. 114-115; Immerzeel 1842-43, vol. 1, pp. 149-150;
Michiels 1865-76, vol. 9 (1874), pp. 78-83; Génard 1869-76, passim; Rom-
bouts, van Lerius 1872, vol. 1, p. 665; vol. 2, passim; Rooses 1879, vol. 3,
pp. 49-53; Ruelens 1882; van den Branden 1883, pp. 560, 564, 775, 894-899;
Levin 1888, p. 137; K. Zoege van Manteuffel, in Thieme, Becker 1907-50,
vol. 7 (1912), p. 513; Oldenbourg 1918a, pp. 96, 139; Schneider 1933, pp. 109-
111; Labègue 1943, p. 16; Laes 1950; Boyer 1957, pp. 45-46; Brussels 1965,
pp. 44-45; Bodart 1970, vol. 1, p. 71; vol. 2, pp. 20, 97-98; Alpers 1971, pp. 34,
57, 200, 222, 254-256; Jaffé 1971; Martin 1972, pp. 41, 50, 54, 57, 166-169, 173;
Hairs 1977, pp. 31-32; Paris 1977-78, pp. 59-61; Nicolson 1979, pp. 43-44;
Cavelli-Bjorkman 1981, pp. 120-123; Stoffels 1986; Cologne/Vienna 1992-
93, pp. 422-423.

Peter de Jode after Jan Cossiers, *Jan Cossiers*, engraving,
from Cornelis de Bie, *Het gulden cabinet . . .*, 1661,
fol. 267.

Jan Cossiers
62. The Five Senses

Oil on canvas, 113 x 155.5 cm (44 ½ x 61 ¼ in.)
London, Richard Green Gallery

Fig. 1. Jan Saenredam after Hendrick Goltzius, *Sight* (from a series of the Five Senses), ca. 1595-1596, engraving, 176 x 122 mm.

PROVENANCE: sale London (Christie's), 13 March 1987, lot 106, ill.

SIX ELEGANTLY DRESSED men and women, together representing the Five Senses, are grouped around a cloth-covered table in an interior hung with curtains. At the center of the composition, a silver *puntschotel* laden with sweetmeats is set before a young woman in red and green who represents the sense of Taste; she raises a glass of wine to her lips and with her left hand grasps the handle of an earthenware Siegburg jug. On the far right, the sense of Smell is represented by a woman who delicately sniffs a carnation, while a surfeit of pink and white roses fills her lap to overflowing. In the background, an embracing couple enacts the sense of Touch as the man eagerly slips his fingers inside the woman's chemise. The relaxed, velvet-clad figure of the lutenist embodies the sense of Hearing. His black hat casts a stark silhouette against the sunlit opening at the rear of the scene, where a young woman representing the sense of Sight pushes aside the heavy curtain and gestures at the figures within.

From antiquity the Five Senses were conceived as man's way of experiencing his surroundings, and as a crucial link between the micro- and macrocosms. Sensory perception was also the point of departure in classical thought for the theory of the Four Elements. Particularly in the Middle Ages, the senses acquired a moralizing dimension as well; to succumb to sensual temptations was considered a vice, and ideally the senses should be kept firmly in check by reason and virtue. By the seventeenth century, however, the preoccupation with the negative connotations of sensuality was waning in favor of a more empirical interest in the knowledge gained through sensory experience.

The Five Senses enjoyed particular popularity in Netherlandish art during the sixteenth and seventeenth centuries.[1] The earliest images depict the individual senses as abstract personifications with symbolic attributes, as in print series such as those by Cornelis Cort after Frans Floris, of 1561.[2] In Jan Saenredam's series of engravings after Hendrick Goltzius (ca. 1595-1596), each of the Five Senses is illustrated by a couple in what was then contemporary dress, with moralizing inscriptions appended below each image (fig. 1). Goltzius's series was an important step in the development of the Netherlandish tradition of cloaking allegories of the senses in the guise of everyday genre scenes.[3] Representations uniting all Five Senses in a single composition also developed in the graphic arts of the late sixteenth century, for example in prints by Adriaen

Fig. 2. Adriaen Collaert after Adam van Noort, *The Five Senses*, ca. 1590, engraving.

Collaert after Adam van Noort, ca. 1590 (fig. 2); or Jacob Matham after Hendrick Goltzius, dated 1588.[4] In both prints, the senses are represented by allegorical figures rather than persons in contemporary dress, and are accompanied by representations of the Four Elements. Louis Finson's *Merry Company at a Table (The Five Senses)* (fig. 3; Braunschweig, Herzog Anton Ulrich-Museum, inv. 37) is among the first images to include all the senses in a single composition, represented by fashionably dressed figures grouped around a table: the same formula used by Cossiers in his *Five Senses*.[5] The idea of incorporating the Five Senses within a merry company scene flourished in the Southern Netherlands in the seventeenth century in works by Joos van Craesbeeck, David Teniers, Simon de Vos, Theodoor Rombouts, and others (fig. 4).[6]

Although a certain element of moral admonition was implicit in many scenes of the Five Senses, by the seventeenth century this aspect received less and less emphasis in the Southern Netherlands.[7] Indeed negative connotations seem to be completely absent from Cossiers's scene, unless they are residually expressed by the extravagant clothing of the participants.

The attributes which allude to the individual senses in Cossiers's painting are for the most part predictable, and recur with little variation in other contemporary interpretations of the Five Senses. Hearing was almost always represented by music, for example, Taste by food or drink, and Smell by flowers. The only exception is in Cossiers's representation of the sense of Sight. Rather than carrying the customary attribute of a mirror, magnifying glass, spectacles, or reading material (usually a music book), the woman at the left literally embodies the

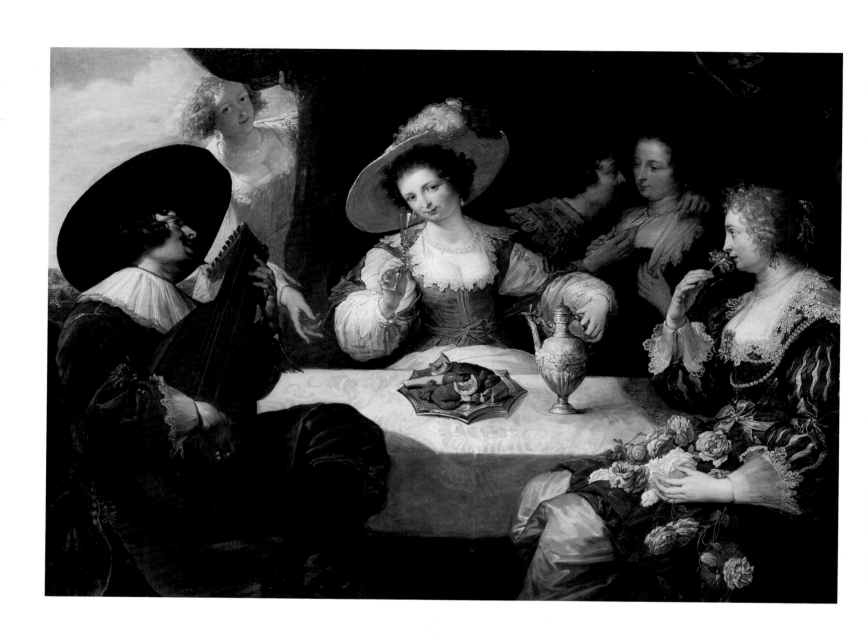

Fig. 3. Louis Finson, *Merry Company at a Table* (*The Five Senses*), oil on canvas, 141 x 189 cm, Braunschweig, Herzog Anton Ulrich-Museum, inv. 37.

Fig. 4. Theodoor Rombouts, *The Five Senses*, oil on canvas, 207 x 288 cm, Ghent, Museum voor Schone Kunsten, inv. s-76.

1. On the representation of the Five Senses in Netherlandish art, see: H. Kauffmann, "Die Fünfsinne in der niederländischen Malerei des 17. Jahrhunderts," in *Kunstgeschichtliche Studien. Dagobert Frey zum 23. April 1943* (Breslau, 1943), pp. 133-157; Chu-tsing Li, "The Five Senses in Art. An Analysis of Its Development in Northern Europe" (unpubl. Ph.D. diss., State University of Iowa, 1955); S. Slive, *Frans Hals* (London, 1970), vol. 1, pp. 78-79; M. Putscher, "Die fünf Sinne," *Aachener Kunstblätter* 41 (1971), pp. 152-173; Amsterdam 1976, pp. 112-115; exh. cat. Braunschweig, Herzog Anton Ulrich-Museum, *Die Sprache der Bilder. Realität und Bedeutung in der niederländischen Malerei des 17. Jahrhunderts* (6 September-5 November 1978), pp. 67-73; Müller Hofstede 1984, esp. pp. 266-271; and C. Nordenfalk, "The Five Senses in Flemish Art before 1600," in G. Cavalli-Björkman, ed., *Netherlandish Mannerism* (Stockholm, 1985), pp. 135-154.

2. Hollstein 1949-, vol. 5, nos. 231-235. See exh. cat. Braunschweig 1978, pp. 68-69.

3. Hollstein 1949-, vol. 8, nos. 380-384. See exh. cat. Braunschweig 1978, pp. 70-72.

4. Jacob Matham after Hendrick Goltzius, engraving, 301 x 207 mm, dated 1588; Hollstein 1949-, vol. 8, no. 238, as part of a series of allegories.

5. On the interpretation of Finson's painting, see: exh. cat. Braunschweig 1978 (see note 1), pp. 67-73 (cat. 10); Müller Hofstede 1984, p. 269; and exh. cat. Utrecht, Centraal Museum and Braunschweig, Herzog Anton Ulrich-Museum, *Nieuw Licht op de Gouden Eeuw: Hendrick ter Brugghen en tijdgenoten* (1986-87), pp. 261-263.

6. Joos van Craesbeeck, *Five Senses* ([formerly] Brussels, collection Arenberg); David Teniers, *Merry Company with the Five Senses*, 1634 (Brussels, Musées Royaux des Beaux-Arts de Belgique, inv. 544); Simon de Vos, *Five Senses* (Copenhagen, Statens Museum for Kunst); Gerard Seghers (attributed), *Five Senses* (ill. de Mirimonde 1965, p. 153; see also p. 155, fig. 31); and Theodoor Rombouts, *Five Senses* (Ghent, Museum voor Schone Kunsten, inv. s-76).

7. See Müller Hofstede 1984, pp. 69-71.

8. Jan Cossiers, *Merry Company* (*The Five Senses*), oil on canvas, 128 x 194 cm, sale London (Christie's) 29 January 1954, lot 150; and Jan Cossiers, *Sight and Taste* (from a series of the Five Senses), sale Vienna (Dorotheum), 30 January 1928, lots 57 and 58.

9. Oil on canvas, 65 x 90 cm; sale London (Phillips), 14 December 1990, lot 33; copies that omit the couple include: oil on canvas, 118 x 160 cm, Havanna, Museo Naçional de Bellas Artes, no. 7-13; and oil on canvas, 61 x 91 cm, sale London (Sotheby's), 26 October 1988, lot 43.

sense of Sight by lifting the curtain to spy upon the gathered company (thus allowing sunlight to illuminate the interior), and engages the viewer to similarly gaze upon the scene.

The Five Senses fits well with Cossiers's other genre scenes of merry companies, card players, smokers, and gypsies grouped around a table and viewed at half- or three-quarter length, although it adopts a lighter palette than his more tenebrous Caravaggesque works. The costume suggests a date in the 1640s. Cossiers painted at least one other representation of the Five Senses in a similar format, and possibly a series of paintings illustrating the senses individually.[8] Several copies or variants of the present painting are known, among them two versions that omit the embracing couple at the rear of the composition.[9]

MEW

Adriaen Brouwer

(Oudenaarde 1605/6-Antwerp 1638)

Isaac Bullaert, one of the artist's earliest biographers, stated that Adriaen Brouwer was born in Oudenaarde in Flanders near the Dutch border, and died in Antwerp at the age of thirty-two. The record of the artist's burial on 1 February 1638 suggests, therefore, that he was born in 1605 or early 1606. He may have first studied with his father (d. 1621/2), a designer of tapestry cartoons in Oudenaarde. The precise date of Brouwer's arrival in Holland has not been determined, but he probably emigrated around 1621, and may have stopped briefly in Antwerp on the way. Houbraken believed that the artist was born in Haarlem, and was a pupil or assistant of Frans Hals (ca. 1582/83-1666) by 1623 or early 1624. Given the dubious nature of Houbraken's other statements about Brouwer's life, his tutelage with Hals must be regarded with skepticism. The first documentary evidence concerning the artist places him in Amsterdam in March 1625, at an inn kept by the painter Barent van Someren (ca. 1572-1632). On 23 July 1626, he was again in the city, acting as a witness to a notarial act concerning a sale of pictures.

Brouwer evidently returned to Haarlem in 1626 and was admitted to the rhetoricians chamber, or amateur literary society, "De Wijngaertranken" (The Vine Tendril), whose motto was *In Liefd Boven Al* (Love above all); Frans Hals was also a member. On 20 March 1627, Pieter Nootmans, poet and director of the society, dedicated a tragedy to Brouwer, hailing him as "the world-famous Haarlem painter." Other contemporaries, including Mathijs van den Bergh (1617-1687), also called Brouwer a *Haarlemensis* (native of Haarlem).

During the winter of 1631-1632 Brouwer was in Antwerp, where he was admitted to the guild of St. Luke and accepted Jean Baptiste d'Andois (Jan Baptist Dandoy) as a pupil. On 4 March 1632, he stood witness in Antwerp to authenticate a number of paintings attributed to him. Van Dyck (q.v.) included him in his *Iconography*, a series of portraits of famous artists, scholars, and statesmen; and inventories reveal that both Rembrandt (1606-1669) and Rubens owned several of his works. Despite the admiration of his colleagues, however, Brouwer had financial problems, and de Bie's claim that he often paid his bills with quick sketches from life in the taverns he frequented is borne out by several notarial acts. In the summer of 1632 his mounting debts necessitated an inventory of his effects.

According to a document dated 23 February 1633, Brouwer was arrested and confined to the citadel at Antwerp, possibly for a tax debt, although early biographers attributed the arrest more directly to his dissolute life. A record from 23 September shows that Brouwer was still imprisoned. The date of his release is unknown, but on 26 April 1634 he was living on the Everdijstraat in Antwerp, in the house of the engraver Paulus Pontius. In the same year he joined the Antwerp rhetoricians chamber "de Violieren." On 1 March 1636 he signed a document together with the painters Jan Lievens (1607-1674) and Jan Davidsz. de Heem (q.v.). The cause of Brouwer's early death remains unknown. He was buried in the church of the Carmelite monastery at Antwerp.

Prized by his contemporaries for his innovative subject matter and technical virtuosity, Brouwer was the most influential figure in the development of low-life genre painting in The Netherlands – both north and south – in the seventeenth century. He was the first artist to dramatically alter or revise the tradition of peasant painting that had been created a century earlier by Pieter Breugel the Elder (before 1525-1569). His expressive and unapologetically earthy portrayal of peasant life was instrumental in the formation of scores of artists. His influence is most keenly felt in the works of Adriaen (1610-1685) and Isack (1621-1649) van Ostade, Pieter de Bloot (1601-1658), Cornelis Saftleven (ca. 1607-1681), and Hendrick Sorgh (1609/11-1670) in the north; and Joos van Craesbeeck, David III Ryckaert, David II Teniers (qq.v.), and Gillis van Tilborch (ca. 1625-ca. 1678) in the Southern Netherlands. In addition to genre scenes, Brouwer also painted a handful of portraits and landscapes.

Boetius Schelte à Bolswert after Anthony van Dyck, *Adriaen Brouwer*, engraving, from the *Iconography*.

Schrevelius 1648, pp. 455-466; de Bie 1661, pp. 91-95, 399; Félibien 1666-88, vol. 4, p. 92; Sandrart 1675-79, pp. 174-179; van Hoogstraeten 1678, pp. 15, 67, 87; Félibien 1679, p. 50; Bullaert 1682, vol. 2, p. 487-489; Houbraken 1718-21, vol. 1 (1718), pp. 318-333; *Levensbeschryving* 1774-83, vol. 1 (1774), pp. 194-200; Immerzeel 1842-43, vol. 1 (1842), pp. 104-106; Raepsaet 1852; Blanc 1854-90, vol. 1 (1854), p. 525; Kramm 1857-64, vol. 1 (1857), pp. 170-171; Nagler 1858-79, vol. 1 (1858), pp. 146, 191; Siret 1859; Michiels 1865-76, vol. 9 (1874), pp. 160-168; van der Willigen 1870, p. 346; Rombouts, van Lerius 1872, vol. 2, pp. 22, 29, 31, 66, 78, 90; Schmidt 1873; Mantz 1879-80; van den Branden 1881a; van den Branden 1881b; van den Branden 1882-83; Bode 1883, pp. 208-213; van de Branden 1883, pp. 847-863; Bode 1884a; Bode 1884b; Unger 1884; Ephrussi 1884-85; de Permentier 1885; Schlie 1887; de Mont-Louis 1895; Wurzbach 1906-11, vol. 1, pp. 193-201; Donnet 1907, pp. 215, 217-218; Schmidt-Degener 1908a; Schmidt-Degener 1908b; Hofstede de Groot 1908-27, vol. 3 (1910), pp. 557-667; F. Schmidt-Degener in Thieme, Becker 1907-50, vol. 5 (1911), pp. 74-75; Friedländer 1918; Bode 1922; Bode 1924; Schneider 1926-27; Schneider 1927; Drost 1928; Reynolds 1931; de Graaf 1937; Böhmer 1940; van Puyvelde 1940a; van Gelder 1940-41; Vermeylen 1941; Hollstein 1949-, vol. 3, pp. 246-249; Valentiner 1949; Höhne 1960; Salinger 1960; Trautscholdt 1961; Knuttel 1962; Legrand 1963, pp. 125-127 et passim; Gudlaugsson 1964; Rosenberg, Slive, ter Kuile 1966, pp. 110-112; Stechow 1966, pp. 173-174, 179-180; Ruurs 1974; Amsterdam 1976, pp. 54-57; New York/Maastricht 1982, pp. 9-20, 32-53; Scholz 1982; Haak 1984, pp. 237-238; Philadelphia/London/Berlin 1984, pp. 161-167; Scholz 1985; Renger 1986; Vlieghe 1986; Wind 1986; Raupp 1987; Renger 1987; Cologne/Vienna 1992-93, pp. 415-418.

Adriaen Brouwer
63. *Tavern Yard with a Game of Bowls*

Oil on panel, 40.6 x 61 cm (16 x 24 in.)
Monogrammed AB in ligature on the bowl
at the right
Anonymous private collection

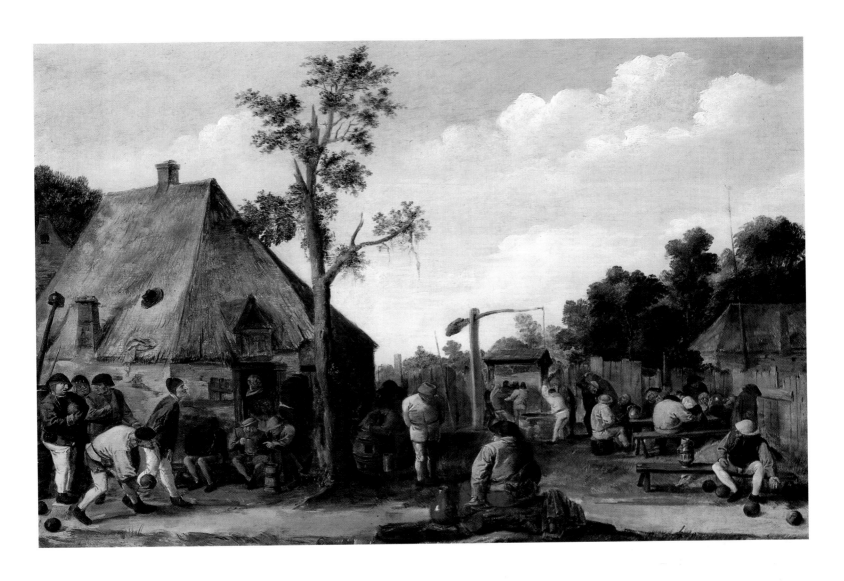

PROVENANCE: sale The Hague (Van Marle & Bignell), 6 June 1944, no. 7, ill.; Menton collection, Aerdenhout; G. van Trijt, Amsterdam; G. Meyer, Amsterdam; acquired by present owner in 1985.

ACROSS THE FOREGROUND of the open yard of a tavern a half-dozen peasants play bowls on a dirt alley. Players prepare to bowl at the far left and a man in a cap seated on a bench in the far right gestures toward the bowls. In the immediate foreground, a figure with his back to the viewer is seated on a log with a jug beside him. At the left, about a dozen figures assemble before a thatched tavern beneath a tall and sparsely foliated tree. At the back right, other peasants gather at a table to drink, carouse, and quarrel. In the back center figures draw water from a well and others help a drunken member of their party home through a covered gateway.

This unpublished painting appears to be a very early work by Adriaen Brouwer. The slightly caricatured, squat figure types, and the palette (the combination of pink, violet, yellow, and rose with earth colors) may be compared to the other works that are assumed to date from the artist's first period, such as *Inn with Drunken Peasants* (The Hague, Mauritshuis, no. 847, on loan from the Rijksmuseum, Amsterdam) and *Fighting Peasants* (The Hague, Mauritshuis, no. 919, on loan from the Rijksmuseum, Amsterdam; fig. 1), *The Pancake Baker* (Philadelphia Museum of Art, John G. Johnson collection, no. 68), the *Peasant Feast* (Zurich, Kunsthaus, Ruzicka Stiftung, cat. 1949-50, no. R4), and the *Tavern Interior* (Rotterdam, Museum Boymans-van Beuningen, no. 1102).[1] The monogram reappeared on the bowl at the far right when the picture was cleaned recently, and appears faintly in a photograph (at the Rijksbureau voor Kunsthistorische Documentatie, The Hague) that

was taken at the time of the painting's sale in 1944. Brouwer painted several other images of outdoor tavern scenes with figures playing bowls, including a fully signed painting in an upright format in the museum in Brussels (no. 2854),[2] and with smaller figures playing bowls with a ring in an open horizontal landscape in Berlin.[3] A copy of the present painting with very nearly the same dimensions but with much more foliage on the central tree was sold by H. P. Piefersz in Wassenaar, 25 February 1936, no. 6, ill.[4]

The theme of bowls was treated earlier in village festivals and kermesses depicted in German sixteenth-century woodcuts by Barthel Beham and Hans Sebald Beham, where it often was coupled with gambling that results in knife fights[5]; and by Pieter Bruegel and his followers.[6] The patrons of the tavern in the present work are well behaved relative to the mortal combats and brawls in which they often engage (compare Brouwer's *Fighting Peasants*, fig. 1). Craesbeeck (see cat. 71) and other Brouwer followers repeatedly depicted the quarrels and deadly disputes that arose outside taverns. Later painters like Teniers also took up the bowls and skittle themes, but typically in more decorous surroundings and featuring better company (see cat. 67).[7]

PCS

1. Compare also the outdoor *Village Scene with Men Drinking* attributed to Brouwer in the Thyssen-Bornemisza collection, Madrid, no. 1930.10 (see cat. by I. Gaskell, *Seventeenth-Century Dutch and Flemish Painting. The Thyssen-Bornemisza Collection* [London, 1989], cat. no. 42, ill). This painting is difficult to assess because of condition problems but may also be an early work by Brouwer.

2. Signed "Brouwer," panel, 25.5 x 21 cm, Musées Royaux des Beaux-Arts de Belgique, Brussels, inv. no. 2854.

3. Monogrammed, panel, 23.5 x 33.5 cm, Staatliche Museen zu Berlin, Gemäldegalerie, no. 853J; see *Gemäldegalerie Berlin Gesamtverzeichnis der Gemälde* (Berlin, 1986), p. 223, no. 473; and Bode 1924, p. 22, fig. 88. There also is a very freely executed landscape with a game of bowls uncertainly attributed to Brouwer that was on the London art market in the late 1940s (dealer Graupe, London, 1948); panel, 26.8 x 35.8 cm (10 x 14 in.), previously in the sale London (Christie's), 18 December 1936, no. 106; and with dealer A. Goldschmidt, London, 1937.

4. Panel, 42 x 63 cm, with dealer D. Vaartier, Rotterdam, 1934; A. van Welie, The Hague, ca. 1935. This picture or the present painting may be the picture that was seen by C. Hofstede de Groot in the collection of W. C. Escher-Abegg, Zurich, in August 1919 (see the Hofstede de Groot "fiches," in the Rijksbureau voor Kunsthistorische Documentatie, The Hague) and described as "Vroeg schilderij; kleurig, 30 figuurs, boeren speelen boccia. Met de karakteristieke bleekpaarse, lichtgeele, roode en grijze tinte in de kleeren en blauwgroene boomen. Niet heelemaal fijn genoeg. Ik durf er niet op aan." ("Early painting, colorful, 30 figures, peasants playing *bocci* [bowls]. With the characteristic lavander, light yellow, red and gray tints in the clothing and blue-green trees. Not entirely good enough. I can't verify the attribution.") A painting described as "Peasants Playing Bowl in the Yard of an Inn," panel, 12 x 21 in., appeared in the Henry Haworth Sale, London, 14 December 1923, no. 30. There also was a painting assigned to Brouwer and described only as "Landscape, Playing Bowls," which was exhibited by G. H. Hibbert at the British Institution, London, 1818, no. 105.

5. See Barthel Beham's *Country Fair* and Hans Sebald Beham's *Great Country Fair* of 1539 and "*Dance of Noses at Gimpelsbrunn*"; repr. in Max Geisberg, *The German Single-Leaf Woodcut 1500-1550*, vol. 1 (New York, 1974), pp. 130-132, 236-237.

6. See the variant of a bowls game in the foreground of Bruegel's well-known print of *The Fair at Hoboken* (Bartsch no. 208; repr. in H. A. Klein, *Graphic Worlds of Pieter Bruegel the Elder* [New York, 1963], no. 23), which carries admonitory Flemish verses about the peasants' foolish entertainments and habit of getting "blind-drunk like beasts."

7. Close in conception to the present work is the image of skittles players arranged horizontally in the foreground of a tavern courtyard in a painting in a private collection; see New York/Maastricht 1982, p. 23, fig. 17.

Fig. 1. Adriaen Brouwer, *Fighting Peasants*, oil on panel, 25.5 x 34 cm, The Hague, Mauritshuis, inv. 919, on loan from the Rijksmuseum, Amsterdam.

Adriaen Brouwer
64. Barber-Surgeon Performing a Foot Operation, ca. 1631

Oil on panel, 31.4 x 39.6 cm (12 ⅜ x 15 ⅝ in.)
Munich, Bayerische Staatsgemäldesammlungen,
Alte Pinakothek, inv. 561

Fig. 1. Adriaen Brouwer, *The Back Operation*, oil on panel, 34 x 27 cm, Frankfurt, Städelsches Kunstinstitut, inv. 1050.

Fig. 2. Adriaen Brouwer, *Allegory of the Sense of Touch*, oil on panel, 23.1 x 20.3 cm, Munich, Alte Pinakothek, inv. 581.

PROVENANCE: collection Johann Wilhelm, Elector Palatinate (1716), Düsseldorf; no. 139 in the 1730 inventory of the Düsseldorfer Galerie ("Ein Barbier so einem patienten verbindet"); transferred in 1730 from Düsseldorf to Mannheim and in 1780-1781 to Munich.

EXHIBITIONS: Munich 1986, no. 6.

LITERATURE: Dezallier d'Argenville 1745-52, vol. 3 (1752), p. 193; van Gool 1750-51, vol. 2 (1751), p. 564; van den Branden 1883, p. 853; Bode 1884, pp. 42-44; Wurzbach 1906-11, vol. 3 (1911), p. 198; Hofstede de Groot 1908-27, vol. 3 (1910), p. 573, no. 37; Bode 1924, p. 84; Reynolds 1931, pp. 30-32, 62; Höhne 1960, pp. 59f.; Knuttel 1962, pp. 107-109; New York/Maastricht 1982, pp. 12-13; Munich, cat. 1983, pp. 97-98; Munich 1986, pp. 38-39, 48-50, 106-107, 131; Renger 1987, pp. 274-275, 277-278.

A PLAINLY DRESSED traveler has solicited the ministrations of a village barber-surgeon for his injured foot. The man's cap, pack, and walking stick are tossed on the floor behind him; his discarded left shoe is tucked beside him on the seat. The surgeon crouches before his patient, his red hat pulled low over his eyes. He peers eagerly at the wounded foot and pokes at it with a sharp instrument, eliciting from the unfortunate patient an audible gasp and a face contorted with pain. Leaning over a brazier balanced on the arm of a chair, an old crone hovers behind the pair, readying a poultice for the wound. Her attention is momentarily distracted by the man who enters through the door at the left. Beside a fireplace at the right rear of the scene, a second barber shaves his customer by the dim light of a diamond-paned window. This man may be a roving musician, to judge by the hat and lute or mandolin on the table before him. A cat slumbers atop the foot-warmer at his feet. On shelves throughout the room are glass flasks and other attributes of the surgical profession, including a skull. The traveler's stick at the left and the broom at the right frame the composition and define the pictorial space.

The use of strong local colors – the traveler's blue breeches, the surgeon's red cap – shows an affinity with works from the artist's early Haarlem period (mid-1620s), but the thinner, more scattered application of these colors indicates a somewhat later date for the work.[1] In modeling forms the artist utilizes areas of ground showing through his brushstrokes; in fact in some areas the painting seems almost subsumed by the earthen brown ground. The cool, delicate tonalities of more thickly painted areas, such as the head and torso of the patient, are also characteristic of near-contemporary works by Adriaen van Ostade, and scholars have posited an influence from Brouwer to his younger Dutch colleague.[2] In light of this relationship, Bode,[3] Renger,[4] and others have suggested that the present painting (along with other similar works such as the *Fight over Cards* also in the Alte Pinakothek, Munich) may have been executed at the close of Brouwer's Haarlem period, or just

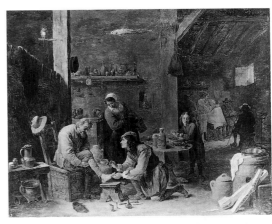

Fig. 3. David Teniers the Younger, *The Village Barber-Surgeon*, oil on panel, 55.5 x 69 cm, signed lower right: D.TENIERS.FEC; Kassel, Gemäldegalerie Alte Meister, inv. GK 147.

after his return to Antwerp in ca. 1631-1632, when he could still have been working in a style developed in Holland. Typical of works from this period is a delicate, refined brushwork; Bode likened the fineness of paintings like the *Barber-Surgeon* to works by Gerrit Dou or Frans van Mieris, although their individual techniques are quite dissimilar.[5]

There is a long tradition of representations of charlatans, quack doctors, and dentists plying their trade at fairs and markets.[6] To some extent Brouwer relies on the formal conventions of these pictures, which almost uniformly present the doctor as a risible charlatan and the patient as ignorant fool.[7] In his depictions of doctors and barber-surgeons, however, Brouwer focuses specifically on the surgeon's actions and their spontaneous effect upon his patient. This is seen most strongly in Brouwer's later representations of village barber-surgeons at work, in which he reduces the composition to just a few figures placed close to the picture plane, as for example in the Frankfurt *Foot Operation* and *Back Operation* and the Munich *Allegory of the Sense of Touch* (figs. 1, 2).[8] Although the present painting presents a more detailed and well-defined interior, the narrative of the scene is nonetheless fully played out in the facial expressions of the two key protagonists: the secondary figures of the barber and his client, or the next patient coming through the door at the left, exist primarily to localize the actions of the surgeon and his anguished victim. In the sense that Brouwer's painting is principally an illustration of painful sensation, the *Barber-Surgeon Performing a Foot Operation* is allied more with allegories of the Five Senses than with traditional representations of doctors and their patients.[9]

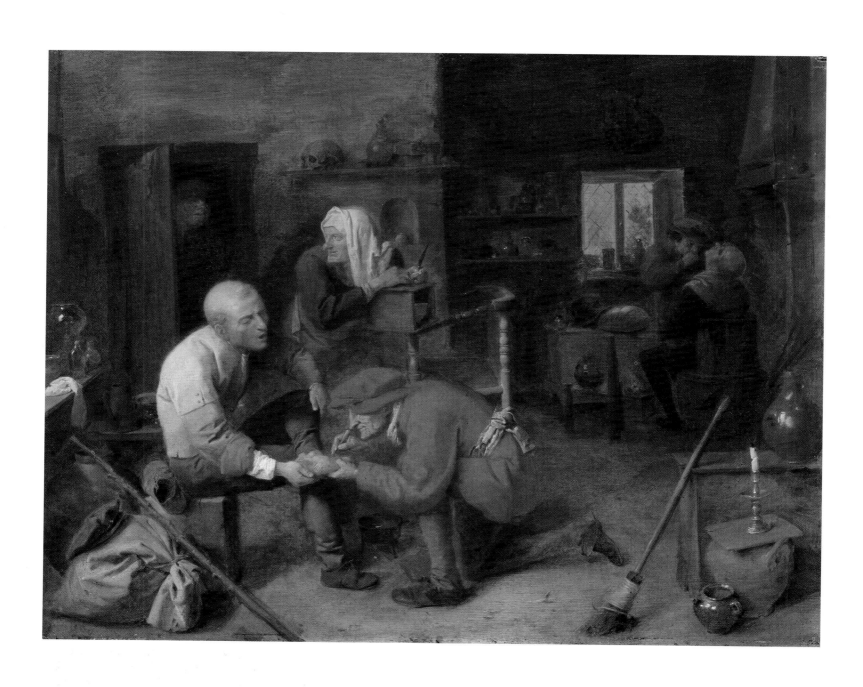

Adriaen Brouwer
65. Tavern Scene

Oil on panel, 48 x 76 cm (18⅞ x 29⅞ in.)
Signed on top step, below woman's skirt: A. Brouwer
Private collection

The understated skill of Brouwer's achievement in characterization and facial expression is made all the more conspicuous by comparing this painting with similar works by his followers, for example David Ryckaert III (Valenciennes, Musée des Beaux-Arts, inv. 46.1.392), and David Teniers the Younger, who painted several versions of this subject.[10] In a version in Kassel (fig. 3), Teniers also adduces the secondary scene of a barber shaving a customer, but the surgeon in the foreground of the scene applies a healing potion to his patient's wound, rather than actively excising it. Little can be learned from the figures' rather neutral expressions, and Teniers's scene becomes a "harmless painting of the social scene."[11]

MEW

1. For a detailed analysis of Brouwer's stylistic development see Renger, in Munich 1986, pp. 47-52, esp. p. 49; and on the artist's technique, H. von Sonnenburg, in Munich 1986, pp. 103-112.

2. Renger, in Munich 1986, p. 49. Houbraken states that Brouwer and Ostade studied together in the studio of Frans Hals in Haarlem, although there is no conclusive proof for this (Houbraken 1718-21, vol. 1, p. 319).

3. Bode 1924, p. 84.

4. Renger, in Munich 1986, p. 49.

5. Bode 1924, p. 84.

6. On the theme of charlatans and quack doctors in Netherlandish art see exh. cat. Amsterdam 1976, nos. 16, 30, 59 and 61; Lyckle de Vries, "Jan Steen 'de Kluchtschilder'" (Ph.D. diss. Groningen, 1977), pp. 91-98; and exh. cat. Philadelphia/Berlin/London 1984, nos. 59 and 105, all with further literature. The theme of "lovesickness" in Netherlandish (particularly Dutch) art has received more specialized study by Jan Baptist Bedaux and Einar Petterson, among others.

7. Raupp 1987, p. 242.

8. Renger, in Munich 1986, p. 38.

9. Ibid., p. 39.

10. In addition to the painting in Kassel, there are closely related works in the Szépművészeti Múzeum, Budapest (signed and dated 1636; oil on panel, 46 x 63 cm, inv. 565) and in a private collection (signed and dated 1678; oil on canvas, 39.5 x 47 cm); both reproduced in exh. cat. Antwerp 1991, nos. 14 and 93, respectively.

11. Renger 1987, pp. 277-278.

PROVENANCE: possibly owned by the artist Dirck Bleker, Amsterdam, before 1658 (see commentary and note 11); F. Boursault, Paris, whose collection was bought as a whole by H. Arteria in 1838 for E. Higginson of Saltmarsh Castle, cat. 1842, no. 61; sale Edmund Higginson, London, 4 June 1846 (£127, to Lake); Sir Hickman Bacon, Gainsborough, by 1890 (see Exhibitions); on loan to The National Gallery, London, from 1907 until 1988; by descent to Sir Edmund Bacon, Raveningham Hall; by descent to the present owner.

EXHIBITIONS: London, Corporation of London, Guildhall Art Gallery, Loan Collection of Pictures, 1890, no. 65; London, Burlington Fine Arts Club, Exhibition of Pictures by Dutch Masters of the Seventeenth Century, 1900, no. 45.

LITERATURE: Higginson collection, cat. 1842, no. 61; Hofstede de Groot 1908-27, vol. 3 (1910), pp. 586-587, no. 69; Bode 1917, p. 322; Bode 1924, pp. 156-159, 181-182, fig. 110; London, The National Gallery, Catalogue (London, 1929), p. 43; Gerson 1960, p. 144, pl. 128B; Knuttel 1962, p. 111, fig. 69, pl. IX; O. Benesch, Master Drawings in the Albertina. European Drawings from the 15th to the 18th Century (Greenwich, CT, 1964), under cat. 156; K. Renger, in Munich 1986, pp. 10, 51, 71, 123, notes 15 and 23; A. Blankert, Museum Bredius, Catalogus van de schilderijen en tekeningen (The Hague, 1978), p. 36, under cat. 26; 2nd ed., 1991, p. 56, under cat. 26.

A MAN seated in a tub chair on a low platform beneath a window at the left of a tavern interior tries to put his hand up a young woman's skirt. She counters by grabbing his arm and pulling his hair. He cries out but does not desist. A jug has toppled over and beer spills down the steps of the platform. From a small shuttered window in the wall above, a peasant peeps down at the couple. To the right six more peasants gather around the fireplace to smoke, drink, and laugh at the couple's roughhousing. Two of their number sit with their backs to the ruckus and converse with a drinker whose white cap may indicate that he is the tavern owner, while three stand at the back and cackle. At the lower right is firewood, a barrel, and a ceramic pitcher, above right, a shelf with brass pots and a hatchet and rag hanging on the wall, together with candles suspended by their wicks. The timbers of the ceiling beams enhance the spatial recession.

This is one of Adriaen Brouwer's largest and most animated paintings. It has probably been correctly dated by Bode and Knuttel to the artist's later career, or after 1631/32 when he returned to Antwerp from the Netherlands.[1] It displays the more naturalistic figure type, the increasingly descriptive touch, and the greater use of a unifying atmosphere and tone that Brouwer developed in his mature years, no doubt partly in response to Dutch genre painters. However none of his Dutch counterparts, including Frans Hals, had Brouwer's talent for vivid characterization of peasant figures on a small scale. The heavily slack form of the drinker grinning like a simian on the right, or the couple who grapple with such alarming earnestness on the left, capture a coarse vitality no longer glossed by caricature as in earlier peasant paintings. The vividness of Brouwer's achievement is made clear by comparison with a

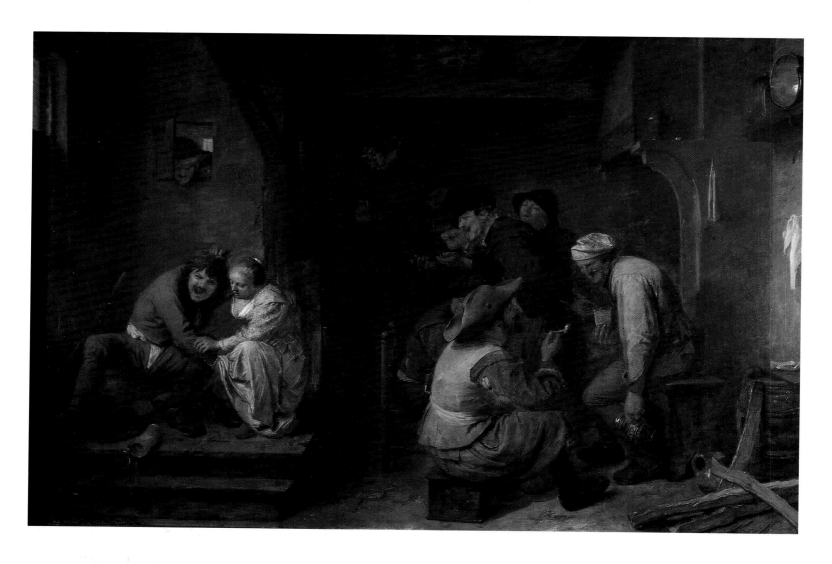

painting of a similar subject once thought to be by Brouwer (fig. 1), indeed regarded by Knuttel and others as a precursor of the present painting, but which is now correctly (albeit still tentatively) re-assigned to the Rotterdam painter and Brouwer follower, Pieter de Bloot.[2] In the latter painting the figures revert to creatural anonymity and stereotypes of the lower classes.

Despite this greater degree of nauralism, Brouwer's image remains closely wedded to earlier pictorial and iconographic traditions of depicting low life. As Renger and Raupp have demonstrated, the romantic view of Brouwer as a modern bohemian *avant la lettre*, uncritically recording the bumptious life of an underworld in which he himself lived is surely a fiction; it ignores not only the pictorial but also the long literary and philosophical precedents for a satirical view of the peasantry, in which the figures became exemplars of human depravity, carnality,

and foolishness, designed to educate a higher class of viewer.[3] The couple at the left, for example, has a long ancestry in tavern and drinking scenes. However in the nineteenth century their grappling was censored, not only with polite bowdlerization (the Guildhall Gallery exhibition catalogue of 1890, no. 65, refers to "a man and a woman disagreeing") but also by literal editing out; Hofstede de Groot mentioned matter-of-factly in 1910 that "the offensive passage is repainted,"[4] and Bode in 1924 explained that the "objectionable part" was over-painted to make the picture "presentable in a salon [or parlor]" ("um das Bild salonfähig zu machen"). In the illustration in the latter's book, the man's hand no longer is under the woman's dress but clutches her breast.[5]

Couples often embrace in rough lovemaking in earlier sixteenth-century Northern prints, drawings, and paintings depicting the Effects of Intemperance,

Fig. 2. Hans Sebald Beham, *Peasant Lovers with a Spectator (Procuress)* from the series "The Peasant's Feast," engraving, 46 x 36 mm, Cambridge, Harvard University Art Museums, Fogg Art Museum, Gift of Charles Bain Hoyt, acc. no. M3032.

Fig. 1. Pieter de Bloot, *Tavern Scene*, panel, 27 x 35 cm, The Hague, Bredius Museum, no. 26.

Fig. 3. Adriaen Brouwer, *Tavern Scene*, pen and wash on paper, 140 x 183 mm, Vienna, Albertina, inv. no. 9033.

the Prodigal Son squandering his inheritance, and in representations of Lust or Unchastity in series on the Seven Deadly Sins. However the exceptionally gross gesture of the man putting his hand up the woman's skirt is exclusively that of drunken peasants (see fig. 2)[6] and fools.[7] Naturally the woman's gesture of pulling the man's hair had long been associated with wrathful women (see, for example, Erhard Schön's woodcut of 1530 with popular broadsheet entitled *The Twelve Properties of an Insanely Angry Wife*[8]; it may be significant that the gesture survived in scenes of incensed wives discovering their husbands with prostitutes, as in Jan van Bijlert's painting dated 1626, Herzog Anton Ulrich-Museum, Braunschweig, cat. 1983, no. 188). In her elegant satins the woman is unusually well dressed for the rude company that she keeps and, like prostitutes as depicted in other paintings of the period, seems fully capable of defending herself. Renger implied that he believed

that the present work could be the work by Brouwer described as "een Bordeeltken" (a little bordello) that Brouwer had already begun painting when mentioned in an Antwerp notarial document of 12 February 1635.[9]

Less persuasively, Bode also speculated that the present work could be the picture briefly described in Rubens's estate inventory as "De Jaloersche Boer" (the Jealous Peasant), because of the appearance of the peasant poking his head through the little window to spy on the couple from above.[10] This more speculative provenance aside, it seems quite possible that the present work could be identical with one mentioned in two documents of 1658 in the Amsterdam archives, discovered by Abraham Bredius and wrongly associated with his own painting (our fig. 1), which was owned by Dirck Bleker and described as "door Adriaen Brouwer, Konstryck schilder . . . een vrouwtje, dat een maneetje oneerlijk wierde angetast" (by Adriaen Brouwer, the artful painter . . . a woman who is dishonorably attacked by a man).[11]

Bode identified a drawing (fig. 3; *not* in Dresden's Kupferstichkabinett, as he claimed) as Brouwer's preparatory compositional study for the present painting.[12] However, Knuttel felt that the drawing was not of sufficient quality to be by the master himself and might only be a copy of a lost version of the painting.[13] The subtle changes from the drawing to the painting, such as the elimination of the man who leans out the window at the far left, the figure peering around a wood partition at the back center, and the dog in the lower center, as well as the peasant in the small window at the upper left improve the composition, and thus could not, as Knuttel observed, be the inventions of a copyist. The weaknesses in the sheet, most conspicuous in the figures on the right, support the assumption that it may be a copy of a lost drawing by Brouwer, but it seems highly unlikely that there ever existed an autograph painting that was such a close variant of the present design.

PCS

1. See Bode 1924, p. 156; Knuttel 1962, p. 111.

2. Ibid.; for the attribution to Pieter de Bloot, see A. Blankert, *Museum Bredius, Catalogus van de schilderijen en tekeningen* (2nd ed., Zwolle, 1991), cat. 26, ill.

3. See Renger in Munich 1986, pp. 19-44; and Raupp 1987, pp. 225-251.

4. Hofstede de Groot 1908-27, vol. 3 (1910), p. 587, no. 69.

Adriaen Brouwer
66. A Fat Man, ca. 1634-1637

Oil on panel, 23 x 16 cm (9 x 6 ¼ in.)
The Hague, Royal Cabinet of Paintings Mauritshuis, no. 607

5. Bode 1924, p. 156, fig. 110.

6. See F. W. H. Hollstein, *German Engravings, Etchings and Woodcuts*, vol. 3 (Amsterdam, n.d.), pp. 94-95, nos. 166-177, ill.

7. See, for example, the couple of a fool and a woman on the extreme right of Hans Sebald Beham's large moralizing print of the *Banquet of Herod*; Hollstein, *German Engravings*, vol. 3, p. 180, reproduced in M. Geisberg, *The German Single-Leaf Woodcut: about 1500-1550* vol. 1 (New York, 1974), pp. 160-161, nos. G179-180.

8. For illustration and discussion of this and other such mysoginistic prints, see K. Moxey, *Peasants, Warriors and Wives. Popular Imagery of the Reformation* (Chicago and London, 1989), pp. 115-118, fig. 5.16. Hair pulling is a female tactic in brawls of peasant couples at least as early as prints by the Housebook Master.

9. Renger, in Munich 1986, p. 10.

10. Bode 1924, p. 158, "276 Le paysan jaloux," reprinted and annotated in Muller 1989, pp. 140. This peasant was wrongly identified as an old woman in The National Gallery *Catalogue* (London, 1929), p. 43.

11. See Gemeentearchief Amsterdam, Prot. Not. P. van Buytene, N.A.A. no. 2748, fol. 753; and Prot. Not. W. van Veen, N.A.A. no. 2874B, fol. 1607; quoted in full by Blankert 1991, under no. 26.

12. See Bode 1924, pp. 156, and 181-182, fig. 109.

13. Knuttel 1962, p. 114, note 1, fig. 69. The drawing is accepted as a preparatory work for the present painting by Otto Benesch, (1964), no. 156, ill.

PROVENANCE: (probably) sale Paris, L[apeyrière], 14 April 1817, no. 16 [fr. 150, to Perignon][1]; acquired from the dealer Dowdeswell, London, in 1897.

EXHIBITIONS: Delft, Stedelijk Museum "het Prinsenhof," *De Schilder en zijn wereld* (19 December 1964-24 January 1965; also shown at Koninklijk Museum voor Schone Kunsten, Antwerp, 6 February-14 March 1965), no. 18, fig. 27; New York/Maastricht 1982, no. 11; Cologne/Vienna 1992-93, no. 69.4, ill.

LITERATURE: Schmidt-Degener 1908b, p. 53, ill.; Hofstede de Groot 1908-27, vol. 3 (1910), no. 229; Bode 1924, pp. 22, 164, fig. 6; Schneider 1927, p. 154, ill. p. 153; E. J. Reynolds, *Some Brouwer Problems* (Lausanne, 1931), p. 53, pl. 30; Höhne 1960, p. 50, pl. 20; Knuttel 1962, pp. 159, 183, pl. XII; H. van Hall, *Portretten van Nederlandse beeldende Kunstenaars* (Amsterdam, 1963), p. 50, no. 4; J. Buyck, "Aantekeningen bij een zoogenaamd 'zelf portret' van Adriaen Brouwer in het Mauritshuis," *Nederlands Kunsthistorisch Jaarboek* 15 (1964), pp. 221-228, fig. 1; P. J. J. van Thiel, "Marriage Symbolism in a Musical Party by Jan Miense Molenaer," *Simiolus* 2 (1967/68), p. 94; The Hague, Mauritshuis, cat. 1977, p. 51, no. 607; Raupp 1984, pp. 320-321; Lyckle de Vries, "Tronies and Other Single Figure Netherlandish Paintings," *Leids Kunsthistorisch Jaarboek* 8 (1989), p. 190.

A STOUT, casually dressed man is viewed half length and nearly frontally, his head turned to the viewer's left. His right hand is stuck in his open coat; his left hand is not visible. He has unkempt brown hair, a thin beard, and a mustache. His brown jacket, fastened by three buttons at his chest, reveals his white shirt at the open neck and at a triangle on his substantial stomach. In the background is a glimpse of a sketchily brushed dune landscape with a walking couple.

Since this painting emerged early in this century, the attribution to Brouwer has never been questioned and all authors who have discussed its dating agree that the free and loose technique suggests that it is a late work, painted as late as ca. 1634-1637. Schmidt-Degener, Hofstede de Groot, Bode, Knuttel, van Hall, and Raupp claimed that the painting was a self-portrait,[2] while Schneider, Klinge, and Renger rejected the assumption,[3] and E. J. Reynolds implausibly suggested that the sitter was Gerard Seghers.[4] The portraits of Brouwer by van Dyck (fig. 1) and Jan Lievens (fig. 2), and the self-portrait that was reported by J. C. Weyerman to appear in *The Smokers* by Brouwer (see Introduction, fig. 64) offer no compelling support for identifying the sitter in the Mauritshuis painting as the artist.[5] Despite the fact that the sitter's features differ, many authors have insisted on identifying the work as a self-portrait no doubt in part because the image seemed to accord so well with Cornelis de Bie's well-known poetic description of Brouwer and his art in 1661,[6] and Sandrart's claim (1675), "er sich durch seine lustige Natur, die zum Possenreissen und Lustreden nach Art des Diogenes Cinici geneiget, fast bey jedermann beliebt gemacht."[7] Bode even suggested that the sitter's neglectful attire accords with the simple clothes listed in the 1632 inventory of Brouwer's posses-

Fig. 1. Boetius Schelte à Bolswert after Anthony van Dyck, *Adriaen Brouwer*, engraving, from the *Iconography*.

Fig. 2. Jan Lievens, *Portrait of Adriaen Brouwer*, drawing, Paris, Fondation Custodia (Collection F. Lugt).

Fig. 3. Lucas Vorsterman, after A. Brouwer, *Luxuria*, etching.

sions.[8] However, with the modern consciousness of the legacy of errors that have resulted from the biographical fallacy in art, we must question whether the painting depicts Brouwer in his literary persona of the "Diogenus Cynicus."

More historically significant for the subject's identification is the fact that, as Hofstede de Groot first observed, a copy of the present picture was sold as part of a series of the *Seven Vices* in Paris in 1902.[9] In the sale catalogue the copy was identified as a personification of the sin of Luxuria. As Buyck first observed in discussing the Mauritshuis painting, the depiction of Vices in the form of genre figures was a pictorial tradition to which Brouwer made important contributions; for example, in a print series by Lucas Vorsterman, the inscription on which claims that Brouwer designed the originals, the figure Luxuria is represented by a half-length image of a bearded man with one hand shoved in his coat, but with a wineglass in the other, standing before a landscape (fig. 3).[10]

The inscription on the print is an implicit admonition: "Een teuge rijnschen wijn hef ic seer geren op:/ Hy sinckt tot inde broeck, al steijght ij na de kop" (A draft of Rhine wine I'll gladly hoist/ It descends to my belly then climbs to my head).[11] The resemblance between the painting and the print is not entirely congruous; despite the shared gesture, the gentleman in the latter is far better dressed and actually holds a wineglass. Susan Koslow has discussed in depth depictions of the sin of Acedia (sloth or idleness) and related representations of the phlegmatic temperament – images which often depicted genrelike figures with one or, more commonly, both arms wreathed across the body and hands stuck in the bosoms of their garments.[12] She did not include the *Fat Man* in her considerations, but pointed out that one of the exceedingly drunk and dozing patrons in Brouwer's early *Tavern Scene* owned by the Rijksmuseum (no. A64; on loan to the Mauritshuis, The Hague, no. 847) also buries his hand in his jacket. Thus while the warning against the self-indulgent behavior of the vices of either Luxuria or Acedia might be deduced from the fat man's idle and unkempt appearance, in the absence of proof that it belonged to a larger series, and considering the fact that the image departs from the canonical iconography of the various vices we cannot assume that it functions either metaphorically or as a personification.[13]

PCS

1. "Un précieux échantillon, représentant un homme vu à mi-corps, ayant la main dans sa veste. La tête, qui est très-fine de touche et de couleur, se détache sur un fond de paysage." Copies of the Mauritshuis painting were in the sale Mrs. Percy Mitford et al., London, 28 April 1919, no. 113; and sale Graf Lassus, Berlin, 17 April 1928, no. 49.

2. Schmidt-Degener 1908, p. 53; Hofstede de Groot 1908-27, vol. 3 (1910), p. 662, no. 229; Bode 1924, pp. 22, 164; Knuttel 1962, pp. 159, 183; van Hall (1963), p. 50, no. 4; and Raupp 1984, p. 320.

3. Schneider 1927, p. 148; Klinge, in exh. cat. New York/Maastricht 1982, no. 11, ill.; Renger, in Munich 1986, p. 39, and in Cologne, Vienna 1992-93, p. 418.

4. Reynolds 1931, p. 53.

5. J. Campo Weyerman (1729-69, vol. 2, p. 69) mentioned that Brouwer painted a "historiestuk" (which could mean not only a history painting but also any figure painting with a narrative) with portraits of the painters de Heem, Cossiers, and himself sitting down to drink and smoke. The work is today identified with the painting in New York; for discussion see Schneider 1927, p. 149f; Knuttel 1962, pp. 23, 96; Liedtke in New York, Metropolitan, cat. 1984, vol. 1, pp. 5-10; and Renger in Munich 1986, p. 17, note 55.

6. de Bie 1661, p. 91: "Hij heeft altijdt veracht al 's wereldts ijdel goet. / Was traegh in 't Schilderen, en milt in het verteren. / Met 't pijpken in den mont in slechte pis-taverne, / Daer leefden sijne jeught, schoon hij was sonder gelt / Ghelijk hij was in 't werck, so droegh hij in 't leven." ("He always scorned the world's vanity. / He was slow in painting and spent money generously. / With pipe in his mouth in foul taverns, / There he spent his youth, completely out of money / He lived the life he painted.")

7. See Sandrart, Peltzer 1925, p. 174: "Because of his merry nature, which was inclined to buffoonery and humorous stories in the style of Cynical Diogenes [Diogenes Cinici], he was liked by almost everyone."

8. Bode 1924, p. 164. De Bie (p. 91) wrote "Sijn verstant was soo groot / dat hy onder den deckmantel van spotsghewijse / redenen en manieren / de sotte dulheydt des wereldts wist aen jeder te ontdecken." (His knowledge was so vast that he was able to reveal to everyone the drunken stupidity of the world, under the cloak of satirical [illustrations of] proverbs/sayings and manners.)

9. Sale J. Lenglart of Lille, Paris (Hôtel Drouot), 10 March 1902, nos. 21-27 as attributed to Joos van Craesbeeck; Hofstede de Groot 1908-27, vol. 3 (1910) p. 662. Other copies of this popular image are in the museums in Besançon (no. 49) and Le Puy, and the collection of J. Seymour Maynard, London (1935).

10. Buyck 1964, pp. 221-228. Raupp (1984, p. 320) also mentions a woodcut by Cornelis Anthonisz. (called Theunissen) from the year 1544 showing a peasant with his hand under his jacket (A. Grosjean, "Toward an Interpretation of Pieter Aertsen's Profane Iconography," *Kunsthistorisk tidskrift* 43, nos. 3-4 [1974], p. 126, fig. 6).

11. Hollstein 1949-, vol. 3, p. 249, nos. 111-123.

12. See S. Koslow, "Frans Hals's *Fisherboys*: Exemplars of Idleness," *The Art Bulletin* 57, no. 3 (1975), pp. 418-432.

13. See Renger, in Antwerp/Cologne 1992-93, p. 418.

David Teniers the Younger

(Antwerp 1610-Brussels 1690)

Pieter de Jode after David Teniers the Younger,
David Teniers the Younger, engraving.

Baptized in Antwerp on 15 December 1610, David Teniers was the son of as well as father of painters of the same name. David Teniers the Elder (1582-1649), an art dealer and painter of small-scale history paintings, was his son's first teacher. Even as a youth, Teniers the Younger was attracted to very different subjects than his father, above all rustic genre and some "high-life" scenes. He became a master in the Antwerp guild in 1632/33, and dated his first paintings in these years. On 22 June 1637, he married Anna Brueghel (1620-1656), the daughter of Jan Brueghel (q.v.) and moved into his father-in-law's house "De Meerminne" (the Siren) on the Lange Nieuwstraat. In the 1640s Teniers prospered and was able to rent (and would later, in 1662, buy) a manor-farmhouse called "Dry Toren" (Three Towers) near Perck, between Mechelen and Vilvorde. In 1645 he became a dean of the Antwerp guild. In these years he also enjoyed the patronage of Antonius Triest, Bishop of Ghent, and in 1647 received his first commission from the newly appointed govenor of the southern Netherlands, Archduke Leopold Wilhelm. In about 1657 Leopold Wilhelm named Teniers *Ayuda da camara* (chamberlain); he had assumed the duties of court painter in Brussels upon the death of his predecessor, Jan van den Hoecke (1611-1651). Teniers was also made director of Leopold Wilhelm's painting collection, a post that sent him to London in 1651 to buy Italian paintings from the collection of Charles I at Whitehall. During the same year, 1651, Teniers painted interior views of the archduke's gallery (Brussels, Musées Royaux des Beaux-Arts, no. 2569; and Madrid, Museo del Prado, no. 1813; see also cat. 124). He later made small copies of Leopold Wilhelm's Italian paintings to serve as models for engravers (see cats. 126, 127, 128); finished in October of 1656, four months after Leopold Wilhelm's departure from the Netherlands, the 244 engravings appeared as the celebrated *Theatrum Pictorium Davidis Teniers antverpiensis*, published under the supervision of David's brother Abraham.

Teniers remained court painter to the new governor, Don Juan of Austria, until 1659, fulfilling commissions and also, according to Descamps, teaching Don Juan to draw and paint. He also worked for Philip IV of Spain and perhaps more unexpectedly, for Willem II, stadholder of the Northern Netherlands. An application in 1649 for elevation to the rank of nobility apparently went unrequited, but Teniers was later granted a family coat of arms. After the death of his first wife, he was married in 1656 to Isabelle di Fren (1624-1686), daughter of the secretary of the Council of Brabant. With the consent of the local St. Luke's Guild and King Philip IV of Spain,

Teniers opened an art academy in Antwerp in 1665. An unusually prolific artist, he continued to date paintings at least as late as 1680. He died in Brussels on 25 April 1690.

Together with his mentor, Adriaen Brouwer (q.v.), David Teniers the Younger was the most important seventeenth-century Flemish painter of low-life genre scenes. In addition, he painted history and mythological subjects and allegories (Five Senses, Four Elements, etc.). Besides his specialty in peasant subjects, he painted a few high-life scenes and various lower-class professions, including barber-surgeons, alchemists, quacks, and charlatans. In the tradition of Hieronymus Bosch he painted witches and demons and images of the temptation of St. Anthony. Teniers also popularized a curious form of humorous genre painting that substitutes monkeys for human figures (see Freedberg, fig. 3). His landscapes are descended from those of Paulus Bril and Joos de Momper (qq.v.). Especially in his mature career, he collaborated with other artists, including Jan van Kessel the Elder and Jan Davidsz. de Heem (qq.v.). An enormously prolific and long-lived artist, Teniers had many followers whose weak imitations of his art have obscured the high quality of the autograph œuvre. In addition to the numerous prints which disseminated his compositions, tapestries were woven from his designs.

Theatrum Pictorum 1660; de Bie 1661, pp. 334-339; de Piles 1699; Houbraken 1718-21, vol. 1, pp. 345-347; Weyerman 1729-69, vol. 2, pp. 89-91; Descamps 1753-64, vol. 2, pp. 152-169; Smith 1829-42, vol. 3 (1831), pp. 247-502, vol. 9 (1842), pp. 405ff, 813, 848ff; Immerzeel 1842-43, vol. 3 (1843), pp. 130-132; Kramm 1857-64, vol. 6 (1864), pp. 1609-1612; Pinchart 1860; Simillion 1863-64; Vermoelen 1865; Michiels 1865-76, vol. 7 (1869), pp. 428-464, vol. 8 (1869), pp. 3-51; Michiels 1869; Rombouts, van Lerius 1872, vol. 2, pp. 35, 41-42, 124, 127, 140, 149, 153, 165, 169, 191, 209, 275, 312, 546; Rooses 1879, pp. 588-603 and passim; van den Branden 1883, pp. 981-1003; Bode 1884; London 1884; Marès 1887; von Frimmel 1892-93; Rosenberg 1895; de Pauw 1897; Wauters 1897; Wurzbach 1906-11, vol. 2 (1910), pp. 693-698; Donnet 1907, pp. 244, 268, 311, 425; Schellekens 1912; Peyre 1913; Bode 1918; Boquet 1924; Bautier 1926a; Eekhoud 1926; Marillier 1932; Minnaert 1932; Schneider 1933; K. Zoege von Manteuffel in Thieme, Becker 1907-50, vol. 32 (1938), pp. 527-529; Grancsay 1946; Valentiner 1949; Speth-Holterhoff 1957, pp. 127-160; Edman 1958; Vlieghe 1959-60; Gerson, ter Kuile 1960, pp. 5, 144-148, 156, 165, pls. 130-131, 135, 143; Smolakaya 1962; Legrand 1963, pp. 127-129; Brussels 1965, pp. 257-264; Vlieghe 1966; Garas 1967; Martin 1968; Klinge-Gross 1969; Valentiner 1969; London 1972; Rye 1972; Florence 1977; Davidson 1978; Dreher 1978a; Dreher 1978b; Leppert 1978; Davidson 1979; M. Klinge, in Brussels 1980, pp. 251-258; Schütz 1980; New York/Maastricht 1982; Klinge 1990; Antwerp 1991; Madrid 1992; Cologne/Vienna 1992-93, pp. 380-387, 410-411, 430-433, 550-551 et passim.

David Teniers the Younger
67. Dice and Skittles Players in a Tavern Courtyard

Oil on panel, 38 x 61 cm (15 x 24 in.)
Signed lower right: D.TENIERS F.
London, private collection

PROVENANCE: Rothschild family collection, England, since the middle of the nineteenth century; with Thos. Agnew & Sons, London, 1951, from whom it was acquired by the present owner.

EXHIBITIONS: London, Agnew's, 35 Masterpieces of European Painting, December 1946, no. 4; Brussels 1980, no. 205, ill.; New York/Maastricht 1982, no. 26, ill.; Norwich, Norwich Castle Museum, Dutch and Flemish Paintings in Norfolk, 10 September-20 November 1988, pp. 115-116, no. 61, ill.; Antwerp 1991, pp. 106-107, no. 30, ill.

LITERATURE: (possibly) Dubois de Saint-Gelais 1727, p. 115; La Galerie du Duc d'Orléans au Palais Royal, vol. 2 (Paris, 1801), as Teniers, no. VIII; Buchanan, 1824, vol. 1 , p. 189; Smith 1829-42, vol. 3 (1831), no. 338; Waagen 1837-38, vol. 1 (1837), p. 519; Waagen 1854-57, vol. 2 (1854), p. 503; Casimir Stryienski, La Galerie du Régent Philippe Duc d'Orléans (Paris, 1913), p. 191, no. 518.

IN THE COURTYARD of an inn, a company of five men and a woman have gathered around a wooden table. At the end of the table, at the left an old man in black with a black skull cap takes a wide-legged stance as he prepares to toss the dice. The assembled party looks on in interest. At the far left, the innkeeper brings a jug and plate of food; behind him a man with his back to the viewer stands in the doorway of the tavern. Before a crude plank fence at the back right a man plays skittles as two of his fellows and a woman in a doorway look on.

This painting is one of many by Teniers of common folk gaming in the rustic courtyard of an inn. His conception of the dicing game in both secular and religious subjects (see, for example, Teniers's *Dice Game*, Amsterdam, Rijksmuseum, no. C300; and the two versions of the *Soldiers Gaming as St. Peter is Freed from Prison*, Dresden, Gemäldegalerie Alte Meister, no. 1077; and London, Wallace Collection, no. P210)[1] is ultimately derived from Adriaen Brouwer's *Dicing Soldiers* (fig. 1). However, as Klinge has observed, Teniers characteristically expresses his own artistic personality by conveying the excitement and tension of the game more in the figures' faces than through their actions.[2] Teniers's tonality also typically is lighter and more silvery, his palette more delicate, and his touch crisper than Brouwer's tenebrous mature works.

Klinge has also correctly dated the present painting to the 1640s.[3] It may have originated in the middle of the decade since it closely resembles in style and facture several works dated 1644, including the so-called *"Le Bonnet Rouge"* (Wrotham Park, England), *"Le Bonnet Blanc"* (private collection) and the *Feast of the Prodigal Son* (Paris, Musée du Louvre, inv. no. 1878). The last mentioned is also set in the courtyard of an inn but naturally includes more elegantly dressed figures.[4]

Like dicing, the game of skittles or ten pins was depicted repeatedly by both Brouwer (see cat. 63) and Teniers.[5] The object in Dutch skittles was to try to knock over the kingpin without disturbing the rest, or to knock over the others and leave the kingpin standing.[6] It is not clear what sort of dicing game is played in the present painting. Smith described the game in a version or copy of this painting as "odd or even"[7]; similarly, another version was sold with the John Penrice collection (London), 6 July 1844, no. 12, as *"Par ou non Par."* Church authorities predictably disapproved of dicing, cards, and other games of chance, just as they condemned tavern visits (see Introduction); however religious leaders soon reconciled themselves to the fact that such pastimes were probably ineradicable. Indeed priests began using metaphors from games in their sermons (one of which was called "Het Geestelyck Kaert-spel" – The Spiritual Cardgame), while the Church fathers had long since discovered in the sixteenth century the utility of lotteries for building campaigns such as the one which constructed the Sint Jakobskerk in Antwerp.[8]

The assumption that the present work once belonged to the duc d'Orléans was long accepted, indeed even by Klinge herself.[9] However, she has now concluded that the present painting cannot be identical to the Orléans version, which was recorded as on canvas and of different dimensions and format, and must, therefore, like four other known variants and/or copies, be derived from the present painting, which she correctly regards as the primary version.[10] It is worth recalling William Buchanan's characterization in 1824 of the qualities of Teniers's art in his memoirs of the Orléans collection, if only to observe an English gentleman's patronizing *apologia* within the tradition that we have come to call the "biographical fallacy." Buchanan observed that Teniers "avoided that vulgarity of character and expression [of the Ostades] and those objectionable representations which are too often to be met with in the works of Brouwer and Jan Stein (*sic*). He associated indeed with the lower classes . . . but it was to study their manners and habits, not to enjoy their company."[11]

PCS

1. See respectively Antwerp 1991, cats. no. 20, 21 and fig. 21a. Dicing also figures centrally in Teniers's *Tavern*, Munich, Alte Pinakothek, no. 441. A late painting on an upright format (panel, 33.6 x 25.5 cm) by Teniers, signed and dated 1665, returns to the present painting's subject and paraphrases the left side of its composition; see exh. London, Eugene Slatter Gallery, *Life and Still Life*, 1944-45, no. 40; also DIAL 43C55.

2. Klinge, in New York/Maastricht 1982, p. 84.

3. Klinge, in Antwerp 1991, p. 106, cat. 30.

4. See respectively Antwerp 1991, cat. nos. 32, 33 and 37.

5. Among the many other images of skittles players by Teniers are the paintings in the Hermitage, St. Petersburg (no. 2778); the Wellington Museum, London, no. 1579; the Los Angeles County Museum of Art, cat. 1954, vol. 2, no. 23; the National Gallery of Victoria, Melbourne;

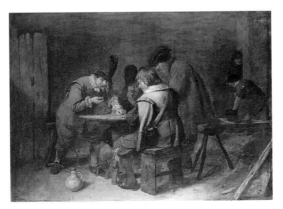

Manchester City Art Gallery, Manchester, England, no. 1979.507; with dealer Goudstikker, Amsterdam, cat. 1918, no. 53; with Sedelmeyer Gallery, Paris, 1894, no. 49, ill.; and sale Princess Labia, London (Sotheby's), 27 November 1963, no. 24, ill.

6. On the theme see W. E. Woolfenden, "*The Game of Skittles* by Jacob Duck," in *Bulletin of the Detroit Institute of Arts* 28 (1948/49), p. 5.

7. Smith 1829-42, vol. 3 (1831), no. 338.

8. See Thijs 1990, pp. 152-153.

9. See New York/Maastricht 1982, no. 26.

10. Antwerp 1991, no. 30. Copies of the present painting were in the important early American collection assembled in the mid-nineteenth century by Thomas Bryan, later part of the New-York Historical Society, (see sale New York [Sotheby's, Parke Bernet], 9 October 1980, no. 29, ill.), and with the dealer J. Denijs, Amsterdam, 1942.

11. Buchanan, 1824, vol. 1 (1824), p. 187.

Fig. 1. Adriaen Brouwer, *Dicing Soldiers*, oil on panel, 35.7 x 47.2 cm, Munich, Alte Pinakothek, no. 242.

David Teniers the Younger
68. *The Alchemist*, 1649

Oil on panel, 59.4 x 83.8 cm (23 ⅜ x 33 in.)
Signed in the right foreground: D. Teniers, fec. and
dated Ano 1649 on the drawing on the right.
Philadelphia, Philadelphia Museum of Art,
John G. Johnson collection, no. 689.

PROVENANCE: sale Pieter Leendert de Neufville, Amsterdam, 19 May
1765, no. 100 [fl. 1580, to Cok]; sale Baroness van Leyden (née Comtesse de
Thom'), Warmond Castle (near Leiden), 31 July 1816, no. 38 [as on canvas;
fl. 800]; (possibly) sale Varroc and La Fontaine, Paris, 28 May-2 June 1821,
no. 85 [without measurements; bought in at frs. 8000]; sale Chevalier
Everard of the Château de la Muette, Paris, 7 August 1832, no. 145
[frs. 7100]; sale Sir Edward J. Dean Paul, London (Christie's), 27 June 1896,
no. 115 [787 Gns., to Wallis]; John G. Johnson, Philadelphia, by 1913.

EXHIBITIONS: New York, New York Cultural Center, *Antwerp's Golden
Age*, 1973.

LITERATURE: Smith 1829-42, vol. 3 (1831), p. 376, no. 447; W. Roberts,
Memorials of Christie's (London, 1897), vol. 2, p. 270; A. Graves, *Art Sales*
(London, 1918), vol. 3, p. 201; Philadelphia, Johnson, cat. 1913, pp. 172-173,
ill. p. 479 [as Adriaen Brouwer]; Philadelphia, Johnson, cat. 1941, p. 38
[as David Teniers the Younger]; Philadelphia, Johnson, cat. 1972, p. 85,
no. 263 [as David Teniers the Younger]; Liedtke et al. 1992, p. 371, ill.

AN ELDERLY BEARDED ALCHEMIST, wearing a
short-brimmed cap and tabard, stands in profile
beside a hearth on the left, stoking the fire with a
bellows. Beside him stands a young boy, no doubt
his apprentice/assistant, holding a glass vial. In the
right background, lighted by a hidden doorway,
three men assemble around a table, one seated work-
ing with a mortar and another holding a glass bot-
tle. In the right foreground is a still life of ceramic
pots, a brazier, bottles and vials, and an animal skull.
The wooden partition behind is decorated with a
drawing of a man and provides a perch for an owl.
Below, a cat prowls amidst laboratory apparatus. In
the center other vessels and a cloth rest on a stool
and, at the left beside the oven, are a pile of books
and another brazier. Additional beakers, vials, and a
smaller animal skull appear on the side of the
hearth.

The alchemist was a traditional theme in
Netherlandish literature and low-life genre prints,
drawings, and paintings. It can be traced back at
least to the time of Pieter Bruegel the Elder, who in
1558 made a print of one of these quacks vainly wast-
ing his money in the pursuit of a formula for obtain-
ing gold from baser metals (fig. 1).[1] Numerous six-
teenth- and seventeenth-century emblems also
admonish the alchemist's costly folly.[2] Typical of
these is a depiction from Florentius Schoonhovius's
Emblemata (Gouda, 1618), of an alchemist (fig. 2)
using a bellows to stoke the fire in his crowded labo-
ratory; this image and others were discussed in 1978
in connection with Teniers's painting of an
alchemist in Braunschweig (Herzog Anton Ulrich-
Museum, inv. no. 140).[3] The Latin verses appended
to the emblem stress the ruinous waste of the
alchemist: "While I pursue uncertainty with certain
means, I convert everything into smoke and worth-
less ash."[4] Some of these pseudo-scientists undoubt-
edly made actual contributions to learning during
the seventeenth century's "Age of Observation,"

when the distinction between magic and science was
not so rigorously drawn as in modern times. The
Dutch inventor and engineer Cornelis Drebbel, for
example, also dabbled in alchemy. However the liter-
ary tradition invariably treats alchemists as figures
of scorn, ridicule, and folly, and the pictorial tradi-
tion ought to be interpreted in kind.

Although the painting inexplicably was cata-
logued by Valentiner in the first Johnson collection
catalogue of 1913 as the work of Adriaen Brouwer, it
had been recognized since at least the eighteenth
century as a representative, indeed exceptionally
good, work by Teniers.[5] Algernon Graves, for exam-
ple, singled it out for praise.[6] Teniers painted the
alchemist theme at least one dozen times.[7] The
pseudo-scientist is almost always depicted as an old-
er bearded man dressed in exotic clothing, frequent-
ly wearing the fur-trimmed cap and tabard seen
here. Though not caricatured as broadly as in six-
teenth-century depictions of alchemists, he is usual-
ly a figure of studious concentration if not obsessive-
ness. When the present work appeared in the sale of
Chevalier Everard's collection in Paris in 1832, the
cataloguer remarked, "Il y a des pensées dans la tête
de ce chimiste; il semble qu'il parlerait s'il etait
moins occupé de son creuset. Ces livres, ces pots, ce
chat sont imités à s'y méprendre; ce désordre est bien
celui d'un laboratoire."[8] Invariably Teniers's
alchemists are surrounded by the clutter of their
laboratories – crucibles, alembics, retorts, hour-
glasses, colanders, and other paraphernalia, as well
as rare specimens (skulls and petrified fish or lizards
suspended from the ceiling). Often he reads a book
(see versions in The Hague, Anholt, Polesden Lacey,
and Braunschweig) or stokes the fire of his oven
with a bellows (see the paintings in Dresden,
no. 1072, Madrid, in the Earl of Crawford and
Balcarres's collection, sale New York [Christie's],
31 May 1990, no. 41, and sale New York [Sotheby's],
12 December 1990, no. 96).

Although Teniers probably treated the theme
earlier than 1649, the present painting appears to be
one of the earliest dated examples of this subject in
his œuvre.[9] At about this same time, the subject
became quite popular among Dutch and Flemish
painters; David Ryckaert (Leipzig, Museum der
bildenden Künste, no. 350, dated 1648), Adriaen van
Ostade took up the theme (his *Alchemist* in The
National Gallery, London, no. 1481, dated 1661, is
inscribed, "Oleum et operam perdis" [Lose your time
and effort]) and somewhat later, his pupil Cornelis
Bega and Thomas Wijck painted several examples.[10]
Whether Brouwer initiated this interest is unknown,
since no works by his hand of this subject have sur-

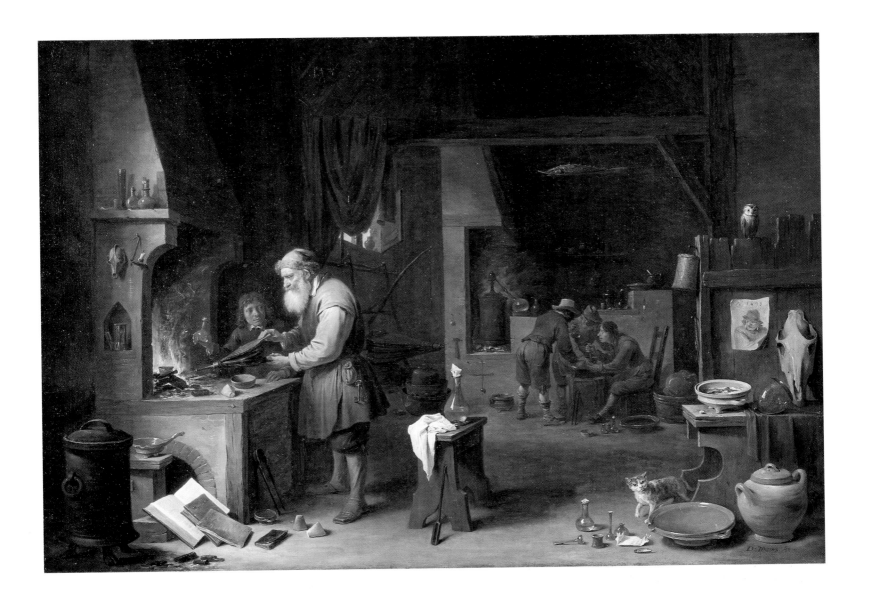

Fig. 1. Hieronymus Cock, after Pieter Bruegel the Elder, *The Alchemist*, engraving.

Fig. 2. Emblem of an Alchemist, from Florentius Schoonhovius's *Emblemata* (Gouda, 1618).

vived, but in 1668 several Antwerp experts asserted that an *Alchemist* described only as an early work by Brouwer had fetched the relatively high prices of 300 or 400 florins.[11] At least one copy of the Philadelphia painting is known.[12]

<div align="center">

PCS

</div>

1. On the alchemist theme, see J. Read, *The Alchemist in Life, Literature and Art* (London, 1947); F. C. Legrand, "Alchimistes et sabbats de sorcières vus par les peintres du XVIIe siècle," *Cahiers de Bordeaux–Journées internationales d'études d'art 1957*; J. van Lennep, *Art et Alchimie* (Paris/Brussels, 1966); idem, "L'Alchimiste: Origine et développement d'un thème de la peinture du dix-septième siècle," *Revue belge d'archéologie et d'histoire de l'art 35*, no. 3/4 (1966), pp. 149-168; E. E. Ploos, H. Schipperger, H. Roosen Runge, *Alchimia* (Munich, 1970). Specifically on Bruegel's print, see J. van Lennep, "L'Alchimie et Pierre Brueghel l'ancien," *Bulletin des Musées Royaux des Beaux-Arts, Bruxelles 14* (1965), pp. 105-126; M. Winner, in Berlin, Kupferstichkabinett, Staatliche Museen preussischer Kulturbesitz, *Pieter Bruegel der Ältere als Zeichner* (1975), pp. 11-12, 60-64, cat. no. 67; and P. Dreyer, "Bruegels Alchimist von 1558 – Versuch einer Deutung ad sensum mysticum," *Jahrbuch der Berliner Museen 19* (1977), pp. 69-113; and M. Winner, "Zu Bruegels Alchimist," *Pieter Bruegel und seine Welt* (Berlin, 1979), pp. 193-202.

2. See Henkel, Schöne 1967, part v, p. 1059

3. See Braunschweig, Herzog Anton Ulrich-Museum, *Die Sprache der Bilder*, 1978, cat. no. 35.

4. "Dum certis incerta sequor,/Rem prodigus omnem/converti in fumos et miseros cineres." See also the emblems by Sebastián de Couarrubias Orozco (1610) and Johannes Sambucus (1566) listed by Henkel and Schöne (nos. Sp. 1407 and Sp. 1059), and discussed in the Braunschweig catalogue (note 3), which similarly warn against the senseless and unnatural (the former appears under the motto: Natura potentioristis [Nature is mightier than you]) pursuit of gold.

5. Philadelphia, Johnson, cat. 1913, pp. 172-173, cat. no. 689, ill. p. 479. In the 1941 catalogue it also incorrectly is stated that the picture is "transposed [from panel] to canvas."

6. W. Roberts, *Memorials of Christie's* (London, 1897), vol. 2, p. 270; A. Graves, *Art Sales* (London, 1918), vol. 3, p. 201.

7. In addition to the painting in Braunschweig mentioned above, see: The Hague, Mauritshuis, no. 261; Madrid, Museo del Prado, no. 1804; Dresden, Gemäldegalerie Alte Meister, nos. 1072 and 1080; Munich, Bayerische Staatsgemäldesammlungen (Schleissheim, Staatsgalerie, no. 1847 [dated 1680]); Duke of Devonshire, Chatsworth, inv. no. 657; Earl of Crawford and Balcarres, Scotland; Polesden Lacey, Dorking, cat. 1948, no. 59; H. M. the Queen, Buckingham Palace; Edward R. Bacon, New York, cat. (by J. B. Townsend & W. Stanton Howard), 1919, no. 226; Furst zu Salm-Salm, Anholt; sale Gutterman, New York (Sotheby's), 14 January 1988, no. 37, ill.; sale New York (Christie's), 31 May 1990, no. 41, ill. [dated 1652]; and sale Madame X, Paris (Galerie Charpentier), 14 June 1960, no. 52 (formerly with dealer Goudstikker, Amsterdam, 1919-20, cat. no. 4); and sale London (Christie's), 11 July 1980, no. 51. In the last mentioned the alchemist remarkably is a copy of the central rabbi in Ribera's *Christ Disputing with the Doctors* (Vienna, Kunsthistorisches Museum, no. 326), which was copied by Teniers when it was in the Archduke Leopold Wilhelm's collection in Brussels, and published as an engraving (in reverse) in Teniers's *Theatrum Pictorium* of 1658. Teniers's very late alchemist of 1680 (Staatsgalerie, Schleissheim, inv. 1847) appears to be a self-portrait.

8. Sale Paris, 7 August 1832, p. 161; "There are thoughts in this chemist's head; he seems as if he would speak were he less occupied by his crucible. There's no mistaking these books, these pots, this cat; this disorder is truly that of a laboratory."

9. The *Alchemist* catalogued by Smith 1892-46, vol. 3 (1831), no. 141, as in the Bridgewater collection (16 x 20½ in.) was also reported to be dated 1649.

10. See Philadelphia/Berlin/London 1984, cat. no. 3. Among the other Dutch artists to take up the subject were Pieter Potter, Pieter Quast, Gerrit Dou, Jan Steen, Hendrick Martensz. Sorgh, Jacob Toorenvliet, Egbert van Heemskerk, H. Herschop, and Egbert van der Poel. Flemish: Marten de Vos, Matthieu van Helmont, Gerard Thomas, and Justus van Bentum, see DIAL. 49E39.

11. See van den Branden 1883, p. 854; Hofstede de Groot 1908-27, vol. 3 (1910), no. 221b.

12. Sale M. Soehle, Munich, 29 October 1907, no. 224, ill. (panel, 59 x 83.5 cm). This may be identical with the copy that was in the H. C. Boysen collection, Berlin, ca. 1928.

David Teniers the Younger
69. Butcher Shop, 1642

Oil on panel, 68.4 x 98 cm (26 ⅞ x 38 ⅝ in.)
Signed lower right: D. TENIERS F and dated 1642 on
the drawing on the wall on the right
Boston, Museum of Fine Arts, Sidney Bartlett
bequest, inv. no. 1889.500

PROVENANCE: sale Louis de Moni, Leiden (de Moni & Delfos), 13 April
1772, no. 109; sale Dirk Haak, Leiden, 18 April 1782, no. 19 [fl. 49, to Hey-
broek; see Lunsingh Scheurleer et al. 1990, p. 801 in Literature below]; sale
J. W. Heybroek, Rotterdam, 9 April 1788, no. 79 [fl. 50, to Heybroek]; sale
Hendrik Twent, Leiden (Delfos), 11 August 1789, no. 49 [fl. 20.10, to
Delfos]; Prince Demidoff, San Donato Palace, Florence; sale Palais de
San Donato, Florence, 15 March 1880, no. 1030, ill. with an etching by
G. Perrichom [frs. 16,200, to Jackson Jarvis]; Stanton Blake, Boston;
Bequest to the Museum of Sidney Bartlett.

EXHIBITIONS: New Orleans, Louisiana, Delgado Museum of Art, *Fêtes
de la Palette*, November-January, 1963, no. 63, pl. 11.

LITERATURE: Hubert Janitschek, "Berichte und Mitteilungen aus
Sammlungen und Museen . . . Aus Amerikanischen Galerien," *Reper-
torium für Kunstwissenschaft* 11 (1888), p. 79; Wurzbach 1906-1911, vol. 2
(1910), p. 696; Museum of Fine Arts, Boston, *Catalogue of Paintings* (Boston,
1921), p. 44, no. 100; K. M. Craig, "Rembrandt and *The Slaughtered Ox*,"
Journal of the Warburg and Courtauld Institutes 46 (1983), p. 238; M. Klinge, in
exh. cat. New York/Maastricht, 1982, n.p. under cat. 23; Boston, cat. 1985,
p. 275; Th. H. Lunsingh Scheurleer, C. Willemijn Fock, and A. J. van Dis-
sel, *Het Rapenburg: Geschiedenis van een Leidse gracht*, vol. 5b (Leiden, 1990),
pp. 785, 801, fig. 13, vol. 6a (1992), pp. 499-500; Liedtke et al. 1992, p. 370, ill.

THE CARCASS of a slaughtered ox hangs from a
beam suspended by ropes from the ceiling of a tall
half-timbered interior. A woman on the right cuts
up the lungs and liver. She looks to her right at a dog
which laps at blood dripping from the carcass into a
basin. On the floor at the left is the hide and above it
on a bench the flayed ox's head and a bowl. Nailed to
the wall above are the tongue and a calendar. In the
back of the room beside a large hearth, a man in
white cap and apron, no doubt the butcher, holds a
glass of wine and a pipe and talks to a woman hold-
ing a ceramic jug. A man is just departing through
a door on the right. At the back left of the room
behind the ox are a stool, chairs, and ceramic uten-
sils. On the wall above the woman in the foreground
are a bust-length drawing of a peasant holding a
glass and a stoppered vial of clear liquid in a niche.

The etching of this painting by Perrichom for the
San Donato sale catalogue of 1880 (the stamp of
which appears on the back of the present panel)
records Teniers's scene just as it appears today save
for the detail of the vial in the niche, which may
have then been overpainted. The catalogue of that
sale and several later references also inaccurately
identified the work as no. 517 in Smith's catalogue of
the artist's work, which is in fact another smaller
and presumably later panel painting by Teniers of an
interior with a large still life of kitchen utensils in
the foreground and a slaughtered ox hanging beside
a couple by a hearth at the back right.[1] The present
painting appears to be Teniers's earliest dated paint-
ing of the slaughtered animal theme: he depicted,
for example, a slaughtered pig carcass with children
blowing up the bladder in a painting dated 1646
(fig. 1)[2]; in the Uffizi in Florence there is an undated
painting (no. P1680) of an interior with slaughtered

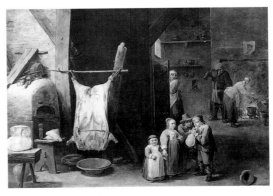

Fig. 1. David Teniers the Younger, *A Slaughtered Pig
with Children Blowing up a Bladder*, signed and dated
1646, oil on panel, 46 x 67.5 cm.; sale London
(Christie's), 14 May 1965, no. 117.

Fig. 2. P. Galle, after Martin van Heemskerk, *Slaughter
of the Fatted Calf, from the Parable of the Prodigal Son*,
engraving, Amsterdam, Rijksprentenkabinet,
inv. 1980:65.

pig, kitchen still life, butcher, and woman dressing
the meat[3]; the Kunsthistorisches Museum in Vienna
owns a painting of a woman making sausage beside
a slaughtered pig[4]; and the Nationalmuseum in
Stockholm has one of a sheep butcher, catalogued as
"Anonymous Flemish" but possibly by David
Teniers.[5] There also are several exact and partial
copies of the present composition, suggesting that it
was a very popular work.[6]

Slaughtered oxen and other animals appear with
some frequency in sixteenth- and seventeenth-cen-
tury Northern painting, having been treated by
many artists, from Bruegel to Rembrandt.[7] In late
medieval art the slaughtering of the ox or pig was
one of the Labors of the Months and was specifically
associated with the month of November.[8] The
slaughtered animal, especially in conjunction with
the children blowing up the bladder (see fig. 1),

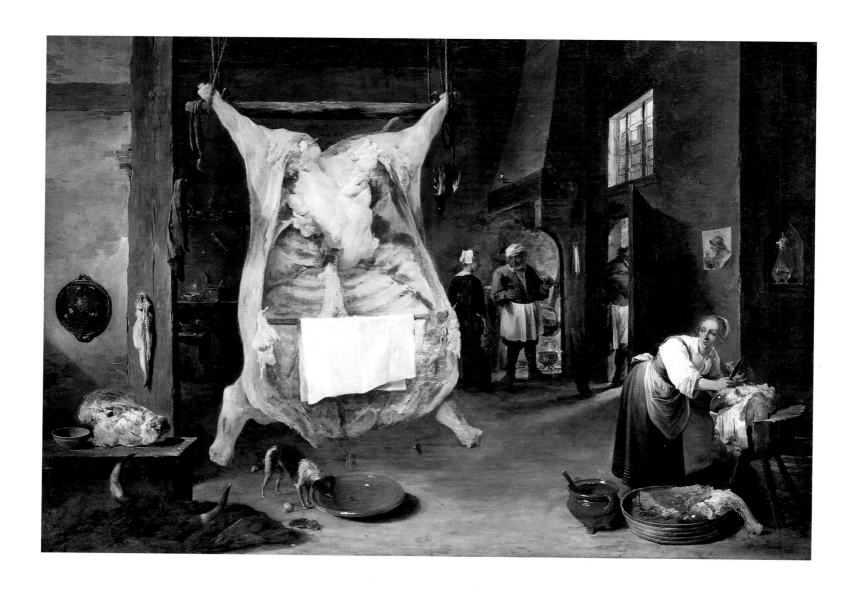

could be a *vanitas* or *memento mori* (*homo bulla*) image.[9] As C. Campbell and K. Craig have demonstrated, the theme of the slaughtered ox was also closely allied with the parable of the Prodigal Son (Luke 15:11-32), whose father celebrated his homecoming with the killing of the fatted calf (see, for example, the print by Martin van Heemskerk, fig. 2).[10] The parable was traditionally interpreted as alluding to God's forgiveness of sinners, and many commentaries equate the ox with the crucified Christ; St. Jerome clearly states that "The fatted calf ... is the Savior Himself, on whose flesh we feed, whose blood we drink daily."[11] The slaughtered animal thus is clearly associated with the crucifixion of Christ and his sacrifice for mankind. This may account for the curiously spiritual resonance of some

of the slaughtered ox paintings, especially those, like Rembrandt's, that focus on the carcass.

In the sixteenth century Pieter Bruegel also used the image of the slaughtered ox in a design for an engraving in a series of the Virtues as the attribute of Prudentia (Prudence) (see the detail on the right of fig. 3). Prudence not only conveyed a matter of cautious, circumspect behavior, as in the modern sense of the word, but of wisdom and the ability to distinguish good from evil. Bruegel's print was filled with everyday objects connoting practical wisdom. Obviously storing meat for the winter is a form of prudent behavior. By the same token, the carcass's residue of biblical associations may suggest that spiritual provisions for the future ought also to be made.[12] It is unclear to what extent Teniers was

Fig. 3. Probably by P. Galle, after Pieter Bruegel the Elder, PRUDENCIA, engraving, Amsterdam, Rijksprentenkabinet, inv. OB377.

aware of the slaughtered animal's Christian associations. However the viewer was surely confronted with an image of death, appetites (and their warning of gluttony), sacrifice, and prudence, and, lest one forget, their reward of abundance.

The eighteenth-century provenance of this painting is here published for the first time. The painting passed through the Louis de Moni sale in 1772,[13] the Dirk Haak sale in 1782, when it was purchased by J. W. Heybroek,[14] who sold it six years later,[15] and finally it passed through the Hendrik Trent sale in 1789.[16]

PCS

1. Panel, 33 x 44 cm, now in a private collection; see M. Klinge in Antwerp 1991, cat. no. 23, ill. and fig. 23b, Teniers's own etching of the painting which is dated on the wall 1650, the numerals reversed.

2. Panel, 46 x 67.5 cm, sale London (Christie's), 11 December 1987, lot. 74; sale Amsterdam (Christie's), 20 June 1989, lot 102; sale London (Christie's), 14 May 1965, no. 117; from the von Moltke collection in Stockholm, cat. (1913), no. 13.

3. Canvas, 64 x 87 cm, Gallerie Statali di Firenze, inv. Feroni, no. 48 (photo: no. GFS 168542); see Gli Uffizi Catalogo Generale (Florence, 1979), p. 537, ill.; and Florence 1977, no. 124, ill.

4. Canvas, 54.5 x 64.5 cm, Vienna, Kunsthistorisches Museum, no. 715.

5. See Illustrated Catalogue – European Paintings (Stockholm, 1990), p. 403, ill.

6. Four otherwise exact copies omit the dog (perhaps once overpainted): sale Ober-Morlen, Frankfurt, 7-9 October 1920, no. 254 (panel, 72 x 102 cm, signed); Antwerp, Institute Terninck, exh. Antwerp 1930, no. 295 (canvas, 67 x 88 cm); and sale Brussels (G. Giroux), 5 March 1928, no. 54 (panel, 74 x 105 cm); and sale Bern (Dobiaschofsky), 19-22 October 1983, no. 750 (panel, 44 x 63 cm, signed). A copy omitting the ox was with the dealer Ch. Sedelmeyer in Paris in 1897, no. 41; in the Sedelmeyer sale, Paris, 3 June 1907, no. 48 (canvas, 64 x 79 cm; as signed and dated 1651); and later in the F. Rappe collection and the Bergsten collection, Stockholm, 1927. A copy of the right hand side only, substituting a kitchen still life for the ox and details on the left, was in the A. Branicki collection, Wilna, when exhibited in Warsaw, 1939, no. 126 (panel, 73.7 x 105 cm, signed). A copy of the right hand side only was in sale Cologne (Lempertz), 10 May 1916, no. 102, ill. (panel, 75 x 50 cm); and sale Bangel, Frankfurt, 28 March 1917, no. 80 (panel, 72 x 52 cm). Finally, a variant

probably not by Teniers quotes the pose of the woman on the right but omits all the other details and substitutes a slaughtered pig for the ox: sale Stein, Paris (G. Petit), 8-10 June 1899, no. 337, ill. (panel, 76 x 58 cm). A farmhouse with a slaughtered ox and woman at a well by a follower of Teniers in the Metropolitan Museum of Art, New York, no. 74.55 (canvas, 84.1 x 117.2 cm, signed), is an independent composition by an imitator. A painting focusing on the carcass of an ox with a figure in the doorway in the background was optimistically attributed to Teniers in sale, Paris (Hôtel George V), 17 June 1980, no. 71, ill. (panel, 44 x 38.5 cm).

7. See J. Foucart et al. in exh. cat. Paris, Petit Palais, Le Siècle de Rembrandt, tableaux hollandais des collections publiques françaises, 1970, no. 179, and Craig 1983 (note 10 below).

8. See J. A. Emmens, "Reputatie en betekenis van Rembrandt's 'Geslachte Os,'" Museumjournaal 12 (1967), p. 81.

9. See E. de Jongh in exh. cat. Brussels, Palais des Beaux-Arts Rembrandt en zijn tijd, 1971, p. 170; and Amsterdam 1976, cat. 24.

10. See C. Campbell, "Rembrandt's 'Polish Rider,' and the Prodigal Son," Journal of the Warburg and Courtauld Institutes 33 (1970), p. 296; and K. M. Craig, "Rembrandt and The Slaughtered Ox," Journal of the Warburg and Courtauld Institutes 46 (1983), pp. 236-237.

11. Quoted by Craig 1983, p. 236, from The Letters of St. Jerome, trans. C. C. Mierow (London, 1963), pp. 122-123.

12. For the Bruegel, see Hollstein 1949, vol. 3, p. 279, no. 136. The Latin inscription on the print reads, "Si prudens esse cupis, in futurum prospectum ostende, et quae posunt contingere animotua cuncta propone" (If you are intelligent, you will always be mindful of the future and consider all conceivable precautionary measures). The relationship between the Prudentia print and Teniers's scenes of slaughtered oxen has been noted repeatedly by Klinge, in Brussels 1980, p. 266; and Antwerp 1991, cat. 23.

13. "D. Teniers Een geslachte hangende Os, een Meid die ommeloop schoonmaakt eene andere aan den slager een glas bier gegeven hebbende, zyn Knegt na buiten gaande, de gevilde kop van dit Beest en noch veel ander bywerk, 29 x 40 duim (ca. 75.9 x 104.7 cm)."

14. With the same description as above but adding "alles zeer natuurlyk op Paneel." On the collection of Dirk Haak, who lived on the Rapenburg no. 56 in Leiden, see Th. H. Lunsingh Scheurleer, C. Willemijn Fock, and A. J. van Dissel, Het Rapenburg: Geschiedenis van een Leidse gracht, vol. 5b (Leiden, 1990), p. 785.

15. "Teniers . . . een hangende geslagten Oster rechterzyd een Vrouwtje die 't ingwand schoon maekt en ter linkerzyde de huid en kop op een bank liggen: agter dezelve de Slagter met zyne Vrouw en een ander Persoon die de deur uitgaan. Op paneel 27 x 39 duim [ca. 75.9 x 102 cm]."

16. Same description as above.

Jan Davidsz. de Heem

(Utrecht 1606-Antwerp 1683/84)

Born in all likelihood in Utrecht (not Antwerp as is sometimes stated), Jan Davidsz. de Heem was the son of David Jansz. van Antwerpen and Hillegand Theunis (betrothed in Utrecht on 21 July 1603). Like his father and uncles, in his youth Jan Davidsz. used the surname "van Antwerpen," which may refer to the home of the painter's grandfather, a pin maker. The profession of his father is uncertain, but in a document of 1610 he was referred to as a "spe[elm]an," or musician, when he was living at the Vismarkt (fish market) at the foot of the Domkerk tower in Utrecht. The following year Jan's father bought a large chapter house on the Domkerkhof which, after he died (before June 1612), was renamed "Hochdeutsche Vergulde Bibel" (The Gilt German Bible) and rented to the family of the famous *femina universalis*, Anna Maria van Schurman (born 1607), who was Jan Davidsz.'s contemporary.

As a result of a misreading of Cornelis de Bie's poetic reference in 1661 to the father and son [de Heem] both "living by art" ("Hier leven twee door Kunst, de zoon met zynen vader"), Houbraken mistakenly suggested that Jan Davidsz.'s father was also an artist and his teacher; however, de Bie was probably referring to Jan Davidsz. and his own sons. The artist's father, David Jansz. van Antwerpen, could not have been his teacher (despite repeated claims in the literature) because he died when the boy was only six. A document of 7 February 1625 states that de Heem (referred to as "Jan Davidsz. van Antwerpen") was nineteen years old that Easter, was a painter by profession, and intended to travel to Italy. In the document, Jan Davidsz. requested fl. 150 for expenses from the proceeds of the recent sale of the house on the Vismarkt that had been sold to pay creditors of de Heem's stepfather, the bookbinder Johan Jacobsz. Coornheert. However, it seems unlikely that he was able to undertake the journey since the administrators of the orphanage board refused de Heem's request for money, perhaps to protect the young man's patrimony from his stepfather's financial difficulties until he had reached his majority. In any event, the family moved to Leiden (the hometown of both de Heem's mother and Coornheert) before 27 June 1625, and in all liklihood, Jan Davidsz. accompanied them. In Leiden on 3 December 1626, he married Aletta (Aeltgen) Cornelisdr. van Weede, a young women from Utrecht. When the couple's banns were published in Utrecht on 11 November the painter used for the first time the surname "de Heem," the inspiration for which is unknown. He also dated his first paintings in 1626. A son David born on 29 November 1628 died young, but Cornelis, born 8 April 1631, grew up to be de Heem's pupil and follower.

Although the first documentary reference to de Heem in Antwerp is in 1636, he probably moved there in late 1631 or 1632. He joined the Antwerp guild of St. Luke in 1635/36. The following year he became a citizen, and was frequently mentioned in the guild registry. In Antwerp, he became a friend of Jan Lievens (1607-1674) and Adriaen Brouwer (q.v.). In 1641 he had three pupils in Antwerp: Alexander Cosemans, Thomas de Klerck, and Leonaerd Rougghe. On 29 March 1643 his first wife died; the following 6 March he married Anna Ruckers, daughter of a clavier maker. Of the couple's six children, one son, Jan Jansz. II, became a painter. From 1658 de Heem lived in Antwerp only intermittently, registering as a non-resident citizen ("buitenpoorter"). He moved to Utrecht in 1667, and in 1669 joined the painters' guild there. De Heem lived in Utrecht until 1672 when the French invaded the Netherlands. He fled back to Antwerp and remained there until his death, sometime between 14 October 1683, when he was still listed as the owner of a house in Utrecht, and 26 April 1684. Sandrart gave as the unlikely reason for returning to Antwerp not the threat of French troops but the lure of rarer and fresher fruit. According to Houbraken, de Heem's many pupils included Cornelis Kick, Abraham Mignon, Maria van Oosterwyck, Jacob Roodtseus, Jacob Marellis, Elias van den Broeck, and M. Simons. The artist's *Self-Portrait* is in Amsterdam (Rijksmuseum) and Jan Lievens drew his portrait for Paulus Pontius's engraving (drawing London, British Museum).

One of the most accomplished and influential flower and still-life painters of the age, de Heem began his career painting in the manner of the Leiden artists David Bailly, Pieter Potter, and Balthasar van der Ast. No paintings from his earliest Utrecht period (before 1626) have been discovered. Later he was attracted to the monochrome "tonal" still lifes of Pieter Claesz. and Willem Claesz. Heda. In Antwerp, the colorful and exuberant banquet tables and game still lifes of Frans Snyders (q.v.) and his followers had a profound effect on de Heem, as did the flower paintings of Daniel Seghers (q.v.). De Heem permanently transformed the grandly scaled banquet piece, creating the definitive Flemish *pronkstilleven*, replete with precious metalware, rich foods, and rare fruit. In addition to his pupils, his Dutch and Flemish imitators included Pieter de Ring, Th. Aenvanck, Hendrick Schook, Jan Pauwel Gillemans the Elder, H. Loedingh, Joris van Son, and Jan van Kessel (q.v.).

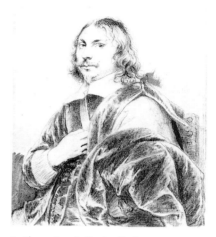

Jan Lievens, *Portrait of Jan Davidsz. de Heem*, black chalk, 26.5 x 20.2 cm, London, British Museum, no. H3.

David Teniers the Younger and Jan Davidsz. de Heem

70. Kitchen Interior, 1643

Oil on panel, 48.5 x 64.1 cm (19 1/16 x 25 1/4 in.)
Signed and dated lower left and center:
H.D. TENIERS [and] J.D. Heem f A° 1643
Los Angeles, Los Angeles County Museum of Art,
Gift of H. F. Ahmanson and Company in memory
of Howard F. Ahmanson, acc. no. M 72.67.1

De Bie 1661, pp. 216-219; Sandrart 1675, p. 307; Houbraken 1718-21, vol. 1 (1718), p. 209; vol. 3 (1721), p. 83; Weyerman 1729-69, vol. 1 (1729), p. 407; vol. 2 (1729), p. 69; Nagler 1835-52, vol. 6 (1838), pp. 33ff; Kramm 1857-64, vol. 3 (1858), pp. 653-654; Nagler 1858-79, vol. 3 (1863), pp. 296-297, 889-890; Rombouts, van Lerius 1872, vol. 2, pp. 71, 77, 134, 142, 501; S. Muller 1880, passim; van Lerius 1880-81, vol. 1, pp. 219-248; van den Branden 1883, p. 862, 864, 866-870; Bredius 1886; Toman 1888a; Toman 1888b; Woermann 1888; Wurzbach 1906-11, vol. 1 (1906), pp. 656-658; H. Schneider, in Thieme, Becker 1907-50, vol. 16 (1923) pp. 223-225; Martin 1925; Glück 1933, pp. 222, 243-251, 260, 262, 357; Hairs 1955, pp. 137-41, 219-223; Bergström 1956a, passim; Bergstrom 1956b; Greindl 1956, pp. 102-106, 171-174; Gerson, ter Kuile 1960, pp. 145, 160-163; Seifertová-Korecká 1962; Brussels 1965, pp. 99-101; de Mirimonde 1970; Vroom 1980, pp. 16-17, 26, 37, 58, 86, 96, 118, 120, 122, 124, 184, 196, 206; Brenninkmeyer-de Rooij 1983; Greindl 1983, pp. 123-128; Hairs 1985, pp. 392-398, 479-481; Tiethoff-Spliethoff 1985; Bergström 1988; Meijer 1988; Delft/Cambridge/Fort Worth 1988, pp. 141-156, 240-242; M. L. Wurfbain, "Het Verblijf van de Schilder Johannes de Heem te Leiden," in J. W. Marsilje et al., Uit Leidse bron geleverd. Studies over Leiden en de Leidenaren . . . aangeboden aan Drs. B. N. Leverland (Leiden, 1989) pp. 432-442; Bok 1990; Utrecht/Braunschweig 1991.

PROVENANCE: sale Smeth van Alpen, Amsterdam, 1-2 August 1810, no. 99 (fl. 1000, to de Vries); sale Mme Anna Maria Hogguer-Ebeling, Amsterdam, 18 August 1817, no. 81 (fl. 1190, to du Pré); sale Mme Le Rouge, Paris, 27 April 1818, no. 58 [18 x 24 in., "The Master of the house gives orders to his valet"; fl. 3510, to Storcks]; Duc de Morny? (Sedelmeyer cat.); Charles Sedelmeyer, Paris, 1894; S. del Monte collection, Brussels (cat. 1928, no. 15); sale S. del Monte, London (Sotheby's), 24 April 1959, no. 59 (£2,000, to Millard Streets).

EXHIBITIONS: The Hague, Kunstzaal Kleykamp, 1932, no. 15; The Hague, Gemeentemuseum, Oude Kunst uit Haagsch Bezit, 12 December 1936-31 January 1937, no. 193.

LITERATURE: Smith 1829-42, vol. 3 (1831), p. 377, no. 450; One Hundred Paintings of Old Masters Belonging to the Sedelmeyer Gallery (Paris, 1894), p. 60, no. 50, ill.; G. Glück, La Collection del Monte (Vienna, 1928), cat. and pl. 15; A. L. Mayer, "Die Sammlung del Monte in Brussel," Pantheon 3 (1929), p. 442; Los Angeles County Museum of Art Bulletin (1973), p. 38, fig. 4; S. Schaeffer and P. Fusco, European Painting and Sculpture in the Los Angeles County Museum of Art (Los Angeles, 1987), p. 49, ill.

THREE FIGURES appear in a crude kitchen interior with a large still life of utensils and comestibles in the foreground. A mustachioed man with a walking stick, fur cap, and fur-trimmed coat stands at the left directing the activity of a young boy. Behind him stands a slender hunting dog and at the back right a serving woman appears at an open door. The still life in the right foreground includes several large brass vessels, a wood tub, a pitchfork, firewood, a barrel, and various vegetables: cabbages, lettuce, radishes, carrots, etc. At the left is a small brass wine cooler with a bottle of wine, a pair of slippers, and a wicker basket and broom. Beside the serving boy in the middle distance is a pile of fruit on a table. In the wall on the right is an oven with a long chimney sweep. On the back wall is a shelf with, amongst other household objects, a colander and a small clock.

This painting was a collaborative effort. David Teniers the Younger painted the figures and the background, while Jan Davidsz. de Heem painted the still-life elements. The artists' partnership is confirmed by the signatures of both on the painting. While Teniers collaborated with several artists, including Joos de Momper and Lucas van Uden, this is the only certain case of his working on a painting with de Heem. The painting of stable or rustic kitchen interiors (known in Dutch as a "boereschuyr," "boerehuys," or "schuurstuk," and in German as "schueneninterieur") with large still lifes of household goods and utensils and/or groceries became popular in both the Northern and Southern Netherlands around 1640. With local variations on the theme, it became a specialty almost simultaneously in Rotterdam, Antwerp, Leiden, and Haarlem. Horst Gerson first observed that Teniers's interest in this type of painting was probably piqued by the examples of Dutch artists, specifically those active in and around Rotterdam, including Cornelis (1607-1681)

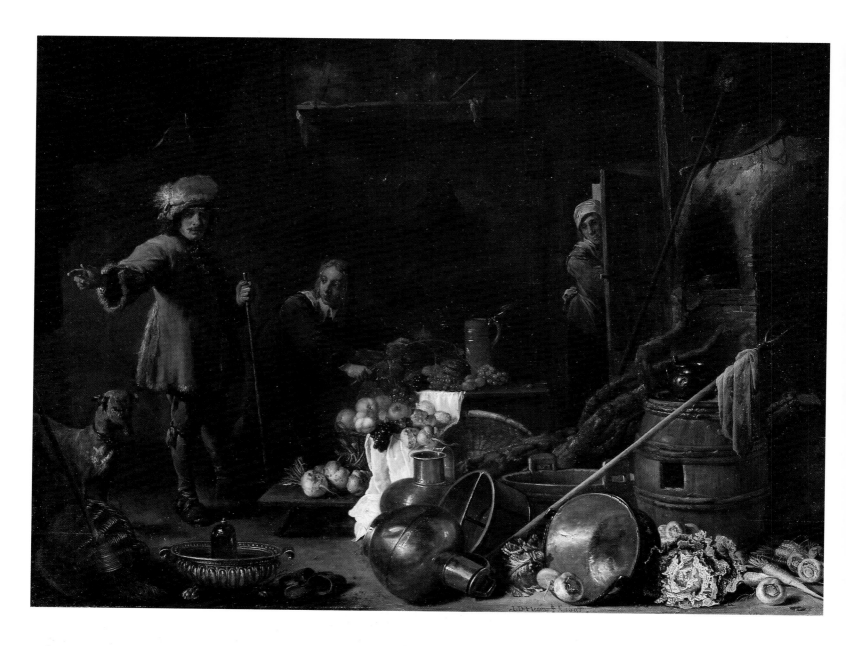

and Herman Saftleven (1609-1695), Pieter de Bloot (1601-1658), and Frans Rijkhals (ca. 1600-1647).[1] The type of simple farm interior with, on one side, a still life of crude everyday objects, and on the other, relatively large-scale, low-life figures is seen in Herman Saftleven's early painting in Brussels of 1634 (fig. 1); Herman had made a drawing of a stable interior with a still life of utensils without figures as early as 1630.[2] In Leiden at the same moment Jan Davidsz. de Heem (see fig. 2) and Pieter Potter were also painting figureless interiors of kitchens or peasant huts with simple pots, pans, tubs, and other utensils.[3] De Heem probably painted figure 2 just before departing for Antwerp. Shortly thereafter, Isack and

Adriaen van Ostade also began painting similar pictures in Haarlem as did Willem Kalf in Antwerp.[4] David Teniers the Younger's own paintings of this type date from at least as early as 1634 (see fig. 3). Klinge has supported Gerson's view, and referred specifically to Cornelis Saftleven's visit to Antwerp around 1632-1634, in pinpointing the source of this influence.[5] She also maintained that Teniers painted figures into interiors by Herman Saftleven in 1634, however Schultz has disputed the notion that Teniers ever collaborated with either of the Saftleven brothers.[6]

While Teniers seems to have painted and drawn a few pure stable and kitchen still lifes,[7] and regularly

Fig. 1. Herman Saftleven, *Stable Interior with Still Life of Kitchen and Farm Utensils with Two Boys Playing Marbles*, signed and dated 1634, oil on panel, 41 x 57.5 cm, Brussels, Musées Royaux des Beaux-Arts de Belgique, inv. no. 407.

Fig. 2. Jan Davidsz. de Heem, *Interior with Kitchen Still Life*, signed and dated 1631, oil on panel, 36 x 48 cm, Leiden, Stedelijk Museum "de Lakenhal," no. 957.

Fig. 3. David Teniers the Younger, *Interior with Still Life and Couple Eating*, signed and dated 1634, oil on panel, 46.5 x 63.5 cm, Karlsruhe, Staatliche Kunsthalle, no. 193.

painted highly accomplished still-life elements into his own figure compositions, he obviously admired de Heem's still lifes sufficiently to believe that it would complement his own figure painting style. During the same period he nonetheless continued to paint interiors with kitchen still lifes and figures entirely on his own; see for example, *Peasant Kitchen with Still Life*, also signed and dated 1643 (panel, 35 x 50 cm, Madrid, Museo del Prado, no. 356).[8]

The Los Angeles painting has carried several titles but is usually described simply as a kitchen interior.[9] Probably correctly, Smith described the standing man in fur cap and fur-trimmed coat and stick as the "master of the house . . . giving orders to the servant."[10] Teniers depicted elegantly dressed figures in furs with sticks in several paintings from this period, including a stable scene of 1645 in the Prince of Liechtenstein collection, Vaduz (no. 553), a guardroom scene in the Hermitage, St. Petersburg (no. 673), the falconer in the *Kitchen Scene* of 1646 that is an Allegory of the Four Elements, also in the Hermitage (no. 586), and the painting formerly in the Widener collection, Philadelphia.[11] Citing the important sixteenth-century precedents of the paintings by Aertsen and Beuckelaer, Klinge has interpreted the still lifes in Teniers's kitchen and stable interiors symbolically.[12] The elegant wine cooler's juxtaposition with the simple brass milk vessels and common buckets surely helps underscore the social contrast of the master and his servant; however the search for deeper symbolic meanings here and in other similar stable images of Teniers and his contemporaries tends to obscure the painting's more general appeal as an account of, on the one hand, abundance, and on the other, a compellingly accurate account of a variety of commonplace objects.

PCS

1. Gerson 1960, p. 145. On the tradition, see A. Heppner, "Rotterdam as a Center of a 'Dutch Teniers Group,'" *Art in America* 34 (1946), pp. 14-30; Margaret Klinge-Gross, "Herman Saftleven als Zeichner und Maler bäuerlicher Interieurs. Zur Entstehung des südholländischen Bildtyps mit Stilleben aus ländlichem Hausrat und Gerät," *Wallraf-Richartz Jahrbuch* 38 (1976), pp. 68-91; see also Klessmann 1960; Grisebach 1974; and Schnackenburg 1970, in note 4 below, and W. Schulz, *Cornelis Saftleven 1607-1681* (Berlin/New York, 1978), pp. 19-22.

2. For the Brussels painting and a drawing in Cologne (Wallraf-Richartz-Museum, inv. no. Z1806) of the *Stable Interior* dated 1630, see W. Schultz, *Herman Saftleven* (Berlin/New York, 1982) nos. 2 and 1406; and Klinge 1976, respectively figs. 14 and 1.

3. See also Pieter Symonsz. Potter's *Interior with Kitchen Still Life*, signed and dated 1631, panel, 32.5 x 41 cm, Muzeum Narodowe, Warsaw, no. 46503; both paintings first published by I. Bergstrom, in "De Heem's Painting from His First Dutch Period," *Oud Holland* 71 (1956), pp. 173-183, esp. p. 176, respectively figs. 4 and 5; see also Klinge 1976, pp. 73-74, fig. 8 and 9; and Segal, in Utrecht 1991, cat. no. 5.

4. See R. Klessmann, "Die Anfänge des Bauerninterieurs bei den Brüdern Ostade," *Jahrbuch der Berliner Museen*, n.f. 2 (1960), pp. 92-115; B. Schnacken-

Joos van Craesbeeck

(Neerlinter 1605 or 1608-Brussels before 1662)

burg, "Die Anfänge des Bauerninterieurs bei Adriaen van Ostade," *Oud Holland* 85 (1970), pp. 158-169; and L. Grisebach, *Willem Kalf* (Berlin, 1974) pp. 73-76.

5. See Klinge in New York and Maastricht 1982, p. 20, and Antwerp 1991, p. 19. On Cornelis's trip see Schultz 1978, pp. 2-3.

6. Schultz 1982, pp. 17ff on Teniers's collaboration with Herman Saftleven; see also Klinge 1976, figs. 18, 20, and 21. Despite the references in Leopold Wilhelm's 1659 inventory to the painting by Cornelis Saftleven of 1634, now in the Kunsthistorisches Museum, Vienna (no. 750), as "Originael von Sachtleben unndt die Figuren von David Theniers," Schultz (1978, pp. 21-22, and no. 659, fig. 14) asserts that this painting is by a single hand and disputes as "hardly logical" the notion that Cornelis or Herman Saftleven ever collaborated with Teniers.

7. See as examples, H. M. the Queen, Buckingham Palace, no. 137; Bonnefantenmuseum, Maastricht, cat. 1958, no. 181; and the painting that was in the N. K. Goosen collection, The Hague, 1976, and exhibited at Dordrecht, *Nederlands Stilleven uit de 17de eeuw*, 1962, cat. no. 94 (canvas, 46 x 35.5 cm, RKD neg. no. L57703); and his drawings of vegetables and utensils, Musée des Beaux-Arts, Besançon, inv. no. D150, and Staatsgalerie, Stuttgart, inv. no. C88/3585, ill. in Antwerp 1991, respectively cat. nos. 113 and 114.

8. Ill. in Antwerp 1991, p. 304, fig. 113a, the painting for which the Besançon drawing (see note 7) is a study.

9. In the Los Angeles County Museum's *Illustrated Summary Catalogue* (Los Angeles, 1987), p. 49, it was incongruously titled "An Artist in His Studio"; however there is nothing to indicate that the elegantly dressed gentleman is an artist or that he is arranging a still life. When the painting sold at Sotheby's in 1959, the cataloguers described the scene as including "a man and his wife giving orders to their servant," though it is scarcely likely that the haughty looking gentleman is married to the charwoman in the doorway.

10. Smith 1829-42, vol. 3 (1831), p. 377, no. 450. In Glück's *La Collection del Monte* (1928), no. XV, it was simply called "Intérieur de cuisine," with facsimiles of the signatures.

11. Sale Amsterdam, 30 November 1909, no. 50.

12. See, for example, her sexually overheated interpretation of fig. 3, in Antwerp 1991, p. 19.

Born at an indeterminate date in Neerlinter in Brabant, Joos van Craesbeeck (Craesbeke) was the son of an alderman and baker. On 25 July 1631 he became an Antwerp citizen and gave his occupation as baker. In 1633/34 he was registered in the Antwerp guild of St. Luke as both a painter and a baker. Craesbeeck baked bread for the citadel of Antwerp, where he encountered, probably in 1633, the prisoner Adriaen Brouwer (q.v.), who had been imprisoned for tax debts. Brouwer's art subsequently influenced Craesbeeck's low-life genre scenes. On 22 January 1631 he married Johanna Tielens (d. 1637), the daughter of the deceased baker at the citadel. Their son was baptized on 9 February 1631. In 1651 Craesbeeck became a citizen of Brussels, and a master in the corporation of painters in that city. According to van den Branden he probably died soon thereafter; de Bie noted in 1661 that the artist was deceased. The early accounts of his life suggesting that he was a drunk and a delinquent find some support in the accounts of Siret and van den Branden, but other early anecdotes, especially those concerning his dealings with Brouwer, are probably embroidered fictions.

Craesbeeck is primarily remembered as a low-life genre painter who was influenced not only by Brouwer, but also possibly by the Dutch peasant painters. He also occasionally depicted the middle and upper classes and also painted a few religious subjects. The absence of dated paintings makes it difficult to establish a chronology for his work.

De Bie 1661, pp. 109-110; Houbraken 1718-21, vol. 1 (1718), pp. 311, 333-335; Weyerman 1729-69, vol. 2 (1729), p. 78; Descamps 1753-64, vol. 2, pp. 138-140; Immerzeel 1842-43, vol. 1 (1842), p. 153; Kramm 1857-64, vol. 1 (1857), p. 294; Michiels 1865-76, vol. 9 (1874), pp. 168-183; Rombouts, Lerius 1872, vol. 2, pp. 48, 56, 865; A. Siret, in *Biographie Nationale* 1866-1964, vol. 4 (1873), pp. 474-479; Pinchart 1878, pp. 321ff; van den Branden 1881a; van den Branden 1883, pp. 857-863; Wurzbach 1906-11, vol. 1 (1906), pp. 355-356; vol. 3 (1911), p. 70; K. Zoege von Manteuffel, in Thieme, Becker 1907-50, vol. 8 (1913), pp. 44-46; Zoege van Manteuffel 1916; Denucé 1932, 99, 200, 203; Buyck 1954-60; Gerson, ter Kuile 1960, pp. 147, 194 note 12; Knuttel 1962, pp. 39-48; Legrand 1963, pp. 129-153; Brussels 1965, pp. 44-46; Paris 1977-78, pp. 62-63; Baudouin 1991, pp. 76-79; Cologne/Vienna 1992-93, pp. 424-425.

A. Pinssio after J. B. Descamps, *Joseph van Craesbeeck*, engraving, from d'Argenville's J. B. Descamps, *Vie des Peintres*, vol. 1 (1842).

Joos van Craesbeeck
71. Brawl at an Inn: "Death is Fierce and Quick (De Dood is Fel en Snel)"

Oil on canvas, 73 x 103 cm (28 ¾ x 40 ½ in.)
Monogrammed CB on the signboard
Antwerp, Koninklijk Museum voor Schone Kunsten,
inv. no. 850

PROVENANCE: sale J. M. de Birkenstock, Vienna, March 1811, no. 276
["Une melée de paysans ivres, qui se battent à mort avec des couteaux,
des cruches etc.; on voit un mort couché à terre, une femme et des enfans
en lamentation etc."; Thl. 200]; von Rath, Budapest; sale Baron Eduard
von Niesewand (Mülheim an der Ruhr), London (Foster), 9 June 1886,
no. 59; L. Nardus, Surenes; acquired from F. Kleinberger, Paris, in 1906.

EXHIBITIONS: Antwerp, Stedelijke Feestzaal, Scaldis: Tentoonstelling
oude kunst en cultuur, 20 July-9 September 1956, no. 555; Antwerp, cat. 1988,
no. 341, ill. no. 137; Cologne/Vienna 1992-93, no. 74.1.

LITERATURE: J. J. Mak, De gedichten van Anthonius de Roovere naar alle tot
dusver bekende handschriften en oude drukken (Zwolle, 1955), pp. 70, 262;
Antwerp, cat. 1958, pp. 61-62; Knuttel 1962, p. 48; Legrand 1963, p. 133;
R. Genaille, "'Naer den Ouden Brueghel': La rixe de Paysans," Jaarboek van
het Koninklijk Museum voor Schone Kunsten, Antwerpen 1980, p. 80, fig. 11;
Antwerp, cat. 1988, p. 100, ill.

A FIGHT breaks out before a tavern. Beside an over-
turned table and still life of crockery and tableware,
the corpse of a young man lies in a pool of blood on
the ground. On the left the suspected murderer is
surrounded by the other brawling peasants. He rais-
es a jug over his head as if to strike the man kneeling
before him. However, with his blow checked by his
adversaries, he turns to grimace at the viewer as the
kneeling man stabs him in the side. In the midst of
the tumult the figure of death presses toward the
attacker, wearing a white winding sheet, draped
with straw and vines, and a black turban. This desic-
cated figure brandishes a knife in one hand and a
bone in the other. Beside the dead man is a woman,
presumably his widow, and two grieving children.

The presence of a moralizing message in this
painting is hinted at by the signboard of the tavern
which displays a head sticking its tongue out at the
donnybrook in the foreground and, by implication,
at the viewer. An admonition is explicitly stated in
the inscription from a poem by Anthonis de Roovere
(Rhetoricale wercke [1562], fol. 50v) that appears in the
lower right on a stone supporting a beer mug in
which a tiny skeleton with a scythe appears:

> De dood is fel en snel
> Wacht u van sonden, zoo doedy wel
> Ende wilt niemant vermaken
> Dat Godt u 't zelve niet en doet smaken
> En neemt niemant 't sy, soo houdt ghy 't u
>
> (Death is fierce and quick
> Watch out for sins, behave well
> And wish no one injury
> Lest God do the same unto you
> And not gather you unto him
> So watch yourself.)

This warning to the foolish is underscored by a sec-
ond inscription on the oversized spectacles lying
beside the upturned table. They seem to address the
viewer in the first person. "Ten is mijn schuld niet
dat den mensch niet beter en siet" (It is not my fault
that people do not see better).[1]

Fig. 1. Joos van Craesbeeck, Brawl outside a Tavern,
monogrammed, panel, 62 x 78.5 cm, Zurich, art
market, 1949.

One of the earliest surviving Netherlandish
"genre" paintings, namely Hieronymus Bosch's
tabletop decorated with the Seven Deadly Sins
(Madrid, Museo del Prado, no. 2822), personified Ira
(wrath) with a knife fight between enraged peasants
outside a tavern. The tradition of the tavern brawl
was perpetuated by Pieter Bruegel, whose now-lost
Peasants Fighting over Cards was copied repeatedly by
his dynastic family[2]; well into the seventeenth cen-
tury, Pieter Brueghel the Younger, for example, con-
tinued to repeat this subject (see, for example, The
Fight at the Cabaret, New York, Metropolitan Muse-
um of Art, no. 71.25). Pieter the Younger's several ver-
sions of this theme are probably (like so many of his
paintings) based on a lost work by his father, which
may also have influenced Craesbeeck. Craesbeeck
often depicted brawls in public houses in which the
combatants overturn furniture and slug it out
amidst screaming women and crying children (see,
for example, fig. 1[3]). While the subject of a work like
the last mentioned could also involve casualties,
none of Craesbeeck's other brawls conjure up Death,
whose entrance here drives home the fatal point that
mindless anger is a mortal sin. However the artist
frequently introduced skeletons in their more tradi-
tional role as personifications of death, the most
comprehensive use of which appeared in Pieter
Bruegel the Elder's famous Triumph of Death of
ca. 1562 (Madrid, Museo del Prado). Several paintings
by Craesbeeck illustrate this time-honored theme of
death coming to gather an old person (see, for exam-
ple, his Old Man [an Alchemist (?)] Sleeping, with Death
as a Skeleton Shooting Him with an Arrow; sale Mme
M. L., Brussels, 19 December 1927, no. 32, ill., mono-
grammed) or a couple, as in his Death at the Door

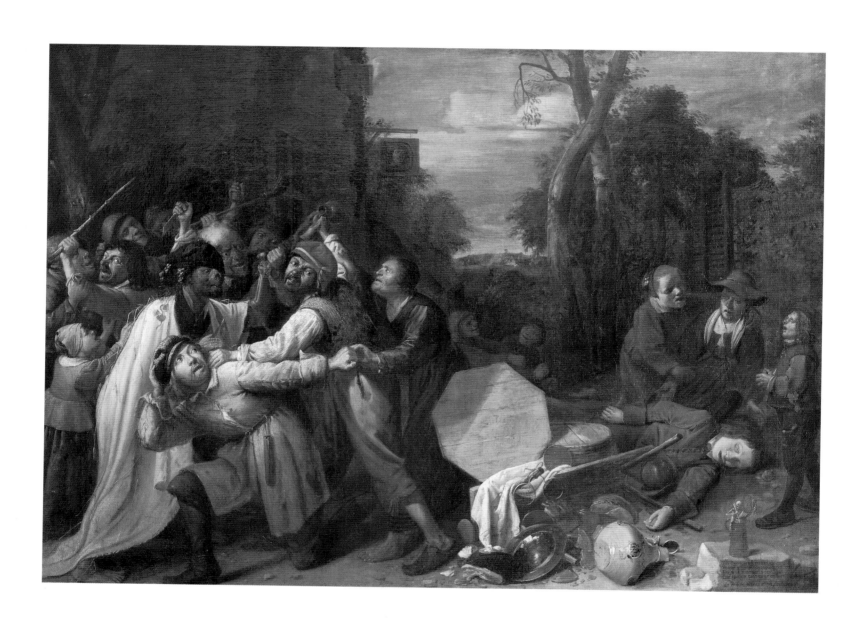

Fig. 2. Joos van Craesbeeck, *Death at the Door*, mono-grammed, panel, 27 x 25 cm, Gotha, Schlossmuseum, inv. Ahv. 90.

(fig. 2). Such subjects can be traced to the Middle Ages and enjoyed popularity in the sixteenth centu-ry. However they seem to have undergone a revival in the circle of Antwerp artists around 1640. Jan Lievens painted his *Avaricious Couple with Death* (signed and dated 1638, Lady Teresa Agnew, Melbury House) in Antwerp in 1638.[4] About this same time Lievens also probably painted the *Fighting Card Play-ers and Death* (fig. 3),[5] which the artist reproduced in an etching that adds a window at the back.[6] The

Fig. 3. Jan Lievens, *Fighting Card Players and Death*, signed, oil on canvas on panel, 65 x 85 cm, Berlin, formerly coll. Dr. A. Heppner.

creatural brutality of the combatants suggests that the revival of the fighting peasants subject at this moment in Antwerp probably has something to do with Adriaen Brouwer's return to the city around 1631 (see, for example, Brouwer's *Peasants Fighting over Cards*, Munich, Alte Pinakothek, inv. 562). The impact of the latter's vital and unapologetically visceral art on both Craesbeeck and Lievens is clear. However the use of the personification of death would be exceptional for Brouwer and seems rather to reflect the survival of sixteenth-century Bruegelian traditions of moralizing genre.

PCS

1. Jan Muylle (exh. Antwerp, cat. 1988, cat. no. 341) noted that this expres-sion recalls the saying "Wat baet er kaers en bril, als den uil niet zien en wil," which conveys the idea that it is futile to try to enlighten the invet-erately ignorant (see cat. 46).

2. For the many copies, see Marlier 1969, pp. 271-274; see also the discus-sion of a painting in a private collection in Antwerp 1993, cat. no. 73. On the theme's history, see R. Genaille, "'Naer den ouden Brueghel': La rixe de paysans," *Jaarboek van het Koninklijk Museum voor Schone Kunsten, Antwerpen* 1980, pp. 61-91.

3. Since this painting is on panel instead of canvas, it and not the Antwerp picture was the painting of fighting peasants owned by the author J. B. Descamps in 1754 (vol. 2, p. 140) and described as follows: "un tableau capital qui est sur bois. Ce sont des Paysans qui s'égorgent dans

une guinguette; tout y est renversé, tables, pots, verres, hommes, femmes & enfants: Ici un des combattants est étendu mort, un autre tient à la gorge celui qui l'a blessé d'un coup de couteau. Ce tableau est du bontemps de notre Artiste, il est entierement dans la manière de Brouwer." The painting known as "In 't Wapen van Antwerpen," Konink-lijk Museum voor Schone Kunsten, Antwerp, no. 731, depicts a less destructive argument; see also sale Amsterdam (Mak van Waay), 4 Nov-ember 1974, no. 20, ill. On the subject of fighting in Craesbeeck's art, see Buyck 1960, pp. 89ff, esp. p. 93.

4. See Braunschweig, Herzog Anton Ulrich-Museum, *Jan Lievens, ein Maler im Schatten Rembrandts*, 6 September-11 November 1979, no. 34, ill.

5. W. Sumowski, *Gemälde der Rembrandt Schüler* (Landau/Pfalz, 1983-90), vol. 3 (1983), no. 1198.

6. See Amsterdam, Museum het Rembrandthuis, *Jan Lievens Prenten & Tekeningen* (cat. by P. Schatborn), 5 November 1988-8 January 1989, no. 37, ill.

David III Ryckaert

(1612-Antwerp-1661)

Son of the landscape painter David II Ryckaert (1586-1642) and Catharina de Meere, David III Ryckaert was baptized in Antwerp on 2 December 1612. He was one of an extended family of artists: his grandfather David I (1560-1607) was a painter, as was his uncle, the landscapist Marten Ryckaert (1587-1631); his sister Catharina married Gonzales Coques (q.v.) in 1642. The younger Ryckaert was a pupil of his father, and became a master in the Antwerp guild of St. Luke in 1636/37. On 31 August 1647 he married Jacoba Pallemans (d. December 1663); the couple had eight children, the eldest of whom, David IV (b. 1648), may also have been a painter.

Ryckaert apparently never left his native city of Antwerp. On 2 May 1649 he purchased the house "het Keizershoofd" ("the Emperor's Head") in the Arensbergstraat, which had previously been owned by Tobias Verhaecht (1561-1631); and in 1658 rented the house "de Munt" ("the Mint") near the Cathedral. He was quite successful and garnered many distinguished patrons, including the Archduke Leopold Wilhelm, who owned several of his paintings. The artist was named dean of the St. Luke's Guild in 1651, and because of his bovine features and contrary temperament was dubbed "den Os van Sint Lucas" ("St. Luke's Ox"). Ryckaert died in Antwerp on 11 November 1661.

Ryckaert was a versatile painter of genre scenes, and dated paintings are extant from 1637 until the year of his death. His earliest works are rustic peasant companies in the manner of Adriaen Brouwer (q.v.), with particular attention lavished on still-life elements. Like David Teniers (q.v.), Ryckaert also painted alchemists, and fantastical demons in scenes of witchcraft and temptation. Under the influence of Gonzales Coques and others, from about 1650 Ryckaert increasingly depicted high-life scenes, predominantly musical companies. Certain stock characters – such as a bearded old man, his heavy-set female counterpart, and a young fop – and poses recur in various combinations in paintings dating throughout the artist's career.

De Bie 1661, p. 308; Houbraken 1718-21, vol. 2 (1719), p. 14; Descamps 1753-64, vol. 2, pp. 233-236; Nagler 1835-52, vol. 14 (1845), p. 108; Immerzeel 1842-43, vol. 3 (1843), p. 46; Kramm 1857-64, vol. 5 (1861), p. 1421; Rombouts, van Lerius 1872, vol. 2, pp. 80, 87, 123, 171, 183, 194, 203, 212, 221, 233, 234, 239, 243, 253, 255, 267, 275, 284, 291, 301, 310, and 331; Michiels 1865-76, vol. 9 (1874), pp. 34, 49ff, 60-66; Rooses 1879, pp. 606-610 and passim; van de Branden 1883, pp. 606-608; Donnet 1907, pp. 256, 480; Wurzbach 1906-11, vol. 2 (1910), pp. 528-529; Zoege von Manteuffel 1915, pp. 53ff; Thieme, Becker 1907-50, vol. 29 (1935), pp. 251-252; Gerson, ter Kuile 1960, pp. 146-148; Legrand 1963, pp. 153-160; Brussels 1965, p. 230; de Mirimonde 1968; Florence 1977, pp. 240-244; New York, Metropolitan, cat. 1984, vol. 1, pp. 237-241; Filipczak 1987, pp. 117, 126, 142-143; Cologne/Vienna 1992-93, pp. 428-430.

David III Ryckaert

72. Musical Company ("As the Old Ones Sing, So the Young Ones Pipe"), 1650

Oil on canvas, 104 x 134 cm (41 x 52 ¾ in.)
Signed and dated lower left: D. Ryckaert f. 1650
London, Artemis Group

73. Peasants Merrymaking in a Tavern ("As the Old Ones Sing, So the Young Ones Pipe"), 1650

Oil on canvas, 103.5 x 135.5 cm (40 ¾ x 53 ¼ in.)
Signed and dated lower left on the corner:
D. Ryckaert 1650
London, Artemis Group

PROVENANCE: acquired for the Czernin collection, Vienna, by 1822; with Galerie Sanct Lucas, Vienna, ca. 1989-90.
LITERATURE: H. von Bockh, *Merkwürdigkeiten der Haupt- und Residenzstadt Wien* (Vienna, 1822), p. 294; G.F. Waagen, *Die vornehmsten Kunstdenkmäler in Wien* (Vienna, 1866), p. 296, no. 25; *Katalog der Graf Czernin'schen Gemälde-Galerie in Wien* (Vienna, 1899), p. 22, nos. 220 and 221; Wurzbach 1906-11, vol. 2 (1910), p. 529; Thieme, Becker 1907-50, vol. 29, p. 252; K. Wilczek, *Katalog der Graf Czernin'schen Gemäldegalerie in Wien* (Vienna, 1936) p. 80, nos. 220 and 221; W. Bern, *Die Niederländischen Maler des 17. Jahrhunderts* (Munich, 1948) 1948, nos. 706-709; *Residenzgalerie Salzburg mit Sammlung Czernin und Sammlung Schönborn Buchheim* (Salzburg, 1962), pp. 74-75, nos. 162-163, fig. 25; Legrand 1963, p. 157; *Galerie Sanct Lucas Wien Gemälde Alter Meister* (Vienna, winter 1992/93), nos. 8, 9.

Frederick Bouttats after David Ryckaert, *David Ryckaert*, engraving, from Cornelis de Bie, *Het gulden cabinet . . .*, 1661, fol. 309.

A COMPANY of sixteen elegantly dressed figures makes music on an enclosed terrace with a glimpse on the left of a classical facade and a landscape. In the center a seated woman dressed in white satin and a feathered cap sings to the accompaniment of a young man in a red cape and boots playing a guitar. The other musicians include: a young man seated on the right wearing an armored cuirass, sword, feathered cap with large salmon-colored sash, and playing a viola da gamba; to his right is a young boy playing a flute; on the far side of the table, a woman playing a violin and a boy singing; and at the back right, a young woman plays a virginal while a young man plays a flute. In the right center a balding old man with a beard serves a roemer of wine with a peeled lemon, and on the left stands a serving boy holding a pitcher and platter. Beside the latter a couple converses, and at the back right another couple embraces. A greyhound and a small lapdog appear in the foreground. The lid of the virginal is decorated with a musical company playing *en plein air*. On the back wall two paintings of tavern scenes in the style of David Teniers the Younger flank a landscape with an old man with a cane before a view of a town by a river.

In the companion piece a company of twenty-seven figures gathers in a tavern to sing, eat, drink, and generally carouse. At a table in the left foreground an old man with a white beard sings beside an old woman in red, white, and blue holding a pair of tongs. To the left a woman nurses an infant. On the far side of the table a man in a black beard sings as he cradles his beer mug, while other drinkers sing, yawn, smoke, or embrace. At the right an old woman

in a wicker chair helps a young boy to a drink as another man drains his long flute glass. Four children appear at the lower right, one of whom plays a short pipe while another pisses. Five drunken figures gather around a hearth at the back right as a hurdy-gurdy player stands in the open door. A sleeping loft appears overhead and a second hearth at the left. Hung from the loft and suspended from a small iron rack are dried meats and fish. Tacked to the sleeping loft is a large print of an owl with a nest of owlets.

The subject of these two paintings is revealed in an inscription partially preserved on the print in the background of the peasants tavern which now reads only "... pijpen de jongen," the remnants of the saying "So de ouden songen, so pijpen de jongen." While the pendants clearly juxtapose high- and low-life musical companies, their moral message is the same: "How you hear it is how you sing it," since antiquity an admonition to wise pedagogy. Ryckaert undoubtedly knew the earlier illustrations of this theme by Jacob Jordaens, who had begun painting these subjects in 1636 (see cat. 46). Both artists introduced pipes and flutes into their scenes, as well as flute glasses and pitchers with a long spout, also known as "flutes," as a play on the words of the saying. Ryckaert also followed Jordaens in symbolically linking the theme with owls, a traditional admonition against drunkenness and stupidity.[1] However by adding a nest of owlets (uilskuiken, a slang term referring to nincompoops) he underscored the dangerous example that parents set for their children. As early as 1640 (see fig. 1) Ryckaert illustrated the theme of "As the Old Ones Sing ..." with drunken peasants singing as their children blow a pipe and drink at the lower right. That work and Ryckaert's version of the theme dated 1642 now in Dresden (fig. 2), anticipate the general composition of the low-life scene in the present pair (note particularly the seated singers with a nursing mother on the left and the small boy on the extreme right, whose pose is repeated virtually verbatim). It also includes a print of a bird with peeping young on the back wall.[2] David Teniers the Younger, who together with Adriaen Brouwer was an important influence on Ryckaert, had included bird prints on the back wall of his low-life tavern scenes (fig. 3).[3] Whether the candle which burns brightly in figure 1 and rests extinguished in the foreground of the present picture is an allusion to the popular saying, "Wat baet er kaers en bril, als den uyl niet zien en wil" (What need does the owl have for candles or spectacles if he cannot or will not see) is uncertain.[5] However there can be no doubt as to the subject, which Ryckaert again actually inscribed into his painting in the

Fig. 1. David Ryckaert, "As the Old Ones Sing, So the Young Ones Pipe," signed and dated 1640, oil on canvas, 66 x 103 cm, present location unknown.

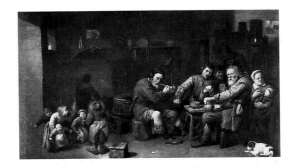

Fig. 2. David Ryckaert, "As the Old Ones Sing, So the Young Ones Pipe," signed and dated 1642, oil on panel, 64.5 x 101 cm, Dresden, Gemäldegalerie Alte Meister, no. 284.

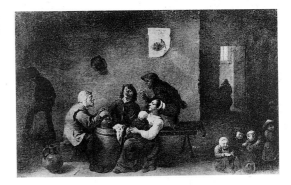

Fig. 3. Attributed to David Teniers the Younger, Flemish Tavern, 1634, oil on canvas, 36 x 55 cm, present location unknown.

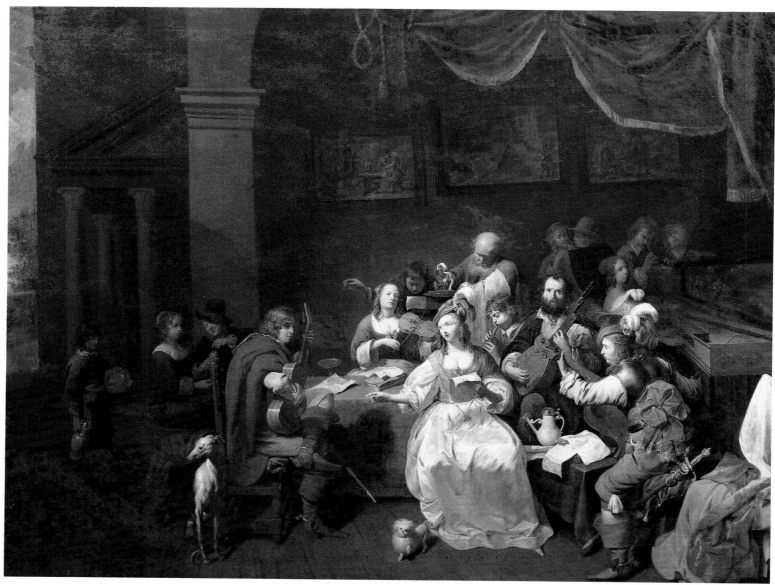

cat. 72

Fig. 4. David Ryckaert, *Musical Party*, signed and dated
1650, oil on panel, 90 x 127 cm, Vaduz, Prince of
Liechtenstein collection, inv. no. 554.

cat. 73

Willem van Herp

(ca. 1614-Antwerp-1677)

Szépmüvészeti Múzeum, Budapest, and illustrated repeatedly.[5]

The old bald man, who plays the role of the elderly servant in the high-life scene, and who may possibly be identified in the singing old man seated in the foreground of the low-life scene, was one of Ryckaert's favorite models (see fig. 4). He appeared alone sleeping at a table by a large jug of wine in a print after Ryckaert by I. de Weert with the graphic inscription: "I yawn, I pour, I fill my stomach / With food and drink: but I have a complaint / Namely that I can't keep my belly full / Because I eat and drink until I puke."[6] The same model often seems to have played the central role in Ryckaert's cautionary images of excess. Many of the models for the painter's high-life subjects also recur. In its general conception and design as well as in its cast of characters, the present high-life musical company closely resembles a painting in the collection of the Prince of Liechtenstein (fig. 4); compare also the musical companies in the Schönborn collection, Schloss Weissenstein, Pommersfelden (cat. 1894, no. 495),[7] and The King Drinks, a subject often linked with the present theme, in the Niedersächsisches Landesmuseum, Hanover (no. 153).[8] A date of 1650 also appears on the stylistically related painting in Vaduz (fig. 4) and in the Concert Scene in Copenhagen (no. 584).[9]

Ryckaert's interest in the traditional function of pendants, whose opposing subjects enrich the shared narrative, is also well illustrated in his pairing of the time-honored themes of peasant joy and peasant sorrow in two large canvases (120 x 175 cm) dated 1649 in the Kunsthistorisches Museum, Vienna (no. 729, a scene of a kermesse, and no. 733, soldiers plundering a village; ill. Introduction, figs. 71-72).

PCS

1. On the symbolism of the owl, see cat. 46, notes 8-10; and cat. 119.

2. See Brussels 1965, no. 243, where, however, the print and its meaning are not discussed.

3. Exh. Brussels, Trésor de l'art Belge au XVIIᵉ siècle, 1910, no. 134 (collection Markus Kappel, Berlin).

4. For dicussion of the expression as alluded to by Jordaens and Jan Steen, see cat. 46.

5. See Budapest, cat. 1968, vol. 1, p. 608, no. 53.452, inscribed: "Soo de Oude songhen / soo pijpen de Jonghe." See also the signed and dated painting of 1651, which sold in Vienna (Dorotheum), 4 December 1973, no. 115.

6. "Ick gaep, ick giet, Ick vul de Maegh / Met Cost en dranck: maer 'k heb een plaegh / Dat ick geen vollen Büyck behou / Want 'k eet en drink tot dat ick spou."

7. Oil on canvas, 94 x 123 cm.

8. Oil on canvas, 121 x 122 cm. An outdoor high-life party with musicians by Ryckaert was in the sale London (Christie's), 10 April 1970, no. 32 (canvas, 86.4 x 128 cm).

9. Panel, 56 x 78 cm. See Copenhagen, cat. 1951, p. 259, no. 584.

Willem (Gilliam) van Herp was born in Antwerp, probably ca. 1614; in a document of 14 July 1676 he declared himself to be 62 years old. He was listed in the guild records for 1625/26 as the pupil of Damiaan Wortelmans, and for 1628/29 as the pupil of Hans Biermans. He became a master in the guild in 1637/38. On 10 July 1654 he married Maria Wolffort (d. 1701), daughter of the artist Artus Wolffort. Of the couple's four children, two sons, Norbertus (b. 1644) and Willem II (1657-ca. 1729), also became painters. Van Herp's other pupils included Pieter Schoof in 1645 and Melchior Hamers in 1654.

In the 1650s and sixties he worked for the Antwerp art dealer Matthijs Musson and for the Forchoudt firm painting pictures for export, specifically to Spain. Many were small works on copper, including both original compositions and copies after Rubens and other artists. Van Herp also received independent commissions from Spanish patrons; in 1663 he worked with Luigi Primo (1606-1667), Adam Frans van der Meulen, and David II Teniers (qq.v.) on a series of twenty small paintings on copper, illustrating episodes from the life of Guillermo Ramon Moncada and his brother, with decorative borders by Jan I van Kessel (q.v.). Several of the compositions (including four by van Herp) were subsequently woven into tapestries in Flanders. Van Herp was buried in Antwerp on 23 June 1677.

Van Herp executed religious, historical, and mythological paintings, as well as both high- and low-life genre scenes and possibly even – from the evidence of dealers' inventories – some still lifes. His eclectic œuvre is difficult to analyze, in part because only fifteen signed paintings by the artist are known, of which only a few are dated. The small scale and genre subject matter of his works is reminiscent of Teniers, but his warm palette and lively brushwork are more directly influenced by Rubens and Jordaens. In addition to the series mentioned above, van Herp appears to have also collaborated with Erasmus Quellinus II (q.v.), Antoon Goubau (1616-1698), and P.-A. Immenraet (1627-1679).

Houbraken 1718-21, vol. 3, p. 53; Kramm 1857-64, vol. 3 (1858), pp. 644, 680; Michiels 1865-76, vol. 8 (1869), pp. 248-255; Rombouts, van Lerius 1872, vol. 1, pp. 623, 632, 662; vol. 2, pp. 91, 95, 164, 252, 457, 630; van den Branden 1883 p. 916; Wurzbach 1906-11, vol. 1 (1906), pp. 681; K. Zoege van Manteuffel, in Thieme, Becker 1907-50, vol. 16 (1923), pp. 529-530; Denucé 1949, pp. LXVIII, XCIII; van Puyvelde 1959; Legrand 1963, pp. 167-175; Brussels 1965, p. 102; London, National Gallery, cat. 1970, pp. 82-84; Valdiveso 1973; Díaz Padrón 1977-78; Paris 1977-78, p. 95; Díaz Padrón 1982; Díaz Padrón 1988; Díaz Padrón 1990.

Willem van Herp
74. Tavern with Merrymakers and Card Players

Oil on copper, 79 x 100 cm (31 x 39 ¼ in.)
New York, French & Co.

PROVENANCE: private collection, Europe [as unattributed]; sale London (Sotheby's), 7 December 1988, no. 118, ill.

LITERATURE: Greindl et al. 1990, p. 238, pl. 233.

FOURTEEN PEOPLE make merry in the interior of a tavern. Some take liberties with the hostess, while others smoke, drink, or play cards. At the left is a large open hearth decorated on the mantle with crockery. Before the hearth a man lights his pipe, and the tavern hostess indulges the importunities of two customers while a child tugs on her apron. To the right, figures seated at a long table smoke and play cards. At the rear a serving woman keeps the tally on a small narrow slate; hanging on the back wall are utensils, traveling bags, candles, and a print of the Crucifixion. In the foreground are a cat and dog, a brazier and jug, and several brass ladles.

Van Herp painted several dozen merry company scenes, which usually employ horizontal compositions that depict a tavern populated by various low-life figures who smoke, eat and drink, and play cards. Often the interior is a basement with stairs leading to a lighted doorway. Although he often signed his paintings, as Legrand reported, only two are dated.[1] The *Merry Company* dated 1654 in the collection of the Duke of Sutherland (fig. 1) is the earlier of the two; it depicts a scene comparable to that of the present painting. The greater elaboration of the present scene and slightly more attenuated proportions may indicate a somewhat later date.[2]

Fig. 1. Willem van Herp, *Merry Company*, signed and dated 1654, Ellesmere, Merton Saint-Boswells (formerly Bridgewater House), cat. no. 181.

Fig. 2. Willem van Herp, *Merry Company*, signed, canvas, 62 x 86 cm, Czechoslovakia, Kroměříz, Castle, inv. 344.

The subject of the merry company with card players in a tavern descends from Adriaen Brouwer and David Teniers (compare, for example, the latter's *Tavern Interior with Card Players*, signed and dated 1645, Paris, Musée du Louvre, no. R.F. 1530). Indeed the little tussle with the tavern hostess, where the man slips his hand under her apron, are the polite vestiges of Brouwer's famously gross companies; compare, specifically, *Tavern Interior* (see. cat. 65) where a woman pulls the hair of a screaming lout who tries to put his hand up her dress.

Van Herp's merry companies include everything from a single couple seated alone in a tavern (sale London [Sotheby's], 24 October 1973, no. 125, ill.) to gatherings of more than a dozen people. Some of these paintings seem to celebrate special feast days and are reminiscent of Jordaens's genre scenes (see, for example, the so-called *Le Jour de fête de grand-père*, Malmö, Count Pontus de la Gardie, 1911[3]) while

others appear to depict spontaneous tavern amusements. Several represent musical companies or at least a fiddler among the revelers.[4] More elaborate compositions add the favored motif of a lighted stone stairway on the left, through which jocular figures arrive, as well as a richer, more complex architecture at the rear with arches and vaults.[5] One of these more elegant interiors (fig. 2) also features a figure at the left jollying up the tavern maid, and adds a jester figure at the back center of the company who holds up a tall stick with a pig's bladder, a traditional *vanitas* admonition.[6] In the present painting the print of the Crucifixion on the back wall also introduces a moral counterpoint; however it is unlikely that van Herp intended a hectoring warning; the detail seems rather a vestigial footnote to his surprisingly tame and decorous merrymaking.

One or more copies of this painting are known,[7] and a 1764 Amsterdam sale may have included a somewhat smaller version or variant of the composition.[8]

<div align="center">PCS</div>

1. Legrand 1963, p. 167, fig. 63. The second painting, dated 1664, is the *Siege of a Farm* (formerly Harrach collection, Vienna), which depicts a battle of peasants and soldiers in the tradition of David Vinckboons.

2. Van Herp's figures can become almost mannered in their graceful attenuation; see, for example, *The Birth of the Virgin*, copper, 94 x 117 cm, sale New York (Christie's),12 June 1981, no. 239.

3. Signed, panel, 60 x 89 cm; see O. Granburg, *Inventaire général des Trésors de l'art*, 3 vols. (Stockholm, 1911), vol. 1, no. 397, pl. 6.

4. See, as examples, the Duke of Sutherland's other painting by van Herp (panel, 57.2 x 80 cm; see Earl of Ellesmere, Bridgewater House, London, cats. 1897 and 1907, no. 180); and the *Merry Company*, signed, copper, 68 x 97 cm, in the E. Thorn collection, Chercq (see Legrand 1963, fig. 64; and exh. Brussels 1965, no. 108, ill.).

5. See the two versions of the same merry company composition in the collections of the Marquess of Bute (signed, copper, 78.7 x 114.7 cm); and formerly Earl of Wemyss, Gosford House, inv. (1948) no. 255 (canvas, 83 x 119 cm), sale London (Christie's), 14 December 1962, no. 134.

6. See the exh. of *Dutch and Flemish Seventeenth-Century Paintings from Moravian Collections*, Oblastní Galerie, Gottwaldov, 1981, no. 43. On the pig's bladder, see cat. 69.

7. When the present painting sold in 1988, the Sotheby's catalogue mentioned a probable copy in the Moltke sale, Copenhagen (U. Winkel and Magnussen), 1 June 1931, no. 53; possibly identical with the copy in sale Holger Drukker, Copenhagen (Rasmussen), 25 April 1961, no. 14, ill. (54 x 77 cm).

8. Sale Amsterdam (Jolles, de Winter), 23 April 1764, no. 12: "Van Herp. Een capitaal stuk, verbeeldende een Boere Gezelschap van twaalf beelden, ter zyde aan een tafel zitten zes beelden, en agter denzelve eenige staande, op de voorgrond een hond en kat en eenige potten en pannen zynde een fraay ordinantie en zoo kragtig en konstig geschildert op een paneel als men van dien meester zien kan, 24 ½ duim, 35 ½ duim."

Michiel Sweerts
75. *The Schoolroom*

Oil on canvas, 89.5 x 114 cm (35 ¼ x 44 ⅞ in.)
Berkeley Will Trust

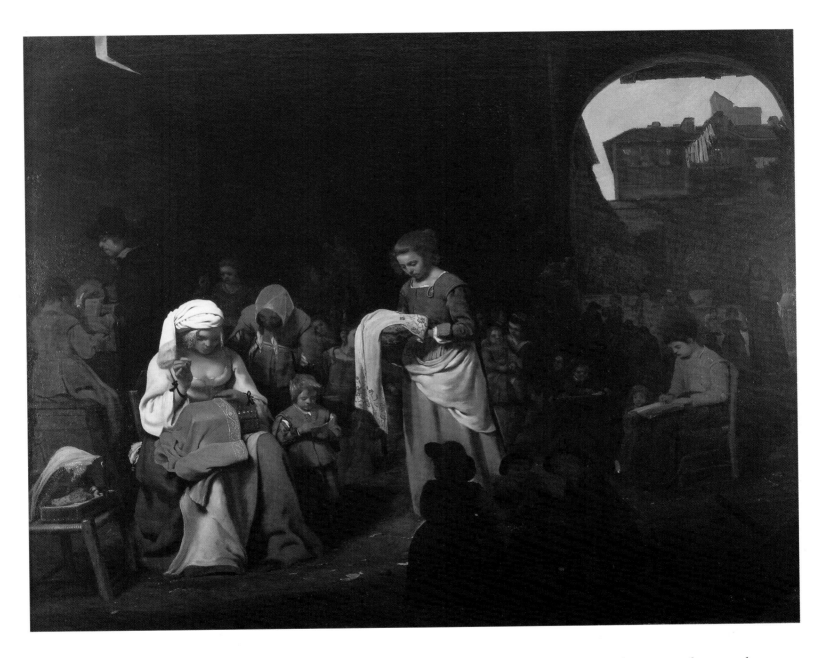

PROVENANCE: collection R. M. Berkeley, eighth Earl of Berkeley (d. 1942), Berkeley Castle; by descent to the present owner.

EXHIBITIONS: Montreal 1990, no. 60.

LITERATURE: Longhi 1958, pp. 73-74, ill. 29 (wrongly as in private collection, Rome); Waddingham 1983, pp. 281, ill. 1, 282.

A CROWD of people – mostly women and children – are gathered in a shadowy cavelike interior; the darkness is relieved by the archway in the right background, which opens onto a garden courtyard bounded by other buildings. In the foreground a shaft of light illuminates the central figures of the composition, a seated embroideress wearing a white turban, and another woman who approaches, carrying her needlework in her hands. Standing at the knee of the seated woman, a small boy reads from a book. Beyond this grouping are several other figures engaged in various activities. At the far left, a music master instructs a young woman at the keyboard; at the right, a seated girl writes in a book propped on her knees while a small child looks on. In the immediate foreground, three children warm their hands at a brazier.

Despite the cavernous setting, *The Schoolroom* presents an intimate glimpse of quotidian activities in seventeenth-century Rome, a popular theme

Fig. 1. Michiel Sweerts, *Visiting the Sick*, oil on canvas, 75 x 99 cm, Amsterdam, Rijksmuseum, inv. A2848.

Fig. 2. Michiel Sweerts (?), *Artist's Studio with Woman Sewing*, oil on canvas, 82.5 x 106.7 cm, Zurich, Fondation Rau, inv. GR 1.874.

among Italianate painters. During his years in Italy (from 1646 to at least 1652), Sweerts figured among the Bamboccianti, a group of Northern artists who painted scenes of everyday life in Rome.[1] The group's name derives from il *Bamboccio* ("clumsy doll"), the nickname given to Pieter van Laer (1599-ca. 1642), one of the founders of this informal school of painters in the late 1620s. Bamboccianti genre scenes presented unsparing depictions of the disenfranchised urban poor engaged in gambling, brawling, working simple trades, eking out a meager existence in the streets and public spaces of the Italian city, or huddled beneath picturesque ruins in the Roman campagna. In many ways these Bamboccianti figures are the Mediterranean counterparts of Adriaen Brouwer's earthy Flemish peasants, made even more appealing to a Northern audience by the picturesque exoticism of their surroundings.

While Sweerts's work is very much a part of Bamboccianti art in terms of his use of an Italianate set-

ting and choice of humble subject matter, it differs both stylistically and conceptually from paintings produced by his mostly Dutch contemporaries. The monumental figures which populate Sweerts's compositions project an aura of solemn quietude which recalls the pervasive gravity of works by the Le Nains, Georges de la Tour, or Nicolas Poussin.[2] In contrast to the rough earthy characters painted by his Northern contemporaries, Sweerts's figures are distinguished by their classical proportions and carefully studied musculature,[3] as well as by their deep absorption in mundane tasks which corresponds to the artist's own intense identification with his subject matter. Sweerts took a strong interest in social problems and conditions, and this humanistic outlook was deepened by an almost fanatical religious fervor.[4] His peity imbues even his secular compositions with humility and concern, resulting in works – like *The Schoolroom* – which are "less obviously religious yet essentially humane."[5] The nurturing theme of *The Schoolroom* recalls Sweerts's series of the seven Acts of Mercy, presented in the guise of contemporary Bamboccianti genre (fig. 1).[6]

The primary subject of *The Schoolroom* is education, both instruction (represented, e.g., by the music master and his student) and the practice and repetition that bring knowledge and skill, represented by the calm industry of the embroideress.[7] Related images in Sweerts's œuvre include his several depictions of young draughtsmen diligently at work in an artist's atelier, as well as individual figures of women engaged in needlework.[8] In the seventeenth century, moreover, the purpose of elementary schooling was not just to impart the rudiments of knowledge and practical skills, but also to furnish the child with sound moral training in preparation for properly discharging the responsibilities of adulthood.[9] The latter aspect was, of course, particularly in harmony with Sweerts's humanistic concerns.

The majestic figure of the seated seamstress at the left of Sweerts's composition also appears as an artist's model in a related painting in the collection of the Fondation Rau, Zurich (inv. GR 1.874; fig. 2),[10] which Waddingham has labeled an inferior work, "hard to accept without reservations."[11] The rather harsh forms in the Zurich painting (some of which may be due to the overcleaned state of the work) and the additive quality of the composition suggest that the work may be a pastiche, partially based on the Berkeley painting and possibly although not indisputably by the artist's hand.[12]

MEW

1. The Bamboccianti were a subgroup of the "Bentveughels," a social and professional organization of Northern artists in Rome; on the Bent and its artists, see Hoogewerff 1952, and, more briefly, Montreal 1990, pp. 22-27. For more broad-ranging and synthetic discussions of the Bamboccianti and their art, see Hoogewerff 1952; Briganti, Trezzani, Laureati 1983; and most recently Cologne/Utrecht 1985-86.

2. Sweerts was first termed the "Hollandschen Le Nain" by Willem Martin (1907). The relationship of Sweerts's art to that of the Le Nains (especially Louis) and Nicolas Poussin is detailed in Kultzen 1983. Compare also Sweerts's *Plague in an Ancient City* (cat. 129) and its specific relationship to Poussin's *Plague at Ashod*.

3. Sweerts established an academy for life drawing upon his return to Brussels in 1656 and executed several paintings of artists' studios featuring pupils drawing after a nude model, or after fragments of antique statuary. See M. Waddingham, "Michael Sweerts, *Boy Copying the Head of a Roman Emperor*," *The Minneapolis Institute of Arts Bulletin* 63 (1976-77), pp. 57-65; Kultzen 1982; and cat. 57.

4. As noted in the Biography, Sweerts's contemporaries described his zealous devotion to charitable acts and extreme acts of generosity. See also Liedtke 1983, especially p. 122.

5. Waddingham 1983, p. 282.

6. Paintings from the series are located in Amsterdam, Rijksmuseum (inv. nos. A2845, A2846, A2847, and A2848), Hartford, Wadsworth Athenaeum (inv. 1941.595), Zurich, Fondation Rau (inv. nr. GR 1.102) and in a private collection. Sweerts may also have executed a second series of paintings with this theme; see Liedtke 1983. The tradition of depicting the Acts of Mercy in an Italianate setting was distinctly Flemish, as noted by S. D. Muller, *Charity in the Dutch Republic: Pictures of Rich and Poor for Charitable Institutions* (Ann Arbor, 1985), p. 270, note 24.

7. Compare J. A. Emmens's analysis of the Aristotelian trilogy of nature – training – practice within the context of Dutch art, "Natuur, Onderwijzing en Oefening: Bij een drieluik van Gerrit Dou," in *Album Discipulorum aangeboden aan Professor Doctor J. G. van Gelder* (Utrecht, 1963), pp. 125-136.

8. The latter group includes the *Woman Spinning* (Gouda, Museum; ill. Kultzen 1983, pl. 5) and *Seated Woman Spinning* (with Matthiesen, London, 1983; ill. Waddingham 1983, p. 283), both of ca. 1648-1650.

9. M. F. Durantini, *The Child in Seventeenth-Century Dutch Painting* (*Studies in the Fine Arts: Iconography, 7*) (Ann Arbor, 1983), p. 112.

10. Sale London (Christie's), 10 July 1981, no. 14; Cologne/Utrecht 1985-86, no. 33.10.

11. Waddingham 1983, p. 283.

12. The entry for the Zurich painting in the catalogue of the Cologne/Utrecht exhibition makes no mention of the painting's relationship to the Berkeley work.

Hendrick van Steenwijck the Younger

(Antwerp? ca. 1580-The Netherlands? ca. 1649)

Son of the architectural painter Hendrick van Steenwijck the Elder (ca. 1550-1603) and Helena van Valckenborch (daughter of the painter Maerten van Valckenborch), the younger Steenwijck was born about 1580, probably in Antwerp. His father had joined the Antwerp guild of St. Luke in 1577 but had relocated to Frankfurt by 1586. Steenwijck undoubtedly trained in his father's studio; works by the two artists are very similar in style and frequently confused. Van Mander speaks of the younger Steenwijck as already active in 1604, and extant paintings are dated as early as 1603.

Steenwijck was probably in Antwerp during the first decades of the seventeenth century, and may have resided there for a period in the 1590s as well, although there is no firm documentary evidence for either stay and he was never enrolled in the artists' guild in that city. A document of 15 November 1617 mentions the artist as "presently living in London." He received some patronage from Charles I and painted architectural backgrounds for portraits by Daniel Mijtens and others (for example, *Portrait of Charles I*, signed by Steenwijck and Mijtens and dated 1626/27; Turin, Galerie Sabauda). There is no evidence of English activity for Steenwijck after 1637. The artist subsequently moved to The Hague, possibly as early as 1638; the portrait print of Steenwijck included in the 1645 edition of van Dyck's *Iconography* describes him as a painter from The Hague. Steenwijck was married to the artist Susanna Gaspoel. One of her rare paintings, dated 1642, is in the Stedelijk Museum de Lakenhal, Leiden. Although the exact date of his death is not known, Steenwijck is thought to have died in 1649. He signed and dated a painting in that year (Berlin, Staatliche Museen zu Berlin), but his wife is referred to as a widow in a document dated 17 November 1649.

Steenwijck's early works – primarily church interiors and related subject pieces (for example, St. Peter in Prison, St. Jerome in His Study) – are similar in technique and subject matter to paintings by his father. Later works exhibit a more refined touch and vibrant local colors. His compositions became more decorative, his interiors more spacious and less densely forested with columns and supports. Steenwijck's secular views of courtyards and palatial interiors are much influenced by the works of Hans and Paul Vredeman de Vries; several of his compositions are based on the detailed renderings of orthagonal perspective published by these artists. Steenwijck's dated works range from 1603 to 1649. In addition to his English period collaborations with Mijtens, he worked also with Jan Brueghel the Elder (q.v.) and Frans Francken the Younger. Unfortunately, these collaborations cannot securely attest to Steenwijck's presence in Antwerp at a given time, as the figures could have been (and frequently were) added to his compositions at a later date.

Van Mander 1604, fol. 261v; Descamps 1753-64, vol. 1, pp. 384-386; Kramm 1857-64, vol. 5 (1861), p. 1568; Nagler 1835-52, vol. 17 (1847), p. 247; Nagler 1858-79, vol. 3, p. 1664; Crivelli 1868, p. 119; Rooses 1879, pp. 658-659; Wurzbach 1906-11, vol. 2 (1910), pp. 660-661; Jantzen 1910, pp. 33-40, 170-172; Bredius 1915-22, vol. 7 (1921), pp. 167, 216; Sandrart, Peltzer 1925, pp. 166-168; Thieme, Becker 1907-50, vol. 31 (1937), pp. 522-523; Ballegeer 1967, pp. 58-59; London, National Gallery, cat. 1970, pp. 240-248; Paris 1977-78, pp. 224-225; Ertz 1979, pp. 508-512; Jantzen 1979, pp. 33-40, 235-237; Härting 1989, pp. 163-165; Rotterdam 1991, pp. 31-34, 71-76; Cologne/Vienna 1992-93, pp. 379-380.

Paulus Pontius after Anthony van Dyck, *Hendrick van Steenwijck the Younger*, engraving, from the *Iconography*.

Hendrick van Steenwijck the Younger
76. An Imaginary City Square, 1614

Oil on copper, 47 x 70 cm (18 ½ x 27 ½ in.)
Signed and dated lower left: H.V S. / 1614
The Hague, Royal Cabinet of Paintings Mauritshuis,
inv. 171

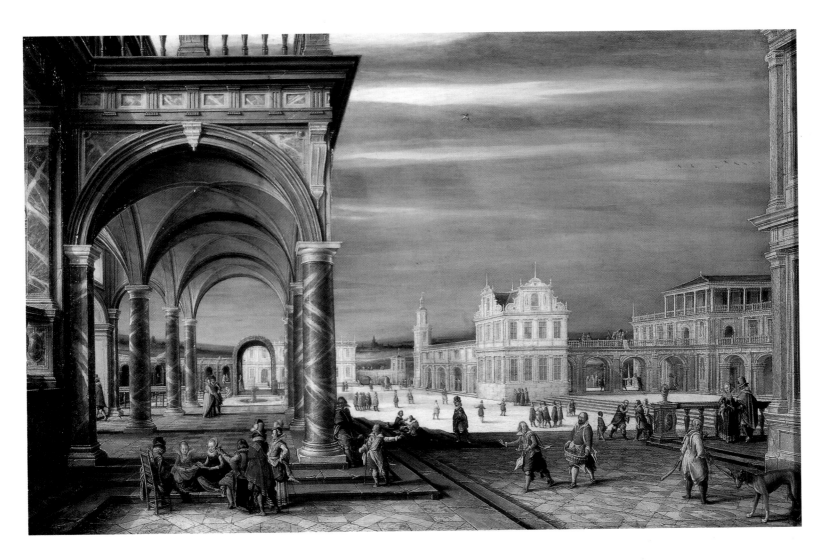

PROVENANCE: sale Ewout van Dishoek, Lord of Domburg, The Hague,
9 June 1745, lot 23 (fl. 140); collection of the stadholders Willem IV (1711-
1751) and Willem V (1748-1806), Paleis Het Loo, Apeldoorn; Willem V
Gallery, The Hague (until 1795); removed to the Louvre, Paris, by
Napoleon's troops, 1795-1815; Royal Picture Cabinet, Willem V Gallery,
The Hague, 1815-1822; Mauritshuis, The Hague (from 1822); Prince
Willem V Gallery, The Hague (from 1977).

EXHIBITIONS: Utrecht, Centraal Museum, *Nederlandse Architectuur-
schilders 1600-1900* (1953), no. 94; Utrecht, Centraal Museum, *Pieter Jansz.
Saenredam* (1961), no. 237; Rotterdam, Museum Boymans-van Beuningen,
Perspectives: Saenredam and the Architectural Painters of the 17th Century
(15 September-24 November 1991), no. 6.

LITERATURE: Hoet 1752, vol. 2, p. 170; W. Bürger [T. Thoré], *Musées de la
Hollande*, 2 vols. (Paris, 1858-60), vol. 1 (1858), p. 276; The Hague, Maurits-
huis, cat. 1895, pp. 395-396; H. Jantzen, *Das Niederländische Architekturbild*
(Leipzig, 1910), pp. 36-37 and p. 170, no. 457; London, National Gallery,
cat. 1970, p. 242; S. W. A. Drossaers and T. H. Lunsingh Scheurleer, *Inven-
tarissen van de inboedels in de verblijven van de Oranjes en daarmede gelijk te
stellen stukken 1567-1795*, 3 vols. (Rijks Geschiedkundige Publicaties, The
Hague, 1974-76), vol. 2 (1975), p. 640, no. 29 and vol. 3 (1976), p. 232, no. 155;
The Hague, Mauritshuis, cat. 1977, p. 229; H. Jantzen, *Das Niederländische
Architekturbild* (2nd ed. Braunschweig, 1979), pp. 36-37 and p. 235; The
Hague, Mauritshuis, cat. 1985, p. 446; Guido Jansen, in exh. cat. Rotter-
dam 1991, pp. 74-76.

A BRILLIANT BLUE SKY, streaked with wispy
clouds and crossed by subtle shafts of sunlight, forms
the backdrop for a palatial court bounded by richly
varied fantastic structures. An open portico support-
ed by red marble columns frames the left side of the
square; the opposite side is lined with majestic
palaces and linked arcades, displaying a wealth of
pseudo-Renaissance architectural details. Beyond the
loggia is a large fountain; in the distance, the arched
entrance of a leafy bower frames the vanishing point
of Steenwijck's perspective construct. The courtyard
is dotted with groups of sprightly animated figures.
At left is a musical company of two men and two
women; another couple has paused to listen to their
performance. Two servants hurry across the piazza,
carrying a wine cooler and a tray with glasses. At the
right is a brilliantly costumed jester leading a grey-
hound. Other figures greet one another, converse,
stroll, or play cards or other games.

Fig. 1. Paul Vredeman de Vries, *Dorica*, from
Perspective, dat is de hoogh-gheroemde Conste . . . , 1604.

Fig. 2. Paul Vredeman de Vries, *Architectural Fantasy
with the Coronation of Esther by Ahasuerus*, signed and
dated 1612, oil on panel, 118.5 x 171.5 cm, Darmstadt,
Hessisches Landesmuseum, inv. GK 988.

Fig. 3. Hendrick van Steenwijck the Younger, *A Man
Kneels before a Woman in the Courtyard of a Renaissance
Palace*, signed and dated 1610, oil on copper, 40.2 x 69.8
cm, London, The National Gallery, inv. 141.

Steenwijck apparently began painting imaginary
piazzas and palace courtyards about 1610, inspired by
the architectural views and perspective studies of
Hans Vredeman de Vries (1527-before 1609) and his
son Paul (1567-before 1636?). Hans Vredeman de
Vries, the teacher of Hendrick I Steenwijck, was the
first artist to specialize exclusively in architectural
painting; he was also a practicing architect and an
architectural theorist. Following the example of
texts by Vitruvius and Sebastiano Serlio (1474-1554),
he published a volume clearly diagramming the
construction of illusionistic perspective in paintings,
and profusely illustrated with engravings of imagi-
nary architecture.[1] These whimsical and inventive
compilations of architectural forms and motifs from
classical antiquity were a rich resource for later
artists, who occasionally copied them directly but
more usually borrowed isolated details or were
inspired by them in a general way.[2]

An Imaginary City Square is loosely based on a
print from the *Perspective* illustrating the Doric
order, and also representing the sense of Hearing
(fig. 1). Steenwijck reversed the composition, but
retained the monumental foreground loggia and the
verdant arbor framing the central vanishing point as
well as the musical figures seated before the loggia.
There is, however, no indication that Steenwijck also
intended his painting as an allegory of the sense of
hearing. Similar comparisons can be made with
paintings by the Vredeman de Vrieses, for example
Paul's 1612 *Architectural Fantasy with the Coronation of
Esther by Ahasuerus* (Darmstadt, Hessisches Landes-
museum, inv. GK 988; fig. 2). Despite the parallels
with the works of these artists, however, Steenwijck's
compositions are consistently more spacious, with
lighter, more delicate structures pushed to the sides
of the composition to open up a larger central area.

Several other paintings by Steenwijck are closely
related to the exhibited work; in fact, most of the
artist's fanciful courtyard scenes are quite similar in
composition, and nearly all feature an open loggia in
the foreground. His earliest dated works in this
genre are from 1610, in the collection of F. C. Butôt,
and in The National Gallery, London (fig. 3).[3] He
dated similar works in 1618 and 1623,[4] and thus con-
tinued to paint these intricate perspectival fantasies
after his move to London in 1617.

Steenwijck's views of imaginary piazzas – like
those of his predecessors Hans and Paul Vredeman
de Vries, and later Dutch painters such as Bar-
tolomeus van Bassen and Dirck van Delen – have
been described as representative of an international
"court style."[5] Each of these artists was active at a
court center throughout Europe, and their complex

Peeter Neeffs the Elder

(Antwerp [?], ca. 1578-Antwerp, 1656/61)

architectural fantasies appealed to an aristocratic and intellectual clientele on several different levels.[6] The painstakingly detailed execution and frequent use of copper as a support (which was not only more costly, but which also enhanced the luster of the paint surface) elevated these works to the level of precious cabinet pieces. The artist's facility with an extensive vocabulary of classical architectural forms, and his conspicuous use of an artificial perspective scheme to construct a clever illusion of space, appealed to the sophisticated collector whose enjoyment was heightened by a knowledge of the mathematical principles that formed the basis of these works. And, of course, the aristocratic viewer could relate on a personal level to the refined figures serving as staffage in these idealized and decorative palaces, while the socially aspiring owner might simply enjoy the flight of social fancy. The architectural backgrounds painted by Steenwijck for portraits of Charles I and other luminaries of the English court are the logical extension of this illusionistic conceit; these same patrons also collected Steenwijck's architectural fantasies.[7]

While many of Steenwijck's imaginary architectural views are enhanced with figures by another hand, it is not possible to attribute the staffage in *An Imaginary City Square* to a specific collaborator, and the figures may well be by Steenwijck himself.

MEW

1. *Architectura, die hooghe ende vermaerde conste . . . van de fondamenten der perspectiven dienstelck voor alle schilders, beeldhouwers . . .* (The Hague, 1604), known by the abbreviated title *Perspective, dat is de hoogh-gheroemde Conste. . . .* A supplementary volume was published in the following year.

2. On other artists' borrowings from the works of Vredeman de Vries, see Ballegeer 1967, especially p. 56.

3. Respectively: copper, 25 x 36 cm, signed and dated 1610; and copper, 40.2 x 69.8 cm, signed and dated 1610 (London, The National Gallery, inv. 141).

4. For example, the imaginary palace courtyard views in the Museum der bildenden Künste, Leipzig (inv. 505; panel, 20 x 26 cm, signed and dated 1618); Galleria Nazionale, Palazzo Barberini, Rome (copper, 13.5 x 16.5 cm, signed and dated 1618); and the Hermitage, St. Petersburg (inv. 1197; copper, 55.5 x 81.4 cm, signed and dated 1623).

5. W. Liedtke, "The Court Style: Architectural Painting in The Hague and London," in Rotterdam 1991, p. 33.

6. Hans and Paul Vredeman de Vries were active at Antwerp, Wolfenbüttel, Prague, and The Hague; Steenwijck at Antwerp, London, and The Hague; van Bassen and van Delen at The Hague.

7. For a brief summary of Steenwijck's activities for Charles I, see Liedtke, in Rotterdam 1991, p. 34. The king owned about six independent architectural paintings by Steenwijck (not including the portraits for which he painted architectural backgrounds), as well as "A little boock of Prosspectives." See O. Millar, "Abraham van der Doort's Catalogue of the Collections of Charles I," *The Walpole Society* 37 (1958-60), p. 226 and passim; and A. MacGregor, "Sports, Games and Pastimes of the Early Stuarts," in *The Late King's Goods: Collections, Possessions and Patronage of Charles I in the Light of the Commonwealth Sale Inventories* (London and Oxford, 1989), p. 416. On Netherlandish collectors of architectural paintings in general, see J. M. Montias, "'Perspectives' in 17th-Century Inventories," in Rotterdam 1991, pp. 19-28.

Peeter Neeffs the Elder, son of Aart Neeffs and Margaretha Verspreet, was probably born in Antwerp about 1578. He entered the Antwerp guild of St. Luke in 1609 as the pupil of Laureys de Cater, about whom nothing further is known. Based on the similarity of the artists' styles, Jantzen (1910) proposed that Neeffs studied with Hendrick van Steenwijck the Elder (q.v.) and the Younger about 1590-1600. In fact Neeffs painted several copies of Steenwijck compositions, including his earliest dated church interior of 1605 (Dresden, Gemäldegalerie Alte Meister, inv. 1183).

Neeffs married Maria Lauterbeens in Antwerp on 30 April 1612. The couple had five children between 1614 and 1623, including Lodewijck (born 1617) and Peeter the Younger (1620-after 1675), both of whom became painters. Maria Lauterbeens died in 1655 or 1656; Neeffs was still alive in February 1656 but probably died shortly thereafter, and certainly before 1661.

Neeffs was the leading Flemish specialist in church interiors. A large proportion of his paintings are nocturnal scenes, doubtless inspired by similar works by the Steenwijcks. Neeffs's sons also painted church interiors and probably worked with him in his studio. There is some confusion between works by the elder and younger Peeter Neeffs, although in general works by the latter artist are of lesser quality, with a less harmonious transition between areas of light and shadow. The figures in Neeffs's interiors were executed by other artists, among them Frans Francken II (1581-1642) and Frans Francken III (1607-1667).

De Bie 1661, p. 155; Descamps 1753-64, vol. 1 (1753), pp. 269-270; Michiels 1865-76, vol. 9 (1874), pp. 98-101; Rombouts, van Lerius 1872, vol. 1, pp. 454, 487, vol. 2 (1910), p. 272; van den Branden 1883, pp. 608-614; Wurzbach 1906-11, vol. 2, pp. 219-220; Jantzen 1910, pp. 40-45, 165-167; *Monatsheft für Kunstwissenschaft* 14 (1921), pp. 43ff; Thieme, Becker 1907-50, vol. 25 (1931), pp. 373-374; Ballegeer 1967, p. 60; London, National Gallery, cat. 1970, pp. 98-99; Harting 1989, p. 163; Rotterdam 1991, pp. 77-79; Cologne/Vienna 1992-93, pp. 377-379.

Peeter Neeffs

77. Interior of the Cathedral of Antwerp at Night, 1638

Oil on panel, 39.3 x 49.8 cm (15 ½ x 19 ⅝ in.)
Signed and dated on base of pier at lower right:
P. NEFS. / 1.6.3.8
Boston, Museum of Fine Arts, William Sturgis
Bigelow collection, inv. 21.1456

PROVENANCE: gift of Dr. William Sturgis Bigelow, 1921.

EXHIBITIONS: Andover, MA, Phillips Academy, Addison Gallery of American Art, 9 February-1 March 1936.

LITERATURE: *Bulletin of the Museum of Fine Arts* 19 (October 1921), p. 62; Wilenski 1960, pl. 650; U. A. Härting, *Studien zur Kabinettbildmalerei des Frans Francken II 1581-1642: Ein repräsentativer Werkkatalog* (Hildesheim/Zurich/New York, 1983), p. 106, note 239 [figures by Frans Francken III]; Boston, cat. 1985, p. 217; Härting 1989, p. 218, note 903; Rotterdam 1991, p. 79; J. Ingamells, *The Wallace Collection Catalogue of Pictures, IV: Dutch and Flemish* (London, 1992), p. 227.

A FEW WIDELY PLACED CANDLES, lamps, and torches pierce the dim nocturnal recesses of a cavernous church interior. Save for the brightly illuminated foreground area, architectural forms are only intimated by subtle modulations of light and shadow. In the foreground, a page bearing a smoking torch lights the way for two men deep in conversation with a priest; another lad follows behind. Other groups of figures are scattered throughout the shadowy interior.

The interior depicted in the present painting is based on the interior of the Cathedral [Onze-Lieve-Vrouwekerk] at Antwerp, but Neeffs has exaggerated the height and length of the nave and incorporated paintings and sculptural details of his own invention. Neeffs frequently repeated structures in his compositions, with minor alterations in furnishings, staffage, angle of view, or time of day; several versions of this particular view are known. Jeroen Giltaij has noted that the setting of the Boston painting is identical to that of paintings in the Museo del Prado, Madrid, dated 1636 (inv. 1600; fig. 1); in the Szépmüvészeti Múzeum, Budapest, dated 1637 (inv. 576); and in the Musées Royaux des Beaux-Arts de Belgique, Brussels (inv. 145).[1] Other views of the same church, but in daylight, are in the Gemäldegalerie der Akademie der bildenden Künste, Vienna (inv. 719); in the Wallace Collection, London (inv. P152); and in the Gemäldegalerie Alte Meister, Kassel (inv. GK 68).

The figures in Neeffs's *Interior of the Cathedral of Antwerp at Night* in Boston have been convincingly attributed to Frans Francken III (1607-1667).[2] Although both Frans Francken II (1581-1642) and III collaborated with Neeffs, the younger Francken's figures are smaller in relationship to the interior space, with conspicuously long arms and heavy torsos, and lack the expressive individuality of comparable staffage by Frans Francken II.[3]

The placque affixed to a pier to the right of the scene is inscribed: "SIPPELTVR / E. VAN. HE / ER. ANTON / IVS. LAV / TERBENS. / PASTOR. VN / 1638." Antoon Lauterbeens (died before 1656), Neeffs's brother-in-law, was pastor of the church at Turnhout, to the northeast of Antwerp.[4] Neeffs's

Fig. 1. Peeter Neeffs, *Procession in a Church Interior*, signed and dated 1636, oil on panel, 51 x 80 cm, Madrid, Museo del Prado, inv. 1600.

Procession in a Church Interior of 1636 in the Prado (fig. 1) bears a similar plaque on the pier at right, denoting the sepulchre "Van Heer Anthonis Lauter."[5] The tablet on the pier at the far right reads: "PETRVS / VAN / HOEREN / EYEISA / PROBIT / AT . . . IA / A . . ."; the lettering on the columns at the right is less legible.[6]

MEW

1. In Rotterdam 1991, p. 79. For other related paintings, see Ingamells, *Wallace Collection*, p. 227.

2. Härting, 1983, p. 106, note 239; and Härting 1989, p. 218, note 903.

3. Härting 1989, p. 187. A list of works attributed jointly to Neeffs the Elder and Frans Francken III is included in ibid., p. 218, note 903.

4. Van den Branden 1883, p. 614.

5. Madrid, Prado, cat. 1975, vol. 1, p. 206. Van den Branden (1883, p. 614) cites a *Church Interior* by Neeffs in the Rijksmuseum, Amsterdam, which includes a gravestone with a similar inscription: "Seppeltvre van Heer Anthonius Lavterbeins pastoir van de vrijheyt van Turrenavt. Anno 1625."

6. I am grateful to Brigitte Smith of the Paintings Conservation Department, Museum of Fine Arts, Boston, for her help in deciphering these inscriptions.

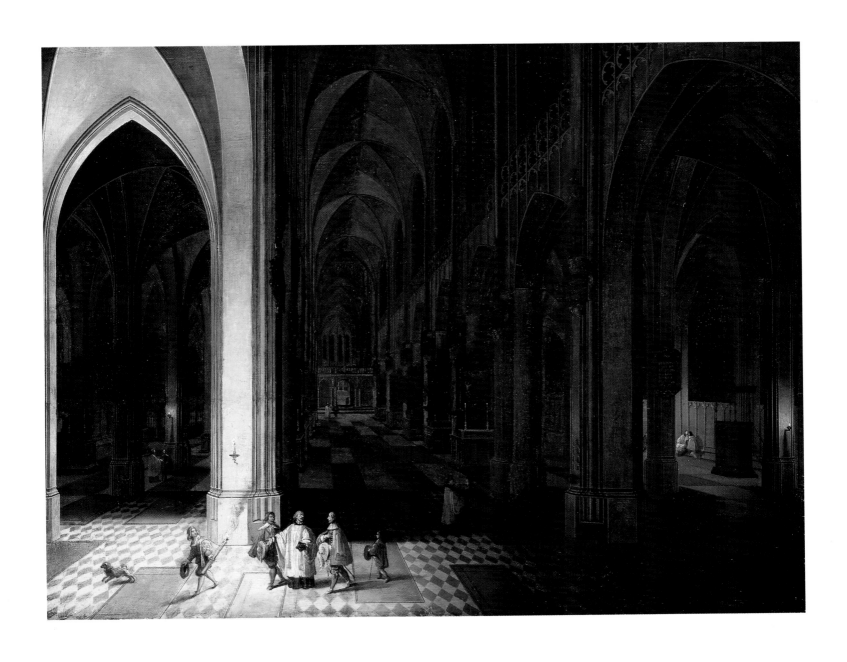

Gillis van Coninxloo

(Antwerp 1544-Amsterdam 1607)

The son of Jan van Coninxloo and Elisabeth Hasaert, Gillis van Coninxloo was born in Antwerp on 24 January 1544. According to van Mander, his first teacher was Pieter Coecke van Aelst (1502-1550), but this is a confusion with Gillis van Coninxloo II (1581-1618/20), who had no relationship with the present artist – who is, nevertheless, sometimes called Gillis III. Coninxloo made a trip to France before entering the guild of St. Luke in Antwerp in 1570. In this same year he married Maeyken Robroeck. In 1585 Coninxloo was forced to leave Antwerp, after the city was conquered by Alexander Farnese and the religious persecution of Protestants increased. He fled first to Zeeland and then to Frankenthal in Germany, where he remained from 1587 to 1595. In 1595 he settled in Amsterdam, and became a citizen (poorter) of that city in April 1597. He was a member of the rederij-kerskamer "Het Wit Lavandel." In 1603 he married for the second time. He was buried in his adopted city of Amsterdam on 4 January 1607. The posthumous sale of his works on 1 March 1607 was well attended by artists and collectors and testifies to the importance and influence of his compositions.

Van Mander believed Coninxloo to be the best landscapist of his day. His earliest surviving dated work is the *Landscape with the Judgment of Midas* (Dresden, Gemäldegalerie Alte Meister, inv. 857), painted in Frankenthal in 1588; other dated works indicate that he was active until the end of his life. His earliest compositions are comparatively open panoramic views, framed by coulisses, in the manner of Jan Brueghel (q.v.). After his move to Amsterdam, Coninxloo was influenced by the works of Hans Bol, Paulus Bril (q.v.), and Jacob Savery, and his woodland scenes become closer and denser, with tunneling vistas framed by lush overgrown trees. In Frankenthal he was the leader of a small group of landscape painters who painted intimate woodland scenes based on Venetian models. This group include Pieter Schoubroek (1570-1607) and Anton Mirou (before 1586-1661?). Coninxloo's students outside this group included the Dutch landscapist Hercules Segers (1589/90-1633/38). Maerten van Cleve (1527-1581), David Vinckboons (1576-ca. 1630), and Esaias van de Velde (ca. 1591-1630) painted the staffage in some of his landscapes. Coninxloo influenced an entire generation of landscape painters, especially those who emigrated from Flanders to the United Provences, among them Alexander Keirincx, Karel van Mander (1548-1606), Jacob Savery (1545-1602), Vinckboons, and Roelant Savery. Nicolaes de Bruyn made many etchings after Coninxloo's landscape compositions.

Van Mander 1604, fol. 267b; Sandrart 1675, vol. 1, pp. 278-279; Descamps 1753-64, vol. 1, pp. 172-173; Rombouts, van Lerius 1872, vol. 1, p. 134; de Roever 1885; Starcke 1898; Wurzbach 1906-11, vol. 1 (1906), pp. 326-327, vol. 3 (1911), pp. 66-67; K. Zoege van Mantueffel, in Thieme, Becker 1907-50, vol. 7 (1912), pp. 302-304; Plietzsch 1910, pp. 24-74; Raczyński 1937, pp. 24-36; Laes 1939; Bialostocki 1950; Thiéry 1953; Wellensieck 1954a; Wellensieck 1954b; Gerson, ter Kuile 1960, pp. 59, 64-67; Münch 1960; Mannheim 1962; Franz 1963; Arndt 1965-66; Stechow 1966, pp. 65-67; Wegner 1967; Franz 1968; Franz 1968-69; Franz 1969, pp. 270-288; Briels 1976, pp. 94-95, 220-224; Gerszi 1976; Genaille 1983; Haak 1984, pp. 174-75; Thiéry 1986; Amsterdam/Boston/Philadelphia 1987, pp. 288-290; Devisscher 1987, passim; Hanschke 1988, passim; H. Devisscher, in Cologne/Vienna 1992-93, pp. 191-194, 297-298.

Gillis van Coninxloo

78. Forest Landscape, 1598

Oil on panel, 41.8 x 61 cm (16½ x 24 in.)
Signed and dated lower left:
G. V. CONINCXLOO 1598
Vaduz, Collection of the Prince of Liechtenstein,
inv. G751

PROVENANCE: sale Prince Anton Kaunitz, Vienna, 13 March 1820,
no. 47 (as on canvas, 16 x 23 pouces; fr. 99, to Bauer).

EXHIBITIONS: Lucerne, Kunstmuseum, *Meisterwerke aus den Sammlun-
gen des Fürsten von Liechtenstein* (1948), no. 87; Vaduz, Schloss, *Flämische
Malerei im 17. Jahrhundert* (1956-57); New York 1985, no. 179; Cologne/
Antwerp/Vienna 1992-93, no. 24.1.

LITERATURE: J. Falke, *Katalog der Fürstlich Liechtensteinischen Bilder-
Galerie im Gartenpalais der Rossau zu Wien* (Vienna, 1873), no. 1058; van den
Branden 1883, p. 308; *Katalog der Fürstlich Liechtensteinischen Bilder-Galerie
im Gartenpalais der Rossau zu Wien* (Vienna, 1885), no. 751; Th. von Frim-
mel, in *Blätter für Gemäldekunde* 3 (1907), p. 83; Plietzsch 1910, pp. 3, 39, 44-
47, 54 no. 14; Thieme, Becker 1907-50, vol. 7 (1912), p. 303; Th. von Frim-
mel, *Lexikon der Wiener Gemäldesammlungen* (Munich, 1913-14), vol. 2
(1914), p. 339; Th. von Frimmel, *Studien und Skizzen zur Gemäldekunde* 4
(1918-19), p. 14; Liechtenstein, cat. 1931, no. 751; Raczyński 1937, pp. 34-35;
A. Stix and E. von Strohmer, *Die Fürstlich Liechtensteinsche Gemäldegalerie in
Wien* (Vienna, 1938), fig. 32; F. Klauner, "Zur Landschaft Jan Brueghels
d. Ä.," *Nationalmusei Årsbok* 1949-50, pp. 12-13; Thiéry 1953, p. 16, 19;
Wellensiek 1954a; H. G. Franz, "De boslandschappen van Gillis Coninxloo
en hun voorbeelden," *Bulletijn Museum Boymans-van Beuningen* 14 (1963),
p. 74; Arndt 1965-66, pp. 6-11; Stechow 1966, p. 66; Liechtenstein, cat. 1967,
p. 12, no. 751; Franz 1968, pp. 15-16, 33; Franz 1969, vol. 1, pp. 274-275, 278;
von der Osten, Vey 1969, p. 333; Gerszi 1976, pp. 205, 211ff, 227-228;
F. Baumgart, *Blumen-Brueghel (Jan Brueghel d. Ä.): Leben und Werk* (Cologne,
1978), p. 41; Ertz 1979, p. 198; R. Baumstark, *Masterpieces from the Collection
of the Prince of Liechtenstein* (New York, 1980), no. 37; C. Brown, in exh. cat.
London, The National Gallery, *Dutch Landscape: The Early Years, Haarlem
and Amsterdam 1590-1650* (3 September-23 November 1986), p. 20;
P. C. Sutton, in Amsterdam/Boston/Philadelphia 1987-88, p. 21;
U. Hanschke, *Die flämische Waldlandschaft. Anfänge und Entwicklungen im
16. und 17. Jahrhundert* (Worms, 1988), p. 40; Devisscher 1989, p. 118;
W. S. Gibson, "*Mirror of the Earth*": *The World Landscape in Sixteenth-Century
Flemish Painting* (Princeton, 1989), p. 80; H. Devisscher, "Die Entstehung
der Waldlandschaft in den Niederlanden," in Cologne/Vienna 1992-93,
pp. 191-193, 200.

PIQUANT DETAILS of flora and fauna fleck the
bosky undergrowth of a forest interior: a heron and
some deer stand in a clearing at the left; brilliantly
plumed birds nestle in trees and on the ground.
Irises and other wildflowers edge the shallow stream
that flows through the break in the trees at the
right. Attended by his dogs, a hunter crosses the
bridge over the stream; a second brightly clothed
hunter rests at the foot of a tree in the center of the
composition. Almost the entire picture plane is cov-
ered with a densely woven tapestry of trees and
foliage, completely encircling the small patch of
open land in the foreground. To either side, coulisses
of gnarled trees frame tunnellike views into the
depths of the forest; at the left, the intricate tangle of
foliage is pierced by a veiled glimpse of open sky.
Coninxloo's close-up view of the enveloping forest
enhances the immediacy of the scene, and lures the
viewer into the silent seclusion of the primeval for-
est. A sophisticated play of light and shadow high-
lights the subtle nuances of Coninxloo's palette.

Dated 1598, the Vaduz *Forest Landscape* is one of
four dated works by the artist. It was painted rela-
tively late in his career, shortly after his move from
Frankenthal to Amsterdam in 1595. Coninxloo's only
earlier dated work, the *Judgment of Midas* of 1588

Fig. 1. Lucas van Valckenborch, *Angler by a Woodland
Pool,* dated 1590, oil on panel, 47 x 56 cm, Vienna,
Kunsthistorisches Museum, inv. 1073.

(Dresden, Gemäldegalerie Alte Meister, inv. 857) is,
like other landscapes from the Frankenthal period
(1587-1595), a much more traditionally conceived
"world landscape." Figures assume a much greater
role in the latter work, and the viewpoint is some-
what elevated, affording an unimpeded vista of dis-
tant mountains.

With the Vaduz *Forest Landscape* cited as the
prime example, Coninxloo has traditionally been
considered the founder of the close-up forest land-
scape in the Netherlands,[1] although more recent
research has demonstrated that other artists almost
certainly preceded him in this venture.[2] His contri-
bution to the development of the genre is still con-
siderable, though his role as an innovator is proba-
bly overvalued. Although he may well have
experimented in painting forest landscapes prior to
the dated Vaduz painting, his efforts were probably
inspired by contact with the group of innovative
landscapists working in Amsterdam, which included
Hans Bol and Jacob Savery. The fact that Coninxloo
seems to have produced densely forested scenes like
the present work only after his move to Amsterdam
in 1595 argues convincingly for the influence of these
artists.

The densely forested landscape was a distinct
subgenre in Netherlandish painting from the 1590s
and through the seventeenth century.[3] Pieter
Bruegel the Elder's drawings of forest landscapes,
widely disseminated via prints by Hieronymus Cock,
were undeniably a powerful stimulus for later
artists.[4] Towards the end of the sixteenth century
Hans Bol (1534-1593) and especially Lucas van
Valckenborch (ca. 1535-1597) painted and drew forest
landscapes in Amsterdam and Frankfurt, respective-
ly. One of the most important of these early examples

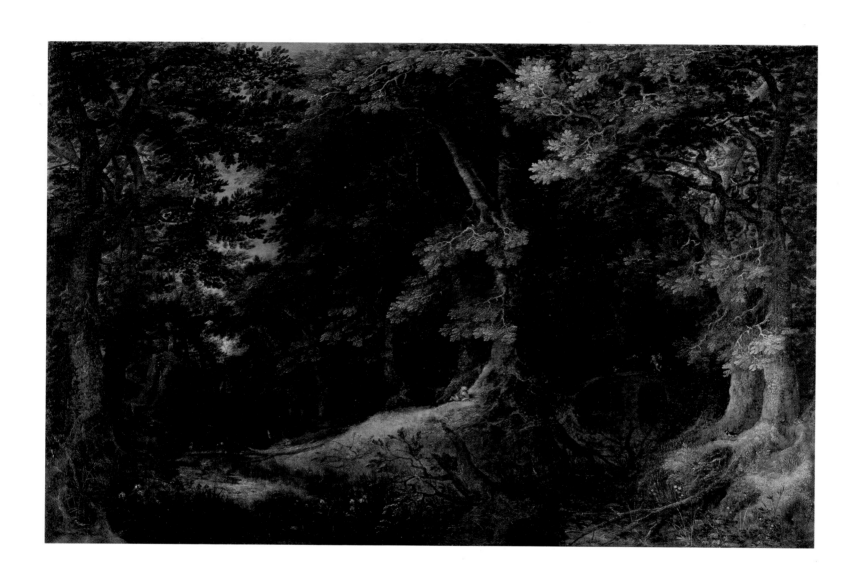

Fig. 2. Jan Brueghel the Elder, *Forest Landscape*,
ca. 1595-1596, oil on copper, 25 x 32 cm, Milan,
Pinacoteca Ambrosiana, inv. 74f-20.

is Valckenborch's *Angler by a Woodland Pool*, dated
1590 (Vienna, Kunsthistorisches Museum, inv. 1073;
fig. 1),[5] a close woodland view in which the figures
are dwarfed by the massive trees. Nonetheless, only
isolated examples of the close-up wooded landscape
exist prior to dated works by Jan Brueghel the Elder
and Paulus Bril, thus supporting claims for these
artists as the key figures in the development of the
forest landscape in the North.[6]

In Italy during the 1590s, Jan Brueghel and
Paulus Bril were both inspired by Pieter Bruegel's
landscape views and vied with each other in further
developing the wooded landscape.[7] Bril's work was
circulated to the North via prints engraved by
Egidius Sadeler.[8] Perhaps the earliest painted forest
interior by the extraordinarily versatile Brueghel is
the *Forest Landscape* of ca. 1595-1596 (Milan, Pinacote-
ca Ambrosiana; fig. 2), painted in Italy for Cardinal
Federigo Borromeo. In both the overall composition
and in specific details, the Milan painting is strik-
ingly close to Coninxloo's *Forest Landscape* in Vaduz;
compare also one of Brueghel's earliest dated forest
interiors, *Wooded Landscape with Abraham and Isaac*,
signed and dated 1599 (cat. 79). It is not known
if Coninxloo had contact with Jan Brueghel in
Frankenthal; in any event such a meeting could only
have taken place prior to Brueghel's visit to Italy in
ca. 1590 – at a time when Coninxloo was still produc-
ing more traditional landscapes.[9]

Regardless of the fact that other painters can lay
claim to primacy in making the switch from distant
"world landscape" views to painting the enclosed
intimacy of the forest interior, the Vaduz *Forest Land-
scape* is one of the finest and most evocative examples
of Coninxloo's art. His paintings of forest interiors –
and prints after his designs – worked a powerful
influence on later artists, including Denijs van

Alsloot, Abraham Govaerts, Kerstiaen de Keuninck
(see cat. 81), Roelant Savery, Adriaen van Stalbemt,
and David Vinckboons.

MEW

1. Raczyński 1937, pp. 34-35.

2. On Coninxloo's sources see especially the various publications by
Franz cited in the Literature; and Gerszi 1976.

3. On the development of the genre see most recently the survey by
Devisscher in exh. cat. Cologne/Vienna 1992-93, pp. 191-202, with further
literature.

4. See Arndt 1972.

5. Gerszi 1976, pp. 225-226; see also H. Devisscher, in Vienna, Kunsthisto-
risches Museum, cat. 1989, pp. 112-113; and A. Wied, *Lucas und Marten van
Valckenborch (1535-1597 und 1534-1612). Das Gesamtwerk mit Kritischem
Œuvrekatalog* (Freren, 1990), pp. 18, 21, 30, 47, 163-164, no. 60.

6. Devisscher, in Cologne/Vienna 1992-93, p. 200; see also Gerszi 1976.

7. Gerszi 1976, p. 219.

8. Franz (1969) and Gerszi (1976) have discussed the integral role of prints
in transmitting the imagery of the close forest interior view.

9. Gerszi 1976, p. 215; see also Ertz 1979, pp. 192ff.

Jan Brueghel the Elder
79. Wooded Landscape with Abraham and Isaac, 1599

Oil on panel, 49.5 x 64.7 cm (19 ½ x 25 ½ in.)
Signed and dated lower left: I. BRVEGHEL 1599
Private collection

PROVENANCE: sale Amsterdam (Mak van Waay), 14 March 1972, no. 12.
LITERATURE: Ertz 1979, p. 199, cat. 56, figs. 236, 237 (detail).

ON A HEAVILY WOODED HILLSIDE with great trees stretching to the very top of the scene, five figures gather firewood while Abraham and Isaac make their way along the path in the lower left. Abraham rides an ass and Isaac walks carrying an armload of wood. In the middle distance a stream rushes down the mountain. Between two tall trees on the right the valley stretches off into the blue distance. The palette is dominated by deep green and brown with blue, red, yellow, and lavender accents provided by the figures' costumes; distant forms are subsumed in a bluish haze.

This is one of the earliest dated forest interior landscapes. Although Gillis van Coninxloo (cat. 78) has in the past been awarded primacy in the invention of these subjects, recent research has shown that his work is indebted to Pieter Bruegel's designs, perhaps known through Hieronymus Cock's engravings or descended via the art of Lucas van Valkenborch, Hans Bol, and Jan Brueghel the Elder.[1] Jan's forest scene in the Pinacoteca Ambrosiana, Milan (see cat. 78, fig. 1) is at least contemporary with and probably earlier than Coninxloo's earliest dated forest scene of 1598 (see cat. 78). Aspects of the present design – the darkened, triangular-shaped foreground descending from the trees on the left, the lighted middle distance of the stream, and the distant prospect – are anticipated in drawings by Paulus

Fig. 1. Jan Brueghel the Elder, *Forest Landscape with the Rest on the Flight into Egypt*, 1607, oil on panel, 51.5 x 91.5 cm, St. Petersburg, Hermitage, inv. 424.

Bril, with whom Brueghel was in contact while in Italy.[2] But Brueghel's dense forest has a richness of observed detail and naturalistic elaboration scarcely imagined by Bril's schema. It is far closer to the dense screens of trees that figure in his father's designs; see, for example, Pieter Bruegel the Elder's drawing, *Forest with a Stream and Five Bears*, 155(4?) (Prague, Národní Galerie, inv. no. K4493).[3] His drawing of the twisted trunks and limbs of the trees, the masterfully organized and nuanced distribution of light and shade, and the subtle adjustments of color that enhance the essentially mannerist spatial formulae show Jan at the height of his powers.

A second version of this composition, preserved in the Mittelrheinisches Landesmuseum, Mainz (inv. 152), is regarded by Ertz as an autograph replica.[4] Still another variant of the design dated 1607 in the Hermitage replaces the figures of Abraham and Isaac with the Holy Family on the Flight into Egypt (fig. 1).[5] In the Hermitage picture, Brueghel attenuates the design laterally and opens up more of the vista on the right. The subject of the Sacrifice of Abraham in mountainous countryside had appeared in earlier prints by Cock, and drawings by Bol.[6] The less common subject of Abraham and Isaac on their way to the sacrifice on Mount Moriah had been depicted earlier (simultaneously with images of other episodes in the narrative) in an altarpiece by Barent van Orley (Schwerin, Gemäldegalerie Alte Meister, no. 757), set in a rocky mountainous landscape in a print by Cock,[7] and outside a village in a drawing dated 1590 by Jacob Savery (Amsterdam, Rijksprentenkabinet, inv. 31.181). However, Jan Brueghel seems to have been the first to depict the obedient father and son in the woods on their trip up the mountain.[8] The story of the Sacrifice (Genesis 22:1-14), in which God tests Abraham's faith by commanding him to make a burnt offering of his son Isaac, had since the Middle Ages been regarded as an

Old Testament prefiguration of God's sacrifice of Christ in the Crucifixion; Isaac carrying the wood for his own funeral pyre likewise prefigured Christ carrying the cross. Thus the mountainous woodland setting, especially with the faggot gatherers, might be interpreted as revealing the New Testament prefiguration, functioning not unlike the earliest sixteenth-century landscapes by Patinir and his followers by promoting reflection on the meaning of the biblical narrative. However we hasten to add that Brueghel's readiness to substitute another biblical narrative (see fig. 1) for the present one suggests that the associations of the woodland setting were not specific to the Abraham and Isaac story; rather Brueghel probably regarded it simply as an environment befitting an arduous and divinely ordained journey.

PCS

1. See, in addition to the Introduction and cat. 78: Franz 1968; Gerszi 1976; and Devisscher in Cologne/Vienna 1992-93, pp. 191-201.

2. See Gerszi 1976, figs. 19 and 21; and Cologne/Vienna 1992-93, p. 198, fig. 9.

3. See Brussels 1980, cat. 11, ill. Compare also Cock's print after Bruegel of the *Forest with the Temptation of Christ*; Hollstein 1949–, vol. 4, p. 175, no. 2; Gerszi 1976, fig. 8.

4. Oil on panel, 48.5 x 70 cm; Ertz 1979, p. 201, cat. 57, fig. 238.

5. Ertz 1979, cat. 54, fig. 239.

6. See Franz 1969, figs. 169 (Cock's engraving dated 1551) and figs. 312-313 (Bol's drawings of 1570 and 1573, respectively in the Kupferstichkabinett, Berlin, and the Galleria degli Uffizi, Florence). See also the prints by Nicolaes de Bruyn after Gillis van Coninxloo, and by Pieter van der Borcht (respectively, Franz 1969, figs. 420, 274, and 283).

7. See Franz 1969, fig. 175.

8. A painting wrongly attributed to Kerstiaen de Keuninck when with P. de Boer, Amsterdam, ca. 1945 (R.K.D. neg. no. L836o) is undoubtedly later than the present painting. Abraham Govaerts's *Forest Landscape with the Sacrifice of Isaac* (oil on copper, 22 x 27 cm, Munich, Bayerische Staatsgemäldesammlungen, inv. 4818) may also owe a debt to Brueghel's painting; however, Anton Mirou's painting of this theme in Dessau (Gemäldegalerie, cat. 1929, no. 41) owes more to de Bruyn's print after Coninxloo.

Joos de Momper the Younger

(1564-Antwerp-1635)

Praised by Karel van Mander for "painting land-scapes excellently with a clever technique," the prolific Joos de Momper was born in Antwerp in 1564. He was the son of the painter and art dealer Bartholomeus de Momper (1535-after 1589) and Suzanna Halfroose; his grandfather, Joos de Momper the Elder (1500-1559), was also a painter. After learning his craft from his father, the younger Joos de Momper became a master in the Antwerp guild of St. Luke in 1581, during his father's tenure as dean. De Momper seems to have traveled to Italy shortly thereafter, where he may have worked in the studio of Lodewijck Toeput ("il Pozzoserrato") in Treviso. Although it is not known how long the artist stayed in Italy, he was back in Antwerp by 4 September 1590, when he married Elisabeth Gobijn in the Onze-Lieve-Vrouwekerk. The couple had ten children, including two sons, Philippe (1598-1634) and Gaspard, who also became painters. In 1596 de Momper purchased a house ("de Vliegende Os") on the Vaart-plaats; the artists Tobias Verhaecht and Sebastian Vrancx (q.v.) lived in the same street. In addition to the several pupils mentioned in the guild registers throughout the 1590s, Joos's nephew Frans de Momper (1603-1660) also worked in his studio and painted landscapes in his manner. De Momper was elected assistant dean of the St. Luke's Guild in 1610, and head dean in 1611.

In 1594 de Momper worked with Adam van Noort, Tobias Verhaecht, and Cornelis Floris on decorations for the triumphal entry of the Archduke Ernest into Antwerp. He also designed several tapestries for the archduke. In 1626 the artist was granted exemption from wine and beer taxes and from other civic duties in acknowledgment of his years of work for the archdukes. De Momper experienced financial difficulties in his later years, forcing him to sell his house in order to support his children; he apparently traded paintings for wine at the tavern "de Robijn," and still owed 483 guilders at his death. De Momper died on 5 February 1635 and was buried in the St. Joriskerk in Antwerp.

De Momper was an important figure in the transition between mannerist "world landscapes" of the late sixteenth century and more naturalistic landscapes of the seventeenth century. Early works, to about 1600, are typically panoramic views related in composition and color scheme to works by Pieter Bruegel the Elder and Paulus Bril (q.v.). During the first two decades of the seventeenth century, the artist produced grottos, summer and winter landscapes, and an infinite variety of the fantastic mountainous landscapes for which he became famous. Very few signed works by the artist are known, and

virtually no dated ones; his chronology is thus difficult to reconstruct and there remain many works wrongly attributed to him. He had many followers and imitators, the closest of which was his nephew Frans de Momper. De Momper collaborated with the figure painters Jan Brueghel the Elder and Younger, Hendrick van Balen, Frans Francken the Younger, David Teniers the Younger, Tobias Verhaecht, and Sebastian Vrancx.

Van Mander 1604, fol. 295v; de Bie 1661, p. 60; Houbraken 1718-21, vol. 1, pp. 87, 188; Dezalliers d'Argenville 1745-52, vol. 3, pp. 309ff; Descamps 1769, pp. 28, 39, 82, 128, 295; Nagler 1835-52, vol. 9 (1840), p. 384; Immerzeel 1842-43, vol. 2 (1843), p. 236; Kramm 1857-64, vol. 4 (1858), pp. 1140-1141; Michiels 1865-76, vol. 9 (1874), p. 123; Crivelli 1868, pp. 208, 295, 309-310, 315, 328-329, 337-338; Rombouts, van Lerius 1872, vol. 1, pp. 279, 365, 380, 409, 459, 474, 478, 526, 588, vol. 2, pp. 20, 67; Rooses 1879, pp. 192-196; van den Branden 1883, pp. 253, 309-316, 1421; Donnet 1907, p. 101; Wurzbach 1906-11, vol. 2 (1910), pp. 181-182; Oldenbourg 1918a, p. 9; Grosse 1925, passim; Brussels 1926; Vaes 1926/27, pp. 207-209, 212; Chemnitz 1927; Zoege van Manteuffel 1927-28a; Zoege van Manteuffel 1927-28b; Amsterdam 1930-31; Cohen 1931; Düsseldorf 1931; Thieme, Becker 1907-50, vol. 25 (1931), pp. 52-53; Paris 1936, pp. 87-92; Raczyński 1937, pp. 66-71; Reelick 1948; Burkham 1950; Laes 1952; Thiéry 1953, pp. 52-60, 186-187; Boström 1954; Hoogewerff 1954, pp. 107-108; de Maeyer 1955, pp. 160-162, 205-207; Offerhaus 1959; Kalinowski 1960; Breda/Ghent 1960-61; Incisa della Rocchetta 1961; Brussels 1965, pp. 140-143; Koester 1966; de Mirimonde 1966a; Dupret 1967; Thiéry 1967; Franz 1968; Salerno 1968; Franz 1968-69; Franz 1969; Greindl 1976; Paris 1977-78, pp. 132-135; Salerno 1977-80, vol. 1 (1977), pp. 52-55, vol. 3 (1980), p. 1059; Gerszi 1978; Ertz 1979, pp. 470-491; Franz 1982; Ertz 1984, pp. 81-82; Gerszi 1985; Ertz 1986; Härting 1989, pp. 148-152; Cologne/Vienna 1992-93, pp. 447-448.

Anthony van Dyck, *Joos de Momper*, etching.

Joos de Momper
80. *Mountain Landscape with Travelers*, 1623

Oil on canvas, 185 x 334 cm (72 ¾ x 132 ½ in.)
Signed and dated bottom left: Joes · de momper 1623
London, Thomas Agnew and Sons

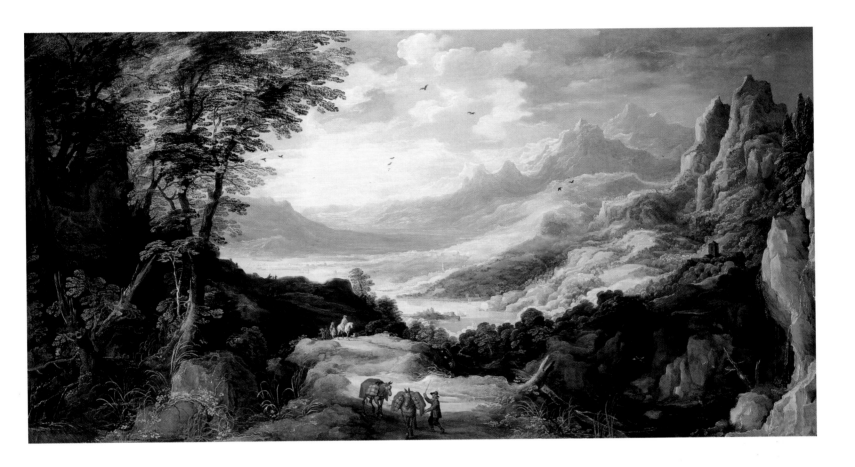

PROVENANCE: (probably) Don Diego de Messía de Guzmán, Marqués de Leganés (d. 1655), Madrid, possibly by 1642; by descent to the Condes de Altamira; by descent to the eighth Conde de Altamira; (possibly) the Marqués de Salamanca; Neer-Heylissem (Belgium), Comte d'Oultremont collection.

LITERATURE: Thiéry 1967, pp. 235-237; Ertz 1986, pp. 93, 484-486, no. 84; Thiéry 1986, pp. 139-140.

IN THE FOREGROUND of the composition, a man urges his two heavily laden pack mules along a rude mountain track; their red blankets add a vibrant note of local color to the harmonious hues of the landscape. Other travelers, on horseback and afoot, crest a rise in the middle distance. A rocky hillside and dense foliage mask the rising sun on the left of the composition; pale beams tint clouds and distant landscape forms a delicate yellow. At the right, a shallow pool fed by streams trickling from a cleft in the rugged cliffs is home to a lone heron. Framed between these rocky coulisses, a broad river valley unwinds amidst a delicate fantasy of towering mountain peaks.

Mountain Landscape with Travelers of 1623 is Joos de Momper's only known signed and dated painting, although several signed and dated drawings by the artist exist.[1] The style and execution of the painting supports the development proposed by Ertz and others for the artist.[2] Like many of de Momper's works from the 1620s, it is painted with a comparatively free and suggestive technique. It nonetheless retains the mannerist formula of perspectival organization which dominates the artist's earlier works, dividing the landscape into overlapping layers of predominantly brown in the foreground and green in the middleground, with distant forms dissolved in a bluish haze.

This painting is among the largest and most majestic of de Momper's fantastic mountain landscapes, a premiere example of the genre for which the artist was most famous. Although he painted many such landscapes in cabinet format (see Ertz 1986, cats. 17-278, passim), he produced only a handful of mountain views on this outsized scale: for example the paintings now in the Prince of Liechtenstein collection, Vaduz (Introduction, fig. 86); in the Kunsthistorisches Museum, Vienna; in the Prado, Madrid; in the sale Madrid (Edmund Peel), 29 October 1991, no. 11; and in a private collection in Montreal.[3] These works share a slightly elevated

viewpoint and framing coulisses, and were probably all executed during the 1620s.

Together with the works now in the Liechtenstein collection and formerly in the Madrid sale, the present painting is possibly one of the six large landscapes by de Momper which during the seventeenth century were in the collection of the Marqués de Leganés.[4] The paintings are mentioned among the 1333 art works listed in the 1655 inventory of his estate: "seis pinturas de paises de mompar, de hermitanos y caçadores, de 2 baras y tercia de alto y poca diferencia de largo, del numero 126 hasta el 131, en 7,200 [reales]" (six paintings of landscapes by Momper, with hermits and hunters, [approximately 198 cm] in height and little different in width, numbers 126 to 131, 7,200 reales).[5] The Liechtenstein canvas bears the old inventory number 131 at lower left; the landscape in the Madrid sale is numbered 130. The Marqués de Leganés (d. 1655) was an ambassador of the Spanish court in the Southern Netherlands during the 1620s, and was resident in Brussels from 1630 to 1635.[6] He married Policena Spinola, daughter of Ambrogio Spinola, commander of the Spanish forces in the Netherlands, in 1627. Although Leganés's *mayorazgo* (entailment of estate) statement of 1630 lists only a handful of paintings and none by de Momper, by 1642 he had amassed an impressive collection of 1149 paintings which included several by the artist, as well as works by other contemporary Flemish painters such as Rubens, van Dyck, Frans Snyders, Hendrick de Clerck, and Gaspar de Crayer.[7] It is very likely that Leganés acquired the majority of these works during his stay in Brussels during the 1630s. The picture collection remained essentially intact until the early nineteenth century, when it was dispersed by Leganés's descendants.

As Ertz has suggested, the monumental scale of the *Mountain Landscape with Travelers* suggests that it was planned for a palatial setting,[8] although nothing is known of the original commission. The figures in the present work were probably painted by de Momper himself.

MEW

1. On the spurious dated works attributed to the artist, see Ertz 1986, pp. 92-93. Dated drawings by de Momper are discussed by Ertz (ibid., pp. 94-97); see also Thiéry 1986, pp. 144-148.

2. Ertz 1986; see also Thiéry 1986, pp. 138-160; and Koester 1966, passim.

3. Oil on canvas, 192 x 294 cm, Vaduz, Prince of Liechtenstein collection, inv. 730 (Ertz 1986, cat. 198); oil on canvas, 209 x 286 cm, Vienna, Kunsthistorisches Museum, inv. 644 (Ertz 1986, cat. 195); oil on canvas, 174 x 256 cm, Madrid, Museo del Prado, inv. 1592 (Ertz 1986, cat. 79); oil on canvas, 199 x 277 cm, sale Madrid (Edmund Peel), 29 October 1991, no. 11, ill.; and oil on canvas, Montreal, private collection.

4. According to the present owner of the painting, this was suggested independently by both Mary Crawford Volk and Klaus Ertz. On Leganés and his collection see especially Crawford Volk 1980; and J. Brown, "Der spanische Hof und die flämische Malerei," in Cologne/Vienna 1992-93, p. 98.

5. J. Lopez Navio, "La gran coleccion de pinturas del Marqués de Leganés," *Analecta Calasanctiana* 7/8 (1962), p. 275.

6. Crawford Volk 1980, p. 262.

7. Ibid., pp. 257, 261.

8. Ertz 1986, p. 307.

Kerstiaen de Keuninck
(Kortrijk ca. 1560-Antwerp ca. 1632/33)

Kerstiaen de Keuninck
81. Mountain Landscape with the Prodigal Son

Oil on panel laid down on board,
45.5 x 76 cm (17 ⅞ x 29 ⅞ in.)
Signed: K. D. Keuninck
Private collection

PROVENANCE: H. Coray Stoop, Erlenbach, Zurich; sale Coray Stoop, Lucerne (Galerie Fischer), 29 July 1925, no. 50 [as Alexander Keirincx]; Baron Evence Coppée III, Brussels, thence by descent; sale London (Phillips), 8 December 1992, no. 48, ill.

LITERATURE: Laes 1931b, p. 228, fig. 24; C. Sterling, "Un Tableau retrouvé de Kerstiaen de Keuninck," *Bulletin des Musées de France* 4 (1932), p. 102; Raczyński 1937, p. 63; Thiéry 1953, p. 26; E. Greindl, *La Peinture flamande au XVIIe siècle* (Paris, 1961), fig. 35; Debrabandere 1963, p. 48; Zwollo 1982, p. 95ff; Devisscher 1984a, p. 140, no. G-9; Devisscher 1987, pp. 27, 31, 52, 63, 98 and 151, cat. A9 ill.; S. Lilian, *Old Master Paintings* (Amsterdam, 1993), p. 22, ill.

One of seven children of the linen merchant Hendrik de Keuninck and Isabeau Marrin (d. ca. 1580), Kerstiaen de Keuninck was probably born in Kortrijk (Courtrai) about 1560. He became a master in the Antwerp St. Luke's Guild in 1580/81. The name of his teacher is not known, although it was probably an Antwerp master and possibly Hans Bol. A document of 16 September 1585, in which de Keuninck asked to be released from the supervision of his guardians so that he might marry, indicates that the artist was then still under twenty-five years of age. No record of the marriage survives and the name of his wife is not known. The couple had at least one child, Kerstiaen (d. ca. 1642/43), who joined the St. Luke's Guild in 1613 and in 1627 was active in the atelier of Jan Brueghel the Younger.

Further documentary information concerning the elder de Keuninck is sparse. He had at least one pupil, Carel de Ferrara, in 1599; it is not clear whether Engel Ergo, registered as a pupil in 1639/40, was a pupil of the elder or younger de Keuninck. His wife died in 1632/33, and de Keuninck is thought to have died shortly thereafter.

About sixty paintings by the artist are known, of which four are dated: 1610 (two), 1627, and 1630. De Keuninck's early works are expansive panoramic valley landscapes framed by fantastic rock formations; in later works the panorama is restricted to a view through the rocks or trees that dominate the foreground. In the latter part of his career he painted wooded landscapes in the manner of Gillis van Coninxloo, Jan Brueghel the Elder, and Paulus Bril (qq.v.), albeit with distinctive touches of his own, such as chimerical castles perched on hilltops. De Keuninck is also known for his representations of incendiary calamities, usually with a historical or biblical theme; compare works such as the *Burning of Troy* (Kortrijk, Museum van Schone Kunsten, inv. 36) or *Lot Leaving Sodom* (St. Petersburg, Hermitage, inv. 8484).

Rombouts, van Lerius 1872, vol. 1, pp. 273, 303, 337, 410, 496; vol. 2, pp. 7, 44; Caullet 1903; Wurzbach 1906-11, vol. 1 (1906), p. 264; K. Zoege van Manteuffel, in Thieme, Becker 1907-50, vol. 7 (1912), p. 226; Vaes 1926-27, passim; Laes 1931b; Paris 1936, pp. 84-88; Raczyński 1937, pp. 60-65; Thiéry 1953, pp. 26-27; Fekhner 1956; Debrabandere 1963, pp. 46-48; Brussels 1965, pp. 127-129; Franz 1968-69, pp. 55-57; Zwollo 1982; Devisscher 1984a; Devisscher 1984b; New York, Metropolitan, cat. 1984, pp. 126-129; Thiéry 1986, pp. 35-40; Devisscher 1987; Cologne/Vienna 1992-93, pp. 443-444.

IN THIS dramatically conceived landscape, a mountain rises steeply on the right and a tall silhouetted tree serves as a *repoussoir* on the left. A road winds its way between fantastical outcroppings of rocks up the mountain to a ruin at the summit. At the far right a waterfall plunges to the rocks below, sending up spattered spray and mist. In the center foreground the Prodigal Son kneels down in repentance amidst five cows. Beyond the tree on the left a valley studded with castles and trees stretches to a distant horizon. Enhancing the drama and religious import of the scene are rays of divine light spreading across the sky and terrain from the upper left.

In 1925 this painting was mistakenly sold as the work of Alexander Keirincx, no doubt because of a misreading of the signature, but it is a fully characteristic work by de Keuninck, indeed one of only twenty-six signed paintings by the artist. As Devisscher has noted, it is most closely related in design to a *Mountain Landscape with Good Samaritan* (also signed but undated) by de Keuninck formerly with the dealer P. de Boer in Amsterdam (fig. 1).[1] With its steeply rising mountain on the right and coulisse and prospect on the left, it also resembles the *Rocky Landscape* in the Metropolitan Museum of Art, New York (no. 1983.452), the *Rocky Landscape with Highway Robbery* (formerly with P. de Boer in Amsterdam), and *The Fall of Phaeton* (Kiev, State Museum of Occidental and Oriental Art).[2] All of these works employ the panoramic mountain landscape formulae first perfected by Herri met de Bles and Pieter Bruegel the Elder, and developed by artists like Bol, de Momper, and Jan Brueghel. Among the only four dated works by de Keuninck, the two earliest are the *Landscape with Castle* (F. Brockhaus, Leipzig) and the *Woodland with Hunters* (Wallraf-Richartz-Museum, Cologne) both of 1610. These paintings both employ a later landscape style than the group of mountain panoramas to which the present painting belongs; thus Devisscher has logically suggested that they predate 1610.[3]

The subject of the Prodigal Son in repentance in a landscape was a fairly rare subject in earlier northern art; more commonly he was depicted in a barnyard

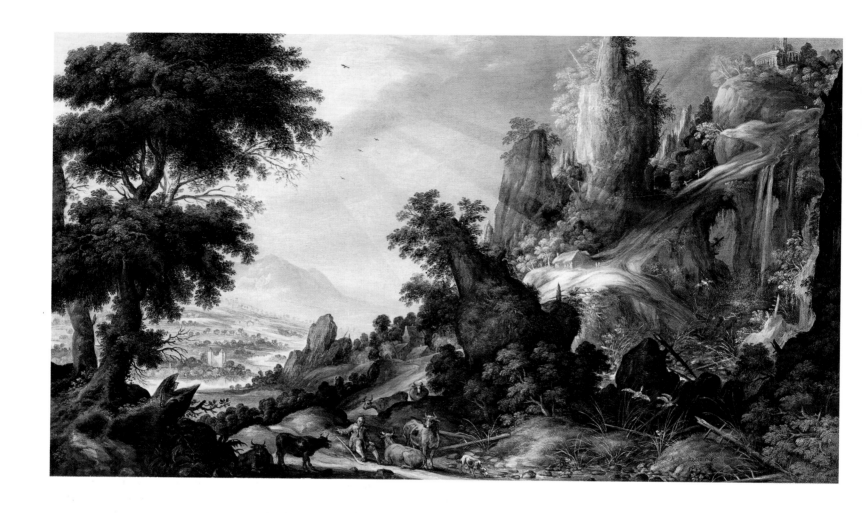

Fig. 1. Kerstiaen de Keuninck, *Mountain Landscape
with the Good Samaritan*, oil on panel, 68 x 100 cm,
Amsterdam, with dealer P. de Boer, 1960-61.

Jan Brueghel the Elder
82. *A Road with a Ford in a Wood*, 1608

Oil on copper, 33.7 x 48.3 cm (13 ¼ x 19 in.)
Signed and dated lower right: BRU[EGH]EL 1[60]8
Private collection

Fig. 2. Kerstiaen de Keuninck, *Mountain Landscape
with the Sacrifice of Abraham*, oil on panel, 42 x 60 cm,
Basel, Öffentliche Kunstsammlung, inv. 1262.

landscape among swine at the trough.[4] De Keuninck
favored dramatic biblical and mythological staffage
captured in a moment of revelation or crisis; see, for
example, *Mountain Landscape with Sacrifice of Abraham*
(fig. 2) where he again employs the convention (no
doubt inspired by the graphic arts) of rays of divine
light which spread miraculously over the scene.
De Keuninck's theatrical streak also undoubtedly
helped pique his interest in the challenge of depict-
ing the mist and spray of cataracts and waterfalls,
perhaps in imitation of his fellow Kortrijk (Courtrai)
painters, the Savery brothers, or Paulus Bril (see
cat. 85), who also favored crashing streams in his
early works. But the technique of using spattering
flecks of paint from a loaded brush to evoke plumes
of spray is more pronounced in de Keuninck's works
than in that of any other Flemish landscapist.

<div align="right">PCS</div>

1. See Devisscher 1987, pp. 29, 98, cat. A8.
2. See respectively Devisscher 1987, cats. 7, 10 and 11, ills. pp. 148, 150, 151.
3. Ibid., pp. 26, 977.
4. See, for example, the painting by Marten van Valckenborch, Kunst-
historisches Museum, Vienna; and the print by Pieter van der Borch;
Franz 1969, figs. 381 and 284. The *Mountainous Landscape with an Oxcart*,
pen and wash drawing (St. Petersburg, Hermitage) by Lodewijk Toeput
(Pozzoserrato) seems to include the Prodigal kneeling in the foreground.

PROVENANCE: Palais Royal collection, Paris; private collection,
England.
LITERATURE: *Galerie du Palais Royal* (Paris, 1808), no. 11, with engraved
illustration by J. B. Racine [as "Pierre Breughel" (II)].

A HEAVILY TRAVELED thoroughfare bisects a
wooded landscape. In the left foreground a hunter
with two dogs and travelers on horseback ford an
inundated hollow in the road fed by a stream that
disappears behind a hillock. Two open carts are just
descending into the water while a green covered
wagon with a well-to-do female passenger is moving
away. Farther back, drovers with their stock and
other covered wagons travel the road that meanders
over low hills into the central distance. At the left is
a path traveled by pedestrians. Tall leafy trees with
lacy foliage bracket the scene. In the left distance is
the church spire of a town.

This important landscape has not been pub-
lished since 1808, when it was praised in the cata-
logue of the Galerie du Palais Royal.[1] Beneath the
engraving by Racine, the work was wrongly ascribed
to "Pierre Breughel" (presumably the Younger),
though there can be no question about the painting
having been executed by Jan Brueghel the Elder. Jan
played a central role in codifying many of the most
important themes of Netherlandish landscape
painting, including the river landscape, landscapes
incorporating both level plains and mountain val-
leys, the wayside inn, and, of course, the road
through the woods. His earliest fully resolved exam-
ple of the road through the woods seems to be the
painting of 1605 in Munich (fig. 1),[2] which employs
the same general composition as well as many of the
same motifs (notably the ford and bracketing trees)
and figure types as the present work. However in
that prototypical work, the secondary vista that fun-
nels into the distance at the left is still sufficiently
pronounced as to recall the stereoscopic views of
landscape drawings by Jan's father, Pieter Breugel
the Elder. Immediately preceding the present paint-
ing is the *Woodland Road with Travelers* dated 1607 in
the Metropolitan Museum of Art (fig. 2),[3] which fea-
tures a ford and a large broken tree at the center left
that prefigure the residual puddle and tree stump in
the present work. Here the flanking forest recedes
and the composition opens up, but Brueghel still
retains his meticulous technique, bright local
palette with tripartite color scheme, and the vestiges
of the complementary triad in the scale of motifs
and the staffage – relatively larger figures in the fore-
ground, medium-sized ones in the middle distance,
and tiny motifs in the blue distance. At least eight
other paintings by Brueghel are dated 1608.[4] While

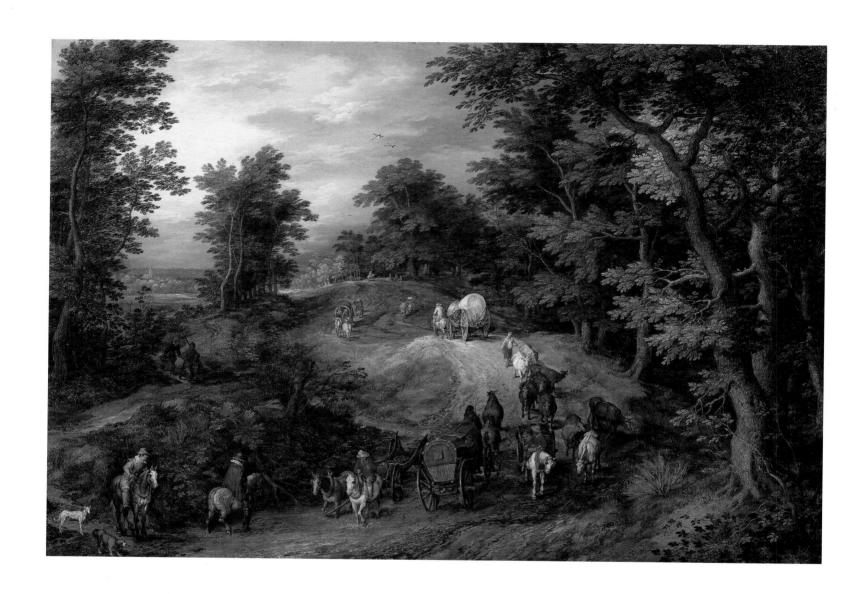

Fig. 1. Jan Brueghel the Elder, *Road in a Wood*, signed
and dated 1605, oil on copper, 25.4 x 35.8 cm, Munich,
Alte Pinakothek, inv. no. 1880.

Fig. 2. Jan Brueghel the Elder, *Woodland Road with
Travelers*, signed and dated 1607, oil on panel, 46.4 x
83.2 cm, New York, Metropolitan Museum of Art.

Jan Brueghel the Elder
83. *Wooded Landscape with Travelers*, 1610

Oil on copper, 52 x 72 cm (20 ½ x 28 ¼ in.)
Signed and dated lower left: BRVEGHEL 1610
Private collection

PROVENANCE: sale New York (Sotheby's), 1 June 1990, no. 20; Newhouse Gallery, New York.

Jan's other paintings of roads in a wood at times feature attacking bandits, gypsy fortune-tellers, or figures resting heavily at the side of the road, here the travelers press on restlessly.

No preparatory drawings for the present composition have been identified, but a sheet in Berlin's Kupferstichkabinett[5] probably documents an early idea for three related compositions (in the Koetser collection, Kunsthalle, Zurich, and Wellington Museum, London [both dated 1611], and the Hermitage, St. Petersburg)[6] which constitute a still later development of the present theme. There, the narrow road through the wood has become a broad highway that no longer meanders over rolling hills but moves briskly at a diagonal between trees into the distance. A roadside inn is also added.

The mark of Brueghel's favorite copper panelmaker, Pieter Stas, is on the back of the panel, together with the date 1608, which confirms the only partially legible date beside the signature.[7]

<div align="right">PCS</div>

1. *Galerie du Palais Royal* (Paris, 1808), no. 11, with engraving by J. B. Racine. An identical painting (signed, oil on panel, 35 x 50 cm) advertised by the dealer Jonkheer in *Tableau* 2 (December 1978-January 1979), must be a version or copy, since the present owner assures us that the picture in question was obtained from an English private collection where it had long resided.

2. Ertz 1979, cat. 112, fig. 14.

3. Ertz 1979, cat. 149, fig. 40. A replica of this painting is in a Belgian private collection; see Ertz 1979, cat. 156, fig. 154. Four other variations on this composition are listed by Ertz (see 1979, p. 149, and respectively his cats. 157, 159, 158, 160, figs. 155, 156, 157, and not illustrated).

4. See Ertz 1979, cats. 171-173, 178-179, 187, 190, 194, respectively figs. 17, 41, 195, 333, 331, 377, 445, and 489.

5. Ertz 1979, p. 153-154, fig. 166.

6. Respectively, Ertz 1979, cats. 232, 241-242, figs. 165, 167-168.

7. See also Brueghel's *Wooded Landscape with Travelers* of 1610 (cat. 83). Stas's mark is reproduced in the catalogue of the sale New York (Sotheby's), 1 June 1990, no. 20. Osias Beert (q.v.) also obtained panels from Stas; compare the mark and date 1609 on the back of a still life by Beert (cat. 106, fig. 1), reproduced in Greindl 1983, cat. no. 11, detail fig. 31c. A small (unsigned) *Landscape with a Windmill* by Jan Brueghel the Elder recently on the London art market (see Johnny van Haeften's 1992 catalogue) also bears Stas's mark.

A RUTTED DIRT ROAD skirts the edge of a dense forest before descending into the valley below. In the foreground, a covered passenger wagon pulled by a team of three horses passes an open wicker cart traveling in the opposite direction. Further back are another small horse-drawn cart, a woman on horseback, and a larger wagon descending the slope. Other wagons and pedestrians traverse a track in the middle distance at the right. A herd of cattle meanders into the foreground, urged along by a woman with a switch and a brass milk jug. Pulled up by the side of the road, a lone rider observes the passing spectacle, attended by his patient hound. The opposing paths of the various travelers along the road enhance the illusion of spatial perspective in the composition.

The present painting belongs to a distinct type of landscape that Brueghel turned to repeatedly between about 1600 and 1619. The basic composition of all these works juxtaposes a close-up view of a wooded road with a panoramic landscape view, abruptly separated from the foreground area by a precipitous drop.[1] The transition between the landscape fields in these compositions is, however, more smoothly resolved than in works such as Brueghel's *Road to Market* of 1603 (Vienna, Kunsthistorisches Museum, inv. 6328). Although this group of landscapes is remarkably homogeneous, there is a gradual development away from the use of elevated bird's-eye perspective and strong vertical elements, to scenes described from a more natural viewpoint, with greater horizontal emphasis and a more expansive distant view.[2] The *River Landscape with an Animal Skeleton* in Dresden, dated 1608 (fig. 1) is particularly close to the present painting in overall composition, and indeed shares some of the same individual motifs, such as the large tree in the copse at the far left and the jagged tree trunk silhouetted against the more lightly hued distant landscape.

Brueghel frequently repeated specific vignettes of flora and fauna in his landscape compositions. The white cow with crooked foreleg, the horse-drawn wagon with sides rolled up to reveal the passengers within, and the solitary rider viewed in profile by the side of the road seem to have been particular favorites of the artist and recur in a number of paintings from the period. Many of these motifs can also be found in the *Village Road with Cattle and Wagon*, dated 1611, in the Kunsthaus, Zurich (fig. 2).[3]

On the back of the unusually large copper panel support of the *Wooded Landscape with Travelers* is the

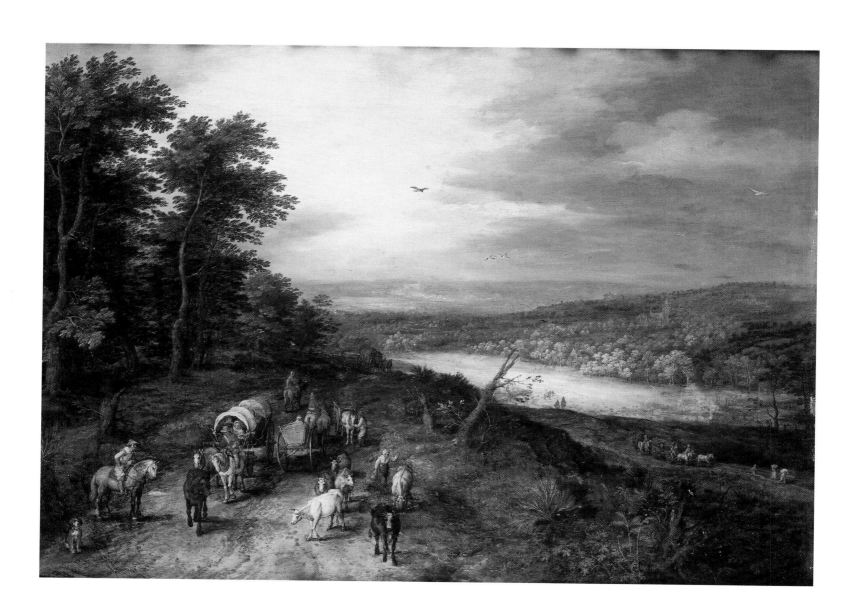

Fig. 1. Jan Brueghel the Elder, *River Landscape with an Animal Skeleton*, signed and dated 1608, oil on copper, 17.5 x 23 cm, Dresden, Gemäldegalerie Alte Meister, inv. 885.

Fig. 2. Jan Brueghel the Elder, *Village Road with Cattle and Wagon*, signed and dated 1611, oil on copper, 26.5 x 37.9 cm, Zurich, Kunsthaus, The Betty & David Koetser Foundation, inv. KS 8.

Sebastian Vrancx

(1573-Antwerp-1647)

mark of the Antwerp coppersmith Pieter Stas, the date 1610, and the stamp of the Antwerp St. Luke's Guild, a citadel with three towers flanked by a pair of hands.[4] Brueghel's *Road with a Ford in a Wood*, dated 1608 (cat. 82), was also painted on a panel made by Stas.

Until the present painting reappeared at auction in 1990, the composition was known only through a slightly smaller copy in the Hermitage, attributed by Ertz to Jan Brueghel the Younger.[5] Although faithful to the original in most details, it exhibits a certain stiffness characteristic of the younger artist's work.

MEW

1. Ertz 1979, pp. 47-51, and cats. 60, 84, 171, 216, 261, 280, and 347.
2. Ertz 1979, p. 49.
3. Ertz 1979, cat. 232. Ertz (pp. 79-90) has charted the recurrence of a number of motifs in Brueghel's paintings, particularly his landscapes.
4. Illustrated in sale cat. 1990. On Stas, see Greindl 1983, pp. 27, 190 fig. 31c (with reference to paintings by Osaias Beert) and J. Welu, in Worcester 1983-84, pp. 49, 135. See also the entry for cat. 82, note 7.
5. Oil on panel, 48 x 67 cm; St. Petersburg, Hermitage, inv. 2446; Leningrad, Hermitage, cat. 1958, vol. 2, p. 40 as by Jan Brueghel the Elder. See also Ertz 1979, p. 233, fig. 370; and Ertz 1984, pp. 60, 204, cat. 23.

Sebastian Vrancx was born in Antwerp and baptized in the Sint-Jacobskerk on 22 January 1573. According to Karel van Mander, he was a pupil of Adam van Noort (1562-1641), probably in the early 1590s. In 1594 he joined the Antwerp rhetoricians chamber "de Violieren," and was a prolific author of farces, comedies, and tragedies (now lost) performed by members of the chamber. Vrancx traveled to Italy in about 1597, but was back in Antwerp by 1600, when he became a master in the St. Luke's Guild. He was named *mededeken* (assistant dean) of the Guild in 1611 and *hoofddeken* (head dean) in 1612. He was elected to membership in the Society of Romanists in 1610; other members of this exclusive group included Jan Brueghel the Elder and Hendrick van Balen (qq.v.), as well as Wenceslas Coebergher and Otto van Veen. Vrancx was made dean of the Society in 1617.

In 1612 Vrancx married Maria Pamphili (1576-1639), daughter of a paintings dealer and sister-in-law of the painter Tobias Verhaecht (1561-1631). The couple had one daughter, Barbara, who died in 1639. In addition to his personal and professional obligations, Vrancx was also active in civic organizations. He was a member of the *burgerwacht* (civic guard) from 1613, and was made captain in 1626. Sebastian Vrancx died on 19 April 1647 and was buried in the Antwerp church of the Carmelites.

An important figure in the transition between sixteenth and seventeenth century art, Vrancx's lively and innovative cavalry subjects were nonetheless quite traditionally composed, and their encyclopedic and narrative spirit reflects the art of the previous century. He is best known for his detailed and energetic depictions of battle scenes and village plunderings. *The Battle between Bréauté and Leckerbeetje, at Moykerheide by 's-Hertogenbosch, 1600* (1601; Antwerp, Koninklijk Museum voor Schone Kunsten, inv. 772) and *The Battle with King Sebastian of Portugal* are perhaps his most well known paintings; many contemporary copies of each are known, and the compositions were also disseminated through engravings. Vrancx also painted pure landscapes, religious and mythological scenes, allegories of the Seasons and the Months, and illustrations of proverbs in the tradition of Pieter Bruegel (Brussels, Musées Royaux des Beaux-Arts de Belgique, inv. 3301). His carnival scenes and landscapes with classical ruins may have been inspired by his Italian sojourn. He collaborated with Hendrick van Balen, Jan Brueghel, Joos de Momper (qq.v.), and David Vinckboons, among others. His followers included Pieter Snayers, Cornelis de Wael, and Pieter Meulener.

Sebastian Vrancx
84. Attack on a Caravan, 1618

Oil on panel, 73 x 116 cm (28 ½ x 45 ½ in.)
Signed with a monogram sv (ligated) on the rump
of the brown horse in the lower right and dated:
ao 1618
London, Peter Tillou Works of Art Ltd.

Van Mander 1604, fol. 295b; de Bie 1661, p. 100; Houbraken 1718-21, vol. 1, p. 51ff; Nagler 1835-52, vol. 21 (1851), pp. 7-8; Nagler 1858-79, vol. 5 (1879), p. 83, 263; Michiels 1865-76, vol. 7 (1869), pp. 268-272, 285ff; Rombouts, van Lerius 1872, vol. 1, pp. 412, 443, 474, 483, 485, 487, 490, 511, 524, 539; vol. 2, pp. 108, 185; Rooses 1879, pp. 235-236 and passim; van den Branden 1883, p. 312, 469-474; Rubens-Bulletijn 4 (1896), p. 175; Lynen 1901; Donnet 1907, pp. 8-26 passim, 28-30, 33, 41, 94, 101-103, 144, 176, 357; Frimmel 1907; Wurzbach 1906-11, vol. 2 (1910), p. 824-825; Thieme, Becker 1907-50, vol. 34 (1940), pp. 567-568; van Puyvelde 1950, p. 108; Grauls 1960; Takacs 1961; Legrand 1963, pp. 189-201; Winkler 1964; Ballegeer 1967, pp. 60-62; vander Auwera 1979; Ertz 1979, pp. 505-508; vander Auwera 1981; Keersemaekers 1982; Härting 1989, p. 165; Ruby 1990; Cologne/Vienna 1992-93, pp. 455-457.

PROVENANCE: private collection, Germany, 1934; sale Zurich (Köller), 27 November-1 December 1984, no. 5088; Brussels, private collection; private collection, U.S.A.

EXHIBITIONS: Düsseldorf, Galerie Stern, *Gemälde Alter Meister aus Rheinisch-Westfälischem Privatbesitz*, 24 February-31 March 1934, no. 88.

LITERATURE: Peter H. Tillou. *Works of Art* (London, n.d.), p. 8, ill.

Boetius Schelte à Bolswert after Anthony van Dyck, *Sebastian Vrancx*, engraving, from the *Iconography*.

IN AN OPEN LANDSCAPE bracketed by a few trees, heavily armed soldiers and cavalry attack a military convoy. The foreground is filled with combatants on foot and horseback and the scene stretches back to detail more hostilities. Everywhere human and equine victims lie dead or dying while the unscathed flee for safety. In the center middle distance, mounted knights in armor ride in from the left to attack. In the distance supply wagons travel a road that curves back to the blue horizon. They too fall victim to the onslaught. Silhouetted on the crest of a far hill in the center of the scene is the three-columned form of a gallows, seemingly the emblem of the scene's carnage. A similar motif appears on Vrancx's *Attack on a Convoy* in the Prado, Madrid (no. 1884).

Although he also painted idyllic high-life genre scenes in parklike settings,[1] peaceful market scenes, and, in his capacity as a distinguished rhetorician (see Introduction), composed comedic plays and pastoral verses,[2] Vrancx is primarily remembered as a battle painter. He specialized in scenes of cavalry engagements, of the pillaging of villages, and scenes, like the present one, of attacks on military or civilian wagon trains or convoys. His teacher, Karel van Mander, praised him as early as 1604 for his artful treatment of "landscape(s), little horses, and little figures" (*lantschap, peerdekens, en beeldekens*).[3] With its relatively high horizon line and additive multitude of carefully observed figures, the present composition attests to Vrancx's admiration for the landscape conventions of Pieter Bruegel the Elder, which were so eagerly commended to young artists by van Mander in his *Grondt der edel vry schilder Konst* of 1604.[4] Indeed the combatants and other motifs in this scene are so carefully and deliberately placed, and so meticulously observed as to recall van Mander's own recommendations on perspective in landscape: "See how the hazy landscape in the distance begins to look like the sky, almost merging with it. . . . Notice how the ditches and furrows of the field taper and converge at the same vanishing point, just as in a tiled floor. Take special care in recording all of this since it will provide you with a convincing spatial background."[5]

Other aspects of the picture's design, however, acknowledge Vrancx's absorption of earlier pictorial traditions of representing battles. For example, the

Fig. 1. Jacques de Gheyn, *Charge Your Pike at the Right Foote; and Draw Your Sword*, pen and brown ink, gray wash on paper 26.8 x 18.7 cm, private collection, The Netherlands.

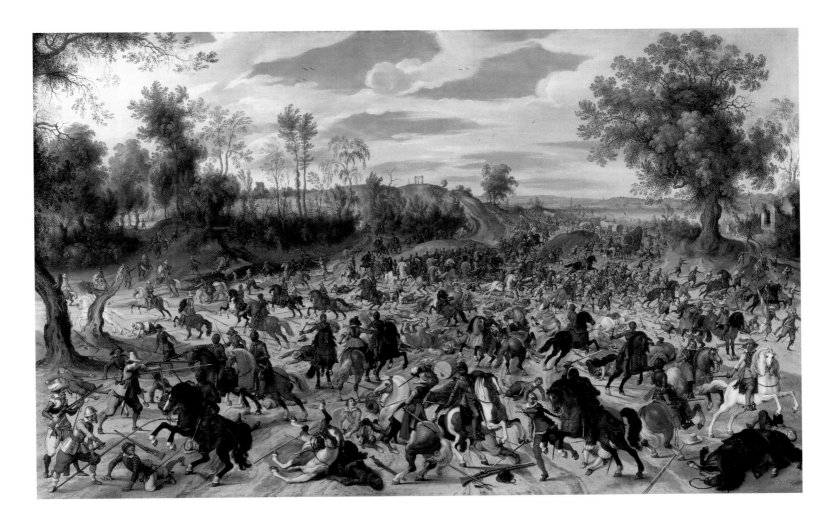

use of two large combatants on horseback to anchor the central foreground of the chaotic scene of war may distantly recall, indeed paraphrase, the central motif in Raphael's *Battle of the Milvian Bridge* (1520-1523) in the Sala di Constantino in the Vatican, which Vrancx might have come to know during his early trip to Italy (ca. 1597-1600). Certain and conspicuous quotations in Vrancx's painting are the three soldiers with pikes, swords, and muskets in the lower left of his composition, which are borrowed from Jacques de Gheyn's famous manual on arms, *Wapenhandelinghe van Roers, Musquetten end Spiessen* (1608)[6]; compare, for example, figure 1.[7]

Vrancx painted mostly anonymous battles, military engagements, and plundering, however his most repeated subject was the famous battle between Bréauté and Leckerbeetje which took place on the heath outside Vught on 5 February 1600 (see, for example, Antwerp, Koninklijk Museum voor Schone Kunsten, no. 772).[8] He also depicted the *Siege of Ostend under Spinola* in the same year that he paint-

Fig. 2. Sebastian Vrancx, *Attack on a Convoy*, signed and dated 1616, oil on panel, Windsor Castle, H. M. Queen Elizabeth II.

ed the present picture.[9] In an *Attack on a Convoy* dated two years earlier in the collection of H. M. the Queen, Windsor Castle (fig. 2), Vrancx already employs the open composition of the present design, as well as the road retreating almost perpendicularly from the picture plane. In that picture there can be

little question that the painter's sympathies are with the victims of the assault. They presumably are a Catholic trade caravan. Not only are the corpses of dead travelers strewn about the road, including one watched over by his faithful dog, but two Dominican friars in the lower left are brutally clubbed and stabbed by their attackers. On the other hand the present picture has been assumed by Joost vander Auwera to express sympathies with the Dutch who are thought to be the mounted figures in armor with orange sashes who seem to be gaining the upper hand over the Spanish forces in flamboyant yellow with red doublets and hose.[10] However, since military costumes had not yet been codified, the loyalties of the soldiers are less than certain. Indeed many marauding soldiers were not aligned with any particular ruler or nation; a major social problem in the early decades of the seventeenth century during the Eighty Years War was the phenomenon of *vrij-buiters*, mutinous soldiers loyal only to their own self-interest and the most recent paymaster. Vrancx was a citizen of Antwerp which had once been sympathetic to the Protestant cause, but, as we have seen (see Introduction), had become a bulwark of Catholicism by 1618 when the picture was painted. Thus vander Auwera may not be overreading the imagery in seeing it as expressive of an ambivalence about the Dutch triumph by painting them as "faceless and mechanical victors."[11] However, common observation about Vrancx's soldiers is that they are fastidiously observed but often marionette-like; to quote Legrand, his "scenes of war [are] more pleasant than tragic."[12]

Yet those features of his art were sufficiently well admired that no less a connoisseur than Rubens made copies of his soldiering paintings (see Florence, Uffizi, Gabinetto di Stampe e Disegni, no. 1334E),[13] and the artist and dealer Jan Brueghel the Younger assured his business partner in Seville in 1634 that Vrancx was much in demand: "Vrancx has plenty to do but refuses to employ studio assistants, which means that the work takes a long time. He does not allow copies to be put in circulation."[14] Nonetheless he was not averse to collaboration, often working with Jan Brueghel the Elder and Joos de Momper, who painted the landscape backgrounds in his battle scenes.[15] In the same year that Vrancx executed the present work he also collaborated with Jan Brueghel the Elder, Frans Franken II, and Hendrick van Balen on the decorations for the blazon for the Antwerp rhetoricians' company "de Violieren" (see Introduction, fig. 58).

Old photographs of the present painting preserved at the Rijksbureau voor Kunsthistorische Documentatie suggest that it may once have had two later additions of approximately 11 cm each on the right and left sides, with additional but crudely executed soldiers in an extended landscape.[16]

PCS

1. M. H. Takacs, "Un tableau de Sebastien Vrancx à la Galerie des Maîtres Anciens," *Bulletin du Musée National Hongrois des Beaux-Arts* 18 (1961), pp. 51-62.

2. See especially Keersemaekers 1982, pp. 165-186, with earlier literature.

3. Van Mander 1604, fol. 295.

4. Ibid., fol. 233-234.

5. Van Mander, *Den Grondt* (1604), stanza 8, fol. 34v-35: "Siet al 't verre Landtschap ghedaente voeren Der Locht / en schier al in de Locht verflouwen … In't veldt / floten / bozen / wat wy aenschowen / Oock achterwaert al inloopen en nouwen / Dit acht te nemen laet u met verdrieten / Want 't doet u achter-gronden seer verschieten."

6. See Hollstein 1949-, vol. 7, p. 138. For the specific drawings on which the prints (which were not reversed) are based, see I. Q. von Regteren Altena, *Jacques de Gheyn. Three Generations*, 3 vols. (London, 1983), cat. no. 456 (fig. 152), cat. no. 398 (fig. 116), and cat. 399 (fig. 117).

7. See exh. cat. Rotterdam, Museum Boymans-van Beuningen, *Jacques de Gheyn II. Drawings 1565-1629*, 1985-86, cat. no. 20, ill.

8. See for other examples of his treatment of the theme, F. C. Legrand, "Un 'Combat de Cavaliers' par Sebastien Vrancx," *Bulletin des Musées Royaux des Beaux-Arts de Belgique* 3 (1952), pp. 96, 100; Legrand 1963, p. 192, figs. 78 and 79. The present painting was wrongly identified as the *Death of Lekkerbeetjen* in the Düsseldorf exhibition at Galerie Stern in 1938.

9. Monogrammed and dated 1618, panel 23 x 39 in., lent by Lord Aldenham to exh. London 1953-54, no. 305.

10. *Peter H. Tillou. Works of Art* (London, n.d.) p. 8. See also J. vander Auwera, "Sebastiaen Vrancx (1573-1648). Een monografische benadering" (unpub. thesis, Rijksuniversiteit Ghent, 1979).

11. Ibid.

12. See Legrand 1963, p. 201.

13. Adler 1982, figs. 21 and 22.

14. Quoted and translated by Gerson 1960, p. 63, note 33.

15. See Ertz 1979, pp. 505-508; Joost vander Auwera, "Sebastiaen Vrancx (1573-1647) en zijn samenwerking met Jan I Brueghel (1568-1625)," in *Jaarboek van het Koninklijk Museum voor Schone Kunsten, Antwerpen* (1981), pp. 135-150; and Ertz 1986, p. 398.

16. As exhibited at the Galerie Stern, Düsseldorf, 1934, no. 88 and probably still in this state when in sale Zurich (Koller), 27 November-1 December 1984. Monogrammed and dated s. v. A° 1618, panel, 72 x 139 cm; RKD neg. no. L18825.

Paulus Bril

(Antwerp 1554-Rome 1626)

Paulus Bril, from d'Argenville, *Abregé de la vie de les plus fameux peintres* (1745), p. 127.

One of the most influential figures in Italianate landscape painting, Paulus Bril was born in Antwerp in 1554. His father, Matthijs Bril the Elder (active ca. 1550) and brother, Matthijs Bril the Younger (ca. 1550-1583) were also landscape painters. Paulus trained in Antwerp with his father (or, according to van Mander, with Damiaen Ortelmans), then followed his brother to Rome. Traveling via France, he was documented in Lyon in 1574, and is first recorded in Rome when he joined the Accademia di San Luca in 1582. Bril was named *principe* (president) of the organization in 1620. Bril married Octavia Sbarra (d. 1629) in Rome in 1592; the couple had three children, a daughter and two sons. Apart from a visit to Naples in ca. 1602-1603, Bril seems to have spent the rest of his life in Rome, living first in the Via Paolina (now the Via del Babuino) until 1617 and then in the Via San Sebastianello (near the Piazza di Spagna). He was friends with the German painter Adam Elsheimer (1578-1610), and with Rubens during his stay in Rome. Bril died in Rome on 7 October 1626, and was buried in the church of Sta. Maria dell'Anima. About forty paintings are listed in the inventory of his estate after his death, almost all by his own hand.

From about 1585-1600 Bril worked frequently for Pope Gregory XIII and his successors Sixtus V and Clement VIII on fresco decorations for the Vatican. He also executed landscape frescos in the sacristies of Sta. Maria Maggiore, Sta. Cecilia, San Giovanni in Laterno (1589-1590), and il Gesù (ca. 1599). Departing from the artist's mannerist training, these frescoes are heavily influenced by the Italian landscapist Girolamo Muziano (1528-1592), as well as by his contemporary Annibale Carracci (1560-1609). During the same period Bril also produced small landscape paintings, frequently on copper, for private collectors. A number of signed and dated easel paintings makes it possible to trace the artist's development. His early works show the influence of prints by Hans Bol (1534-1593) and, to a lesser extent, of works by Gillis van Coninxloo (q.v.); after about 1600, however, the small landscapes adopt the simpler compositions and more classical organization of his work in fresco. His late work (after about 1619) becomes increasingly classical, betraying the influence of Domenichino and Guercino. Bril returned to fresco painting in about 1610; among his commissions were decorations for the Palazzo Pallavincini (1610), which were engraved by Egidius Sadeler in 1615. Bril himself was a prolific draughtsman and etcher; in fact his prints were the primary conduit for his considerable influence on artists in the north.

Van Mander 1604, fol. 291r-292v; Baglione 1642, pp. 196-197; Sandrart, Pelzer 1925, pp. 150-151; Pio 1724, p. 261; Fétis 1857-65, vol. 1, passim; Bertolotti 1880, pp. 57, 104; Rooses 1879; Wurzbach 1906-11, vol. 1 (1906), pp. 183-185; Mayer 1910; Thieme, Becker 1907-50, vol. 5 (1911), pp. 16-17; Hoogewerff 1913, p. 88, 98, 255; Baer 1930; Hoogewerff 1942-43, p. 170; Thiéry 1953, pp. 37ff, 173; Vey 1964; Faggin 1965; Utrecht 1965, pp. 17-18, 49-56; Bodart 1970, vol. 1, pp. 212ff; Salerno 1977-80, vol. 1 (1977), pp. 12-29, vol. 3 (1980), pp. 1002-1006; Boon 1980; Montreal 1990, pp. 104-107; H. Devisscher, in Cologne/Vienna 1992-93, p. 197; Berger 1993.

Paulus Bril
85. *Landscape with Nymphs and Satyrs*, 1623

Oil on canvas, 70.5 x 103.2 cm (27 ¾ x 40 ⅝ in.)
Signed and dated lower right: PAOLO BRILL 1623
Oberlin, Ohio, Allen Memorial Art Museum, Oberlin
College; Friends of Art, A. Augustus Healy,
R. T. Miller Jr., Charles F. Olney Funds, 1953,
acc. no. 53.257

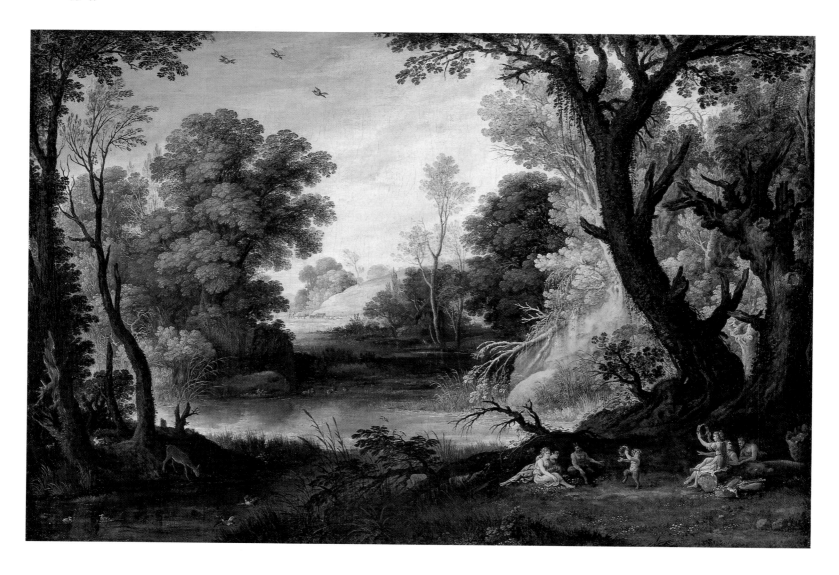

PROVENANCE: Earl of Lonsdale, Lowther Castle, by 1864; Alan P. Good, Glympton Park, Woodstock, Oxon; sale Alan P. Good, London (Sotheby's), 15 July 1953, no. 8 [£360, to P. de Boer]; purchased from dealer P. de Boer, Amsterdam, 1953.

EXHIBITIONS: Delft, "Antiekbeurs," 1953; New York, Knoedler & Co., *Paintings and Drawings from Five Centuries*, 1954, no. 38; Cambridge, MA, Fogg Art Museum, Harvard University, *Landscape: Massys to Corot*, 1955, no. 1.

LITERATURE: Waagen 1854-57, vol. 3 (1854), p. 260; W. Stechow, "A Landscape by Paul Bril," *Allen Memorial Art Museum Bulletin* 12 (1954-55), pp. 23-31; Oberlin, Allen Memorial Art Museum, cat. 1957, p. 51; Faggin 1965, pp. 24, 33, no. 67; Oberlin, cat. 1967, p. 24, fig. 5; Salerno 1977-80, vol. 1 (1977), pp. 16, 28, fig. 220, vol. 3 (1980), p. 1005, note 52; Duparc & Graif, in exh. Montreal 1990, p. 106, fig. 44; Liedtke et al. 1992, p. 320, no. 131.

TALL TREES bracket a grove with a placid stretch of
water. The low-lying darkened foreground links the
flanking and over-arching silhouettes of the trees in
a single aperture of shadow. Offering a contrast with

the foreground, the lighted middle ground features
a pool surrounded by trees of various forms, some in
full foliage, others slender and denuded. At the back
the trees part to offer a glimpse of a distant blue
landscape with hills and herdsmen. In the lower
right foreground several nymphs and satyrs cavort
in a clearing, while on the left a deer, a rabbit, and
ducks gather. The colors, like the value contrasts and
brushwork, are richly and subtly variegated.

This painting is a late example of Bril's land-
scapes. In his early career in Rome he had executed
landscapes in a late mannerist style with extrava-
gantly movemented forms, dramatically superim-
posed coulisses, plunging perspectives, and an
emphatic division of colors into retreating zones of
brown, green, or yellow, and blue (see Introduction,
fig. 87, the earliest dated Bril of 1594). These early

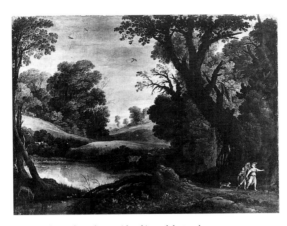

Fig. 1. Paulus Bril, *Landscape with Tobias and the Angel*,
signed and dated 1624, oil on canvas, 76.5 x 101 cm,
formerly Dresden, Gemäldegalerie Alte Meister,
no. 861.

works attest to his admiration for the art of Lode-
wijck Toeput, whom he met in Venice, but are most
clearly connected with the Flemish landscape tradi-
tion descended from Pieter Bruegel, perhaps via
artists like Hans Bol and Jan Brueghel the Elder,
with whom Bril worked to mutual advantage in
Rome. During the first decade of the seventeenth
century, Bril developed a more naturalistic approach
to landscape under the influence of the German
painter Adam Elsheimer, whom he, like Rubens,
befriended in Rome. Responding also to the art of
Annibale Carracci and possibly Domenichino, Bril
developed a highly organized approach to landscape
design, which featured prominent framing devices,
alternating and carefully differentiated tonal zones,
a gradual zigzagging recession, directed by carefully
balanced and alternating forms, with the whole uni-
fied by a soft greenish light. These developments, so
clearly manifested in Bril's late works, form the basis
for the classical Roman-French landscape painting
tradition ultimately brought to fruition by Claude,
Poussin, and Dughet. In the Oberlin painting we
may appreciate this calm and deliberately composed
landscape style – a manner that is still much more
realistic in details than it would become in the later
works of Claude, but which, nonetheless, presents an
essentially ideal landscape. In his exemplary little
article on the painting, Stechow quoted Goethe's
remarks on Bril, "no more does he represent an
entire world [as in the landscapes of Pieter Bruegel]
but details significant in themselves and yet point-
ing beyond themselves."[1]

Some of the compositional order of the Oberlin
painting is anticipated in two paintings dated 1620
(by which time Bril was the *principe* or president of
the Academy of St. Luke in Rome), in the Museo de
Arte de Ponce, Puerto Rico (no. 61.0173),[2] and sale
Schloss Drachenberg, Cologne (Konigswinter),
16 October 1930, no. 288, ill. However Stechow right-
ly drew the closest comparison with a painting of a
Landscape with Tobias and the Angel, signed and dated
1624, that was formerly in Dresden (fig. 1).[3] Also
comparable in its order and spacious calm is the
unsigned and undated *Landscape with Pan and Syrinx*
(Fine Arts Museums of San Francisco, inv. 49.11),
which has correctly been recognized as another late
painting by Bril.[4] Stechow also recognized that the
tiny staffage figures – a gay company of nymphs and
satyrs with a small satyr boy dancing to the sound of
a tambourine played by one of the girls – and the
tiny dots of small flowers on the ground at the right
are by another hand; he suggested it was "an Italian
hand," with "even some resemblance to certain fig-
ure drawings by Agostino Tassi."[5] Salerno, on the
other hand, argued that the figures in this work and
several others were by Pietro Paolo Bonzi, called
Gobbo dei Carracci (ca. 1576-1636), a long-forgotten
artist who is mentioned by early biographers
(Mancini, Baglione, and Malvasia) and whose works
are listed in old inventories, but whose (unsigned)
œuvre remains largely a matter of conjecture.[6]

PCS

1. W. Stechow, 1954-1955, pp. 23-31; quoting and translating from
"Landschaftliche Malerei," in *Über Kunst und Altertum* 4, no. 3 (1832).

2. See J. S. Held, *Catalogue I. Paintings of the European and American Schools*
(Ponce, 1965), pp. 20-21, fig. 48.

3. Stechow 1954-55, p. 29, fig. 5; see Faggin 1965, p. 31, no. 24.

4. Montreal 1990, no. 26; Faggin 1965, p. 34, no. 95.

5. Stechow 1954-55, p. 31.

6. See Salerno 1977-80, vol. 1 (1977), p. 16, 28; on Bonzi, see ibid., pp. 100-
102, vol. 3 (1980), pp. 1002-1005.

Joos de Momper and Jan Brueghel the Elder (?)
86. *A Winter Rural Landscape*, 1620s

Oil on panel, 49.5 x 82.5 cm (19 ½ x 32 ½ in.)
Private collection

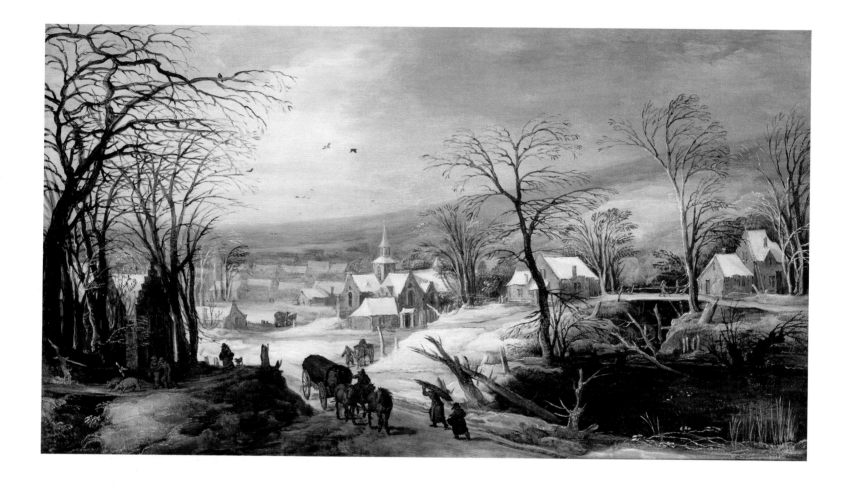

PROVENANCE: dealer Richard Green, London (1989).

HUNCHED against the winter's cold, figures and animals scurry about their business in a hillside village. Horse-drawn wagons and carts and figures laden with baskets and bundles follow a winding road through the village; at the left, a woman with a dog and a couple herding two pigs negotiate a track past the gabled facades of houses nestled in a stand of trees. In the foreground at the right is an icy pond bordered by frost-rimed grasses and dead trees. Birds circle in the air and perch amidst the delicate filigree of bare branches silhouetted against the vaporous sky. The strong local colors of the foreground staffage stand out against the pastel hues of the distant structures and landscape forms.

Although his dramatic mountain landscapes are perhaps the most well-known aspect of his œuvre (see cat. 80), Joos de Momper contributed significantly to the development of the winter landscape in the Southern Netherlands.[1] Long popular in the context of cycles of the months or of the seasons, the winter landscape was introduced as an independent genre by Pieter Bruegel the Elder (*Winter Landscape with Bird Trap*, 1565; Brussels, Musées Royaux des Beaux-Arts de Belgique, inv. 8724) and was perpetuated in the last quarter of the sixteenth century by artists such as Jacob and Abel Grimmer, and Lucas van Valckenborch. De Momper's early winter scenes, like those of his colleague Jan Brueghel the Elder, retain the elevated horizon, panoramic bird's-eye view, square format, and bright local colors of sixteenth-century tradition (compare, for example, works such as the *Winter Landscape* of 1599, fig. 1 [with figures by Jan Brueghel the Elder]; Kassel, Gemäldegalerie Alte Meister, inv. 51).

The present painting is one of a group of works by de Momper from the 1620s which are noteworthy in their depiction of a flatter, more naturalistic Northern landscape, seen from a lowered viewpoint and composed in an expanded horizontal format. The subtle hues of snow-covered earth and overcast

Fig. 1. Joos de Momper and Jan Brueghel the Elder, *Winter Landscape*, dated 1599, oil on copper, 39 x 44.7 cm, Kassel, Gemäldegalerie Alte Meister, inv. 51.

Fig. 2. Joos de Momper, *A Village Street in Winter*, oil on panel, 58.2 x 82.2 cm, with David M. Koetser, Zurich, 1986.

sky indicate the artist's development towards a more neutral, tonal palette. The painterly and evocative rendering of distant forms contrasts with the crisp calligraphic details of foreground vegetation. The middle ground gains in importance through the use of prominent motifs, such as the church and other village structures to the right. Ertz has commented on the masterful, deceptively simple compositional structure of these winter landscapes of the 1620s, which effectively draw the viewer into the scene.[2]

The staffage motifs in de Momper's winter landscapes are frequently drawn from the repertoire of Jan Brueghel the Elder, although they are not always by his hand.[3] After the elder Brueghel's death in 1625, de Momper continued to collaborate with his son, Jan the Younger (1602-1678), at least through the late 1620s.[4] As Jan the Younger often imitated his father's works, it can be difficult to attribute the diminutive figures in these landscapes to one or the

other master. The fact that none of de Momper's winter landscapes is dated, or can be reliably dated on stylistic grounds any more closely than the decade of the 1620s, adds to the difficulty of attributing the staffage in the present painting.

De Momper frequently painted variants of his own compositions, with minor alterations in buildings or landscape forms or, more usually, in the vegetation and staffage. Compare, for example, the artist's *Winter Landscape with Windmill* (private collection; Ertz 1986, cat. 427), and *Winter Landscape with Ambush* (location unknown; Ertz 1986, cat. 423). Several paintings can be related to the present work. *A Village Street in Winter* (fig. 2; with David M. Koetser, Zurich, 1986) retains the same basic landscape forms and disposition of the buildings, although three skiffs have replaced the trees and branches rimming the pond at right and the staffage is completely different.[5] A copy with minor variations, attributed by Ertz to Frans de Momper,[6] is in the Národní Galerie, Prague (inv. 064). Finally, many of the same motifs appear in *Village Landscape in Winter with Hunters* (panel, 57.5 x 82.9 cm; Sheffield, Graves Art Gallery, inv. 3027), with staffage attributed to a follower of Sebastian Vrancx (q.v.).[7] Although the catalogue description is not specific enough to ensure positive identification, the *Rural Winter Landscape* may be the painting mentioned in the sale François de Bouchaut, Ghent, 14 June 1784, no. 44 ("Monper. Une petite ville, pleine de petites Figures à pied & à cheval, dont les maisons, l'Eglise &c. sont couvertes de niege; sur le devant un Chariot attelé à trois Chevaux, par le même Brueghel [de Velours] . . . sur bois," 20 x 30 pouces [ca. 54 x 81 cm]).

M E W

1. The development of the winter landscape in the Southern Netherlands is briefly surveyed in Evert van Straaten, *Koud tot op het bot. De verbeelding van winter in de zestiende en zeventiende eeuw in de Nederlanden* (The Hague, 1977), pp. 70-94.

2. Ertz 1986, pp. 246-256.

3. About eighty paintings attributed jointly to both de Momper and Jan Brueghel the Elder are mentioned in seventeenth-century inventories, including a handful of winter landscapes; see Ertz 1979, p. 472.

4. See Ertz 1984, p. 81; and Ertz 1986, pp. 392-396.

5. Oil on panel, 58.2 x 82.2 cm; formerly Prague, Národní Galerie, inv. 08269. See Ertz 1986, pp. 247-248, 578-579, cat. 410; and Ertz 1979, pp. 483, 486, cat. 398.

6. Ertz 1986, p. 574, cat. A 191.

7. Ertz 1986, cat. 448. A similar but more restricted view of a village in winter is in the Niedersächsisches Landesmuseum, Hanover, inv. KM89 (oil on panel, 45 x 74 cm).

Joos de Momper and Jan Brueghel the Elder
87. A Market and Bleaching Fields

Oil on canvas, 166 x 194 cm (65 ⅜ x 76 ⅜ in.)
Madrid, Museo del Prado, no. 1443

PROVENANCE: Possibly the painting mentioned in the inventory compiled on 12 January 1659 of the Royal Palace in Brussels as hanging in the Large Gallery: "Nr. 13 Un paysage de Monsper con figuras de Breugel, largo de 6 pies y alto de quatro, representando un boyero que sigue unas vacas y otras figuras" (see de Maeyer 1955, doc. no. 271; Ertz 1986, p. 54); inventory of the Zarzuela, 1700, no. 66 or 67; also in the inventories of 1742 and 1749; in 1772 recorded as in the apartments of the Infanta in the Palacio Nuevo; in 1794 hung in the dressing room of the Queen, valued at 40,000 reales; in 1834 valued at 60,000 reales; inventories and catalogues of the Prado: inv. 1849, no. 1422 [here and in later catalogues as Jan Brueghel]; cats. of 1854-1858, no. 1422; 1872-1907, no. 1279; 1910-1972, no. 1443; Madrid, cat. 1975, no. 1443 [as Joos de Momper and Jan Brueghel].

EXHIBITIONS: Brussels 1975, pp. 110-111, no. 27, ill. p. 126 [as Joos de Momper the Younger]; Brussels, Palais des Beaux-Arts, *Splendeurs d'Espagne et les Villes belges 1500-1700*, 25 September-22 December 1985, no. D30.

LITERATURE: P. Beroqui, in *Boletín de la Sociedad Española de Excursiones* 15, no. 172, (Madrid, 1917), p. 130 [as Jan Brueghel]; G. Winkelmann-Rhein, *Blumen Brueghel* (1968), p. 84, ill. p. 55 [as Jan Brueghel]; M. Díaz Padrón and A. Recchiuto, "Application of X-rays to the Study of Some Paintings in the Prado Museum," in *Medicamundi* (Madrid, 1973), p. 103 [as possibly by Joos de Momper]; M. Díaz Padrón, "Dos Lienzos de Joost de Momper Atribuidos a Jan Brueghel en el Museo del Prado," *Archivo Español de Arte* 190-191 (1975), pp. 270-274, fig. 6 [as Joos de Momper and Jan Brueghel, and likewise hereafter]; idem, in Madrid, cat. 1975, vol. 1, p. 198, no. 1443, p. 442, vol. 2, pl. 141; idem, "La Exposición de Maestros Flamencos del siglo XVII del Museo del Prado y Colecciones Españolas en el Museo Real de Bruselas," *Goya Revista de Arte* 133 (1976), p. 27, ill.; F. Baumgart, *Blumen Brueghel* (Cologne, 1978), p. 55, pl. 2; Ertz 1979, pp. 447, 488, 490 and 491, figs. 591 and 594 (detail), cat. 423; M. Klinge, in exh. cat. Brussels 1980, p. 272; H. Devisscher, in Ertz 1986, pp. 54, 90, 200, 202, 261, fig. 217, cat. 375; Madrid, cat. 1989, pp. 138-139.

ON THE LEFT, a busy market filled with people extends up a village street leading to a small church. In a broad field bordered by a canal on the right, figures spread out linen in neat patterns to bleach in the sun. In the lower right is a pond with ducks. The two parts of the scene are divided by a tall tree that reaches to the top of the canvas and has yet to unfurl its early spring leaves. In the market there are vendors with fish, vegetables, and other wares, a horse with a cart, pigs, cows, and other livestock. Tall stepped gables decorate the buildings and a hilly landscape stretches away in the right distance.

In the inventory compiled in 1700 of the Zarzuela, this painting was described as one of a pair of landscapes: "Dos países de dos varas y media en cuadros flamencos con variedad de figuras y en el uno hay unas lavanderas con ropa tendida, tasadas a sesenta doblones cada una, pieza quinta, núms. 66 y 67."[1] Díaz Padrón rejected P. Beroqui's suggestion that the pendant might be Prado no. 1441, which is a geographic map, but suggested that it could be no. 1896, a work now probably correctly assigned to Jan Wildens (fig. 1).[2] That canvas is of identical dimensions and depicts figures taking the waters of a spa, while two men in the lower right hold up a painted topographic projection of a city with a watering place, which is inscribed "SPA" and probably depicts

Fig. 1. Jan Wildens, *The Spa*, oil on canvas, 120 x 187 cm, Madrid, Museo del Prado, no. 1896.

the Belgian city of that name; in the lower left of the little map is a separate scene with the inscription "Savonir" (La Savonnière) and to the right another titled "fonteine spaon."[3] Since both paintings deal with themes of water, namely the pure waters needed for bleaching and the healthy waters required of a spa, they could have been conceived as companions, but it is not known whether they were joined by the artists, their early patrons, or later owners.

The early inventories of the Spanish royal collection, as well as the catalogues of the Prado prior to 1975, attributed the present painting to Jan Brueghel the Elder (an attribution also supported by Winkelmann-Rhein in 1968 and Baumgart in 1978). Díaz Padrón and Recchiuto first raised the possibility of reassignment to Joos de Momper II, and the painting was at last unconditionally reattributed to that artist in the catalogue of the 1975 exhibition in Brussels of Flemish paintings from Spanish collections.[4] However, in the Prado's catalogue of Flemish paintings that also appeared that year, Díaz Padrón correctly observed that while the landscape in this scene bears all the stylistic characteristics of de Momper's mature style, the figures are indeed by Jan Brueghel the Elder.[5] This opinion has the support of Ertz in his studies both of Brueghel (1979) and de Momper (1986).[6] While the figures in this scene are exceptionally large for Jan Brueghel the Elder, they have the detailed execution and articulation typical of his work.

We know from three of Brueghel's letters of 1622 that he and de Momper were well acquainted; indeed in a letter dated 7 May 1622 that Rubens wrote to Ercole Bianchi for him, Brueghel refers to "Mio amico Momper" (my friend Momper).[7] Their collaboration is also recorded in documents as early

Fig. 2. Joos de Momper II and Jan Brueghel the Elder, *Return from the Wheatfield*, oil on canvas, 165 x 165 cm, Madrid, Museo del Prado, no. 1440.

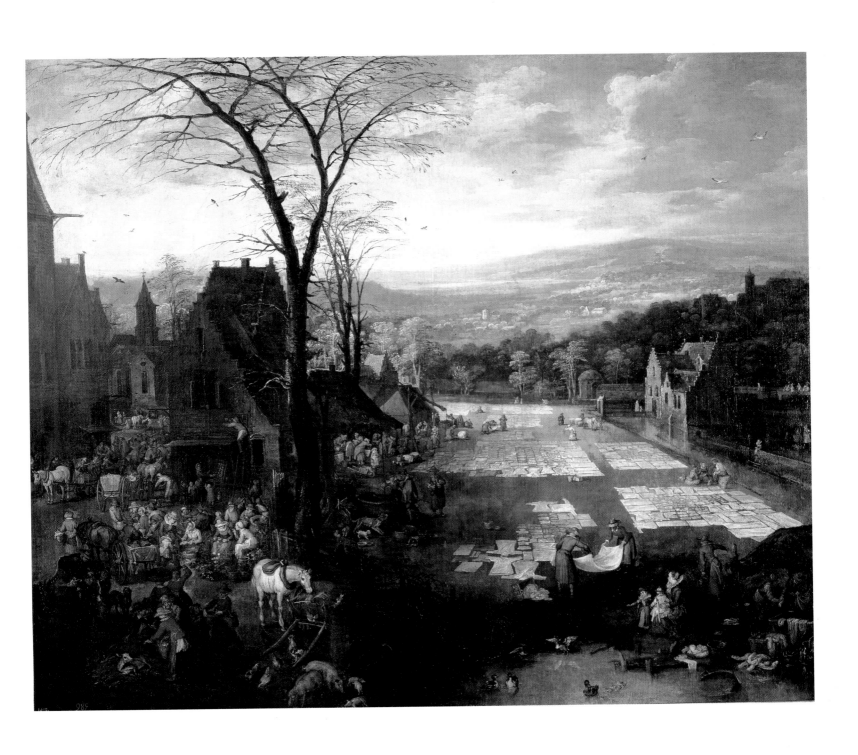

as 1612-1613, when Brueghel claimed to have painted the figures in six paintings by Momper and also to have provided staffage for a *Four Seasons* series by the artist.[8] Furthermore Franz has noted that works executed jointly by the two artists were well enough known by their contemporaries and sufficiently desirable to appear with dual labels in David Teniers's *kunstkamer* paintings.[9] Díaz Padrón and Ertz are probably correct in dating the present work and another unusually large landscape on a square-format canvas by the two artists (fig. 2) to their later years of collaboration, or ca. 1621-1622.[10]

The bleaching field spread with linen was a favored motif in these two artists' collaborations, and was frequently featured in their paintings juxtaposing winter and spring,[11] or depicting spring in a series of the Four Seasons (fig. 3).[12] Just as sowing, harvesting, and hunting were associated with the other three seasons, the washing and bleaching of the linen that had remained untended all winter was one of the traditional springtime activities of village life. The spring washing was a substantial task, mostly shouldered by women, and could last for several days. Public washing areas and bleaching grounds existed throughout the Northern and Southern Netherlands in the seventeenth century and were regularly depicted in prints by, for example, Claes Jansz. Visscher and Jan van de Velde II.

In addition to de Momper and Brueghel, David Teniers the Younger (fig. 4) also painted bleaching fields in the 1640s, probably under Brueghel's influence. However Teniers's works are independent landscapes without a series.[13] Later Dutch painters, most notably Jacob van Ruisdael, but also artists like Jan Vermeer van Haarlem and the landscapist Jan van Kessel, made a specialty of painting panoramic landscapes with views of bleaching fields.[14] In his analysis of Ruisdael's images of bleaching fields, Wiegand posited that they offered emblematic allusions to the purified Christian soul, basing his conclusions on references in biblical passages and seventeenth- and eighteenth-century emblem books.[15] This has recently inspired some misleading or at least excessively narrow interpretations of Flemish as well as Dutch landscapes with bleaching fields.[16] In her extensive analysis of images of textiles in Dutch art, Stone-Ferrier has correctly stressed that Ruisdael's images of the Haarlem bleaching fields should be understood primarily as part of a cartographic and topographic tradition in which linen bleaching was depicted as an important local industry and source of international fame.[17] She also rightly stressed that the Flemish images of bleaching grounds by Jan Brueghel and Teniers represent

Fig. 3. Joos de Momper II and Jan Brueghel the Elder, *Spring*, from a *Four Seasons Series*, oil on panel, 55.5 x 97 cm, Braunschweig, Herzog Anton Ulrich-Museum, inv. no. 64.

Fig. 4. David Teniers the Younger, *The Bleaching Grounds*, signed, oil on canvas, 85 x 120 cm, Birmingham, University of Birmingham, The Barber Institute of Fine Arts, cat. (1983), no. 99.

Fig. 5. Attributed to Jan Brueghel the Elder, *Village with Bleaching Field*, signed, oil on copper, 22 x 32.5 cm, present location unknown.

an alternative pictorial tradition, in which the scale of the figures and buildings is bigger and the largely imaginary topography represents no specific village or town.[18] The figures in these images bleach both clothing and uncut cloth, while the long unfurled bolts of the latter dominate the images from Haarlem. While bleaching was a lucrative business in the

Bonaventura Peeters

(Antwerp 1614-Hoboken 1652)

Southern Netherlands, its imagery had less to do with the celebration of local industry than with the traditional depiction of seasonal village occupations. The present picture probably depicts the yearly washing rather than a commercial enterprise, as is depicted in a painting which was dubiously assigned to Jan Brueghel the Elder when sold by R. H. van Schaik, Amsterdam (F. Muller & Co.), 11 March 1952, no. 660, ill. (fig. 5).

PCS

1. "Two Flemish genre landscapes measuring two and a half varas [approx. 209 cm] with a variety of figures and in one there are washer-women tending clothes, valued at 70 doubloons each, fifth room, numbers 66 and 67" (translated by Michael Armstrong Roche) and as by an anonymous Flemish painter; see M. Díaz Padrón, in Madrid, cat. 1975, p. 198, no. 1443.

2. See P. Beroqui, "Adiciones y correcciones al catálogo del Museo del Prado," Boletín de la Sociedad castellana de Excursiones 15, no. 172 (1917), p. 130; and Madrid, cat. 1975, p. 198, no. 1443.

3. See Madrid, cat. 1975, vol. 1, pp. 442-443, no. 1896, vol. 2, pl. 305; and Adler 1980, p. 110, no. G78, fig. 111.

4. See Díaz Padrón and Recchiuto 1973, p. 103, and Brussels 1975, no. 27.

5. Díaz Padrón 1975, p. 198, no. 1443.

6. Ertz 1979, cat. no. 423, and 1986, cat. no. 375.

7. See Crivelli 1868, pp. 207-208, 296-297, 310; Ertz 1979, p. 470, note 833.

8. See Ertz 1979, p. 470, note 832. See also Jan II's inventory of his father's collection, which included seven de Mompers, two of which had figures by Jan I (see Vaes 1926-27, pp. 207-209; and Ertz 1979, p. 542, doc. nos. 53 and 55).

9. See H. G. Franz, "Landschaftsbilder als kollektive Werkstattschöpfungen in der flämischen Malerei des 16. und frühen 17. Jahrhunderts," Jahrbuch des Kunsthistorischen Institutes der Universität Graz 18 (1982), pp. 174-177, citing two paintings by Teniers of the Collection of Archduke Leopold in Brussels (both in the Bayerische Staatsgemäldesammlungen, Munich, and housed at Schleissheim) in which, respectively, the painting within the paintings are signed on the frame "MOMPER F BREVGHEL" and "MOMPER F. BREVGHEL"; see his figs. 26-29 (details of the paintings within the paintings).

10. Madrid, cat. 1975, pp. 197-198 [ca. 1622]; Ertz 1986, p. 200 [ca. 1621].

11. See Prado, inv. no. 1589 (pendant to no. 1588); Ertz 1986, no. 557, fig. 218.

12. See Ertz 1986, no. 563, fig. 232.

13. See Antwerp 1991, no. 27, ill.; and Dresden, Gemäldegalerie Alte Meister, no. 1067.

14. See, as examples, Ruisdael's haerlempjes in the Rijksmuseum, Amsterdam, no. A1351; the Mauritshuis, The Hague, no. 155, and Ruzicka Stiftung, Kunsthaus, Zurich, no. R32.

15. W. Wiegand, Ruisdael-Studien: Ein Versuch Ikonologie der Landschaftsmalerei, Ph.D. diss., Hamburg University 1971, pp. 101-105 citing biblical references (Psalms 51; Jeremiah 2:22; Isaiah 1:16-18; Revelations 7:14 and 19:8) as well as references to seventeenth-century literature and emblems, such as the Pietist Jan Luiken's depiction of a bleacher in his moralizing book on professions, Een Honderd Verbeelding van Ambachten (Amsterdam, 1694), p. 285.

16. See, for example, Helga Möbius, Women of the Baroque Age (Montclair, NJ, 1984), which interprets Teniers's Bleaching Field in Dresden (see note above no. 13, and her fig. 55) as "a hidden message . . . a sign of the soul being purified by divine consolation." John Walford's new book on Ruisdael (Jacob van Ruisdael and the Perception of Landscape [New Haven & London, 1991], pp. 43, note 33, and 114-115) happily offers a more complex view of the subject.

17. Linda Stone-Ferrier, Images of Textiles. The Weave of Seventeenth-Century Dutch Art and Society (Ann Arbor, 1985), pp. 120-145.

18. Ibid., pp. 156-161.

Baptized in the Church of St. Walpurgis in Antwerp on 23 July 1614, Bonaventura Peeters was the younger brother of the landscape painter Gillis Peeters (1612-1653), with whom he seems to have shared a studio. Bonaventura's teacher is unknown; however, his marines are influenced not only by the Flemish mannerist seascapes of Hans Savery I and others but also reveal stylistic resemblances with works by the Dutch artists Jan Porcellis (1580/84-1632; active in Antwerp 1615-1622), Jan van Goyen (1596-1656), and Simon de Vlieger (1601-1653). Bonaventura joined the Antwerp guild of St. Luke in 1634/35. In 1639 Bonaventura and Gillis received joint payment of 480 guilders for a large canvas depicting the Seige of Calloo, which had been commissioned by the municipal authorities of Antwerp. Reportedly in poor health, Bonaventura moved at the end of his life to nearby Hoboken, where he died on 25 July 1652. In addition to his activity as a painter, Peeters was also a poet and wrote several satires attacking the Jesuits. Some writers have speculated that these writings forced his departure from Antwerp.

Besides a variety of marine paintings depicting tempests, shipwrecks, and naval battles, Bonaventura executed landscapes, small-scale figure paintings, and etchings. His sister Catharina and brother Jan (1624-1677) were both his pupils and worked in his manner.

De Bie 1661, pp. 170-171; Houbraken 1718-21, vol. 2, pp. 12-13; Weyerman 1729-69, vol. 2, pp. 124-126; Immerzeel 1842-43, vol. 2 (1843), p. 301; Kramm 1858-64, vol. 4 (1860), pp. 1262-1263; Michiels 1865-76, vol. 9 (1874), pp. 218-225; Rombouts, van Lerius 1872, vol. 2, pp. 59, 67, 133; van den Branden 1883, pp. 1046-1050; Wurzbach 1906-11, vol. 2 (1910), pp. 319-320; Willis 1911, pp. 77-79; Sandrart/Peltzer 1925, p. 182; Thieme, Becker 1907-50, vol. 27 (1933), pp. 6-7; Gerson, ter Kuile 1960, p. 157; Brussels 1965, pp. 150-152; Larsen 1970, pp. 125-130; Bol 1973, pp. 7-9; Paris 1977-78, pp. 135-136; Goedde 1986, pp. 139-149; Mertens 1987; Goedde 1989, pp. 89, 94, 107-108, 124-125, 196-199; Sutton 1990, pp. 230-232; Cologne/Vienna 1992-93, pp. 448-449.

Bonaventura Peeters
88. Dutch Men-of-War in the West Indies, 1648

Oil on panel, 47 x 71.5 cm (18 ½ x 28 ⅛ in.)
Signed in monogram and dated at lower left: B·P 1648
Hartford, Wadsworth Atheneum, Ella Gallup
Sumner and Mary Catlin Sumner Collection,
inv. 1940.403

PROVENANCE: (possibly) sale Breteuil, Paris (Lebrun), 16-25 January 1786, suppl. no. 10 ["un beau Paysage et Marine ornée de vaisseaux, abordant une isle de Sauvages. Hauteur 17 pouces 6 lignes, largeur 26 pouces 6 lignes"]; Julius H. Weitzner, New York.

EXHIBITIONS: Hartford, Wadsworth Athenuem, *The Ella Gallup Sumner and Mary Catlin Sumner Fund: Recent Acquisitions*, 1 February-1 April 1941, no. 25; Detroit, Detroit Institute of Arts, *Five Centuries of Marine Painting*, 6 March-5 April 1942, no. 16; Newport, Art Association of Newport, *The Coast and the Sea: A Loan Exhibition Assembled from the Collections of the Wadsworth Atheneum, Hartford*, 3-30 September 1964, no. 19; Brussels 1965, no. 164; Montreal, Montreal Museum of Fine Arts, *The Painter and His World*, 9 June-30 July 1967, no. 6; Washington, D.C., The National Gallery of Art (also shown at Cleveland, Cleveland Museum of Art, and Paris, Grand Palais), *The European Vision of America*, 1975-77, no. 81.

LITERATURE: "Recent Acquisitions-Purchases from the Sumner Fund," *Wadsworth Atheneum Bulletin* 6 (1940); W. R. Valentiner and F. W. Robinson, "Down to the Sea in Pictures for 500 Years," *Art News* 41 (1942), p. 15, ill.; Larsen 1970, pp. 130-131; J. de Sousa-Leão, *Frans Post: 1612-1680* (Amsterdam, 1973), pp. 42f; P. C. Sutton, in *Wadsworth Atheneum Paintings, Catalogue I: The Netherlands and the German-speaking Countries, Fifteenth-Nineteenth Centuries*, E. Haverkamp Begemann, ed. (Hartford, 1978), pp. 171-172; Sutton 1990, pp. 231-232; Liedtke et al. 1992, p. 356.

Wenceslas Hollar, *Bonaventura Peeters*, engraving, from Cornelis de Bie, *Het gulden cabinet . . .*, 1661, fol. 171.

TWO LARGE men-of-war flying the flag of the Northern Netherlands are anchored off a rocky coast; other ships are visible on the open waters in the distance. A canoe with four Indians approaches the closest ship, as two small dinghies ferry Europeans to or from shore. In the immediate foreground, a group of Indians have gathered on a spit of land to witness the arrival of the foreign visitors. Several of them hold up parrots, and one man brandishes what appears to be a bunch of coconuts.

The exotic parrots – as well as the feathered headdresses, bows and arrows, spears, and scanty wraps of the figures in the foreground – indicate that Peeters's scene is set in the New World, probably Brazil, which was briefly colonized by the Dutch between 1630 and 1654.[1] Although Peeters was best known for his vividly theatrical scenes of shipwrecks and craggy, storm-battered coastlines,[2] he also painted more temperate seascapes, and a number of views of American shores. Most of the latter (like the present painting) depict the calm waters of a natural harbor, but a few, such as the tempestuous *Shipwreck on a Rocky Coast* of ca. 1640 (fig. 1), combine the artist's acknowledged specialty with the exotic intrigue of the Americas.[3] Peeters apparently never traveled outside Flanders, and his views of the New World and its inhabitants were probably derived from drawings and annotations furnished by another artist – possibly his older brother Gillis, who is said to have traveled to Brazil in the entourage of the Dutch prince Johan Maurits van Nassau-Siegen (1604-1679) in 1636-1637 and perhaps again in 1640.[4] Gillis Peeters painted several landscapes and harbor scenes of Brazilian sites from 1637. In contrast to the

Fig. 1. Bonaventura Peeters, *Shipwreck on a Rocky Coast*, ca. 1640, signed, oil on panel, 44.5 x 68.5 cm, Philadelphia, Philadelphia Museum of Art, inv. 70-2-1.

Fig. 2. Bonaventura Peeters, *Dutch Vessel Standing off the Brazilian Coast*, signed and dated 1640 or 1646, oil on panel, 45.1 x 64.1 cm, São Paulo, Brazil, collection João Fernando de Almeida Prado.

Peter Paul Rubens
89. Landscape with a Cart Fording a Stream ("La Charrette Embourbée")

Oil on canvas transferred from panel,
87 x 129 cm (34 ¼ x 50 ¾ in.)
St. Petersburg, State Hermitage Museum, no. 480

highly specific paintings of the New World by Dutch artists such as Frans Post or Albert Eckhout, the tiny, rather generalized Indians in Peeters's coastal scenes do not function as an ethnographic or historical record, but instead have an affective purpose, signaling to the viewer that this place is remote, unfamiliar, and possibly dangerous.

The composition of the Hartford painting resembles that of Peeters's *Dutch Vessel Standing off the Brazilian Coast*, signed and dated 1640 or 1646 (São Paulo, Brazil, collection João Fernando de Almeida Prado; fig. 2), albeit in reverse. The two paintings differ also in the various ships and foreground staffage. As Larsen has noted, the artist's close repetition of the composition indicates the popularity of these exotic coastal scenes among his contemporaries.[5] The fanciful tempests and coastlines depicted by Peeters, one of the few marine painters active in the Southern Netherlands during the mid-seventeenth century, are in marked contrast to the tradition of naturalistic seascapes which flourished in the North during the same period. The ongoing blockade of the Scheldt River by the Dutch had brought local shipping to a virtual standstill, while Dutch ships freely roamed coastal waterways and the open seas, ever expanding their marine empire; it is not coincidental that the men-of-war in Peeters's painting display the flag of the Northern Netherlands.

MEW

1. On the Dutch colonization of Brazil and the role of Johan Maurits van Nassau-Siegen as governor, explorer, and patron of the arts, see exh. cat. The Hague, Mauritshuis, *Zo wijd de wereld strekt*, 21 December 1979-1 March 1980; and, more recently, P. J. P. Whitehead and M. Boeseman, *A Portrait of Dutch 17th-century Brazil: Animals, Plants and People by the Artists of Johan Maurits of Nassau* (Amsterdam, Oxford, New York, 1989).

2. Houbraken (1718-21, vol. 2, pp. 12-13) commented especially vividly on the artist's ability to depict tempests and shipwrecks.

3. Sutton (1990, pp. 231-232) lists several other paintings by Peeters that feature native Americans. See also Larsen 1970, p. 130; and Hartford, cat. 1978, pp. 171-172. In addition, the Antwerp art dealer Forchoudt listed two East Indian scenes by Peeters in his inventory of September 1698: "Twee halfdoeckens van Buenaventuer Peeters, het eene daer de Hollanders de eerste reys in Oostindien comen, en van de Indianen wel onthaelt worden, het ander daerse met hun slaeghts syn" (Denucé 1931, p. 223).

4. On Gillis Peeters's supposed travels to Brazil, see Larsen 1970, esp. pp. 137-140. Whitehead and Boeseman, however (1989, p. 194), have noted that Gillis's paintings resemble "a three-dimensional drawing extrapolated from maps and plans," and doubt whether he actually made the journey to South America.

5. Larsen 1970, p. 130.

PROVENANCE: (probably) Cardinal Mazarin, Paris, inv. 1661, no. 1286; sale D. Potter, The Hague, 19 May 1723, no. 44 (fl. 1000); sale Earl Cadogan, London, 14-22 February 1726; Robert Walpole, first Earl of Oxford, Houghton Hall (1676-1745); sold in 1779 by George Walpole, third Earl of Oxford (1730-1791; for whose 1788 inventory it was engraved by J. Browne) to Catherine II, Empress of Russia.

EXHIBITIONS: Montreal, International Fine Arts Exhibition, *Man and His World*, 28 April-27 October 1967, no. 80 (entry by Julius Held), ill. [ca. 1620]; Dresden, Gemäldegalerie Alte Meister, *Europäische Landschafts-malerei 1550-1650* (also shown at Warsaw, Prague, Budapest, and Leningrad), 29 April-11 June 1972, no. 84, ill.; Washington, D.C., National Gallery of Art, *Master Paintings from the Hermitage and the State Russian Museum, Leningrad* (also shown at New York, M. Knoedler & Co.; The Detroit Institute of Art; Los Angeles County Museum of Art; and Houston, The Museum of Fine Arts), 1975-76, no. 16; Antwerp 1977, no. 42, ill. [ca. 1617]; Leningrad, Hermitage, *Rubens and the Flemish Baroque* (in Russian) 1978, no. 32; Vienna, Kunsthistorisches Museum, *Gemälde aus der Eremitage und dem Puschkin-Museum*, 13 May-9 August 1981, pp. 112-115, ill.; Sapporo, Hokkaido-ritsu Kindai Bijutsukan, *Works by Western European Masters from the Hermitage Collection* [in Japanese], 13 July-22 August 1985, no. 27, ill.; New York, The Metropolitan Museum of Art, *Dutch and Flemish Paintings from the Hermitage*, 26 March-5 June 1988 (also shown at the Art Institute of Chicago, 9 July-18 September 1988), no. 46, ill.; Cologne/Vienna, 1992-93, no. 89.1, ill.

LITERATURE: Descamps 1753-64, vol. 1 (1753), p. 316; H. Walpole, *Ædes Walpolianæ* (London, 1752), p. 87; H. Walpole, *Anecdotes of Painting in England*, vol. 1 (London, 1762), pp. 310-312; Smith 1829-42, vol. 2 (1830), no. 547, vol. 9 (1842), no. 216; F. Labensky, *Livret de la Galerie impériale de l'Ermitage de Saint-Pétersbourg* (St. Petersburg, 1838), p. 12; G. Waagen, *Die Gemäldesammlungen in der kaiserlichen Ermitage zu St. Petersburg* (Munich, 1864), p. 143, no. 594; Le Comte de Cosnac, *Les Richesses du Palais Mazarin* (Paris, 1884), p. 344, no. 1286; Rooses 1886-92, vol. 4 (1890), pp. 369-370, no. 1178, pl. 336; Burckhardt 1898, pp. 316-317 [ca. 1617]; A. Somof, in St. Petersburg, Hermitage, cat. 1901, pp. 371-372, no. 594; A. Rosenberg 1905, p. 404, ill.; Dillon 1909, p. 184, pl. 456; Oldenbourg 1921, p. 285 [ca. 1620]; D. A. Smidt, *Rubens and Jordaens* (in Russian) (Leningrad, 1926), p. 23; C. Sterling, *Les Paysages de Rubens* (Paris, 1928), pp. 186-187, 192, 195-196; Keiser 1931, pp. 15-16, 23; H. Herrmann, *Untersuchungen über die Land-schaftsgemälde des P. P. Rubens* (Stuttgart, 1936), pp. 15, 18, 34, 70, note 34; van den Wijngaert 1940, p. 36, under no. 93; A. H. Cornette et al., *Geschiedenis van de Vlaamsche Kunst* (Antwerp, ca. 1940), pp. 724, 739; Evers 1942, p. 392, fig. 220; idem, 1943, pp. 176, 350, no. 2; Glück 1945, pp. 18-19, 56, pl. 7; F. Grossmann, "Holbein, Flemish Paintings and Everhard Jabach," *The Burlington Magazine* 93 (1951), p. 20, no. 65; Larsen 1952, p. 201, pl. 160; Thiéry 1953, p. 92; Leningrad, Hermitage, cat. 1958, vol. 2, p. 82, no. 480, fig. 83; Held 1959, vol. 1, p. 144, under cat. 129; V. F. Levinson-Lessing, *Dutch and Flemish Masters, Hermitage, Leningrad* (London, 1964), pl. 7; J. Theunissen, "De kar en de wagen in het werk van Rubens," *Jaarboek van het Koninklijk Museum voor Schone Kunsten, Antwerpen* (1966), p. 199; G. Martin 1968a, p. 211; London, National Gallery, cat. 1970, p. 208, note 15, ill.; M. Varshavskaya, *Rubens' Paintings in the Hermitage Museum* (Leningrad, 1975), pp. 127-131, no. 19, ill.; L. Steinberg, "Remarks on Certain Prints Relative to a Leningrad Rubens on the Occasion of the First Visit of the Original to the United States," *The Print Collector's Newsletter* 6, no. 4 (1975), pp. 98-100, 102, note 9, fig. 5 [ca. 1618]; Leningrad, Hermitage, cat. 1981, p. 62; Adler 1982, pp. 80-82, no. 19, fig. 62 [ca. 1617]; Vergara 1982, pp. 48-55, 194, fig. 25; C. Scribner III, *Peter Paul Rubens* (New York, 1989), pl. 10 [ca. 1617-1618]; M. Varshavskaya and N. Gritsai, in *Peter Paul Rubens: Paintings from Soviet Museums* (Leningrad, 1989), pp. 95-96; J. Hayes, *The Landscape Paintings of Thomas Gainsborough* (Ithaca, 1982), p. 145, fig. 177.

BRACKETED by two tall oaks and studded with smaller trees, pollard willows, and shrubs, a rocky mound rises in the center of a twilit landscape. A cart heavily laden with quarried stones precariously descends on a road to the left toward a shallow ford; the driver, seated on the white horse that works in double harness with a bay, looks around anxiously at

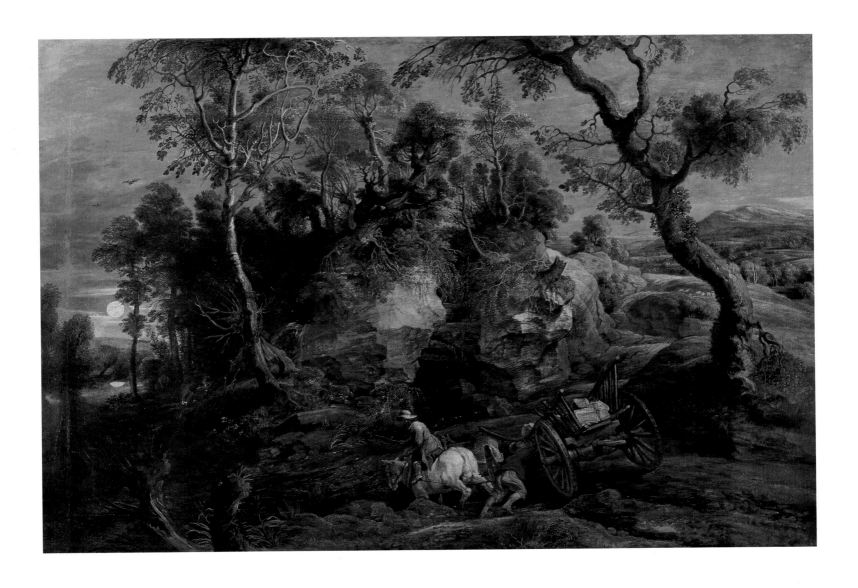

Fig. 1. Peter Paul Rubens, *A Man Threshing beside a Wagon, Farm Buildings Beside*, red, black, blue, green, and yellow chalk with touches of pen and brown ink on pale gray paper, 253 x 415 mm, Malibu, California, J. Paul Getty Museum.

his partner, who, barefoot and wearing a bright red coat, pushes the side of the cart in an effort to prevent it from toppling over. On the right the daylit landscape retreats to a high horizon with distant mountains, while on the left a full moon rises in a cloud-filled sky over a low stretch of calm water. In the darkness at the foot of the rocky rise a man and a woman are seated by a campfire. At the center of this stereoscopic design a cleft in the rocks reveals a cave. The stream passes in front of the opening and, like the road, runs downhill toward the lower left corner. Countering these movements are the pollard willows, the straining wagoner, and the diagonal fall of daylight.

The title "La Charrette Embourbée" was employed as early as the eighteenth century by

Descamps but is surely apocryphal.[1] Although Rooses regarded the landscape as by Lucas van Uden and dated the painting as late as 1635-1640,[2] there is no reason to doubt that Rubens painted the entire painting. Most scholars have also regarded it as a relatively early work of 1617-1620.[3] Rubens's earlier landscapes tend to be more dramatically conceived, employ higher horizons, stronger local colors, and thicker paint application, while his later works are more peaceful and bucolic, his execution looser and more atmospheric, given to veils of tone and color.

The foreshortened wagon with rack that figures centrally in this scene was recorded in a drawing formerly in Chatsworth and now in the J. Paul Getty Museum (fig. 1),[4] which also served as a preparatory study for the first cart outside the barn in *Winter* (H. M. the Queen, Windsor Castle)[5] and in *The Prodigal Son* (Antwerp, Koninklijk Museum voor Schone Kunsten, no. 781).[6] No drawings can be directly linked to the landscape composition, but there probably once existed studies made from nature, like Rubens's famous pen and chalk drawing of a *Fallen Tree* in the Louvre (Paris, Cabinet des Dessins, no. 20212),[7] or the black chalk drawing of a *Pollard Willow* in the British Museum, London (inv. no. 5213-2).[8]

The design of the landscape, with a large central form dividing two distant prospects with horizons of differing heights, and the twisting trunks of tall gnarled trees serving as decorative *repoussoirs,* generally recalls compositions first developed in drawings by Pieter Bruegel the Elder and revived around the turn of the century by several northern artists, including Jan Brueghel the Elder, Paulus Bril, and Gillis van Coninxloo (qq.v.).[9] Evers analyzed in great formal detail this rich composition and its fusing and reconciliation of two quite different landscapes which subtly contrast day and night, high and low views, terrestial depressions and projections. He was the first to observe that Rubens's staffage are not passive figures used merely to populate the scene as in other, lesser landscapists' art, but active creatures who engage their environment and vitalize it.[10] Evers also likened the bifurcated forms of the composition to medieval stage designs and pointed to the tradition of representing temporal cycles (morning and evening, day and night, summer and winter, the Four Seasons, and the Twelve Months), which invariably were associated with the rotation and cycle of life. Leo Steinberg wrote compellingly of the landscape's conflict of opposing directions, noting that the wagoner not only seems to hold up the cart, but "tilts against gravity, against oncoming night, against the very scarp and dip of the land."[11] Ver-

gara developed these ideas even further, grandly characterizing the scene as a "cosmological landscape" which reconciles opposites and establishes an equilibrium, balance, and harmony among the four elements as well as other properties of nature opposed in Renaissance thought and art theory.[12] While her claims for the painting as an enigmatic universal allegory is surely overly specific in its comprehensive detail, her conclusion that it expresses Rubens's "optimistic nature as well as his political philosophy, the practice of his profession, and his personal and religious life," does not overstate the expressive power of this great and thoughtfully composed work.[13] As the day dwindles, man struggles and the center holds.

The nocturnal effects of the present work, especially the cool moonlight reflected on the water and juxtaposed with the campfire, suggested to several authors the influence of Adam Elsheimer's nocturnal *Flight into Egypt* of 1609 (Munich, Alte Pinakothek, no. 216), although it must be said that Rubens's touch is much more painterly than the slick handling of his source.[14] In a letter of 1611 Rubens requested that Elsheimer's widow send him the painting and he subsequently paraphrased it in his own *Flight into Egypt* in the Louvre (inv. 1765).[15]

The present painting has been copied repeatedly,[16] and was engraved by Schelte à Bolswert as well as other, anonymous engravers.[17] It may also have been reiterated in a later, apparently lost painting by Rubens, which is recorded in a reproductive etching by Lucas van Uden.[18] Finally it influenced later landscapists, such as Gainsborough, whose *Harvest Wagon* in the Art Gallery of Ontario, Toronto (no. 2578), owes a debt to the Rubens, which the English painter could have seen when it was in the Walpole collection.[19] The provenance of the picture has been confused in the past. The painting undoubtedly was in the collection of Cardinal Mazarin in 1661,[20] but was not in the Jabach collection sale in 1696 and cannot be confirmed as in the collection of P. J. Mariette in 1756. As Varshavskaya and Gritsai observed, the painting cannot have been in the Lassay collection in 1753 when Descamps claimed to have seen it, nor could it have appeared in the sale of the Comte de Griche in 1771 because it was in the Walpole collection as early as 1735 (when it appeared in a handwritten catalogue of Houghton Hall, now in the Cholmondeley collection), from whence it was purchased with the rest of the Walpole collection in 1779.[21]

PCS

Jacques d'Arthois

(1613-Brussels-1686)

1. Descamps 1753-64, vol. 1 (1753), p. 316; however it is not certain that Descamps could have known the painting, see note 21 below. Also in Walpole's 1788 inventory under this title.

2. Rooses 1886-92, vol. 4 (1890), p. 369, no. 1178. A. Rosenberg (1905, p. 404, ill.) followed suit in the dating, while Somof (1901, no. 594) also accepted that Rubens only painted the central part.

3. Burckhardt 1898, p. 316 [ca. 1617]; Oldenbourg 1921, p. 184, ill. [ca. 1618-1620]; Glück 1945, p. 18 [ca. 1618-1620]; Levinson Lessing 1964, no. 7 [ca. 1620]; Held 1967, p. 168 [ca. 1620]; exh. Dresden 1972, no. 84 [ca. 1620]; Varshavskaya 1975, p. 128 [ca. 1620]; Steinberg 1975, p. 98 [ca. 1618]; exh. Antwerp 1977, p. 107 [ca. 1617]; Vergara 1982, p. 48 [ca. 1617-1620]; Adler 1982, p. 82 [ca. 1617]; Scribner 1989 [ca. 1617-1618].

4. Held 1959, vol. 1, p. 144, no. 129, pl. 141; Adler 1982, p. 101, no. 26a, fig. 76. Held assumed that the Antwerp painting preceded the Leningrad and Windsor pictures, and thus was the first use of the drawing.

5. Rooses 1886-92, vol. 4 (1890), no. 1173; Adler 1982, no. 21, fig. 66; exh. London 1991, no. 38, ill.

6. Rooses 1886-92, vol. 2 (1888), no. 260; Adler 1982, no. 26, fig. 75.

7. Held 1959, vol. 1, no. 131, vol. 2, pl. 140; Adler 1982, no. 18a, fig. 58.

8. Held 1959, vol. 1, no. 134, vol. 2, pl. 146; Adler 1982, no. 73, fig. 53. Adler's comparison of the tree in the Hermitage's painting to a drawing dubiously assigned by the author to Rubens now in the Stedelijk Prentenkabinet in Antwerp (his no. 8, fig. 28) is not compelling.

9. On this Breugelian revival, see Gerszi 1976, pp. 201-229.

10. Evers 1942, p. 392.

11. Steinberg 1975, p. 100.

12. Vergara 1982, pp. 48-55.

13. Ibid., p. 54. See also Scribner 1989, p. 66, pl. 10, who also felt that the Hermitage's painting expressed "a broader cosmological principle." However the reader should consult with care Erik Larsen's "The Metaphysical Foundations of the Rubens Landscape," *The Ringling Museum of Art Journal* (1982), pp. 226-233.

14. Varshavskaya 1975, p. 218; exh. Vienna 1981, p. 112; Vergara 1982, p. 55, note 90; exh. New York/Chicago 1988, p. 104.

15. Magurn 1955, p. 54.

16. Adler (1982, p. 80, copies nos. 1-6), lists four painted copies as well as drawings in the Metropolitan Museum of Art, New York (possibly by Lucas van Uden) and in the Louvre (no. 20.329).

17. Ibid., copies 7-10. See also Voorhelm Schneevoogt 1873, no. 53.5; and Steinberg 1975, pp. 97-102, with an illustration (his fig. 14) of an anonymous print combining elements of a print of the Story of Elisha by Ryckemans after de Jode, with the landscape in Schelte à Bolswert's print after the present Rubens.

18. See the print illustrated by G. Martin, "Lucas van Uden's Etchings after Rubens," *Apollo* 87 (1968), p. 211, fig. 4.

19. See J. Hayes, *The Landscape Paintings of Thomas Gainsborough* (Ithaca, 1982), p. 145, fig. 176.

20. See Le Comte de Cosnac, *Les Richesses du Palais Mazarin* (Paris, 1884), p. 344, no. 1286: "Un Paysage, faict par Rubens, au milieu duquel est un chariot qui tombe, avecq quelques figures; hault de deux piedz huiet poulces, large de trois piedz unze poulces, 600 livres."

21. Varshavskaya and Gritsai 1989, p. 96.

Premier landscapist of the Brussels school, Jacques d'Arthois was baptized in the Church of St. Gudule in Brussels on 12 October 1613. In 1625 he was apprenticed to the otherwise unknown painter Jan Mertens (active from 1599), and became a master in the guild of St. Luke on 3 May 1634. He married Marie Sambels in Brussels in 1632. D'Arthois was proficient in both small and large formats, executing both cabinet paintings and large decorative projects. He received numerous commissions from churches and convents, including one for several paintings in the transcept of the Cathedral of Sts. Michael and Gudule in Brussels. D'Arthois also supplied cartoons for the tapestry weavers of Brussels, Mechelen, and Oudenaard. Most of his woodland scenes were set in the picturesque Soignes Forest south and east of Brussels, where the artist purchased the house "den Crekelenberch" in 1655. Praised by his contemporaries as early as 1649, in 1660 d'Arthois received a gold chain and medal from the Duke de Caracena, Spanish governor of the Netherlands. Despite his artistic and financial success, however, d'Arthois's extravagant lifestyle led to an accumulation of debts (for which he was imprisoned briefly in 1658), and he died impoverished in May 1686.

D'Arthois's earliest works were influenced by the densely forested landscapes of Denijs van Alsloot (1570-1628). Subsequent paintings exhibit the graceful fluidity of Lodewijk de Vadder's more open landscape compositions. As few of his paintings are dated, a series of thirteen engravings by Wenceslas Hollar after d'Arthois's landscapes, dated 1648-1652, provide a framework for his early chronology. By the mid-1650s his work shows the influence of Rubens's grand landscapes: they are more broadly painted and more expansive, yet retain a calm, static quality linked to sixteenth-century traditions. Throughout his career, d'Arthois enlisted the aid of figure painters, who contributed the staffage to his landscapes: among them, Gonzales Coques, Gaspar de Crayer, Willem van Herp, Hendrik van Minderhout (1632-1696), Gerard Seghers (1591-1651), David II Teniers (qq.v.) and the Dutch portraitist Bartholomeus van der Helst. D'Arthois's students and followers included Jan Baptist Wans (1628-1684), Jan Baptist Huysmans (1654-1716), and Cornelis Huysmans (q.v.), his brother Nicolaes (b. 1617), and his son Jan Baptist d'Arthois (b. 1638).

Jacques d'Arthois
90. Road through a Forest

Oil on canvas, 124.5 x 176 cm (49 x 69 ¼ in.)
Signed on rock at lower right: Jacques d'Arthois
Boston, Museum of Fine Arts, Gift of Mrs. Francis
Brooks, 1884, inv. 84.249

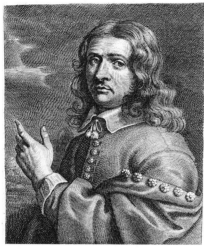

Pieter de Jode after Joannes Meyssens, *Jacques
d'Arthois,* engraving, from Cornelis de Bie, *Het gulden
cabinet . . .,* 1661, fol. 301.

Meyssens 1649; de Bie 1661, pp. 300-303; Descamps 1753-64, vol. 2, pp. 213-215; Descamps 1792, p. 40; Immerzeel 1842-43, vol. 1 (1842), p. 13; Couvez 1852, passim; Michiels 1865-76, vol. 9 (1874), pp. 127-142; Neeffs 1875, pp. 34-35; Pinchart 1878, pp. 315-332; Wurzbach 1906-11, vol. 1 (1906), pp. 29-30; vol. 3 (1911), p. 11; Thieme, Becker 1907-50, vol. 2 (1908), pp. 162-163; Hymans 1920; Brussels 1926, p. 7; Laes 1949, pp. 170 ff; Thiéry 1953, pp. 136-143, 170-171; Laes 1958; Gerson, ter Kuile 1960, pp. 153-154; Plietzsch 1960, pp. 216-217; Brussels 1965, pp. 7-10; Claessens 1966; Lorthois 1966; Bodart 1973a; Brussels 1976, pp. 13-14, 21-22; Kervyn de Meerendré 1976; Paris 1977-78, pp. 38-39; New York, Metropolitan, cat. 1984, pp. 1-2; Concha Herrero 1986; Thiéry, Kervyn de Meerendré 1987, pp. 125-144.

PROVENANCE: [possibly sale Boston (Hennessy & Co.), 17-18 May 1855, lot 35 ("J. D. Arthois, A fine *Landscape* . . . from the Collection of M. de Villars")]; purchased by Mr. & Mrs. Francis Brooks from James Davis, New York (as by Herman van Swanevelt)[1]; given by Mrs. Brooks to the Museum, 1884.

LITERATURE: Thiéry, Kervyn de Meerendré 1986, pp. 140, 230, no. 22.

IN THE FOREGROUND, a sheep- and goatherd urges his charges along a sunken road leading into the heart of a dense forest. A single figure rounds a bend in the path further on, and a patch of sunlight illuminates a group of three travelers in the distance. The woods that dominate the right half of the composition give way at the left to an airy view of a pond and rolling tree-lined hills, punctuated by the steepled silhouette of a church nestled close to the edge of the forest.

The low hills and woodland scenery depicted in d'Arthois's painting are typical of the topography of the Forêt de Soignes, a large forest to the southeast of Brussels.[2] From the Middle Ages, the forest was the property of the dukes of Brabant, and was a favored hunting terrain for the local nobility. Although large areas remained relatively wild and unpopulated throughout the seventeenth century, the forest encompassed the ducal castle of Tervueren, as well as other country estates, small hamlets, and several convents and monasteries.

The dense woodland of the Forêt de Soignes, generously interspersed with open heath and numerous small ponds and streams, was a constant inspiration for Brussels landscape painters of the seventeenth century. During the first quarter of the century, one of the earliest of these artists, Denijs van Alsloot (ca. 1570-1626), painted not only landscapes generally reminiscent of the area, but also exacting topographical views of castles and other prominent landmarks.[3] Hans Collaert (1566-1628) published a series of twenty-four plates of *Views of the Environs of Brussels* after drawings by Hans Bol, which included eleven views of the forest, its hamlets, churches, and châteaux.[4] Lodewijk de Vadder (1605-1655) and his pupil Ignatius van der Stock (active second half of the seventeenth century) were among other notable painters of Brussels and its environs.

Of all the Brussels landscapists, d'Arthois was perhaps the most skilled in capturing the spirit of the forest, and in fact he purchased a house in the Fôret de Soignes (near Bosvoorde/Boisfort) at the height of his career.[5] Unlike earlier artists, such as Alsloot or Gillis van Coninxloo (q.v.), d'Arthois specialized in views of the edge of the forest rather than the interior.[6] This afforded not only the juxtaposition of bosky woods with an airy vista of water and open land, but also enabled the artist to include a

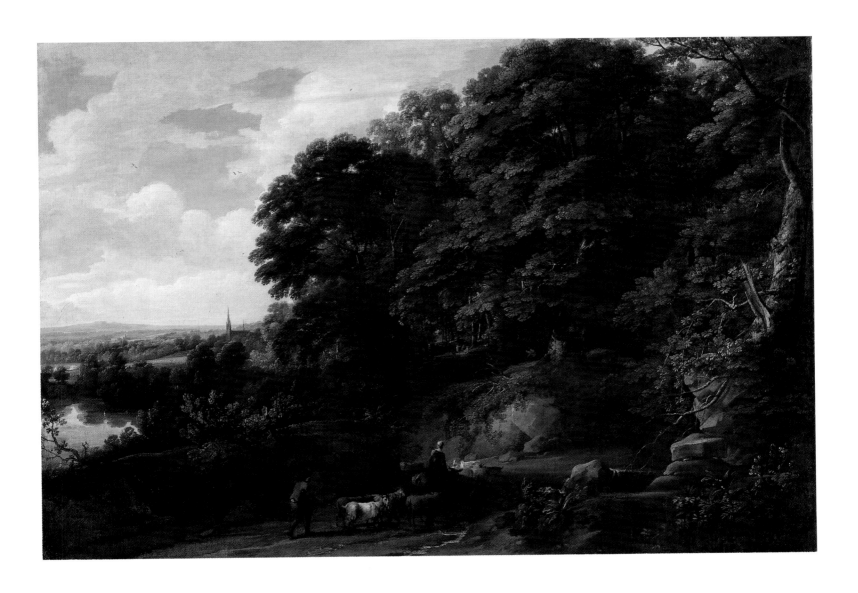

Fig. 1. Jacques d'Arthois, *View of the Forêt de Soignes with the Rouge-Cloître [Roode Klooster]*, oil on canvas, 62 x 76 cm, signed, Brussels, private collection.

Fig. 2. Jacques d'Arthois, *The Edge of the Woods*, signed, oil on canvas, 151 x 226.5 cm, Brussels, Musées Royaux des Beaux-Arts de Belgique, inv. 581.

Cornelis Huysmans

(Antwerp 1648-Mechelen 1727)

greater variety of tree forms and other vegetation native to the area. Although the sites depicted in several of d'Arthois's landscapes have been identified by the precisely detailed rendering of a distant church or town (see fig. 1),[7] the exact locale of the Boston landscape cannot be precisely identified. The profile of the church does, however, somewhat resemble that of the Church of Notre Dame at Alsemberg, which d'Arthois depicted from a different aspect in *The Edge of the Woods* (Brussels, Musées Royaux des Beaux-Arts de Belgique, inv. 581; fig. 2).[8] Compositionally, *Road through a Forest* is most closely related to d'Arthois's *Landscape with a Shepherd* in Salzburg (oil on copper, 69.5 x 87 cm; Residenzgalerie, inv. 4) which, however, includes a coulisse of a hillock and tree at the far left.

<div align="center">MEW</div>

1. Reference in Museum file. But not in the sale of paintings from his "Gallery," Boston (L. Bird), 14 November 1883.

2. A brief discussion of the Forêt de Soignes is contained in Brussels 1976, pp. 11-14; a more exhaustive study is S. Pierron, *Histoire illustré de la Forêt de Soignes*, 3 vols. (Brussels, n.d. [ca. 1935]). Several of d'Arthois's forest views feature well-to-do hunting parties, for example the *Sporting Party, with Ladies and Muleteers in a Mountainous Landscape*, with figures by Gonzales Coques (sale Lady O'Hagen et al., London [Christie's], 24 November 1922, lot 41, ill.), or the *Stag Hunt* and *Hawking Party* pendants in Schleissheim (Staatsgalerie, invs. 5560, 5561).

3. On van Alsloot, see Larsen 1948; and Thiéry, Kervyn de Meerendré 1987, pp. 99-107.

4. Published in Amsterdam by Hans van Luyck; a later edition was published by Claes Jansz. Visscher (Hollstein 1949-, vol. 4, nos. 149-172). See Pierron, *Histoire*, vol. 3, figs. 570, 719-726, and pp. 380-386. Collaert's prints are arranged so that one can take a visual "stroll" through the Forêt de Soignes; on this tradition in Dutch art, see D. Freedberg, *Dutch Landscape Prints of the Seventeenth Century* (London, 1980), pp. 15-16.

5. W. Laureyssens, in Brussels 1976, p. 13; see also Claessens 1966 and Lorthois 1966.

6. Thiéry, Kervyn de Meerendré 1986, p. 134.

7. For example fig. 1, *View of the Forêt de Soignes with the Rouge-Cloître [Roode Klooster]* (62 x 76 cm, signed, Brussels, private collection); for other landscapes with identifiable sites, see W. Laureyssens, in Brussels 1976, pp. 13-14, and Thiéry, Kervyn de Meerendré 1986, pp. 230-233, passim. Thiéry and Kervyn de Meerendré (1986, pp. 132, 135) note that d'Arthois collaborated with the Brussels architectural painter P. du Pont and suggest that the latter artist may be responsible for the more precisely painted monuments in d'Arthois's compositions.

8. On Alsemberg, see E. H. C. van den Blieck, *Historie van de Hertogelijke Kerk van Alsemberg* (1869); Jan Bols, *De Kerk van Alsemberg* (1910); and Pierron, *Histoire* (note 2), vol. 3, pp. 273-276.

Much of the information we have concerning the life of Cornelis Huysmans is confirmed in a manuscript written by the Mechelen painter and biographer Egide Joseph Smeyers (1694-1771), friend of the artist (see Neefs 1875). Cornelis Huysmans, son of Hendrik Huysmans and Catharina van der Heyden, was baptized in Antwerp on 2 April 1648. He was a pupil first of the Antwerp landscape painter Pieter de Witte (1617-1667), then spent two years (ca. 1672-74?) in the atelier of Jacques d'Arthois (q.v.) in Brussels. On 13 January 1675 Huysmans became a master in the Brussels St. Luke's Guild. He remained in that city for several years, but visited Antwerp at least once, on 15 February 1681. Shortly thereafter, Huysmans settled in Mechelen, where on 26 January 1682 he married Maria Anna Scheppers (d. 1744). The couple had three children. Huysmans moved to Antwerp in 1702, and joined that city's guild of St. Luke in 1706/07. He returned to Mechelen in 1716, where he died on 1 June 1727 and was buried in the St. Janskerk. According to George Vertue, Huysmans also visited England, probably prior to 1702; while there, he painted two landscapes in exchange for frames made for him by the famed English woodcarver Grinling Gibbons (1648-1721). In addition to his independent landscape paintings, decorative wall paintings, and screens, Descamps notes that Huysmans also contributed landscape backgrounds to history paintings by his contemporaries, and "retouched" landscapes by d'Arthois, Lucas Achtschellinck (1626-1699), and Hendrik van Minderhout (1632-1696).

Like his mentor d'Arthois, Huysmans painted mostly views of the forests of Brabant, but he also executed landscapes with a more Italianate flavor, influenced by the works of Salvator Rosa and Gaspard Dughet. His woodland landscapes are distinguished by vigorous brushwork and a rich glowing autumnal palette, which (as in the landscapes of Peter Paul Rubens) has its source in sixteenth-century Venetian painting. The comparatively loose structure and open composition of his works presage later eighteenth-century developments in landscape painting. Huysmans's pupils include his brother, the landscape painter Jan Baptist Huysmans (1654-1716), and in Mechelen, the virtually unknown A. C. Ridel and Jean Edmond Turner (active 1702).

Cornelis Huysmans, engraving, from d'Argenville's J. B. Descamps, Vie des Peintres, vol. 2 (1842).

Cornelis Huysmans
91. Wooded Landscape

Oil on canvas, 117 x 135.5 cm (46 ⅛ x 53 ⅜ in.)
Amsterdam, Kunsthandel K. & V. Waterman

Weyerman 1729-69, vol. 3, p. 195; Vertue 1930-55, vol. 5 [1742], p. 20; Descamps 1753-64, vol. 3, pp. 241-244; Descamps 1769, passim; Mariette 1853, vol. 2, p. 392; Kramm 1857-64, vol. 3 (1858), pp. 776-777; Michiels 1865-76, vol. 9 (1874), pp. 142-155; Rombouts, van Lerius 1872, vol. 2, pp. 649, 651; Siret 1874; Neefs 1875; Walpole 1876, passim; van den Branden 1883, pp. 1077-78; Wurzbach 1906-11, vol. 1 (1906), p. 739; K. Zoege van Manteuffel, in Thieme, Becker 1907-50, vol. 18 (1925), pp. 203-204; Thiéry 1953, pp. 152-153; Ogden, Ogden 1955, pp. 112, 143-144; Laes 1958; Gerson, ter Kuile 1960, pp. 153-154; Lille/Calais/Arras 1977, pp. 73-74; Salerno 1977-80, vol. 2 (1977), pp. 892-893; Thiéry, Kervyn de Meerendré 1987, pp. 182-186, 240.

PROVENANCE: collection M. de Potemkin (ref. sale 1899); sale Valentin-Roussel, Brussels, 14 June 1899, lot 15, ill.; sale Wichtrach (Galerie Heiniger), 29 November-1 December 1973, lot 298, ill.; with Kunsthandel K. & V. Waterman, Amsterdam, by 1987.

LITERATURE: Thiéry, Kervyn de Meerendré 1986, p. 185, ill.; Greindl et al. 1990, p. 201, ill.

IN THE FOREGROUND of a rolling landscape, sandy bluffs overhang a shallow pond, where a group of herders water their cattle. Radiating out from the pool, a system of overlapping landscape forms creates a strong zigzag through the center of the composition. Steeply pitched trees line the bluffs to the left and right, juxtaposing airy foliage against the slim spears of bare tree trunks, and framing a view to a meadow studded with low farm buildings. In the middle distance, two travelers and a cart cautiously make their way over the craggy terrain. The broad painterly execution of the foreground figures, vegetation, and sandy escarpments contrasts with the more smoothly painted panorama in the distance.

Huysmans frequently situated weathered cliffs and rocky outcroppings in the foreground of his compositions, with a shaft of sunlight accentuating the starkly undercut contours.[1] He incorporated a less dramatic version of this motif in the *Landscape* now in Kassel (inv. GK 170). The *Landscapes* in Valenciennes (Musée des Beaux-Arts, inv. 61) and Brussels (Musées Royaux des Beaux-Arts de Belgique, inv. 228; fig. 1) resemble the exhibited painting more closely, not only in the striking use of the precariously eroded overhang left of center, but also in the juxtaposition of denuded tree trunks with the lush foliage of the surrounding trees. It is of interest that the Brussels *Landscape* substitutes classical staffage for the rustic herders who populate the *Wooded Landscape*; the effortlessness of this change emphasizes how incidental the figures are to the majestic sweep of the land.

Although the locale depicted in *Wooded Landscape* is imaginary (as in nearly all of Huysmans's landscapes), the topography is loosely based on that of the Soignes Forest outside Brussels, an area characterized by sunken roadways, small streams, sand pits, and lush vegetation.[2] To some extent, Huysmans's landscape compositions follow the local tradition of decorative landscape painting in Brussels, as practised by (among others) Huysmans's mentor Jacques d'Arthois (q.v.) and Lodewijk de Vadder (1605-1655). Works by these earlier artists employ a similar combination of wooded area and relatively barren eroded earth (see cat. 90). In general, however, Huysmans's landscapes are more open and less densely wooded than those by d'Arthois. De Vadder's

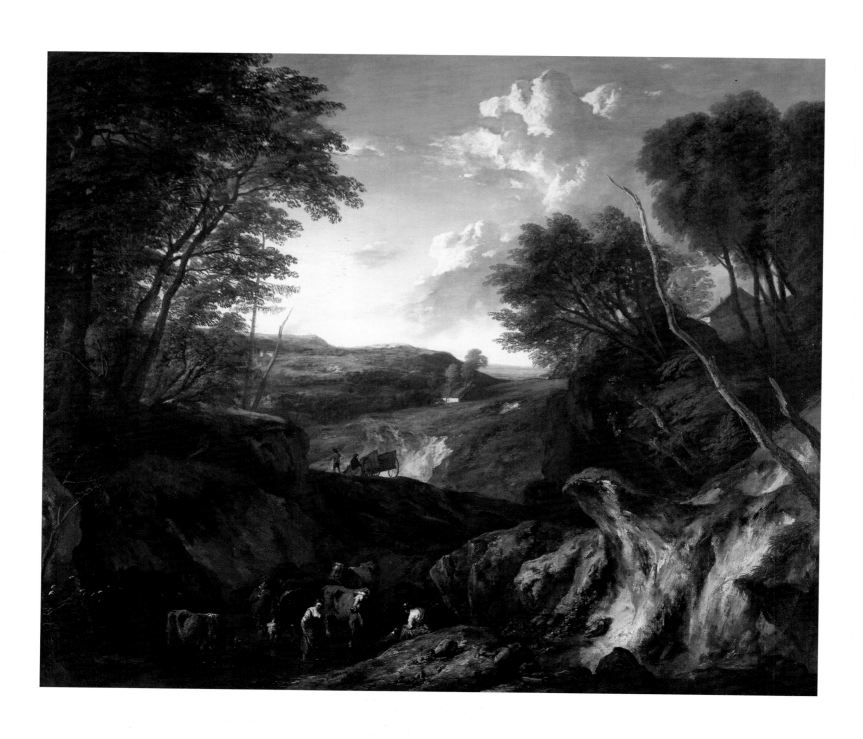

Fig. 1. Cornelis Huysmans, *Classical Landscape*, oil on canvas, 133 x 168 cm, Brussels, Musées Royaux des Beaux-Arts de Belgique, inv. 111.

Fig. 2. Lodewijk de Vadder, *Wooded Landscape*, oil on canvas, 118 x 142 cm, Brussels, Musées Royaux des Beaux-Arts de Belgique, inv. 80.

Fig. 3. Salvator Rosa, *Landscape with the Finding of Moses*, oil on canvas, 123 x 202 cm, Detroit, Institute of Arts, inv. 47.92.

landscapes offer a closer parallel, not only in the arrangement of formal components, but also in the profound, almost proto-romantic sensitivity to nature, and the vital painterly technique (compare de Vadder's *Wooded Landscape* [Brussels, Musées Royaux des Beaux-Arts de Belgique, inv. 80]; fig. 2).[3] Both de Vadder and Huysmans were exuberant colorists; the latter's views are marked by a warm blond autumnal palette, and a clear golden light alternating with shadowy patches of undergrowth.

Despite ties with the earlier school of Brussels landscapists, the more fantastic elements of Huysmans's *Wooded Landscape* – such as the roughly hewn escarpments and dead trees, which allude to the hostile forces of nature – indicate an awareness of the works of Salvator Rosa (1615-1673; fig. 3).[4] The awful beauty of Rosa's untamed landscapes is achieved through a barren and prohibitively rugged terrain which dominates the composition, overwhelming the scant vegetation and small-scale staffage, and enhanced by the tactile contrast of light and shade. His work, though well known in the North, did not inspire the vast following that attended the amenably civilized arcadian landscapes of Gaspard Dughet or Claude Lorrain. Huysmans's landscapes offer a moderate interpretation of Rosa's violent nature, and his views remain distinctly Northern, rather than Italian, but his compositions nonetheless place a similar emphasis on powerful and dramatic earth forms, rather than vegetation, as the key components of the landscape.

Huysmans's predilection for composing his landscapes around a strikingly undercut sandy bluff is continued in the work of his younger brother and pupil, Jan Baptist Huysmans; a comparable work is the latter's *Landscape* (Amsterdam, Kunsthandel K. & V. Waterman).

MEW

1. L. Hardy Marais, in Lille/Calais/Arras 1977, pp. 73-74.

2. On the Forêt de Soignes, see the entry on d'Arthois's *Road through a Forest* (cat. 90), with further bibliography.

3. Thiéry, Kervyn de Meerendré 1986, p. 186.

4. Gerson, ter Kuile 1960, p. 153; Thiéry, Kervyn de Meerendré 1986, p. 186. On Rosa, see: L. Salerno, *Salvator Rosa* (Florence, 1963); exh. cat. London, Hayward Gallery, *Salvator Rosa* (1973); and idem, 1977-80, vol. 2, pp. 546-567; specifically on the Northern followers of Rosa, see (briefly) ibid., 1977-80, vol. 2, pp. 806-809.

Jan Siberechts

(Antwerp 1627-London ca. 1703)

Born in Antwerp on 29 January 1627, Jan Siberechts was the son of the sculptor of the same name and Suzanna Mennens. He was apprenticed to Adriaen de Bie, a portrait painter from Mechelen. In 1648/49 he became a master in the Antwerp guild. Fokker assumed that he made a trip to Italy around 1650, but there is no documentary record of the journey, only the evidence of Italian scenery in his paintings. Siberechts married Maria Anna Croes in Antwerp on 2 August 1652. He was active in Antwerp until 1672 when, according to his chronicler, he was invited to England by the second Duke of Buckingham to his property at Chefden. Siberechts remained in England and painted country houses, parks, equipages, and the rural diversions of the British aristocracy until his death in London in about 1703.

Siberechts was a painter of bucolic landscapes, often with figures tending livestock or travelers fording streams, and, after about 1672, of castles and images of the country life of the English nobility. Few of his approximately ninety paintings are dated before 1661 (they range in date from 1653 to 1697), but his early works seem to acknowledge the influence of the second generation of seventeenth-century Dutch Italiante painters: Herman van Swanevelt, Jan Asselijn, Nicolaes Berchem, and Karel du Jardin. His mature paintings from the Antwerp years (ca. 1661-1672) offer a charmingly direct and prosaic, though scarcely naive, account of the quiet activities of Flemish rural life. Only after moving to England did he execute domestic interiors and panoramic landscapes, often with hunters. His portrait was painted in England by Nicolas de Largilliere, about 1674-1679.

De Bie 1661, p. 373; B. Buckeridge, *An Essay towards an English School of Painters*, in Roger de Piles, *The Art of Painting* (trans. R. Graham, 1706), p. 416; Houbraken 1718-21, vol. 2 (1719), p. 142; Descamps 1753-64, vol. 2, pp. 359-360; Descamps 1769, passim; Walpole 1876, passim; Nagler 1835-52, vol. 16 (1846), p. 343; Immerzeel 1842-43, vol. 3 (1843), p. 87; Kramm 1857-64, vol. 5 (1864), p. 1517; Nagler 1858-72, vol. 4 (1863), p. 427; Rombouts, van Lerius 1872, vol. 2, pp. 197, 201; Rooses 1879, pp. 625-627; van den Branden 1883, pp. 1064-1065; von Frimmel 1906; Wurzbach 1906-11, vol. 2 (1910), p. 619; Matsvansky 1907; Marcel 1912; Bredius 1914; Plietzsch 1916-17; Bode 1928; Fokker 1931; Laes 1931a; Vertue Note Books, in *The Walpole Society* 24 (1935-36), p. 110; Thieme, Becker 1907-50, vol. 30 (1936) pp. 579-580; Thiéry 1953, pp. 116-128, 193-195; Ogden, Ogden 1955, pp. 100, 122-123, 125, 127-128, 132, 135, 143-145, 155, 160-163; Gerson 1960, pp. 154-155; Plietzsch 1960, pp. 217-223; Brussels 1965, pp. 241-242; Paris 1977-78, pp. 218-219; Müllenmeister 1978-81, vol. 3, pp. 56-58; Cassidy 1986; Thiéry, Kervyn de Meerendré 1986, pp. 77-95, 250-252.

Jan Siberechts
92. Ebony Cabinet Inset with Italianate Landscape Panels, 1653

Wood, with ebony veneer, tortoiseshell inlay, and thirteen painted panels, 160 x 100.3 x 48.9 cm (63 x 39½ x 19¼ in.) (with stand)
Signed (indistinctly) and dated on the left inside door, lower left: Siberechts 1653; and on the right inside door, lower left: I · Siberechts· / 1653
New York, Otto Naumann Ltd.

PROVENANCE: Count Karl Lanckoronski, Vienna; private collection, New York.

EXHIBITIONS: Brussels 1910.

LITERATURE: von Frimmel 1906, p. 20; Plietzsch 1916-17, p. 65; G. de Térey, *Trésors de l'Art belge au XVIIe siècle. Mémoire de l'Exposition d'art ancien à Bruxelles* (Brussels, 1911-12), pp. 255, 258; Fokker 1931, pp. 16, 18-19, 105, plates 2, 3a; Plietzsch 1960, p. 218; Thiéry, Kervyn de Meerendré 1986, p. 78.

THIRTEEN painted panels are set into an ebony-veneered kunstkabinet: two inner doors (41 x 33 cm; figs. 1, 2), a hinged top (25 x 63 cm), eight drawer fronts (8.2 x 23.5 cm), one smaller drawer front (5 x 15.5 cm), and one arched panel (15.5 x 10 cm) set into a door in the middle of the cabinet. Most of the small horizontal panels are similarly composed, divided diagonally by the overlapping forms of a hill or sloping spit of land. A portion of each landscape is reserved for a limpid body of water, either a river or a tranquil lake; slender trees frame the view, their lacy foliage silhouetted against a clear sky. The ruins depicted in the central panel echo the arched format of the panel itself. The larger landscape views on the two doors play up the vertical sweep of craggy hillsides, spindly trees, and indigenous architecture. Each of the landscapes is inhabited by a few travelers, or lone herdsmen with their flocks.

Not only is this cabinet one of the few surviving examples to be decorated with signed works by a known artist,[1] it is also one of the artist's earliest dated works. With the *Italianate Landscape* in Berlin, also dated 1653 (fig. 3), the panels in this *kunstkabinet* are the cornerstones of Siberechts's early Italianate style. Based on the Italianate scenery in these early paintings, Fokker assumed that Siberechts made a trip to Italy around 1650,[2] although it is at least equally possible that he was inspired at second hand by the works of contemporary Dutch Italianate landscapists. The clear, even illumination, cool palette, and delicate forms of these small panels particularly acknowledge works by artists such as Jan Asselijn, Jan Both, and Adam Pynacker. Siberechts's later works, after about 1661 (see cat. 93), retain the tranquil ambiance of these Italianate scenes, but the land itself becomes more Flemish in character and a greater emphasis is placed on the staffage within the landscape.

The decorative kunstkabinet, a chest housing several small drawers and compartments, developed in the sixteenth century as a utilitarian piece of furniture but by the seventeenth century had evolved into a luxury display piece.[3] Antwerp – the artistic hub of the Southern Netherlands – was also an

Thomas Chambers after Nicolas de Largilliere, *Jan Siberechts*, engraving, from Walpole's *Anecdotes of Painting*.

important center for the production of these cabinets, which usually involved a collaborative effort between craftsmen in several media. The body of the piece was frequently veneered with precious woods and inlays; doors and drawer fronts were decorated in various media, including paintings, ivory or silver plaques (either embossed or engraved), needlework, tortoiseshell, precious woods, or *pietre dure*. Among surviving seventeenth-century kunstkabinets with painted panels, a large number depict popular themes from Ovid's *Metamorphoses*, although moralizing emblems and religious scenes (both Old and New Testament, as well as cycles illustrating the lives of Mary, Christ, or one of the saints) were also popular.[4] Much of the imagery was copied from prints.[5] Landscapes were particularly suited to the narrow horizontal format of the drawer fronts, and offered pleasantly calm, peaceful vistas. Contemporary documents and inventories mention several kunstkabinets with panels depicting specifically Italianate landscapes, although none give the name of the artist.[6] A kunstkabinet with twenty-eight painted marble panels depicting Italianate landscapes is in the Stichting Hannema-de Stuers, Heino.[7]

The more elaborately decorated kunstkabinets of the seventeenth century were designed for private use by connoisseurs and collectors, both in the Southern Netherlands and throughout Europe.[8] The cabinets were either set on their own stand (as in the present work) or occasionally displayed on a table.[9] Fabri has suggested that kunstkabinets with amorous scenes from the *Metamorphoses* or emblem books may have been placed in the more private rooms of a home, while those outfitted with less controversial landscapes or religious scenes may have been displayed in public reception rooms, salons, or offices.[10] Small objects of all descriptions were stored in kunstkabinets; contemporary inventories list such items as jewelery, miniatures and small paintings, relics, vials of perfume, cutlery and precious tablewares, lace, fans, gloves, medals and antique coins, papers and documents.[11]

<div style="text-align:center">MEW</div>

1. Other examples of seventeenth-century kunstkabinets with signed paintings include a cabinet with the story of the Prodigal Son, by Frans Francken the Younger (Amsterdam, Rijksmuseum, inv. NM 4190); and one with scenes from the Life of Christ, also by Francken (Apeldoorn, Rijksmuseum Paleis Het Loo, inv. L428; Härting 1989, no. 475).

2. Fokker 1931, p. 9ff. Siberechts is documented in Antwerp in 1648/9 and in 1652.

3. On various aspects of the kunstkabinet in the seventeenth century, see: Ria Fabri, *De 17de-eeuwse Antwerpse kunstkast: Typologische en historische aspecten* (Verhandelingen van de Koninklijke Academie voor Wetenschappen, Letteren en Schone Kunsten van België, vol. 53, no. 53 [Brussels, 1991]).

4. Fabri 1991, pp. 52-57.

5. Idem, in Cologne/Vienna 1992-93, p. 390, under no. 59.1.

6. Fabri 1991, p. 55.

7. See exh. cat. Amsterdam, Amsterdams Historisches Museum, *De wereld binnen handbereik: Nederlandse kunst- en rariteitenverzamelingen 1585-1735*, 26 June-11 October 1992, no. 82; and exh. cat. Utrecht, Centraal Museum, *Nederlandse 17de eeuwse Italianiserende landschapschilders*, 1965, no. 9, where the landscapes are attributed to Gerard ter Borch the Elder (ca. 1583-1679).

8. Fabri 1991, pp. 181-184, discusses the European market for kunstkabinets manufactured in Antwerp. See also the Introduction on Antwerp as an international center for the production of luxury goods.

9. As, for example, in Erasmus Quellinus's *Woman before a Mirror*, ca. 1645, location unknown; see de Bruyn 1988, cat. 78, ill. Kunstkabinets appear in many contemporary paintings of interiors; see, among many examples, Hieronymus Janssens's *Family Portrait*, ca. 1670 (Vienna, Liechtenstein'sche Fürstliche Sammlungen) and the *Family Being Fitted for Shoes*, probably by Gillis van Tilborch, in a private collection in Barcelona (exh. Madrid 1992, no. 34, as by Gonzales Coques).

10. Fabri 1991, p. 186.

11. Ibid., pp. 187-188. See also C. Willemijn Fock, "Kunst en rariteiten in het Hollandse interieur," in *De wereld binnen handbereik: Nederlandse kunst- en rariteitenverzamelingen 1585-1735* (Amsterdam and Zwolle, 1992), pp. 75-78.

Fig. 2. Jan Siberechts, *Italianate Landscape* (right inside door), signed and dated lower left: I · Siberechts · / 1653, oil on panel, 41 x 33 cm, New York, Otto Naumann Ltd.

Fig. 1. Jan Siberechts, *Italianate Landscape* (left inside door), signed (indistinctly) and dated lower left: Siberechts 1653, oil on panel, 41 x 33 cm, New York, Otto Naumann Ltd.

Fig. 3. Jan Siberechts, *Italianate Landscape*, signed and dated on rock at right: I · Siberechts · 16 · 53·, oil on canvas, 81.8 x 67.6 cm, Berlin, Staatliche Museen zu Berlin, Gemäldegalerie, inv. 2028.

Jan Siberechts
93. The Flooded Roadway, 1664

Oil on canvas, 88 x 103 cm (34 ⅝ x 40 ½ in.)
Signed and dated lower right: J. Siberechts · fc / · 1664 ·
Hanover, Niedersächsisches Landesmuseum,
inv. PAM 870

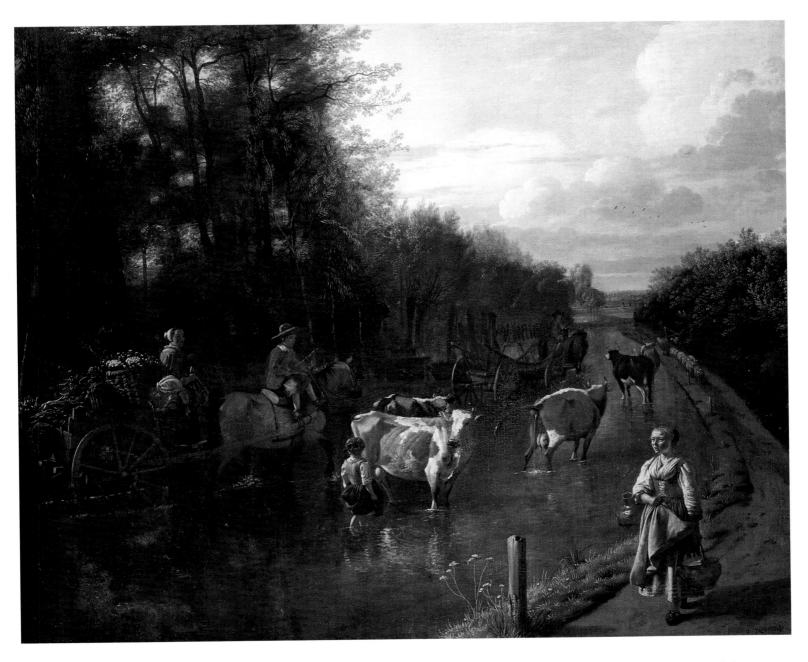

PROVENANCE: collection Johann Wilhelm Loffhagen, Hamburg
(d. 1811); collection Wichmann, Hamburg; collection Bernhard Haus-
mann, Hanover, from 1812 (cat. 1831, no. 106); Königlichen Hannover-
isches Besitz, from 1867; Fideicommiss-Galerie des Gesamthauses Braun-
schweig und Lüneburg, from 1893; acquired by the Landesgalerie, 1925.

LITERATURE: Parthey 1863-64, vol. 2 (1864), p. 551, no. 3; Rooses 1879,
p. 626; Kunst für Alle vol. 2 (1886/87), p. 124; Frimmel 1906, p. 20; Marcel
1912, pp. 366, 368 and 376; Plietzsch 1916-17, col. 65; Fokker 1931, pp. 29-30,
37, 42, 69, 72, 94, and pl. 7a; K. Zoege van Manteuffel, in Thieme, Becker
1907-50, vol. 30 (1936), p. 579; Thiéry 1953, pp. 118, 124-125; G. van der
Osten, Katalog der Gemälde Alter Meister in der Niedersächsischen Landes-
galerie Hannover (Hanover, 1954), p. 148; London, National Gallery, cat.
1970, p. 237; Thiéry, Kervyn de Meerendré 1986, pp. 80, 88-89; M. Trudzin-
ski, Verzeichnis der ausgestellten Gemälde in der Niedersächsischen Landesgalerie
Hannover (Hanover, 1989), p. 88.

A FLOODED ROADWAY curves gently between a
stand of trees on the left and an overgrown hedge on
the right. Along the right side of the road is a dirt
track trodden by a stolid maid with milk jugs in the
foreground and, further in the distance, a flock of
sheep. Making their way back through the shallow
water are two farm carts, the near one loaded with
baskets of produce and guided by a young boy
perched atop the horse. Five cows, one of which lifts
its tail to relieve itself, are urged along by a young
farm girl who wades through the water with her
skirts hiked to her knees.

Fig. 1. Jan Siberechts, *Milkmaid and Vegetable Seller*,
signed and dated *1667*, oil on canvas, 115.5 x 179.5 cm,
Budapest, Szépművészeti Múzeum, inv. 4074.

Siberechts made a specialty of depicting people,
carts, and animals fording a stream or making their
way along a flooded roadway; he frequently repeated
typical motifs such as the vegetable cart heading to
market, the girl wading with hoisted skirts, and the
milkmaid carrying her metal jug and pail. The basic
composition of the present painting is repeated in
an expanded horizontal format in the *Milkmaid and
Vegetable Seller* in Budapest, signed and dated 1667
(fig. 1)[1]; the cart on the left and the three cows closest
to the picture plane were used also in a *Landscape*
signed and dated 1673, which was in the collection of
Comte Santar, Lisbon, in 1931.[2]

As much figure and animal paintings as they are
landscapes, Siberechts's views of watery highways
are imbued with a quiet monumentality, expressed
most cogently by the simple, solid forms of country
folk and their livestock. With measured grandeur,
they push against the resistance of the shallow water
which slows and impedes their movement, raising
the bright ripples and splashes which are a hallmark
of the artist's work.[3] This depiction of movement is
subtly heightened by the contrast of opposing direc-
tions in the painting, the cows and carts moving
away from the picture plane and the farm girl strid-
ing inexorably closer.

Siberechts's landscapes are illuminated by the
clear, even light of midday rather than the indirect
glow of sunrise or sunset. Unlike the majority of
Flemish landscape painters (compare, for example,
works by Rubens or Huysmans, cats. 89 and 91),
Siberechts was not a flamboyant colorist; his land-
scapes are drawn from neutral harmonies of muted
brown, green-gray, and blue, with vibrant accents of
local color supplied in the garments of the figures.
His work has frequently been compared to that of
Dutch, rather than Flemish, landscape painters,
among them Jan Asselijn, Karel du Jardin, Adam

Pynacker, and Adriaen van de Velde.[4] Siberechts may
have been familiar with the work of these artists
from his putative trip to Italy in about 1650. The rur-
al themes treated by the Dutch landscapists have
much in common with Siberecht's works, but the
latter's paintings are distinguished by the constant
processional movement of figures and animals, and
by the greater proportion of the painting devoted to
landscape, rather than sky. The theme of farmers
bringing their wares to market was popularized
earlier in the century in landscape paintings by Jan
Brueghel the Elder (see cats. 82-83).

M E W

1. Budapest, cat. 1968, vol. 1, p. 640, no. 4074. Fokker (1931, pp. 72 and 90)
describes the Budapest painting as the work of a studio assistant.

2. Fokker 1931, p. 96, ill. pl. 32. There are also variants of the Hannover
painting which appeared in the sale London (Christie's), 4 July 1956,
no. 60 [signed and dated 1667; to Koetser], and in the sale Brussels (Palais
des Beaux-Arts), 27 October 1959, no. 515, ill.

3. Fokker 1931, p. 64.

4. Thiéry, Kervyn de Meerendré 1986, pp. 92-93.

Adam Frans van der Meulen

(Brussels 1631-Paris 1690)

Pieter van Schuppen after Nicolas de Largillierre,
Adam Frans van der Meulen, engraving, Paris,
Bibliothèque Nationale, Da 58, vol. v.

Eldest child of the notary Pierre van der Meulen and
Marie van Steenwegen, Adam Frans van der Meulen
was baptized on 11 January 1632 in the Church of
St. Nicolas in Brussels. In May 1646 he was appren-
ticed to Pieter Snayers (1592-1667), a painter of battle
and hunt scenes attached to the court of the Arch-
duke Leopold Wilhelm in Brussels. Van der Meulen
became a master in the guild of St. Luke in 1651; at
about the same time he married Catherine Huseweel
(d. 1677) in Brussels. There is no further documenta-
tion concerning the artist's activities prior to his
departure for France in ca. 1662. His paintings of the
1650s and first years of the 1660s depict contempo-
rary military and political events in and around
Brussels.

According to tradition, Jean-Baptiste Colbert,
Louis XIV's powerful minister of buildings and mon-
uments, suggested to van der Meulen that he come
to work for the king for an annual pension of
2000 livres. Van der Meulen's earliest French works
are dated 1663. He officially entered the service of the
French king on 1 April 1664, and kept a *Mémoire*
recording works executed for the king from this date
until his death (published in Guiffrey 1879). Van der
Meulen began working as a tapestry designer for the
Gobelins factory in 1665, and collaborated with
Charles Le Brun (1619-1690) on several commissions,
including a series of the months and one of views of
royal residences.

As court painter, van der Meulen was specifically
charged with depicting the military conquests of
Louis XIV, and followed the king on his military
campaigns throughout the late 1660s and into the
1680s. He made several trips through Flanders and
into the Northern Netherlands, recording French
victories at Dunkerque, Tournai (Doornik), Courtrai
(Kortrijk), Lille, Maastricht, Cambrai, etc. In 1669
the king granted the artist permission to publish
engravings after his compositions. Van der Meulen
was admitted to the Académie Royale de Peinture in
Paris in 1673, exempted from the required submis-
sion of a presentation piece. He was elected *conseiller*
(counsellor or professor) of the Académie in 1681 and
premier conseiller in 1686.

Following the death of his first wife in 1677, van
der Meulen married Catherine Lobri (d. 1680) in 1679,
and Marie de Bye, a cousin of Charles Le Brun, on
12 January 1681. Six children survived from the
artist's three marriages. He died at the Hôtel des
Gobelins on 15 October 1690.

Van der Meulen specialized in battle paintings
and topographical views; many of his works include
diminutive portraits that show him to be the equal
of Gonzales Coques or David Teniers (qq.v.) in this
genre. His mature works abandon the all-encom-
passing bird's-eye view favored by his predecessors
in the realm of battle painting (among them Snayers
and Sebastian Vrancx, q.v.), opting for a more natu-
ralistic perspective. Attention is focused on elegantly
clad cavalry officers in the foreground of the compo-
sition; the gorier aspects of war are relegated to
the distance, often masked by a pall of gunsmoke.
While traveling in the service of the king, van der
Meulen made hundreds of sketches of cities and
châteaux, fortifications, and emplacements, as well
as animated figure studies done from life (Paris,
Musée du Louvre, Cabinet des Dessins).

De Bie 1661, p. 399; Houbraken 1718-21, vol. 2 (1719), p. 329; Sandrart,
Peltzer 1925, pp. 363, 425; Weyerman 1729-69, vol. 2 (1729), pp. 334-336;
Dezallier d'Argenville 1745-52, vol. 2, pp. 206ff; Descamps 1753-64, vol. 3,
pp. 1ff; Mariette 1853, vol. 5, pp. 364ff; Nagler 1835-52, vol. 9, p. 201; Fétis
1857-65, vol. 2 (1858), pp. 104ff; Kramm 1857-64, vol. 4 (1860), p. 1107;
Michiels 1865-76, vol. 9 (1874), pp. 282-287; Herluison 1872, pp. 22, 132,
228, 401-402; Jal 1872, p. 860; Rombouts, van Lerius 1872, vol. 2, p. 298;
Herluison 1873, p. 298; Pinchart 1877, pp. 317, 320; Guiffrey 1879; Guiffrey
1881, vol. 1, passim; A. Wauters, in Biographie Nationale 1866-1964, vol. 14
(1881), cols. 669-682; van den Branden 1883, pp. 667, 1096; Wurzbach 1906-
11, vol. 2 (1910), pp. 152-154; H. Schneider, in L'Art français 2 (1925), pp. 140-
141; Thieme, Becker 1907-50, vol. 24 (1930), pp. 450-451; Legrand 1963,
pp. 212-215; Brussels 1965, pp. 133-136; Morris 1970; Schulz 1974-80;
Richefort 1980; Richefort 1988; Starcky 1988.

Adam Frans van der Meulen
94. Philippe-François d'Arenberg Saluted by the Leader of a Troop of Horsemen, 1662

Oil on canvas, 58.5 x 81 cm (23 ¹⁄₁₆ x 31 ⁷⁄₈ in.)
Signed and dated:
A. F. V. MEVLEN. FEC: 1662. BRVXEL.
London, The Trustees of The National Gallery,
inv. 1447

PROVENANCE: collection Prince Lothar Franz von Schönborn (1655-1729) at Pommersfelden, by 1719; sale Comte de Schönborn (Galerie de Pommersfelden), Paris (Drouot), 17 May 1867, lot 194 [frs. 8100, to Reiset]; sale Mrs. Lynne Stephens, London (Christie's), 11 May 1895, lot 336 [£147, to Agnew's for The National Gallery].

LITERATURE: J. R. Byss, *Fürtrefflicher Gemähld- und Bild-Schatz, so in denen Gallerie und Zimmern des Churfürstl. Pommersfeldischen ... Privat Schloss zu finden ist* (1719), p. 10 [carriage occupant identified as the "old" Duke of Lorraine]; *Verzeichniss der Schildereyen in der Gallerie des hochgräflichen Schönbornischen Schlosses zu Pommersfelden* (1774), p. 26, no. 205; J. Heller, *Die gräflich Schönborn'sche ... Gemäldesammlung ... in Pommersfelden* (1845), p. 43; Wurzbach 1906-11, vol. 2 (1910), p. 153 [carriage occupant identified as Louis XIV]; S. J. Gudlaugsson, *Gerard Ter Borch* (The Hague, 1959-60), vol. 2 (1960), p. 76; Legrand 1963, p. 213; London, National Gallery, cat. 1970, pp. 95-96; Morris 1970, pp. 19, 52-53, and p. 101 no. 23; Starcky 1988, p. 20.

A SPLENDID CARRIAGE has pulled up at the edge of a woods, drawn by six matched gray horses which prance impatiently at the delay. To the left, a mounted horseman clad in golden tan pays his respects to the occupant of the carriage, who has removed his hat in response to the greeting. Other riders are clustered at the rear of the coach, while in front of the carriage is a liveried outrider in scarlet and silver. To the right of the scene sits a hunter surrounded by his faithful hounds. A panoramic view of low hills fills the distance. Van der Meulen's airy composition is complemented by his use of a light palette; the carefree elegance of the figures is conveyed with delicate but precise detail.

The man seated to the right in the coach has been identified as Philippe-François d'Arenberg (1625-1674), first duke of Arenberg and duke of Aerschot and Croy; the likeness is consistent with an engraved portrait of Arenberg dated 1666 (fig. 1).[1] Arenberg, an important figure at the Brussels court, was created duke of Arenberg by the Holy Roman Emperor Ferdinand III in 1644, and a knight in the Order of the Golden Fleece in 1646. He had a distinguished career in the army of the Southern Netherlands and became captain general of the Flemish fleet in 1660. He was appointed *grand bailli*, governor and captain general of Hainault in 1663.

The London painting can be grouped with other similar works executed by van der Meulen during the late 1650s and early 1660s, prior to his move to France in 1664. The *Departure of a Princess* (fig. 2) and *Arrival of a Prince at Brussels* (both signed and dated 1659; Kassel, Gemäldegalerie Alte Meister, nos. GK 153 and GK 154, respectively) also depict picturesque processions through a landscape; the coach, horses, and various figures in the *Departure of a Princess* are repeated (in reverse) in the London painting. Van der Meulen also utilized a processional format for the representation of historical subjects (*Landscape with Rudolf von Hapsburg and the Priest*; Vienna, Kunsthistorisches Museum, no. 3692)[2] and

military themes (*Military Convoy*, signed and dated 1660; Madrid, Museo del Prado, no. 1349). He continued to paint depictions of riders or carriages before a landscape after his move to Paris,[3] but in general, the requirements of his work for Louis XIV altered the focus of these compositions. The artist's later works place a greater emphasis on the accurate and detailed rendering of the background view, whether depicting a battle scene or other historical event, or a city or palace specifically associated with the king. These scenes thus lean more toward the category of reportage or history painting.[4] *D'Arenberg Saluted by the Leader of a Troop of Horsemen*, on the other hand, although incorporating an identifiable portrait, adheres more to the tradition of genre painting because the generic nature of the setting cannot be tied to an exact location or event.

The presentation of a likeness in the context of a procession by coach or on horseback was a popular tradition in both the North and South Netherlands, and drew upon a variety of formal sources, including military genre scenes depicting rulers and generals in a triumphant or proprietary role before a battle scene or topographical view. Works by the battle painters Sebastian Vrancx and Pieter Snayers (1592-1667), court painter to the archdukes and the teacher of van der Meulen, are particularly relevant sources for the latter artist.[5] The most significant influence, however, came from representations of triumphal entries, often published in print form and widely circulated (see, for example, fig. 3). The ceremony of the triumphal entry, or "Blijde Inkomst," traditionally combined a popular festival with a ceremony in which the town professed loyalty to the visitor in exchange for a confirmation of their rights and prerogatives.[6] The image of the procession or entry symbolized the sovereignty of the ruler and fealty of his or her subjects.

Fig. 1. Portrait of Philippe-François d'Arenberg (1625-1674), First Duke of Arenberg and Duke of Aerschot and Croy, engraving, dated 1666.

Fig. 2. Adam Frans van der Meulen, *The Departure of a Princess*, signed and dated 1659; oil on canvas, 65.5 x 94 cm, Kassel, Gemäldegalerie Alte Meister, no. GK 153.

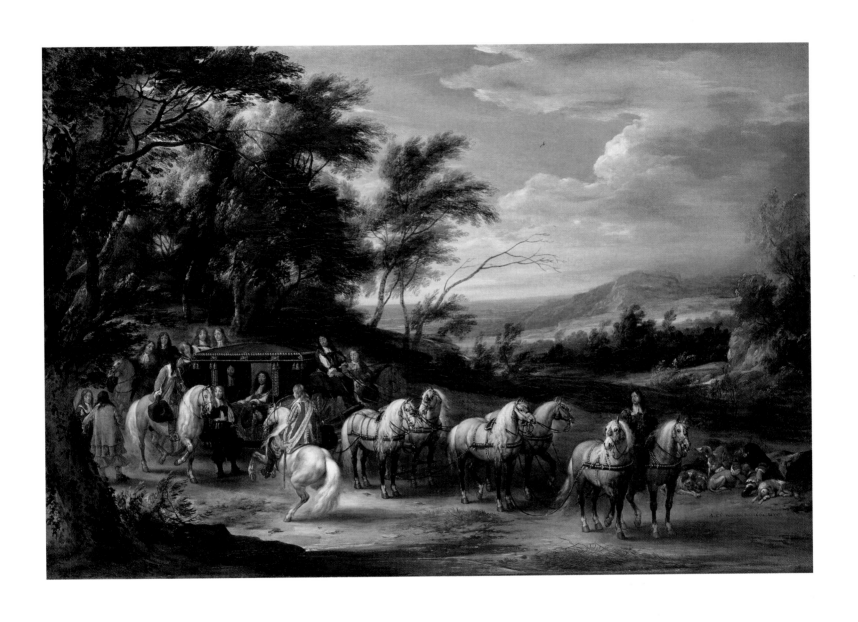

Fig. 3. P. Nolpe after Jan Maertensz. de Jonge, *The Entry of Marie de' Medici into Amsterdam, 31 August 1638*, engraving, part 6 of 7, Amsterdam, Rijksprentenkabinet, no. FM 1790-6.

Images such as van der Meulen's portrait of Arenberg also carry connotations of power and privilege, although the precise interpretation hinges on the person and site depicted. Depicting a named sitter before an identifiable site, for example, may allude to a specific event in that person's life, as in Gerard ter Borch's *Portrait of Adriaen Pauw and His Family Arriving at Münster* (1646; Münster, Landesmuseum).[7] More closely related to van der Meulen's portrait of Arenberg are works such as *Cornelis de Graeff with His Wife and Sons Arriving at Soestdijk*, by Jacob van Ruisdael and (probably) Thomas de Keyser, which casts de Graeff as a prosperous landowner seeking bucolic relaxation in the countryside after laboring assiduously in the service of city and country.[8] David Teniers the Younger's paintings of anonymous country estates and their proprietors have been interpreted as more generalized expressions of the seigneurial ideal.[9] Like paintings that incorporate portraits of the nobility into bourgeois genre scenes of kermesses or wedding feasts, the paintings by Ruisdael, Teniers, and van der Meulen do not commemorate a specific event, but depict the sitter in an act or situation associated with and thereby reinforcing his function or position.[10] In van der Meulen's portrait, Arenberg is not depicted before the site of a military or political victory, or in the vicinity of his country estate. He is situated in an open landscape surrounded by a group of hunters on horseback, an understated reminder that hunting was the exclusive domain of the nobility.

MEW

1. The identification was proposed by Count Th. de Limburg Stirum in a letter to The National Gallery dated 14 February 1966; see London, National Gallery, cat. 1970, p. 95. For the biography of Arenberg, see Jacques Deschemaeker, *Histoire de la Maison d'Arenberg d'après les archives françaises* (Neuilly, 1969), pp. 129-138; and *Biographie Nationale . . . de Belgique*, vol. 1 (Brussels, 1866), cols. 405-410. A likeness of Philippe-François d'Arenberg is also included in the *Procession of the Knights of the Golden Fleece Leaving the Palais at Brussels*, by François Duchatel (Brussels, Musées Royaux des Beaux-Arts de Belgique, inv. 196). For earlier identifications of the sitter as Louis XVI and a duke of Lorraine, see London, National Gallery, cat. 1970, pp. 95-96, esp. notes 2 and 8.

2. The painting by van der Meulen appearing in the sale Monaco (Sotheby's), 16/17 June 1989, lot 350 ("*Procession dans un grand paysage*") is surely also a representation of this subject; see also Rubens's depiction of the subject (ca. 1618-1620, oil on canvas, 198 x 283 cm, Madrid, Museo del Prado, inv. 1645).

3. For example, the *Journey of Louis XIV*, signed and dated 1664 (St. Petersburg, Hermitage, inv. 3522) which is, however, conceived on a grander scale, with a more extensive vista. Other versions of the composition are in Dresden and Edinburgh.

4. Noted also by Morris 1970, p. 52.

5. On the development of military genre painting in the Southern Netherlands, see Legrand 1963, pp. 189-226.

6. Held 1980, vol. 1, p. 221; see also the introduction to the subject in D. P. Snoep, *Praal en Propaganda: Triumfalia in de Noordelijke Nederlanden in de 16de en 17de eeuw* (Alphen aan den Rijn, 1974), pp. 9-15.

7. On ter Borch's painting see the entry in *Gerard Ter Borch, Zwolle 1617-Deventer 1681* (exh. cat. The Hague, Mauritshuis, 1974), pp. 68-71.

8. The pastoral and literary associations of the painting are discussed by Seymour Slive in *Jacob van Ruisdael* (exh. cat. The Hague, Mauritshuis, and Cambridge, Fogg Art Museum, 1981-82), p. 23; see also H. Potterton, *Dutch Seventeenth and Eighteenth Century Paintings in the National Gallery of Ireland* (Dublin, 1986), pp. 135-136. A. Adams (*The Paintings of Thomas De Keyser*, diss. Harvard University, 1985, vol. 3, pp. 165-66 [cat. D-2]) questions the attribution of the figures in the painting to de Keyser.

9. Dreher 1978b. See also Wieseman.

10. For example, Jan Brueghel the Elder, *Wedding Banquet with Portraits of the Archdukes Albert and Isabella* (Madrid, Museo del Prado, inv. 1442; ill. History, fig. 17). See Dreher 1978b, p. 702.

Jan Brueghel the Elder
95. *Vase with Flowers*, 1605

Oil on panel, 50 x 39.5 cm (19 ¼ x 15 ½ in.)
Signed and dated lower left: BRVEGHEL · 1605
The Netherlands, private collection

Fig. 1. Jan Brueghel the Elder, *Vase of Flowers*, ca. 1607, oil on panel, 51 x 40 cm, Vienna, Kunsthistorisches Museum, inv. 548.

Fig. 2. Jan Brueghel the Elder, *Vase of Flowers with Gems, Coins, and Shells*, ca. 1605-1606, oil on copper, 65 x 45 cm, Milan, Pinacoteca Ambrosiana, inv. 66.

PROVENANCE: private collection, England; Hallsborough Ltd., London; Galerie Nathan, Zurich; collection Mr. and Mrs. Leigh Block, Chicago; Noortman and Brod Gallery, London and New York, 1981-82; private collection, The Netherlands.

EXHIBITIONS: The Hague 1992, no. 10.

LITERATURE: Ertz 1979, pp. 280-282, 585, cat. 165 [as autograph replica of Vienna painting, painted ca. 1607]; S. Segal, "Een vroeg bloemstuk van Jan Brueghel de Oude," *Tableau* 4, no. 5 (1982), pp. 490-499; Hairs 1985, pp. 37, 463 [as dated 1603, "chronology debatable"]; S. Segal, "Exotische bollen als statussymbolen," *Kunstschrift Openbaar Kunstbezit* 31, no. 3 (1987), p. 96; S. Segal, in Delft/Cambridge/Fort Worth 1988, p. 100; Brenninkmeyer-de Rooij 1990, p. 245; H. Robels, in Cologne/Vienna 1992-93, p. 212 note 29.

FLOWERS of all descriptions issue from a spherical earthenware vase. The lavish bouquet is composed of both spring and summer flowers: pansies, forget-me-nots, carnations, snowdrops, rosemary, hyacinths, roses, jonquils, tulips, lilies, narcissi, irises, larkspur, snake's head fritillaria, and daffodils are just a few of the fifty-eight species and seventy-two varieties represented.[1] At the foot of the vase is a clump of cyclamen, and, at the lower right, three sapphires and five diamonds.

Dated 1605, the *Vase with Flowers* is Jan Brueghel's earliest dated flower piece (other bouquets are dated 1608, 1612, and 1617), and a convincing argument has been made for it being his very first flower painting as well. Two other versions of the present painting are known. The first, previously considered the original and probably an autograph replica of the present painting, is in the Kunsthistorisches Museum, Vienna (inv. 548; fig. 1); a second, rather attenuated version possibly by Jan Brueghel the Younger, is in the Villa del Poggio Imperiale, Florence (on loan from the Palazzo Pitti, inv. 165).[2] Neither of these paintings is signed or dated, which argues for the primacy of the present version. Segal has suggested that the Vienna painting may have been executed with assistance from the studio[3]; Brenninkmeyer-de Rooij assumed the primacy of the Vienna version and termed the present painting a "replica with fewer flowers."[4] Ertz (who knew the present painting only in a photograph), doubted the authenticity of the *Vase with Flowers* primarily because the signature and date were distorted by overpaint and read as "BRUEGEL 1603," an improbably early date for a flower piece by the artist.[5] With cleaning, however, the "H" has reappeared and the last digit, although indistinct, can be deciphered as a "5."[6]

Brueghel introduced some changes in each version, although the basic composition and arrangement of flowers is almost identical. The Vienna painting, for example, has more flowers and foliage filling out the edges of the bouquet, and some individual blossoms have been changed: an iris is substituted for a tulip at the top of the bouquet, and a

different, larger tulip appears at the right. Both the Vienna and Florence paintings exhibit additional objects on the tabletop at the foot of the vase: individual blossoms, a ring, gold coins, insects, and a shell, in addition to the clump of cyclamen and the scattered gems in the present painting.[7]

Brueghel's *Vase of Flowers with Gems, Coins, and Shells*, begun for Cardinal Federigo Borromeo in 1605 and delivered to him in 1606 (Milan, Pinacoteca Ambrosiana, inv. 66; fig. 2), had previously been considered the artist's earliest flower painting, although contemporary documentation is ambiguous on this point.[8] The Milan painting is first referred to in a letter of 14 April 1606 from Brueghel to Ercole Bianchi, Cardinal Borromeo's agent: the artist mentions that he has taken the initiative – without a specific commission from the cardinal – to paint for him a bouquet, which he hopes to have finished and ready to send to him by the first of June. A few days later Brueghel writes: "Your Excellency must believe me, that I have never painted a comparable painting. I believe the flowers should be life-sized, more than one hundred, the majority of them very rare and beautiful...."[9] Segal rightly stresses the word "comparable"[10]; Ertz and others have interpreted the passage to mean that the Milan painting was the first flower piece painted by the artist, rather than one unequalled in his œuvre. In later correspondence with Bianchi, Brueghel writes that "the first [flowers] I made were those for the Cardinal; the second for the Infante in Brussels...."[11] A certain degree of flattery and salesmanship may be involved here (as was frequently the case in Rubens's letters), assuring an esteemed patron that he has received the artist's finest efforts.[12] Segal has proposed that the *Vase with Flowers* predates Brueghel's flowerpiece for Cardinal Borromeo, which he terms a "richer variant of the 1605 dated painting," and suggests that the *Vase with Flowers* remained in the artist's studio as a model for composing subsequent flower pieces.[13]

Brueghel wrote about his working process in several letters to Bianchi. Each spring he made several similar paintings, all painted directly (*alla prima*) from nature, without the use of drawings or sketches. He wrote repeatedly of the difficulties of painting flower pieces, with all activity necessarily restricted to the spring and summer months, and of making special trips to Brussels (probably to the garden of the archdukes) to paint species of flowers that were unavailable in Antwerp.[14] Brenninkmeyer-de Rooij has shown that although Brueghel indeed worked primarily from live blooms, he also enlisted the aid of botanical prints, finished paintings in his atelier, and possibly also artificial flowers as models.[15]

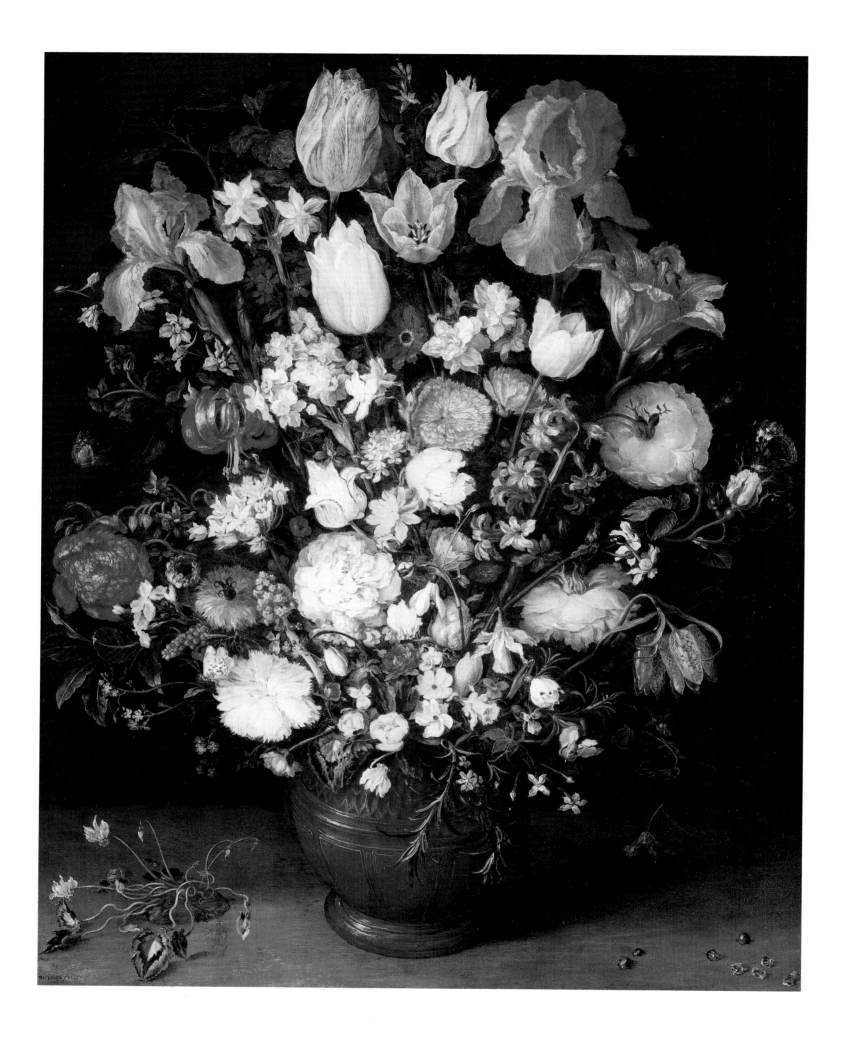

Brueghel's statement that he worked on several similar paintings (alcuni quadri simile) at the same time is borne out by the fact that many of his compositions (as, for example, the present painting) exist in more than one autograph version.

Brueghel's meticulously detailed flower pieces were extraordinarily highly valued among his contemporaries.[16] In his Musaeum (Milan, 1625), Cardinal Borromeo indicated the value he placed on Brueghel's Vase of Flowers with Gems, Coins, and Shells (fig. 2): "But no less is the battle of the flowers, whose merit Brueghel himself, who made them, indicated with a most graceful invention. He painted at the bottom of the vase a diamond, which makes us understand that which we would have thought just the same, namely, the work is as valuable as a gem, and we payed for it as such."[17] Brueghel expressed the same sentiments in a letter dated 25 August 1606: "Under the flowers I have placed a jewel, with minted coins [and] with rarities from the sea. Your excellency must judge for yourself if the flowers do not surpass gold and jewels."[18] In the present painting as well, the diamonds and sapphires scattered at the foot of the vase allude to beauty and value of the rare botanical jewels depicted above; not only were painted flower pieces considered precious works of art, but the individual flowers depicted were often rare and costly specimens.

Although Segal and others have interpreted the Vase with Flowers and similar works as embodying concepts of vanitas and transitoriness (the former alluded to by the jewels in the foreground and the latter expressed in the wealth of short-lived flowers),[19] various sources suggest that this was not necessarily the seventeenth-century view. Brueghel never once alluded to a vanitas aspect of his flower pieces in his correspondence; nor did Cardinal Borromeo attach any moralizing interpretation to these works. Describing a Winter Landscape with a Glory of Angels by Brueghel and Hans Rottenhammer, the cardinal noted the effect of the work: ". . . as if the beauty of the flowers and the icy snow are the extremes of nature, as if earthly misery is represented by the face of winter, and the joy of Heaven by spring. But, to tell the truth, when I ordered the picture I was not thinking at all of either symbols or mysteries. . . ."[20] In his autobiographical Pro suis studiis (unpublished manuscript dated 1628), Borromeo discussed more specifically the still-life paintings which hung in his study:

> . . . [I have enjoyed] having various vases in the room, and varying these according to opportunity, and according to my pleasure. Then when winter encumbers and restricts everything with ice, I have enjoyed

from sight – and even imagined odor, if not real – fake flowers . . . expressed in painting . . . and in these flowers I have wanted to see the variety of colors, not fleeting as some of the flowers that are found [in nature], but very stable and very endurable.[21]

Thus the painted bouquets were viewed as an eternal monument, rather than a reminder of transitory pleasures. The cardinal's appreciation of these naturalistic flower pieces on a visual level did not preclude his appreciation of them on a sacred level as well, although the latter was more in the nature of glorifying the miracles of God's creation than morbid forebodings of decay.[22]

MEW

1. A diagram and complete list of all the species and varieties of flowers represented is published in Segal 1982, pp. 496-497.

2. The Vienna painting was in the collection of the Archduke Leopold Wilhelm by 1659. The painting in Florence (oil on panel, 63 x 41.5 cm) was in the collection by 1773; see Segal 1982, pp. 490, 493, ill. fig. 3; and Ertz 1984, pp. 435-436, no. 274, who attributes the painting to Jan the Younger and dates it to the late 1620s. In addition, Ertz (1979, p. 585, under cat. 164) notes a "weak copy with slight changes" of the Vienna painting in the Art Institute of Chicago, inv. 1948.571.

3. Segal 1982, p. 493.

4. Brenninkmeyer-de Rooij 1990, p. 245.

5. Ertz 1979, pp. 280-281, 585.

6. Segal 1982, pp. 490, 492.

7. Ibid., pp. 494 and 499, for a detailed enumeration of the items and identification of the different coins which appear in the Vienna and Florence paintings.

8. On the Milan painting, see especially Ertz 1979, pp. 252-260, 581, cat. 143; Segal 1982, pp. 492, 494; and Brenninkmeyer-de Rooij 1990, passim.

9. "VS Ill.mo credo per certo che io non habio mai fatto un quadro simili. Credo che serrano de fiore fatta grando comme il naturale, in nomre pieu di centi, il maigior parta tutta raro et belli." Crivelli 1868, pp. 63-64.

10. Segal 1982, p. 499.

11. "Il prima (fiore) che io fece e quella del sig. Cardinal: il secondo ho fatto per le ser.mo Enfante in Brusselo." Letter of 22 April 1611; Crivelli 1868, p. 168.

12. As noted by Brenninkmeyer-de Rooij 1990, p. 235.

13. Segal 1982, p. 494.

14. On Brueghel's working process, see Brenninkmeyer-de Rooij 1990, pp. 230-235; Hairs 1985, pp. 58-59; and Freedberg 1981, p. 126. The artist comments on his working methods in letters to Bianchi dated 27 January 1606 (Crivelli 1868, p. 62), 14 April 1606 (Crivelli 1868, p. 63), 25 August 1606 (Crivelli 1868, pp. 74-75), 25 March 1611 (Crivelli 1868, p. 167), and 22 April 1611 (Crivelli 1868, p. 168), among others.

15. Brenninkmeyer-de Rooij 1990, p. 235.

16. See Freedberg 1981, p. 144 notes 88-91.

17. Musaeum (Milan, 1625), p. 26; trans. A. Quint, Cardinal Federigo Borromeo as a Patron and a Critic of the Arts and His MVSAEVM of 1625 (New York and London, 1986), p. 245.

18. "Sotti i fiori ha fatta una Gioia con manefatura de medaiglie, con rarita del maro. Metta poi VS Ill.mo per judicare, se le fiori non passeno ori et gioii." Crivelli 1868, pp. 75.

19. Segal 1982, p. 499.

20. Musaeum (Milan, 1625), p. 25; trans. P. M. Jones, "Federico Borromeo as a Patron of Landscapes and Still Lifes: Christian Optimism in Italy ca. 1600," Art Bulletin 70 (1988), p. 267.

21. Federigo Borromeo, Pro suis studiis (unpubl. ms. Milan, Biblioteca Ambrosiana, 1628) fols. 245v-255r; cited in Jones 1988, p. 269.

22. See Jones 1988, pp. 269-271; Brenninkmeyer-de Rooij 1990, pp. 230, 236-238.

Jan Brueghel the Elder
96. Flowers in a Glass Vase

Oil on panel, 41.9 x 33 cm (16 ½ x 13 in.)
Private collection

PROVENANCE: collection Desmond O'Brien, Esq., of Arden; sale London (Sotheby's), 24 March 1965, no. 16, ill.

EXHIBITIONS: London 1979, no. 19.

LITERATURE: Ertz 1979, pp. 276, 588, cat. 180; Hairs 1985, p. 466.

ALTHOUGH he perfected the opulent encyclopedic floral arrangement in works such as the magnificent *Floral Still Life* of 1605 (cat. 95), Jan Brueghel the Elder also executed charming flower pieces on a more intimate scale. In the present painting, a limited number of flowers (including roses, carnations, narcissi, tulips, forget-me-nots, jasmine, and delphinium) have been arranged in a simple glass roemer. Several insects traverse the blossoms and leaves; a nearly invisible dragonfly hovers over the red carnation at the right. At the foot of the glass are a spray of rosebuds, and a stem of forget-me-nots with two loose blossoms. With delicate yet lively touches of color, Brueghel painstakingly re-creates the varied shadings and striations of individual blossoms and leaves; unerring touches of brilliant white simulate the refractions of light in the knobbled glass roemer. The sinuous lines of the tulip stems threading through the bouquet add a graceful verticality to the composition, and look forward to the more attenuated flower pieces of Daniel Seghers and Jan Philips van Thielen (cats. 98, 104).

The earliest of Brueghel's more modest floral compositions (fig. 1) was created in 1608 for his great patron Cardinal Federigo Borromeo, who also had in his collection one of the artist's early encyclopedic bouquets (see cat. 95, fig. 2).[1] The comparatively sparse number of blossoms in the former painting nonetheless includes several rare and and unusual specimens.[2] Brueghel painted a number of small floral bouquets in roemers or glass vases during this period; although none are dated, all presumably postdate the Milan prototype of 1608. Among the related still lifes of flowers in glass vases are paintings in the sale New York (Sotheby's), 12 January 1979; and in the sale New York (Sotheby's), 13 January 1978, no. 127.[3] The simplicity and graceful informality of these bouquets appealed to collector and copyist alike, with the result that there are frequently several versions of a single composition, some of which may also be by the artist himself.[4] There are no known variants of the present painting, however, and the lively composition and sensitive, refined execution are characteristic of Brueghel at his finest.

<div align="center">MEW</div>

1. Ertz 1979, cat. 178.

2. Letter from Brueghel to Borromeo's agent Ercole Bianchi, dated 13 June 1608; Crivelli 1868, p. 104. See also Brenninkmeyer-de Rooij 1990, p. 230.

3. Oil on copper, 35 x 25.5 cm, signed BRVEGHEL (Ertz 1979, cat. 180); and oil on panel, 41.5 x 33.5 cm (Ertz 1979, cat. 181). See also the paintings discussed in ibid., pp. 274-279.

4. See the discussion of Brueghel's studio practice in cat. 95 and the references cited there. Ertz (1979, pp. 274, 546) notes a "schilderyken, gelaesken met bloemen, van Bruegel, geestimeert op tzestich gulden" (a small painting, a glass with flowers by Brueg[h]el, assessed at sixty guilders) in the inventory of the Antwerp collection of Nicolaus Cornelius Cheeus, 4 May 1622 (see also Denucé 1932), pp. 29-35).

Fig. 1. Jan Brueghel the Elder, *Flowers in a Glass Vase*, signed and dated lower right: BRVEGHEL 1608, oil on copper, 43 x 30 cm, Milan, Pinacoteca Ambrosiana, inv. 58.

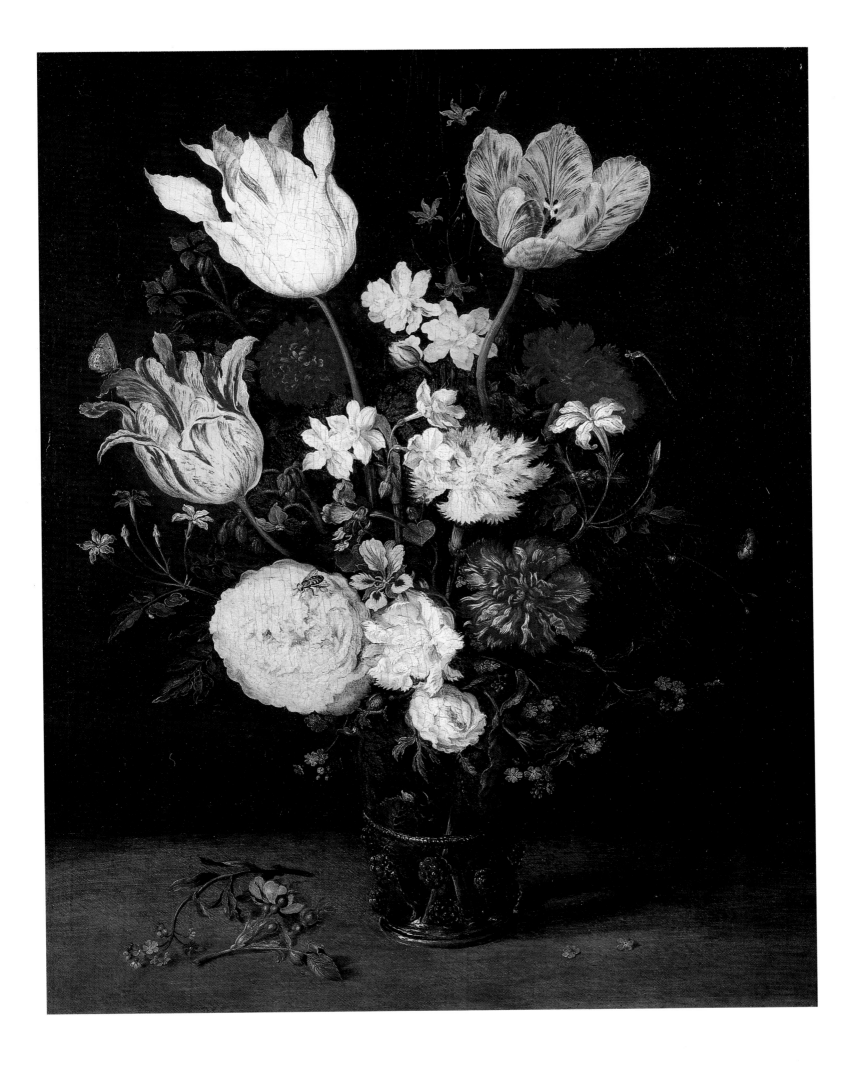

Jacob van Hulsdonck

(1582-Antwerp-1647)

Jacob van Hulsdonck was born in Antwerp in 1582. Although his teacher is not known, it is thought that he may have learned to paint in Middelburg (Zeeland) under the Antwerp-born still-life and flower painter Ambrosius Bosschaert (1573-1621), because of the striking similarities in their styles. Van Hulsdonck returned to Antwerp by 1608, when he joined the guild of St. Luke. He married Maria la Hoes on 24 November 1609; the couple had seven children, including a son Gillis (b. 1626), who later became a painter. Following the death of his first wife in 1629, the artist married Josina Peeters on 17 August 1632. From 1609 until his death in early 1647, van Hulsdonck rented a house in the Happart-straat in Antwerp.

Van Hulsdonck painted simple flower pieces, breakfast still lifes, and baskets or platters of fruit, often in combination with a vase of flowers. His richly colored arrangements, set against a dark background, are characterized by a meticulous rendering of textures and forms. In addition to his son Gillis, van Hulsdonck had four recorded pupils between 1613 and 1623.

Nagler 1835-52, vol. 6 (1838), p. 359; Immerzeel 1842-43, vol. 2 (1843), p. 64; Rombouts, van Lerius 1872, vol. 1, pp. 447, 497, 500, 542, 544, 584, 668; vol. 2, p. 185; Siret 1878; van den Branden 1883, pp. 637-638; Wurzbach 1906-11, vol. 1 (1906), p. 734; K. Zoege van Manteuffel, in Thieme, Becker 1907-50, vol. 18 (1925), p. 113; Hairs 1955, pp. 130, 131, 244; Greindl 1956, pp. 31-34, 175; Greindl 1983, pp. 36-43, 364-365; Hairs 1985, pp. 347-348, 482; Washington/Boston 1989, p. 111.

Jacob van Hulsdonck
97. Carnations in a Glass Vase

Oil on panel, 33.7 x 24.5 cm (13 ¼ x 9 ⅝ in.)
Signed lower left: · I V HVLSDONCK · FE ·
(I V H in ligature)
Mrs. H. John Heinz III

PROVENANCE: private collection, France.

EXHIBITIONS: Washington/Boston 1989, no. 20.

LITERATURE: I. Bergström, in Washington/Boston 1989, p. 111; S. Segal, in exh. cat. Osaka/Tokyo/Sydney 1990, p. 185.

TEN FULLY OPENED CARNATIONS and several buds are simply arranged in a roemer of greenish glass. On the wood ledge to either side of the glass are a red carnation and a stem with two buds; a fly crawls on one of the buds.

Although Hulsdonck's still lifes and flower arrangements are uniformly modest and restricted to a minimum of objects, the present painting is unusual in that it depicts just one type of flower, albeit represented in varying permutations of red and white striations. Bouquets of a single type of flower are rare but not unknown in seventeenth-century Netherlandish still-life painting. For example, Ambrosius Bosschaert the Elder painted a *Vase of Tulips* (ca. 1615; The Hague, Bredius Museum, inv. 27-1946); Jacob Marell a *Vase with Tulips* (ca. 1630s; present location unknown); Alexander Adriaenssen, *Tulips in a Vase* (signed and dated 1635; London, L. Koetser [1971]); and Simon Verelst, *Double Daffodils in a Vase* (before 1669; Hartford, Wadsworth Atheneum, inv. 1956.782).[1] There are also paintings that depict a single (rare) bloom with specific botanical interest, such as Dirck van Delen's *Tulip in a Kendi Vase* (signed and dated 1637; Rotterdam, Museum Boymans-van Beuningen, inv. 2887) or Balthasar van der Ast's *Tulip in a Glass Vase* (ca. 1640; Solingen, Galerie Müllenmeister).[2]

Interestingly, among these depictions of single-specied bouquets there are a handful that represent carnations: in addition to the present painting, for example, Georg Flegel's *Bouquet of Carnations*, ca. 1610s; Balthasar van der Ast's *Carnations in a Wan-li Vase*, signed and dated 1622; and Philippe de Marlier's *Bouquet of Carnations in a Glass Vase*, signed and dated 1639 (fig. 1).[3] A second painting of *Carnations in a Glass Vase* by Hulsdonck was in the sale Princesse de X et al., Paris (Charpentier), 12 June 1953, no. 59. While an artistic interest in the depiction of tulips or other bulb flowers is understandable in light of the infamous "tulip mania" which swept the Netherlands in the first decades of the seventeenth century,[4] the apparent interest in carnations is less obvious, and may have embodied a specific symbolic meaning. Carnations, or pinks, were a traditional symbol of betrothal and of conjugal fidelity.[5] In addition to the array of carnations, at the base of Hulsdonck's bouquet are two sprigs of rosemary, which was a symbol of eternity and remembrance, and was frequently included in bridal garlands as a

Fig. 1. Philippe de Marlier, *Bouquet of Carnations in a Glass Vase*, signed and dated 1639, oil on panel, 45.5 x 34 cm, private collection (formerly Vienna, Galerie Sanct Lucas).

Daniel Seghers

(1590-Antwerp-1661)

reminder of faithfulness.[6] Although one is properly cautioned against the overinterpretation of still-life paintings, the juxtaposition of two plants with such complementary connotations is surely not an arbitrary choice. The combination of rosemary and carnations in a marriage context is seen also in Clara Peeter's *Still Life with Tart* (cat. 107).

MEW

1. On the Bosschaert, see A. Blankert, *Museum Bredius, Catalogus van de schilderijen en tekeningen* (The Hague, 1991), pp. 52-53; on the Marrell, B. Brenninkmeyer-de Rooij, "De liefhebberij van Flora," in exh. cat. The Hague, Mauritshuis, *Boeketten uit de Gouden Eeuw* (1992), pp. 19-20, ill.; and on the Verelst, B. Broos, in exh. cat. The Hague 1990-91, pp. 452-455. The Adriaenssen is illustrated in Spiessens 1990, cat. 14, pl. 9.

2. On tulip "portraits" see Broos, in exh. cat. The Hague/San Francisco 1990-91, p. 454; and B. Brenninkmeyer-de Rooij, "'Schoone en uitgelezene bloemen, een goede schikking en harmonie, en een zuivere en malsse penceel,'" *Kunstschrift Openbaar Kunstbezit* 31, no. 3 (1987), p. 101.

3. Flegel: oil on copper, 24 x 17 cm, private collection (ill. exh. cat. Münster/Baden-Baden 1983, p. 325); van der Ast: oil on panel, 28.5 x 20 cm, Amsterdam, Stichting Piet en Nellie de Boer.

4. On "tulip mania," see E. H. Krelage, *Bloemenspeculatie in Nederland* (Amsterdam, 1942), pp. 15-145; exh. cat. Haarlem, Frans Halsmuseum, *Tulpomanie* (1974); and S. Schama, *The Embarrassment of Riches* (New York, 1987), pp. 350-365.

5. See F. Mercier, "La valeur symbolique de l'œillet dans la peinture du moyen âge," *Revue de l'art ancien et moderne* 71 (1937), pp. 233-234; and G. de Tervarent, *Attributs et symboles dans l'art profane* (Geneva, 1958), cols. 288-289.

6. Noted by Segal in exh. cat. Osaka/Tokyo/Sydney 1990, p. 185; see also idem, in Delft/Cambridge/Fort Worth 1988, p. 68; and idem, "Exotische bollen als statussymbolen," *Kunstschrift Openbaar Kunstbezit* 31, no. 3 (1987), p. 97.

We are unusually well informed about Daniel Seghers's life and career, thanks in part to an autobiographical statement dated 6 January 1615, written by the artist upon his admission to the Jesuit order. According to this document, Seghers was born in Antwerp on 3 December 1590, son of the silk merchant Pierre Seghers and Marguerite van Gheel. Following the elder Seghers's death in about 1601, his widow converted to Calvinism and emigrated to the United Provinces. Daniel Seghers's first teacher is not known, but he apparently began his study of painting about 1605. In 1611 he was a pupil of Jan Brueghel the Elder (q.v.), and was admitted to the Antwerp guild of St. Luke in the same year. Seghers continued to paint prolifically after joining the Jesuit order in Mechelen in 1614. In Antwerp 1617-1621, he may have contributed to the decoration of the Church of St. Charles Borromeo, which was consecrated in 1621. Seghers was in Brussels from 1621 to 1625. After taking his final vows on July 1625, the artist journeyed to Rome, where he was undoubtedly occupied in painting floral garlands and still lifes for ecclesiastical patrons. Upon his return north late in 1627, Seghers settled in Antwerp where, aside from a few brief trips to other cities, he resided for the rest of his life. After a prolonged illness, the artist died in Antwerp on 2 November 1661.

Passionately dedicated to his art, Seghers was a prolific painter of floral garlands and still lifes; nearly all of his works are recorded in the "Catalogue of Flower Pieces which I have painted with my own hand, and for whom" compiled by the artist during the course of his career. Most of his floral garlands encircle a religious scene, a portrait, a trompe l'œil sculptural image or other motif, frequently executed by another painter. Seghers's collaborators in these works include Thomas Willeboirts Bosschaert (1613/14-1654), Antoon Goubau (1616-1698), Hendrick van Balen, Gonzales Coques, Abraham van Diepenbeeck, Erasmus Quellinus, Rubens (qq.v.), Gerard Seghers (1591-1651), Cornelis Schut (1597-1655), Simon de Vos (1603-1676), Nicolas Poussin (ca. 1594-1665), and Domenichino (1581-1641). The majority of Seghers's works were not sold, but were presented by the artist and the Jesuit order to rulers and dignitaries across Europe as tokens of honor and esteem. The artist was honored by his contemporaries in prose and verse, and his studio was visited by the Cardinal Infante Ferdinand in 1635, the Archduke Leopold Wilhelm in 1648, and the future Charles II of England in 1649, among others. These and other luminaries presented Seghers with munificent gifts in exchange for his paintings. Seghers's only recorded pupil was the flower painter Jan Philips van Thielen (q.v.).

Jan Meyssens after Jan Lievens, *Daniel Seghers*, engraving, from Cornelis de Bie, *Het gulden cabinet . . . ,* 1661, fol. 213.

Daniel Seghers
98. *Flowers in a Glass Vase*, 1635

Oil on panel, 81.2 x 51.7 cm (32 ¹⁄₁₆ x 20 ⅜ in.)
Signed and dated lower right:
D Segers Soc.^tis Jesu. A° 1635
Toledo, The Toledo Museum of Art, no. 53.85

De Rieu 1658, part 1, p. 13; de Bie 1661, pp. 213, 566; van den Vondel 1662; Bullart 1695, vol. 2, p. 500; Houbraken 1718-21, vol. 1 (1718), p. 140; vol. 2 (1719), pp. 52, 131, 293; Vos 1726, p. 329; Dezallier d'Argenville 1745-52, vol. 3, p. 327; Descamps 1753-64, vol. 1, pp. 391-394; Immerzeel 1842-43, vol. 3 (1843), pp. 84-85; Papebrochius 1845-58, vol. 5, p. 390; Kramm 1857-64, vol. 5 (1861), p. 1508-1509; Allard 1869; Rombouts, van Lerius 1872, vol. 1, pp. 474, 477, 480; Michiels 1865-76, vol. 9 (1874), pp. 194-207; Rooses 1879, pp. 649-652; Pinchart 1881, pp. 218-223; van den Branden 1883, pp. 1128-1130; Kieckens 1884a; Kieckens 1884b; Wurzbach 1906-11, vol. 2 (1910), pp. 613-614; Sandrart, Pelzer 1925, pp. 185, 192, 201; Thieme, Becker 1907-50, vol. 30 (1936), p. 443; Hairs 1955, pp. 51-86, 233-240; Hairs 1957, pp. 150, 152-162; Aldana Fernandez 1960, pp. 76-77; Hairs 1960, pp. 205-227; Burke-Gaffney 1961; Hairs 1964; Brussels 1965, pp. 238-241; Couvreur 1967; Vlieghe 1967a; Bodart 1970, vol. 1, pp. 471-473; Wright 1974; Hairs 1977, p. 21; Paris 1977-78, pp. 212-215; Morel-Deckers 1978, pp. 157-184; de Bruyn 1980; Freedberg 1981, p. 134; Härting 1989, p. 160; Cologne/Vienna 1992-93, pp. 472-474.

PROVENANCE: Leo Spick, Berlin, to 1953; dealer Eugene Slatter, London.

LITERATURE: Hairs 1955, pp. 60-61, 72, 75, 77, 238, pl. 21, p. 190 note 638; J. R. Martin, "Review of Marie-Louise Hairs, *Les Peintres Flamands de Fleurs au XVII Siècle*," *Art Bulletin* 39 (1957), p. 319; G. Bazin, *A Gallery of Flowers* (London, 1960), pp. 102-105, color ill.; S. Aldana Fernandez, "En torno a Daniel Seghers," *Archivo Español De Arte* 33 (1960), p. 74; Burke-Gaffney 1961, p. 15, ill.; E. Hubala, *Die Kunst des 17. Jahrhunderts* (*Propyläen Kunstgeschichte*, vol. 9) (Berlin, 1970), p. 176, ill. Abb. 134; P. Mitchell, *European Flower Painters* (London, 1973), p. 234; Toledo cat. 1976, p. 150, pl. 104; E. Kock, *Du Grund unserer Freude: ein Marienbuch* (Limburg, 1979), p. 14, 133, color ill.; Hairs 1985, pp. 134, 136, 142, 172, 176-177, p. 131 fig. 34.

RECENTLY DESCRIBED as "among the most serenely beautiful things in the history of flower painting,"[1] the bouquets of Daniel Seghers excel in their union of compositional simplicity and pictorial brilliance. *Flowers in a Glass Vase*, one of the most elegant and refined examples from Seghers's hand to have survived, consists of a subtly balanced arrangement that includes budding and fully blossomed roses, a splendid solitary striped tulip, a blooming orange branch, and four irises, three of the garden variety (*iris germanica*) and a magisterial English iris, or Pyrenaean flag (*iris xiphioides*) crowning the whole.[2] A butterfly, three inchworms, and a pair of insects are seen on the brown ledge, the foot of the vase, and among the flowers.

Seghers depicted floral bouquets throughout his career: his œuvre in large measure is composed of collaborative endeavors in which he contributed floral garland surrounds to religious images by other painters (see cat. 99). The artist's own inventory of his paintings, "Cataloge van de Bloemstukken, die ik selfs met mijn hand heb geschildert en voor wie," lists 239 pictures of which more than one-quarter describe such independently composed "bloempotten," including ones that predate his sojourn to Italy (1625-1628), as well as examples executed while in Rome.[3] The Toledo picture, however, is Seghers's earliest known signed and dated painting. Though a verifiable identification of it in Seghers's list is not possible, it is highly plausible as no. 47, a work painted for the governor of Roermond, Jakob van Randwyck, sometime between August 1632 and August 1637.[4]

Hairs discusses sixteen known, signed bouquets by Seghers rendered before dark impenetrable backgrounds, including the present example, and on stylistic grounds is able to attribute seven or eight unsigned ones to him.[5] In most the portrayed flowers are equal in height to the ubiquitous glass vessel containing them. The Toledo painting, one of Seghers's largest works on panel, is therefore atypical due to its elongated format and bears resemblance to a slightly larger painting on copper, dated 1643,

Fig. 1. Daniel Seghers, *Bouquet in a Glass Vase*, 1643, copper, 85.5 x 64.5 cm, formerly Dresden, Gemälde-galerie Alte Meister, no. 1201 [destroyed in war].

formerly in the museum in Dresden (fig. 1).[6] As Hairs has observed, two panels owned by the Abbey of Tongerlo are also similar in appearance and format.[7]

If it is prudent to refrain from claiming the primacy of a symbolic interpretation when considering certain seventeenth-century Flemish still-life paintings – see for example the interpretation urged for Jan Davidsz. de Heem's *Flower Still Life* (cat. 102) – the life and art of Seghers present an entirely different set of circumstances. That a sizable majority of the paintings collaborated on by this lay brother in the Jesuit Order include images of the Madonna and Child, saints, or scenes from Christ's passion (see cat. 99) lends credence to the argument that the present *Flowers in a Glass Vase* and comparable "pure" still lifes are replete with symbolic meaning. Thus, the metaphoric associations of the flowers here may be seen to refer to the Virgin directly or as attributes of her nature. For example, the iris is the flower of the Virgin and could allude to her as the Queen of Heaven. Roses symbolize love, and white roses in particular connote purity. Moreover, a tradition existed of referring to the Virgin as a "rose without thorns."[8] So too, among the many associations tulips could engender in the seventeenth century was the concept of virginity.[9] In this light, endowing the butterfly with the allegorical significance of the Resurrection is wholly in keeping with the collective religious tenor of the composition.

LWN

1. Mitchell 1973, p. 234.

2. Bazin 1960, p. 102.

3. Couvreur 1967, no. 7-10, 15-17, and 19-22; see also Hairs 1985, p. 134.

4. Couvreur 1967, pp. 136-139, analyses the arrangement of Seghers's list, which for the most part is ordered chronologically. No. 47: "een bloem-pot voor de Gouveneur van Rueremont als order de Staeten was," see ibid. p. 90, no. 40, and p. 137. Other potential candidates to be equated with the panel now in Toledo are nos. 77, 106, and 146.

5. Hairs 1985, pp. 134-136, and 177-178. A closely related compositional variant on this theme is Seghers's bouquets placed within niches such as those painted for the Escorial in ca. 1630 (see cat. 100, fig. 2).

6. A letter preserved in the Toledo Museum files from Dr. Mayer-Meintschel, dated 31 July 1973, states that the picture was a war casualty. She also notes that *Bouquet Surmounted by Roses in a Glass Vase* (dated 1643, copper, 45.5 x 35 cm, Dresden, Gemäldegalerie Alte Meister, no. 1202), frequently compared in the literature to both no. 1201 and the Toledo panel, left the collection in 1924.

7. Panels, 76.5 x 29.5 cm, and 77 x 29 cm; see Hairs 1985, pp. 177-178, pl. 48.

8. See Koch 1979, pp. 14 and 133; and G. Ferguson, *Signs and Symbols in Christian Art* (London, 1971), pp. 32 and 37.

9. See E. de Jongh, in Haarlem 1986, pp. 83-86.

Daniel Seghers and Erasmus II Quellinus
99. *Flower Garland with Christ as the Man of Sorrows*

Oil on canvas, 129.5 x 98 cm (51 x 38 ⅝ in.)
Signed at bottom left: Daniel. Seghers. Soc^tis JESV.
Berlin, Staatliche Museen zu Berlin, Gemäldegalerie.
Property of the Kaiser-Friedrich-Museums-Verein,
inv. KFMV 281

PROVENANCE: acquired from the dealer John H. Schlichte Bergen, Amsterdam, by the Kaiser-Friedrich-Museums-Verein for the Staatliche Museen Preussischer Kulturbesitz, 1989.

LITERATURE: J. Kelch, in *Ten Years of Kunsthandel Drs. John H. Schlichte Bergen 1979-1989* (Zwolle, 1989), pp. 34-35; J.-P. de Bruyn, "Erasmus II Quellinus (1607-1678): addenda en corrigenda," *Jaarboek van het Koninklijk Museum voor Schone Kunsten, Antwerpen* (1990), p. 323; "Gemäldegalerie: Erwerbungen," *Jahrbuch der Berliner Museen* 32 (1990), p. 293.

IN THE CENTER of the composition, a trompe l'œil sculpted figure of Christ as Man of Sorrows is set within an oval niche, surrounded by an elaborately carved cartouche of dark gray stone. The cartouche is surmounted by an eagle with outspread wings. Tucked around the central image is a brilliant assortment of lush blossoms and bristling foliage; two butterflies are poised delicately among the tendrils. The central figure of Christ is by Erasmus II Quellinus; the flora, fauna, and sculptural cartouche were supplied by Daniel Seghers.

Seghers and Quellinus produced at least twenty-nine paintings in collaboration, all floral garlands encircling a central religious image. Daniel Seghers's inventory of his own paintings, "Cataloge van de Bloemstukken, die ik selfs met mijn hand heb geschildert en voor wie" lists twenty-eight works done in collaboration with Quellinus.[1] Of these, about half can be identified with known paintings; de Bruyn attributes several other (unsigned) compositions to this collaboration, bringing the total number of works by the two artists again up to twenty-eight, not including the present, recently discovered painting. Only one of these paintings is known to have been signed by both artists, a *Garland Surrounding a Bas-relief of the Miracle of St. Bernard* (completed in 1648),[2] although most other works attributed to the artists were signed by one of the hands. On the basis of the chronological entries in Seghers's "Cataloge," it can be deduced that the two artists worked together from about 1630 until Seghers's death in 1661.[3] Seghers probably completed his portion of the composition before passing it on to Quellinus or another artist for the painting of the central medallion; there are several existing paintings by Seghers in which a garland of flowers encircles a blank cartouche.[4] Most of the images supplied by Quellinus for these cartouches were rendered as illusionistic sculptures and bas reliefs; he also painted scenes in grisaille and in color.[5]

The significance of paintings such as the *Flower Garland with Christ as the Man of Sorrows* lies in the fact that the floral garland encircles not a traditional image of Christ himself, but a trompe l'œil image, a painting or sculpture contained within the painting itself. The iconography and associations of this type

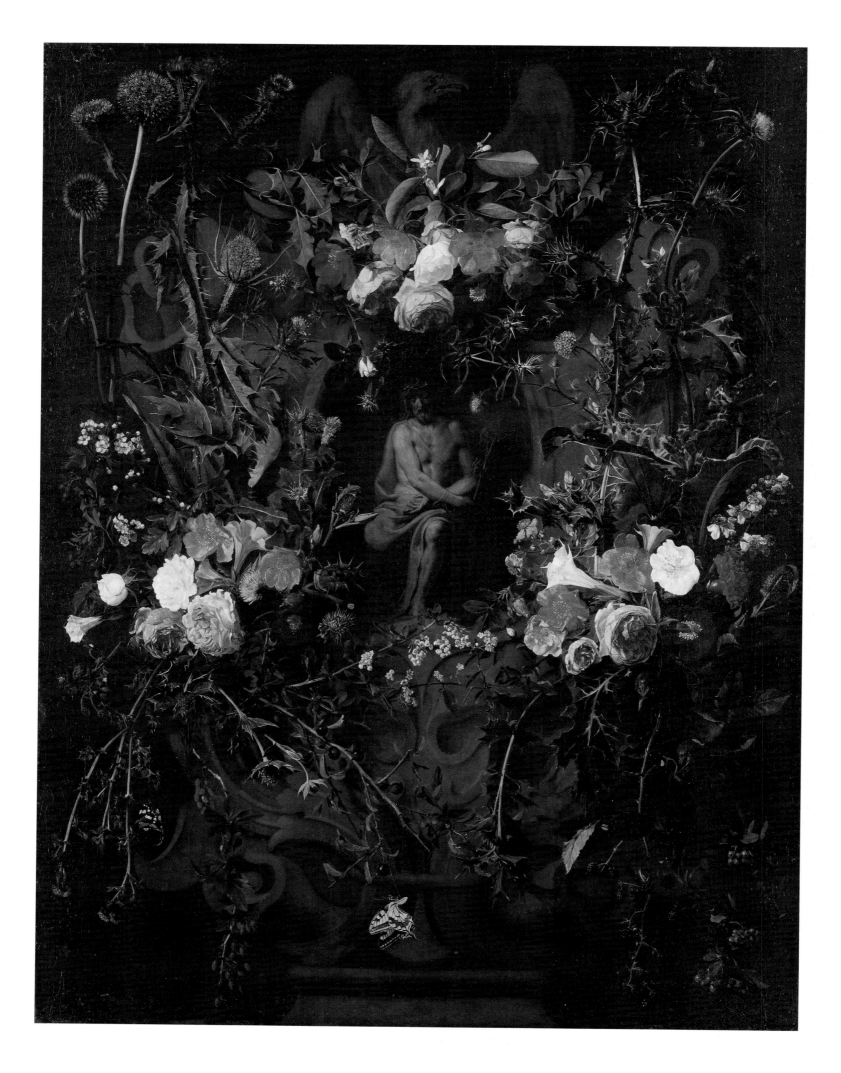

Fig. 1. Daniel Seghers and Erasmus Quellinus, *Flower Garland with Pietà*, 1651, oil on canvas, 146 x 114 cm, formerly Dessau, Schloss Mosigkau, inv. 46.

Fig. 2. Daniel Seghers, *St. Catherine Receiving the Crown of Thorns*, oil on canvas, 120 x 90 cm, Antwerp, Koninklijk Museum voor Schone Kunsten, inv. 331.

Fig. 3. Daniel Seghers and Erasmus Quellinus, *Flower Garland with Ecce Homo*, oil on canvas, 94.5 x 71 cm, Monumenti, Musei e Gallerie Pontificie Viale Vaticano, inv. 443.

of image have been analyzed by David Freedberg, with particular reference to images of the Madonna within a floral surround.[6] Briefly, these paintings were created to confirm the status and validity of images as objects of veneration, which was a fundamental aspect of Catholic treatises on art following the Iconoclastic (anti-image) riots of 1566, and which was based on the belief that any veneration paid to the image passed to its prototype. The garlands of flowers painted around the image were also a symbolic and metaphorical extension of the contemporary practice of draping garlands around images for feast and holy days. Finally, there is the more mundane consideration of the value that the painted flowers bestowed on the image as a whole because of their intrinsic – rather than metaphorical – significance: then as now, floral still lifes were among the most costly and highly prized works of art.[7]

The majority of images enclosed within flower garlands depicted the Madonna and Child; secular subjects, images of saints, and scenes from Christ's Passion were somewhat less common. The Man of Sorrows, like the Madonna and Child, was a traditional devotional image and not a depiction of a biblical event; contemplation of the image was intended to arouse in the viewer strong empathy for Christ's suffering and sacrifice. Its use in this context – a trompe l'œil image contained within a floral garland – would have been intended to validate it as a devotional image. Quellinus's representation conforms to the pictorial tradition, showing Christ seated with a cloak draped loosely about him, his hands bound at the wrist. He wears a crown of thorns and in one hand holds a reed scepter, two attributes of the Passion that were awarded him by the mocking soldiers who were his captors.

Spiky, thorny plants predominate in the sprays of flowers and foliage surrounding the central medallion of the *Flower Garland with Christ as Man of Sorrows*. Plants such as the holly, brambles, and several varieties of thistle depicted here all allude to Christ's crown of thorns, and thus reiterate the theme represented in the central medallion.[8] The menacing aspect of these plants is softened by the meticulously painted floral bouquets of roses, anemones, orange blossoms, stramonium, carnations, and other blooms. The eagle which crowns the composition – a rare figural motif among Seghers's sculpted cartouches – was a symbol of Christ, and more specifically of his Resurrection. The butterflies at the base of the composition were also a traditional symbol of the Resurrection.

Flower Garland with Christ as Man of Sorrows has been dated to ca. 1645-1650. If, however, as Hairs sug-

gests, the use of thorny bouquets such as in the present painting, and in paintings in Dessau (dated 1651; Schloss Mosigkau; fig. 1) and Antwerp (Koninklijk Museum voor Schone Kunsten, inv. 331; fig. 2), dates to the end of Seghers career,[9] the present work may have been executed towards the end of this period, about 1650 or slightly later. This is consistent with the stylistic development of figure types in Quellinus's painted bas-reliefs; de Bruyn notes that Quellinus painted in a more classical and less Rubensian style in the early 1650s.[10]

MEW

1. On the collaboration of Seghers and Quellinus, documented paintings, and more recent attributions, see de Bruyn 1980a; and de Bruyn 1988, pp. 61-62. Daniel Seghers's inventory was published (with extensive annotations) in Couvreur 1967. The Berlin painting cannot be positively identified with any of the paintings listed in the inventory.

2. Canvas, 100.5 x 73 cm; signed lower left: *Daniel Seghers. Soctis JESV.* and on the medallion: *Erasmus Quellinus*, with Leger Galleries, London, 1981. The painting was done for Seghers's nephew Domenicus Bocx. See de Bruyn 1980a, pp. 273, 276; and Hairs 1985, p. 176.

3. For a discussion of the chronology of Seghers's "Catalogue," see Couvreur 1967, pp. 136-139.

4. For example, in the Museum voor Schone Kunsten, Ghent (inv. 1886-A) and Statens Museum for Kunst, Copenhagen (inv. 658), ill. Hairs 1985, pp. 161 and 158, respectively. There are similar examples of empty cartouches in the works of other garland painters, such as Jan Philips van Thielen (Vienna, Kunsthistorisches Museum, inv. 285) and Joris van Son (Copenhagen, Statens Museum for Kunst, invs. 674 and 675).

5. See de Bruyn 1980a, passim. It is worth noting in this context that Quellinus came from a family of sculptors; he is known to have painted copies of sculptural groups by his brother Artus I Quellinus. See Gabriels 1930, pp. 170-71; and de Bruyn 1984, p. 274.

6. Freedberg 1981.

7. Ibid., p. 126. See also cat. 95.

8. Of the eleven paintings listed in Seghers's "Catalogue" that feature *distelen, doornen* and/or *steekende bloemen* (thistles, thorns and/or spiky flowers), seven entries mention the theme of the central image: three Pietas, two Ecce Homos, one Crowning of Christ, and one Madonna with the Instruments of the Passion (see Couvreur 1967, nos. 152, 176, 177, 178, 203, 221 and 232). A survey of extant paintings with thorny garlands yields similar results, including *St. Catherine Receiving the Crown of Thorns* (Antwerp, Koninklijk Museum voor Schone Kunsten, inv. 331) and an *Allegory of the Immaculate Conception* (Dresden, Gemäldegalerie Alte Meister, inv. 1204).

9. Hairs 1985, pp. 174, 183.

10. De Bruyn 1984, pp. 310-11.

Jan van Kessel the Elder

(1626-Antwerp-1679)

Jan van Kessel was baptized in the Sint Joriskerk in Antwerp on 5 April 1626. His father, Hieronymus II van Kessel (1578-ca. 1635), was a painter and some-time collaborator of Jan Brueghel the Elder (q.v.); his mother, Paschasia, was the daughter of Jan Brueghel the Elder. In 1634/35, van Kessel was registered in the Antwerp guild of St. Luke as the pupil of Simon de Vos (1603-1676). He apparently also received instruction from his uncle Jan Brueghel the Younger (1601-1678); in 1646 Brueghel commissioned van Kessel to execute copies after his paintings. Van Kessel became a master in the guild in 1644/45, with the designation "blomschilder" (flower painter). He married Maria van Apshoven (d. 1678) in the Onze-Lieve-Vrouwekerk in Antwerp on 11 June 1647; among the witnesses was the artist's uncle, David Teniers the Younger (q.v.). The couple had thirteen children, of whom Ferdinand (1648-1696) and Jan the Younger (1654-1708) also became painters.

On 24 September 1655 van Kessel purchased the house "De Witte en de Rode Roos" (The White and the Red Rose), near the Sint-Joris cemetery in Antwerp. The artist dictated his last will and testament on 17 April 1679, and on 18 October died in relative poverty, having mortgaged his home to cover his debts.

Van Kessel's dated paintings range from 1648 to 1676, and are predominantly small-scale works on copper or panel, brilliantly hued and executed with miniaturistic detail. His subject matter included animals (mostly birds, fish, and insects), still lifes of fruits, vegetables, game or decorative objects, and flower pieces and garlands, the latter frequently achieved in collaboration with other artists. Van Kessel's allegorical representations of the Five Senses, the Four Elements, or the Four Parts of the World are strongly indebted to Jan Brueghel the Elder. His many detailed sketches of insects and plants exhibit an almost scientific precision reminiscent of similar studies by Joris Hoefnagel. Van Kessel executed decorative borders for a series of twenty paintings illustrating scenes from the lives of the Spanish noblemen Antonio and Guillermo Ramon Moncada; the central images were painted by Teniers, Willem van Herp, Adam Frans van der Meulen (qq.v.), and Luigi Primo (Louis Cousin).

Meyssens 1649; de Bie 1661, pp. 409-411; Houbraken 1718-21, vol. 2 (1719), pp. 139-140, vol. 3, p. 238; Weyerman 1729-69, vol. 2 (1729), p. 208; Descamps 1753-64, vol. 2, pp. 385ff; Kramm 1857-64, vol. 3 (1858), p. 852; Rombouts, van Lerius 1872, vol. 2, pp. 62, 65, 155, 162, 467; Michiels 1865-76, vol. 9 (1874), pp. 208ff, vol. 10 (1876), p. 429; van den Branden 1883, pp. 1098-1101; Wurzbach 1906-11, vol. 1 (1906), p. 258; Oldenbourg 1918a, pp. 17, 198; K. Zoege van Manteuffel, in *Monatshefte für Kunstwissenschaft* 14 (1921), pp. 4off; Thieme, Becker 1907-50, vol. 20 (1927), pp. 201-202; Hairs 1955, pp. 112-113, 225-228; Greindl 1956, pp. 127-128, 176-177; Speth-Holterhoff 1957, pp. 123-126; Munich 1973; Müllenmeister 1978-81, vol. 2, pp. 84-86; Brussels 1980, pp. 313-332; Greindl 1983, pp. 156-162, 365-368; Hairs 1985, pp. 287-300, 483-485; I. Bergström, in Washington/Boston 1989, pp. 112-114.

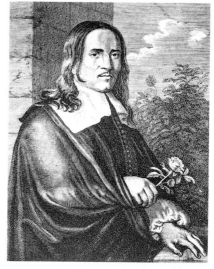

Erasmus II Quellinus, *Jan van Kessel the Elder*, engraving.

Jan van Kessel the Elder
100. *Flowers in a Glass Vase*, ca. 1652

Oil on copper, 75.6 x 57.5 cm (29 ¾ x 22 ⅝ in.)
Signed: J v Kessel fecit
Mrs. H. John Heinz III

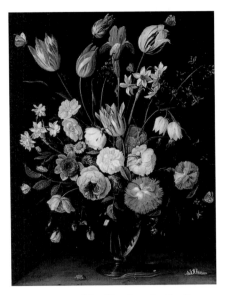

Fig. 1. Jan van Kessel the Elder, *Flowers in a Glass Vase*, signed and dated lower right: J. V. Kessel fecit / anno 1652, oil on copper, 77.5 x 60 cm, London, Richard Green Gallery (sale New York [Christie's], 31 May 1991, lot 86).

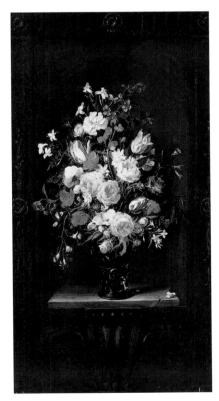

Fig. 2. Daniel Seghers, *Bouquet of Flowers in a Niche*, signed, oil on canvas, 121 x 64 cm, Madrid, Escorial Monastery.

PROVENANCE: collection Marquis de las Nievez, 1936; private collection.

EXHIBITIONS: Madrid, Sociedad Española de amigos del arte, *Floreros y bodegones en la pintura Española* (1936-40), no. 135, ill.; Washington/Boston 1989, no. 22.

LITERATURE: J. Cavestany, in exh. cat. Madrid 1936-40, pp. 52, 80, 167; G. Oña Iribarren, *165 firmas de pintores tomadas de cuadros de flores y bodegones* (Madrid, 1944), pp. 31, 93; Hairs 1955, p. 226; Hairs 1965, p. 292; Hairs 1985, p. 484; I. Bergström, in Washington/Boston 1989, pp. 112-114.

101. *Flowers in a Porcelain Vase*, 1652

Oil on copper, 75.6 x 57.5 cm (29 ¾ x 22 ⅝ in.)
Signed and dated bottom center:
J v Kessel fecit A° 1652
Mrs. H. John Heinz III

PROVENANCE: collection Marquis de las Nievez, 1936; private collection.

EXHIBITIONS: Washington/Boston 1989, no. 21.

LITERATURE: I. Bergström, in Washington/Boston 1989, pp. 112-114.

IN *Flowers in a Porcelain Vase*, striped tulips, snake's head fritillaria, lilies, apple blossoms, roses, morning glories, forget-me-nots, narcissi, a crown imperial, and other flowers are loosely arranged in a blue and white Chinese vase. A dragonfly and several butterflies flutter about the blooms, while a caterpillar, ladybug, and other tiny insects traverse petals and stems. On the pedestal are a fallen leaf and a handful of small shells, a butterfly, and a bee. In the pendant painting, irises, hyacinth, roses, cornflowers, lilies, tulips, daffodils, and other blooms spill exuberantly forth from a glass roemer. Several insects investigate the flora, including bees, butterflies, a spider, and a dragonfly; a snail and a grasshopper inch along the contours of the supporting console.

This pair of paintings is apparently part of a series of eight monumental flower pieces on copper by Jan van Kessel.[1] Including *Flowers in a Porcelain Vase*, at least five of the works are dated 1652. Two paintings from the series were in the collection of the Marquis de Goubea in 1975[2]; two others were in the sale New York (Christie's), 31 May 1991, lots 86 (fig. 1) and 87[3]; and a seventh, signed and dated 1652, is in a private collection in the United States.[4]

These large-scale works on copper seem to be unique in van Kessel's œuvre. His other flower pieces are more modest in format, and depict correspondingly simpler arrangements. The imposing scale and complexity of the present works suggest that they were executed for an important commission, although we have no specific information about who the patron may have been. The fact that the two exhibited paintings, as well as the other works in the

series, all first appeared in Spanish collections may indicate that they were originally executed for a Spanish patron. There is, however, no reason to assume that van Kessel was himself active in Spain, as Bergström has stated.[5] More plausibly, Bergström has also suggested that Daniel Seghers, who frequently worked for Spanish patrons, may have been instrumental in securing such a commission for the younger artist, whose flower pieces owe much to Seghers's distinctively crisp style.[6] Intriguing in this regard is the similarity between van Kessel's unusually majestic series and Daniel Seghers's pendant paintings of floral bouquets in niches, painted for the Escorial monastery in ca. 1630 (fig. 2).[7]

The same selection of objects is repeated among the seven known works from van Kessel's series. For example, the unusual Chinese porcelain vase fitted with gilt mounts in cat. 101, set atop a draped pedestal littered with shells and insects, is seen also in one of the Goubea paintings. Similarly, the glass roemer in cat. 100, placed on a pedestal ornamented by an elaborately sculpted cartouche, recurs in the other piece from the Goubea collection. The wide variety of insects incorporated in each of the paintings in the series recalls van Kessel's numerous small panels with studies of individual butterflies, insects, and small blossoms (see Introduction, fig. 95).

MEW

1. Washington/Boston 1989, p. 113; see also M. Díaz Padrón, in Brussels 1975, pp. 97-98.

2. Both 76 x 59 cm, signed and dated 1652; exh. Brussels 1975, nos. 20 and 21, as formerly in the collection of the duc d'Aveyro.

3. Both 77.5 x 60 cm; the former signed and dated 1652.

4. Signed and dated 1652; illustrated in Washington/Boston 1989, p. 113, fig. 4.

5. Bergström (in Washington/Boston 1989, p. 113) suggested that Jan van Kessel the Elder was in Spain as court painter to Philip IV, citing as his source Francisco Javier Sanchez y Cantón, *Los Pintores de Cámara de los Reyes de España* (Madrid, 1916, p. 104). The latter text, however, clearly refers to van Kessel's son Jan the Younger, who was active in Spain from at least 1679 until his death in 1708.

6. Washington/Boston 1989, p. 114.

7. The paintings may be identical with those mentioned in Seghers's inventory of his works: "twee voor onze Princesse Infante [the Infanta Isabella Clara Eugenia] op doek in d'een had Sr Simon Devos distelen en stekende bloemen geschildert, in d'ander waeren alle soorten van bloemen ronde kransen die Don Francisco De Mello heeft mede gedragen in Spagnien" (see Couvreur 1967, pp. 109-110). Compare also Seghers's *Bouquet in a Glass Vase*, signed and dated 1643 (formerly Dresden, Gemäldegalerie Alte Meister, inv. 1201; ill. cat. 98, fig. 1).

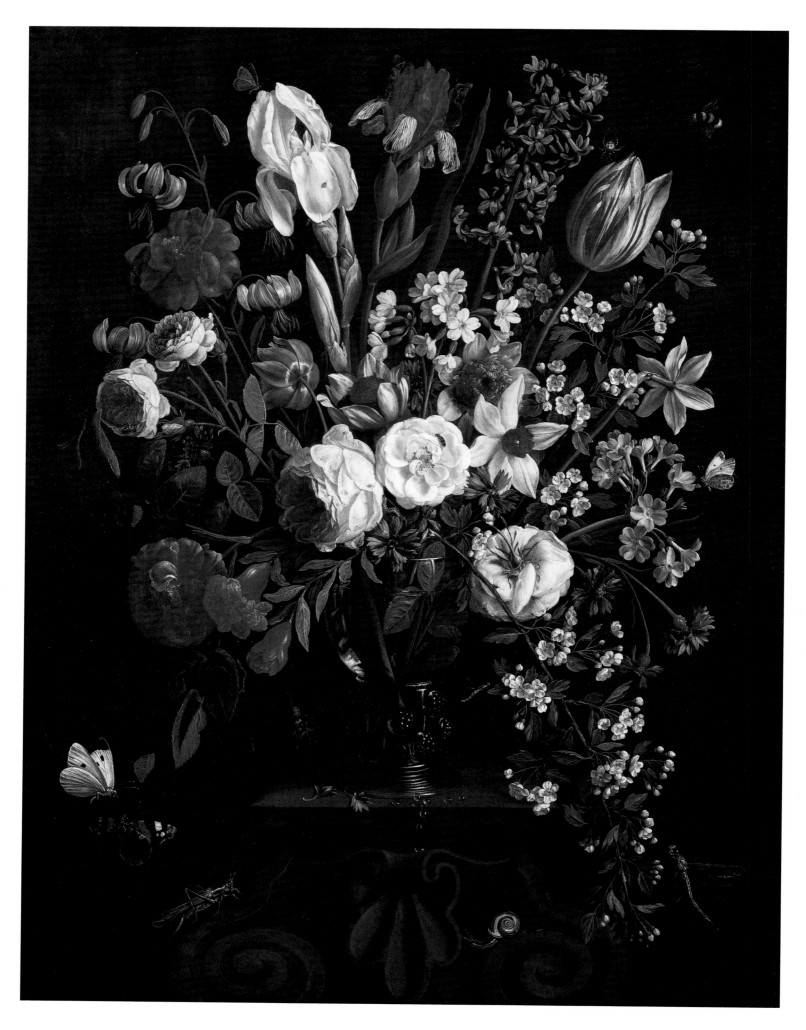

cat. 100

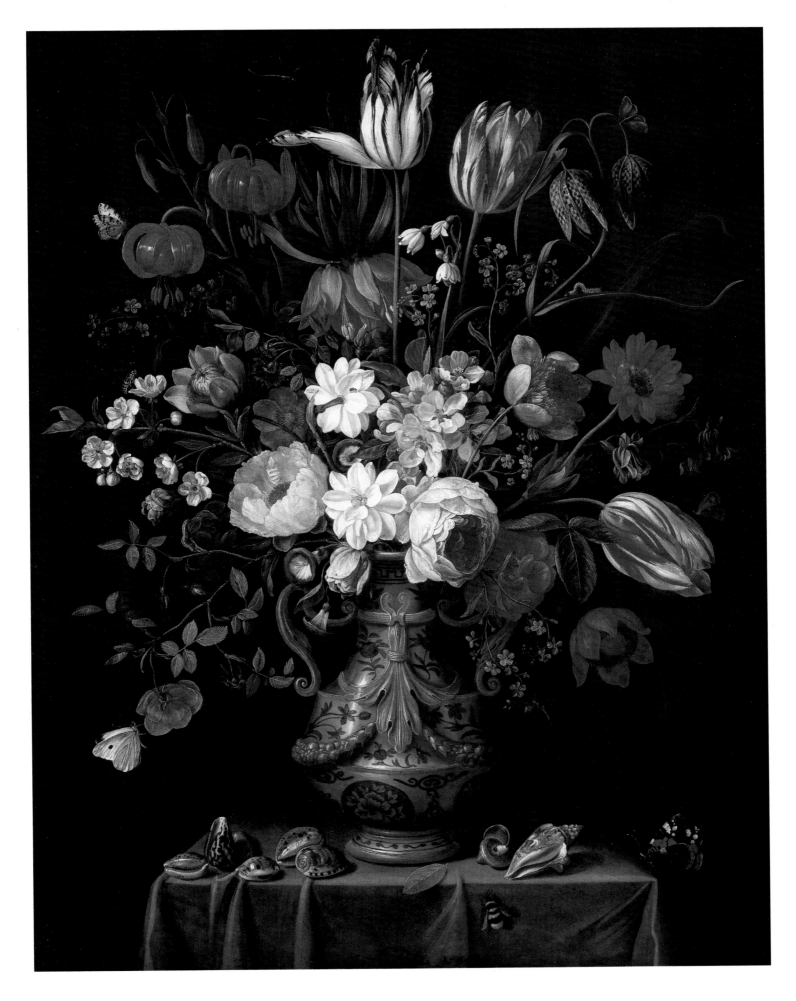

cat. 101

Jan Davidsz. de Heem
102. *Flower Still Life*

Oil on copper, 48.9 x 38.1 cm (19 ¼ x 15 in.)
Signed on the edge of the table: J. D. De Heem f.
Private collection

PROVENANCE: M. Potocki, Jablonna, until at least 1939; seized by the Nazis during World War II; Ronald A. Lee, London, 1948; with dealer Duits, London, 1948; F. Jurgens, Englefield Green, Surrey; sale Monte Carlo (Christie's), 3 April 1987, no. 9, ill.

EXHIBITIONS: Warsaw, *Wazan z Kwiatami* (cat. by Michal Walicki), 1939, no. 51.

LITERATURE: W. Tomkiewicz, *Catalogue of Paintings Removed from Poland by the German Occupation Authorities during the Years 1939-1945* (Warsaw, 1950), p. 60, no. 149, pl. 143; Sutton in The Hague/San Francisco 1990-91, pp. 117, fig. 22.

AN ARRANGEMENT of flowers in a glass vase rests on a stone ledge. The blossoms include poppies, roses, tulips, a yellow Geum, Queen Anne's lace, dianthus, aquilegia, anemones, morning glory, carex, primula, a branch of cherry blossoms, scilla, and tradescantia, interspersed with blades of wheat. Butterflies, snails, caterpillars, spiders, beetles, ants, and a bee also appear, as well as a sprig of crab apple.

Flower still lifes with bouquets in a vase had been a specialty of Netherlandish artists since Jan Brueghel, Roelant Savery, and Ambrosius Bosschaert the Elder inaugurated the tradition in the early years of the seventeenth century. A later practitioner of this genre, de Heem's earliest signed and dated flower still life of 1635 is in the style of Bosschaert's son, Ambrosius Bosschaert the Younger (Paris, Musée du Louvre, inv. RF. 39-10),[1] but the majority of his flower still lifes proper seem to date from after ca. 1650. These works follow earlier conventions in depicting a variety of blossoms from different seasons symmetrically arranged in a vase on a stone ledge against a darkened background. De Heem's own contribution to this important sub-genre of still life was to bring to it an even higher standard of naturalistic observation, coupled with unprecedented harmony of color and compositional coherence. His bouquets are brilliantly varied and rich in form, color, and detail. Though the overall effect at first appears decorative, close examination reveals that the harmony arises from a sophisticated balancing of complementing formal elements: unity and variety, repose and activity, pattern and relief.

Especially later in his career, in the 1660s, de Heem depicted bouquets together with other objects, usually shells, fruit, or rich metalware on relatively large canvases.[2] The present work is more restrained and less ornamental than these paintings and the *Flower Still Life* in Washington (fig. 1), which nonetheless employs a comparable design and some of the same blossoms.[3] Painted on copper, an especially prestigious support, it is also more preciously finished. Most comparable to the present work in scale as well as subject is the *Flower Still Life in a Glass Vase on a Stone Ledge* (on wood panel) in the Musées

Royaux des Beaux-Arts, Brussels (inv. 105),[4] while another comparable but somewhat smaller work (on panel) was sold in London at Sotheby's on 9 December 1987, no. 91.[5]

Some of de Heem's flower still lifes undoubtedly have a symbolic dimension; for example, the *Flower Still Life with Shells and Skull* in Dresden (fig. 2), which is probably comparable in date to the present work, includes an inscription on a paper "Memento Mori" (think on death) to stress the *vanitas* associations of the skull and of the flowers that like all life will soon fade and die.[6] However it would probably be a misguided effort to assign symbolic meanings to each of the blossoms in the present bouquet, and it would surely be a mistake to attempt to tally up all those associations in the search for a collective meaning. While for the metaphorically minded seventeenth-century viewer many of the motifs – in the present work and especially the prominence of the poppy – might have inspired reflections on a rich history of symbolism, the allegorical aspect of this work is probably secondary to its virtuoso celebration of the inherent beauty of the flowers.

PCS

1. Canvas, 69 x 58 cm, cat. 1979, p. 78, as by Jan Jansz. de Heem and dated 1685 (but see S. Segal in Utrecht/Braunschweig 1991, p. 20, fig. 1); also Berlin, Staatliche Museen zu Berlin, Gemäldegalerie, no. 906-A, which is probably a relatively early flower still life by de Heem.

2. See, as examples, the *Flower Still Life with Apricots and Other Fruit*, oil on canvas, 100 x 75.5 cm; Dresden, Gemäldegalerie Alte Meister, inv. no. 1267; and *Flower Still Life with Tazza and Birds*, oil on canvas, 114.5 x 94.5 cm; private collection; respectively Utrecht/Braunschweig 1991, cats. 31 and 33.

3. See Utrecht/Braunschweig 1991, cat. 30, ill.

4. Signed, oil on panel, 47.5 x 37 cm.

5. Signed "J. D. De Heem R.," oil on panel, 34 x 27 cm; Brussels 1965, no. 104 (with incorrect dimensions and signature).

6. See Utrecht/Braunschweig 1991, cat. 28, ill.

Fig. 1. Jan Davidsz. de Heem, *Flower Still Life with Poppies*, signed, oil on canvas, 69 x 56 cm, Washington, D.C., National Gallery of Art, no. 1961.6.1.

Fig. 2. Jan Davidsz. de Heem, *Flower Still Life with Shells and Skull*, signed, oil on canvas, 87.5 x 65 cm, Dresden, Gemäldegalerie Alte Meister, no. 1265.

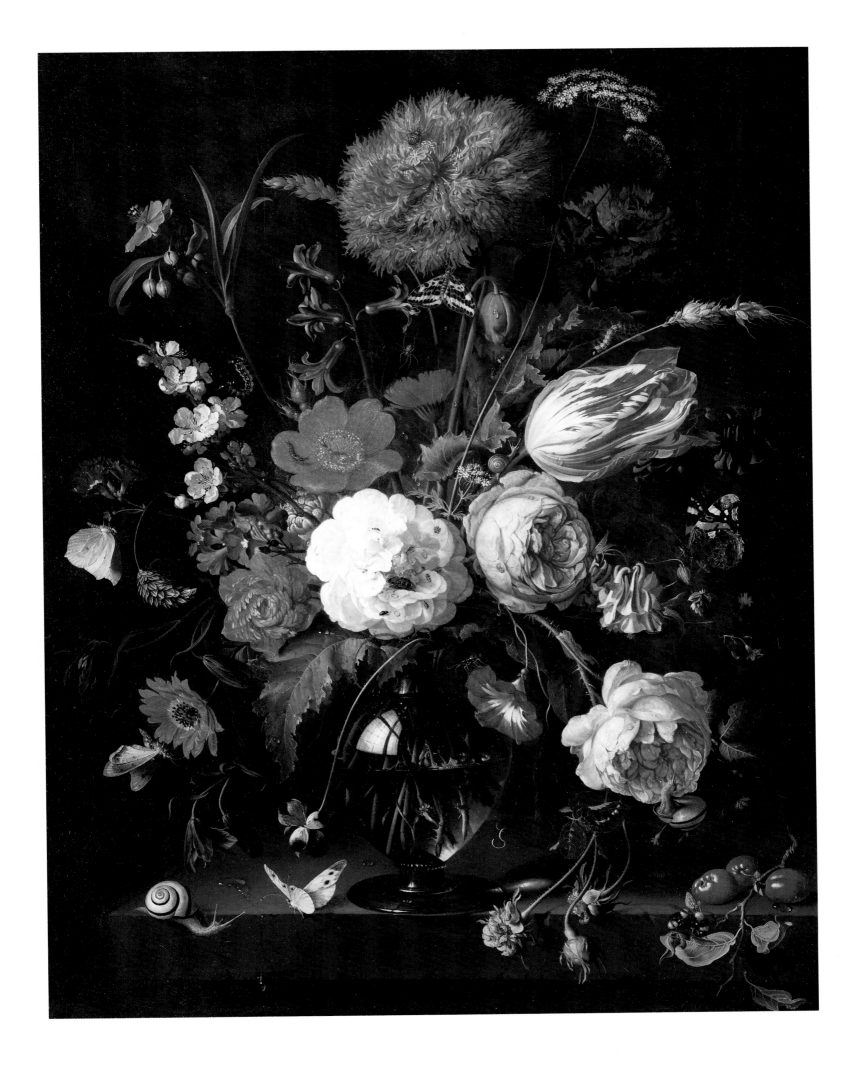

Jan Davidsz. de Heem

103. Fruit and Flower Garland about a Wine Glass in a Niche, 1651

Oil on canvas, 122.5 x 86.5 cm (48 ¼ x 34 in.)
Signed and dated in the left middle:
J De Heem f / Ao 1651
Berlin, Staatliche Museen zu Berlin, Gemäldegalerie,
inv. 906B

PROVENANCE: (possibly) Jacomo de Wit, Antwerp; (possibly) sale J. de Wit, Antwerp, 15 May 1741, no. 16 [fl. 400]; collection Joseph Cardinal Fesch (d. 1839), cat. 1844, vol. 2, no. 98 [called L'Œil de la providence]; sale Leroy d'Etoilles, Paris (Hôtel Drouot), 21-22 February 1861, no. 46 [bought in]; Reiset collection, Paris; acquired through B. Suermondt in Paris in 1878 for the Kaiser Friedrich-Museum, Berlin; from 1946 to 1950 in the Soviet Union.

EXHIBITIONS: Brussels, Exposition de tableaux et dessins d'ancien maîtres, organisée par la société néerlandaise de la bienfaisance à Bruxelles, 1873, p. 35, no. 89; Essen, Museum Folkwang, Blumen und Gärten in Gemälden alter Meister, 1938; Dresden, Gemäldegalerie Alte Meister, Das Stilleben und sein Gegenstand, 1983, p. 123, no. 74, ill. 81; Utrecht/Braunschweig 1991, no. 21, ill.

LITERATURE: Hoet 1752, vol. 2, p. 32; G. F. Waagen, Handbuch der deutschen und holländischen Malerschulen (Stuttgart, 1862), vol. 2, p. 248; van Lerius 1880-81, p. 240; Toman 1888a, p. 137; Wurzbach 1906-11, vol. 1 (1906), p. 657; A. Sjölblom, Die koloristische Entwicklung des niederländischen Stillebens im 17. Jahrhunderts (Würzburg, 1917), pp. 52-53; Schneider, in Thieme, Becker 1907-50, vol. 16 (1923), p. 224; Warner 1928, pp. 59, 96-97, no. 43b, ill.; Bergström 1956a, pp. 205, 207-208, 211, ill. p. 173; Hairs 1955, p. 138, 219; Hairs 1965, pp. 268, 283; Knipping 1974, vol. 2, p. 300; C. Klemm, "Weltdeutung-Allegorien und Symbole im Stilleben," in exh. cat. Münster/Baden-Baden 1979-80, p. 42; Veca, in exh. cat. Bergamo, Galleria Lorenzelli, Vanitas – Il simbolismo del tempo, 1981, pp. 121-122, 205-206, ill. fig. 143; I. Geismeier, in exh. cat. Dresden 1983, p. 123; I. Bergström and S. Segal, "A Feast for the Eye and Mind – The Dresden Still Life Exhibition," Tableau 6, no. 4 (1984), p. 78; Hairs 1985, vol. 1, p. 394, vol. 3 p. 29; H. Marx, Stilleben als Augentauschung – Trompe l'œil (Leipzig, 1985), pp. 14-15, no. 8 ill.; O. Dolenda in exh. cat. Caen, Musée des Beaux-Arts, Symbolique et botanique – Les sens cachés des fleurs dans la peinture au XVIIe siècle, 1987, p. 19, ill.; F. Meijer, in Rotterdam, Museum Boymans-van Beuningen, Eigen collectie: Stillevens uit de Gouden Eeuw, 1989, p. 84, note 4; Segal 1990, pp. 218-219, fig. 53c.

Fig. 1. Jan Davidsz. de Heem, Monstrance with Garland of Flowers and Fruit, signed and dated 1648, oil on canvas, 138 x 125 cm, Vienna, Kunsthistorisches Museum, inv. no. 571.

GARLANDS adorn a stone cartouche with a central niche holding a roemer half filled with white wine. The garlands are suspended by ivy and include a wide variety of fruit and flowers. On the bottom of the cartouche is a plinth surmounted by a carved lion's head. To either side of the niche are two winged stone seraphim with red and blue headbands forming part of the upper decoration of the cartouche. The latter is surmounted by a shell. Insects, butterflies, a lizard, and a bird also appear.

As early as 1844, when the painting appeared in the collection of Cardinal Fesch (cat. 1844, vol. 2, no. 98) it was entitled "L'œil de la providence" (The Eye of Providence), no doubt in reference to the eye which is just visible in the miraculous triangle of light.[1] The painting has correctly been recognized as one of a fairly large group of still lifes devoted to the theme of the Triumph of the Eucharist,[2] the tradition of which was discussed in detail by Christian Klemm.[3] As seen in several paintings in this exhibition, the Counter Reformation emphasized the importance of the sacraments, especially the eucharist and confession.[4] Particularly in the Southern Netherlands, the real presence of Christ in the bread and wine of communion was stressed by the Jesuits. The devotion to the eucharist was fostered by the resurgent Roman Catholic Church and enforced by the archdukes and their court and, later, by Cardinal Infante Ferdinand. Initially the doctrine of transubstantiation was visually conveyed by garland paintings with figures in the center, as in the Madonna and Child with Flower Garland by Rubens and Jan Brueghel the Elder in the Alte Pinakothek, Munich (Introduction, fig. 30) and later by the monstrance of the eucharist with the host.

As Knipping and others have observed, de Heem painted a picture very similar to the present painting three years earlier (fig. 1) which depicts a silver chalice with the glowing symbol of the host as well as a tiny representation of the crucified Christ in a garland-covered niche.[5] There, as here, the ears of ripened wheat in conjunction with the grapes are traditional symbols of the eucharist. This 1648 painting of the chalice from the mass already figured in the 1659 inventory of the Archduke Leopold Wilhelm of Austria and was probably commissioned directly from de Heem when Leopold Wilhelm was in Brussels.[6] The latter assembled a large group of flower still lifes of this type, which like the rest of his collection are preserved in the Kunsthistorisches Museum, Vienna.[7] In both the 1648 painting and the present work the sheaves of wheat and grapes refer respectively to the bread that is the body of Christ (as well as the Church), and the wine that is his blood (or his teachings). These traditional symbols also figure in the cornucopia in the foreground of the Rubens's eucharist tapestry modello, cat. 22.

The fruit, flowers, insects, and animals in the painting have all been meticulously identified by Segal, who noted the exceptional care with which they have been observed and the subtle details in such passages as the skins of the gooseberries, the silk of the ears of wheat, and the different stages of the flora's development, from mere buds to ripened fruit.[8] Geismeier, Klemm, and Segal all drew attention to the prominence of the sunflower and the pomegranate in the present work.[9] The latter is a traditional Christian symbol of the Church, its seeds standing for the faithful who are covered and nourished by the fruit. By its position directly above the glass the sunflower probably has an even more central symbolic role. Because of its heliotropic behavior (the flower always turns to follow the sun), the sunflower appeared in several emblem books as a symbol of love, both sacred and profane.[10] In 1625 Zacharius Heyns published an emblem of a sunflower (fig. 2) with the motto "Christi, actio imitatio nostra" (Let us follow Christ), together with a text from John 8:2, quoting Jesus: "I am the light of the world; he who follows me will not walk in darkness, but will have the light of life."[11] The miraculous glow emanating in a triangular shape from the wine glass surely is this heavenly light, just as the eye that hovers in its midst was correctly identified long ago as the all-seeing eye of Providence. While the wine glass with the alternating prunts decorating the stem and "pearl necklace" base is not a proper monstrance, Segal has noted that this is a rare type of glass and undoubtedly holds eucharistic wine.[12] Klemm has suggested that the seraphim allude generally to the sacred character of the subject.[13] However it seems more likely that they allude specifically to the angels who graced the Ark of the Covenant (compare the angels surmounting the Ark in cat. 22).[14] As Segal noted, the bird and the butterfly are traditional symbols of deliverance.[15]

A later though undated painting by de Heem also depicted a cartouche with a wine glass,[16] and other artists also took up this theme.[17]

PCS

1. See Cardinal Fesch catalogue 1844, vol. 2, p. 80, no. 98.

2. See Bergström 1947, p. 212, fig. 173; Bergström 1956a, p. 206, fig. 173; Geismeier 1976, p. 41; and Utrecht/Braunschweig 1991, pp. 164-167, cat. no. 21, ill.

3. See C. Klemm, "Eucharistische Symbolik," in his essay "Weltdeutung-Allegorien und Symbole in Stilleben," in exh. cat. Münster/Baden-Baden 1979-80, pp. 182-190. On the eucharist in art generally, see K. Lankheit, Reallexikon zur deutschen Kunstgeschichte, vol. 6 (Munich, 1973), pp. 154-254; M. Vloberg, L'eucharistie dans l'art, 2 vols. (Grenoble, 1946); and Knipping 1974, pp. 297-308.

4. See cats. 20-22, Rubens's various modelli for the "Triumph of the Eucharist" tapestry series; and his sketch for St. Norbert (cat. 25), the national saint of the eucharist.

5. See Knipping 1974 (1st ed. 1939-41), vol. 2, pp. 300-301, pl. 284; followed by Klemm 1979-80, p. 183, ill.; and Utrecht/Braunschweig 1991, p. 166, ill.

6. See Utrecht/Braunschweig 1991, p. 167, note 5, referring to the handwritten inventory of 1659, fol. 187, no. 140; Berger 1883, p. LXVII. There was formerly an inscription on the painting which read: "Bacchus et alma Ceres caelestia pabula signant, Imperium signent et Leopolde, tuum" (Bacchus and the sublime Ceres allude to [or denote] the celestial nourishment, let them also, Leopold, allude to your empire). Wine and bread, connected with Bacchus and Ceres in antique myths, had been appropriated by the Christian iconography of the eucharist. Thus, as Segal has pointed out (Utrecht/Braunschweig 1991, p. 166), de Heem's inscription employs clever humanistic allusions to suggest that Christ's grace will favor and make fruitful the archduke's reign.

7. See G. Heinz, "Geistliches Blumenbild und dekoratives Stilleben in der Geschichte der kaiserlichen Gemäldesammlungen," Jahrbuch der Wiener Kunstsammlungen 69 (1973), pp. 7-54. See for example, the Eucharist with Flower Garland by Jan Anton van der Baren, Vienna, Kunsthistoriches Museum, no. 1145; ill. by Klemm 1979-80, p. 185, fig. 103. For another example, see François van Aachen's Monstrance with Flower Garland, dated 1669, sale London (Christie's), 19 April 1991, no. 76, ill.

8. Utrecht/Braunschweig 1991, p. 165 lists all the objects and supplies their Latin names.

9. Geismeier in Dresden 1983, p. 123; Klemm 1979-80, p. 574, note 155; Utrecht/Braunschweig 1991, pp. 166-167.

10. On the symbolism of the sunflower, see J. de Bruyn and J. A. Emmens, "De zonnebloem als embleem in een schilderlijst," Bulletin van het Rijksmuseum 1 (1956), pp. 3-9; E. de Jongh, "Bol vincit amorem," Simiolus 12 (1981-82), pp. 147-161, esp. 158; and Utrecht/Braunschweig 1991, p. 166.

11. Z. Heyms, Emblemata, Sinne-Beelden streckende tot Christelijcke Bedenckinghe ende Leere der Zedicheyt (1625), p. D2. Also attached are the verses "Soo moet de mensche med'oock daglyckx syn bereyt / Om volghen 's levens licht en syn gherechtigheyt" (So must man also be prepared each day / To follow the light of his life and his responsibility). The heliotropic behavior of the sunflower was also familiar from the story of Clytia, recounted by Ovid in his Metamorphoses (IV: 256-270), which tells of the nymph who was so in love with the sun that she was transformed into a flower that always followed her beloved. In the medieval Ovide moralisé the story was often interpreted as a metaphor for the love of Christ.

12. Utrecht/Braunschweig 1991, p. 167, note 2.

13. Klemm 1979-80, p. 574.

14. See Knipping 1974, p. 300, note 19. A garland still-life painting signed and dated 1650 by de Heem in Berlin, Staatliche Museen zu Berlin, Gemäldegalerie, no. 963, depicts two guardian angels amidst the traditional eucharist symbols of grapes and wheat but the central image has been replaced (presumably at a later date) by a mirror.

15. Utrecht/Braunschweig 1991, p. 140.

16. Signed, canvas, 98 x 76 cm; see Segal 1990, p. 167, note 10.

17. See, for example, Dresden, Gemäldegalerie Alte Meister, inv. no. 1268, as "de Heem" but reattributed by Utrecht/Braunschweig 1991, p. 167 to Joris van Son.

Fig. 2. Zacharias Heyn, emblem of a Sunflower, engraving, from Emblemata (Rotterdam, 1625).

Jan Philips van Thielen

(1618-Mechelen-1667)

Jan Philips van Thielen was baptized on 1 April 1618 in the Church of St. Rombout in Mechelen. He was the son of Librecht van Thielen, Lord of Couwenburgh, and Anna Rigoults. Van Thielen is mentioned as a pupil of his brother-in-law Theodoor Rombouts (q.v.) in the registers of the Antwerp St. Luke's Guild in 1631/32; he was subsequently accepted into the workshop of Daniel Seghers (q.v.) and was, in fact, the latter's only pupil. Van Thielen became a master in the guild in 1641/42.

In 1639 van Thielen married Francisca de Hemelaer, sister-in-law of Erasmus Quellinus (q.v.). The couple's nine children were all baptized in the Onze-Lieve-Vrouwekerk in Antwerp. Three of van Thielen's daughters also became flower painters: Maria Theresia (1640-1706), who became a master in the St. Luke's Guild in 1665; Anna Maria (b. 1642); and Francisca Catharina (b. 1645).

Van Thielen was registered as a *buitenpoorter* (non-resident citizen) in Antwerp on 9 March 1660, and on 14 March was accepted into the painter's guild in Mechelen. He apparently resided in that city for the remainder of his life. He died in 1667 and was buried at Boisschot, east of Mechelen.

Van Thielen was exclusively active as a flower painter. In addition to floral bouquets and festoons, he also painted garlands encircling cartouches with a central image by another artist, most frequently Erasmus Quellinus. About twenty-three examples of this partnership are known, dating from about 1635/40 to at least 1661. He also collaborated with Frans Francken the Younger, Cornelis Schut, and other artists. Van Thielen's works reveal the influence of Daniel Seghers in their vivid colors and firm technique; his arrangements tend to be more symmetrical than those of his mentor, however. Dated works by van Thielen are known from 1645 until the year of his death. Although the majority of his paintings are signed "I. P. van Thielen," he occasionally also used the signatures "I. P. van Thielen Rigouldts" (Florence, Galleria degli Uffizi, inv. 863; Vienna, Kunsthistorisches Museum, inv. 1128; Milan, Pinacoteca di Brera, inv. 652) and "I. P. van Thielen Heere van Couwenberghe" (exh. Brussels 1975, cats. 43, 44).

De Bie 1661, pp. 344-345; Houbraken 1718-21, vol. 2, p. 52, vol. 3, p. 105; Weyerman 1729-69, vol. 2 (1729), pp. 151ff; Descamps 1753-64, vol. 2, passim; Papebrochius 1845-48, vol. 5, pp. 220-221; Kramm 1857-64, vol. 6 (1864), p. 1623; Michiels 1865-75, vol. 8 (1869), p. 352; Rombouts, van Lerius 1872, vol. 2, pp. 27, 29, 128, 135; Neefs 1876, pp. 366-370; van den Branden 1883, pp. 993, 1132-1133; Wurzbach 1906-11, vol. 2 (1910), p. 707; Zoege van Manteuffel 1921a, pp. 34-35; K. Zoege van Manteuffel, in Thieme, Becker 1907-50, vol. 33 (1939), pp. 27-28; Hairs 1955, pp. 107-110, 243-245; Hairs 1965, pp. 204-207, 417-419; Brussels 1975, pp. 148-149; Morel-Deckers 1978, pp. 184-191; de Bruyn 1980a; Hairs 1985, pp. 263-275, 498-500; de Bruyn 1988, passim.

Erasmus II Quellinus, *Jan Philips van Thielen*, oil on paper on wood, 19 x 14 cm, Cologne, Galerie Abel.

Jan Philips van Thielen

104. *Bouquet in a Glass Vase*

Oil on panel, 52 x 37.5 cm (20 ½ x 14 ¾ in.)
Signed lower right: I. P. Van Thielen R.
London, Richard Green Gallery

PROVENANCE: private collection, France.

EXHIBITIONS: London, Richard Green Gallery, *The Flowerpiece through the Centuries*, 1990, no. 1; London, Richard Green Gallery, *Exhibition of Fine Old Master Paintings*, 1991, no. 19.

BRILLIANTLY ILLUMINATED against a neutral dark backdrop, an array of flowers is arranged in a footed glass vase. The blooms include several varieties of roses, tulips, and carnations; an iris, cyclamen, lilies of the valley, bitter orange and dwarf nasturtium; butterflies and smaller insects accent the restrained profusion. A blue butterfly, a caterpillar, and a large beetle explore the ledge on which the vase rests.

According to Hairs,[1] about twenty floral bouquets by van Thielen are known; none are dated. With few exceptions, they are set before a neutral background, with only the edge of a ledge or tabletop in the foreground of the composition to define the pictorial space. The flowers themselves are crisply highlighted and rendered with a rich creamy texture. The arrangement of the flowers within the vase in the present painting reveals van Thielen's debt to his mentor Daniel Seghers, who characteristically clustered rounded blossoms such as roses or anemones against the rim of the vase at the base of the bouquet (compare, for example, cat. 98). In works by both artists, the arrangement becomes airier at the perimeter, with lighter blooms lofted on supple but delicate stems.[2] Van Thielen's bouquets are often more attenuated, however, and the rendering of forms stronger and less finely detailed than Seghers's.

All of van Thielen's bouquets are judiciously composed of a comparatively restricted number of flowers, the blossoms clearly separated and easily distinguishable. The sleek striped tulip, highly prized among seventeenth-century horticulturists and tulip-bulb speculators,[3] seems to have been a favorite of the artist, and occurs in nearly all of his bouquets. A conspicuous indication of his interest in this flower is the *Bouquet of Tulips and Roses* formerly with the Nystad Gallery in The Hague (fig. 1), which depicts several of these tulips interspersed with a few roses; each stem is numbered and a slip of paper at the foot of the vase, weighted by a bottle of ink, records the Latin names of each specimen.

The numerous tiny insects which inhabit this bouquet and the ledge below are meticulously detailed yet lively, and recall Jan van Kessel's similarly miniaturistic and delightfully animated studies of insects with sprigs of flowers or fruit (see Introduction, fig. 95). Van Thielen signed the *Bouquet in a Glass Vase* with an "R." for Rigouldts (his mother's

Nicolaes van Verendael

(1640-Antwerp-1691)

Fig. 1. Jan Philips van Thielen, *Bouquet of Tulips with Two Roses*, signed, oil on panel, 89 x 67.5 cm, The Hague, Nystad Gallery (1954).

maiden name) following his name; although unusual, the same signature appears on several other works by the artist.

<div align="right">MEW</div>

1. Hairs 1985, p. 268; see also pp. 498-500, passim.

2. Ibid., pp. 134-135. Compare also the pendant *Vases with Flowers* by Seghers in a private collection (oil on panel, 76.5 x 29.5 and 77 x 29 cm, respectively; exh. The Hague, Mauritshuis, *Boeketten uit de Gouden Eeuw*, 1992, no. 25).

3. See J. Loughman, in exh. cat. Dordrecht, Dordrechts Museum, *De Zichtbaere Wereld*, 1992-93, p. 153; and Paul Taylor, "The Flower Fadeth. Looking at Floral Still Lifes in Golden Age Holland" (Ph.D. diss. Cambridge University, 1991), p. 24.

Nicolaes van Verendael (or Veerendael), son of the painter Willem van Verendael, was baptized in the Antwerp St. Andrieskerk on 19 February 1640. He was a pupil of his father, and joined the guild of St. Luke in 1656/57. On 20 March 1669 he married Catharina van Beveren, daughter of the sculptor Matthijs van Beveren. The couple had ten children by 1691, of whom only two survived. Verendael was not a wealthy man; in a document of March 1691 he acknowledged owing 140 guilders rent on his house on the Jodenstraat in Antwerp, and agreed to pay 18 guilders a year in order that his household goods not be repossessed. On 7 August 1691 Verendael drew up his last testament and four days later was buried in the abbey church of St. Michael. On 24 March 1692 his widow gave birth to his posthumous child.

Verendael is principally known as a painter of floral still lifes and garlands, although he also executed other sorts of still lifes and animal paintings. His early works of the 1660s include bouquets with a strong vertical axis, and garlands in the manner of Daniel Seghers (q.v.). Flowerpieces of the 1670s are less rigidly arranged, with a compositional and coloristic emphasis on the diagonal. In the 1680s, Verendael's technique becomes less refined and his compositions freer and more lively. Verendael collaborated with the figure painters Jan Boeckhorst and Gonzales Coques (qq.v.), with Jan Davidsz. de Heem (Munich, Alte Pinakothek, inv. 568), and with David Teniers the Younger and Carstiaen Luyckx (qq.v.; Dresden, Gemäldegalerie Alte Meister, inv. 1091; ill. Introduction, fig. 59).

Weyerman 1729-69, vol. 3, pp. 234f; Nagler 1835-52, vol. 20, p. 97; Nagler 1858-79, vol. 4, p. 2717; Génard 1863, p. 13; Michiels 1865-76, vol. 9 (1874), pp. 210-218; Rombouts, van Lerius 1872, vol. 2, pp. 278, 283, 500, 551, 866; van de Branden 1883, pp. 1141-1143; *Oud Holland* 18 (1900), p. 202; Wurzbach 1906-11, vol. 2 (1910), pp. 745-746, vol. 3, p. 172; Denucé 1932, passim; K. Zoege van Manteuffel, in Thieme, Becker 1907-50, vol. 34 (1940), p. 178; Hairs 1955, pp. 114, 245-247; Hairs 1957, p. 158; S. Segal, in New York 1983, pp. 87-90; Hairs 1985, pp. 301-308, 501-502.

Nicolaes van Verendael
105. Flower Still Life, 1677

Oil on canvas, 59.7 x 47 cm (23 ½ x 18 ½ in.)
Signed and dated at bottom right:
Ni. V. Verendael fec. / 1677
Norfolk, Virginia, Mr. and Mrs. George M. Kaufman
collection

PROVENANCE: (possibly) sale Pierre André Joseph Knyff, Antwerp (Grange), 18 July 1785, no. 160 ["Une grande bouteille posée sur une pierre grisâtre; elle contient plusieurs sortes de fleurs, des roses blanches, rouges et jaunes, & leurs boutons; un œillet, une tulippe, des narcises, un épi de bled, un œillet d'inde, & d'autres fleurs entremêlées de leurs feuilles: on y decouvre des gouttes d'eau, un papillon, un limaçon avec sa coquille, des fourmis et d'autres insectes," 22 ½ x 17 ¾ pouces (ca. 60 x 48 cm); fl. 29, to Quertemont]; dealer John Mitchell and Son, London, 1986.

FRAMED by an arched niche, a lush bouquet of flowers arises from a spherical glass vase placed at the edge of a stone table. The flowers, which have been studied in detail by Sam Segal,[1] include nasturtiums, several varieties of anemones, white, pink, and yellow roses, jasmine, gentian, narcissus, a tulip, a carnation, poppies, oleander, a French marigold, a small morning glory, a snake's head fritillaria, fennel, brambles with berries, and a blade of wheat. The light flooding from the left side of the composition highlights the droplets of water on leaves and petals and on the tabletop, and creates a subtle glimmer in the water in the vase. Scattered throughout the painting are a snail and various insects, including a red admiral butterfly and a ladybug.

Dated works occur regularly throughout Verendael's œuvre, making it relatively simple to track his development.[2] Typical of works of the mid- to late 1670s is the use of a round glass vase, which reflects a multi-paned window on the surface of the vessel, and captures reflected light within. In addition, Verendael often used the same or similar assortments of flowers in paintings of the same year or close in date: some works also dated 1677 are extraordinarily close to the present composition, and others can be grouped with these dated examples.[3] Unlike other still-life painters, however (notably Jan Brueghel the Elder, q.v.), Verendael rarely used the same identical flower study in more than one painting.[4]

The influence of Jan Davidsz. de Heem is strongest in Verendael's work of the 1670s (compare cat. 103). Most of de Heem's flower still lifes were painted after about 1650. Like the present painting by Verendael, works such as de Heem's *Vase of Flowers* in the National Gallery of Art, Washington (ill. cat. 102, fig. 1) feature a loose arrangement of blooms in a glass vase placed on a weathered stone ledge. The palettes of the two artists are also similar, keyed to contrasting hues of red or vermilion, orange, white, and blue. An interesting sidelight to the stylistic relationship between the two artists is their collaborative *Vase of Flowers with a Crucifix and a Shell* (mid-1670s; Munich, Alte Pinakothek, inv. 568 ; fig. 1), signed by both artists, for which Verendael presumably painted the floral arrangement and de Heem the remainder of the composition.[5]

Although the inherently transient nature of the subject matter generally associates flower pieces with the concept of *vanitas*, the present painting incorporates several elements that have been specifically interpreted as *vanitas* symbols.[6] The earthbound snail indicates the slow but irrevocable progress of time; the butterfly, the freed soul ascending to heaven; the ants (on the white rose in the center of the arrangement) allude to their diligent industry in preparing for the future.

MEW

1. Sam Segal, Research no. 14667, dated 26 November 1986.

2. Verendael's stylistic development is outlined by Sam Segal in *A Selection of Dutch and Flemish Seventeenth-Century Paintings* (exh. cat. New York, Hoogsteder-Naumann, Ltd., 1983), pp. 87-90.

3. Among those compositions closest to the present painting are: a *Still Life of Flowers in a Glass Vase*, signed and dated 1677 (oil on canvas, 57 x 43 cm, with Leger Galleries, London, ca. 1968); and the undated *Flowers in a Vase* (oil on canvas, 54 x 100 cm, Antwerp, Koninklijk Museum voor Schone Kunsten, inv. 906).

4. Segal 1983, p. 90. On Jan Brueghel's reuse of individual floral motifs, see Brenninkmeyer-de Rooij 1990, pp. 232-235, and cat. 95.

5. On this painting, see S. Segal, in Utrecht/Braunschweig 1991, pp. 191-193. See also Introduction, fig. 59.

6. Segal 1983, p. 91. More generally on the *vanitas* interpretations of flower still lifes, see Bergström 1956; and E. de Jongh, "The Interpretation of Still-life Paintings: Possibilities and Limits," in *Still-life in the Age of Rembrandt* (exh. cat. Auckland City Art Gallery, 1982), esp. p. 31.

Fig. 1. Nicolaes van Verendael and Jan Davidsz. de Heem, *Vase of Flowers with a Crucifix and a Shell*, signed on paper lower left: JD De heem, on plinth bottom center: J- De heem f, and upper right: ni: v: veerendael, oil on canvas, 103 x 85 cm, Munich, Alte Pinakothek, inv. 568.

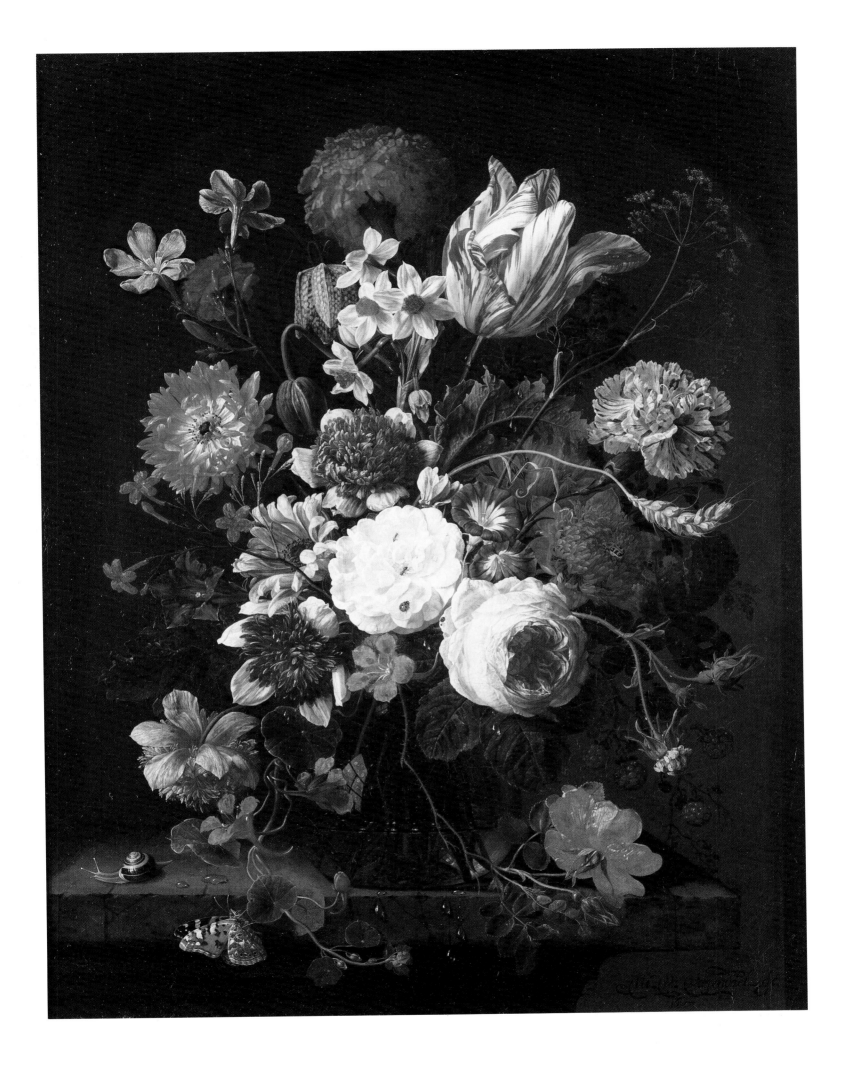

Osias Beert

(ca. 1580-Antwerp-1623/24)

Probably born in Antwerp around 1580, Osias Beert was a leading figure in the first generation of Flemish still-life painters. In 1596 he became a pupil of the obscure Andris van Baseroo, and subsequently joined the Antwerp guild of St. Luke in 1602. Beert married Margarita Ykens (d. 1646/7) on 8 January 1606. The couple had but one child, Elias (1622-1678), who became a master in the St. Luke's Guild in 1644/45 under the name Osias Beert II. It is likely that the older Beert did not become wealthy practicing his art, since his house ("den Koning der Mooren") was situated in a modest area of the city, and he was also active as a cork merchant. Beert was a member of the rhetorician's chamber "de Olijftak" (the Olive Branch) from 1615 until his death in late 1623 or 1624. Among his pupils were the engraver Paulus Pontius (1603-1638), and his wife's nephew, the still-life painter Frans Ykens (1601-1693).

Beert's floral and tabletop still lifes are stylistically allied with works by his contemporaries Peter Binoit (active 1611-1642), Ambrosius Bosschaert (1573-1621), Georg Flegel (1563-1638), and Clara Peeters (q.v.). His sure, powerful draughtsmanship is complemented by the use of strong chiaroscuro effects, sometimes dramatized by the inclusion of a lit candle within the composition. Although Beert dated none of his paintings, several of his works on copper are approximately datable to 1607-09 (or later), because of the dates marked on their back by their maker, Pieter Stas. Beert apparently collaborated with Rubens (or his studio) on at least one occasion (Sarasota, FL, John and Mabel Ringling Museum of Art, inv. SN 219).

Rombouts, van Lerius 1872, vol. 1, pp. 395, 419, 432, 467, 470, 477, 479, 516, 520, 528, 542, 600, 680; vol. 2, pp. 156, 185; van den Branden 1883, pp. 1118-1119; Wurzbach 1906-11, vol. 1 (1906), p. 72; Thieme, Becker 1907-50, vol. 3 (1909), p. 171; Dilis 1910, passim; Denucé 1932, pp. 40, 204; Benedict 1938; Hairs 1951; Sterling 1952, pp. 68-69, 78; Hairs 1953; Hairs 1955, pp. 122-126; Bergström 1956, pp. 104-105, 109-111, 142; Greindl 1956, pp. 28-31, 149-150; Bergström 1957; Münster/Baden-Baden 1979-80, pp. 408, 410; Greindl 1983, pp. 22-36, 181-191, 335-337; Cologne/Vienna 1992-93, pp. 462-465.

Osias Beert the Elder
106. *Still Life with Oysters and Sweetmeats*, ca. 1610

Oil on canvas, 74 x 108.5 cm (29 ⅛ x 42 ¾ in.)
Remnants of a signature on the lid of the lower box:
.. EERT
Private collection

PROVENANCE: private collection, Belgium, ca. 1983 (see Greindl 1983); sale London (Sotheby's), 9 December 1987, no. 64, ill.; with John Hoogsteder, The Hague, who sold it to the present owner.

LITERATURE: Greindl 1983, pp. 22, 28, 335, cat. 4, fig. 15; *Weltkunst* 58, no. 3 (1988), ill. p. 233; *Tableau* 11, no. 1 (1988), ill. p. 30; C. J. A. Jörg, "Kraakporselein," *Antiek* 25, no. 2 (1990), pp. 61-62, fig. 14.

PLATES and bowls of food, three glass vessels, and round boxes are arranged on a tabletop viewed in steep perspective. In the lower left foreground is a platter of ten oysters. Beside it are a porcelain bowl and platter decorated with plums, both in Wan-li style, filled with sweetmeats, almonds, and confectionery goods. Behind are three platters of other dainties, candied citrus fruits, figs, dried raisins, roasted chestnuts, and other nuts. On the right are three round wood boxes surmounted by a small wan-li lacquered cup with gilt interior. A wood sieve tipped on its side and resting against the boxes reveals red currants. A fluted *façon-de-Venise* glass appears on the left and a second example with a bulbed design is on the right. In the center is a tall *façon-de-Venise* wine goblet with cover and decorative prunts. At the upper left an olive green curtain rises to reveal a column behind.

This image of elegant dishes and other costly objects additively arranged upon a steeply pitched tabletop is characteristic of Osias Beert's art. Although a pioneer in the early history of still life, Beert was long forgotten; his œuvre has only gradually been reconstructed in this century. The early practitioners of the tabletop still life included the Germans Georg Flegel and Jeremias van Winghen, the rare Flemish artist who emigrated to Holland, Frans Badens, and his better known compatriot, Jacques de Gheyn the Younger, who may have had an influence on both Beert and Clara Peeters (q.v.).[1] The tabletop still lifes by these artists typically pile the objects vertically up the surface of the picture in a fashion that minimizes overlapping. The goal was to give the fullest possible pictorial account of each object, in defiance of perspective. Beert's paintings differ from those of the other early practitioners by employing stronger contrasts of light and shade, coupled with subtler atmospheric effects and a more descriptive account of the surface textures of objects. His touch is not as dry, for example, as that of his immediate contemporary Clara Peeters.

While Beert's œuvre now includes more than one dozen signed paintings, there are no dated works known.[2] However several of his paintings on copper are stamped with the mark of the metal worker Pieter Stas, and dated 1607, 1608, or 1609.[3] One of those dated 1609 depicts a platter of oysters and a tazza of sweets in a niche (fig. 1). The greater elegance

Fig. 1. Osias Beert the Elder, *A Plate of Oysters and a Tazza of Sweets in a Niche*, monogrammed by the artist and marked and dated by the copper panel maker Pieter Stas, 1609, oil on copper, 51 x 44 cm, private collection.

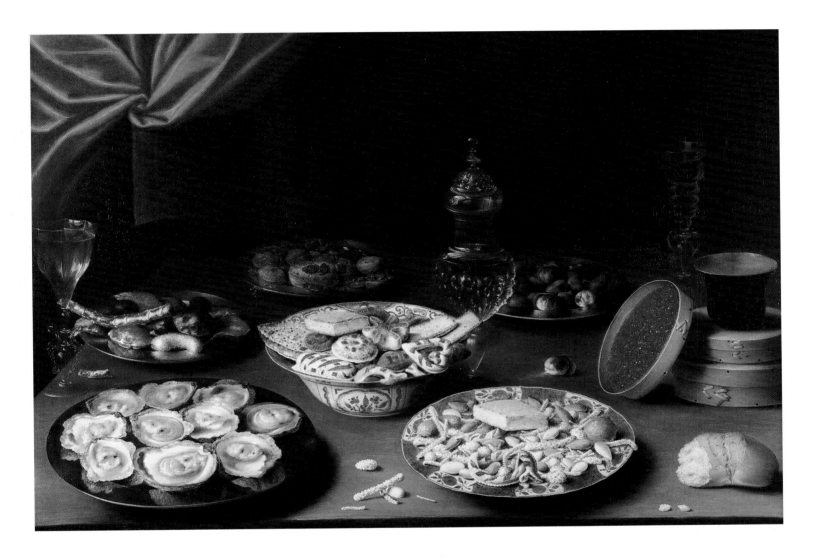

and complexity of the present work may indicate a slightly later date. A close variant of the present design in the museum in Brussels differs only in the glassware and other minor details, but is signed and is on panel rather than on canvas (fig. 2).[4] Canvas was an unusual support for Beert, who usually employed wood or copper, but in this case it is an exceptionally fine linen which is well suited to detail.

Like other still-life artists of the period, Beert often reused objects in his compositions. For example, the covered glass cup and wood boxes recur in a very similarly conceived tabletop still life in the Heinz collection, which Ingvar Bergström has dated to ca. 1610.[5] The two boxes with lacquerware cup on top reappear in a painting in the Prado (Madrid, no. 1606). The round *façon-de-Venise* glass on the right also reappears in several Beert still lifes,[6] as does the faceted glass on the left.[7] C. J. A. Jörg identified the porcelain bowls in the present work as some of the earliest examples of the "kraak" porcelain from the wan-li period (Ming dynasty, 1573-1619) that was imported from China by the Dutch India Company and which became so popular in the Northern and Southern Netherlands during the course of the seventeenth century.[8] "Kraak" porcelain also regularly appears in the still lifes of Jacob van Hulsdonck and Isaak Soreau (qq.v.). However, the lacquerware cup seems to be a unique example.[9] The glasses could have originated either in Venice or in Antwerp since the *façon-de-Venise* glassware industry had taken root locally by this time. Segal noted that the drinking glass on the right is a *fopglas* or "trick glass," which appears elsewhere in Beert's art.[10] The five bulbous chambers of this tall vessel make the wine rush out in a single flood, thus making the inexperienced drinker look foolish.

The confectionery in this scene features a remarkable variety of sweets, including cracknel,

Fig. 2. Osias Beert the Elder, *Still Life with Oysters and Sweetmeats*, monogrammed, oil on panel, 71 x 105 cm, Brussels, Musées Royaux des Beaux-Arts de Belgique, inv. 6303.

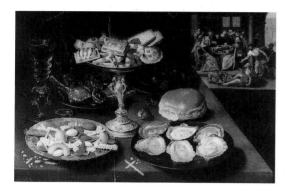

Fig. 3. Osias Beert the Elder, *Still Life with Lazarus at the Rich Man's Door*, oil on panel, 49.5 x 71.5 cm, England, private collection.

sugared biscuits, cakes, candied almonds, and sweets known as "œufs de grenouille" and "cœurs de Saint Nicolas"; Edith Greindl notes that such dainties were often consumed in Flanders on the occasion of the baptisms of children or the celebrations of their patron saint days.[11] Sugar, made from sugar cane, was still a relatively new product in Northern Europe in the seventeenth century, and like the almonds, figs, and raisins, had to be imported.[12] Oysters were also regarded as luxurious delicacies, though they also could carry the aphrodisiacal associations they had had since antiquity – as libidinous foods or medicinal aids to fertility and sexual potency.[13] The combination of oysters and sweetmeats appears frequently in Beert's art, surrounded by other objects of luxury. Both Bergström and Segal have drawn attention to one of the artist's tabletop still lifes featuring these objects, but adding a scene in the background of Lazarus at the Rich Man's Door (fig. 3).[14]

This type of juxtaposition had appeared earlier to moral effect in the art of Hieronymus Francken the Younger (see the *Allegory of Worldly Riches* in the Wadsworth Atheneum, Hartford [CT], no. 1942.327, which includes a scene in the background related to *Ars Moriendi* [the Art of Dying] imagery and the theme of Death and the Miser).[15] Bergström argued that the juxtaposition with the tale of Lazarus (Luke 16:19-25) was designed to comment on the splendor and epicurianism of the still life, suggesting that it implied that a life of wealth and luxury might jeopardize the salvation of the soul[16]: when the Rich Man died he went to hell, whereas Lazarus ascended

to heaven ("thou in thy lifetime receivest thy good things, and likewise Lazarus evil things; but now he is comforted, and thou art tormented," Luke 16:25). Segal went on to speculate that the rich meal in the foreground of Beert's work was an "incitement to Christian charity," calling attention to the sweetmeats in the form of a cross in the foreground.[17] Despite the similarity in subject and design to the present work, it is unclear whether Beert had such a specific moral allegory in mind in this still life.

PCS

1. For a general discussion of these developments, see Sam Segal, in Delft/Cambridge/Fort Worth 1988, pp. 56-70.

2. See Greindl 1983, pp. 22-36, 335-337.

3. See Greindl 1983, cats. 11 and 12 (both signed and marked with the date 1609), cat. 28 (unsigned, marked 1608) and cat. 57 (unsigned, marked 1607).

4. Ibid., cat. no. 6, fig. 19.

5. See Washington/Boston 1989, cat. no. 4, ill.; see also Greindl 1983, cat. 85, fig. 16. The cup also appeared in a painting by Beert that was with Kurt Meissner in Zurich in 1974 (see Greindl 1983, cat. no. 86, fig. 29).

6. See, for example, Berlin, Staatliche Museen zu Berlin, Gemäldegalerie, no. 2/60 (Greindl 1983, cat. 28, fig. 7).

7. See, for example, Stuttgart, Staatsgalerie, inv. 2752 (Greindl 1983, cat. 78, fig. 14); see also Greindl 1983, figs. 24 and 30.

8. C. J. A. Jörg, "Kraakporselein," *Antiek* 25, no. 2 (1990), pp. 61-62, fig. 14. On Kraak porcelain generally, see M. Rinaldi, *Kraak Porcelain – A Moment in the History of Trade* (London, 1989).

9. According to S. Segal's (unpublished) report (no. 18437), dated 6 May 1990.

10. Ibid.

11. Greindl 1983, p. 22.

12. See S. W. Mintz, *Sweetness and Power. The Place of Sugar in Modern History* (New York, 1987).

13. See G. D. J. Schotel, *Het Oude-Hollandsch huisgezin in de zeventiende eeuw* (Amsterdam, 1903), pp. 302-303; E. de Jongh in Amsterdam 1976, under cats. 51 and 62; and L. Cheney, "The Oyster in Dutch Genre Painting: Moral or Erotic Symbolism," *Artibus et Historiae* 15 (1987), pp. 135-158.

14. Segal, in Delft/Cambridge/Fort Worth 1988, p. 65, cat. 6, ill. 59; Bergström, in Washington/Boston 1989, p. 96, cat. no. 4, fig. 1.

15. See Bergström 1956, pp. 25-26; Segal, in Delft/Cambridge/Fort Worth 1988, p. 46, fig. 35.

16. Bergström, in Washington/Boston 1989, p. 96.

17. Segal, in Delft/Cambridge/Fort Worth 1988, p. 65. Segal (see note 9) has also proposed symbolical meanings for the sieve, citing Cesare Ripa's explanation (1644, p. 365) of the sieve as a symbol of discernment (that separates wheat from chaff), biblical references to distinguish good from evil (Psalms 75,8), and Pieter Bruegel's use of the sieve as an attribute of the virtue *Prudentia* in his print series on the Vices (H. A. Klein, *The Graphic World of Pieter Bruegel the Elder* [New York, 1963], pp. 235-237, ill.). Extending this association of discernment to eucharistic imagery (the bread and wine), he suggests that the combination in the Beert "points to the teachings of Christ as a base for the good choice." However this analysis, especially in its cumulative reasoning, is overly speculative when considered within the larger context of the painting and Beerts's art generally.

Clara Peeters

(active first half of the seventeenth century, Antwerp)

Clara Peeters, *Still Life with Pronk Goblets, Flowers and Shells* (detail), signed and dated 1612, oil on panel, 59.2 x 49 cm, Karlsruhe, Staatliche Kunsthalle, inv. 2222.

Little is known of the life of Clara Peeters, one of the foremost still-life painters of the first part of the seventeenth century in Flanders. She was probably born in Antwerp, although the exact date is not known. A Clara Peeters, daughter of Jan Peeters, was baptized in the Antwerp Church of St. Walpurgis on 15 May 1594, but this date seems incompatible with the mature works painted by the artist as early as 1608. The marriage of a Clara Peeters to Hendrick Joossen on 31 May 1639, noted also in the St. Walpurgis registers, may or may not refer to the artist. Peeters is not mentioned in the registers of the Antwerp guild of St. Luke. She is supposed to have worked in Amsterdam in 1612 and The Hague in 1617, but no documents have been found to confirm this. It is not known when the artist died; dated paintings are extant from 1607/09 to 1621.

Though we know almost nothing of the artist herself, her works were evidently highly prized in both Dutch and Flemish collections. Sandrart wrote of a *Vanitas* still life with a reflected self-portrait by a talented "Holländerin" (possibly Peeters), which was purchased for the gallery of Archduke Leopold Wilhelm for 1000 rijksdaalders. Peeters painted predominantly tabletop still lifes of flowers, foods and delicacies, delicate porcelain, glassware, and costly metal vessels. Her early works (before ca. 1612), with their even distribution of compositional elements and strong local colors, are similar to works by Osias Beert (q.v.) and the Haarlem still-life painters Floris van Dyck and Nicolaes Gillis. The more uniform tonality, low viewpoint, and condensed compositions of Peeters's later works may have been influential for the development of the "monochrome banquets" of her Haarlem contemporaries; a number of such still lifes signed with the monogram of an interlaced C and P have been ascribed to both Peeters (erroneously) and the Haarlem still-life painter Pieter Claesz.

Nagler 1835-52, vol. 11 (1841), p. 165; Nagler 1858-79, vol. 2 (1860), pp. 48, 359; Kramm 1857-64, vol. 4 (1860), p. 1264; Hymans 1894; Wurzbach 1906-11, vol. 2 (1910), p. 320; Sandrart/Pelzer 1925, p. 349; Thieme, Becker 1907-50, vol. 27 (1932), p. 7; Vorenkamp 1933, p. 59; Sterling 1952, pp. 66, 68; Hairs 1955, pp. 126-128, 230-231; Bergström 1956, pp. 104-107, 109, 111; Greindl 1956, pp. 34-37, 178-179; Brussels 1965, pp. 152-153; de Wilde 1967; Bol 1969, pp. 18-20; Vroom 1980, vol. 1, pp. 88-100, vol. 2, pp. 99-107; van Dedem 1981; Auckland 1982, pp. 65-69; Greindl 1983, pp. 45-49, 371-372; Brusati 1991; Decoteau 1992; Cologne/Vienna 1992-93, pp. 470-472.

Clara Peeters
107. *Still Life with Tart*

Oil on panel, 52 x 84 cm (20 ½ x 33 ⅛ in.)
Signed on edge of knife handle, bottom center:
CLARA PEETERS
The Netherlands, private collection

PROVENANCE: private collection, The Netherlands.

AN ASSORTMENT of culinary delicacies and costly tableware are casually displayed on a tabletop. To the left are three shells (including a *conus marmoreus*), a plate of oysters, a porcelain cup in a gilt mount, and a silver-gilt tazza with a tempting heap of sweet pastries (one of which is decorated with bits of gold leaf) and glacé fruits. Tipped against a wood box at the rear is a round custard or pie in a wood form; on top of the box are an orange and a citron, and to the right a roemer and a *façon-de-Venise* flute. A blue and white pitcher with gilt mounts, a sack of almonds, and a plate with still more pastries, glacé fruits, and sugar dainties fill the right side of the composition. In the foreground are a knife, two flowers, and a small cone of paper.

The composition is dominated by a large flat tart decorated with colored sugars, artificial carnations (or pinks) made of red, white, and blue feathers, and sprigs of rosemary hung with small gold ornaments. A more elaborate pie, but without the decorative flourishes, appears in Peeters's *Still Life with Pie* in the Prado (fig. 1); smaller decorated versions occur in other works by Peeters and artists in her circle.[1] Although such tarts seem to have been standard fare at sumptuous banquets (a tart decorated with a stem of flowers is the centerpiece of the banquet in Wouter Crabeth II's *Wedding Feast of Jan Dirx Westerhout and Emmetgen Pietersdr. [The Marriage at Cana]*, ca. 1641)[2], the unusual decorations represented in the present painting suggest that this may be a "bruidstaart," a pie or tart traditionally served at wedding feasts. Carnations and pinks (whether real or artificial) were a symbol of betrothal and conjugal fidelity; rosemary was a symbol of eternity and remembrance and, in a marital context, a reminder of faithfulness.[3] A branch of rosemary hung with similar gold trinkets is laid alongside a plate of sweets and a *façon-de-Venise* wineglass in the artist's early *Still Life with a Candle*, dated 1607 or 1609, a painting which Segal has interpreted (with heavy Christological overtones) as an allusion to the transient nature of material pleasures, a reading reinforced by the presence of the fly and the candle.[4]

Peeters's meticulous attention to detail is brought to the fore in the depiction of objects such as the distinctive knife in the center foreground of the *Still Life with Tart*. The same knife also appears in three other paintings by the artist: the *Still Life with Pie*, ca. 1611 (Madrid, Museo del Prado, fig. 1), the *Still Life with Fruit and Flowers*, ca. 1620 (Oxford, Ashmolean Museum, fig. 2), and a *Still Life with Cheese* formerly in the von Welie collection, The Hague.[5] This

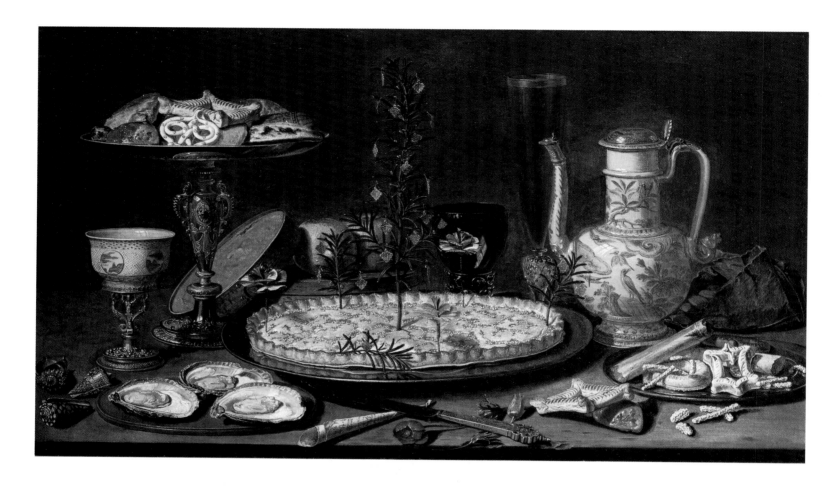

type of knife, paired with a matching fork in a decorated case and known as a *bruidsbestek*, was a popular wedding or betrothal gift in both the North and South Netherlands.[6] The top and bottom sides of the handles were typically decorated with stylized ornamental motifs, and biblical scenes or allegorical figures suitable to a marriage context. Peeters's knife includes the allegorical figures of FIDES (fidelity) and TEMPOR (temperance) in niches along the shaft, and clasped hands holding a burning heart between the volutes at the top. The narrow side of the handle is inscribed with Peeters's name; surviving seventeenth-century *bruidsbestek* are frequently engraved with the bride's name and date of the marriage. Although Segal has questioned whether this can represent an actual knife,[7] the fact that it is repeated so precisely in each of the four paintings argues in favor of the artist working from an existing model.[8]

Caught beneath the knife handle are two cut anemones and a screw of paper with ground pepper, then considered an exotic and costly spice. The legible words on the scrap of paper may be a fragment of either a bill or a recipe.[9]

In addition to the *bruidsmes* (bridal knife) and the festively adorned tart, other elements in Peeters's *Still Life with Tart* can be provisionally related to contemporary wedding practices in the Netherlands. At the announcement of a forthcoming marriage, the future bride presided over a table strewn with blossoms and leaves; hippocras (a spiced wine), sweet pastries, and *bruidssuiker* (sugar dainties) were distributed to well-wishers (fig. 3).[10] At the wedding feast, it was customary for guests to present the newlyweds with housewares ranging from the practical to the expensive, fragile, and decorative, often – although not exclusively – decorated with bridal motifs.[11] Oysters were not only a culinary delicacy but also a noted aphrodisiac. Interpreting the *Still Life with Tart* as representing a wedding banquet offers an intriguing alternative to the usual classification of lavish tabletop displays as exclusive exemplars of *vanitas* and the ephemeral nature of worldly possessions.

One of Peeters's finest works, the *Still Life with Tart* is closely related to other magnificent banquet scenes by the artist such as the *Still Life with Pie* (fig. 1)

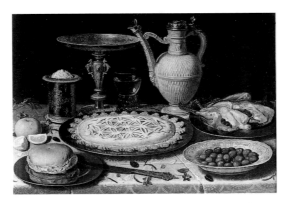

Fig. 1. Clara Peeters, *Still Life with Pie*, ca. 1611, signed:
CLARA PEETERS, oil on panel, 55 x 73 cm, Madrid,
Museo del Prado, inv. 1622.

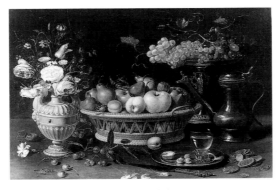

Fig. 2. Clara Peeters, *Still Life with Fruit and Flowers*,
ca. 1620, oil on copper, 64 x 89 cm, Oxford, Ashmolean
Museum, inv. A585.

Fig. 3. Pieter Serwouters or Jan van de Velde after
David Vinckboons, engraving, from Johan van
Heemskerck, *Minne-kunst. Minne-baet. Minne-dichten.
Mengel-dichten* (Amsterdam, 1626).

and *Still Life with Flowers and Sweets*, dated 1611, in the
Prado.[12] The dense compilation of items, tentative
overlapping of forms, and only minimally elevated
viewpoint indicate a date of about 1611 or slightly
later for the painting.

MEW

1. *Still Life with Flowers, Covered Gilt Cup and Pie*, oil on panel, 47 x 33 cm,
private collection, Italy (attributed by Decoteau [1992, pp. 50-51] to
"Circle of Clara Peeters"); see also the *Still Life with Pie* in the Rothschild
collection, Pauillac (oil on panel, 39 x 53 cm), catalogued by Decoteau
(1992, pp. 152-154) as "Misattributed to Peeters," no. 56.

2. Oil on canvas, 137 x 205 cm, Gouda, Museum Het Catharina Gasthuis;
see exh. cat. Haarlem 1986, no. 77, ill. Compare also the tart decorated
with posies depicted in a print by Jacob Matham after David Vinckboons,
of the Prodigal Son feasting (ca. 1620).

3. On the symbolism of pinks and rosemary (particularly in a marital
context) see the entry on Hulsdonck's *Carnations in Glass Vase*, and the
references cited there (cat. 97; notes 5 and 6).

4. Segal, in Delft/Cambridge/Fort Worth 1988, p. 68.

5. Oil on panel, 35 x 49 cm; Decoteau 1992, cat. 29 (ca. 1630).

6. On *bruidsbestek* see: A. Bara, "A propos de l'aquisition d'une trousse de
table de 1597," *Bulletin des Musées Royaux d'Art et d'Histoire*, ser. 3, vol. 5
(1943), pp. 70-83; and exh. cat. Antwerp, Rockoxhuis, *Zilver uit de Gouden
Eeuw van Antwerpen*, 10 November 1988-15 January 1989, nos. 90-97.

7. Amsterdam/Braunschweig 1983, pp. 66-68. Segal makes no mention of
the fact that this is a *bruidsmes* and, based on his interpretation of the fig-
ures of Faith and Temperance represented on the knife in the Prado *Still
Life with Pie* (fig. 1), arrives at an elaborately contrived Christological
interpretation of that painting.

8. The knife and Segal's comments are discussed by Decoteau 1992, pp. 21,
42 and 96-97, where she notes a similar *bruidsmes* in a painting by Pieter
Binoit (Stockholm, private collection), taking this as evidence that Binoit
copied the knife directly from Peeters's paintings.

9. " – [zegge] 3 / – [zegge] 1¼ / som[m]a / suycker / rosynen / vyghen / . . . /
peper / noten [?]" (the remainder indecipherable) (" – [say] 3 / – [say]
1¼ / total / sugar / raisins / figs / . . . / pepper / nuts [?]"). A similar cone
of pepper is included in a still life by Peeters in Poltava (Decoteau 1992,
cat. 16); the writing there has been deciphered by S. Segal ("vrij . . . / so
sijn wij!" ["Free . . . so are we!"]), and interpreted rather implausibly as an
allusion to the massive emigration due to religious persecution (see: "A
Feast for the Eye and the Mind: The Dresden Still-Life Exhibition,"
Tableau 6, no. 4 [February 1984], p. 77).

10. P. van Boheemen and J. van Haaren, "Ter bruiloft genodigd," in
Kent, en versint, Eer datje mint: Vrijen en trouwen 1500-1800 (Zwolle, 1989),
pp. 157-158.

11. Ibid., pp. 166-170; and R. Pinon and Y. Moreau, in exh. cat. Liège,
Musée de la Vie Wallonne, *Aspecten van het volksleven in Europa: Liefde en
Huwelijk* (1975), p. 124.

12. Oil on panel, 52 x 73 cm, signed and dated "CLARA P. A. 1611," Madrid,
Museo del Prado, inv. 1620; Decoteau 1992, no. 4.

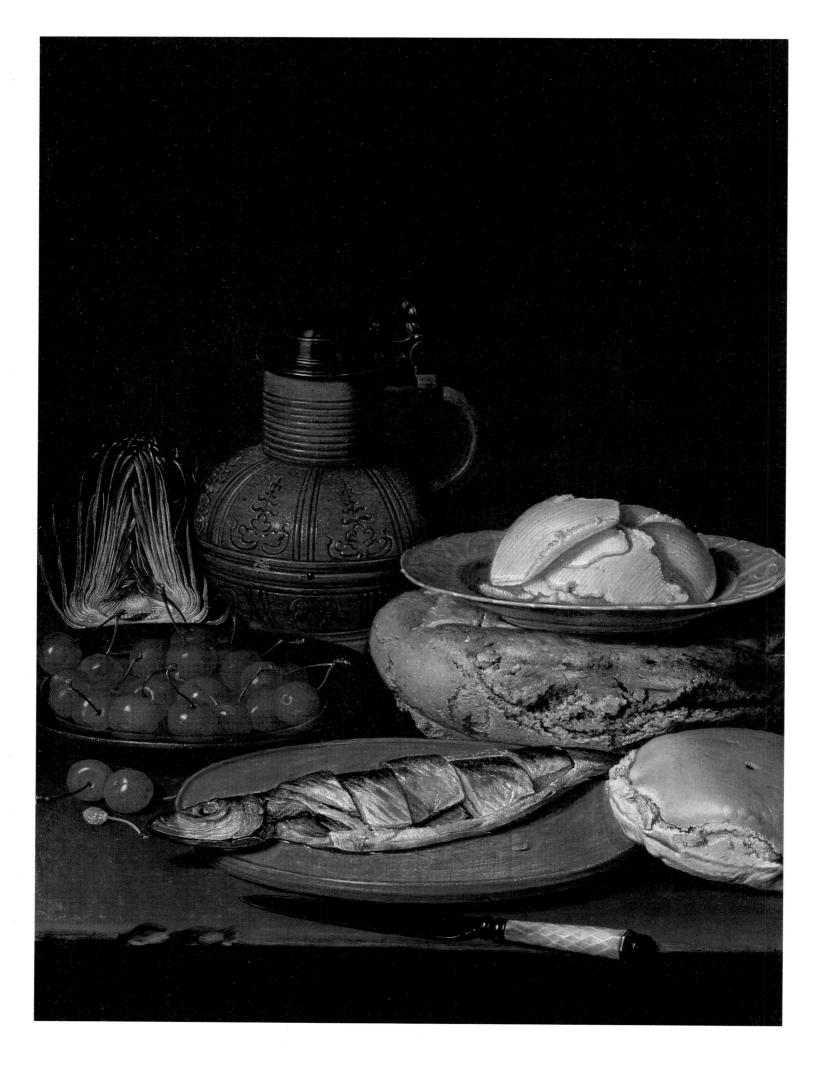

Clara Peeters
108. *Still Life with Herring, Cherries, and an Artichoke*, 1612

Oil on panel, 45.5 x 33.5 cm (17⅞ x 13¼ in.)
Signed and dated on plinth at bottom left:
CLARA P. A° 1612
Private collection

PROVENANCE: London, Speelman Gallery, 1977; private collection, U.S.A., 1988; London, Richard Green Gallery.
EXHIBITIONS: Delft/Cambridge/Fort Worth 1988, no. 8.
LITERATURE: Segal, in Delft/Cambridge/Fort Worth 1988, pp. 69, 229; Decoteau 1992, pp. 31, 32-33, 35, 105, 119 plate V, 180.

109. *Still Life with Gilt Cup, Sweets, and Pomegranate*

Oil on panel, 45.5 x 33.5 cm (17⅞ x 13¼ in.)
Signed on plinth at bottom left: CLARA PEETERS
Private collection

PROVENANCE: London, Speelman Gallery, 1977; private collection, U.S.A., 1988; London, Richard Green Gallery.
EXHIBITIONS: Delft/Cambridge/Fort Worth 1988, no. 9.
LITERATURE: Segal, in exh. cat. Delft/Cambridge/Fort Worth 1988, pp. 69-70, 230; Decoteau 1992, pp. 32-33, 35, 105, 120 plate VI, 180.

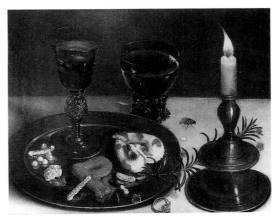

Fig. 1. Clara Peeters, *Still Life with Candle, Sweets, and Wine*, signed and dated 1607, oil on panel, 23.7 x 36.7 cm, England, private collection.

A MODEST selection of foodstuffs and tablewares is displayed in the *Still Life with Herring*: a smoked herring is served on an earthenware charger, accompanied by a roll, a porcelain dish mounded with butter resting on a loaf of brown bread, half an artichoke, and a cream-colored Siegburg beer jug. Two cherries and a pit are scattered on the table by a pewter plate filled with cherries. In the foreground, a pearl-handled knife extends slightly over the chipped edge of the tabletop. Beneath the thinly painted surface of the *Still Life with Herring*, a grid of underdrawn lines can be detected, passing through the herring and the dish of butter; the lines may have been used as an aid to accurately drawing the circular plates in perspective.[1] Indeed, these plates are more convincingly rendered than those in Peeters's earliest paintings, for example her *Still Life with Candle, Sweets, and Wine*, signed and dated 1607 (fig. 1).

In *Still Life with Gilt Cup, Sweets, and Pomegranate*, a shallow Chinese porcelain dish holds cookies and sweet pastries; other confections are strewn across the tabletop in the foreground. To the right is a Wan-li porcelain dish heaped with dried figs, raisins, and almonds, balanced atop a celadon green bowl. At the left is a pomegranate which has been cut open to reveal the succulent flesh. The cookie in the shape of the letter "P" recurs in several still lifes by Peeters and has been claimed as an allusion to the artist's last name,[2] although similar pastries occur also in contemporary works by Osias Beert (q.v.), Pieter Binoit (Groningen, Groninger Museum), Jacob van Es, Georg Flegel, Floris van Dyck, and others.

The focal point of the *Still Life with Gilt Cup* is an elaborate covered gilt goblet, identical to the one in Peeters's *Still Life with Pronk Goblets, Flowers, and Shells*

in Karlsruhe, also dated 1612 (fig. 2).[3] In design and decoration, the piece is nearly identical to one made by the Nuremburg silversmith Gregor Schuelein about 1590-95 (Nuremburg, Germanisches Nationalmuseum).[4] Crowning the lid of the goblet is a tiny figure of a warrior with lance and shield. Sam Segal has suggested that the figure may symbolize the *Miles Christianus*, Knight of Christ and protector and defender of Truth, as described in the apocryphal book of Wisdom (5:8-21).[5] The Knight's spiritual weapons (including justice, unerring judgment, and divine wrath) were associated with the metaphorical choice between the spiritual and the material worlds, between virtue and vice; it is this element of choice which Segal proposes to see in Peeters's painting(s). In the context of the composition as a whole, however, this emphatically moralizing interpretation of this figure seems a bit overstated. Chased decorations on the body of the goblet include cherubs, garlands, grotesques, and cornucopias, as well as a deer hunt just below the rim of the lid.[6]

It has been suggested that the *Still Life with Herring* and *Still Life with Gilt Cup, Sweets, and Pomegranate* are pendants,[7] but this theory is impossible to substantiate. In fact, Peeters executed several paintings in the same size and format during this period, for example the *Still Life with Seafood and Wine*, signed and dated 1612 (panel, 46 x 35 cm; Poltava [Russia], Poltava Art Museum), and *Flowers in a Glass Vase*, ca. 1612 (signed, panel, 46 x 34 cm; location unknown).[8] Typical of Peeters's work of about 1612 and slightly later, the *Still Life with Herring* and *Still Life with Gilt Cup* are meticulously executed with a precise, almost linear delineation of forms. The comparatively sophisticated overlapping of objects, low-

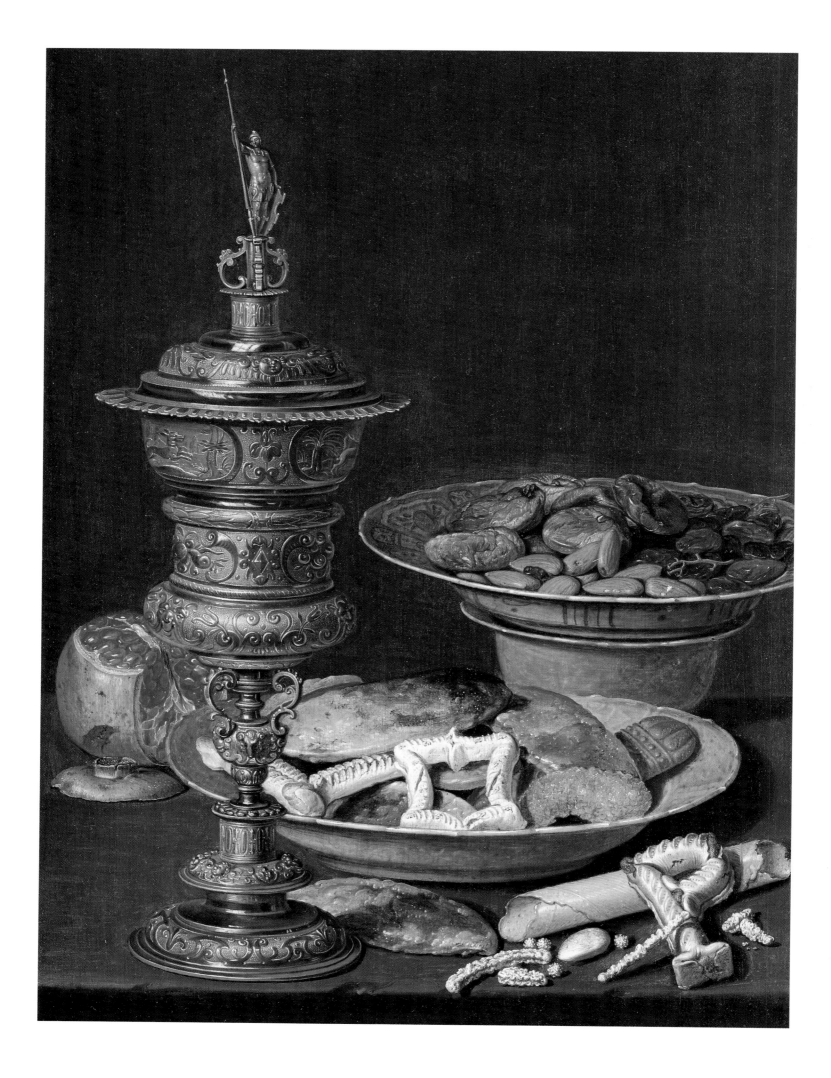

Isaak Soreau

(1604 Hanau-after 1638)

Fig. 2. Clara Peeters, *Still Life with Pronk Goblets, Flowers, and Shells*, signed and dated 1612, oil on panel, 59.2 x 49 cm, Karlsruhe, Staatliche Kunsthalle, inv. 2222.

ered viewpoint, and convincing illusion of spatial recession is a marked transformation from the artist's more additive earlier works, and predates similar developments in the works of her contemporaries; compare, for example, Osias Beert's *Still Life with Oysters and Sweetmeats*, ca. 1610 [cat. 106]).

MEW

1. Decoteau 1992, p. 33, citing information in a letter from Wouter Kloek dated 17 August 1988.

2. Segal, in Delft/Cambridge/Fort Worth 1988, p. 67.

3. Similar covered goblets figure also in Peeters's *Still Life with Flowers, Fruit, and Pretzels* (Madrid, Museo del Prado, inv. 1620), as well as in a *Still Life* in an Italian private collection attributed to the circle of Clara Peeters (see Decoteau 1992, ill. 36, plate XIV).

4. Nuremburg, Germanisches Nationalmuseum, *Wenzel Jamnitzer und die Nürnberger Goldschmiedekunst 1500-1700* (28 June-15 September 1985), cat. 83.

5. Segal, in exh. cat. Delft/Cambridge/Fort Worth 1988, p. 70. Segal states that although goblets with a warrior on the lid were a popular motif in paintings by numerous Netherlandish still-life painters (among them Adriaen van Utrecht [*Still Life with Parrot*, dated 1636, Brussels, Musées Royaux des Beaux-Arts de Belgique, inv. 4731], Floris van Schooten, Pieter Claesz. [Dresden, Gemäldegalerie Alte Meister], Frans Ryckhals [Budapest, Szépmüvészeti Múzeum], and Willem Claesz. Heda [Amsterdam, Rijksmuseum]), few such goblet covers survive. In fact, however, in addition to the Nuremburg example cited above (note 4), several such works by Antwerp silversmiths are still extant; see Antwerp, Rockoxhuis, *Zilver uit de Gouden Eeuw van Antwerpen* (10 November 1988-15 January 1989, nos. 10, 11, 48, 113 and fig. 25.

6. According to Segal (in exh. cat. Delft/Cambridge/Fort Worth 1988, p. 70), the deer hunt symbolizes the search for the pure soul or a longing for Christ.

7. Segal, in exh. cat. Delft/Cambridge/Fort Worth 1988, pp. 69, 229-230.

8. Illustrated in Decoteau 1992, pp. 30 and 28 respectively.

Isaak Soreau was born in Hanau, near Frankfurt, and baptized on 17 October 1604. His father, Daniel Soreau (d. 1619), was a wool merchant, architect, and painter; among his pupils were Joachim von Sandrart and Sebastian Stosskopf (1597-1657), both in 1618. The Soreau family had emigrated from Tournai to Frankfurt by 1586, then moved to the newly created Walloon settlement of Hanau in 1599. Isaak probably studied first with his father and then possibly with Stosskopf, who took over the latter's studio upon the elder Soreau's death in 1619. He lived in Hanau at least until 1626, when he is mentioned as a witness to a baptism. It is not known when he died; his only known dated painting is from 1638 (Schwerin, Staatliches Museum, inv. 638). Isaak was one of ten children; his brother Jan (Johannes, Jean, 1591-1626) and twin brother Peter were also painters.

Bott (1962) was the first to propose a stylistic identity for the artist; prior to that time his œuvre was attributed to his brother Jan. Isaak painted still lifes of fruit and flowers in the manner of Jacob van Hulsdonck and Osias Beert (qq.v.). His tabletop arrangements are composed from a limited repertoire of elements; most characteristic are baskets or platters of grapes and other fruits with a scattering of smaller individual elements in the immediate foreground.

Bott 1962, pp. 33, 40-48, 58-74; Greindl 1983, pp. 64-69, 383-384.

Isaak Soreau

110. *Still Life with Grapes and Other Fruit*

Oil on panel, 60.7 x 89.8 cm (23 ⅞ x 35 ⅜ in.)
Boston, Museum of Fine Arts, Juliana Cheney
Edwards Collection, no. 62.1129

PROVENANCE: Miss K. Ames, Holmdene, Burghfield; W. A. R. Ames, Esq. (Miss Ames's nephew); sale Ames, London (Christie's), 29 June 1962, no. 113 [as by Ambrosius Bosschaert]; to Hallsborough and Weizner; sold to the Museum in 1962, as by Jan Soreau.

LITERATURE: *Christie's Review of the Year 1961-62* (London, 1962), p. 20, ill. [as by A. Bosschaert]; *Art in America* 37, no. 5 (1963), p. 123 [as by A. Bosschaert]; Greindl 1983, p. 383, no. 8 [as by Isaak Soreau]; Boston, cat. 1985, p. 266 [as by Isaak Soreau].

A LARGE PEWTER platter of green and red grapes with grape leaves and tendrils at the apex rests on a light-colored wood table top. A small glass vase of pink roses stands at the left rear; raspberries and blackberries lie on a leaf before the vase. At the right is a blue and white wan-li porcelain bowl with peaches, one of which is split in half with a fly on it. A knife with a black and gold checked handle rests on the table beside the bowl. A butterfly alights on the grape twig above the peaches. In the left foreground is a twig laden with five apricots, its leaves sprinkled with droplets of water. Other small motifs are strewn about in the foreground: a whole hazelnut and several broken ones, a small cluster of green grapes, a pear and a white butterfly in the center foreground. A small twig of red currents appears at the right foreground. The background is a dark, neutral brownish green.

This painting was sold in London in 1962 as by the Middelburg painter Ambrosius Bosschaert. Its attribution was changed by the purchaser, Hallsborough Galleries, to Jan Soreau, who was Isaak's younger brother (born in 1591) but by whom no certain signed works are known – or, more precisely, are presumed to be known since it is conceivable that since "Is" and "Js" were often formed the same way in this period that either of the painters might have executed the still lifes signed "I. Soreau." Following the publication of Gerhard Bott's article on the painter Isaak Soreau in 1962, the attribution was changed by the Museum to Isaak[1]; although Bott was not aware of the Boston painting when he wrote his article, he later confirmed the attribution in a letter dated 27 August 1980.[2] Greindl also supported the attribution in her survey of Flemish still lifes.[3] In the interim, however, an alternative attribution had been thoughtfully promoted by P. de Boer to the Antwerp fruit painter Jacob van Hulsdonck (q.v.). Hulsdonck, who specialized in tabletop fruit still lifes featuring large central bowls and platters of peaches or grapes, seems to have been an important influence on Soreau.

Although Soreau is known to have descended from a Walloon Protestant family from Antwerp, virtually nothing is known of his artistic upbringing after having been trained, presumably by his father,

Fig. 1. Isaak Soreau, *Plates of Grapes and Blackberries*, 1638, oil on canvas, 38.4 x 56.3 cm, Schwerin, Staatliches Museum, Gemäldegalerie, inv. 638.

Fig. 2. Isaak Soreau, *Still Life*, oil on panel, 36.8 x 51.5 cm, Munich, Bayerische Staatsgemäldesammlungen, inv. 7053.

Fig. 3. Isaak Soreau, *Still Life with Grapes and Peaches*, oil on panel, 59.5 x 89.5 cm, Hamburg, Kunsthalle, inv. 170.

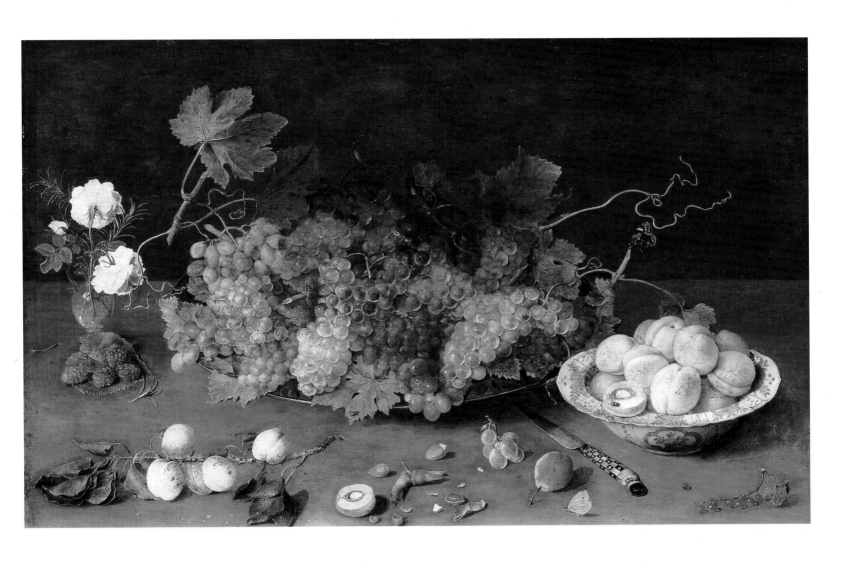

Daniel (d. 1626), in his native Hanau outside Frankfurt. However it is quite possible, given the strong resemblance to Hulsdonck's art, that, like other Frankfurt artists, he had contact with the artistic community and possibly even was trained in Antwerp. Like Osias Beert, Hulsdonck, and Clara Peeters, Soreau had a static and rather deliberate approach to composition but an especially delicate draughtsman's touch. His light tonality, airy spacious designs, and fine sense of decorative patterning, as well as bright color accents are readily distinguishable from the Antwerp masters' but are entirely in the Flemish tabletop tradition. Soreau also had a special talent for painting the translucence of some fruits, notably grapes and mulberries.

His only signed and dated painting is a *Still Life with a Platter of Grapes* of 1638 in the Staatliches Museum, Schwerin (no. 638) (fig. 1).[4] The present work is more elaborately conceived, perhaps indicating a somewhat later date, but with only a single dated work in a total œuvre scarcely larger than two dozen, any dating is conjectural. It appears to be closest in conception to another still life with grapes in the Alte Pinakothek, Munich (no. 7053) (fig. 2): the blackberries resting on the leaf, the branch of apricots with dew drops, the small bunch of grapes on the table, the double hazelnut and the broken shell along side, the split fruit with fly, and the general arrangement of the grapes on the pewter plate, all are similar.[5] Soreau, like Hulsdonck and other Antwerp still-life painters, freely varied the components and configurations of his most successful compositions. Compare also the *Still Life with Grapes and Peaches* in the Kunsthalle, Hamburg (no. 170) (fig. 3),[6] which includes a bowl similar in color but not identical in design, and the *Still Life of Grapes and Berries* (sale Paris [Ader, Picard, Tajan], 28 November 1978, lot 31).[7]

<div align="right">PCS</div>

1. Bott 1962.
2. Museum of Fine Arts, Boston, object file.
3. Greindl 1983, p. 383, no. 8.
4. Ibid., 1983, cat. no. 2, fig. 228. A closely related design is in the Heinz collection, Washington/Boston, 1989, no. 38, ill.
5. Bott 1962, no. 3; Greindl 1983, no. 18.
6. Bott 1962, no. 16; Greindl 1983, no. 10.
7. Ibid., 1983, no. 25.

Jan Davidsz. de Heem
111. Banquet Piece with Shells and Instruments, 1642

Oil on canvas, 152 x 206 cm (59 7/8 x 81 1/8 in.)
Signed and dated at the upper right on the base of the column: J. De Heem F. A° 1642
Private collection, Europe

PROVENANCE: presumed to have been acquired by Charles I for Windsor Castle; taken by George III to one of the royal hunting lodges; sold in 1800 to Mr. Atkins, Bath; sold by Atkins's grandson to Colnaghi's, London; with dealer Frederik Muller, Amsterdam, 1912 (see Exhibitions); with dealer Goudstikker, Amsterdam (cat. October 1916, no. 16, ill.); Galerie O. Granberg, Stockholm; sale Björk, Stockholm, 16 December 1922, no. 31, pl. 10; Karl Bergsten, Stockholm (cat. 1925, no. 24); private collection; sale New York (Christie's), 15 January 1988, no. 107, ill.

EXHIBITIONS: Amsterdam, Frederik Muller, *Importants tableaux anciens*, July-September 1912, no. 15; Stockholm, Nationalmuseum, *Holländska mästare i svensk ägo*, 1967, p. 15, no. 17, ill.; Utrecht/Braunschweig 1991, pp. 25, 136-137, cat. 7, ill.

LITERATURE: H. Schneider, in Thieme, Becker 1907-50, vol. 16 (1923), p. 234; K. Madsen, *Catalogue de la Collection de M. & Mme. Karl Bergsten – Art Ancien*, vol. 1 Peinture (Stockholm, 1925), no. 24, ill.; Bergström 1947, pp. 204, 205, fig. 167; Bergström 1956a, pp. 189, 199, fig. 167; Å. Bengtsson and H. Omberg, "Changes in Dutch Seventeenth-Century Landscape, Still Life, Genre and Architectural Painting," Figura 1 (1951), pp. 37-38, ill.; Hairs 1955, p. 222; Greindl 1956, pp. 103, 173; O. Millar, "Abraham van der Doort's Catalogue of the Collection of Charles I," *Walpole Society* 37 (1960), p. 196; Hairs 1965, p. 386; de Mirimonde 1970, pp. 278, 280-281, figs. 35-37; Leppert 1977, part 1.1, p. 84, part 1.2, col. 64, no. 266; T. J. Kinder, "Pieter de Ring: A Still-Life Painter in Seventeenth Century Holland," *Indiana University Art Museum Bulletin* 2, no. 1 (1979), p. 35; Greindl 1983, p. 362, no. 123; M. Kirby Talley, "'Small, usual and vulgar things': Still Life Painting in England 1635-1670," *Walpole Society* 49 (1983), p. 195; Hairs 1985, p. 30; The Hague, Rijksdienst, cat. 1985, pp. 116, 206, no. 5, under cat. no. V1-27; George Keyes, in Minneapolis/Houston/San Diego 1985, p. 52, note 1; Segal, in Delft/Cambridge/Fort Worth 1988-89, pp. 19, 146-149, 161, 217, notes 7-11, fig. 8.3.

A HEAVILY laden banquet table stands before a terrace bordered by the columns of a portico supported by a low wall. Musical instruments and shells lie on a chair and bench in the foreground. Overhead a green curtain is drawn up to reveal a landscape with a river and cathedral spire in the distance. Vines and climbing roses cover the stonework. A puce cloth is draped over a blue-covered chair on the left, upon which are a lute, a recorder, a colorfully striped silk shawl, and two letters or documents. On the smaller bench to the right are shells, books, and a flute; a guitar is propped against one side. On the banquet table, from left to right, are: a tin plate with pomegranate and walnuts; a basket with napkin and ceramic dish in the wan-li style with two lobsters; a lemon, bread, and a bunch of plums; a silver, partially gilt glass-holder (*bekerschroef*) with a glass dish; a silver saltcellar; a tall gilt covered cup (known in German as a "buckelpokal"); an engraved silver beaker; a flute glass with red wine and a broad, shallow goblet with white wine and helixing lemon peel, both vessels in a *façon-de-Venise* style; another *façon-de-Venise* goblet (with conical shape); a pewter or silver plate with lemons and blue grapes; a whole as well as a sliced orange; a wan-li style plate with peaches, a pear, blue and green grapes, a cut melon, and a walnut; a glass vase with roses; a watch with blue ribbon and key; a silver tazza tipped on its side; a pewter or silver plate stacked on another holding

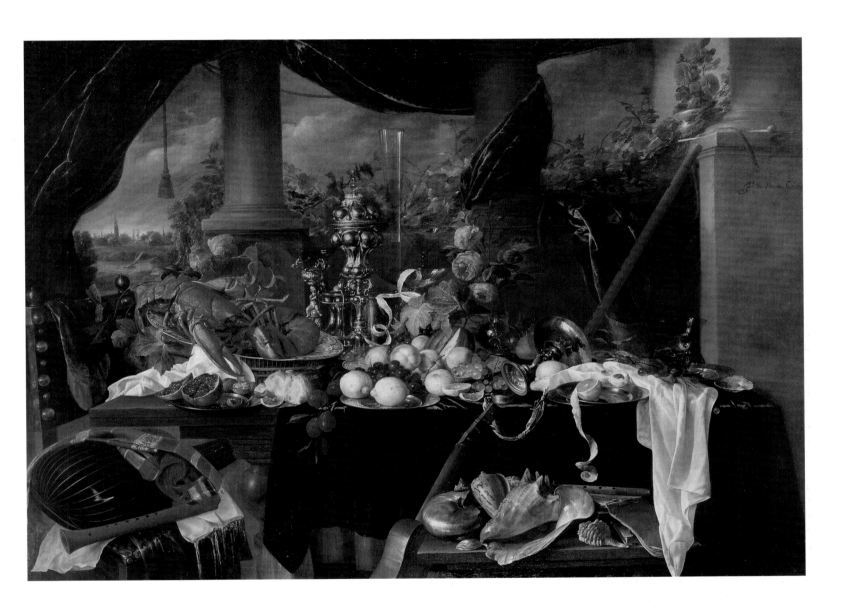

a sliced peach and lemon with spiraling rind; a
white napkin; a bunch of cherries; a flute resting
against the wall; a pewter or silver plate on which
rests a *berkemeier* wine glass; a small roemer and
some oysters.

This is the largest still life by Jan Davidsz. de
Heem known and his most ambitiously conceived
pronk still life. His first essay in large-scale banquet
scenes on canvas was the very similarly designed
painting dated 1640 in the Louvre (fig. 1). That work
anticipates the composition of the present painting,
with the banqueting table arranged horizontally,
the curtain drawn up to reveal architecture beyond,
and the instruments and low table in the foreground.
The close view of the table, which crops the scene

Fig. 1. Jan Davidsz. de Heem, *Banquet Still Life*, signed and dated 1640,
oil on canvas, 149 x 203 cm, Paris, Musée du Louvre, inv. 1321.

above the floor, enhances the immediacy of the objects. The luxuriousness of the scene arises not merely from the costly objects depicted but also from the grand format and the lavish record of surfaces and textures. Even the artist's subtle adjustments of technique seem calculated to delight a connoisseur's appreciation of the different renderings of gilt silver, the sheen of a nautilus shell, or the nubble of a lemon peel. The abundance and seemingly casual disarray of the precious objects evokes an ideal of monied insouciance, the pictorial equivalent of leisured wealth.

When exhibited in the monographic show of de Heem's work in Utrecht and Braunschweig in 1991, the painting was extensively analyzed by Sam Segal who identified all the different exotic shells, noting that they came from the Indian, Indo-Pacific, and Caribbean Oceans, and discussed the glass and metalware.[1] The *façon-de-Venise* glassware could have been manufactured in Antwerp, while the tall covered cup may have been crafted in Nuremburg.[2] The silver saltcellar and engraved beaker could have originated in either Amsterdam or Antwerp.[3] The silk shawl is probably middle eastern in origin. However, as Segal also noted, the musical instruments are less accurately rendered: the German flute has one hole too many.[4] He also observantly pointed out that the canvas on which this monumental work is executed is exceptionally finely woven; such supports were apparently reserved for prestigious works, such as this one, of exceptional technical virtuosity.[5]

According to the catalogue of the Bergsten collection of 1925, the painting was a pendant to a work dubiously assigned to Jacob Jordaens and Jan Fyt, depicting a hunter with two women, two dogs, and dead birds.[6] However it scarcely seems likely that this larger (175 x 220 cm) and very differently composed work was conceived by its authors as a companion to the present painting. The two works were reported to have come from one of the hunting lodges of the English King George III. As Segal noted, if this information is correct the first owner of the picture could have been Charles I, who in fact did own a painting by de Heem which was cursorily described in an early inventory as "baeht bij de king don by hemeson – itm a pis in a blak fram auff som silffr shel and wijt wijnpot standing opan a tabel" (bought by the king, done by [de] Heem-szoon – item, a piece in a black frame of some silver shell[s] and [a] wide wine pot standing upon a table).[7] However this description accords better with another still life with a nautilus cup, probably by a follower of de Heem, which is still in the Royal Collections.[8]

PCS

1. Segal, in Utrecht/Braunschweig 1991, pp. 136-138, cat. no. 7.

2. Segal (ibid., p. 138, note 4) cites similar examples of ca. 1635-1640; see Nuremberg, Germanisches Nationalmuseum, *Wenzel Jamnitzer und die Nürnberger Goldschmiedekunst 1500-1700* (28 June-15 September 1985), cat. nos. 125 and 137.

3. Segal (ibid., p. 118, note 5) compares the former to a similar saltcellar crafted by Anthony Grill in Amsterdam in 1646; see exh. cat. Rotterdam, Museum Boymans-van Beuningen, *Zout op tafel – De Geschiedenis van het zoutvat*, 1976, no. 24.

4. Utrecht/Braunschweig 1991, p. 138.

5. Ibid., p. 138, note 2. The weave is comprised on average of 15 threads per cm, while the customary seventeenth-century still-life canvas usually had only 10 to 12.

6. Madsen, Catalogue (1925), cat. 24. The two works also appeared together in Goudstikker's catalogues in 1912, 1915, and 1917, as well as the Björk sale in 1922. Segal (Utrecht/Braunschweig 1991, p. 137, note 10) suggested an attribution to Jan Boeckhorst for the figures in the putative pendant.

7. See Millar, "Abraham van der Doort's Catalogue" (1960), p. 196.

8. See C. White, *The Dutch Pictures in the Collection of Her Majesty the Queen* (Cambridge, 1982), cat. no. 60.

Jan Davidsz. de Heem

112. *Still Life with Glass, Glass Stand, and Musical Instruments, ca. 1645*

Oil on canvas, 139.5 x 114.1 cm (54⅞ x 44⅞ in.)
Signed at bottom center, on sheet of music:
J. D. de Heem
The Hague, Rijksdienst Beeldende Kunst, inv. NK 2711
(on loan to the Centraal Museum, Utrecht)

Fig. 1. Abraham Mignon, *Still Life with Fruit and a Finch Drawing Water*, oil on canvas, 78 x 67 cm, Amsterdam, Rijksmuseum, inv. A266.

PROVENANCE: coll. Christoph van Loo, Berlin (1906)[1]; coll. Dr. James Simon, Berlin (ca. 1906)[2]; sale Mrs. U. M. Kneppelhout-van Braam et al., Amsterdam (F. Muller), 16 December 1919, no. 29, ill.; dealer P. Cassirer, Berlin (ca. 1925); coll. Mr. & Mrs. May-Fuld, "De Breul," Zeist; sale S. P. D. May and Mrs. May-Fuld, Amsterdam (F. Muller), 14-17 October 1941, no. 311, ill.; removed to Germany during World War II; Stichting Nederlands Kunstbezit, Amsterdam, 1945-48, no. 1010; to Dienst voor 's Rijks Verspreide Kunstvoorwerpen (now Rijksdienst Beeldende Kunst), 1948.

EXHIBITIONS: Berlin 1906, no. 57; Utrecht, Jaarbeurs, *Musement* (19 June-13 July 1969); Leiden/Groningen 1985, no. VI-27; Delft/Cambridge/Fort Worth 1988, no. 38; Utrecht/Braunschweig 1991, no. 8.

LITERATURE: R. van Luttervelt, *Schilders van het stilleven* (Naarden, 1947), pp. 23, 46, 50, ill.; Utrecht, Centraal Museum, *Catalogus der Schilderijen* (1952), pp. 56-57; Greindl 1956, pp. 103, 105, 174; de Mirimonde 1960, p. 11, note 17; J. Foucart, *Musées de Hollande – La peinture hollandaise* (Paris, 1965), dossier 33, ill.; G. Bott, "Stilleben des 17. Jahrhunderts-Jacob Marrell," *Kunst im Hessen und am Mittelrhein 6* (1966), p. 110; M. E. Houtzager et al., *Röntgenonderzoek van de oude schilderijen in het Centraal Museum te Utrecht* (Utrecht, 1967), pp. 238-239; de Mirimonde 1971, pp. 280-282, ill. (with incorrect provenance); Grisebach 1974, p. 125, note 285; Leppert 1977, vol. 2, col. 64, no. 270; Sarasota, cat. 1980, under no. 84; Greindl 1983, pp. 124, 249 ill., 362; The Hague, Rijksdienst, cat. 1985, pp. 50-51, 116-117, 204, 206; J. A. L. de Meyere, in exh. cat. Cologne, Wallraf-Richartz-Museum, and Utrecht, Centraal Museum, *Niederländische Malerei des 17. Jahrhunderts aus Budapest*, 1987, p. 41, ill.; Delft/Cambridge/Fort Worth 1988, pp. 143, 148-149, 152, 217 note 20; Robels 1989, p. 164; Utrecht/Braunschweig 1991, pp. 139-141 [as "Pronkstilleven with Goldfinch"].

A PROFUSION of rare and costly objects are arranged on and near a table covered by a deeply fringed green velvet cloth and a white napkin. At left is an ornate gilt covered chalice, possibly from Nuremburg[3]; at the center are a tall flute with wine, and a *bekerschroef* (glass stand) with a *berkemeier* (goblet) atop a jewel casket covered in blue silk. Among the foodstuffs spread across the table are nuts, several types of grapes, a lemon, a cut melon, a platter with a lobster and shrimp, peaches, a pomegranate, oysters, and a bread roll. A small dance-master's violin (called a kit or *pochette*) and bow are propped against the jewel casket at right; towards the center are a pepper pot and a luminous nautilus shell. On a bench in the foreground are a richly embossed silver platter, a lute and recorder with a sheet of music, and writing implements. A curtain is looped at upper left; at right are a broken column and rotting wood beams twined with a grapevine, on which is perched a goldfinch.

This elegant sort of banquet still life, with its abundant display of delectable foods and costly vessels and serving dishes, was called a *pronkstilleven*. *Pronk* is perhaps best translated as "ostentatious" or "showy"; it also implies an object which is beautiful or rare and not for everyday use.[4] From the early 1640s, *pronkstilleven* were a popular sub-genre in both the North and South Netherlands. Flemish versions tended to be more painterly than their Northern counterparts, with a more varied palette; they are more generously scaled and there is a greater attention given to spatial effects. This is particularly evi-dent in this painting, where the objects spilling over into the foreground and the background view to a distant sky extend the space beyond the confines of a tabletop display. De Heem included similar or more extensive vistas in several of his most elaborate banquet still lifes (for example cat. 113). Many of the individual elements in the *Still Life with Glass, Glass Stand, and Musical Instruments* occur in other works from this period: the magnificent silver gilt *bekerschroef*, for example, is featured also in de Heem's *Banquet Piece with Shells and Instruments* (cat. 111). Three delicate clips hold the glass in place above a tapered vaselike form covered with grotesques; the stem of the piece is formed of a putto seated astride a dolphin, who appears to hold a shell in his hands. The figure of the putto is copied from two similar pairs of salts designed by the Amsterdam silversmith Joannes Lutma (1585-1669), dated 1639 and 1643 (Amsterdam, collection Dreesman); the putto, similarly posed in each piece, holds a shell, a piece of coral (twice), and a piece of seaweed.[5] An identical (or very similar) *bekerschroef* appears in several works by de Heem's pupil Joris van Son (1623-1667), and may confirm the latter's presence in de Heem's studio during the early 1640s (Introduction, fig. 96).[6]

The deliberate selection of the objects juxtaposed in de Heem's *Still Life with Glass, Glass Stand, and Musical Instruments* may incorporate a deeper meaning, although the interpretation of *pronkstilleven* is still problematic.[7] It has been proposed that this painting (like many such works) should be interpreted as an allegory of the choice between good and evil: the key to this reading is the orange lying prominently on the cushion in the foreground, fruit of the Knowledge of Good and Evil.[8] The ripe fruits, costly treasures, and music are all transitory pleasures; the bread and wine represent the more lasting rewards of the eucharist. The vine (flourishing amidst the decay of man's constructs) is a symbol of Christ; the goldfinch represents the soul, which is nourished as it feeds on the grapes, symbol of Christ's teachings. Other elements in the composition have been given similarly moralizing and religious interpretations.[9]

An underlying message of moderation has also been imputed to de Heem's work, and this – rather than the overtly religious message outlined above – may be the more accurate reading of the composition. A painting by de Heem now known only through copies was inscribed "Niet hoe veel Maar hoe Eel" ("Not how much, but how noble," e.g., quality over quantity). The same sentiment was expressed by Samuel van Hoogstraeten in his 1678 *Inleyding tot de hooge schoole der schilderkonst*, in exhorting young

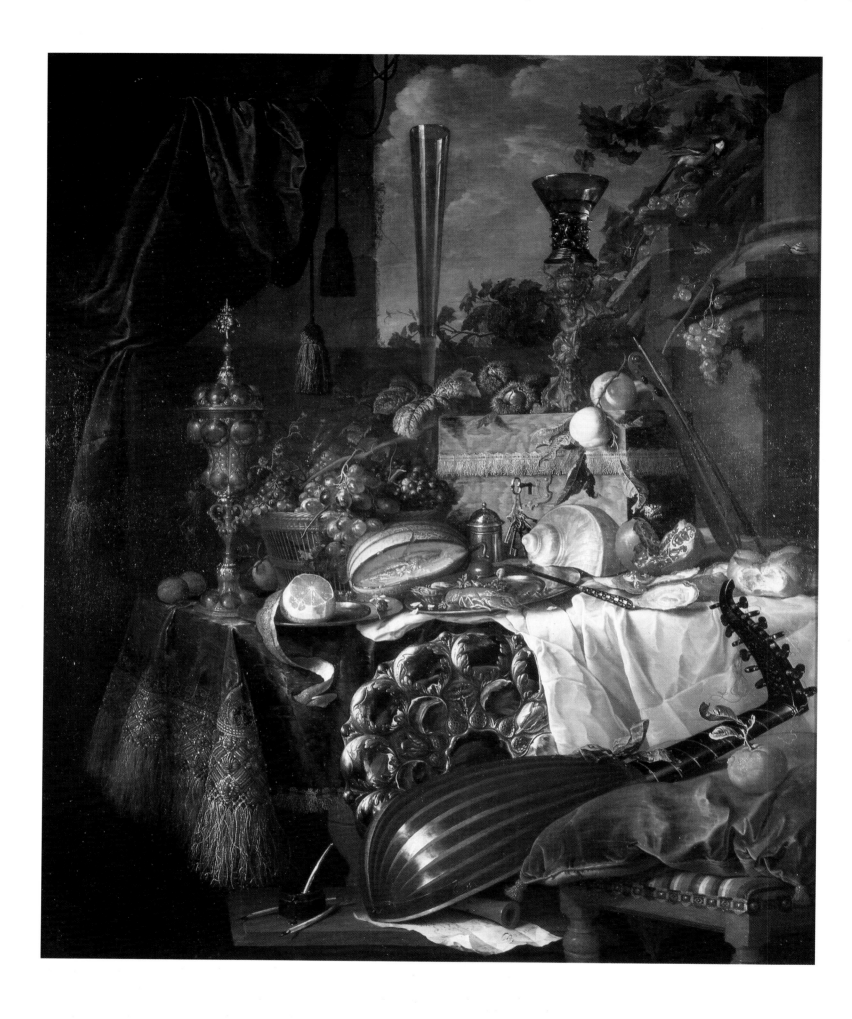

Jan Davidsz. de Heem
113. Banquet *Still Life with Parrots*,
late 1640s

Oil on canvas, 150 x 116.2 cm (59 ¼ x 45 ¾ in.)
Signed lower right, on side of table: J. D. De Heem. f
Sarasota, Florida, The John and Mable Ringling
Museum, inv. SN289

painters to moderation: "You should not overburden
your work with too many unnecessary things: as de
Heem wrote, 'Not how much, but how noble.' A host
of objects which perform no function is disgust-
ing."[10] Elements in this composition that have been
specifically cited in the context of moderation are
the half-filled wineglass prominently silhouetted
against the sky (signifying temperence), the lemon,
and the cut melon.[11]

A nearly identical version of the present work,
possibly by David Davidsz. de Heem, was formerly in
the Kunsthalle in Bremen.[12] There are also striking
similarities with works by the Utrecht still-life
painter Abraham Mignon (1640-1679), who may have
worked with de Heem during his stay in Utrecht
1667-1672 (fig. 1).[13] The *Still Life with Glass, Glass
Stand, and Musical Instruments* is difficult to situate in
de Heem's œuvre. Based on the closeness of the com-
position to Mignon's work, the painting has tenta-
tively been dated to de Heem's Utrecht period,[14]
although there are also strong – and convincing –
parallels with paintings of the 1640s.

<div align="right">MEW</div>

1. Utrecht/Braunschweig 1991, p. 139.

2. The Hague, Rijksdienst, cat. 1985, p. 117.

3. Delft/Cambridge/Fort Worth 1988, p. 149; Utrecht/Braunschweig 1991, p. 140 note 4.

4. Delft/Cambridge/Fort Worth 1988, pp. 15-16.

5. See J. W. Frederiks, *Dutch Silver*, vol. 1 (The Hague, 1952), pp. 218, 221, ill.

6. J. Welu (in exh. cat. Worcester 1983-84, p. 121, note 4) lists the following
paintings by van Son which include this *bekerschroef*: *Vanitas Still Life*,
signed and dated 1651 (oil on canvas, 77 x 110.5 cm; sale London [Sothe-
by's], 12 July 1978, no. 222); *Fruit Still Life with Boiled Lobster*, signed (oil on
panel, 56.2 x 87.1 cm; Karlsruhe, Staatliche Kunsthalle, inv. 219); *Still Life*,
signed (oil on canvas, 81 x 106 cm; sale Stockholm [Bukowski], 30 October
1979, no. 452); and *Vanitas Still Life in a Landscape*, signed (oil on canvas,
51.5 x 66.5 cm; sale New York [Sotheby's], 4 June 1987, no. 78).

7. See E. de Jongh, "The Interpretation of Still-life Paintings: Possibilities
and Limits," in Auckland 1982, esp. pp. 32, 34.

8. Sam Segal, in Delft/Cambridge/Fort Worth 1988, p. 149; and in
Utrecht/ Braunschweig 1991, pp. 140-141. The same author elsewhere
interprets the fruit as "a symbol of eternity and eternal youth" (Delft/
Cambridge/Fort Worth 1988, pp. 152-153).

9. Delft/Cambridge/Fort Worth 1988, pp. 149; Utrecht/Braunschweig
1991, pp. 140-141.

10. ". . . dat gy uw werk niet te zeer met onnodige dingen overlast: want
Niet hoe veel, maar hoe eel, schreef de *Heem*. Een menichte van beelden, die
geen werk doen, is walchelijk." Van Hoogstraeten 1678, p. 186; cited also
in Delft/Cambridge/Fort Worth 1988, p. 148.

11. Lemons were used to cut the sweetness of wine (Utrecht/Braun-
schweig 1991, p. 132); in the sixteenth and seventeenth centuries melons
were popularly thought to produce insanity when eaten in large quanti-
ties (Delft/Cambridge/Fort Worth 1988, p. 149).

12. Oil on canvas, 130.5 x 110 cm, signed *David de Heem*; sold from Bremen
at Cologne (Lempertz) 27 November 1935, no. 147 (see The Hague, Rijks-
dienst, cat. 1985, p. 116). David Davidsz. de Heem joined the Utrecht
guild of St. Luke in 1668; his relationship to Jan Davidsz. is not known.

13. The connection between de Heem and Mignon was noted by Fred
G. Meijer; see The Hague, Rijksdienst, cat. 1985, p. 116.

14. Ibid.

PROVENANCE: collection of the Counts of Schönborn, Castle Pom-
mersfelden, catalogues of 1719 and 1857 (no. 307) [as a "masterpiece by
Jan de Heem"]; sale Pommersfelden, Paris (Drouot), 17/18 May 1867,
no. 38 ("peinture d'une magnificence superlative"; 8000 livres [with-
drawn]); purchased by John Ringling between 1925 and 1930; acquired by
the museum as part of the Ringling Bequest, 1936.

EXHIBITIONS: San Francisco, *Golden Gate International Exposition*, 1940;
New Orleans, Delgado Museum, *Fêtes de la Palette*, 1962-63, no. 35; Nor-
folk Museum, *Masterpieces from Southern Museums*, 1969; New York,
Wildenstein Galleries and Tampa, The Tampa Museum, *Masterworks from
the John and Mabel Ringling Museum of Art* (1981), pp. 22 no. 33, 34, pl. 22;
Hanover/Raleigh/Houston/Atlanta 1991-93, pp. 230-232, no. 11, pl. 1,
cover ill.

LITERATURE: W. E. Suida, *A Catalogue of Paintings in the John and Mabel
Ringling Museum of Art*, 1949, p. 247; F. W. Robinson, in Sarasota, cat. 1980,
no. 84, ill. and cover; A. F. Janson, *Great Paintings from the John and Mabel
Ringling Museum* (New York, 1986), p.33, ill.; Utrecht/Braunschweig 1991,
p. 143 (under no. 9), ill.; M. Vandenven, in Liedtke et al. 1992, pp. 307-309,
ill.

A VOLUMINOUS dark curtain, drawn aside to
reveal the base of a column and brooding evening
landscape, serves as the foil for a dazzling assem-
blage of still-life elements. On a table draped in a
fringed red velvet cloth, the vertical accents of a pep-
per pot, silver ewer, covered gilt cup,[1] and partially
filled wine flute punctuate the composition and
emphasize the vertical format. The luxurious food-
stuffs include citrons, both whole with the rind
unfurled and cut, shrimp, a pewter platter of oysters
and two oranges which rests upon a split pomegran-
ate, a sliced melon and an immature fruit, and a bas-
ket containing grapes, peaches, plums, and walnuts.
A blue silk box with a lobster on the lid commands
the center of the arrangement, behind which a roe-
mer is just visible. A bronze wine cooler containing a
wine bottle entwined in grape leaves has been placed
under the left corner of the table. The bench in the
right foreground supports a collection of costly
imported items, including a lustrous nautilus (*Nau-
tilus pompilius*) and a triton shell (*Strombous gigas*), as
well as a blooming branch of Seville oranges and
some figs. A recorder leans unobtrusively to one
side. Various insects and butterflies are scattered
throughout the banquet. From its circular perch at
the apex of the composition, an African gray parrot
tempts a magnificent red and yellow macaw with a
piece of fruit.

While some still lifes may have been painted on
commission (see cat. 111), the majority of de Heem's
lavish compositions were probably painted for the
open market. *Banquet Still Life with Parrots* is a partic-
ularly vibrant example of the kind of *pronkstilleven*
produced for wealthy bourgeois or aristocratic
patrons in Antwerp during the 1640s for which de
Heem was justly lauded by contemporaries.[2] Two
other versions of this composition which may have

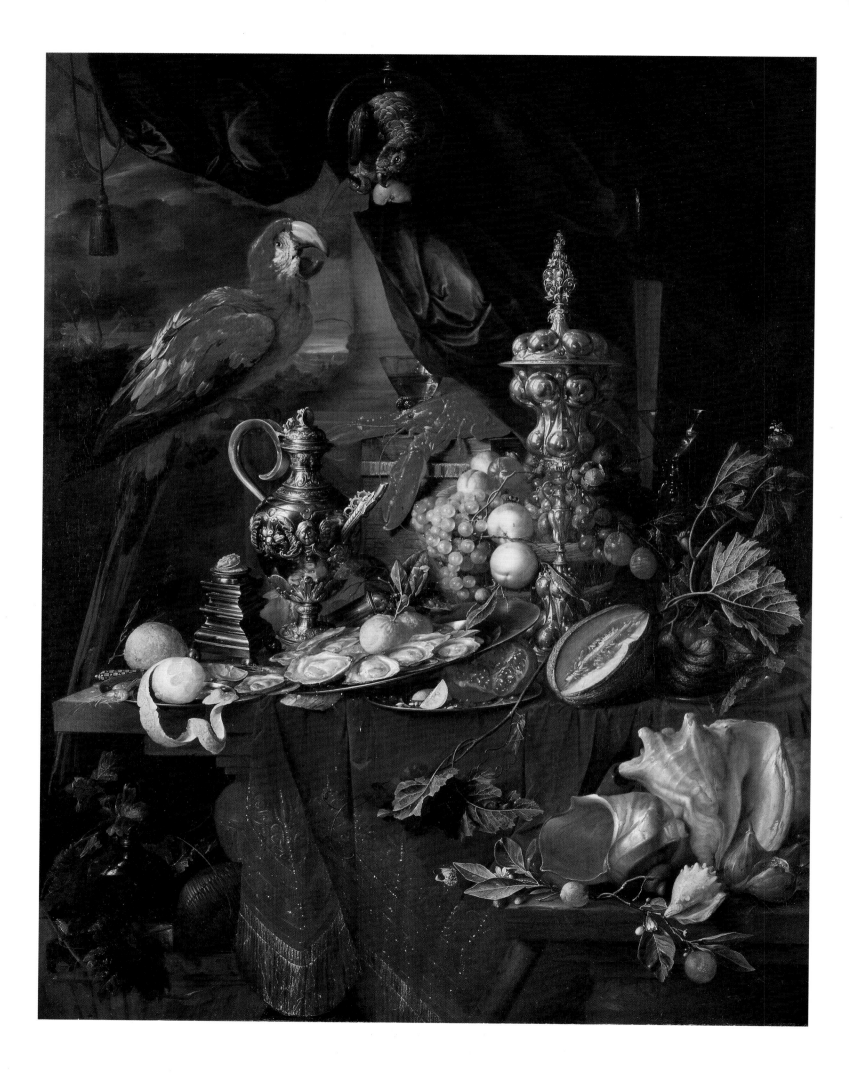

Fig. 1. Jan Davidsz. de Heem, *Still Life with Parrot*,
oil on canvas, 115.5 x 170 cm, Vienna, Gemäldegalerie
der Akademie der bildenden Künste, no. 612.

been produced in de Heem's studio are known, and
attest to its popularity.[3]

Upon his arrival in Antwerp from the United
Provinces in 1635, de Heem became influenced by
artists working in Rubens's circle, including Jan Fyt,
Adriaen van Utrecht, and especially Frans Snyders.
He assimilated the bright tonalities and spacious
formats which were characteristic of their work with
his own complex methods of presentation. The
impression of casual disarray conveyed by the jum-
ble of objects displayed in *Banquet Still Life with Par-
rots* belies the highly balanced and controlled appli-
cation of color, in which considered juxtapositions of
strong primaries (red and blue) as well as secondary
hues (orange and silver) provide maximum visual
impact. The tonal relationships of the objects is par-
alleled by their arrangement on several intersecting
planes comprised of strong diagonals and horizon-
tals. These costly items are arranged so that their
varied textures and forms are shown to best advan-
tage: for example, the shimmering nautilus against
the red pile of the table cloth, and the covered cup
whose lobes are reiterated in the shapes of the sur-
rounding fruit. The parrots which animate the
upper portion of the composition appear relatively
infrequently in de Heem's œuvre (fig. 1), and suggest
his debt to Snyders and van Utrecht (see Introduc-
tion, fig. 98: Adriaen van Utrecht, *Still Life of Metal-
ware with a Parrot*, Brussels, Musées Royaux des
Beaux-Arts de Belgique, inv. 4731), whose still lifes
were frequently populated by these expensive and
showy birds.[4]

Banquet Still Life with Parrots incorporates a num-
ber of compositional elements that characterize
de Heem's paintings dating from the mid- to
late 1640s, and which recur again in his works of the
1660s. During the 1640s, beginning with *Banquet Still
Life* (cat. 111, fig. 1), he frequently staged sumptuous
displays against backdrops of curtains, columns, and
landscape scenes (see cats. 111 and 112).[5] The device
of a low table placed in the foreground also appears
during this time (see cat. 111), as does the motif of a
red lobster on a blue box. This last element is used by
de Heem in several other paintings, including *Still
Life* (Rotterdam, Museum Boymans-van Beuningen,
inv. 1289),[6] and was a detail frequently picked up by
followers, including Jan Jansz. de Heem and Nicolas
van Gelder.[7]

Kenseth recently presented a detailed symbolic
interpretation of this painting.[8] Specific symbolic

allusions to temperance (the half-filled wine glass),
or the *vanitas* associations of acquisitiveness (repre-
sented by the rare shells) would have been apparent
to a contemporary.[9] From medieval times, complex
symbolism has been ascribed to parrots; they have
been associated in particular with man's praise of
God because of their unique ability to mimic the
human voice.[10] However, like the precious objects
beneath them, parrots were considered a great luxu-
ry in the seventeenth century. They add a living
dimension to this display, which in its scale and
variety was intended to convey decorative rather
than didactic themes of abundance.

ATW

1. This "buckelpokal" is similar to examples produced in Nuremburg
between 1635 and 1640. See Nuremburg, Germanisches Nationalmuseum,
Wenzel Jamnitzer und die Nürnberger Goldschmiedekunst 1500-1700 (28 June-
15 September 1985), nos. 99, 125, 137; and cats. 111 and 112.

2. De Bie 1661, pp. 216-218.

3. Both differ from Sarasota's painting slightly in their dimensions and
in the treatment of the lower portion of the column. One was sold in
Lucern (Galerie Fischer), 25-29 June 1957, no. 2590, pl. 39 (151 x 112 cm,
signed at the right "De Heem - f."; "Werk des Meisters von bester Erhal-
tung"). Another was in a Paris private collection in 1935. See M. Vanden-
ven, in Liedtke et al. 1992, p. 307; and F. W. Robinson, in Sarasota,
cat. 1980, no. 84.

4. Utrecht/Braunschweig 1991, pp. 141-143, no. 9. De Heem incorporated
two parrots (an African gray and an Indian ringneck parakeet) in a simi-
lar arrangement in *Celestial Sphere, Lute, Lobster and Fruit with Two Parrots*,
dated either 1638 or 1658 (formerly Zurich, Galerie David Koetser, 1968);
see Greindl 1956, pp. 153, 251, pl. 132.

5. The author of the *Fêtes de la Palette* cat. entry (n.p.) suggested that de
Heem had "apparently painted [the Ringling *Still Life with Parrots*] in the
same setting" as the *Still Life* (New York, The Metropolitan Museum of
Art, inv. 12.195) then attributed to Jan Davidsz. de Heem, and recently
reassigned to his son, Jan Jansz. de Heem. However, the elegant setting is
simply an imaginative construct contrived to enhance the elegance of
the scene. See W. Liedtke, "Addendum to *Flemish Paintings in the Metropol-
itan Museum of Art*," *Metropolitan Museum of Art Journal* 27 (1992), pp. 112-
115.

6. Delft/Cambridge/Fort Worth 1988, pp. 241, no. 39. For a somewhat
later example, see de Heem's *Still Life with Fruit and Lobster* (signed and
dated 1667, oil on canvas, 57.2 x 68.3 cm; Brussels, Musées Royaux des
Beaux-Arts de Belgique, inv. 3166).

7. Jan Jansz. de Heem, *Banquet Still Life with View of a Farm*, private collec-
tion; Utrecht/Braunschweig 1991, pp. 196-198, ill. Van Gelder's painting
(Amsterdam, Rijksmuseum, inv. A1536) dates from 1664; Delft/Cam-
bridge/Fort Worth 1988, p. 244, no. 44; ill. p. 159

8. Hanover/Raleigh/Houston/Atlanta 1991-93, pp. 230-232, no. 11.

9. Delft/Cambridge/Fort Worth 1988, pp. 77-78.

10. Braunschweig/Utrecht 1991, p. 143. Segal cites *Physiologus* as the
basis for this interpretation. Delft/Cambridge/Fort Worth 1988, p. 157
and Utrecht/Braunschweig 1991, p. 143 (see cat. 45). For an overview of
the parrot in art, see J. Douglas Stewart, "'Hidden Persuaders': Religious
Symbolism in van Dyck's Portraiture; With a Note on Dürer's 'Knight,
Death and the Devil,'" in *Review d'Art Canadienne/Canadian Art Review*
(RACAR) 10 (1983), pp. 67-68.

Frans Snyders

(1579-Antwerp-1657)

Painter of animals, hunt scenes, and still lifes, Frans Snyders was baptized in the Onze-Lieve-Vrouwekerk in Antwerp on 11 November 1579. His father, Jan Snyders, was the owner of a large inn frequented by artists. Snyders became a pupil of Pieter Brueghel the Younger (1564-ca. 1638) in 1593, and according to Meyssens (1649) may subsequently have studied with Hendrick van Balen as well (q.v.). Snyders became a master in the Antwerp guild of St. Luke in 1602. He traveled to Rome in spring 1608; in September of that year, his friend Jan Brueghel the Elder (q.v.) wrote to Cardinal Federigo Borromeo in Milan announcing Snyders's imminent arrival in that city, and soliciting the cardinal's patronage for the young artist. Snyders returned to Antwerp by 4 July 1609.

He married Margaretha de Vos, sister of the painters Cornelis and Paulus de Vos, on 23 October 1611. The couple lived on the Korte Gasthuisstraat and later, from 24 December 1620, in a large house on the Keizerstraat next door to Nicolaes Rockox. In 1619 Snyders joined the Confraternity of Romanists, and was elected their dean (deken) in 1628. Snyders visited the Northern Netherlands in 1641 (in the company of Abraham Brueghel [1631-ca. 1690], Gerard Seghers [1591-1651], and Adriaen van Utrecht [1599-1653]), and in 1642 (with Jacob Jordaens [q.v.] and Adriaen van Utrecht). He may have made other journeys north; a painting of 1646 is signed "fecit in Breda." Of the three pupils of Snyders documented in Guild records, only one is known today: Nicolaes Bernaerts (1620-1678), a designer of hunt-scene tapestries. Snyders had several followers, including his brother-in-law, Paulus de Vos, and Jan Fyt (q.v.), who probably worked in Snyders's studio in the 1620s. Margaretha de Vos died on 2 September 1647; nearly a decade later, on 19 August 1657, Snyders died and was buried alongside his wife in the Minderbroederskerk in Antwerp. The several testaments drawn up throughout Snyders's life (1613, 1627, 1655) attest to his considerable wealth.

Snyders's paintings exhibit a baroque vitality and grandeur far removed from the miniaturistic delicacy and conspicuous organization of his predecessors in the art of still-life painting. His dynamic compositions are complemented by a broad range of clear, brilliant colors and superb re-creation of textures. He was a close friend and working partner of Rubens from about 1610 until the latter's death in 1640. He collaborated with Rubens on a number of works (most famously, the *Prometheus Bound* of ca. 1611-12, finished by 1618, cat. 10; see also cats. 12 and 14), and through him received commissions from Philip IV of Spain for decorations for the Torre de la Parada in 1636-38. There are also documented instances of Snyders's collaboration with Jan Boeckhorst, Anthony van Dyck, Abraham Janssens, Jacob Jordaens, Erasmus Quellinus, Theodoor van Thulden, Cornelis de Vos, Jan Wildens (qq.v.), and Thomas Willeboirts Bosschaert.

Meyssens 1649; de Bie 1661, pp. 60-61; Houbraken 1718-21, vol. 1 (1718), pp. 84-85, vol. 2 (1719), p. 49; Weyerman 1729-69, vol. 1 (1729), pp. 350-351; Dezalliers d'Argenville 1745-52, vol. 2, pp. 150ff; Descamps 1769, vol. 1, pp. 330-333; Nagler 1835-52, vol. 16 (1846), pp. 540ff; Immerzeel 1842-43, vol. 3 (1843), pp. 96-97; Kramm 1857-64, vol. 5 (1861), pp. 1537-1538, vol. 6 (suppl.), p. 139; Nagler 1858-79, vol. 2, p. 2484; Crivelli 1868, pp. 110-113; Michiels 1865-76, vol. 7 (1869), pp. 408-427; Rombouts, van Lerius 1872, vol. 1, pp. 373-374, 418, 456, 528, 575, vol. 2, pp. 54, 185, 282, 284; Rooses 1879, pp. 396-401 et passim; van den Branden 1883, pp. 672-679, 1086, 1277, 1376; Wurzbach 1906-11, vol. 2 (1910), pp. 633-635; Ozzóla 1913; Dilis 1922, p. 460; Glück 1933, pp. 358ff; K. Zoege van Manteuffel, in Thieme, Becker 1907-50, vol. 31 (1937), pp. 190-191; Manneback 1949; Ninane 1949; Sterling 1952, pp. 12, 49, 51-52, 58-59, 75, 85; Funk 1954; Greindl 1956, pp. 49-63, 179-187; Robels 1969; Bodart 1970, vol. 1, p. 466; Mecklenburg 1970, pp. 17-21; Alpers 1971, pp. 37-39, 117-121; Jaffé 1971; Hairs 1977, pp 15-16; Müllenmeister 1981, vol. 3, pp. 59-61; Sullivan 1981; Greindl 1983, pp. 71-86, 373-380; Sutton 1983; Sullivan 1984, pp. 16-22; Huvenne 1985; Van der Stighelen 1987; Robels 1989; Sutton 1990, p. 298; Cologne/Vienna 1992-93, pp. 474-477.

Anthony van Dyck, *Frans Snyders*, etching, Boston, Museum of Fine Arts, inv. Wib. 11.

Frans Snyders
114. Fruit Still Life with Squirrel

Oil on copper, 56 x 84 cm (22 x 38 ⅛ in.)
Signed and dated 1616
Boston, Museum of Fine Arts, by exchange

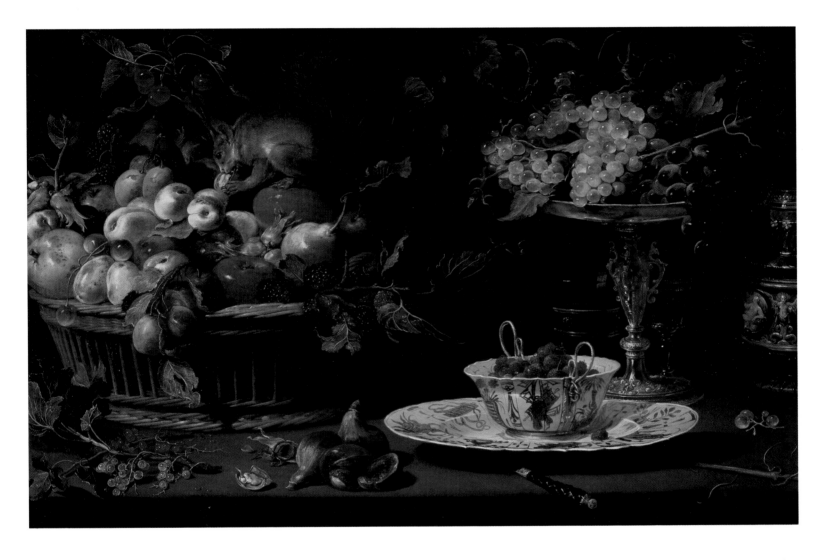

PROVENANCE: Schaumburg-Lippe collection; sale Régine Charles, Brussels (Galerie Fierez), 16 December 1929, no. 90; dealer A.G. Luzern, 1934; Edward Meert, Saint-Nicholas-Waas; with Edward Speelman Ltd., London, 1972.

LITERATURE: Greindl 1956, p. 54, 181; Gerson, ter Kuile 1960, p. 159; Greindl 1983, pp. 73, 374, no. 44 ill. p. 293, no. 199; D. F. Lunsingh Scheurleer, *Chinesisches und japanisches Porzellan in europäischen Fassungen* (Braunschweig, 1980), pp. 30, 197, fig. 57; Greindl 1983, pp. 79, 293, fig. 199 and p. 374, cat. no. 44; Delft/Cambridge/Fort Worth 1988, pp. 75-76, ill., and note 61; Robels 1989, p. 79, no. 125, ill.

ON THE LEFT of this tabletop still life a nibbling squirrel is perched atop a basket of fruit (including apples, peaches, plums, raspberries, pears, and cherries). To the right are a porcelain cup and dish in the wan-li style containing strawberries. Behind it is a tazza with grapes, and several glasses, while at the far right is a ceramic jug in the style of Palissy. In the immediate foreground from left to right are a sprig of currents, figs, and the handle of a knife extending illusionistically over the edge of the table.

This painting is one of a group of cabinet-sized tabletop still lifes that Snyders executed during the second decade of the century which adopt some of the formal conventions of the earlier specialists in this painting type, namely Osias Beert, Clara Peeters, and Peter Binoit. Snyders's compositions, however, offer a more colorful palette, more rhythmic organization with enlivening contrasts of light and shade, and smoother brushwork. These developments had certainly begun by 1613 when Snyders dated his tabletop still life with fruits and vegetables, dead game, and similar tazza of grapes and wan-li porcelain, now in a private collection in Neuilly-sur-Seine (fig. 1),[1] and Robels suggests that the developments might have begun approximately three years earlier.[2] Many of the same objects recur in this group, notably the straw basket, the tazza, porcelain and ceramic jug; compare, for example, the objects in a contemporaneous tabletop still life in the Rijks-

Carstiaen Luyckx

(Antwerp 1623-after 1653)

Fig. 1. Frans Snyders, *Still Life with Game, Fruit, and Vegetables*, signed and dated 1613, oil on panel, 59 x 87 cm, Neuilly-sur-Seine, private collection.

museum, Amsterdam (no. 2208).³ Even the nibbling squirrel recurs in Snyders's still lifes in the collection of the Earl of Wemyss and March, Gosford House; and formerly with the dealer Müllenmeister, Solingen.⁴ Also signed and dated 1616 is Snyders's tabletop still life with cat and popinjay in the Koetser collection now in the Kunsthaus, Zurich (cat. 1988, no. 11).

While Snyders naturally favored canvas supports for his very large hunt and market scenes (compare his *Boar Hunt*, cat. 121), he often turned to wood panels when working with greater detail on a more intimate scale in his tabletop still lifes. However he only employed copper supports in a handful of instances.⁵ Copper was the most costly support, but its exceptionally smooth surface lent itself to the especially fine effects of brushwork and coloristic brilliance that we witness in this rare painting. Robels drew attention to a drawing after the painting by Paulus de Vos in the Prentenkabinet in Antwerp (inv. no. A XXVI 2).⁶

<div align="right">PCS</div>

1. Robels 1989, cat. no. 110.

2. Robels 1989, pp. 75-79.

3. Robels 1989, cat. no. 121.

4. Robels 1989, cat. nos. 58 and 98.

5. See also Robels 1989, cat. no. 1821 (Munich, Bayerische Staatsgemälde-sammlungen, Alte Pinakothek, no. 1852), and no. 115.

6. Robels 1989, p. 261; See A. J. J. Delen, *Catalogue des dessins anciens, Ecoles Flamande et Hollandaise* (Brussels, 1938), vol. 1, p. 83; Greindl 1988, p. 387, no. 10.

Carstiaen (Cerstiaen) Luyckx (Luckx) was baptized in Antwerp on 17 August 1623; his parents apparently died shortly thereafter. Luyckx entered an apprenticeship with the still-life painter Philippe de Marlier (ca. 1573-1668) on 26 February 1639. Upon the completion of this training he joined the studio of Frans Francken III (1607-1667). He worked with Francken from 1642 to 1644, copying history paintings and also executing independent still lifes as early as 1643.

Luyckx made a brief journey to Lille in 1644 but had returned to Antwerp by 27 May 1645, when he married Geertruid Janssens van Kilsdonck in the Onze-Lieve-Vrouwekerk. The couple had one daughter, Maria. Luyckx was registered as a master in the Antwerp guild of St. Luke on 17 July 1645. In a document dated 18 September 1646, Luyckx is referred to as being "in the service of His Majesty the King of Spain" ("wesende in dienst van Zijne Conincklijcke Majesteijt van Spanje"). Following the death of his first wife, Luyckx married Maria Matthijssens in Antwerp's St. Walpurgiskerk on 24 September 1648. A son Willem was baptized on 16 August 1653; this is the last documentary mention of the artist. It is not known when or where he died, although on the basis of a signed *Kitchen Interior with Still Life* (Dresden, Gemäldegalerie Alte Meister, inv. 1091 [see Introduction, fig. 59]) executed in collaboration with David Teniers and Nicolaes van Verendael (qq.v.), it is thought that the artist may have still been alive in about 1670.

One of the most accomplished seventeenth-century Flemish still-life painters, Luyckx remains surprisingly unknown. He executed floral bouquets, fruit still lifes, *pronk* still lifes, bird and game still lifes, and a variety of garlands and festoons in the manner of Jan Davidsz. de Heem and Frans Snyders (qq.v.). None of the artist's works are dated.

Rombouts, van Lerius 1872, vol. 2, pp. 119, 123, 155, 161; van den Branden 1883, pp. 1134-1136; Ebenstein, in *Jahrbuch der kunsthistorischer Sammlungen des allerhöchsten Kaisershauses 26* (1906), pp. 213-215; Wurzbach 1906-11, vol. 2 (1910), p. 75; Thieme, Becker 1907-50, vol. 23 (1929), p. 487; Hairs 1955, p. 120; Greindl 1956, pp. 100-101, 177; Greindl 1983, pp. 120-122, 368-369; S. Segal, in exh. cat. Amsterdam/Braunschweig 1983, p. 72; Hairs 1985, pp. 321-322, 486; I. Bergström, in exh. cat. Washington/Boston 1989, p. 116.

Carstiaen Luyckx
115. *Still Life Banquet Scene*

Oil on panel, 45.5 x 71 cm (17⅞ x 28 in.)
Signed below edge of tabletop at left:
Carstian Luckx. fecit
Private collection

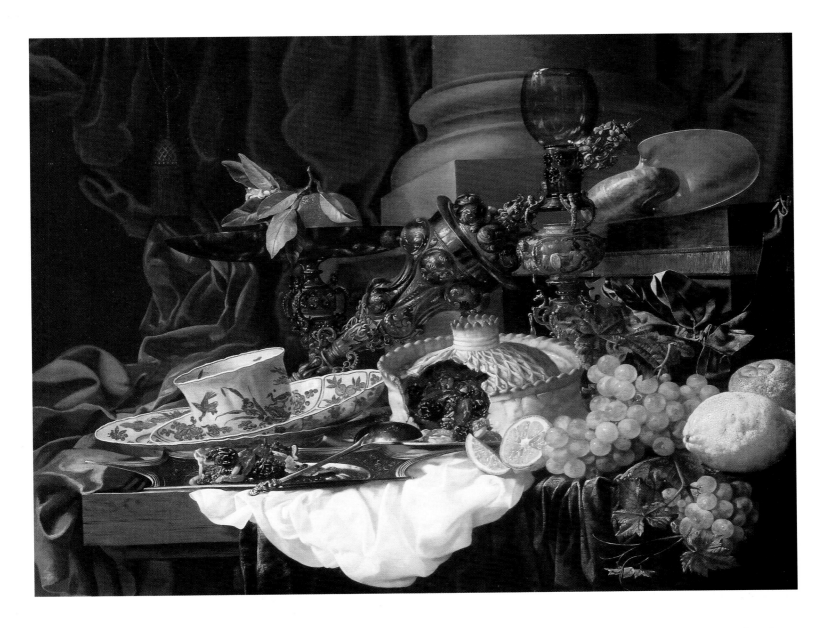

PROVENANCE: sale Amsterdam (Mak van Waay), 24 May 1966, no. 319, ill.; Leonard Koetser Gallery, London, 1966; sale London (Sotheby's), 2 July 1986, no. 169, ill.; Peter Tillou Gallery, Litchfield, CT, 1989.

EXHIBITIONS: Delft/Cambridge/Fort Worth 1988, no. 47.

LITERATURE: S. Segal, in Delft/Cambridge/Fort Worth 1988, pp. 164, 245; I. Bergström, in Washington/Boston 1989, pp. 116-117, ill.; M. E. Wieseman, in exh. cat. Boston, Museum of Fine Arts, *Prized Possessions: European Paintings from Private Collections of Friends of the Museum of Fine Arts, Boston* (17 June-16 August 1992), p. 173.

CANTED on its side, a silver-gilt pronk goblet dominates the luxurious display atop a table draped in green and white cloths at the base of a column. The bulbous lobes which decorate the body and lid of the *buckelpokal* are typical of Nuremburg work of the early to mid-seventeenth century; compare, for example, similar goblets by Hans Beutmüller of ca. 1610-1620 (Zurich, Schweizerisches Landesmuseum); Friedrich Hirschvogel of ca. 1635-1640 (Nuremburg, Germanisches Nationalmuseum), or Franz Fischer of ca. 1645-1650 (Nuremburg, Stadtgeschichtliches Museum).[1] An almost identical goblet, also topped by a delicate spray of silver blossoms, appears in Jan Davidsz. de Heem's *Still Life with Glass, Glass Stand, and Musical Instruments* (cat. 112), *Still Life with Parrots* (cat. 113) and *Banquet Piece with Shells and Instruments*, dated 1642 (cat. 111).

To the left of the pronk goblet is a silver tazza[2]; a Seville orange with leaves and blossoms still attached is set in the shallow bowl. The glass holder (*bekerschroef*) to the right of center has been

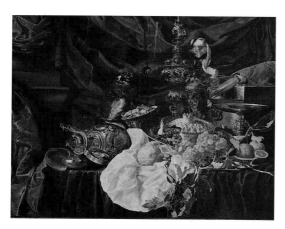

Fig. 1. Carstiaen Luyckx, *Banquet with a Monkey*, 1650s,
oil on canvas, 83.5 x 105 cm, Mrs. H. John Heinz III.

elements, these two works showcase the artist's considerable abilities as a painter of elaborate "pronk" still lifes in the manner of Jan Davidsz. de Heem. Both the *Banquet Scene* and the *Banquet with a Monkey* can probably be dated to the 1650s.

MEW

1. Nuremburg, Germanisches Nationalmuseum, *Wenzel Jamnitzer und die Nürnberger Goldschmiedekunst 1500-1700* (28 June-15 September 1985), p. 119, fig. 91; pp. 270-271, cat. 99; and pp. 283-284, cat. 137, respectively.
2. Segal (Delft/Cambridge/Fort Worth 1988, p. 164) likens this tazza to one made by the Delft silversmith Cornelis van der Burch in about 1600; the comparison is not particularly convincing.
3. Ibid.

compared by Segal to one made in 1609 by the Amsterdam goldsmith Leendert Claesz. van Emden (Amsterdams Historisch Museum).³ The ovoid form just below the prongs which support the delicately reflective roemer is decorated with a vignette of a reclining figure, framed by two grotteschi.

At the left are two Chinese blue and white porcelain dishes and a small bowl; a similar stack appears in Luyckx's *Still Life with Dead Fowl and a Cat* (oil on canvas, 48 x 63 cm; Dublin, National Gallery of Ireland, inv. 529). On the edge of the table in the immediate foreground, steeply foreshortened, is an engraved silver *puntschotel* with a portion of pie, bridged by a spoon with a finial in the form of a lion with a shield. The bowl of the spoon rests on the edge of a platter holding a massive pie with succulent fruits spilling forth from the flaky crust. Next to the pie are a whole and a cut orange, a citron, and a bunch of grapes with leaves attached. At the upper right, a pearly nautilus shell rests atop a velvet-covered chest used to store tableware. A crisp blue ribbon loosely wraps the corner of the chest to loop through the latch in front.

When the painting was sold in 1986, a layer of gray overpaint obscured the red drapery to the left of the column, to a point just above the edge of the porcelain bowls. Restored to its original appearance, the billowing folds of fabric enhance the seemingly casual disorder of the remains of an extravagant banquet and cast ruddy reflections in the gleaming metalware.

Many of the objects in the present painting (or similar ones) also appear in Luyckx's somewhat larger *Banquet with a Monkey* in the Heinz collection (fig. 1). Although the majority of Luyckx's still lifes are more simply composed and of less ostentatious

Franciscus Gijsbrechts

(active 1670s, Leiden and Antwerp)

Little is known about Franciscus Gijsbrechts's life and career. A "François Gijsbrechts" joined the Antwerp St. Luke's Guild in 1637/38 as an art dealer; "Fransiskus Gijsbrechts" became a member of the painters' guild in Leiden in 1674; and "Francus Gijsberechts, schielder [sic], Wijnmeester [son of a guild member]" joined the Antwerp guild in 1676/77. It is conceivable that the art dealer Gijsbrechts was an older relation (father?) of the painter, whose only extant dated work is from 1672. Franciscus Gijsbrechts was certainly also related to Cornelis Norbertus Gijsbrechts (active 1659-1675), a painter of trompe l'œils and still lifes active in Antwerp, Hamburg, and Copenhagen; there are strong similarities between the two artists' works. Franciscus Gijsbrechts specialized in *vanitas* still lifes, and in trompe l'œil depictions of windows and vitrines laden with prints, papers, and other objects. His almost monochromatic compositions are comparable to works by the Leiden still-life painter Edwaert Collier (ca. 1640-after 1706).

Rombouts, van Lerius 1872, vol. 2, pp. 91, 95, 450, 454; Obreen 1877-90, vol. 5 (1882/3), p. 234; Wurzbach 1906-11, vol. 1 (1906), p. 623; Frimmel 1912; Thieme, Becker 1907-50, vol. 15 (1922), p. 378; van Riemsdijk 1926; Vorenkamp 1933, p. 108; Gammelbo 1952-55, pp. 141-142, 152-153; de Mirimonde 1971, pp. 263-268; Washington/Boston 1989, p. 107.

Franciscus Gijsbrechts
116. Trompe l'Œil Window of a Cabinet

Oil on canvas, wood, and metal,
136.5 x 102.3 cm (53 ¼ x 40 ¼ in.)
Signed (verso) on the lower inside edge
of the window: F. Gysbrechts
Mrs. H. John Heinz III

PROVENANCE: private collection, France; with Johnny van Haeften Ltd., London.

EXHIBITIONS: Washington/Boston 1989, no. 17, ill.

LITERATURE: P. C. Sutton, in The Hague/San Francisco 1990-91, p. 110, fig. 8.

THE CANVAS depicts an illusionistic casement window with a painted pine frame and leaded mullions; on the right, actual hinges permit the inner section of the window, also on canvas, to actually swing open. Depicted as if slipped between the window's crosspiece and the panes of glass are illusionistically depicted prints, documents, and other printed pages. On the right hangs a red seal, a stick of sealing wax, and a feather; a powder horn dangles from a nail at the upper left.

Windows, cabinet doors, letter racks or boards, or other thin or shallow objects posted with paper notices had long been popular subjects for trompe l'œil paintings throughout Europe, no doubt in part because such themes enhanced the effect of illusionism by stressing the picture plane and minimizing the need for pictorial relief. Illusionistic cabinets with partly open windows, for example, had appeared in fifteenth-century Italian intarsia and a few illusionistic cupboards were painted in the sixteenth century.[1] In the Low Countries, interest in this type of painting was stimulated by the art theorist and Rembrandt pupil Samuel van Hoogstraeten, who was from Dordrecht but developed this type of painting while working at the Hapsburg court in Vienna in the mid-1650s.[2] Artists in Antwerp might have come to know of these experiments in illusionism through the Hapsburg connections of their local Spanish court.

The painters Cornelis Norbertus and Franciscus Gijsbrechts were undoubtedly related, though their precise relationship is unknown; both were active in Antwerp, although Franciscus was also a member of the Leiden guild (see Biography). Cornelis Norbertus may have been the older of the two because he dated trompe l'œil still lifes as early as 1660[3]; he had painted illusionistic window frames with leaded mullions and the window partly ajar by 1665 (fig. 1).[4] In 1668 he was court painter to Frederick III in Copenhagen, and later to Christian V. As a consequence of these appointments, many of the artist's illusionistic paintings are now preserved in the Museum in Copenhagen, including a trompe l'œil of a free-standing easel with painting supplies supporting a painting of a fruit piece and the canvas of another picture turned and resting against it (fig. 2).[5] Another painting by Cornelis from this group is an illusionistic window dated 1670, conceived in a fashion

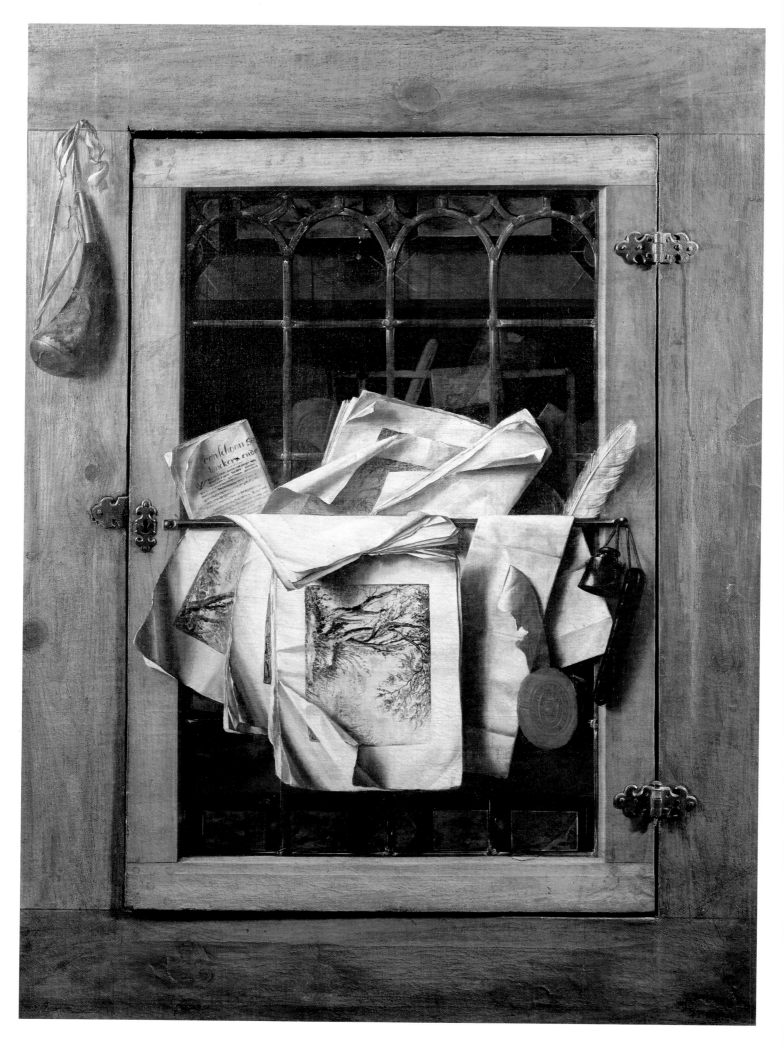

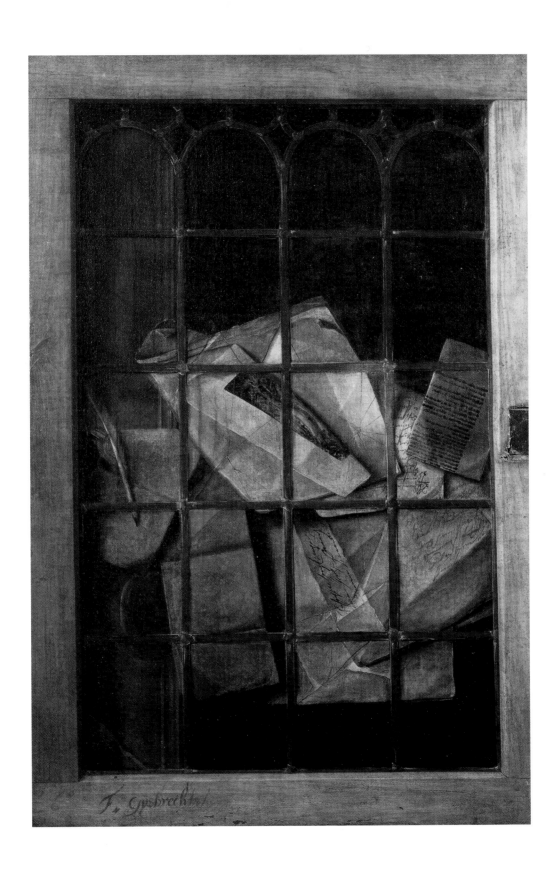

very similar to the Heinz painting, with a wood case-ment, letters, and a quill stuck in the crosspiece and, most significantly, actual metal hinges which enable the window to be opened and the other side, also rendered as a painted illusion, to be examined.[6] This kinetic feature extended the illusion to three dimen-sions, and no doubt was designed to enhance the visual delight of deception. Since the Heinz painting is not dated we cannot say with certainty that Fran-ciscus did not invent this trick, but since Cornelis Norbertus's œuvre is more varied and innovative he was probably the pioneer. However there is little or no difference in the quality of the two artists' works. With only a single dated painting (1672), Franciscus's small œuvre of only about one dozen paintings can-not be organized in strict chronology; however, this painting may date from the mid-1670s.

Franciscus painted at least five other trompe l'œil paintings of cabinets with the glass door ajar. These reveal various objects inside the cabinet and often feature a trumpet hanging from the top of the win-dow and notes and prints stuffed in the crosspiece.[7] Through the (painted) glass of the closed window in the Heinz painting we can see at the top and bottom the suggestion of four black and red (marbleized?) drawers, much like the ones that can be seen more clearly in Franciscus's painting of a cabinet window in Hamburg (fig. 4),[8] suggesting that here too the window opens not to the out-of-doors but to a wall cabinet or *kastje*.

Franciscus's illusionistic paintings of this type could have influenced the Dutch artist Edwaert Collier (ca. 1640-after 1706) while they were both in Leiden. Indeed some cabinet window paintings attributed to Collier may be by Franciscus Gijs-brechts.[9]

<div align="center">PCS</div>

1. See examples and discussions of these traditions, Joseph Lammers, "Innovation und Virtuosität," in exh. Münster/Baden-Baden 1979-80, pp. 480-572, ills.; pp. 486-492. The German painter Georg Flegel's paint-ings of illusionistic collectors' cupboards (see Prague, Národní Galerie) predate Gijsbrechts's but the several examples by Johann Georg Hainz are probably approximately contemporary (see Münster/Baden-Baden 1979-80, cats. 249 and 250).

2. See, for example, *Trompe l'Œil Window*, dated 1653, Kunsthistorisches Museum, Vienna, cat. 1973, p. 47, no. 378, pl. 96; and *Trompe l'Œil of a Cabinet Door*, dated 1655, Akademie der bildenden Künste, Vienna, see R. Trnek, *Die holländische Gemälde des 17. Jahrhunderts in der Gemäldegalerie der Akademie der bildenden Künste in Wien* (Vienna, 1992), no. 80, ill.

3. Signed and dated 1660, Musée de Carcassone, oil on canvas, 95 x 73 cm; see Gammelbo 1952-55, p. 145, no. 1, ill.

4. Signed and dated 1665, canvas 86.4 x 73.7 cm, private collection; see Gammelbo 1952-55, p. 146, no. 11, ill.; and D. Folga-Januszewska, "Trompe-L'Œil de C. N. Gijsbrechts dans les collections du Musée National de Varsovie," *Bulletin du Musée National de Varsovie* 22 (1981), p. 64, fig. 12.

5. Gammelbo 1952-55, no. 23, ill.; cat. 1951, p. 102.

6. Ibid., no. 21, fig. 3. This is not the painting in Copenhagen (Statens Museum for Kunst, no. 3075), as stated in Washington/Boston 1989, p. 108; the latter is another illusionistic window by Cornelis Norbertus, also signed and dated 1670, but is not actually hinged (see Gammelbo 1952-55, no. 20, ill.).

7. See: the paintings on the Brussels art market in 1966 (de Mirimonde 1971, p. 261, fig. 55); exhibited in London in 1963 (de Mirimonde 1971, p. 262, fig. 56); sale London (Phillips), 6 December 1988, no. 59, ill. (de Miri-monde 1971, p. 262, fig. 57); and in the Library of the Castle of Beauvorde, in Wulveringen (de Mirimonde 1971, p. 262, fig. 59).

8. Kunsthalle, Hamburg, cat. 1956, p. 70, no. 523, ill.

9. See Sale Amsterdam (Sotheby-Mak van Waay), 22 April 1980, no. 24, ill. [as E. Collier], canvas 93 x 80 cm.

Fig. 1. Cornelis Norbertus Gijsbrechts, *Trompe l'Œil Window*, signed and dated 1665, oil on canvas, 86.4 x 73.7 cm, private collection.

Fig. 2. Cornelis Norbertus Gijsbrechts, *Trompe l'Œil Easel*, signed, oil on panel, 226 x 123 cm, Copenhagen, Statens Museum for Kunst, cat. 1951, no. 248.

Fig. 3. Cornelis Norbertus Gijsbrechts, *Trompe l'Œil Window*, signed and dated 1670, canvas, 99.4 x 89.3 cm, Copenhagen, Statens Museum for Kunst, no. 3076.

Fig. 4. Franciscus Gijsbrechts, *Trompe l'Œil Window of a Cabinet*, signed, oil on canvas, 116 x 68.5 cm, Hamburg, Kunsthalle, no. 523.

Jan Pauwel Gillemans the Younger

(Antwerp 1651-Amsterdam? 1721/22?)

Peeter Gysels

(1621-Antwerp-1690)

Jan Pauwel Gillemans the Younger was baptized in Antwerp's St. Jacobskerk on 3 September 1651, the son of the still-life painter Jan Pauwel Gillemans the Elder (1618-ca. 1675) and Paulina Uyt den Eeckhout. He was registered as a pupil of Joris van Son (1623-1667) in 1665/66, and became a master in the St. Luke's Guild in 1673/74. In 1697 he gave two fruit pieces valued at 36 guilders to the guild, in order to be exempted from serving as dean. On 3 March 1693 Gillemans married Isabella Maria van den Eynde (died 1697), daughter of the sculptor Norbertus van den Eynde. The couple had one son, Peter Pauwel, baptized in the St. Joriskerk in 1695, with the landscape painter Pieter Rysbraeck (1655-1729) standing as godfather. Following the death of his first wife, Gillemans married the wealthy widow Joanna van Hellefort on 22 March 1698; of this union two sons were born, Kaspar Jozef (b. 1700) and Geeraard Frans (b. 1702).

Although Gillemans lived in Antwerp (in the house "Kleine Antwerpen" in the Arensbergstraat) for much of his life, he appears to have worked in Middelburg as well. In 1675 he was involved in a dispute with the local guild over selling paintings in that city, and became a master in the guild ca. 1700-1702. Early biographers (including Weyerman, who knew the artist) recount that Gillemans moved to Amsterdam in 1713, where he fell into a canal one evening and drowned, aged seventy (ca. 1721/22).

Gillemans was primarily active as a painter of fruit still lifes and garlands, usually on a small scale. He collaborated with the classical landscapist Pieter Rysbraeck, as well as with history painters active at the end of the century, such as Pieter Ykens (1648-1695) and Godfried Maes (1649-1700).

Weyerman 1729-69, vol. 3 (1769), pp. 375-379; P. Rémy, Catalogue Raisonné des Tableaux (Paris, 1757), p. 36; Kramm 1857-64, vol. 2 (1858), pp. 573-574; Rombouts, van Lerius 1872, vol. 2, pp. 363, 365, 429, 435, 594, 605; Obreen 1877-90, vol. 6, pp. 212, 214, 232; Rooses 1879, p. 653; van den Branden 1883, pp. 1114-1116; Wurzbach 1906-11, vol. 1 (1906), p. 585; K. Zoege van Manteuffel, in Thieme, Becker 1907-50, vol. 14 (1921), pp. 35-36.

The landscape, still-life, and animal painter Peeter Gysels was baptized in the St. Jacobskerk in Antwerp on 3 December 1621. In 1641/42 he was registered as a pupil of Jan Boots in Antwerp; according to Houbraken he met Jan Brueghel the Younger (1601-1678) at this time. Gysels became a master in the guild of St. Luke in 1648/49. On 13 November 1650 he married Joanna Huybrecht; the couple had at least one son, born the following year. Gysels painted small-format landscapes with figures, similar to and influenced by the works of Brueghel the Younger, although much of his œuvre consists of animal pieces and still lives of game and implements of the hunt which are analogous to works by the Dutch painter Jan Weenix, albeit on a smaller scale. His fastidiously painted still lifes were much in demand among contemporary collectors, and he apparently worked frequently on collaborative efforts with other artists (see cats. 58 and 117).

Houbraken 1718-21, vol. 3 (1721), p. 53; Weyerman 1729-69, vol. 2 (1729), p. 377f; Kramm 1857-64, vol. 2 (1858), p. 615; Michiels 1865-76, vol. 5 (1868), pp. 378ff; Rombouts, van Lerius 1872, vol. 2, pp. 131, 134, 208, 210, 484, 551; Rooses 1879, pp. 632-633; van den Branden 1883, pp. 39-42; K. Zoege van Manteuffel, in Thieme, Becker 1907-50, vol. 15 (1922), pp. 378-379; Greindl 1983, pp. 148, 358.

Attributed to Jan-Erasmus Quellinus, Jan Pauwel Gillemans the Younger, and Jan van Kessel I or Peeter Gysels
117. *Still Life with Architecture*

Oil on canvas, 112.3 x 82.9 cm (44 ¼ x 32 ⅝ in.)
Boston, Museum of Fine Arts, Ernest Wadsworth
Longfellow Fund, acc. no. 50.2728

PROVENANCE: sale H. J. Stier d'Aertselaer, Antwerp, 29-30 July 1822, no. 25 [as "J. Feyt et Quellin (sic)"] (fl. 200 , to Daronnous for Baranowsky of Vienna; or, according to a note from Hans Swarzenski [Museum object file], bought by Baron Nathaniel Rothschild, Vienna); Puthon collection (according to Gsell sale cat.); sale Comte S. Festetit, Vienna, 11 April 1859, no. 101 ["Johann Fyt, Todtes Wild und Früchte," canvas, 43 x 32 zoll]; sale F. J. Gsell, Vienna, 14 March 1872, no. 30 [as by Fyt and E. Quellinus; bought in at M. 6600]; acquired from dealers Rosenberg and Stiebel, New York, 1950.

EXHIBITIONS: Boston, Museum of Fine Arts "Seventeenth-Century Dutch and Flemish Still Life Paintings," 7 October-30 November 1980 (no catalogue); Tokyo, Isetan Museum of Art, Shinjuku, *Masterpieces of European Painting from the Museum of Fine Arts, Boston*, 21 October-4 December 1983 (also shown at Fukuoka, Fukuoka Art Museum, 6-29 January 1984), and Kyoto, Municipal Museum of Art, 25 February-8 April 1984, cat. no. 13, ill.

LITERATURE: Greindl 1956, p. 80 [as J. Fyt and E. Quellinus]; Greindl 1983, p. 106; Boston, cat. 1985, p. 108, ill. [as J. Fyt and E. Quellinus]; Stebbins, Sutton 1986, p. 43, ill. [as Fyt and E. Quellinus]; M. Vandenven, in Liedtke et al. 1992, pp. 310-311, ill. [as Fyt and E. Quellinus].

BEFORE an elaborate portico, a still life of fruit, dead game and live animals is distributed about a table and chair and across the floor of a stone terrace. In the background two large Corinthian columns are surmounted by an entablature and a broken balustrade. An archway decorated with a swag of drapery frames the still life on the terrace below. The still life is comprised primarily of fruit, abundantly arranged on dishes and in baskets on the table, a chair with a boiled lobster on a plate, and dead game strewn about the floor. The latter include a dead roebuck, wild boar, swan, and peacock as well as rabbits and smaller game birds. A monkey tugs at the fruit while a parrot alights atop a chair supporting an abandoned lute. A second parrot perches on the column at the right. Two greyhounds and a spaniel sniff and fidget nervously about the game at the lower right. A peacock perches on the iron crosspiece of the arch above. A wine cooler, rosebush, and a tree appear on the left. Through the arches is glimpsed on the left a statue in the pose of the antique *Venus Pudica* (or *Frigida*), above is a bust of a man with a laurel wreath (perhaps Apollo), and on the right a landscape with mountains and water.

As early as the 1822 sale of the Stier d'Aertselaer collection in Brussels, this painting was attributed to "Fyt [and] Quellin," which have been assumed to refer to the animal- and still-life painter, Jan Fyt, and the painter of Rubensian figures and architectural settings, Erasmus Quellinus II. The work retained this assignment in the Gsell sale of 1872 and was purchased as such by the Museum of Fine Arts, Boston, from Rosenberg and Stiebel in 1950. The attribution was also repeated in the catalogues of 1985 and 1986. While there are documents linking Fyt and Quellinus in 1642 and 1660,[1] there exist no paintings which are certain to be by both artists (i.e.,

with either dual signatures or supporting documentation); while the *Portrait of a Boy with Two Dogs* (cat. 54) makes a strong claim to dual authorship, it is only on stylistic grounds. The other works assigned jointly to the two artists tend to be relatively large canvases with dead game still lifes or hunting scenes with the animals by Fyt and figures attributed to Quellinus: see, for example, *Still Life with Page*, signed by Fyt and dated 1644 (London, Wallace Collection, no. P101)[2] and *Diana with the Spoils of the Hunt* (Berlin, Gemäldegalerie, no. 967).[3] Yet while the attribution has never been fully rejected in the literature, Marc Vandenven recently observed that it could only be maintained "with some reservation," adding that the classicizing elements and the composition as a whole are closer to the work of Jan-Erasmus Quellinus, the son of Erasmus II.[4] Not dissimilar in conception, for example, is the background of the scene of *Mercury and Aglarus before Architecture* (fig. 1) signed indistinctly by Jan-Erasmus and Jan Baptist Huysmans (1654-1716).

Despite the claim of George Plach in the catalogue of the Gsell sale, Vienna, 1872 that the present painting is "The only known cabinet piece by these masters,"[5] and the still life authority Edith Greindl's support for the assignment,[6] the attribution to Fyt cannot be substantiated. While Fyt painted elaborate dead game and fruit still lifes with animals before architecture (see, for example, the signed painting in the Kunsthistorisches Museum, Vienna, no. 1171; canvas, 174 x 225 cm), his touch was much broader and looser and his colors are not so brilliant.

Fred Meijer (private communication) has tentatively advanced an attribution for the still life to Jan Pauwel Gillemans II, who was a late follower of Jan Davidsz. de Heem. The small scale and the finely delineated and colorful treatment of the fruit in this piece resembles Gillemans the Younger's manner (see for example fig. 2), inasmuch as it is understood. The latter's art is sometimes confused with that of his father of the same name (1618-after 1675).[7] The present composition's elaborate incorporation of architecture is also closer to the luxurious and grandly artificial designs of Jan Pauwel II; however it must be said that the latter's execution is usually more labored and fastidious.[8] Details of the still life seem to attest to the influence of other earlier Flemish still-life artists; while the overall composition recalls Fyt's designs (see the *Diana* mentioned above), and thus explains the work's past misattribution, its details harken back to paintings by Pieter Boel,[9] Adriaen van Utrecht,[10] and, of course, Jan Davidsz. de Heem.

Fig. 1. Jan-Erasmus Quellinus and Jan-Baptist Huysmans, *Mercury and Aglarus before Architecture*, oil on canvas, 122 x 102 cm, Marseilles, Musée des Beaux-Arts.

Fig. 2. Jan Pauwel Gillemans II, *Fruit Still Life*, signed indistinctly, (one of a pair) with P. de Boer Gallery, Amsterdam.

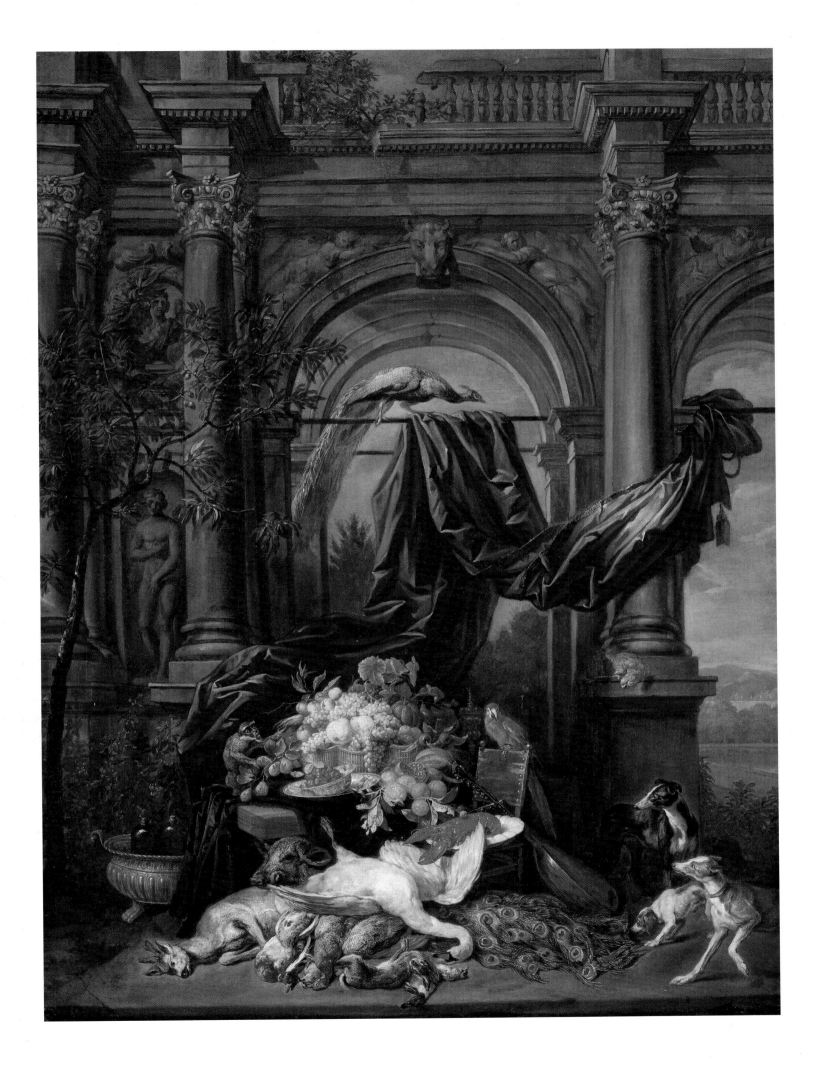

Fig. 3. Peeter Gysels, *Still Life before a Portico*, signed, canvas, 86 x 116 cm, Antwerp, Koninklijk Museum voor Schone Kunsten, no. 673.

Yet a third hand may be at work here. The treatment of the live animals and dead game elements of the still life recalls the small-scale technique of Jan van Kessel I (q.v.) and also might be compared to the corresponding parts of some later works by Peeter Gysels (1621-1690). Gysels painted richly conceived gamepieces before elaborate porticos which are very similar in conception if not in technique to the present work (see fig. 3).[11] But a firm attribution for the Boston painting may have to await a better understanding of later seventeenth-century Flemish still-life painters.

The painting's sumptuous subject, with its noble colonnade set before a parklike setting and rich still life, befits a grand banquet hall; however its dimensions are intimate, even domestic, perhaps suggesting that the expansive tastes of aristocratic patrons were adopted on a more modest scale by haute bourgeois collectors later in the century. Without grand scale or proportions, the picture evokes an aristocratic world with exotic pets and a rich array of game, the hunting of which was reserved for the nobility and regulated by the court. Surely there can have been little sport in shooting swans and peacocks, but their inclusion in this still life ensures the picture's ambition to luxuriant excess.

<div align="right">PCS</div>

1. See Glück 1919, pp. 347-348.

2. Canvas, 121.5 x 205 cm; London, Wallace, cat. 1992, p. 127.

3. Canvas, 79 x 116 cm, Berlin, cat. 1986, no. 499, ill. p. 231. See also the *Hunter with His Dogs*, signed by Fyt and dated 1645, collection Baron Louis de Rothschild (Greindl 1983, p. 106, and no. 157).

4. See Liedtke et al. 1992, p. 310, no. 101.

5. *Versteigerung der Grossen Gallerie und der übrigen Kunst-sammlungen des ... Herrn F. J. Gsell zu Wien in den Salen des Künstlerhauses am 14. März 1872* (Vienna 1872), p. 9, no. 30.

6. Greindl 1956, p. 80; idem 1983, p. 106.

7. For examples of Jan Pauwel Gillemans I's art, see *Oysters and Fruit*, signed and dated 1662, panel, 50 x 60 cm, Brussels, Musées Royaux des Beaux-Arts de Belgique, inv. 3274; *Fruit Still Life*, signed and dated 1663, Innsbruck, Museum Ferdinandeum, cat. 1928, no. 741; *Still Life with Lobsters*, signed and dated 1675, sale Stockholm (Bukowski), 24-27 April 1974 (ill. in *Weltkunst*, March 1974, p. 392); as well as the following: signed, canvas, 55 x 78 cm, sale Cologne (Lempertz), 26 November 1970, no. 76, ill.; sale London (Christie's), 13 December 1974, no. 92; sale Paris (Drouot), 10 March 1976, no. 90, ill.; signed, sale London (Christie's), 8 October 1976, no. 103; canvas, 40 x 41 in., sale London (Sotheby's), 18 February 1987, no. 43, ill. [as Joris van Son, but probably by Gillemans, according to Meijer].

8. For examples of Gillemans II's work: see Antwerp, Museum Mayer van den Bergh, no. 477 (signed and dated 1675, canvas, 74 x 97 cm); sale New York (Sotheby's), 14 January 1988, no. 101, ill. (signed and dated 1683, canvas, 56 x 77 cm); sale Monte Carlo (Sotheby's), 20 June 1987, no. 352, ill.; sale New York (Sotheby's), 7 November 1984, no. 21; sale London (Christie's), 10 April 1987, no. 17, ill.; sale Lucern (Fischer), 6-9 November 1990, no. 2049, ill.; and especially the *Pronk Still Life with Architectural Background with Sculpture in a Niche*, signed, canvas, 65 x 73.3 cm; sale London (Christie's), 1 November 1991, no. 150.

9. For the motifs of the swan and wine cooler, see the painting in exh. London 1953-54, no. 462, lent by Baron Descamps, wrongly as Fyt.

10. Compare the works in Madrid, Museo del Prado, no. 1852, and in Oxford, Ashmolean Museum, cat. (1950) no. 82, dated 1645.

11. Compare also Peeter Gysels, *Still Life before an Italianate Villa*, canvas, 52.5 x 64.5 cm, St. Petersburg, Hermitage, no. 662.

Jan Wildens

(1585/6-Antwerp-1653)

Paulus Pontius after Anthony van Dyck, *Jan Wildens*, engraving, from the *Iconography*.

Son of Hendrik Wildens and Magdalena Vosbergen, Jan Wildens was born in Antwerp in 1585 or early 1586. Although the precise date of his birth is not known, the artist gave his age as twenty-seven in a testament dated 22 May 1613. Wildens was apprenticed in 1596 to Pieter Verhulst and joined the Antwerp guild of St. Luke in 1604. He left for Italy in June 1613, and returned to Antwerp by late August 1616. There is no evidence that he visited Rome; he may have remained in Genoa, where he painted a series of the months and a number of other works for the Palazzo Bianco.

The period immediately following Wildens's return to Antwerp (ca. 1616-1620) coincided with his greatest activity in Rubens's atelier. The landscape backgrounds in Rubens's cartoons for the Decius Mus cycle, as well as in works such as the *Rape of the Daughters of Leucippus* (Munich, Alte Pinakothek) are among the passages that have been attributed to Wildens. The two artists were close friends as well; in 1619, Rubens, "zijnen goeden vriendt" (his good friend) witnessed Wildens's marriage contract with Maria Stappaert (the aunt of Rubens's second wife, Hélène Fourment). The couple married on 12 November 1619 and had two sons, both of whom became artists: Jan Baptist (1620-1637) and Jeremias (1621-1653).

Following the death of his wife in 1624, Wildens moved from the Minderbroederstraat to his mother's house at Lange Nieuwstraat 97, where he added a painting gallery to the house. It was probably at this time that he became more active as an art dealer; in 1632, 1635, 1641, 1642, and 1643 he requested passports for travel, probably to Paris for the annual Fair of Saint-Germain. Wildens died in Antwerp on 16 October 1653 and was buried in the Cathedral (Onze-Lieve-Vrouwekerk). Most of the 720 paintings listed in the inventory of the estate of Jeremias Wildens (drawn up upon his death on 30 December 1653) were inherited from his father, and had formed the stock of the latter's business as art dealer.

Wildens's earliest landscapes are derived from the bird's-eye perspective and precipitous mountain views of Joos de Momper and Jan Brueghel the Elder (qq.v.). While in Italy, his work was influenced by the broader, more open and more spontaneous landscapes of Paulus Bril (q.v.) and Adam Elsheimer. Upon his return to Antwerp, Wildens continued to paint naturally composed Flemish landscapes characterized by discreet, often nearly monochromatic, color harmonies of gray, blue, and green. After Rubens's death in 1640, Wildens painted a number of small, vigorously painted landscapes in emulation of the master. His more characteristic works, however,

are simply and symmetrically composed, with a pervading sense of calm. Wildens's last works are of somewhat lesser quality. In addition to his collaborative work with Rubens, Wildens also worked with Frans Snyders (cat. 119), Jan Boeckhorst, Abraham Janssens, Jacob Jordaens, Theodoor Rombouts (qq.v.), Cornelis Schut, Gerard Seghers, and Paulus de Vos. Three pupils are recorded: Abraham Leers in 1610, and Philipp Leers and Hans Rymaker in 1628/29.

De Bie 1661, pp. 100, 126; Houbraken 1718-21, vol. 1, pp. 218-219; Descamps 1753-64, vol. 1, pp. 336-338; Immerzeel 1842-43, vol. 3, pp. 235ff; Nagler 1835-52, vol. 21 (1851), pp. 438ff; Kramm 1857-64, vol. 6 (1864), pp. 1862-1863; Nagler 1858-79, vol. 4, pp. 195-196; Michiels 1865-76, vol. 8 (1869), pp. 174-180; Rombouts, van Lerius 1872, vol. 1, pp. 394, 425, 470, 575, 651 and 663, vol. 2, pp. 117, 255-256; Rooses 1879, pp. 403-405 et passim; van Lerius 1880-81, vol. 1, pp. 54, 57, vol. 2, p. 309; van den Branden 1883, pp. 558, 683-687; Wurzbach 1906-11, vol. 2 (1910), p. 882; Oldenbourg 1918, p. 174; Prims 1931, passim; Glück 1933; M. Manneback, in Thieme, Becker 1907-50, vol. 35 (1942), pp. 562-564; Delen 1938; Thiéry 1953, pp. 113-116, 199-200, 209; Gerson 1960, pp. 151-152; Brussels 1965, p. 288; Bodart 1970, vol. 1, pp. 287-288; Hairs 1977, pp. 17-18; Adler 1980; Balis 1986, passim; Härting 1989, p. 154; Cologne/Vienna 1992-93, pp. 457-459;

Frans Snyders and Jan Wildens
118. The Rooster and the Jewel

Oil on panel, 101.5 x 68 cm (40 x 26 ¾ in.)
Aachen, Städtisches Suermondt-Ludwig-Museum,
inv. GK 484

PROVENANCE: (possibly) sale Joan de Vries and Anna van Aelst,
The Hague, 13 October 1738, no. 35 ("De Fabel von den haen en diamant,
door Rubbens of Snyders"); sale Eugène Kraetzer of Mainz, Paris (Hôtel
Drouot), 31 March 1869, lot 38 [as Rubens "Le Coq et la Perle," panel, 98 x
67 cm (annot. E. Warneck: "école flamande à la suite de Sneyder")] bt. in];
B. Suermondt collection, 1883.

EXHIBITIONS: Brussels, Palais du Cinquentenaire, Exposition de l'art
belge au XVIIe siècle, 1910, p. 201, no. 348 [as Rubens].

LITERATURE: B. Suermondt collection cat. (1883), no. 118 [as Rubens];
Rooses 1886-92, vol. 4 (1890), no. 1167 and no. 927 [as Rubens and titled
"Le Coq et la perle"]; A. Rosenberg 1905, p. XVIII, p. 465, fig. 27 [as Rubens];
W. Bode, "Kritik und Chronologie der Gemälde von P. P. Rubens,"
(review of A. Rosenberg 1905), in Zeitschrift für bildenden Kunst, n.f., 16
(1905), p. 201 [as Frans Snyders]; M. Rooses, in Onze Kunst (1911), p. 9 [as
Rubens]; H. Fierens-Gevaert, Trésor de l'art belge au XVII siècle. Mémorial
de l'exposition d'art ancien à Bruxelles en 1910, vol. 1 (1912), p. 12, pl. 3 [as
Rubens]; Oldenbourg 1921, p. 451, ill. [as Snyders]; Aachen, Städtisches
Suermondt-Museum, Gemälde-Katalog (Aachen, 1932), pp. 160-161, no. 484
[as F. Snyders and J. Wildens]; Glück 1933, pp. 158, 358, 391; A. Bastin, "Le
paysage et la marine dans l'œuvre de Rubens," Musées Royaux des Beaux-
Arts, Bulletin. Conférences 1940-41, p. 4; E. G. Grimme, "Das Suermondt-
Museum," Aachener Kunstblätter 28 (1963), p. 290, no. 164, ill.; E. de Jongh,
Zinne- en minnebeelden in de schilderkunst van de zeventiende eeuw (1967), p. 18,
note 26; K. Arndt, "'De gallo et iaspideo.' Ein Fabelmotiv bei Frans Sny-
ders," in Festschrift für Kurt Badt (Cologne, 1970), pp. 290ff, reprinted in
Aachen Kunstblätter 40 (1971), pp. 286-293; Robels 1989, pp. 94, 309-310, cat.
no. 202, ill.; H. Robels, "Entwicklungsphasen der Antwerpener Stillleben-
malerei," in exh. cat. Cologne/Vienna 1992-93, p. 208, note 60, fig. 7.

IN A LANDSCAPE with low hills a rooster stands
proudly silhouetted against the sky. His right talon
foremost, he strides toward a large pyramid-shaped
jewel mounted in a gold setting with bezel lying on
the straw-covered ground. In the distance are woods
and fields and, on the right, a farmhouse.

If the painting is identical with the picture that
sold in The Hague in 1738 (see Provenance), the attri-
bution to either Rubens or Snyders was already a
matter of confusion in the eighteenth century.
When it was in the Kraetzer sale in Mainz in 1882,
when it entered the Suermondt collection in Aachen
in 1883, and when it was catalogued by Rooses in
1890 and Rosenberg in 1905, the painting was attrib-
uted to Rubens and was assumed to be the painting
that Rubens gave in 1606 to the doctor from Bam-
berg, Johann Faber, in Rome out of gratitude for cur-
ing him of a grave illness.[1] However that painting
was inscribed with a dedication referring to Faber as
Rubens's own Aesculapius (the Greco-Roman god of
medicine), presumably as a reference to the antique
pagan tradition of offering sacrifices to the gods for
one's health.[2] The present painting bears the rem-
nants of an "R" in the lower left; though a later addi-
tion, and a monogram that Rubens never used, it has
been cited as support for the attribution. There is no
inscription on the panel. Reviewing Rosenberg's
book in 1905, Wilhelm Bode was the first to reat-
tribute the painting to Frans Snyders,[3] an attribu-
tion that has since won general acceptance. Rooses
had suggested that the landscape could be by anoth-

er Flemish artist.[4] Since the publication of the 1932
Aachen catalogue, the landscape has been unequivo-
cally attributed to Jan Wildens.[5] While Karl Arndt
reported in 1971 that Wolfgang Adler, the Wildens
specialist, accepted the attribution on the basis of a
photograph, the latter did not mention the painting
in his 1980 study of the artist.[6] Robels lent the attri-
bution of the landscape to Wildens her tacit support.[7]

In the 1932 Aachen catalogue it was reported that
Ludwig Burchard had first observed that a "picture
on stone; A rooster looking at a diamond [by Sny-
ders]" (Un cuadro de piedra; un gallo que mira un
diamante [Snyders]) was mentioned in the inventory
drawn up on 21 February 1655, of the painting collec-
tion of the Marqués de Leganés, Don Diego de Messía
de Guzmán; however the reference to "piedra" in the
citation probably refers to a version or variant paint-
ed on slate or marble.[8] If the present painting is
identical with the de Vries and van Aelst sale (1732)
picture, the fact that its subject is drawn from a fable
was already recognized in the eighteenth century.
Rooses, who incorrectly titled it the "Cock and the
Pearl," also implicitly recognized it as a fable illus-
tration. However the painting's meaning was only
explained in detail by Arndt.[9] Its Aesopian fable was
first related by Phaedrus.[10] The cock who finds a
jewel (or, as in the original Aesop tale, the hen who
discovers the pearl) has no use for it, thus referring
to materialism and ignorance that recognizes no
higher value or good. The animal also came to
embody the stupidity that cannot grasp the value
and meaning of fables themselves. Ulrich Boner's
Edelstein, which appeared in 1349, took its title from
the fable of the Cock and the Jewel, implying that
the book was like a precious stone, but only for those
who understood its emblematic value. Gradually the
fable's reference expanded from emblematic litera-
ture and its allegorical meaning, to art in general,
and finally to all of mankind's higher goals. These
medieval ideas influenced the versions of Aesop's
fables produced by Steinhöwel around 1476 and by
Virgil Solis in 1566 (fig. 1), both of whom illustrated
the theme of the Cock and the Jewel.[11]

However the most likely immediate source of
inspiration for Snyders's painting was probably
Marcus Geeraerts's engraving of 1567 (fig. 2) for Edwe-
waerd de Dene's De waarachtige Fabulen der Dieren,
published by Pieter de Clerk (Bruges, 1567).[12] The
print is inscribed with the Latin admonition, Quid
prodest stulto habere divitias, cum sapientiam emere non
posset (What good are riches to a fool, since he cannot
buy wisdom). It also carries the Dutch inscription
"D'onwetende dach en nacht/Alle wijsheit veracht"
(Day and night the ignorant scorn all wisdom).

Fig. 1. Virgil Solis, Hen and the Jewel, woodcut illus-
tration from Aesopi Phrygis Fabulae (Frankfurt, 1566),
p. 146.

Fig. 2. Marcus Geeraerts, Hen and the Jewel, engraved
illustration from Edewaerd de Dene, De Waarachtige
Fabulen der Dieren (Bruges, 1567).

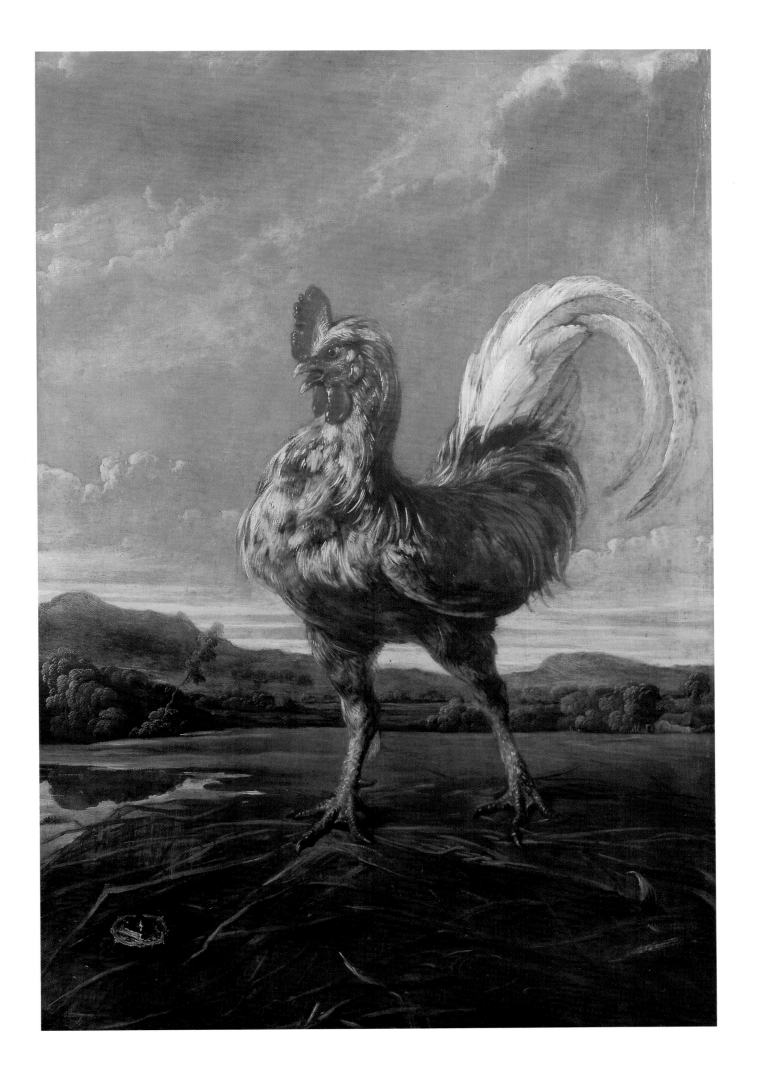

Arndt wisely cautions that it is uncertain which of the fable's richly layered literary interpretations, nuances, and emphases should be applied to the Aachen painting since we know nothing about the patron, the circumstances of its commission, or the place for which it was intended.[13] Although one has the precedents of Phaedrus and Boner, the temptation to assume that Snyders was referring to the public's ignorance of the value of his own art probably conforms too readily to modern (which is to say twentieth-century) assumptions about artists and their critics to be accepted without skepticism. But, Arndt and Robels both noted, what is clear is that Snyders's conception of the theme greatly enhances its meaning. While he took over the earlier representations' suggestion of a farm or barnyard amidst low hills (now only adumbrated), he monumentalized the rooster by silhouetting its form dramatically against the sky and stressing its proud posture – chest extended, leg flexed, and head tossed back with beak open. The animal is naturalistically conceived but also expressive of the type of pompous ignorance that the fable criticizes. Snyders's keen observation not only of wild creatures but also of domestic animals is also reflected in his other barnyard images of roosters fighting; see, as examples, Antwerp, Koninklijk Museum voor Schone Kunsten, inv. no. 946 and Berlin, Staatliche Museen zu Berlin, Gemäldegalerie, inv. 878.[14] Robels reasonably surmised that the date 1615 on the latter painting provides an approximate date for the present work.[15] Snyders also illustrated several of Aesop's other fables, including *The Lion and the Mouse* (versions: Prime Minister of Great Britain, Chequers, inv. 129; Cuzean Castle, Ayrshire; Madrid, Museo del Prado, inv. 1756),[16] *The Fox and the Stork* (versions: Stockholm, Nationalmuseum, inv. no. 1486; Rochester, Memorial Art Gallery, inv. no. 72.75) and the *Tortoise and the Hare* (Madrid, Museo del Prado, inv. 1753).[17] The pendants depicting the fables of the *Dog and His Shadow* and the *Goat Suckling the Wolf* sometimes attributed to Snyders in the Prado, Madrid (nos. 1875 and 1766), are regarded by Robels as the works of followers.[18]

A copy of the painting which reverses the image was in a private collection in Madrid in 1944.[19]

PCS

1. Rooses 1886-92, vol. 4 (1890) no. 1167; the reference to the Faber painting is Rooses no. 927; A. Rosenberg 1905, p. xviii, fig. 27.

2. Johann Faber, *Rerum medicarum Novae Hispaniae Thesaurus* (Rome, 1651), p. 831: the inscription reads "Pro Salute - V.C. Joanni Fabro M.D. Aesculapio meo-olim damnatus. L.M. votum solvo." (To the illustrious doctor, Johannes Faber, my Aesculapius, I dedicate this picture for restoring my health at a moment when I was condemned). See Rooses 1886-92, vol. 4 (1890), pp. 153-154.

3. *Zeitschrift für bildende Kunst* n.f. 16, p. 201. Glück also attributed the Aachen painting to Snyders in his review of A. Rosenberg 1905; see "Zum Rubens-band der 'Klassiker der Kunst,'" in *Kunstgeschichtliche Anzeigen* (Innsbruck, 1905), p. 55.

4. Rooses 1886-92, vol. 4 (1890), p. 356.

5. Aachen, Städtisches Suermondt-Ludwig-Museum, *Gemälde-Katalog* (Aachen, 1932), pp. 160-161, no. 484; See also E. G. Grimme, "Das Suermondt-Museum," *Aachener Kunstblätter* 28 (1963), p. 290, no. 164.

6. See K. Arndt, "'De gallo et iaspideo.' Ein Fabelmotiv bei Frans Snyders," *Aachener Kunstblätter* 40 (1971), p. 192, note 3. On Wildens, see Adler 1980.

7. Robels 1989, p. 309.

8. Aachen cat. 1932, p. 161; see *Boletín de la Sociedad Española de Excursiones* (Madrid, 1898), p. 127.

9. Arndt 1971, pp. 186-193.

10. Ibid. p. 190, *Phaedri Augusti liberti Liber Fularum*, Part 3, 12; see L. Havet, *Phaedri Augusti liberti fabule Aesopiae* (Paris, 1895), p. 62.

11. See Arndt 1971, p. 188, fig. 2, from Steinhowel's *Aesop* (Ulm, 1476), and fig. 3, from Virgil Solis's *Aesop Phrygis Fabulae* (Frankfurt, 1566) p. 146.

12. See also Arndt 1971, p. 189, fig. 4. See also the Dutch edition by Dirck Pietersz. Pers, *Vorstelijck Warande der Dieren* (Amsterdam 1617; reprinted by Foresta B.V., Groningen, 1984).

13. Arndt 1971, p. 192.

14. See Robels 1989, nos. 2031, ill. p. 311, and 2041, pl. VII.

15. Ibid., p. 94.

16. Ibid., no. 210, ill., p. 317, no. 211, 212, ill. p. 316.

17. Ibid., no. 218, ill., p. 321.

18. Ibid., nos. A225 and A226.

19. Oil on canvas, 98.5 x 95 cm, exhibited in Madrid at the Sala Vilches, March 1949, no. 9.

Frans Snyders and Jan Wildens
119. "The Bird Trap," ca. 1620

Oil on panel, 64.5 x 106.5 cm (25 ⅜ x 41 ⅞ in.)
Signed at bottom, right of center: F. Snÿders fecit
Aachen, Städtisches Suermondt-Ludwig-Museum,
inv. GK 483

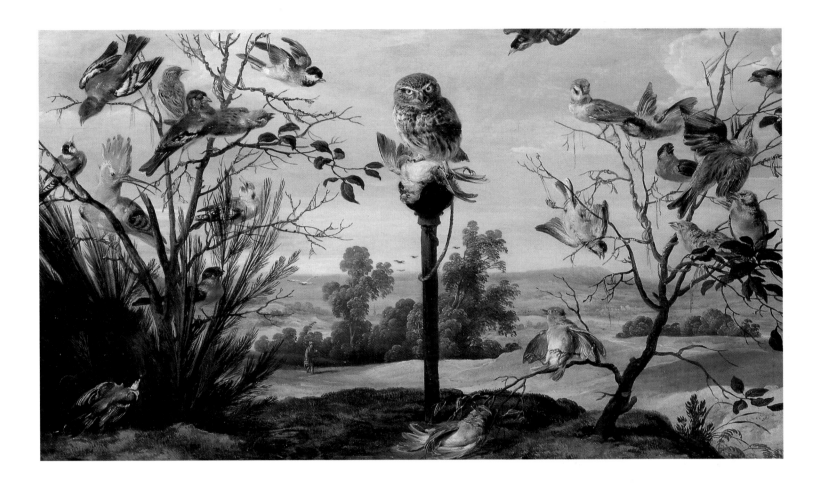

Fig. 1. Crispijn de Passe, Emblem no. 95 from Gabriel Rollenhagen, *Nucleus emblematicum selectissimorum*, (Maagdenburg 1611), Amsterdam, Rijksprentenkabinet, inv. KOG O 202.

PROVENANCE: sale T. van Saceghem (Ghent), Brussels, 2–3 June 1851, no. 59 (as Snyders, "La Chasse au Hibou," 63 x 106 cm; frcs. 420, to Comte Dulus [Du Bus?]); sale Du Bus de Gisignies, Brussels, 9–10 May 1882, no. 68 (as by Snyders and Wildens; frcs. 1700, to Suermondt); Stiftung Barthold Suermondt, 1883.

LITERATURE: Aachen, cat. 1883, no. 129; Paul Perdrizet, "La chasse au chouette," *Revue de l'art ancien et moderne* 22 (1907), p. 147; Aachen, cat. 1932, p. 160; E. G. Grimme, "Das Suermondt-Museum," *Aachener Kunstblätter* 28 (1963), p. 292, no. 166; Robels 1989, pp. 95, 114, 115, 303–304, no. 192.

AN OWL tethered to his perch commands the center of the composition, his captured prey held fast beneath his talons. A variety of songbirds – including larks, finches, a hoopoe, a goldfinch, and a bullfinch – are caught in the bushes to either side, held fast by snares and sticky birdlime. A bird-catcher plods through the gently rolling landscape in the middleground, his profession indicated by the characteristic basket he carries. The birds are by Snyders; the landscape, with its subdued tonalities and undulating forms, is typical of works by Jan Wildens, and has been convincingly attributed to him.[1]

The subject of the painting refers to an episode from Aesop's fables, in which the owl, hated and mocked by other birds, was used as a decoy to lure them to the gluey snares surrounding his perch.[2] The fable's moral emphasized the hazards of blind hatred. The story was subsequently adopted by sixteenth-century emblematists, who associated the image with the motto "The ignorant hate the arts"; the poem accompanying the emblem in Johannes Sambucus's *Emblemata* (Antwerp, 1566) explains that in doing so, they hurt only themselves.[3] The birds are ignorant and, as they draw near to mock the owl (representing knowledge and the arts), they are caught in the sticky traps.

The owl was subject to a range of interpretations, both positive and negative, too numerous for detailed discussion here.[4] In the late Middle Ages, the nocturnal bird was the representative of sin and vice, and day birds of Christian souls and spiritual values, as described in the *Dialogus creaturarum* (Gouda, 1480): "It [the owl] is cruel, greatly loaded

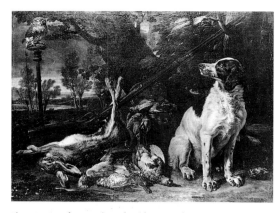

Fig. 2. Jan Fyt, *The Hunter's Trophy with a Dog and an Owl*, oil on canvas, 98 x 131 cm, Warsaw, Muzeum Narodowe, inv. 129028.

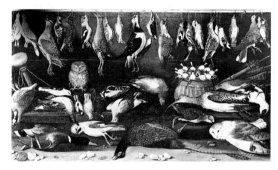

Fig. 3. Follower of Caravaggio, *Still Life with Birds*, oil on canvas, 103.5 x 173 cm, Rome, Galleria Borghese, inv. 301.

with feathers, full of sloth and feeble to fly...With this bird many other birds be taken that fly about her and rob her of her feathers. For all they hate her and be enemies unto her."[5] This enmity is illustrated in several ornamental prints of the fifteenth and sixteenth centuries by Martin Schongauer, Nicolaes de Bruyn, and Hans Collaert.[6] During the course of the late fifteenth and early sixteenth centuries, the position of the owl became less unequivocally negative; in the text accompanying a woodcut ascribed to Albrecht Dürer of an owl mocked by smaller birds, the emphasis is placed on the envy and hatred of the day birds which persecute the owl, rather than on the owl as the embodiment of sin.[7] It is this more positive view of the owl which is the subject of an illustration by Crispijn de Passe for Gabriel Rollenhagen's 1611 *Nucleus emblematicum selectissimorum*,[8] and which relates most directly to Snyders's painting; in the background of the image is a birdcatcher tending his nets (fig. 1).

Aside from the various literary traditions, the technique of using an owl as a bait bird was actually employed in the Netherlands to capture both gamebirds and live songbirds, which were then sold as pets.[9] A hunting still life by David de Coninck of dead birds and game includes not only a hunting dog to guard the trophy, but also an owl tethered to his perch close by (Warsaw, Narodowe Muzeum, inv. 395; fig. 2); a related painting by Fyt (Ghent, Museum voor Schone Kunsten) depicts an owl poised atop his cage, surrounded by dead birds.[10] A further variation on the theme of the owl as predator is depicted in an anonymous Italian still life of the late sixteenth or early seventeenth century (Rome, Galleria Borghese; fig. 3): a live owl tethered to a padded perch identical to that in Snyders's painting is surrounded by an abundant display of dead song- and gamebirds.[11]

"The Bird Trap" is closely related to Snyders's more light-hearted paintings of "Bird Concerts," many of which also include an owl perched by an open songbook who leads the other birds in a musical chorus.[12] Robels dates the Aachen painting to about 1620; Koslow[13] opts for a slightly later date, in the 1620s. Koslow has further noted that only the birds to the right of the scene appear to be caught in the sticky filaments, while those on the left continue to taunt the owl, and suggests that "The [Aachen] picture's arrangement and the actions portrayed recall the Last Judgment, with the damned and saved to right and left of the Last Judge, but whether Snyders intended this connection is unknown."

MEW

1. From at least 1882. For a general discussion of Snyders's collaboration with Wildens, see Robels 1989, pp. 147-148.

2. For Snyders's depictions of fables, see also cat. 118.

3. Reproduced in Henkel, Schöne 1967, col. 894.

4. On the extensive symbolism of the owl, in addition to the more specific studies cited below, see P. P. Paskiewicz, "Nocturnal Bird of Wisdom: Symbolic Functions of the Owl in Emblems," *Bulletin du Musée National de Varsovie* 23 (1982), pp. 56-84; and, primarily on the negative connotations of the bird in sixteenth-century art, P. Vandenbroeck, "Bubo Significans. Die Eule als Sinnbild von Schlechtigkeit und Torheit, vor allem in der niederländischen und deutschen Bilddarstellung und bei Jheronimus Bosch I," *Jaarboek van het Koninklijk Museum voor Schone Kunsten, Antwerpen* (1985), pp. 19-135. See also the entries on Jordaens's *"As the Old Sing, So the Young Pipe"* (cat. 46), and Ryckaert's *Peasants Merrymaking in a Tavern* (cat. 73).

5. English translation from *The Dialogues of Creatures Moralized* (1511), dialogue LXXXII, cited in J. Rosenberg, "On the Meaning of a Bosch Drawing," in *De Artibus Opuscula: Essays in Honor of Erwin Panofsky* (Millard Meiss, ed.; New York, 1961), p. 424.

6. The Schongauer is illustrated in Rosenberg 1961, fig. 6; the prints by de Bruyn and Collaert (cited by Robels 1989, p. 304) in *Ornamentprenten in het Rijksprentenkabinet I, 15de en 16de eeuw* (The Hague, 1988), ill. pp. 38, no. 37 B.9; 59, no. 69.6; and 60, no. 69.B.1.

7. On Dürer's woodcut, see Rosenberg, 1961, p. 425, as well as the alternative interpretation proposed by L. Grote, "Dürer-Studien," *Zeitschrift des deutschen Vereins für Kunstwissenschaft* 19 (1965), pp. 166-167.

8. Noted in Robels 1989, p. 304; reproduced in Henkel, Schöne 1967, col. 895-896.

9. S. A. Sullivan, *The Dutch Gamepiece* (Totowa and Montclair, 1984), p. 38.

10. On Fyt's paintings see Paskiewicz 1982, p. 83. Other paintings juxtaposing an owl and its prey include David de Coninck, *Dead Birds and Game with Gun Dogs and a Little Owl* (London, The National Gallery, no. 1903) and Pieter Boel, *Still Life* (Rotterdam, Museum Boymansvan Beuningen, no. 1069 [cat. 1989, no. 4, ill.]).

11. The similarity was noted by Robels 1989, p. 95, note 213; on the Italian painting see New York, Metropolitan Museum of Art, *The Age of Caravaggio* (exh. 1985; catalogue entry by M. Gregori), pp. 206-208; and New York, National Academy of Design, *Italian Still Lifes from Three Centuries* (1983; catalogue by J. T. Spike), pp. 41-46.

12. Robels 1989, pp. 115-117, and cats. 193-201.

13. S. Koslow, in her forthcoming monograph on the artist, cat. 134.

Frans Snyders and Jan Wildens
120. *Two Lions Attacking a Roebuck*

Oil on canvas, 163 x 240 cm (64 ⅛ x 94 ½ in.)
Munich, Bayerische Staatsgemäldesammlungen,
inv. no. 631

PROVENANCE: the Archduke's Gallery in Munich; Schleissheim inventory 1748, (fol. 1 recto: "Un Lion qui terifie un Sanglier"); in 1781 transferred from Schleissheim to the Munich Hofgartengalerie.

LITERATURE: Parthey 1863-64, vol. 2 (1864), p. 560; Munich, cat. 1904, p. 207, no. 956; Wurzbach 1906-11, vol. 2 (1910), p. 634; Oldenbourg 1918a, p. 192; Munich, cat. 1922, p. 162; Manneback 1949, p. 151; Munich 1958; C. Kruyfthooft and S. Buys, *P. P. Rubens et la peinture animalière* (Antwerp, 1977), pp. 44, 58, ill. p. 42; Müllenmeister 1978-81, vol. 3, pp. 60, 62, no. 410, ill.; A. Balis, in Antwerp, Zoo, *Het Aards Paradijs*, 1982, p. 97; Munich, cat. 1983, p. 500, ill.; Balis 1986, pp. 79-80, note 59; Robels 1989, pp. 92-93, 147, 150, 350-351, no. 258, ill.

ON THE LEFT two lions spring toward the viewer, rearing up on their hind legs with claws extended and fangs bared. The lead lion turns its head while the other leaps straight at the viewer. A nimble roebuck leaps to the right, its body virtually in profile save for its antlered head turned back at the predators. A wooded landscape fills the background.

The painting has long been assumed to be the pendant to the *Lion Attacking a Wild Boar* (fig. 1), also in Munich[1]; however, according to the 1958 catalogue of the Alte Pinakothek the present work has been enlarged by a 9 cm strip of canvas at the bottom.[2] This addition was certainly added after the original paint had dried and probably was amended by a later hand to facilitate the two works' companionship. Thus, while it seems uncertain, even unlikely, that Snyders himself conceived the pair as pendants, both works have always been attributed to the artist despite the fact that neither is signed. Oldenbourg regarded the style of the two pictures as so close to Rubens's earlier hunt scenes that he assumed that Snyders was working from sketches made by Rubens.[3] As Robels observed, the lion on the back of the boar in figure 1 recalls the motif of the attacking tiger in Rubens's hunt scene in the Musée des Beaux-Arts, Rennes (inv. 811.1.10), and its leonine counterpart in the variant in the Gemäldegalerie Alte Meister, Dresden (no. 972), both of which have antique precedents.[4] Balis observed that the two lions chasing the roebuck seem to be based on the leaping animal in the center background of the *Lion Hunt* that Rubens painted for Maximilian of Bavaria, formerly in Bordeaux but destroyed by fire and now known only through painted copies (fig. 2), drawings, and prints.[5] Balis also suggested that "the contrapposto attitude" of the foremost lion is reminiscent of the central wolf in the foreground of the *Wolf and Fox Hunt* by Rubens and his atelier in The Metropolitan Museum of Art, New York (inv. no. 10.37).[6]

Snyders often illustrated fables and proverbs in his animal paintings (see cat. 118). The fight between the lion and the boar in figure 1 reminded Robels of depictions in prints and at least one painting by

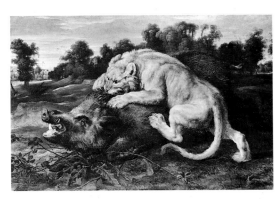

Fig. 1. Frans Snyders, *Lion Attacking a Wild Boar*, oil on canvas, 164 x 239 cm, Munich, Bayerische Staatsgemäldesammlungen, no. 620.

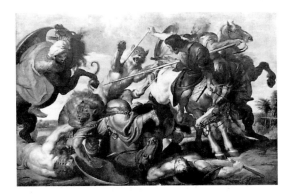

Fig. 2. Studio of Rubens, copy after Rubens's *Lion Hunt*, oil on canvas, 219 x 313 cm, Madrid, private collection.

Paulus de Vos (Madrid, Museo del Prado, no. 1490) of one of Aesop's fables, in which a laughing vulture awaits the outcome of the struggle between the lion and a boar as an allusion to the blindness of avid combatants.[7] While the influence of prints is plausible, particularly those by Marcus Geeraerts which were surely known by Snyders (see cat. 118), the fact that the vulture is missing from the painting undermines any thematic and symbolic connections to the fable. Robels's further speculation that the putative pendant here exhibited depicts two young rival lions who have missed their prey out of "blind jealousy" (*blinde Eifersucht*) is such a clever explanation as to strain credulity.[8] But the author rightly observes that in pictures such as this any emblematic meaning is secondary to the exotic associations of the hunt; she wisely contrasts the present work with Snyders's straightforward illustration of Aesop's fables in such works as the depiction of the lion who was freed from the net by the mouse (fig. 3).[9] In the

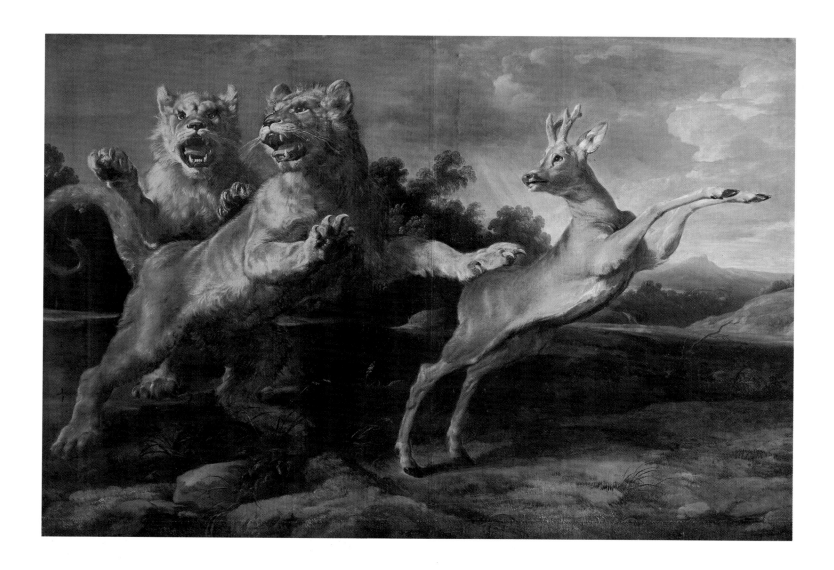

Fig. 3. Frans Snyders, *Fable of the Lion and the Mouse*, ca. 1620, oil on canvas, dimensions unknown, Chequers, Residence of the Prime Minister, inv. no. 129

latter painting the foremost lion in the Munich painting reappears in the captor's role.

Observing the frozen, almost "stuffed" appearances of the two lions in the Munich painting, several authors, including Manneback and Kruythooft and Buys,[10] have cited the oft-quoted claim of Tobey Matthew to Sir Dudley Carleton in a letter of 25 February 1617 that Rubens would object to any comparison with Snyders in the painting of animals, because "the talent of Snyders, is to represent beasts especiallie (*sic*) Birds altogether dead, and wholly w[i]thout anie action, [while in Rubens's art the] beasts are all alive."[11] Yet by this point Rubens certainly had a high enough regard for Snyders's ability to paint lifelike animals in action to ask him to paint the very live eagle in his great *Prometheus* (cat. 10). Rather the arrested motion and unfocused attention of the two

lions seem deliberatly designed to convey the inaccuracy of their lunge at their nimble prey.

Robels plausibly attributed the landscape background in this work and figure 1 to Jan Wildens. She also tentatively catalogued two oil sketches of the heads of the two young lions as possibly preparatory to the Munich picture, though they are probably copies (formerly with David Koetser; and a replica in the Wallraf-Richartz-Museum, Cologne, inv. Dep. 419).[12] Balis listed eight copies of this popular composition,[13] while Robels catalogued six workshop replicas and copies.[14] In the inventory of the Marqués de Leganés of 1655 there was a similar picture described only as: "otra de mismo tamaño [2 x 4 varas] y mano [Snyders], con 2 leones cachorros un corço."[15]

<div align="right">PCS</div>

1. Munich, cat. 1983, p. 500, no. 620, ill.; Robels 1989, pp. 350-352, cat. no. 258, ill.

2. Munich, cat. 1958, p. 95, no. 631.

3. Oldenbourg 1918a, p. 192. Manneback (1949, p. 151) also assumed that the lions were derived from Rubens, while the Munich catalogue of 1983 (p. 500) asserted that they were based on an unspecified Rubens drawing. However, Balis correctly observed (1986, p. 80, notes 59 and 61, copy no. 8) that the print by A. Blooteling said to be after Rubens in the series *Variae Leonum Icones*, which depicts the same two young lions in reverse without the roebuck, is probably only a copy of the present painting.

4. Robels 1989, p. 92; see Balis 1986, cat. no. 7, fig. 57, cat. no. 8, fig. 63.

5. Balis 1986, p. 80, and see his cat. no. 6, fig. 51; also Robels 1989, p. 93.

6. Balis 1986, p. 81, cat. no. 2, fig. 31. He also notes that the head and hind legs of this lion resemble those of the foremost lion in Rubens's *Meeting at Lyons* from the Medici Cycle (Paris, Musée du Louvre, inv. 1775); Balis 1986, p. 81, note 62, and in Antwerp, Zoo, *Het Aards Paradijs*, 1982, p. 98.

7. Robels 1989, p. 93. See for Alciati's emblem, Henkel, Schone 1967, col. 788; and for Marcus Geeraerts's illustration of the fable from Edewaerd de Dene's *De Waarachtige Fabulen der Dieren* (Bruges, 1567), see Robels 1989, p. 350. The latter served as the source for the de Vos (Madrid, Museo del Prado, cat. 1975, vol. 1, p. 431, no. T.1400).

8. Robels 1989, pp. 93 and 351.

9. Robels 1989, p. 93, cat. no. 210.

10. Mannebank 1949, p. 151, and Kruythooft and Buys 1977, p. 44, who even suggested that the lions might have been modeled after a taxidermist's creations.

11. Rooses, Ruelens, 1887-1909, vol. 2 (1898), p. 99.

12. Robels 1989, p. 492, no. ASKi I, canvas, 59 x 73 cm (ill. *The Connoisseur* 24 [1909], p. 210); and no. ASKi II, oil on canvas, 88 x 110 cm (see also Balis 1986, p. 79, note 59 [as a copy]).

13. Balis 1986, pp. 79-80, note 59.

14. Robels 1989, cats. 259a-f. The lion was also used by Jan van Kessel in the *Four Continents* in Madrid and Munich (see Munich cat. 1973, p. 15, no. 9, pl. 10).

15. "... another of the same dimensions [2 x 4 varas] and by the same hand [Snyders], with 2 lion cubs and a deer." J. López Navio, "La gran colección de pinturas del Marqués de Leganés," *Analecta Calasanctiana*, 1962, p. 273, no. 69. On the Marqués of Leganés, see M. Crawford Volk, "New Light on a Seventeenth-Century Collector: The Marquis of Leganés," *Art Bulletin* 62 (1980), pp. 258-268; and Jonathan Brown, in Cologne/Vienna 1992-93, p. 98.

Frans Snyders
121. Boar Hunt

Oil on canvas, 220.6 x 505 cm (86 ⅞ x 198 ⅞ in.)
Signed on the collar of the wounded dog on the right: F. Snyders fecit.
Boston, Museum of Fine Arts, Gift of J. Templeman Coolidge, Jr., no. 17.322

PROVENANCE: Don Sebastian Gabriel de Bórbon y Braganza, Infante of Spain, Madrid and Naples; Don Pedro de Bórbon, Duque de Dúrcal; sale Duque de Dúrcal, New York (American Art Galleries) 5-6 April, postponed to 10-13 April 1889, no. 54; gift to the Museum of Fine Arts from J. Templeman Coolidge in 1917.

EXHIBITIONS: Boston, Copley Society, Copley Hall, *Loan Collection of Pictures by Old Masters and Other Painters*, 1903, no. 91 (lent by J. T. Coolidge).

LITERATURE: *Studio* 3 (April 1889), p. 70; *Museum of Fine Arts Bulletin* 15 (1917), no. 88, p. 22, ill.; Museum of Fine Arts, Boston, *Catalogue of Paintings* (Boston, 1921), p. 43, no. 97; Manneback 1949, p. 148; Boston cat., 1985, p. 265, ill.; Robels 1989, pp. 41, 99, 103, 327-328, cat. 226. ill. [ca. 1625-1630].

THIRTEEN hunting dogs chase a wild sow and her six young. The hunt extends friezelike from right to left across the foreground of a wooded landscape. As the huge sow leaps in profile to the left, several hounds lunge to bite the creature or race in pursuit, while others tumble underfoot on the ground at the right. In the leafy foreground on the left two dogs have caught two of the squealing young boars.

Depictions of hunt scenes descended from medieval manuscript illuminations and tapestries that often included representations of the labors of the months. In the sixteenth century, tapestry designs of Barent van Orley and prints by Jan van der Straet (Stradanus) and Phillip Galle perpetuated the tradition. However, as Balis has demonstrated, the hunting theme was given a new impetus early in the seventeenth century by Rubens, who revitalized the subject with a new dynamism and spontaneity.[1] In Rubens's hunt scenes, man is always at the center of the conflict, whether it is presented in a mythological, contemporary European, or exotically fanciful context. Robels has shown that in Frans Snyders's art, even at the outset of his career, man is but a marginal player and quickly disappears entirely as the painter concentrates on the combat of the animals. Very often Snyders chose the moment when the dogs at last overtake their prey – the climax of the chase, and the moment of the greatest danger for both the hunters and the hunted. Snyders's talent was for naturalistic observation, which must in part have resulted from his experience of actual hunts.[2] While Rubens usually employed assistants in the execution

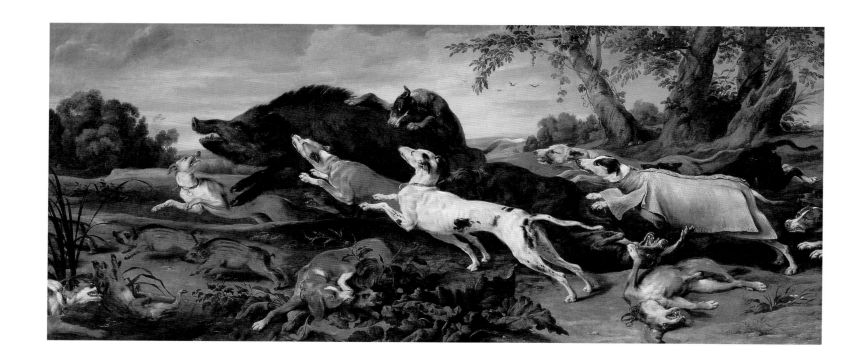

of his large hunt scenes, Snyders, Robels maintains, rarely engaged collaborators or other helpers when addressing this favored subject.[3]

This painting is the largest of Snyders's hunt scenes. Its unusually grand format suggests that it was an important commission, though the painting's early history is unknown.[4] According to the catalogue of the sale in 1889 of the collection of Don Pedro de Bórbon (b. 1862), the consignee inherited his paintings from his father, Don Sebastian Gabriel, Infante of Spain (born in Rio de Janeiro in 1811), who in turn was a grandchild of Don Juan the Sixth, King of Portugal. A Captain-General of the Spanish army, Don Sebastian married the daughter of the king of Naples. Through his association with the local nobility he reportedly acquired many works of art in Italy. Thus the painting could have descended from several different royal sources: Spanish, Portuguese, or Italian. An unidentified seal on the back of the canvas includes the cursive letters "s.G." surmounted by a crown, presumably the emblem of [Don] Sebastian Gabriel.

Snyders's games pieces and still lifes far outnumber his hunt scenes, but Robels accepted fifteen boar hunts.[5] Only the late works are dated, but Robels has conjectured that Snyders's earliest boar hunt was one which featured a peasant with a pike and dated it from ca. 1615 (Rome, Galleria Nazionale d'Arte Antica, Galleria Corsini, inv. 482).[6] This figure is the only human presence in any of Snyders's hunt

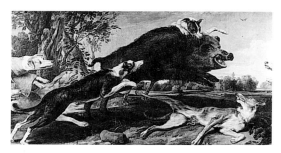

Fig. 1. Frans Snyders, *Boar Hunt*, oil on canvas, 163 x 298 cm, Prague, Národní Galerie, inv. no. Do-4351.

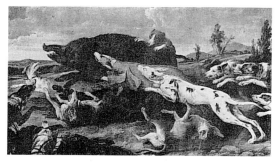

Fig. 2 Frans Snyders (?), *Boar Hunt*, oil on canvas, 197 x 342 cm, Barcelona, private collection, 1950.

Fig. 3. Virgil Solis, *Boar Hunt*, engraving.

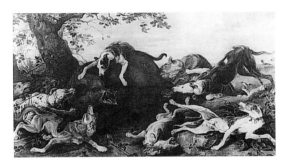

Fig. 4. Frans Snyders, *Boar Hunt*, oil on canvas, 197 x 342 cm, Poznan, Muzeum Narodowe, inv. nr. MO91.

scenes. A painting in the Národní Galerie in Prague (fig. 1) employs the unifying compositional device of a boar lunging from left to right across the scene with the dogs in hot pursuit or tumbling perilously underfoot,[7] while a painting in a private collection in Barcelona reverses the design and seems to anticipate the action at the center left of the Boston painting (fig. 2).[8] The formal relationship between the latter two paintings is very close. Robels implied that the Barcelona painting, which she dated to the 1620s, preceded the Boston picture, which in turn elaborates the design into a larger and considerably wider composition. She characterized the Boston painting as the "most important work from [Snyders's] middle period, about 1625-30,"[9] citing the greater unity of the animals and the landscape and the greater variety and complexity of the overall design. The unusually wide format and friezelike design of this painting may distantly recall hunt scenes depicted in Virgil Solis's sixteenth-century prints (fig. 3), though there again the human presence is emphasized and the scale is utterly different.[10]

Virtually every stage in a boar hunt was represented by Snyders. In his painting in Poznan the dogs have overtaken the boar and attack from every side (fig. 4),[11] while a painting in the Alte Pinakothek, Munich (inv. no. 543), depicts the fearsome boar standing its ground amidst a ring of snarling hounds.[12] In Snyders's later hunt scenes the landscape often became more prominent and the animals sleeker, more attenuated; see, for example, the paintings of boar hunts formerly in Sanssouci, Potsdam (inv. no. GKI5155; lost in World War II),[13]

and in the Royal Collection, Kensington Palace, London, signed and dated 1653 (inv. nr. 70A).[14] In or before 1636, Philip IV of Spain commissioned Rubens to decorate his hunting lodge, the Torre de la Parada, with mythologies and hunt scenes. This commission and others for the royal residences (e.g. Buen Retiro and the Alcázar) employed Snyders and Paulus de Vos in the production of numerous hunt scenes and animal paintings.

While there are preparatory drawings by Snyders for some of the artist's other boar hunts,[15] none has been identified with the present work. Snyders's boar hunt paintings inspired many contemporary and later artists, including Jan Fyt (see especially, Brussels, Musées Royaux des Beaux-Arts, no. 3901), Pieter Boel (qq.v), the Frenchman François Desportes, and the Dutchman Abraham Hondius.

PCS

1. See Balis 1986, pp. 50ff.

2. Robels 1989, pp. 39-41.

3. Ibid., p. 91.

4. Ibid., p. 99.

5. Ibid., cat. nos. 221-236, ills.

6. Ibid., cat. no. 221.

7. Ibid., cat. no. 222.

8. Ibid., cat. 225 (possibly with the collaboration of Paulus de Vos) where she lists six painted copies and variants of this composition as well as an etching by François Joullain with the inscription: *Sneidre invenit/F. Desportes pinxit* (a similar painting by Desportes is in the museum in Lyon). There also exist an etching by Pieter Boel (Hollstein 1949-, vol. 3, p. 58, no. 7) and an engraving by Lucas Vorsterman after Boel, which prove that Boel employed the design as well.

9. Robels 1989, p. 328, no. 226.

10. See *The Illustrated Bartsch,* vol. 19, part I (New York, 1987), p. 170. no. 371 (285).

11. Robels 1989, no. 223 I, ill.

12. Ibid., no. 224, ill.

13. Ibid., no. 234, ill.

14. Ibid., no. 236, ill.

15. See, for example, ibid., no. 235, the compositional sketch in pen and wash in Holkham Hall that is preparatory to the painting in Munich (see note 12 above).

Jan Fyt
122. *Dogs with a Still Life of Wild Game*, 1649

Oil on canvas, 138.3 x 198.5 cm (54 ½ x 78 ¼ in.)
Signed and dated in the lower middle:
Ioannes·Fyt·1649·
Berlin, Staatliche Museen zu Berlin, Gemäldegalerie,
no. 883A

PROVENANCE: Graf Friederich Mauritz von Brabeck, died 1814; by
descent to Graf Stolberg zu Söder; sale Graf Stolberg zu Söder, Hanover,
31 October 1859, no. 100 [566 thaler, to Suermondt]; Suermondt Museum,
Aachen 1863-1875.

EXHIBITIONS: Brussels, *Exposition de tableaux et dessins d'anciens maîtres
organisée par la société néerlandaise de bienfaisance à Bruxelles* (Brussels, 1873),
p. 35, no. 88 (lent by B. Suermondt).

LITERATURE: Friedrich Wilhelm Basilius von Ramdohr, *Beschreibung
der Gemälde-Galerie des Freiherrn von Brabeck* (Hanover, 1792), pp. 83, 237;
W. B., in *Courrier Littéraire et Scientifique* (November 1859), p. 463 ["une des
belles œuvres du maître"]; Parthey 1863-64, vol. 1 (1863), p. 467, no. 50;
J. Meyer and W. von Bode, *Beschreibendes Verzeichnis der ausgestellten
Gemälde and Handzeichnungen aus den im Jahre 1874 erworbenen Sammlungen
des Herrn Berthold Suermondt* (Berlin, 1875), p. 130, no. 164; Woermann 1888,
p. 538; Wurzbach 1906-11, vol. 1 (1906), p. 561; Rooses 1914, p. 298, fig. 540;
Thieme, Becker 1907-50, vol. 12 (1916), p. 613; Bode 1919, p. 442, ill.;
A. Philippi, *Die Blüte der Malerei in Belgien* (Leipzig/Berlin, 1921), p. 128,
fig. 80; Berlin, Staatliche Museen zu Berlin, *Beschreibender Verzeichnis der
Gemälde im Kaiser-Friedrich-Museum* (Berlin, 1931), p. 176, no. 883A [with
facsimile of the signature and date]; Greindl 1956, p. 158; Berlin, Staat-
liche Museen zu Berlin, Gemäldegalerie, *Holländische und flämische
Gemälde des siebzehnten Jahrhunderts im Bode Museum* (Berlin, 1976), cata-
logue by Irene Geismeier, p. 37, no. 883A, p. 127, ill.; Greindl 1983, p. 348,
no. 22 [incorrectly as in West Berlin].

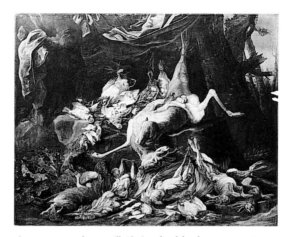

Fig. 1. Jan Fyt, *Dead Game Still Life*, signed and dated
1651, oil on canvas, 183 x 214 cm, Stockholm,
Nationalmuseum, inv. no. NM433.

AN ARRAY of dead game including a gutted roe-
buck, large waterfowl, woodcocks, partridges, and a
rabbit are piled beneath and hung from a tree in a
landscape. A long hunting rifle lies across the heaped
game. At the left are two hunting dogs, one of which
strains at its leash to get at the game.

Like many other Netherlandish still-life painters,
Jan Fyt evidently used preparatory drawings because
several of the motifs in this painting recur in other
paintings. The roebuck reappears in the same posi-
tion in a dead game still life dated two years later in
the museum in Stockholm (fig. 1),[1] and the dog
straining at the leash reappears in an undated paint-
ing in the Gemäldegalerie Alte Meister in Kassel
(fig. 2).[2]

According to Greindl, the earliest dated work by
Fyt is a game piece of 1638.[3] It already employs the
device of the angled hunting rifle as a unifying and
animating element of the design. The present pic-
ture is one of at least five by Fyt dated 1649[4]; a paint-
ing of a pile of dead game with three hunting dogs
formerly in the Thyssen-Bornemisza collection,
Lugano, is closest in conception to the present work
(fig. 3).[5]

While Fyt's colleague and probable teacher, Frans
Snyders, painted many dead game still lifes with the
cartwheeling form of a gutted deer strung up by one
leg at the center of the composition and hunting
dogs to one side sniffing the game, he rarely set the
scene out of doors.[6] Dead game still lifes in the open
air were Fyt's specialty. In the Stockholm painting,
he even drapes a swag of drapery from the branches
of the tree to fancifully underscore the abundance
and elegance of such a princely take of quarry. Fyt's

palette and technique also differ from Snyders,
whose colors tend to be brighter and more saturated
and his execution smoother and thicker. Fyt's brush-
work has a more nervous animation which flecks the
bodies of the game with quick stabbing strokes, suc-
cessfully conveying the textures of fur, feathers, and
down. In his compositions without fruit his colors
run to darker tans, browns, grays, blacks, and earth
colors. These formal qualities and a greater elegance
of design may acknowledge Fyt's admiration for Ital-
ian still-life painting, for example that of Baldassare
Castiglione.

PCS

1. See Brussels 1965, p. 93, no. 95; Stockholm, Nationalmuseum, *Illustrated
Catalogue-European Paintings* (Stockholm, 1990), p. 137, ill.

2. The motif of two dogs sniffing dead game was common in the art of
both Snyders and Fyt; see, for example, Brussels, Musées Royaux des
Beaux-Arts de Belgique, no. 2857.

3. See Greindl 1983, p. 102 (Madrid, Museo Lazaro Galdiano). A date of
1641 on the painting from the Wetzlar collection now in the Mauritshuis
(no. 925) has not been verified, but Greindl (1989, p. 349, no. 79) catalogues
a *Game Still Life* that was reported to be signed and dated 1642 when with
Richard Green, London, in 1983. Several works are also dated 1644: Lon-
don, Wallace Collection, no. P101; formerly Dessau, Amalienstiftung,
no. 318 (destroyed); and Rudolph Kann collection, Paris, cat. 1907, p. xiv,
no. 16, ill.

4. See Greindl 1983: no. 15 (private collection, Antwerp); no. 95 (Madrid,
Museo del Prado, no. 1528); and no. 150 (Venice, Galleria dell'Accademia,
inv. 346; see Brussels 1965, no. 94, ill.).

5. See Greindl 1983, no. 94, and *The Thyssen Bornemisza Collection*, 2 vols.
(Castagnola, 1969), the Dutch and Flemish paintings catalogued by
J. C. Ebbinge-Wubben, vol. 1, p. 118, no. 103, vol. 2, pl. 191; however it was
not in Ivan Gaskell's 1990 catalogue of this part of the collection.

6. For the rare exceptions, see Robels 1989, no. 85 (Earl of Bradford's col-
lection, Weston Park, Salop) and 86 (sale New York [Sotheby's], June 9,
1983, no. 84, ill.). See also Snyders's pen and ink drawing of a sheet of
eighteen studies of dead roebuck in the Kupferstichkabinett, Berlin,
inv. no. 8497 (Robels 1989, no. Z43, ill.).

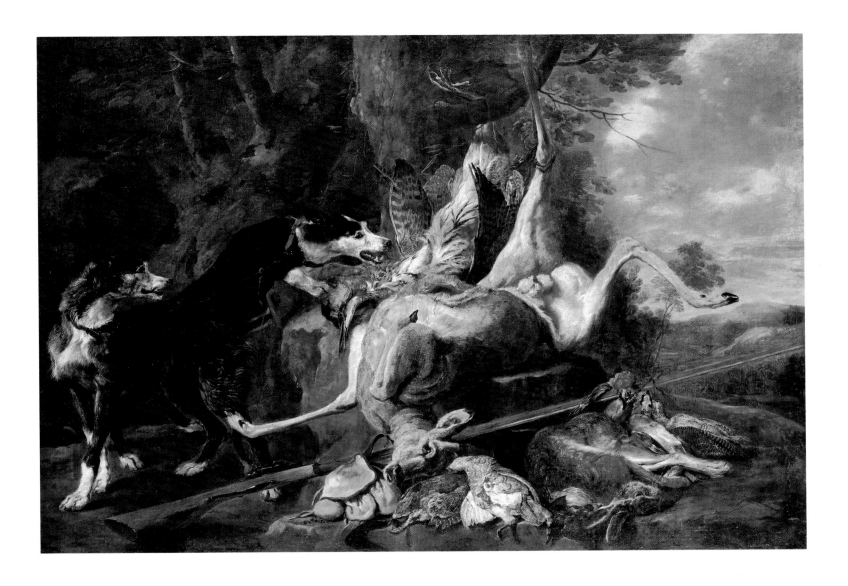

Fig. 2. Jan Fyt, *Dead Game Still Life with Dog*, oil on canvas, 112 x 165 cm, Kassel, Gemäldegalerie Alte Meister, cat. (1958), no. 160.

Fig. 3. Jan Fyt, *Dead Game with Dogs*, signed and dated 1649, oil on canvas, 137 x 200 cm, formerly Lugano-Castagnola, Thyssen-Bornemisza collection, cat. (1969), no. 103.

Pieter Boel

(Antwerp 1622-Paris 1674)

Baptized in Antwerp on 22 October 1622, Pieter Boel was born into a family of artists. His father, Jan (1592-1640), was an engraver, publisher, and art dealer; his uncle Quirin I was an engraver; his brother Quirin II [Coryn] (1620-1640) was a print-maker; and his sons Jan Baptist (active 1674/5-1689) and Balthasar Lucas were also artists. According to Jan-Erasmus Quellinus, the son of Erasmus II Quellinus (q.v.), who worked closely with the artist, Boel was a pupil of Jan Fyt (q.v.). Félibien suggests, however, that he was a student of Frans Snyders (q.v.). Boel apparently spent several years in Italy, probably during the late 1640s. He visited Rome and also Genoa, where his uncle Cornelis de Wael (1592-1667) was active as a painter, printmaker, and art dealer. An inventory of de Wael's estate made after his death lists: "no. 48, sei libri con animali di Pietro Boul." Following his return to Antwerp, Boel joined the guild of St. Luke in 1650. In about the same year he married Maria Blanckaert (1632-1658/9); four children were born of their marriage. Among Boel's pupils was the animal painter David de Coninck (1636-1699).

Boel moved to Paris in late 1668, where he worked alongside the French painter Charles LeBrun (1619-1690) designing tapestries for the Gobelins factory. Boel was appointed court painter ("peintre ordinaire du Roi") to Louis XIV in 1674, and died in Paris on 3 September of that year. He was buried in the Church of St. Hippolyte the following day; among the mourners was his friend and colleague, the Flemish battle painter Adam Frans van der Meulen (q.v.).

Boel is best known as a painter of hunt scenes and still lifes of dead birds and game in the tradition of Snyders and Fyt. Though his compositions and subject matter closely resemble those of Fyt, Boel's colors are heavier and more opaque. His most elaborate compositions include richly chased metalware and other luxurious objects to contrast with the textures of feather and fur; connotations of *vanitas* are often inherent in the display. Boel was a prolific draughtsman, and also executed several etchings. One series of six prints, entitled "Diversi Uccelli," depicts birds and animals against a backdrop of Roman ruins; others are set against a neutral background. Boel collaborated on paintings with Erasmus Quellinus, Jacob Jordaens, and Gonzales Coques (qq.v.).

De Bie 1661, pp. 362-364; Le Comte 1699, vol. 2, p. 329; Houbraken 1718-21, vol. 2, p. 141; Weyerman 1729-69, vol. 2 (1729), p. 211; Descamps 1753-64, vol. 2, pp. 349-350; Sopriani 1768, p. 466; Immerzeel 1842-43, vol. 1 (1842), p. 67; Rombouts, van Lerius 1872, vol. 2, pp. 215, 220, 241, 298, 305-306, 436, 865; van Lerius 1880-81, vol. 1, pp. 107-121; van den Branden 1883, pp. 1095-1096; Levin 1888, p. 171; Wurzbach 1906-11, vol. 1 (1906), pp. 123-124; Donnet 1907, p. 402; H. Hymans, in Thieme, Becker 1907-50, vol. 4 (1910), pp. 199-200; Paris 1936, pp. 3-4; Sterling 1952, pp. 52, 58, 75; Greindl 1956, pp. 92-96; Gerson, ter Kuile 1960, p. 161; de Mirimonde 1964; Brussels 1965, pp. 16-17; Bodart 1970, vol. 1, pp. 205, 317, 475-476, 498, 505, 511, 524, 535; Faré 1974, p. 256; Paris 1977-78, pp. 43-45; Greindl 1983, pp. 112-116; Konecny 1983; Sullivan 1984, pp. 21-22, 31, 60, 64; de Bruyn 1985.

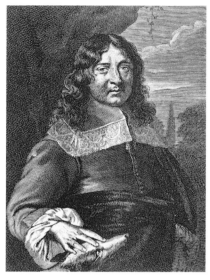

Conrad Lauwers after Erasmus II Quellinus, *Pieter Boel*, engraving.

Pieter Boel
123. *Fish Market Still Life*

Oil on canvas, 166 x 156 cm (65 ⅜ x 61 ⅜ in.)
Amsterdam, Kunsthandel K. & V. Waterman

PROVENANCE: Galerie Bruno Meissner, Zurich, 1978; dealer Noortman and Brod, Maastricht, 1983.

LITERATURE: Greindl 1983, pp. 114, 340; *Weltkunst* (1 October 1983), p. 2473; Greindl et al. 1990, p. 109, ill.

A RICH ASSORTMENT of sea creatures including several codfish, perch, carp, a pair of red gurnards, a skate, two sea turtles, and a squid form a slippery cascade from a rough wooden ledge to the ground below. Tucked beneath the plank is a basket of oysters; a partially gutted fish is suspended from a hook at the upper right. The moist slimy surfaces of the fish are a powerful example of Boel's virtuoso rendering of textures; the coral flesh of the red gurnards in the center of the composition is a piquant contrast to the silvery grays and browns of the other fish, and is echoed in the ruddy accents scattered throughout the display. Interspersed among the various aquatic creatures are the implements of their capture, cleaning, and display: a fishing net, a cleaver imbedded in a piece of wood lying across the mouth of a wood tub, a set of balances with metal pans, a brass bucket, and a large metal bowl. Beyond the imposing foreground display is a distant view of massive city ramparts, and at the left, boats in a harbor.[1]

In the seventeenth century Antwerp was only nominally active as a fishing port and imported much of its fish from the Northern Netherlands.[2] Perhaps not coincidentally, the subgenre of fish still lifes was far less popular among Flemish painters than among their colleagues to the north; Alexander Adriaenssen (1587-1661) was one of the few Flemish artists who made a specialty of painting fish.[3] Most contemporary fish still lifes place their wares in the context of a kitchen, surrounded by household implements and other foodstuffs; comparatively few depict the more commercial aspects of the fishing industry, choosing to present fish as a comestible rather than fish as a commodity.

The present painting is the only still life known by Boel which focuses exclusively on fish, although other paintings by the artist depict sea creatures in conjunction with dead game or other still-life elements. For example, Boel's *Still Life with Fish and Dead Birds* in the Prado (fig. 1) balances a cascade of fish, shells, and other sea creatures with a festoon of dead birds on the opposite side of the composition. Much as in the present work, the Prado painting includes a view to a coastal landscape in the center of the composition, hinting at the fertile origins of the foreground elements.

Boel's painting is a descendant of sixteenth-century fish markets by Joachim Beuckelaer and his followers which, however, incorporate a complex

Fig. 1. Pieter Boel, *Still Life with Fish and Dead Birds*, signed, oil on canvas, 168 x 237 cm, Madrid, Museo del Prado, inv. 1366.

Fig. 2. Frans Snyders, *Fish Market*, ca. 1616-1621, oil on canvas, 209 x 343 cm, St. Petersburg, Hermitage, inv. 1320.

panoply of iconographic associations not present in Boel's painting.[4] Closer parallels are found in fish markets by Frans Snyders (for example, fig. 2), which similarly hint at the origins of the wares by including seaside views in the background of a tumultuous display of fish and other aquatic creatures.[5] Snyders also painted a pure still life of fish (without figures), which includes a glimpse of ships' masts through a window at the rear of the composition[6]; a *Fish Market* attributed to Michel de Boullion (active 1638) also juxtaposes a display of fish and vegetables with a view of a harbor.[7]

A variant of Boel's *Fish Market Still Life* is featured in a *Painting Gallery* by Charles Emmanuel Biset, Wilhelm Schubert von Ehrenberg, and other artists (Munich, Bayerische Staatsgemäldesammlungen, inv. 896; fig. 3); the date of 1666 on the latter work provides an approximate *terminus ante quem* for Boel's painting. Boel himself may have executed the miniature replica, which is monogrammed "P.B."[8]

MEW

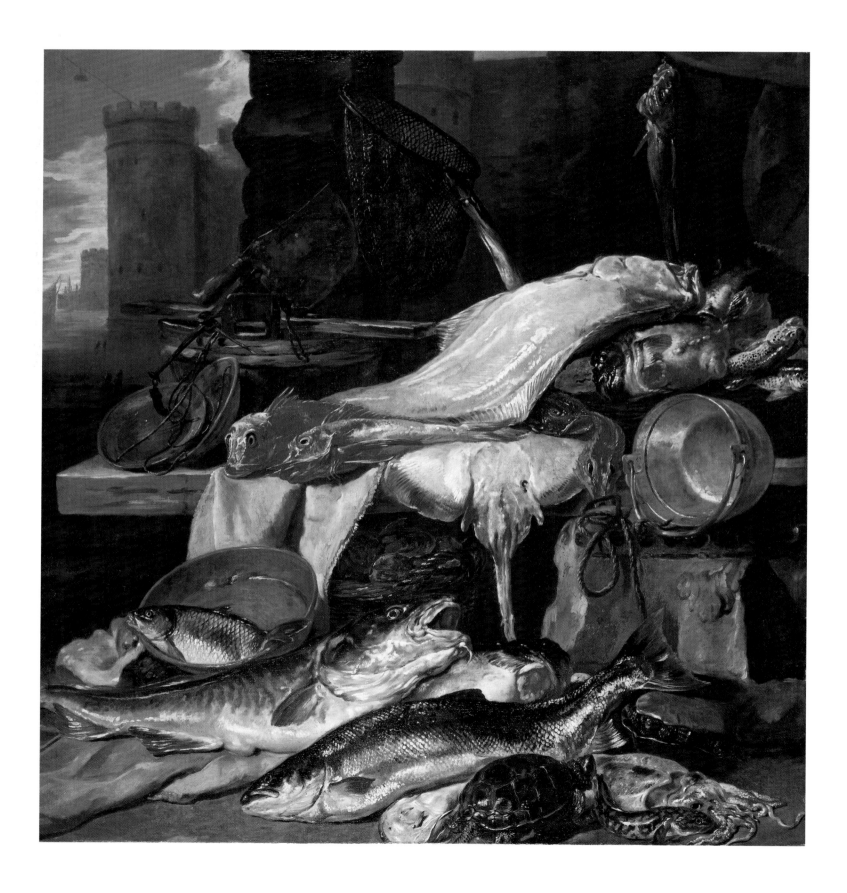

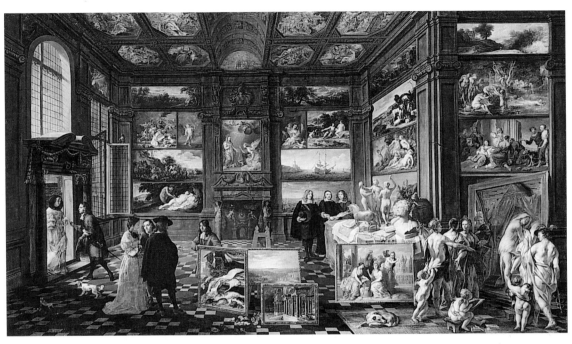

Fig. 3. Charles Emmanuel Biset, Wilhelm Schubert
von Ehrenberg, and other artists, *Painting Gallery*,
signed and dated 1666, oil on canvas, 141 x 236 cm,
Munich, Bayerische Staatsgemäldesammlungen,
inv. 896.

1. The round towers of the structure in the background of Boel's paint-
ing recall in a very general sense the smokehouse (in which herring were
smoked and salted) located to the north of the fish market on the quays
at Antwerp; see the print by F. J. Linnig after J. B. Bonnecroy, illustrated
in F. Suykens et al., *Anwterp: A Port for All Seasons* (Antwerp, 1986), p. 156.
A similar tower appears in the background of Frans Snyders's *Fish Market*
of ca. 1616-1621 in the Hermitage (fig. 2).

2. Suykens et al. 1986, pp. 155-157 and 262-263.

3. On Adriaenssen see Spiessens 1990. Clara Peeters also painted several
fish still lifes in the first decades of the seventeenth century; see
Decoteau 1992, ills. 5, 7, 25, 26, 27 and 32.

4. On the multivalent interpretation of these works see most recently
E. A. Honig, "Painting and the Market. Pictures of Display and Exchange
from Aertsen to Snyders" (unpubl. Ph.D. diss., Yale University, 1992); and
exh. cat. Ghent 1986-87, with further literature.

5. On Snyders's fish markets see Robels 1989, pp. 62-63 and 194-198, who
interprets the images as expressing an exhortation to moderation. Honig
(1992) disagrees with this essentially Calvinistic bourgeois interpretation
and views Flemish market still lifes as affirmations to the upper class
that the riches depicted are gifts to be possessed: the market of the world
is present on their wall.

6. Ca. 1610-1612; oil on panel, 70 x 106 cm; Brussels, Musées Royaux des
Beaux-Arts de Belgique, inv. 3361; Robels 1989, cat. 101.

7. Oil on canvas, 151 x 116 cm; sale Monaco (Sotheby's), 9 December 1984,
no. 581 [as "entourage de Alexander Adriaenssen"]; the attribution to
Boullion was proposed by Fred G. Meijer on the photo mount at the
RKD.

8. On the gallery painting see Speth Holterhoff 1957, pp. 185-190;
Filipczak 1987, pp. 155-156 (who discusses the composition as a glorifica-
tion of the fine arts in Antwerp, and suggests that each of the paintings
depicted was contributed by a different artist); H. Buijs and M. van
Berge-Gerbaud, *Tableaux Flamands et Hollandais du Musée des Beaux-Arts de
Lyon* (Paris/Lyon, 1991), pp. 16, 18-19; and M. Díaz Padrón and M. Royo-
Villanova, in exh. cat. Madrid 1992, pp. 240-249 (the *Fish Still Life* as a vari-
ant of the Madrid painting, our fig. 1). A *Landscape with Animals* on the
side wall of the gallery also bears Boel's monogram.

David Teniers the Younger
124. *Archduke Leopold Wilhelm Visiting His Gallery in Brussels*, ca. 1651

Oil on canvas, 123 x 163 cm (48 ½ x 64 ³/₁₆ in.)
Vienna, Kunsthistorisches Museum, Gemäldegalerie
inv. 739

PROVENANCE: (probably) sent by Archduke Leopold Wilhelm to his brother, Emperor Ferdinand III in Prague; first mentioned in the Prague inventory of 8 April 1718, no. 320 ("Teniers. Orig.: Ihro durchlaucht erzherzog Leopoldi galleria und dessen sambt anderen contrafeèn").[1]

EXHIBITIONS: Washington, D.C., National Gallery of Art, *Art Treasures from the Vienna Collections*, 1949-50, no. 95 (also shown at New York, Metropolitan Museum of Art; The Art Institute of Chicago; and San Francisco, M. H. De Young Memorial Museum).

LITERATURE: K. Köpl, "Urkunden, Acten, Regesten und Inventare aus dem k.k. Statthalterei-Archiv in Prag," *Jahrbuch der kunsthistorischen Sammlungen des allerhöchsten Kaiserhauses, Wien* 10 (1889), p. CXXXVI; Th. von Frimmel, *Gemalte Galerien* (Berlin, 1896), p. 8; Vienna, Kunsthistorisches, cat. 1931, p. 212; Speth-Holterhoff 1957, pp. 139-141; Garas 1967, p. 40 ill., p. 44; Vienna, Kunsthistorisches, cat. 1973, p. 173; Schütz 1980, pp. 22-23, 28-29; J. Welu, in Worcester 1983-84, p. 10; Filipczak 1987, p. 125, fig. 65; K. Schütz, in Vienna, Kunsthistorisches, cat. 1989, pp. 208-210, 285; Antwerp 1991, pp. 220, 222; M. Díaz Padrón, in Madrid 1992, pp. 32, 37, 38-39, 44; A. Scarpa Sonino, *Cabinet d'Amateur: Le Grandi Collezione d'Arte nei dipinti dal XVII al XIX Secolo* (Milan, 1992), pp. 85-88; Cologne/Vienna 1992-93, pp. 166-168, 381.

ARCHDUKE Leopold Wilhelm, somberly clad in black and wearing a hat, converses with his court painter David Teniers the Younger in a gallery densely hung with fifty-one paintings from the ruler's own collection. With his stick he indicates one of these, a *Portrait of a Man* by Vincenzo Catena (original in Vienna, Kunsthistorisches Museum, inv. 87). The group of figures clustered around the table in the left foreground includes the flower painter and court chaplain, Jan Anton van der Baren (1615-1686/7), distinguished by his clerical robes and his diminutive stature.[2] Klinge has identified the man holding some keys at the far left as the archduke's High Chamberlain, Johann Adolf Graf von Schwarzenberg.[3] Standing next to him is an as-yet unidentified man holding a small bouquet of tulips; on the far side of the table are two men examining prints.

Leopold Wilhelm (1614-1661) was an avid and perspicacious collector and patron of the arts during his tenure as Governor of the Southern Netherlands from 1647 to 1656. Although Thomas Howard, Earl of Arundel (see cat. 28), visiting Vienna in 1636 declared, "Visiting the Archduke's lodging on the following day we saw only a few pictures," the situation had changed radically within a few years of Leopold Wilhelm's move to Brussels.[4] His taste for Italian (specifically Venetian) paintings had been formed during his years at the court in Madrid, and this became a focus of the collection. Teniers began working for the archduke almost immediately after the latter's arrival in the Netherlands, and was appointed court painter and director of the collections in 1651.[5]

During the early 1650s Teniers produced eleven different fictionalized views of Leopold Wilhelm's gallery of paintings.[6] A version of the present com-position at Petworth (fig. 1) and an example in the museum at Brussels (inv. 2569), both signed and dated 1651, are the earliest examples known; the present painting probably dates from 1651 as well.[7] The Vienna and Petworth paintings are identical in size and format, and in the selection of paintings hung on the walls of the gallery, but differ in the figures and the attitude of the dogs in the center foreground.[8] Both depict Italian paintings exclusively; all of these works can be identified and most are still in the collection of the Kunsthistorisches Museum in Vienna (see fig. 2). Teniers freely altered the relative sizes of the paintings to suit the composition.

Teniers's multiple versions of Leopold Wilhelm's *kunstkamer*, each with an immediately recognizable likeness of the archduke, probably functioned much as traditional court portraits of a ruler – albeit now with a specifically artistic bent – and were accordingly distributed among the archduke's favored contemporaries to give an indication of the extent and appearance of his recently gathered gallery of paintings. The present painting, for example, was almost certainly given to the archduke's brother in Prague; a version now in the Prado (inv. 1813) was sent to his cousin, King Philip IV of Spain.[9]

In addition to gallery paintings, Teniers also made small sketches after individual paintings in Leopold Wilhelm's collection, many of which were eventually engraved for the *Theatrum Pictorium* (see cats. 126, 127, 128). The sketches probably postdate the composite views of the collection, but were mostly complete by 1656, when the archduke moved with his collection to Vienna. It may be that this ambitious project was commissioned of Teniers in response to a positive reception of the artist's depictions of the archduke amidst his collection, and aimed at a somewhat broader audience.

The Vienna *Gallery* and Teniers's other *kunstkamer* paintings of 1651 may be linked with the archduke's purchase of a significant group of Italian paintings formerly in the Hamilton collection in England.[10] At the behest of the Marquess of Hamilton, in 1638 the Ambassador Basil Fielding acquired the renowned painting collection of Bartolommeo della Nave in Venice for Charles I. When the paintings arrived in England the following year the king was unable to come up with the funds with which to purchase them; the collection reverted to Hamilton and remained in his possession until his execution in 1649. It is not known precisely when or how Leopold Wilhelm acquired the 400-odd paintings from this collection, but it is known that Teniers was in England in 1651 with Alonso Pérez de Vivero, Count of Fuensaldeña, purchasing paintings for the

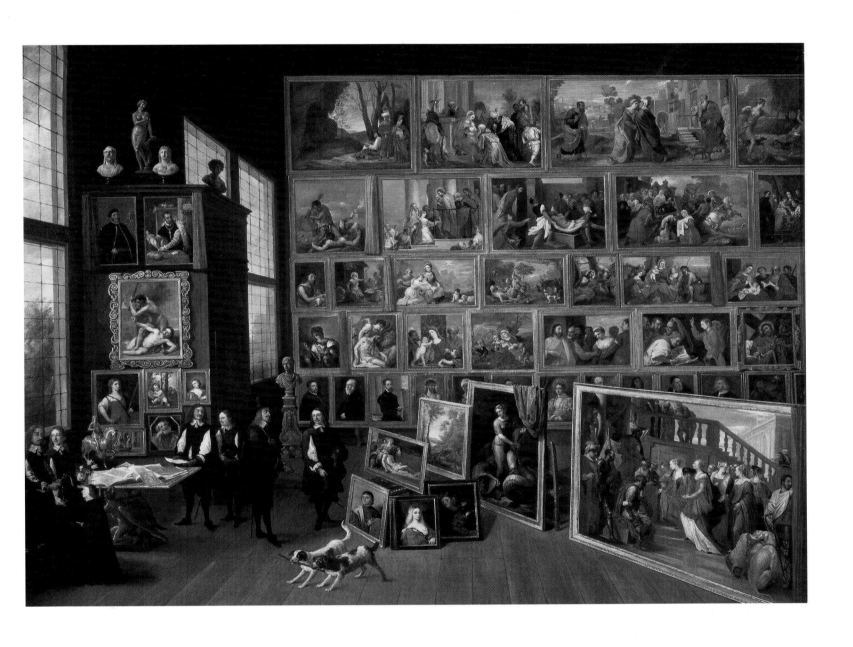

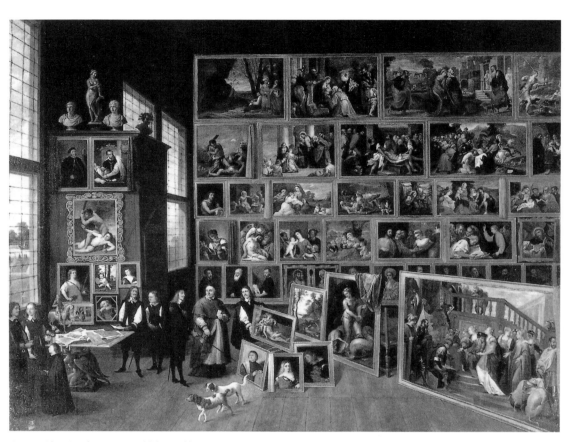

Fig. 1. David Teniers the Younger, *Archduke Leopold Wilhelm with Antonius Triest in His Picture Gallery in Brussels*, signed and dated 1651, oil on canvas, 127 x 163 cm, Petworth House, The National Trust [Lord Egremont collection].

archduke from the dispersed collections of Charles I and others.[11] All the works reproduced in miniature in the Vienna, Petworth, and Brussels paintings, as well as the majority of those included in other galleries, are works from the newly acquired Hamilton collection.

The majority of Teniers's representations of Leopold Wilhelm's cabinet include dogs, and although these pampered pets were the ubiquitous companions of the well-to-do, in this instance they may have an additional significance as well. Here, two dogs each grip one end of a long stick in their teeth; as Klinge points out, this may be a reference to the Flemish proverb "Twee honden aan één been komen zelden overeen" (Two dogs seldom agree over one bone), which she interprets as an allusion to acquisitive competition for a work of art.[12]

Although certainly the greatest portion of the gallery is devoted to paintings, there are several pieces of sculpture set about the room, and examples of the graphic arts cover the table before the windows at the left. This magnificent table appears in seven other paintings by Teniers of the archduke's gallery.[13] Commissioned by Leopold Wilhelm's uncle, Emperor Rudolf II (1552-1612) at Prague, the table's *pietre dure* top was executed by Florentine craftsmen and completed around 1597/98; the base, representing Ganymede, cup bearer of the gods, with Jupiter in the guise of an eagle, was done by Rudolf's court sculptor Adriaen de Vries (1545-1626) about 1607.[14] The table remained at Brussels after the archduke's removal to Vienna in 1656, and was destroyed in the fire that ravaged the palace in 1731.[15] The distinctive piece was probably included in the representations of Leopold Wilhelm's gallery not only because it was a particularly favored object, but also as a nod to Rudolf's illustrious career as Maecenas and collector, a role that his nephew proudly assumed in the following generation.

MEW

List of identified paintings and sculptures reproduced in David Teniers the Younger, *Archduke Leopold Wilhelm Visiting His Gallery in Brussels*.[16] Some of the works are inscribed with the name of the artist to whom it was attributed at that time. The list below includes the present location of the original (if known) and current attribution if different from that given in the painting, and if the work was engraved for the *Theatrum Pictorium*. The plates in the *Theatrum Pictorium* are numbered only in the second edition of 1684.

1. Giorgone, *The Three Philosophers*, inscribed: GIORGIONE (Vienna, Kunsthistorisches Museum, inv. 111); *Theatrum Pictorium* 1660; 1684, pl. 20.

2. Paolo Veronese, *The Adoration of the Magi*, inscribed: P. VERONES F (Vienna, Kunsthistorisches Museum, inv. 1515); *Theatrum Pictorium* 1660; 1684, pl. 123.

3. Palma Vecchio, *The Visitation*, inscribed: PALMA VECHIO (Vienna, Kunsthistorisches Museum, inv. 56); *Theatrum Pictorium* 1660; 1684, pl. 208.

4. Titian, *Diana and Actaeon*, inscribed: TITIANUS (London, The National Gallery, inv. 6420); *Theatrum Pictorium* 1660; 1684, pl. 73.

5. Titian, *Portrait of Fabrizio Silvaresio*, inscribed: TITIANUS (Vienna, Kunsthistorisches Museum, inv. 1605); *Theatrum Pictorium* 1660; 1684, pl. 89.

6. Titian, *Portrait of Jacopo Strada*, inscribed: TITIANUS (Vienna, Kunsthistorisches Museum, inv. 81); *Theatrum Pictorium* 1660; 1684, pl. 92.

7. *Cain's Fratricide*, inscribed: PALMA (present location unknown); *Theatrum Pictorium* 1660; 1684, pl. 202 [I. Palma iunior].

8. Paolo Veronese, *The Raising of the Young Man at Nain*, inscribed: P. VE. (Vienna, Kunsthistorisches Museum, inv. 52); *Theatrum Pictorium* 1660; 1684, pl. 124.

9. Pordenone, *The Raising of Lazarus*, inscribed: PORDENON. F (Prague, Castle); *Theatrum Pictorium* 1660; 1684, pl. 110.

10. Giovanni Cariani, *The Carrying of the Cross*, inscribed: IONANES CARIANI (present location unknown); *Theatrum Pictorium* 1660; 1684, pl. 166.

11. Domenico Feti, *The Mystic Marriage of St. Catherine* (Vienna, Kunsthistorisches Museum, inv. 167); *Theatrum Pictorium* 1660; 1684, pl. 222.

12. *Cain's Fratricide*, inscribed A. D. COREGI (Vienna, Kunsthistorisches Museum, inv. 363, as Guido Reni).

13. *John the Baptist* (present location unknown).

14. Dosso Dossi, *St. Jerome*, inscribed: COS.. FERARE (?) (Vienna, Kunsthistorisches Museum, inv. 263); *Theatrum Pictorium* 1660; 1684, pl. 232.

15. Andrea Schiavone, *The Holy Family with St. Catherine and the Infant St. John*, inscribed A. SCHIAVONI (Vienna, Kunsthistorisches Museum, inv. 325); *Theatrum Pictorium* 1660; 1684, pl. 140.

16. Jacopo Bassano, *The Good Samaritan*, inscribed: GI. BASSAN. (Vienna, Kunsthistorisches Museum, inv. 12); *Theatrum Pictorium* 1660; 1684, pl. 152.

17. *The Temptation of Christ*, inscribed: TINTORETTO (present location unknown); *Theatrum Pictorium* 1660; 1684, pl. 100.

18. Palma Vecchio, *Virgin and Child with Ss. Catherine, Celestinus, and John the Baptist*, inscribed: PALMA VECHIO F (Vienna, Kunsthistorisches Museum, inv. 60); *Theatrum Pictorium* 1660; 1684, pl. 206.

19. Titian, *Virgin and Child with Ss. Stephen, Maurice, and Jerome* (Vienna, Kunsthistorisches Museum, inv. 93); *Theatrum Pictorium* 1660; 1684, pl. 68.

20. Carlo Saraceni, *Judith with the Head of Holofernes*, inscribed: CAR. . . VEN. . . (?) (Vienna, Kunsthistorisches Museum, inv. 41); *Theatrum Pictorium 1660*; 1684, pl. 39.

21. Andrea Schiavone, *The Dead Christ Supported by Nicodemus and an Angel*, inscribed: A. SCHIAVONI F (Dresden, Gemäldegalerie Alte Meister, inv. 274); *Theatrum Pictorium 1660*; 1684, pl. 133.

22. Titian, *Madonna of the Cherries*, inscribed: TITIANUS (Vienna, Kunsthistorisches Museum, inv. 118); *Theatrum Pictorium 1660*; 1684, pl. 62.

23. *The Holy Family with Mary Magdalen*, inscribed: PALMA VECHIO F (Vienna, Kunsthistorisches Museum, inv. 2161, as Palma Vecchio [?]); *Theatrum Pictorium 1660*; 1684, pl. 205.

24. *Christ and the Woman Taken in Adultery*, inscribed: TITIANUS (Vienna, Kunsthistorisches Museum, inv. 114, as Titian and workshop); *Theatrum Pictorium 1660*; 1684, pl. 67.

25. José [Jusepe] de Ribera, *Jesus and the Scribes*, inscribed: SPANILETTO F (Vienna, Kunsthistorisches Museum, inv. 326); *Theatrum Pictorium 1660*; 1684, pl. 141.

26. *Christ Carrying the Cross and Veronica with the Sudarium* (present location unknown); *Theatrum Pictorium 1660*; 1684, pl. 144 [I.BASSAN P.].

27. *St. Catherine*, inscribed: TITIANUS (Vienna, Kunsthistorisches Museum, inv. 59, as Venetian, 16th century); *Theatrum Pictorium 1660*; 1684, pl. 58 [Tizian].

28. *The Little Tambourine Player*, inscribed: TITIANUS (Vienna, Kunsthistorisches Museum, inv. 96, as Venetian, ca. 1520-1525); *Theatrum Pictorium 1660*; 1684, pl. 80.

29. Palma Vecchio, *Portrait of a Young Woman as the Magdalen*, inscribed PALMA VECH . . . (Vienna, Kunsthistorisches Museum, inv. 66); *Theatrum Pictorium 1660*; 1684, pl. 196.

30. Domenico Feti, *Tobias Burying the Israelite*, inscribed: FETTI (present location unknown); *Theatrum Pictorium 1660*; 1684, pl. 216.

31. Guido Reni, *The Penitent Peter*, inscribed: GUIDO RENI (Vienna, Kunsthistorisches Museum, inv. 243); *Theatrum Pictorium 1660*; 1684, pl. 226.

32. *Portrait of a Man*, inscribed: TITIANUS F (Vienna, Kunsthistorisches Museum, inv. 315, as Venetian, ca. 1560); *Theatrum Pictorium 1660*; 1684, pl. 53.

33. Jacopo Tintoretto, *Portrait of a Man with a White Beard*, inscribed: TINTORETO F (Vienna, Kunsthistorisches Museum, inv. 25); *Theatrum Pictorium 1660*; 1684, pl. 103.

34. *Portrait of a Man with a Letter* (Vienna, Kunsthistorisches Museum, inv. 88, as Moroni); *Theatrum Pictorium 1660*; 1684, pl. 230 [KALKER p.].

35. Titian, *Ecce Homo*, inscribed: TITIANUS (Sibiu, Romania, Muzeul Brukenthal); *Theatrum Pictorium 1660*; 1684, pl. 78.

36. *Mater Dolorosa* [pendant to the preceding] (present location unknown).

37. Parmigianino, *Portrait of a Young Lady* (Vienna, Kunsthistorisches Museum, inv. 327).

38. *Portrait of an Old Man*, inscribed: TINTORETO.

39. *Portrait of a Man*, inscribed: GIORGIONE (?).

40. *Half-Length Portrait of an Old Man*, inscribed TITIANUS (present location unknown); *Theatrum Pictorium 1660*; 1684, pl. 52.

41. *Portrait of the Physician Parma*, inscribed: TITIANUS (Vienna, Kunsthistorisches Museum, inv. 94); *Theatrum Pictorium 1660*; 1684, pl. 57. For Teniers's sketch after the original, see cat. 128.

42. *Orpheus* (present location unknown); *Theatrum Pictorium 1660*; 1684, pl. 15 [GIORGIONE].

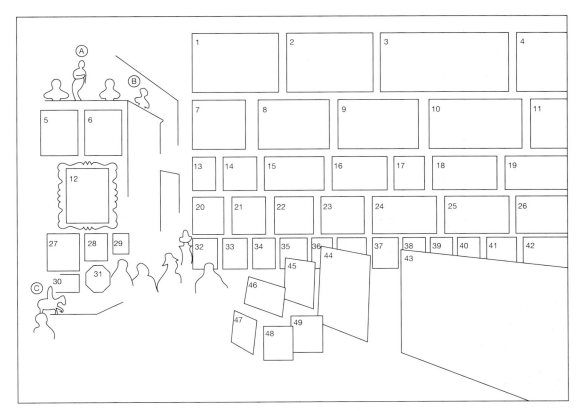

Fig. 2. Line diagram showing paintings reproduced in David Teniers the Younger, *Archduke Leopold Wilhelm Visiting His Gallery in Brussels*.

43. Paolo Veronese, *Esther before Ahasuerus* (Florence, Galleria degli Uffizi, inv. 912); *Theatrum Pictorium 1660*; 1684, pl. 125.

44. Raphael, *St. Margaret*, inscribed: R. URBIN F (Vienna, Kunsthistorisches Museum, inv. 171); *Theatrum Pictorium 1660*; 1684, pl. 2.

45. *Pastoral Landscape*, inscribed: P. BRIL (present location unknown).

46. Annibale Carracci, *The Lamentation*, inscribed: CARATCCI F (Vienna, Kunsthistorisches Museum, inv. 230); *Theatrum Pictorium 1660*; 1684, pl. 40.

47. Vincenzo Catena, *Portrait of a Man with a Book*, inscribed: VINCENTIUS CATENA PINXIT (Vienna, Kunsthistorisches Museum, inv. 87); *Theatrum Pictorium 1660*; 1684, pl. 242.

48. *"La Violante,"* inscribed: PALMA VECHIO (Vienna, Kunsthistorisches Museum, inv. 65, as attributed to Titian); *Theatrum Pictorium 1660*; 1684, pl. 194.

49. *"Il Bravo,"* inscribed: GIORGION. F (Vienna, Kunsthistorisches Museum, inv. 64, as Titian [?]); *Theatrum Pictorium 1660*; 1684, pl. 23.

A. Hieronymus Duquesnoy, *Venus Amphitrite* (Vienna, Kunsthistorisches Museum, inv. KK 5850).

B. Pier Jacopo Alari-Bonacolsi, called Antico, *Bacchus* (Vienna, Kunsthistorisches Museum, inv. KK 5987).[17]

C. Mid-seventeenth century, possibly Florentine, *Equestrian Statue of Archduke Leopold Wilhelm* (Vienna, Kunsthistorisches Museum, inv. KK 6002).

1. Inventory published in Köpl 1889, pp. CXXXII-CXLI. M. Díaz Padrón (in Madrid 1992, p. 39), notes that the painting is mentioned in a Prague inventory of 1685 but does not cite a source.

2. Van der Baren was also director of the archduke's collection in Brussels and Vienna, and compiled the first inventory of his paintings in 1659. See M. L. Hairs, *Jan Anton van der Baren* (Vienna, 1970); and Hairs 1985, pp. 309-312, with further literature.

3. M. Klinge, in Antwerp 1991, p. 222. Schwarzenberg was also a patron of Teniers, and employed him to copy and restore paintings and purchase tapestries; see F. Mares, "Beiträge zur kenntnis der Kunstbestregungen des Erzherzogs Leopold Wilhelm," *Jahrbuch der Kunsthistorischen Sammlungen des allerhöchsten Kaiserhauses, Wien* 5 (1887), pp. 349-350, 355.

4. F. C. Springell, *Connoisseur and Diplomat* (London, 1963), p. 68; on Leopold Wilhelm's acquisitions during these years, see Garas 1967.

5. On Teniers's activities while in the service of the archduke, see Vlieghe 1966, and Schütz 1980.

6. In addition to the present painting and the version in Petworth, these include: 1. oil on canvas, 96 x 129 cm, signed and dated 1651, Brussels, Musées Royaux des Beaux-Arts de Belgique, inv. 2569; 2. oil on copper, 106 x 129 cm, Madrid, Museo del Prado, inv. 1813; 3. oil on canvas, 96 x 125 cm, signed, Schleissheim, Staatsgalerie (Bayerische Staatsgemälde-sammlungen), inv. 1819; 4. oil on canvas, 95 x 127 cm, signed, Schleissheim, Staatsgalerie (Bayerische Staatsgemäldesammlungen), inv. 1839; 5. oil on canvas, 95 x 126 cm, Schleissheim, Staatsgalerie (Bayerische Staatsgemäldesammlungen), inv. 1840; 6. oil on canvas, 93 x 127 cm, Schleissheim, Staatsgalerie (Bayerische Staatsgemäldesammlungen), inv. 1841; 7. oil on canvas, 99 x 129.5 cm, Woburn Abbey; 8. oil on canvas, 70 x 86 cm, signed and dated 1653, Vienna, Kunsthistorisches Museum, inv. 9008; 9. oil on canvas, 97 x 124.5 cm, signed, sale New York (Sotheby's), 6 March 1975.

7. M. Klinge, in Antwerp 1991, p. 220.

8. On the Petworth painting, which includes a portrait of Antonius Triest, Bishop of Ghent and noted patron of the arts, see Speth-Holterhoff 1957, pp. 141-43; and M. Klinge, in Antwerp 1991, no. 76 (pp. 220-223).

9. Speth-Holterhoff 1957, p. 50; M. Díaz Padrón, in Madrid 1992, p. 36.

10. On the Hamilton collection, see E. K. Waterhouse, "Paintings from Venice for Seventeenth-Century England," *Italian Studies* 7 (1952), pp. 1-23; on paintings from this collection acquired by the archduke, see Garas 1967, pp. 44ff; and Madrid 1992, pp. 32-33.

11. W. A. Vergara, "The Count of Fuensaldeña and David Teniers: Their Purchases in London after the Civil War," *The Burlington Magazine* 131 (1989), p. 128.

12. M. Klinge, in Antwerp 1991, p. 222.

13. Speth-Holterhoff 1957, pp. 137, 139.

14. On the table see L. O. Larsson, *Adriaen de Vries: Adrianvs Fries Hagiensis Batavvs 1545-1626* (Vienna and Munich, 1967), pp. 45-46; and C. Willemijn Fock, "Pietre Dure Work at the Court of Prague: Some Relations with Florence," *Leids Kunsthistorisch Jaarboek* 1 (1982), pp. 264-267. Speth-Holterhoff (1957, p. 137) and others have wrongly attributed the table base to Hieronymus (Jerome) Duquesnoy the Younger (1604-1659), who was a sculptor at the court of Leopold Wilhelm.

15. Speth-Holterhoff 1957, p. 137, note 162. The table is mentioned in an inventory compiled in 1732, of works of art destroyed in the fire, no. 44: "C'est dans cette chambre qu'étoit la riche table de Rodolphe portée par un aigle, d'un fameux maître" (Brussels, Algemeen Rijksarchief, Ouvrages de la Cour, no. 399, fols. 166-167; published in de Maeyer 1955, doc. 280, p. 466).

Michel de Saint Martin specifically noted the table during his tour of the Palace in 1661: "L'on môntre en la mesme Galerie une Table, qui fut donnée au Roy d'Espagne par l'Empereur Rodolphe à condition de la laisser toûjours dans le Palais; elle donne de l'admiration à tous ceux qui la voyent, pour estre composée d'Agathes, de Rubis, de Saphirs, et autres pierres precieuses." (A. de Behault de Dornon, ed., "Relation d'un séjour de Michel de Saint Martin à Anvers, en 1661," *Annales de l'Académie Royale d'Archéologie de Belgique*, ser. 5, vol. 4 [1902], p. 200.)

16. The diagram and list are derived from those published in Antwerp 1991, pp. 222-223, pertaining to the Petworth version of the painting. My thanks to Ms. Eva Dewes of the Department of Paintings, Kunsthis-torisches Museum, for her assistance in confirming inscriptions and in identifying the pieces of sculpture represented.

17. Identified by H. J. Hermann, "Pier Jacopo Alari-Bonacolsi, gennant Antico," *Jahrbuch der kunsthistorischen Sammlungen des allerhöchsten Kaiserhauses, Wien* 28 (1909-10), p. 277.

David Teniers the Younger
125. *A Picture Gallery*, ca. 1670

Oil on canvas, 60 x 75.5 cm (23 ⅝ x 29 ¼ in.)
Signed lower right: D·TENIERS·FEC
New York, collection of Saul P. Steinberg

PROVENANCE[1]: collection William Courtenay, later ninth Earl of Devon; sale Lord Courtenay, London (Christie's), 26-27 April 1816, no. 73 ["Portraits of D. Teniers and a friend, in the Picture Gallery of the Former"; £163.16, to Gen. Edmund Phipps]; collection The Hon. General Edmund Phipps, M.P. (1760-1837), 1821; collection The Hon. Edmund Phipps, Esq. (d. 1857); sale Phipps, London (Christie's), 25 June 1859, no. 60 [*Interior of the Picture Gallery of the Archduke Leopold*; bought in at Gns. 260]; collection Edmund Rothschild; dealer Noortman, Maastricht, 1982.

EXHIBITIONS: London, British Institution, 1821, no. 39; London, British Institution, 1847, no. 39 ["The Leopold Gallery"]; Maastricht, Noortman, *Opening Exhibition of Fine Paintings, Watercolours and Drawings*, May 1982, no. 8; Worcester 1983-84, no. 33.

LITERATURE: Smith 1829-42, vol. 3 (1831), p. 379, no. 455; Waagen 1854-57, vol. 2 (1854), p. 228, no. 1; *An Account of all the Pictures Exhibited in the Rooms of the British Institution from 1813 to 1823* (London, 1924), p. 200, no. 26; Speth-Holterhoff 1957, p. 217 note 188 ["The Artist and His Father," wrongly as in the Ford collection]; James A. Welu, in Worcester 1983-84, pp. 122-127; Filipczak 1987, p. 154; M. Díaz Padrón, in Madrid 1992, pp. 45-46.

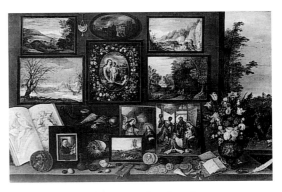

Fig. 1. Frans Francken the Younger, *A "Kunstkamer,"* signed and dated 1618, oil on panel, 56 x 85 cm, Antwerp, Koninklijk Museum voor Schone Kunsten, inv. 816.

SEATED at a cloth-covered table in a painting gallery, a fashionably dressed young man examines a red chalk drawing. His silver-gray costume is trimmed with blue and gold ribbons; red bows accent the white ruffles at his neck and wrist. His plumed hat is slung over the back of his chair, and his sword hangs at his side. Additional drawings, some small statues, seals, and medallions lie on the table before him. At his side, a plainly clad older man holds a red wax seal for his inspection. The painting exhibits the light, delicate touch characteristic of Teniers's mature style and can be dated to about 1670 or slightly earlier, a date in keeping with the young man's modish garments.

Gallery or *kunstkamer* paintings were a popular tradition in Antwerp from the beginning of the second decade of the seventeenth century. The genre was unknown in other cities or countries, except as practiced by Antwerp artists.[2] Frans Francken the Younger and Jan Brueghel the Elder (q.v.) were probably the earliest practitioners of the genre, followed closely by lesser-known artists such as Tobias Verhaecht and Cornellis de Bailleur.[3] These compositions generally depicted an eclectic mix of curiosities ranging from shells and medallions to flowers and the fine arts (fig. 1). Many of these early gallery paintings – particularly those by Jan Brueghel – were the settings for allegories of the Five Senses (for example, works by Brueghel and others in Madrid, Museo del Prado, invs. 1394, 1395, 1397, 1398, 1403, 1404) or of Pictura. Gallery paintings continued to serve as vehicles for representing abstract concepts or allegories,[4] but also gained in popularity as an independent genre devoted to glorifying the fine arts, specifically painting. This development parallels a contemporary shift in collecting patterns, from amassing encyclopedic collections of natural and

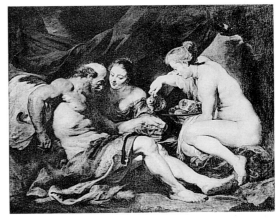

Fig. 3. Peter Paul Rubens, *Lot and His Daughters*, oil on canvas, 188 x 225 cm, Biarritz, private collection.

man-made rarities, to collections that focused increasingly on painting.[5]

Although the individual paintings depicted within these cabinets are often identifiable, few gallery paintings can be associated with specific collections (Teniers's own depictions of the cabinet of the Archduke Leopold Wilhelm are the most notable exception, see cat. 124). Even those galleries in which the collector can be identified do not record the exact setting or the manner in which the paintings were displayed.[6] More important than the exact transcription of reality, these gallery paintings convey the rarified ambiance of a collection, a grand room in which the owner might receive a visitor and display his treasures.[7] Whether lightly fictionalized portraits or imaginative genre scenes, *kunstkamer* paintings were primarily an expression of the social status of the collector, as the ownership of such a collection (whether in actuality or by proxy, in the form of

these small "painted galleries") was considered the mark of a cultured gentleman.[8]

This is certainly the case in the present painting. The identities of the figures are not known, although the young man is to be understood as an affluent collector and the older man possibly – by virtue of his modest attire and solicitous mien – as a dealer. The paintings gathered in this fictionalized gallery could never have been part of a single collection.[9] Most of the Italian paintings depicted on the rear wall are from the collection of the Archduke Leopold Wilhelm (fig. 2, nos. 7, 8, 9, 11, 13, 14, 15, 17 and 20), and also appear in Teniers's views of the

archducal gallery. Several of these copies (fig. 2, nos. 7, 11, 17) are mirror images of the original works, suggesting that Teniers was working from the engravings after the originals (made from his own sketches of the archduke's paintings) published in the *Theatrum Pictorium*. The more prominently displayed works in the foreground of *A Picture Gallery* are Flemish, including a Peasant Dance by Teniers himself (fig. 2, no. 18). This work cannot be linked to any known painting by the artist; it may record a lost work, or may have been composed specifically for this imaginary gallery. The two figures on the left in the painting of Lot and His Daughters (fig. 2,

List of paintings reproduced in David Teniers the Younger, *A Picture Gallery*. The list below includes the present location of the original [when known], and the current attribution.

1. Landscape

2. *Lot and His Daughters*

3. Joos de Momper, *Winter Landscape*

4. Grotto Landscape

5. Moonlight Landscape

6. Portrait of a Man

7. Studio of Jacopo Tintoretto, *Portrait of Doge Niccolo da Ponte* (Vienna, Kunsthistorisches Museum, inv. 26).

8. Jacopo Tintoretto, *Portrait of a Man with a White Beard* (Vienna, Kunsthistorisches Museum, inv. 25).

9. Jacopo Tintoretto, *Portrait of a Man*

10. A saint or prophet

11. Domenico Feti, *The Blind Leading the Blind* (Dresden, Gemäldegalerie Alte Meister, inv. 422).

12. Landscape with St. Anthony (?)

13. Jacopo Bassano, *Landscape with a Shepherd*

14. Andrea Schiavone, *Marcus Curius Denatus* (Vienna, Kunsthistorisches Museum, inv. 148).

15. Dosso Dossi, *St. Jerome* (Vienna, Kunsthistorisches Museum, inv. 68).

16. Elijah Visited by an Angel

17. School of Titian, *Portrait of a Woman with a Weasel* ([formerly] Vienna, Kunsthistorisches Museum, inv. 5667 [until 1933]).

18. David Teniers the Younger, *Peasants Merrymaking*

19. Portrait of a Doge

20. Pietro della Vecchia, *A Warrior* (Vienna, Kunsthistorisches Museum, inv. 433).

21. Jan Gossaert, *Madonna and Child*

22. Portrait of a Man in a Black Skullcap

23. Battle Scene

24. Bonaventura Peeters (?), *Harbor Scene*

Fig. 2. Line diagram of paintings reproduced in David Teniers the Younger, *A Picture Gallery*.

no. 2) are similar to those in a version of the subject by Peter Paul Rubens of about 1614, in a private collection in Biarritz (fig. 3).[10] According to Welu, the monkey seated on a bench at the center of *A Picture Gallery* symbolizes the imitative qualities of painting and sculpture ("art is the ape of nature").[11] Clad in the typical red and yellow costume of the fool, the monkey gazes raptly at the apple held in his hand in seeming parody of the actions of the human connoisseurs, more entranced by this simple fruit than the treasures which surround him. Similarly, the parrot, seen perched atop the open casement at the upper left, was an animal popularly associated with mimicry and opulence.

MEW

1. The present painting may be identical to either or both of the following works: sale Graave Lichtervelde, London (Christie's), 29 May 1801, no. 48 ["David Teniers, A View of the Picture Gallery of D. Teniers, on which he has introduced his own portrait"; £28.7, to Kershaw]; and sale Drury, London (Christie's), 8 March 1806, no. 48 ["D. Teniers, An Interior of a Picture Gallery with the Portrait of Himself, from the Orleans Collection"; bought in at £21].

2. M. Winner, *Die Quellen der Pictura-Allegorien in gemälten Bildergalerien des 17. Jahrhunderts zu Antwerpen* (Ph. D. diss. Cologne, 1957), p. 1; and Filipczak 1987, pp. 47-48.

3. Speth-Holterhoff (1957) presents an overview of Flemish gallery paintings of the seventeenth century; other more recent studies include Filipczak 1987; Madrid 1992; Ekkehard Mai, "Pictura in der 'Constkamer' – Antwerpens Malerei in Spiegel von Bild und Theorie," in exh. cat. Cologne/Vienna 1992-93, pp. 39-54; and Karl Schütz, "Das Galeriebild als

Spiegel des Antwerpener Sammlertums," in exh. cat. Cologne/Vienna 1992-93, pp. 161-70. For a discussion of the beginnings of the genre, see Mai, in Cologne/Vienna 1992-93, esp. pp. 48-50; Härting 1989, pp. 83-91; and Filipczak 1987, with further literature.

4. For example, Jan van Kessel, *The Four Continents*, 1664 (Munich, Bayerische Staatsgemäldesammlungen, Alte Pinakothek, invs. 1910-1913).

5. Although this is the general trend, it is by no means all-inclusive; briefly, see K. Van der Stighelen's review of Filipczak 1987, in *Simiolus* 20 (1990/91), esp. pp. 294, 298. A recent study of the encyclopedic "kunstkamer" in the Northern Netherlands throughout the seventeenth century is R. van Gelder, "De wereld binnen handbereik: Nederlandse kunst- en rariteitenverzamelingen 1585-1735," in E. Bergvelt and R. Kistemaker eds., *De wereld binnen handbereik: Nederlandse kunst- en rariteitenverzamelingen 1585-1735*, 2 vols. (Amsterdam and Zwolle, 1992), pp. 15-38.

6. Examples of gallery paintings in which the collectors (or collections) have been plausibly identified include Frans Francken the Younger, *Banquet in the House of Burgomaster Nicolaas Rockox*, ca. 1630-1635 (Munich, Alte Pinakothek, inv. 858; ill. Muller, fig. 2); and Willem van Haecht, *The Cabinet of Cornelis van der Geest*, 1628 (Antwerp, Rubenshuis).

7. K. Schütz, in Vienna, Kunsthistorisches Museum, cat. 1989, p. 210.

8. See Filipczak 1987, pp. 53-56, 67; on art collecting (and specifically the appreciation of painting) as a mark of gentlemanly virtù, see W. E. Houghton, "The English Virtuoso in the Seventeenth Century, II," *Journal of the History of Ideas* 3 (1942), pp. 205-211.

9. The paintings reproduced are identified and discussed by Welu, in Worcester 1983-84, pp. 122-125.

10. Oil on canvas, 188 x 225 cm; d'Hulst, Vandenven 1989, no. 8. Rubens's painting, which remained in Antwerp until about 1698 (ibid., p. 50), is more closely reproduced as a chimney piece in Cornelis de Vos's *Portrait of Suzanna de Vos-Cock with a Woman and Three Children*, ca. 1625 (Stockholm, Nationalmuseum, inv. 407).

11. Welu, in Worcester 1983-84, p. 124. See also H. W. Janson, *Apes and Ape Lore in the Middle Ages and the Renaissance* (London, 1952), pp. 287-325.

David Teniers the Younger after
Domenico Feti
126. *The Drowned Leander Borne by Nereids*

Oil on canvas, 61 x 83.5 cm (24 x 32⅞ in.)
Monogrammed: DT
Los Angeles, collection of Daisy and Daniel Belin

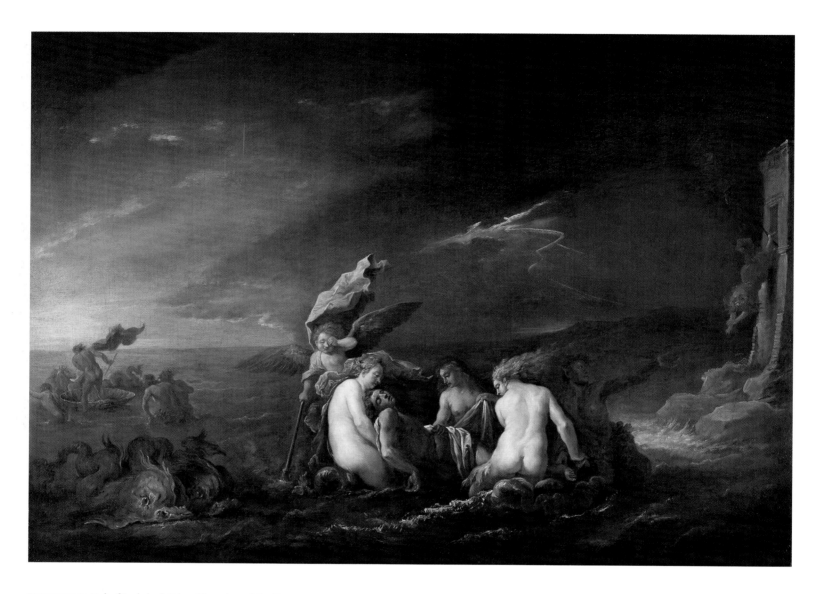

PROVENANCE: Earls of Sunderland, Althorp House; descended to The
Hon. John Spencer (mentioned in inventory of 1742); inherited in 1746 by
his son, John, who was named first Earl Spencer in 1765 (no. 172 in Knap-
ton's MS. catalogue of 1746); thence by descent; sale London (Sotheby's),
3 July 1985, no. 60, ill. [bought in]; sale London (Sotheby's), 3 July 1985,
no. 60, ill.; with dealer Johnny van Haeften, London; private collection,
Europe; sale New York (Sotheby's), 2 June 1989, no. 22, ill.

EXHIBITIONS: London, Johnny van Haeften Gallery, *Dutch and Flemish
Old Master Paintings*, cat. no. 18, ill.

LITERATURE: G. Knapton, *Catalogue of the Pictures at Althorpe and Wim-
bledon Belonging to the late Honble. Mr. Spencer* (1746), no. 172; Althorp
House cats. 1750, 1831, no. 31; Smith 1829-42, vol. 3 (1831), no. 650; Waagen
1854-57, vol. 3 (1857), p. 459; K. J. Garlick, "A Catalogue of the Pictures at
Althorp," *Walpole Society* 45 (1976), p. 82, no. 638.

Fig. 1. Domenico Feti, *Hero and Leander*, oil on panel,
42 x 96 cm, Vienna, Kunsthistorisches Museum, inv. 160.

THE DEAD BODY of Leander is borne over the
waters by three nereids and a triton. Cupid, in
despair, extinguishes his torch in the sea. The griev-
ing Hero throws herself from the tower at the far
right to the rocky shore below. At the left are two

dolphins, and beyond Neptune on his shell with
attendants.

The story of the ill-fated lovers, Hero and Leander,
is told by both the Greek poet Musaeus (5th-6th cen-
tury A.D.) and by Ovid in his *Heroides* (1st century
B.C.), Epistles 18-19, though the latter omits men-

Fig. 2. David Teniers the Younger, *Brussels Gallery No. 2*,
oil on canvas, 96 x 28 cm, Munich, Bayerische Staats-
gemäldesammlungen, inv. no. 1839.

tion of their deaths.[1] Leander, a youth from Abydos
on the Asian shore of the Hellespont, swam each
night across the strait at the narrowest point of the
Dardanelles to meet his lover, Hero, a virgin priest-
ess of Aphrodite. She would guide him by holding
aloft a torch in her tower, but one night its flame
went out and Leander drowned. When his body was
discovered, Hero committed suicide by throwing
herself out of the tower into the sea.

This painting is one of approximately 240 small
copies that Teniers executed, probably at times with
assistants, of the Italian paintings in the collection of
Archduke Leopold Wilhelm in Brussels, of which
Teniers was the curator.[2] The paintings served as
models for the engravings published in Teniers's
Theatrum Pictorium (Antwerp, 1660). The present work
records a composition by Domenico Feti now pre-
served in Vienna (fig. 1).[3] In his copy Teniers has fol-
lowed his prototype quite carefully but has com-
pressed Feti's horizontal design into a somewhat
narrower composition. He has heightened the emo-
tion of the scene not only through the expressions of

the figures, but also in the landscape, with greater
contrasts of light and shade and the introduction of
a bolt of lightning. The source for the Feti was
Rubens's early *Hero and Leander*, now preserved at
Yale (cat. 6).[4] The Flemish artist probably painted
this picture in Mantua around 1604-1605 and Feti in
all likelihood encountered it during his stay in that
city in ca. 1613-1621. The ancient and tragic union of
the lovers Hero and Leander greatly appealed to
poets as well as painters. Indeed Rubens's painting
inspired not only poems by Giambattista Marino,
but also elegies by the Dutch poets Joost van den
Vondel (1587-1679) and Jan Vos (1615/20-1667).[5]
While the *Ovide moralisé*, for example, by Pierre
Bersuire (Berchorius) and others, interpreted the
subject allegorically (Leander as mankind traversing
the sea of this mortal life; Hero as divine wisdom,
her torch the light of faith and doctrine which
guides mankind to Paradise),[6] the poets seem most
concerned with the lovers' tragedy, despair, and loss:
de Vos, for example, cautioned that while "lovers
must take risks... / The returns of love that one

David Teniers the Younger after Andrea Schiavone
127. *Venus and Adonis*

Oil on panel, 22.5 x 17.2 cm (8 ⅞ x 6 ¾ in.)
Philadelphia, Philadelphia Museum of Art,
The John G. Johnson collection, inv. 695

recovers with danger of life / Is much too dearly paid for."[7]

The presence of the Feti painting in Leopold Wilhelm's collection in Brussels is documented not only by the latter's inventory of 1649,[8] and Teniers's copy here exhibited, but also by Teniers's (imaginary?) view of the *kunstkamer* gallery (see fig. 2) where the Feti appears at the upper left.

Like Rubens's painting (which may have later been part not only of the collections of the heirs of the Duke of Buckingham, but also of the painters Rembrandt and Peter Lely), the Teniers subsequently entered an important collection, namely that of the Earl of Sunderland and Spencer at Althorp House. Most of the Teniers copies, in fact, seem to have later made their way into British collections: Blenheim Palace, for example, at one point housed no fewer than 117 of them before they were auctioned in 1886. While at Althorp, the present painting was described by John Smith in 1831 as "A pasticcio in the manner of the Caracci (*sic*), in which the artist has not only attempted, with considerable success, the grandeur of the Bolognese School, but has also embodied in his subject considerable poetic taste and feeling."[9] Smith did not know of Feti's original, but his allusion to the Carracci may have been partly inspired by the fact that Annibale included a medallion of Hero and Leander in the decorations for the ceiling in the Farnese Palace.[10]

PCS

1. See Ovid, *Heroides*, ed. and trans. Grant Showermans (Cambridge, 1958), pp. 245-275; and Musaeus, *Hero and Leander*, trans. Cedric Whitman (London/Cambridge, 1975), pp. 291-389. For additional discussions, see Golahny 1990 (note 4 below).

2. See Vlieghe 1966, pp. 135ff; Klinge, in Antwerp 1991, pp. 23-24, 278-279.

3. See Eduard A. Safarik, *Feti* (1990), p. 247, no. 112.

4. On the Rubens, see cat. 6, and A. Golahny, "Rubens' *Hero and Leander* and Its Poetic Progeny," *Yale University Art Gallery Bulletin*, 1990, pp. 21-37, with earlier literature. Rubens's painting was first described in a poem by Giambattista Marino (1569-1625), written when he was court poet to Vincenzo Gonzaga, Duke of Mantua, from 1606-1608 (see Golahny 1990, p. 28).

5. See Golahny 1990, pp. 28-32.

6. F. Ghisalberti, "Le 'Ovidius Moralizatus' di Pierre Bersuire," *Studi Romanzi* 23 (1933), p. 117. See also C. de Boer, ed., "Ovide Moralisé Poème du commencement du quatorzième siècle," *Verhandelingen der Koninklijke Akademie van Wetenschappen, Afd. Letterkunde*, n s., vol. 21 (1920), pp. 78ff.

7. Golahny 1990, p. 31.

8. Garas 1968, p. 216, no. 232.

9. Smith 1829-42, vol. 3 (1831), p. 432, no. 650.

10. See J. R. Martin, *The Farnese Gallery* (Princeton, 1965), p. 100, fig. 54.

PROVENANCE: (probably) sale the Duke of Marlborough, London (Christie's), 26 June 1886, no. 136[1]; collection John G. Johnson, Philadelphia, by 1913.

LITERATURE: Philadelphia, Johnson, cat. 1913, p. 174; Philadelphia, Johnson, cat. 1941, p. 39; London, National Gallery, *National Gallery Catalogues: 16th Century Venetian School*, cat. by C. Gould (1959), p. 101 (Johnson painting a copy of Schiavone after Titian); Philadelphia, Johnson, cat. 1972, pp. 85-86; H. E. Wethey, *The Paintings of Titian, vol. 3: The Mythological and Historical Paintings* (London, 1975), p. 194; Madrid 1992, p. 76.

VENUS, accidentally wounded by Cupid's dart, falls in love with the beautiful hunter Adonis. Fearful of Adonis's passion for hunting large game, Venus attempts to dissuade him from joining the chase by recounting the tale of Atalanta and Hippomenes to demonstrate the vengeance of wild beasts. After she leaves, however, Adonis ignores her warnings, goes on a boar hunt and is summarily and fatally gored (Ovid, *Metamorphoses*, X: 519ff).

The original painting on which Teniers's "pasticcio" was based, a copy by Andrea Schiavone after Titian, is now lost. The entwined figures of Venus and Adonis paraphrase those in Titian's famous version of the subject in Madrid (Museo del Prado, inv. 422; fig. 1) which, however, situates the protagonists in a more expansive horizontal landscape. According to Panofsky, Titian was the first to depict Adonis physically breaking free of Venus's entreating charms, an alteration of Ovid's original tale.[2] Titian's Prado composition exists in numerous versions and copies, with the best-known replicas in the National Gallery, London (inv. 34); Galleria Nazionale, Rome; Metropolitan Museum of Art, New York; and National Gallery of Art, Washington, D.C. (inv. 680). Rubens made a copy (now lost) of Titian's *Venus and Adonis* during his visit to Madrid in 1628-1629.[3]

Fig. 1. Titian, *Venus and Adonis*, ca. 1553-1554, oil on canvas, 186 x 207 cm, Madrid, Museo del Prado, inv. 422.

David Teniers the Younger after Titian
128. Portrait of a Man, Called Parma the Physician

Oil on panel, 17 x 12.1 cm (6 ¾ x 4 ¾ in.)
Boston, Museum of Fine Arts, Gift of the Estate
of Gardiner Howland Shaw, inv. 66.266

Like Rubens, Leopold Wilhelm also admired the Titian painting during his stay at the court of Philip IV in Madrid, and subsequently acquired no fewer than three versions of the composition.[4] The first of these came originally from the collections of Bartolommeo della Nave and the Marquess of Hamilton,[5] and was listed in the 1659 inventory of the archduke's collection (no. 309) as a work of Titian.[6] The second example owned by the archduke is listed in the 1659 inventory (no. 310) as "attributed to Palma Giovane."[7] The third, that from which Teniers made his copy, is mentioned as no. 225 in the inventory of 1659 and is reproduced in the *Theatrum Pictorium* (engraved by Quirin Boel) as a work by Andrea Schiavone. This last version attributed to Schiavone, which also came from the della Nave (no. 109) and Hamilton collections (inv. 1649, no. 116), was exhibited in the Stallburg in Vienna in 1735, and was reproduced in F. von Stampart and A. von Prenner, *Prodromus zum Theatrum Artis Pictoriae* (Vienna, 1735).[8] The work is included among other archducal treasures in Teniers's depiction of Leopold Wilhelm's painting gallery in Madrid, Museo del Prado, inv. 1813.

There is a second version of the Johnson Collection sketch in the collection of Willem Russell, Amsterdam (oil on panel, 22.3 x 16.7 cm).[9]

<div align="right">MEW</div>

1. The nearly 120 sketches by Teniers after Italian paintings in the collection of the Archduke Leopold Wilhelm which formed part of the collection of the Duke of Marlborough may have been acquired by John, first Duke of Marlborough (1650-1722), who was instrumental in the alliance between England and Austria during the Wars of the Spanish Succession.

2. E. Panofsky, *Problems in Titian, Mostly Iconographic* (New York, 1969), pp. 152-154.

3. Muller 1989, p. 104, no. 45.

4. The versions are listed and described by Díaz Padrón, in Madrid 1992, p. 76.

5. No. 186 in the 1638 inventory of the Hamilton collection: "A peice [sic] of Venus and Adonis and 3 doggs, Cupid sleepinge upon a hyllocke harde by, his Bowe and quiver hanging upon a tree of Titian" (Garas 1967, p. 67). On the della Nave and Hamilton collections, see cat. 124.

6. No. 309: "Ein Stückhel von Öhlfarb auf Leinwath, Venus nackhent siczt, vnndt Adonis in seiner rechten Handt ein Lanczen und in der linckhen an einem Strickh drey Hundt hatt, auff der Seithen siczt Cupido vnd schlafft...hoch 3 Spann 1 Finger vnndt 2 Span 9 Finger braith. Man halts van Tiziano." (A. Berger, "Inventar der Kunstsammlung des Erzherzogs Leopold Wilhelm von Österreich, Nach der Originalhandschrift im fürstlich Schwarzenberg'schen Centralarchiv," *Jahrbuch der kunsthistorischen Sammlungen des allerhöchsten Kaiserhauses* 1 [1883], p. CIV.

7. No. 310: "Ein Stückhel von Öhlfarb auff Zün, warin Venus vnd Adonis mit zwey Hundten, der eine weiss, der ander roth, hinder ihnen ligt Cupido gegen einem Baun vnd schlafft...hoch 2 Span 4 Finger vnd 2 Span braidt. Man sagt, es sey von dem jungen Palma." Berger 1883, p. CIV.

8. See H. Zimmerman, in *Jahrbuch der kunsthistorischen Sammlungen des allerhöchsten Kaiserhauses* 7 (1888), p. 17.

9. Possibly the painting mentioned in Smith 1829-42, vol. 9 (1842), p. 466, no. 194 (oil on panel, 9 x 6 ½ in.), as in the sale Lady Hampden, London (Christie's), 19 April 1834.

PROVENANCE: sale Duke of Marlborough, London (Christie's), 26 June 1886, no. 102; collection H. R. Shaw, Boston; lent to the Museum of Fine Arts by J. Archibald Murray, guardian for G. H. Shaw, 1911-16; collection Gardiner Howland Shaw, Boston; given to the Museum in 1966.

LITERATURE: *Theatrum Pictorium* 1660; 1684, no. 57 (engraving by J. Troijen); Boston, cat. 1985, p. 280.

A MIDDLE-AGED MAN with chin-length gray hair and a thin mustache is turned three-quarters to the left, wrapped in a voluminous black robe over a white chemise and a deep red doublet. With his beringed left hand he grasps a fold of his robe at hip level. This tiny painting is one of about 240 sketches made by Teniers after works in the Archduke Leopold Wilhelm's collection (see also cats. 126, 127). The model for Teniers's "pasticcio" was Titian's so-called *Portrait of Parma the Physician* of about 1515-1518 (Vienna, Kunsthistorisches Museum, inv. 94), which had entered the archduke's collection together with other Italian paintings from the Bartolommeo della Nave collection via the Marquess of Hamilton.[1]

The sitter has been identified as Parma, Titian's own physician, from at least the early seventeenth century, when the original painting was in the della Nave collection. Nothing more is known about Parma or indeed the accuracy of the identification, although the strong features and active intelligence which characterize both Titian's original and Teniers's copy suggest that the sitter was a man of some intellect.

Teniers's sketch of *Parma the Physician* was translated into an engraving in the *Theatrum Pictorium* (no. 57) and, like many of the works reproduced in these small copies, appears also in two of the artist's views of the archduke's painting gallery. It can be seen second from the right in the bottom row of paintings in the *Gallery of Leopold Wilhelm* in Vienna (cat. 124; no. 41 in diagram fig. 2),[2] and (with some alterations) at the upper left in the *Gallery of Leopold Wilhelm in Brussels* (Schleissheim, Staatsgalerie [Bayerische Staatsgemäldesammlungen], inv. 1840).

<div align="right">MEW</div>

1. On Titian's painting see H. E. Wethey, *The Paintings of Titian*, vol. 2, *The Portraits* (London, 1971), p. 121, no. 70. See also cat. 124 for information concerning the Italian paintings purchased by the archduke from the della Nave and Hamilton collections.

2. Díaz Padrón, in Madrid 1992, p. 40, notes that in the version of the gallery painting in Petworth House (cat. 124, fig. 1), the *Portrait of the Physician Parma* is replaced by a *Portrait of a Man* attributed in the seventeenth century to Titian, but now catalogued as a work by Lambert Sustris (Vienna, Kunsthistorisches Museum, inv. 77).

Michiel Sweerts

129. Plague in an Ancient City

Oil on canvas, 120 x 172.7 cm (47 ¼ x 68 in.)
New York, collection of Saul P. Steinberg

PROVENANCE: Horton Langstone, whose father was reported to have brought it back from Cadiz; according to Smith (1837) it may also have been sold at Christie's London, 1804, for 1000 guineas; Henry Hope (uncle to Morton Langstone's wife); sale Henry Hope, London (Christie's), 19 April 1816, no. 97 [as by Poussin; to Norton for 200 guineas]; Sir Philip Miles, Leigh Court near Bristol, by 1822; sale Sir Philip Miles, London (Christie's), 28 April 1884, no. 53 [as by Poussin, 400 guineas]; Sir Herbert Cook, Doughty House, Richmond; by descent to Francis Cook, who lent it to the Southampton Art Gallery, London (1950s), to Kenwood House, London, and to Manchester City Art Gallery from 1962; sale London (Christie's), 6 July 1984, no. 116, ill.; with dealer Richard L. Feigen & Co., New York.

EXHIBITIONS: Rotterdam 1958, no. 33, fig. 38; Rome 1958-59, no. 34, fig. 34; New York 1988, cat. no. 49, ill., pp. 114-115.

LITERATURE: engraved by J. Fittler for Forster's Gallery of Engravings (1807) [as Poussin]; John Young, Catalogue of the Pictures at Leigh Court (1822), no. 19 [as by Poussin]; Smith 1829-42, vol. 8 (1837), no. 178 [as by Poussin]; Waagen 1854-57, vol. 3 (1857), p. 180 [as by Poussin]; E. Magne, Nicola Poussin, premier peintre du roi, 1594-1665 (Brussels/Paris, 1914), p. 202, no. 91, ill.; W. Friedländer, Nicolas Poussin (Munich, 1914), p. 114 [not by Poussin]; O. Grautoff, Nicolas Poussin, 2 vols. (Munich and Leipzig, 1914), vol. 1, note 121 [not by Poussin], vol. 2, ill. p. 280; M. W. Brockwell, A Catalogue of the Paintings at Doughty House, Richmond (London, 1915), vol. 3, no. 431 [as Poussin]; idem, "The Cook Collection. Part III," Connoisseur 50 (1918), p. 3 [as by Poussin]; idem, Abridged Catalogue of the Pictures at Doughty House (London, 1932), pp. 8-9, no. 431 (17) [as by Poussin but attribution contested]; Longhi 1934, pp. 271-277 [as by M. Sweerts]; C. Brière-Misme, "Overzicht der Literatuur betreffende Nederlandsche Kunst," Oud-Holland 54 (1937), p. 47; Kultzen 1954, pp. 85-90, 200-202 notes 178-183, 273-274, no. 42; Longhi 1958, pp. 73-74, fig. 32, detail of background [background by Viviano Codazzi]; V. Bloch (review of Rotterdam 1958), The Burlington Magazine 100 (1958), pp. 440-441; E. Schaar (review of Rotterdam 1958), Kunstchronik 12 (1959), p. 43; H. H. Mollaret and J. Brossollet, "La peste, source méconnu d'inspiration artistique," Jaarboek van het Koninklijk Museum voor Schone Kunsten, Antwerpen (1965), pp. 4, 14, 107; Bloch 1965, pp. 165-166, fig. 95; A. Blunt, The Paintings of Nicolas Poussin. A Critical Catalogue (London, 1966), p. 25, 176, no. R-65; Bloch 1968, pp. 12, 21, 90, fig. 13; H. H. Mollaret and J. Brossollet, "Nicolas Poussin et Les Philistines frappés de la peste," Gazette des Beaux-Arts 73 (1969), p. 178, note 15; Bodart 1970, vol. 1, p. 340; J. Thuillier, L'Opera Completa di Poussin (Rome, 1974), no. R82; M. Marini, "Viviano Codazzi, il Capriccio del Vero," Ricerche di Storia dell'Arte 3 (1976) pp. 123, 127, notes 20, 21; Waddingham 1980, p. 63, note 5; Kultzen 1982, pp. 122, 129, notes 35-36; idem, 1983, p. 130, fig. 4; Briganti, Trezzani, Laureati 1983, pp. 28, 301-325; G. Briganti, "Viviano Codazzi," I Pittori Bergameschi del seicento, vol. 1 (1983), p. 696, no. 68, ill. p. 727; Liedtke et al. 1992, p. 27.

LIT by a dramatic, eerily crepuscular light, a splendid city piazza is filled with dead, dying, and grieving figures, all of whom are attired in classical drapery or undress. Several dramatically foreshortened victims (whose poses were commended by Waagen in 1854) lie in the immediate foreground; the most poetic of these is a dead mother with a nursing child. Behind, some figures minister to the stricken, while others stand dazed or move about like somnambulists. A few figures raise their hands in hysterical supplication or tear their hair in anguish, while at the right a group kneels in prayer before the steps of a temple. At the left is a cavernous Gothic-styled catacomb with figures performing some sort of pagan rite. Many figures draw their handkerchiefs to their faces to wipe away tears or stave off the stench of death. At the far left an old woman sits with head in

hand in the traditional attitude of Melancholia.

Smith wrote of the picture in 1837, "It is perhaps impossible for art to depict with greater pathos or more solemn effect a subject so heartrending as this picture exhibits. . . . It would be harrowing to describe all the scenes of misery and dismay which meet the eye . . . the very air appears pregnant with pestilence, and death in his most horrible aspect reigns triumphant throughout."[1] For Smith and his contemporaries, the picture depicted the Plague in Athens and was by Nicolas Poussin.[2] This attribution was generally accepted for at least 150 years (while the painting was in the Longstone, Hope, Miles, and Cook collections) until it was doubted by Friedländer and Grautoff in their separate studies of Poussin in 1914.[3] Roberto Longhi was the first to correctly attribute the painting to Sweerts in 1934.[4] He also subsequently suggested, probably correctly, that the architecture in the distance of the work is by Viviano Codazzi.[5] Like the earlier Poussin scholars, Longhi connected the present composition to the great French master's Plague at Ashod (fig. 1), painted in Rome in 1630-1631 and still there in the possession of a sculptor called "Matteo" in 1647-1649 when Sweerts was in the city.[6] In all probability Poussin's painting influenced Sweerts. Its design inspired at least one other imitation by a northerner, namely Bertholet Flémal (q.v.) whose painting now in Liège (fig. 2) was probably based on a print after the Poussin since the composition is reversed. However Sweerts's creative interpretation is scarcely so slavish; indeed it seems to incorporate elements taken directly from Poussin's own source, Marcantonio Raimondi's print after Raphael's Plague of Phrygia (fig. 3).[7] As Adams observed, the Raimondi print could have suggested to Sweerts not only the general composition, with prone figures in the foreground and the prospect to the right, but also the dramatic lighting, the grotto at the left dimly lit by torchlight, and several individual figure groups.[8] The motifs, for example, of the boy holding his hand to his nose and the group with the dead mother appear in both the Raimondi and the Sweerts, and have been traced by Adams to Pliny's description of a painting by Aristides representing the seizure of a city.[9]

As Jennifer Kilian observed, Sweerts also quotes himself in this painting: the figure of a standing man in the striped tunic in the middle right distance had appeared in his Cardplayers (sale London [Christie's], 11 April 1986, no. 35, ill.), and he even reused some of the plaster casts that appear in his paintings of The Artist's Studio (e.g. Detroit Institute of Arts, dated 1652, acc. no. 217).[10] The toothless old

Fig. 1. Nicolas Poussin, *Plague at Ashod*, ca. 1630-1631, oil on canvas, 148 x 198 cm, Paris, Musée du Louvre, inv. 710.

Fig. 2. Bertholet Flémal, *The Plague of the Philistine*, oil on canvas, Liège, Musée de l'Art Wallon.

Fig. 3. Marcantonio Raimondi, after Raphael, *Plague of Phrygia*, engraving.

woman at the far left also reappears as a model elsewhere in Sweerts's art (see for example the head studies in the Museo Correale, Sorrento, and Museo Civico, Piacenza[11]) while her pose recalls that of the *Portrait of a Young Man* dated 1656 (St. Petersburg, Hermitage, no. 3654).

At least as early as 1837, when Smith catalogued the painting, the subject was assumed to be the Plague of Athens. Thucydides described the plague in his *History of the Peloponnesian Wars* (chapter VII). Adams noted that the obelisk in the painting seems more appropriate to Rome than to Athens[12]; however this detail is of less use in identifying the locale than in further acknowledging the painting's debt to Poussin's *Plague at Ashod* (fig. 1), which, of course, represents a biblical subject (Samuel 5:1-6). It is not clear which if any specific plague from literature and the Bible Sweerts is depicting. He not only had the precedents of the plague subjects in the Poussin and the Raphael, but also might have been inspired by other famous antique plagues. Adams hypothesized that, despite its classical architecture and clothing, the painting might allude to the plague that ravaged Rome in 1648-1650. She further suggested that the painting may well date from that time, and, given its size and complexity, might have been a commissioned work.[13] Similarly, Blunt previously supposed that Poussin's picture was inspired by the plague that ravaged Milan in 1629-1630.[14] In this pestilence-stricken century, the Southern Netherlands also suffered from the plague, with an especially bad epidemic striking Antwerp in 1649-1652. The probability that Codazzi collaborated on the picture not only suggests that it was painted in Rome, but also that it postdates 1647, when the Italian artist returned to the city. Kultzen suggested on stylistic

grounds that the picture might postdate the *Card-players*, of about 1652.[15] A *terminus ante quem* is 1656, by which time Sweerts had returned to Brussels.

PCS

1. Smith 1829-42, vol. 8 (1837), no. 178.

2. Ibid.

3. Friedländer 1914, p. 114; Grautoff 1914, vol. 1, note 121, vol. 2, p. 280, who suggested that it might be by an eighteenth-century German artist who was active in Rome.

4. Longhi 1958, p. 74, fig. 32 (detail).

6. Longhi 1934, p. 274; see Blunt 1966, p. 25. no. 32, ill.

7. Bartsch 1978, vol. 27, p. 105, no. 417; see A. Blunt, *Nicolas Poussin* (Washington, 1958), p. 94; Blunt 1966, p. 25; and W. Friedländer, *Nicolas Poussin* (Munich, 1966), p. 106, who suggest that the print influenced Poussin.

8. Adams, in New York 1988, cat. 49.

9. Ibid., note 8.

10. Unpublished entry on the present painting cited by Adams in New York 1988, cat. 49, notes 11, 13-15.

11. Waddingham 1965, figs. 101-102.

12. Adams, in New York 1988, cat. 49.

13. Ibid., citing on the Roman plague, Lorenzo del Panta, *La epidemie nella storia demografica italiana (secoli XIV-XIX)* (Turin, 1980), pp. 163-166.

14. Blunt 1966, p. 25.

15. Kultzen 1954, no. 40.

Bertholet Flémal

(1614-Liege-1675)

Bertholet Flémal, *Self-Portrait*, oil on canvas, Liège, Musée de l'Art Wallon.

Dubbed by Sandrart the "Netherlandish Raphael," Bertholet Flémal (Flémalle) was born in Liège on 23 May 1614. His father, Renier Flémal, was a glass painter, as was his brother Guillaume. Bertholet studied first with his father, then with the obscure Henri Trippet (1584-1675), and was finally apprenticed to Gérard Douffet (1594-1661/65), the leading painter in Liège. In 1638 Flémal embarked on a trip to Italy. He spent several years in Rome where he may have met Nicolas Poussin, but in any event was certainly influenced by his art. On his leisurely return north, Flémal stopped in Florence and in Paris, where he enjoyed the patronage of Chancellor Séguier and executed some painted decorations for the palace at Versailles and Hôtel Lambert. He returned to Liège by 1646, but in 1649 was forced to flee to Brussels as a result of political unrest. Upon his return to Liège in 1651, Flémal received numerous commissions from churches and religious orders for altarpieces and decorative paintings, and worked also for Elector Maximilian Hendrick of Bavaria.

Flémal's paintings were also highly regarded in France, and in 1670 he returned briefly to Paris, where he executed a ceiling painting for the king's audience chamber in the Tuilleries. At the same time he was elected to the Académie Royale de Peinture et Sculpture, and was named a professor there. He returned to Liège and continued painting until his death on 1 July 1675.

In addition to painting religious subjects, histories, and portraits, Flémal was also the architect of at least two churches in Liège, and in 1663 designed for himself a sumptuous Italianate villa decorated with mural paintings (destroyed in 1692). He also designed ecclesiastical furnishings such as rood screens and high altars. His architectural interests are reflected as well in the classical structures that form the background for many of his painted compositions.

It is difficult to reconstruct the chronology of Flémal's works as there are no signed and dated paintings extant, and only a few can be dated on documentary evidence. His earliest known paintings postdate his return to Liège in ca. 1646, and from then through the 1650s his paintings are characterized by the use of antique architectural settings, a warm and lively palette, and a multitude of figures. From ca. 1665, his paintings become more somber, with a cooler, more subtle palette and conspicuously simpler compositions. By far the most potent influence on his work is that of contemporary French painters such as Eustache Le Sueur, Charles LeBrun, and particularly Poussin. The classical reserve characteristic of paintings by the latter artist is merged in Flémal's work with a degree of Northern realism and more heart-felt expressions of pathos and emotion. Flémal's pupils included Guillaume Carlier, Jean-Gilles Del Cour, Englebert Fisen, and Gerard de Lairesse (q.v.).

De Bie 1661, pp. 507-508; Sandrart 1675, vol. 2, pp. 83-84; de Monconys 1695, p. 240; Félibien 1666-88, vol. 2, p. 256; Houbraken 1718-21, vol. 3 (1721), pp. 106-107; Descamps 1753-64, vol. 2, pp. 226-31; Dezalliers d'Argenville 1745-52, vol. 3, pp. 194-197; Pinchart 1860; Fétis 1865, vol. 2, pp. 374-392; Abry 1867, pp. 209-225; Rombouts, van Lerius 1872, vol. 2, p. 117; Michiels 1865-76, vol. 10 (1876), pp. 137-160; Helbig 1903, pp. 253-274; Wurzbach 1906-1911, vol. 1 (1906), pp. 535-536; Helbig 1911, vol. 2, pp. 41-49, 148; K. Zoege van Manteuffel, in Thieme, Becker 1907-50, vol. 12 (1916), pp. 88-90; Dewez 1927-28; Denucé 1932, pp. 275, 374; Hendrick 1934; Philippe 1945, pp. 19-22; Brussels 1965, pp. 80-81; Philippe 1965; Hendrick 1973, pp. 30-38; Liège 1975; Hendrick 1977; Bosson 1981; Kairis, Bosson 1983; Kairis 1984; Larsen 1985, pp. 265-267; Bosson 1986; Thuillier 1986; Hendrick 1987, pp. 127-146.

Bertholet Flémal
130. The Expulsion of Heliodorus

Oil on canvas, 146 x 174 cm (57 ½ x 68 ½ in.)
Traces of a signature at lower right
Brussels, Musées Royaux des Beaux-Arts de Belgique,
inv. 1299

PROVENANCE: (probably) sale Maréchal de Noailles, Paris, 1767, no. 48 [not sold][1]; purchased by the museum at sale Henkart, Liège, 20 January 1854, no. 1 (frs. 2415).

EXHIBITIONS: Liège, *Exposition de l'art ancien au Pays de Liège* (1905), no. 1068; Liège, Cloître de Saint-Paul, *Art mosan et arts anciens au pays de Liège* (September-October 1951), no. 683; Brussels 1965, no. 82; Liège, Musée de l'art Walloon, *Le siècle de Louis XIV au pays de Liège (1580-1723)* (1975), no. 320.

LITERATURE: E. Fétis, *Catalogue descriptif et historique du Musée royal de Belgique* (Brussels, 1864), pp. 299-300, no. 195; Michiels 1865-76, vol. 10 (1876), p. 140; Helbig 1903, p. 272; H. Fierens-Gevaert, *La Peinture ancienne à l'Exposition de Liège* (1905), n.p.; Dewez 1927-28, p. 140; Philippe 1945, pp. 20-21, pl. XI; Hendrick 1973, p. 33; Knipping 1974, vol. 1, p. 222; Brussels, cat. 1984, p. 106; Thuillier 1986, p. 18; Hendrick 1987, pp. 131, 136, 139-140.

Fig. 1. Raphael, *The Expulsion of Heliodorus*, 1511-1514, fresco, Rome, Vatican, Stanza d'Eliodoro.

THE STORY of the expulsion of Heliodorus from the Temple of Jerusalem is recounted in the Second Book of the Maccabees, chapter 3, verses 1-40.[2] Informed that the Temple was withholding a surplus from the royal subsidy, Seleucus Philippator, King of Syria (ruled 186-175 B.C.), dispatched his agent Heliodorus to recover the treasure. The High Priest Onias told Heliodorus that the monies were being held in trust for widows and orphans; when Heliodorus nonetheless attempted to remove the treasure, the fervent prayers of the Priest were answered by the appearance of a man in gold armor mounted on a white charger, which trampled the intruder beneath its hoofs, and two youths, who beat him relentlessly. The First and Second Books of the Maccabees, now considered apocryphal, were confirmed as canonical at the Councils of Florence (1439) and Trent (1545-1563). In exegetical texts and commentaries from late antiquity and the Middle Ages, Heliodorus was interpreted as an example of those who would commit sacrilege under the influence of pride and avarice.[3] Avarice was, according to Thomas Aquinas, the worst of the vices and the greatest enemy of Charity.

In Flémal's interpretation of the scene, Heliodorus cowers before the avenging horseman and his two angelic assistants, who pummel him with their fists and scourge him with knotted cords. His sturdy pike and shield lie forgotten on the ground. Through the columns to the left, the High Priest and his followers pray for deliverance; at the right, the other representatives of the Syrian king exit from the Temple with their pillaged goods.

Depictions of the theme are rare in Northern art. Flémal's composition was inspired by Raphael's fresco of the same subject in the Stanza d'Eliodoro in the Vatican (1511-1514; fig. 1). He may have seen the work during his visit in Rome (from 1638), or in any event could have known of it through a print. In the present painting, Flémal has shifted the figures of Heliodorus and his attackers to the center of the

composition; although the contorted figure of the fallen Heliodorus is taken directly from Raphael, the actions of the horseman are more tempestuous and the two angelic youths have already begun to beat the hapless emissary. Rather than defining the contours of the figures, Flémal's dramatic flourishes of drapery form graceful arabesques that heighten the impact of the scene. The flurry of activity in the foreground is balanced by the heavy sweep of crimson drapery at the upper left, and, as in Raphael's fresco, by the measured space demarcated by columns and the geometric forms of the Temple architecture.

Independent of the direct inspiration of Raphael's example in the *Expulsion of Heliodorus*, Flémal customarily employed complex architectural settings in his compositions, particularly in works of the late 1640s and early 1650s. Similar arrangements of classical architecture and deep views into secondary spaces are found in Flémal's *Virgin and St. Anne* (Madrid, Museo del Prado, inv. 2239) and *Death of Lucretia* (Kassel, Gemäldegalerie Alte Meister, inv. GK 468). This careful attention to architectural and archaeological detail was a noted characteristic of Liégeois painters from Lambert Lombard (1506-1566) to Flémal and Gerard de Lairesse (see cat. 132).[4] The *Expulsion of Heliodorus* has been dated about 1649 or slightly later, thus about the time Flémal left Liège for a brief stay in Brussels (1649-1651).[5] The simple scheme of rich primary colors – red, blue, gold, and a vivid salmon pink – contrasted against the neutral hues of the background architecture is also typical for this period, and recalls the artist's debt to works by Nicolas Poussin (see also cat. 131).

MEW

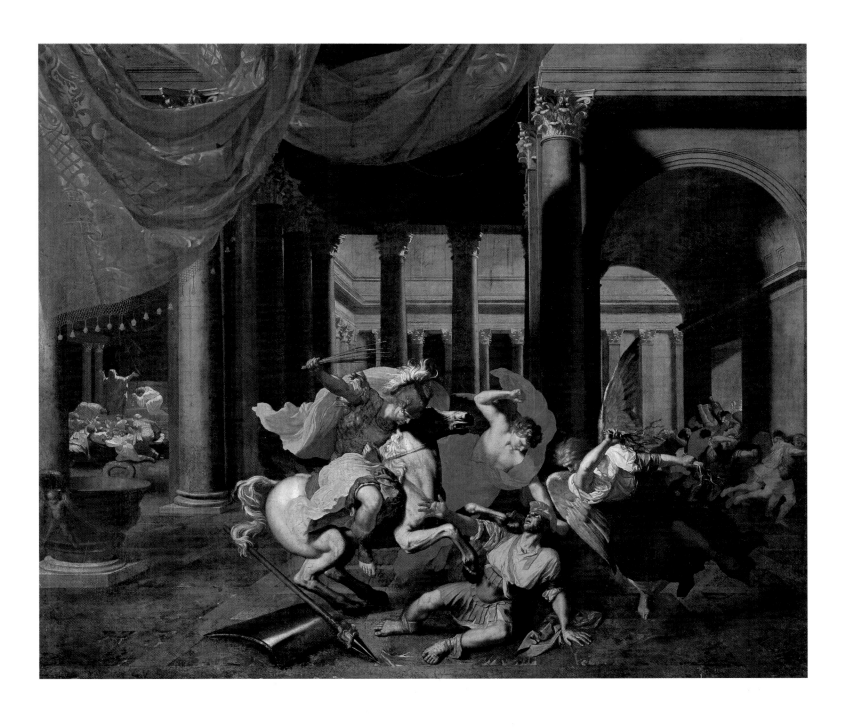

Bertholet Flémal

131. *Mary with the Dead Christ and Mourning Angels*, ca. 1665

Oil on canvas, 73 x 61.5 cm (28 ¾ x 24 ¼ in.)
Karlsruhe, Staatliche Kunsthalle, inv. 2442

1. "Héliodore battu de verges dans un superbe Temple; sur le devant, vers le milieu de ce Temple on remarque trois Anges, dont un est casqué & vêtu à la Romaine, monté sur un très beau cheval blanc sous les genoux duquel Heliodore est abbatu & renversé. Plus loin & à droite plusieurs de ses soldats se sauvent chargés de differentes choses qu'ils ont pillées dans le Temple: dans le fond à gauche l'on apperçoit la famille du Grand-Prêtre à table qui paroît effrayé; plus loin, le Grand-Prêtre avec sa suite, sont en prière devant l'Autel … sur une toile de 4 pieds 6 pouces sur 5 pieds 9 pouces."

2. Daniel, *First Maccabees, Second Maccabees*, with commentary by J. C. Collins (Wilmington, 1981), pp. 279-286.

3. See E. Bickerman, "Héliodore au temple de Jérusalem," in idem, *Studies in Jewish and Christian History* (Leiden, 1980), vol. 2, pp. 159ff; and more briefly, J. Shearman, "The Expulsion of Heliodorus," in *Raffaello a Roma: Il convegno del 1983* (Rome, 1986), pp. 80-82.

4. Hendrick 1987, *passim*, and p. 140.

5. Philippe 1945, pp. 20-21; and J. Hendrick, in Liège 1975, p. 95.

PROVENANCE: D. Reimer collection, Berlin; acquired by the Kunsthalle from a private collection in 1958.

EXHIBITIONS: Liège 1975, no. 319.

LITERATURE: Karlsruhe, Staatliche Kunsthalle, *Flämische Meister Karlsruhe* (1961), no. 22; Karlsruhe, Staatliche Kunsthalle, cat. 1966, p. 117; Hendrick 1973, pp. 35, 36-37; Liège 1975, pp. 94-95; P. Rosenberg, in *Catalogue de l'exposition nouvelles acquisitions du Musée d'Orléans* (Paris, 1976), under no. 16; Hendrick 1977, p. 139-140; Bosson 1981, p. 67; Pierre-Yves Kairis, "A propos d'une 'Déploration' de Bertholet Flémal et de sa copie Hutoise," *Les amis du Musée d'art religieux et d'art mosan* (September 1984), pp. 17-30; Larsen 1985, pp. 265-266; Bosson 1986, p. 15; Hendrick 1987, pp. 131-132.

EXPOSED on a slab of stone draped with a voluminous winding cloth, the nearly nude body of the dead Christ stretches across the foreground of the composition. His lifeless form is watched over by the grieving Virgin Mary; hands clasped in prayer, her columnar figure is swathed in a heavy cloak, casting her down-turned face into shadow. By her side crouches a mourning angel, his profile hidden by a fall of hair. To the left are two more angels, a recurring motif in the artist's works. The standing one holds Christ's crown of thorns; the other kneels and covers his face with his hands. In the left distance is a landscape view; the rocky outcropping at right recalls Christ's tomb. Flémal's cool monochromatic palette as well as the figures' extraordinary economy of gesture underscore the somber pathos of the occasion.

The restrained emotion and classicism which characterize Flémal's work and Liégeois painting in general reflect the southern orientation of painters in that province, who looked more to France and Italy for their inspiration than to their Flemish colleagues.[1] The French-speaking province of Liège was a staunch bastion of Catholicism throughout the seventeenth century. Because of the linguistic affiliation, painters tended to complete their training in France; this, coupled with the less urgent need for strong Counter Reformation propaganda, meant that both formally and iconographically, painting in Liège was more closely allied with French art than Flemish. Moreover Liégeois painting generally lacks the interest in popular life, in the quotidian reality that characterizes Flemish art.[2] Contemporary Flemish representations of the *Lamentation* by Rubens (see cat. 13, of 1614) or van Dyck, for example, are more intense, more histrionic images which emphasize the humanity of Christ's suffering. Although Abraham Janssens's *Dead Christ in the Tomb, with Two Angels* (New York, The Metropolitan Museum of Art, inv. 1971.101; cat. 3) is, like Flémal's *Dead Christ*, limited in the number of figures, the large figures crowding the picture plane make it more dynamic and immediate.

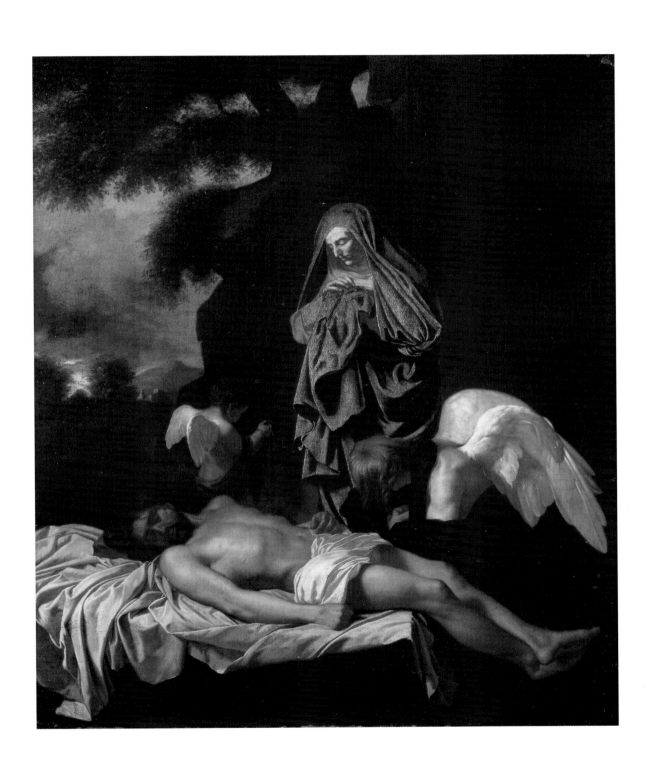

Fig. 1. Nicolas Poussin, *The Entombment*, ca. 1655, oil on canvas, 94 x 130 cm, Dublin, The National Gallery of Ireland, inv. 214.

Flémal had strong ties with France, and extensive knowledge of contemporary French art, especially the works of Charles Le Brun, Eustache Le Sueur, and Nicolas Poussin. The *Dead Christ* (first attributed to Flémal by Charles Sterling, and formerly regarded as a work by Poussin)[3] reveals his debt to the austere gravity and iconic quality of Poussin's late paintings: compare especially Poussin's similarly composed *The Entombment* of ca. 1655 (Dublin, The National Gallery of Ireland, inv. 214), fig. 1.[4] One might also cite in this context the French painter's more emotional *Lamentation* of ca. 1630 or slightly earlier (canvas, 101 x 145 cm; Munich, Alte Pinakothek, inv. 625) and the secular variation of the theme in *The Testament of Endimias* (canvas, 110.5 x 138.5 cm, ca. 1655; Copenhagen, Statens Museum for Kunst, inv. 3889).

In limiting the composition to a few monumental and motionless figures aligned along strong horizontal and vertical axes, Flémal graphically contrasts the dead Christ and the living Mary, thus also emphasizing the apparent finality of his death. Probably intended as an altarpiece for private devotions, it is an image which inspires both subdued grief and veneration, and was meant to encourage the worship of Christ. The stone on which Christ's body lies may be identified as a Stone of Unction, on which Christ's body was anointed, and which came to be a symbol of the altar and by extension, of the sacraments celebrated there.[5] In addition, the prayerful figure of the Virgin in Flémal's composition alludes to her role as intercessor between man and Christ (integral to Counter Reformation theology), and also in drawing God's attention to the Passion of her son.[6] The presence of several angels mourning the dead Christ was a comparatively recent development in the iconography of the theme, described by Emile Mâle

as a conflation of the imagery of the Lamentation with that of the Vision of St. Gregory, in which Christ appeared to the saint in his tomb, supported by angels.[7] The imagery remained popular, despite attack from some theologians, among them Cardinal Federigo Borromeo (in *De Pictura sacra*, 1634, p. 80), who objected to angels usurping the role rightfully allotted to those for whom Christ died.

Flémal's *Dead Christ* certainly postdates Poussin's representations of the theme, and on stylistic grounds has been convincingly dated by Bosson to ca. 1665 or slightly later.[8] In this later period of his career, Flémal turned to a more restricted and sober palette, and limited his compositions to the essential minimum of figures. The painting is closely related to Flémal's *Dead Christ Mourned by Angels* (oil on canvas, 125 x 140 cm; Orléans, Musée des Beaux-Arts; fig. 2).[9] Hendrick suggested that the present work was a preparatory work for the larger Orléans painting,[10] although there is no concrete visual or documentary evidence to support his theory and, as Kairis points out,[11] the high degree of finish in the Karlsruhe painting is inconsistent with that of a sketch.

MEW

Fig. 2. Bertholet Flémal, *Dead Christ Mourned by Angels*, oil on canvas, 125 x 140 cm, Orléans, Musée des Beaux-Arts, no. RL 12242.

1. Hendrick 1987, pp. 104-107; and, specifically on the non-Flemish qualities of Flémal's several versions of the *Lamentation*, Kairis 1984, p. 22.

2. Hendrick 1987, p. 107.

3. Karlsruhe, cat. 1966, p. 117.

4. On Poussin's painting see A. Blunt, *Nicolas Poussin*, 2 vols. (New York, 1967), vol. 1, p. 304. Compare also the print by Pietro del Po (Wildenstein 70) after a lost *Lamentation* by Poussin, which is even closer to Flémal's composition and includes but three figures, a tomb at left, and a rocky outcropping at right; ill. A. Mérot, *Nicolas Poussin* (New York, 1990), p. 266, no. 83.

5. On the Stone of Unction, see M. E. Graeve, "The Stone of Unction in Caravaggio's Painting for the Chiesa Nuova," *Art Bulletin* 40 (1958), pp. 223-238; on the use of this imagery in Rubens's work see Eisler 1967.

6. The latter is even more graphically expressed in Walther Damery's *Lamentation over the Dead Christ* of 1674 (Limburg, Church of St. George; ill. Kairis 1984, fig. 5).

7. Mâle 1932, pp. 288-291.

8. Bosson 1986, p. 15.

9. Other versions of the subject by Flémal or indebted to him include a copy after the Orléans painting, dated 1668, in Huy, Eglise Saint-Remy; and a variant of the composition (possibly a copy after Flémal) in Bamberg, Staatsgalerie (Bayerische Staatsgemäldesammlungen, inv. 1961). See Kairis 1984.

10. Hendrick 1977, p. 140.

11. Kairis 1984, p. 20.

Gerard de Lairesse
(Liège 1640-Amsterdam 1711)

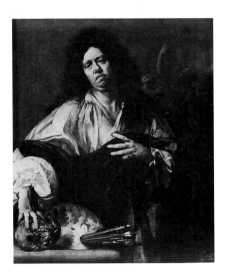

Gerard de Lairesse, *Self-Portrait*, ca. 1675-80, oil on canvas, Bayonne, Musée Bonnat, inv. 1007.

Much of what is known of Gerard de Lairesse's life was recorded in a biography written about 1715 by his contemporary and friend, Louis Abry (1643-1720). Lairesse was baptized in the Church of St. Adelbert in Liège, the son of Renier de Lairesse (1609-1669) and Catherine Taulier, herself the daughter of a painter. Gerard was probably a pupil of his father, a painter for whom no documented works survive. More importantly, however, Lairesse's work was strongly influenced by Bertholet Flémal (q.v.), who returned to Liège from Italy in 1646 and made an immediate impact with his Poussinesque classicism.

Although no records survive for the goldsmiths guild (which also included painters) in Liège during this period, it is assumed that Lairesse became an independent master in about 1660. In that year he set out for Cologne to seek work at the court of the Elector Maximilian Hendrick of Bavaria; after pausing in Aachen to paint an altarpiece for the Church of St. Ursula, however, he returned to his native city. As early as 1662, he was receiving commissions from distinguished patrons for history paintings and portraits in the manner of Bertholet Flémal. On 22 April 1664 Lairesse was attacked by two women who accused him of reneging on a marriage agreement; in defending himself, the artist mortally wounded one of the women. Hounded by the police, he sought sanctuary in a monastery, and several days later secretly left Liège for Maastricht. He was accompanied by his distant cousin, Marie Salme, whom he hastily married in Navaigne, on the outskirts of Liège.

The couple settled in Utrecht, where their son Andries was baptized on 5 April 1665. In that same year Lairesse moved to Amsterdam, where he worked for the art dealer Gerrit Uylenburch, had his portrait painted by Rembrandt (New York, The Metropolitan Museum of Art, Lehman Collection), and became an avid participant in the city's intellectual community. In 1669, together with the dramatic poet Andries Pels and the writer and philosopher Lodewijck Meyer, Lairesse founded "Nil Volentibus Arduum" (Nothing valuable without effort), a literary society devoted to promoting classical ideals.

Throughout the 1670s and 1680s Lairesse executed easel paintings, and large decorative works and grisailles for public and private structures, including an ensemble of eight ceiling paintings for the Lepers Asylum in Amsterdam (1675; Amsterdams Historisch Museum); decorations for the Amsterdam homes of Andries de Graeff, Jacob de Flines, and others (1672 and 1687, respectively); and several paintings for the palace of Willem III at Soestdijk (1676-1682). From 1684 the landscape painter Johannes Glauber (1646-

1726) lived in Lairesse's home on the Nieuwmarkt and collaborated with him on numerous works. Although much of Lairesse's mature activity was confined to Amsterdam, he joined the Schilders Confrerie in The Hague in 1684 and painted decorations for the council chambers in the Binnehof (installed 1688); in 1687 he returned to Liège for the installation of his altarpiece in the Cathedral of St. Paul.

Lairesse went blind probably during the course of 1690. Although his earliest biographers offer no explanation, by the mid-eighteenth century the artist's affliction was routinely described as punishment for his dissolute lifestyle. More recent studies have suggested that Lairesse's blindness was a consequence of hereditary syphilis, a diagnosis supported by the characteristic collapse of the bridge of his nose. During the last decades of his life Lairesse lectured on the visual arts, and with the aid of his sons wrote a treatise on the art of drawing (*Grondlegging der Tekenkonst*, 1701) and a more complete artists' manual (*Het Groot Schilderboek*, 1707). Lairesse died in poverty, and was buried outside Amsterdam on 28 July 1711.

During the artist's early period in Liège (until 1664) the influence of Flémal was dominant in his work, also (indirectly) that of Nicolas Poussin. His work is characterized by a profound interest in subjects from antiquity and mythological and allegorical themes, and more specifically, by dramatic flourishes of drapery and detailed architectural settings. His interest in the theatre is evident in the attention given to even minute details of the mise-en-scène, and the clearly understood rhetorical gestures and expressions. Lairesse was an important conduit for the spread of classicism from Italy and France, via Liège, to the Northern Netherlands in the latter part of the seventeenth century.

In addition to painted works, Lairesse left a large corpus of prints by his own hand, and etchings and engravings made after his designs. His pupils included Ottmar Elliger (1666-1732) and Philipps Tideman (1657-1705), and his sons Abraham (1666-1726/27) and Jan (born 1674). Lairesse's brothers Jacques (1643-1709) and Jan Gerard (1645-1690) also worked with him in his studio in Amsterdam.

Gerard de Lairesse
132. *Hermes Ordering Calypso to Release Odysseus*, ca. 1668-1670

Oil on canvas, 91.3 x 114.8 cm (36 x 44 ¼ in.)
Cleveland, Cleveland Museum of Art,
Mr. and Mrs. William H. Marlatt Fund, inv. 1992.2

Sandrart 1679, p. 264; Sandrart 1683, p. 319; Abry 1715, pp. 242-261; Houbraken 1718-21, vol. 3 (1721), pp. 106-133; Weyerman 1729-69, vol. 2 (1729), pp. 409-411; Saumery 1744, vol. 1, pp. 273-278; Descamps 1753-64, vol. 3, pp. 100ff; Dezalliers d'Argenville 1745-52, vol. 3, pp. 59-60; *Levensbeschryving* 1774-83, vol. 4 (1777); Bartsch 1803-21, vol. 5 (1805); Becdelièvre 1836-37, vol. 2, pp. 194-208; Nagler 1835-52, vol. 7 (1839), pp. 242-243; Immerzeel 1842-43, vol. 2 (1843), pp. 150ff; Le Blanc 1854-89, vol. 2 (1856); Fétis 1855; Kramm 1857-64, vol. 3 (1858), pp. 935ff; Nagler 1858-79, vol. 3 (1858), pp. 1007, 1009, 1082; Helbig 1873, pp. 207-214; Michiels 1865-76, vol. 10 (1876), pp. 184-428; Alberdingk Thijm 1879; J. Helbig, in *Biographie Nationale* 1866-1964, vol. 11 (1890-91), cols. 58-67; de la Montagne 1900; Helbig 1903, passim; Micha 1908; Wurzbach 1906-11, vol. 2 (1910), pp. 6-8; Wiener 1912; Schmidt-Degener 1913; Urban 1914; M. D. Henkel, in Thieme, Becker 1907-50, vol. 22 (1928), pp. 233-237; van de Graft 1942; Timmers 1942; Philippe 1945, pp. 29-33; Hollstein 1949-, vol. 10 (1955); G. Kauffmann 1957; Bernaud 1965; Jans 1968; Snoep 1970; Hendrick 1973; Dolders 1983; Dolders 1985; Roy 1986a; Roy 1986b; Hendrick 1987, pp. 165-201; Jans 1989; Kloos 1989; Roy 1992.

PROVENANCE[1]: private collection, Brazil; sale New York (Christie's), 9 October 1991, no. 195; dealer Johnny van Haeften, London.

IN A CASUAL EMBRACE, the Greek warrior Odysseus and the nymph Calypso relax in a tangle of bedclothes. Dozens of chubby putti busy themselves scattering flowers, weaving garlands, adorning a statue of a woman (possibly representing Chastity) at the right, or hoisting the heavy drapery slung across the upper portion of the composition. A council of the gods takes place above amidst a swirl of clouds, from which the messenger god Hermes precipitously descends. At the left, posed before steps leading to a verdant landscape, is a putto costumed in the helmet and weaponry of Odysseus; beyond the curtain to the right several putti and handmaidens prepare a feast in a columned hall.

At the close of the Trojan War, Odysseus was rescued from a shipwreck by Calypso (daughter of Atlas), and was held captive by her on the island of Ogygia (Homer, *Odyssey*, book 5). Despite Calypso's attentive ministrations, Odysseus longed to return to his family and home on the island of Ithaca:

> "The awesome goddess took me in and loved me passionately and tended me, vowing that she would make me immortal and ageless for ever and ever. Withal she did not wholly beguile the heart in my breast. Nevertheless for seven years did I endure, years without end. Ever I would water with my tears the clothes (immortal clothes) in which Calypso did me honour."[2]

At a council of the gods, Athena pleaded passionately for Odysseus's return, and Zeus sent the messenger god Hermes to command Calypso to set her imprisoned warrior free.

Lairesse's interpretation of the episode from the *Odyssey* departs considerably from Homer's text. According to the narrative, Hermes found Calypso alone in her cave, while Odysseus "sat weeping on the shore as was his wont, crying out his soul with groaning and griefs and letting flow his tears while he eyed the fruitless sea."[3] After imparting his message to the nymph, Hermes departed, leaving her to break the news to the long-suffering hero. In Lairesse's painting, however, Hermes descends to catch the couple in languid dalliance. It is Odysseus who first glimpses the god, while Calypso gazes seductively at the viewer and a putto pushes ineffectually at the winged messenger. The palatial terrace on which the scene takes place, moreover, little recalls the cave described by Homer. Lairesse's approach to Homer's text recalls the advice given to painters in his own theoretical treatise, *Het Groot*

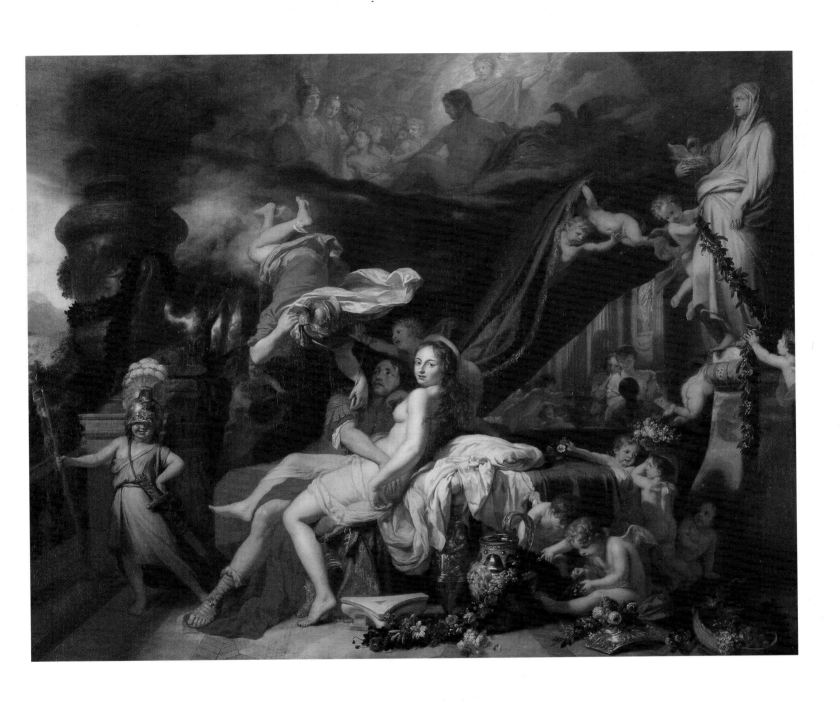

Fig. 1. Gerard de Lairesse, *Mars and Venus*, pen and brown ink, 165 x 212 mm; Rotterdam, Museum Boymans-van Beuningen, inv. G.v.d.Lairesse 3.

Schilderboek (1707). Lairesse praised inventiveness in interpreting tales from Ovid, Virgil, and Homer, and the embellishment of narrative for visual effect, so long as it was not unnatural or improbable.[4] It goes without saying that adapting the original story to admit a sensual lovers' embrace greatly enhanced the contemporary appeal of Homer's heroic epic.

Although depictions of this scene from the *Odyssey* are rare in Netherlandish art, Lairesse executed at least three versions of Hermes appearing to Odysseus and Calypso, and illustrated several other themes from Homer's epic as well.[5] Chong has noted a preparatory drawing for the Cleveland painting in the Museum Boymans-van Beuningen in Rotterdam (fig. 1). The poses of the figures in the sketch are more or less the same, but the composition is reversed and differs in some details from the final painting. Most significant is the omission of the figure of Hermes, the catalyst and identifying feature in the tale of Odysseus and Calypso. The Rotterdam drawing's current title of *Venus and Mars* underscores the closeness of the imagery in *Hermes Ordering Calypso to Release Odysseus* to that in other representations of mythological lovers. The mischievous armor-bearing putto, for example, symbolizing the warrior disarmed by love, is also a key player in representations of Mars and Venus as lovers.[6] The same putto appears in Lairesse's later version of *Hermes Ordering Calypso to Release Odysseus*, commissioned ca. 1676-1682 for the Dutch stadholder Willem III's palace at Soestdijk (Amsterdam, Rijksmuseum, inv. A 212).[7] In the latter painting it is Calypso who reacts with dismay to Hermes' message, while Odysseus remains oblivious. The pendant to the Soestdijk painting depicts Mars and Venus as lovers, further emphasizing the close visual relationship of

the two themes.[8] Many of the same elements are present also in *Hermes Ordering Aeneas to Leave Dido* (ca. 1675-1680; Strasbourg, private collection), in which the messenger god descends to tear the lovers apart; here, too, the couple is attended by a putto which has playfully donned the warrior's armor.[9]

The Cleveland *Hermes Ordering Calypso to Release Odysseus* can be dated about 1668, shortly after Lairesse's move from Liège to Amsterdam; in its cool palette, crisp illumination, and overall conception of the figures it is consistent with other works of the period, such as *Venus Presenting Arms to Aeneas*, signed and dated 1668 (Antwerp, Museum Mayer van den Bergh, inv. 323). Lairesse seems to have been particularly drawn to themes from Homer's *Odyssey* during the late 1660s; the present painting may be grouped with several other works which have been dated by Alain Roy to ca. 1665-1668, such as the somewhat larger pendants of *Odysseus and the Sirens* and *Athena Appearing at the Toilet of Odysseus on Ithaca* (oil on canvas, 144 x 186 cm; Munich, Alte Pinakothek, invs. 1805 and 1795, respectively).

Although the present painting was executed after Lairesse's departure from the Southern Netherlands, considering the work within a Flemish context reveals the deep and lasting effects of his artistic formation in Liège. The emphasis on the accurate and detailed rendering of classical architecture and decorative elements in Lairesse's art was a persistent legacy of his Liégeois training. A similar aesthetic colors works by Lairesse's mentor Bertholet Flémal (such as *The Expulsion of Heliodorus*, cat. 130) and Gérard Douffet (1594-1660), as well as the few works that have been attributed to Gerard's father, Renier de Lairesse (1609-1667).[10] In *Het Groot Schilderboek*, Lairesse discusses the appropriate architectural settings for various biblical and historical themes, and stresses how the classical elements enhance and ennoble the depiction.[11]

M E W

1. A photograph in the Witt Library, London, of a painting formerly with J. Singer, London (1946), shows an identical composition, with the dimensions 28 x 36 in. (71.1 x 91.4 cm) and signed on the base of the statue at right. The work seems to be identical to the present painting in all respects (other than the dimensions); however, no trace of a signature can be found on the Cleveland painting. I am grateful to Alan Chong for sharing with me the results of his research on the present painting, which will be published in a forthcoming Cleveland Museum of Art *Bulletin*.

2. *The Odyssey of Homer*, trans. by T. E. Lawrence; with introduction by B. Knox (New York and Oxford, 1991), p. 101 (Book 5).

3. Ibid., p. 71.

4. Gerard de Lairesse, *Het Groot Schilderboek* (Amsterdam, 1707; 2nd ed. 1740), vol. 1, pp. 89, 115ff.

5. For Homerian themes in the work of Gerard de Lairesse see Roy 1992, cats. P 11, P 19, P 20, P 33, P 54, P 94, P 119, P 120, P 129, P 139, P 186, P 197 and G 52.

6. For example, Sandro Botticelli's *Venus and Mars*, 1480s, oil on panel, 69.2 x 173.4 cm, London, The National Gallery, inv. 915. On the theme of Mars and Venus in seventeenth-century Netherlandish art, see E. de Jong, *Een schilderij centraal. De Slapende Mars van Hendrick ter Brugghen* (Utrecht, Centraal Museum, 1981), pp. 14-18; and P. C. Sutton, "A Pair by Van Bijlert," *Hoogsteder-Naumann Mercury 8* (1989) pp. 4-16.

7. Roy 1992, pp. 299-300, cat. P 139. On the Soestdijk commission, see Roy 1992, pp. 77-78; and Snoep 1970, p. 98.

8. There is little to support Roy's suggestion that the pendant also depicts Odysseus and Calypso (Roy 1992, p. 299, cat. P 138); as Chong notes, the models for the protagonists in the two works are clearly different, and there is insufficient narrative development in the lovers' story to occasion two separate scenes.

9. Roy 1992, pp. 285-286, cat. P 121.

10. On the impact of Flémal on the formation of the younger artist, see Roy 1992, pp. 60-63, 105-107; on the work of Reynier de Lairesse see ibid., pp. 59-60.

11. Lairesse 1707, vol. 1, pp. 112-113.

Bibliography

Abry 1715
 Louis Abry. *Les hommes illustres de la nation liégeoise.* Edited by
 H. Helbig and S. Bormans. Liège, 1867.

Adler 1980
 Wolfgang Adler. *Jan Wildens: der Landschaftsmitarbeiter des Rubens.*
 Fridlingen, 1980.

Adler 1982
 —. *Landscapes and Hunting Scenes.* (*Corpus Rubenianum Ludwig
 Burchard,* part XVIII, vol. 1). London/Philadelphia, 1982.

Adriaanse 1930
 J. Adriaanse. *Gedenkboek der Hulstersche Stede.* Amsterdam, 1930.

Adriani 1965
 G. Adriani. *Anton van Dyck. Italienisches Skizzenbuch.* 2nd ed. Vienna,
 1965.

Alberdingk Thijm 1879
 J. A. Alberdingk Thijm. "Gérard Lairesse, eene studie op de
 Nederlandsche Kunstbeweging van de tweede helft der XVIIe eeuw."
 Nederland 2 (1879), pp. 333-391.

Aldena Fernandez 1960
 Salvator Aldena Fernandez. "En Torno a Daniel Seghers." *Archivo
 Español de Arte* 38 (1960), pp. 67-77.

Allard 1869
 H. J. Allard. "Broeder Daniel Seghers, S. J.," in Jos. Alberdingk Thijm,
 ed., *Volks Almanack voor Nederlandse Katholieken in het Jaar O. H. 1870*
 (Amsterdam, 1869), pp. 114-154.

Alpers 1971
 Svetlana Alpers. *The Decoration of the Torre de la Parada.* (*Corpus
 Rubenianum Ludwig Burchard,* part IX). London/New York, 1971.

Amsterdam 1930-31
 Amsterdam, Gallery P. de Boer. *Tentoonstelling van werken van Joost de
 Momper, eenige voorlopers en tijdgenooten.* 1930-31.

Amsterdam 1976
 Amsterdam, Rijksmuseum. *Tot Lering en Vermaak.* Catalogue by E. de
 Jongh et al. 1976.

Amsterdam/Boston/Philadelphia 1987
 Amsterdam, Rijksmuseum. *Masters of 17th-Century Dutch Landscape
 Painting.* Catalogue by Peter C. Sutton et al. 1987. Also shown at
 Boston, Museum of Fine Arts; and Philadelphia, Philadelphia
 Museum of Art.

Amsterdam/Braunschweig 1983
 Amsterdam, Gallery P. de Boer. *A Fruitful Past. A Survey of the Fruit Still
 Lifes of the Northern and Southern Netherlands from Brueghel till Van Gogh.*
 Catalogue by Sam Segal. 1983. Also shown at Braunschweig, Herzog
 Anton Ulrich-Museum.

Amsterdam/'s-Hertogenbosch 1982
 Amsterdam, Gallery P. de Boer. *A Flowery Past. A Survey of Dutch and
 Flemish Flower Painting from 1600 until the Present.* Catalogue by Sam
 Segal. 1982. Also shown at 's-Hertogenbosch, Noordbrabants
 Museum.

Andresen 1870-73
 A. Andresen. *Handbuch für Kupferstichsammler oder Lexicon der Kupfer-
 stecher, Maler-Radirer und Formschneider aller Länder und Schulen nach
 Massgabe ihrer geschätztesten Blätter und Werke.* 2 vols. Leipzig, 1870-73.

Antwerp 1899
 Antwerp, Koninklijk Museum voor Schone Kunsten. *Exposition van
 Dyck à l'Occasion du 300e anniversaire de la naissance du maître.* 1899.

Antwerp 1905
 Antwerp, Koninklijk Museum voor Schone Kunsten. *Jacob Jordaens.*
 1905.

Antwerp 1949
 Antwerp, Koninklijk Museum voor Schone Kunsten. *Van Dyck
 Tentoonstelling.* 1949.

Antwerp 1977
 Antwerp, Koninklijk Museum voor Schone Kunsten. *P. P. Rubens:
 Paintings, Oil Sketches, Drawings.* 1977.

Antwerp 1978a
 Antwerp, Koninklijk Museum voor Schone Kunsten. *Jordaens in
 Belgisch bezit.* Catalogue by Marc Vandenven. 1978.

Antwerp 1978b
 Antwerp, Museum Plantin-Moretus. *Jacob Jordaens, Tekeningen en
 Grafiek.* Catalogue by R.-A. d'Hulst. 1978.

Antwerp 1991
 Antwerp, Koninklijk Museum voor Schone Kunsten. *David Teniers de
 Jonge: Schilderijen, Tekeningen.* Catalogue by Margret Klinge. 11 May-
 1 September 1991.

Antwerp 1992-93
 Antwerp, Koninklijk Museum voor Schone Kunsten. *Van Brueghel tot
 Rubens. De Antwerpse schilderschool 1550-1650.* Catalogue by Frans
 Baudouin et al. 19 December 1992-8 March 1993. Also shown at
 Cologne, Wallraf-Richartz-Museum, 4 September-22 November
 1992; and Vienna, Kunsthistorisches Museum, 2 April 1993-20 June
 1993.

Antwerp 1993
 Antwerp, Koninklijk Museum voor Schone Kunsten. *Jacob Jordaens
 (1593-1678),* vol. 1: *Paintings and Tapestries.* Catalogue by
 R.-A. d'Hulst, Nora de Poorter, and Marc Vandenven. 27 March-
 27 June 1993.

Antwerp, cat. 1988
 Antwerp, Koninklijk Museum voor Schone Kunsten. *Catalogus
 Schilderkunst Oude Meesters.* 1988.

Antwerp/Münster 1990
 Antwerp, Rubenshuis. *Jan Boeckhorst 1604-1668: medewerker van
 Rubens.* 1990. Also shown at Münster, Westfälisches Landesmuseum
 für Kunst und Kulturgeschichte.

Antwerp/Rotterdam 1960
 Antwerp, Rubenshuis. *Antoon Van Dyck: Tekeningen en olieverfschetsen.*
 Catalogue by R.-A. d'Hulst and Horst Vey. 1960. Also shown at
 Rotterdam, Museum Boymans-van Beuningen.

Antwerp/Rotterdam 1966-67
 Antwerp, Rubenshuis. *Tekeningen van Jacob Jordaens, 1593-1678.*
 Catalogue by R.-A. d'Hulst. 1966-67. Also shown at Rotterdam,
 Museum Boymans-van Beuningen.

Antwerpen 1989
 Antwerpen in de XVIIde eeuw (Genootschap voor Antwerpse
 geschiedenis). Antwerp, 1989.

Arents 1940
 Prosper Arents. *Geschriften van en over Rubens.* Antwerp, 1940.

Arents 1943
 —. *Rubens-Bibliografie. Geschriften van en aan Rubens.* Brussels, 1943.

Arndt 1965-66
 Karl Arndt. "Pieter Bruegel als Vorlaufer Coninxloos: Bemerkungen
 zur Geschichte der Waldlandschaft." *Kunstgeschichtliche Gesellschaft
 zu Berlin. Sitzungsberichte* 14 (1965-66), pp. 9-11.

Arndt 1972
 —. "Pieter Brueghel d. Ä. und die Geschichte der 'Waldlandschaft.'"
 Jahrbuch der Berliner Museen 14 (1972), pp. 69-121.

d'Arschot 1942
 Ph. d'Arschot. "Tableaux peu connus conservés en Brabant, I." *Revue
 Belge d'Archéologie et d'Histoire de l'Art* 12 (1942), pp. 259ff.

Auckland 1982
 Auckland, Auckland City Art Museum. *Still Life in the Age of
 Rembrandt.* Catalogue by E. de Jongh et al. 1982.

vander Auwera 1979
 Joost vander Auwera. "Sebastiaen Vrancx (1573-1647). Een mono-
 grafische benadering." Unpub. thesis, Rijksuniversiteit Ghent, 1979.

vander Auwera 1981
 —. "Sebastiaen Vrancx (1573-1647) en zijn samenwerking met
 Jan I Brueghel (1568-1625)." *Jaarboek van het Koninklijk Museum voor
 Schone Kunsten, Antwerpen* 1981, pp. 135-151.

vander Auwera 1985
 —. "Rubens' 'Kroning van de Overwinnaar' te Kassel in het licht van
 zijn bestemming," in *Rubens and His World. Bijdragen opgedragen aan
 Prof. R.-A. d'Hulst* (Antwerp, 1985), pp. 147-156.

vander Auwera 1989
 —. "Conservatieve tendensen in de contrareformatorische kunst.
 Het geval Abraham Janssen." *De zeventiende eeuw* 5 (1989), pp. 32-43.

Baer 1930
 R. Baer. *Paul Bril. Studien zur Entwicklungsgeschichte der Landschafts-
 malerei um 1600.* Munich, 1930.

Baetens 1976
 R. Baetens. *De nazomer van Antwerpens welvaart. De diaspora en het han-
 delshuis De Groot tijdens de eerste helft van 17e eeuw.* 2 vols. Brussels, 1976.

Baglione 1642
 G. Baglione. *Le Vite dei Pittori.* Rome, 1642.

Balis 1985
 Arnout Balis. "Mécénat espagnol et art flamand au XVIIe siècle," in

exh. cat. Brussels, Palais des Beaux-Arts, *Splendeurs d'Espagne et les Villes Belges 1500-1700* (1985), pp. 283-296.

Balis 1986
—. *Rubens Hunting Scenes. (Corpus Rubenianum Ludwig Burchard, part XVIII, vol. 2)*. London/New York, 1986.

Ballegeer 1967
J. P. C. M. Ballegeer. "Enkele Voorbeelden van de Invloed van Hans en Paul Vredeman de Vries op de Architectuurschilders in de Nederlanden gedurende de XVIe en XVIIe eeuw." *Gentse Bijdragen* 20 (1967), pp. 55-70.

Barnes 1986
Susan J. Barnes. "Van Dyck in Italy." 2 vols. Ph.D. diss., Institute of Fine Arts, New York, 1986.

Baron 1948
L. Baron. "Jean de Reyn." *Bulletin de la Commission historique du département du Nord* 36 (1948), pp. 209-216.

Bartsch 1803-21
Adam Bartsch. *Le peintre-graveur*. 21 vols. Vienna, 1803-21.

Bartsch 1978-
—. *The Illustrated Bartsch*. Walter L. Strauss, general ed. New York, 1978-.

Baudiment 1934
F. Baudiment. *F. Pallu, principal fondateur de la Société des Missions Etrangères (1626-1684)*. Paris, 1934.

Baudouin 1969
Frans Baudouin. "Le 'cabinet d'amateur' de Corneille van der Gheest, peint par Guillaume van Haecht." *Antwerpen* 15 (1969), pp. 158-173; reprinted in Baudouin 1977, pp. 283-302.

Baudouin 1972
—. "Altars and Altarpieces before 1620," in exh. cat. Princeton, Princeton University Art Museums, *Rubens before 1620* (1972), pp. 45-92.

Baudouin 1977
—. *Pietro Paolo Rubens*. Trans. by Elsie Callander. New York, 1977.

Baudouin 1985
—. "Le sentiment religieux et son impact sur l'art des Pays-Bas méridionaux, 1500-1700," in exh. cat. Brussels, Palais des Beaux-Arts, *Splendeurs d'Espagne et les Villes Belges 1500-1700* (1985), pp. 137-170.

Baudouin 1989
—. "Iconografie en Stijlontwikkeling in de Godsdienstige Schilderkunst te Antwerpen in de XVIIde Eeuw," in *Antwerpen in de XVIIde Eeuw* (Antwerp, 1989), pp. 329-364.

Baudouin 1991
—. "Schilderijen van Rubens en Van Dyck in het bezit van Filips Godines en Sebilla van den Bergh (en enkele aantekeningen over Alexander Adriaenssen en Joos van Craesbeeck." *Academiae Analecta (Mededelingen van de Koninklijke Academie voor Wetenschappen, Letteren en Schone Kunsten van België)* 51, no. 1 (1991), pp. 61-82.

Baumstark 1974
Reinhold Baumstark. "Ikonographische Studien zu Rubens Krieges und Friedensallegorien." *Aachener Kunstblätter* 45 (1974), pp. 125-234.

Baumstark 1983
—. "The Decius Mus Cycle of Tapestries at Vaduz." *The Ringling Museum of Art Journal* 1983, pp. 178-191.

Bautier 1926a
P. Bautier. "A propos de Gaspard de Crayer." *Beaux-Arts* (1926), pp. 147-149.

Bautier 1926b
—. "Les tableaux de singeries attribués à Teniers." *Annales de la Société Royale d'Archéologie de Bruxelles* 32 (1926), pp. 86-88.

Bautier 1946
—. *Les peintres Van Oost et la fin de l'école de Bruges. (Conférence de la diffusion artistique des Musées Royaux des Beaux-Arts de Belgique.)* Brussels, 1946.

Becdelièvre 1837
Antoine-Gabriel de Becdelièvre-Hamal. *Biographie liégeois*, vol. 2. Liège, 1837.

Bedo 1962
R. Bedo. "Ein doppelporträt des Michael Sweerts." *Acta Historiae Artium* 8 (1962), pp. 107-110.

Belkin 1989
Kristin Lohse Belkin. "Rubens's Latin Inscriptions on his copies after Holbein's *Dance of Death*." *Journal of the Warburg and Courtauld Institutes* 52 (1989), pp. 245-250.

Bellori 1672
G. Pietro Bellori. *Le vite dei pittori, scultori ed architetti moderni*. Rome, 1672. Facsimile reprint Rome, 1931.

Benedict 1938
C. Benedict. "Un peintre oublié des natures mortes, Osias Beert." *L'Amour de L'Art* 19 (1938), pp. 307-313.

Berger 1993
Andrea Berger. *Die Tafelgemälde Paul Brils (Studien zur Kunstgeschichte, 12)*. Munster, 1993.

Bergström 1956a
Ingvar Bergström. *Dutch Still-Life Painting in the Seventeenth Century*. London, 1956.

Bergström 1956b
—. "De Heem's Painting of His First Dutch Period." *Oud Holland* 71 (1956), pp. 173-183.

Bergström 1957
—. "Osias Beert the Elder as a Collaborator of Rubens." *The Burlington Magazine* 99 (1957), pp. 120-124.

Bergström 1988
—. "Another Look at De Heem's Early Dutch Period, 1626-35." *Hoogsteder-Naumann Mercury* 7 (1988), pp. 37-50.

Berlin, cat. 1977
Berlin, Staatliche Museen Preussischer Kulturbesitz, Kupferstichkabinett. *Peter Paul Rubens: Kritischer Katalog der Zeichnungen*. Catalogue by Hans Mielke and Matthias Winner. 1977.

Berlin, cat. 1978
Berlin, Staatliche Museen Preussischer Kulturbesitz. *Peter Paul Rubens. Kritischer Katalog der Gemälde im Besitz der Gemäldegalerie Berlin*. Catalogue by Jan Kelch. 1978.

Bernaud 1965
Germaine Bernaud. "Sur quelques tableaux de Gérard de Lairesse." *Revue du Louvre* 2 (1965), pp. 59-67.

Bernt 1979-80
Walther Bernt. *Die Niederländischen Maler des 17. Jahrhunderts*. 4 vols. Munich, 1948-62. Third edition: *Die Niederländischen Maler und Zeichner des 17. Jahrhunderts*. 5 vols. Munich, 1979-80.

Bertolotti 1880
A. Bertolotti. *Artisti belgi ed olandesi a Roma, nei secoli XVI e XVII. Studi e richerche negli Archivi romani*. Florence, 1880.

Bertolotti 1887
—. *P. P. Rubens, Corneille de Wael, Jean Roos, Antoine van Dyck. Lettres et renseignements*. Antwerp, 1887.

van Bever 1946
G. van Bever. *Les "Tailleurs d'Yvoire" de la Renaissance au XIX-ième siècle*. Brussels, 1946.

Bialostocki 1964
Jan Bialostocki. "The Descent from the Cross in Works by Peter Paul Rubens and His Studio." *Art Bulletin* 46 (1964), pp. 511-524.

de Bie 1661
Cornelis de Bie. *Het gulden cabinet vande edele en vry schilder-const*. Antwerp, 1661. Reprint Soest, 1971.

Bieneck 1992
Dorothea Bieneck. *Gerard Seghers 1591-1651: Leben und Werk des Antwerpener Historienmalers*. Lingen, 1992.

Biographie Nationale 1866-1964
Biographie Nationale (publiée par L'Académie royale des Sciences, des Lettres et des Beaux-Arts). 28 vols. Brussels, 1866-1944. (Brussels 1957-64, 4 supplements).

Blanc 1854-90
Charles Blanc. *Manuel de l'amateur d'estampes*. 4 vols. Paris, 1854-90.

Blanc 1868
—. *Histoire des peintres, Ecole Flamande*. Paris, 1868.

de la Blanchardière, Bodart 1974
Noelle de la Blanchardière and Didier Bodart. "Pietro Pescatore e gli affreschi di Cornelis Schut e di Timan Craft al Casino Pescatore di Frascati." *Arte Illustra* 7 (1974), pp. 179-190.

Bloch 1958
Vitale Bloch. "On Michael Sweerts." *The Burlington Magazine* 100 (1958), pp. 440-441.

Bloch 1965
—. "Michael Sweerts und Italien." *Jahrbuch der Staatlichen Kunstsammlungen in Baden-Württemberg* 2 (1965), pp. 155-174.

Bloch 1968
—. *Michael Sweerts*. The Hague, 1968.

Bloch 1973
—. "Postscriptum zu Sweerts," in *Album Amicorum J. G. van Gelder* (The Hague, 1973), pp. 40-41.

Blunt 1977
Anthony Blunt. "Rubens and Architecture." *The Burlington Magazine* 119 (1977), pp. 609-621.

Bodart 1970
Didier Bodart. *Les peintres des Pays-Bas méridionaux et de la principauté de Liège à Rome au XVIIième siècle*. 2 vols. Brussels, 1970.

Bodart 1973a
—. "Un repos champêtre de Bartholomeus van der Helst et Jacques d'Arthois." *Revue des Archéologues et Historiens d'Art de Louvain* 6 (1973), pp. 212-215.

Bodart 1973b
—. "Le voyage en Italie de Gérard Seghers," in *Studi offerti a G. Incisa della Rocchetta (Miscellanea della Società Romana di Storia Patria* 23 [1973]), pp. 79-88.

Bodart 1976
—. "'The Allegory of Peace' by Abraham Janssens." *The Burlington Magazine* 118 (May 1976), pp. 308-311.

Bode 1883
Wilhelm von Bode. *Studien zur Geschichte der holländischen Malerei*. Braunschweig, 1883.

Bode 1884
—. "Adriaen Brouwer: Ein Bild seines Lebens und seines Schaffens." *Die graphische Künste 6* (1884), pp. 21-72.

Bode 1917
—. *Die Meister der Holländischen und Vlämischen Malerschulen.* Leipzig, 1917. 8th ed., 1956 (ed. E. Plietzsch).

Bode 1918
—. "David Teniers." *Zeitschrift für bildende Kunst 53* (1918), pp. 191-202.

Bode 1919
—. *Die Meister der holländischen und vlämischen Malerschulen.* 2nd ed. Leipzig, 1919.

Bode 1922
—. "Adriaen Brouwer, Erweiterung seines Malerwerks." *Jahrbuch der königlich preussischen Kunstsammlungen 43* (1922), pp. 35-46.

Bode 1924
—. *Adriaen Brouwer sein Leben und sein Werk.* Berlin, 1924.

Bode 1928
—. "Jan Siberechts." *Berliner Museen: Berichte aus den preussischen Kunstsammlungen 49*, no. 5 (1928), pp. 106-108.

Böhmer 1940
G. Böhmer. *Der Landschafter Adriaen Brouwer.* Munich, 1940.

Bok 1990
Marten Jan Bok. "Jan Davidsz. de Heem's Birthplace and Family." *The Hoogsteder Mercury 11* (1990), pp. 48-52.

Bol 1969
Laurens J. Bol. *Holländische Maler des 17. Jahrhunderts nahe den grossen Meistern: Landschaften und Stilleben.* Braunschweig, 1969.

Bol 1982
—. *Goede Onbekenden.* Utrecht, 1982.

Boon 1980
Karel G. Boon. "Paul Bril's 'perfetta imitazione de'veri paesi,'" in *Relations artistiques entre les Pays-Bas et l'Italie à la Renaissance: études dédiées à Suzanne Sulzberger* (Brussels, 1980), pp. 5-14.

Boquet 1924
L. Boquet. *David Teniers.* Paris, 1924.

Borea 1975
Evalina Borea. "I quattro Elementi di Cornelis Schut." *Prospettiva 3* (1975), pp. 52-59.

Bosson 1981
Claude Bosson. "Bertholet Flémal, peintre et architecte liégeois 1614-1675." Mémoire de licence (unpub.), Université de Liège, 1981.

Bosson 1986
—. "L'art de Bertholet Flémal à travers quelques œuvres peu connues," in *Actes du Colloque La peinture liégeoise aux XVIIe et XVIIIe siècles* (Liège, Université de Liège; 20-22 January 1986), pp. 13-16.

Boston, cat. 1985
Boston, Museum of Fine Arts. *European Paintings in the Museum of Fine Arts, Boston. Illustrated Summary Catalogue.* Catalogue by Alexandra Murphy. 1985.

Boström 1954
Kjell Boström. "Joos de Momper och det tidiga marin-malerit i Antwerpen." *Konsthistorisk Tidskrift 23* (1954), pp. 45-66.

Bott 1962
Gerhard Bott. "Stillebenmaler des 17. Jahrhunderts: Isaak Soreau - Peter Binoit." *Kunst in Hessen und am Mittelrhein 1/2* (1962), pp. 27-93.

Bouchery, van den Wijngaert 1941
Herman Bouchery and Frank van den Wijngaert. *P. P. Rubens en het Plantijnsche Huis.* Antwerp/Utrecht, 1941.

Boyer 1957
Jean Boyer. "Peintres et sculpteurs flamands à Aix-en-Provence." *Revue Belge d'Archéologie et d'Histoire de l'Art 26* (1957), pp. 41-73.

van den Branden 1881a
F. Joseph van den Branden. *Adriaan Brouwer en Joos van Craesbeeck.* Haarlem, 1881.

van den Branden 1881b
—. "Adriaan Brouwer." *Nederlandsche kunstbode 3* (1881), pp. 156-157.

van den Branden 1882-83
—. "Adriaan Brouwer." *Nederlandsch Dicht- und Kunsthalle 4* (1882), pp. 532-540; 5 (1883), pp. 11-20.

van den Branden 1883
—. *Geschiedenis der Antwerpsche Schilderschool.* Antwerp, 1883.

Brans 1959
J. V. Brans. *Vlaamse schilders in dienst der Koningen van Spanje.* Louvain, 1959.

Breda/Ghent 1960-61
Breda, Cultureel Centrum "de Beyerd." *Het Landschap in de Nederlanden 1550-1630. Van Pieter Breugel tot Rubens en Hercules Seghers.* Catalogue by Horst Gerson. 1960-61. Also shown at Ghent, Museum voor Schone Kunsten.

Bredius 1896
A. Bredius. "Het geboortejaar van Jan Davidsz. de Heem." *Oud-Holland 4* (1896), p. 214.

Bredius 1914
—. "Een onbekende Siberechts te Berlijn." *Onze Kunst 25* (1914).

Bredius 1915-22
—. *Künstler-Inventare: Urkunden zur Geschichte der holländischen Kunst*

des XVI, XVII, und XVIII Jahrhunderts. 8 vols. The Hague, 1915-22.

Brenninkmeyer-de Rooij 1982
Beatrijs Brenninkmeyer-de Rooij. "Noties betreffende de decoratie van de Oranjezaal in Huis ten Bosch." *Oud Holland 96* (1982), pp. 133-190.

Brenninkmeyer-de Rooij 1983
—. *Jan Davidsz. de Heem (1606-1683/4) - Allegorisch Portret van Prins Willem III.* The Hague, 1983.

Brenninkmeyer-de Rooij 1990
—. "Zeldzame Bloemen, 'Fatta tutti del natturel' door Jan Brueghel I." *Oud Holland 104* (1990), pp. 218-248.

Briels 1967
J. G. C. A. Briels. "De Zuidnederlandse bijdrage tot het ontstaan van de Hollandse landschapschilderkunst ca. 1600-1680." Thesis, Louvain, 1967.

Briels 1976
—. "De Zuidnederlandse immigratie in Amsterdam en Haarlem omstreeks 1572-1630." Diss., Rijksuniversiteit Utrecht, 1976.

Briels 1980
—. "Amator Pictoriae Artis-De Antwerpse Kunstverzamelaar Peeter Steevens (1590-1668) en zijn Constkamer." *Jaarboek van het Koninklijk Museum voor Schone Kunsten, Antwerpen 1980*, pp. 137-226.

Briels 1987
—. *Vlaamse Schilders in de Noordelijke Nederlanden in het begin van de Gouden Eeuw.* Antwerp, 1987.

Briganti, Trezzani, Laureati 1983
Giuliano Briganti, Ludovica Trezzani, and Laura Laureati. *The Bamboccianti: The Painters of Everyday Life in Seventeenth Century Rome.* Translated by Robert Erich Wolf. Rome, 1983.

Brown 1982
Christopher Brown. *Van Dyck.* London, 1982.

Brown 1984
—. "Allegory and Symbol in the Work of Anthony van Dyck," in H. Vekeman and J. Müller Hofstede, eds., *Wort und Bild in der niederländische Kunst und Literatur des 16. und 17. Jahrhunderts* (Erfstadt, 1984), pp. 123-136.

Bruges/Venice/Rome 1951
Bruges, Stedelijk Museum van Schone Kunsten. *I Fiamminghi e Italia: meesterwerken van Vlaamse en Italiaanse meesters van de XVe tot de XVIIIe eeuw.* 1951. Also shown at Venice, Palazzo Ducale, and Rome, Palazzo Barberini (*I Fiamminghi e Italia: pittore italiani e fiamminghi dal XV al XVIII secolo*).

Bruges 1956
Bruges, Musée Communal (Stedelijk Museum van Schone Kunsten). *L'Art flamand dans les collections brittaniques et la Galerie nationale de Victoria.* 1956.

Brusati 1991
Celeste Brusati. "Stilled Lives: Self-portraiture and Self-reflection in Seventeenth-century Netherlandish Still-life Painting." *Simiolus 20* (1991), pp. 168-182.

Brussels 1910
Brussels, Palais du Cinquentenaire. *Catalogue de l'Exposition d'art ancien. L'art belge au XVIIe siècle.* 1910.

Brussels 1926
Brussels, Musées Royaux des Beaux-Arts de Belgique. *Catalogue de l'exposition du paysage flamand.* Catalogue by Hippolyte Fierens-Gevaert and Arthur Laes. 1926.

Brussels 1935
Brussels. *Exposition d'art ancien. Cinq siècles d'art bruxellois.* 24 May-13 October 1935.

Brussels 1965
Brussels, Musées Royaux des Beaux-Arts de Belgique. *Le Siècle de Rubens.* Brussels, 1965.

Brussels 1975
Brussels, Musées Royaux des Beaux-Arts de Belgique. *Maîtres Flamands du dix-septième siècle, du Prado et de collections privées espagnoles.* 1975.

Brussels 1976
Brussels, Musées Royaux des Beaux-Arts de Belgique. *Le Paysage Brabançon au XVIIe siècle: De Brueghel le Jeune à d'Arthois.* Catalogue by Willy Laureyssens. 1976.

Brussels 1977
Brussels, Musée d'Art Ancien. *La sculpture au siècle de Rubens dans les Pays-Bas méridionaux et la principauté de Liège.* 1 July-2 October 1977.

Brussels 1980
Brussels, Palais des Beaux-Arts. *Brueghel: Une dynastie de peintres.* 18 September-18 November 1980.

Brussels 1985
Brussels, Palais des Beaux-Arts. *Splendeurs d'Espagne et les Villes Belges 1500-1700.* Catalogue edited by Jean-Marie Duvosquel and Ignace Vandevivere. 25 September-22 December 1985.

Brussels, cat. 1984
Brussels, Musées Royaux des Beaux-Arts de Belgique. *Catalogue inventaire Peinture ancienne.* 1984.

Brussels/Schallaburg 1991
Brussels, Gemeentekrediet. *Stad in Vlaanderen. Cultuur en maatschappij*

1477-1787. 1991. Also shown at Vienna, Schloss Schallaburg.

H. de Bruyn 1879
 H. de Bruyn. "Anciennes et nouvelles peintures de l'église de Notre-Dame de la Chapelle." *Bulletin des Commissions royales d'Art et d'Archives* (1879), pp. 191-197.

de Bruyn 1977
 Jean-Pierre de Bruyn. "Werk van Erasmus II Quellinus, verkeerdelijk toegeschreven aan P. P. Rubens." *Jaarboek van het Koninklijk Museum voor Schone Kunsten, Antwerpen* 1977, pp. 291-323.

de Bruyn 1979
 —. "Samenwerking van de Rubensepigoon Erasmus II Quellinus (1607-1678) met de Vruchtenschilder Joris van Son." *Jaarboek van het Koninklijk Museum voor Schone Kunsten, Antwerpen* 1979, pp. 281-294.

de Bruyn 1980a
 —. "Erasmus II Quellinus en de bloemenschilder Jan-Philips van Thielen. Catalogus van een samenwerking." *Bulletin des Musées Royaux des Beaux-Arts de Belgique* 23-29 (1974-80), pp. 207-244.

de Bruyn 1980b
 —. "De samenwerking van Daniël Seghers en Erasmus II Quellinus." *Jaarboek van het Koninklijk Museum voor Schone Kunsten, Antwerpen* 1980, pp. 261-329.

de Bruyn 1981
 —. "Biografische gegevens over de Antwerpse Kunstenaar Erasmus II Quellinus." *Jaarboek van het Koninklijk Museum voor Schone Kunsten, Antwerpen* 1981, pp. 153-194.

de Bruyn 1983
 —. "Officiële opdrachten aan Erasmus II Quellinus." *Jaarboek van het Koninklijk Museum voor Schone Kunsten, Antwerpen* 1983, pp. 211-260.

de Bruyn 1984
 —. "Erasmus II Quellinus. Een stijlkritische benadering." *Jaarboek van het Koninklijk Museum voor Schone Kunsten, Antwerpen* 1984, pp. 271-329.

de Bruyn 1985a
 —. "De samenwerking van Pieter Boel en Erasmus II Quellinus." *Jaarboek van het Koninklijk Museum voor Schone Kunsten, Antwerpen* 1985, pp. 277-287.

de Bruyn 1985b
 —. "Voorstellingen van de Immaculata Conceptio in het œuvre van Erasmus II Quellinus," in *Rubens and His World*. Bijdragen opgedragen aan R.-A. d'Hulst (Antwerp, 1985), pp. 289-296.

de Bruyn 1986
 —. "Erasmus II Quellinus als tekenaar." *Jaarboek van het Koninklijk Museum voor Schone Kunsten, Antwerpen* 1986, pp. 213-271.

de Bruyn 1988
 —. *Erasmus II Quellinus (1607-1678). De schilderijen, met catalogue raisonné*. Freren, 1988.

de Bruyn 1990
 —. "Erasmus II Quellinus: addenda en corrigenda." *Jaarboek van het Koninklijk Museum voor Schone Kunsten, Antwerpen* 1990, pp. 303-332.

Buchanan 1824
 William Buchanan. *Memoirs of Painting, with a Chronological History of the Importation of Pictures by the Great Masters into England since the French Revolution*. 2 vols. London, 1824.

Buchelius 1928
 [Arend van Buchell]. *Arnoldus Buchelius, "Res Pictoriae," 1583-1639.* Edited by G. J. Hoogewerff and I. Q. van Regteren Altena. The Hague, 1928.

Budapest, cat. 1968
 Budapest, Szépmüvészeti Múzeum. *Katalog der Galerie Alter Meister.* 2 vols. 1968. Catalogue by Anton Pigler.

Bullaert 1682-95
 Isaac Bullaert. *Académie des Sciences et des Arts.* Vol. 1, Paris, 1682; vol. 2, Brussels, 1695.

Burchard 1928
 Ludwig Burchard. "Jugendwerke von Jacob Jordaens." *Jahrbuch der Preussischen Kunstsammlungen* 49 (1928), pp. 207-218.

Burchard 1929
 —. "Genuesischen Frauenbildnisse von Rubens." *Jahrbuch der Preussischen Kunstsammlungen* 50 (1929), pp. 319-349.

Burchard, d'Hulst 1963
 Ludwig Burchard and R.-A. D'Hulst. *Rubens Drawings.* 2 vols. Brussels, 1963.

Burckhardt 1898
 Jakob Burckhardt. *Erinnerungen aus Rubens.* Basel, 1898. Translated into English as *Recollections of Rubens*, with notes and introduction by Horst Gerson. London, 1950.

Burke-Gaffney 1961
 M. W. Burke-Gaffney, S. J. *Daniel Seghers (1590-1661). A Tercentenary Commemoration.* New York/Washington/Hollywood, 1961.

Burkham 1950
 F. McPherson Burkham. "Joos de Momper's 'Mountain Landscape.'" *Bulletin of the Allen Memorial Art Museum, Oberlin* 8 (1950), pp. 5-16.

Buschmann 1905
 P. Buschmann. *Jacob Jordaens. Eene studie naar aanleiding van de tentoonstelling zijner werken ingericht te Antwerpen in MCMV.* Brussels, 1905.

Buyck 1960
 J. Buyck. "Gevechtstaferelen van Joos van Craesbeeck." *Jaarboek van het Koninklijk Museum voor Schone Kunsten, Antwerpen* 1954-60, pp. 89-98.

Cambridge/New York 1956
 Cambridge, Fogg Art Museum. *Rubens Drawings and Oil Sketches from American Collections.* Catalogue by Agnes Mongan. 1956. Also shown at New York, Morgan Library.

Carpenter 1844
 William Hookham Carpenter. *Pictorial Notices: Consisting of a Memoir of Sir Anthony van Dyck, with a Descriptive Catalogue of the Etchings Executed by Him: and a Variety of Interesting Particulars Relating to Other Artists Patronized by Charles I.* London, 1844.

Carton de Wiart 1941
 Comtesse Carton de Wiart. "Gaspard de Crayer et la corporation des poissonniers de Bruxelles." *Publications du patrimoine des Musées des Beaux-Arts de Belgique* (Brussels, 1941), pp. 19-29.

Cassidy 1986
 Brendan Cassidy. "Largilliere's Portrait of Siberechts." *The Burlington Magazine* 128 (1986), pp. 414-416.

Casteels 1961
 M. Casteels. *De Beeldhouwers de Nole te Kamerijk, te Utrecht en te Antwerpen.* Brussels, 1961.

Castelfranchi Vegas 1969
 L. Castelfranchi Vegas. "'Michael Sweerts' di Vitale Bloch." *Paragone* 20 (1969), pp 68-72.

Caullet 1903
 G. Caullet. "Le peintre Chrétien de Coninck et sa famille de Courtrai." *Handelingen van den Geschied- en Oudheidkundigen kring te Kortrijk* 1 (1903), pp. 75-93.

Caullet 1906-1907
 —. "Une épisode de la vie du peintre Théodore Rombouts." *Bulletin du Cercle historique et archéologique de Belgique* 4 (1906-1907), pp. 310-314.

Cauwels 1966-67
 Roni Cauwels. "Cornelis Schut Leven en Werk." Thesis, Rijksuniversiteit Ghent, 1966-67.

van Cauwenberghs 1891
 Clement van Cauwenberghs. *Notice historique sur les peintre-verriers d'Anvers du XVe au XVIIIe siècle.* Antwerp, 1891.

Cavelli-Björkman 1981
 Görell Cavelli-Björkman. "Three Netherlandish Paintings in the Österby Collection." *Nationalmuseum Stockholm Bulletin* 5 (1981), pp. 116-126.

Chemnitz 1927
 Chemnitz, Kunsthütte. *Josse de Momper 1564-1635.* 1927.

Chomer 1979
 G. Chomer. "The 'Virgo inter Virgines' of Abraham Janssens." *The Burlington Magazine* 121 (1979), pp. 508-511.

Claessens 1966
 P.-E. Claessens. "Quelques circonstances de la vie du peintre Jacques d'Arthois." *L'Intermédiare des généalogistes* 125 (1966), pp. 263-265.

Coekelberghs 1978-79
 Denis Coekelberghs. "Le Martyre de saint Lambert (1617), tableau caravagesque de Théodore van Loon." *Bulletin de l'Institut royal du patrimoine artistique* 17 (1978-79), pp. 139-147.

Coekelberghs 1981
 — et al. *L'Eglise Saint-Jean-Baptiste au Béguinage à Bruxelles et son mobilier.* Brussels, 1981.

Cohen 1931
 W. Cohen. "Der Landschaftsmaler Joost de Momper. Zu der Ausstellung bei P. de Boer in Amsterdam." *Pantheon* 7 (1931), pp. 60-65.

Cologne 1977
 Cologne, Kunsthalle. *Peter Paul Rubens.* Catalogue by Justus Müller Hofstede. 1977.

Cologne/Utrecht 1985-86
 Cologne, Wallraf-Richartz-Museum. *Roelant Savery in seiner Zeit.* Catalogue by Ekkehard Mai, Kurt J. Müllenmeister et al. 1985. Also shown at Utrecht, Centraal Museum, 1985-86.

Cologne/Utrecht 1991-92
 Cologne, Wallraf-Richartz-Museum. *I Bamboccianti: Niederländische Malerrebellen im Rom des Barock.* Catalogue by David A. Levine and Ekkehard Mai et al. 28 August-17 November 1991. Also shown at Utrecht, Centraal Museum, 9 December 1991-9 February 1992.

Cologne/Vienna 1992-93
 Cologne, Wallraf-Richartz-Museum. *Von Brueghel bis Rubens: Das goldene Jahrhundert der flämischen Malerei.* Catalogue edited by Ekkehard Mai and Hans Vlieghe. 4 September-22 November 1992. Also shown at Antwerp, Koninklijk Museum voor Schone Kunsten, 19 December 1992-8 March 1993; and Vienna, Kunsthistorisches Museum, 2 April 1993-20 June 1993.

Combe 1942
 Jacques Combe. *Brueghel de Velours.* Paris, 1942.

Concha Herrero 1986
 C. Concha Herrero. "Los 'Paises metamórficos' de Jacques d'Arthois en el Palacio Real de la Graya." *Reales Sitios* 23 no. 90 (1986), pp. 17-24.

Constable 1949
W. G. Constable. "Rubens in the Museum of Fine Arts, Boston," in *Miscellanea Leo van Puyvelde* (Brussels, 1949), pp. 127-134.

Coolidge 1966
John Coolidge. "Louis XIII and Rubens: The Story of the Constantine Tapestries." *Gazette des Beaux-Arts* ser. 6, vol. 67 (1966), pp. 271-290.

Couvez 1852
A. Couvez. *Inventaires des objets d'art qui ornent les églises et les établissements publics de la Flandre Occidentale.* Bruges, 1852.

Couvreur 1967
W. Couvreur. "Daniël Seghers' inventaris van de door hem geschilderde bloemstukken." *Gentse Bijdragen tot de Geschiedenis 20* (1967), pp. 87-158.

Crawford Volk 1980
Mary Crawford Volk. "Rubens in Madrid and the Decoration of the Salón Nuevo in the Palace." *The Burlington Magazine* 122 (1980), pp. 168-180.

Crawford Volk 1981
—. "Rubens in Madrid and the Decoration of the King's Summer Apartments." *The Burlington Magazine* 123 (1981), pp. 513-529.

Crick-Kuntziger 1938
Marthe Crick-Kuntziger. "Les cartons de Jordaens au Musée du Louvre et leurs traductions en tapisseries." *Annales de la Société royale d'Archéologie de Bruxelles* 62 (1938), pp. 135-146.

Crivelli 1868
G. Crivelli. *Giovanni Brueghel, Pittor Fiammingo e sue Lettere e Quadretti esistenti presso l'Ambrosiana.* Milan, 1868.

Cruzada Villaamil 1874
G. Cruzada Villaamil. *Rubens diplomático espagñol.* Madrid, 1874.

Cust 1900
Lionel Cust. *Anthony van Dyck. An Historical Study of His Life and Works.* London, 1900.

Cust, van den Branden 1915
Lionel Cust and F. Joseph van den Branden. "Notes on Pictures in the Royal Collections XXXII: on a Painting of a Picture Gallery by Gonzales Coques." *The Burlington Magazine* 27 (1915), pp. 150-158.

Davidson 1978
Jane P. Davidson. "Religious and Mythological Paintings of David II Teniers." Ph.D. diss., University of Kansas, 1975. Ann Arbor, 1978.

Davidson 1979
—. *David Teniers the Younger.* Boulder, 1979.

Debrabandere 1963
P. Debrabandere. *Geschiedenis van de Schilderkunst te Kortrijk, 1400-1800.* Kortrijk, 1963.

Decoteau 1992
Pamela Hibbs Decoteau. *Clara Peeters 1594-ca. 1640 and the Development of Still-Life Painting in Northern Europe.* Lingen, 1992.

van Dedem 1981
W. Baron van Dedem. "Een Pieter Claesz of Clara Peeters." *Tableau* 3 (1981), pp. 602-604.

Delen 1938
Adriaen Jean Joseph van Delen. "Teekeningen van Jan Wildens." *Annuaire des Musées Royaux des Beaux-Arts de Belgique* 1 (1938), pp. 171-176.

Delevoy 1940
R. Delevoy. "L'œuvre gravée de Luc van Uden." *Revue belge d'Archéologie et d'Histoire de l'Art* 10 (1940-42), pp. 47-58.

Delft/Cambridge/Fort Worth 1988
Delft, Stedelijk Museum "Het Prinsenhof." *A Prosperous Past: The Sumptuous Still-life in the Netherlands 1600-1700.* Catalogue by Sam Segal. 1988. Also shown at Cambridge, Fogg Art Museum; and Fort Worth, Kimbell Art Museum.

Denucé 1931
Jean Denucé. *Kunstuitvoer in de 17e eeuw te Antwerpen: De Firma Forchoudt.* (Bronnen voor de geschiedenis van de Vlaamsche kunst, I). Antwerp, 1931.

Denucé 1932
—. *De Antwerpsche "Konstkamers": Inventarissen van kunstverzamelingen te Antwerpen in de 16e en 17e eeuwen.* (Bronnen voor de geschiedenis van de Vlaamsche kunst, II). Antwerp/The Hague, 1932.

Denucé 1934
—. *Brieven en Documenten betreffend Jan Brueghel I en II.* (Bronnen voor de geschiedenis van de Vlaamsche kunst, III). Antwerp, 1934.

Denucé 1949
—. *Na Peter Pauwel Rubens: Documenten uit den Kunsthandel te Antwerpen in de XVIIe eeuw van Matthys Musson.* (Bronnen voor de geschiedenis van de Vlaamsche kunst, V). Antwerp, 1949.

Dérival de Gomicourt 1782-83
A. P. Dérival de Gomicourt. *Le Voyageur dans les Pays-Bas Autrichiens ou lettres sur l'état actuel de ce pays.* 4 vols. Amsterdam, 1782-83.

Descamps 1753-64
Jean Baptiste Descamps. *La vie des peintres flamands, allemands et hollandais.* 4 vols. Paris, 1753-64.

Descamps 1769
—. *Voyage pittoresque de la Flandre et du Brabant.* Rouen, 1769.

Devisscher 1984a
Hans Devisscher. "Bijdrage tot de studie van de zestiende-eeuwse Vlaamse landschapschilder Kerstiaen de Keuninck." *Gentse Bijdragen tot de Kunstgeschiedenis* 26 (1981-84), pp. 89-160.

Devisscher 1984b
—. "De landschapschilder Kerstiaen de Keuninck, Kortrijk 1560-Antwerpen 1632." *De Leiegouw* 26 (1984), pp. 3-52.

Devisscher 1987
—. *Kerstiaen de Keuninck 1560-1633. De Schilderijen met catalogue raisonné.* Freren, 1987.

Dewez 1927-28
L. Dewez. "Un maître liégeois du XVIIe siècle, Bertholet Flémalle 1614-1675." *La Vie Wallonne* 8 (1927-28), pp. 129-148.

Dezalliers d'Argenville 1745-52
J. Dezalliers d'Argenville. *Abrégé de la Vie des plus fameux Peintres avec leurs Portraits gravés.* 3 vols. Paris 1745-52; 2nd ed. 1762.

Díaz Padrón 1963-67
Matías Díaz Padrón. "Nuevas pinturas de Gaspar de Crayer en España." *Arte Espanol* 25 (1963-67), pp. 154-162.

Díaz Padrón 1969
—. "Un lienzo de Erasmo Quellinus en el Museo del Prado, 'Psiquis el y Amor dormido.'" *Revue belge d'Archéologie et d'Histoire de l'Art* 38 (1969), pp. 99-105.

Díaz Padrón 1982
—. "Nuevas pinturas de Guillaume van Herp," in *Miscellanea de Arte Instituto Diego Velásquez* (Madrid, 1982), pp. 168-171.

Díaz Padrón 1983a
—. "Una Adoración de los Reyes de Hendrick van Balen en la embajada de España en Paris." *Boletín del Museo del Prado* 4 (1983), pp. 37-38.

Díaz Padrón 1983b
—. "Una alegoria de la Musica de Jean Boeckhorst atribuida a Gasper de Crayer." *Archivo Español de Arte* 56 (1983), pp. 150-151.

Díaz Padrón 1984
—. "Una Adoración de los Reyes de Hendrick van Balen atribuida a Frans Franken II en la Universidad de Gottinga." *Archivo Español de Arte* 57 (1984), pp. 326-328.

Díaz Padrón 1985a
—. "L'art des Pays-Bas méridionaux et de l'Espagne aux XVIe et XVIIe siècles: Influences et relations," in exh. cat. Brussels, Palais des Beaux-Arts, *Splendeurs d'Espagne et les Villes Belges 1500-1700* (1985), pp. 297-332.

Díaz Padrón 1985b
—. "Un lienzo de Gerard Seghers atribuido a Rubens en la Casa de Alba." *Archivo Español de Arte* 58 (1985), pp. 108-114.

Díaz Padrón 1986
—. "Nuevas Pinturas de Cornelio de Vos identificado en collecciones españolas y extranjeras." *Archivo Español de Arte* 60 (1986), pp. 121-146.

Diderot 1777
Denis Diderot. *Pensées détachées.* Paris, 1777.

Dilis 1910
Emile Dilis. *De Rekeningen der rederijkerskamer "de Olijftak" over de jaren 1615 tot 1629.* Antwerp/The Hague, 1910.

Dilis 1922
—. "La confrerie de Romanistes." *Annales de l'Académie Royale d'Architecture de Belgique* 70 (1922).

Dillon 1909
Edward Dillon. *Rubens.* London, 1909.

Dolders 1983
Arno Dolders. "Eenige opmerkingen over het Groot Schilderboek van Gerard Lairesse." Diss., Utrecht, Rijksuniversiteit, 1983.

Dolders 1985
—. "Some Remarks on Lairesse's Groot Schilderboek." *Simiolus* 15 (1985), pp. 197-220.

Donnet 1896
Fernand Donnet. "Histoire d'un livre (Pompa Introitus Ferdinandi)." *Annales de l'Académie d'archéologie de Belgique* 49 (4 ser., vol. 9) (1896), pp. 355-402.

Donnet 1907
—. *Het Jonstich Versaem der Violieren. Geschiedenis der Rederijkerkamer de Olijftak sedert 1480.* Ghent/The Hague, 1907.

Dony 1979-80
Frans Dony. *Het komplete werk van Rubens (Meesters der Schilderkunst).* 2 vols. Rotterdam, 1979-80.

Dreher 1977
Faith Paulette Dreher. "David II Teniers Again." *Art Bulletin* 59 (1977), pp. 108-110.

Dreher 1978a
—. "The Vision of Country Life in the Paintings of David Teniers II." Diss., New York, Columbia University, 1975. Ann Arbor, 1978.

Dreher 1978b
—. "The Artist as Seigneur: Châteaux and Their Proprietors in the Work of David Teniers II." *Art Bulletin* 60 (1978), pp. 682-703.

Drost 1928
W. Drost. *Motivübernahme bei Jakob Jordaens und Adriaen Brouwer.* Königsberg, 1928.

Dubois de Saint-Gelais 1727
Louis François Dubois de Saint-Gelais. *Description des tableaux du Palais Royal, avec la vie des peintres à la tête de leurs ouvrages.* Paris, 1727.

Du Bon 1964
 David Du Bon. *Tapestries from the Samuel H. Kress Collection at the Philadelphia Museum of Art. The History of Constantine the Great Designed by Peter Paul Rubens and Pietro da Cortona.* London, 1964.

Dupret 1967
 Jacqueline Dupret. *Essai sur Josse de Momper.* Thesis, Rijksuniversiteit Ghent, 1967.

Düsseldorf 1931
 Düsseldorf, Galerie Baumann. *Josse de Momper.* 1931.

Dutuit 1881-88
 Eugène Dutuit. *Manuel de l'amateur d'estampes.* 6 vols. Paris/London, 1881-88.

Duverger 1968
 Erik Duverger. "Bronnen voor de Geschiedenis van de artistieke betrekkingen tussen Antwerpen en de Noordelijke Nederlanden tussen 1632 en 1648," in *Miscellanea Jozef Duverger* (Ghent, 1968), vol. 1, pp. 336-373.

Duverger 1972a
 —. "Abraham van Diepenbeeck en Gonzales Coques aan het werk voor de stadhouder Frederik Hendrik, prins van Oranje." *Jaarboek van het Koninklijk Museum voor Schone Kunsten, Antwerpen 1972,* pp. 181-237.

Duverger 1972b
 —. "De moeilijkheden van Abraham van Diepenbeeck met de Antwerpse Sint-Lukasgilde." *Jaarboek van het Koninklijk Museum voor Schone Kunsten, Antwerpen 1972,* pp. 239-261.

Duverger 1984-
 —. *Antwerpse kunstinventarissen uit de zeventiende eeuw (Fontes Historiae artis neerlandicae).* Brussels, 1984-.

Duverger, Vlieghe 1971
 Erik Duverger and Hans Vlieghe. *David Teniers der Ältere: ein vergessener flämischer Nachfolger Adam Elsheimers.* Utrecht, 1971.

Duvivier 1860
 C. Duvivier. "Documents concernant le peintre Jean Brueghel." *Revue d'Histoire et d'Archéologie* 2 (1860), pp. 329-335, 439-461.

van Dyck 1974
 G. C. M. van Dyck. "De Bossche kunstenaar Abraham van Diepenbeeck." *Brabants heem* 26 (1974), p. 84.

Edman 1958
 D. R. Edman. "The Influence of David Teniers on the Watteau Circle." Diss., Oberlin College, Oberlin, Ohio, 1958.

Eekhoud 1926
 G. Eekhoud. *Teniers.* Brussels, 1926.

Eemans 1964
 M. Eemans. *Brueghel de Velours.* Brussels, 1964.

Eigenberger 1927
 R. Eigenberger. *Die Gemäldegalerie der Akademie der bildenden Künste in Wien.* 2 vols. Vienna/Leipzig, 1927.

Eisler 1967
 Colin Eisler. "Rubens' Uses of the Northern Past: The Michiels Triptych and Its Sources." *Bulletin des Musées Royaux des Beaux-Arts de Belgique* 16 (1967), pp. 43-77.

Elewijt 1962
 Elewijt, Château Rubens. *Rubens Diplomate.* Catalogue by Frans Baudouin. 1 July-15 September 1962.

Ephrussi 1884-85
 C. Ephrussi. "A propos d'Adriaen Brouwer." *Gazette des Beaux-Arts,* ser. 2, vol. 31 (1885), pp. 164-176.

Ertz 1979
 Klaus Ertz. *Jan Brueghel der Ältere: Die Gemälde.* Cologne, 1979.

Ertz 1981
 —. *Jan Breughel der Ältere.* Cologne, 1981.

Ertz 1984
 —. *Jan Breughel der Jüngere.* Freren, 1984.

Ertz 1986
 —. *Josse de Momper der Jüngere. Die Gemälde mit kritischem Œuvre-Katalog.* Freren, 1986.

van Even 1890
 E. van Even. "De schilder Erasmus Quellin, Vlaamsch dichter," in *Bulletin van de Koninklijke Vlaamsche Academie voor Taal- en Letterkunde.* Ghent, 1890.

Evers 1942
 H. G. Evers. *Peter Paul Rubens.* Munich, 1942.

Evers 1943
 —. *Rubens und sein Werk. Neue Forschungen.* Brussels, 1943.

Faggin 1965
 G. T. Faggin. "Per Paolo Bril." *Paragone* no. 185 (July 1965), pp. 21-35.

Faré 1974
 Michel Faré. *Le grand siècle de la nature morte en France: le XVIIe siècle.* Fribourg/Paris 1974.

Fekhner 1956
 E. Y. Fekhner. "Christiaen de Keuninck and the Dutch Landscape at the End of the XVIth Century." *Trudy Gosudarsvennogo Ermitaga, Zapadno Europejsko Iskusstvo* 1 (1956), pp. 104-118 (in Russian).

Félibien 1666-88
 André Félibien. *Entretiens sur les vies et les ouvrages des plus excellens peintres anciens et modernes.* 5 vols. Paris, 1666-88.

Félibien 1679
 —. *Noms des peintres les plus célèbres et les plus connus, anciens et modernes.* Paris, 1679. Reprint Geneva, 1972.

Fétis 1855
 E. Fétis. "Artistes belges à l'étranger: Gérard de Lairesse." *Bulletin de l'Académie Royale de Belgique* 22 (1855), pp. 468-492.

Fétis 1857-65
 —. *Les artistes belges à l'étranger.* 2 vols. Brussels, 1857-65.

Fierens 1946
 Paul Fierens, ed., *L'art en Belgique.* 2nd ed. Brussels, 1946.

Fierens-Gevaert 1905
 Hippolyte Fierens-Gevaert. *Jordaens.* Paris, 1905.

Filipczak 1987
 Zirka Zaremba Filipczak. *Picturing Art in Antwerp 1550-1700.* Princeton, 1987.

Florence 1977
 Florence, Palazzo Pitti. *Rubens e la pittura fiamminga del seicento nelle collezioni pubbliche fiorentine.* Catalogue by Didier Bodart. 1977.

Florence 1983
 Rubens e Firenze (Acts of a Colloquium held in Florence, October 1977). Edited by Mina Gregori. Florence, 1983.

Fokker 1931
 T. H. Fokker *Jan Siberechts, peintre de la paysannerie flamande.* Brussels, 1931.

Foucart 1983
 Jacques Foucart. "Quelques œuvres de Gérard Seghers," in *Essays in Northern European Art in Honor of Egbert Haverkamp Begemann* (Doornspijk, 1983), pp. 89-93.

Fransolet 1942
 M. Fransolet. *François du Quesnoy, sculpteur d'Urbain VIII, 1597-1643.* Brussels, 1942.

Franz 1963
 Heinrich Gerhard Franz. "De boslandschappen van Gillis van Coninxloo en hun voorbeelden." *Bulletin Museum Boymans-van Beuningen* 14 (1963), pp. 66-85.

Franz 1968
 —. "Das niederländische Waldbild und seine Entstehung im 16. Jahrhunderts." *Bulletin des Musées Royaux des Beaux-Arts de Belgique* 17 (1968), pp. 1-2, 15-38.

Franz 1968-69
 —. "Meister der spätmanieristischen Landschaftsmalerei in den Niederlanden." *Jahrbuch des Kunsthistorischen Instituts der Universität Graz* 3-4 (1968-69), pp. 19-72.

Franz 1969
 —. *Niederländische Landschaftsmalerei im Zeitalter des Manierismus.* 2 vols. Graz, 1969.

Franz 1970
 —. "Niederländische Landschaftsmaler im Künstlerkreis Rudolf II." *Umeni* 18 (1970), pp. 224-245.

Franz 1982
 —. "Landschaftsbilder als kollektive Werkstattschöpfungen in der flämischen Malerei des 16. und frühen 17. Jahrhunderts." *Jahrbuch des Kunsthistorischen Instituts der Universität Graz* 18 (1982), pp. 165-181.

Freedberg 1976a
 David Freedberg. "The Problem of Images in Northern Europe and Its Repercussions in the Netherlands." *Hafnia (Copenhagen Studies in the History of Art)* 1976, pp. 25-45.

Freedberg 1976b
 —. "The Representation of Martyrdoms during the Early Counter-Reformation in Antwerp." *The Burlington Magazine* 118 (1976), pp. 128-138.

Freedberg 1978a
 —. "L'Année Rubens: Manifestations et publications en 1977. Etats de recherches." *Revue de l'Art* 39 (1978), pp. 82-94.

Freedberg 1978b
 —. "Rubens as a Painter of Epitaphs 1612-1618." *Gentse Bijdragen tot de Kunstgeschiedenis* 24 (1976-78), pp. 51-71.

Freedberg 1981
 —. "The Origins and Rise of the Flemish Madonnas in Flower Garlands: Decoration and Devotion." *Münchner Jahrbuch der bildenden Kunst* 32 (1981), pp. 115-150.

Freedberg 1984
 —. *The Life of Christ after the Passion (Corpus Rubenianum Ludwig Burchardt, part VII).* London/Oxford, 1984.

Friedländer 1918
 Max J. Friedländer. "Adriaen Brouwer." *Der Belfried* 2 (1918), pp. 324-327.

Friedländer 1923
 —. *Die niederländische Malerei des 17. Jahrhunderts.* (Propyläen Kunstgeschichte). Berlin, 1923.

von Frimmel 1891-94
 Theodor von Frimmel. *Kleine Galeriestudien.* Vol. 1, Bamberg, 1891; vol. 2, Vienna, 1894.

von Frimmel 1892-93
 —. "Zur Erläuterung des grossen Galerie-Bildes von Teniers in

Wien." *Kunstchronik und Kunstmarkt* n.s. 4 (1892-93), pp. 536-537.

von Frimmel 1904
—. "Bildchen von Hendrick de Clerck und einige Bemerkungen zu Denis van Alsloot." *Blätter für Gemäldekunde* 1 (1904), pp. 59-61.

von Frimmel 1906
—. "Das Sittenbild des Siberechts in der königlichen Galerie zu Kopenhagen." *Blätter für Gemäldekunde* 3 (1906), pp. 18-21.

von Frimmel 1912
—. "Franciscus Gijsbrechts." *Blätter für Gemäldekunde* 7 (1912), p. 118.

Fuchs 1975
R. H. Fuchs. "Jacob van Oost. Portret van een Brugse familie." *Openbaar Kunstbezit* 13 (1975), pp. 136-37.

Funk 1954
Horst Funk. "Frans Snyders oder Paul de Vos?" in *Edwin Redslob zum 70. Geburtstag* (Berlin, 1954), pp. 316-320.

Gabriels 1930
J. Gabriels. *Artus Quellien de Oude.* Antwerp, 1930.

Gachard 1877
P. L. Gachard. *Histoire politique et diplomatique de Rubens.* Brussels 1877.

Galesloot 1868
Louis Jean Guillaume Galesloot. "Un procès pour une vente de tableaux attribués à Antoine van Dyck, 1660-1662." *Annales de l'Académie d'Archéologie de Belgique* 24 (1868), pp. 561-606.

Gammelbo 1952-55
Poul Gammelbo. "Cornelis Norbertus Gijsbrechts og Franciskus Gijsbrechts." *Kunstmuseets Årskrift* 1952-55, pp. 125-156.

Garas 1967
Klara Garas. "Die Entstehung der Galerie des Erzherzogs Leopold Wilhelm." *Jahrbuch der Kunsthistorischen Sammlungen in Wien* 63 (1967), pp. 39-80.

Garas 1968
—. "Das Schicksal der Sammlung des Erzherzogs Leopold Wilhelm." *Jahrbuch der Kunsthistorischen Sammlungen in Wien* 64 (1968), pp. 181-278.

van Gelder 1940-41
J. G. van Gelder. "Adriaen Brouwer." *Maandblad voor beeldende kunst* 27 (1940-41), pp. 65-72.

van Gelder 1948-49
—. "De schilders van de Oranjezaal." *Nederlands Kunsthistorisch Jaarboek* 1 (1948-49), pp. 119-164.

van Gelder 1949
—. "De opdrachten van de Oranje's aan Thomas Willeboirts Bosschaert en Gonzales Coques." *Oud Holland* 64 (1949), pp. 40-56.

van Gelder 1950-51
—. "Rubens in Holland in de zeventiende eeuw." *Nederlands Kunsthistorisch Jaarboek* 3 (1950-51), pp. 103-150.

van Gelder 1959
—. "Anthonie van Dyck in Holland in de zeventiende eeuw." *Bulletin des Musées Royaux des Beaux-Arts de Belgique* 8 (1959), pp. 43-86.

van Gelder 1977
—. "De Waardering van Rubens, een terugblik." *Antwerpen. Tijdschrift der Stad Antwerpen* 31, no. 4 (1977), pp. 178-197.

Genaille 1983
R. Genaille. "De Bruegel à G. van Coninxloo: Remarques sur le paysage maniériste à la fin du 16e siècle." *Jaarboek van het Koninklijk Museum voor Schone Kunsten, Antwerpen* 1983, pp. 129-168.

Génard 1852
Pierre Génard. *Notice sur Jacques Jordaens (Extrait du Messager des sciences historiques, des arts et de la bibliographie de Belgique).* Ghent, 1852.

Génard 1854
—. *Luister der Sint-Lucasgilde.* Antwerp, 1854.

Génard 1856
—. *Verzameling van de graf- en gedenkschriften van de Provincie Antwerpen,* vol. 1. Antwerp, 1856.

Génard 1860
—. "Les grandes familles artistiques d'Anvers." *Revue d'Histoire et d'Archéologie* 2 (1860).

Génard 1863
—. "Nicolas van Veerendael." *Journal des Beaux-Arts* 5 (1863), p. 13.

Génard 1865
—. "De nalatenschap van P. P. Rubens." *Antwerpsch Archievenblad* 2 (1865-66), pp. 69ff.

Génard 1869-76
—. "Intrede van den Prins-Kardinaal Ferdinand van Spanje te Antwerpen op 17 April 1635." *Antwerpsche Archievenblad* 6 (1869), pp. 405-472; 7 (1870), pp. 1-113; 13 (1876), pp. 215-345.

Génard 1877
—. *P. P. Rubens, Aantekeningen over den groten meester en zijn bloed-verwanten.* Antwerp, 1877.

Genoa 1955
Genoa, Palazzo dell'Academia. *100 Opere di Van Dyck.* 1955.

Genoa 1977-78
Genoa, Palazzo Ducale. *Rubens e Genova.* 18 December 1977-12 February 1978.

Gerlach 1965
P. Gerlach. "Schilderijen van Theodoor van Thulden in het Capucijnenklooster te Breda." *Jaarboek van de Geschied- en Oudheidkundige Kring van Stad en Land van Breda, "de Oranje boom"* 18 (1965), pp. 155-164.

Gerson, ter Kuile 1960
Horst Gerson and Engelbert Hendrick ter Kuile. *Art and Architecture in Belgium: 1600-1800.* Harmondsworth, 1960.

Gerszi 1976
Teréz Gerszi. "Bruegels Nachwirkung auf die niederländischen Landschaftsmaler um 1600." *Oud Holland* 90 (1976), pp. 201-229.

Gerszi 1978
—. "Les antécédents du tableau de Jean Brueghel, paysage rocheux avec Sainte Antoine, et son influence." *Bulletin du Musée Hongrois des Beaux-Arts* 51 (1978), pp. 107-122.

Gerszi 1985
—. "Joos de Momper und die Brueghel-tradition," in *Netherlandish Mannerism* (Stockholm, 1985), pp. 155-164.

Geudens 1904
E. Geudens. *Les tableaux des hospices civils d'Anvers.* Antwerp, 1904.

Ghent 1975
Ghent, Museum voor Schone Kunsten. *Gent. Duizend jaar kunst en kultuur.* Catalogue by Jean-Pierre de Bruyn et al. 1975.

Ghent 1986-87
Ghent, Museum voor Schone Kunsten. *Joachim Beuckelaer: Het markt- en keukenstuk in de Nederlanden 1550-1650.* 1986-87.

Glen 1977
T. L. Glen. *Rubens and the Counter-Reformation. Studies in His Religious Paintings between 1609 and 1620.* New York, 1977.

Glen 1991
—. "In the footsteps of Rubens. Van Dyck's Lamentation in the Alte Pinakothek Munich." *Gazette des Beaux-Arts* ser. 6, vol. 118 (1991), pp. 79-86.

Glück 1903
Gustave Glück. "Aus Rubens' Zeit und Schule. Bemerkungen zu einigen Gemälden der Kaiserlichen Galerie in Wien: Gerard Zegers." *Jahrbuch der Kunsthistorischen Sammlungen des allerhöchsten Kaiserhauses* 24 (1903), pp. 1-48.

Glück 1923
—. "Rubens' Kreuzaufrichtungsaltar," in Paul Clemen, ed., *Belgische Kunstdenkmäler* (Munich, 1923), vol. 2, pp. 161-184.

Glück 1931
—. *Van Dyck, Des Meisters Gemälde (Klassiker der Kunst, 30).* 2nd ed. Stuttgart/Leipzig, 1931.

Glück 1933
—. *Rubens, van Dyck und ihr Kreis.* Vienna, 1933.

Glück 1940
—. "Rubens as a Portrait Painter." *The Burlington Magazine* 76 (1940), pp. 173-183.

Glück 1945
—. *Die Landschaften von Peter Paul Rubens.* 2nd ed. Vienna, 1945.

Glück, Haberditzl 1928
Gustave Glück and F. M. Haberditzl. *Die Handzeichnungen von P. P. Rubens.* Berlin, 1928.

Goethals 1862
Félix Victor Goethals. *Miroir des notabilités nobiliaires de Belgique, des Pays-Bas et du Nord de la France.* 2 vols. Brussels, 1862.

Goodman 1992
Elise Goodman. *Rubens' The Garden of Love as 'Conversatie à la Mode'.* Amsterdam/Philadelphia, 1992.

van Gool 1750-51
Johan van Gool. *De nieuwe schouberg der Nederlantsche Kunstschilders en schilderessen.* 2 vols. The Hague, 1750-51. Reprint Soest, 1971.

Goossens 1954
Karel Goossens. *David Vinckboons.* Antwerp/The Hague, 1954.

Goovaerts 1879
A. Goovaerts. "Le peintre van Hulsdonck." *Journal des Beaux-Arts* 21 (1879), p. 2.

Goris 1940
Jan Albert Goris. *Lof van Antwerpen: Hoe reizigers Antwerpen zagen, van de XVe tot de XXe Eeuw.* Brussels, 1940.

Goris, Held 1947
Jan Albert Goris and Julius S. Held. *Rubens in America.* New York, 1947.

de Graaf 1937
D. A. de Graaf. "Drie eeuwen na den dood van Adriaen Brouwer." *Historia* 3 (1937), pp. 266-268.

van de Graft 1942
C. C. van de Graft. "Gerard Lairesse (1640-1711) en Utrecht." *Maandblad van Oud Utrecht* 17, no. 7 (July 1942), pp. 49-52.

Grancsay 1946
S. V. Grancsay. "Arms and Armor in Paintings by David Teniers the Younger." *Journal of the Walters Art Gallery* 9 (1946), pp. 23-40.

Grauls 1960
J. Grauls. "Het Spreekwoordenschilderij van Sebastiaan Vrancx." *Bulletin des Musées Royaux des Beaux-Arts de Belgique* 9 (1960), pp. 107-164.

Greindl 1939a
 Edith Greindl. "Les Portraits de Corneille de Vos." *Annuaire des Musées Royaux des Beaux-Arts de Belgique* 2 (1939), pp. 131-172.
Greindl 1939b
 —. "Einige besondere Wesenszüge der Bildnisse des Cornelis de Vos." *Pantheon* 23 (1939), pp. 109-114.
Greindl 1944
 —. *Corneille de Vos.* Brussels, 1944.
Greindl 1949
 —. "Jan Fyt, Peintre de Fleurs," in *Miscellanea Leo van Puyvelde* (Brussels, 1949), pp. 163-165.
Greindl 1956
 —. *Les Peintres flamands de nature morte au XVIIe siècle.* Brussels, 1956.
Greindl 1976
 —. "A propos des 'Etoffeurs' des paysages de Joos de Momper." *De Antiquair* 26 (June 1976), pp. iv-vii.
Greindl 1983
 —. *Les Peintres flamands de nature morte au XVIIe siècle.* Drogenbos (Brussels), 1983.
Greindl et al. 1990
 Edith Greindl et al. *De zeventiende eeuw: De Gouden Eeuw van de Vlaamse Schilderkunst.* Antwerp, 1990.
Grisebach 1974
 Lucius Grisebach. *Willem Kalf 1619-1693.* Berlin, 1974.
Grosse 1925
 R. Grosse. *Die Holländische Landschaftskunst 1600-50.* Berlin/Leipzig, 1925.
Gudlaugsson 1964
 Sturla J. Gudlaugsson. "Adriaen Brouwer," in *Kindlers Malerei Lexikon,* vol. 1 (Zurich, 1964), pp. 540-544.
Guiffrey 1879
 Jules Marie Joseph Guiffrey. "Mémoire des travaux de Van der Meulen exécutés pour le roi depuis le 1ᵉʳ avril 1664." *Nouvelles Archives de l'Art français* (1879), pp. 119-145.
Guiffrey 1881-1901
 —. *Comptes de Bâtiments du roi sous le règne de Louis XIV.* 5 vols. Paris, 1881-1901.
Guiffrey 1882
 —. *Antoine van Dyck, sa vie et son œuvre.* Paris, 1882.
Haak 1984
 Bob Haak. *The Golden Age: Dutch Painters of the Seventeenth Century.* New York, 1984.
Haarlem 1986
 Haarlem, Frans Hals Museum. *Portretten van echt en trouw. Huwelijk en gezin in de Nederlandse kunst van de zeventiende eeuw.* Catalogue by E. de Jongh et al. 1986.
Haberditzl 1908
 F. M. Haberditzl. "Die Lehrer des Rubens." *Jahrbuch der Kunsthistorischen Sammlungen des allerhöchsten Kaiserhauses* 27 (1908), pp. 161-235.
van der Haeghen 1906
 Victor van der Haeghen. *La Corporation des Peintres et des Sculpteurs de Gand, XVIe - XVIIe siècles.* Brussels, 1906.
The Hague/San Francisco 1990-91
 The Hague, Koninklijk Kabinet van Schilderijen Mauritshuis, and the Fine Arts Museums of San Francisco. *Great Dutch Paintings from America.* Catalogue by Ben Broos et al. 1990-91.
The Hague 1992
 The Hague, Koninklijk Kabinet van Schilderijen Mauritshuis. *Mauritshuis in Bloei: Boeketten uit de Gouden eeuw (The Mauritshuis in Bloom: Bouquets from the Golden Age).* Catalogue by Beatrijs Brenninkmeyer-de Rooij et al. 1992.
The Hague, Mauritshuis, cat. 1895
 The Hague, Mauritshuis. *Catalogue raisonné des tableaux et des sculptures.* Catalogue by C. Hofstede de Groot and A. Bredius. 1895.
The Hague, Mauritshuis, cat. 1977
 The Hague, Koninklijk Kabinet van Schilderijen Mauritshuis. *Illustrated General Catalogue.* 1977.
The Hague, Mauritshuis, cat. 1985
 The Hague, Koninklijk Kabinet van Schilderijen Mauritshuis. *The Royal Picture Gallery Mauritshuis.* Edited by H. R. Hoetink. Amsterdam and New York, 1985.
The Hague, Rijksdienst, cat. 1985
 The Hague, Rijksdienst Beeldende Kunst. *Seventeenth-Century North Netherlandish Still Lifes (Catalogue of Paintings by Artists Born before 1870, vol. 6).* Catalogue by Onno ter Kuile. 1985.
Hairs 1951
 Marie-Louise Hairs. "Osias Beert l'Ancien, Peintre de Fleurs." *Revue belge d'Archéologie et d'Histoire de l'Art* 20 (1951), pp. 237-251.
Hairs 1953
 —. "Deux Tableaux de Fleurs attribués à l'atelier d'Osias Beert." *Bulletin des Musées Royaux des Beaux-Arts de Belgique* 5 (1953), pp. 21-26.
Hairs 1955
 —. *Les Peintres flamands de fleurs au XVIIe siècle.* Paris/Brussels, 1955.
Hairs 1957
 —. "Collaboration dans des tableaux de fleurs flamands." *Revue belge d'Archéologie et d'Histoire de l'Art* 26 (1957), pp. 149-162.
Hairs 1960
 —. "Pour un tricentenaire. Daniël Seghers (1590-1661)." *Revue belge d'Archéologie et d'Histoire de l'Art* 29 (1960), pp. 205-227.
Hairs 1965a
 —. *Les Peintres flamands de fleurs au XVIIe siècle.* 2nd ed. Brussels, 1965.
Hairs 1965b
 —. "Théodore van Thulden (1606-1669)." *Revue belge d'Archéologie et d'Histoire de l'Art* 34 (1965), pp. 11-73.
Hairs 1966
 —. "Jean Boeckhorst, Satellite de Rubens." *Revue belge d'Archéologie et d'Histoire de l'Art* 35 (1966), pp. 27-49.
Hairs 1968
 —. "Le peintre anversois Erasme Quellin à Liège." *Fédération Archéologique et Historique de Belgique, Annales du Congrès de Liège* (1968), pp. 141-157.
Hairs 1973
 —. "Erasme Quellin, disciple de Rubens." *Revue belge d'Archéologie et d'Histoire de l'Art* 42 (1973), pp. 31-74.
Hairs 1977
 —. *Dans le sillage de Rubens. Les peintres d'histoire anversoise au XVIIe siècle.* Liège, 1977.
Hairs 1985
 —. *The Flemish Flower Painters of the XVIIth Century.* Translated by Eva Grzelak. Brussels, 1985.
Hanover/Raleigh/Houston/Atlanta 1991-93
 Hanover, NH, Hood Museum of Art, Dartmouth College. *The Age of the Marvelous.* Edited by Joy Kenseth. 21 September-24 November 1991. Also shown at Raleigh, North Carolina Museum of Art, 25 January-22 March 1992; Houston, The Museum of Fine Art, 24 May-25 August 1992; and Atlanta, High Museum of Art, 6 October 1992-3 January 1993.
Hanschke 1988
 U. Hanschke. *Die flämische Waldlandschaft. Anfänge und Entwicklungen im 16. und 17. Jahrhundert.* Worms, 1988.
Härting 1989
 Ursula Härting. *Frans Francken der Jüngere (1581-1642). Die Gemälde mit kritischem Œuvrekatalog.* Freren, 1989.
Härting, Müllenmeister 1988
 Ursula Härting and K. J. Müllenmeister. *Mythologie und ein Bibelthema in vlämischen Gemälden des Brueghel-Kreises um 1600.* Solingen, 1988.
van den Haute n.d.
 Charles van den Haute. *La Corporation des Peintres de Bruges.* Bruges, n.d.
Haverkamp Begemann 1975
 E. Haverkamp Begemann. *The Achilles Series. (Corpus Rubenianum Ludwig Burchard, Part X).* London, 1975.
Hecquet 1751
 R. Hecquet. *Catalogue des Estampes gravées d'après Rubens.* Paris, 1751.
Heidrich 1924
 E. Heidrich. *Vlämische Malerei.* Jena, 1924.
Heins 1914
 A. Heins. "Les frères de Vos." *Bulletin de la Société d'Histoire et d'Archéologie de Gand* 22 (1914), pp. 175-182.
Helbig 1873
 J. Helbig. *Histoire de la peinture au pays de Liège.* Liège, 1873.
Helbig 1903
 —. *La Peinture au pays de Liège et sur les bords de la Meuse.* 2nd ed. Liège, 1903.
Helbig 1911
 —. *L'Art Mosan depuis l'Introduction du Christianisme jusqu'à la fin du XVIIIe siècle.* 2 vols. Brussels, 1911.
Held 1933
 Julius S. Held. "Nachträglicher veränderte Kompositionen bei Jacob Jordaens." *Revue belge d'Archéologie et d'Historie de l'Art* 3 (1933), pp. 214-223.
Held 1939
 —. "Malerier og tegininger af Jacob Jordaens i Kunstmuseet." *Kunstmuseets Årskrift* 26 (1939), pp. 1-43.
Held 1940a
 —. "Unknown Paintings by Jordaens in America." *Parnassus* 12 (1940), pp. 26-29.
Held 1940b
 —. "Jordaens' Portraits of His Family." *Art Bulletin* 22 (1940), pp. 70-82.
Held 1949
 —. "Jordaens and the Equestrian Astrology," in *Miscellanea Leo van Puyvelde* (Brussels, 1949), pp. 153-156. Reprinted in Held 1982a, pp. 32-34.
Held 1951
 —. "A Supplement to 'Het Caravaggisme te Gent.'" *Gentse Bijdragen tot de Kunstgeschiedenis* 13 (1951), pp. 7-12.
Held 1952
 —. "'The Burdens of Time,' a Footnote on Abraham Janssens." *Bulletin des Musées Royaux des Beaux-Arts de Belgique* 1 (1952), pp. 11-17.

Held 1954
—. *Peter Paul Rubens*. New York, 1954.

Held 1955
—. "Notes on Flemish Seventeenth Century Painting: Jacob van Oost and Theodor van Loon." *The Art Quarterly* 18 (1955), pp. 146-157.

Held 1956
—. "Drawings and Oil Sketches by Rubens from American Collections." *The Burlington Magazine* 98 (1956), pp. 123-124.

Held 1957
—. "Artis Pictoriae Amator. An Antwerp Art Patron and His Collection." *Gazette des Beaux-Arts* ser. 6, 50 (1957), pp. 53-84; reprinted in Held 1982a, pp. 35-64.

Held 1958
—. "Le Roi à la Ciasse." *Art Bulletin* 40 (1958), pp. 138-149. Reprinted in Held 1982a, pp. 65-79.

Held 1959
—. *Rubens: Selected Drawings*. 2 vols. New York, 1959.

Held 1965
—. "Notes on Jacob Jordaens." *Oud Holland* 80 (1965), pp. 112-122.

Held 1967
—. "Jan van Boeckhorst as Draughtsman." *Bulletin des Musées Royaux des Beaux-Arts de Belgique* 16 (1967), pp. 137-154.

Held 1969
—. "Jordaens at Ottawa." *The Burlington Magazine* 111 (1969), pp. 265-272.

Held 1974
—. Review of Vlieghe 1972. *Art Bulletin* 56 (1974), pp. 452-454.

Held 1980
—. *The Oil Sketches of Peter Paul Rubens*. 2 vols. Princeton, 1980.

Held 1982a
—. *Rubens and His Circle. Studies by Julius S. Held*. Edited by A. W. Lowenthal, D. Rosand, and J. Walsh, Jr. Princeton, 1982.

Held 1982b
—. "Rubens and Titian," in D. Rosand ed., *Titian, His World and His Legacy* (New York, 1982), pp. 283-339.

Held 1983a
—. "The Case against the Cardiff 'Rubens' Cartoons." *The Burlington Magazine* 125 (1983), pp. 132-136.

Held 1983b
—. "Thoughts on Rubens' Beginnings." *The Ringling Museum of Art Journal* 1983, pp. 14-35.

Held 1985
—. "Nachträge zum werk des Johann Bockhorst (alias Jan Boeckhorst)." *Westfalen* 63 (1985), pp. 14-37.

Held 1986a
—. *Rubens: Selected Drawings*. Second revised ed. Mt. Kisco, NY, 1986.

Held 1986b
—. "Some Studies of Heads by Flemish and Dutch Seventeenth-Century Artists." *Master Drawings* 23-24 (1986), pp. 46-53.

Hendrick 1934
Jacques Hendrick. "Bertholet Flémalle." Unpublished thesis, Université de Liège, 1934.

Hendrick 1973
—. *La Peinture Liégeoise au XVIIe siècle*. Gembloux, 1973.

Hendrick 1977
—. "Rectifications d'attributions et identifications de tableaux de peintres liégeois des XVIe et XVIIe siècles." *Bulletin de la Société Royale de Le Vieux Liège* 9 (1977), pp. 137-154.

Hendrick 1987
—. *La Peinture au pays de Liège, XVIe, XVIIe et XVIIIe siècles*. Liège, 1987.

Henkel, Schöne 1967
Arthur Henkel and Albrecht Schöne. *Emblemata: Handbuch zur Sinnbildkunst des XVI. und XVII. Jahrhunderts*. Stuttgart, 1967.

Hensbroek-van der Poel 1986
D. B. Hensbroek-van der Poel. Review of D. W. Steadman, *Abraham van Diepenbeeck*. *Oud Holland* 100 (1986), pp. 206-208.

Herluison 1872
H. Herluison. *Recueil des actes concernant les artistes....* Orleans, 1872.

Herluison 1873
—. *Actes d'état civil d'artistes français*. Orléans, 1873.

's-Hertogenbosch 1970
's-Hertogenbosch, Noordbrabants Museum. *Theodoor van Thulden 1606-1669*. Catalogue by G. J. Schweitzer. 1970.

's-Hertogenbosch/Strasbourg 1991-92
's-Hertogenbosch, Noordbrabants Museum. *Theodoor van Thulden: Een Zuidnederlandse barokschilder/Un peintre baroque du cercle de Rubens*. Catalogue by Alain Roy et al. 7 December 1991-23 February 1992. Also shown at Strasbourg, Musée des Beaux-Arts, 13 March-17 May 1992.

Herzner 1979
Volker Herzner. "Honor refertur ad prototypa. Noch einmal zu Rubens' Alterwerken für die Chiesa Nuova in Rom." *Zeitschrift für Kunstgeschichte* 42 (1979), pp. 117-132.

Hezenmans 1894
J. A. C. Hezenmans. "Abraham van Diepenbeeck." *Taxandria* 1 (1894), pp. 69-91, 270-273.

Höhne 1960
Erich Höhne. *Adriaen Brouwer*. Leipzig, 1960.

Hoet 1752
Gerard Hoet. *Catalogus of Naamlyst van schilderyen*. 3 vols. in 2. The Hague, 1752.

Hoffman 1979
M. Hoffman. *The Rubens Year 1977: a Bibliography*. Uppsala, 1979.

Hofstede de Groot 1908-27
Cornelis Hofstede de Groot. *A Catalogue Raisonné of the Works of the Most Eminent Dutch Painters of the Seventeenth Century*. Translated by Edward G. Hawke. 8 vols. London, 1908-27.

Hollstein 1949-
F. W. H. Hollstein. *Dutch and Flemish etchings, engravings and woodcuts*. Vols. 1-. Amsterdam 1949-.

Hoogewerff 1911
G. J. Hoogewerff. "Nadere gegevens over Michiel Sweerts." *Oud Holland* 29 (1911), pp. 134-138.

Hoogewerff 1913
—. *Bescheiden in Italië omtrent Nederlandsche kunstenaars en geleerden*. The Hague, 1913.

Hoogewerff 1916
—. "Michael Sweerts te Rome." *Oud Holland* 34 (1916), pp. 109-110.

Hoogewerff 1942-43
—. *Nederlandsche Kunstenaars te Rome (1600-1725): Uittreksels uit de pariochiale archieven*. 2 vols. The Hague, 1942-43.

Hoogewerff 1952
—. *De Bentvueghels*. The Hague, 1952.

Hoogewerff 1954
—. *Het landschap van Bosch tot Rubens*. Antwerp, 1954.

van Hoogstraten 1678
Samuel van Hoogstraeten [Hoogstraten]. *Inleyding tot de hooge schoole der Schilderkonst: Anders de Zichtbaere Werelt*. Rotterdam, 1678. Reprint Soest, 1969.

Horster 1974
H. Horster. "Antikkenntis in Michiel Sweerts 'Römischen Ringkampf.'" *Jahrbuch der Staatlichen Kunstsammlungen in Baden-Württemberg* 11 (1974), pp. 145-158.

Houbraken 1718-21
Arnold Houbraken. *De Groote Schouburgh der Nederlantsche Konstschilders en Schilderessen*. 3 vols. Amsterdam, 1718-21; 2nd printing, Amsterdam, 1753. Reprints: Maastricht, 1943-53 (P. T. Swillens, ed.); Amsterdam, 1976.

Huemer 1977
Frances Huemer. *Portraits (Corpus Rubenianum Ludwig Burchard, part XIX, vol. 1)*. Brussels, 1977.

d'Hulst 1946
R.-A. d'Hulst. "Jacob van Oost de oude. Brugsch schilder der 17de eeuw." Unpublished thesis, Ghent, 1946.

d'Hulst 1951
—. "Caravaggeske invloeden in het œuvre van Jacob van Oost de Oude, schilder van Brugge." *Gentse Bijdragen tot de Kunstgeschiedenis* 13 (1951), pp. 169-192.

d'Hulst 1952
—. "Jacob Jordaens en de 'Allegorie van Vruchtbaarheid.'" *Bulletin des Musées Royaux des Beaux-Arts de Belgique* 1 (1952), pp. 18-31.

d'Hulst 1953a
—. "Jacob Jordaens. Schets van een chronologie zijner werken, ontstaan vóór 1618." *Gentse Bijdragen tot de Kunstgeschiedenis* 14 (1953), pp. 89-138.

d'Hulst 1953b
—. "Zeichnungen von Jacob Jordaens aus seiner Frühzeit, bis etwa 1618." *Zeitschrift für Kunstgeschichte* 16 (1953), pp. 208-220.

d'Hulst 1956a
—. *De tekeningen van Jacob Jordaens. Bijdrage tot de geschiedenis van de XVIIe-eeuwse kunst in de Zuidelijke Nederlanden. (Verhandelingen van de Koninklijke Vlaamse Academie voor Wetenschappen, Letteren en Schone Kunsten van België, Klasse der Schone Kunsten, 10)*. Brussels, 1956.

d'Hulst 1956b
—. "Jordaens and His Early Activities in the Field of Tapestry." *Art Quarterly* 19 (1956), pp. 236-254.

d'Hulst 1961
—. "Jacob Jordaens. Apollo beurtelings in strijd met Marsyas en Pan." *Bulletin des Musées Royaux des Beaux-Arts de Belgique* 10 (1961), pp. 28-36.

d'Hulst 1966a
—. "Enkele onbekende schilderijen van Jacob Jordaens." *Gentse Bijdragen tot de Kunstgeschiedenis* 19 (1961-66), pp. 81-94.

d'Hulst 1966b
—. "Over een schilderij en een schets van David III Ryckaert." *Gentse Bijdragen tot de Kunstgeschiedenis* 19 (1961-66), pp. 95-101.

d'Hulst 1967a
—. "Drie vroege schilderijen van Jacob Jordaens." *Gentse Bijdragen tot de Kunstgeschiedenis* 20 (1967), pp. 71-86.

d'Hulst 1967b
—. "Jacob Jordaens en de Schilderskamer van de Antwerpse Academie." *Jaarboek van het Koninklijk Museum voor Schone Kunsten, Antwerpen* 1967, pp. 131-149.

d'Hulst 1969a
—. "Abraham Janssens (1574/75-1632), Scaldis en Antwerpia." *Openbaar Kunstbezit in Vlaanderen* 7 (1969), pp. 4a-4b.

d'Hulst 1969b
—. Review of Ottawa 1968-69. *Art Bulletin* 51 (1969), pp. 378-388.

d'Hulst 1970
—. "Cornelis de Vos (1583/84-1651), Portret van de kunstenaar en zijn gezin." *Openbaar Kunstbezit in Vlaanderen* 8 (1970), pp. 6a-6b.

d'Hulst 1972
—. "Enkele tekeningen van Cornelis Schut." *Nederlands Kunsthistorisch Jaarboek* 23 (1972), pp. 303-316.

d'Hulst 1973
—. "Enkele tekeningen van Theodoor van Thulden," in *Album Amicorum J. G. van Gelder* (The Hague, 1973), pp. 186-190.

d'Hulst 1974
—. *Jordaens Drawings.* (Monographs of the Nationaal Centrum voor de Plastische Kunsten van de XVIde en XVIIde Eeuw, 5). 4 vols. Brussels/London/New York, 1974.

d'Hulst 1980
—. "Jordaens Drawings: Supplement I." *Master Drawings* 18 (1980), pp. 360-370.

d'Hulst 1981
—. "Enkele aanvullingen bij het œuvre van Van Uden en Van Thulden," in *Feestbundel bij de opening van het Kolveniershof en het Rubenianum* (Antwerp, 1981), pp. 495-501.

d'Hulst 1982
—. *Jacob Jordaens.* London, 1982.

d'Hulst, Vandenven 1989
R. A. d'Hulst and M. Vandenven. *The Old Testament* (Corpus Rubenianum Ludwig Burchard, part III). London, 1989.

Huvenne 1985
Paul Huvenne. "Een Vruchtenkrans van Frans Snijders herontdekt," in *Rubens and His World. Bijdragen opgedragen aan Prof. Dr. Ir. R.-A. d'Hulst* (Antwerp, 1985), pp. 193-200.

Hymans 1879
Henri Simon Hymans. *La gravure dans l'école de Rubens.* Brussels, 1879.

Hymans 1893
—. *Lucas Vorsterman. Catalogue raisonné de son œuvre précédé d'une notice sur la vie et les ouvrages du maître.* Brussels, 1893.

Hymans 1894
—. "Le Musée du Prado: Clara Peeters." *Gazette des Beaux-Arts* 11 (1894), p. 192.

Hymans 1920
—. *Œuvres de Henri Hymans, études et notices relatives à l'histoire de l'art dans les Pays-Bas*, vol. 2: *Près de 700 biographies d'artistes belges.* Brussels, 1920.

Immerzeel 1842-43
J. Immerzeel. *De Levens en werken der Hollandsche en Vlaamsche kunstschilders, beeldhouwers, graveurs en bouwmeesters van het begin der 15de eeuw tot heden.* 3 vols. Amsterdam, 1842-43.

Incisa della Rocchetta 1959
G. Incisa della Rocchetta. "La mostra di Michael Sweerts a Roma." *Arte Antica e Moderna* 2 (1959), pp. 115-118.

Incisa della Rocchetta 1961
—. "Tre altri quadri di Giovanni de Momper." *Arte Antica e Moderna* 13/16 (1961), pp. 388-390.

Incisa della Rocchetta 1962-63
—. "Documenti editi e inediti sui quadri del Rubens nella Chiesa Nuova." *Atti della Pontificia Accademia Romagna di Archeologia, III series, Rendiconti* 35 (1962-63), pp. 161-183.

van Isacker, van Uytven 1986
Karel van Isacker and Raymond van Uytven, eds. *Antwerp. Twelve Centuries of History and Culture.* Antwerp, 1986.

Jaffé 1953
Michael Jaffé. "Rubens' Sketching in Paint." *Art News* 52 (May 1953), pp. 34-37, 64-67.

Jaffé 1963
—. "Peter Paul Rubens and the Oratorian Fathers." *Proporzioni* 4 (1963), pp. 209-241.

Jaffé 1966
—. *Van Dyck's Antwerp Sketchbook.* 2 vols. London, 1966.

Jaffé 1969
—. "Reflections on the Jordaens Exhibition." *Bulletin of the National Gallery of Canada* 13 (1969), pp. 1-40.

Jaffé 1971a
—. "Figure Drawings Attributed to Rubens, Jordaens and Cossiers in the Hamburg Kunsthalle." *Jahrbuch der Hamburger Kunstsammlungen* 16 (1971), pp. 39-50.

Jaffé 1971b
—. "Rubens and Snijders: A Fruitful Partnership." *Apollo* 93 (1971), pp. 184-196.

Jaffé 1977
—. *Rubens and Italy.* Oxford, 1977.

Jaffé 1983a
—. "Rubens's Aeneas Cartoons at Cardiff." *The Burlington Magazine* 125 (1983), pp. 136-150.

Jaffé 1983b
—. "The Aeneas Cartoons at Cardiff: not Boeckhorst, Rubens." *The Burlington Magazine* 125 (1983), pp. 480-487.

Jaffé 1984
—. Review of d'Hulst 1974 and d'Hulst 1982. *The Burlington Magazine* 126 (1984), pp. 783-787.

Jaffé, Cannon-Brookes 1986
Michael Jaffé and Peter Cannon-Brookes. ". . . Sono dissegni coloriti di Rubens." *The Burlington Magazine* 128 (1986), pp. 780-785.

Jal 1872
Auguste Jal. *Dictionnaire critique de biographie et d'histoire.* 2nd ed. Paris, 1872.

Janeck 1968
A. Janeck. *Untersuchung über den holländischen Maler Pieter van Laer, genannt Bamboccio.* Diss. Würzburg, 1968.

Jannasch 1940
A. Jannasch. *Die Niederländischen Maler des 17 Jahrhunderts.* (Propyläen Kunstgeschichte). 4th ed. Berlin, 1940.

Jans 1968
René Jans. "Un duel à Liège qui eut ses répercussions sur l'histoire de l'Art." *Chronique Archéologique du Pays de Liège* 59 (1968), pp. 43-48.

Jans 1989
—. "D'autres peintres Damery (et apparentés, Taulien et les Lairesse) qui ont compté." *Bulletin de l'Institut Archéologique Liégeois* (1989), pp. 49-72.

Jansen, Van Herck 1949
A. Jansen and C. Van Herck. *Kerkelijke Kunstschatten.* Antwerp, 1949.

Jost 1963
Ingrid Jost. "Hendrik van Balen. Versuch einer Chronologie der Werke aus den ersten Zwei Jahrzehnten des siebzehnten Jahrhunderts unter besonderer Berücksichtigung der Kabinettsbilder." *Nederlands Kunsthistorisch Jaarboek* 14 (1963), pp. 83-128.

Judson, van de Velde 1978
J. Richard Judson and Carl van de Velde. *Book Illustrations and Title Pages* (Corpus Rubenianum Ludwig Burchard, part XXI). 2 vols. London/Philadelphia, 1978.

Juten 1911
W. J. F. Juten. "De Schildersfamilie van Diepenbeeck." *Taxandria* 8 (1911), pp. 97-100.

Kahr 1975
Madlyn Millner Kahr. "Velásquez and *Las Meninas*." *Art Bulletin* 57 (1975), pp. 225-246.

Kalinowski 1960
K. Kalinowski. "Pejzaz Josse de Momper w zbiorach poznanskich (Paysages de Josse de Momper dans les collections de Poznan)." *Biuletyn histori sztuki* 22 (1960), pp. 65-77.

G. Kauffmann 1957
G. Kauffmann. "Studien zum Grossen Malerbuch des Gérard de Lairesse." *Jahrbuch für Aesthetik und Allgemeine Kunstwissenschaft* 3 (1955/57), pp. 153-196.

Kauffmann 1927
H. Kauffmann. "Die Wandlung des Jacob Jordaens," in *Festschrift Max J. Friedländer* (Leipzig, 1927), pp. 191-208.

Kaufmann 1988
Thomas DaCosta Kaufman. *The School of Prague: Painting at the Court of Rudolf II.* Chicago/London, 1988.

Keersemaekers 1982
A. Keersemaekers. "De Schilder Sebastiaen Vrancx (1573-1647) als rederijker." *Jaarboek van het Koninklijk Museum voor Schone Kunsten, Antwerpen* 1982, pp. 165-186.

Keiser 1931
E. Keiser. "Tizians und Spaniens Einwirkungen auf die späteren Landschaften des Rubens." *Münchner Jahrbuch der bildenden Kunst n.f.* 8 (1931), pp. 281-291.

Keiser 1942
—. "Die Rubensliteratur seit 1935." *Zeitschrift für Kunstgeschichte* 10 (1942), pp. 300-319.

van der Kellen 1866
J. Philip van der Kellen. *Le Peintre-graveur hollandais et flamand.* Utrecht, 1866.

Kervyn de Meerendré 1976
Michel Kervyn de Meerendré. "Jacques d'Arthois (1613-86)," in *XLIVe Session, Congrès de Huy, Annales, Fédération des Cercles d'Archéologie et d'Histoire de Belgique* (1976), vol. 3, pp. 841-847.

Kervyn de Volkaersbeke 1857-58
Ph. A. Kervyn de Volkaersbeke. *Les églises de Gand.* 2 vols. Ghent, 1857-58.

Kieckens 1884a
P. Fr. Kieckens. "Daniel Seghers, de la Compagnie de Jésus, peintre de fleurs, sa vie et ses œuvres 1590-1661." *Annales de l'Académie d'Archéologie de Belgique* 40 (1884), pp. 355-467.

Kieckens 1884b
—. "Daniel Seghers en eenige zijner tijdgenooten en bewonderaars." *De Vlaamsche School* (1884), pp. 13-18.

Klinge 1990
Margret Klinge. "David Teniers the Younger (1610-1690), Fashion

and Taste," in *1990 Handbook of the European Art Fair* (Maastricht, 1990), pp. 22-27.

Klinge-Gross 1969
Margret Klinge-Gross. "Zu einigen datierten Frühwerken von David Teniers d. J. aus dem Jahre 1633." *Jaarboek van het Koninklijk Museum voor Schone Kunsten, Antwerpen* 1969, pp. 181-200.

Kloos 1989
Titia Kloos. "Het feestmaal van Cleopatra door Gerard Lairesse." *Bulletin van het Rijksmuseum* 37 (1989), pp. 91-115.

Knipping 1974
John B. Knipping. *Iconography of the Counter Reformation in the Netherlands: Heaven on Earth*. 2 vols. Nieuwkoop/Leiden, 1974.

Knuttel 1962
Gerard Knuttel. *Adriaen Brouwer: The Master and His Work*. Translated by J. G. Talma-Schilthuis and Robert Wheaton. The Hague, 1962.

Koester 1966
O. Koester. "Josse de Momper the Younger, Prolegomena to the Study of His Paintings." *Artes* 2 (1966), pp. 5-70.

Konecny 1983
Lubomir Konecny. "Überlegungen zu einem Stilleben von Pieter Boel (Samt einigen Hypothesen zum Grafen von Arundel und W. Hollar)." *Artibus et Historiae* 7 (1983), pp. 125-139.

Kramm 1857-64
Christiaan Kramm. *De levens en werken der Hollandsche en Vlaamsche kunstschilders, beeldhouwers, graveurs, en bouwmeesters, van den vroegsten tot op onzen tijd*. 6 vols. Amsterdam, 1857-64.

Kraus 1952
K. Kraus. "Zwei Altarbilder von Gaspar de Crayer in der Gymnasialkirche zu Meppen," in *Meppen, Festschrift zur 300-Jahrsfeier des Gymnasiums zu Meppen* (Meppen, 1952), pp. 45-65.

Kronig 1910
J. O. Kronig. "Ueber einige Bilder von Michael Sweerts." *Zeitschrift fur bildende Kunst* n.s. 21 (1910), pp. 45-48.

Kultzen 1954
R. Kultzen. *Michael Sweerts (1624-64)*. Hamburg, 1954.

Kultzen 1980
—. "Frühe Arbeiten von Michael Sweerts." *Pantheon* 38 (1980), pp. 64-68.

Kultzen 1982
—. "Michael Sweerts als Lernender und Lehrer." *Münchner Jahrbuch der bildenden Künste* 33 (1982), pp. 109-130.

Kultzen 1983
—. "Französische Anklänge im Werk von Michael Sweerts," in *Essays in Northern European Art Presented to Egbert Haverkamp Begemann on His Sixtieth Birthday* (Doornspijk, 1983), pp. 127-133.

Kultzen 1987
—. "Michael Sweerts als Bildnismaler." *Wiener Jahrbuch für Kunstgeschichte* 40 (1987), pp. 207-217.

Kumsch 1899
E. Kumsch. *Ein Wandteppich des 17. Jahrhunderts von Cornelis Schut.* Dresden, 1899.

Labègue 1943
R. Labègue. *Les correspondants de Peiresc dans les anciens Pays-Bas.* Brussels, 1943.

Laes 1931a
Arthur Laes. "Jan Siberechts, peintre anversois du XVIIe siècle," in *Gedenkboek A. Vermeylen* (Bruges, 1931), pp. 243-249.

Laes 1931b
—. "Un paysagiste flamande de la fin du 16e siècle: Kerstiaen de Keuninck," in *Mélanges Hulin de Loo* (Brussels/Paris, 1931), pp. 225-230.

Laes 1939
—. "Gillis van Coninxloo, rénovateur du paysage flamand au XVIe siècle." *Annuaire des Musées Royaux des Beaux-Arts* (Bruxelles) 2 (1939), pp. 109-122.

Laes 1949
—. "Le paysage flamand. Notes, remarques, reflexions," in *Miscellanea Leo van Puyvelde* (Brussels, 1949), pp. 166-182.

Laes 1950
—. "Autour d'un tableau oublié de Jean Cossiers." *Revue belge d'Archéologie et d'Histoire de l'Art* 19 (1950), pp. 43-49.

Laes 1952
—. "Paysages de Josse et Frans de Momper." *Bulletin des Musées Royaux des Beaux-Arts de Belgique* 1 (1952), pp. 57-67.

Laes 1958
—. "Le paysage flamand au Musée de Glasgow, Jacques d'Arthois, Corneille Huysmans dit de Malines, Jean-François van Bloemen dit Orizonte." *Revue belge d'Archéologie et d'Histoire de l'Art* 27 (1958), pp. 3-28.

Lahrkamp 1982
Helmut Lahrkamp. "Der 'Lange Jan,' Leben und Werke des Barockmalers Johann Bockhorst aus Münster." *Westfalen* 60 (1982), pp. 3-199.

Lanzi 1882
Luigi Lanzi. *Storia pittorica della Italia, dal risorgimento delle belle arti fin presso al fine del XVIII secolo.* 4th ed. Florence, 1882.

Larsen 1948
Eric Larsen. "Denis van Alsloot, Peintre de la Forêt de Soignes."

Gazette des Beaux-Arts ser. 6, vol. 34 (1948), pp. 331-354.

Larsen 1952
—. *P. P. Rubens, with a Complete Catalogue of His Works in America.* Antwerp, 1952.

Larsen 1967
—. *Flemish Painting Seventeenth Century.* New York, 1967.

Larsen 1970
—. "Some Seventeenth-century Paintings of Brazil," *Connoisseur* 175 (1970), pp. 123-131.

Larsen 1980
—. *L'opera completa di Van Dyck.* 2 vols. Milan, 1980.

Larsen 1985
—. *17th Century Flemish Painting.* Freren, 1985.

Larsen 1988
—. *Van Dyck: The Paintings.* 2 vols. Freren, 1988.

Launay 1894
Adrien Launay. *Histoire générale de la Société des Missions étrangères.* 3 vols. Paris, 1894.

Launay 1905
—. *Lettres de Monseigneur Pallu.* Angoulême, 1905.

Laureyssens 1960
Willy Laureyssens. *Theodor van Thulden, zijn leven en zijn werk.* Unpubl. thesis, Rijksuniversiteit Ghent, 1960.

Laureyssens 1966a
—. "Hendrick De Clercks triptiek uit de Kapellekerk te Brussel." *Bulletin des Musées Royaux des Beaux-Arts de Belgique* 15 (1966), pp. 165-176.

Laureyssens 1966b
—. "Hendrick De Clercks Kruisafneming uit de Sint-Pieters- en Guidokerk te Anderlecht." *Bulletin des Musées Royaux des Beaux-Arts de Belgique* 15 (1966), pp. 257-264.

Laureyssens 1967
—. "De Samenwerking Hendrick de Clerck en Denijs van Alsloot." *Bulletin des Musées Royaux des Beaux-Arts de Belgique* 16 (1967), pp. 163-178.

Laureyssens 1985-88
—. "Enkele nieuwe gegevens over Hendrik de Clerck." *Bulletin des Musées Royaux des Beaux-Arts de Belgique* 35-37 (1985-88), pp. 111-117.

Lavalleye 1936
J. L[avalleye]. "Abraham Janssens, peintre néoromainiste." *Bulletin de l'Institut historique belge de Rome* 17 (1936), pp. 324-325.

Le Blanc 1854-89
Ch. Le Blanc. *Manuel de l'amateur d'estampes.* 4 vols. Paris, 1854-89.

le Comte 1699-1700
Florent le Comte. *Cabinet des Singularitez d'architecture, peinture, sculpture et gravure.* 3 vols. Paris, 1699-1700.

Lefèvre 1945
Pl. F. Lefèvre. "Documents relatifs aux vitraux de Sainte Gudule, Bruxelles, du XVIe et du XVIIe siècle." *Revue belge d'Archéologie et d'Histoire de l'Art* 15 (1945), pp. 124-129, 143-147.

Legrand 1956
Francine Claire Legrand. "Erasme Quellin, peintre de batailles." *Bulletin des Musées Royaux des Beaux-Arts de Belgique* 5 (1956), pp. 61-69.

Legrand 1963
—. *Les Peintres flamands de genre au XVIIe siècle.* Brussels/Paris, 1963.

Leningrad, Hermitage, cat. 1958
Leningrad, The Hermitage. *Musée de l'Ermitage, Département de l'Art Occidental, Catalogue des Peintures, vol. 2.* 1958.

Leningrad, Hermitage, cat. 1981
Leningrad, The Hermitage. *Musée de l'Ermitage, Catalogue 2: Peinture de l'Europe Occidentale.* 1981.

Leppert 1977
Richard D. Leppert. *The Theme of Music in Flemish Paintings of the Seventeenth Century.* 2 vols. Munich, 1977.

Leppert 1978
—. "David Teniers the Younger and the Image of Music." *Jaarboek van het Koninklijk Museum voor Schone Kunsten, Antwerpen* 1978, pp. 63-155.

van Lerius 1874
Th. van Lerius. *Catalogue du Musée Royal des Beaux-Arts d'Anvers.* Antwerp, 1874.

van Lerius 1880-81
—. *Biographies d'artistes anversois.* 2 vols. Antwerp, 1880-81.

Lesmarie 1930
M. Lesmarie. "A propos du portraitiste Jean de Reyn (1610-1678)." *Bulletin des Musées de France* 2 (1930), pp. 112-113.

Lesuisse 1953
R. Lesuisse. *Le sculpteur Jean Del Cour.* Nivelles, 1953.

Leurs 1939
Stan Leurs et al. *Geschiedenis van de Vlaamsche Kunst.* 2 vols. Antwerp, 1939.

Levensbeschryving 1774-83
Levensbeschryving van eenige voornaame meest Nederlandse mannen en vrouwen. 10 vols. Amsterdam/Harlingen, 1774-83.

Levin 1888
Theodor Levin. "Handschriftliche Bemerkungen von Erasmus

Quellinus." *Zeitschrift für bildende Kunst* 23 (1888), pp. 133-138; 171-176.

Libertus 1938
Br. Libertus M. *Lucas Faydherbe, Beeldhouwer en Bouwmeester.* Antwerp, 1938.

Liedtke 1983
Walter A. Liedtke. "Clothing the Naked by Michiel Sweerts." *Apollo* 117 (1983), pp. 21-23.

Liedtke 1984-85
—. "Anthony van Dyck." *Metropolitan Museum of Art Bulletin* 42 (1984-85), pp. 4-48.

Liedtke et al. 1992
Flemish Paintings in America: A Survey of Early Netherlandish and Flemish Paintings in the Public Collections of North America (Flandria Extra Muros). Introduction by Walter A. Liedtke. Antwerp, 1992.

Liège 1975
Liège, Musée de l'art Wallon. *Le siècle de Louis XIV au pays de Liège (1580-1723).* September-November 1975. Catalogue by Jean Lejeune and Jacques Hendrick et al.

Lille/Calais/Arras 1977
Lille, Musée des Beaux-Arts. *Trésors des Musées du Nord de la France III: La Peinture flamande au temps de Rubens.* 1977. Also shown at Calais, Musée des Beaux-Arts, and Arras, Musée des Beaux-Arts.

Lind 1946
L. R. Lind. "The Latin Life of Peter Paul Rubens by His Nephew Philip, a Translation." *Art Quarterly* 9 (1946), pp. 37-44.

Lindemans 1912-13
J. Lindemans. "Gaspar de Crayer en zijne schilderijen in onze West-Brabantse kerken." *Eigen Schoon* 2 (1912), pp. 97-100, 129-134, and 169-174; 3 (1913), pp. 65-72.

Lindemans 1949
—. "Een schilderij van Kaspar de Crayer in de kerk van Wieze." *Het Land van Aalst* 1 (1949), pp. 102-104.

Linnik 1956
Irina Linnik. "Gerard Seghers." *Gosudarstvennij Ermitaz* 1 (1956), pp. 167-177.

Linnik 1962
—. "Studies of Male Heads and Half Length Figures by Cornelis Schut." *Report of the Hermitage Museum (Leningrad Ermitazh Soobshcheniia)* 23 (1962), pp. 36-38 (in Russian).

Linnik 1970
—. "A Newly Identified Sketch by Cornelis Schut." *Report of the Hermitage Museum (Leningrad Ermitazh Soobshcheniia)* 31 (1970), pp. 21-23 (in Russian).

Logan 1977
Anne-Marie Logan. "Three Drawings by Johann Boeckhorst." *Master Drawings* 15 (1977), pp. 162-166.

Logan 1985
—. "The Prodigal Son Series – by Rubens or Van Thulden?" in *Rubens and His World. Bijdragen opgedragen aan R.-A. d'Hulst* (Antwerp, 1985), pp. 207-214.

London 1884
London, Davis' Gallery. *A Collection of One Hundred and Twenty Paintings by David Teniers, the Property of His Grace the Duke of Marlborough.* 1884.

London 1887
London, Grosvenor Gallery. *Exhibition of the Works of Sir Anthony van Dyck.* 1887.

London 1900
London, Royal Academy of Arts. *Exhibition of Works by Van Dyck, 1599-1641.* Winter 1900.

London 1927
London, Royal Academy of Arts. *Exhibition of Flemish and Belgian Art, 1300-1900.* 8 January-5 March 1927.

London 1953-54
London, Royal Academy of Arts. *Flemish Art, 1300-1700.* Catalogue by M. W. Brockwell et al. 1953-54.

London 1968
London, Thos. Agnew and Sons. *Exhibition Sir Anthony van Dyck.* London, 1968.

London 1972
London, Kenwood House. *Cabinet Pictures by David Teniers.* 1972.

London 1972-73
London, The Tate Gallery. *The Age of Charles I, Painting in England 1620-1649.* Catalogue by Oliver Millar. 1972-73.

London 1979
London, Brod Gallery. *Jan Brueghel the Elder.* Catalogue by Klaus Ertz. 1979.

London 1982-83
London, National Portrait Gallery. *Van Dyck in England.* Catalogue by Sir Oliver Millar. 1982-83.

London, National Gallery, cat. 1970
London, The National Gallery. *The Flemish School, circa 1600-circa 1900.* 1970. Catalogue by Gregory Martin.

London, Wallace, cat. 1992
London, The Wallace Collection. *The Wallace Collection Catalogue of Pictures IV: Dutch and Flemish.* 1992. Catalogue by John Ingamells.

Longhi 1934
Roberto Longhi. "Zu Michael Sweerts." *Oud Holland* 51 (1934), pp. 271-277.

Longhi 1950
—. "Michiel Sweerts: 'Vita in campagna.'" *Paragone* 3 (1950), pp. 57-58.

Longhi 1958
—. "Qualche appunti su Michele Sweerts." *Paragone* 107 (November 1958), pp. 73-74.

Longhi 1965
—. "Le prime incidenze Caravaggesche in Abraham Janssens." *Paragone* 183 (1965), pp. 51-52.

Lorthois 1966
Jacques Lorthois. "Notes sur la propriété du peintre Jacques d'Arthois à Boitsfort et à Bruxelles." *L'Intermédiaire des généalogistes* 125 (1966), pp. 265-267.

Los Angeles 1946-47
Los Angeles, County Museum of History, Science and Art. *Forty-three Paintings by Rubens and Twenty-five by van Dyck.* 1946-47.

Lugt 1921/1956
Fritz Lugt. *Les Marques de Collections, de Dessins et d'Estampes.* Amsterdam, 1921. Supplement, The Hague, 1956.

Lugt 1949
—. *Musée du Louvre. Inventaire général des dessins des écoles du Nord. Ecole flamande.* Paris, 1949.

Lynen 1901
A. Lynen. *Sebastian Vrancx.* Brussels, 1901.

Madrid 1977-78
Madrid, Palacio de Velázquez. *Pedro Pablo Rubens (1577-1640). Exposición Homenaje.* Catalogue by Matías Díaz Padrón. 1977-78.

Madrid 1992
Madrid, Museo del Prado. *David Teniers, Jan Brueghel y los Gabinetes de Pinturas.* Catalogue by Matías Díaz Padrón and Mercedes Royo-Villanova. 1992.

Madrid, cat. 1975
Madrid, Museo del Prado. *Catalogo de pinturas, I: Escuela Flamenca, siglo XVII.* 2 vols. Catalogue by Matías Díaz Padrón. 1975.

Madrid, cat. 1989
A. Balis, M. Díaz Padrón, C. van de Velde and H. Vlieghe. *De Vlaamse Schilderkunst in het Prado (Flandria Extra Muros).* Antwerp, 1989.

Maeterlinck 1900
L. Maeterlinck. "Gaspard de Crayer sa vie et ses œuvres à Gand." *Bulletin van de Maatschappij van Geschiedenis en Oudheidkunde van Gent (Bulletin de la Société d'histoire et d'archéologie de Gand)* 8 (1900), pp. 83-98.

Maeterlinck 1904
—. "Gérard Zegers et Frans Wouters au Musée de Gand." *Bulletin van de Maatschappij van Geschiedenis en Oudheidkunde van Gent (Bulletin de la Société d'histoire et d'archéologie de Gand)* 12 (1904), pp. 277-304.

de Maeyer 1953
Marcel de Maeyer. "Denijs van Alsloot (voor ca. 1573-1625 of 1626) en de tapijtkunst." *Artes Textiles* 1 (1953), pp. 3-11.

de Maeyer 1955
—. *Albrecht en Isabella en de Schilderkunst (Verhandelingen van de Koninklijke Vlaamse Academie voor Wetenschappen, Letteren en Schone Kunsten van België, 9).* Brussels, 1955.

Magurn 1955
Ruth Saunders Magurn. *The Letters of P. P. Rubens.* Cambridge, MA, 1955.

Mai 1991
Ekkehard Mai. "Gaspar de Crayer: Alexander und Diogenes, Ein Bild macht Politik." *Kölner Museums-Bulletin* 2 (1991), pp. 25-40.

Mâle 1932
Emile Mâle. *L'art religieux après le concile de Trente.* Paris, 1932.

de Man 1980
R. de Man. "Documenten over het mecenaat van R. Braye (ca. 1550-1632) te Kortrijk en de schilderijen van G. de Crayer en A. van Dyck." *Jaarboek van het Koninklijk Museum voor Schone Kunsten, Antwerpen* (1980), pp. 233-259.

van Mander 1604
Karel van Mander. *Het Schilderboeck.* Haarlem, 1604. Reprint Utrecht, 1973.

Manneback 1949
Marguerite Manneback. "Paul de Vos et François Snyders," in *Miscellanea Leo van Puyvelde* (Brussels 1949), pp. 147-152.

Mannheim 1962
Mannheim, Städtisches Reiss-Museum. *Die Frankenthaler Maler.* Catalogue by H. Wellensiek. 1962.

Mantua 1977
Mantua, Palazzo Ducale. *Rubens a Mantova.* Catalogue by G. Mullazzani et al. 25 September-20 November 1977.

Mantz 1879-80
Paul Mantz. "Adrien Brauwer." *Gazette des Beaux-Arts* ser. 2, 20 (1879), pp. 465-476; 21 (1880), pp. 26-49.

Marcel 1912
H. Marcel. "Un peintre de la vie rustique du XVIIe siècle: Jean Siberechts." *Gazette des Beaux-Arts* ser. 4, 8 (1912), pp. 366-378.

Marès 1887
F. Marès. "Beitrage zur Kentniss der Kunstsammlungen des Erzhertogs Leopold Wilhem." *Jahrbuch der Kunsthistorischen Sammlungen des allerhöchsten Kaiserhauses* 5 (1887), pp. 351ff.

Mariette 1853
Pierre Jean Mariette. *Abecedario.* Edited by P. de Chennevieres and A. de Montaiglon. (*Archives de l'art français* 4). Paris, 1853.

Marillier 1932
H. C. Marillier. *Handbook to the Teniers Tapestries.* London, 1932.

Marlier 1969
G. Marlier. *Pieter Brueghel le Jeune.* Brussels, 1969.

Marrow 1982
Deborah Marrow. *The Art Patronage of Maria de' Medici* (*Studies in Baroque Art History,* 4). Ann Arbor, 1982.

G. Martin 1968a
Gregory Martin. "Lucas van Uden's Etchings after Rubens." *Apollo* 87 (1968), pp. 210-211.

G. Martin 1968b
—. "A View of Het Sterckshof by David Teniers the Younger." *The Burlington Magazine* 100 (1968), pp. 574ff.

Martin 1968
John Rupert Martin. *The Ceiling Paintings for the Jesuit Church in Antwerp.* (*Corpus Rubenianum Ludwig Burchard,* part I). London, 1968.

Martin 1969
—. *Rubens: the Antwerp Altarpieces.* London, 1969.

Martin 1972
—. *The Decorations for the Pompa Introitus Ferdinandi.* (*Corpus Rubenianum Ludwig Burchard,* part XVI). London, 1972.

W. Martin 1907
Willem Martin. "Michiel Sweerts als schilder." *Oud Holland* 25 (1907), pp. 133-156.

W. Martin 1916
—. "Nog een Sweerts." *Oud Holland* 34 (1916), pp. 181-182.

W. Martin 1925
—. "Figuurstukken van Jan Davidsz. de Heem." *Oud Holland* 42 (1925), pp. 42-45.

W. Martin 1935-36
—. *De Hollandsche schilderkunst in de zeventiende eeuw.* 2 vols. Amsterdam, 1935-36.

Mauquoy-Hendrickx 1956
M. Mauquoy-Hendrickx. *L'iconographie d'Antoine van Dyke, Catalogue raisonné.* 2 vols. (*Académie royale de Belgique, Classe des Beaux-Arts, Mémoires,* ser. 2, vol. 9). 1956.

Mayer 1910
August L. Mayer. *Das Leben und die Werke der Brüder Matthäus und Paul Bril.* Leipzig, 1910.

Mayer 1923
—. *Anthonis van Dyck.* Munich, 1923.

McGrath 1978
Elizabeth McGrath. "The Painted Decorations of Rubens's House." *The Journal of the Warburg and Courtauld Institutes* 41 (1978), pp. 245-277.

Mecklenburg 1970
Carl Gregor Herzog zu Mecklenburg. *Flämische Jagdstilleben von Frans Snyders und Jan Fyt* (*Die Jagd in der Kunst*). Hamburg/Berlin, 1970.

Meijer 1988
Fred G. Meijer. "Jan Davidsz. de Heem's Earliest Paintings, 1626-1628." *Hoogsteder-Naumann Mercury* 7 (1988), pp. 29-36.

de Mendonça 1940-41
M. J. de Mendonça. "As tapeçarias de Historia de Marco Aurelio." *Boletim dos Museus nacionais de arte antiga, Lisboa* 1 (1940-41), 57-67.

Mensaert 1763
Guillaume Pierre Mensaert. *Le peintre amateur et curieux, ou Description générale des tableaux des plus habiles maîtres. . . .* 2 vols. in 1. Brussels, 1763.

Mertens 1987
Sabine Mertens. *Seestrum und Schiffbruch: Eine motivgeschichtliche Studie.* Hamburg, 1987.

Meulemeester 1984
Jean Luc Meulemeester. *Jacob van Oost de Oudere en het zeventiende-eeuwse Brugge.* Bruges, 1984.

de Meyer 1903
J. D. de Meyer. *Les Van Oost. Peintres brugeois du XVIIe siècle. Notice biographique.* Ghent, 1903.

Meyssens 1649
J. Meyssens. *Images de divers hommes d'esprit sublime.* Antwerp, 1649.

Micha 1908
Alfred Micha. *Les graveurs liégeois.* Liège, 1908.

Micha 1911
—. *Les peintres célèbres de l'Ancien pays de Liège.* Liège, 1911.

Michel 1900
E. Michel. *Rubens, sa vie, son œuvre et son temps.* Paris, 1900.

Michel 1771
J. F. M. Michel. *Histoire de la vie de P. P. Rubens, Chevalier, & Seigneur de Steen.* Brussels, 1771.

Michiels 1854
Alfred Michiels. *Rubens et l'école d'Anvers.* Antwerp, 1854.

Michiels 1865-76
—. *Histoire de la peinture flamande depuis ses débuts jusqu'en 1864.* 10 vols. 2nd edition. Paris, 1865-76.

Michiels 1869
—. "Génie de David Teniers." *Gazette des Beaux-Arts* 11 (1869), pp. 220-239.

Michiels 1882
—. *Van Dyck et ses élèves.* Paris, 1882.

Millar 1963
Oliver Millar. *The Tudor, Stuart and Early Georgian Pictures in the Collection of Her Majesty the Queen.* 2 vols. London, 1963.

Minnaert 1932
P. Minnaert. "Le folklore dans l'œuvre de Teniers le Jeune." *Fédération archéologique et historique de Belgique, Annales du Congrès de Liège* 1932, pp. 396-407.

Minneapolis/Houston/San Diego 1985
Minneapolis, Minneapolis Institute of Arts. *Dutch and Flemish Masters. Paintings from the Vienna Academy of Fine Arts.* Catalogue by George Keyes and Renate Trnek. Also shown at Museum of Fine Arts, Houston, and San Diego Museum of Arts. 1985.

de Mirimonde 1960
A. P. de Mirimonde. "Joris et Jan van Son dans les musées de Province." *La Revue des Arts* 10 (1960), pp. 7-18.

de Mirimonde 1963
—. "La musique dans les œuvres flamandes du XVIIe siècle au Louvre." *La Revue du Louvre et des Musées de France* 13 (1963), pp. 167-182.

de Mirimonde 1964
—. "Les natures mortes à instruments de musique de Peter Boel." *Jaarboek van het Koninklijk Museum voor Schone Kunsten, Antwerpen* 1964, pp. 107-143.

de Mirimonde 1965
—. "Les sujets de musique chez les caravaggistes Flamandes." *Jaarboek van het Koninklijk Museum voor Schone Kunsten, Antwerpen* 1965, pp. 113-173.

de Mirimonde 1966a
—. "L'Helicon ou la visite de Minerve aux Muses de Hendrik van Balen et Josse de Momper." *Jaarboek van het Koninklijk Museum voor Schone Kunsten, Antwerpen* 1966, pp. 141-150.

de Mirimonde 1966b
—. "Les 'Cabinets de musique.'" *Jaarboek van het Koninklijk Museum voor Schone Kunsten, Antwerpen* 1966, pp. 141-180.

de Mirimonde 1967
—. "Les sujets de musique chez Gonzales Coques et ses émules." *Bulletin des Musées Royaux des Beaux-Arts de Belgique* 16 (1967), pp. 179-208.

de Mirimonde 1968
—. "La musique et le fantastique chez David Ryckaert III." *Jaarboek van het Koninklijk Museum voor Schone Kunsten, Antwerpen* 1968, pp. 177-216.

de Mirimonde 1969
—. "Les sujets de musique chez Jacob Jordaens." *Jaarboek van het Koninklijk Museum voor Schone Kunsten, Antwerpen* 1969, pp. 201-246.

de Mirimonde 1970
—. "Musique et symbolisme chez Jan Davidszoon de Heem, Cornelis Janszoon et Jan II Janszoon de Heem." *Jaarboek van het Koninklijk Museum voor Schone Kunsten, Antwerpen* 1970, pp. 241-296.

de Mirimonde 1971
—. "Les peintres flamands de trompe l'œil et de natures mortes au XVIIe siècle et les sujets de musique." *Jaarboek van het Koninklijk Museum voor Schone Kunsten, Antwerpen* 1971, pp. 223-272.

de Mirimonde 1981
—. "Musique et symbolisme dans l'œuvre de Théodore van Thulden." *Jaarboek van het Koninklijk Museum voor Schone Kunsten, Antwerpen* 1981, pp. 195-234.

Monbaillieu 1978
A. Monbaillieu. "Het probleem van het 'portret' bij Rubens' altaarstukken." *Gentse Bijdragen tot de Kunstgeschiedenis* 24 (1976-78), pp. 154-179.

de Monconys 1665-66
Balthasar de Monconys. *Journal des voyages de Monsieur de Monconys.* 3 vols. Lyon, 1665-66.

de Monconys 1695
—. *Voyages de M. de Monconys.* 4 vols. Paris, 1695.

de Mont-Louis 1895
René de Mont-Louis. *Adrien Brouwer, le petit peintre flamand.* Limoges, 1895.

de la Montagne 1900
V. de la Montagne. "Philips Tideman en Gerard de Lairesse." *Amsterdams Jaarboekje* 1900, pp. 17-28.

Montreal 1990
Montreal, The Montreal Museum of Fine Arts. *Italian Reflections: Dutch Painters of the Golden Age.* Catalogue by Frederik J. Duparc and Linda L. Graif. 8 June-22 July 1990.

Morel-Deckers 1978
Y. Morel-Deckers. "Catalogus van de 'Bloemenguirlandes omheen

een middentafereel' bewaard in het Koninklijk Museum te Antwerpen." *Jaarboek van het Koninklijk Museum voor Schone Kunsten, Antwerpen* 1978, pp. 157-203.

Moretus 1878
"Boek gehouden door Jan Moretus als deken der St. Lucasgilde 1616/17." Antwerpen 1878, pp. 1-108.

Morris 1970
Inga Morris. "Adam Frans van der Meulen 1632-1690." Diss., Münster, 1970.

Müllenmeister 1978-81
Kurt J. Müllenmeister. *Meer und Land im Licht des 17. Jahrhundert.* 3 vols. Bremen, 1978-81.

Müllenmeister 1983
—. "Diana als Jagdgöttin." *Weltkunst* 53 (1983), pp. 394-396.

Müllenmeister 1988
—. *Roelandt Savery: Die Gemälde mit kritischem Œuvrekatalog.* Freren, 1988.

Müller Hofstede 1962
Justus Müller Hofstede. "Zur Antwerpener Frühzeit von P. P. Rubens." *Münchner Jahrbuch der bildenden Künste* 13 (1962), pp. 179-216.

Müller Hofstede 1965
—. "Bildnisse aus Rubens' Italienjahren." *Jahrbuch der Staatlichen Kunstsammlungen in Baden-Württemberg* 2 (1965), pp. 89-154.

Müller Hofstede 1971
—. "Abraham Janssens: Zur problematik des flämischen Caravaggismus." *Jahrbuch der Berliner Museen* 13 (1971), pp. 208-305.

Müller Hofstede 1972
—. "Drei neue Historienbilder des Cornelis de Vos." *Nederlands Kunsthistorisch Jaarboek* 23 (1972), pp. 291-302.

Müller Hofstede 1984
—. "'Non Satuatur Oculus Visu'–Zur 'Allegorie des Gesichts' von Pieter Paul Rubens und Jan Brueghel d. Ä.," in H. Vekeman and J. Müller Hofstede, eds., *Wort und Bild in der niederländische Kunst und Literatur im 16. und 17. Jahrhunderts* (Erfstadt, 1984), pp. 243-289.

Müller Hofstede 1987-88
—. "Neue Beiträge zum Œuvre Anton van Dycks." *Wallraf-Richartz-Jahrbuch* 48/49 (1987-88), pp. 123-186.

Münch 1960
Ottheinz Münch. "Ein Spätwerk des Gillis van Coninxloo." *Mitteilungen des Historischen Vereins der Pfalz* 58 (1960), pp. 275ff.

Münster/Baden-Baden 1979-80
Münster, Westfälisches Landesmuseum für Kunst und Kultur-geschichte. *Stilleben in Europa.* 1979-80. Also shown at Baden-Baden, Staatliche Kunsthalle.

Muller 1982
Jeffrey M. Muller. "Rubens's Theory and Practice of the Imitation of Art." *Art Bulletin* 64 (June 1982), pp. 229-247.

Muller 1989
—. *Rubens: The Artist as Collector.* Princeton, 1989.

S. Muller 1880
Samuel Muller. *De Utrechtse Archieven I: Schildersvereenigingen te Utrecht.* Utrecht, 1880.

Muls 1933
J. Muls. *Cornelis de Vos: Schilder van Hulst.* Antwerp, 1933.

Munich 1973
Munich, Bayerische Staatsgemäldesammlungen, Alte Pinakothek. *Jan van Kessel 1626-1679: Die Vier Erdteile.* Catalogue by Ulle Krempel. 8 May-30 September 1973.

Munich 1986
Munich, Bayerische Staatsgemäldesammlungen, Alte Pinakothek. *Adriaen Brouwer und das niederländische Bauerngenre: 1600-1660.* Catalogue by Konrad Renger. 25 April-29 June 1986.

Munich, cat. 1904
Munich, Alte Pinakothek. *Katalog der Gemälde-sammlung der Kgl. Aelteren Pinakothek in München.* 1904.

Munich, cat. 1973
Munich, Bayerische Staatsgemäldesammlungen, Alte Pinakothek. *Alte Pinakothek München, Katalog I: Deutsche und Niederländische Malerei zwischen Renaissance und Barock.* Catalogue by E. Brochhagen and K. Löcher. 3rd edition. 1973.

Munich, cat. 1983
Munich, Bayerische Staatsgemäldesammlungen, Alte Pinakothek. *Alte Pinakothek München: Erlauterungen zu den ausgestellten Gemälden.* 1983.

Nagler 1835-52
G. K. Nagler. *Neues allgemeines Künstler-Lexikon.* 22 vols. Munich, 1835-52.

Nagler 1858-79
G. K. Nagler et al. *Die Monogrammisten und diejenigen bekannten und unbekannten Künstler.* 6 vols. Munich, 1858-79.

Neefs 1875
Emmanuel Neefs. "Corneille Huysmans." *Bulletin des Commissions Royales d'Art et d'Archéologie* 14 (1875), pp. 25-40.

Neeffs 1876
—. *Histoire de la peinture et de la sculpture à Malines,* vol. 1. Ghent, 1876.

Nelson 1986
Kristi Nelson. "Jacob Jordaens' Drawings for Tapestry." *Master Drawings* 23-24 (1986), pp. 214-228.

Nelson 1990
—. "Jacob Jordaens: Family Portraits," in H. Blasse-Hegeman et al., eds., *Nederlandse Portretten* (*Leids Kunsthistorisch Jaarboek* 8 [1989], The Hague, 1990), pp. 105-119.

Nemitz 1963
Fritz Nemitz. "Jan Brueghel der Ältere Blumenstraussen Alte Pinakothek, München." *Kunstwerke der Welt aus dem öffentliche bayerische Kunstbesitz* 3 (1963), no. 93.

New York 1909
New York, M. Knoedler & Co. *Exhibition of Portraits by Van Dyck from the Collections of Mr. P. A. B. Widener and Mr. H. C. Frick.* 1909.

New York 1942
New York, Schaeffer and Brandt, Inc. *Peter Paul Rubens. Loan Exhibition for the Benefit of the United Hospital Fund.* 23 November-19 December 1942.

New York 1983
New York, Hoogsteder-Naumann Ltd. *A Selection of Dutch and Flemish Seventeenth-Century Paintings.* Catalogue by Otto Naumann. 1983.

New York 1985
New York, The Metropolitan Museum of Art. *Liechtenstein: The Princely Collections.* Catalogue by Reinhold Baumstark et al. 26 October 1985-1 May 1986.

New York 1988
New York, National Academy of Design. *Dutch and Flemish Paintings from New York Private Collections.* Catalogue by Ann Jensen Adams. 1988.

New York 1991
New York, The J. Pierpont Morgan Library. *Van Dyck Drawings.* Catalogue by Christopher Brown. 1991.

New York, Metropolitan, cat. 1984
New York, The Metropolitan Museum of Art. *Flemish Paintings in the Metropolitan Museum of Art.* 2 vols. Catalogue by Walter A. Liedtke. New York, 1984.

New York/Maastricht 1982
New York, Noortman and Brod. *Adriaen Brouwer, David Teniers the Younger.* Catalogue by Margret Klinge. 1982. Also shown at Maas-tricht, Noortman and Brod.

Nicolson 1958
Benedict Nicolson. "Further Notes on the Sweerts Exhibition." *The Burlington Magazine* 100 (1958), p. 441.

Nicolson 1971
—. "Gerard Seghers and the 'Denial of St. Peter.'" *The Burlington Magazine* 113 (1971), pp. 304-309.

Nicolson 1979
—. *The International Caravaggesque Movement. Lists of Pictures by Cara-vaggio and His Followers throughout Europe from 1590-1650.* Oxford, 1979.

Nicolson 1990
—. *Caravaggism in Europe.* 3 vols. 2nd edition, revised and enlarged by Luisa Vertova. Turin, 1990.

Ninane 1949
Lucie Ninane. "Rubens et Snyders," in *Miscellanea Leo van Puyvelde* (Brussels, 1949), pp. 143-146.

Norris 1940
Christopher Norris. "Rubens before Italy." *The Burlington Magazine* 86 (1940), pp. 184-195.

Oberlin, cat. 1967
Oberlin, Allen Memorial Art Museum. *Catalogue of European and American Paintings and Sculpture in the Allen Memorial Art Museum.* Catalogue by Wolfgang Stechow. 1967.

Obreen 1877-90
Fr. D. O. Obreen, ed. *Archief voor Nederlandsche Kunstgeschiedenis.* 7 vols. Rotterdam, 1877-90. Reprint Soest, 1976.

Offerhaus 1959
J. Offerhaus. "Joos de Momper. Landschap met everzwijn-jacht." *Bulletin van het Rijksmuseum* 7 (1959), pp. 56-57.

Ogden, Ogden 1955
Henry V. S. Ogden and Margaret S. Ogden. *English Taste in Landscape in the Seventeenth Century.* Ann Arbor, 1955.

Oldenbourg 1915
Rudolf Oldenbourg. "Jan Boeckhorst und Rubens." *Jahrbuch der königlichen preussischen Kunstsammlungen* 36 (1915), pp. 162-175.

Oldenbourg 1918a
—. *Die Flämische Maleri des XVII. Jahrhunderts.* Berlin, 1918. 2nd ed., 1922.

Oldenbourg 1918b
—. "Die Nachwirkung Italiens auf Rubens und die Gründung seiner Werkstatt." *Jahrbuch der Kunsthistorischen Sammlungen des allerhöchsten Kaiserhauses* 24 (1918), pp. 159-218.

Oldenbourg 1921
—. *P. P. Rubens, Des Meisters Gemälde* (*Klassiker der Kunst,* 50). 4th ed. Stuttgart and Berlin, n. d. [1921].

Oldenbourg 1923
—. "Abraham Janssens," in P. Clemen, ed., *Belgische Kunstdenkmäler*

(Munich, 1923), vol. 2, pp. 243-258.

Oldenbourg, Bode 1922
—. *Peter Paul Rubens. Sammlung der von Rudolf Oldenbourg veröffentlichten vorbereiteten Abhandlungen über den Meister.* Edited by Wilhelm von Bode. Munich and Berlin, 1922.

Osaka/Tokyo/Sydney 1990
Osaka, Nabio Museum of Art. *Flowers and Nature: Netherlandish Flower Painting of Four Centuries.* Catalogue by Sam Segal. 1990. Also shown at Tokyo, Tokyo Station Gallery, and Sydney, The Art Gallery of New South Wales.

van der Osten, Vey 1969
G. van der Osten and H. Vey. *Painting and Sculpture in Germany and the Netherlands 1500-1600.* Harmondsworth, 1969.

Ostrand 1975
Janice E. Ostrand. *Johann Boeckhorst: His Life and Work.* Diss., University of Missouri at Columbia, 1975.

Ottawa 1968-69
Ottawa, National Gallery of Canada. *Jacob Jordaens.* Catalogue by Michael Jaffé. 1968-69.

Ottawa 1980a
Ottawa, National Gallery of Canada. *The Young van Dyck / Le jeune van Dyck.* Catalogue by Alan McNairn. 1980.

Ottawa 1980b
Ottawa, National Gallery of Canada. *Van Dyck's Iconography / L'Iconographie de van Dyck.* Catalogue by Alan McNairn. 1980.

Ozzola 1913
Leandro Ozzola. "Vier unbekannte Gemälde von Frans Snyders." *Der Cicerone* 5 (1913), pp. 247-251.

Padua/Rome/Milan 1990
Padua, Palazzo della Ragione. *Pietro Paolo Rubens.* Catalogue by Didier Bodart et al. 1990. Also shown at Rome, Palazzo delle Esposizioni, and Milan, Società per le Belle Arti ed Esposizioni Permanente.

Papebrochius 1845-48
Daniel Papebrochius. *Annales Antverpienses ab urbe condita ad annum M.DCC.* 5 vols. Edited by F. H. Mertens and E. Buschmann. Antwerp, 1845-48.

Papi 1990
G. Papi. "Un'apertura sul soggiorno italiano di Jacob van Oost il Vecchio." *Studi di Storia dell'arte* 1 (1990), pp. 171-201.

Paris 1936
Paris, Musée de l'Orangerie. *Rubens et son temps.* Catalogue by Charles Sterling. 1936.

Paris 1977-78
Paris, Grand Palais. *Le siècle de Rubens dans les collections publiques françaises.* 1977-78.

Paris 1981
Paris, Institut Néerlandais. *Antoon van Dyck et son Iconographie.* Catalogue by Dieuwke DeHoop Schaeffer. 1981.

Paris, Louvre, cat. 1979
Paris, Musée du Louvre. *Catalogue sommaire illustré des peintures du Musée du Louvre, I: Ecoles flamande et hollandaise.* Catalogue by A. Brejon de Lavergnée, J. Foucart, and N. Reynaud. 1979.

Parthey 1863-64
Gustav F. C. Parthey. *Deutscher Bildersaal: Verzeichnis der in Deutschland vorhandenen Oelbilder verstorbener Maler aller Schulen.* 2 vols. Berlin, 1863-64.

de Pauw 1897
Napoléon de Pauw. "Les trois peintres David Teniers et leurs homonymes." *Annales de l'Académie Royale d'Archéologie de Belgique* ser. 4, vol. 10 (1897), pp. 301-359.

Pelzer 1916
Rudolf Arthur Pelzer. "Hans Rottenhammer." *Jahrbuch der Kunsthistorischen Sammlungen des allerhöchsten Kaiserhauses* 33 (1916), pp. 293-365.

de Permentier 1885
A. de Permentier. *Adrien Brauwer.* Brussels, 1885.

Pevsner 1936
Nikolaus Pevsner. "Some Notes on Abraham Janssens." *The Burlington Magazine* 69 (1936), pp. 120-125.

Peyre 1913
R. Peyre. *David Teniers.* Paris, n.d. [1913].

Philadelphia 1964
Philadelphia, Philadelphia Museum of Art. *Constantine the Great, The Tapestries, The Designs.* 1964. Catalogue by David DuBon.

Philadelphia, cat. 1965
Philadelphia, Philadelphia Museum of Art. *Checklist of Paintings in the Philadelphia Museum of Art.* 1965.

Philadelphia, Johnson, cat. 1913
Philadelphia, John G. Johnson Collection. *Catalogue of a Collection of Paintings and Some Art Objects, vol. 2: Flemish and Dutch Paintings.* Catalogue by W. R. Valentiner. Philadelphia, 1913.

Philadelphia, Johnson, cat. 1941
Philadelphia, John G. Johnson Collection. *Catalogue of Paintings.* Catalogue by Henri Marceau. Philadelphia, 1941.

Philadelphia, Johnson, cat. 1972
Philadelphia, John G. Johnson Collection. *Catalogue of Flemish and Dutch Paintings.* Catalogue by Barbara Sweeney. Philadelphia, 1972.

Philadelphia/Berlin/London 1984
Philadelphia, Philadelphia Museum of Art. *Masters of Seventeenth Century Dutch Genre Painting.* Catalogue by Peter C. Sutton et al. 18 March-13 May 1984. Also shown at Berlin, Staatliche Museen Preussischer Kulturbesitz, Gemäldegalerie; and London, Royal Academy of Arts.

Philippe 1945
Joseph Philippe. *La peinture liégeoise au XVIIe siècle.* Brussels, 1945.

Philippe 1965
—. *Les artistes liégeois à Rome, 16e-19e siècle.* Liège, 1965.

Pigler 1956
Anton Pigler. *Barockthemen.* 2 vols. Budapest, 1956.

Pigler 1974
—. *Barockthemen.* 2nd ed. 3 vols. Budapest, 1974.

de Piles 1677
Roger de Piles. *Conversation sur la connaissance de la peinture.* Paris, 1677.

de Piles 1681
—. *Dissertation sur les œuvres des plus fameus peintres.* Paris, 1681.

de Piles 1699
—. *Abrégé de la vie des Peintres.* Paris, 1699. 2nd edition Paris, 1715.

Pilo 1990
Giuseppe M. Pilo et al. *Rubens e l'eredità veneta* (Arte Documentato, Liber Extra 1). Rome, 1990.

Pinchart 1860
Alexandre Joseph Pinchart. "David Teniers le Jeune," in *Archives des Arts, Sciences et Lettres* (Ghent, 1860-81), vol. 1 (1860), pp. 53-55, 287.

Pinchart 1878
—. "La corporation des peintres de Bruxelles," in *Messager des Sciences historiques* (Ghent, 1878).

Pinchart 1881
—. "Daniel Zeghers," in *Archives des Arts, Sciences et Lettres* (Ghent, 1860-81), vol. 3 (1881), pp. 218-223.

Pio 1724
Nicola Pio. "Le Vite Pittori Scultori et Architetti in Compendio . . ." (unpub. ms., 1724), in F. A. F. Orbaan, *Bescheiden in Italië omtrent Nederlandsche Kunstenaars en Geleerden* (The Hague, 1911).

Plantegna 1926
J. H. Plantegna. *L'Architecture religieuse dans l'ancien duché du Brabant.* The Hague, 1926.

Plietzsch 1910
Eduard Plietzsch. *Die Frankenthaler Maler.* Leipzig, 1910. Reprint Soest, 1972.

Plietzsch 1916-17
—. "Ein bild von Jan Siberechts." *Amtliche Berichte aus den königlichen Kunstsammlungen* 38 (1916-17), cols. 61-66.

Plietzsch 1960
—. *Holländische und flämische Maler des 17. Jahrhunderts.* Leipzig, 1960.

van de Poele 1899
C. van de Poele. "Eene schilderij van Jacques van Oost den oude (in St. Jacobs te Brugge)." *Kunst* 3, no. 9/10 (1899), p. 72.

de Poorter 1978
Nora de Poorter. *The Eucharist Series.* (Corpus Rubenianum Ludwig Burchard, part II). London and Philadelphia, 1978.

de Poorter 1985
—. "Cornelis Schut als tapijtontwerper: de reeks van 'De Zeven Vrije Kunsten,'" in *Rubens and His World. Bijdragen opgedragen aan R.-A. d'Hulst* (Antwerp, 1985), pp. 245-263.

de Poorter 1988
—. "Rubens 'onder de wapenen.' De Antwerpse schilders als gildebroeders van de Kolveniers in de eerste helft van de 17de eeuw." *Jaarboek van het Koninklijk Museum voor Schone Kunsten Antwerpen* 1988, pp. 203-252.

Prims 1927
Floris Prims. *Rubens en zijne eeuw.* Brussels, 1927.

Prims 1931
—. *Geleerden en Kunstenaars en de rekeningen der Stad Antwerpen, van 1570 tot 1650.* Brussels, 1931.

Prims 1940
—. "Aloude portrettengalerie, nr. 424, Cornelis Schut (1597-1655)." *Zondagsvriend* (21 March 1940), p. 290.

Princeton 1972
Princeton, Princeton University Art Museum. *Rubens before 1620.* Catalogue by John Rupert Martin et al. 1972.

Princeton 1979
Princeton, Princeton University Art Museum. *Van Dyck as Religious Artist.* Catalogue by John Rupert Martin and Gail Feigenbaum. 1979.

Prinz 1973
W. Prinz. "The 'Four Philosophers' by Rubens and the Pseudo-Seneca in Seventeenth-Century Painting." *Art Bulletin* 55 (1973), pp. 410-423.

van Puyvelde 1929
Leo van Puyvelde. "L'Œuvre authentique d'Adam van Noort, Maître de Rubens." *Bulletin des Musées Royaux des Beaux-Arts de Belgique* 2 (1929), pp. 36ff.

van Puyvelde 1933
　—. "Les Débuts de Van Dyck." Revue belge d'Archéologie et d'Histoire de l'Art 3 (1933), pp. 193-213.
van Puyvelde 1934
　—. "Unknown Works by Jan Brueghel." The Burlington Magazine 65 (1934), pp. 16-21.
van Puyvelde 1940a
　—. Les Equisses de Rubens. Basel, 1940.
van Puyvelde 1940b
　—. "The Development of Brouwer's Compositions." The Burlington Magazine 77 (1940), pp. 140-144.
van Puyvelde 1940c
　—. "On Rubens' Drawings." The Burlington Magazine 77 (1940), pp. 123-127.
van Puyvelde 1941
　—. "The Young Van Dyck." The Burlington Magazine 79 (1941), pp. 177-185.
van Puyvelde 1942
　—. The Flemish Drawings in the Collection of His Majesty the King at Windsor Castle. London, 1942.
van Puyvelde 1947
　—. The Sketches of Rubens. London, 1947.
van Puyvelde 1950a
　—. La Peinture Flamande à Rome. Brussels, 1950.
van Puyvelde 1950b
　—. Van Dyck. Brussels, 1950.
van Puyvelde 1951
　—. "Un tableau symbolique de Rubens," in Essays in Honor of Georg Swarzenski (Chicago, 1951), pp. 185-188.
van Puyvelde 1952
　—. Rubens. Paris/Brussels, 1952.
van Puyvelde 1953
　—. Jordaens. Paris/Brussels, 1953.
Raczyński 1937
　J. A. Raczyński. Die flämische Landschaft vor Rubens. Frankfurt, 1937. Reprint Soest, 1972.
Raepsaet 1852
　H. Raepsaet. Quelques recherches sur Adrien de Brauwere. Ghent, 1852.
Raupp 1984
　Hans-Joachim Raupp. Untersuchungen zu Künstlerbildnis und Künstlerdarstellung in den Niederlanden im 17. Jahrhundert. Hildesheim/New York, 1984.
Raupp 1986
　—. Bauernsatiren. Entstehung und Entwicklung des bäuerlichen Genres in der deutschen und niederländischen Kunst ca. 1470-1570. Niederzier, 1986.
Raupp 1987
　—. "Adriaen Brouwer als Satiriker," in Holländische Genremalerei im 17. Jahrhundert (Jarhbuch Preussischer Kulturbesitz, Sonderband 4 [1987]), pp. 225-251.
Reelick 1948
　P. F. J. J. Reelick. "Jodocus de Momper of Paulus Bril?" Oud Holland 63 (1948), pp. 120-121.
van Regteren Altena 1959
　I. Q. van Regteren Altena. "Over Michael Sweerts als portrettist." Oud Holland 74 (1959), pp. 222-224.
van Regteren Altena 1972
　—. "Het Vroegste Werk van Rubens." Mededelingen van de Koninklijke Academie van Wetenschappen, Letteren en Schone Kunsten van België (Klasse der Schone Kunsten) 34 (1972), pp. 3-23.
Renger 1974
　Konrad Renger. "Dubens Dedit Dedicavitque. Rubens' Beschäftigung mit der Druckgraphik, I: Der Kupferstich." Jahrbuch der Berliner Museen 16 (1974), pp. 122-175.
Renger 1975
　—. "Rubens Dedit Dedicavitque. Rubens' Beschäftigung mit der Druckgraphik, II: Radierung und Holzschnitt–Die Widmungen." Jahrbuch der Berliner Museen 17 (1975), pp. 166-213.
Renger 1987
　—. "Adriaen Brouwer. Seine Auseinandersetzung mit der Tradition des 16. Jahrhunderts," in Holländischen Genremalerei in 17. Jahrhundert (Jarhbuch Preussischer Kulturbesitz, Sonderband 4 [1987]), pp. 253-282.
Rens 1977
　L. Rens. "Rubens en de Literatuur van zijn tijd." Dietsche Warande en Belfort (1977), pp. 328-355.
Reynolds 1931
　E. J. Reynolds. Some Brouwer Problems. Lausanne, 1931.
Reynolds 1819
　Sir Joshua Reynolds. A Journey to Flanders and Holland in the Year MDCCLXXXI. London, 1819.
Rich 1936
　Daniel Catton Rich. "A new Landscape by Joos de Momper." Bulletin of the Art Institute of Chicago 30 (1936), pp. 38-39.
Richefort 1980
　Isabelle Richefort. "Adam Frans van der Meulen: l'homme, l'œuvre et l'art." Thesis, Ecole des Chartes, Paris, 1980.
Richefort 1988

　—. "Nouvelles précisions sur la vie d'Adam Frans van der Meulen, peintre historiographe de Louis XIV." Bulletin de la Société de l'Histoire de l'Art Français 1986 [1988], pp. 57-80.
van Riemsdijk 1926
　B. W. F. van Riemsdijk. "Twee zeldzame Meesters, II: Franciscus Gijsbrechtsz." Oud Holland 43 (1926), pp. 105-107.
du Rieu 1658
　Florent du Rieu. Les Tableaux Parlans du Peintre Namurois. Namur, 1658.
Robels 1969
　Hella Robels. "Frans Snijders' Entwicklung als Stillebenmaler." Wallraf-Richartz Jahrbuch 31 (1969), pp. 43-94.
Robels 1989
　—. Frans Snijders, Stilleben- und Tiermaler 1597-1657. Munich, 1989.
Robert-Dumesnil 1835-71
　A. P. F. Robert-Dumesnil. Le peintre-graveur français ou catalogue raisonné des estampes gravées par les peintres et les dessinateurs de l'école française. 11 vols. Paris, 1835-71.
Roblot-Delondre 1930
　M. Roblot-Delondre. "Gérard Seghers." Gazette des Beaux-Arts ser. 6, vol. 4 (1930), pp. 184-199.
Roelandts n.d.
　O. Roelandts. De Beeldhouwers Hiëronymus Duquesnoy, vader en zoon. Ghent, n.d.
de Roever 1885
　N. de Roever. "De Coninxloo's." Oud-Holland 3 (1885), pp. 33-53.
Roggen 1925
　D. Roggen. Les Arcs de triomphe de la joyeuse Entrée de 1635. Ghent, 1925.
Roggen 1932
　—. "Abraham Janssens en zijn werk, Handelingen van het eerste Congres voor algemeene kunstgeschiedenis." Maandblad voor oude en jonge kunst 3 (1932), p. 350.
Roggen 1935
　—. "De chronologie der werken van Theodoor Rombouts." Gentse Bijdragen tot de Kunstgeschiedenis 2 (1935), pp. 175-190.
Roggen 1949-50
　—. "Theodoor Rombouts 1597-1637." Gentse Bijdragen tot de Kunstgeschiedenis 12 (1949-50), pp. 225-227.
Roggen 1951
　—. "Werk van M. Stomer en Th. Rombouts." Gentse Bijdragen tot de Kunstgeschiedenis 13 (1951), pp. 269-273.
Roggen, Pauwels, de Schrijver 1949-50
　D. Roggen, H. Pauwels, and A. de Schrijver. "Het Caravaggisme te Gent." Gentse Bijdragen tot de Kunstgeschiedenis 12 (1949-50), pp. 255-285.
Roggen, Pauwels 1953
　D. Roggen and H. Pauwels. "Nog bij 'Het Caravaggisme te Gent." Gentse Bijdragen tot de Kunstgeschiedenis 14 (1953), pp. 201-206.
Roggen, Pauwels 1955-56
　—. "Het Caravaggistisch œuvre van Gerard Zegers." Gentse Bijdragen tot de Kunstgeschiedenis 16 (1955-56), pp. 255-301.
Rombouts, van Lerius 1872
　Ph. Rombouts and Th. van Lerius. De liggeren en andere historische archieven der Antwerpsche Sint Lucasgilde. 2 vols. The Hague, 1872.
Rome 1950
　Rome, Palazzo Massimo alle Colonne. I Bamboccianti. Pittori della vita popolare nel seicento. Catalogue by G. Briganti. 1950.
Rome 1958-59
　Rome, Galleria Nazionale d'Arte Antica, Palazzetto Venezia. Michael Sweerts e i Bamboccianti. Catalogue by R. Kultzen. 1958-59. Also shown at Rotterdam, Museum Boymans-van Beuningen (Michael Sweerts en Tijdgenoten).
Rooses 1878
　Max Rooses. Boek gehouden door Jan Moretus II als Deken der St. Lucasgilde (1616-1617). Antwerp, 1878.
Rooses 1879
　—. Geschiedenis der Antwerpsche schilderschool. Antwerp, 1879.
Rooses 1886-92
　—. L'œuvre de P. P. Rubens. Histoire et description de ses tableaux et dessins. 5 vols. Antwerp, 1886-92.
Rooses 1895
　—. "Staat van goederen in het sterfhuis van Isabella Brant." Rubens-Bulletijn 4 (1895), pp. 154-188.
Rooses 1903
　—. Rubens' leven en werken. Antwerp, 1903.
Rooses 1904
　—. Rubens. 2 vols. Translated by Harold Child. London, 1904.
Rooses 1906
　—. Jordaens, leven en werken. Antwerp/Amsterdam, 1906.
Rooses 1908
　—. Jacob Jordaens: His Life and Work. Translated by E. C. Broers. London, 1908.
Rooses 1914
　—. Le Musée Plantin-Moretus. Antwerp, 1914.
Rooses, Ruelens 1887-1909
　Max Rooses and Charles Ruelens, eds. La Correspondance de Rubens et

documents épistolaires concernant sa vie et ses œuvres. 6 vols. Antwerp, 1887-1909.

A. Rosenberg 1895
Adolf Rosenberg. Teniers der Jüngere. Bielefeld/Leipzig, 1895.

A. Rosenberg 1905
—. P. P. Rubens: Des Meisters Gemälde (Klassiker der Kunst, 5). Leipzig, 1905. Rev. ed. 1911.

Rosenberg, Slive, ter Kuile 1966
Jakob Rosenberg, Seymour Slive, and E. H. ter Kuile. Dutch Art and Architecture, 1600-1800. Harmondsworth/Baltimore, 1966.

Rotterdam 1953
Rotterdam, Museum Boymans-van Beuningen. Olieverfschetsen van Rubens. Catalogue by E. Haverkamp Begemann. 1953.

Rotterdam 1958
Rotterdam, Museum Boymans-van Beuningen. Michael Sweerts en Tijdgenoten. Catalogue by R. Kultzen. 1958. Also shown at Rome, Galleria Nazionale d'Arte Antica, Palazzetto Venezia (Michael Sweerts e i Bamboccianti).

Roy 1974
Alain Roy. "Théodore van Thulden (1606-1669)." Unpublished thesis, Université de Strasbourg, 1974.

Roy 1979
—. "Un peintre flamand à Paris au début du XVIIème siècle: Théodore van Thulden." Bulletin de la Société de l'Histoire de l'Art français 1977 [1979], pp. 67-76.

Roy 1985
—. "Un cycle inédit de la Vie de saint François de Paule par Théodore van Thulden," in Rubens and His World. Bijdragen opgedragen aan R.-A. d'Hulst (Antwerp, 1985), pp. 227-233.

Roy 1986a
—. "La période liégeoise de Gérard de Lairesse," in Actes du Colloque "La peinture liégeoise aux XVIIᵉ et XVIIIᵉ siècles" (Université de Liège, 20-22 January 1986), pp. 24-26.

Roy 1986b
—. "La période liégeoise de Gérard de Lairesse." Art et Fact 5 (1986), pp. 36-38.

Roy 1992
—. Gérard de Lairesse (1640-1711). Paris, 1992.

Rubens 1622
Peter Paul Rubens. Palazzi di Genova. Antwerp, 1622.

Ruby 1990
Louisa Wood Ruby. "Sebastiaen Vrancx as Illustrator of Virgil's Aeneid." Master Drawings 28 (1990), pp. 54-73.

Ruelens 1882
Charles Ruelens. "Notices et documents: Jean Cossiers." Rubens-Bulletijn 1 (1882), pp. 261-274.

Ruelens 1883
—. "La vie de Rubens par Roger de Piles." Rubens-Bulletijn 2 (1883), pp. 157 ff.

Ruurs 1974
Rob Ruurs. "Adrianus Brouwer, gryllorum pictor." Proef 3 (1974), pp. 87-88.

Rye 1972
Rye, The Rye Art Gallery. High Life–Low Life. David Teniers the Younger. 1972.

Sacré 1924-25
M. Sacré. "De schilderijen van De Crayer in de O. L. V. Kerk te Merchtem." De Brabander 4 (1924-25), pp. 187-190.

Sainsbury 1859
W. N. Sainsbury. Original Unpublished Papers Illustrative of the Life of Sir Peter Paul Rubens as an Artist and a Diplomat. London, 1859.

St. Petersburg, Hermitage, cat. 1901
St. Petersburg, Hermitage. Catalogue de la Galerie des Tableaux, vol. 2: Ecoles Néerlandaises et Ecole Allemande. Catalogue by A. Somof. 1901.

Saintenoy 1935
P. Saintenoy. L'art et les artistes à la Cour de Bruxelles. 2 vols. Brussels, 1935.

Salerno 1968
Luigi Salerno. "Per il catalogo di Giovanni Momper." Palatino 12 (1968).

Salerno 1977-80
—. Pittori di paesaggio del seicento a Roma (Landscape Painters of the 17th Century in Rome). 3 vols. 1977-80.

Salinger 1960
Margaretta M. Salinger. "Adriaen Brouwer (Brauwer)," in Encyclopedia of World Art, vol. 7 (1960), cols. 605-606.

Sandrart 1675
Joachim von Sandrart. L'Academia todesca del architectura, sculptura e pittura; oder, Teutsche Academie der edlen Bau-, Bild- und Mahlerey-Künste. 2 vols. Nuremburg, 1675.

Sandrart 1683
—. Academia nobilissima Artis Pictoriae.... Nuremburg, 1683.

Sandrart, Pelzer 1925
Joachim von Sandrart. Joachim von Sandrarts Academie der Bau-, Bild-und Mahlerey-Künste von 1675. Edited with a commentary by A. R. Pelzer. Munich, 1925.

Sarasota, cat. 1980
Sarasota, The John and Mable Ringling Museum of Art. Catalogue of the Dutch and Flemish Paintings 1400-1900. Catalogue by F. W. Robinson and W. H. Wilson. 1980.

van Sasse van Ysselt 1900
A. van Sasse van Ysselt. "Een paar Schepenakten betreffende den Schilder Theodoor van Thulden." Taxandria 7 (1900), pp. 210-215.

van Sasse van Ysselt, Juten 1911
A. van Sasse van Ysselt and F. Juten. "Eenige Aanteekeningen betref-fende de familie van Thulden uit de Bossche Schepenregisters." Taxandria 18 (1911), pp. 118-125.

de Saumery 1744
P. L. de Saumery. Les Delices du Pays de Liège, vol. 1. Liège, 1744.

Schaeffer 1909
E. Schaeffer. Van Dyck, Des Meisters Gemälde. (Klassiker der Kunst, 13). Stuttgart/Leipzig, 1909.

Schellekens 1912
O. Schellekens. Les trois peintres David Teniers. Les Teniers et Termonde. Dendermonde, 1912.

Schlie 1887
Friedrich Schlie. "Adriaen Brouwer." Zeitschrift für bildende Kunst 22 (1887), pp. 133-144.

Schlugleit 1937
D. Schlugleit. "L'Abbé de Scaglia, Jordaens et 'L'Histoire de Psyché' de Greenwich-House (1639-42)." Revue belge d'Archéologie et d'Histoire de l'Art 7 (1937), pp. 139-166.

Schmidt 1873
Wilhelm Schmidt. Das Leben des Malers Adriaen Brouwer: Kritische Beleuchtung der über ihn verbreiteten Sagen. Leipzig, 1873.

Schmidt-Degener 1908a
F. Schmidt-Degener. Adriaen Brouwer et son évolution artistique. Brussels, 1908.

Schmidt-Degener 1908b
—. Adriaen Brouwer en de ontwikkeling zijner kunst. Amsterdam, 1908.

Schmidt-Degener 1913
—. "Rembrandt's Portret van Gérard de Lairesse." Onze Kunst 23 (1913), pp. 117-129.

Schneede 1967
Uwe M. Schneede. "Interieurs von Hans und Paul Vredeman." Nederlands Kunsthistorisch Jaarboek 18 (1967), pp. 125-166.

Schneider 1925
Hans Schneider. "Erasmus Quellinus te Amsterdam." Oud Holland 42 (1925), pp. 54-57.

Schneider 1926-27
—. "Bildnisse Adriaen Brouwers und seiner Freunde." Zeitschrift für bildende Kunst 60 (1926-27), pp. 270-272.

Schneider 1927
—. "Bildnisse des Adriaen Brouwer," in Festschrift für Max J. Fried-länder zum 60. Geburtstage (Leipzig, 1927), pp. 148-155.

Schneider 1928
—. "Theodoor van Thulden en Noord-Nederland." Oud Holland 45 (1928), pp. 1-15; 200-209.

Schneider 1933
—. "Een prinselijke opdracht aan David Teniers d. J." Oudheidkundig Jaarboek (Bulletin van den Nederlandschen oudheidkundigen Bond) 2 (1933), p. 1.

von Schneider 1933
A. von Schneider. Caravaggio und die Niederlanden. Marburg, 1933.

Scholz 1982
Horst Scholz. "Brouwer delineavit – Zwei Federzeichnungen Adriaen Brouwers." Zeitschrift für Kunstgeschichte 45 (1982), pp. 57-65.

Scholz 1985
—. Brouwer invenit. Druckgrafische Reproduktionen des 17.-19. Jahr-hunderts nach Gemälden und Zeichnungen Adriaen Brouwers. Marburg, 1985.

Schreiner 1975
Ludwig Schreiner. "Die 'Dorfstrasse' von Jan Brueghel d. Ä." Niederdeutsche Beiträge zur Kunstgeschichte 14 (1975), pp. 113-126.

de Schrevel 1899
A. C. de Schrevel. "Jacques van Oost, le Vieux, est chargé, par les chanoines de St.-Donatien de peindre un tableau représentant la Résurrection, 1636." Handelingen van het genootschap voor geschiedenis van Brugge (1899), pp. 281-283.

Schrevelius 1648
T. Schrevelius. Harlemias: Of, de eerste stichting der stad Haarlem. Haarlem, 1648.

Schulz 1974-80
Wolfgang Schulz. "Adam Frans van der Meulen und seine Condé Ansichten." Bulletin des Musées Royaux des Beaux Arts de Belgique 1974-80, pp. 245-268.

Schütz 1980
Konrad Schütz. "David Teniers der Jüngere als Kopist im Dienst Erzherzog Leopold Wilhelms," in Original–Kopie–Replik–Paraphrase (exh. cat. Vienna, Akademie der bildenden Künste, 1980), pp. 21-33.

Scribner 1975
Charles Scribner III. "Sacred Architecture: Rubens's Eucharist

Tapestries." *Art Bulletin* 57 (1975), pp. 519-528.

Scribner 1982
—. *The Triumph of the Eucharist: Tapestries Designed by Rubens (Studies in Baroque Art History, I).* Ann Arbor, 1982.

Seifertová-Korecká 1962
H. Seifertová-Korecká. "Stilleben von Jan Davidsz. de Heem in der Gemäldegalerie der Stadt Liberec (Reichenberg)." *Oud Holland* 77 (1962), pp. 58-60.

Simillion 1863-64
Konstantijn Simillion. "Levensschets van Davide Teniers den Jonge." *De Vlaamsche School* 9 (1863), passim; 10 (1864), passim.

Siret 1859
A. Siret. "Revendications nationales: Sur le lieu de naissance d'Adrien Brouwer." *Journal des Beaux-Arts et de la Littérature* 1 (1859), pp. 3-5.

Siret 1874
—. "Corneille Huysmans." *Bulletin des Commissions Royales d'Art et d'Archéologie* 13 (1874), pp. 174-182.

Slothouwer 1945
D. F. Slothouwer. *De paleizen van Frederik Hendrik.* Leiden, 1945.

Smith 1829-42
John A. Smith. *A Catalogue Raisonné of the Works of the Most Eminent Dutch, Flemish and French Painters.* 9 vols. London, 1829-42.

Smolskaya 1962
N. Smolskaya. *Teniers.* Leningrad, 1962.

Snoep 1970
D. P. Snoep. "Gérard de Lairesse als plafond- en kamerschilder." *Bulletin van het Rijksmuseum* 18 (1970), pp. 159-220.

Sopriani 1674
Raffaelle Sopriani. *Le vite de' pittori, scultori, ed architetti genovesi e de' forastieri che in Genova operano.* Genoa, 1674.

Speth-Holterhoff 1957
S. Speth-Holterhoff. *Les peintres flamands de cabinets d'amateurs au XVIIe siècle.* Paris/Brussels, 1957.

Speth-Holterhoff 1966
—. "Portrait de Henri van Dongelberghe, bourgmestre de Bruxelles et de sa femme, par Gaspard de Crayer." *Revue belge d'Archéologie et d'Histoire de l'Art* 35 (1966), pp. 223-224.

Spicer 1983
Joaneath Spicer. "'De Koe voor d'aerde staat': The Origins of the Dutch Cattle Piece," in *Essays in Northern European Art Presented to Egbert Haverkamp Begemann* (Doornspijk, 1983), pp. 251-256.

Spiessens 1990
Godelieve Spiessens. *Leven en werk van de Antwerpse schilder Alexander Adriaenssen (1587-1661) (Verhandelingen van de Koninklijke Academie van Wetenschappen, Letterkunde en Schone Kunsten van België, Klasse der Schone Kunsten 52, no. 48).* Brussels, 1990.

Spilbeeck 1901
I. van Spilbeeck. "Iconographie norbertine: Les images des saints de l'Ordre de Prémontré d'après Abraham van Diepenbeeck." *Bulletin archéologique de Belgique* 2 (1901), pp. 161-166.

Starcke 1898
E. Starcke. "Die Coninxloo's." *Oud Holland* 16 (1898), pp. 129-146.

Starcky 1988
Laure C. Starcky. *Mobilier National. Dessins de Van der Meulen et son atelier (Inventaire des collections publiques françaises, no. 33).* Paris, 1988.

Steadman 1982
David Steadman. *Abraham van Diepenbeeck, Seventeenth-century Flemish painter.* Ann Arbor, 1982.

Stebbins, Sutton 1986
Theodore E. Stebbins and Peter C. Sutton. *Masterpiece Paintings in the Museum of Fine Arts, Boston.* Boston, 1986.

Stechow 1951
Wolfgang Stechow. "Some Portraits by Michiel Sweerts." *Art Quarterly* 14 (1951), pp. 206-215.

Stechow 1966
—. *Dutch Landscape Painting of the Seventeenth Century. (Kress Foundation Studies in the History of European Art, vol. 1).* London/New York, 1966.

Stechow 1968
—. *Rubens and the Classical Tradition.* Cambridge, MA, 1968.

Sterling 1952
Charles Sterling. *La nature morte de l'antiquité à nos jours.* Paris, 1952. English edition: *Still Life Painting from Antiquity to the Twentieth Century.* New York, 1981.

Van der Stighelen 1987
Katelijne Van der Stighelen. "Corneille de Vos versus Cornelis de Vos: geen portretten maar toch een historie stuk." *Arca Lovaniensis* 15/16 (1987), pp. 284-287.

Van der Stighelen 1988
—. "Cornelis de Vos (1584/5-1651): 't dier tyt een van de vermaerste conterfeyters.' Een studie over een Antwerpse portretschilder en zijn kliënteel." Diss., Louvain, 1988.

Van der Stighelen 1989a
—. "De (atelier-)bedrijvigheid van Andries Snellinck (1583-1653) en Co." *Jaarboek van het Koninklijk Museum voor Schone Kunsten, Antwerpen* 1989, pp. 303-342.

Van der Stighelen 1989b
—. "Cornelis de Vos as a Draughtsman." *Master Drawings* 27 (1989), pp. 322-340.

Van der Stighelen 1990a
—. *De portretten van Cornelis de Vos (1584/5-1651). Een kritische catalogus (Verhandelingen van de Koninklijke Academie van Wetenschappen, Letterkunde en Schone Kunsten van België, Klasse der Schone Kunsten 52, no. 51).* Brussels, 1990.

Van der Stighelen 1990b
—. "'Op dat het recht gae': Elf familie portretten van Cornelis de Vos (1584/5-1651)," in H. Blasse-Hegeman et al., eds., *Nederlandse Portretten* (Leids Kunsthistorisch Jaarboek 8 [1989], The Hague, 1990), pp. 121-144.

Van der Stighelen 1991a
—. "Van 'marchant' tot 'vermaert conterfeiter': het levensverhaal van Cornelis de Vos (1584/5-1651)." *Jaarboek van het Koninklijk Museum voor Schone Kunsten, Antwerpen* 1991, pp. 87-156 (forthcoming).

Van der Stighelen 1991b
—. "Young Anthony. Archival Evidence on Van Dyck's Early Years." *Studies in the History of Art* (1991) (forthcoming).

Stoffels 1986
Jozef Stoffels. "Jan Cossiers (ca. 1600-1671). Een monografische benadering." Unpubl. thesis, Rijksuniversiteit, Ghent, 1986.

Strong 1972
Roy Strong. *Van Dyck: Charles I on Horseback.* New York, 1972.

Stubbe 1948
A. Stubbe. *Jacob Jordaens en de Barok.* Antwerp/Brussels/Ghent/Louvain, 1948.

Sullivan 1981
Scott A. Sullivan. "Frans Snyders, Still life with Fruit, Vegetables and Dead Game." *Bulletin of the Detroit Institute of Arts* 59 (1981), pp. 30-37.

Sullivan 1984
—. *The Dutch Gamepiece.* Totowa/Montclair, 1984.

Sutton 1989
Peter C. Sutton. "Rubens's *Sacrifice of the Old Covenant*, from the Coolidge Collection." *Journal of the Museum of Fine Arts, Boston* 1 (1989), pp. 5-21.

Sutton 1990
—. *Northern European Paintings in the Philadelphia Museum of Art, from the Sixteenth through the Nineteenth Century.* Philadelphia, 1990.

Takacs 1961
M. Takacs. "Un tableau de Sébastien Vrancx à la galerie des maîtres anciens [de Budapest]." *Bulletin du Musée national hongrois des Beaux-Arts* 18 (1961), pp. 51-62.

van Terlaan 1926
E. van Terlaan. "Un grand artiste méconnu: Gaspard de Crayer." *Beaux-Arts* (1926), pp. 93-108.

Terlinden 1952
Vicomte Terlinden. "Henri de Clerck 'le peintre de Notre-Dame de la Chapelle' 1570(?)-1630." *Revue belge d'Archéologie et d'Histoire de l'Art* 21 (1952), pp. 81-112.

Terwesten 1770
Pieter Terwesten. *Catalogus ofte Naamlyst van Schilderyen, met derselver prysen zedert den 22 Augusti 1752 tot den 21 November 1768.* The Hague, 1770. (supplement to Hoet 1750-51).

Theatrum Pictorium 1660
Davidis Teniers Antverpiensis, pictoris eta cubiculis Ser^{mis} Principis Leopoldo Giul. Archduci, et Joanni Austriaco Theatrum Pictorium. Brussels, 1660.

van Tichelen 1932
Jos. van Tichelen. "De Begraafplaats van den Kunstschilder Hendrik de Clerck." *Archives, bibliothèques et musées de Belgique* 9 (1932), p. 30.

Thieme, Becker 1907-50
Ulrich Thieme and Felix Becker. *Allgemeines Lexikon der bildenden Künstler von der Antike bis zur Gegenwart.* 37 vols. Leipzig, 1907-50.

Thiéry 1953
Yvonne Thiéry. *Le Paysage flamand au XVIIe siècle.* Paris/Brussels, 1953.

Thiéry 1967
—. "Notes au sujet des paysages de Josse de Momper II." *Bulletin des Musées Royaux des Beaux-Arts de Belgique* 16 (1967), pp. 233-246.

Thiéry 1986
Yvonne Thiéry. *Les peintres flamands de paysage au XVIIe siècle: Des precurseurs à Rubens.* Brussels, 1986.

Thiéry, Kervyn de Meerendré 1986
Yvonne Thiéry and Michel Kervyn de Meerendré. *Les peintres flamands de paysage au XVIIe siècle: Le baroque anversois et l'école bruxelloise.* Brussels, 1986.

Thijs 1974
Alfons K. L. Thijs. "Het Hagelkruisfeest te Ekeren (1622) door S. Vrancx in de Alte Pinakothek te München." *Jaarboek van het Koninklijk Museum voor Schone Kunsten, Antwerpen* (1974), pp. 187-199.

Thijs 1990
—. *Van Geuzenstad tot Katholiek Bolwerk. Maatschappelijke betekenis van de kerk in het contrareformatorisch Antwerpen.* Turnhout, 1990.

Thuillier 1967
Jacques Thuillier. *Le storie di Maria de' Medici di Rubens al Lussemburgo.*

Milan, 1967. English ed.: New York, 1970.

Thuillier 1986
—. "Bertholet Flémal: problèmes de catalogue et de chronologie," in *Actes de Colloque "La peinture liégeoise aux XVIIᵉ et XVIIIᵉ siècles"* (Université de Liège, 20-22 Jan. 1986), pp. 16-20.

Thys 1873
Augustin Thys. *Histoire des rues et places publiques de la ville d'Anvers.* Antwerp, 1873. Also published in Flemish as: *Historiek der straten en openbare plaatsen van Antwerpen.* Antwerp, 1893.

Tiethoff-Spliethoff 1985
M. E. Tiethoff-Spliethoff. "Bloemstilleven van Willem III vol symbolen." *Tableau* 7 (1985), pp. 36-37.

Tijs 1983
Rutger J. Tijs. *P. P. Rubens en J. Jordaens: barok in eigen huis: een architectuurhistorische studie, verval en restauratie van twee 17de eeuwse kunstenaarswoningen te Antwerpen.* Antwerp, 1983.

Timmers 1942
J. J. M. Timmers. *Gérard Lairesse.* Amsterdam, 1942.

Toledo, cat. 1976
Toledo, Toledo Museum of Art. *Catalogue of European Paintings.* 1976.

Toman 1888a
H. Toman. "Über die Malerfamilie De Heem." *Repertorium für Kunstwissenschaft* 11 (1888), pp. 123-146.

Toman 1888b
—. "J. D. de Heem." *Kunstchronik* 23 (1888), cols. 607-610.

Trautscholdt 1961
E. Trautscholdt. "'De oude Koekebakster': Nachtrag zu Adriaen Brouwer." *Pantheon* 19 (1961), pp. 187-195.

Unger 1884
J. H. W. Unger. "Adriaan Brouwer te Haarlem." *Oud Holland* 2 (1884), pp. 166-69.

Unger 1891
—. "Brieven van eenige schilders aan Constantijn Huygens." *Oud Holland* 9 (1891), pp. 181-206.

Urban 1914
Bruno Urban. *Das Groot Schilderboek des Gerard de Lairesse: Die literarischen Unterlagen zur kunstgeschichtliche Behandlung.* Berlin, 1914.

Utrecht/Antwerp 1952
Utrecht, Centraal Museum. *Caravaggio en de Nederlanden.* 1952. Catalogue by J. G. van Gelder, D. Roggen et al. Also shown at Antwerp, Koninklijk Museum voor Schone Kunsten.

Utrecht/Braunschweig 1991
Utrecht, Centraal Museum. *Jan Davidsz. de Heem en zijn kring.* 16 February-14 April 1991. Catalogue by Sam Segal, with Liesbeth Helmus. Also shown at Braunschweig, Herzog Anton Ulrich-Museum.

Vaes 1924
Maurice Vaes. "Le séjour de Van Dyck en Italie (Mi-Novembre 1621 - Automne 1627)." *Bulletin de l'Institut historique belge de Rome* 4 (1924), pp. 163-234.

Vaes 1926-27
—. "Le Journal de Jean Brueghel II." *Bulletin de l'Institut historique belge de Rome* 6/7 (1926-27), pp. 162-223.

Vaes 1927
—. "L'auteur de la biographie d'Antoine van Dyck de la Bibliothèque du Musée du Louvre." *Bulletin de l'Institut historique belge de Rome* 7 (1927), pp. 139-141.

Valabrègue 1885
Antony Valabrègue. "Jean de Reyn (1610-1678)." *Nouvelles Archives de l'Art Français (Revue de l'Art Français)* ser. 3, vol. 2 (1885), pp. 147-149.

Valabrègue 1887
—. *Notice sur Jean de Reyn.* Dunkirk, 1887.

Valdiveso 1973
E. Valdiveso. "Obras inéditas de Willem van Herp." *Boletín del Semenario de Estudios de Arte y Arqueología, Valladolid* (1973), pp. 487ff.

Valentiner 1912
Willem R. Valentiner. "Gemälde Rubens in Amerika." *Zeitschrift für bildende Kunst* 23 (1912), pp. 181-187, 263-271.

Valentiner 1914
—. *The Art of the Low Countries.* New York, 1914.

Valentiner 1930
—. "A painter's Atelier by Michael Sweerts." *Bulletin of the Detroit Institute of Arts* 12 (1930), pp. 4-6.

Valentiner 1946
—. "Rubens Paintings in America." *The Art Quarterly* 9 (1946), pp. 153-168.

Valentiner 1949
—. "Teniers and Brouwer." *The Art Quarterly* 12 (1949), pp. 89-91.

van de Velde 1992
Carl van de Velde. "In de ban van Caravaggio en Rubens. De Schilder Gerard Seghers." *Belgisch Tijdschrift voor Oudheidkunde en Kunstgeschiedenis* (forthcoming).

van de Velde, Vlieghe 1969
Carl van de Velde, Hans Vlieghe. *Stadsversieringen te Gent in 1635 voor de Blijde Intrede van de Kardinaal-Infante.* Ghent, 1969.

Velge 1913
G. Velge. "Gaspar de Crayer en zijn schilderijen in onze West-Brabantsche Kerken." *Eigen Schoon* 3 (1913), pp. 1-5.

Vergara 1982
Lisa Vergara. *Rubens and the Poetics of Landscape.* New Haven/ London, 1982.

Vergara 1983
—. "Steenwijk, De Momper and Snellinx. Three Painter's Portraits by Van Dyck," in *Essays in Northern European Art Presented to Egbert Haverkamp Begemann* (Doornspijk, 1983), pp. 283-286.

Verkest 1903
M. Verkest. "De Schilders Van Oost, Vader en Zoon." *Kunst* 7, no. 9 (30 June 1903), pp. 61-62.

Vermeersch 1966
V. Vermeersch. "Portret van een Brugse familie." *Openbaar Kunstbezit in Vlaanderen* 4 (1966), pp. 25a-26b.

Vermeylen 1941
A. Vermeylen. "Adriaen Brouwer," in *100 groote Vlamingen: Vlaanderens roem en grootheid in zijn beroemde mannen* (Utrecht, 1941), pp.235-237.

Vermoelen 1865
Jan Vermoelen. *Teniers le Jeune, sa vie, ses œuvres.* Antwerp, 1865.

Verreyt 1901
Ch. C. V. Verreyt. *Jan Roelofszoon en Abraham van Diepenbeeck.* Bergen-op-Zoom, 1901.

Verreyt 1906
—. "De Glas- en Kunstschilders Jan Roelofszn. van Diepenbeeck en Abraham van Diepenbeeck." *Taxandria* 7 (1906), pp. 173-191, 215-232.

Verwoerd 1937
C. Verwoerd. "Michael Sweerts, een Nederlandsche Kunstschilder uit de XVII eeuw Aspirant Broeder Missionaris." *Het Missiewerk* 18 (1937), pp. 166-167.

Vey 1956
Horst Vey. "Anton van Dycks Ölskizzen." *Bulletin des Musées Royaux des Beaux-Arts de Belgique* 5 (1956), pp. 167-208.

Vey 1958
—. *Van Dyck-Studien.* Cologne, 1958.

Vey 1962
—. *Die Zeichnungen Anton van Dycks.* 2 vols. Brussels, 1962.

Vey 1964
—. "Zwei Miniaturgemälde Paul Brils." *Museen in Köln* 3 (1964), pp. 291-295.

Vey 1968
—. "Südniederländische Künstler und ihre Kölnischen Auftraggeber." *Jaarboek van het Koninklijk Museum voor Schone Kunsten, Antwerpen* 1968, pp. 7-32.

Vienna 1977
Vienna, Kunsthistorisches Museum. *Peter Paul Rubens 1577-1640.* Catalogue by W. Prohaska, K. Schütz, et al. 1977.

Vienna, Kunsthistorisches, cat. 1973
Vienna, Kunsthistorisches Museum. *Verzeichnis der Gemälde.* Vienna, 1973.

Vienna, Kunsthistorisches, cat. 1989
Arnout Balis et al. *Flämische Malerei im Kunsthistorischen Museum Wien.* Zurich, 1989.

Vlieghe 1959-60
Hans Vlieghe. *David Teniers II in het Licht der geschreven bronnen.* Ghent, 1959-60.

Vlieghe 1966
—. "David II Teniers (1610-1690) en het Hof van Aartshertog Leopold-Wilhelm en Don Juan van Oostenrijk 1647-1659." *Gentse Bijdragen tot de Kunstgeschiedenis* 19 (1961-66), pp. 123-150.

Vlieghe 1967a
—. "Grisailles van Erasmus Quellien in bloemstukken van Daniel Seghers. Een rechtzetting." *Bulletin des Musées Royaux des Beaux-Arts de Belgique* 16 (1967), pp. 295-301.

Vlieghe 1967b
—. "Nieuwe toeschrijvingen aan Cornelis Schut." *Jaarboek van het Koninklijk Museum voor Schone Kunsten, Antwerpen* 1967, pp. 195ff.

Vlieghe 1967c
—. "Ongepubliceerde documenten over het werk van Caspar de Crayer." *Gentse Bijdragen tot de Kunstgeschiedenis* 20 (1967), pp. 181-191.

Vlieghe 1969-72
—. "Enkele getekende modelli door Cornelis Schut." *Gentse Bijdragen tot de Kunstgeschiedenis* 22 (1969-72), pp. 183-197.

Vlieghe 1971
—. "Zu den römischen Jahren des Malers Cornelis Schut." *Mitteilungen des Kunsthistorischen Instituts in Florenz* 15 (1971), pp. 207-218.

Vlieghe 1972
—. *Gaspar de Crayer, sa vie et ses œuvres.* 2 vols. Brussels, 1972.

Vlieghe 1972-73
—. *Saints. (Corpus Rubenianum Ludwig Burchardt, part VIII)* 2 vols. London, 1972-73.

Vlieghe 1976
—. "Een pastorale door [Gerard Seghers]" *Jaarboek van het Koninklijk*

Museum voor Schone Kunsten, Antwerpen 1976, pp. 297-304.

Vlieghe 1977a
—. "Erasmus Quellinus and Rubens' Studio Practice." *The Burlington Magazine* 119 (1977), pp. 636-643.

Vlieghe 1977b
—. "Rubens en zijn Atelier." *Spiegel Historiael* 6 (1977), pp. 340-347.

Vlieghe 1979-80
—. "Gaspar de Crayer: Addenda et Corrigenda." *Gentse Bijdragen tot de Kunstgeschiedenis* 25 (1979-80), pp. 158-207.

Vlieghe 1983
—. "The Identity of the Painter of the Cardiff Cartoons: A Proposal." *The Burlington Magazine* 125 (1983), pp. 350-356.

Vlieghe 1984
—. "Oelskizzen von Cornelis de Vos," in *Beiträge zur Geschichte der Oelskizze vom 16. bis zum 18. Jahrhundert.* Rudiger Klessmann, ed. (Braunschweig, 1984), pp. 59-70.

Vlieghe 1987a
—. *Rubens Portraits of Identified Sitters Painted in Antwerp (Corpus Rubenianum Ludwig Burchard, part XIX, vol. 2).* London, 1987.

Vlieghe 1987b
—. "Letter: The Cardiff Cartoons: Boeckhorst after All." *The Burlington Magazine* 129 (1987), pp. 598-599.

Vlieghe 1990a
—. "Cornelis Schut in Italië." *The Hoogsteder Mercury* 11 (1990), pp. 28-41.

Vlieghe 1990b
—. "Theodoor Rombout en zijn gezin geportretteerd door van Dyck," in H. Blasse Hegeman et al., eds., *Nederlandse Portretten (Leids Kunsthistorisch Jaarboek 8* [1989]) (The Hague, 1990), pp. 145-157.

van den Vondel 1662
Joost van den Vondel. *Bespiegeling van Godt en Godtdienst.* Amsterdam, 1662.

Voorhelm Schneevoogt 1873
C. G. Voorhelm Schneevoogt. *Catalogue des estampes gravées d'après P. P. Rubens avec l'indication des collections où se trouvent les tableaux et les gravures.* Haarlem, 1873.

Vorenkamp 1933
A. P. A. Vorenkamp. *Bijdrage tot de Geschiedenis van het hollandsche stilleven in de zeventiende eeuw.* Leiden, 1933.

Vos 1726
Jan Vos. *Alle de Gedichten van Jan Vos.* Amsterdam, 1726.

Vroom 1980
N. R. A. Vroom. *A Modest Message as Intimated by the Painters of the "monochrome banketje".* 2 vols. Schiedam, 1980.

de Vuyst 1981
Guy de Vuyst. "Gonzales Coques." Thesis, Rijksuniversiteit Ghent, 1981.

Waagen 1837-39
G. F. Waagen. *Kunstwerke und Künstler in England und Paris.* 3 vols. Berlin, 1837-39.

Waagen 1854-57
—. *Treasures of Art in Great Britain.* 4 vols. London, 1854-57.

Waddingham 1958
M. R. Waddingham. "The Sweerts Exhibition in Rotterdam." *Paragone* 9 (1958), pp. 67-73.

Waddingham 1961
—. "Michael Sweerts in Rome: an Inedited Masterpiece." *Paragone* 12 (1961), pp. 49-50.

Waddingham 1972
—. "An Unrecognised Masterpiece by Michael Sweerts in the Louvre." *Paragone* 23 (1972), pp. 51-54.

Waddingham 1980
—. "Additions to the Œuvre of Michael Sweerts." *J. Paul Getty Museum Journal* 8 (1980), pp. 63-68.

Waddingham 1983
—. "Recently Discovered Paintings by Sweerts." *Apollo* 118 (October 1983), pp. 281-283.

Waddingham 1986
—. "Two Enigmatic Portraits by Michael Sweerts." *Apollo* 124 (August 1986), pp. 95-97.

Walpole 1876
Horace Walpole. *Anecdotes of Painting in England; with Some Account of the Principal Artists.* 3 vols. London, 1876.

Warner 1928
R. Warner. *Dutch and Flemish Fruit and Flower Painters of the 17th and 18th Centuries.* London, 1928. Reprinted, with additions by Sam Segal, Amsterdam, 1975.

Warnke 1965
Martin Warnke. *Kommentare zu Rubens.* Berlin, 1965.

Warnke 1980
—. *Peter Paul Rubens. Life and Work.* Translated by Donna Pedini Simpson. New York, 1980.

Washington 1990-91
Washington, National Gallery of Art. *Anthony van Dyck.* Catalogue by Arthur K. Wheelock, Jr., Susan J. Barnes, Julius S. Held et al. 11 November 1990-24 February 1991.

Washington, cat. 1985
Washington, National Gallery of Art. *European Paintings. An Illustrated Catalogue.* 1985.

Washington/Boston 1989
Washington, National Gallery of Art. *Still Lifes of the Golden Age: Northern European Paintings from the Heinz Family Collection.* 14 May-4 September 1989. Also shown at Boston, Museum of Fine Arts. Catalogue by Ingvar Bergström, Arthur K. Wheelock, Jr., et al.

Wauters 1877
Alphonse Wauters. "Essai historique sur les tapisseries et les tapisseries de haute- et de basse-lice de Bruxelles." *Bulletin des Commissions Royales d'Art et d'Archéologie* 16 (1877), pp. 305-306.

Wauters 1897
—. "David Teniers et son fils, le troisième du nom." *Annales de la Société d'Archéologie de Bruxelles* 11 (1897), pp. 5-40.

Wegner 1967
Wolfgang Wegner. "Zeichnungen Gillis van Coninxloo und seiner Nachfolge." *Oud Holland* 82 (1967), pp. 203-224.

Wellensiek 1954a
Hertha Wellensiek. *Gillis van Coninxloo: Ein Beitrag zur Entwicklung der niederländischen Landschaftsmalerei um 1600.* Diss., Bonn, 1954.

Wellensiek 1954b
—. "Das Brüsseler "Elias-Bild," ein Werk des Gillis van Coninxloo?" *Bulletin des Musées Royaux des Beaux-Arts de Belgique* 3 (1954), pp. 109-116.

Weyerman 1729-69
Jacob Campo Weyerman. *De levens-beschryvingen der Nederlandsche konst-schilders en konst-schilderessen.* 4 vols. The Hague, 1729-69.

White 1987
Christopher White. *Peter Paul Rubens: Man and Artist.* New Haven and London, 1987.

Wiener 1912
Oskar Wiener. "Das Mahler-Buch des Herrn de Lairesse." *Die Kunstwelt* 2 (1912), pp. 437-446.

van den Wijngaert 1940
F. van den Wijngaert. *Inventaris der Rubeniaansche Prentkunst.* Antwerp, 1940.

de Wilde 1967
Eliane de Wilde. "'Stilleven' door Clara Peeters." *Bulletin des Musées Royaux des Beaux-Arts de Belgique* 16 (1967), pp. 35-42.

Wilenski 1960
Reginald Howard Wilenski. *Flemish Painters.* 2 vols. London, 1960.

van der Willigen 1870
Adriaan van der Willigen. *Les Artistes de Haarlem: Notices historiques avec un précis sur la Gilde de St. Luc.* Haarlem, 1870. Reprint Nieuwkoop, 1970.

Willis 1911
Fred C. Willis. *Die niederländische Marinemalerei.* Leipzig, 1911.

Wilmers 1991
Ida Gertrude Wilmers. "The Paintings of Cornelis Schut the Elder (1597-1655)." Diss., Columbia University, New York, 1991.

Wind 1986
Barry Wind. "Adriaen Brower: Philosopher in Fool's Cap." *Source* 5 (1986), pp. 15-19.

Winkelmann-Rhein 1968
G. Winkelmann-Rhein. *Blumen-Brueghel.* Cologne, 1968.

Winkler 1964
F. Winkler. "Der unbekannte Sebastian Vrancx." *Pantheon* 22 (1964), pp. 322-334.

Winner 1961
Matthias Winner. "Zeichnungen des ältern Jan Brueghel." *Jahrbuch der Berliner Museen* 3 (1961), pp. 190-241.

Winner 1972
—. "Neubestimmtes und Unbestimmtes im zeichnerischen Werk von Jan Brueghel d. Ä." *Jahrbuch der Berliner Museen* 14 (1972), pp. 122-160.

Wishnevsky 1967
Rose Wishnevsky. "Studien zum 'portrait historié' in den Niederlanden." Diss., Munich, 1967.

de Wit 1910
Jacobus de Wit. *De Kerken van Antwerpen (schilderijen, beeldhouwwerken, geschilderde glasramen, enz., in de XVIIIe eeuw beschreven door Jacobus de Wit).* Edited and with notes by J. de Bosschere. Antwerp/The Hague, 1910.

Woermann 1888
K. Woermann. "J. D. de Heem." *Repertorium für Kunstwissenschaft* 11 (1888), pp. 344-345.

Worcester 1983-84
Worcester, Worcester Art Museum. *The Collector's Cabinet: Flemish Paintings from New England Private Collections.* 1983-84. Catalogue by James A. Welu.

Worcester/Philadelphia 1939
Worcester, Worcester Art Museum. *The Worcester-Philadelphia Exhibition of Flemish Painting.* 1939. Also shown at Philadelphia, The John G. Johnson Collection at the Philadelphia Museum of Art.

Wright 1974
 Christopher Wright. "A Virgin and Child by Poussin in Brighton."
 The Burlington Magazine 116 (December 1974), pp. 755-756.
Wurzbach 1906-11
 Alfred von Wurzbach. *Niederländisches Künstler-Lexikon auf Grund
 archivalischer Forschungen bearbeitet.* 3 vols. Vienna Leipzig, 1906-11.
Wyss 1987
 Edith Wyss. "An Unexpected Classical Source for Jacob Jordaens."
 Hoogsteder-Naumann Mercury 5 (1987), pp. 29-35.
Zoege von Manteuffel 1915
 Kurt Zoege von Manteuffel. "David Ryckaert III." *Mitteilungen aen
 den sächsichen Kunstsammlungen* 6 (1915), p. 53ff.
Zoege von Manteuffel 1916
 —. "Joos van Craesbeeck." *Jahrbuch der preussischen Kunstsammlungen*
 37 (1916), pp. 315-337.
Zoege von Manteuffel 1921a
 —. "Bilder Flämische Meister in der Galerie des Uffizien zu Florenz."
 Monatshefte für Kunstwissenschaft 1 (1921), pp. 29-49.
Zoege von Manteuffel 1921b
 —. *Das flämische Sittenbild des 17. Jahrhunderts.* Leipzig, 1921.
Zoege von Manteuffel 1927-28a
 —. "Das flämische Landschaftsbild des 16. und 17. Jahrhunderts:
 Ausstellung in der Galerie Dr. Gottschewski & Dr. Schäffer."
 Zeitschrift für bildende Kunst 61 (1927-28), pp. 105-107.
Zoege von Manteuffel 1927-28b
 —. "Die Ausstellung Joos de Momper in der Kunsthalle Chemnitz."
 Zeitschrift für bildende Kunst 61 (1927-28), pp. 90-91.
Zweite 1980
 A. Zweite. *Marten de Vos als Maler.* Berlin, 1980.
Zwollo 1982
 An Zwollo. "Pieter Stevens: Nieuw werk, contact met Jan Brueghel,
 invloed op Kerstiaen de Keuninck." *Leids Kunsthistorisch Jaarboek* 1982,
 pp. 95-118.

Index

TENAFLY PUBLIC LIBRARY
TENAFLY, NJ 07670

TENAFLY PUBLIC LIBRARY
TENAFLY, NJ 07670